THE PELICAN HISTORY OF ART

EDITOR: NIKOLAUS PEVSNER
ASSISTANT EDITOR: JUDY NAIRN

ETRUSCAN AND ROMAN ARCHITECTURE
AXEL BOËTHIUS AND J. B. WARD-PERKINS

Ephesus, Temple of Hadrian, *c.* A.D. 117–25

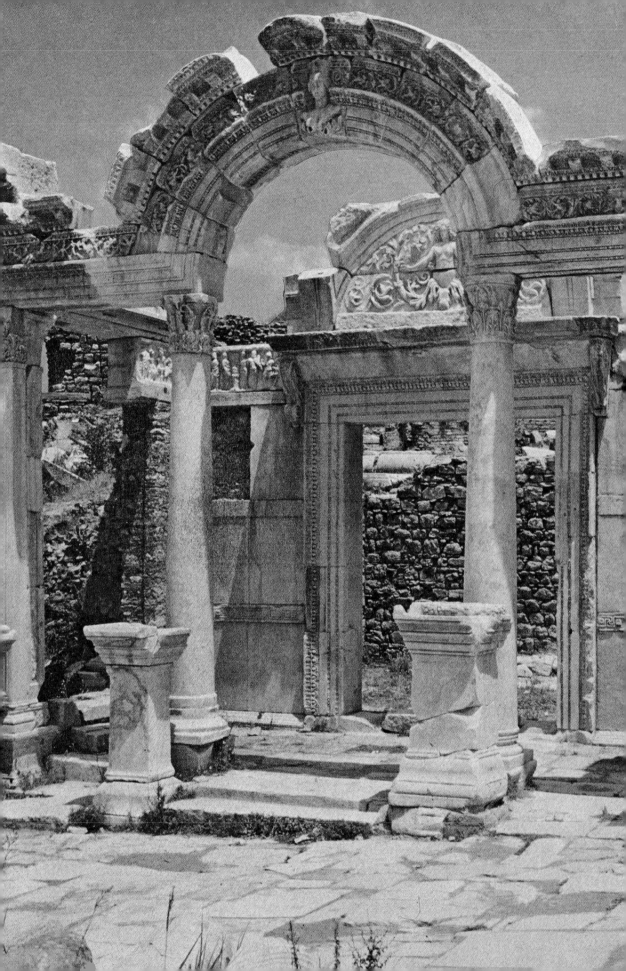

AXEL BOËTHIUS
J. B. WARD-PERKINS

ETRUSCAN AND ROMAN ARCHITECTURE

PUBLISHED BY PENGUIN BOOKS

Penguin Books Ltd, Harmondsworth, Middlesex
Penguin Books Inc., 7110 Ambassador Road, Baltimore, Maryland, 21207, U.S.A.
Penguin Books Australia Ltd, Ringwood, Victoria, Australia

★

Text printed by Richard Clay (The Chaucer Press) Ltd, Bungay, Suffolk
Plates printed by Hunt Barnard & Co. Ltd, Aylesbury
Made and printed in Great Britain

★

★

S B N 14 056032 7

CONTENTS

LIST OF FIGURES ix

LIST OF PLATES xv

FOREWORD xxiii

MAPS xxvii

PART ONE
Architecture in Italy before the Roman Empire
BY AXEL BOËTHIUS

1. THE STONE AND BRONZE AGES 3

2. THE EARLY IRON AGE 13

3. ETRUSCAN ARCHITECTURE 25
 Introduction 25
 Techniques and Materials 27
 Temples 29
 The Early Temples – Types of Plan and Superstructure – Plans – Podia – The Orders – Pediments and Roofs – Ornament – Liturgical Disposition
 Town Planning 56
 Domestic Architecture 63
 Roads and Bridges 77
 Tombs and Cemeteries 77
 Conclusion 82

4. ETRUSCAN ROME 84

5. ROME DURING THE STRUGGLE FOR SUPREMACY IN ITALY (386–about 200 B.C.) 96

6. HELLENIZED ROME 'CONSUETUDO ITALICA' 115
 Techniques and Materials in Public Buildings 116
 Techniques and Materials in Domestic Architecture 118
 Fora 121
 Basilicas 127
 Temples 132
 Ornament – Types of Plan and Superstructure

CONTENTS

Town Planning 148
Domestic Architecture 152
Villas 159
Baths, Theatres, and Other Public Buildings 162
 Baths and Palaestrae – Stadia – Theatres
Utilitarian Architecture 173
Tombs and Cemeteries 175
Conclusion 179

PART TWO

Architecture in Rome and Italy from Augustus to the Mid Third Century

BY J. B. WARD-PERKINS

7. AUGUSTAN ROME 183

8. ARCHITECTURE IN ROME UNDER THE JULIO–CLAUDIAN
 EMPERORS (A.D. 14–68) 202
 Tiberius (A.D. 14–37) 202
 Caligula (A.D. 37–41) 204
 Claudius (A.D. 41–54) 208
 Nero (A.D. 54–68) 211

9. ARCHITECTURE IN ROME FROM VESPASIAN TO TRAJAN (A.D.
 69–117) 217
 Vespasian (A.D. 69–79) 217
 Titus (A.D. 79–81) 224
 Domitian (A.D. 81–96) 226
 Nerva and Trajan (A.D. 96–117) 235

10. MATERIALS AND METHODS: THE ROMAN ARCHITECTURAL
 REVOLUTION 245

11. ARCHITECTURE IN ROME FROM HADRIAN TO ALEXANDER
 SEVERUS (A.D. 117–235) 264
 Hadrian (A.D. 117–38) 264
 Antoninus Pius to Commodus (A.D. 138–93) 267
 The Severan Emperors (A.D. 193–235) 269
 Private Funerary Architecture in the Second Century 275

12. OSTIA 279
 The Early Imperial City 279
 Ostia in the Second and Third Centuries 284

CONTENTS

13. ITALY UNDER THE EARLY EMPIRE 290
 Campania 290
 Northern Italy 301

14. DOMESTIC ARCHITECTURE IN TOWN AND COUNTRY 312
 The Towns 312
 Suburbs and Countryside 318
 The Late Roman Town Houses of Ostia 334

PART THREE
The Architecture of the Roman Provinces
BY J. B. WARD-PERKINS

15. THE EUROPEAN PROVINCES 339
 The Iberian Peninsula 340
 Gaul, Britain, and the Germanies 341
 Central and South-Eastern Europe 363

16. GREECE 369
 Corinth 369
 Athens 378
 Other Roman Sites 384

17. ASIA MINOR 386
 Building Materials and Techniques 386
 The Central Plateau 389
 The Western Coastlands 391
 Pamphylia and Cilicia 406
 The Contribution of Asia Minor to the Architecture of the
 Empire 410

18. THE ARCHITECTURE OF THE ROMAN EAST 412
 Judaea: The Buildings of Herod the Great 414
 Baalbek and the Lebanon 417
 North-West Syria 426
 Damascus 430
 Southern Syria: Petra and the Decapolis 431
 The Hauran 439
 The Mesopotamian Frontier Lands: Dura-Europos and Hatra 447
 Palmyra 453

CONTENTS

19. THE NORTH AFRICAN PROVINCES 458
 Egypt 458
 Cyrenaica 462
 Tripolitania 464
 Tunisia, Algeria, Morocco 479

PART FOUR

Late Pagan Architecture in Rome and in the Provinces

BY J. B. WARD-PERKINS

20. ARCHITECTURE IN ROME FROM MAXIMIN TO CONSTANTINE
 (A.D. 235–337) 497

21. THE ARCHITECTURE OF THE TETRARCHY IN THE PROVINCES 516
 Trier 517
 Thessalonike (Salonica) 522
 Spalato (Split) 524
 Piazza Armerina 529
 North Italy 533
 Constantinople 535

 LIST OF PRINCIPAL ABBREVIATIONS 537

 NOTES 539

 SELECT GLOSSARY 581

 BIBLIOGRAPHY 587

The Plates

INDEX 605

LIST OF FIGURES

1 Tavoliere, near Foggia, settlement. Neo-
lithic. Plan 5
2 Luni, Apennine hut. Bronze Age. Recon-
struction by Jerker Asplund and C. E.
Östenberg 6
3 Luni, Apennine huts. Bronze Age. Plan 7
4 Pantalica, near Syracuse, 'Anaktoron'.
Bronze Age. Plan 9
5 Palmavera, Sardinia, nuraghi. Bronze
Age. Elevation and plan 11
6 Pozzo tomb from the Via Sacra, Rome.
Early Iron Age. *Rome, Antiquarium
Forense* 14
7 Velletri, Vigna d'Andrea, corbel-vaulted
tomb. Early Iron Age. Section 15
8 San Giovenale, huts. Early Iron Age. Plan 17
9 Hut urn from Campofattore, near Marino.
Early Iron Age. *Rome, Museo della Pre-
istoria e Protostoria del Lazio* 18
10 Lid of an archaic stele from Tarquinia.
Early Iron Age. *Florence, Museo Archeo-
logico* 19
11 Volsinii (Bolsena), Poggio Casetta, temple.
Early sixth century B.C. Plan 30
12 Orvieto, Belvedere Temple. Fifth century
B.C. Plan 32
13 Model from Satricum of a temple with
two columns in the pronaus. *Rome, Museo
di Villa Giulia* 33
14 Cippus from Clusium (Chiusi) showing a
temple with two columns in the pronaus
and animals above the pediment. *c. 500*
B.C. *Berlin, Altes Museum* 34
15 Tarquinia, 'Ara della Regina' Temple.
Plan 35
16 Veii, Portonaccio Temple. Plan 36
17 Pyrgi (Santa Severa), temples. Plan 37
18 Sovana, Tomba Ildebranda. Second cen-
tury B.C. Elevation and plan 38
19 Faesulae (Fiesole), temple. Etruscan, re-
built in the first century B.C. Axonometric
plan 39
20 Model of a temple from Velletri. Sixth
century B.C. *Rome, Museo di Villa Giulia* 39
21 Falerii (Civita Castellana), Contrada Celle,
temple. Fourth–third century B.C. Plan 40
22 Rome, Capitoline Temple. Dedicated 509
B.C. Plan by E. Gjerstad and B. Blomé 41

23 Vignanello, tomb with a Tuscan column.
c. 500 B.C. Section and plan 45
24 Cosa, Capitolium. Reconstruction 47
25 Cosa, strigillated sima and cresting 48
26 Terracotta model of a temple roof from
Nemi. *Rome, Museo di Villa Giulia* 49
27 Model of a temple from Satricum. *Rome,
Museo di Villa Giulia* 50
28 Veii, Portonaccio Temple. Reconstruc-
tion. Elevation 53
29 Relief showing the sack of Muṣaṣir,
Urartu. Eighth century B.C. 55
30 Veii, street. Plan 57
31 Vetulonia, street. Plan 57
32 Veii, terraced city wall and substructures.
Before 396 B.C. Section 58
33 Luni, acropolis, mound with a tower at
the eastern end. Early fourth century B.C.
Reconstruction 59
34 Marzabotto, with the acropolis with
temples and altars in the upper left-hand
corner. Founded late sixth century B.C.
Plan 61
35 Pompeii in A.D. 79. North and east quar-
ters laid out between 520 and 450 B.C. Plan 62
36 Veii, house. Elevation 64
37 San Giovenale, Porzarago cemetery,
chamber-tomb. *c. 600* B.C. Section and
plan by B. Blomé 67
38 Perugia (near), Tomb of the Volumnii.
Section and plan 67
39 Tarquinia, Tomba del Cardinale. Interior 68
40 Ardea, tomb. *c. 300* B.C. Interior 69
41 Norchia, tomb with porch. Elevations 69
42 Cinerary urn reproducing the façade of a
common type of house. *Florence, Museo
Archeologico* 70
43 Sovana, gabled tomb with prodomus.
Elevation and section 71
44 Cerveteri (Caere), Banditaccia cemetery,
Tomb of the Greek Vases. Plan 72
45 Pompeii, Casa del Chirurgo. Fourth–
third century B.C. Plan 73
46 Cerveteri (Caere), Tomba del Tablino.
Fifth century B.C. Interior 74
47 Model of an atrium displuviatum from
Clusium (Chiusi). Fourth or third century
B.C. *Berlin, Altes Museum* 75

ix

48 Pompeii, Casa del Fauno in its last period. Second century B.C. (first period). Plan 75

49 Quinto Fiorentino, Montagnola tholos tomb. c. 600 B.C. Section and plans 79

50 The Columna Minucia as reproduced on a coin of the late second century B.C. 80

51 Ardea, remains of the bridge leading over the fossa and of the gate (destroyed c. 1930), with the agger west of the fossa. Sixth–fifth century B.C. Elevation 84

52 Rome, map of the Republican remains 86

53 Fragment of the Forma Urbis Romae, showing three atrium and peristyle houses and the usual rows of shops (tabernae). A.D. 203–11 88

54 Ostia, from the third century to the end of the Republic, plan by I. I. Gismondi 90

55 (A) Minturnae (Minturno), castrum and Late Republican town. Castrum 295 B.C.(?); (B) Pyrgi (Santa Severa), castrum. Third century B.C. Plan 98

56 Pyrgi. Plan 99

57 Ardea, acropolis, terrace wall. c. 300 B.C.(?), the bastion probably dating from the Gothic wars in the sixth century A.D. Elevation and plan 101

58 Via Amerina, bridge. c. 240 B.C. Elevation 102

59 Manziana, Ponte del Diavolo. c. 100 B.C. Elevation and plan 102

60 Failaka (Ikaros), temple and fortification built by Alexander the Great on his march to the East. Plan, somewhat simplified 104

61 Opus incertum 106

62 Rome, Porticus Aemilia(?). 193 B.C., restored in 174 B.C. Axonometric plan 107

63 Rome, Largo Argentina, temples. Temples A and C c. 300 B.C. Plan 109

64 Cosa, Capitolium. c. 150 B.C.; Signia (Segni), Capitolium. Elevations and plans 110

65 (A) Cosa, Temple B; (B) Cosa, Temple D; (C) Cosa, Port Temple; (D) Norba, temple. Last centuries B.C. Elevations and plans 111

66 Paestum, Tempio della Pace. First period c. 270, second period c. 100 B.C.(?). Plan 112

67 Terracina, Via dei Sanniti, tabernae of an insula. Early first century B.C. Elevation 119

68 Pompeii, forum baths. c. 80 B.C. Plan 120

69 Cosa, forum and comitium. Plan and reconstructed section 123

70 Alba Fucens, forum, basilica, and Temple of Hercules. Early first century B.C. Plan 125

71 Ardea, basilica. c. 100 B.C. Plan 129

72 Coin of 59 B.C. showing the Basilica Aemilia as it was after a restoration in 78 B.C. 130

73 Roman temples. (1) Largo Argentina; (2) Jupiter Stator, 146 B.C.; (3) Forum Holitorium. Plans 132

74 Rome, Forum Holitorium, temples. Plan 133

75 Late Republican capitals. (A) Morgan's interpretation of Vitruvius; (B) Tibur (Tivoli), Temple of Vesta; (C) Cora (Cori), Temple of Castor and Pollux 135

76 Gabii, theatre-temple. c. 150 B.C. Plan 139

77 Tibur (Tivoli), Temple of Hercules Victor. c. 50 B.C. Reconstruction 141

78 Praeneste (Palestrina), Temple of Fortuna Primigenia. c. 80 B.C. Axonometric plan 142

79 Praeneste (Palestrina), forum and Temple of Fortuna Primigenia. c. 80 B.C. Section 144

80 Ferentinum, bastion. Second century B.C. (second half). Elevation 147

81 Alba Fucens. Founded c. 300, walls and the final, regular town-plan early first century. Plan 150

82 Pompeii, one of the houses on the south-western slope of Pompeii ('the House of General Championnet'), a second-century atrium-house with additional storeys built against the hillside in the first century B.C. Section 157

83 Rome, Theatre of Marcellus, dedicated in 13 or 11 B.C. Plan, sections, and sectional view 187

84 Rome, the Imperial Fora. Plan 189

85 Rome, restored view of the Temple of Mars Ultor, dedicated in 2 B.C., and part of the Forum Augustum 190

86 Rome, (A) Basilica Aemilia, rebuilt after 14 B.C.; (B) Basilica Julia, rebuilt between c. 12 B.C. and A.D. 12. Plans 193

87 Part of the Severan Marble Plan of Rome, showing the Porticus Divorum, the Temple of Minerva Chalcidica, the Sanctuary of Isis and Serapis, part of the Saepta Julia, the Diribitorium, the Baths of Agrippa, the north end of the group of Republican temples in the Largo Argentina, and the north-east corner of the colonnaded gardens behind the Theatre of Pompey 207

88 Rome, junction of two corridors within Nero's Domus Transitoria, before A.D. 64, later incorporated within the platform of the Temple of Venus and Rome. Plan and sectional view 212

89 Rome, fountain court of Nero's Domus Transitoria, destroyed in A.D. 64 and later incorporated in the substructures of Domitian's Palace. Axonometric view 213

90 Rome, Nero's Golden House, A.D. 64-8. Sketch-plan of the probable extent of the park, showing the known structures 215

91 Rome, Temple of the Deified Claudius (Claudianum), façade of platform, soon after A.D. 70 218

92 Rome, Templum Pacis ('Forum of Vespasian'), 71-9. Restored view 220

93 Rome, Amphitheatrum Flavium (Colosseum), inaugurated in 80. Plans, sections, and sectional view 222

94 Rome, Baths of Titus, inaugurated in 80. Plan, after Palladio 225

95 Rome, Flavian Palace (Domus Augustana), inaugurated in 92. Plan 231

96 Rome, Trajan's Market, c. 100-12. Axonometric view 240

97 Rome, Trajan's Market. Axonometric view 241

98 Rome, Nero's Golden House, 64-8. Octagonal hall. Axonometric view from below, section, and plan 249

99 Rome, Flavian Palace (Domus Augustana), inaugurated in 92. Domed octagonal hall. Sections, plan, and axonometric view from below 252

100 Tivoli, Hadrian's Villa. Plans. (A) Island villa ('Teatro Marittimo'), 118-25; (B) Piazza d'Oro, pavilion, 125-33 255

101 Rome, Pantheon, c. 118-c. 128. Restored view of the façade 257

102 Rome, Pantheon, c. 118-c. 128. Axonometric view and section 258

103 Rome, Temple of Antoninus and Faustina, begun in 141. (A) As shown on a contemporary coin; (B) restored view; (C) as the church of S. Lorenzo in Miranda 268

104 Rome, Baths of Caracalla, 212-16. Plan 272

105 Rome, Vatican Cemetery, Tomb of the Caetennii, mid second century 277

106 Ostia. Plan of a typical quarter, to the south of the forum 280

107 Ostia, theatre and Piazzale of the Corporations. Before 12 B.C., with substantial later modifications. Plan 282

108 Ostia, 'Horrea (granaries) of Hortensius', c. 30-40. Plan 283

109 Ostia. (A) Barracks of the Vigiles, headquarters of the fire brigade, 117-38. Plan;

(B) Horrea Epagathiana, warehouse, c. 145-50. Plan 286

110 Ostia, bath-buildings. Plans. (A) Forum Baths, c. 160; (B) Neptune Baths, 117-38 287

111 Ostia. Façade of an insula with a cookhouse on the ground floor 288

112 Pompeii, forum in course of reconstruction in 79. Plan 293

113 Pompeii, Central Baths, 63-79. Plan 295

114 Pozzuoli (Puteoli), market, first half of second century. Plan 298

115 Pozzuoli (Puteoli), tomb beside the Via Celle, second century. Axonometric view 300

116 Aosta (Augusta Praetoria), laid out in 24 B.C. Plan of the Roman in relation to the modern town 303

117 Turin (Augusta Taurinorum), Porta Palatina, probably early first century. Restored view 304

118 Velleia, forum, early first century. Plan 305

119 Herculaneum, House of the Mosaic Atrium and House of the Stags, shortly before 79. Plan 313

120 Herculaneum, House of the Mosaic Atrium and House of the Stags. The south façade, built out over the old city wall. Elevation and restored view 314

121 Pompeii, house and garden of Loreius Tiburtinus, 62-79. Section and view 315

122 Rome, House on the Esquiline, probably first or second century. Plan after Lanciani 317

123 Pompeii, Villa of the Mysteries. Plans. (A) Second half of the second century B.C.; (B) before the earthquake of A.D. 62 320

124 Francolise, San Rocco Villa, early first century. Plan 321

125 Island of Brioni Grande, villa of Val Catena, first-second century. Plan 322

126 Capri, Villa Jovis, built by Tiberius (14-37). Sections and plan 325

127 Tivoli, Hadrian's villa, between 118 and 134. Plan 329

128 Sirmione, 'Grotte di Catullo', probably early second century. Plan 331

129 Rome, Via Latina, Villa of Sette Bassi, c. 140-60. Restored view of villa and façade 332

130 Ostia. Plans of houses and apartment-houses. (A) House of Fortuna Annonaria, late second century, remodelled in the fourth century; (B) House of Cupid and Psyche, c. 300; (C) House of Diana, c. 150; (D) Garden House, 117-38 335

131 Augst (Augusta Raurica), restored view of the centre of the town, mid second century with later modifications 343
132 Trier (Augusta Treverorum). Plans and elevations of (A) Temple 38 in the Altbachtal sanctuary, second century; (B) Temple of Lenus-Mars, in its latest, classicizing form, third century 350
133 Champlieu, Gallo-Roman sanctuary, c. 200. Plan 352
134 Bath-building at Saint-Rémy (Glanum). Plans. (A) In its original form, second half of the first century B.C.; (B) as reconstructed in the second half of the first century A.D. 354
135 Bath-buildings in Gaul and the Rhineland. (A) North Baths at Saint-Bertrand-de-Comminges (Lugdunum Convenarum), second century. Plan; (B) Verdes, date uncertain (second century?). Plan; (C) Badenweiler, original form of the buildings, probably first half of the second century. Elevation and plan 355
136 Vaison-la-Romaine (Vasio), House of the Silver Bust, later first century. Plan 357
137 Fishbourne, villa. Third quarter of the first century. Plan 359
138 Köln-Müngersdorf, villa, in its fully developed form, third century. Elevation and plan 360
139 Nennig, villa, third century. Restored elevation and plan 361
140 Chedworth, restored view of the villa, c. 300 362
141 Aquincum, ceremonial wing of the Governor's Palace. Ascribed to the early second century. Plan 365
142 Asseria, archway-gate, 112. Restored view 366
143 Doclea, forum and basilica, probably first century, with later modifications. Plan 367
144 Corinth, agora, first–second century. Plan 370
145 Typical Greek and Roman theatres. Plans. (A) Epidaurus, mid fourth century B.C.; (B) Orange (Arausio), first century A.D. 374
146 Stobi, theatre, second century. Elevation and plan 376
147 Athens, Odeion of Agrippa, c. 15 B.C. Elevation and axonometric view 380
148 Pergamon, Sanctuary of Asklepios (Aesculapius), c. 140–75. Plan 394
149 Izmir (Smyrna), agora and basilica, mid second century. Partial plan and restored axonometric view of the north-west angle 396
150 Ephesus, Library of Celsus, completed c. 135. Restored view and plan 398
151 Ephesus, bath-buildings (gymnasia). Plans. (A) Harbour Baths, partial plan, probably late first century, several times remodelled; (B) Baths of Vedius, mid second century; (C) East Baths, early second century, remodelled temp. Severus (193–211) 400
152 Ephesus, Harbour Baths, second-century marble decorative screen. Restored view 401
153 Miletus, fountain-building (nymphaeum), beginning of the second century. Restored view 404
154 Side, fountain, 71. Restored view 407
155 Side. Plans of temples. (A) Small temple beside the theatre, first century; (B) Temple N1, early second century; (C) Apsidal Temple, third century 408
156 Baalbek, sanctuary, begun early first century, completed c. 250. Axonometric view 418
157 Baalbek, Temple of Venus, third century. Plan and axonometric view 422
158 Niha, interior of Temple A, late second century. Restored view 424
159 Kalat Fakra, temple, late first or second century. Restored view 425
160 Seleucia-Pieria, near Antioch. Plan of a Roman house, early third century 427
161 Buildings in North Central Syria. Elevations and plans. (A) House at Taqle, fourth century; (B) house at Banaqfur, first century; (C) bath-building at Brad, third century 429
162 Petra, 'Qasr Fira'un' temple, probably second century. Axonometric view 435
163 Seeia (Si'), Sanctuary of Ba'alshamin, late first century B.C., and South Temple, late first century A.D. Plans and elevations 440
164 Bath-buildings in Syria. Plans. (A) Bostra, South Baths, probably third century; (B) Antioch, Bath C, rebuilt in the fourth century following the second-century plan 444
165 Bostra, 'Basilica', probably third century. Elevation and plan 445
166 Umm el-Jemal, house, third–fourth century. Elevation, plan, and section 446
167 Dura-Europos, bazaar quarter occupying the site of the hellenistic agora, mid third century 448
168 Dura-Europos, Temple of the Palmyrene Gods, built into an angle of the city walls. (A) Plans, first and early third centuries; (B) restored view, early third century 450

169 Dura-Europos, Palace of the Dux Ripae, first half of the third century. Axonometric view 452
170 Palmyra, Temple of Bel, dedicated in 32. (A) Axonometric view and (B) plan 454–5
171 Cyrene, Caesareum, second half of the first century B.C. Plan. The basilica is a modification of the first century A.D., the central temple an addition of the second century 460
172 Ptolemais, 'Palazzo delle Colonne'. Probably first half of the first century. Axonometric view 463
173 Lepcis Magna, Old Forum. Laid out in the second half of the first century B.C. and developed principally during the first century A.D. Plan 466
174 Lepcis Magna, market, 8 B.C. Restored view 468
175 Theatres in Tripolitania. (A) Lepcis Magna, A.D. 1–2; (B) Sabratha, last quarter of the second century 470
176 (A) Lepcis Magna, Hunting Baths, late second or early third century. Axonometric view; (B) Thenae, baths, second–third century. Plan 474
177 Lepcis Magna, temple in honour of the Severan family, c. 216. Restored view 476
178 Lepcis Magna, Severan Forum and Basilica, dedicated in 216. Plan 476
179 Lepcis Magna, Severan Basilica, dedicated in 216. Restored view 477
180 Thamugadi (Timgad), forum, 100. Plan 480
181 North Africa, market buildings. Plans. (A) Hippo Regius (Hippone), date uncertain; (B) Cuicul (Djemila), Market of Cosinius, second century; (C) Thamugadi (Timgad), Market of Sertius, third century 482
182 Thamugadi (Timgad), bath-buildings. Plans. (A) South Baths, mid second century; (B) North Baths, third century 484
183 Cuicul (Djemila), bath-buildings, 183. Plan 485
184 Carthage, Antonine Baths, 143. Plan 486
185 (A) Volubilis, House of Venus, mid third century. Plan; (B) Althiburos, House of the Muses, second century. Plan 488
186 Tipasa, house overlooking the sea, third century. Plan 489
187 North Africa, temples. (A) Thuburbo Maius, Temple of the Cereres, first century. Plan; (B) Gigthis, Temple A (Capitolium?), second century. Plan; (C) Lambaesis, temple dedicated in 162 to Aesculapius and a group of other divinities. Elevation and plan 492
188 Rome, Porta Appia, as originally constructed, 275–80. Elevation 498
189 Rome, Temple of the Sun (Sol), 275–80. Plan, after Palladio 499
190 Rome, Baths of Diocletian, c. 298–305/6. Plan 501
191 Rome, Mausoleum of Tor de' Schiavi, c. 300. (A) View and plan, after Durm; (B) possible alternative reconstruction of façade 504
192 Rome, Basilica of Maxentius. Reconstructed view of the interior as originally planned by Maxentius (307–12) 506
193 Rome, Baths of Constantine, c. 320. Plan, after Palladio 508
194 Rome, pavilion in the Licinian Gardens ('Temple of Minerva Medica'), early fourth century. Plan 510
195 Trier, Basilica, early fourth century. (A) Reconstructed view of exterior; (B) plan 519
196 Trier, S. Irminio Warehouses, early fourth century. Elevation 520
197 Trier, Imperial Baths ('Kaiserthermen'), early fourth century. Restored view and plan 521
198 Thessalonike (Salonica), Mausoleum of Galerius and monumental approach to it, including the Arch of Galerius across the main colonnaded street of the city. Before 311. Restored view 522
199 Thessalonike (Salonica), Mausoleum of Galerius (church of St George). Mainly before 311, but dome completed later. Section and plan 523
200 Spalato (Split), Palace of Diocletian, c. 300–6. Plan 525
201 Spalato (Split), Porta Aurea, c. 300–6. Restored view 528
202 Piazza Armerina, villa, probably of Maximian, early fourth century. Axonometric view 530
203 Portus Magnus, near Oran, villa, c. 300. Plan 532
204 Desenzano, part of a rich villa, fourth century. Plan 534

LIST OF PLATES

Where not otherwise indicated, copyright in photographs belongs to the museum in which objects are located, by whose courtesy they are reproduced.

Frontispiece: Ephesus, Temple of Hadrian, *c.* A.D. 117–25 (R. H. Tilbrook)

1 Su Nuraxi di Barumini, Sardinia, nuraghe, dating from *c.* 1500 B.C. and onwards (Fotocielo, Rome)

2 San Giovenale, remains of the Early Iron Age village (*San Giovenale*, figure 265)

3 Hut urn from Castel Gandolfo, Early Iron Age. *Museo della preistoria e protostoria di Lazio* (P. G. Gierow, *The Iron Age Culture of Latium*, figure 204, 1)

4 Square hut urn from Tarquinia, Early Iron Age. *Florence, Museo Archeologico* (Soprintendenza Antichità)

5 Implements from tomb no. 63 at S. Antonio, Sala Consilina, with ash urn and model of a house, Early Iron Age (Oenotrio–Ausonian). *Salerno, Museo Provinciale*

6 Relief from Aquileia showing the foundation of a colonia. Imperial Age. *Aquileia, Museo Archeologico*

7 Reconstruction by A. Davico of part of the Early Iron age hut settlement on the Palatine, Rome (Courtesy A. Davico)

8 Rome, foundations of a hut in the Early Iron Age village on the south-west side of the Palatine (United Press, Albert Blasetti 1954)

9 Faliscan ash urn, seventh century B.C. *Rome, Museo di Villa Giulia*

10 Hut urn from the cemetery at Monte Abatone, sixth century B.C. *Rome, Museo di Villa Giulia* (Soprintendenza Roma II)

11 Model of a temple from Teano, Late Republican (Soprintendenza alle Antichità, Naples)

12 Reconstruction of an Etruscan temple as described by Vitruvius (IV, 7). *Rome University, Istituto di Etruscologia e di Antichità Italiche*

13 Model of a temple from Vulci, Late Republican. *Rome, Museo di Villa Giulia*

14 Rome, Temple C on the Largo Argentina, late fourth century B.C., podium (Fototeca Unione, Rome)

15 Caere (Cerveteri), Banditaccia cemetery, podium of a tumulus, sixth century B.C. (Fototeca Unione, Rome)

16 Caere (Cerveteri), Banditaccia cemetery, Late Etruscan tomb with Tuscan column (J. Felbermeyer)

17 Capital of a temple on the Forum Boarium, Rome, sixth–fifth centuries B.C. *Rome, Palazzo dei Conservatori* (Filippo Reale)

18 Caere (Cerveteri), Banditaccia cemetery, Tomb of the Doric Columns, sixth century B.C. (Josephine Powell)

19 San Giuliano, Tomb of Princess Margrete of Denmark, Doric capitals, sixth century B.C. (*San Giovenale*)

20 Norchia, tombs with temple façades, third century B.C. (Josephine Powell)

21 Gabii, temple, late third century B.C., podium with benches for statues along the sides and back (J. Felbermeyer)

22 Roof of temple model with rectangular pantiles and semi-cylindrical cover tiles with antefixes. *Rome, Museo di Villa Giulia*

23 Ridge-pole revetment from a temple at Fratte, fourth century B.C. *Salerno, Museo Provinciale*

24 Antefix from Ardea, *c.* 500 B.C. *Rome, Museo di Villa Giulia* (Courtesy Professor Arvid Andrén)

25 San Giovenale, Etruscan wall of the early fourth century B.C. below the thirteenth-century castle (Fototeca Unione, Rome)

26 Luni, walls, early fourth century B.C. (C. E. Östenberg)

27 Orvieto, street in the Necropoli di Crocefisso del Tufo, begun sixth century B.C. (Professor M. Bizzarri)

28 Caere (Cerveteri), Banditaccia cemetery, air view, showing tombs of Early and Late Etruscan date (*c.* 650–100 B.C.) (Fotocielo, Rome)

29 Marzabotto, founded *c.* 500 B.C., the acropolis hill and part of the town, showing a street with a drain in front of typical quarters (Soprintendenza, Bologna)

30 Relief from Clusium (Chiusi) showing wooden scaffolding for spectators and umpires of games, fifth century B.C. *Palermo, Museo Nazionale*

31 San Giovenale, houses of *c.* 600 B.C. on the northern side (*San Giovenale*)

32 San Giovenale, House K in the western quarter, bedroom, *c.* 600 B.C. (J. Felbermayer)

33 Caere (Cerveteri), Tomb of the Thatched Roof, late seventh century B.C. (Alterocca, Terni)

34 San Giovenale, chamber tomb with lintel, sixth century, B.C. (Ab Allhem, Malmö)

35 Caere (Cerveteri), Banditaccia cemetery, Tomba dei Capitelli, *c.* 500 B.C.

36 Caere (Cerveteri), Banditaccia cemetery, Tomba della Cornice, *c.* 500 B.C. (Alterocca, Terni)

37 Caere (Cerveteri), Banditaccia cemetery, Tomba dell'Alcova, third century B.C. (Alterocca, Terni)

38 Luni, Tomb of the Caryatids, Second Pompeiian Style, *c.* 100 B.C. (C. E. Östenberg)

39 Model of Late Etruscan tombs built into the hillside at San Giuliano (Courtesy the municipality of Barbarano)

40 Ash urn with arched door from Chiusi, Late Etruscan. *Florence, Museo Archeologico* (Soprintendenza Antichità)

41 The entrance to the underworld on a Late Etruscan ash urn. *Florence, Museo Archeologico* (Soprintendenza Antichità)

42 Caere (Cerveteri), Regolini Galassi tomb, *c.* 650 B.C. (Alinari)

43 Caere (Cerveteri), Tomba di Mercareggia, Late Etruscan atrium displuviatum (J. Byres, *Hypogaei or Sepulchral Caverns*)

44 Ostia, peristyle, Late Republican (Fototeca Unione, Rome)

45 Tomb of the Volumnii near Perugia, second century B.C. (Alinari)

46 Tarquinia, Tomba Giglioli, second century B.C. (Fondazione Lerici, courtesy M. Moretti, Soprintendenza alle Antichità dell'Etruria Meridionale)

47 Tholos tomb from Casal Marittimo, *c.* 600 B.C., reconstructed. *Florence, Museo Archeologico* (Alinari)

48 Model of a Late Etruscan tomb with a round façade in the valley at San Giuliano (Courtesy the municipality of Barbarano)

49 San Giuliano, tomb façades after 400 B.C. (Courtesy the municipality of Barbarano)

50 San Giuliano, 'Tomba della Regina', Late Etruscan (Courtesy Professor Å. Åkerström)

51 Luni, Tomb of the Caryatids, false door and entrance below the door, Late Etruscan (C. E. Östenberg)

52 Ardea, air view (Aerofototeca, Ministero della Pubblica Istruzione, Rome)

53 Ardea, agger, sixth–fifth centuries B.C., with the road in the centre (J. Felbermeyer)

54 Pompeii, Strada dei Teatri, row of tabernae (Josephine Powell)

55 Rome, old Via Sacra and Clivus Palatinus, after 390 B.C., in front of the Arch of Titus (Josephine Powell)

56 Terracotta revetment from the Forum Romanum, sixth century B.C. *Rome, Soprintendenza Foro Romano e Palatino*

57 Signia (Segni), gate in the wall, fourth century B.C. (?) (Josephine Powell)

58 Arpinum, corbelled gate, 305 B.C. (Fototeca Unione, Rome)

59 Norba (Norma), walls and gate, fourth century B.C. (second half) (Josephine Powell)

60 Cosa, city gate, with door chamber inside the wall, 273 B.C. (Fototeca Unione, Rome)

61 Alatrium (Alatri), terrace wall, third century B.C. (Josephine Powell)

62 Signia (Segni), temple, terrace, probably fifth century B.C. (Josephine Powell)

63 Rome, 'Servian Wall' at the Aventine, begun 378 B.C., rebuilt with an arch for catapults in 87 B.C. (Wahlgren)

64 S. Maria di Falleri, gate, 241–200 B.C. (Josephine Powell)

65 Sarcophagus from the Via Cristoforo Colombo, third century B.C. *Rome, Palazzo dei Conservatori*

66 Pompeii, a typical Late Republican atrium (Josephine Powell)

67 Rome, 'Temple of Vesta' on the Tiber, first century B.C. (first half) (?) (Fototeca Unione, Rome)

68 Rome, building on the south side of the Palatine, the left-hand arch Late Republican (Josephine Powell)

69 Pompeii, forum baths, staircase and corridor to the baths, *c.* 80 B.C. (Josephine Powell)

70 Pompeii, Via dell'Abbondanza, houses with porticoes (cenacula) on the second floor, built and rebuilt during the last centuries of Pompeii (Fototeca Unione, Rome)

71 Rome, Porticus Aemilia, begun 193 and restored 174 B.C. (?), before the modern buildings on the site (Fototeca Unione, Rome)

72 Rome, Tabularium, 78 B.C. (Fototeca Unione, Rome)

73 Pompeii, basilica, *c.* 120 B.C. (?) (Josephine Powell)

74 Tibur (Tivoli), Temple of Hercules Victor, Late Republican, western façade of terrace (Fototeca Unione, Rome)

75 Rome, Forum Holitorium, Late Republican portico on the eastern side (Fototeca Unione, Rome)

76 Rome, Temples A and B on the Largo Argentina, *c.* 100 B.C. and mid second century B.C. (Fototeca Unione, Rome)

77 Rome, 'Temple of Fortuna Virilis' on the Tiber, second century B.C. (second half) (?) (Fototeca Unione, Rome)

78 Cori, Temple of Hercules, late second century B.C. (Fototeca Unione, Rome)

79 Relief of the Imperial Age, probably representing the Temple of Juno Moneta on the Arx in Rome, dedicated 374 B.C. *Ostia, Museum* (Fototeca Unione, Rome)

80 Tibur (Tivoli), tetrastyle temple, seond century B.C. (second half) (?) (Fototeca Unione, Rome)

81 Reconstruction of the Temple of Jupiter Anxur at Terracina, *c.* 80 B.C. *Excavations Museum* (Soprintendenza, Rome)

82 Gabii, theatre temple, second century B.C. (?) (J. Felbermeyer)

83 Tibur (Tivoli), 'Temple of Vesta', early first century B.C. (Fototeca Unione, Rome)

84 Praeneste (Palestrina), general view (Soprintendenza, Rome)

85 Praeneste (Palestrina), curia, with aerarium on the left, *c.* 80 B.C. (Fototeca Unione, Rome)

86 Praeneste (Palestrina), Corinthian above Doric portico in front of the basilica behind the temple, *c.* 80 B.C. (J. Felbermeyer)

87 Praeneste (Palestrina), basilica, *c.* 80 B.C., north wall (Fototeca Unione, Rome)

88 Terracina, Temple of Jupiter Anxur, *c.* 80 B.C., terrace (Alterocca, Terni)

89 Pompeii, Villa dei Misteri, *c.* 200 B.C., basis villae (podium) (Fototeca Unione, Rome)

90 Ferentinum (Ferentino), acropolis, bastion added in the second century B.C. (second half) (Fototeca Unione, Rome)

91 Ferentinum (Ferentino), Porta Sanguinaria, second century B.C. (Alterocca, Terni)

92 Ferentinum (Ferentino), Porta Maggiore or 'di Casamari', *c.* 80–70 B.C. (J. Felbermeyer)

93 Ostia, Late Republican temple on the lower level (next to the Temple of Hercules), with stuccoed tufa columns and opus incertum

94 Pompeii, Casa del Chirurgo, fourth or third century B.C. (Fototeca Unione, Rome)

95 Early Imperial Age paintings from Pompeii showing terraced villas by the sea (German Archaeological Institute, Rome)

96 Cosa, villa, second century B.C. (Fototeca Unione, Rome)

97 Terracotta model of a stage building, *c.* 300 B.C. *Naples, Museo Nazionale* (Soprintendenza, Naples)

98 Ferentinum (Ferentino), Via Latina, market hall, *c.* 100 B.C. (Alterocca, Terni)

99 Pompeii, amphitheatre, after 80 B.C. (Fototeca Unione, Rome)

100 Agrigento, 'Tomb of Theron', hellenistic (H.M. the King of Sweden)

101 Tomb of S. Sulpicius Galba, consul of 108 B.C. (Fototeca Unione, Rome)

102 Rome, Capitoline Hill, tomb of C. Poplicius Bibulus, hellenistic (Fototeca Unione, Rome)

103 Rome, Via Appia, tumuli, from the south, with the Late Republican 'Tumulo degli Orazi e dei Curiazi' (Fototeca Unione, Rome)

104 Rome, Forum Romanum seen from the Palatine (Fototeca dell'Unione, Rome)

105 Rome, Theatre of Marcellus, dedicated in 13 or 11 B.C. Part of the outer façade (Fototeca dell'Unione, Rome)

106 Rome, Temple of Mars Ultor, dedicated in 2 B.C., and part of the Forum Augustum (Fototeca dell'Unione, Rome)

107 (A) Coin of Augustus showing the Senate House (Curia), as restored in 44–29 B.C. (Fototeca dell'Unione, Rome)
(B) Coin of Caligula, A.D. 37, showing an Ionic temple, usually identified as that of the Deified Augustus (Fototeca dell'Unione, Rome)
(C) Coin of Vespasian depicting the Temple of Jupiter Optimus Maximus Capitolinus, rebuilt after A.D. 70, rededicated in 75, and again destroyed in 80 (Fototeca dell'Unione, Rome)
(D) Rome, coin of Alexander Severus, depicting Elagabalus's Temple of Sol Invictus, A.D. 218–22, after its rededication to Juppiter Ultor (Fototeca dell'Unione, Rome)

108 Rome, Forum Augustum, *c.* 10–2 B.C., caryatid order from the flanking colonnades (Comune di Roma, Ripartizione X)

109 Rome, Temple of Mars Ultor, dedicated in 2 B.C., capital (Comune di Roma, Ripartizione X)

110 Rome, Temple of Apollo Sosianus, *c.* 20 B.C., frieze from the interior of the cella (Comune di Roma, Ripartizione X)

111 Rome, Basilica Aemilia, rebuilt after 14 B.C. Drawing by Giuliano da Sangallo (Fototeca dell'Unione, Rome)

112 Relief, probably from the Ara Pietatis Augustae, dedicated in A.D. 43, depicting the façade of the Temple of Magna Mater on the Palatine, restored after A.D. 3 (German Archaeological Institute, Rome)

113 Rome, Temple of Concord, dedicated in A.D. 10. Restored marble cornice block, now in the Tabularium (Fototeca dell'Unione, Rome)

114 Rome, Castra Praetoria, the north outer wall (Fototeca dell'Unione, Rome)

115 Rome, Porta Maggiore (Fototeca dell'Unione, Rome)

116 Rome, the Porta Labicana and Porta Praenestina of the Aurelianic Walls (A.D. 270–82; modified by Honorius, A.D. 403), incorporating the Claudian archway at the Porta Maggiore. Drawing by Rossini, 1829 (Fototeca dell'Unione, Rome)

117 Rome, archway of rusticated travertine, A.D. 46, carrying the restored Aqua Virgo. Engraving by Piranesi (Fototeca dell'Unione, Rome)

118 Rome, Underground Basilica beside the Via Praenestina, mid first century A.D. (Fototeca dell'Unione, Rome)

119 Pompeii, Forum Baths, stucco decoration of vaulting (Gabinetto Fotografico Nazionale)

120 Rome, Porta Tiburtina. Arch, 5 B.C., carrying the Aqua Marcia across the Via Tiburtina, later incorporated as a gateway into the Aurelianic Walls (A.D. 270–82) (Gabinetto Fotografico Nazionale)

121 Rome, Amphitheatrum Flavium (Colosseum), inaugurated in 80 (Leonard von Matt)

122 Rome, Temple of the Deified Claudius (Claudianum), completed by Vespasian after 70. The rusticated travertine upper arcades of the west façade of the temple terrace (Professor Adriano Prandi)

123 Rome, Flavian Palace (Domus Augustana), inaugurated in 92. The courtyard of the domestic wing (Fototeca dell'Unione, Rome)

124 Rome, Temple of Venus Genetrix, rebuilt by Trajan and dedicated in 113. Marble cornice block from the pediment (Fototeca dell'Unione, Rome)

125 Rome, Tomb of Annia Regilla, third quarter of the second century. Detail of moulded brick entablature (Mr A. Davidson)

126 Rome, Forum Transitorium (Forum of Nerva), dedicated in 97. 'Le Colonnacce', part of the decorative façade towards the Templum Pacis (Fototeca dell'Unione, Rome)

127 Rome, Trajan's Market, c. 100–12, façade of the lower hemicycle (Fototeca dell'Unione, Rome)

128 Rome, Trajan's Market, c. 100–12 (Fototeca dell'Unione, Rome)

129 Rome, Trajan's Market, c. 100–12. Interior of the market hall (Fototeca dell'Unione, Rome)

130 Rome, Nero's Golden House, 64–8. Octagonal fountain hall (Fototeca dell'Unione, Rome)

131 Rome, Pantheon, c. 118–c. 128, façade (A. F. Kersting)

132 Rome, Pantheon, c. 118–c. 128, interior (after Panini) (National Gallery of Art, Washington, D.C., Samuel H. Kress Collection)

133 Rome, Pantheon, c. 118–c. 128, interior (Leonard von Matt)

134 Tivoli, Hadrian's Villa. The island villa ('Teatro Marittimo'), 118–25 (Fototeca dell'Unione, Rome)

135 Tivoli, Hadrian's Villa. The island villa ('Teatro Marittimo')

136 Tivoli, Hadrian's Villa. The Canopus, after 130 (German Archaeological Institute, Rome)

137 Tivoli, Hadrian's Villa. Vestibule to the Piazza d'Oro, after 125 (Mansell Collection)

138 Rome, Via Latina, painted stucco vaulting in the Mausoleum of the Anicii, second century (Anderson, Rome)

139 Rome, Vatican cemetery, Tomb of the Caetennii, mid second century, interior (Reverenda Fabbrica di S. Pietro)

140 Rome, Mausoleum of Constantina ('Santa Costanza'), second quarter of the fourth century (Alinari)

141 Rome, Baths of Caracalla, 212–16 (Alinari)

142 Rome, Baths of Caracalla, 212–16, north façade of the central block (Fototeca dell'Unione, Rome)

143 Rome, Septizodium, dedicated in 203. Drawn by Martin van Heemskerk between 1532 and 1536 (Fototeca dell'Unione, Rome)

144 Fragment of the Severan Marble Map of Rome, showing part of the Aventine Hill with the Temples of Diana Cornificia, restored under Augustus, and of Minerva (Fototeca dell'Unione, Rome)

145 Fragment of the Severan Marble Map of Rome, showing three old-style atrium–peristyle houses, rows of shops and street-front

porticoes, a flight of steps leading up to a pillared hall (warehouse?) with internal shops or offices, and a porticoed enclosure with a central garden (Fototeca dell'Unione, Rome)

146 Rome, Via Appia, Tomb of Annia Regilla, wife of Herodes Atticus, third quarter of the second century (Dr Lorenzo Quilici)

147 Ostia, Capitolium, c. 120 (Fototeca dell'Unione, Rome)

148 Ostia, House of Diana, mid second century. South façade (Fototeca dell'Unione, Rome)

149 Ostia, House of the Triple Windows, third quarter of the second century (Fototeca dell'Unione, Rome)

150 Ostia, House of the Charioteers, shortly before 150. Central courtyard (J. B. Ward-Perkins)

151 Ostia, 'House of the Lararium', second quarter of the second century (Fototeca dell'Unione, Rome)

152 Ostia, Horrea Epagathiana, c. 145-50. West façade (Fototeca dell'Unione, Rome)

153 Ostia, south-western decumanus, looking towards the Porta Marina, second quarter of the second century (Fototeca dell'Unione, Rome)

154 Ostia, row of shops (Regio IX, insula 15), mid second century (J. B. Ward-Perkins)

155 Pompeii, south end of the forum, looking across to the Building of Eumachia (Fotocielo, Rome)

156 Morgantina, market building, second century B.C. (Fototeca dell'Unione, Rome)

157 Pompeii, Central Baths, façade of the main wing, 63-79 (Fototeca dell'Unione, Rome)

158 Herculaneum, streetside portico with timber-framed superstructure, before 79 (Fototeca dell'Unione, Rome)

159 Pompeii, 'Third Style' architectural wall paintings in the House of Lucretius Fronto, mid first century (Anderson, Rome)

160 Pompeii, painting of a seaside villa with projecting wings and porticoed façade from the House of Lucretius Fronto, mid first century (Fototeca dell'Unione, Rome)

161 Baiae, 'Temple of Venus', second quarter of the second century (Fototeca dell'Unione, Rome)

162 Susa, Arch of Augustus, 9-8 B.C. (Alinari)

163 Brescia (Brixia), model of the Capitolium, third quarter of the first century

164 Santa Maria Capua Vetere (Capua), mausoleum ('Le Carceri Vecchie') beside the Via Appia, probably first half of the second century (Fototeca dell'Unione, Rome)

165 Santa Maria Capua Vetere (Capua), mausoleum ('La Connocchia') beside the Via Appia, second half of the second century (Fototeca dell'Unione, Rome)

166 Verona, Porta dei Borsari, probably third quarter of the first century (Alinari)

167 Velleia, forum and basilica, early first century, from the air (General Giulio Schmiedt)

168 Rimini (Ariminum), bridge, 22 (Fototeca dell'Unione, Rome)

169 Ancona, Arch of Trajan, 115 (Fototeca dell'Unione, Rome)

170 Capri, Villa Jovis, the private, mountain-top retreat built by the emperor Tiberius (14-37) (Allhem Publishers, Malmö, Sweden; photo H. Hammer)

171 Herculaneum, the southern garden verandas of the House of the Stags and the House of the Mosaic Atrium, shortly before 79 (Fototeca dell'Unione, Rome)

172 Herculaneum, House of the Mosaic Atrium, the internal courtyard, shortly before 79 (Fototeca dell'Unione, Rome)

173 Pompeii, House of Loreius Tiburtinus, 62-79 (Fototeca dell'Unione, Rome)

174 Tivoli, Hadrian's Villa, between 118 and 134, model (German Archaeological Institute, Rome)

175 Rome, Via Latina, Villa of Sette Bassi, c. 140-60, façade (from a photograph taken by Rodolfo Lanciani early in the century)

176 Ostia, House of Cupid and Psyche, c. 300 (Fototeca dell'Unione, Rome)

177 Segovia, aqueduct, variously dated to the early first and to the early second century (A. F. Kersting)

178 Alcántara, bridge over the Tagus, 106 (German Archaeological Institute, Madrid)

179 Pont du Gard, carrying the aqueduct of Nîmes over the river Gardon, late first century B.C. (Fototeca dell'Unione, Rome)

180 Saint Rémy (Glanum), courtyard house, first half of the first century (J. B. Ward-Perkins)

181 Vaison-la-Romaine (Vasio), street and streetside portico, later first century (J. B. Ward-Perkins)

182 Lyon (Lugdunum), theatre and odeion, Hadrianic (117-38), the former enlarging and embellishing a building of the end of the first century B.C. (H. Rutter, Lyon)

183 Autun (Augustodunum), model of the Porte Saint-André, after 16 B.C. (Mansell Collection)

184 Nîmes (Nemausus), Maison Carrée, begun *c.* 19 B.C. (Fototeca dell'Unione, Rome)

185 Nîmes (Nemausus), amphitheatre, second half of the first century A.D. (Arts Photomécaniques, Paris)

186 Arles (Arelate), amphitheatre, second half of the first century A.D. (Fototeca dell'Unione, Rome)

187 Saint Rémy (Glanum), arch and monument of the Julii, second half of the first century B.C. (J. B. Ward-Perkins)

188 Orange (Arausio), monumental arch, built shortly after 21 (A. F. Kersting)

189 Ditchley, Roman villa and its dependencies revealed by air photography. *c.* 100 (Ashmolean Museum)

190 Magdalensberg, unfinished temple of Claudius and part of the forum (Fototeca dell'Unione, Rome)

191 Autun (Augustodunum), temple of square Celtic type known as 'the Temple of Janus', second century (Foto Marburg)

192 Athens, capital from the Odeion of Agrippa, *c.* 15 B.C. (J. B. Ward-Perkins)

193 Eleusis, capital from the Inner Propylaea, *c.* 50-40 B.C. (J. B. Ward-Perkins)

194 Athens, part of the façade of the Library of Hadrian (117-38) (Alison Frantz, Athens)

195 Athens, Arch of Hadrian, probably erected shortly after his death in 138 (Alison Frantz, Athens)

196 Lepcis Magna, north-east forum portico, early third century (J. B. Ward-Perkins)

197 Athens, Tower of the Winds, towards the middle of the first century B.C. (Alison Frantz, Athens)

198 Ephesus, Baths of Vedius, mid second century. Detail of the coursed rubble masonry (J. B. Ward-Perkins)

199 Miletus, Baths of Capito, mid first century (J. B. Ward-Perkins)

200 Aspendos, pitched brick vaulting in the substructures of the basilica, end of the third century (Dr M. H. Ballance)

201 Ephesus, aqueduct of Pollio, between 4 and 14 (J. B. Ward-Perkins)

202 Nicaea (Iznik), city walls, between 258 and 269 (German Archaeological Institute, Rome)

203 Ancyra (Ankara), Temple of Rome and Augustus (*temp.* Augustus, 27 B.C.-A.D. 14) (A. F. Kersting)

204 Aizani, Temple of Zeus, completed *c.* 125 (Dr Michael Gough)

205 Pergamon, Serapaeum, central hall, beginning of the third century (J. B. Ward-Perkins)

206 Pergamon, Sanctuary of Asklepios (Aesculapius), between 140 and 175, partly subterranean rotunda at the south-east corner (J. B. Ward-Perkins)

207 Ephesus, theatre, restored and enlarged in the second half of the first century, and Arkadiané (colonnaded street), fourth century (J. B. Ward-Perkins)

208 Ephesus, Harbour Baths, part of the late-second-century bath-building (J. B. Ward-Perkins)

209 Ephesus, Library of Celsus, completed *c.* 135 (J. B. Ward-Perkins)

210 Aspendos, theatre, second century (J. B. Ward-Perkins)

211 Ephesus, Library of Celsus, restored model (Mansell Collection)

212 Perge, South Gate (Augustan?), remodelled into a nymphaeum between 117 and 122 (J. B. Ward-Perkins)

213 Aspendos, one of the two pressure-towers of the third-century aqueduct (J. B. Ward-Perkins)

214 Attaleia (Antalya), mausoleum overlooking the harbour, first century (J. B. Ward-Perkins)

215 Pergamon, Sanctuary of Asklepios (Aesculapius), typical 'marble-style' Corinthian capital of the mid second century (J. B. Ward-Perkins)

216 Lepcis Magna, capital from the Severan Forum, early third century (J. B. Ward-Perkins)

217 Masada, 'Hanging Palace', before 4 B.C. (Yigael Yadin, the Masada Expedition, Israel)

218 Kalat Fakra, altar, first century B.C. or A.D. (J. B. Ward-Perkins)

219 Baalbek, Temple of Jupiter Heliopolitanus, first century (G. E. Kidder Smith, New York)

220 Baalbek, Temple of Bacchus, mid second century (G. E. Kidder Smith, New York)

221 Petra, rock-cut mausoleum of ed-Deir, mid second century (A. F. Kersting)

222 Petra, 'Qasr Fira'un' temple, probably second century (Elia Photo-Service, Jerusalem)

223 Hegra (Medaein Saleh), rock-cut Nabataean mausolea of the third quarter of the first century (Courtesy of the Saudi Arabian Embassy, Rome)

224 Baalbek, part of the forecourt, as rebuilt in the second century (J. B. Ward-Perkins)

225 Gerasa, fountain building, 191 (A. F. Kersting)

226 Gerasa, monumental approach to the Temple of Artemis, third quarter of the second century (Department of Antiquities, Amman)

227 Gerasa, oval piazza, third quarter of the first century (Department of Antiquities, Amman)

228 Philippopolis (Shehba), vaulted bath-buildings, 241–5 (University of Princeton)

229 Gerasa, West Baths, third quarter of the second century. Hemispherical vault of dressed stone (University of Yale)

230 Es-Sanamen, Tychaeon, 191 (University of Princeton)

231 Palmyra, from the air (Institut français d'archéologie, Beyrouth)

232 Palmyra, Temple of Bel, dedicated in 32 (J. B. Ward-Perkins)

233 Palmyra, colonnaded street, second century (Dr Hell, Reutlingen)

234 Palmyra, arch, 220, and colonnaded street, early third century (Dr Hell, Reutlingen)

235 Mismiyeh, 'Praetorium', 160–9. Drawing by De Vogüé (*Syrie Centrale*, plate 7)

236 Luxor, Temple of Serapis, 126 (Dr Müller-Weiner)

237 Philae, 'Kiosk' of Trajan, *c.* 100 (Photo Borel-Boissonas, Geneva)

238 Karanis, House C 65 (University of Michigan, Kelsey Museum)

239 Cyrene, Caesareum, second half of the first century B.C. with alterations and additions in the second century A.D. (Aerofilms and Aero Pictorial Ltd)

240 Lepcis Magna, limestone market pavilion, Romano-Punic, 8 B.C. (German Archaeological Institute, Rome)

241 Cuicul (Djemila), Market of Cosinius, mid second century (German Archaeological Institute, Rome)

242 Lepcis Magna, main street (J. B. Ward-Perkins)

243 Lepcis Magna, theatre (German Archaeological Institute, Rome)

244 Lepcis Magna, aerial view (British School at Rome)

245 Lepcis Magna, Hunting Baths, late second or early third century (J. B. Ward-Perkins)

246 Lepcis Magna, Hadrianic Baths, public lavatory (German Archaeological Institute, Rome)

247 Lepcis Magna, Severan Basilica, dedicated in 216 (German Archaeological Institute, Rome)

248 Lepcis Magna, Severan Nymphaeum, beginning of the third century (J. B. Ward-Perkins)

249 Sabratha, forum, first–second century (British School at Rome)

250 Sabratha, theatre, reconstructed stage-building, last quarter of the second century (Dr Friedrich Rakob)

251 Thamugadi (Timgad), air photograph (Department of Antiquities, Algeria)

252 Thamugadi (Timgad), 'Arch of Trajan', late second century, and streetside colonnades (G. E. Kidder Smith, New York)

253 Sufetula (Sbeitla), forum and Capitolium, mid second century (Dr Friedrich Rakob)

254 Cuicul (Djemila), air photograph (Department of Antiquities, Algeria)

255 Cuicul (Djemila), Temple of the Severan Family, 229 (J. B. Ward-Perkins)

256 Thuburbo Maius, Capitolium, 168 (Josephine Powell)

257 Thuburbo Maius, unidentified temple, second half of the second century (Josephine Powell)

258 Rome, Via Appia, Circus, Mausoleum, and remains of Villa of Maxentius, 307–12 (Fototeca dell'Unione, Rome)

259 Rome, Baths of Diocletian, *c.* 298–305/6. The central hall remodelled as the church of Santa Maria degli Angeli (Gabinetto Fotografico Nazionale)

260 Rome, pavilion in the Licinian Gardens ('Temple of Minerva Medica'), early fourth century (Fototeca dell'Unione, Rome)

261 Rome, pavilion in the Licinian Gardens, from a drawing by Franz Innocenz Kobell, 1780 (Fototeca dell'Unione, Rome)

262 Rome, Arch of Constantine, completed in 315 (Leonard von Matt)

263 Rome, Porta Appia (Porta San Sebastiano), in its present form the work of Honorius and Arcadius, 403 (Leonard von Matt)

264 Rome, Temple of Venus and Rome, cella, as restored by Maxentius, 307–12 (German Archaeological Institute, Rome)

265 Rome, Basilica of Maxentius, 307–12, completed by Constantine after 312 (Fototeca dell'Unione, Rome)

266 Thessalonike (Salonica), Mausoleum of Galerius (church of St George), mainly before 311. Detail of vaulting (J. B. Ward-Perkins)

267 Rome, Circus of Maxentius, 307–12 (Fototeca dell'Unione, Rome)

268 Trier, Porta Nigra, probably early fourth century. Unfinished (Landesmuseum, Trier)

269 Trier, Basilica, early fourth century (Landesmuseum, Trier)

270 Trier, Imperial Baths ('Kaiserthermen'), exterior of the main caldarium. Early fourth century (Landesmuseum, Trier)

271 Trier, Basilica, early fourth century (Landesmuseum, Trier)

272 Spalato (Split), Palace of Diocletian, the 'Peristyle' or ceremonial courtyard, c. 300–6 (Tošo Dabac)

273 Piazza Armerina, general view of the central peristyle, early fourth century (Fototeca dell'Unione, Rome)

274 Piazza Armerina, view from the vestibule across the central peristyle towards the basilica, early fourth century (Fototeca dell'Unione, Rome)

275 Thessalonike (Salonica), Mausoleum of Galerius (church of St George), mainly before 311 (Hirmer Fotoarchiv, Munich)

FOREWORD

This foreword is written on behalf of both authors. The line of division between our respective contributions has been a clear one, from the nature of the problems involved as well as chronologically. Nevertheless there has been much common ground between us, not least in the sense of deep indebtedness which we both feel to a common circle of friends and helpers that is far too wide to be named individually. For both of us this book is the fruit of a dozen years' work, and during this time there can be few of our colleagues who have not contributed some vital fact or some fruitful idea. To name some would be to omit others. We can only express our heartfelt gratitude to one and all.

Professor Boëthius has asked me in addition to acknowledge the help that he received from many persons in the preparation of his English text; from Miss Margherita Steinby of the Finnish Institute in Rome in checking his references; and from Professor Arvid Andrén in the laborious task of seeing the book through press in its final stages.

I myself owe a special debt to Dr Friedrich Rakob, to Professor Homer Thompson, to M. Henri Seyrig, and to Mr Martin Frederiksen for reading and criticizing substantial parts of the text; and to Professor Donald Strong for allowing me to make liberal use of his unrivalled knowledge of the architectural ornament of the Imperial Age. I also owe a great deal to the Princeton Institute for Advanced Study and to the Harvard Institute in Florence, without whose generous hospitality my own part of the book would never have been written.

In a work in which the illustration plays so large a part we have both of us been fortunate in securing the collaboration of Dr Ernest Nash and of Miss Sheila Gibson. Theirs is as much an original contribution as our own.

The dimensions throughout are expressed both in feet and inches and in metres and centimetres. In all cases it is the latter figure which is that of our original text.

The proper names of the classical world present a familiar dilemma, particularly when one moves from the Greek to the Roman period. In France, for example, where so many of the ancient sites have been continuously occupied since Roman times, it is natural to speak of Paris or Lyon rather than of Lutetia or Lugdunum; whereas in Africa or Asia Minor, where so many have been deserted, it is no less natural to use the classical forms. Both in the text and in the maps we have opted for clarity rather than absolute consistency.

In dealing with the architecture of the Imperial Age, and in particular with the architecture of the provinces, I have myself been very conscious of having to omit many buildings of great intrinsic quality and interest. In doing so I have tried to concentrate attention upon those regions and those individual monuments which have seemed to me to be most significant for, or to illustrate best, the larger picture of the development of the architecture of the Roman Empire as a whole. To be selective is to invite criticism. I would only ask the reader who finds his favourite Roman monument omitted to recall the sheer quantity of Roman building, much of it ill-published, that is available for discussion. If my work has in any way helped to put into perspective the rich classical architecture of the Roman world, or to stimulate the regional surveys that so much of it has still to receive, it will have served its purpose.

Rome, April 1969

On 7 May 1969, a few days after the preceding words were written, Axel Boëthius died in Rome, a few months short of his eightieth birthday.

His had been a full and active life. Born in 1889 at Arvika, in the heart of Sweden, of a family long distinguished in his country's ecclesiastical, academic, and cultural life, his own early career was at first directed towards Greek studies. Then in 1925 he was chosen by the then Crown Prince to be the first Director of the Swedish Institute in Rome, opened in the following year. Thereafter Rome was to be his second home and Roman topography and architecture the main interests of a busy working life. After serving as Professor and subsequently as Rector Magnificus of the University of Göteborg, he retired to Rome to settle. The sudden death of his wife in 1965 was a tragedy from which he never really recovered. For the last few years he had been in very poor health, and only his indomitable courage and strength of purpose saw the present work to completion. It is sad indeed that he did not live to see it in print.

The first part of this book, taken in conjunction with the published version of his Jerome Lectures (The Golden House of Nero: some aspects of Roman architecture, University of Michigan, 1960), is the culmination of, and an enduring memorial to, a lifetime's interest and research. It is good that he lived to complete it, for he was an exacting, self-critical scholar to whom sustained writing never came easily; most of his other published work is in the form of comparatively short articles and lectures, always full of fresh and stimulating ideas but not really comparable in their totality to his stature as a scholar and a teacher. His was an influence that was always felt, and will long continue to be felt, far beyond his published work. As a teacher he left an indelible mark upon successive generations of Swedish classical scholars; and as a colleague, the warmth of his personality, the infectious quality of his enthusiasms, and the breadth of a knowledge that was equally at home in the works of the classical authors and in the monuments of Rome and Italy made a lasting impression on all who came into contact with him. There can be few scholars in his field, in Italy or elsewhere, who have not at one time or another found themselves in his debt, and none of those who knew him who does not also remember him with gratitude and deep affection.

He was above all a giver, whether it was from the stores of his knowledge and experience or from the sheer native goodness of his heart. Nothing was ever too much trouble when it came to helping others, no work so poor that he could not find something kind to say about it. He has left a gap which will not soon be filled.

J. B. WARD-PERKINS

Professor Boëthius was able before his death to pass the proofs of text, notes, and bibliography. In the later stages, as mentioned above, Professor Arvid Andrén was good enough to undertake to examine the proofs of the plates and of the map, to answer outstanding queries, and to make final checks; for this I wish to thank him most whole-heartedly.

NIKOLAUS PEVSNER

MAPS

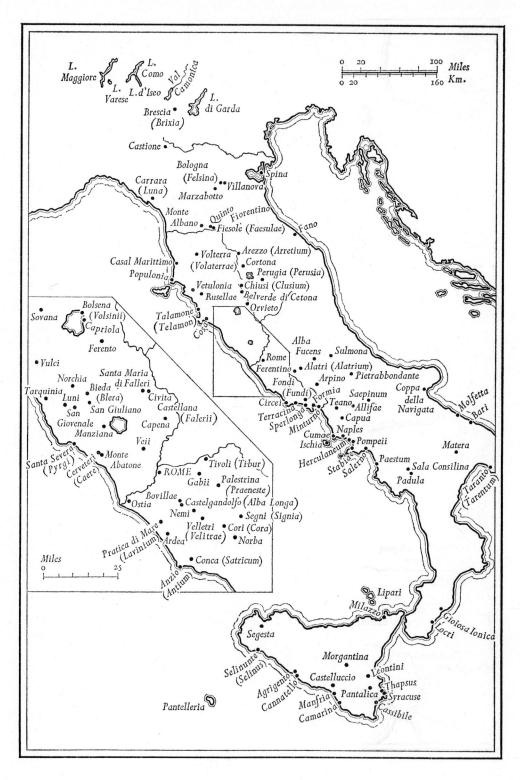

Map relating to Part One

xxviii

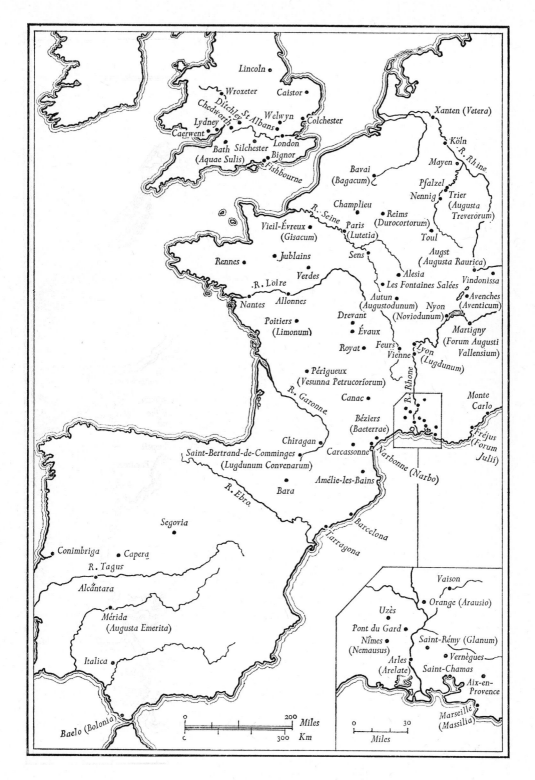

Map relating to Parts Three and Four

xxix

Map relating to Parts Two, Three, and Four

Map relating to Part Three

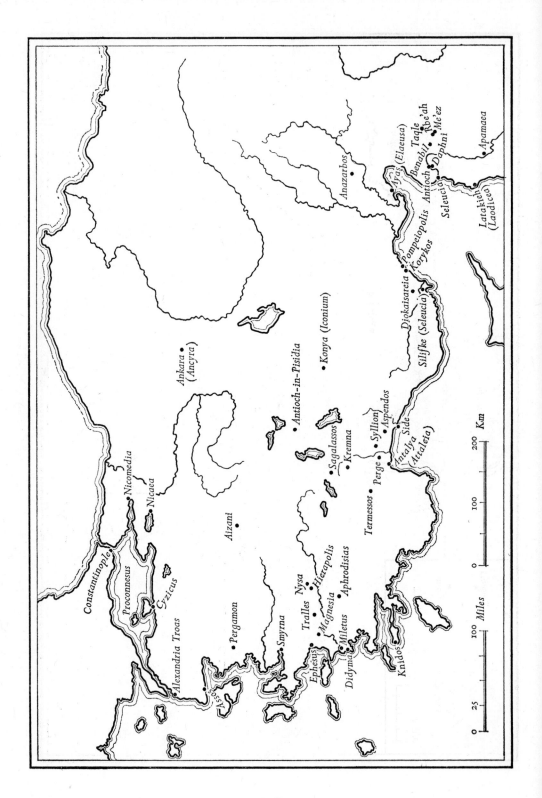

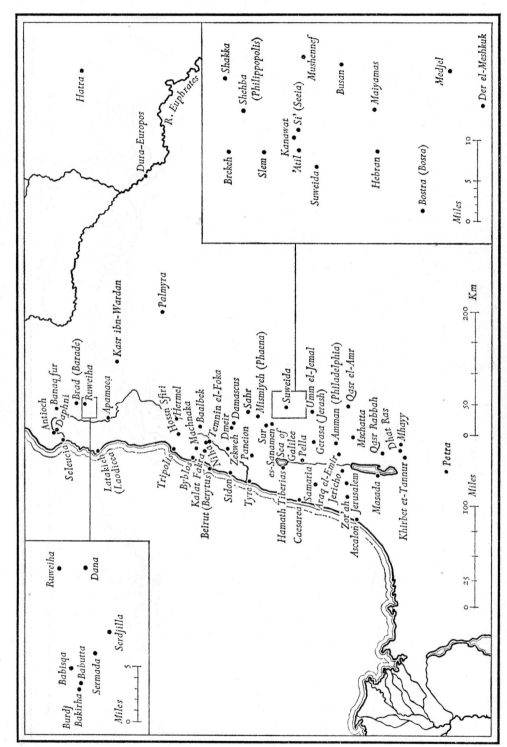

Maps relating to Part Three

xxxiii

PART ONE

ARCHITECTURE IN ITALY
BEFORE THE ROMAN EMPIRE

BY

AXEL BOËTHIUS

THE STONE AND BRONZE AGES

Dociles vires are the splendid words with which Pliny in his *Historia Naturalis* (XXXVI, 101) characterizes the achievements of the Romans as architects and town-planners. The words emphasize on the one hand their capacity to learn from others, and on the other their strength in adapting and reshaping their borrowings according to the traditions and demands of their own life and society. The process was not one of using undigested elements from the Greeks and the Orient, nor of retaining the petrified remains of old Italic lore; all indigenous traditions as well as foreign loans were gradually transmuted into a new unity with its own capabilities for development.

The final result of these eight hundred years of endeavour (as Pliny puts it) was the Late Republican and Augustan architecture of Rome, the hellenized Italic architecture which Vitruvius in the fifth book of his *De architectura* styles *consuetudo italica*. It was destined to be of the greatest importance for the common Mediterranean architecture of the Roman Empire when, after Sulla and Caesar, the old world became a mighty cultural unity, a Roman κοινή, with contributions from all its lands. For a full understanding of this Roman architecture as it appears in remains from the Augustan Age and the first centuries A.D., and as it will be found described in the fifth and sixth chapters of this book, it seems necessary to study its background in oldest Italy, and in the Orient, Greece, and the Etruscan city-states of the eighth and following centuries.

The history of ancient Italy differs fundamentally from that of Greece. Italy inherited no higher culture, no great memories and legends from the Bronze Age. Further, Italy had no Early Iron Age comparable with the Greece of the Geometric Period and of Homer; indeed, Roman authors very often delight in describing the primitive simplicity of Old Latium with its shapeless wooden gods and their simple dwellings (καλιάδες) – if, indeed, they had any huts and images at all[1] – its pastoral life in green valleys, its poor pottery or wooden cups.

Typical, for instance, are Vergil's descriptions in the *Aeneid* (VIII, 359–69) of the poor home of Evander on the Palatine, and of the couch of leaves covered by a Libyan bearskin upon which 'big Aeneas' slept. Equally suggestive is Propertius's picture of the Rome of Romulus and Remus in the first elegy of his fourth book. Modern archaeological research proves that this rustic, albeit romantic, conception of prehistoric life in Italy was substantially correct. But occasionally poets and historians also tried to recast the early history of their country in a heroic Greek mould. Undisturbed by the current rustic conception, they describe great palaces – like that of Latinus in Vergil's description of Laurentum (*Aeneid*, VII, 170 ff.) – and attribute to them impregnable walls and mighty gates. The descriptions of this and other palaces of the *Aeneid* are based on hellenistic models, however, and have no true archaic basis whatever. Moreover, again and again it becomes clear that their heroic wars fought by mighty armies were really

nothing more than quarrels about damaged crops and stolen cattle which disturbed the peace between petty city-states and villages of the Campagna. The real background to the history of Roman architecture is the millennial cultural twilight and rude primitivism of Western Europe before the Phoenicians, Etruscans, and Greeks brought eastern culture to the far and barbaric Hesperian coasts of the eighth century B.C.

It has to be remembered that trade from the glorious Minoan and Mycenaean Bronze Age of Greece reached south Italy. The northernmost outposts in Italy of this trade with the great eastern cultural world, as far as we know at present, are Ischia and Luni (Monte Fortino), in a central position on the River Mignone south-west of Viterbo, but recent research has shown that influence from the Minoan world reached even as far as Stonehenge. A real problem which remains to be explained is why only superficial influence from this high eastern culture can be traced even in the south of Italy. It is true that the south of the peninsula enjoyed somewhat less barbarous conditions than central and northern Italy, even in the Stone Age, and that it had more contact with the civilized world; but barbarous it was and barbarous it remained all the same, right down to the later Iron Age.

The influences from the Near East and Greece towards the end of the eighth century made a clear break with the past and marked the arrival of a new era, in total and evident contrast to the Bronze Age. As we see it, the pioneers were Phoenician traders and also – as Geometric vases show and Homer describes – Greek adventurers like Odysseus. After them came Greek colonists. Thus the high culture from the east attained a strong position in the distant barbaric land and at the same time met with a people prepared to receive it – the Etruscans. From the seventh century the art and architecture of the Etruscan and archaic Greek city-states conquered central Italy, and provided Rome and the Latin towns with new means of expressing the spirit of their commonwealth.

The aim of the first chapters of this book is to contribute to the discussion about the relation between these overwhelming foreign cultural influences and local architectural traditions, by means of a factual survey of what the builders of the settlements of the Stone, Bronze, and Early Iron Ages had achieved in central Italy, and especially in Latium and Etruria (the Lazio and Tuscany of future ages). What we know about these attainments proves that those early periods of central Italy belonged to the ageless prehistoric barbarian life of Western Europe. They were barren and poor in their architecture. Antiquated evolutionistic and nationalistic doctrine has tried to establish that the architecture and town planning of the historical periods were heralded in the primitive gropings of the Stone, Bronze, and Early Iron Ages; but as soon as we succeed in sweeping away the cobwebs, we see plainly that the Italians, not only in the eighth century but right through the great ages of Roman history, received rather than created the external forms of higher architecture. There is, however, another kind of originality which one feels in almost all their architecture: a mood, an indigenous social tradition; in short, the inner *vires* of which Pliny speaks.

A study of the prehistoric villages reveals the conditions in which the new imported culture developed. Diodorus's description of the Ligurians of the Augustan Age, who spent their nights 'in the fields, rarely in a kind of rude shanty, more often in the hol-

lows of rocks and in natural caves which may offer them sufficient protection', could apply equally to Neolithic and Eneolithic life, so far as the remains permit us to judge. More important for an explanation of traditions persisting in the daily life of later ages is the evidence for clusters of huts. The most common huts of these primitive villages had conical roofs. They were circular or elliptical, with fireplaces in the centre, and made of wicker- or branch-work, covered with clay or perhaps sometimes with skins. Just like many buildings of the Bronze and Iron Ages, they were sometimes half sunk in the ground, sometimes more or less on ground level. Already in this early age, cave burials could be replaced by rock-cut tombs imitating huts. Here is the beginning of an architectural tradition of great importance for south Italy, Sicily, and Sardinia.

In south Italy rectangular huts of the Neolithic Age have also been found. Thus excavations at Pantelleria have revealed such huts with foundations of several layers of flat stones. At Molfetta (Apulia) a network of crooked, paved paths ties together the huts of a Stone Age village. Both in Sicily (Cannatello) and in south Italy (Coppa Nevigata) a tendency to create an open central area can be traced.[2]

Stone Age stratification has in our times been recognized in different parts of central Italy too, even near Rome; Luni affords an especially clear example, with Chalcolithic (Rinaldone) and Apennine layers appearing above the Stone Age stratum. Recently, aerial photographs of the coast of southern Etruria, south of Montalto di Castro, have shown round villages with protecting earthen ramparts akin to the great concentrations of Neolithic settlements found in Apulia on the Foggia plain (Tavoliere) and near Matera. On the Tavoliere over two hundred roughly circular sites with one to eight enclosure ditches have been traced (Figure 1). The largest (Passo di Corvo) measures about 550 by 875 yards. Inside these enclosure ditches lie smaller circular enclosures, individually surrounded by ditches of sizes varying from some 50 to 150 feet across. In the largest villages more than a hundred 'compounds' of this kind have been identified; smaller 'homesteads' contain only a few. No doubt dwellings were built

Figure 1. Tavoliere, near Foggia, settlement. Neolithic. Plan

within these enclosures for family groups and their cattle. The enclosure openings usually have the same general orientation, probably pointing towards the main entrance to the village. Otherwise no regular planning appears inside the great enclosures, and it must be noted that the villages of Latium and Etruria even of the Bronze and Iron Ages have not up to now afforded us any instances of regular external shapes such as those of the Apulian sites and the coast of Etruria, nor of planning of any kind.[3]

For the purpose of this survey of the earliest architectural endeavours in central Italy, it would be an unnecessary digression to enter upon the much disputed questions concerning the population of Italy during the Stone and Bronze Ages. The country originally was inhabited probably by very sparse non-Indo-European tribes. At the begin-

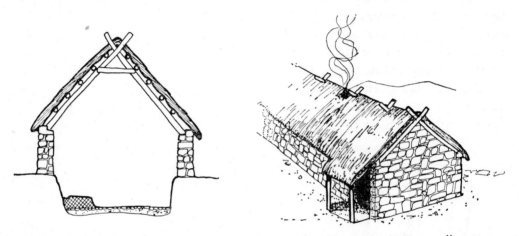

Figure 2. Luni, Apennine hut. Bronze Age. Reconstruction by Jerker Asplund and C. E. Östenberg

ning of historical times, peoples speaking Indo-European languages, with Latin, Faliscan, Umbro-Sabellic dialects, Oscan, and so on, predominated in central Italy, except in Etruria, where Etruscan was spoken by the entire population. To this may be added that many scholars believe, with Dionysius of Halicarnassus, the Greek historian of the Augustan Age (1, 30), that the Etruscans were descendants of the Italian pre-Indo-European tribes.

From the point of view of architecture there is no break between the Neolithic, Eneolithic, and Bronze Age periods. A really new *facies*, a clear progress beyond this primitive life in caves and wattle-and-daub huts, appears after about 1500 B.C. with the so-called Apennine culture. The Apennine culture used to be called 'extra terramaricolan'. On the Aeolian islands it is called Ausonian, and in Morgantina in Sicily Morgetian; roughly contemporary were the so-called Terramara villages in the Po valley. Of course, even this new culture was still barbaric compared with the grandiose palaces of Malta, the Minoan and Mycenaean palaces of the second millennium, and even the earliest nuraghi of Sardinia, which remained a distant horizon (Plate 1).

It has been suggested that the Apennine culture was a product of early Indo-European infiltration and represents a new racial situation created by the crossing of the immigrants with the old population. Furthermore, it has been assumed that the tribes which

spread the Apennine culture over central and southern Italy were more or less nomadic shepherds, using tombs as rallying places – as were the royal tombs of the Scythians, according to Herodotus (IV, 71 f.). In Apulia, from Gargano in the north to Lecce and its neighbourhood in the south, megalithic tombs and dolmens exist akin to those of Spain, southern France, Corsica, Sardinia, and Africa, and they could have been centres of this kind. Rock-cut tombs in the neighbourhood of Bari, accessible by a vertical shaft leading down to the door of a subterranean cave, have rightly been compared with the huts of the Bedouins and referred to as reproductions of nomads' cots.

Although some of the Apennine people may have been pastoral, remains of permanent residences with agriculture and pasture-farming are typical features of the Apennine culture of central Italy. On a hill near Bolsena, called Capriola, close to Early Iron Age settlements, remains of several Apennine huts have been found. Rock-cut foundations attest to oval wattle-and-daub huts. Of great importance is the Apennine village on the acropolis of Luni, which can be dated to the centuries between 1400 and 1100 by fragments of Late Mycenaean (Late Helladic) pottery in the Apennine stratification (Figures 2 and 3). Here we meet with rectangular houses of considerable size; the largest is 138 feet long and 16 feet wide (42 by 5 m.). As in so many prehistoric buildings, their lower parts are cut down into the rock. The floors of rammed clay above a

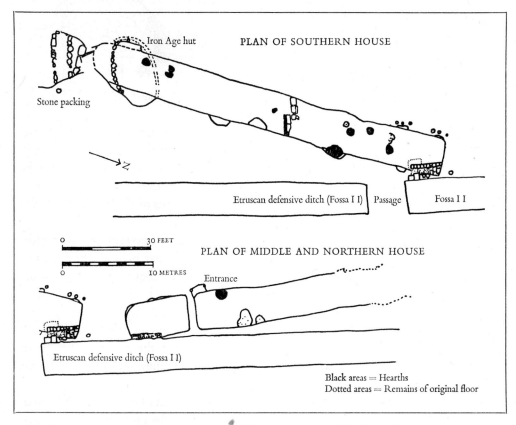

Figure 3. Luni, Apennine huts. Bronze Age. Plan (1 : 400)

bottom layer of limestone chips lie from about 3 to 7 feet below the surface. The walls seem to have been built of rough stones and roofs were of straw or reeds. Indoors, fire-places, portable cooking-stands and other earthenware, hand mills, bread-wheat, barley, beans, and peas have been found. The finds of bones indicate that the villagers of Luni had more cattle and pigs than goats and sheep. In short, Luni shows us in the clearest pos-sible way how people settled and built their houses in central Italy in the centuries around 1300. Probably a rock-cut chamber tomb on the southern slope of the acropolis belonged to this village. It seems to prove connexions with the large number of rock-cut chamber tombs of southern Italy and Sicily. Below the medieval castle on the neighbour-ing acropolis of San Giovenale, south-west of Viterbo, where later a great Villanovan village and an Etruscan town were built, a deep stratification starting with Apennine layers and continuing through sub-Apennine times has been studied (Plate 2). All the layers show floors of rammed clay and post-holes of huts. In one hut, which was oval, a bed of pebbles from the near-by river is laid along the inside of the wall, as also in Bronze Age villages at Manfria near Gela, San Giovenale, and still in shepherds' huts in Sicily (below, p. 65 f. and Note 52).

Excavations south of the Capitoline Hill on the Forum Boarium (by the church of S. Omobono) prove that Rome also belonged to the Apennine settlements of central Italy and that her history started at least as early as about 1500 or 1400 B.C. Finds of pottery near Civitavecchia attest the existence of Apennine villages along the coast. Added to this are Apennine finds from the districts round Veii and Clusium (Chiusi), and scattered finds from the Faliscan district (round Civita Castellana). Thus we can conclude that Apennine hamlets of the type of Luni and Capriola were scattered over the area of the later Latin and Etruscan Iron Age culture during the second half of the second millennium B.C.

Towards the end of the Apennine culture we meet with strongholds fortified with wide walls of irregular blocks. It seems that the Apennine tribes, assaulted by invaders about 1000, needed *points d'appui*. One of these was Coppa Nevigata in Apulia on the Bay of Manfredonia, with walls nearly 20 feet wide, which long served as a place of resort for the Apennine people. The same seems likely regarding the rather primitive walls of Casa Carletti, near the Apennine village of Belverde in Tuscany, where there are fortified sites with dwellings comparable to those of the hill towns on the Aeolian islands and other Bronze Age strongholds of southern Italy and Sicily.

The isolated yet prosperous life of the Aeolian islands met with a sudden change after about 1250. An Apennine culture from the mainland, here called Ausonian I and II, apparently supplanted the old culture, evidently in connexion with an invasion of main-land people. The same happened in Sicily. On the acropolis of Lipari 'Ausonian' foundations, both oval and roughly square and denoting huts generally built of wood on stone, replace the older type from about 1800. This, incidentally, confirms that the Apennine tribes did live in permanent villages.

As we have seen, finds of Late Mycenaean pottery prove that after about 1400, sailors from the highly civilized kingdoms of the palaces of Cnossos, Mycenae, Tiryns, and Pylos, from Rhodes and Cyprus, came to the coasts of Sicily, to south Italy, and as far

north as the Aeolian islands and Ischia. They may have been on their way to France and Spain, in search of obsidian from Lipari, copper from Sardinia, ores from the mines of Etruria, and other raw materials; perhaps they were also looking for slaves, as in Homeric days (*Od.*, XXIV, 211, 366, 389), from Sicily and elsewhere. Directly or by intermediaries this trade reached the interior of Sicily (Morgantina) and also – as the finds from Luni have already shown us – the interior of Etruria.[4]

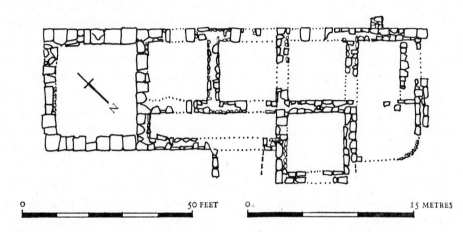

O 50 FEET O 15 METRES

Figure 4. Pantalica, near Syracuse, 'Anaktoron'. Bronze Age. Plan (1 : 325)

In Sicily the so-called 'Anaktoron' at Pantalica, near Syracuse, is one construction which reveals influence from the Mycenaean palaces (Figure 4). What remains is foundations of a rectangular building measuring about 130 by 40 feet, built of large polygonal blocks and divided into several rooms. However, a dispassionate judgement of the known archaeological material warns us not to conjure up 'empires' and 'palaces' even here: it seems safer to avoid a terminology suggesting more than a rather primitive coalescence of villages and local improvements, even if it is true that not only the 'Anaktoron' but also the rock-hewn chamber tombs in Sicily and south Italy enhance the impression of a rising level of civilization and of influence from the Mycenaean east. At Cassibile, Pantalica, and Thapsus in Sicily hundreds of rock-cut tombs, sometimes with several chambers and with elaborately carved and decorated door jambs, have been discovered. In an earlier period entrance doorways to tombs at Castelluccio (Noto) were closed with stone slabs and decorated with spiral motifs vaguely resembling Maltese reliefs of the Tarxien period. All this may indicate that the houses had some decoration as well. Rough beehive tombs in Sicily prove that this important kind of architecture reached Italy in the period of the Mycenaean connexions. Further, when we encounter corbel-vaults in the nuraghi in Sardinia (Figure 5), and much later in the Etruscan tholos tombs, we must ask ourselves whether they were more or less distantly connected with Mycenaean influence, or whether they were derived from independent origins. Traditions of early tholos architecture in Italy very likely live on today in the corbelled stone huts (truddhi, trulli) for shepherds and tools in the fields of Apulia and Sicily and in the strange beehive houses of Alberobello and its environs (Plate 1).[5]

9

No doubt Mycenaean sailors, with their ships and the tools and pottery on them, brought rudiments of the achievements of Bronze Age Greece to the Italic peoples. All the same, when discussing architecture, it is no understatement to say that nowhere in Italy did the ships from the east encounter a state of life sufficiently mature to partake in the high cultures of Mycenaean Greece.

On the northern outskirts of the Apennine culture in central Italy there appear, besides the cave-dwellers of Liguria already referred to, the much discussed lake dwellings of the Alpine and sub-Alpine districts and hut villages of the Po valley, generally described as 'Terramare', because of the black earth of their refuse dumps, or 'Palafitte arginate'.

The story of the Terramare starts about 1500. It seems likely that immigrants came from Hungary at that time, bringing with them a vigorous primitive culture with a fine metal industry (probably connected with Austrian copper mines) and refined pottery with varied shapes and decoration, evidently evolved in a well-established tradition developed elsewhere, as was no doubt also the social organization. The Terramare villages were supported on piles, just like Spina and Ravenna in centuries to come (Strabo, v. 1. 7). Sometimes they were protected against the floods of the Po valley by moats, ramparts of earth, and even timber constructions, the 'gabbioni'. Typical of the Terramare sites are cemeteries, also protected by moats and with pile substructures, containing close-packed cinerary urns. It seems quite possible that the first Terramare colonists brought with them the custom of cremation.

The Terramare huts were round or rectangular. Open spaces, very likely used for cattle, always seem to have occupied the centre of the villages. But the shapes of the villages varied, and without new complete excavations nothing can be claimed as certain about them. The regular plans which have been widely reproduced and believed typical are all imaginary reconstructions of no archaeological value, and all that has been claimed for them as prototypes for the regular towns which we shall meet with in Italy in the sixth century B.C. has no solid foundation.[6]

Among the achievements of these early ages which have never since been forgotten should be mentioned the timber constructions and corner joints in the *gabbioni* of Castione and the living-platform made with uprights and a floor of planks in the Grotta di Pertosa near Salerno.

The so-called lake dwellings around Lago Maggiore, Lago di Varese, Lago di Como, and Lago d'Iseo, and, farther east, the peat-bog villages of Lago di Timon and Aqruà Petrarca are all older than the Terramare. It is almost certain that these lake dwellings were not built on artificial islands in the lakes but on the shores. They represent, in any case, a social organization to be compared with the circular villages in Apulia: building plots on piles with straight streets paved with planks and a common entrance. The huts were quadrangular cabins of logs and planks.

From the transitional phase between the Bronze and Early Iron Ages and through the centuries right down to the Roman conquest of 16 B.C., one has also to remember the carvings chiselled into the rocks of the Alpine mountainside in the valley of Camonica. They represent a highly characteristic log-cabin architecture.[7]

All this provides a distant background to what Vitruvius tells us about timber houses

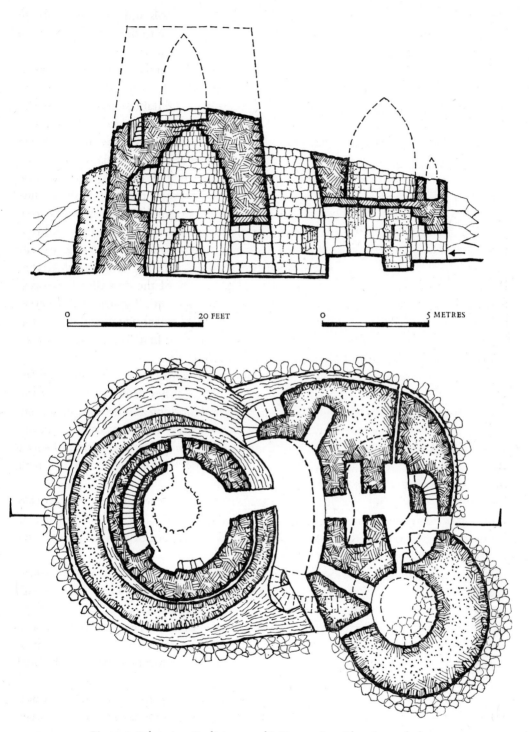

Figure 5. Palmavera, Sardinia, nuraghi. Bronze Age. Elevation and plan

20 FEET

5 METRES

in countries 'where there are forests in plenty', and about a tower, made of larch planks, in the neighbourhood of the Alps (II, 1. 4; 9. 15).

The Terramare villages of the Po valley, the fairly rich Apennine culture of south Italy and its Mycenaean relations, and the Apennine villages in the country between the Tiber and the Arno were the centres of architectural activity on the mainland of Italy during the Bronze Age. Looking down from Populonia, one of the later hill towns of the Apennine district of central Italy, one can see distant Sardinia, as Strabo (v. 2. 6) remarks before entering on his charming description of that rich island. But there is an amazing contrast between the architecture and culture of Sardinia and the Apennine villages some 100 miles east of the island, a contrast much the same as that between the Apennine villages and Malta. About seven thousand nuraghi are known in Sardinia (Figure 5). They were the most conspicuous architectural achievements of the great period of Bronze Age culture on the island from about 1250 onwards. The nuraghi were towers on hills above the plains, built all over the island within sight of each other and obviously representing a carefully planned system of defence. The oldest nuraghi were isolated circular towers of truncated conical form, containing two (or even three) corbelled round chambers set one above the other. They were constructed of blocks reminiscent of later Italian cyclopean walls. To the nuraghi belonged villages with stone-built, circular, corbel-vaulted huts (Plate 1).

The impressive Sardinian bronze figurines, both of warriors in fantastic attire and of ordinary people, seem to show Etruscan and Greek influence and to illustrate the later periods of life in and around the nuraghi. Bastions and extensive additional fortifications which we now see around the nuraghi are remains of continued efforts to strengthen the old fortresses and use them in the stubborn resistance of the Sardinians against the Phoenicians, Carthaginians, Greeks, and finally – from the third century onwards – the Romans. Only the Roman conquest ended the free existence and Bronze Age traditions of the mountaineers of the central parts of Sardinia – one of the first instances of an interesting local culture yielding to the style of the Roman Empire. The Etruscan tholoi (Plate 47 and Figure 49, below, p. 78 f.) may perhaps have had some direct or indirect connexions with the corbelled vaults of the nuraghi. Otherwise we can only state the strange fact that the great Bronze Age architecture of Sardinia and Malta, so far as we can see, belonged to a quite different sphere from the Bronze Age settlements on the mainland of Italy. The Tyrrhenian Sea was the dividing line. Even the people of Iron Age Etruria seem to have made only occasional contacts with the western islands, and the Greeks never colonized Sardinia. What was, in fact, of great importance for the Sardinians, from the eighth century onwards, was the influence of the Phoenicians and Carthaginians, who built great towns with conspicuous sanctuaries on the coastal plains and penetrated inwards towards the villages of the nuraghi. The first contacts seem to have been quite peaceful, but later the resistance arose which has just been mentioned. In any case, it is significant that the Romans of Late Republican times called the culti-vated Sardinians of the coast 'Punici', while they used various tribal names for the despised people of the old nuraghi in the rugged interior of the island.[8]

THE EARLY IRON AGE

THE Apennine and sub-Apennine hut builders of central Italy, whether they were partly Indo-Europeans or a local race destined to become absorbed by new invading Indo-European tribes, no doubt bequeathed some technical knowledge to the more developed architecture of the Iron Age. They may also have cut chamber tombs, as suggested on p. 8; but their architectural legacy was all the same inconsiderable. In spite of Mycenaean influence, dolmens, strongholds, and the variety of chamber tombs, not even south Italy and Sicily impress us as having reached any higher degree of cultural or architectural capability. But it seems that a new era began in the tenth or ninth century. A still primitive but all the same remarkably vigorous Iron Age culture spread over central Italy in the eighth century (Figure 6). At Luni (Monte Fortino) and on the western part of the acropolis of San Giovenale one sees uncommonly well how huts of a new kind were built above the Apennine villages (Plate 2 and Figure 8). This new culture is usually called the Villanovan culture, after the first great finds at Villanova, near Bologna; but as the new types of dwelling show great variation, Early Iron Age culture is perhaps a preferable name, taking into account also the related types of the culture in the southern parts of Italy (Plate 5). It was very rich around Tarquinia in the eighth century, but had a poorer character in Latium (the 'Latin Iron Age').

For central Italy the Early Iron Age culture meant a great reversal of conditions, the first revolution in a development which resulted in the changed appearance of the country in Etruscan and Roman times. New villages were built on hills, defensible by steep scarps, rivers, and ravines filled with brushwood. Extensive cemeteries prove a large population. Many of these large hill villages were to have a great future in Etruscan and Roman times, and in some cases have survived to our own days. It seems evident that villages on the Palatine and other hills were the first inhabited areas of this kind in Rome; in the seventh and sixth centuries Rome gradually united the settlements on the surrounding Esquiline and Quirinal Hills and also the Caelian, creating a civic and religious centre for them all on the future Forum Romanum. Already before that time, the Palatine village extended towards the forum over what had been its old cemetery along the Via Sacra. Remains of important Early Iron Age villages of the same kind have been studied on the Alban and other hills of Latin towns, such as Ardea, Lavinium (Pratica di Mare), Tibur (Tivoli), and on the future Etruscan sites of Veii, Caere (Cerveteri), Tarquinia, Vulci, Luni, San Giovenale, and others.

The tombs of these towns are to a great extent cremation tombs with ash urns in roughly circular shafts (*pozzi*, *pozzetti*). The urns and tomb gifts, such as terracotta vases, miniature cooking stands, fibulas, razors, and so forth, could be placed directly in the pozzetti, but frequently they were preserved in terracotta dolia (Figure 6), sometimes in stone receptacles or in rough rectangular coffins of stone slabs. In a tomb at Velletri in

the Alban Hills the shaft is corbel-vaulted with tufa blocks, which is noteworthy (Figure 7). One wonders whether it had any connexion with the larger Bronze Age structures of the same kind in Greece or was inspired by the tholos architecture of the Etruscans.

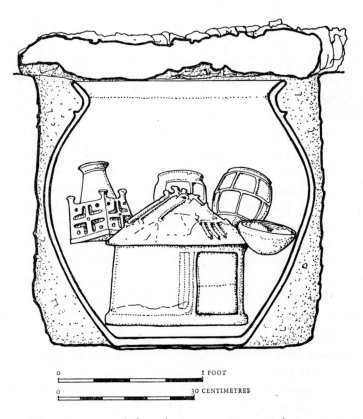

Figure 6. Pozzo tomb from the Via Sacra, Rome. Early Iron Age.
Rome, Antiquarium Forense

Rock-cut fossa tombs also occur, and sometimes contain coffins of oak trunks or even of terracotta imitating a tree-trunk. Iron Age Tibur (Tivoli) had a cemetery with fossa tombs of the seventh century and earlier, which are surrounded by travertine slabs forming grave circles with a diameter of 10 to 16 feet. The slabs are about 12 inches high and 16 to 20 inches wide. Together with grave circles of the Apennine districts, they remind us of both primitive and highly developed Mycenaean grave circles, as well as of the later Etruscan *tombe a circolo*. At Vetulonia we meet with both Iron Age and Etruscan grave circles. The former are surrounded by rough unhewn blocks which herald the cyclopean and polygonal walls of later periods.[1]

These Early Iron Age villages had new, more forcible, and artistically more valuable crafts producing imposing biconical ash urns covered by helmets (or clay models of helmets) or by lids imitating roofs, ash urns reproducing huts (Figure 9 and Plates 3–5), and above all richly developed metalwork, including helmets, shields, fibulas, and other

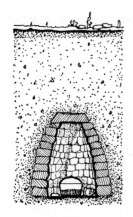

Figure 7.
Velletri, Vigna d'Andrea,
corbel-vaulted tomb.
Early Iron Age. Section

ornaments. Life in central Italy tended to wider horizons. It is evident that the new Iron Age villages were centres for improved farming and metal-mining.

As far as archaeological evidence can tell, this development unified central Italy. It came into existence within the pale of Apennine culture and probably often in competition with the Apennine villages. The villages of the Early Iron Age converted the mainland of Italy, in a much more radical way, to a new manner of life and habitation. In this context the clearly connected but much more variegated and rich culture south of Latium must be considered, as we can see from biconical ash urns and finds of impasto ceramics from Padula, Sala Consilina (Plate 5), the Sele valley, Milazzo on the mainland of Sicily south of Lipari, and many other places.[2] The old explanation that this great change was due to a final Indo-European invasion is probably true, and may show the process by which Italy assumed its ultimate Indo-European shape. On the other hand, recent research makes it more and more probable that the Indo-European–Italic peoples of whom we know before Rome's final Latinization of Italy about 100 B.C. (the Umbrians, Sabines, Latins, Sabellic tribes, Oscans, etc.) received their characteristic ethnographic and cultural character, known from historic times, in Italy, by mingling with the probably rather sparse Bronze Age population which was perhaps to some extent already Indo-European.

When the Romans tried to visualize these old villages, they cherished stories of a round or quadrangular primitive Rome.[3] Nothing has substantiated such ancient tales about regular town planning in the Early Iron Age settlements nor the modern theories about it. It should be noted that no Villanovan village known at present displays regularity of town planning, externally or internally. Groups of huts were built on hills which offered a common natural defence – nativa praesidia, to use Cicero's expression (De republica, II, 6). Like the Apennines, the Villanovans sometimes strengthened the defences of their hillsides. Most conspicuous is a place called Città Danzica south of Rapino in the country of the Samnite tribe of the Marrucini.[4] It is a big hill measuring about 3 miles from north to south and half a mile to a mile from east to west. On this plateau are dense remains of an Early Iron Age village. The western part of the settlement was defended by the steep sides of the hill, but all along the eastern side, where the slope is smooth and open to assault, a protecting wall of small rough blocks of the local calcareous stone was built. A stretch of nearly a third of a mile of the wall is still to be seen, in some places some 10 feet high. A road, constructed upon a terrace wall of the same material as the enceinte, leads to the village. This strongly fortified Early Iron Age centre is indeed an early and interesting predecessor of Etruscan defensive works, especially those of Rusellae of about 600 B.C. (see p. 59). Bologna, on the other hand, offers an instance of a great Villanovan village built on a plain. The physical features of the Po valley make that, needless to say, very understandable.

In this connexion it has to be remembered that, even in Imperial times, when the Romans planned to build a colony they traced with a plough drawn by a bull and a cow yoked together a continuous furrow with an earthen wall on its inner side (Plate 6). Plutarch (*Romulus*, XI) adds that a brazen ploughshare should be used, which seems to prove that the custom was very old – but this, of course, could also have been an archaistic notion. Plutarch, like Varro (*Lingua Latina*, V, 143), says that Romulus founded Rome *etrusco ritu*, 'after summoning from Tuscany men who prescribed the details in accordance with certain sacred ordinances and writings, and taught them to him as in a religious rite' (with a sacrificial pit, *mundus*, and by ploughing).

As discussed on p. 56, the old Etruscan towns remained irregular until the sixth century, and even then only their colonies on the plains seem to have had regular patterns. It may be that both the Etruscan and the common Italic practice of the very old way of marking off the villages from surrounding agricultural lands and pasturage on the hills, or on a plain such as that of Bologna, was inherited from the Early Iron Age villages. But neither such usage nor what we know about the boundaries (*pomeria*) of Rome and other towns prove that the old settlements had fixed geometric shapes.[5]

The manner of building the huts of these settlements, with wattle and daub, which we meet on the Palatine and in all villages akin to it, is the same as in the Apennine hamlets. But otherwise the huts display a much higher standard, stabilized types, and an increased wish for adornment. On the Palatine Hill remains of two villages of the Early Iron Age have been found (Plates 7 and 8), one towards the southern slope of the hill, the other below the so-called Aula Regia of the Palace of Domitian. Between them an Early Iron Age tomb has been excavated; a great cemetery along the Via Sacra north of the Palatine (Figure 6) and – it appears – another on the south slope also belonged to these villages.

The foundations of one hut on the southern slope of the Palatine are especially well preserved (Plates 7 and 8), and the village can be reconstructed in all main respects. The hut measured 16 by 12 feet (4·90 by 3·60 m.). The floor is cut into the tufa of the hill to a depth of about 20 inches. The hut was rectangular with rounded corners. Six large post-holes along the long sides were evidently made for the supports of the roof. The walls were of wattle daubed with clay, as has been proved by the discovery of fire-baked fragments in different places and many huts. The huts had hipped roofs of thatch. A post-hole in the centre of the Palatine hut shows that the roof-ridge was supported by a pole. The hut had no central hearth; instead, a portable cooking stand of a type well known from miniature tomb gifts and fragments from many Early Iron Age villages was used for preparing food. On the southern short side is a fairly wide entrance flanked by four post-holes, two inside and two outside the door. The latter, no doubt, were made for posts carrying a canopy (cf. Figure 9). We see on a hut urn from Tarquinia (Plate 4), at Leontini, in the Athenaeum of Syracuse in Sicily, in Lipari, and elsewhere, as on the Palatine, that these primitive huts could be square or squarish; but the hut urns (Plate 3) and also the Early Iron Age villages of Luni, San Giovenale, and Veii prove that the most usual shape was oval.[6] The oval huts of San Giovenale are very large (Figure 8 and Plate 2): one of them measures some 36 by 19 feet. As occurred in the

Apennine hut of Capriola, the outline was drawn by a furrow in the surface of the tufa hill in which the lower edge of the wattle-and-daub walls was embedded. The hut has post-holes for the roof supports, holes which probably served to stabilize tables, beds, or other furniture (as in the shepherds' huts of today on the Roman Campagna), and a door on the western short side.

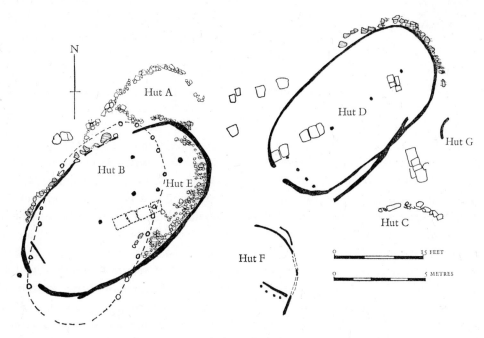

Figure 8. San Giovenale, huts. Early Iron Age. Plan (1 : 200)

Interesting and illuminating is the burial equipment from a tomb at Sala Consilina (Plate 5). In the tomb, together with an ash urn of the usual Early Iron Age type containing the bones of a cremated body and the usual funeral gifts, was a model of a house packed with ashes. The type is quite different from the Villanovan huts. It has a saddle-back roof adorned by volutes and birds, reminiscent both of ash urns and of the end acroteria of the ridge-poles of Archaic Greek and Etruscan temples. The walls are decorated with briskly painted white geometric designs. Compared with all we know about the Early Iron Age huts, the decorations of the ridge-pole and the roof construction seem to prove that the model reproduces a new type of house, probably inspired by the earliest temples and houses of the Greek immigrants, such as we know them from the Geometric Age and later.

At Luni and San Giovenale have been found square subterranean rooms of considerable size which have to be remembered among Early Iron Age instances of possible domestic or even palatial architecture. At the westernmost end of the acropolis of Luni is a shaft measuring some 60 by 30 feet and cut down in the rock about 20 feet. Between 800 and 900 cubic yards of tufa have been removed. There are charred remains of a wooden roof and walls covered with clay, though we do not know whether these once

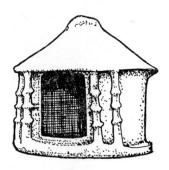

Figure 9.

Hut urn from Campofattore, near Marino. Early Iron Age. *Rome, Museo della Preistoria e Protostoria del Lazio*

belonged to a carefully constructed basement or (as seems most probable to me) to a collapsed building constructed above the basement. There is, in any case, no entrance to the sunk room. The finds of pottery indicate that this Early Iron Age 'palace' was burnt down in the eighth century. Of later date is a similar but less pretentious structure belonging to the Early Iron Age settlement of San Giovenale. It is almost square, with sides measuring about 50 feet, and cut down to a depth of about 18 feet; stairs lead down to the lower part of the shaft. Whether basements or houses, these constructions represent a quite different, more stately architecture than the huts.[7]

The hut urns from cemeteries (Plates 3–5 and Figure 9) complete our picture of the usual type of Italic Iron Age huts. The ash was put into the urn through its door. The diameters of most of these receptacles vary between 12 and 16 inches (30 and 40 cm.). On an average, 12 inches may be singled out as a most usual width, corresponding to a height of about 8 to 12 inches. Exceptions to those with the usual round or oval plans are huts which have curved corners and square huts. A square urn from Tarquinia (Selciatello; Plate 4) measures $11\frac{1}{2}$ by $10\frac{1}{4}$ inches and is $11\frac{1}{2}$ inches high (29 by 26 by 29 cm.). The roof is slightly curved. It has an almost rectangular door with a window indicated to the left. Thus, except for the plan, it exhibits the common features of all hut urns. The roofs can be described as conical hipped roofs. At each end of the roof-beams on many hut urns is a vent for smoke. On the long sides of the roof they show ridge-logs to weigh down the thatched roof. The same device, usually three short ridge-logs, is often seen below the vents. The projecting tops of the logs, which cross each other at the ridge, are often elongated and shaped in a decorative way. This may seem to herald the ornamental rows of crossing rafters on archaic temples and houses from the seventh century onwards (Plate 9). The short ridge-logs of the vents and the cross-beam to which their upper ends are attached are also often fashioned in decorative ways. The walls of the hut urns frequently rest on a plinth and can be straight or sloping, upwards or (more rarely) downwards. A human figure outside above the door also occurs. Doors with more or less decorative door-posts or even frames are common. The doorways are closed by slabs with central knobs. They have transverse holes corresponding to holes in the door-posts, evidently intended for ropes or twigs which functioned as bars; shepherds of today can still be seen latching their doors in the same way when they leave their temporary huts. Some hut urns have fairly large windows in the wall to the left of the entrance or in both long walls. Many show incised geometric decoration filled with white or yellow colour or with strips of tin. It seems clear that the wattle-and-daub huts had incised and painted geometric wall decoration of the same kind, though the ornamentation of the hut urns may sometimes be more free and rich. The hut urns of Latium show a more primitive and simple decoration, as against the more ornate buildings of the towns farther north, from Tarquinia to Vetulonia; but

the latter still belong to the characteristically restricted creations of prehistoric life, even if they already display fixed types far superior to the primitive dwellings of the past.

The origin of the habit of using models of huts as ash urns has been much discussed. The technique of the decoration clearly connects the Early Iron Age pots, including hut urns, with Switzerland and Central Europe. Probably there was a link of some kind, but it has been pointed out that the hundred-odd hut urns known from Central Europe and Scandinavia seem all to be slightly later than the urns of the Early Iron Age in Italy. Other suggested parallels or prototypes seem irrelevant. The hut urns from Early Minoan to post-Minoan times on Crete, which have been adduced, were not used as ash urns and are altogether too different to be taken into serious consideration. Hut-shaped urns from Este have also been put forward, but it is uncertain whether they were hut urns, lamps, or ovens, and they do not afford us any more conclusive evidence than do the Cretan parallels.

Figure 10. Lid of an archaic stele from Tarquinia.
Early Iron Age. *Florence, Museo Archeologico*

Before we continue with architecture in the Early Iron Age, we have to consider whether these huts had any formal qualities of importance for the future. Scholars have emphasized the axial tendency of the Early Iron Age huts, with their entrances always in one of the short end walls, and have compared this with the axiality of the Tuscan temples and houses. To me it seems to display a fantastic typological bias to compare such a natural primitive disposition with the elaborate architecture which we shall meet in the next chapter. But some external features may deserve more consideration; for example, the crossing logs on archaic temples may perhaps be traditional remains of the refinements of the ridge-poles of the Early Iron Age huts (Plate 9), and the lid of an archaic stele (Figure 10) from Tarquinia also recalls the early Etruscan temples. On the whole, however, such characteristics, though interesting and noteworthy, seem vague and of slight importance when we consider the quite different architecture of the seventh and following centuries. What has been said about the Bronze Age seems in the main valid about the architecture of the Early Iron Age, in spite of its evident progress.[8]

A quite different matter is social traditions, that is, inherited habits of daily life or of defence formed in the old villages. No doubt such a legacy lived on, but architectural features of any importance which existed when the architecture of the towns of the eastern Mediterranean world conquered Italy, are very rare. One example may be the round Temple of Vesta at the eastern end of the Forum Romanum. The temple of the Imperial Age that we see today was rebuilt in marble after a fire in the year A.D. 191, and we know that it had also been reshaped previously in the styles of earlier ages. Ancient authors were convinced that the round shape was inherited from curvilinear shrines of Vesta (and from the round Early Iron Age huts). Ovid writes delightfully about the old form of the Temple of Vesta in the *Fasti* (VI, 261–82): 'The buildings which you now see roofed with bronze you might then have seen roofed with thatch, and the walls were woven of tough osiers. This little spot, which now supports the house of the Vestals, was then the great palace of unshorn Numa. But the shape of the temple, as it now exists, is said to have been its shape of old . . .' After discussing the round shape (*forma rotunda*) of the ground, he adds: 'The form of the temple is similar; there is no projecting angle in it; a dome protects it from the showers of rain.' It should be kept in mind that the Early Iron Age village on the Palatine in the seventh century extended over the old cemetery along the Via Sacra. Huts had been built even as far as the place where, much later, the equestrian statue of Domitian was erected in the Forum Romanum. Also, from all archaeological points of view it seems most probable that the traditions from the curved shrines of the Early Iron Age villages survived. Recent excavation in the neighbouring building, the 'regia', which according to Roman traditions one of the oldest kings gave to the head of the state clergy, the Pontifex Maximus, have revealed remains of a large Early Iron Age hut below the fifth-century palace of megaton type.[9]

We know that the Romans of the Imperial Age cherished memories of Latin villages with primitive huts, such as could – and can still today – be seen among shepherds throughout the countryside. Propertius wanted straw huts (*casae stramineae*) even for kings in the profligate Rome of his and Cynthia's time (II, 16. 20); Livy's Camillus talks of the famous hut of Romulus (V, 53), and Imperial coins reproduce such dwellings of the old sagas. Vitruvius also (II, 1. 5) tells us about old-fashioned rustic structures kept as a reminder of olden times in Italy, referring to the hut of Romulus on the Capitoline Hill, as on the Acropolis of Athens. Dionysius (I, 79), speaking of the life of herdsmen and the struggle for existence in oldest Latium, describes the 'huts which they built, roofs and all [αὐτόροφοι], out of twigs and reeds'. He continues: 'One of these called the hut of Romulus remained even to my day on the flank of the Palatine Hill which faces towards the Circus, and it is preserved holy by those who are in charge of these matters; they add nothing to it to render it more stately, but if any part of it is injured, either by storms or by the lapse of time, they repair the damage and restore the hut as nearly as possible to its former condition.' The flavour of ancient times is still more enhanced by Cassius Dio's report from the year 12 B.C. that the hut was set ablaze by crows which dropped burning meat from some altar upon it; so there must still then have been a thatched roof (LIV, 29).

Vergil was of the opinion that the rustic Romulean regia was on the Capitoline Hill (*Aen.*, VIII, 654). Dionysius makes it quite clear that the hut which he describes was situated on the south-western part of the Palatine, on the same part of the hill where the Early Iron Age village (Plates 7–8) has been excavated. What the ancient authors affirm at least establishes that there was an old tradition dating from the Prehistoric Age alive on the spot. It seems much less likely that the huts on the Palatine and the Capitoline Hills were inventions suggested by learned hellenistic romanticism, the hut on the Acropolis of Athens, and what the Romans could see in old-fashioned dwellings in the Campagna all around them.[10]

By the time we get an equally clear picture of the somewhat later settlements in Tuscany and Latium, the cultural situation of all Italy had completely changed. From the eighth century onwards, influence from the Orient and the city-states of Homeric, Geometric, and Archaic Greece had contributed to the civilization and reorganization of the country between the Tiber and the Arno in a far more fundamental way than, for instance, the culture of the Early Iron Age had changed Bronze Age conditions. A new kind of architecture, inhumation connected with tombs of new types, a rich import of Oriental and Greek luxury, inscriptions written with Greek letters adapted for the Etruscan language, and other devices of high culture all mark the new era.

In Augustus's age Dionysius of Halicarnassus, describing the completely legendary Arcadians of the Palatine in Rome, gives us a remarkably vivid picture of how well the Romans knew that this was a revolution caused by influence from countries with a higher culture. According to him Evander, the king of the Arcadian saga, was the first to introduce into Italy the use of Greek letters, and also music performed 'on such instruments as lyres, trigons, and flutes; for their predecessors [the Early Iron Age tribes in Italy] had used no musical invention except shepherds' pipes. The Arcadians are said also to have established laws, to have transformed men's mode of life from the prevailing bestiality [ἐκ τοῦ θηριώδους, from primitive conditions, that is] to a state of civilization, and likewise to have introduced arts and professions and many other things conducive to the public good'. If we add to this list a new kind of architecture, it is indeed – attribution to the Arcadians apart – an excellent summary of the result of influences from the great Eastern cultural world which ended the Early Iron Age in Italy and overthrew its primitive and monotonous life.

What happened in Italy in the eighth and following centuries must be related to the great expansive cultural revival in the eastern Mediterranean countries after the decline about 1000 B.C. It was the age of the Assyrian and Neo-Babylonian Empires, of the Late Hittite kingdoms north of Syria with their marvellous art, of the Phrygian and Lydian kingdoms, of Urartu, of the Saitic renaissance in Egypt and of Phoenician trade and skilful imitations and new combinations of the great artistic traditions of the Near East and Egypt. As Homer, Herodotus, and later authors describe, Phoenician merchants were important intermediaries between Europe and this Eastern world in its late renaissance. Closely connected with all this was the Homeric Greek era and the unparalleled strength and originality with which the Greeks reshaped Eastern influences into their Homeric and Archaic culture. During and after this period of revived activity

from the eastern Mediterranean countries, Greek Archaic culture both at home and in the Italian colonies became more important than anything else for Italy.

We must now return to the primitive villages of Italy among the wilderness and pastures and try to look at them with the eyes of the sailors from the Eastern world. They saw artefacts, such as weapons and ornaments, which proved that these barbaric western lands had considerable mineral resources. Along the west coast of Italy and in Sicily were vast rich plains which, whether cultivated or not, must have attracted immigrants as offering great possibilities for their more developed agriculture. The picture preserved for us of the Greek arrival in Italy is filled with acts of piracy and outrageous atrocities. The descriptions of Odysseus's landings on the barbaric west coast give us a very lively impression (see, for instance, *Od.*, x, 144 ff.), and marvellous paintings of shipwrecks on Geometric eighth-century vases from Ischia and Athens tell of the hardships of the sailors, not so different from those suffered by Odysseus. No less important is Ephorus's statement, preserved by Strabo (v, 2. 2), that before the earliest Greek towns (that is, before the later half of the eighth century) the Greeks 'were so afraid of the bands of Tyrrhenian pirates and the savagery of the barbarians in this region that they would not so much as sail thither for trafficking'. King Agrios in Hesiod's *Theogonia* (1013) may also belong to the era of these tales of ancient savagery at the dawn of history.

But soon the situation changed. The Greeks built their towns in southern Italy and Sicily in the style and with the organization they brought with them. All this is known history, though some of the dates are disputed. Typical and of special importance for architecture and for the entire culture of central Italy are the two northernmost Greek settlements, Cumae and Ischia. The lofty, isolated acropolis of Cumae stands above a wide beach where the ships were drawn up after their long adventurous voyages, and the settlement on Ischia lies on a hillock at the western end of the island, with a bay for the boats. Newcomers to Italy are described in the sagas in the persons of Diomedes, the Argive founder of Tibur (Tivoli), the Arcadian Evander of the Palatine, Aeolus of the Liparian islands, and others. Such tales are evidently attempting to explain the introduction of Greek culture to Italy from the eighth century onwards, even if in some cases the legends may go back to the Greeks of the Mycenaean Age. The rich country of south Italy and Sicily, with the considerable metal resources of the former, now fell into the hands of a quite new kind of people, endowed with an almost unparalleled heroic genius and energy in opposing such enormous powers as the despotic kingdoms of the Near East and the oppressive primitive life in the west. The same can be said of the Etruscans, whatever their origin was, and in spite of what they learned from the Greeks. Pictures of ships, and a few words about Aphrodite and Nestor's cup scratched on a Geometric pot from the cemetery of Ischia, bring to life for us these sailors and immigrants with their Homeric language and culture.[11]

While the Greek city-states in southern Italy remained Greek oases surrounded by native tribes, from the eighth century onwards the country between the Lydius Thybris, as Vergil (*Aen.*, II, 781) styles the Tiber, and the Arno was penetrated and unified by the highly characteristic Etruscan version of Oriental and Greek culture. Where

previously the Early Iron Age culture had given the same general appearance to all the villages, a new, strong nation with a language of its own arose, with rock-cut chamber tombs of a new type (cf. Figure 37) from about 700 B.C., painted walls from the first half of the seventh century (Tomba delle Anatre at Veii), and hoards of imported Oriental and Greek tomb gifts.

The people who introduced this new luxury, the Etruscans, seem to have called themselves the Rasenna, while in the Greek and Italic language they were known as Etrusci, Tusci, Tyrrheni, or Tyrseni. North and west of the Tiber these Etruscan-speaking tribes were spread all over the country, except for a territory with an Indo-European language round Falerii (Civita Castellana) and Capena, the Faliscan plain on the western shore of the river, which kept its Indo-European language in spite of overwhelming Etruscan influence from the seventh century onwards. All our literary sources of Late Republican and Augustan times affirm that the people on the Etruscan side, the *litus etruscum*, or *Lydia ripa*, as the riverside of Trastevere was still called in Imperial times, knew Latin only by contact with Rome and Latium or by 'having had Romans among them as colonists' (to quote Livy, I, 27. 9). As Varro affirms in *Lingua Latina* (VII, 34), 'the roots [radices] of the words' were quite different in Etruscan and Latin.[12] How did this happen? What brought about this new cultural situation on the west coast, dissociating Etruria from Latium and its other neighbouring lands? How can it be explained that the Etruscans were prepared to make the new high culture and architecture of the Near East and Greece their own, a hundred years or even more before the Italic peoples around them – in complete contrast to what happened when Mycenaean influences had reached Italy?

The most plausible explanation is that a new people with Eastern affinities had discovered Etruria and immigrated to harbours on the west coast, especially those of Caere (Cerveteri), Tarquinia, Vulci, and other south Etrurian towns in the making. From these starting-points the newcomers would by amalgamation have reshaped the pre-existing Indo-European tribes, their language and their villages, gradually occupying the inland villages such as San Giovenale (about 630 B.C.), Luni, and – even earlier – the Faliscan district. This attempt to explain the archaeological facts by assuming an immigration from the East agrees with what all ancient historians (except Dionysius of Halicarnassus), as well as the Etruscans themselves and the Romans, believed. These old tales may be uncertain, chronologically confused, reshaped by frequently told sagas about famine-stricken emigrating peoples; but they cannot possibly be discarded *en bloc* and must be considered together with the linguistic and archaeological evidence. They all have in common the firm belief that the Etruscans were immigrants from Asia Minor.

At the head of these legends stands Herodotus's famous tale (I, 194) wherein he describes the Etruscans as a part of the Lydian people which emigrated to Italy after building ships at Smyrna, 'whereon they set all their gods that could be carried on shipboard'. Tacitus (*Annals*, IV, 55) proves that this notion was alive among the Romans and the Lydians of the Imperial Age: he relates that envoys from Sardes in Tiberius's time quoted a decree of their kindred country Etruria, according to which a son of King

Atys of Lydia, Tyrrhenus, had emigrated to Etruria with a part of the Lydian people. But there are also other tales of connexions of the Etruscans with the Near East, linking them with the Pelasgians, and of Tyrsenians (or Tyrrhenians) on Lesbos, Lemnos, Delos, and Imbros. In the Homeric hymn to Dionysus we meet them as pirates on the Aegean.[13]

But, on the other hand, there is Dionysius criticizing the prevalent idea about the Lydian origin of the Etruscans (I, 30): 'I do not believe that the Tyrrhenians were a colony of the Lydians; for they do not use the same language as the latter, nor can it be alleged that, though they no longer speak a similar tongue, they still retain some other indications of their mother country. For they neither worship the same gods as the Lydians nor make use of similar laws or institutions . . . Indeed, those probably come nearest the truth who declare that the nation migrated from nowhere else, but was native to the country, since it is found to be a very ancient nation and to agree with no other either in its language or in its manner of living [οὔτε ὁμόγλωσσον οὔτε ὁμοδίαιτον ὄν].' The evident objection to this is that conditions in the Lydia of Dionysius's days must have changed entirely since the time when the Etruscans would have emigrated (though a recent find proves that the Lydian language survived into the hellenistic period); but all the same, Dionysius's reasoning is highly interesting, especially since he makes it clear that the Etruscans were different both in language and way of life from their Italian neighbours and all other peoples – in spite of the hellenized external forms of their culture and architecture.

Modern scholars have tried to revive and corroborate Dionysius's opinion by research showing the connexions between the Etruscan culture and prehistoric life in central Italy. What is here assumed to be influence from the new tomb architecture on the old local types and other results of the merging of immigrants and the local population, they consider as proof that the Etruscan people had been living in Etruria since the dawn of prehistory. But how did it happen that this supposed aboriginal people was spared only there? Does it seem likely that the Early Iron Age culture of central Italy was created by two different races with the Tiber as a dividing line between them? Ingenious suggestions that it may have been the Etruscans who brought the Early Iron Age culture to Italy some time about 900 B.C. and that it spread from their new settlements do not, it seems, solve the difficulties.[14]

Anyhow, for the present study of the architecture of the Etruscans it is enough to state that a new architecture of common Mediterranean stamp was brought to Italy by a people that spoke Etruscan. If the Etruscans were immigrants from Asia Minor, they probably started their life in Italy with a rather low form of culture from the Near East. It seems likely that they brought with them basic architectural traditions. In any case, it is clear that refined Etruscan architecture, as we see it, was developed in the cities of the Etruscans under continuous influence from the Orient and Greece. The reshaping power of this influence was so strong that the question whether or not the immigrants brought fundamental architectural ideas with them almost becomes one of secondary importance.

ETRUSCAN ARCHITECTURE

INTRODUCTION

THE Etruscans enjoyed a free existence as independent city-states for some six hundred years, from the eighth century to the eighties of the first century B.C., when internal warfare and Sulla's victories put an end to particularism in Italy and latinized the whole country (excepting only the Greek towns). The culture of the Roman Empire and the architecture of Augustan Rome then imposed themselves on the ancient Etruscan centres of agriculture, mining, handicraft, art, and shipping. Their ill-famed and dreaded piracy, carried on even in the third century B.C., to the scandal of the hellenistic world, had been stopped by the Romans about 300.

Especially important for Rome was Veii, the rich and great neighbour town with painted chamber tombs already from the seventh century B.C. According to Livy, the Romans destroyed Veii in 396. Rome's next important Etruscan neighbour was Caere (Cerveteri, Etruscan Chaisrie). Three famous inscriptions on golden plates, two in Etruscan and one in the Punic language, found between two temples at Pyrgi (Figure 17), one of Caere's harbour towns, show that Caere about 500 had close connexions with Carthage. From the fourth century onwards Caere became closely connected with Rome and soon lost its independence, Pyrgi receiving a strongly fortified Roman colony outside its spreading township in the third century B.C. (Figure 56). The roster of the greatest towns, glorious coastal successors of the Villanovan villages, must include Tarquinia, Vulci, Talamone, Rusellae, Vetulonia, Populonia, and Volaterrae (Volterra); to these should be added such inland towns as Faesulae (Fiesole), Arretium (Arezzo), Clusium (Chiusi), Volsinii in the neighbourhood of medieval and modern Bolsena, Blera (Bieda), and such unidentified towns as those of the majestic, archaic tholos tomb called La Montagnola di Quinto Fiorentino (Figure 49), of Orvieto, San Giuliano, San Giovenale, and Luni (Monte Fortino). Falerii (Civita Castellana) had a special position, since it was the centre of the Indo-European Faliscans and yet politically and by its culture closely connected with the Etruscans.

Boundaries and different political associations and constitutions no doubt caused conflicts; but the Etruscan towns of the centuries which we know did not make war on each other, as did the Greek city-states at home and in Italy, though they gave no aid to Veii when it was conquered by the Romans. They organized themselves into a confederation with its centre in the Temple of Voltumna in the neighbourhood of Volsinii, and even, in the seventh, sixth, and fifth centuries B.C., successfully established a dominion comprising the Po valley and Campania, with control over Latium through such Etruscan dynasties as the Tarquinii in Rome. Their architecture and culture spread over central Italy from the sixth century onwards, and it should be remembered,

especially in the Campanian towns, that such features as regular town planning and atrium-houses can be explained by cultural influence and by no means necessarily imply Etruscan builders. In the Po valley Etruscan town planning and architecture asserted themselves around Felsina (Bologna), in new centres such as Spina or the Etruscan colony at the Reno River, called Marzabotto, which were both founded towards the end of the sixth century (Figure 34). In Campania, Capua, Pompeii, and even a town on the Sorrento peninsula, Marcina (probably Fratte near Salerno), had their Etruscan periods. The Etruscans of these early days also controlled the sea around Corsica and Elba.

The period of greatest power gradually came to an end in the fifth and fourth centuries. Latium, according to the Roman tradition, was lost in 509 because of the rise of the Roman Republic. Samnite invaders from the central mountain districts expelled the Etruscans from their capital Capua and from Campania in the fifth century. By 474 their sea power had already had a serious setback in a battle against the Greeks at Cumae. North of the Alps and the Po valley the Gauls, another powerful rival of the Etruscans, developed a great military force and organization comprising cavalry with iron horseshoes (a novelty in the ancient wars). Among other material a rich tomb from the Saar shows that they had an interesting and rich culture of their own, at least the higher classes, and could import real treasures, as, for instance, the large Greek bowl from Vix. Then, towards 400, the Gauls invaded the Po valley, ending the Etruscan dominion. They proceeded to raid the towns of Etruria, and in 387 they even sacked Rome. Meanwhile, after the subjugation of Veii, a century of wars began between Rome and Tarquinia. This double warfare against the Gauls and Rome rendered necessary what proved to be one of the great architectural achievements of the Etruscans: the construction of town walls in their fully developed shape (Plate 26; below, p. 59). They confirm in a monumental way what Livy says over and over again about the military strength displayed by the Etruscans even in these late and losing wars. The end came between 280 and 241, when all Etruscans and Faliscans were brought under the sway of Rome with more or less reduced independence and territories.

For a historical study of Etruscan architecture it is most important to remember that the dependence on Rome and the decline of political power in the third and second centuries by no means put an end to the wealth or to the architectural activity of the Etruscans: on the contrary, after the final Roman victories, as in Pompeii, a period of increasing prosperity was inaugurated for the Etruscan towns. This was due to the peace under Rome, to Italy's contacts with the hellenistic world after the victory over Hannibal, and to great landowners and other wealthy people, protected by Rome.

The main buildings in which the Etruscans demonstrated their state, culture, religion, and family traditions were the temples and the palatial houses of kings and nobles, as we see them reproduced in monumental tombs. In contrast to these – but also to the tenement houses with upper storeys, which we shall meet with already in third-century Rome – stand out the one-storey houses of the common people which our archaeological material has revealed at Marzabotto, San Giovenale (Plate 31), Veii, Vetulonia (Figure 31), Rusellae, and in a few other places. Vitruvius remarks especially (VI, 5. 1)

that the ordinary people in towns, where the rich lived in atrium-houses built in grand style, did not need such luxury.

The densely populated quarters of the common people housed a free population, though one which never seems to have attained the importance of the Roman plebs. Cicero (*De republica*, II, 16) says that even at the outset Romulus divided the Roman plebs among the aristocratic clienteles; the same system seems to have been typical of the Etruscan towns, prevailing until the decline of old Etruria. The grouping of qualified slaves, freedmen, and clients around the influential families seems to have been very important. A great proportion of the artisans were slaves, according to Livy (v, 1). They had the same kind of dwellings as the majority of the common free people which Varro mentions (*Lingua Latina*, 58).

To these introductory remarks may be added a few words about Vitruvius and his description of Etruscan architecture. References to his famous Ten Books on Architecture, written about 25 B.C., have already been made and will accompany all the following chapters right down to Late Republican times in Rome. It may therefore be useful to state at once that Vitruvius was first and foremost an architect who – as he eloquently and even ardently proclaims – wished to contribute to the grandeur of Augustan Rome by reviving traditional styles of architecture. He preached to a younger generation about the honest, highly experienced architects of bygone days, expressing himself in a strong but sometimes rather ambiguous pre-classical Latin. He wanted to adapt the classical styles to the demands of his own times, but at the same time claims to have re-established their ideal proportions and forms. He thus wishes primarily to be the practising architect, not a teacher of the history of architecture, and to establish rules for all kinds of buildings in the Augustan Age. Vitruvius bases his ideal rules for Etruscan temples and their *dispositiones* upon his knowledge of the more or less modernized architecture of Etruscan stamp which he could see all over Latium and Etruria. He may even have studied Roman or Etruscan treatises on the old architecture – comparable to the compendia of Etruscan religious and political wisdom compiled in the Late Republican Age and characteristic of the learned interest of that period. While he is an unsafe guide on archaic architecture, his rules often approximate to the measurements of preserved Later Etruscan and Roman buildings. When Vitruvius tries to fix measurements for the various elements of their construction, he is evidently combating a confusion prevailing under hellenistic influence. What he intends to do is to arrive at general rules of his own based on actual buildings, but not by reproducing any one example.[1]

TECHNIQUES AND MATERIALS

When Oriental and Greek culture arrived in the eighth century B.C., the old wattle-and-daub structures soon seemed to belong to a remote past, though wattle and daub remained in everyday architecture even in Imperial times as an indestructible undergrowth. Vitruvius (II, 8. 20) expresses a wish that it had never been 'invented'. In inland places like San Giovenale we see with almost dramatic vividness how the Etruscan

chamber tombs of the Oriental and Greek luxury of about 700 B.C. began to appear
about 650. On the acropolis of San Giovenale and Luni foundations of roughly square
structures suddenly superseded the old village. We meet with rectangular houses and
the common Mediterranean manners of building, which from the great Etruscan
coastal towns spread to the out-of-the-way corners of inland Etruria, Latium, and all
central Italy.

Timber construction appears at an early date at Veii. The ceilings, which the rock-
cut chamber tombs at Caere (Cerveteri) and other Etruscan cities reproduce, show the
mastery of timber-work which the Etruscans attained in the sixth century (Plates 35 ff.).
In sixth-century San Giovenale and at Veii (that is before 396), we also meet with
a crude masonry of tufa blocks in various sizes in the houses. Ashlar work and poly-
gonal walls belonged to Etruscan architecture from early times, especially in royal
tombs, city walls, and the podia of temples. Sun-dried brick and half-timber on stone
foundations became highly important, as seen at Veii, San Giovenale, Vetulonia, and
many other places. At Marzabotto the bricks seem to be partly fired, and the founda-
tions of the houses are of river boulders embedded in mud (Plate 29). Sometimes walls
were made of rammed clay (*pisé*), sometimes they could be built with the mud brick
directly on the ground. It is evident that these modes of construction were brought to
perfection and general use in central Italy in the seventh century. What reached the
villages of the Early Iron Age was a technique known already from the third millen-
nium in Malta, from such Bronze Age villages on Crete as Vrokastro, Kavousi, Karphi,
and so on.[2]

Vitruvius (II, 8. 9), like Pliny (xxxv, 173), describes the ancient mud-brick city wall
at Arretium (Arezzo) as 'excellently built', and a description of 1536 and excavations of
1916–18 have substantiated his praise; beautifully cut bricks and scarcely visible mortar
joints were revealed. At Rusellae a mud-brick terrace wall on a foundation of rough
polygonal blocks was built about 600 (cf. p. 59). Vitruvius distinguishes between the
square sun-dried bricks of the Greeks and the rectangular Greek Lydian bricks, 'being
the kind which our people use, a foot and a half long and one foot wide'. Bricks actually
found at Arretium and Vetulonia show roughly the same proportions. The name
'Lydian' reminds us of the *Lydia ripa* of the Tiber, and may indicate real knowledge
of an eastern provenance of the technique or may merely be a synonym for 'Etruscan'.
In any case, though the Greeks preferred other proportions, there can be no doubt that
the Etruscans learned from their mud-brick architecture, of which the enlarged city wall
of Gela, of the fourth century, still affords a monumental example.[3]

Etruscan mud-brick architecture started a great new tradition in Italy. Augustus,
contrasting the old Rome of brick with his marble city (that is, his city with its temples
and other monumental buildings faced with marble), has in mind concrete and mud-
brick. Pliny (xxxv, 173) says that in his time no mud-brick walls were built in Rome.
Vitruvius (II, 3 and 8. 16) warmly defends mud-brick architecture, but he makes us
understand that the Romans of the Augustan Age could not build their high houses
(*insulae*), so necessary for the constantly increasing population, of mud-brick, since the
space of the city was so limited that there was no room for the bulky walls needed for

high mud-brick structures. In any case, a description of an inundation of the Tiber in 54 B.C. shows that mud-brick houses still survived in great numbers during the first century B.C.[4]

Mud-brick and wood evidently remained the normal building material for the walls of Etruscan temples and houses down to the last centuries of Etruscan history, in contrast to the Egyptian and Greek stone-built temples. This perishable material doomed Etruscan domestic architecture when decline came. Roman and medieval activity on the Etruscan acropolises completed the havoc. The tombs are – at least for the time being – our best archaeological evidence of what the palatial houses of the nobility were like. The case of the temples is different. Their podia and foundations were more monumental and less perishable. A rich supply of terracotta decoration and tiles often permits a reconstruction;[5] but not only in places without known Etruscan names, such as San Giuliano, San Giovenale, or its neighbour Luni (Monte Fortino), but also in many great Etruscan centres such as Clusium (Chiusi), Volaterrae, Cortona, Arretium (Arezzo), and Perusia (Perugia), remains of temple foundations have so far been sought in vain.

TEMPLES

We learn from the tombs that the domestic architecture of the nobility and the Lucomones, as the Etruscan kings were called, assumed stately forms. But the centres of the new towns in Italy, with their foreign culture and luxury (already known from the tombs of the seventh century), were evidently the temples, with their piazzas and altars in front of them. The late compilers of Etruscan tradition report that the founders of the Etruscan towns thought that every proper town ought to have three gates, three main roads, and three temples (those of Tinia, Uni, and Minvra, i.e. Jupiter, Juno, and Minerva; Servius ad Aen., I, 422). In the Etruscan towns known to us there is no trace of such planning, but Vitruvius (I, 7) confirms that the Etruscans had rules for their temples handed down by the haruspices.

The Early Temples

A temple on the acropolis (Piazza d'Armi) at Veii seems to illustrate the first tentative beginnings of Etruscan temple building. It was a rectangular (49 feet 9 inches by 26 feet 3 inches; 15·15 by 8·07 m.) timber-framed house (with mud-brick), without pronaus or podium, and the foundation consisted of coarse tufa blocks. It had a frieze and antefixes of crude archaic workmanship. These early temples also include one at Volsinii (Bolsena) with a roughly quadrangular temenos measuring 56 feet 5 inches by 44 feet (17·20 by 13·40 m.), surrounded by a wall (Figure 11). A cella without pronaus (26 feet 3 inches by 21 feet 8 inches; 8 by 6·60 m.) is built against the back wall of the temenos. A model of a house from an Etruscan tomb in Monte Abatone (Plate 10) and also older models of houses with decorative crossing rafters from Falerii and from Sala Consilina (Plates 5 and 9) may be considered together with this early sanctuary.[6]

To a foreign architectural tradition belongs the old Temple of Mater Matuta at Satricum, famous for its terracotta revetments and datable to about 500. It is surrounded by a peristyle and has an oblong cella and deep pronaus. It is an interesting instance of a temple with a Greek plan transmitted from Latium during its Etruscan Age. It may, of course, have been due to Greek influence from Campania, but Dionysius (I, 21. 2) tells us that the Temple of Juno at Falerii was built on the model of the Temple of Hera near Argos. Thus, temples of the Greek type, like Greek columns (cf. p. 44), were not alien to the Etruscans. They were probably scarce, but can be compared with the Doric temples of Oscan Pompeii, or to Elyman Segesta with its unfinished columns and cella of mud-brick.[7]

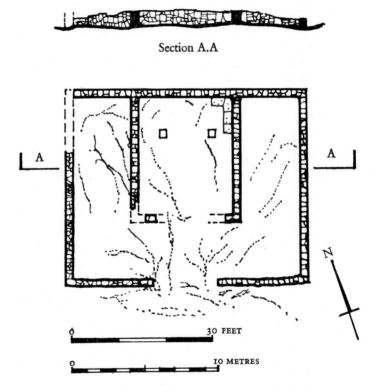

Section A.A

Figure 11. Volsinii (Bolsena), Poggio Casetta, temple.
Early sixth century B.C. Plan (1 : 250)

Funerary urns and models show small chapels with pitched roofs but without pronaus, a type which no doubt persisted *per saecula*. But of real importance for monumental Etruscan sacred architecture from the fifth century down to Roman times were only what Vitruvius in his famous chapter about Etruscan temples refers to as 'tuscanicae dispositiones', the typically Etruscan rules for temples (IV, 6 f.; Figure 22). There are several variations of this highly characteristic type. Vitruvius describes two of them but does not claim that they were archetypes: he just wished to re-establish an ideal arrange-

ment and proportion, and therefore chose two types which were most in vogue in his day, because they were used for Roman Capitolia (below p. 137). However, modern scholars have assumed that all the variations of Etruscan temples were derived from Vitruvius's two types – an unfounded conclusion, which has given rise to strained categorization and arbitrary reconstructions. The obvious approach to our material seems to be an empirical description of common features and an unbiased classification of the various types and their long and interesting career in Etruscan, Roman Republican, and Imperial architecture.[8]

As far back as we know the temples had external terracotta decoration in the Greek style (Figures 24–5); but their most typical features clearly were not Greek. Typical of all Etruscan temples are roomy colonnaded pronai in front of the cellas and entrances only on the front, a distinctive feature no doubt due to the nature of Etruscan religious rites. They thus had an innate axial tendency, which was also visible in the early temple areas at Volsinii (Bolsena) and Orvieto (Figures 11 and 12). In Roman times this was emphasized by altars placed in front of the centre of the entrance. Common to all the various temples with this general arrangement are wide spaces between the columns. These large intercolumniations made it impossible to employ stone or marble for the architraves, so wooden beams were laid upon the columns, and the whole entablature was of wood, which again is completely at variance with the practice in Greek temples (Vitruvius, III, 2. 5). Many temples of Etruscan type had columns along the side walls, but they never had a peristyle on all four sides as had the great Greek temples. The back walls were closed in all cases, but they could be extended right and left of the cellas if the temples had side rooms (wings, *alae*) with columns outside the walls of the central cella (or cellas), as Vitruvius says (IV, 7. 2; Plate 12, cf. Figure 63, Temple C, Largo Argentina).[9]

A very characteristic feature is the use of podia and flights of stairs or ramps on the front (Plate 14). When a temple is built directly on rock without a podium, like, for instance, the temenos and archaic temple at Volsinii (Figure 11), it is an anomaly explained by the site, which allowed a spur of bedrock to serve as a natural podium.

These Etruscan temples have been compared with Greek temples *in antis* or *megara* from Mycenaean times and later. Vitruvius's description of the Greek temples *in antis* (III, 2. 1) may suggest that, and permits a connexion to be made (IV, 8. 5). Yet the wide pronai of the Etruscan temples, the closed extensions of the back walls, and the podia give them a different and fundamentally foreign character. Neither the old simple houses of the gods nor Greek influence can give any real explanation or background to these new temples in central Italy. It is, indeed, natural that Vitruvius, trying to renew classical styles and discussing the various types, has treated the *mos tuscanica*, the *dispositiones tuscanicae*, as something different from all other kinds of temples (IV, 7; cf. III, 3. 5). He omits variations, which will be discussed below, though they may have been as old and typical as the two kinds of Etruscan temples which he has chosen: great temples with large open pronai, on a quadrangular plan, with either three cellas against the closed rear wall or open wings (*alae*). Vitruvius was further misled, no doubt, by later Roman and Etruscan temples with their many innovations. Both the Etruscans and the

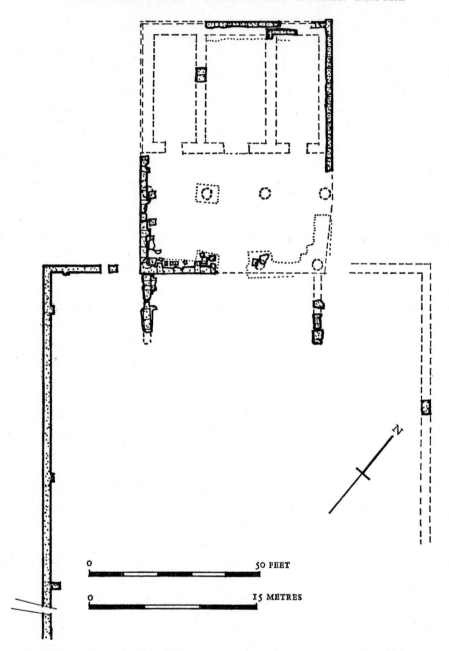

Figure 12. Orvieto, Belvedere Temple. Fifth century B.C. Plan (1 : 325)

Romans started in the third century B.C. (perhaps even before) to build stone temples on the old Etruscan plan, but with high Greek columns (see below, Figure 66, p. 112). In small temples, where the intercolumniations were not too wide, they even built Greek entablatures in stone (instead of employing the low wooden roofing of the ancient shrines). This most important combination of the principles of Greek and Etruscan buildings, occasionally mentioned by Vitruvius (IV, 8. 5), was a part of the modernized

consuetudo Italica, as in his fifth book he called the hellenized Italic architecture of Late Republican times. Vitruvius's remarks about areostyle temples in his third book evidently show such modernisms, which were typical of Roman Late Republican architecture.[10]

All the same, partly due to Vitruvius and ancient descriptions, but more to the archaeological material now available, the genuine old Etruscan temples can be reconstructed in their main lines, with low wooden entablatures and delightfully colourful terracotta revetments in Greek style protecting the wooden parts of the buildings. In addition to these ornaments, fantastic antefixes, decorating the ends of the cover tiles above the eaves, were used, and charming rich acroteria and sometimes terracotta statues on the ridge of the roofs or on the eaves above the gables of the front (Figure 28 and Plate 12). Before describing the superstructures of this highly original sacred architecture it is necessary to discuss what archaeological study has revealed about typical ground plans.

Types of Plan and Superstructure

There are three types of temples with the Etruscan stress on the front which Vitruvius may have had in mind when describing the Greek temples *in antis* and prostyle temples (III, 2. 2–3), but which he leaves aside in his main description (IV, 7).

One kind of temple with a deep pronaus having two columns on the axis of the lateral walls of the cella seems old and not unusual (Figure 13). There is no reason to doubt that a cippus from Chiusi, dated about 500 B.C., represents a temple of this kind with two Tuscan columns (Figure 14); in any case, a fragment of the roof of a terracotta model, also dating from about 500, proves that these two-columned temples belonged to the archaic Etruscan Age. A relief of the Imperial period suggests that the Temple of Juno Moneta on the Arx of Rome had a prodomus with only two columns, as has also the small model of a temple from Teano, which is Late Republican (Plates 11 and 79).[11]

A great and important group of Roman temples seems to have been related to the Etruscan ones. These Roman temples had a cella – sometimes pseudo-peripteral – without alae and with four or more columns in the pronaus. The pronaus tends to occupy the front half of the building. This type, destined to be a model for classicistic architecture in Europe and America in the eighteenth and nineteenth centuries, occurs in our present Roman material from about 200 B.C., but probably had Etruscan predecessors. The earliest instances at present known are Temples B and D and the Port Temple at Cosa, the larger temple on the acropolis of Norba, and the so-called Punic temple at Cagliari (below,

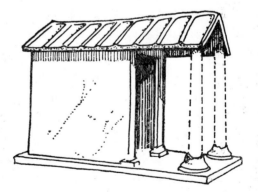

Figure 13. Model from Satricum of a temple with two columns in the pronaus.
Rome, Museo di Villa Giulia

p. 138). These temples may, of course, remind us of the prostyle temples in Vitruvius's list of Greek temples. Yet I repeat that the deep pronaus, the podium, and the great emphasis on the front show that the Etruscan arrangement described by Vitruvius (IV, 7) was even more important to their builders.

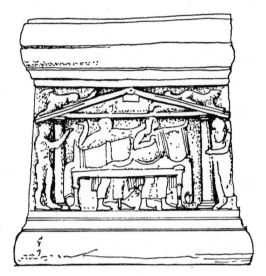

Figure 14. Cippus from Clusium (Chiusi) showing a
temple with two columns in the pronaus and
animals above the pediment. *c.* 500 B.C.
Berlin, Altes Museum

We now arrive at the two types which Vitruvius (IV, 7) selected in order to represent the ideal Etruscan temple. It is for these that he laid down rules (Figure 22 and Plate 12). According to him, the length and width of the building plot ought to start at a ratio of 6 to 5. The length should be divided into two equal parts, a rear part for the cellas, or for one cella with alae, and a front part (with stairs and entrance) for the columns. In temples with three cellas four-tenths of the width should be given to the central cella, and three-tenths to the right and three-tenths to the left cella or to the alae in temples with one cella. The corner columns of the pronaus should be placed in front of the antae on the line of the outside walls (if there were three cellas, otherwise the corner columns – as on the Temple of Jupiter Capitolinus (Figure 22) – terminate the row of columns along the outside of the alae). Two other columns should be placed between the corner columns on a line with the side walls of the central cella. In the space between the four front columns and the entrance to the central cella should be placed a second row of columns, arranged on the line of the cella walls.[12]

From the proportions of the ground plan Vitruvius passes on to the inner arrangements, giving first place to the three-cella temples and merely mentioning the possibility of temples with one cella and alae (Figure 63, Temple C). It seems clear that the three-cella temple can by no means be claimed as necessarily dominant and especially

typical of Etruscan sanctuaries. The number of the cellas depended, of course, on the number of divinities worshipped, and triads (or dyads) seem not to have played any commanding role in the organization of the Etruscan gods. Hardly any evidence from Etruria, for example, attests the triad Jupiter, Juno, and Minerva (Tinia, Uni, and Minvra) in the Etruscan towns.[13]

The 'Ara della Regina' Temple at Tarquinia (Figure 15), famous for the splendid terracotta horses in hellenistic style from its pediment, proves that great monumental

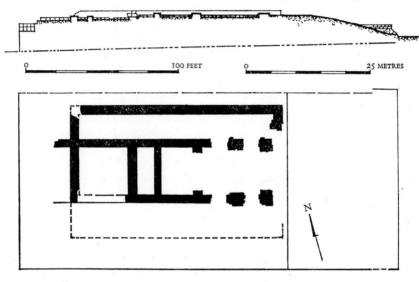

Figure 15. Tarquinia, 'Ara della Regina' Temple. Plan (1 : 750)

temples with a tripartite inner arrangement, Etruscan disposition, and podium could be built on a quite different plan from the quadrangle prescribed by Vitruvius. It measures 253 feet 1 inch by 116 feet 8 inches (77·5 by 35·55 m.). A temple on the acropolis of Ardea which otherwise displays Vitruvius's *dispositiones tuscanicae* measures 85 by 130 feet (26 by 40 m.). On the other hand, in the Portonaccio Temple of Veii (Figures 16 and 28), which once carried the famous terracotta gods now in the Villa Giulia Museum on its ridge and which measures 61 by 61 feet (18·50 by 18·50 m.), we meet with the measurements recommended by Vitruvius. The larger temple at Pyrgi (Figure 17) measures 78 feet 9 inches by 112 feet 10 inches (24·05 by 34·40 m.). Vitruvius's description of these tripartite temples has generally suggested reconstructions of Etruscan sanctuaries with columns in open pronai in front of the cellas. This is not altogether certain (cf. p. 37 f.), but seems likely. A recently excavated temple at Vulci is Vitruvian. Thus one has to consider three possible superstructures: temples with three cellas, as Vitruvius prescribes, with three cellas and alae, as seen in the Temple of Jupiter Capitolinus in Rome (Figure 22), and temples with one cella and open alae or closed corridors (Figure 19).[14]

Typical of the temples with alae is that the closed back wall extends right and left of the cella (or cellas like those of the Capitoline Temple of Rome). The columns in the alae along the sides of the cella were placed on the edges of the podium in line with

antae, which turned off at right angles from the extended rear wall, and ended with the external columns of the pronaus. Temples with alae were very popular in Late Republican days in Rome, but the hellenized Tomba Ildebranda at Sovana, which evidently imitates a temple of the second century B.C., proves that the Etruscans also favoured this type (Figure 18). On a high podium, below which the rock-cut chamber of the tomb is hidden, stands a colonnade in front of a broad central rock-cut block. There are six columns in front and three on the sides of this massive centrepiece. It reproduces in

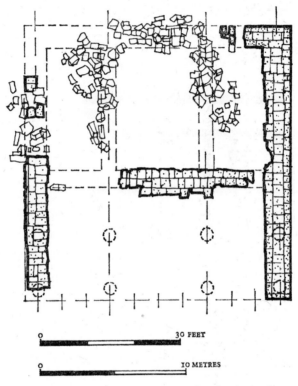

Figure 16. Veii, Portonaccio Temple. Plan (1 : 250)

reduced shape a three-cella temple with colonnades in front of the prodomus and alae left and right of the cellas as in the Capitoline Temple in Rome.[15]

The alae could also be changed to lateral corridors. Vitruvius does not mention this variation, but it has been revealed by excavations of a temple at Faesulae (Figure 19). This temple was rebuilt in Roman times (first century B.C.), but there are older remains below the present structure. It is of great importance for a discussion of the reconstruction of the mud-brick temples, for it is built of ashlar masonry, and that means that for once we can clearly see the superstructure. Against the closed rear wall is a cella measuring 27 feet 9 inches by 14 feet 5 inches (8·45 by 4·40 m.); the pronaus in front of the cella is 26 feet 8 inches (8·14 m.) deep; the proportion of cella to prodomus thus roughly corresponds to that prescribed by Vitruvius. The rear wall behind the cella continues on either side of it for 9 feet 3 inches and 8 feet 11½ inches (2·82 and 2·73 m.), and from the

ends of these extensions run side walls along the side walls of the cella to the front of the podium. Thus, the open colonnaded wings were, in the Fiesole temple, closed corridors along the side walls of the central cella. Between the side walls of the cella (on the front edge of the podium) were two columns. Stairs led up to this pronaus. A special characteristic of this structure is that only the front of the pronaus – i.e. the spaces between the antae and the columns – was left open. It reminds us of what Vitruvius says (IV, 8. 5): 'Where there are projecting antae in the pronaus, some set up two columns in a line with each of the cella walls, thus making a combination of Tuscan and Greek buildings (*tuscanicorum et graecorum operum comunis ratiocinatio*).' A late, but very useful reproduction of the type is a small temple model from Vulci (Plate 13).

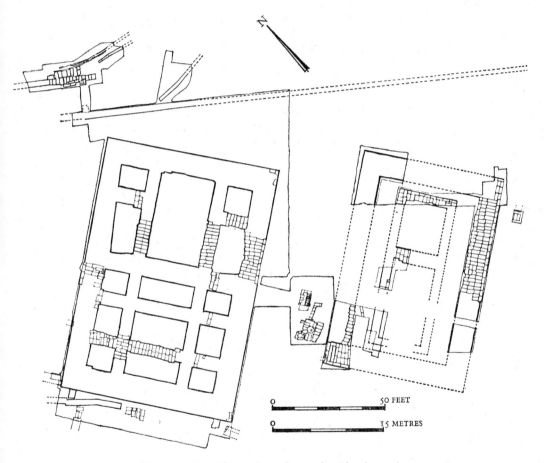

Figure 17. Pyrgi (Santa Severa), temples. Plan (1 : 750)

Among the later Etrusco-Roman temples of Latium there is no structure like the Fiesole temple and the model from Vulci, but a model dating from the sixth century, found at Velletri, shows us the same construction (Figure 20). That pushes it back to the archaic period – in spite of the fact that in this case there are two cellas covered by a flat roof inside the building. The shrine was obviously dedicated to two divinities.[16]

The alae and the pronaus with side walls of the Fiesole temple should make us reconsider the current reconstructions of even such great and famous temples as that on the acropolis of Ardea, the 'Ara della Regina' Temple at Tarquinia, and the Portonaccio Temple at Veii (Figures 15 and 16). It is not only uncertain whether they had three cellas or alae, but we must also admit as a possibility that they had closed side walls in their pronai, like the Fiesole temple, and only four columns in front of the walls of the central cella. At Veii, inscriptions seem to indicate a triad (Artemis, Minerva, and perhaps Turan), but the remains are inconclusive. The larger temple at Pyrgi (Figure 17)

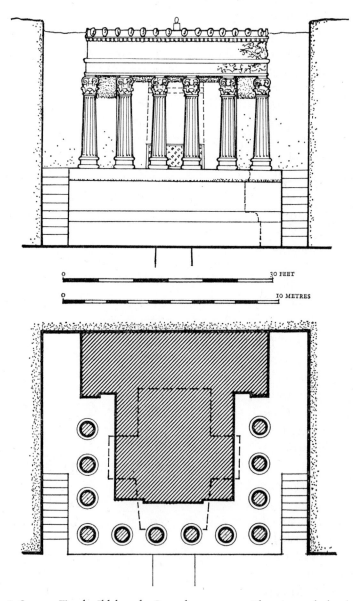

Figure 18. Sovana, Tomba Ildebranda. Second century B.C. Elevation and plan (1 : 125)

seems to have been the wealthy sanctuary of Leucothea (Eileithyia), which Dionysius, the tyrant of Syracuse, plundered in 383. Thus, it most probably had one cella and alae. The smaller temple is supposed to be related to Punic-Greek temples.

Some other temples may illustrate the different possibilities. Temple C on the temple terrace of Marzabotto, dated to the fifth century, seems to have been a temple with cella and alae, but even there different reconstructions have been proposed. The great fourth–third-century temple in the Contrada Celle at Falerii (Civita Castellana) (Figure 21) and the fifth-century temple at the Belvedere at Orvieto (Figure 12) seem also to have been three-cella temples. The former is truly grandiose. The width of the cellas is about 130 feet. They are built against the rear wall of an almost square enclosure, measuring some 260 by 260 feet. The smaller three-cella temple of Orvieto measures 71 feet 11 inches by 55 feet 5 inches (21·91 by 16·90 m.). To the right and left, in line with the four columns of the temple front, is a wall of tufa blocks which enclosed the sacred area. It projects some 30 feet beyond the corners of the front of the temple and then turns at right angles. Some 175 feet (53 m.) of the left side wall are preserved, and a short part of the right one. These enclosed areas in front of the temples have an archaic predecessor in the temple of Volsinii (Bolsena) (Figure 11). Their tradition seems to live on in the Imperial fora of Rome. The arrangement implies strict axial symmetry.[17]

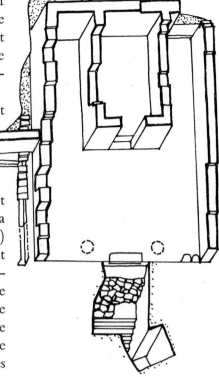

Figure 19. Faesulae (Fiesole), temple. Etruscan, rebuilt in the first century B.C. Axonometric plan

Plans

Indisputable evidence for the plan of an old Etruscan temple is afforded by Vulci, Pyrgi, and the already mentioned three-cella temple dedicated in 509 to the triad Jupiter Optimus Maximus, Juno, and Minerva on the Capitoline Hill in Rome (Figure 22). Etruscan diviners, a

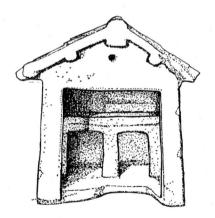

Figure 20. Model of a temple from Velletri. Sixth century B.C. *Rome, Museo di Villa Giulia*

sculptor from Veii (Vulca), and Etruscan workers were employed for the planning, decoration, and construction of the Roman temple. As the centuries went on, the temple was restuccoed and the interior lavishly modernized – as were Early Christian and medieval churches in Renaissance and Baroque times.[18] But the old-fashioned archaic temple remained as a reminder of Etruscan culture in central Italy throughout the rapid progress of Rome in the sixth century until a great fire destroyed it in 83 B.C. It was reconstructed in 69 B.C., and after that it was embellished – that is,

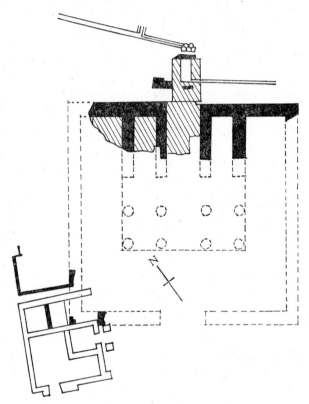

Figure 21. Falerii (Civita Castellana), Contrada Celle, temple.
Fourth-third century B.C. Plan reconstructed by A. Andrén

rebuilt in the hellenistic style with high Greek marble columns – but Dionysius (IV, 61) affirms that the old plan was kept. Tacitus (*Historiae*, IV, 53), in addition, writes that the plan was venerated and considered sacrosanct when the temple was rebuilt in the grand Imperial marble style after fires in the Flavian Age. *Nolle deos mutari veterem formam*; the actual remains on the Capitoline Hill wholly substantiate these solemn words.

Still to be seen is a mighty substructure which, in conformity with Vitruvius's prescriptions (III, 4. 1), was 'carried down into the solid ground as far as the magnitude of the work seems to require, and the whole substructure . . . as solid as it possibly can be laid'. The same kind of irregularly piled-up substructures in shafts below buildings can be seen in many places; for instance, below the (now vanished) podium of the temple on the acropolis of Ardea. Such irregular substructures also occur below regu-

larly built fortification walls, as, for instance, in the outer circuit of Veii (Figure 32) and below the Etruscan fortification under the medieval palace of San Giovenale (Plate 25). Above the Capitoline substructure an inner wall of the podium can still be seen, once destined to carry the columns in front of the eastern wall of the cellas (it now

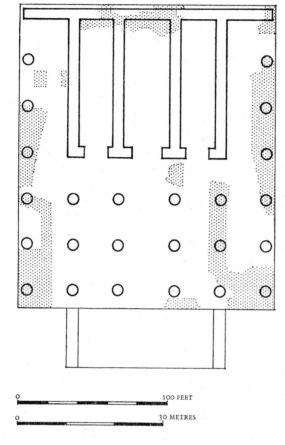

0 100 FEET

0 30 METRES

Figure 22. Rome, Capitoline Temple. Dedicated 509 B.C.
Plan by E. Gjerstad and B. Blomé (1 : 750)

serves as a wall of the corridor between the Palazzo dei Conservatori and the Museo Nuovo). The height of the podium seems to have been about 13 feet – a height which, according to Varro, Catulus, the builder of the temple of 69 B.C., considered low (Gellius, *Noctes Atticae*, II, 10). The width of the preserved inner wall of the podium of the cellas is *c.* 13 feet 7 inches (4·15 m.). The whole podium measured 204 by 175 feet (62·25 by 53·30 m.). The relation between length and width is thus roughly 7 : 6; yet Vitruvius (IV, 7) prescribes 6 : 5 for his smaller model temple with two rows of four columns in front and no alae flanking the three cellas. Dionysius (IV, 61) says the podium was 800 feet in circumference and almost square. The excess of length over width was not a full 15 feet. This statement is incompatible with the remains of the temple, and scholars have in vain tried to explain the incongruities. In a general way, however, it

confirms that the Capitoline Temple was very large and appeared squarish – as Vitruvius prescribes (IV, 7) in his rules for an Etruscan temple without columns along the side walls. The substructure and the remains of the podium, as they stand today, further show that – in spite of Dionysius's erroneous measurements – we can safely believe his general description of the plan of the old temple. It had, he says, a closed rear wall (with extending wings right and left), and consisted of three parallel cellas under one roof, separated by partition walls; the middle shrine was dedicated to Jupiter, while on one side stood that of Juno and on the other, that of Minerva. The central part of the building, inside the peristyle, was in other words just what Vitruvius (IV, 7) demands in his prescription for a Tuscan temple. Both Dionysius (VI, 61) and the remains prove that the three cellas of the Capitoline Temple had alae with a row of columns outside the side walls and in front of the eight columns of the pronaus. Instead of Vitruvius's eight columns in front of the three cellas, the Capitoline Temple thus had eighteen columns in its monumental prodomus.[19]

The Capitoline Temple is the largest Etruscan temple known to us. We may ask if it was the worship of the Roman triad, Jupiter, Juno, and Minerva, known already from an older temple, the Capitolium Vetus on the Quirinal (Varro, *Lingua Latina*, V, 158; below, p. 92), which first induced the Etruscan master builders, employed by the Etruscan kings of Rome, to build three cellas, thereby enlarging the type in breadth. We must, of course, also ask ourselves if there could have been still older and more distant prototypes for the arrangement with three cellas which Vitruvius regarded as the full development of the type. It may further be noted as an interesting fact that the width of the temple – that is, the distance between the corner columns on the front of the podium (163 feet 2 inches; 49·73 m.) – vies with the largest Greek temples: the corresponding measurements are for the Olympieion at Athens 134 feet 11 inches (41·11 m.), for the Temple of Artemis at Ephesus 180 feet 9 inches (55·10 m.), for the Heraion of Samos 195 feet 10 inches (59·70 m.), for Temple GT at Selinus 164 feet 3 inches (50·07 m.), and for the Olympieion at Agrigento 173 feet (52·74 m.).

To sum up: the plans of Etruscan temples, and especially the two types which Vitruvius emphasized as his *mos tuscanicus* or *dispositiones tuscanicae*, reveal a most characteristic arrangement of their own, with podia, frontal emphasis, closed back wall, and colonnades in the prodomus and in temples with alae along the side walls. These are the basic archaeological facts.

Podia

A discussion of the elevations must start with the podia. As a general rule it can be said that podia of ashlar masonry with stairs in front are typical of Etruscan temples. Vitruvius, in his third book (4. 4–5), mentions stairs in front of the podium. Already in the archaic temples we meet two kinds of podia. As already stated, the podium of the Capitoline Temple was 13 feet high. The south-east corner shows that the façade was straight and probably stuccoed. It probably had a cornice on top, as has the oldest temple in the Largo Argentina (Temple C, dated to the late fourth century), where a

moulding and an abacus crown a straight wall of about the same height as the Capitoline Temple (Plate 14).[20]

The temple in the lower town at Ardea has a rather different type of podium. It is one of the temples of Latium, which, like the Capitoline Temple, attests the beginnings of Etruscan architecture south of the Tiber. It is dated by its oldest terracotta revetments to about 500. There are still some remains of swelling mouldings below the podium wall. There was, no doubt, also a cornice on top of the wall. These mouldings were connected with the rich Italic development of Greek mouldings known from the substructures of Etruscan sixth- and fifth-century tumuli (Plate 15), and also seen in the hourglass-shaped altars, with upper and lower echini, supporting sacrificial tables.[21]

The material customary for the cellas and the closed rear walls built on the podia seems to have been mud brick and timber. This accounts for the remains of the temples usually consisting only of subterranean substructures, podia, and fragments of terracotta revetments. Here one must remember Vitruvius's rule (II, 8. 17) that higher mud-brick walls should be two or three bricks thick. Instead of such clumsy walls, ashlar work may have been used for the greatest temples, as often in the sanctuaries of the latest centuries B.C.

The Orders

Vitruvius, in his third book (III, 5) and in his general rules (IV, 7), gives very clear data for the proportions of the columns and their height.[22] The columns should be one-third of the width of the temple. In some cases his rule gives fairly reasonable measurements, but in the case of the Capitoline Temple – both in 509 and 69 B.C. (below, p. 137) – as its width is 163 feet 2 inches (49·728 m.), the height of the columns should, if we follow Vitruvius's rule for a three-cella temple without alae, be 54 feet 5 inches (16·576 m.), a height which surpasses the columns of the great Doric temples in Sicily and almost equals the columns of the Olympieion in Athens (55 feet 5 inches; 16·89 m.). This height has been strongly advocated for the temple of 509, but I would not be prepared to allow such a scale for archaic Etruscan temples, or to accept Vitruvius's rules as a reliable basis for so sensational an assumption. Vitruvius's measurements are very likely those of the magnificent rebuilt temple of 69 B.C. In his second Verrine oration (IV, 31), Cicero exclaims that the fire of 83 seemed to him to have been almost sent by the gods 'to ensure that as the Capitol has been rebuilt with greater splendour, so it shall be adorned with greater richness than before (quemadmodum magnificentius est restitutum, sic copiosius ornatum sit quam fuit)'. When Dionysius (IV, 61) says that the foundations remained but that the costliness of the building was increased after the fire of 83, he evidently means the same. Finally, there is Varro's statement that the builder of the new temple of 69 regarded the old podium as too low and out of proportion to the stately pediment he intended to build.

The columns of the old temples were often of stuccoed wood. Etruria was famous for its 'very straight and very long beams' (Strabo, V, 2. 5). But in high temples, and especially in the later heightened temples, columns of stone – as, for instance, the central

support of the sixth-century tholos of Quinto Fiorentino (Figure 49) – no doubt were preferred or even necessary. If the capitals and bases of wooden columns were not of stone, they were encased in terracotta.[23]

In his rules for columns, Vitruvius recommends the so-called Tuscan column, with accurate prescriptions for diminution at the top of the column, the height of base and plinth, the height of the capital, and the width of the abacus (IV, 7. 3). Characteristic of the Tuscan column is the unfluted shaft, whether straight or tapering towards one or both ends, and a capital akin to the Doric, consisting of a round cushion (*echinus*) and a square abacus. The bases were evidently inspired by Ionic columns. As in the case of the podia, a simple basic shape was enriched by influence from Greek architecture – as was the whole temple building.

We can trace columns of the Tuscan type from about 500, both in tombs and domestic architecture (Figure 23). In the Etrusco-Roman temples of the third and second centuries, Tuscan columns and wooden Etruscan entablatures seem to have prevailed (for example, Signia, Alatri, Alba Fucens, Mons Albanus, Cosa). Tuscan columns and capitals further became popular in various kinds of Late Republican architecture, as seen in late tombs at Caere (Cerveteri; Plate 16), porticoes in Rome and Pompeii, and, for instance, a peristyle of a sumptuous rebuilt house in Morgantina (Sicily). Imperial architecture – the Theatre of Marcellus, the Colosseum, and so on – continues this tradition.

This late renown of Tuscan columns and what Vitruvius concluded about their specific and original Italic character probably determined his choice of Tuscan columns as most appropriate for Etruscan temples: he evidently thought that they were more truly Italic. This may reveal the same romantic nationalistic tendency which can be traced in his age in Roman poetry, and sometimes also in architecture, side by side with an overwhelming predilection for hellenistic elegance and architectural decoration which temples began to display more than a hundred years before Vitruvius.[24]

It would be wrong to assume, however, that Tuscan columns were essential from the beginning for Etruscan temples; Vitruvius is, again, too dogmatic and relied too much on the evidence of later Etrusco-Roman architecture. A casing of a capital from the archaic temples of Fortuna and Mater Matuta in the Forum Boarium in Rome shows that as early as the sixth and fifth centuries columns with fluted Ionic shafts and capitals of a quite different shape from those prescribed by Vitruvius could be used in temples of the Etruscan type (Plate 17). A fourth-century column from Vulci confirms that fluted Ionic shafts were adopted also in Etruria itself at an early date. Tombs (Plates 18–19 and 35) prove that Doric, Ionic, and especially the so-called Aeolic capitals were popular among the Etruscans from the sixth century onwards.[25]

I must restate that, at least as early as the Romans, the Etruscans could amalgamate an Etruscan plan with Greek columns and architraves of stone, as seen in the tombs imitating temple façades. Two tombs at Norchia (Plate 20) have rock-cut gables, with Doric columns and Doric entablatures displaying some characteristic Etruscan liberties. The columns were perhaps unfluted. Above a smooth architrave follows the frieze of triglyphs with guttae pointing downwards and elongated metopes with human heads on

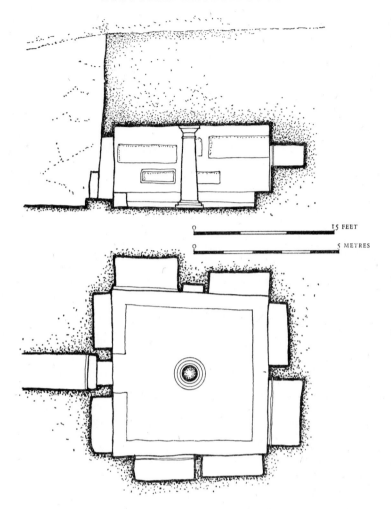

0 15 FEET

0 5 METRES

Figure 23. Vignanello, tomb with a Tuscan column. *c.* 500 B.C.
Section and plan (1 : 125)

them. The unorthodox impression is increased by Ionic dentillated cornices above the frieze. In the pediments are preserved remains of highly agitated reliefs. The earliest possible date seems to me to be the fourth century.

To the second century belongs a still more elaborate sepulchral temple façade on an Etruscan plan and with a most lively hellenistic elevation: the famous Tomba Ilde-branda of Sovana (Figure 18). The capitals of the colonnades have Ionic volutes to right and left of a female head and a Corinthian motif at the bottom. The first impression of the whole capital recalls the freely varied Aeolic capitals of many of the Etruscan tomb chambers, though capitals with figures are a hellenistic device known from the eastern parts of the Greek world. The Greek towns of south Italy or Sicily may have transferred it to the Etruscans, the Romans, and to Campania. The Ildebranda tomb

stands out as a most interesting specimen of Etruscan temple architecture in the provincial, unrestrained hellenistic style with figured capitals and griffons and a rich floral pattern on architrave and frieze. The tombs of Norchia and Sovana may show what Vitruvius reacted against when he summarized his stern classicistic rules for the real Etruscan style: they are in evident contrast both to the Early Hellenistic Age in Italy and the florid and enriched decoration of the post-Augustan, Imperial Age.[26]

Pediments and Roofs

After his rules for proportions and height of columns, Vitruvius (IV, 7. 4–5) proceeds to a very clear description of the wooden entablatures of what he considered the real Etruscan temples (Figures 24 and 25):

> Upon the columns lay the main beams [*trabes compactiles*, corresponding to the architrave of a Greek temple] fastened together, commensurate with the requirements of the size of the building. These beams fastened together should be laid so as to be equivalent in thickness to the necking at the top of a column, and should be fastened together by means of dowels and dovetailed tenons. . . . Above the beams and the walls [that is, above the wooden architrave] let the mutules [*projecturae mutulorum*] project to a distance equal to one quarter of the height of a column; along the front of them nail casings; build the tympanum of the pediment either in masonry or in wood.

The *projecturae mutulorum* were the projecting ends of the joists (*tigna*) laid lengthwise above the architrave of the side walls from the rear wall to the front of the temple. In greater temples, joists were also laid in between and parallel with the architraves of the side walls.

This description is, no doubt, reliable for temples which Vitruvius had actually seen – for instance, at Cosa – though temples without projecting mutules (pp. 48 and 50) seem to have been more usual. There seems to be nothing to add to it except that the description of the pediment is chosen in Vitruvius's usual way among several different possibilities among which he codifies one as the orthodox Etruscan disposition. The paragraph ends with the much-discussed words about the *stillicidium*; that is, the eaves of the Etruscan temple. Above the pediment, Vitruvius says, 'its ridge-pole, rafters, and purlins are to be placed in such a way that the eaves of the completed roof should be equivalent to one-third [of the roof without eaves] (ut stillicidium tecti absoluti tertiario respondeat)'. Scholars have referred this 'one-third' to the completed roof (Morgan, Fensterbuch), to the pitch of the roof (Granger in the Loeb edition), to the width of the cella (Frank Brown), or to the height of the columns, which, since Vitruvius derived their height from the width of the temple, serve as a basic unit of the design in paragraphs 3–5 (Reber). In any case, one essential fact is evident: the Etruscan temples had very wide eaves. This seems quite natural, as the walls of mud brick had to be protected. It is one of the distinctive features which must be kept in mind when trying to visualize them.

The appearance of the roofs can be illustrated by a much-discussed small terracotta

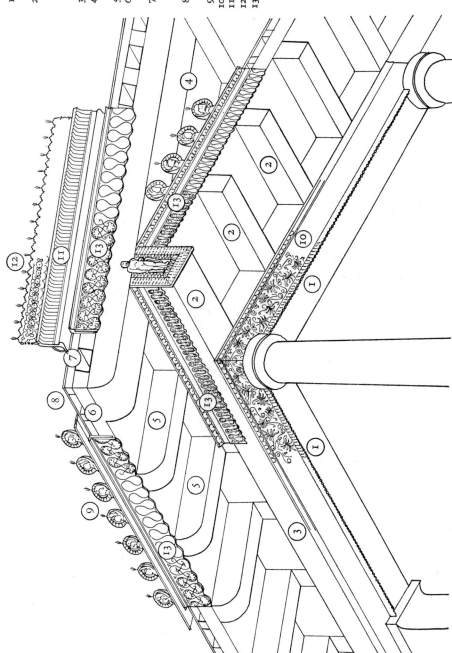

1. Architrave (trabes compactiles)
2. Mutules (traiecturae mutulorum; cf. Figure 29) projecting in front of the tympanum
3. Mutules (tigna)
4. Pediment (tympanum, fastigium)
5. Rafters (cantherii)
6. Purlins (templa; Vitruvius VII, 2. 1)
7. Common rafters (asseres; Vitruvius VII, 2. 1)
8. Sheeting of planks (copercula)
9. Antefixes
10. Frieze of the architrave
11. Sima
12. Pierced cresting
13. Revetment planks below the sima and eaves

Figure 24. Cosa, Capitolium. Reconstruction

model from Nemi, when the eaves which are broken are restored to the roof (Figure 26). Confirmation comes from the actual remains. On the temple in the lower town at Ardea from the Etruscan period of Latium (*c.* 500 B.C.), the drip-line along the south-east side of the podium proves that the overhang of the eaves was at least 6 feet 9 inches (2·05 m.). Observation of the drip-line along the north flank of the Roman Capitolium of Cosa shows that its overhang was 7 feet 7 inches (2·30 m.). The recent Spanish excavations at Gabii have revealed benches for terracotta statues in front of the long sides and the back of the podium (Plate 21). These statues were probably protected by the eaves, and as they were placed about 2 feet (60 cm.) from the wall of the podium, the eaves were probably between 3 and 6 feet wide. Archaic naiskoi in Sicily could have the same distance – some 6 feet between wall and gutter. The wide eaves belong to the

Figure 25. Cosa, strigillated sima and cresting

many external features of Etruscan architecture of which we do not know whether they were due to Etruscan traditions or to a legacy from Archaic Greek structures, which were kept and developed in central Italy, while the Greeks often gave them up. In the case discussed here, it seems self-evident that the earlier temples of the Roman Republic inherited their wide eaves from the Etruscans. Like the Tuscan columns, they were kept until the radical hellenization of the second century.

Vitruvius (II, 1. 5) speaks about thatched roofs of old temples on the Arx of Rome, and Pliny (XVI, 36) quotes Cornelius Nepos's statement that the roofs in Rome were covered with shingles (*scandula*) until the beginning of the third century. As far back as we have material from Etruscan temples it is clear that the purlins of the roofs (*templa*), with common rafters (*asseres*) and a sheathing of planks above them, were protected by flat rectangular tiles (*tegulae*) with semi-cylindrical cover-tiles (*imbrices*) above the joints. The overhang of the lowest tiles along the eaves had a decorated underside, visible from below; and the foremost cover-tiles were protected by antefixes resting upon these eaves-tiles (Plates 22 f.).[27]

The pediments were, of course, the most conspicuous part of the roof. They could, no doubt, be differently arranged during the Etruscan *saecula*. The joists (*tigna*) above the

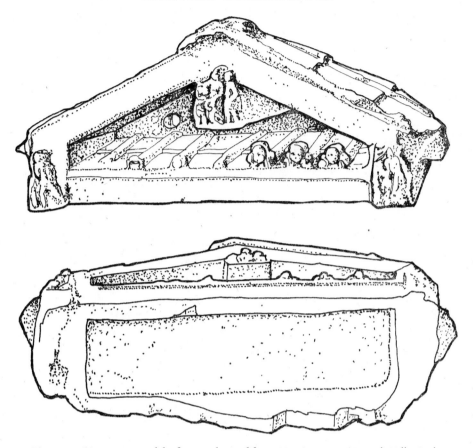

Figure 26. Terracotta model of a temple roof from Nemi. *Rome, Museo di Villa Giulia*

architraves (*trabes compactiles*) of the side walls, with their projecting mutules, of which Vitruvius speaks (IV, 7. 4–5; p. 46, Figure 24), carried the ceiling of the cella (in larger temples, together with beams in between) and of the pediment. The joists above the side wall architraves further carried the rafters of the roof (*cantherii*). In each gable heavy rafters formed the pediments.

After summarizing what we know about the roof it is necessary to return to Vitruvius's rule that the mutules should project in front of the architrave, which on the front of the temple rested upon the columns of the pronaus, 'to a distance equal to one-quarter of the height of the columns'. Perhaps the model of a temple roof from Nemi (Figure 26) shows traces of this strange arrangement, illustrated by the tentative reconstruction of Figure 24. Still more illuminating is a model of a temple from Satricum (Figure 27), in spite of the columns in front of the end of the mutules. We may also compare a small model of a temple from the Heraion near Argos, though there is only a flat balcony, supported by two columns, in front of the temple. If we follow what the Roman temples of Cosa suggest, in Temple C (first phase 170–160) Vitruvius's rule would give us a projection of the mutules in front of the architrave measuring 3 feet 10 inches (1·16 m.), which seems perfectly possible. On the Capitolium of Cosa (about 150) the

result of Vitruvius's rule would be a projection of about 5 feet 7 inches (1·70 m.). This unsupported span is surprisingly wide, especially since the pediment had to carry terracotta figures, but it seems to be confirmed by the west end of the drip-line along the south side of the temple, which continues 5 feet 10 inches (1·78 m.) beyond the west wall.

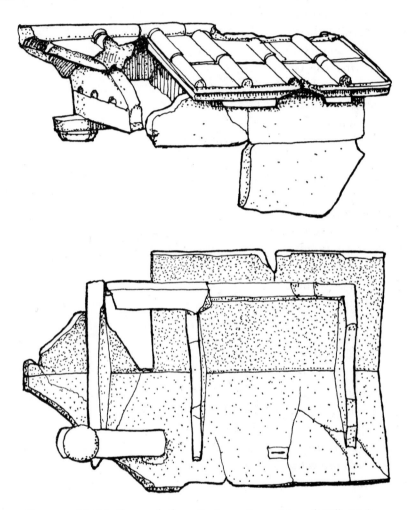

Figure 27. Model of a temple from Satricum. *Rome, Museo di Villa Giulia*

In larger temples Vitruvius's rule for the projecting mutules is structurally hardly possible. As usual, he has probably dogmatized and codified traditional rules of proportion, which the temples did not always follow. In the case of the mutules he might have been reacting against the prevailing Greek type of temples. This fact has been disputed, but the gist of his words cannot be ignored: he had seen temples with projecting mutules, and considered them to represent the correct Etruscan *dispositiones*.[28]

Scholars generally reconstruct Etruscan temples without projecting pediments (Plate 12), in clear contrast to Vitruvius's description as it stands, but with support from

terracotta models (Plate 11),[29] the tombs of Norchia (Plate 20), and later Roman hellenized temples such as the Temple of Fortuna Virilis by the Tiber in Rome and the Doric temple at Cori (cf. Plates 77 f.). Again, we cannot doubt that the Etruscans built temples in that way – probably under the influence of Greek temples, which never had such strange projecting pediments. But when the Etruscans first abandoned the special type of pediments described by Vitruvius cannot be established. Very likely both types were used from the earliest time of Greek influence.

From the sixth century onwards the pediment could be left plain or be decorated with sculpture after the Greek fashion. The rear pediment and pediments of small temples no doubt usually remained undecorated. A very characteristic shape could be given to the plain pediments. The model from Nemi (Figure 26) has a deeply recessed pediment with an inner flat roof probably projecting in front of the architrave. It rests on the mutules and is covered by tiles. On the cover-tiles along the edge of the inner roof are antefixes. This pediment from Nemi and other archaeological material show casings nailed on the mutules of the side walls, as Vitruvius prescribes, and on the end of the ridge-pole.

A convincing reconstruction of a pediment with warriors from a small Etruscan temple or treasury in the Ny Carlsberg Glyptotek proves that as early as the sixth century the Etruscans began to use sculpture in the Greek manner. To the beginning of the fifth century belongs a pediment of the larger temple of Pyrgi (Figure 17) which – at least in its centre below the ridge-pole – had a powerful gigantomachia in later archaic style, but with quite a strong flavour of the wild Etruscan temperament. Much later, probably in the second century, the pediments from Talamone, as reconstructed in the Florence Museum, again have complicated pictorial compositions, though now in the hellenistic style. Pediment sculpture from Orvieto (Temples of the Belvedere and Via di S. Leonardo), Civita Castellana (Lo Scasato), Civita Alba, and the well-known team of two winged horses from the 'Ara della Regina' Temple at Tarquinia show (as do other finds) that pediment sculpture flourished in the fourth and following centuries. Sometimes it even displays capricious violations of what we consider Greek taste – for instance, the heads and shoulders of terracotta figures on the pediment of the Belvedere Temple at Orvieto project beyond the triangular space of the tympanum, intruding on the cornice of the pediment.[30]

Ornament

The pedimental sculpture was only a part of the external terracotta ornament which the Etruscans added to their temples (Figures 24 and 25). The origin of all this decoration was the Archaic Greek temples with terracotta revetments. The main Greek centre during the seventh century seems to have been the towns of central Greece. The habit of adorning temples with terracotta revetments soon spread to the Ionian towns, to Sardis (as we know from a beautiful terracotta), and all over the Greek world, assuming different stylistic characteristics in its various centres. Towards 550 it reached Etruria and central Italy. It inspired a lively, sometimes exuberant style, whether the artists were

from Greek towns or were Etruscans, like Vulca of Veii (Pliny, xxxv, 157). The delightful terracottas from south Italy and Sicily also had characteristics of their own and their technically exquisite and artistically refined art persisted longer than in Greece. As a rule the Greek temples were built of stuccoed limestone, poros and other durable material, or in marble. The rock-cut tympana of the tombs of Norchia (Plate 20) as well as several sarcophagi show that the Etruscans could use alabaster, tufa, and even marble or travertine for their reliefs. But the old terracotta revetments obviously served their exuberant, lively artistic taste better, and they remained popular until the end of Etruscan freedom about 100 B.C. and also in Late Republican Rome.

Pliny (xxxv, 12, 152, 157 f.) praises the artistic and technical quality of the venerable terracotta sculpture. As a matter of fact, it forms a most important part of the history of Etruscan art and must be discussed in another volume of *The Pelican History of Art*. Here I can only briefly mention how the coroplasts retold Greek sagas, used contaminated and revived Greek ornaments, or represented their own processions, horse races, or at times historical events. With some delay, due to the use of old models for casting, conservatism, and, of course, provincial isolation, they followed the successive Greek styles from Archaic to Classic and hellenistic, but were never quite happy with Greek discipline and showed a certain capriciousness with their fabulous beasts and half-human beings. There is in many of these reliefs a wild spirit, an unrestrained vivacity, and an agility which mark them as Etruscan.[31]

Whatever the stylistic causes of this predilection for terracottas, it is evident, in any case, that the terracottas were structurally necessary for the protection of the wooden parts of Etruscan mud-brick temples. But even after mud brick had been given up, we still occasionally see terracotta ornament persisting on temples of stuccoed tufa or limestone of the last centuries B.C. in central Italy.

Now for the antefixes along the eaves. These were more or less horseshoe-shaped reliefs. They can be merely decorative, but often represent gods, the head of Medusa, daemons, or heroic or comic groups of figures. The figures can – like the pediment sculpture from Orvieto, or like the figures in front of the terracotta gutters above the pediments – boldly swagger in front of the horseshoe-shaped antefixes or even rise in an outrageous manner above them, in which case they had decorated back supports on them, as shown by fragments of an antefix probably from the temple on the acropolis of Ardea (*c.* 500 B.C.; Plate 24). On these terracotta end-pieces of the cover-tiles the imagination, love of colour, and agitation of the Etruscan and Italic artistic mind found a place to work triumphs. If human figures appear they repeat Greek motifs, but it seems superfluous to seek precise Greek models for the exuberant Italic development of borrowed prototypes.[32]

The same is true of the quadrangular casings nailed on the ends of the mutules or the round discs which protected the ends of the ridge-poles and crowned the pediments. These discs were sometimes larger than the end of the ridge-pole, and were suspended from it as from a peg (Plate 23). When Vitruvius, speaking about aerostyle temples (III, 3. 5), says that the gables (*fastigia*) of the Tuscan temples were ornamented with statues of terracotta or bronze, he is probably referring to richly developed acroteria

above the pediments. Pliny and other authors tell of a terracotta group (Jupiter on a quadriga) on the apex of the Capitoline Temple, and Livy informs us that in 296 it was replaced by another, probably of gilded bronze. These crowning decorations could assume fantastic shapes such as high palmettes and groups of warriors. Pliny (XXXV, 154) seems to indicate that the old Temple of Ceres, Libera, and Liber on the Aventine Hill also had sculpture above both pediments. The same obsessive and tireless desire to brighten the exterior of temples with lavish ornament also inspired, from oldest times, rich acroteria on the pediments. To the temples on the Forum Boarium (dated about 500; see p. 44) belonged acroteria with volutes rising 4 feet 1 inch (1·24 m.) from an oval base measuring 2 feet (0·6 m.) high. Such ornaments were placed in a sloping row along the simas, facing the acroteria of the eaves, as shown on a coin dated *c.* 78 B.C. Pairs of volutes of this kind could also have crowned the apex or the whole ridge-pole of a temple, renewing a motif known already from the Early Iron Age, although there it was purely ornamental and without structural function.[33]

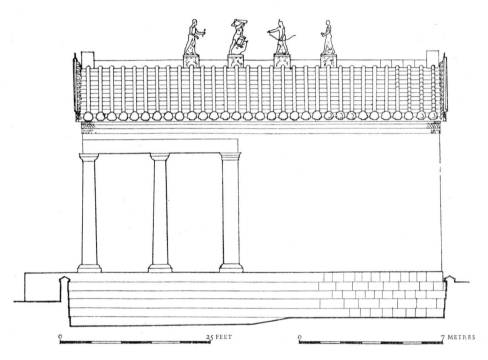

Figure 28. Veii, Portonaccio Temple. Reconstruction. Elevation (1: 175)

In the great Portonaccio Temple of Veii some of the cover-tiles of the ridge-pole were in the form of saddles, acting as bases for the famous terracotta statues of Apollo, Mercury, Hercules, and Latona (now in the Villa Giulia Museum in Rome; Figure 28). The gods thus seemed to move along the ridge of the roof. With these can be compared animals adorning the ridge-poles of archaic models of houses and great central acroteria of Greek temples from south Italy and Sicily, as, for instance, a horseman sitting on a

ridge-tile which is shaped like a horse, from Camarina, or the youth on a galloping horse from Locri.[34]

The Roman temple at Gabii affords us another instance of assiduous endeavours to enliven the temples. As already referred to on p. 48, benches with indentations for feet and with lead dowels in them for terracotta statues were constructed in front of the long sides of the podium, reaching to the stairs, and along the back (Plate 21). Thus, the podium was surrounded by figures on three sides; a decoration which may, however, have been a Roman addition. There is still no parallel from Etruria.

The external terracotta embellishments must, at their richest, have given the temples a fantastic appearance. Another very impressive feature was the revetments of the core of the building (Figures 24 and 25). There were ornamental reliefs nailed to the door jambs, and (as has already been said) on the ends of the ridge-poles, and on the project- ing mutules above the architraves of the side walls of the temples. Rich, purely orna- mental or figurative reliefs covered the architraves. The raking, usually strigilated simas above the pediments were crowned with pierced crests. Revetment plaques hung below the simas and in front of the purlins (*templa*) and below the common rafters (*asseres*) and planks (*opercula*) of the eaves. Revetment plaques also adorned the ends of the projecting mutules between the large plaques nailed on the end of the joists of the walls of the long sides. To what has been said about figures rising above antefixes and pediments may be added as a last example the simas from Arezzo, datable about 400, with warriors fighting.

These protective ornaments remained, on the whole, in the same position during the whole history of the temples of Etruscan type in central Italy down to the second century. At the end a classicistic taste inspired by Greek architecture reacted against the late terracotta decoration in the overflowing hellenistic style.[35]

Abundant archaeological material shows that Etruscan furniture, chariots, etc., could be covered with plates of bronze from the very beginnings of Etruscan culture in Italy in the seventh century. When we hear about 'buildings of bronze' in the Orient, Greece, and Rome, this, of course – except for some fairy tales – refers to metal-coated structures of wood or mud brick. That this common Mediterranean method of protec- tion and adornment of buildings was regarded as ancient in Italy, as in Greece, is shown by what was told in Rome about a tiny *aedicula aenea* which was originally erected by Numa Pompilius on the Via Appia. Our actual material from central Italy begins with references to bronze gates of the so-called Servian Wall, an aenea aedicula erected on the Forum Romanum in 304, and remains of architectural ornament in bronze dating from the fourth century. The latter consists of fragments of plain bronze tiles and revetments of the same sort as those of terracotta, found at the sanctuary of Diana at Nemi and at Palestrina.[36]

Liturgical Disposition

The strict frontality of the temples may have suggested an axial planning of the areas and altars in front of them. It became the prevailing rule for the temples of the Roman Republic and for temples of the Roman type throughout the Empire. It should, of

course, always be remembered that axial symmetry was fashionable, at least in later hellenistic temples.[37] However, axial symmetry cannot be claimed for the old Etruscan altars: it seems, on the contrary, that they were placed according to the demands of the cult, facing east, or as old traditions (from before the building of the temples) determined. On the other hand, from archaic times onwards we find regular square areas in front of the temples with entrance on the central axis of the cella; for example, at the old temple of Volsinii (Figure 11) and probably the temples on the Contrada Celle of Falerii (Figure 21) and at the Belvedere of Orvieto (Figure 12). The Capitolium of Cosa had a square area of the same type as these Etruscan temples, though with altar and entrances oriented in agreement with the city plan and the oldest traditions of the place.

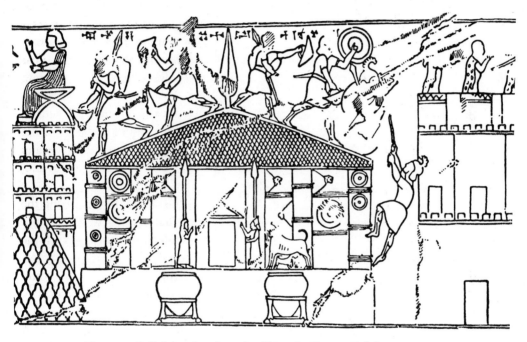

Figure 29. Relief showing the sack of Muṣaṣir, Urartu. Eighth century B.C.

The Etruscans, no doubt, had rules for the placing of the temples much the same as those we know for altars and places 'set aside and limited by certain formulaic words for the purpose of augury or the taking of the auspices' (Varro, *Lingua Latina*, VII, 8). Vitruvius and some other architects recommended that temples face the western quarter of the sky, enabling the worshippers at the altars to face simultaneously the sunrise and the statues in the temple. This rule, probably Greek, and the exceptions to it admitted by Vitruvius (IV, 5. 2) do not agree with our archaeological findings. Here we note a prevailing tendency to make the temples face south, though with considerable deviations, no doubt due to lost traditions of the different cults. In any case, it seems clear that the general direction, which we can trace in our material, comes from a basic, non-Greek, tradition present in Etruscan temples even in their hellenized form.[38]

Before leaving these temples and their characteristic plan, their wide eaves, their

display of colourful terracottas, and, often, most fanciful silhouettes formed by acroteria or even sculpture on the roof, I wish briefly to sum up my opinion on the origin of their basic *dispositio* with closed rear wall, great prodomus, and frontal emphasis. It seems clear to me that these features were introduced into Italy by the Etruscan culture in the eighth and seventh centuries, either through trade, or brought to the country between the Tiber and the Arno by Etruscan emigrants from Asia Minor. The famous eighth-century relief of the temple at Muṣaṣir in Urartu seems to me to show a part of this background of different types of temples in Asia (Figure 29).[39] In any case, I regard the basic concept of the typical Etruscan temples as of Eastern and not of Greek origin. But whatever the origin, it seems evident that a new history of this type of temple started in Italy and resulted in the monumental, externally hellenized great Etruscan and Roman sanctuaries. I assume that their history and development resembled that of the atrium-houses, which also seems to me to display a fundamentally foreign architectural type, though in Italy such houses became hellenized by columns and decorations in the Greek style and later were largely remodelled after the Greek fashion.

TOWN PLANNING

When we turn from the temples to the towns around them, we again have to keep in mind possible aboriginal Etruscan elements, common Mediterranean culture, Greek influence, and the specific development of all of these during the six Etruscan centuries in Italy. As in the case of the placing of temples, the Etruscans developed rules for building their towns. These rules, which we know about only from learned Late Roman elaborations, were found in the *Libri tagetici* or *sacra tagetica* of the Etruscans, ascribed to the mythical lawgiver Tages, and they include those about the foundation of towns (see p. 16) by means of a furrow ploughed around the future township (Plate 6). Whether this was taken over from the Early Iron Age, as I believe (see p. 16), or was part of Eastern elements in Etruscan life is not clear. To these founding ceremonies belonged also the *mundus*, a sacrificial pit in which the first fruits were deposited. The Romans employed the 'Etruscan ritual' (*etruscus ritus*) for their newly founded colonies, but also assumed that Lavinium and Rome had been founded in the same way. Roman writers have related how Romulus had summoned men from Etruria who prescribed all the details in accordance with their sacred ordinances and writings, thus giving the sanctity of old rites to their new towns.

The axial planning suggested by Etruscan temples and the rules about places for auguries and auspices may well have been a source of inspiration for the creation of regular towns. Vitruvius (I, 7. 1) quotes haruspices and rules for the location of temples from Etruscan treatises (*scripturae*), and ancient experts on the *disciplina etrusca* said that no old town was considered a proper one without three gates and three main streets (cf. p. 29). But in our archaeological evidence we cannot trace any master plan or any fixed quadrangular or circular perimeter heralding the Roman four-sided coloniae and castra among the oldest Etruscan towns or in Rome itself.[40]

Our material is scanty, but the scraps of evidence with which we must work seem to indicate that the original Etruscan settlements, *vetusta munificia*, were like the old, untidy, gradually developed Mediterranean towns such as Rome and Athens. They replaced in central Italy the Early Iron Age villages with crowds of square buildings of wood or mud brick or of stone along narrow crooked streets. This is the impression which the small excavated parts of Veii (Figure 30), Vetulonia (Figure 31), and the archaic settlement spread over the acropolis of San Giovenale give us.[41]

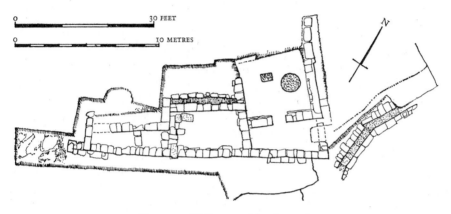

Figure 30. Veii, street. Plan (1 : 250)

Like the Early Iron Age villages, these old towns were mostly built on hills. The area of the settlement was in many cases defined by the shape of the hills and the lines of natural defence – *nativa praesidia*. Sometimes the table-lands were very large, and the settlement in such cases might have been somewhat dispersed. In the towns of San Giovenale and Luni, the larger old settlement – apparently because of the wars against Rome from about 400 – was restricted to the parts of the hills which could most easily be defended. Veii and Tarquinia are the most famous examples of such hill towns, not

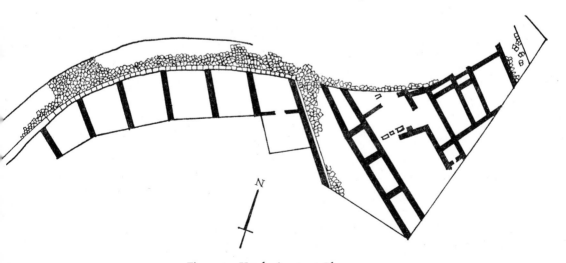

Figure 31. Vetulonia, street. Plan

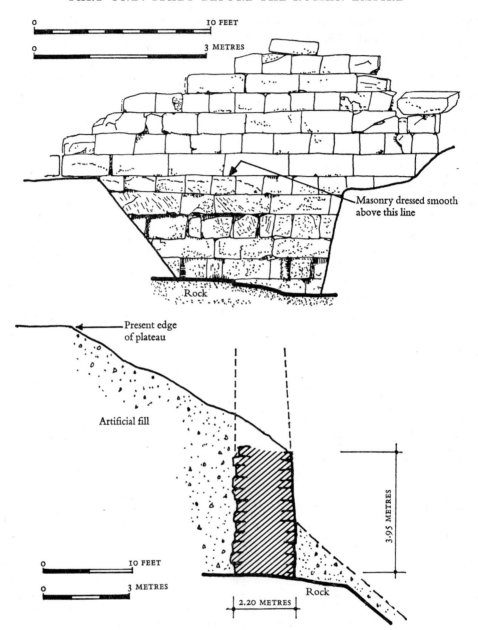

Figure 32. Veii, terraced city wall and substructures. Before 396 B.C. Section

to speak of their offspring on the hills of Latium from the sixth century onwards: the Palatine, Esquiline, and Quirinal, Lavinium, Antium, Ardea (Plate 52), and many others.

The hillsides, if insufficient for defence, were supplemented by terrace walls (Plates 25 and 26 and Figure 32). The great period of these mighty strengthening walls came only during the wars against the Romans and Gauls in the fifth century and later.

Among the most conspicuous are those protecting the lower town of Populonia, east of the acropolis, the walls of San Giovenale and Luni, and those of Tarquinia. At Veii the fortifications were strengthened by terrace walls against the Romans before the final defeat of 396. On the north-west side an agger was constructed and crowned by a wall supported by a solid substructure, as Vitruvius prescribes (1, 5. 1; Figure 32). A wall of the same kind was built against the east slope of the acropolis of San Giovenale and provided with an agger, protecting the outer side of the substructure. This wall, the steep slopes to the north and south, and a rock-cut fossa to the west fortified the central part of the acropolis (Plate 25). The old, larger settlement of the seventh and sixth centuries was restricted to this fortress. The same happened at Luni (Plate 26). The hillsides of the east part of the acropolis were strengthened by mighty ashlar walls where necessary, two fossas protected the west side, and in a gap in the natural defences at the easternmost point a mound was thrown up around a substructure for a crowning tower (Figure 33).

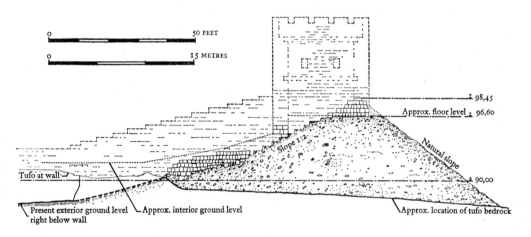

Figure 33. Luni, acropolis, mound with a tower at the eastern end. Early fourth century B.C. Reconstruction

These fortress-towns obviously belonged to the time of the Roman war against Veii, or were, in any case, a part of the frontier of Tarquinia against Rome in the ensuing war in the fourth and early third centuries. Already before the Romans had conquered Veii, the Faliscans of Capena enlarged their fortifications, foreseeing that the Romans after Veii would continue the war, attacking them and the Etruscans, whom they had warned in vain.

These fortifications seem to belong to a type pioneered by the Etruscans in central Italy; no doubt they themselves were inspired by Greek town walls. At Rusellae, north of Grosseto, as early as about 600 a wall of mud bricks measuring some $2\frac{3}{4}$–$3\frac{1}{3}$ by 16–18 inches (7–8·5 by 40–45 cm.) was built upon a stone foundation, as in Smyrna. In the sixth century it was replaced by a stronger terrace wall of polygonal stone blocks. The walls of Rusellae may have been built against the local tribes, but they may also, of course – like the Greek city walls in south Italy – have been connected with internal

feuds among the Etruscans themselves, before the system of city-states of the fifth and following centuries, as known to us, was established.[42]

Varro and other authors affirm that land surveying (*limitatio*) belonged to the *disciplina etrusca*, and the Romans (no doubt correctly) regarded the Etruscans as their teachers, though they soon developed their special *centuriatio* on the lands around their towns, especially around their newly built colonies.

The Etruscan limitatio, no doubt from its beginnings, was connected with Greek geometry (Herodotus, II, 109) and common Mediterranean practice, but evidently the Etruscans gradually developed this international science in their own way with typical religious precautions of their own, claiming special divine inspiration. Safe conclusions concerning the modes of their limitatio can be drawn from what the Roman land surveyors tell us: they connect it with the regular division of the fields outside the cities, as also does Varro (*Lingua Latina*, VI, 53). In old towns (*vetusta municipia*), the previous crowded settlements and the town hills (*locorum difficulates*) prevented the Roman agrimensores from systematizing the town plan.[43] But in new towns they could achieve what they considered to be the ideal master plan (*pulcherrima ratio*) of straight streets carried in from four gates and meeting in a central forum.

This type, whether Etruscan or Roman, brings us from the Etruscan limitatio to a great revolution in the history of ancient town planning.[44] In the sixth century or even before, the Greeks in Sicily, the Ionians in Asia Minor, and the Etruscans had started to plan their new towns in a rational, regular way. No doubt it had a background in the town planning of the old Oriental empires, as related by Herodotus (I, 179) of Babylon.

Whatever memories of their old towns may have predisposed the Etruscans to this regular type, it is evident that the new systematization was connected with the omnipresent Greek influence in archaic Etruria – in this case with the ideas formulated by Hippodamus of Miletus in the fifth century. We can clearly trace these new endeavours in the Crocefisso cemetery at Orvieto (Plate 27), where – in contrast to the dispersed great mounds of Caere (Cerveteri; Plate 28) – chamber tombs, covered with tumuli with crowning memorial tablets, are arranged in rectangular blocks, accessible by a system of straight streets. Recent excavations have confirmed that this regular planning of the cemetery began in the second half of the sixth century. Later on we also see regular streets in the Banditaccia cemetery at Caere, which may give an idea of the elegance of Etruscan streets.

Interesting specimens of regular town planning belong to the centuries when the Etruscans were masters of the Po valley. In the last decades before 500 they founded the colony at Marzabotto, on the road from Etruria to Felsina (Bologna).[45] It was built on a riverside plain where nothing interfered with the regular plan. The rectangular blocks of the grid are 540 feet (165 m.) long, but their width varies (115, 130–225 feet; 35, 40–68 m.) (Figure 34 and Plate 29). The long sides follow the main streets (*per strigas*). Marzabotto shows the closest affinity to Greek towns such as Naples, Paestum, Olynthus, and Piraeus. Recent discoveries have elucidated the close relationship between the chequerboard pattern of the town and the terrace of temples and altars on the acropolis

at the north-west corner. As along the fashionable streets of Pompeii and Ostia, the entrances of the houses faced the streets.

Most interesting is the Greco-Etruscan town of Spina in the delta of the Po, founded, like Marzabotto, about 500. Similar to Venice or, as Strabo describes it, Roman Ravenna (v, 1. 7), it was built on piles and crossed by canals provided with bridges and ferries. Aerial photographs have revealed a system of rectangular blocks, as at Marzabotto, centring upon a large straight canal (100 feet wide) which leads to the harbour. It is again the planning which Aristotle refers to when speaking of the modern fashion of Hippodamus (*Politica*, VII, 1330 b, 21 f.), though here in terms of canals.

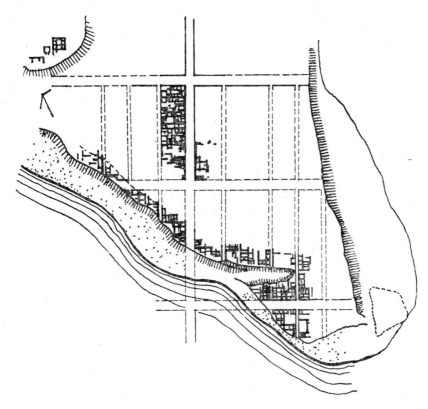

Figure 34. Marzabotto, with the acropolis with temples and altars in the upper left-hand corner. Founded late sixth century B.C. Plan

About 600, when the Etruscan city-states extended their dominion to the Oscan population of Campania, Capua became their chief town. Cato maintained that it was founded in 471, but that date probably indicates an enlargement or reorganization. Livy (IV, 37) tells us that the Etruscans admitted Samnite immigrants from the mountainous central parts of Italy to 'a share in the city and its fields', as did also the Greeks in Naples, according to Strabo (v, 4. 7). Very likely the regular rectangular blocks at Capua, shown on aerial photographs, received their final shape in the age of the great extension when Capua received the fatal Samnite immigrants who, according to Livy, were to take over the town in 423.[46] Like Fratte (Marcina) (Strabo v, 4. 13) the old

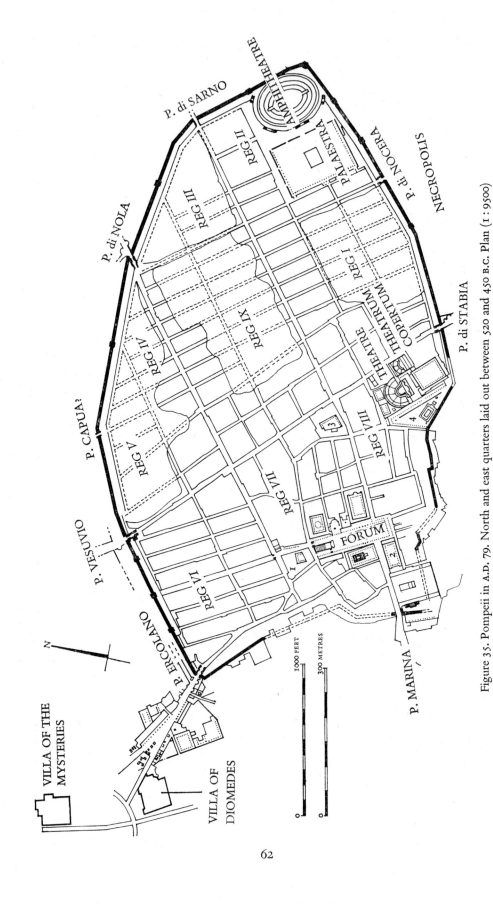

Figure 35. Pompeii in A.D. 79. North and east quarters laid out between 520 and 450 B.C. Plan (1 : 9500)
1. Forum Baths 2. Basilica 3. Stabian Baths 4. Greek Temple

irregular parts of Pompeii (Reg. VII–VIII) were an Etruscan outpost, at least for some decades around 500. It seems most likely that the extensive regular quarters north and east of the old crowded hill town were laid out some time between 520 and 450 (Figure 35). The differing orientation and shapes of the blocks indicate that the greatly enlarged town only gradually filled up vacant parts of the level space inside the walls. It seems at least possible that some of these rectangular blocks and straight streets were outlined by the Etruscans; they may, indeed, already have started to enlarge the town to receive the Samnite immigrants (as the Etruscans did at Capua). It is, of course, also possible that the Oscans became independent and gradually reshaped their town after the first great defeat of the Etruscans in Campania in the battle against the Greeks at Cumae in 474. In this case, the fortifications would have been a part of the Oscan and Greek resistance against the Etruscans. In their second, late-fifth-century period, the walls clearly belonged to the Campanians of mixed Oscan and Samnite ancestry known from Roman history.[47]

The enlarged Pompeii with its Greek wall was among the regular towns which in the fifth century became common all over Italy, when new towns were founded on plains or new quarters added to old hill towns. However, it seems clear that the Etruscans were the first to adopt the new ideas in central Italy. As town planners and land surveyors, they remained the forerunners and teachers of the Italic peoples.

Now to secular building in towns. A wall painting in the Tomba delle Bighe at Tarquinia and a relief from Chiusi (sixth and fifth centuries; Plate 30) show that wooden scaffolding was erected around open places for spectators and umpires of the games.[48] These representations show seats raised on supports which may have been about 12 feet high, as Livy describes the 'rows' (*fori*) of the senators and knights in the Circus Maximus of Tarquinius in Rome (I, 35. 8 f.). Vitruvius (V, 1. 1) attests, also from Rome, 'a custom handed down from our ancestors that gladiatorial shows should be given in the forum'. The painting in the Tomba delle Bighe shows that the Etruscans had already started to use linen awnings (*vela*) in the theatres.

DOMESTIC ARCHITECTURE

In his dramatic description of the sack of Rome in 386, Livy (V, 41. 7–8) tells us that the plebeians boarded up their dwellings, while the patricians bravely left the halls of their palatial houses, their 'domus', open and awaited the enemy in the vestibules in front of them, wearing their ornaments and apparel which – in the eyes of the Gauls – made them appear like gods. Literary sources and archaeological material from Etruscan towns (foundations of houses, and tombs and funerary urns reproducing houses) substantiate this distinction between the domus of the kings (*lucomones*) and aristocracy on the one hand, and, on the other, the great majority of the dwellings of the lower classes, the plebs, and, above all, of the qualified slaves, artificers (to speak with Livy, V, 1), clients, and affranchised, described by Posidonius (Diodorus, V, 40) and Dionysius of Halicarnassus.

The archaeological material makes up for our lack of literary information about the

dwellings of the lower classes – men of ordinary means (*communis fortuna*), as Vitruvius calls them. We have remains of ordinary business quarters in the towns, the long rows of small uniform tombs in the great Banditaccia cemetery of Cerveteri, and cippi in the form of miniature gabled houses for the women (and pillars for the men). While skilled slaves, as Diodorus says, had houses like those of the plebs, miners and rural slaves, the *tumultuariae agrestium cohortes* referred to by Livy (IX, 36. 12), no doubt lived in barracks, the *tusca ergastula* still mentioned by Juvenal (VIII, 180). That was, in any case, typical of the great latifundia of the Etruscan countryside, which Tiberius Gracchus saw on his way to Rome. An agricultural centre excavated near San Giovenale belongs to that time, and contains store-rooms and – it seems – a dormitory for the slaves.[49]

Figure 36. Veii, house. Elevation

The archaeological material indicates that the common folk in the Etruscan towns lived in modest rectangular houses. In the confusion of low foundations inside the regular rectangular blocks of Marzabotto, small rectangular houses can be distinguished (Figure 34). They often have party walls (*parietes communes*) and inner courtyards with wells. Rectangular houses are common, usually some 10 to 13 feet wide, with porches on the front towards the street and two rooms *en suite*. These houses resemble the Greek megara. Often they had rooms added to their right and left flanks. Usually they had a door directly on to the street. But all over the town are also *tabernae*, used as shops, workshops, or perhaps as dwellings of the proletariat, which were wide open towards the streets. Narrow rooms behind the shops or connected with the megaron-like houses were very likely staircases leading to a garret. Under the straight streets in front of the houses run common sewers (Plate 29). The rectangular and regularly disposed blocks of Marzabotto and the distribution of rather uniform houses within them obviously represent the final achievement of Etruscan town planning of about 500.

As has already been stated, the old settlement of San Giovenale extended all over the acropolis. The eastern part of the hill is crowded with small houses which are difficult to visualize in detail. But on the slope towards the valley on the north side of the acropolis (B) were built terraced rectangular houses on high, carefully constructed substructures of ashlar tufa (Plate 31). They faced the valley with their northern, short sides. The stratification indicates a date about 600. The completely preserved foundations of one of the houses measure 24 feet 7 inches by 12 feet 10 inches (7·50 by 3·90 m.). Contrary to the arrangement of the chequerboard sections of Marzabotto, where the short sides of the houses face the streets, the houses of the north slope of the acropolis of San Giovenale are built in rows and obviously had their entrances on the long sides, opening on alleys between them. One street is preserved and has a width of about 8 feet, that is, as described in the Twelve Tables of the Law. There seem to have been similar terrace houses facing the valley on the south side of the acropolis.

The excavated part of Vetulonia (Figure 31) shows a winding, 10-foot-wide main street (for which the term decumanus would be quite out of place) and two oblique transverse roads. Six tabernae face the south-western half of the main street on its south side. Along the first transverse road is a row of rooms resembling those on the north side of San Giovenale, while the north-eastern half of the main road seems to be faced by rectangular houses with open porches towards the street, resembling those of Marzabotto.[50]

On the north side of Veii we find a building of higher standard, with irregular rooms on its west side (Figures 30 and 36). Like the houses of Marzabotto and the Greek megara, it faces the street with a porch accessible from a wide entrance. A door with tapering jambs – like those of many Etruscan tombs of all periods – leads to a room measuring 15 by 13¾ feet (4·60 by 4·20 m.). The jambs and ashlar walls are preserved to a height of 4 feet 9 inches (1·44 m.) and suggest that the entire building was constructed of tufa blocks.[51]

This megaron-like house of Veii can be compared with some of the chamber tombs and house models of the ash urns. They seem to have been better than the houses along the narrow lanes of San Giovenale and Vetulonia, and are probably the modest domus of more wealthy people. This may also be true of foundations of somewhat roomier houses with a paved courtyard and a well between them west of the fossa across the acropolis of San Giovenale (Plate 32). The great period of these houses was that of the old, larger towns after about 600. Many seem to have resembled to a greater or lesser extent the megaron of Veii. The rear and side walls of one of the rooms in house K at San Giovenale (Plate 32) have low benches of pebbles which have been taken from rivers round the acropolis. Beds of the same kind have been noted in an Apennine hut at San Giovenale, in a Siculo-Geometric house on the lower acropolis of Morgantina in Sicily, and in the inner chamber of the tomb called the Tomb of the Thatched Roof at Caere (Cerveteri), datable to the end of the seventh century (Plate 33). The excavators of Morgantina have seen such timeless resting-places, finished with grass, straw, and goat-skin, among the shepherds of Sicily today. Varro (*Lingua Latina*, V, 166) tells us that the Roman soldiers in his time set up their couches in the camps (*castra*) on straw

coverings (*stramenta*), grass, or wheat stalks 'in order that they may not be on the earth'.[52]

That this arrangement is to be found in the Tomb of the Thatched Roof at Caere suggests that this tomb reproduces a room in a house like that on the western side of San Giovenale. The Etruscans of the upper classes about 600 obviously had such bedrooms, in striking contrast not only to the luxury of the upper-class tombs of the following centuries but also to the royal tombs of the seventh century such as the Regolini Galassi Tomb at Caere, with its imposing stone-built halls and abundant treasuries (Plate 42). After about 600 domestic architecture began to insist on more elegance. Here we can already see heralded the luxurious, over-columniated later architecture of the Etruscans. For such houses more solid roofs were, of course, required, and tile roofs superseded the wide, light, slightly curved thatched roofs, as demonstrated by the archaic tomb of Caere which has just been mentioned, by a contemporary gabled ash urn from the cemetery of Monte Abatone, south of Caere (Plate 10), or by ash urns like the square hut of Plate 4.

Our main sources for the domestic architecture of the upper classes after about 600 are tombs, cinerary urns reproducing houses, and Vitruvius's chapter on the architecture of the upper classes in his time (VI, 3). The great majority of the older tombs consist of one rectangular room cut in the tufa and accessible from the fields above by a sloping passage (Figures 37 f. and Plate 34). Sometimes there is an inner chamber as well. The megaron-type house at Veii (Figures 30 and 36) provides a parallel from an actual town. But there are also tombs with more complex and ambitious suites of rooms. Their arrangement recalls Vitruvius's account of 'Tuscan' upper-class houses (Figures 44–6 and Plates 35–7; cf. below, p. 71 f.), a type to which he gives pre-eminence.[53] Later tombs had very large halls, occasionally with several side chambers (Figure 38). These, as has already been suggested, correspond to the palaces of the great landowners and of the monied classes of the last centuries of Etruscan history. They may, in some cases, have been the communal property of an association.

Like Corrado Alvaro, both non-archaeological visitors and many archaeologists have often sensed that the Etruscans were inspired by the town houses of the rich when, throughout their history in Italy, they cut these chamber tombs in the tufa of the tablelands around their towns or in the slopes of the surrounding valleys, although their special purpose, and the restrictions imposed by having to cut into the living stone, naturally caused modification and simplification.

In contrast to old tombs such as the Tomb of the Thatched Roof (Plate 33), from the sixth century onwards the interiors reproduce by means of sculpture or painting beautiful roofs, door-posts, lintels, and other skilled joinery. The mighty ridge-poles, beams, and planks remind us – as do the dimensions of the terracotta revetments of the temples – of what Strabo (V, 2. 5), Vitruvius (II, 10. 2), and others tell us about the abundance of fine building timber in the central Italian woods in ancient times. As seen in one chamber of the fifth century, the 'Tomba della Scimmia' at Clusium (Chiusi), graceful coffered ceilings were in fashion already about 500. The Tomba del Cardinale at Tarquinia (third century; Figure 39) displays the most imposing sunk panels in the ceiling. The

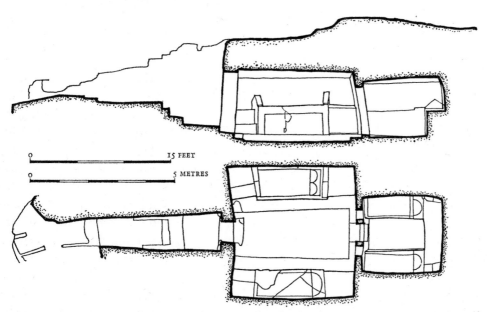

Figure 37. San Giovenale, Porzarago cemetery, chamber-tomb. *c.* 600 B.C. Section and plan by B. Blomé (1 : 125)

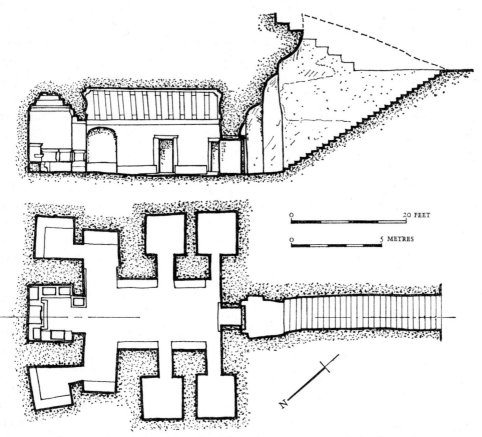

Figure 38. Perugia (near), Tomb of the Volumnii. Section and plan (1 : 200)

67

famous wall paintings of Greek legends, funeral feasts, races, athletic sports of different kinds, and dances known from Tarquinia, Veii, Chiusi, Orvieto, and Cerveteri probably belonged solely to the tombs, at least in older times, though the grand halls of the later Etruscans may perhaps have had historical paintings such as those of the François Tomb at Vulci.

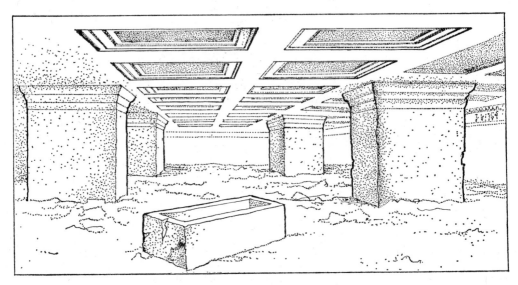

Figure 39. Tarquinia, Tomba del Cardinale. Interior

The walls seem mostly to have been decorated with a high red dado with a wave pattern or parallel bands in different colours above (Figure 40). The so-called First Pompeian Style, which we can follow in the hellenistic world from about 300 and even earlier, perhaps did not appeal to the Etruscans; but in the neighbourhood of Luni there is a chamber tomb displaying the Second Pompeian Style (Plate 38). Tombs at Tarquinia (Plate 46) show how beautifully the ridge-poles and alternating massive planks of the ceilings were painted. The rest of the roofs were decorated with chequerboard patterns, scattered flowers, and other more or less geometric designs or gaudy motifs. In contrast to remains of monumental ceilings and house plans in Cerveteri and other towns, the famous, delightful wall paintings of Tarquinia evidently reproduce colourful tents erected for funerals, the funeral games, and even the landscape outside them. Here different ideas meet: imitation of the architecture of the houses, shelters made only for the occasion of the funerals, and temporary ornament for them. The tombs at Cerveteri, San Giovenale, San Giuliano, and other places, where the polychromy of the imitated wood constructions has largely disappeared, were at least partly furnished with painted adornments – as doubtless were the palatial houses in town and country.[54]

At San Giuliano, Bieda, Norchia, Sovana, and in other places late tombs have been provided with ornate façades, sometimes protected by projecting shed roofs above the entrance (Figure 41). How far these decorated façades reproduce houses of the towns of the last centuries of the Etruscans it is impossible to say. On the other hand, the elegant

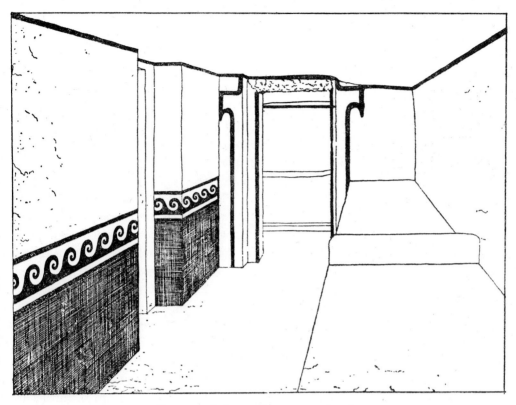

Figure 40. Ardea, tomb. *c.* 300 B.C. Interior

two-storeyed tombs constructed against hillsides in the same way as the terrace houses on the south slope of Pompeii are evidently connected with real architecture (Plate 48). They belong to the flat-roofed domestic architecture of Late Etruscan times. The streets of the Crocefisso cemetery at Orvieto seem to show streets shadowed by blank walls (Plate 27). A cinerary urn in the Museum in Florence (Figure 42), whether it had a

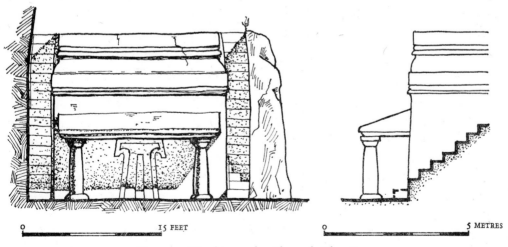

Figure 41. Norchia, tomb with porch. Elevations

69

Figure 42. Cinerary urn reproducing the façade of a common type of house. *Florence, Museo Archeologico*

pitched or a flat roof, gives a good idea of what simple façades in Etruscan towns were like and of how much they resembled the older façades at Pompeii; for instance, the House of the Surgeon in its first period (without taberna) (Figure 45).

As for the entrances, tombs of the later centuries B.C. display elegantly framed doors with lintels extending right and left of them (Plate 36) and tapering or perpendicularly framed door-posts of hellenistic type. Sometimes this motif was painted on the wall round the rock-cut door. The rock-cut outer door of the Tomb of the Thatched Roof at Caere had rough, tapering door-posts resembling the city gates of Segni (below, Plate 57), while the door to the inner room is a rock-cut arch (Plate 33). A hut urn, probably from Chiusi and of about 300, shows that doors with arches formed of voussoirs became a part of Etruscan domestic architecture (Plate 40). Numerous late cinerary urns represent the entrance to the underworld as an arched doorway (Plate 41) as in a real house, even to the beautiful doors. The rock-cut inner doors of the Tomb of the Thatched Roof and other archaic tombs prove that the Etruscans aimed very early at arched entrances. In the famous Tomba Campana of the seventh century at Veii, we see what is very probably a clumsy attempt at imitating a rock-cut arch.[55]

Gabled houses had old traditions in Italy. The model of a house from Sala Consilina (Plate 5) shows that their history starts already in the Early Iron Age. An ash urn from Falerii (Città Castellana) seems also to belong to the eighth or seventh century (Plate 9) (and the roof-shaped top of a stele (Figure 10) seems to reproduce a transitional form between round huts and gable-roofed houses). To the seventh century belongs the Regolini Galassi Tomb at Caere (Plate 42) with its imposing gabled halls, the Tomb of the Thatched Roof, and the gabled ash urn from a tomb in the cemetery of Monte Abatone at Caere (Plate 10) which has already been mentioned. It has highly decorative horns where the rafters meet, reminiscent of the ridge-logs of the hut urns of the Early Iron Age or the ash urn from Falerii, and bold snake-like decoration ending the ridge-poles. Such houses thus belonged to Etruscan architecture from its very beginnings and were considered especially appropriate for imitation in cinerary urns. Later on they also served as models for the hundreds of standard reproductions of houses which marked female interments at the entrances of the tombs. Small gabled tomb houses dating from about 500 have been excavated in a cemetery at Populonia. To the gabled tombs of Tarquinia, Bieda, Sovana, and San Giovenale may be added the central hall of the Tomba dei Volumnii near Perugia of the second century (Figure 38; cf. Plate 45). Especially interesting is a tomb at Sovana (Figure 43) with a porch recalling the houses of Marzabotto and the 'megaron' of Veii (Figures 30 and 36). The gable is of the same type

as the empty pediments of the temples which are well illustrated by many models of roofs of temples.[56]

On the model of the gabled building from Chiusi (Plate 40), obviously meant to represent a luxurious house, the decoration of the façade is no doubt enriched in a manner not corresponding to reality, but this urn is important all the same, not only because it shows in a general way one of the rectangular houses with pitched roof but also because it indicates that such domus could have upper storeys.

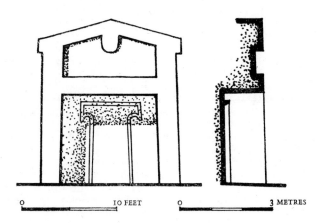

Figure 43. Sovana, gabled tomb with prodomus.
Elevation and section

These houses, reproduced by funerary urns or by tombs, show us the domestic architecture which Vitruvius briefly refers to as gabled (testudinate), and recommends, 'where the span is not great and where large rooms are provided with upper storeys' (VI, 3. 1–2).[57]

Not less typical for the Etruscan towns seem palatial houses with lavishly decorated flat roofs. A most luxurious hall of the third century is the famous Tomba dei Rilievi at Caere. At Caere (Cerveteri), at Tarquinia, and at San Giuliano tombs from the sixth century and onwards reproduce such halls with roofs supported by Doric, Aeolic, or Tuscan columns (Figure 23 and Plates 18, 19, and 35–6).[58]

Flat ceilings, such as for instance that of the Tomb of the Frame at Caere (Plate 36), are typical for an especially distinguished minority of noble and palatial tombs of the sixth, fifth, and following centuries (Figure 44 and Plates 35 ff.). In elegance they vie with the rectangular halls already described, but they surpass them by an impressive, architecturally more differentiated arrangement of the rooms, which seems to be based on old Etruscan traditions. Even among the tombs these houses stand out as the typical domus of the lucomones and patricians. They are evidently akin to the *cava aedium tuscanica*, which Vitruvius mentions first in his chapter on domestic architecture in the sixth book and which we see in late, altogether hellenized, shape throughout Pompeii and Herculaneum and in the Republican layers of Ostia (Figures 45 and 48). The most

characteristic parts (tablinum and alae, see below) may appear also in some houses of Marzabotto, datable to the decades after 450.

The rock-cut tombs of this type, whether gabled, like the Tomb of the Volumnii (Plate 45), or – as was more common – provided with flat roofs, represent everything in a very reduced form, of course, and display only the basic features of the atrium-houses, as Vitruvius describes them. The main entrance to the Roman houses – the *vestibulum* in front of the house and the doorway, *ianua, ostium, fauces,* which lead to the central hall

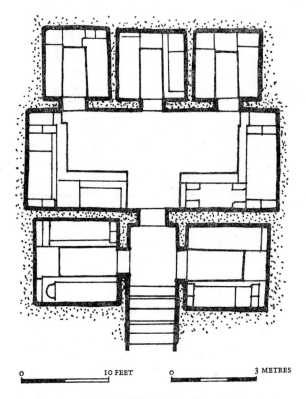

Figure 44. Cerveteri (Caere), Banditaccia cemetery,
Tomb of the Greek Vases. Plan (1 : 125)

of the house, the *atrium* – are replaced in the tombs by a sloping dromos. As in the Pompeiian houses, the rectangular atrium has on its far side a tablinum usually with flanking doors on each side built against the rear wall of the house. The tablinum was originally the main room of the *pater familias* and the mistress of the house, but the beds or benches for interments – later sarcophagi and ash urns – in the atria and side rooms of the tombs are evidently adapted to bedrooms for sepulchral use. A typical tablinum, datable to the fifth century, is in the Tablinum tomb at Caere (Figure 46). The most famous tombs of this palatial type are the Tomba degli Scudi e Sedie, the Tomba dei Capitelli, and the Tomba dei Vasi Greci at Cerveteri, and the Tomba Rosi at San Giuliano. In a most imposing tomb of the sixth century at San Giuliano, named after Princess Margrethe of Denmark, the tripartite division is achieved by two great Doric

columns, and the same arrangement is to be seen in some tombs with plain pillars (Plate 19).[59]

Vitruvius's description of the Roman atrium-houses of his age contains important additions to what we can guess of the houses by going to the tombs. Like the paintings and all the hellenistic decoration which we see at Pompeii and Herculaneum, they evidently belong to the later development of this kind of house. Vitruvius starts his description of the *cava aedium tuscanica* with the *impluvium*, a square basin in the middle of the atrium with reservoirs receiving rainwater from an open space in the roof, which slopes inward (Figures 45 and 48). Thanks to the later excavations at Pompeii we know now that this device for collecting rainwater was a typical feature of the atrium-house during the last centuries B.C.

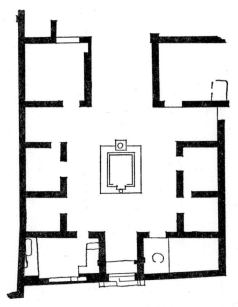

Figure 45. Pompeii, Casa del Chirurgo. Fourth–third century B.C. Plan

That the older Etruscan tombs do not show this arrangement is therefore by no means surprising. In addition, it would, of course, have been most inconvenient in the reduced *cava aedium tuscanica* of the old tombs (though it is reproduced in a displuviate atrium tomb; Plate 43, cf. Figure 47). Equally, neither the alae of the Pompeian houses, which ran like a transept or transverse corridor in front of the tablinum and its side doors, nor the chambers (*cubicula*, kitchens, dining-rooms) along the sides of the atrium, which we see at Pompeii and Herculaneum and which Vitruvius describes, occur in the Etruscan tombs.

If we keep to the main features of the plan of the *cava aedium tuscanica*, which we can deduce both from the atrium-houses of Pompeii and from Vitruvius's description, and compare that with the tombs of the sixth- and fifth-century nobility, it seems evident to me, in spite of the differences, that Vitruvius was right in styling them 'tuscanica'. His description shows us a later development of the same palatial house type which we see in the exceptionally large and elaborate tombs just discussed and in the atria displuviata. I am convinced that the basic arrangement of these houses and of the tombs which reproduced them belong to ancient Etruscan architecture, their origin being Oriental, not Greek.[60]

Together with the *cava aedium tuscanica* and the testudinate houses Vitruvius describes displuviate houses with beams sloping outwards and throwing the rainwater off. A small model from Clusium (Chiusi; Figure 47) and monumental tombs at Caere (Cerveteri; Plate 43) give us a perfect reproduction of this kind of palatial house. They also show that they had roof openings (impluvia) on the top of their hip roofs, but the woodwork and the walls were easily spoiled, because – as Vitruvius maintains – the pipes, which are intended to hold the water that comes dripping down the walls all round, cannot take it quickly enough, but get too full and run over.

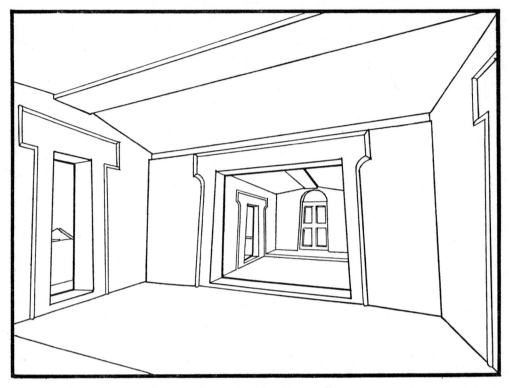

Figure 46. Cerveteri (Caere), Tomba del Tablino. Fifth century B.C. Interior

A new device, obviously inspired by Greek domestic architecture, was that the atria were provided with square colonnades or peristyles (Figure 48 and Plate 44). On the Via della Fortuna Annonaria in Ostia are remains of a peristyle dating from the beginning of the first century B.C., which stood throughout Imperial times. Peristyles became a common luxury at Pompeii in the third and following centuries, and it is, of course, most probable that the Etruscans, as Diodorus affirms (v. 40), had already given peristyles – περίστωα, as he calls them – to their atria. He describes them as a 'useful device for avoiding the confusion when crowds are present'. There is no archaeological evidence for this, but if Diodorus's information is trustworthy, as it probably is, he may have thought of buildings with a plan like that of the Villa dei Misteri outside Pompeii (below, p. 160), where the peristyle is built in front of the atrium and the latter thus became a tranquil retreat. But he may also have thought of houses in which the atrium remained the traditional main reception hall for the *pater familias*, while the peristyle behind it provided privacy.

The enriched colonnaded architecture of Rome and Campania was usually connected with elegant and slender Corinthian, Ionic, and sometimes Doric columns. But – as I have said in discussing the columns of the oldest known temples – Vitruvius, who in his rules for the temples (IV, 7) prefers the plain, Italic Tuscan columns, yet speaks of the Doric and Ionic orders for atrium-houses. Tombs from the last Etruscan centuries (Plate 16) suggest that Tuscan columns could also be used. On the other hand,

many ash urns, some reproducing houses with hipped roofs surrounded by hellenistic columns, and such tombs as the monumental Tomba Ildebranda (Figure 18), show how popular Aeolic, Corinthian, and Ionic columns were in the third and following centuries in Etruria. All this shows the same process of increasing hellenistic sumptuousness and comfort as the atrium-houses of Pompeii and Herculaneum. The Tomba dei Rilievi and the Tomba dell'Alcova at Caere (Plate 37), the very magnificent Tomb of the Volumnii near Perugia (Figure 38 and Plate 45), and other large, late tombs prove how hellenistic decoration dominated among the Etruscans right down to the end of their free life in Italy. The

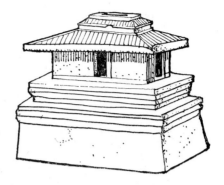

Figure 47.

Model of an atrium displuviatum from Clusium (Chiusi). Fourth or third century B.C. *Berlin, Altes Museum*

Tomb of the Volumnii confirms in a most striking way that these tombs reproduce the later Etruscan palaces. With its gabled central hall (*atrium*), its tablinum behind, its side rooms and various types of coffered and otherwise decorated ceilings, it represents the final stage of the Etruscan palace. Here, as among the fat, complacent Etruscans on the lids of late sarcophagi and ash urns, we can realize what the Romans meant by their arrogant sneers at the luxury of their Etruscan enemies – in spite of the military decoration on the architrave of the Tomb of the Reliefs, in the atrium of the Volumnii, and in other tombs from the last centuries B.C. (Plate 46), and the determined Etruscan resistance in the wars of the fourth and third centuries.[61]

The description of domestic architecture has shown that arches built up of voussoirs became an important part of the hellenized domestic architecture of Etruria (Plate 40). A tomb at Clusium (Chiusi), the Tomba della Paccianese (or del Granduca), has a tunnel-vault built of ashlar in the third or second century. City gates, bridges, and

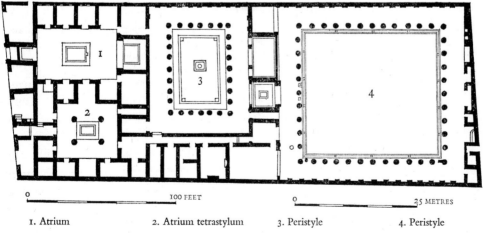

0 100 FEET 0 25 METRES

1. Atrium 2. Atrium tetrastylum 3. Peristyle 4. Peristyle

Figure 48. Pompeii, Casa del Fauno in its last period. Second century B.C. (first period). Plan (1 : 750)

other public structures show that voussoir arches were common in hellenistic archi-
tecture from the fourth century onwards. The recently discovered arched city-gate at
Velia proves that the Greeks were already constructing monumental arches in the fifth
century B.C. At least from the first decades of the second century they also employed
rows of arches for plain yet monumental façades such as those which we see at Lindos,
and such as we shall see in the first century in the terrace below the Temple of Jupiter
at Terracina and in the amphitheatre of Pompeii (Plate 88). Voussoir arches obviously
reached Italy as a more or less complete architectural achievement. It is possible, and
even likely, that the Etruscans were the first to adopt them in central Italy, but there
may soon have been a parallel movement in Rome. The combination of semi-
columns with architrave – so famous from the tabularium at the Forum Romanum
built in 78 B.C., the grandiose terrace below the Temple of Hercules Victor at Tivoli,
and from all later architecture – had predecessors in Etruscan architecture, as shown,
for instance, by an ash urn of about 150 B.C. from Clusium now in the Worcester
(Mass.) Art Museum. Plain pilasters with hellenistic capitals of Ionic character carry the
top border and the lid of the urn, but below them, between the pilasters, are arches
and an architrave. Sepulchral monuments from Delos and Syros datable about 100 B.C.
suggest Greek influence. The beautiful Etruscan arched city-gates, with, for instance,
heads of protecting divinities or other heads in dramatic hellenistic styles on the key
and springer stones, as at Volaterrae (Volterra), or the great gate with shields on the
architrave at Perusia (Perugia), are all of about 300 or later. However, the really great
and creative developments of the voussoir arches and of the vault belong to Roman
architecture.[62]

On the other hand, it is important to remember that the Etruscans at a very early date
brought the principle of lofty vaulting to Italy (as shown by the corbel-vaulted tombs;
below, p. 78 f.), and also, it seems, of light wooden roofs. But, as far as technique goes,
the vaults which the Romans built from the second century have nothing to do with
such forerunners. They depended entirely upon the new, revolutionary Roman manner
of building with concrete.[63]

I have here summarized the sacred and secular architecture of the Etruscans, which
we can follow from the seventh century as a unity, though, especially with regard to
houses and tombs, it must always be borne in mind that the independent city-states
which formed the rather loose Etruscan confederation had many characteristic local
differences in their architecture, art, forms of burial, etc.[64] All the same, there was a
cultural unity, the Etruscan koiné, which spread all over central Italy in the sixth century
B.C., and in its main lines followed the development of Greek art from the Archaic to the
Hellenistic Age. The material just discussed gives a reliable general idea of the old irreg-
ular and the later regular towns, of their temples, of the preponderance of rather small
rectangular houses, and of the stately domus of the aristocracy with elegant interiors, of
textiles, which the wall paintings represent, and of beautiful furniture.

Roads and Bridges

The admirable system of roads and streets paved with blocks of basalt lava belonged to the Roman systematization of Italy. But a coarse and irregular street of stones of different kinds and with narrow pavements has been excavated at Rusellae; it can be dated to the last centuries B.C. At Marzabotto, as in oldest Pompeii, stepping stones occur, leading over unpaved streets. There may also have been tufa-paved streets in the towns, as in fourth-century Ostia. Otherwise, the roads between the towns seem usually to have been of dirt or cut in tufa, with wheel-ruts where they passed over the tufa hills. In comparison with their solid and durable paved roads of the last centuries B.C. and of Imperial times, the Romans must have regarded all the Etruscan roads as displaying what Vitruvius calls rural softness (*viarum campestris mollitudo*; x, 2. 11). In any case, the Etruscan roads had elaborate tunnels and cuttings. These could also be used for rivers, as, for instance, the much visited Ponte Sodo at Veii shows.

Where the roads crossed streams, wooden bridges on ashlar piles were built, as can be seen between the acropolis and a neighbouring hill (the Vignale) at San Giovenale. Arched bridges (like arches in general) belong to the later hellenistic architecture of Etruria as well as Rome. Livy (xl, 51. 4) explicitly describes how a wooden bridge on piles of stone built over the Tiber in Rome in 179 B.C. was replaced in 142 by arches.[65]

Tombs and Cemeteries

Among the great monuments from the centuries before 400, when the Etruscan city-states dominated not only central Italy but also the Po valley and Campania, belong the mounds of the tombs (Plates 15 and 28). They changed the whole aspect of the landscape around the cities, as seen at Cerveteri, San Giovenale, and in other places. Here again we meet with the Etruscan heritage from the Near East and Greece. The great mounds and chamber tombs of Asia Minor show the closest affinity, as do also, for instance, the mounds round Kyrene, on Cyprus, the small tumuli of the Greek immigrants on Ischia thrown up from the eighth century, and what literary sources and remains attest from other Greek towns.[66]

As we have seen, the rock-cut chamber tombs for inhumation came suddenly to Italy about 700. The old tomb types, pozzi and fosse, lived on for a while side by side with the new types of tomb, as can be seen, for instance, at Caere in the Banditaccia cemetery. Some scholars assume an internal development in Italy from the fosse to the chamber tombs; as I see it, there are many instances of obvious influence from the chamber tombs in the latest fosse, but these transitional features by no means prove an inherent continuation, and there is neither time nor material to prove such a gradual unfolding. Here it is not possible to record more than the principal new imported types. Of them I have already discussed the rock-cut chamber tombs below the tumuli in

connexion with domestic architecture. In sixth-century tombs at Tarquinia the interiors were decorated with sculptured stone slabs, placed as a door at the entrance.[67]

Monumental, round or rectangular tomb halls of ashlar masonry with corbelled roofs belonged to the first centuries of higher culture in Etruria. Of the rectangular type, the most magnificent is the Regolini Galassi Tomb with its two rectangular crypts in the Sorbo necropolis west of Cerveteri (Plate 42). The treasures from this tomb and contemporary tombs at Palestrina are among the greatest splendours of the Museo Gregoriano-Etrusco at the Vatican and the Villa Giulia Museum in Rome. Their hoards of imported or imitated Oriental luxury date them to about or shortly after 650 – before the great importation of Greek orientalizing and later pottery and other works of art. The main corbelled, rectangular chamber of the tomb, which contained the most precious finds, measures 24 feet by 4 feet 3 inches (7·30 by 1·30 m.). A dromos with side chamber originally led to this main chamber, but its inner part was later provided with a corbelled roof. It thus became transformed into a large antechamber, 31 feet long and 4 feet 2 inches wide (9·50 by 1·28 m.), in front of the door to the inner original cella. The slit where the curving, corbelled-forward side walls nearly touch, is covered by slabs. This type of construction was gradually developed to a row of rude keystones forming a ridge-beam for the false vault. Among the later rectangular tombs of this kind a stately tomb, La Cocumella di Caiolo, on the outskirts of the San Giuliano cemeteries shows a steeply pitched corbelled ceiling with the top of each course chamfered so as to project beyond the course above. The same feature characterizes the corbelled tomb chambers of Orvieto from about 550 to 525.

Two or more successive corbelled rectangular chambers with side rooms are found at the so-called Meloni del Sodo tombs near Cortona, dated to the sixth century. There are also rock-cut chamber tombs with a slit at the top kept open lengthwise and covered by a lintel of stone. They obviously continued the tradition of the tombs of the seventh to sixth centuries (Plate 34).[68]

Archaic rectangular corbelled grave chambers seem to have been used only in the southern city-states of Etruria. Towards the north, we find instead corbelled domes. These beehive tombs (tholoi) (Plate 47) have no doubt inherited structural traditions from the Mycenaean Age or from yet earlier primitive constructions both of the Mediterranean countries and of Asia Minor. In any case, the corbelled dome is another monumental type which appears fully developed in Italy. Among these beehive tombs the so-called Montagnola and La Mula at Quinto Fiorentino are the most prominent examples (Figure 49). In the Montagnola, after a dromos, which is about 45 feet long, comes a corbelled rectangular antechamber, 22 feet 6 inches (6·85 m.) long, with lateral corbelled rectangular side rooms. Behind this lies the tholos. Its diameter is 17½ feet (5·30 m.), and it is roughly the same in height. In the centre is a massive quadrangular support, carrying the corbelled vault of the dome, a feature known also from several other Etruscan tombs and taken up again by the Romans when they imitated Etruscan tombs in Late Republican times. Rich finds date the tomb to about 600 at the latest. There are other magnificent tombs of this kind in the cemeteries of Populonia and Vetulonia and at Casal Marittimo near Volaterrae (Volterra; Plate 47).[69]

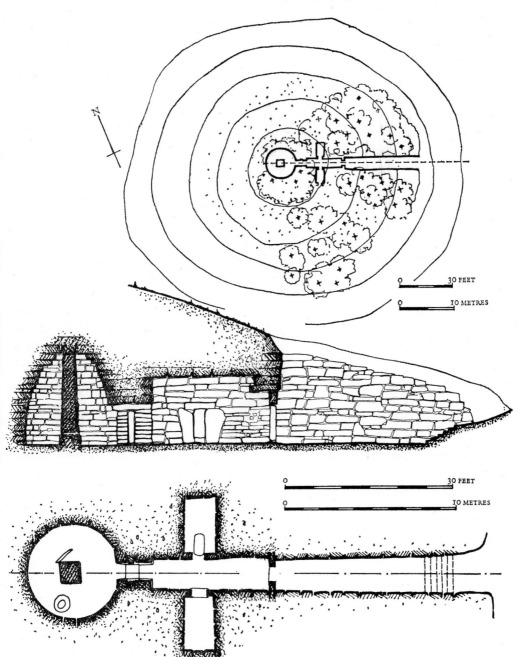

Figure 49. Quinto Fiorentino, Montagnola tholos tomb. *c.* 600 B.C. Section and plans

At Populonia and Vetulonia occur square chambers with primitive squinches in the angles in order to convert the rectangle into a circular shape suitable to carry the dome, as seen, for instance, in the Tomba della Pietrera at Vetulonia. Very important is that early tholos tombs such as the Tomba della Pietrera display careful ashlar work with alternating headers and stretchers. The tombs thus prove that the Etruscans already in

the seventh century (no doubt because of Eastern influence) used this building technique in Italy and had wholly mastered it. Here, no doubt, the Etruscans were the teachers of the Romans. Beehive construction lived on in Roman practice, as shown, for instance, by a cistern near the House of Livia on the Palatine and by the so-called Tullianum (the lower part of the Carcere Mamertino on the Forum Romanum).

The rows of tombs in Orvieto (Plate 27) show that mounds could be reduced to small regular tumuli (cf. Figure 37). The great mounds are usually provided with a circular base of stonework. In tufa districts like Cerveteri they were piled up on beautifully profiled podia, hewn from the living rock (Plates 15 and 28). One late tomb at San Giuliano shows a high, round podium, projecting from the hill behind, which evidently reveals a living tradition from the old tumuli and their podia (Plate 48). The so-called Tomb of Aeneas in southern Latium, which Dionysius (I, 64. 4) describes, and the mound which Vergil calls the mighty tomb of the Laurentine King Dercennus (*Aeneid*, XI, 849), show that tumuli were also constructed in old Latium, and that the revived Roman tumuli of the Late Republican and Imperial Age had antecedents in both Latium and Etruria.[70]

Tombs with a rectangular podium without mounds are seen in the rows of reconstructed tombs in the Banditaccia cemetery at Caere (Cerveteri; Plate 28). Quadrangular also was the podium of Porsenna's tomb, a fantastic tomb, described by Varro as having a circuit of 300 by 300 feet and being 50 feet high. In it was a 'labyrinth', evidently a legendary description of several tomb chambers. Above it stood five cones, one in the centre and four in the corners. They carried a round disc to which bells were attached by chains. The bells could be heard far and wide. If Varro's account is reliable, there were two more storeys with pyramidal pillars above the disc, carried by the five cones.

The bells on Porsenna's tomb – a device known also from Dodona – have been connected with the Columna Minucia in Rome, which also had them (Figure 50; below, p. 173). The cones of a Roman tomb on the Via Appia between Ariccia and Genzano, usually called the Tomba di Arrunte or degli Orazi, have rightly been compared with Porsenna's tomb. It seems to show that this kind of tomb of the *reges atavi* of Etruria was among the antique tombs which the grandees of Republican and early Imperial Rome imitated, in addition to mounds – as seen at the Via Appia – and, perhaps, tholoi. An archaic Etruscan tomb with a cone consisting of superimposed tapering blocks with reliefs found at Vulci seems to be related to this kind of monument.[71]

The gabled tomb huts at Populonia, mentioned on p. 70, should also be remembered. Evidently the variety of types was due to a certain extent to the particularism of the different small city-states or groups of them.

After 400, sepulchral architecture changed.

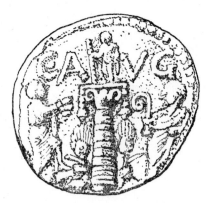

Figure 50. The Columna Minucia as reproduced on a coin of the late second century B.C.

Cremation prevailed, and cinerary urns replaced the sarcophagi of the older centuries. The mounds, furthermore, were gradually given up and replaced by chambers with entrances from the hillsides of the valleys and the deep, narrow gorges which surrounded the old acropolis hills and branched out into the neighbourhood. Very impressive tomb valleys are to be found in the wilderness around San Giuliano (Plate 49), Blera, Sovana, and Norchia. The elegant, often palatial, façades and monumental doorways of the tombs which lined the valleys and transformed them into processional roads belonged to the last centuries of the life of the Etruscan cities, before 100, and to the prosperity which the nobility or the *nouveaux riches* enjoyed under the sway of the Roman state during nearly two centuries of peace in Italy, after the Roman victories in the third century. In tombs like the Tomb of the Reliefs or the Tomba dell'Alcova (Plate 37), the more private of the apartments or bedchambers of the tombs of the old families had already been replaced by large halls with places for many interments. Typical of the last period of free Etruscan life are crowds of ash urns instead of beds and sarcophagi – as in the Tomba Inghirami of Volaterrae (Volterra). There may perhaps have been family crypts; freedmen and clients belonging to the closely limited clans (*familiae*) were probably buried around the family tombs. Late Republican Roman subterranean corridors or rooms with loculi, heralding the catacombs, were obviously connected with these Late Etruscan tombs. In many of the late tombs the interiors are left rough and undecorated.[72]

To what has been stated above about temples and elegant exteriors of houses, and also about the tomb façades of Norchia and Sovana and the entrances of the houses, should now be added, as typical sepulchral architecture, the so-called cube tombs (Plate 50) and the tombs with monumental false doors (Plate 51). The former are more or less isolated square blocks, projecting out of the rock from which they are cut. Beautiful mouldings and elaborate doors of the type already discussed characterize these tombs. False doors to the façades on these and other tomb façades became the fashion in Late Etruscan times. Below them are subterranean entrances to the tomb chambers, which were evidently filled in between each funeral.[73]

Critical descriptions of – above all – Poseidonius, Diodorus (v, 40), Dionysius (IX, 16. 8), and also Livy (X, 16) contrast the Etruscans of these late tombs with their forefathers of the old mounds. The Roman picture of the declining Etruscans is no doubt unfair, and must not prevent us from recognizing a genuine hellenistic renaissance among the Etruscans. Even if it is true that the noble Etruscans, on their sarcophagi, seem *obesi* indeed, and even if Greek observers saw signs of excessive good living among them, we must remember, as I have pointed out, that they resisted the Romans right down to the final defeat about 80 B.C.

The Tomba François at Vulci with its monumental wall paintings of old Etruscan bravery, and the predilection for arms displayed by the Tomba Giglioli at Tarquinia (Plate 46), the Tomb of the Volumnii near Perugia, and other tombs, are as telling as the more frequently mentioned testimonies of luxury and terrifying representations of murder and daemons of death. The latter make many of these late tombs sinister compared with the festive splendour of the tombs of the sixth and fifth centuries. This

morbid streak was connected with the pessimism about life and death common to the entire hellenistic world. When Lucretius tries to combat the superstitions of the Hellenistic Age in Late Republican Rome and to understand the true nature of the fiery thunderbolts, he refers directly to the charms of the Etruscans and the vain search of their scrolls, which are written from right to left.[74]

CONCLUSION

The Etruscan towns of the seventh and sixth centuries evidently inspired the inhabitants of the Iron Age villages on the hills of Rome and Latium to rebuild and reorganize their settlements. That is the starting-point for the architecture of historical Rome, even if the Etruscan influence – that is, the Etruscan rendering of Oriental and Greek culture – met with direct influence from the Greeks in central Italy from about 600. As mentioned above, for a long time the Greeks regarded Rome as an Etruscan or Greek town.[75] Roman historians and poets of the Late Republican and Augustan Ages, in spite of the common habit of caricaturing the contemporary Etruscans, loved to emphasize the importance of their Etruscan teachers. Also among modern scholars many typically hellenistic and international *communia bona* of the Late Etruscan and Roman Republican centuries have been wrongly dated and believed to be Etruscan models for Roman architecture. We have seen, for example, that we have to deprive the Etruscans of their claim to have invented the voussoir arch. On the other hand, the great tombs with high corbelled vaults, and also probably light wooden vaults, prove that the Etruscans brought the principle of lofty vaulting to Italy at an early date, though their manner of building such vaults has nothing to do with the vaulted architecture which the Romans were to develop centuries later. Already in the seventh century the Etruscan had acquired a complete knowledge of ashlar masonry, as their domed tombs show, and they also, long before the Romans, joined the Greeks in introducing regular town planning.

No doubt the Etruscans remained important as teachers, even though Romans and Etruscans went along parallel roads to Greece, and direct cultural influence from Greece on Rome replaced the one-sided influence from the city-states of Etruria. And, in any case, from the fifth and fourth centuries onwards the Romans developed a strong individuality of their own.

In the same way as the Etruscans used and transformed Oriental and Greek elements to guide their art and architecture through their six centuries of free cultural life in Italy, so the Romans digested what they received from the Etruscans and Greeks in accordance with their own traditions – as Dionysius (II, 19. 3) observed even when hellenistic influence ran very high. He rightly distinguished (x, 55. 5) between Roman 'customs of the ancestors' and written laws, in which one could easily trace direct Greek influence and the effects of transitory political situations. Domestic 'customs of the ancestors', originating from the Iron Age and slowly changing and developing in historical times against much conservative resistance, must be remembered when Roman

architecture from the fifth century onwards is examined. But in spite of the special architectural heritage (temples, atrium-houses, etc.), Etruscan and Greek influence was so overwhelming that Roman architecture seems to become for a while just an Etruscan dialect. The Roman 'customs of the ancestors' were, no doubt, a spiritual factor in the strength of the Romans and their capacity to learn. But the history of Roman architecture can never be understood without realizing the completely new starting-point which Etruscan building and the exchange with the Etruscans provided for all Roman building activity in Republican times and its legacy to the Imperial Age.

CHAPTER 4

ETRUSCAN ROME

WHEN turning from Etruria to central Italy south of the Tiber, from about 600 B.C. we shall see the same development as that which started in Etruria in the late eighth century. To a great extent we have until the fourth century B.C. to rely on the one hand on conclusions from Etruscan models and later structures which seem to reveal ancient tradition, and on the other on what we can learn from scattered passages by ancient authors and from legends.

In Latium the villages were not far away from the Etruscan towns which were the source of inspiration for them. Etruscan territory extended to the Tiber, to the *alveus tuscus*, *ripa etrusca*, *ripa lydia*. The great Etruscan town of Veii was only some 8 miles from Rome. Like all the old Etruscan towns, Veii had a period of most impressive prosperity in the sixth and fifth centuries, with famous sculptors and craftsmen.

Under the influence of the rich Etruscan towns the villages of Latium – and among them those of the seven hills of Rome – were reshaped to petty city-states after the Etruscan and Greek model. We see small towns in the Etruscan style everywhere, on the hills of the old villages, and protected by their natural situation – *situ naturali munita* (to use Livy's words, XXIV, 3. 8) (Plate 52). Already in this early period the Romans had begun to construct their famous agger and fossa (a mighty earthwork with a ditch in front) across the open table-land east of the Esquiline and the Viminal Hills (Figure 52). At Ardea we can still see a splendid earthen agger with a fossa of the sixth or fifth century B.C. (Plate 53 and Figure 51), and aggeres can be seen also at Antium – no doubt built during the Volscian wars before the Roman conquest of 338 B.C. – and at Satricum (Conca).

An ashlar wall of the local Roman tufa, *cappellacio*, akin to the substructure and podium of the Capitoline Temple on the south side of the Palatine, shows how the Romans, like the Etruscans at Rusellae, strengthened the natural defences of the hills with terraced walls. Very likely they also built palisades or earthworks between the hills in the valleys with their groves and rivers, as the tradition mentioned by Varro

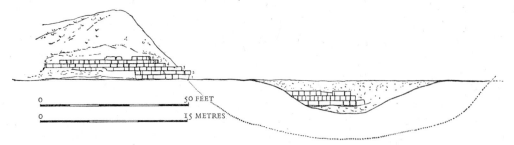

Figure 51. Ardea, remains of the bridge leading over the fossa and of the gate (destroyed *c.* 1930), with the agger west of the fossa. Sixth–fifth century B.C. Elevation

(*Lingua Latina*, v, 48) about the *murus terreus Carinarum* indicates. Dionysius (IX, 68) gives a most illuminating appreciation of this archaic patchwork of natural defence and supplementary additions when he analyses the position of Rome: 'Some sections [of the town] standing on hills and sheer cliffs have been fortified by nature herself and require but a small garrison; others are protected by the river Tiber ... [with] only one bridge constructed of timber, and this they removed in time of war. One section, which is the most vulnerable part of the city, extending from the Esquiline Gate ... to the Colline, is strengthened artificially', that is by the ditch and the agger inside it (Figure 52).[1]

In Rome this old system of defence was of no value when the Gauls attacked the town *c.* 386 B.C. Only one of the fortified hills, the Capitoline, resisted. It is self-evident that Late Roman historians completely misinterpreted these old bulwarks when they introduced the unified wall and the agger and fossa in their fourth-century shape into the old stories and believed that all the great fortification around the seven hills, probably occasioned by the experience of 386 and built with material from tufa quarries of destroyed Veii, was the wall of King Servius (legendary date 578–535 B.C.). But no doubt all these stories incorporated memories of old terraced walls, when the hillsides did not suffice, and aggeres and fossae. Varro's description of the old aggeres and the Roman *murus terreus Carinarum* show that the word *murus* was used also for these earthworks (Varro, *Lingua Latina*, v, 48, 143).

The Romans were always aware that higher culture was introduced to their pastoral and agricultural villages as a finished product, and attributed to the Etruscans almost all the expressions for higher culture which symbolized patrician authority and came entirely to reshape the town life of the early Republic: the twelve lictors and the fasces of the consuls, actually known from a sixth-century tomb at Vetulonia; the ivory chairs of the high officials; the array of the triumphs; the sacred land-surveying (*limitatio*) of the fields around the towns; the whole code for human life and religious ceremonies (the *disciplina etrusca*), and also garments, such as the shoes of the upper classes. Finally, there cannot be any doubt that the last Roman kings were Etruscans, condottieri, who stand out clearly against the earlier legendary rulers on the Roman hills.

To this new higher culture also belonged the alphabet, which the Augustan authors usually styled 'archaic Greek', as was also Etruscan writing. A famous fibula from Praeneste, the so-called Duenos inscription on a buccheroid impasto vase from Rome, and the much-discussed inscription on a stele on the Forum Romanum of about 500 B.C. are the oldest Latin inscriptions so far known. But Etruscan inscriptions – a fragment with one Etruscan word datable to about 600 B.C. found in 1963 at the church of S. Omobono and Etruscan graffito on a bucchero bowl from the Clivus Capitolinus – have also been found in Rome. All this, together with the established traditions about the Etruscan kings of Rome before 509, illustrates the cultural environment which accompanied the nascent higher architecture of Rome and the Latin towns, though it is evident that direct influence from the Greek colonies in Italy also encountered the Etruscan blend of Eastern culture in central Italy. Expressions of the imported higher

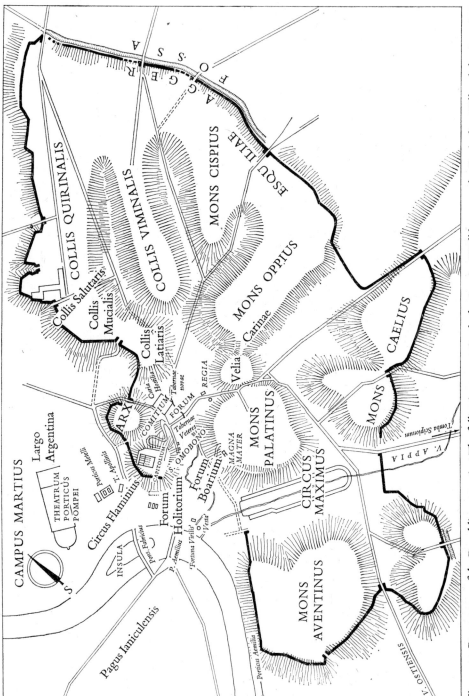

Figure 52. Rome, map of the Republican remains. The following are omitted: the Servian Wall between the Capitoline Hill and the Aventine (see Chapters 4–6), the Regia, and the Temples of Vesta, Castor and Pollux, and Saturn on the south side of the forum

86

culture are met with on hill after hill, in town after town all over central Italy. But what we know of architecture in the town which grew rapidly on the seven hills of Rome must be used as the master key to all the towns of the small world between the Etruscans to the north and the Greeks and Etruscans in Campania. As I have remarked above, the Greeks hesitated whether to classify Rome as a Greek or an Etruscan town (Dionysius, I, 29; Plutarch, *Camillus*, 22); but of course we must always remember also the village traditions of the Early Iron Age and Vergil's magnificent interpretation of that legacy (IX, 603–11):[2]

> Our hardy race takes to the rivers first
> Its children, hardening them to frost and stream;
> Our boys hunt through the nights and tire the woods,
> And shoot the bow and drive their teams for sport:
> Our men inured to work and scanty food
> Harrow the earth or shatter towns in war.
> The sword trains every age: we turn the spear
> To goad our bullocks, nor do the slow years
> Weaken our spirit or impair our strength.
> (Translation by Frank Richards, Trinity College, Cambridge)

That the Romans, as Varro says (*Lingua Latina*, v, 161), imitated the Etruscan style in architecture is evident, as I see it, in the *tuscanicae dispositiones* of the temples and of the *cava aedium tuscanica*. The same is true of the very manner of building. The podium of the Capitoline Temple, the terrace wall of the Palatine, and other remains show that the Romans had learned to use their local tufa for ashlar work. Remains of houses datable to about 300 B.C. prove that this kind of construction could be used at least for the lower parts of ordinary houses, as in the Etruscan towns (Plate 31). In the limestone districts hillsides were no doubt strengthened by polygonal work like that of the Etruscans. Mud brick, *pisé* (puddled earth walls), half-timbered and wooden houses on stone foundations, columns of wood (*columnae ligneae*; Livy, I, 56. 4), and terracotta revetments no doubt became as typical for the towns in Latium after about 600 B.C. as for the Etruscan cities. Archaeologically this is proved not only by the remains of temples and walls but also by the stratification along the Via Sacra of Rome and by numerous finds of archaic architectural terracottas on the Capitoline, Palatine, and Esquiline Hills of Rome, on the Forum Romanum and the Forum Boarium, and in towns all over Latium. The corbelled cisterns mentioned on p. 80 prove that the Romans also adapted that construction.[3]

Livy's description of the Gallic catastrophe (above, p. 63) distinguishes clearly between the domus of the rich and the houses of common people. From the very beginning of Greco-Etruscan culture, we probably have to assume the three types of palatial houses in the towns of Latium which Vitruvius describes (VI, 3) and which I have traced in the Etruscan tombs (p.66 ff.): the *cava aedium tuscanica* (though in its oldest shape, without impluvium), the displuviate houses, and the testudinate houses. The atria described by Vitruvius as the main halls of the *cava aedium tuscanica* (p. 71) were already attributed by Varro to the Etruscans. That was evidently the current opinion in

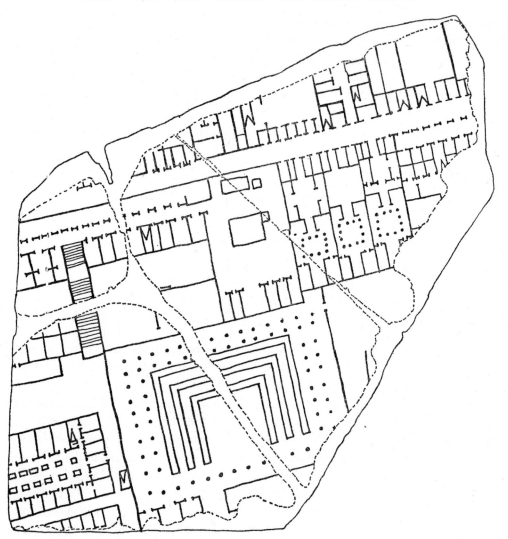

Figure 53. Fragment of the Forma Urbis Romae, showing three atrium and peristyle houses and the usual rows of shops (tabernae) with triangles indicating staircases to the upper storeys. A.D. 203–11

Rome – the younger Pliny refers to the atrium in his Tuscan villa as being *ex more veterum*. On the Forma Urbis (Figure 53) too one still sees the old traditional atria, and the commanding position of atria in Late Republican Ostia, Pompeii, and Herculaneum is in accord with that. But it should be remembered that our archaeological evidence is late and begins only with the oldest atria in Pompeii and Herculaneum of about 200 B.C. and with the Domus of Jupiter Fulminator (datable about 100 B.C.) in Ostia. An early atrium-house has also been excavated at Saepinum (p. 121). The regia at the Forum Romanum, seat of the Rex sacrorum and the Pontifex Maximus, has three rooms but does not show the megaron type with prodomus (p. 65; Figure 30).

According to our literary sources, among the domestic architecture of the lower classes there existed a type destined to be of the greatest importance throughout Roman

history: the *tabernae* (Plate 54). These were square or rectangular shops with a wide door, left open in the day-time, facing the street or an open space. No doubt they could be one-roomed units, as is still seen on Ischia and in various places in Campania. In our oldest archaeological material and the oldest descriptions they always appear in rows. The tabernae were used to house the plebs and for commerce and workshops, as Cato describes in *De re rustica* (135) and Varro confirms (*Lingua Latina*, v, 160). Livy's description of Tusculum, of what it was like in normal peaceful times, is delightful: shops with their shutters down, all wares exposed, busy craftsmen, schools buzzing with the voices of the children (vi, 25. 9). Dionysius adds shops full of arms and butchers' shops with knives on the counters on the forum in old Rome (iii, 68. 4; xi, 37. 5; 39. 7; 40. 1; xii, 2.8; Livy, iii, 48. 5). There is no reason to doubt that already in the early days of Rome such tabernae were aligned in front of private houses along the long north and south sides of the forum, as Varro, Plautus, Livy (i, 35), and Augustan authors describe (although they, of course, were influenced when describing them by the same kind of architecture in their own time). The tabernae which in 179 B.C. were built (or retained) along the south wall of the Basilica Aemilia towards the forum seem to have been constructed of timber-framing and mud brick. The row of shops along the forum of Pompeii, before its systematization in the hellenistic style in the second century B.C., may serve as a comparison (p. 121). The central parts of Pompeii show tabernae along the streets dating from the second century B.C. or even earlier. At Ostia a typical row of tabernae of the third century B.C. runs along the eastern side of the castrum (Figure 54). It may be noted that these tabernae measure about 28 by 21 feet (8·50 by 6·40 m.) and that the portico in front is 10 feet wide.

There is abundant literary but no archaeological evidence for farmyards and villages. Often mentioned along with them are their fortified refuges (*castella*) and the houses of the rich. The latter may sometimes have imitated Etruscan palaces. But more typical of these times were no doubt the humble villas of the grand old days which the late Romans moralized upon. An example is Cicero's grandfather's house near Arpinum; it was small and resembled the houses of the old Romans, of the famous Curius in the Sabine country (*De legibus*, ii, 3), and others.[4]

Together with the domus of the patricians we may at the same time remember that the Etruscan mounds were imitated in Latium. Dionysius (viii, 59) describes the tomb of Aeneas (or Anchises; 1, 64) as 'a mound, around which have been set out in regular rows trees that are well worth seeing'. For Vergil also (*Aeneid*, xi, 849) the tumulus was a typical feature of old Latium, and mounds of the Late Republican and Imperial Age, referred to in Note 96 to Chapter 6, thus appear as an archaistic revival of the venerable old type.

Livy (v, 55. 21–5) speaks of the careless haste with which Rome was rebuilt after the Gallic catastrophe, in a random fashion and without straight streets. It had the appearance of 'a city where the ground has been appropriated rather than divided'. As I said on p. 60, the tombs of the Crocefisso cemetery at Orvieto (550–525 B.C.), parts of the cemetery of Ostia, and both Marzabotto and Pompeii were regularly planned in the fifth century. Older Etruscan traditions, if there were any, encountered Greek ideas

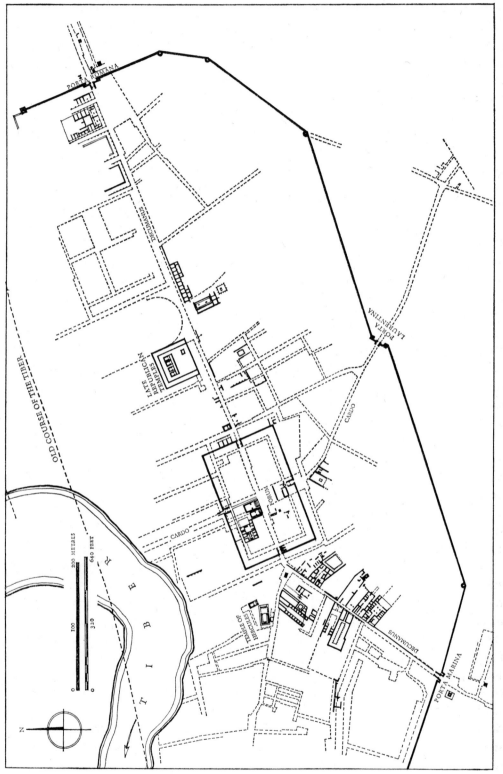

Figure 54. Ostia, from the third century to the end of the Republic, plan by I. Gismondi. The central rectangular fortress is the castrum of the fourth century B.C.

from the sixth century onwards here as in other fields of cultural life. But there is no evidence whatever of regular town planning in Rome itself. What Livy describes and dates to after 386 B.C. was no doubt only a continuation of the indigenous, ineradicable legacy of winding narrow streets, up and down hill, which Cicero (*De lege agraria*, II, 96) contrasts with the towns of the Campanian plains, where regular town planning of the fifth century could be carried out. The narrow, curved street below the wide, straight avenues of Nero between the Forum Romanum and the Palatine still shows us a fragment of the old irregular town after 390 B.C. (Plate 55).

Livy says that before the fire, sewers had been conducted through the public ways, *in publicum* (as at Marzabotto, Plate 29), but that in the Rome which he knew they frequently ran under private buildings. He may be right in explaining this as a result of the chaos after the fire of 386 or as due to other random building activity. His statement about the sewers in any case supports the stories that the Cloaca Maxima was systematized by the kings, that is, in the Archaic Age, as Varro had already maintained. It may have been partly subterranean, though Plautus (*Curculio*, 476) refers to it as an open channel on the forum. The monumental vaulted cloaca which we see today is Augustan.[5]

Connected with what we can see and read about the old irregular towns is the information concerning the oldest camps of the Romans and others which is given in a book on strategy by an unidentified author combined with Frontinus's *Strategemata* (IV, I. 14). He compares them with the huts (*mapalia*) and scattered cottages of the Africans, and ascribes the concentrated and fortified castra to Greek influence. In any case, the characteristic Roman castra seem to have developed later, connected on the one hand with the organization of the Roman infantry – the Roman legions – after the age of the patrician cavalry, and on the other with regular town planning.[6]

Narrow, crooked streets (like those of San Giovenale and Vetulonia; Figure 31), sewers below streets and houses, tabernae, Etruscan atria or megaron-like houses with a porch, and aggeres supplementing the defence of the hillsides were the main characteristics of the architecture which under Etruscan influence replaced the old hut-villages. Above all, the great Temple of Jupiter, Juno, and Minerva on the Capitoline Hill in Rome and other temples in Etruscan style with terracotta decoration became the great marvels of the old crowded towns. Dionysius (III, 69) and Livy (I, 55) recorded legends which seem to contain precious recollections of the victories of the new temples in Rome over the cults of the Early Iron Age. Dionysius (III, 69) describes how 'many altars of the gods and of lesser divinities [had] to be moved to some other place' when the summit of the Capitoline Hill in Rome was cleared for the great three-cella Temple of Jupiter, Juno, and Minerva in 509 B.C. 'The augurs thought proper to consult the auspices concerning each of the altars erected there, and if the gods were displeased, to move them elsewhere.' Wherever Dionysius and Livy got this information, it may well describe what actually happened when the period when no images of the gods were made and simple hut-like shrines and altars of turf were built, was succeeded by that of temples in the Etruscan style with personified gods, occupying the cult-places of the old demons from the Iron Age villages.

The general admiration for the Capitoline Temple of 509 should not make us forget that the Romans began to build temples like those of the Etruscans as soon as the new higher culture began to prevail among them – that is to say throughout the sixth century – whether this was connected with the political supremacy of the Etruscan kings and nobles or only with influence from neighbouring Etruscan towns. It has already been said (p. 20) that the round Temple of Vesta on the Forum Romanum probably represented the survival of a tradition from the Early Iron Age villages, though it was of course rebuilt in the Etrusco-Greek style, as Late Republican coins show. Already before the Capitoline Temple there was, according to Varro (*Lingua Latina*, v, 158), a Capitolium with a temple of Jupiter, Juno, and Minerva on the Quirinal Hill. The Argeorum sacraria, twenty-seven sacraria situated in the ancient central parts of Rome, were evidently also inherited from oldest Rome, and there were legends, too, about sanctuaries built by Romulus, Titus Tatius, and Numa Pompilius – in some cases our authors of the first century B.C. affirm that traces of them remained. As I have stated above, Vitruvius (II, I. 5) mentions the thatched roofs of temples on the Arx of the Capitoline Hill. Dionysius (II, 34. 4) even gives the measurements of the Temple of Jupiter Feretrius on the Capitoline, which he ascribes to Romulus, saying that the longest sides extended less than 15 feet. He also affirms (I, 34. 4) that he had seen the altar of Saturn built by Hercules at the foot of the Capitoline, where the ascent of the Via Sacra begins and where the Temple of Saturn was built. All this taken together only shows, of course, that the Romans themselves attributed some of their old temples to the earliest period of the kings, 753–616 B.C.; they lurked in the shadowy background of the history of their architecture. A fragment of a beautiful terracotta frieze with the Minotaur and processional friezes from the Forum Romanum (Plate 56) as well as finds of terracotta revetments at Ardea and various places in Rome and Latium prove by their quality that the Latin temples of the sixth century were already an important part of the Etruscan province of Greek Archaic art.

Architectural attributions to the less legendary later kings of Rome – Tarquinius Priscus (616–579), Servius Tullius (578–535), and Tarquinius Superbus – seem thus to be in substance reliable. To their period belongs the famous Temple of Diana on the Aventine Hill. Even if the tradition that Servius Tullius 'with his own sceptred hands consecrated' the Temple of Mater Matuta on the Forum Boarium (Livy, v, 19. 6 f., and Ovid, *Fasti*, vi, 479 f.) implies too early a date, the temple was clearly built in the decades about 500. Here we meet with archaeological features belonging to the history of Etruscan architecture: terracotta acroteria in the shape of volutes rising from the base, a casing of a capital, and a small part of a fluted Ionic shaft (Plate 17).

In spite of these earlier examples, the great Capitoline Temple of 509 marked a revolution in Roman life. After 509 the town of Rome, and, of course, also the thoughts of the Romans, were dominated by this marvellous, colourful building and all that was connected with it: personified gods, terracotta images by the Etruscan sculptor Vulca (no doubt similar to the terracotta gods found at Veii), terracotta revetments as already described for Etruscan temples, a new calendar, and other innovations.[7]

According to Roman tradition, the great enterprise was started by Tarquinius

Priscus. The Romans were convinced (so Livy relates, I, 38. 7) that it was he who laid the foundations for the terrace, that is the site of the planned temple, 'with prophetic anticipation of the splendour which the place was one day to possess (iam praesagiente animo futuram olim amplitudinem loci)'. Already the site on the levelled Capitoline was greatly admired by the Romans. Dionysius gives a description of how Tarquinius Priscus and Tarquinius Superbus built the temple (III, 69; IV, 59–61); Pliny mentions the court of the temple among the great creations of the kings, but Livy informs us (VI, 4. 12) that the sixth-century terrace was rebuilt in the great period of the Roman city walls in the fourth and following centuries. It became adequate both for *comitia* (assemblies) and *contiones* (public meetings). Right from the first it was decorated by many monuments, and was no doubt already as spacious as the sites of the Etruscan temples discussed above (Figures 11, 12, and 21). Below were underground chambers and cisterns (*favisae*) in which – according to Varro – it was the custom to store ancient statues that had fallen from the temple and other consecrated objects and votive offerings.

Our literary sources mention several temples of fifth-century Rome; for instance, those of Mercury and of Ceres, Liber, and Libera on the Aventine and the Temples of Saturn (501–493) and of Castor and Pollux (484) on the Forum Romanum. Of the latter two, remains of Etruscan type from the first periods can be traced in the Imperial marble buildings which have replaced them and their successors of the Republican Age.[8] They were situated on the south side of the forum, and, together with the Regia and the round Temple of Vesta to the east, they gave a new, monumental aspect to the old and rustic civic centre, which in these early days fulfilled both a commercial and political function (Figure 52).

A summary of what we know about this centre of Rome may serve as a general illustration of how fora in central Italy began. What we now regard as the Forum Romanum was then an unpaved market-place surrounded by patrician domus behind tabernae on the north and south sides. The domus disappeared only when basilicas were built on the forum after a great fire in 210. As Varro says (*Lingua Latina*, v, 145), the forum was the place to which people brought their disputes and articles which they wished to sell.

The political function of the civic centre was originally restricted to the north-western part of the forum. The ancient gathering-places for public meetings were the slope of the Capitoline Hill and the Arx towards the forum. Later – and until the last centuries of the Republic – an open space at the north-western corner of the Forum Romanum, as we see that large piazza after its final reorganization under Sulla and Caesar, became a centre for assemblies and public meetings. It was called the comitium and occupied the place where Caesar built his curia for the senate; indeed, that is where it still stands, as rebuilt by Diocletian. Literary sources make it quite clear that this open space was located in front of the old curia of the senate, the Curia Hostilia, which was ascribed to King Tullus Hostilius and faced the comitium and forum from a higher level to the north. As Livy says (XIV, 24), the comitium was the 'vestibulum curiae', the forecourt of the curia towards the forum. The curia had stairs in front leading down to the comitium. Roman public meetings could also be held on the forum and in different

places in and outside the Servian Wall, but the regia and the comitium seem to pertain to the Republic about 500 B.C. It has to be remembered that the Romans – in contrast to the Greeks – in accordance with their old traditions always stood at their assemblies and other meetings.

In the fourth century we meet with closed amphitheatre-shaped comitia for voters or assemblies (p. 113), but in Rome the south side of the court of the comitium seems to have been open towards the forum. At its boundary towards the present forum were placed inscriptions and monuments recording political events and famous Romans. Livy calls some of the statues fifth-century, a date which the Etruscan material of course makes very likely (IV, 17. 6). Among these monuments was also a tomb said to be that of Romulus or his father Faustulus or of an ancestor of King Tullus Hostilius. Some of these old monuments, to which the forum inscription of about 500 also relates, are still preserved below the level of the present forum: a black memorial slab, the *lapis niger*, in the Late Republican and Imperial pavement marks the spot. The exact location and shape of the orators' platform – the *rostra*, as it was called, since after the victory in 338 it had been adorned with ships' prows from Antium – has still to be ascertained, but literary sources indicate its close connexion with the comitium and the curia and a position between them and the forum. Pliny (VII, 212) makes it clear that the rostra, a reserved place for foreign messengers (the *graecostasis*), and a later column erected in honour of the victor in the battle of 338, the Columna Maenia, stood along the south side of the comitium. The apparitor of the consuls, the *accensus*, announced noon from the curia when he saw the sun between the rostra and the graecostasis. This information makes it likely, of course, that the stairs of the curia were visible and open to the public on the forum. Varro (*Lingua Latina*, VI, 91) quotes an old commentary on an indictment accusing a certain Trogus of a capital offence and prescribing that an assembly should be proclaimed from the rostra and that the bankers shut up their shops. Thi refers evidently to the tabernae of the bankers along the north side of the forum, and confirms the close relation between the rostra, the comitium, and the forum.[9]

A famous feature of old Rome was the wooden bridge which crossed the Tiber from the Forum Boarium. It was called the Pons Sublicius and, according to tradition, was constructed under King Ancus Marcius, without any sort of metal. Like the old Etruscan bridges, it probably had stone abutments. According to the legends the beginnings of the Circus Maximus in the Vallis Murcia between the Aventine and the Palatine Hills also belonged to this old Etruscan Rome of the kings. There is no reason to doubt that wooden platforms with vela on supports, like those known from Etruscan towns (above, p. 63, Plate 30), were erected along the sides of the long, narrow valley, though the descriptions of the Circus Maximus in Livy (I, 35. 8) and Dionysius (III, 68) refer to the architecture of their own age.

As already pointed out, the Romans marvelled at the grandeur of the Capitoline Temple and explained it in various ways. Apart from the historic problem of the rise of Rome, the cultural context is quite clear, thanks to our archaeological knowledge of Etruscan temples, towns, and tombs. What we see in the Rome of the sixth and fifth centuries and in similar remains from other Latin and central Italian towns is altogether

a part of the greatest age of Etruscan culture and political power in Rome, connected with the Etruscan rulers.

Pliny reports (xxxv, 154) that, in the course of discussing two Greek artists who were employed for the fifth-century Temple of Ceres, Liber, and Libera, Varro stated that before it was built everything in the temples was Tuscan work. We should not restrict that observation to Rome. Varro probably equated the Greek Archaic and the Tuscan style (Plate 56) without realizing that the Etruscans from their beginnings followed the development of Greek art, and that their Archaic style was only a version of Archaic Greek art. What Greek painters and terracotta artists (*plastae*) of the fifth century brought not only to Rome but to all Etruscan central Italy was certainly classic Greek tendencies. After the classic heyday of Athens and Argos they influenced all monumental architecture, monuments, and private works of art in the Etruscan and Latin towns of the fourth and following centuries.

The end of this first period of old Rome was the Gallic catastrophe of 386. The revolution against the Etruscan kings seems already to have retarded the Romans, and then, after 386 and until the victorious age after the war against Hannibal, internal struggles and continuous wars kept them busy. Though traditions from the Etruscan temples lived on and influence from the richer life of the Etruscans and Greeks can be traced, progress was delayed in the two centuries which followed after the Gauls put the great old Archaic town in flames.

ROME DURING THE STRUGGLE FOR SUPREMACY IN ITALY

(386 – about 200 B.C.)

THE old town of Rome described in the previous chapter was damaged or more or less destroyed, with the exception of the Capitoline Temple, when the Gauls, after depriving the Etruscans of their dominion in the Po valley, raided their towns and sacked Rome in 386 B.C.

The Rome which was rebuilt after the Gallic catastrophe in many ways stands out in dramatic contrast to the towns of the peoples that were brought under the sway of the rapidly increasing, overflowing town on the Tiber in the fourth and third centuries. The Romans boasted of their simple, warrior-like life and character, compared with the more luxurious hellenistic culture of the Etruscans and the Campanians; but their control of subject cities in Italy did not mean that they stood in the way of Greek influence. The classic exposition of the cultural differences between the subject states and Rome is Livy's scathing description of degenerate Capua during the war against Hannibal (XXIII, 2 ff.). We can illustrate the culture, of which Livy only gives a caricature, by reference to the refined, appealing life of second-century Pompeii (the so-called tufa period). Before the war against Hannibal, Rome remained stubbornly backward in comparison with her subjects, who had regular town planning and shared Greek cultural life.

As I have said before, Cicero contends in *De Lege Agraria* (II, 35. 96) that the Campanians with their town of Capua, which was spread out on a vast and open plain, laughed at and despised Rome, which sprawled across mountains and deep valleys, with houses of several storeys strung along badly kept streets and very narrow lanes. Fires, floods, continual collapses of houses, and uncontrolled building were typical features of Roman life. According to Strabo (V, 3. 7), the Emperor Augustus was the first really to concern himself about the defects of domestic architecture in Rome, reducing the height of new buildings and organizing a fire brigade. Yet in spite of Augustus's efforts and his speeches about improved domestic architecture, which he supported, according to Suetonius (*Augustus*, 89), old Rome – Vetus Roma before the Neronian fire of A.D. 64 in Tacitus's description – still appears as a town of narrow, twisting lanes and enormous, shapeless, and far from fireproof buildings (*Annales*, XV, 38).

In 338 Rome crushed the resistance of the Volscians around Antium, and thus became mistress of all Latium, extending her power from her strongholds there to her more cultured neighbours to the north and south. Already in the middle of the fourth century the Romans had brought the great and rich Etruscan Caere (Cerveteri) into close alliance, and they soon reduced it to a dependent state. As will be remembered,

the wars against the other Etruscan towns ended with Roman victories about 280. In the fourth century the Romans had waged their great wars against the very efficient confederation of the sturdy Samnite mountaineers, culminating in the victory of 290, and it was in connexion with these wars that Naples and the Campanians came under the control of Rome. The last culturally superior parts of Italy to come under her sway were south Italy (after the war against Pyrrhus, 280–275) and Sicily, which became a Roman province after the first Punic war (227). The Sardinians of the old nuraghi (above, p. 12), with Rome's usual slander against her enemies, were defamed as useless slaves and put up for sale, but they nevertheless revolted frequently, and continued brigandage even in the first century B.C.

The Romans maintained this early dominion by a network of alliances and by granting various degrees of independence or civic rights, until they reduced Italy to uniformity about 80 B.C. This multiform consolidation was controlled by strongly fortified colonies and garrisons of Roman citizens all over Italy; these fortifications are the greatest architectural expression of the system of government, corresponding to the organization and iron discipline of the legions. The consolidation was tested severely during the war with Hannibal, but emerged stronger than ever, thanks, as Livy says (XXVII, 10. 7, speaking among others of Signia and Norba), to her colonies. Later on the fortifications functioned quite differently: during the internal wars in Italy in the second and first centuries they were modernized and provided with arched platforms for catapults, etc. (Plate 63). It is typical that even before crossing the Rubicon Caesar had begun to seize such advantageous positions, starting with Ariminum (Appian, *The Civil Wars*, II, 5. 34 f.).

Following the legends about great city walls and gates, and the old bulwarks and the defence system discussed in the previous chapters, there now emerges a period of truly great fortifications. The heavy terrace walls which strengthened the hillsides of the Etruscan towns during the struggles against Rome from the end of the fifth century and the Greek city walls offered the prototypes, but the Romans developed walls in their own way, as the exigencies of their own system of government and the vicissitudes of the struggle for control over Italy required. The Latins probably built walls for their last defence against Rome, though we have no certain knowledge of them. Most interesting are the rough limestone walls of a quite special, local kind which the Samnites built around their few urban centres. The circuit of Saepinum, the greatest among them, is about 2 miles wide. It still gives us an almost complete counterpart to the infinitely more refined Roman fortifications, and demonstrates the Samnite preparations for the wars with the Romans.

In the Apennine limestone districts the Romans built mighty polygonal ('cyclopic', 'Pelasgic') walls similar to those the Etruscans had constructed since the sixth century; Terracina (probably about 400), Ferentinum (first period; Plate 90), Circeii (393), Signia (Segni, probably fourth century; Plate 57), Cora (Cori; fourth century), Arpinum (305; Plate 58), Praeneste (fourth century), and Norba (second half of the fourth century; Plate 59) are imposing specimens, in some cases built in connexion with the war against the Volscians. North of Rome are the well-preserved walls with which

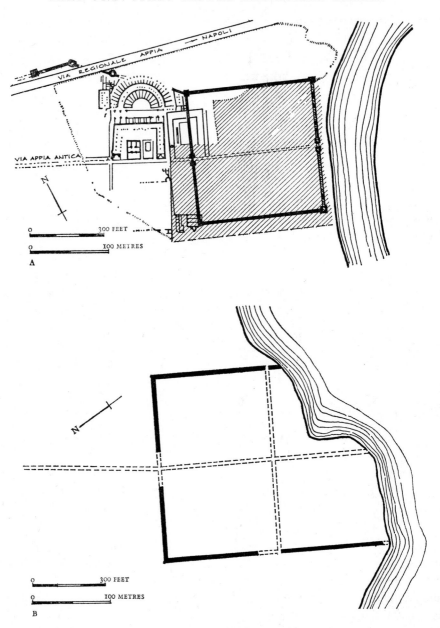

Figure 55. (A) Minturnae (Minturno), castrum and Late Republican town. Castrum 295 B.C.(?);
(B) Pyrgi (Santa Severa), castrum. Third century B.C. Plan (1 : 4500)

in 273 the Romans fortified their colony of Cosa (Plate 60). They are nearly a mile long and include eighteen rectangular towers and three gateways of the interior court type, which project inward from the outside of the wall, as known already from the fourth century at Ostia (Figure 54; below, p. 104). Rectangular walls were built on the plains to defend colonies. They were of the castrum type (see p. 104): examples are Pyrgi (Figures 55B and 56), Minturnae (probably 295; Figure 55A), and Fondi (about 250).

98

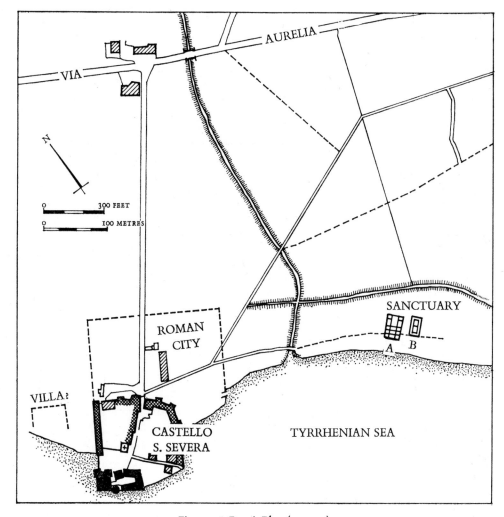

Figure 56. Pyrgi. Plan (1 : 5500)

The majestic walls of Alatri (Plate 61) show the perfection this kind of construction had achieved before it was handed down to the second century.

Different kinds of structure were adapted for different functions. Large, shapeless blocks with the interstices stopped by smaller stones may once have belonged to primitive constructions, but in our material they represent only the simplest and roughest manner used for the less conspicuous parts of the walls (the so-called 'prima maniera'). A more regular wall (the 'seconda maniera') was achieved by smoothing the surface. The true polygonal masonry (the 'terza maniera') has stones accurately fitted together. They were perfectly smooth, or sometimes rusticated, and similar to a rough ashlar wall. The even more sophisticated perfection of the 'quarta maniera' was arrived at decidedly later. In Roman and Latin usage, as we know it, the first three types appear together; their various methods of construction afford no certain clue for dating. The often fantastically mighty blocks of the fortifications seem mostly to have been brought

99

into position by means of earthen ramps on the inside, which usually remained as an inner agger and formed a terrace for the defenders. Free-standing walls for defence, for instance, the wall of Arpinum (Plate 58), seem to have been rare in this early age of Roman fortifications. Clamps and dowels were not used; mortar was a later device. The Romans continued to build polygonal walls in the last centuries B.C., as seen in villa terraces and in the Temple of Fortuna Primigenia at Praeneste (below, p. 140 ff.).

Before arched construction became the rule, gates could be constructed in the polygonal walls with corbelled, sloping walls and heavy lintel blocks, as at Signia (Segni), or with corbelled, pointed arches, as at Arpinum (Plate 58) and Palestrina. The corbelled arch of Arpinum has six courses rising to a height of more than 13 feet, and the lintel block of the acropolis gate at Alatrium measures about 16 feet. Minor gates were spanned by slabs. Polygonal walls were used also for podia and terraces of temples, as at Norba, Signia (Plate 62), and Cosa, and for other substructures such as those along the Via Appia, where they often seem to belong to the first period of this road, i.e. to c. 312.[1]

Ashlar walls were contemporary with these polygonal walls in districts where the volcanic tufa offered a suitable material. With this method of construction, in 378 and the following years the Romans built one of the greatest defensive works of their age, the so-called Servian Wall, by which they unified the seven hills into a strong, closely interrelated fortification (Figure 52 and Plate 63). Instead of employing the rather poor and narrow local cappellaccio blocks of the previous period, they shipped a far superior building material from quarries in the recently conquered territory of Veii, the yellowish so-called Grotta Oscura tufa. The ashlar blocks measure some 2 feet (60 cm.) in height; the length varies between 2 feet 5 inches and 6 feet 11 inches (74 cm. and 2·10 m.) and the width between $17\frac{1}{3}$ and 26 inches (44 and 66 cm.). The wall is laid in alternate courses of headers and stretchers. Some of the blocks are marked with alphabetic signs, which were made either at the quarries or during the building operations. Together with other tufas from the Etruscan quarries north of Rome, the Grotta Oscura tufa remained the most important building material in the fourth and third centuries, though tufas of finer quality and firmer consistency from the Alban Hills (*peperino*), Gabii, and the surroundings of Rome were used for sarcophagi, altars, etc., and gradually replaced the Etruscan tufa even in architecture.

The colossal new town wall consisted mainly of terrace walls built against the hills and inside ramparts. The agger (as maintained on p. 84), which probably earlier connected and defended the plain behind the Esquiline and the Viminal, was amplified into what may be called an artificial ridge with a height of approximately 33 feet. This agger was supported by a wall on its outer side, which continued the fortification of the hillsides and completed the circle of the town wall. Its base is 11 feet 10 inches (3·60 m.) wide. In front of this wall was a stretch of ground measuring some 23 feet, and a ditch, the *fossa*, which was 97 feet (29·60 m.) wide and approximately 30 feet deep. The artificially sloping hillside of the agger towards the town on the inner side of the wall was supported by a retaining wall of cappellaccio blocks, which, together with the huge outer wall, belong to the conspicuous remains of this most startling part of the Servian Wall. Livy tells how it deterred Hannibal from laying siege to Rome.

We see the same kind of terrace walls used at Ardea, probably during the Samnite wars about 300 (Figure 57). The lower town, which was abandoned about 300, and its old agger no longer fulfilling their function, the north-eastern side of the settlement on the acropolis needed new fortification. For this purpose a terrace wall was built against the hill with earth infilling towards the hill on the inside and a fossa dug in front of the wall.[2]

Figure 57. Ardea, acropolis, terrace wall. *c.* 300 B.C. (?), the bastion probably dating from the Gothic wars in the sixth century A.D. Elevation (1 : 750)

Somewhat older than the terrace wall of Ardea is the rectangular castrum of Ostia (see p. 104 f.), a fortification which the Romans threw up in the last decades of the fourth century to protect the Tiber (Figure 54). Fragments of terracotta revetments which seem to be of the sixth and fifth centuries suggest that this modern fort was built on a site contiguous to some older settlement, as was the castrum-fort of Pyrgi. The walls of Ostia were built in a similar manner to the Servian Wall, but with ashlar of the brownish so-called Fidenae tufa with spots of charcoal, which was quarried some 6 miles north of Rome. The thickness of the wall is 5 feet 5 inches (1·65 m.), and the highest preserved stretch measures 21 feet 8 inches (6·60 m.) from bottom to top. The wall probably had a rampart on the inner side. The four gates are of the inner-court type similar to those of Cosa (Plate 60) and run like corridors through the rampart. This type of gate may be considered a typical feature of Roman fortification. Neither at Ostia nor in Rome can we ascertain how the gates were covered, whether by lintels or corbelled.

Approximately a hundred years after the castrum of Ostia, in 241, the Romans destroyed the old Faliscan town of Falerii (Plate 64). They settled the rebellious Faliscans in parts of their old territory and, as was their practice in unreliable districts, founded a strongly fortified new centre, Falerii Novi (Santa Maria di Falleri). It was connected with Rome by a straight military road, the Via Amerina, with beautiful, modern arched bridges (Figure 58). The circuit of the city wall is about 1½ miles. In the typical Roman way it is reinforced by square towers projecting from the wall, as at Cosa. The ashlar blocks of reddish-brown tufa are only about 18 inches (45 cm.) high (they range between 44 and 47 cm.), but otherwise the wall is constructed like the Servian Wall, with the inner side generally attached to the slopes of the lower part of the town.[3]

Among the startling innovations of fourth- to third-century Latium are the elegant

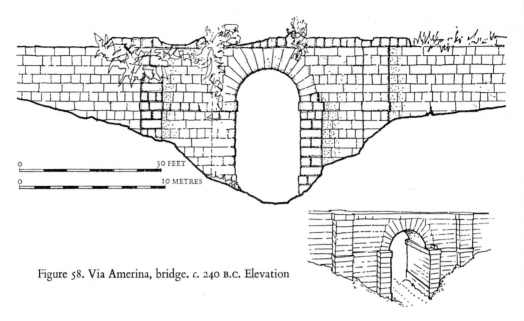

0 30 FEET

0 10 METRES

Figure 58. Via Amerina, bridge. *c.* 240 B.C. Elevation

arched city gates of Falerii Novi and the arched bridge on the Via Amerina. A vaulted drain in front of the Temple of Saturn on the Forum Romanum has been dated to the fourth century, and the oldest Etruscan arches appear to belong to the same period also. The city gates of Falerii display an unusual subtlety. Grey peperino-tufa from the Alban Hills is used for the voussoirs and mouldings. The long, narrow voussoirs describe a circle concentric with the interior curve of the arch. The springers rest upon an impost moulding, and a moulding of the same type surrounds the outer curve of the arch. This type of arch, which is detached from the wall and limits it to right and left and carries it above, was the type usual until the age of Augustus. A fine, perhaps later, specimen is the Ponte del Diavolo at Manziana (Figure 59), which was probably constructed as part of a Roman military road to Tarquinia. The great bridge of the Via Amerina across the Fosso Tre Ponti (Figure 58) shows a different kind of arch construction. The voussoirs have five sides and are fitted into the coursing of the adjoining masonry, a type of arch which is otherwise known only from the time of Augustus

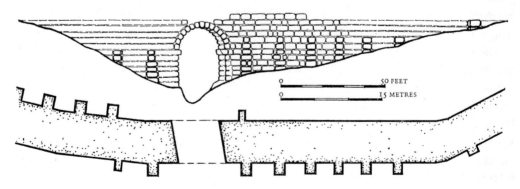

0 50 FEET

0 15 METRES

Figure 59. Manziana, Ponte del Diavolo. *c.* 100 B.C. Elevation and plan

onwards. But the bridge is an indispensable part of the road. There are no remains of any earlier structure; a date in the third century seems therefore certain.[4]

As stated above, Rome was rebuilt after 386 without any regular plan. In their haste after the sack the Romans disregarded the available models of Greek towns in Italy, which were regularly planned perhaps as early as the seventh century, of Etruscan towns of the sixth century, and of town planning of the fifth century in allied Campania. Elsewhere than Rome, however, the Romans began to adopt regular planning for their new towns in the fourth and third centuries, especially for colonies, where old buildings and rough and uneven surfaces did not stand in the way of modern designs. It is evident that regular planning and a street inside the walls were adapted to speedy manning of the walls, sallies, and to other military purposes. The first instance known of regular Roman town planning is at Norba: in connexion with the great walls (Plate 59), during the war against the Volscians and Privernum in the second half of the fourth century the somewhat plain parts of the town between the hills with temples on the south-west and north-east received a regular layout. But Cosa is the first really complete regular Roman town. Although the surface was uneven, rectangular blocks of houses measuring between 107 and 121 feet (32·50 and 37 m.) in width and about 270 feet (82 m.) in length were built over the whole town inside the mighty wall. The oblong blocks and quarters arranged in a chessboard pattern show an obvious affinity to Greek towns like Olynthus and Naples and the regular quarters of Pompeii (which was planned by either Etruscans or Oscans under Greek influence). The regular city plan of Cosa is clearly dated to the decades after the founding of the colony in 273.

Connected with the regular planning of the networks of streets in towns was one of the most important creations of the Roman military genius, their camps, or *castra*. Polybius elucidates this great novelty for the Mediterranean world (VI, 27–42) in a comprehensive and admiring account. He describes a camp as having two parallel main streets, the Via Principalis, which divided the camp into two sections with different kinds of barracks, and the Via Quintana. At each end of the Via Principalis were gates called the Portae Principales Dextra and Sinistra. At right angles to these streets ran a wide central passage which contained the commander's headquarters (*praetorium*), with three streets on each side. The central passage united the two halves of the camp and had gates at each end, the Porta Praetoria and the Porta Decumana. Remains of camps in Spain of the second century and from the Imperial Age as well as towns like Augustan Augusta Praetoria (Aosta) and Turin bear out Polybius's description.

The Romans not only applied regular town planning to the castra; they also, according to Frontinus (*Strategems*, IV, 1. 14), believed that they had taken the idea for their temporary castra from the Greeks. This is very likely true, but Polybius brings into special prominence the originality with which the Romans adapted the new scheme. He emphasizes the importance of the standard planning of the castra, where each soldier knew beforehand in exactly which street and in what part of the street his tent would be, and affirms that the Romans in their castra pursued 'a course diametrically opposite to that usual among the Greeks'. The Greeks, says Polybius (VI, 42), in encamping adapted the camp 'to the natural advantages ..., because they shirk the labour of

entrenching and because they think that artificial defences are not equal in value to the fortifications which nature provides'. Consequently, the Greeks adopted all kinds of shapes to suit the nature of the ground (exactly like the aboriginal hill towns). The Romans, because of entrenching and the fixed organization of the camps, did not require any defence of steep hillsides, rivers, and so on.

Figure 60. Failaka (Ikaros), temple and fortification built by
Alexander the Great on his march to the East. Plan,
somewhat simplified (1 : 750)

The Romans also created a somewhat different plan used especially for permanent rectangular (or quadrangular) castrum-forts with very strong, high town walls, built to house a regular garrison, such as at Ostia (Figure 54), Pyrgi and Minturnae (Figures 55 and 56), Fundi, Allifae, and other fortresses resembling the castra. One may compare fortresses which Alexander the Great built on his march to distant territories of the Persian Empire (Figure 60). The castrum of Ostia is the earliest known instance of these permanent camps, and may serve as an example. It measures 212 by 137 yards (193·94 by 125·70 m.) and has in the centre of each side gates of the type described at Cosa (Figure 54). They are usually referred to by the names of the gates in Polybius's description of a camp. The main streets from these four gates met at right angles in the centre of the town. In modern literature these streets are conveniently called *decumanus* and *cardo*, designations which in their strict sense belong to the regular division of fields;

decumanus is used for streets running lengthwise and cardo for the shorter, transverse streets.

According to the land surveyors it was ideal if the main roads from the surrounding fields could meet at right angles in the centre of the towns without interference from dwellings already in existence on the site. This system with straight, crossing main roads was not alien to the Greeks, as can be seen at Selinus and Paestum. In the enlarged fifth-century Pompeii (Figure 35), too, the main roads from the countryside resulted in a nearly rectangular grid of streets, which gave the town its basic regular layout; and Nicaea in Bithynia, a foundation of Antigonus Monophthalmus and Lysimachus and thus about contemporary with Ostia, was a quadrangular town with four gates which could all be seen from a stone in the middle of the Gymnasium, the typically Greek centre of the town.

To sum up, the city plan of the Roman castrum-forts, like all their other regular town planning, has to be seen in relation both to older and to contemporary designs all over the Greek world. But the final results the Romans achieved – exemplified by the castra described by Polybius, the castrum-forts with polygonal walls such as Minturnae and Pyrgi, and what they express of the particular Roman strength, notions, and manners in their great age – warn us not to overrate foreign influences or underlying traditions which may have lingered in the regular towns of Italy. The way in which Rome gradually developed and forcefully worked out modern ideas becomes of principal importance and should not be ignored. In the Roman Empire the castrum-forts were considered a distinctive mark of Romanity, as were also the Capitolia, the fora with statues of Marsyas, and Roman foundation rites. The remains of towns like Timgad, Egyptian Antinoupolis, and Beirut substantiate this, and the planning of many old towns in Britain, Italy, France, and Germany still reveals the legacy of the Roman castra.[5]

The colony of Cosa is remarkable because it is the most complete surviving Roman town of the otherwise scantily known centuries before 200 B.C. In addition, the method of construction of the houses demands the greatest attention. The grey limestone of the hill itself was used, cut to various shapes and sizes, but, vying with that, mud brick and wood, mortared masonry, and rubble work occurred all over the town. In cisterns barrel-vaults built of rough limestone voussoirs and rubble work or tile are connected with this kind of construction. The rubble work of Cosa ushers in *structurae caementiciae*, concrete, as described by Vitruvius (II, 4–8), which in the hands of Roman builders was destined gradually to revolutionize almost all Roman architecture. Roman concrete was a mixture of rubble and liquid mortar containing volcanic dust (pozzolana earth) with very great cohesive strength. Cato in *De agricultura* (14 f.), written about 160 B.C., mentions the use of mortar as a matter of course in utilitarian architecture. Similar constructions, 'walls of earth and stones constructed in a framework of planks (*in formis*)', called 'formaceae', were common in Africa, Spain, and around Tarentum. Descriptions of how the Roman army demolished Carthage in 146 B.C. seem to infer high, solid houses of this kind, which gave the ravaging Roman soldiers considerable difficulty. A barrel-vault datable to the first decades of the third century above the

Upper Peirene Well on Acrocorinth is built 'of an agglomerate of sea and sand pebbles, held together by a binder . . . with a strong admixture of lime'. Refined concrete and concrete vaults were thus used by the Greeks in the third century, at least in utilitarian architecture. The great, but unsolved, problem is exactly when the Romans developed this kind of building to that degree of perfection and adaptability which made its overwhelming future possible.

It is necessary to pose this question already here, though there is disagreement between scholars on when this turning-point in the history of the architecture of Western Europe was reached. The difference of opinion ranges between fifty and a hundred years. The lower limit seems certain: remains in Rome from about 150 B.C.

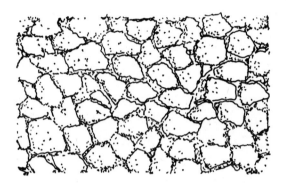

Figure 61. Opus incertum

onwards prove that concrete at that time was fully developed and widely used. The concrete walls were faced externally with stones of irregular shapes and thus displayed the technique which Vitruvius (II, 8. I) praises as the old manner of giving walls a protective surface and calls *genus incertum* (the modern term is *opus incertum*; Figure 61). To the domestic architecture of Pompeii belong various kinds of coarse rubble construction with a framework of limestone and tufa facing. Thanks to a fine mortar of pozzolana, towards the end of the third century walls of this type were developed to entire rubble walls without reinforcement. They resemble the Roman constructions of concrete, though they are less stable and without the more careful Roman facing. Walls of this kind were built in all quarters of Pompeii, together with façades of ashlar tufa and remaining structures of the oldest type built with the local limestone. Akin to the rubble of Cosa is the construction of the podium of the Temple of Magna Mater on the south side of the Palatine, which was consecrated in 191 B.C. It is made of irregular pieces of tufa and peperino laid in thick mortar.[6]

Many scholars believe that concrete began to prevail in Rome only about 150 B.C. But many arguments seem to prove that the new material appeared there as early as the third century, or at any rate about 200. In addition to the rubble of Cosa, the excavations of Ostia have revealed only houses of concrete with opus incertum in the quarters which grew up around the castrum-fort in the third and second centuries. Of crucial

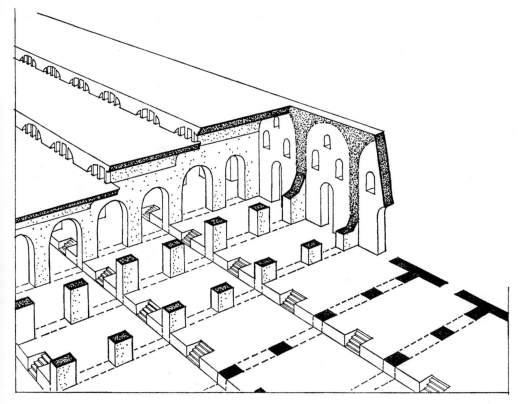

Figure 62. Rome, Porticus Aemilia (?). 193 B.C., restored in 174 B.C. Axonometric plan

importance is the dating of the imposing market hall on the Tiber south-west of the Aventine (Figure 62). This hall and its large granaries, the Horrea Galbae, are reproduced on fragments 23 and 24 of the Forma Urbis Romae, which dates from A.D. 203–11. The remains in the Lungotevere Testaccio and Benjamin Franklin Street measure 160 feet (along the Tiber) by 285 feet (48·7 by 87 m.). This great structure is entirely built of concrete covered with opus incertum of a quality already reminiscent of that technique in Sullan times. The building has arched doors, with alternating arched windows above. Lengthwise, it follows the rising slope along the Tiber on three levels; crosswise, it is divided by barrel-vaulted transepts facing the river. It seems to me indubitable that this highly developed building is identical with the Porticus Aemilia, built in 193 and restored in 174 (Livy, XXXV, 10. 12; XLI, 27. 8). The defenders of a later date for concrete either reject the identification or assume that the hall represents the Porticus Aemilia in a later, rebuilt form, belonging to the decades towards 100 B.C. Yet there appears to be no other building of the importance which Livy's repeated information indicates in the quarter south of the Aventine (outside the Porta Trigemina). Also, no older remains have been found below the hall. It is therefore difficult to deny that already at the beginning of the second century concrete, opus incertum, and vaulting had reached the considerable perfection which the Porticus Aemilia shows, and that the experimental age consequently was the third century. However, there are arguments against this

conclusion, and the fundamental question of when such a building could have been erected in Rome must still be presented as problematical.[7]

Roman and Greek authors such as Strabo (v, 3. 8) maintained that the 'older Romans took but little account of the beauty of Rome' because they were occupied with aqueducts, paved roads, and the construction of sewers. Dionysius says (III, 67) – in spite of the great Late Republican architecture – that the greatness of the Roman Empire can best be seen in these magnificent utilitarian works, and Strabo explains that the Greeks had taken little interest in them, and that this marks a characteristic difference between Rome and Greece. It is, of course, easy to prove that the Greeks were fore-runners in the construction of aqueducts, sewers, and other utilitarian architecture. On the other hand, the Romans – later partly because of their concrete – started a new era in the field, without any of the beauty of 'the useless, though famous, works of the Greeks' (as Frontinus says in his book about the aqueducts of Rome, I, 16). Cicero (*De Oratore*, III, 179–81) even speculated on the charm which is sometimes produced by merely fulfilling practical requirements. But, as Strabo himself says, his remarks refer to the older Romans, whereas the Romans of the last two centuries B.C., and particularly those of his time, filled the city with beautiful buildings of hellenistic types.

Pre-eminent among the utilitarian structures of the fourth and third centuries were the works of 312 erected by the great Censor Appius Claudius. He was the founder of Rome's first, still almost entirely subterranean aqueduct, the Aqua Appia, and the great military road to Capua, the Via Appia, with its viaducts, polygonal terraces, and, as far as possible, straight course. In the third century this famous trunk road was prolonged to Venusia, Brundisium, and Tarentum, connecting the southern parts of Italy with their new, harsh ruler on the Tiber, and at the same time creating the starting point for Rome's wars with the hellenistic kingdoms in the second century. Both Strabo and Dionysius give the Roman roads special prominence, and they are, indeed, one of the historically most important achievements of the third century. In that century the Romans started to use selce (silex, basaltic lava) instead of gravel and tufa for paving, which, allied to massive foundations, provided the legions with new, superior means of conveyance to hold their dominions in check. At the same time they also prepared the way for the future peaceful intercourse of the Empire. The streets of Rome and other towns were gradually reconstructed in the same way.[8]

At the same time, however, numerous temples were being built in Rome and the forum was receiving its first embellishment. Temple C in the Largo Argentina in Rome (Figure 63 and Plate 14) and the smaller temple embedded in the podium of the Late Republican Temple A were built about, and probably before, 300. The podia consist of ashlar work of the same kind as in the Servian Wall. The older temple, A, seems to have belonged to the type with two columns in the pronaus, discussed *à propos* the Etruscan temples (p. 31; Plate 79). Temple C reveals the Etruscan type of one-cella temple with colonnaded alae and close rear wall projecting right and left of the cella, mentioned by Vitruvius (IV, 7; III, 2. 5) and discussed on p. 31. The high podium (Plate 14) is, as always in these temples, accessible only by a flight of stairs in front of the roomy pro-domus. These podia and temples are of stone. This, as well as the somewhat elongated

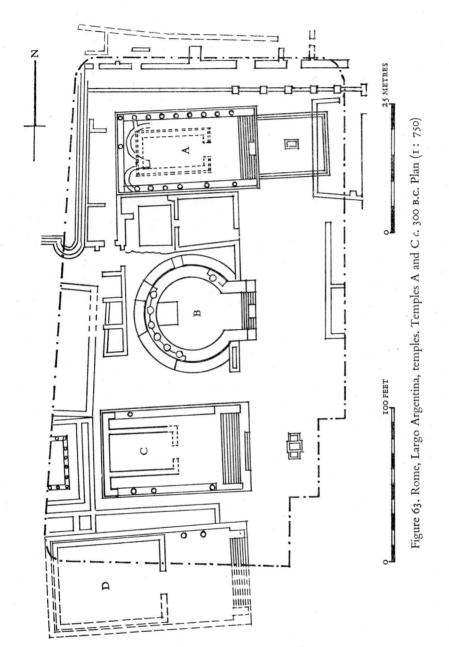

Figure 63. Rome, Largo Argentina, temples. Temples A and C c. 300 B.C. Plan (1 : 750)

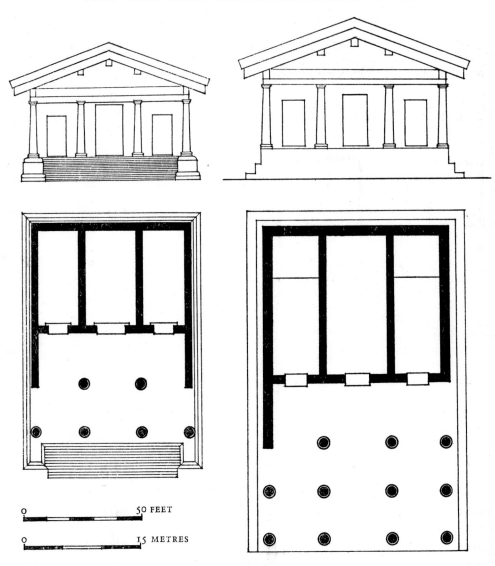

Figure 64. Cosa, Capitolium. *c.* 150 B.C.; Signia (Segni), Capitolium. Elevations
and plans (1 : 450)

proportions of Temple C, may indicate hellenistic influence. The forward orientation of
the temples is emphasized, not only, as in some of the Etruscan temples (Figures 11 and
12), by the open spaces in front but also by altars on the axis of the cellas.

Though the temples of Cosa, of which sufficient elements for a reconstruction remain,
were built in the second century, they afford confirmation of the state of the sanctuaries
in Rome before their final hellenization. The Capitolium of Cosa, dating from about 150
(Figure 64), corresponds largely to Vitruvius's description (and also to the Capitoline
Temple of Jupiter in Rome; IV, 7). Smaller temples (Figure 65) are of the Etruscan
type described on p. 33, with a cella without alae and columns in the prodomus. As

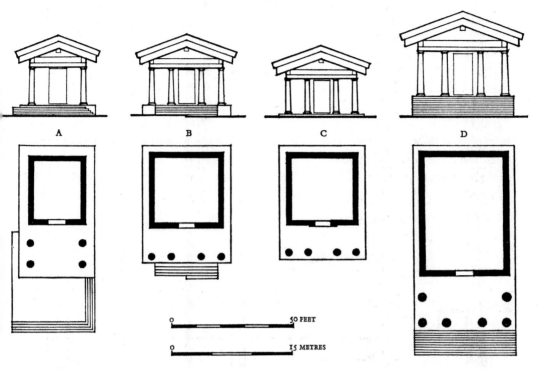

Figure 65. (A) Cosa, Temple B; (B) Cosa, Temple D; (C) Cosa, Port Temple; (D) Norba, temple.
Last centuries B.C. Elevations and plans (1 : 450)

mentioned above, the terracottas of the pediments, the revetments, and the drip-lines
sometimes suggest a construction with, as Vitruvius says (IV, 7. 5), mutules projecting
in front of the façade of the temple and carrying the tympanum of the pediment
(Figure 24). Tuscan columns reinforce the impression that Vitruvius learned much from
exactly this type of Roman temple with its preserved Etruscan *dispositiones* and chose
various items from among such temples when he attempted to re-establish what
genuine Etruscan architecture had been like.

A different kind of temple was the so-called 'Tempio della Pace' in the forum of the
colony which the Romans founded in 273 in the Lucanian town of Paestum, with its
Greek antecedents. It has the Etrusco-Roman plan with a high podium, stairs only in
front, deep pronaus, and a cella with alae (Figure 66). In the second period of the temple
(about 100 B.C.?), the columns on this traditional Italic substructure were Corinthian.
Its capitals belonged to the peopled type to which I have already referred as current in
Etruria and which were typical of Pompeii and south Italy. From Corinthian leafage
below spring two volutes of Ionic type with a head between them. The entablature was
of stone with a Doric frieze above the architrave. The first temple seems to have been
built during the first decades of the Roman colony, and thus – no doubt – already
belonged to the Early Etruscan and Roman sanctuaries, discussed on p. 32, which
introduced the combination of Italic plan and Greek superstructure and were destined
to predominate in the following centuries.[9]

In spite of the temples on the south side and the paved streets around the central area, the Forum Romanum remained a rather shapeless market-place, slightly narrowing towards the main entrance road on the east side, the Via Sacra. Plautus, in *Curculio* (476), gives a wonderfully vivid description of the muddle. He also makes clear that the part of the Cloaca Maxima which passed the forum was an open channel. This old square had no axial disposition, and no dominating temple on its upper short side. Many old Italic fora probably had the same naïve, disorderly character, which contrasts strongly not only with what was to be the result of later, regular town planning but also with the axial orientation native to the Etruscan temples, and what they and their forecourts (Figures 11, 12, and 21) contributed when central Italian towns were planned in agreement with modern Etruscan and Greek urbanization.

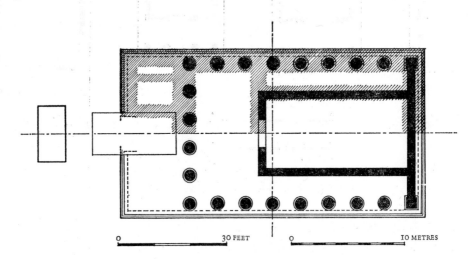

Figure 66. Paestum, Tempio della Pace. First period *c.* 270 (*hatched*), second period *c.* 100 B.C. (?). Plan (1 : 325)

Livy (XXVI, 27; XLIV, 16) describes the private houses which, until after a fire in 210 and later building operations, lay behind the butchers' stalls and shops of the forum – the tabernae veteres on the south side and the novae or argentariae on the north side, as they were then called. In spite of still crowded surroundings they stand out clearly as boundaries for the area of the future regulated forum. In the fourth century the dealers in victuals were banished from the tabernae to special markets in the neighbourhood, and only money-changers and bankers were allowed to have their businesses there. This 'forensis dignitas', to use Varro's words (quoted by Nonius, 532), had a background in the Greek feeling for the dignity of central fora, expressed already by Aristotle (*Politica*, 1331a), and heralded the elegance and systematization of the Forum Romanum of centuries to come.

The conqueror of the Volsci at Antium, C. Maenius, consul in 338, constructed balconies on the upper floors of the tabernae of the forum. These 'Maeniana' projected above the columns in front of the shops, and when the gladiatorial shows were introduced to Rome, probably from Campania in 264, and it became, according to Vitruvius

(v, 1. 1), a custom that they should be given in the forum, the Maeniana were especially convenient and brought in public revenue. About 335 the orators' platform (*tribunal*) at the assembly-place (*comitium*) was embellished by the rostra and the column erected in honour of Maenius, as has already been described.[10] In this forum the funerals of the great families also took place, with a peroration from the rostra and a parade of inherited ceremonial dress, marks of honour, and ancestral masks, as splendidly described by Polybius (VI, 53). After the ceremony the mask of the man who had just died followed those of his ancestors to the family atrium, where the image was placed 'in the most conspicuous position, enclosed in a wooden shrine'.

L. Richardson has drawn attention to oval amphitheatre-shaped comitia, or voting stations. They are so far known to us only from the third and second centuries, at Cosa (Figure 69), at Paestum, and at Agrigentum. As in the case of the comitium in Rome (the *vestibulum curiae*), a curia dominated the site, placed as it was at the top of the stairs on the central axis of the court. Though reversed, the same arrangement also exists in the cavea of the Theatre of Pompey, with the Temple of Venus Victrix facing the stage from the top of the spectators' gallery. The theatre temples of Latium (below, pp. 138 ff.) may also be compared. Whether the Romans followed old traditions and stood on the stairs or were seated after the Greek fashion, this architectural type of assembly building or building for voters seems to have been suggested by Greek municipal architecture.[11]

Our present material adds very little to what has been said about the atria and the domus of patricians and nobles (above, p. 87). They were probably still decorated in the old Etruscan styles, as a tomb at Ardea suggests (Figure 40). Livy (XLIV, 16. 10) relates that the domus of the Scipio family was in the quarter behind the tabernae veteres on the south side of the forum. Together with this domus of one of the best families in Rome he mentions butchers' stalls and shops, as we see tabernae connected with the atrium-houses in second-century Pompeii. As discussed on p. 74, the Etruscans may have added peristyles to their atria – in any case, peristyles behind the atria were a feature of atrium-houses in third-century Campania – but there is nothing either in our sources or in the archaeological material to prove that that luxury reached Rome at this early period, or that the gardens then existed which became such an important addition to the peristyles in Italy (Figure 48).

Far more important than what we learn about the domus is Livy's brief mention (XXI, 62; XXXVI, 37) of tenement houses with upper storeys. He informs us that in 218 an ox fell from the third storey of a house on the Forum Boarium, and that in 191 in another part of Rome, the Carinae, two cows went up the stairs of a house to the very top floor. Together with what Dionysius (X, 32. 5) relates about houses with upper storeys put up already in the fifth century by the plebeians on the Aventine, these events introduce a characteristically Roman type of building of the greatest importance for centuries to come: the high tenement house or *insula*. There is no reason to doubt that such houses were piled up on the tabernae along the streets (Plate 54 and Figure 67) and were accessible by steep staircases directly from the street – the arrangement we see in its accomplished Imperial form throughout Ostia and on the Forma Urbis, and which

can still be seen in old towns or old quarters all over Italy. There are, of course, no remains preserved of these early insulae, but rambling plans, cracking walls, ladders or wooden stairs to the upper storeys, wooden ceilings and floors, and mud-brick walls were doubtless typical of them. Such defects were still complained of by historians and poets of the first century A.D., in spite of great endeavours in the last centuries B.C. to check this uncontrolled individual building activity and to erect many modern insulae.[12]

In our sources high tenement houses are considered unusual in the Mediterranean world. They are mentioned as something exceptional at Parabas in Phoenicia, at Arados in Syria, in Tyre, and in Carthage.[13] Vitruvius is no less definite when he explains the high tenement houses of Rome as a local phenomenon due to the enormous size of Rome's population, which, he says, made it necessary to increase indefinitely the number of dwellings and so to construct high houses and invent for them a less unsuitable material than mud brick. Rows of tabernae, as we see them at Pompeii and in the Republican strata of Ostia, and badly planned and badly built insulae presumably occupied great parts of the town already in the fourth and third centuries.

In 221 another circus, the Circus Flaminius of the Censor C. Flaminius Nepos, was added to the racecourse in the valley of the Circus Maximus. It stood on the Tiber, with one end between the Porticus Metelli and the Pons Fabricius. The Greek hippodromes no doubt offered a model, but both the temporary theatres and the permanent circus buildings in Rome seem, until the first century B.C., to have been either surrounded by sloping earthen ramparts or provided with wooden structures for the spectators. The wooden buildings certainly left architectural traditions of importance for the monumental ashlar and concrete architecture of the centuries to come. It is typical that still in 155 a permanent theatre under construction was torn down by order of the senate, on the grounds that it was inexpedient and would damage the public character of the city. So the plebs in older times still had to stand to see theatrical performances, and the wooden theatres were always demolished after the entertainments.[14]

Livy (XL, 5) reports how the Macedonians at the court of King Philip, like the Campanians of Cicero's day, poked fun at the appearance of Rome about 200: 'It was not yet made beautiful in either its public or its private quarters.' That epilogue has its companion piece in the tomb of the Scipio family on the Via Appia. Originally it was a rough, rock-cut chamber tomb. It has many parallels among the later Etruscan undecorated tombs – for instance, the tomb of the Emperor Otho's Etruscan ancestors, the Salvii, at Ferento – but it is strikingly inferior to the rich, monumental sepulchral halls of some of the great families of Caere and Perugia (Figures 38 and 39, pp. 67–8). Perhaps in its first period, before the present façade in the hellenistic style was built about 100 B.C., the tomb had an adorned rock façade, as did so many Late Etruscan tombs with entrances from the hillsides (Plate 49). The famous sarcophagus (now in the Vatican Museum) of the Consul of 298, Lucius Cornelius Scipio Barbatus – even if it was added to the tomb during the golden age of the Scipiones in the second century – and a beautiful sarcophagus found south of Rome, outside the Aurelian Wall (Plate 65), reveal eloquently the progress of Greek influence and taste among the leading Roman families in the third century.[15]

HELLENIZED ROME 'CONSUETUDO ITALICA'

'THE beginnings of foreign luxury were introduced into the city by the army from Asia' about the year 187 B.C., says Livy (XXXIX, 6. 7). He also affirms (XXV, 40. 2) that already during the war against Hannibal an enthusiasm for Greek art had been awakened in Rome by the statues and paintings from Syracuse seen at Marcellus's triumph (212 B.C.).

Statements of this kind should not make us forget that direct influence from Greece or, still more, such influence in its reshaped Etruscan form, had guided Roman architecture and art from their very first beginnings. What Livy and Pliny mean is that the harsh centuries of 'the early Romans' (to speak with Strabo, V, 3. 8) and of the wars in Italy and against Hannibal were over. The theatres of war were now in the hellenistic world. Rome was transformed by a landslide of influence not only from southern Italy but also directly from the great Eastern capitals of the hellenistic kings. It is of great importance to remember that the culture of the Greek city-states with their restricted aims and scope after Alexander appeared in a far more irresistible and international shape throughout the Mediterranean world. It meant a new epoch for the hitherto obstinately old-fashioned town on the Tiber. In the second century B.C., Cato and the consul and senate, who forbade permanent theatres, were still trying to uphold ancestral customs, old usages, and the unwritten laws of Rome.

Livy speaks about the new charms of town life and new ways of living; Pliny, and even Tertullian, still resound with the contemporary reaction against these hellenistic 'licentious profligacies'. Archaeological material and literary sources prove that hellenistic taste pervaded not only the Roman way of life but also architecture. According to Vitruvius (Preface, VII, 15. 17), the Seleucid king, Antiochus IV (175–163), commissioned a citizen of Rome, Decimus Cossutius, to rebuild the Olympieion in Athens. Vitruvius adds that this was done 'with great skill and supreme knowledge'. This startling information shows, apart from anything else, that there were already contacts between the architecture of the hellenistic states and Rome during the sixties of the second century. In Rome, its colonies, and central Italy, we see the beginning of an inspiring struggle between Etrusco-Italic traditions and the overwhelming riches from the hellenistic towns. This created a new sort of hellenistic architecture. Only very rarely is piety towards old buildings as such attested. The Romulus huts are a special case (above, p. 20); another is the fact that in the midst of the rich resources of Imperial Rome, Pliny (XXXV, 158) speaks of the fine terracotta sculpture in Rome and other towns of Italy as 'more deserving of respect than gold, and certainly less baneful'. On the other hand, Cicero in the second Verrine Oration (II, 4. 68, 69) says that the Capitoline Temple rebuilt after the fire of 83 B.C. was adorned 'as the majesty of the temple and the renown of our empire demand' – that is, with modern hellenistic monumentality.

'Let us feel,' he continues, 'that conflagration to have been the will of heaven, and its purpose not to destroy the temple of Almighty Jupiter, but to demand of us one more splendid and magnificent.' Nothing can better express the victory of hellenistic taste and luxury. But before the curia of the senate rebuilt in Sulla's age, Cicero makes a halt (*De finibus*, V, 2) saying that the old Curia Hostilia evoked thoughts of Scipio, Cato, and other famous men of the olden days, while the new, Sullan curia 'seems to be smaller since its enlargement'.

Vitruvius, in the fifth and sixth books, describes the new variety of hellenistic architecture, which Italic builders could not resist, as 'consuetudo italica'. He points out, over and over again, recurrent Italic features, but he also specifies typical architectural designs of the Greeks which remained alien to the Roman branch of hellenistic architecture – such as fora in the form of a square (V, I. I) and Greek theatres (V, 7). In the sixth book he brings out specially prominently that the Greeks did not use atria (as the Etruscans and the Romans did) and therefore 'do not build their mansions as we do' (VI, 7). The atrium-houses of Pompeii (Figures 45 and 48 and Plate 66) and Republican Ostia preserve the exclusively Italic plan. Vitruvius thus discloses to us on the one hand the legacy of old Rome, its Etrusco-Roman temples, its atria, and its indigenous or long-established buildings, and on the other hand the hellenistic influence which pervaded Roman architecture of the previous centuries. Further, he describes Greek buildings with no Italic tradition, such as the palaestras, the peristyles, and, in private houses, the Egyptian and Cyzicene oeci (saloons), which none the less were imported to this new Rome (V, II. II; VI, 3. 86). What Vitruvius calls 'consuetudo italica' was neither pure old-Italic nor a copy of hellenistic towns: it was a new interpretation of the Roman commonwealth aided by modern adornments, which the increasing renown of the Empire demanded. The influence of Roman traditions upon foreign elements and the amalgamation of Roman architectural patterns with hellenistic taste created something new. However, foreign influence is readily perceived everywhere.

TECHNIQUES AND MATERIALS IN PUBLIC BUILDINGS

In discussing theatres (p. 114), it has already been said that the Romans before Augustus's time rarely used costly material in public buildings. The marble quarries of Luna were discovered only in the Augustan Age (Pliny, XXXVI, 14; Strabo, V, 222). In 146 B.C., however, the first floor of the Capitoline Temple was constructed with a diamond pattern (according to Pliny, XXXVI, 185), and in 142 the ceiling was gilded (Pliny, XXXIII, 57). Catulus, who rebuilt the Capitoline Temple after the fire of 83 B.C., was still both criticized and praised for having gilded the brass tiling of the roof. The victor over the Macedonians, Q. Caecilius Metellus, was the first to build a marble temple in Rome. That was in 146 B.C. His Temple of Jupiter Stator in a portico by the Tiber (later known as the Porticus Octaviae) was pointed out as the first instance of 'the magnificence or luxury of marble' among Roman public buildings. The charming, round marble temple by the Tiber (usually called, without foundation, the 'Temple of Vesta') (Plate

67) seems to belong to the first half of the first century B.C. Preserved from the predecessor of the present temple are foundations of tufa. The marble walls remain to about two-thirds of their height, and three different types of capital and column (twelve later replaced by columns of the Imperial Age). The entablature is lost, but the Corinthian columns with Attic bases, the capitals, fragments of coffering, the cornice, and the elegant plinth and masonry of the walls indicate that that temple – as has been aptly said – was a hellenistic 'intruder upon the Roman scene'. In contrast to the probably somewhat later Italic round temples on podia (p. 136), it was also, in the Greek fashion, surrounded by steps. Some of the Roman generals may have brought a Greek architect and the marble from Greece to Rome, as Sulla sent Corinthian marble columns from the Olympieion in Athens to the Capitoline Temple after the fire of 83.[1]

However, as a rule Late Republican public buildings in Rome, though more and more influenced by hellenistic styles and proportions, were constructed until the age of Augustus with tufa from Rome and its surroundings and additional travertine from Tivoli. In the first century B.C., travertine was even used for entire buildings, thus embarking on the career on which it was to continue in Imperial times. Rubble and concrete could also be employed. Walls, entablatures, capitals, and columns of tufa or travertine were always covered by stucco and painted, whether the buildings were of tufa, travertine, rubble, or concrete. Colourful terracotta revetments on the entablatures remained in favour throughout the Late Republican Age. In Vitruvius's eyes the traditional parsimony with costly materials detracted from Republican buildings; had they been refined by 'the dignity conferred by magnificence and great outlay' (Introduction, VII, 17), they could, according to him, have been included among the first and greatest works of architecture.[2]

As Pliny preaches, morals had already lost the battle against hellenistic luxury about 100 B.C. in the domus and the villas of the rich. A house which was regarded as luxurious in 78 B.C., after thirty-five years no longer ranked among the first hundred in Rome. Sumptuous marbles flooded Rome and were even dragged past the earthenware pediments of the temples to private houses and to temporary theatres.[3] Pliny sometimes (XXXVI, 8. 113) even thinks that Late Republican luxury, in architecture and otherwise, surpassed that of the Imperial Age, or – at least – introduced it (XXXVI, 110).

Ashlar work and mud brick persisted. As the temples and other public buildings of Cosa have shown, rubble came into use already in the third century; in temples from about 100 we meet with walls of concrete. For the podia of the temples and for the walls of utilitarian buildings, *opus caementicium* (concrete) more and more replaced the older techniques. The concrete podia were faced with ashlar of tufa or travertine. In the old temple terraces of Norba, the podium of the Capitolium of Signia (Plate 62), and even in some terraces of Roman villas we still see the old-fashioned polygonal work (though, of course, stuccoed) on podia. The small irregular cover-blocks of tufa, limestone, or selce (*opus incertum*; Figure 61) used for second-century concrete walls became tidier after about 100. The modern name for these more regular, but still uneven, facing-blocks is 'quasi- (or pseudo-) reticulate'. It heralds the famous regular reticulate work (*opus reticulatum*) of the Imperial Age, which, on the evidence we have at present, first

appears in the Theatre of Pompey (55 B.C.) and also in a few structures erected just before that sensational building. According to Vitruvius (II, 8. 1), in his day everybody used such a regular network, though, with his usual conservatism, he maintains that the old incertum was less likely to crack. Excavations at Alba Fucens, a sanctuary in the neighbourhood of Sulmona (the so-called 'Villa d'Ovidio'), and several buildings in other places show that incertum could persist together with other later techniques. Small blocks (*tufelli*) protected door-posts, corners, and other exposed parts of walls, and in these centuries were also used for arches.[4]

TECHNIQUES AND MATERIALS IN DOMESTIC ARCHITECTURE

The most spectacular, original, and important employment of opus caementicium was connected with the improvements of the tenement houses (insulae; see p. 113) and with the Roman vaults. Vitruvius states (II, 8. 17) that high houses of mud brick needed walls two or three bricks thick, while Roman laws forbade walls abutting on public property to be more than $1\frac{1}{2}$ feet thick. All the same, Rome's crowded population made it necessary to increase the number of dwelling-places and to build high. For this dilemma, Vitruvius recommends insulae with concrete walls, strengthened by piers of stone and protected by a layer of baked tiles on top of the concrete walls below the roof.[5] He otherwise distrusts concrete – as he does most novel inventions – and he did not believe that concrete walls were reliable for more than some eighty years (II, 8. 8). But high tenement houses with fairly slender walls could be built with concrete. Vitruvius therefore accepts the material for this purpose and even praises the excellence of the increased accommodation provided by these modern high buildings. Vitruvius's keen interest in insulae makes us understand just how frantic builders' activity of that kind was in Rome during this period, though rows of tabernae without superstructure no doubt also remained along many streets.

Added to that are both Augustus's endeavours to improve the town in a rational way (cf. p. 96), continued uncontrolled building, and the more than five hundred slaves of Crassus 'who were architects and builders'. He bought the plots for his most successful speculative investments – building new tenement houses after fires and collapses when previous owners had let them 'go at a trifling price owing to their fear and uncertainty'. From all this irrational or careless building activity there finally arose the perfection of well-planned, brick-faced insulae which we see all over Ostia from about A.D. 100 and on the Forma Urbis (Figure 53). Thus, domestic architecture developed which was unprecedented in the towns of the ancient world, even if in certain respects it may seem defective to us.

Certainly in Vitruvius's Rome, nobody had conceived the idea of a homogeneous, sturdy, brick-faced town such as second-century Ostia presents. The far less perfect tenements of concrete, which Vitruvius hails as solving the problems of housing in Rome, were by no means as frequent as his words imply. Dio Cassius (XXXIX, 61), describing the great flood of 54 B.C., mentions as something typical walls constructed of

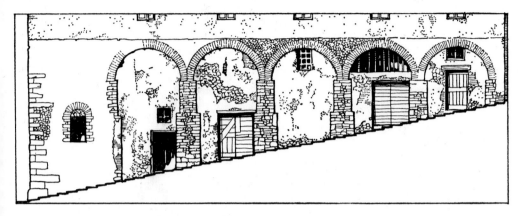

Figure 67. Terracina, Via dei Sanniti, tabernae of an insula. Early first century B.C. Elevation

mud brick, which 'became soaked through and collapsed while all the animals perished in the flood'. Seneca Rhetor (*Controversiae*, II, I. II), like other authors of the earlier Imperial Age and like Strabo (*loc. cit.*; above, p. 96), reports that fires and collapses were still frequent in Rome, adding that the houses were so high and the streets so narrow that there was no escape from such disasters.

From the decades after 100 we have archaeological evidence showing the kind of domestic architecture which Vitruvius recommended some fifty years later. At Terracina five tabernae of a large insula remain from the beginning of the first century B.C. (Figure 67). The house is built of concrete with a cover of opus incertum. Its piers and arches are of small blocks of local limestone. In the street along the south side of the Palatine the remains of a great Late Republican building, erected some decades later, has piers and arches of tufa blocks and concrete walls covered by quasi-reticulate (Plate 68). The same kind of technique is used in various remains of walls along the Via Sacra and in a part of the crowded old Rome with a brothel and a bath, below the Neronian portico and south of the Via Sacra, towards the Clivus Palatinus. In the Republican layers below the rebuilt Ostia of Imperial times, concrete covered by incertum and quasi-reticulate occurs everywhere after a first period of concrete and larger tufa blocks.

The most perfect specimen of a Late Republican tenement house of concrete, from the point of view both of planning and of building technique, is the Roman baths on the north side of the forum of Pompeii (Terme del Foro) (Figure 68). Together with other buildings, they were put up for the colony of Roman veterans, *Colonia Cornelia Veneria*, established in 80 B.C. to punish the Pompeians for their resistance to the Sullan army in the Social War. This building stands out from the usual architecture of Pompeii as a typical Roman insula. It is built of concrete and faced with a quasi-reticulate of lava. On the east and north side of the bathing establishment, which occupies the whole inner part of the site, against Via del Foro and Via delle Terme, rows of tabernae are built with at least one upper storey, accessible by a direct staircase from the street; a corridor leads to the baths themselves (Plate 69). In other words, here we see the standard for the

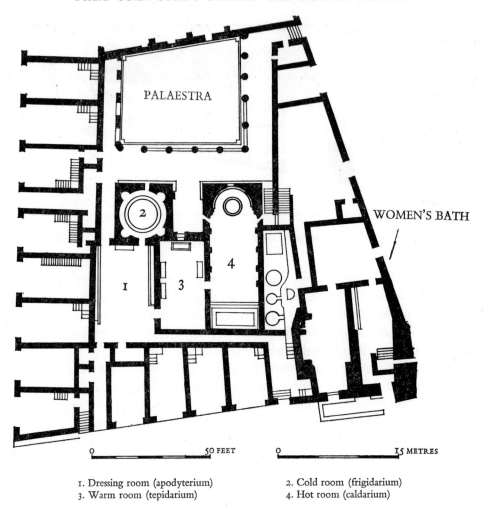

1. Dressing room (apodyterium) 2. Cold room (frigidarium)
3. Warm room (tepidarium) 4. Hot room (caldarium)

Figure 68. Pompeii, forum baths. *c.* 80 B.C. Plan. (1 : 450)

rapidly increasing number of tenement houses with upper storeys in Rome after their first shapeless beginnings: a tenement house built above rows of shops.

Both at Pompeii and at Herculaneum one or even two storeys were often built above atrium and peristyle houses, with elegant colonnaded dining-rooms (*cenacula*) open towards the street (Plate 70), or apartments with staircases of their own down to the pavements. As Varro says (*Lingua Latina*, v, 162): 'After they began to take dinner upstairs, all the rooms of the upper storey were called cenacula.' An interesting attempt to build a tenement house with upper storeys and small apartments around an inner court appears in the so-called 'Casa a Graticcio' at Herculaneum, but it should not be confused with the great, well-planned blocks, with central courts surrounded by tenements and with windows and shops towards the street, which we see in Imperial Ostia and which their discoverer Guido Calza called Palazzi di Tutti.

A taberna at the north-west corner of the Terme del Foro at Pompeii is completely

preserved and exhibits the form common to all shops of the Imperial Age. Above it are the remains of a cornice which once ran above all the shops in the building, like those on the tenement houses of Rome and Ostia. The shop, which is almost intact, has a wide, open entrance from the street and inside a barrel-vault with a garret provided with a small window above the lintel of the door. As in Imperial times, the garret was certainly reached by wooden stairs or ladders within the shop.[6]

Together with the progressively higher tenements of concrete, I have already singled out as one of the most important Roman innovations the vaults, constructed of mass concrete cast over a wooden form in contrast to the stone-built vaults of the East. Here starts a tradition of craftsmanship of enormous importance for the Imperial Age, comprising not only the gradually improving ability to handle a new material but also an efficient organization of carpenters to make the centering of the vaults. Vaults on the principle of the arch, wooden vaults, and the old corbelled vaults were now replaced more and more by the durable concrete vaults of less weight and more convenient construction. The Porticus Aemilia (Figure 62 and Plate 71) has already shown us the most common type, the barrel-vault, as it was probably introduced to Rome in the first decades of the second century B.C. The barrel-vaults of the shops of Terracina and Pompeii show how common this manner of vaulting had become by the beginning of the first century.

As seen in the cooling rooms (*frigidaria*) in the baths of Pompeii, domes with a large circular opening in the centre and resembling the old corbelled domes were moulded of rubble. The portico along the façade of the tabularium on the Forum Romanum and the shops of the terrace below the Temple of Hercules at Tivoli show that rectangular domical vaults also existed in Late Republican Rome.[7] Insulae and concrete vaults were developed in Rome with an energy and to an extent which created new, exclusively Roman types, reducing the possible basic influences from abroad or from the Etruscans to a matter of secondary interest.

FORA

Monumental architecture, porticoes round the fora, baths, private palaces, etc., are a different matter. In these it is necessary to distinguish between the imported architectural achievements of the hellenistic towns – 'non italicae consuetudinis', in Vitruvius's words – and the Italic traditions from Etruscan architecture of the seventh century and through the Roman centuries (cf. Chapter 2, Note 3).

Of great consequence for the future was the development of the Italic market-place towards the axial monumentality and splendour of the Forum of Caesar and the other Imperial fora. Different elements seem to have contributed. First, the old traditions of the Etrusco-Italic temples, with their frontal orientation and their open space in front of the stairs of the pronaus (Figures 11 and 12). Second, the old market-places with their rows of shops, which, as the history of the Forum Romanum shows, were no less deeply rooted in Italic life. However, to take the rectangular forum of Pompeii as an example, before systematization this space had a different orientation – a row of common

tabernae without portico along its eastern side, and no dominating temple at its north short side.[8]

A third formative component was rectangular hellenistic piazzas surrounded by porticoes and having a temple on the longitudinal axis, such as the Kaisareia of Alexandria, Antioch, and Cyrene.[9] In contrast to the monumentalized Italic fora of the last centuries B.C., with a dominating temple built against the rear wall at the upper side, the temples of the Greek piazzas were detached. This can also be seen in the precinct of the Temple of Apollo outside the western portico of the Pompeian forum (Figure 35). A temple area dedicated to Ptolemy III and Berenice at Hermoupolis Magna (Ashmunein) in Egypt of before 221 B.C. already exhibits the fully developed type of this piazza, with porticoes and axial symmetry.

It has to be remembered – together with these direct counterparts to the axial Italic fora – that in the fourth-century revival of Greek towns before and after Alexander, there appears a general, increasing predilection for axiality and symmetry. It stands in strong contrast to the charming free disposition and independence of the majestic architectural units of Olympia, for example, or of the Samian Heraeum and the Acropolis of Athens. The agoras of Assus, Miletus, the planning of the acropolis of Pergamum, or of the centre of Morgantina in Sicily, remind us that also in hellenistic times quite different principles for monumental planning remained with other kinds of beauty than what the new fashion of axiality offered. Yet, the latter inspired such great, strictly ordered complexes as the Temple of Asklepios in Cos or the acropolis of Lindos with the Temple of Athena.[10] It is evident that this axial hellenistic architecture made an overwhelming impression upon Roman builders, but it would be rash and without historical common sense to overlook that because of their traditions from the Etrusco-Italic temples and sacred precincts, they were predisposed, anyway, towards hellenistic symmetry, though they adapted it to the axial tendencies of Etrusco-Italic architecture. The great Roman shrines – such as those of Praeneste and Tibur (Tivoli; below, p. 140) – display in fact a more stringent and rigorous axiality than the hellenistic ones. At Lindos, for instance, no straight axis leads to the temple and porticoes interrupt the open view to it.

At present, the fora of Cosa (Figure 69) and Pompeii (Figure 35) are the first known regular Italic piazzas. Aligned along the northern long side of the forum of Cosa are monumental buildings: a basilica, two temples, and the comitium (see p. 113). A central axis ran from Temple C transversely over the forum – as did the central axis from the Temple of Augustus in Vitruvius's basilica at Fanum (Fano) (V, 1. 7). In the forum at Pompeii, with its longitudinal central axis, we can see still more clearly how the traditions of Etruscan temples and old Italic market-places united with hellenistic magnificence. Even before the Roman colony, c. 150–120, the old forum received a temple of Etruscan type at its upper north end, with stairs and prodomus towards the forum. It thereby obtained a central axis running lengthwise from north to south. The tabernae were demolished, and in the second century, along the east, south, and west sides of the rectangular space, suggested by the orientation of the Etrusco-Italic temple, two-storeyed porticoes with columns and architraves of tufa were built in the hellenistic

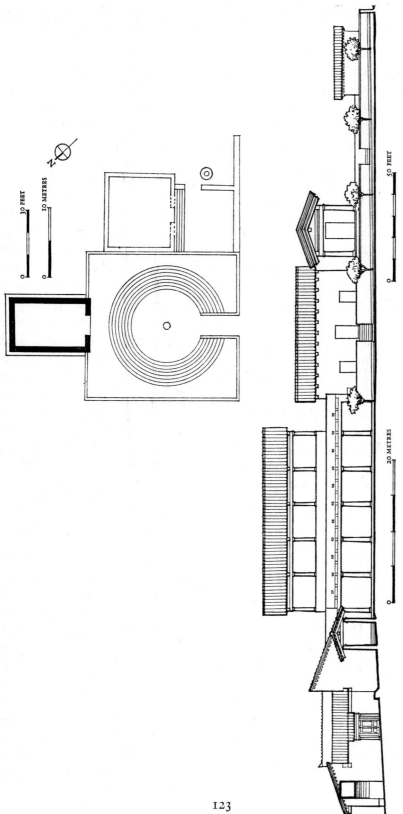

Figure 69. Cosa, forum and comitium: (*above*) plan showing early buildings only; (*below*) reconstructed section across the front of the comitium etc. at a later phase (1 : 525)

30 FEET

10 METRES

N

50 FEET

20 METRES

style. Behind them, on the east and south sides, there seem to have been private buildings or public offices. The porticoes of the west side formed a screen in front of the Temple of Apollo with a differently orientated peristyle and a basilica, which seems to have been built about 120. An important change in this pre-Roman monumental piazza, caused by the Roman colony, was that the temple was transformed into a Capitolium for the Capitoline triad. From this combination of an Italic market-place and a Greek colonnaded piazza is derived Vitruvius's rule (v, 1. 2) that Italic fora should be oblong. He prescribes that the breadth should be two-thirds of the length.

The forum and the Portico of Hercules at Alba Fucens (Figure 70) afford us most instructive specimens of axial systematization, both deriving from the regular planning of the entire colony at the beginning of the first century B.C. The oblong forum – and this seems to have been an innovation – had a longitudinal axis running from a tribunal on the south-eastern rear wall of a basilica (discussed on p. 151), across the basilica and a portico in front of it, and on to a temple at the north end. Like the forum of Cosa, it recalls Vitruvius's description of the forum of Fanum, with a central axis running across the basilica and the middle of the forum to the Temple of Jupiter on the opposite side. We see the same arrangement in the oblong Augustan forum of Augusta Raurica near Basel, though the fora of Alba Fucens and Augusta are longitudinal, not transverse like the fora of Cosa and Fanum. The very narrow Temple of Hercules behind the basilica faced south. In it has been found a splendid statue of Hercules in a grand hellenistic style, and a ciborium built against the rear wall. Before the present temple was built the whole precinct seems to have been a shapeless open space, though perhaps still a forum. Now a great portico measuring some 115 by 245 feet (35 by 75 m.) and surrounded by walls was built in front of the temple, with a central axis running from the northern rear wall of the temple to the presumed exit on the south side of the portico. The central court was open to the sky and only some 30 feet wide. The large porticoes right and left of it had two rows of columns. The whole scheme reminds one both of the basilicas and of the future Imperial fora, and is of importance for the understanding of both.

It is interesting to compare the forum of Brixia (Brescia) as it was regularized when the town was transferred from an old hill site to the plain. The forum of the new, regularly planned town had about the same size and shape as that of Pompeii. However, at its upper end, four small hellenized temples were built and decorated in the so-called Second Pompeian Style. They are datable to the decades after 89 B.C., when Gallia Cisalpina became closely attached to Rome. This seems to be an instance of Roman regard for local deities and cults after the victory in the internal wars of the eighties (as seen also in the Temple of Fortuna Primigenia at Praeneste and the Hercules Temple of 'Villa d'Ovidio' near Sulmona; below, Figure 78 and Plate 84).

The forum of Paestum is another colonnaded, rectangular hellenized market-place, though it had no temple at its upper end to emphasize its longitudinal axis. The monumental buildings around, such as the comitium (p. 113), the somewhat later 'Tempio della Pace' on the northern long side (Figure 66), and what probably was the Shrine of the Lares on the western short side, are arranged without any regard to symmetry.[11]

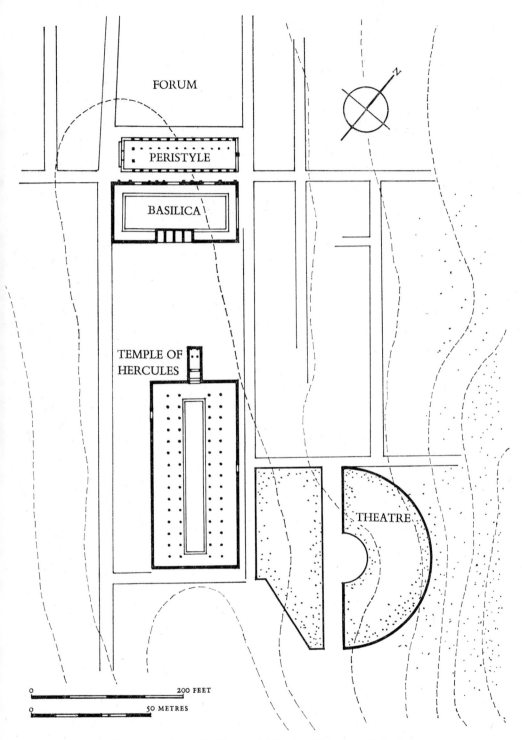

Figure 70. Alba Fucens, forum, basilica, and Temple of Hercules. Early first century B.C.
Plan (1 : 1500)

When the new fashion of systematizing the market-place reached the Forum Romanum, the points of departure were the old tabernae along the northern and southern long sides (Figures 85 and 52). The comitium at the north-west corner, on the other hand, was an obstacle to any axial planning. The beginning of modern systematization came evidently after a great fire in 210, which, according to Livy (XXVI, 27. 2–4), destroyed the shops on the north side. The private houses behind the tabernae were replaced later by basilicas: the Aemilia, built by the censors in the year 180, M. Fulvius Nobilior and M. Aemilius Lepidus, behind the tabernae on the north side, now named Argentariae Novae; and the Sempronia, built in 169 on the site of the old domus of the Scipio family behind the tabernae veteres by Tiberius Sempronius Gracchus. The latter basilica and the tabernae veteres were demolished when Caesar's and Augustus's basilica, the Basilica Julia, was built. It seems likely that the Tabernae Argentariae Novae, with maeniana (second storey to the portico), were rebuilt in ashlar in connexion with a restoration of the Basilica Aemilia in 80–78 B.C., if not before. At any rate, the Basilica Aemilia and the tabernae, though separated by detached dividing walls of their own, remained a unity throughout the Imperial Age. In the manner well known from Greek agoras, there were shops in the two-storeyed porticoes, superseding the old tabernae. That is how Vitruvius describes them; and the fora of Paestum and Lucus Feroniae (north of Rome) also show us this kind of two-storeyed structure in the shape he prescribed: at Lucus Feroniae, at the end of the Republican Age (no earlier than 50), a portico with Tuscan columns and a series of tabernae were built along the west side of the unpaved rectangular market-place with staircases to the upper storey.

For the porticoes in the cities of Italy, Vitruvius prescribes fairly wide intercolumniations because of the shows given in the fora. In contrast to the Greek stoas and the porticoes of the forum of Pompeii, forum porticoes (such as those of the Aemilia at the Forum Romanum) therefore probably still had wooden architraves in Late Republican times.

In 78, the irregular group of structures on the sloping west short side of the Forum Romanum was given a monumental background in the shape of the tabularium (Plate 72), a repository for the state archives built on the south-east slope of the Capitoline Hill. Another modern feature had been added to the old ensemble when in 117 the Archaic Temple of Castor and Pollux was rebuilt in a hellenized style. From hellenized Roman architecture also came *fornices*, honorific arches bearing statues. L. Stertinius had erected such arches, from spoils brought from Spain, in the Circus Maximus and on the Forum Boarium in front of the Temples of Fortuna and Mater Matuta in 196; Scipio erected another in 190 at the entrance to the precinct of Jupiter Capitolinus at the top of the Clivus Capitolinus. This architectural device of unknown origin, the forerunner of the glorious line of marble Imperial triumphal arches, was also introduced to the ensemble of the hellenized Forum Romanum by the Fornix Fabianus of 121. It spanned the entrance of the Via Sacra at the east end of the forum, commemorating a victory over the Allobroges. No remains of these fornices are preserved, but we know that the Fornix Fabianus was rebuilt in 57 B.C. – no doubt with tufa and travertine – and probably represented then the final shape of these monuments before the Augustan marble arches.

The central area of the forum had been paved with tufa slabs before it was covered with the travertine pavement of the two uppermost levels. This reminds one of the elder Cato's complaint about the modernization of the forum; according to him, it ought to have been paved with small sharp stones in order to prevent people from lounging about.

Cato's words recall the political and social temper of his time and the altercations connected with the development of the forum which are revealed by formal analysis. Very important for the development of the axial piazza of the Imperial Age is a characteristic change in the use of the rostra, which took place in the second half of the second century B.C. All earlier popular orators, so Cicero and Plutarch affirm, had, while speaking, turned their heads towards the curia of the senate and the traditional place of public assembly, the comitium. But – it seems, in 145 – a politician 'set a new example by turning towards the forum as he harangued the people . . ., thus by a slight deviation and change of attitude . . . to a certain extent changing the constitution from an aristocratic to a democratic form; for his implication was that speakers ought to address themselves to the people' behind the rostra, and not to the Senate.

Such new fashions in the life of the forum – the hellenized Temple of Castor and Pollux, the porticoes, and the basilicas – were the immediate forerunners of the monumental systematization which the Late Republican Age left to Caesar and Augustus. In contrast to such compromises between modernization and the old disorder of the slightly V-shaped area, outlined by the tabernae, stood the inspiring models of hellenistic piazzas and such accomplished Italic fora as that of Pompeii. It must have seemed quite natural that Caesar should try to make an axial piazza of the forum by radical measures, abolishing the comitium, transferring the curia to its present place on the forum, and building new rostra in the centre of the western short side.[12]

BASILICAS

With the basilicas of the Forum Romanum a new kind of building with a great future enters the history of architecture. Its origins and its Greek name have been widely discussed. Here it may suffice to state that the oldest basilicas known are Roman, in spite of the adopted Greek name. Their antecedents were evidently Greek peristyles and colonnaded piazzas. As a basic conception valid for all the various types of basilicas, this may be proposed: a peristyle with a central space (the nave), covered by a roof supported by timber trusses and surrounded by ambulatories (the aisles) on all four sides.[13] The best archaeological evidence for Late Republican basilicas is the basilica of Pompeii, probably built about 120 (Figure 35 and Plate 73); and by those of Cosa (Figure 69), Ardea (Figure 71), and Alba Fucens, which has already been mentioned (Figure 70), all dating from about 100.

Livy (XXXIX, 44. 7) informs us that Cato, in the face of considerable opposition, bought a building plot west of the curia and the comitium in 184 and built the first basilica in Rome. Plautus speaks in *Curculio* about a basilica near the Sacellum of

Cloacina, and parts of walls in the lowest strata below the Basilica Aemilia may well be remains of this probably insignificant structure.[14]

Vitruvius (v, 1. 5 ff.) describes two types of two-storeyed basilicas. One had columns in two storeys, those of the upper tier being smaller than those of the lower; an upper flooring, he says, should be constructed in the aisles, carried by the lower columns. The other, of somewhat different character, is represented by the basilica at Fanum, the building of which Vitruvius himself supervised. There the columns round the nave went all the way up, but engaged columns against the walls of the building carried an upper flooring between them and the columns of the nave. According to Vitruvius, it was desirable that the parapets of the balconies in the aisles should be so high that people walking in the upper storey would not be seen by those transacting business in the nave.

To understand the function of Roman basilicas, one has to realize that in Late Republican times they were attached to the fora as shelters for businessmen and the public at large, or added to precincts of temples for the benefit of the pilgrims. The basilica of Ardea is clearly connected with a great temple below the acropolis. It was probably a shelter for pilgrims attending the famous sacred rites of the Laurentine and Rutulian coast, believed to have been handed down from the time of Aeneas. It had an open front, and two doors, one in the rear wall and one to what Vitruvius calls a 'Chalcidian porch' (*chalcidicum*), a portico outside the wall of the south-eastern short side towards the temple. A water cistern behind the rear wall corroborates the explanation of the building as a resort of visitors to the temples. Neither the cistern nor the doors display any axiality.[15]

Vitruvius prescribes (v, 1. 4) that the basilicas should be constructed on a site adjacent to the forum and 'in the warmest possible quarter, so that in winter businessmen may gather in them without being troubled by the weather'. Like the Greek stoas, they of course also served as shelters against sun and rain. The first indications of the magistrates beginning to move from the fora into the basilicas are the 'tribunals' of the basilicas of Pompeii and Alba Fucens, and Vitruvius's statement that he built the tribunal in his basilica at Fanum in front of the pronaus of the Temple of Augustus as a semicircle with a curvature inwards 'so that those who are standing before the magistrates may not be in the way of the businessmen in the basilica'.[16]

Vitruvius shows us how he wished to transmit the principles of basilica building to the great Augustan Age, giving his usual detailed prescriptions of measurements and proportions of the ideal basilica and of Egyptian *oeci* (saloons) in private houses, which resembled basilicas (vi, 3. 8 f.). Our main sources are the basilica of Pompeii and preserved remains of walls at Cosa, Ardea, and Alba Fucens, which exhibit two different kinds of basilica plans: the two great basilicas of the Forum Romanum and the small basilicas of Cosa, Ardea, and Alba Fucens turned their long sides towards the public squares in front of them (Figures 69, 70, and 71); the basilica of Pompeii, on the other hand, faced the forum with an open entrance on the eastern short side. The Aemilia and Sempronia were screened off from the Forum Romanum by the rows of two-storeyed shops and the porticoes in front of them, but they were, of course, provided with entrances to the forum, as we know from the Aemilia of the Imperial Age and the

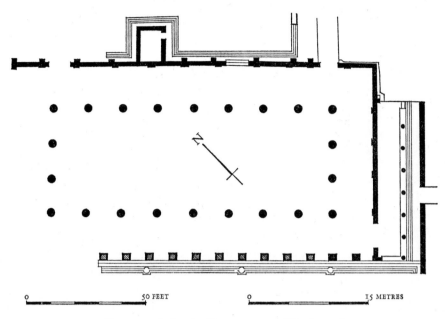

Figure 71. Ardea, basilica. *c.* 100 B.C. Plan (1 : 450)

forum basilica of Alba Fucens, which was separated from the colonnade and the forum in front of the north-western long side by a wall with three doors (Figure 70). The basilicas of Ardea and Cosa were open towards the squares in front of them. Their façades have been discussed. The tabularium of the Forum Romanum (Plate 72) and the great Imperial basilicas had arcaded façades, but it is of course also possible that the aisles of the basilicas at Ardea and Cosa were open colonnades along the front like those in front of the rows of the shops of the Aemilia and Sempronia. In each case this kind of building must have been especially useful as a sheltered, directly accessible appendage enlarging the public open space.

The Aemilia was completely rebuilt on a higher level in 34 B.C., but some $16\frac{1}{2}$ inches (42 cm.) below the floor of the Imperial basilica are remains of parts of a substructure of Grotta Oscura tufa and three bases for columns of tufa with a diameter of about 3 feet 5 inches (1·05 m.). It seems clear that this old tufa structure had spacious ambulatories (aisles) round the nave and a front wall along the rear wall of the porticoes and the tabernae towards the forum. The Basilica Aemilia had two-storeyed aisles with lower columns on the upper floor (as Vitruvius demands, v, 1. 3), as had the porticoes with tabernae outside the south front wall of the basilica. A coin of 59 B.C. confirms this, reproducing the basilica as it was after a restoration in 78, with two-storeyed aisles (Figure 72).[17]

All the basilicas had of course some kind of top lighting for the nave. There is nothing to indicate that naves with two-storeyed aisles had clerestories above them in the centuries under discussion. Vitruvius's basilica at Fanum was lit by windows between the pilasters of the upper storey of the aisles, and we must probably assume the same

129

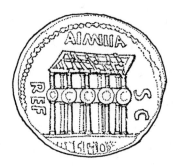

Figure 72.

Coin of 59 B.C. showing the
Basilica Aemilia as it was
after a restoration in 78 B.C.

arrangement in the great forensic basilicas in Rome as well as in the basilica of Pompeii (see below). In the so-called Egyptian *oeci* of private palaces, which Vitruvius describes (VI, 3. 9), an architrave above the columns of the lower storey carried joists between them and the surrounding walls 'with a floor in the upper storey to allow walking under the open sky'. Columns, three-quarters the height of those of the lower storey, carried the roof of the nave, and windows set in between them (as at Fanum) faced the promenades or verandas above the aisles. The tablinum behind the atrium in the so-called 'Casa dell'Atrio a Mosaico' of the Early Imperial Age at Herculaneum was built in this way.[18] The basilicas of Ardea, Cosa, and Alba Fucens were probably built in the same way too, though with lean-to roofs above their one-storeyed aisles.

The basilica of Pompeii (Plate 73) is the best preserved of the known early basilicas. Behind the two-storeyed porticoes of the forum there was a chalcidian hall, probably also two-storeyed, with five intercolumniations towards the portico on one side and the basilica on the other. The columns in the open entrance from the chalcidicum to the basilica were of the same height and type as the engaged Ionic columns which were aligned along the lower parts of the side walls of the basilica, supporting a series of lower pilasters above them. The interior of the basilica resembled Vitruvius's basilica at Fanum. The nave was surrounded by twenty-eight great Ionic columns and roomy ambulatories on all four sides. The columns were constructed of kiln-dried bricks, an exceptional procedure in Late Republican architecture. They were obviously of one giant order and carried the timber truss of a pitched roof above the building. It is uncertain if the lower pilasters along the south and north walls carried upper flooring in the aisles, as at Fanum, though the pilasters above the higher ones of the bottom storey suggest such a motif. It seems most probable that the building was lit by windows between the upper pilasters. The basilica of Pompeii was, of course, not so big as the sensational Aemilia in Rome, but was still much larger than the basilicas of Ardea and Cosa, measuring 79 by 196 feet (24 by 59·85 m.).

The basilica of Pompeii (Plate 73) differed from that of Ardea and the Aemilia in being planned axially. It had a two-storeyed tribunal at its western short end, flanked, like the tablina of the atria in private houses, by entrances right and left. This structure would have dominated the interior, if the view had not been obstructed by the columns on all four sides of the nave. Here we meet with a conflict between the architectural idea of a Greek peristyle and the un-Greek, Italic arrangement with concentration upon a principal room built against or behind the centre of the rear wall. We shall see the same conflict between tablina and peristyles in the peristyles of the domus. As the basilicas of Cosa (Figure 69) and Alba Fucens (Figure 70) have shown, the tribunals in basilicas with their long side towards the public space were placed in the middle of the rear wall with a central axis running transversely through it.

Vitruvius's basilica at Fanum was arranged in this way, but Vitruvius – feeling the conflict between peristyle and axiality – omitted the two middle columns of the long side in front of his tribunal and the prodomus and Temple of Augustus behind it. He did this in order not to interrupt the axis running transversely from that structure in the middle of the rear wall of the basilica to the Temple of Jupiter on the other side of the forum. The Hercules Portico of Alba Fucens had already achieved an open view along the central axis to the temple on its upper side (Figure 70). Vitruvius's views inaugurate the attempts to focus direction on a dominating structure in the centre of the rear wall, thus enabling basilicas to function as monumental assembly rooms, as an expression of the Roman state, represented by its officials, and later of Imperial power, and finally for the Christian cult. In this last case the axial tendency was yet further accentuated and the final goal became the altar in the apse. No doubt a variety of influences contributed to this type of building, which was to achieve such world-wide and millennial significance, but the conflict, given expression by Vitruvius, between Greek peristyles and the straight line from the main entrance to a tribunal in the centre of the rear wall has to be remembered among the stimuli.

The tabularium on the Forum Romanum (Plate 72), referred to on p. 129 as a part of the systematization of the west side of the forum and because of its arcades and domical vaults, is the only building of the Late Republican Age which kept its place in the ensemble of the Imperial forum.[19] The building was erected in 78 by the Consul Quintus Lutatius Catulus for the state archives. It has a high substructure of concrete covered by tufa ashlar from Gabii. This substructure faced the forum and served as a retaining wall against the Capitoline Hill. A corridor, lit by a row of small windows, connected the north and south ends of the building. It was accessible from the forum by a door with a flat masonry arch and a relieving arch above. A direct, barrel-vaulted staircase of sixty-six steps led from the forum side of the slope of the Capitoline Hill to this corridor and to the famous open gallery above it, with its domically vaulted compartments and rooms inside the building. Nothing can be safely confirmed about upper storeys above the gallery. However, the preserved façade of the first storey, with its arcades framed between engaged Doric columns, and an entablature built on the flat arch principle, with *guttae*, belongs to a group of buildings with the same decoration: the Late Republican terrace of the Temple of Hercules Victor at Tibur (Tivoli; Plate 74), part of the portico round the piazza in front of the round Temple of Fortuna Primigenia at Praeneste, and a Late Republican portico in the Forum Holitorium in Rome (Plate 75). As I have pointed out on p. 32, both Greeks and Etruscans knew this architectural motif, but the Theatre of Marcellus and the Colosseum in Rome demonstrate the new monumentality and importance which it acquired at the hands of Roman builders.

TEMPLES

We now come to the temples of the last centuries B.C. and their evidence concerning Roman respect for the Etrusco-Italic religious tradition, even where hellenistic influence changed the external appearance of temples and sacred precincts. Here the most deep-rooted creative forces were at stake. In the chapter on Etruscan architecture, I have tried to trace the various kinds of temples which the Etruscans built and their early appearance in Etruscan towns (pp. 29–56). Of the third, second, and first centuries B.C., which are represented by a large number of temple remains in central Italy, it should first of all be stated that these late, hellenized temples still display the main features of Etruscan architecture: the podium, the frontal emphasis, the deep pronaus, and the closed back wall (Figures 18 and 63). The podium of Temple C on the Largo

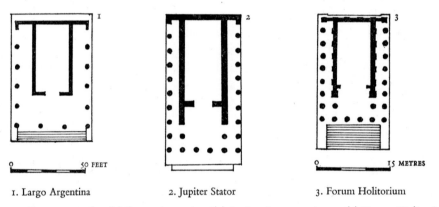

1. Largo Argentina 2. Jupiter Stator 3. Forum Holitorium

Figure 73. Roman temples. (1) Largo Argentina; (2) Jupiter Stator, 146 B.C.; (3) Forum Holitorium.
Plans (1 : 750)

Argentina in Rome – like the temple in the church of St Peter at Alba Fucens – was 13 feet high. It had a simple, vigorous cornice at the top and a straight base. The base and cornice of the podium of the Capitolium of Cosa (c. 150) have Tuscan tori of elliptical curvature. The later temples have elegant mouldings at top and bottom of the podia, reminding us of the development of Italic altars. The height of the podia of the second century is mostly between about 6 and 10 feet. When the Capitoline Temple was reconstructed after the fire of 83, its builder, Q. Catulus (cf. p. 41), wished to heighten the old archaic podium to make it match the scale of his pediment, though it was already some 11 feet (3·352 m.) high. Temples of the Imperial Age – such as the Temple of the Magna Mater on the Palatine as reconstructed by Augustus in 3 B.C., the Temples of Apollo Sosianus and Divus Julius, and, later on, the Capitolium of Ostia – show that this predilection for high podia lived on.[20]

Various Etruscan types of temples reappeared in Late Republican architecture (Figures 64, 65, and 73). But it must be clearly stated that between the old Etruscan and the Late

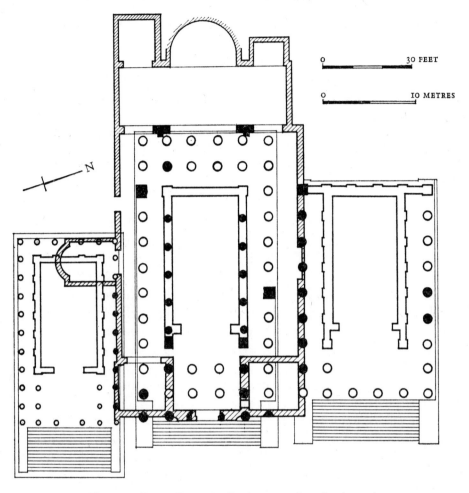

Figure 74. Rome, Forum Holitorium, temples. Plan (1 : 325)

Republican structures lies much independent development during the rather dark
centuries after the Gallic catastrophe of 386. As in the atria of the private domus
(below, p. 154), it is often only basic elements which connect Late Republican buildings
with their distant Etruscan prototypes. Often the traditional pattern is so changed that
the similarities may seem less important than the differences. This is also true of Cam-
panian temples, as shown by models and – above all – by the pre-Roman Temple of
Apollo at Pompeii with its combination of peristyle and Italic orientation (Figure 35).
The same combination of Italic plan and Greek peristyle occurs also in Temple A on the
Largo Argentina in Rome in its third period, i.e. about 100 B.C. (Plate 76 and Figure 63),
and in the two southern temples of the Forum Holitorium in Rome, Doric and Ionic
hexastyle peripteral buildings (Figure 74) connected with a north temple and its closed
back wall.

Ornament

Two main types of embellishment are characteristic of these late temples. On the one hand, the terracotta revetments were richly developed, as can be seen all over central Italy and can be especially well studied in the second-century temples of Cosa (Figures 24 and 25). Art historians can follow a most fascinating gradual unfolding of early hellenistic style, 'perhaps the finest classic style ever achieved in temple terracottas', and Augustan classicism.

As I have already pointed out, remains of pedimental terracotta sculpture from the sixth and fifth centuries show that such decoration in a Greek style appeared early in the Etruscan temples. Pedimental sculpture seems to have been abandoned in Greek temples after the fourth century, though the Heraion at Samothrace and the Temple of Dionysus at Teos indicate a revival in the mid second century. In Etruscan and Roman architecture, pedimental decoration of terracotta flowered in the centuries after 300, as shown by the splendid pair of horses from the so-called Ara della Regina Temple at Tarquinia, by remains from Falerii Veteres and Orvieto, by the vivid scenes on the pediments from Talamone (reconstructed in the Museo Archeologico at Florence), and by fragments of pedimental groups from Cosa.[21]

In contrast to the swan-song of traditional terracotta decoration stands a more radical, new-style hellenization with stuccoed Doric, Ionic, or Corinthian columns of tufa or travertine or tufa columns with travertine capitals, as, for instance, in the great unidentified temple at the Via delle Botteghe Oscure in Rome. As I have said, marble was still rare in temples and public buildings. In smaller temples the entablatures were of stone in the various Greek styles (Plates 77 and 78) with architrave, Ionic frieze or Doric frieze of triglyphs and metopes, and cornice. The terracotta revetments had always followed the successive phases of Greek styles, but these new hellenized superstructures above Italic-plan temples revolutionized temple architecture (Plate 77) and created models for the Imperial Age. Vitruvius, conservative as always, recommends Tuscan columns for his Etruscan temple. At Cosa all the temples originally had Tuscan columns. The same is true of the temples of the Capitolium of Signia (Segni), and of Alatri, Alba Fucens, and other places. Tuscan columns gained increasing popularity in the architecture of the last centuries B.C. and in Imperial times; but in the Latest Republican temples, Greek columns predominated, as, for example, at Cosa, where Temple D in its second phase (100–75) had Doric capitals, as had the southernmost peripteral travertine temple in the Forum Holitorium and the Temple of Hercules at Cori (Plate 78) of the end of the second century. Neither Tuscan nor Doric prevailed in Roman Late Republican temples after about 150: the remains display, above all, a predilection for Corinthian capitals (Figure 75), capitals with inserted human heads, typical of Pompeii, and bunchy Corinthian capitals adorned with a great flower.[22] As in the case of the terracotta revetments, this hellenistic exuberance, which in Italy became still more excessive, was restrained by late hellenistic classicism – as can be observed for instance, in the Ionic

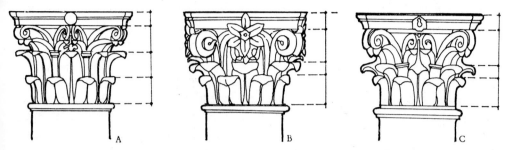

Figure 75. Late Republican capitals. (A) Morgan's interpretation of Vitruvius; (B) Tibur (Tivoli), Temple of Vesta; (C) Cora (Cori), Temple of Castor and Pollux

capitals of the so-called Temple of Fortuna Virilis by the Tiber (Plate 77). The combination of Corinthian columns and Doric triglyph and metopes or Ionic frieze was now accepted – even by Vitruvius (IV, 1. 2–3). The Tempio della Pace on the forum of Paestum shows this combination in its second period (first century B.C.) (Figure 66).

Types of Plan and Superstructure

As regards Italic (Etruscan) plans, which were retained for sacred architecture, something has been said on p. 108 about the first period of this temple, about Temples A and C on Largo Argentina (Figures 63 and 73), and also about Dionysius's golden words concerning the rebuilt Capitolium: 'It stood upon a high base . . . erected upon the same foundations [as the temple of 509], and differed from the ancient structure in nothing but the costliness of the materials' (marble columns; cf. p. 40, and Dionysius. IV, 61).

The Temple of Juno Moneta on the Arx in Rome, according to Roman tradition dedicated in 374 B.C., proves that temples with two columns in the pronaus were still built in Imperial times (Plate 79), but especially important for the future among these hellenized temples with Italic plan was the type with one or two sets of four columns in front of a cella without alae; the type, that is, already discussed in Etruscan temples (above, p. 33) and the temples of Cosa (Figures 64 and 65) and most important for Imperial times. We meet with Ionic pilasters decorating the walls of the cella – as a pseudo-peripteros – and Ionic columns in the tetrastyle temple at Tibur (Tivoli; Plate 80), usually called the Tempio della Sibilla, and in the so-called Temple of Fortuna Virilis by the Tiber in Rome (Plate 77). The temple at Tivoli is built of travertine ashlar on a podium of concrete, faced with travertine slabs. The cella walls project as antae halfway forward of the prodomus, with its columns and stairs in front. The elegant small pseudo-peripteros by the Tiber (Plate 77) has six Ionic columns with capitals in pure Greek style, four in front of the prodomus and one on each side of it. Travertine is used for the facing of the concrete podium, and for the six free-standing columns of the pronaus and the four engaged corner columns of the cella. The walls of the cella are built of tufa. The building was, of course, covered by stucco, as remains show, and it is one of the

most elegant combinations of Italic plan and Greek taste. Both these temples were probably built in the second half of the second century B.C. The same plan reappears in Temple D on the Largo Argentina in Rome, with its ten columns round the prodomus. The magnificent pseudo-peripteros of the Temple of Jupiter Anxur at Terracina (Plate 81) had six columns on the front above the stairs and two columns on each side of the prodomus. It is one of the great structures typical of the age of the Sullan régime (82–79). The small Doric temple of Cori (Plate 78) illustrates the preceding decades. It has four slender columns in front of the deep Italic prodomus and two on each side of it. The columns have low bases and an unfluted lower part, which – as is often seen at Pompeii – was probably stuccoed red. To this group of temples belongs also the Tempio Tetrastilo next to the Temple of Hercules at Ostia (Figure 54) and the four small temples on a common podium on the north side of the piazza next to the theatre of Ostia (on the Late Republican level of Regions 1 and 2, i.e. of *c.* 100–80).

In the second century the type with one or more cellas, alae, and closed rear wall became very popular. Rear-wall wings extended right and left of the cella and often returned at right angles towards the front with short stretches of walls ending in antae. We have already seen this arrangement in the Archaic Capitoline Temple, in the first Tempio della Pace at Paestum, and in Temple C on the Largo Argentina.

A famous group of temples of this kind which I would date to the second century B.C. (though more ancient dates have been proposed) consists of the so-called Temple of Juno at Gabii (Plate 82 and Figure 76); the Temple of Jupiter Stator in the Porticus Metelli (later Octavia) in Rome (Figure 73), built in 146 and drawn on a fragment of the Forma Urbis; the Temple of Diana Tifatina (S. Angelo in Formis), as rebuilt in Roman times; the northernmost temple of the Forum Holitorium in Rome, built in the Ionic style (Figure 74),[23] and finally Jupiter Anxur at Terracina. Then follow the temples of the Imperial Age, a great number of them marble-faced and exhibiting variations of the type, such as the Temple of Divus Julius on the Roman forum, the Maison Carrée at Nîmes, the temple at Vienne, the Temple of Minerva in Nerva's forum in Rome and others.

The temple of Fiesole (Figure 19) has, as I have discussed on p. 36 f., instead of rows of columns along the alae of the long sides, side walls extended from the rear wall to the front of the prodomus. The temple was rebuilt in the same way in Roman times (second century B.C.). A model from Vulci (Plate 13) represents this variation of the temple with alae in the Late Republican Age.

The round Temple of Vesta very likely – as the Romans believed (above, p. 20) – inherited its shape from old Italic huts, but later restorations in the Greek style reshaped it entirely. The marble temple by the Tiber (Plate 67; p. 116, above) has already given us one instance of direct contact with pure Greek architecture of this kind: the Romans combined this Greek influence and their own traditions in the round temples, too, providing them with podia and steps only opposite the entrance to the round cella.

Temple B on the Largo Argentina (Figure 63 and Plate 76) had a cella surrounded by sixteen high slender Corinthian columns with bases and capitals of travertine. The image of the god, in harmony with the axiality of the rectangular temple, stood against

the rear wall opposite the stairs. The columns and the base and cornice of the podium allow us to date the temple to about the middle of the second century, but nothing remains of the entablature.[24] Of the first decades of the first century is the so-called Tempio di Vesta at Tibur (Tivoli) (Plate 83). The round cella is of concrete with a facing of opus incertum. The podium has a sturdy base and an elegant cornice. The eighteen Corinthian columns of travertine have capitals of the bunchy hellenistic type (Figure 75B), and the frieze has heavy ox-heads (not bucrania, as became common during the Imperial Age), connected by rich festoons. The elegant door-jambs and windows slope slightly towards the top. Between the cella walls and the cornice above the frieze is a panelled ceiling of travertine with two concentric rings of sunk panels with rosettes. Nothing indicates how the roof was constructed.

Most important for the centuries after Rome's victories in Italy and in the hellenistic world, and for the Imperial Age, were the temples with three cellas for the Capitoline triad, Jupiter, Juno, and Minerva, to which Vitruvius (IV, 7) gives much prominence.[25] As discussed earlier on p. 37, the great Capitoline Temple of 509 was the glorious model (Figure 22), both in its archaic grandeur and in its rebuilt forms of 69 B.C. (after the fire of 83) and of the Flavian Age. The Capitolia became symbols of the Roman Empire all over the Mediterranean world. The great prototype in Rome was rebuilt after the fire of 83, as Cicero emphasizes in the second Verrine Oration (see above, p. 115), as the Roman Empire demanded, but – as the actual remains confirm – it preserved the original Etruscan plan with three cellas, colonnaded alae, and eighteen columns in the pronaus both in 69 and in the Flavian Age. Ovid further reports in the *Fasti* (II, 669 f.) that even an old altar of Terminus, with a hole in the roof, was retained from the old temple, and Pliny relates the same about an aedicula of Juventus in the cella of Minerva (XXXV, 108). The podium of the Capitoline Temple was heightened by a top layer of ashlar about 16 inches (40 cm.) high, above the twelve earlier courses of blocks measuring about a Greco-Roman foot (also about an English foot; 30–2 cm.).

As I have remarked in discussing the temple of 509, Vitruvius demands that the height of the columns of an Etruscan temple should be 'one-third of the width of the temple', that is in the Capitoline Temple 54 feet 5 inches (16·576 m.), which seems unlikely for the building of the sixth century. But Pliny informs us (XXXVI, 45) that Sulla – who followed the reconstruction of the Capitoline Temple with special interest – brought columns from the Olympieion in Athens 'to be used for temples on the Capitoline Hill'. The height of these Athenian columns is 55 feet 5 inches (16·89 m.), which would be close to Vitruvius's rule for columns. It therefore seems probable that Vitruvius has accepted a height connected with the hellenized Italic temples, and especially with the high columns of the Capitoline Temple. Pliny's statement proves – even apart from the precise information about the columns from the Olympieion – that the rebuilt temple vied in height with the highest Greek temples, and that the Capitoline, by virtue of its columns, belonged to the early marble temples of Rome.

For the entablature of the great temples which preserved the Etrusco-Italic ground plan and wide intercolumniations, Vitruvius (III, 3. 5) prescribes architraves consisting of a 'series of wooden beams laid upon the columns'. Vitruvius mentions this old-

fashioned roof construction both for the Capitoline Temple and for Pompey's Temple of Hercules. His conclusion that 'these temples are clumsily roofed, low, broad' is indeed most startling in being expressed some forty years after the highly admired Capitoline Temple had been built, with its great new pediment and high Greek marble columns. We know (above, p. 41) that the builder of the temple of 69 thought that the podium was too low, but contemporary coins seem to prove that the pediments of the new temple were a sensation. Vitruvius's words may contain recollections of archaic Tuscan temples, but it is also possible that he and his contemporaries really thought that the temple, in spite of its high columns, was wanting in height, as did the Romans of Flavian Age, according to Tacitus (*Historiae*, IV, 53). Vitruvius's statement, in any case, should not be ignored. Tacitus confirms that the high Sullan marble columns of 69 B.C. carried a wooden superstructure. In his description of the riots in Rome in A.D. 69, he tells that the pediments, *aquilae*, which supported the roof of the Capitoline Temple, being of wood, caught and fed the flames of the fire thrown on the roofs by the insurgents (*Historiae*, III, 71).[26]

The plans of these temples transmitted Etruscan traditions to the Imperial Age; some of them proved to have magnificent futures, as I have pointed out in discussing their Etruscan predecessors.

A Roman innovation, it seems, was the Temple of Veiovis, behind the tabularium, between the Arx and the Capitolium. It was built in 196 B.C. and rebuilt in the middle of the second century, but it was enlarged and received its final shape in connexion with the building of the tabularium in 78. Probably in the earlier period, and in any case by about 150, the temple assumed its peculiar plan: a transverse, closed cella, facing south, with a tetrastyle pronaus and stairs in the centre of the southern long side and of the transverse central axis. The type was kept with slightly different orientation in 78 and during a restoration in Domitian's time, and it returns in the Augustan Temple of Concord on the Forum Romanum and in the Capitolium which, in Flavian times, replaced the Sullan temples at the upper end of the forum of Brixia (p.124).[27]

Late Republican temples could not only be connected with fora and temple precincts with altars but could also be used in the context of other architectural schemes. The rows of coordinated temples, such as those of the Largo Argentina (Figure 63), of the Forum Holitorium (Figure 74), and of the Republican forum of Brixia must have made a great impression. The temples of the Largo Argentina originally had rectangular forecourts with altars on the central axis of the temple, recalling in a strictly systematized way the old Etruscan precincts. Later the area in front of them was unified, paved, and finally surrounded by porticoes.

A special, highly monumental group of temples were related by virtue of having semicircular staircases leading up to the façade and imposing terraces and porticoes (Figures 76 ff. and Plate 82). The comitia of Cosa (Figure 69) and Paestum, with their curiae above the amphitheatrical stairs, were like this, as well as Morgantina, with its monumental stairs between the upper and lower agora; no doubt the comitium of Rome was similar, too.[28] Of these theatre-temples the earliest are one at Cagliari on Sardinia,[29] which is certainly Roman and was probably built in the second century,

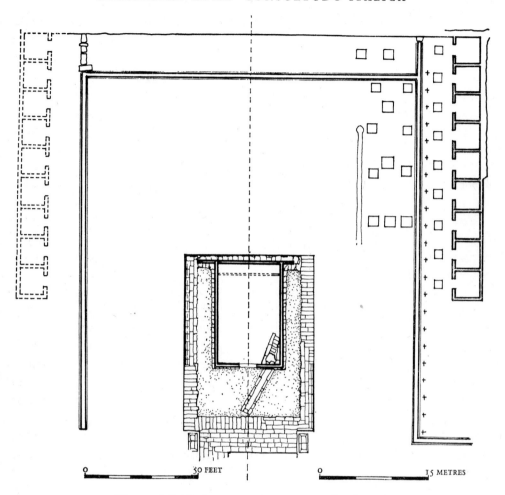

0 50 FEET 0 15 METRES

Figure 76. Gabii, theatre-temple. *c.* 150 B.C. Plan (1 : 500)

and the temple of Gabii (Figure 76; see also Note 23) already discussed. The hexastyle Corinthian temple with alae and flanking rows of terracotta figures (cf. p. 48; Plate 21) lies in the centre of a great rectangular precinct, surrounded by walls and facing south. The walls of the northern half of the precinct are adorned by colonnades; those of the western and eastern long sides had shops in the porticoes, like the Tabernae Novae Argentariae on the Forum Romanum and other Italic and Greek porticoes (p. 126, above). It is typical of these great sanctuaries that they are surrounded by a large number of shops. The festivals seem to have been fairs, with a bustle of dealers and workers. In front of the temple, on its central axis, is the monumental staircase with an orchestra below. It is some 200 feet wide and has about twelve flights of stairs which reach the level of the temple. Behind the orchestra are remains of what certainly was a stage building. It has the same width as the orchestra and projects outside the centre of the south wall of the precinct. It seems evident that this theatre was constructed for shows or ceremonies in front of the temple, and that – in contrast to temporary theatres

in Rome at the same time (below, pp. 165 ff.) – itimitated the permanent hellenistic theatres.

Some hundred years after the probable date of the theatre-temple of Gabii, about 50 B.C., a still more grandiose sanctuary of the same kind was built at Tibur (Tivoli) and dedicated to Hercules Victor (Figure 77). The temple, perhaps reconstructed in Imperial times, lies in the centre of the back of a great transverse, rectangular terrace. Along the eastern long side behind the temple and along the north and south short sides runs a triple portico with Tuscan columns. Above the two outside passages of the portico was a double colonnade. In the centre of the western, open, long side of the terrace is a semi-circular staircase leading up from the orchestra to the stairs of the temple. Behind the orchestra projects a stage building, as at Gabii. It seems clear again that this sanctuary was a theatre-temple built for performances in front of the temple.

The temple, its porticoes, and the stage building are set on a majestic terrace, constructed, like the porticoes, of concrete covered with opus incertum. The mighty wall on the north side of the terrace is most spectacular. It has an elaborate system of inner buttresses and a façade decorated by arches in two storeys. The lower arches are flanked by strong buttresses of travertine ashlar, while the upper row of arches has engaged semi-columns and an architrave like the tabularium (Plate 72). A vaulted tunnel, 28 feet (8·50 m.) wide, runs through the northern part of the terrace, to carry the Via Tiburtina. It has quadrangular roof lights; rows of shops with barrel- or domical-vaults make it obvious that the tunnel served as a shopping centre.[30]

A semicircular staircase is also a part of yet another large sanctuary, which belongs to the best early pieces of Roman concrete construction and vaulting, vying with the great hellenistic ensembles (above, p. 122): the Temple of Fortuna Primigenia at Praeneste (Palestrina; Figure 78 and Plate 84). Praeneste was famous for a sanctuary connected with sortilege and for an image of Fortuna Primigenia seated, with the infants Jupiter and Juno in her lap – evidently one of the statues of maternal goddesses so common in Italy in the centuries before Christ. Carneades, visiting Rome in 156–155 as a member of the famous Athenian delegation of philosophers, remarked that the Fortuna at Praeneste was more fortunate than most oracles of lots. Cicero (*De Divinatione*, II, 85–7) mentions this, and tells us that the origin of the lots was that dreams admonished a distinguished man of noble birth at Palestrina to dig into the rocky hillside of the mountain on which the old independent Praeneste with its rich Etruscan past of the seventh century was built (the present village of San Pietro). Now this hill town was defended by polygonal walls with extensions to a later, lower town with a forum of its own, lying far below on the southern slopes. It is to this lower town that the Temple of Fortuna Primigenia belonged, though it extended up the hillside. When the noble Praenestine, 'disregarding the jeers of his fellow-townsmen, split open the rock at the designated place, close to the statue of Fortuna with Jupiter and Juno in her lap, lots carved on oak with ancient characters appeared in the pit'. And at the same time, Cicero says, honey flowed from an olive tree in 'the spot where the Temple of Fortuna now stands'. There were thus three sacred spots which belonged to the lower, pre-Roman Praeneste: the pit where the lots were found, the statue of Fortuna, and the temple.

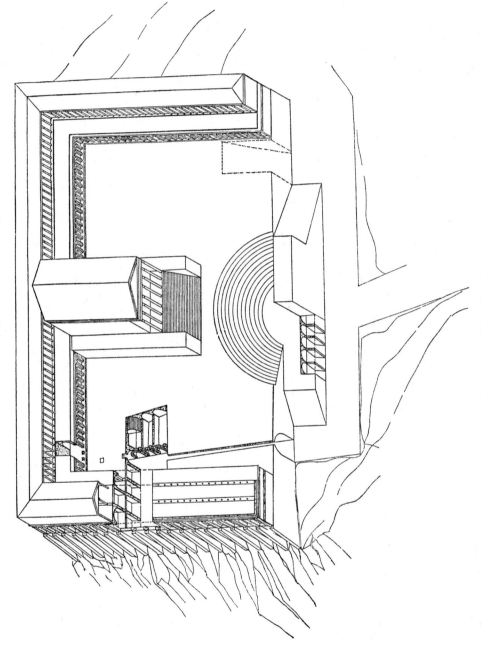

Figure 77. Tibur (Tivoli), Temple of Hercules Victor. c. 50 B.C. Reconstruction

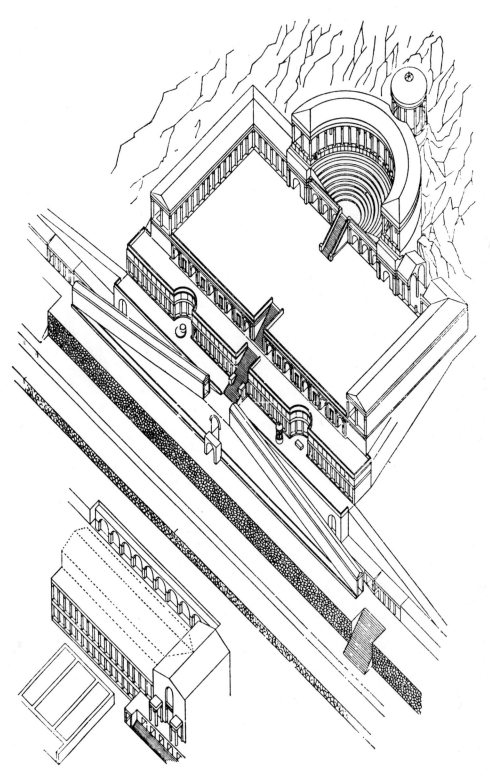

Figure 78. Praeneste (Palestrina), Temple of Fortuna Primigenia. *c.* 80 B.C. Axonometric plan

The end of the ancient town and its freedom came when Sulla gave the place to plunder and executed some 12,000 Praenestini after his victory over the younger Marius, who had taken refuge there in 82 B.C. Sulla then founded a third Praeneste, a colony of his veterans, on the plain below the lower pre-Roman Praeneste. For historical and archaeological reasons those scholars seem to be right who assign both the buildings around the forum of the middle town and the grandiose upper sanctuary with its theatre, which was built above it, to Sulla's re-establishment of the old cults of towns he defeated and to his intense building activity in connexion with the colonies of veterans.

Concrete, covered by opus incertum and of course stuccoed, and columns of tufa with bases and capitals of travertine of the local calcareous stone characterize the last great structure. The whole slope on which the lower pre-Roman town was built was systematized by parallel terraces running east–west, starting at a terrace wall and a propylon towards the road below the hill (Via degli Arconi). A row of barrel-vaulted shops, built against the terrace wall, is the lowest part of the sanctuary shops, which continue on the upper terraces above the forum and the buildings around it. On the highest terrace of the town below the upper sanctuary is the forum of the middle pre-Roman Praeneste, now the piazza of Palestrina; along its north side were a temple built of tufa ashlar (partly preserved in the cathedral), the curia (Plate 85), and the treasury (*aerarium*) of the town. The temple and two picturesque caves in the rocky hillside behind the forum are clearly earlier than Sulla, but all scholars agree that the other monumental buildings round the forum were built after Sulla's victory of 82.[31] On a terrace behind and above the temple and the forum a large basilican building was erected with a bipartite central nave running east–west (Figures 78–9). On the south side was a Doric colonnade on the lower level towards the forum, and above that, on the level of the floor of the basilica, an upper colonnade with Corinthian columns (Plate 86). Along the north side of the bipartite central nave ran an aisle with a rear wall decorated with engaged Corinthian columns (Plate 87). Between them were elegant high windows with a slight inclination inwards and ornamental tablets right and left. Between this wall and the steep hillside behind it, which reaches the level of the lowest terrace of the upper sanctuary, is a narrow barrel-vaulted space to guard against humidity.

It is still an open question whether and how this high building was roofed. As there are no gutters, it seems clear to me that the two central naves were covered with a ridge roof, as the section (Figure 79) suggests. They were no doubt two-storeyed. A row of arcades above the rear wall of the north aisle and its engaged Corinthian columns suggests that (to speak with Vitruvius, VI, 3. 9) it 'had a floor in the upper storey to allow of walking under the open sky'. The same was probably true of the portico along the south side of the basilica. The whole structure would thus resemble the Egyptian oeci of Vitruvius, with verandas on both sides of a central nave and windows between pilasters or columns in the second storey to light it.[32]

This somewhat strangely mixed monumental basilican structure connected buildings in front of the two grottoes in the hillside above the temple. Especially important is a rectangular hall which was built along the eastern short side of the basilica, the curia (Plate 85). It faces the forum, but is on the same higher level as the basilica. Right and

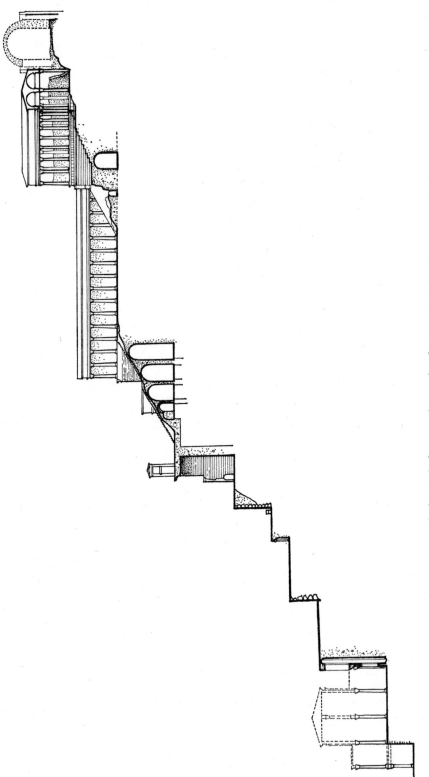

Figure 79. Praeneste (Palestrina), forum and Temple of Fortuna Primigenia. c. 80 B.C. Section

left of the entrance above the stairs from the forum were Corinthian semi-columns, and above the lintel is a large arched window. The interior is decorated by Ionic semi-columns, niches between them, and a podium with a triglyph frieze along the wall – no doubt for statues. The central axis ran from the entrance from the forum to the old east grotto, which now became the apse of the high hall.

In both grottoes mosaics have been found. In the eastern hall was a great landscape of the Nile valley (now in the museum of Palestrina), and in the western grotto delightful marine motifs still remain. It seems likely that these mosaics were added in the Imperial Age. Pliny (xxxvi, 189) mentions 'lithostrata' before discussing tessellated floors in Sullan Praeneste, but it seems evident that in both Varro's and his usage 'lithostrata' means 'opus sectile', in contrast to the typical earlier Late Republican cement floors with small inserted travertine chips, the so-called *opus signinum*.[33]

Whoever visits Praeneste or analyses the plan of the upper and lower sanctuaries (Figure 78) sees that the buildings round the forum and the upper part of the sanctuary are unconnected and that there is no central staircase between them. The upper sanctuary is independent of the forum and a real masterpiece of hellenistic Italic axiality, a triangle with its base on the terrace high above the basilica between the grottoes. Seven terraces lead up to a round temple, which is the apex of the triangle. The third terrace rests upon a wall of polygonal work. To its right and left rise staircases from the second terrace, ending in front of colonnaded well houses. From them great ramps led up to the fourth terrace, where the staircase of the central axis starts. Along the outer side of the ramps ran covered porticoes with a closed outside wall (towards the south). In the centre of the ramp building on the third terrace are niches for statues, which mark the beginning of the central axis. Along the entire rear wall of the fourth terrace a portico was built with a row of shops interrupted by the central staircase and by two hemi-cycles with Ionic columns and coffered barrel-vaults, some 50 feet east and west of the central staircase. In front of the portico at the west end of the eastern hemicycle was a small round Corinthian shrine with triglyph friezes above the architrave and on the high base (now in the museum). Between the columns above the base were a decorative railing and gratings. Below it was a pit. It seems most probable that this was the 'religiously guarded place' where the lots were found.[34]

Following the staircase of the central axis to the fifth terrace we meet with another row of barrel-vaulted shops with purely decorative blocked doors and engaged columns on the walls between them. Above them extends the sixth terrace, a large piazza with double Corinthian porticoes on the east and west sides and along the western and eastern ends of the northern rear wall as well. In the centre of the north wall, right and left of the central staircase, which continues to the seventh terrace, are arches, and between them piers adorned with engaged columns; behind the compartments of this façade, which recalls the tabularium (Plate 72) and the terrace of Hercules Victor, runs a barrel-vaulted corridor from south to north, a so-called crypto-porticus. A crypto-porticus of this kind evidently offered a sheltered walk for the public on hot summer days, and cold winter days as well, as did the crypto-porticus on the terraces of rich landowners' villas. Above this piazza, with its commanding view towards the Campagna and the sea,

towers the seventh terrace. Here we encounter, as at Gabii and Tivoli (above, pp. 138 ff.), an orchestra and semicircular stairs. They are crowned by a semicircular double portico. Behind its centre, in line with the staircase of the central axis, stands the round temple. It is the culmination of the whole layout above the forum buildings, and no doubt had a superstructure visible from the terraces which lead up to it. The theatre indicates that the round temple had a central importance for the religious performances of the sanctuary, very likely choirs and ritual dances on the piazza in front of the theatre stairs (the sixth terrace).

How can the piazza (forum) and the upper sanctuary be explained? It is of course possible that the old temple on the forum of the middle town was the Temple of Fortuna and that the basilica, the hall on the east side of it (the curia in my view), and the two grottoes belonged to it, and this has usually been assumed. One of the grottoes could then have been the place where the lots were found, though Cicero's description makes a site higher up on the slope more likely. There is, at any rate, nothing to disprove that the forum was an ordinary civic centre with basilica, aerarium, curia, and an old, unidentified temple. To me it seems most probable that this was so: that the round temple and the theatre stand on the place of the cult of Fortuna, and that the upper sanctuary connected the holy places of the Fortuna cult. All the great upper sanctuary, viewed as a whole, is focused on the round temple, and the theatre would have been used for ceremonies in front of it, as at Gabii, and later in the sanctuary of Hercules Victor at Tivoli. Up there – according to the suggestion accepted by me – the honey would have flowed from an olive tree when the lots were found, a little lower down the slope.[35]

Another great sanctuary of the Sullan Age was built in the old cult centre of Jupiter Anxur on the mountain east of Terracina (Plate 81). Instructed by the experience of Pyrrhus's and Hannibal's wars, or perhaps because of the danger of internal warfare, in the second century the Romans strengthened the defences of the great roads leading to Rome. In a gorge by the Via Appia between Formia and Terracina a strong fortress was built. The original Via Appia, which reaches the old fortified hill town of Terracina over the hills on its east side, was blocked by a strong wall. This wall connected the town with a quadrangular castrum fort with barracks perched on the top of the mountain of Jupiter Anxur (Plate 81). This great fortification had round towers, a strongly fortified gate where the Via Appia passes the wall, and barracks on the west, east, and north sides of the castrum. Unlike all earlier known Italic defence-works, it was built entirely of concrete covered by coarse opus incertum. Below the open south side of the castrum was added a monumental terrace for the cult of Jupiter Anxur. Like the fortifications, it was built of concrete but covered with a more refined opus incertum of – so it seems to me – unmistakably Sullan type. The terrace had a most imposing arcaded façade without any applied semi-columns or other Greek adornments. It was like, for instance, the amphitheatre and the podium of the Villa dei Misteri at Pompeii (Plates 88 and 89), and of the Late Republican pavilion on the beach of Sperlonga. The terrace of Lindos has already reminded us of the fact that this kind of straightforward façade was not at all alien to hellenistic architecture. As on the north side of the sixth terrace of Praeneste, a barrel-vaulted crypto-porticus was built behind the equally barrel-vaulted compartments of

the façade. The great Temple of Jupiter Anxur (Plate 81), previously described, with ten columns in the prodomus (p. 136, above), was built on this terrace with a surprising oblique orientation, no doubt due to the old ceremonies of the place. Behind the temple, in front of the hillside of the castrum, a portico offered further shelter for the pilgrims who came.[36]

Another of the great Sullan sanctuaries is the Temple of Hercules Curinus, south of Sulmona, usually called the 'Villa d'Ovidio'. Against the steep hillside which overlooks the plain 'rich in ice-cold streams' (as Ovid says), corn, grapes, and olives, three terraces were built. On the highest terrace is the Temple of Hercules, partly constructed of rammed clay (pisé). Its location recalls that of the Temple of Dionysus on the theatre terrace of Pergamon. The second terrace has a portico and a monumental stairway, which connects it with the third terrace and reminds us of the imposing steps between the upper and the lower agora (forum) at Morgantina, Sicily. Below it protrudes the lowest terrace, built of concrete covered by opus incertum and reticulatum. On it are shops, as in the other great sanctuaries of the countryside, evidently constructed for fairs connected with the sacrifices.[37]

The Romans were more original in other fields of architecture, but a survey of the Late Republican temples gives us the best notion of traditionalistic hellenism in the centuries from Naevius and Ennius to Vergil and the young Cicero. The theatre-temples show us how the fundamental Etruscan and Italic traditions could become almost effaced by the variegated combinations and decorations of hellenistic architecture. They also show that stone-built theatre buildings were constructed around Rome earlier than in the capital itself. Vergil, Cicero, and Horace saw the beginning also of the next age, when this architecture met with the marble and classicism of Augustan Rome. Vitruvius was a champion of the latter; the use of marble in Italy depended, however, upon whether it could be found and made ready without great expense (I, 2. 8), but he mentions it, for instance, in connexion with the tombs of the rich (II, 8. 3).

Closely related to the great systematizations of the sanctuaries of Praeneste, Tivoli, and Terracina is an imposing bastion which in the second half of the second century was added to the acropolis of Ferentinum (Plate 90 and Figure 80). There also one recognizes inspiration from the hellenistic world and the riches which the Eastern wars brought to Italy. In the second century the polygonal walls of Ferentinum above the

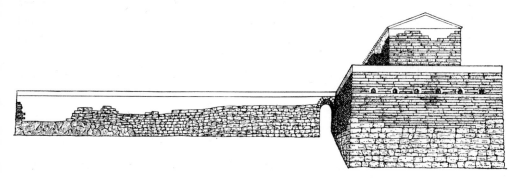

Figure 80. Ferentinum, bastion. Second century B.C. (second half). Elevation

Via Latina (above, p. 97) were heightened by a superstructure of ashlar masonry and provided with arched gates (Plate 91). In addition to this strengthened outer defence, the acropolis was reshaped, probably between 150 and 100, by the erection of the bastion overlooking the valley with the road on the western side of the town (Plate 90).[38] This is another of the reconstructions of old towns around Rome which display evident influence from the hellenistic world. In the small towns they were more freely converted into Italic modes than in Rome itself, where dense quarters and strong traditions hampered even the schemes of a Caesar, an Augustus, and later emperors. The bastion, which thrusts forward towards the valley, has a low foundation of very rough and large polygonal blocks, most likely remains of an older fortification. Upon this base rests a wall of more refined polygonal work, and above this stands the main part of the bastion, built of ashlar. The uppermost part of it contains a great rectangular subterranean concrete basement consisting of a rectangular central structure with somewhat lower, barrel-vaulted crypto-porticus on all four sides. Small, oblique arched windows pierce the ashlar façade. They were no doubt built here also as sheltered walks for hot or cold days. At Aosta and in several French towns shelters of exactly the same kind as on the acropolis of Ferentinum were added to fora of the Imperial Age.[39] The central structure surrounded by the crypto-porticus was divided into two parallel longitudinal naves covered by barrel-vaults. Above them, on the top of the bastion, stood a large hall with columns on benches along the side walls. It can be compared with the Capitolium of Pompeii (above, pp. 122–4), but was perhaps rather a curia or some other public building. Together with the eastern hall on the forum of Praeneste, it may give an indication of what the old Curia Hostilia of the Roman Senate became like when it was enlarged and rebuilt by Sulla in 80 and by his son Faustus in 52 B.C.

TOWN PLANNING

After the fora, the temples, and the monumental layouts which herald the great architectural schemes of the Imperial Age, we must now seek out, in the numerous tabernae in the towns of central Italy and in the tenement houses in Rome, other prominent and characteristic features of the hellenized Italic town: town houses of the wealthy and the bourgeoisie, market halls, baths, and theatres. As an introduction to these partly typically Roman innovations, something about the continued development of town walls and city planning may be added to what has already been said.

As to the shape of the gates, the type known from the so-called 'Servian Wall' of Rome, from the castrum of Ostia (Figure 54), and from Cosa, with a gatehouse projecting on the inside of the wall, persisted in the first century. The Porta di Casamari of Ferentinum (Plate 92) is a very fine example from the seventies. It is built of ashlar, provided with two arches, and attached to a bend of the old polygonal wall on the south-east side of the town.[40]

Openings in the walls for later catapults were also arched. A fine specimen is in that part of the Servian Wall which defends the Aventine (Plate 63). It evidently belongs to

repairs of the year 87, when the consuls fortified Rome with trenches, restored the walls, and planted catapults on them.[41]

Among the specially characteristic late walls are the following. The colony of Alba Fucens, which the Romans founded about 300, was an important rural centre but also a strong fortification with the function of keeping watch over the Samnites and the Etruscans. Alba Fucens was refortified at the beginning of the first century, in connexion with the internal wars in Italy, by imposing polygonal walls, replacing older fortifications of the same kind (Figure 81). They have an oblong polygonal terrace on the west side of the town, with strong towers and a superstructure consisting of a concrete wall with semi-columns – or perhaps a portico with shops on the inside – and an apse at the south-western extremity. The walls are built of concrete covered with opus incertum on the outside and opus reticulatum inside. The apse, no doubt, had a wooden roof and may have housed a statue. On the central axis towards the north end of the terrace stands a high tomb. Whether this elegant piazza was built on the top of an older outer defence work or whether, with its three types of constructional technique, it stood alone, it seems most probable that the great rectangular court with its apse was arranged for fairs and religious gatherings, like the terraces of the Temple of Hercules south of Sulmona.[42]

Concrete became more and more usual both for entirely new buildings, such as the great wall between Terracina and the hill of Jupiter Anxur, and for more or less extensive repairs and additions to polygonal or ashlar structures. Outside the west gate of Terracina the city wall was extended some 200 yards along the north side of the Via Appia. The most conspicuous remains are a round tower on the north side of the same kind as those of the great wall and an imposing square tower standing at the west end of this outer work. The lower part of this tower consists of a structure of very refined polygonal work of calcareous blocks, with a decorated frieze above the seven bottom layers. The upper part is built of concrete covered with opus incertum and has two arched windows. It seems most likely that this additional fortification was contemporary with the great south-eastern wall, and thus should be dated to the second century B.C.[43]

Very extensive are the repairs of concrete with opus incertum on the third-century polygonal walls of Fundi. Like the repairs and round concrete towers of Cora (Cori)[44] they are a most eloquent witness of the internal wars in Marius and Sulla's times. No less eloquent, moreover, on the side of the rebellious Italic people, are the repairs to the fifth-century wall of Pompeii, where, before the final defeat in 89, square concrete towers and other reinforcements of concrete were added to the old walls of tufa ashlar, as it stood with its Italic agger on the inside, more or less in disuse in the second century.[45]

The great outer wall of Ostia encircles the outer town, which after about 300 B.C. grew up round the old castrum-fort (Figure 54).[46] This enlarged Ostia became the seaside suburb of Rome, busily trading with the Mediterranean and the coastal towns of Italy from the mouth of the Tiber. Most probably the wall was built after the city had been plundered by Marius. It is a concrete wall faced with opus incertum, which some-

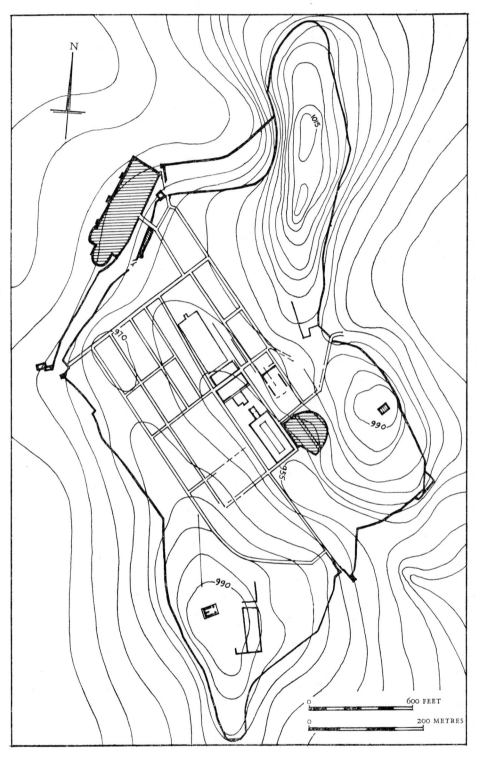

Figure 81. Alba Fucens. Founded *c.* 300, walls and the final, regular
town-plan early first century. Plan (1 : 6650)

times tends to be reticulate and often assumes the aspect of quasi-reticulate. The wall evidently left the river side unfortified. It starts with a strong square tower of ashlar work at the north-east corner of the town and has round concrete towers at each bend. The gates are of the internal gatehouse type (see pp. 98 and 101, above), with the interior faced with ashlar. Their strong military character is emphasized by square flanking towers right and left of the entrances.

The enlarged Ostia, which was surrounded by this wall, represents one of the two main types of Late Republican town. It can be studied in the layers below the brick-faced Ostia of the centuries after A.D. 100. A few temples remained in the Imperial town (Plate 93), but almost all the atria and shops were destroyed and buried below the level of the new town, which had the entirely changed stamp and technique of the greatest days of the Empire. Roads ran from the gates of the old castrum to Rome (Via Ostiensis), to the sea and the river mouth, and on the south side of the town to the villages and villas and to the towns with their obsolete river harbours along the west coast of Latium: Laurentum, Lavinium, Ardea, and so to Antium. They now became the main streets of Late Republican Ostia and remained such, though widened, in the Imperial town above it. Inside the old castrum fort were two straight, main streets: one is the Via Ostiensis, running east to west and in modern usage called *decumanus*; the other, usually called *cardo*, traversed the castrum fort from north to south, crossing the decumanus at right angles in its centre. The decumanus passed the eastern part of the added quarters in a straight line; the riverside between it and the Tiber was reserved, it seems, for ware-houses, etc. But all the rest of the new outer town is old-fashioned oblique streets and irregular quarters. It reminds us of Tacitus's description of the old Rome before Nero's fire, with narrow lanes and sprawling blocks. The plan of Ostia shows how, during centuries of peace, trading towns developed haphazard if military demands or special planning did not impose regularity. The outer wall of Ostia illustrates how, when war came, the defence had to accept such a town as it stood. Lucus Feroniae of the Augustan Age is an example of another town that grew up in the same way, according to the needs of daily life.

Many towns in Italy no doubt grew up like the enlarged Ostia, but regular town planning seems to have prevailed. Its development in the first century is well illustrated at Alba Fucens (Figure 81). The old grid of the town (no doubt regular from its begin-nings) was renewed. The main streets, which passed through the town from the south-east (where the gate of the great highway from Rome, the Via Aurelia, was located), were probably inherited from the earlier periods, as were the streets which crossed them at right angles running north-east–south-west. All this reappeared now in a modernized, elegant shape. Between the two great streets running south-east–north-west were the forum, the basilica with a portico in front, both facing south, and behind them, facing north, the Temple and Porticus of Hercules, as described above, p. 124. Porticus, a theatre, and rows of well-built tabernae along the main streets and facing north, below the tribunal of the basilica, were typical of this replanned, elegant town. It is worth noting that in most other towns the short ends of the rectangular house blocks (*strigae*) face the main street perpendicularly (as, for instance, at Cosa) while at Alba Fucens and

some other towns long sides of the blocks run parallel with the streets. *Scamna* seems to have been the usual term for blocks orientated in this way.[47]

It is interesting to compare Cosa with Alba Fucens, as it was rebuilt some two hundred years later. The polygonal walls and the plan of a temple on a hill east of Alba Fucens, now incorporated with the church of S. Pietro, have preserved the old Italic style, but the concrete faced by opus incertum shows a striking difference from the rubble of Cosa. Altogether, Cosa shows us a Roman colony in the stern age of the earlier wars and conquests, while Alba Fucens displays the enriched and refined colonies of Sullan times.

DOMESTIC ARCHITECTURE

In his description of the Rome of the Neronian fire in A.D. 64, Suetonius (*Nero*, 38) speaks about 'the immense number of tenement houses' – in country towns one would say *tabernae* – and in contrast to them, an aristocratic minority of 'domus of the leaders of old, still adorned with trophies of victory'.

Pompeii, Herculaneum, and the Late Republican layers at Ostia show that the one-family houses of the rich and the well-to-do bourgeoisie filled a much larger place in Late Republican towns than in the Imperial Age, with its apartment houses. There are also different kinds of domus. The gabled (testudinate) type of atrium in the Casa dello Scheletro at Herculaneum,[48] a stately atrium displuviatum such as the Tomba di Mercareccia (above, p. 73; Plate 43), shows that several old Italic one-family house types known from Etruscan tombs and by Vitruvius lived on.

Vitruvius's main recommendation for domus, that is, for houses of a higher standard (VI, 3) concerns the *cava aedium tuscanica*, houses with reception halls called atria and hailed also by Varro (*Lingua Latina*, V, 161) as originally Etruscan. In my opinion, Vitruvius and Varro are perfectly right in deriving these *cava aedium* and their atria from the Etruscans. Their main features seem to be derived from Etruscan palaces such as they are represented in tombs like the Tomba a Tablino, the Tomba degli Scudi e delle Sedie, the Tomba dei Capitelli, the Tomba dei Vasi Greci at Caere, and the Tomba Rosi at San Giuliano in the modified form of the rock-cut chamber tombs (Plates 35 ff.).

Together with the plans of temples, this seems to me to be one of the most spectacular instances of how traditions from archaic Etruscan architecture influenced the building activity of the subsequent centuries, although we have only Vitruvius's description and the tombs to substantiate the Etruscan ancestry. It seems quite clear that Vitruvius's and Varro's *cava aedium tuscanica* became the preferred upper-class mansion of the Etruscan *koine*. Consequently, as in the third chapter (see pp. 63 ff.), I continue to compare the main features of these Late Republican houses with archaic Etruscan tombs. All the same, however, the most interesting task is to describe this virtually new kind of house, created in the last centuries B.C. by innovations such as the impluvium (p. 154, below) and by the victorious Greek taste, and then handed over to Imperial times.

Like the Etruscan tombs, the Roman atrium-houses of the third century onwards (Figures 45 and 48) were strictly axial and symmetrical. They were accessible by a

forecourt and lobby, the *vestibulum*, inside which was the main entrance to the house, the *fauces*. In old atrium-houses the chambers right and left of the fauces were closed towards the street – as still can be seen on the left side of the Casa del Chirurgo (Plate 94 and Figure 45).

On the opposite side of the atria, facing the entrance from the street, was the *tablinum*, which in Vitruvius's description (VI, 3. 5, 6) and in other sources, and in the houses as we see them at Pompeii, appears as the original main room and centre of the household. Pliny (XXXV, 7) tells us that the tablinum also served as an archive room and was filled with family documents. Originally the tablina seem to have been the bedchambers of the master of the house and his wife. As we see them today, they have one side completely open towards the atria, but the wooden screen in the Casa del Tramezzo di Legno at Herculaneum and arrangements for hangings show that they could be – and they probably usually were – separated from the atria.[49] Of old there was a dining-table, the *cartibulum*, at the entry to the tablina, as Varro (*Lingua Latina*, V, 125) describes it from his boyhood days. The known Pompeian cartibula are elegant marble tables which were no longer used for meals in the atria. To the right and left of the broad entrances to the tablina are usually doors to side rooms or passages. We meet this kind of house, described as Etruscan by Vitruvius and Varro, all over Pompeii, Herculaneum, and in the Republican strata below Imperial Ostia.[50] It is evident that Vitruvius, as he often does, has chosen the best-liked traditional type of house from the last centuries B.C. for his special model.

The Late Republican houses which are known today have bedrooms (*cubicula*) along the side walls. In front of the tablina and their flanking doors are open wings (*alae*) extending right and left to the outer walls of the houses, as described by Vitruvius (VI, 3. 4). Very likely this arrangement was inherited from the Etruscan palaces, though it could not be reproduced in the tombs, where the beds of the dead are placed along the walls of the main hall, in the side rooms of the tablinum, and in the tablinum itself.

In the old days the atrium-houses seem to have been mostly free from the bustle of streets with their tabernae, where wares were displayed, where the daylong pounding of the coppersmiths' hammers, the early-rising bakers, the humming voices from the school, the clinking from the moneychangers' are all described for us by Livy (VI, 25. 9), Martial (XII, 57), Juvenal (I, 105), and others. Later, in connexion with the intensified commercial life of the last centuries B.C., the owners of atrium-houses yielded, and opened tabernae to the right and left of the entrances to the atria. This occurred throughout the town and resembled the butchers' stalls and shops which Livy (XLIV, 16) describes at the atrium-house of the Scipiones, their *aedes*, at the Forum Romanum. These tripartite entrances in the façade are a typical feature of Pompeii as we see it.

In the material which we have at present, we come across at the very beginning both aristocratic houses, such as the noble Casa di Sallustio in Pompeii, and middle-class houses with plain façades, such as the Casa del Chirurgo, interrupting the rows of shops along the business streets. Refined Pompeian houses of the late second and first centuries had pilasters with flowery Corinthian or Ionic capitals flanking the main entrances, anticipating the hellenistic decoration of the interior.

The development during the centuries of hellenistic luxury and increasing civic activity and splendour evidently exerted a great influence upon the atrium-houses (whatever their origin), before they attained the rich and varied appearance which we see in Pompeii and Herculaneum. A difference between the old Etruscan tombs and the Late Republican houses is that the back walls of the tablina have wide windows or are left completely open towards gardens (*horti*, *heredia*) behind them. When old-fashioned gardens were replaced by elegant Greek peristyles (Figure 48), the tablina, which had had such an important function in the tombs and older atrium-houses, became chiefly elegant passages and could be remodelled in various ways or even omitted.

As was pointed out on p. 66, the Etruscan tombs reproduce reception halls, in front of the tablina and side rooms, with flat, richly decorated roofs and supporting Doric or Aeolic–Ionic columns. But in the third century we meet with the *cava aedium tuscanica*, the roofs of whose atria have valleys tilting inward to a roof opening, the *compluvium*, with a rectangular tank, the *impluvium*, below.[51] This contrivance was useful in towns for keeping rainwater away from neighbouring houses. A still more important reason for the device was probably to collect water from the tiles of the inward slopes of the roofs. Cisterns were built below the atria for this rainwater (*collecti imbres*), which Horace in one of his epistles (I, 15. 15) seems to disapprove of, but which for many places and during sieges were indispensable. Late Republican atria have gracefully decorated frames round the tops of the tanks (*putealia*) in front of the tablina.

Material which would allow us to follow this development between the fifth and the third century is very scarce. We cannot even establish when, in the fifth century or later, atrium-houses became the most typical kind of dwelling for the upper and middle classes throughout central Italy and Campania. At Saepinum, a town in the Abruzzi rebuilt by the local population after 293, when the old Samnite town was destroyed by the Romans, a regular atrium has been excavated, and an impluvium of terracotta with Oscan inscriptions found below the later stone impluvium. Livy mentions a palm tree which grew in an impluvium in 169 and was considered a prodigy.[52] Pliny's famous description of the ancestral atria with wax models of the forefathers in special cupboards (xxxv, 6–7) refers to the old Roman traditions of the atria; evidently the younger Pliny is right in speaking of an atrium built in the ancestral manner (*ex more veterum*) among all the various modern halls and courts in his Villa Tusca (*Epist.*, v, 6. 15; II, 17. 4).

In the third century we begin to get an overwhelming mass of evidence from atrium-houses at Pompeii and Herculaneum, and, about 100, at Ostia.[53] Like the Etruscan towns, the Osco-Samnite towns of Campania in the third and second centuries still had their own language, city life, and upper classes, which developed their own brand of hellenistic culture and built beautiful atrium-houses. These houses were evidently influenced by Rome, directly by the hellenistic world, and, of course, by Greek neighbours in Naples and farther south. The public buildings show that the Roman colony, the Colonia Cornelia Veneria, affected the life of the towns in many ways from about 80, but in the domus we can hardly discern any difference. The hellenistic *koine* in its Italic shape, the hellenized *consuetudo Italica* of Vitruvius's fifth book, had impressed its common pattern upon all refined domestic architecture in central Italy.

Already in the second century, both at Pompeii and at Herculaneum, we see *cava aedium tuscanica* with high atria surrounded by rooms in two storeys. The Casa delle Nozze d'Argento from the Samnite times of Pompeii (second century B.C.) and the Casa del Tramezzo di Legno at Herculaneum (first century A.D.) show especially well these heightened atria. The rooms of the upper storeys sometimes had windows towards the atria and towards the street in front of their entrances (the *fauces*); in many cases these upper apartments were accessible by direct staircases from the street. Neither these flats round the atria nor flats round central courts (as in the Casa a Graticcio at Herculaneum) developed into the high tenement houses of the future; they seem like a transitional patchwork when compared with the fundamentally different insulae which we know from the Terme del Foro at Pompeii and from Imperial Ostia. As seen, for instance, in the Via Stabiana or the Via dell'Abbondanza at Pompeii, galleries with elegant Greek columns could be arranged above the entrances to the houses (Plate 70). These, as has already been said, were connected with the *cenacula*, the upstair dining-rooms, discussed by Varro (*Lingua Latina*, v, 162), which in his day became common and gave their name to all the upper rooms. In the Casa Samnitica at Herculaneum an open gallery with Ionic columns runs round the upper part of the high atrium.

For the sake of greater elegance, the old impluvia of tufa or terracotta were replaced in the later atria by marble basins. As Vitruvius says and as can be seen in many houses at Pompeii and Herculaneum,[54] the compluvium could be supported by Greek columns at the four angles or all around the impluvium (Figure 48). The former arrangement was called 'tetrastyle' and the latter 'Corinthian'. Corinthian columns became the fashion of the day. Cicero mentions in the second Verrine Oration (147) that columns intended for an impluvium were brought (probably to some villa) a long way over bad roads. Pliny (XVII, 6) reports that six columns of marble from Mount Hymettus were erected in the atrium of the orator Lucius Crassus about 100 B.C., and makes clear that this was considered a great luxury during these Late Republican centuries, when marble columns were rare even in public places.

Another most important part of the hellenization of atrium-houses was the peristyles (*peristyla, peristylia*), the square courts surrounded by colonnades described by Vitruvius (VI, 3. 7 and 5. 2) and, in their most luxurious shape, by Cicero in his account of Clodius's *domus* on the Palatine (*De domo*, 116) (Figure 48). Peristyles were built behind the atria and tablina in town houses (Vitruvius, VI, 5. 3). The colonnades, which presented a delightful view behind the open back walls of the tablina, had various kinds of columns – slender modernized Doric columns as well as Corinthian, Tuscan, and Ionic. They were surrounded by living-rooms (*conclavia*) with a new convivial luxury. As suggested by Diodorus (V, 40) and mentioned above on p. 74, it is possible that the Etruscans introduced or even 'invented' peristyles. In any case, from the second century they belong to the most outstanding and charming parts of the atrium-houses that we know so well in Pompeii and, to say it again, at Ostia a peristyle of about 100 remains at the Villa della Fortuna Annonaria.[55]

The origin of these porticoes poses no problems. The old Italic mansions had gardens (*heredia, horti*) behind the tablina, surrounded – as Livy describes it from the third

century at Capua (xxiii, 8. 8; 9. 13) – by a wall facing the adjacent street (*maceria horti*). In the Casa di Sallustio there are remains of a colonnade surrounding the back of the atrium, as Vitruvius (vi, 5. 3) describes it when discussing villas, and as we actually see it in the Villa dei Misteri outside Pompeii. It must have been natural to substitute for this old arrangement porticoes in the Greek style, at a time when places made varied by countless columns ('innumeris spatia interstincta columnis'; Statius, *Silvae*, iii, v. 90) became characteristic for hellenized Italic towns, and when even in wall paintings of the Second Pompeian Style a predilection is shown for colonnaded architecture. The Greek peristyles, known from private houses such as those of Olynthus and Delos, palaces, gymnasia and palaestrae, market-places, and other sophisticated town architecture, underwent characteristic alterations in their Italic context. The peristyles of the atrium-houses remained gardens. They were a most characteristic expression of the Roman love of nature.[56] The space in the middle, open to the sky, was embellished by greenery. Walking in the open air is very healthy, explains Vitruvius, speaking of colonnades and walks in general (v, 9. 5). The 'iucundissimum' murmur of elegant fountains, which the Romans loved, was often to be heard, as can be understood from Pompeii and as is described by the younger Pliny (*Epist.*, v, 6).

The Romans introduced strict axiality and symmetry into their peristyles too. Of course, this also exists in Greek peristyles (for instance, in the hellenistic gymnasium of Miletus), but more characteristic of Greek architecture is a free disposition of rooms round the peristyle. At Pompeii, on the other hand, over and over again tablina occur with side rooms in the centres of the upper sides of the peristyles, repeating the principal motif of the atria. The palaces of the Imperial Age, with their predilection for open doors or niches flanked by side doors as the centre motifs of the back wall of their courts and halls, still carry on the axiality of Late Republican atrium-houses and peristyles. In addition, actual atrium-houses survived, as is seen on the Forma Urbis, in Imperial Ostia, and also in the younger Pliny's villas (cf. p. 88).[57]

Among the conclavia and dining-rooms drawn up round the peristyles were Corinthian tetrastyle and Egyptian oeci, the latter called by Vitruvius (vi, 3. 8–9) specially elegant. The side of the oecus towards the peristyle was left open. Like the Casa del Labirinto at Pompeii, the Corinthian oeci had barrel-vaults and side rooms with flat ceilings to allow walking above them under the open sky. The best-known tetrastyle oecus belongs to the left side wall of the peristyle in the Casa delle Nozze di Argento at Pompeii. It has an antechamber in front of the barrel-vaulted saloon with its four columns. Still more elaborate were the Egyptian oeci. A fine specimen from Imperial times is the *oecus Aegyptius* that serves as tablinum in the Casa dell'Atrio a Mosaico at Herculaneum,[58] but Vitruvius already gives us a full description (vi, 3. 9). The Egyptian oeci resembled basilicas, though the aisles had only one storey, and above that, as in the Corinthian oeci, an upper floor for promenading under the open sky. Windows in the walls between the upper columns of the nave admitted light to the interior. Vitruvius further singles out so-called Cyzicene oeci as being particularly foreign to Italic manners of building. They had two sets of dining-couches, facing each other, and windows on the right and left 'so that views of the garden may be had from the couches'. The

Casa di Giulia Felice at Pompeii and the main coenatio of the reception wing of the Domus Flavia on the Palatine (Figure 95) show how this disposition lived on in the Imperial Age.[59]

In the eighth region, in the southern part of Pompeii and accessible from the Via della Regina, there is a row of atrium-houses originally dating from the third century. On the level of the town they have atria and tablina of the usual kind. But when at the end of the second century the fortifications on this side were given up, and especially in the age of the Sullan colony, the old houses were enlarged by structures which covered the hillside. Projecting lower storeys supported by terraces were provided, and corridors, staircases, loggias, and windows facing the marvellous view towards the plain, the sea, and the mountains (Figure 82). The sources here must be Etruscan terrace houses and coastal villas of stepped outline known from wall paintings at Pompeii (Plate 95).[60]

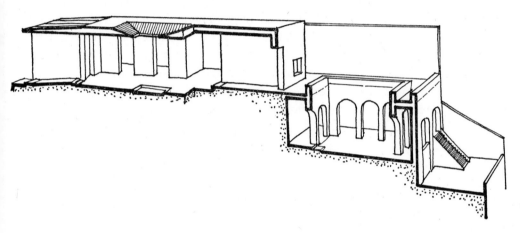

Figure 82. Pompeii, one of the houses on the south-western slope of Pompeii ('the House of General Championnet'), a second-century atrium-house (*left*) with additional storeys built against the hillside in the first century B.C. Section

The beautiful Casa dei Grifi, excavated below the Domus Flavia on the northern slope of the Palatine in Rome, is a terrace house of a similar kind. Against the hillside are built elegant barrel-vaulted rooms with pavement mosaics and paintings and stuccos in the earliest Second Pompeian Style. The date must be the end of the second century. The rooms were probably lit by doors or windows in the destroyed north wall. Very likely there was an atrium on the surface of the Palatine, from which the still-existing staircase led down to the rooms in front of the hill. At the southern edge of the Palatine, south of the early Augustan 'Casa di Livia', are also Late Republican remains, state rooms decorated in the typical style of *c*. 100. It seems at least possible that terraces built against the southern slope of the Palatine with a view towards the Circus Maximus were added to this house, just as on the southern hillside of Pompeii. Perhaps this was the house of one of Augustus's friends and freedmen, from which Augustus, and later Tiberius, used to watch the games in the Circus.[61]

Houses of this kind in Rome, the remains of large atrium-houses in Late Republican

layers below Imperial Ostia, and the peristyle mentioned on p. 155 show us the Roman background of the kind of town architecture which Pompeii and Herculaneum reflect in such a charming way. Wholly to understand Campanian towns and villas, we must look to Rome and to the hellenistic towns of Italy and the eastern countries. This delightful domestic architecture, which spread to towns in the countryside such as Pompeii and no doubt received something of a new flavour there, was accompanied by wall paintings in the so-called Pompeian styles. To the period discussed in this chapter belong the so-called First and Second Pompeian Styles. Painters from Rome, Greek towns, and, no doubt, local painters who adopted the metropolitan ways of decoration gave the rooms an entirely different appearance. The old-fashioned walls, with a fairly high dado and a wave pattern above (Figure 40), were no longer acceptable (cf. p. 68). The First Style (or Incrustation Style) was evidently hellenistic and international. It imitates 'different kinds of marble slabs' (Vitruvius, VII, 5. 1) and is known in the Greek world from the fourth century onwards. We have met it in Sicily during the early third century and see it in Rome and at Pompeii from the second century or even earlier. The Second Style reproduces the overwhelming architectural motif of the day – the colonnaded exterior and interior. It widened the impression of the room by painted columns, which appeared to jut out, 'although the picture is perfectly flat' (Vitruvius, VI, 2. 2). The colonnades were, to use Vitruvius's words again, 'copied from actual realities' (VII, 5. 3). The Second Style began in the late second century.

Besides the paintings there were pavements with variegated sectile work, *lithostraton*, mosaics, and an increasing wealth of other luxurious decorations such as costly marbles – in short, all the elegance of the house of Lepidus, built in 78 and then considered the finest of its age, but thirty-five years later not considered fit even to occupy the hundredth place (Pliny, XXXVI, 109 ff.). Paintings at Pompeii of about 100 and later show elegant modillions and other refinements, which later became typical of the marble architecture of Early Imperial Rome. There is no reason to doubt that they were also to be found in the decoration of Late Republican palaces of the capital. In the Augustan Age the most important type of decoration was the great garden paintings and paintings like the megalography of the Villa dei Misteri and of the Bosco Reale villa, as well as the Odyssey landscapes from the Esquiline (now in the Vatican Museum). Vitruvius devotes a special paragraph to this (VII, 5. 2).[62]

According to Suetonius (*Augustus*, 72), people were amazed that Augustus in his house on the Palatine had only small peristyles, that the columns were of stuccoed Alban stone (*peperino*), and that 'the rooms [were] without any marble decoration or handsome pavements'. Vitruvius (VI, 5. 2), summarizing the demands of the new age, recommends handsome and roomy apartments for advocates, public speakers, and their meetings. 'For men of rank', he continues, must be constructed 'lofty entrance courts in a regal style, and most spacious atria and peristyles, with plantations and walks of some extent in them, appropriate to their dignity. They need also libraries, picture galleries, and basilicas, finished in a style similar to that of great public buildings [like the Egyptian oecus; above, p. 156], since public councils as well as private lawsuits and hearings before arbitrators are very often held in the houses of such men.'

If one compares these modern Italic houses with their hellenistic counterparts – such as the houses of Delos, the peristyle houses of Morgantina, or the House of the Columns at Ptolemais near Cyrene[63] – the first general impression is so very similar that one can almost forget the basic difference not only between Greek megara and Italic atria (emphasized by Vitruvius, VI, 3 and 7) but also between the symmetry always aimed at in Roman houses and the easy-going arrangement which prevailed in Greek mansions. Of the intention in these Late Republican houses to be hellenistic and relaxed there can be no doubt, even if we did not have Strabo (V, 4. 7) to tell us of it with reference to Campania.

VILLAS

The attitude is still more evident in the Roman villas, whether, like Horace's small farm in the Sabine country with its household of five coloni (*Epist.*, I, 14), they remained agricultural (as the word villa originally implies), or whether they became villas in our sense of the word, country residences, to which the owners – as Bassus says in a witty epigram by Martial (III, 47) – went for relaxation with a carriage crammed full of all the abundance of the rich countryside bought in town. As a contrast, with Seneca (*Epist.*, LXXXVI, 5), we may hail Scipio cultivating the soil with his own hands, as the old Romans used to do. In the second century B.C. the luxury of the towns invaded these villas, though the really rural villas evidently often kept their old form and probably, in many cases, remained rustic. Cicero makes the difference very clear when speaking of his family home, the farm on the rivers Fibrenus and Liris below Arpinum (*De Legibus*, II, 1). While his grandfather was alive it was as small as the old villas of unshorn Cato and other idolized heroes of ancient and simple times. Cicero's father rebuilt and enlarged it – in what we call the Pompeian Style – and thus achieved the right hellenistic atmosphere for his 'life of study'. Yards for cattle and farming purposes were typical of the old rural mansions. There are a few such villas preserved with yards facing south and bordering the street, and on the other three sides surrounded by a crowd of rooms without any axial disposition. The whole was purely utilitarian, judging by Roman descriptions of these rural dwellings. Apart from these larger villas there were also, of course, villages and farms with quite small and simple buildings. Such utilitarian and unpretentious holdings were revived in veteran colonies from Sulla's time onwards.[64]

The Villa dei Misteri near Pompeii demonstrates best of all the changes due to the elegance of the houses in town. Though remaining a farming centre, about 200 the villa became what the ancients called a 'villa pseudo-urbana', or 'suburbana' or 'urbana'. It was built on a high podium with plain arches (Plate 89), a *basis villae* as Cicero styles it (*Ad Quintum fratrem*, III, 1. 5). Such podia, family tombs, and cisterns became typical of all country seats. The podia were built of concrete covered by incertum, reticulate, or polygonal work and had internal, barrel-vaulted cryptoporticoes with slanting side openings along the sides, a convenience for walks on hot or

cold days, as was discussed in relation to the public buildings of Praeneste, Ferentinum, and Terracina.

We can follow these villa terraces up to the third century. On the rich plain around Cosa there are several very extensive terraces built of rubble which date from the second century (Plate 96). They obviously reveal the presence of great Roman estates which, after the victories over the Etruscans in the third century, safeguarded by the fortified colony of Cosa, reorganized agriculture in this fertile countryside. One of these villa terraces in Valle d'Oro, the so-called Ballantino, is faced by polygonal work and has along its western side projecting round towers, constructed of coarse rubble covered by rather slipshod ashlar work. Above the lower part of these turrets lies a protective layer of roof tiles with fringes, as Vitruvius prescribes (II, 8. 17, 18) for walls both of concrete and of wattle and daub. This solid lower part of the turrets carries an upper structure with two successive sets of arched dovecots. Above the upper row of these arches is a second protecting layer of roof tiles. The most imposing basis villae around Cosa is called Le Sette Fenestre. It consists of three wide terraces built of coarse rubble and facing north-west. Along the façade of the lowest terrace are turrets with dovecots of the same type as in the Valle d'Oro villa. They alternate with sturdy buttresses. Below the second terrace is a system of barrel-vaulted corridors, which may have served as cryptoporticoes or storehouses or both. They are accessible from the lowest terrace by a row of arches. Between them are buttresses that slope inwards and are crowned by travertine slabs with simple mouldings. On the highest and third terrace the manor house was built, dominating the plain as nowadays a medieval farmhouse does.[65]

The first structure on the large terrace of the Villa dei Misteri outside Pompeii was a rectangular building of about 200 with a courtyard – and probably also a rural side yard – surrounded by walls. From the entrance to the main court a central axis leads to an atrium without alae and to a tablinum, accessible by two doors at the corners of the atrium. A portico of the same kind as that in the Casa di Sallustio in Pompeii, with a view towards the coast and the sea, was at the back of these central rooms and chambers. During the first century and in Augustan times the villa received paintings in the Second Pompeian Style, with architectural and figured motifs; the famous Dionysiac paintings belong to a redecoration in the Augustan Age. In the second half of the second century a peristyle was built round the main court in front of the atrium. The final result was thus exactly in accordance with what Vitruvius records (VI, 5. 3): 'in town, atria are usually next to the front door, while in country seats peristyles come first, and then atria surrounded by paved colonnades'.[66]

This arrangement seems to have been adopted in the Late Republican Villa Suburbana dei Papiri (Villa of the Pisones) outside Herculaneum in its first stage and in the so-called Villa di Diomede near Pompeii, also in its first stage. To these can also be added a large, luxurious villa below Tivoli with walls covered by incertum and reticulate. It was partly re-used when Hadrian built his famous villa on the same site.[67]

The atrium and peristyle villas and their podia – as also the tripartite arrangement for the upper sides of halls and courtyards – were extremely important for the development of Roman palaces. The same is true of the two other kinds of villas: the so-called porti-

cus and landscape villas. The one- or two-storey façades of seaside porticus villas are a favourite subject of the Pompeian painters of the Early Imperial Age (Plate 95). Many of these villas had a quite different origin from the peristyle villas. Like the Roman insulae, they evolved from a row of rooms with wide openings facing a court-yard, a road, the coast, or a view. This type of house is known all over the Mediter-ranean countries from the Bronze Age onwards. At the very end of the Late Republican period architects apparently took it up and gave it all the hellenistic charm of paintings, colonnades, and terraces with fine views. The porticus villa could also be used as a screen in front of a peristyle villa – as in the western half of Nero's Golden House in Rome – but the original form was a long, narrow house with a row of open rooms behind a colonnade, as we see it in the delightful 'Villa di Arianna' at Stabiae (above Castellamare di Stabia).[68] In all the villas one should also remember Agrippa's speech, referred to by Pliny (xxxv, 26), about pictures and statues banished to the villas (*in villarum exilia*), which he wished to make public property instead. Pliny (xxxv, 130) gives an illustration of this, reporting that the famous Late Republican orator Hortensius had Cydias's painting of the Argonauts in a special pavilion at his villa in Tusculum.

Artificial or natural grottoes also still exist, with elegant decoration, mosaic floors, walls adorned with pumice stone, and so on. Roman poetry very often dwells upon romantic specus or speluncae, like the Cave of the Muses, mentioned by Pliny (xxxiv, 19), on the Caelius in Rome; their Late Republican refinement is obviously due to hellenistic influence, as the descriptions of Greek grottoes and the names *nymphaea* and *musaea* suggest. In Greek Locri models of caves with wells and nymphs have been found, and a small barrel-vaulted, apsidal grotto with a well outside the walls of Bovillae, near Albano, obviously continues this tradition. Vault and walls are built of rather rustic stone and should probably be dated to the second century. Soon this kind of shelter for hot days assumed monumentality; highly sophisticated nymphaea were built in front of natural grottoes, but could also be wholly artificial. A charming building of this kind is the barrel-vaulted so-called Doric Nymphaeum below Castelgandolfo, facing the Alban lake, which has three beautifully decorated entrances to a cave behind the rectangular hall. Similar is a nymphaeum in the Villa di S. Antonio at Tibur (Tivoli). This has an apse, and along the side walls semi-columns carry four arches below an architrave. The capitals of these semi-columns, of the four arches, and of two columns which flank the apse are all Corinthian and of travertine. Sunk panels decorate the apse ceiling. On the lowest terrace of a large villa at Formia, the so-called Villa di Cicerone, there are two Late Republican nymphaea with wells in the apses and a mar-vellous view towards the sea. They were redecorated and partly rebuilt in the Imperial Age, but the larger of the two evidently had a nave with columns of somewhat Tuscan type, narrow aisles, and a barrel-vaulted nave. It is 29 feet (8·70 m.) wide. These grottoes are the predecessors of the still grander nymphaea of the Imperial Age – like, for in-stance, the fantastic cave, with its pools and its three Homeric marble groups and other sculpture, which, like a gigantic heathen presepio, faces the sea at Sperlonga. Together with the nymphaea and the cryptoporticoes one has to remember subterranean halls, 'aestivi specus', constructed as shelters against the heat of the warm summer months.

The speluncae are often connected with the type of villa which I venture to call the 'landscape villa'. The stuccoes from the Villa Farnesina in Rome give us a delightful picture of them. We see before us grounds laid out in imitation of natural scenery, towers, bridges, pavilions, statues, trees, and fields. Besides this, Pliny (xxxv, 116) gives an enchanting summary of the paintings of all these rural amenities, including arriving or departing ships, donkeys or carts, and anglers, hunters, and labourers in the vineyards. Horace (*Od.*, II, 15) tells us of lakes larger than Lake Lucrino, and Atticus (in Cicero's *De Legibus*, II, 1) derides 'the artificial streams which some of our friends call "Niles" or "Euripi"', comparing them with the real rivers Fibrenus and Liris at Cicero's family villa and the lovely island in the Fibrenus. Varro (*Res Rustica*, III, 5. 8–17) describes his villa at Casinum, which, according to him, surpassed the improvements of the villa of Lucullus at Tusculum: there were a canal with bridges, groves, fishponds, and colonnades covered with a hemp net, and filled with all kinds of birds. Another aviary was round and domed, with columns and a net again preventing the birds from escaping into a surrounding wood planted with large trees. Inside the dome, the morning and evening stars circled near the lower part of the hemisphere, and a compass of the eight winds indicated the direction of the wind.

In the Roman villas a love of nature, the old agricultural traditions of Italy, and the fanciful luxury and refinement of hellenistic palatial architecture and pleasure grounds (παράδεισοι) met. All that has to be kept in mind also for what Martial (XII, 57. 21) calls 'rus in urbe', i.e. landscape gardens in Rome itself, like that of Nero's Golden House. According to Tacitus (*Ann.*, xv, 42), in the eyes of the Romans the greatest marvel of this palace was that it was a villa brought to the town, with its groves, pastures, herds, wild animals, and artificial rural solitude.[69]

Baths, Theatres, and Other Public Buildings

Pompeii shows, and Vitruvius in his fifth book describes, how hellenistic accomplishments were offered to the public at large and became *consuetudo italica* in the last centuries B.C. The display of works of art, for instance, and the *fornices* (triumphal arches), also with statues, were now part of the everyday life of the citizens. An example is the fornix at Cosa, dating from after 150. The so-called decumanus at Ostia has, in front of a granary of the early first century A.D., porticoes facing the theatre on the opposite, north side of the street. This kind of public amenity was obviously inherited by the Imperial Age from Late Republican towns.[70]

Baths and Palaestrae

The domus and villas, with their peristyles and other luxuries, also had baths (*balneae, balineae, balnea, balinea, balneola*), and they grew larger and larger, and more and more luxurious too. Seneca notes that the bath (*balneolum*) in Scipio Africanus's villa at Liternum in Campania was small and dark, 'according to the old style', 'for our

ancestors did not think that one could have a hot bath except in darkness' (*Epist.*, LXXXVI, 4). That was no doubt also true of the old public baths, but in the second century at Pompeii they began to grow more elaborate (Figure 68). After a dressing-room (*apodyterium*) followed the warm *tepidarium* and the hot *caldarium*. We see this system, obviously Greek in origin, in the Stabian baths of the second century and the forum baths at Pompeii built for the Roman colony about 80 B.C. The *caldaria* have an apse with round basins for cold water (*schola labri*) and, at the other end of the room, a rectangular bath-tub with hot water. Both these baths have domed rooms with an aperture left in the middle of the dome and round basins for cold water (*frigidaria*), attached to the dressing-rooms. Vitruvius (v, 10. 5) recommends rooms of the same kind next to the tepidarium for steam baths. In such *laconica*, as Vitruvius calls them, a bronze disc hung from the aperture in the dome; 'by raising or lowering it, the temperature of the steam bath can be regulated'. These features remained unchanged in all later baths, however grand and sumptuous they became in the Imperial Age. In the Late Republican baths, domes seem to have been the only form of masonry vaulting. Vitruvius discusses wooden vaults with a framework tiled on the underside, and describes how they should be constructed (v, 10. 3). Great vaulted halls came only with the Imperial Age. The first instance known to us is a large rotunda with a mighty dome built of concrete on the seashore at Baiae. It belongs to the very borderline between the Late Republican and the Early Augustan Ages.

The balnea of the towns and villas became hot-air baths, but to start with they were heated by pans containing charcoal. A brazier remains in the tepidarium of the forum baths of Pompeii. About 100 B.C. another system existed with the hot air conducted from a furnace room below the floors, which were supported by pillars of brick. The advantage of the new system was that the rooms were free of smoke, dust, etc. This system spread to baths, and also palaces and private houses, throughout the Roman Empire. It lived on in Byzantine and Turkish baths and also in medieval Europe. The Romans ascribed the 'invention' of *pensiles balineae* to a rich and enterprising Roman, G. Sergius Orata, who lived at the beginning of the first century B.C. and was also the first to have oyster ponds. However, excavations in Greece have shown that the Greeks were again the first.

From the Augustan Age onwards we see in Rome and the provinces large-scale bathing establishments, known as *thermae*, built on large terraces, surrounded by gardens, and with central halls, palaestrae, etc., planned with strict axiality. All this – as far as we know – was unfamiliar to the Late Republican architects, but as the Stabian and forum baths at Pompeii show, peristyles were then already added to the balnear rooms. The swimming pool of the Stabian baths confirms that palaestrae at the back were intended for gymnastic exercise.

This combination of bath and palaestra marks an important step towards the great symmetrical unities of the centuries to come. Vitruvius affirms that palaestrae were not part of the Roman tradition (v, 11. 1), but were Greek meeting-places, where 'rhetoricians and others who delight in learning' gathered in the peristyles, while gymnastics were practised around them. Behind the principal palaestra, Vitruvius

describes stadia, running tracks, etc., such as had existed in Late Republican and Augustan times on the Campus Martius, with the yellow Tiber for swimming and diving. According to Livy (XXIX, 19. 11 ff.), the conservative Romans censured Scipio Africanus because in Magna Graecia he strolled about in the palaestrae, wearing a Greek mantle and sandals, and giving his attention to books in Greek and physical exercise. In contrast to this, the Osco-Samnites of Pompeii already in the second century added a great square peristyle surrounded by porticoes (the so-called 'palaestra Samnitica') to their theatre, as Vitruvius recommends (v, 9. 1), and as Pompey did when he erected his theatre in Rome. The peristyle was built behind the stage, but above the theatre the Osco-Samnite Pompeians also had a small, gracious palaestra, a rectangular peristyle, but without running tracks, etc. (Figure 35). The function of this palaestra was proclaimed by a very fine copy of Polycletus's Doryphorus in front of the back portico. In Imperial times this palaestra was shortened by a Temple of Isis on its eastern side, and the great quadriporticus behind the stage was reshaped and used as a barracks for the gladiators.

We cannot say if second-century Rome approved of the combination of a typically Greek palaestra with the bath-houses as they developed in Italic practice. It may have been connected with the uninhibited way of life of the Campanian towns. In any case, the forum baths of the Roman colony at Pompeii prove that the novelty was accepted in Rome about 100 B.C. Among many other baths, the central baths of Pompeii and the Terme di Nettuno on the decumanus of Ostia show that the asymmetric plan of the balneolae which the architects of Late Republican days had provided for practical demands in hellenized Italic towns, lived on side by side with the majestic, axial architecture of Imperial Age thermae. Several small baths on the Forma Urbis with irregular courts and the usual bathrooms alongside them prove the same. The catalogue of the regions of Rome in the fourth century A.D. lists 11 thermae and 856 balneolae. The latter, no doubt, usually kept the informal Late Republican pattern.

The forum baths at Pompeii and the Terme di Nettuno of Imperial Ostia have one more feature worth mentioning: narrow rows of tabernae surrounded the whole establishment, with upper apartments accessible by direct staircases from the street. This of course made the baths more profitable. In Imperial times we see the same rows of shops with lodgings above them facing the streets around the peristyles of the granaries (*horrea*), and even in the portico around the façade of the Circus Maximus in Rome and of the theatre at Ostia.[71]

Stadia

Another aspect of town life, the entertainment of the people, was provided for in olden days by the Circus Maximus, for horse-races and different kinds of games. It lay in the long valley between the slopes of the Palatine and the Aventine (Figure 52). Later, other circuses and theatres followed, and finally in the Flavian Age the Colosseum was dedicated in A.D. 80. As I have said above, there is no reason to doubt that the tradition of the circus went back to the age of the kings. Livy (VIII, 20. 1) reports that the first permanent carceres (stables) were built in 329 B.C., though they were probably of wood.

They were at the straight, western end of the circus. Cicero (*De divinatione*, I, 108) quotes Ennius describing how the spectators waited eagerly for the chariots to come out of the painted exits. In 174 the censors restored the carceres. Some twenty years before, in 196, L. Stertinius, as an *ex voto* for his victories in Spain, had erected an arch with gilded statues, the Fornix Stertinii (of the same kind as is known somewhat later from the Forum Romanum and Cosa), at the curved east end of the racecourse. Gradually the course was surrounded by wooden seats. It was divided lengthwise by a low wall, the *spina*, around which the races were run. Conical columns, the *metae*, stood at the ends of the spina, marking the turning-points. In Augustan days (Dionysius, III, 68) the spectators' stands had three storeys, the lowest with stone seats and the two upper with wooden seats. On the outside of the circus were shops with dwellings over them, and between the shops were entrances with stairs for the spectators. Probably the lowest rows of seats were built on the slope of the northern and southern hillsides, whereas the upper seats and the building around the curved eastern side were supported by wooden structures.

In 220 the censor C. Flaminius built another circus, the Circus Flaminius, on the low, flat riverside by the Tiber, with its southern end at the crossing to the Tiber island. How was this circus constructed, since there was no natural slope? Perhaps, like a theatre at Capua of about 100 B.C., a small theatre at Gioiosa Ionica, or the stadium of Olympia, the seats were on artificial embankments around the stage; but it seems more probable that wooden structures were erected and that they were among the first of their kind.[72]

Theatres

The history of the Roman theatres exemplifies especially clearly how Greek culture was grafted on to the old and warlike Italic life. Theatres came late. No doubt in central Italy rustic dances and recitations of verse were performed in the early days by 'fauns and native bards', to quote Cicero (*Brutus*, 71), but according to Livy (VII, 2), a change took place in Rome in the fourth century. Among attempts to mitigate the effects of a plague in 364 B.C. was the addition to the Roman circus of players who had been brought from some Etruscan town, just as, according to Herodotus (I, 167), the inhabitants of Caere, in an attempt to get rid of a national scourge, had introduced Greek games and horse races in the sixth century, following advice from Delphi. These *histriones*, as they were called (from *ister*, the Etruscan word for players),[73] 'danced to the strains of the flute and performed not ungraceful motions in the Tuscan fashion without any singing, and without imitating the action of singers'. This tale of Livy's illustrates the beginnings of Roman scenic entertainments. Already about 240 B.C. a Greek from Tarentum, Livius Andronicus, had devised for the Romans a play with a plot. Other Greek theatrical performances – comedies, tragedies, and satirical plays in Latin – soon became a feature of Roman festivals such as the Ludi Romani, Plebeii, Apollinares, Megalenses, Florales, and Ceriales, as well as of burials and the consecration of temples. Plautus and Terence bring all this to life for us.

The theatres which were erected for these early plays in Rome itself were of wood,

and evidently imitated temporary stages in the towns of south Italy, while – as the history of sanctuaries around Rome has shown – outside Rome and its closest environs permanent, stone-built theatres were admitted, at least if they were connected with temples, already about 100 B.C. It should always be remembered that both the great hellenistic permanent theatres, embodying traditions from the fifth century, and the temporary wooden structures of south Italy were known from the beginnings in Rome. In south Italy, after the fashion of the neighbouring Greek towns, permanent theatres were erected a hundred years earlier than in Rome: the highly hellenized Osco-Samnites of Pompeii, for example, built a permanent theatre in the second century. In Rome, Pompey's theatre, built when he had returned from Greece with the theatre of Mitylene in mind, was the first, and dates only from 55 B.C.

At first the theatre at Pompeii simply had tufa or limestone seats resting on the southern hillside of the town, which was north-east of the archaic Greek temple. We can follow this development with the help of Vitruvius (v, 6. 2) and see how sectors of seats (*cunei*) were divided from each other in a regular way by passageways, and how curved cross aisles (*praecinctiones*) after Greek models became accepted practice. The large, square gymnasium, mentioned on p. 164, lay behind the stage. Elegant, stuccoed Doric columns, with an unfluted lower part that was painted red, adorned the porticoes on all sides of the peristyle. Vitruvius (v, 9) gives detailed rules (no doubt Greek) for building these porticoes behind stage-houses, explaining how useful they were for the public when showers interrupted the plays, for walks in the open air, and for 'getting ready all the stage properties'. He also strongly emphasizes how indispensable they became for storing wood in times of siege and war. The theatres of Pompey and Balbus in Rome and the theatre of Ostia with their large peristyles prove that what Vitruvius recommends, and what the Osco-Samnites had built at least a hundred years before, became accepted in Late Republican and Augustan Rome, whether the Romans took the idea from Campania and south Italy or whether Pompey brought it with him from Greece.

From the first, like the Greek theatres, the theatre at Pompeii had a narrow stage-house behind the stage. The stage podium (*pulpitum*, λογεῖον) was wide, but, perhaps also after the Greek fashion, raised fairly high above the orchestra. It had side walls which converged inwards to the façade of the stage-house (παρασκήνια). The latter (the *scaenae frons*) and the stage itself could – with some confusion – be referred to as the *proscenium*.

Wide and low stages were characteristic of the wooden theatres in Rome and of their later tradition. It is obvious that Rome took the main elements of theatrical architecture from the Greeks, though to start with not from the hellenistic theatres known from excavations in Greece and described by Vitruvius, but from the roomy stages of the popular comedies in Italy. These could be high and supported by columns, or low with stairs leading up to the pulpitum from some open space – a sacred precinct, the arena of a circus, or wherever the shows were performed – as retained in Roman theatres. The contemporary Greek stages are delightfully illustrated in south Italian vase paintings. In contrast to them and to the Roman stages, hellenistic theatres had narrow stages

raised up some 10 feet. The chorus and supporting artists gave their performances in the orchestra, in front of the stage. These orchestras were roomier than the Roman ones. A characteristic of the latter – as the theatres of Gabii, Praeneste, and Tivoli (Figures 76, 77, and 78) show – is that they were semicircular.

Vitruvius (v, 6–7) contrasts the final arrangement in Italy with that of hellenistic theatres. According to him, the stages (*pulpita*) of Roman theatres should always be deeper than those of the Greeks and 'raised not more than five feet': this was because the orchestras in Roman theatres contained seats reserved for the senators. Here we see how the demands of Roman social life, together with the kind of shows performed, contributed to the final shape of the Roman theatres.

A terracotta model of a stage building of about 300 B.C. (Plate 97) from a town in southern Italy displays a permanent scaenae frons with the same main characteristics that the Romans adopted. It seems that they almost immediately imitated Greek stage-decorations and – if a short note did not suffice to indicate the setting – that for tragedies they were decorated as palace façades with columns, and for satirical plays as private dwellings with balconies, windows, and upper storeys (*cenacula*: Plautus, *Amphitruo*, 863), or with trees, caverns, mountains, and other rustic properties (Vitruvius, v, 6. 8–9). According to Vitruvius, and as the stage model just referred to shows, the palace sets had double doors in the centre decorated like those of a royal palace and to the right and left the 'doors of the guest chambers'. Another original feature inherited from south Italy and the Greeks was revolving pieces of machinery (περίακτοι) to the right and left of the doors, each with three decorated faces, to indicate the mood. The exits on the short sides were considered to be entrances, 'one from the forum, the other from abroad'. The Romans also adopted from the Greeks curtains (*siparia*) which were hung before parts of the scaenae frons and could be drawn up or to the side, and others (*aulaea*) that were lowered at the beginning of a show and raised at its end from a trench along the front side of the stage towards the orchestra. The theatre at Pompeii shows such an arrangement, and we are told that pictorial hangings were brought to Rome already in the second century from the royal palace of Pergamon and used as drop-scenes. But, like all the other elements of the Roman stage, this achieved its final shape only in the Imperial Age, and for Late Republican times can only be traced in literary sources and from insufficient remains.

At the beginning there were objections not only to Greek entertainments as such but also to allotting seats to the plebs in temporary theatres. Our sources sometimes confuse this with the reaction against permanent theatres, but Tacitus (*Ann.*, XIV, 20) gives a precise summary of the main facts: 'To go further back into the past, the people stood to watch. Seats in theatres, it was feared, might tempt them to pass whole days in insolence.' In any case, in Plautus's comedies we already encounter a theatre with wooden seats: a *cavea*, as the Latin word is. Until 194 plebeians and senators were accommodated together, but in that year Scipio Africanus and the censors ordered the curule aediles to separate the senatorial seats from those of the commoners at the Ludi Romani. The seats could be constructed on earthen embankments or hillsides – like the stone seats of Greek theatres and the theatre at Pompeii – but they could also, of course,

be erected on a flat site, a technique which became important for the large permanent theatres of Rome in the centuries to come.[74]

The seating regulations in Scipio Africanus's time, i.e. in 194, show us how one of these temporary structures operated. In 179 Livy (XL, 51) mentions a stage building and seats for spectators at the Temple of Apollo, no doubt the temple behind the Theatre of Marcellus that in its rebuilt Augustan shape was called Sosianus. Like the theatres of Gabii, Praeneste, and Tivoli, the theatre here was closely connected with a sanctuary; the Augustan Sosianus Temple and the Theatre of Marcellus certainly renewed this connexion. Livy's words (XLI, 27. 5) referring to 174, about 'a stage placed at the disposal of the aediles and praetors', whose duty it was to arrange plays, may indicate a more permanent building. However, as already mentioned, after the censor Lucius Cassius had begun to build a permanent theatre in 154, it was demolished on a motion of P. Scipio Nasica, as a potential hotbed of sedition and because it seemed 'far from desirable that the Romans should be accustomed to Greek pleasures'. According to Velleius Paterculus, it was 'located in the direction of the Palatine from the Lupercal', that is, on the south-western slope of the Palatine, below the Temple of Magna Mater, and had seats facing the valley of the Circus Maximus. The Ludi Megalenses were celebrated in front of this temple, 'in the very sight of the goddess', as Cicero says (*De haruspicum responsis*, 22–9). Cicero clearly indicates that there were two theatres on the slope of the Palatine facing the Circus valley. He is indignant when he tells how Clodius at a celebration of the Megalensia let slaves loose in one theatre and ejected every free man from another (25, 26). This, as well as the mimes of the Ludi Florales in front of the Temple of Flora on the Aventine, directly recalls the theatres in front of the temple at Gabii and the round Temple of Fortuna Primigenia at Praeneste (as I interpret it), the theatre below the great temple of Pietrabbondante, and that of Hercules Victor at Tivoli. One should, in any case, remember that plays were performed at funerals as well and that in 167, according to Polybius (*Athenaeus*, XIV, 615a–c), Lucius Anicius built a very large stage in the Circus Maximus. He summoned distinguished musicians from Greece and posted them with the chorus in the orchestra 'at the front of the stage' (*proscaenium*). Finally, four boxers climbed on to the stage, accompanied by trumpeters and horn players.[75]

The theatre that Lucius Mummius built after his victory in Greece, in 145–144, was no doubt decorated by marbles which he had brought from Corinth. It appears in Tacitus's *Annals* (XIV, 21) as an early and sensational stage building. Among the wasteful luxuries of these temporary structures were cloths that were used as awnings. This convenience, used by the Etruscans already in archaic times (see p. 63), now became common; in Caesar's time it spread to the gladiatorial games on the Forum Romanum and to the adjoining streets (Pliny, XIX, 23). In 99 Claudius Pulcher adorned his theatre with paintings, which, according to Pliny (XXXV, 23), were so realistic that crows tried to alight on the roof tiles, and at the games of Scribonius Libo in 63 the architect Valerius of Ostia (Pliny, XXXVI, 102) roofed the theatre. Roman stage-houses (*scaenae frons*) soon came to be decorated with gold, silver, ivory, or marble façades and columns from Mount Hymettus, and later on from still more famous quarries, and columns from

the temporary theatres were later used in the palaces of the Roman politicians. Pliny echoes the contemporary indignation at this corrupting private luxury. The climax of all this short-lived magnificence – the Romans outdid the luxury of the Campanians and Greeks in the first century – was the theatre erected by M. Scaurus during his aedileship in 58. Pliny affirms that it 'surpassed not merely those erected for a limited period but even those intended to last forever'.

Details no doubt became exaggerated and even legendary before they reached Pliny, but his description makes the main arrangement clear and shows how Roman architects enriched the stage. It is also of considerable interest for the great theatres of the Imperial Age. To understand the link between the stages of south Italy and the later splendours, it is essential to read Pliny's chapter about Scaurus's theatre, even if it is too highly coloured. Tacitus dryly remarks (*Ann.*, XIV, 21) that it was a measure of economy to build permanent theatres instead of wooden structures which had to be reared and razed, year after year.

Scaurus's stage had three storeys: the lowest was of Lucullean marble (either veneer or solid blocks), while the middle one was faced with glass mosaic and the top one with gilded plates. According to Pliny there were 360 columns in front, the lowest to be 38 feet high. For the bronze statues in the spaces between the columns, Pliny gives the fantastic number of 3,000. He also reports that the auditorium accommodated 80,000 spectators, while Pompey's theatre some ten years later had seats for only 40,000 (though the fact is that the latter had room for only about 10,000). To this we have to add the luxurious costumes of the actors, and paintings such as those in the Theatre of Claudius Pulcher. Whether the canal (*euripus*) in which a hippopotamus and five crocodiles were exhibited at the games during M. Scaurus's aedileship was part of the theatre is not certain.

The next sensational innovation seems to have been a theatre erected in 52 by C. Scribonius Curio in honour of his father's funeral. Curio, as Pliny says (XXXVI, 116–20), could not hope to outstrip Scaurus with costly embellishments, but he built two large wooden theatres close to each other, facing in opposite directions and balanced on revolving pivots. Here, as in front of the Temple of Magna Mater, we have two theatres in which performances of different plays were given simultaneously. These theatres could revolve, even with spectators remaining in their seats, so that Curio was able to convert his two theatres into an amphitheatre for gladiatorial combats. For practical reasons we must assume that this amphitheatre was round, like the Imperial amphitheatre of Lucus Feroniae, or the cistern represented in the Egyptian landscape of the great mosaic at Praeneste. We do not know by what means it was rotated and thus have the same problem as with the main, circular banqueting hall in Nero's Golden House, which, according to Suetonius (*Nero*, 31), revolved constantly night and day. According to Pliny, the device put Curio's spectators in as great danger as the gladiators. When the pivots wore out, he kept the amphitheatre and re-erected in it two stages, back to back. They could then be moved aside to make room for the gladiators. As in the case of some of the theatres, Curio's amphitheatre was built on flat ground with free-standing spectators' seating which had to be wholly constructed.[76]

The amphitheatre at Pompeii, built by two Roman magistrates (*duoviri*) for the veterans of the Colonia Cornelia Veneria after 80, shows us how early amphitheatres were constructed (Plate 99). They did not yet have subterranean quarters for the gladiators, animals, equipment, etc. Like the later and more famous ones, this first-known amphitheatre was oval. It measured 500 by 350 feet (150 by 105 m.) and could hold some 20,000 spectators. To start with, the spectators evidently sat either on earthen slopes or on artificial embankments converging towards the arena, with or without wooden benches. The mass of earth – as in the theatre of Pietrabbondante – was surrounded by a broad structure of concrete, covered by opus incertum and strengthened by buttresses joined by arches. This is one of the most impressive plain arcaded façades in Italy. Stone seats were added later. The two lower rows – evidently reserved for magistrates, etc. – were accessible from a corridor which was built on the level of the arena and had special entrances. The two main entrances to the arena were on the main north-east–south-west axis; the latter was blocked by the city wall, but was reached by a corridor from the west façade. Two great double staircases outside the west side of the amphitheatre and single outside staircases towards the northern and southern ends of the structure led to the top of the galleries – in striking contrast to the inner entrances to the cavea of the theatres and amphitheatres of the Imperial Age. Below the central double staircase on the west side was a narrow passage, which has been explained as a reserved entrance for the magistrate in charge of the games or as a gate of Libitina, the goddess of corpses, through which dead gladiators were carried out. The sectors of seats were divided into three tiers, the uppermost perhaps for women. The upper terrace as we see it, with arched boxes, was evidently of later construction, for its building material is different from that of the lower parts of the façade. A parapet with a metal fence protected the spectators from the arena, and another parapet separated the distinguished spectators in the lower seats from the upper tiers (just as the aristocracy came to be separated from the plebs in Roman theatres). As in the theatres, awnings were stretched from poles above the whole interior.[77]

What we can trace of the first period in the theatre of Pompeii and see in the Roman amphitheatre of Sulla's Colonia Cornelia Veneria is obviously important for a full understanding of some of the greatest Roman architectural creations: the great theatres and amphitheatres of the Imperial Age. They reveal formative and creative traditions stemming from south Italy and from the great permanent hellenistic theatres with their pedigree going back to the sixth century, and their encounter with the social and political conditions of Rome and the demands of Roman taste, as well as from the temporary wooden theatres in Rome.

From these early attempts of a temporary character – an outburst of a *nouveau riche* passion for show – it is a far cry to the first great permanent theatre in Rome, the Theatre of Pompey, and also to the two slightly earlier theatres at Pompeii (as remodelled for the Roman colonia), the theatres of the Latin sanctuaries, and the contemporary theatre of Alba Fucens. In them the low, wide stage and the cavea became a unified block, in contrast to the Greek theatres with their open side entrances to the orchestra (*parodoi*), right and left of the stage. Instead, barrel-vaulted entrances to the semicircular orchestra

(*confornicationes*) were built on both sides. Rows of seats continued above the barrel-vaults, exactly as Vitruvius prescribes; this innovation can be seen in the theatre at Pompeii as rebuilt to serve the Roman colony. At this time it received a low Roman stage, and also a curious circular water basin in the orchestra with a diameter of 23 feet (7·10 m.), whose use has been much discussed. Most likely the water was introduced for performances by nude pantomimists. It could hardly have been used in the orchestras of Roman theatres, where the senators had reserved seats. There was an extensive restoration of the theatre in Augustan times, but the stage took its final form only after the earthquake of A.D. 63. During the Augustan period a covered corridor (*crypta*) with six doors (*vomitoria*), leading to the six staircases between the five sectors (*cunei*) of the cavea,[78] was built above the cavea.

Together with the amphitheatre, the small Roofed Theatre at Pompeii is, together with the theatre-temples, the earliest complete archaeological evidence of the permanent achievements of Roman architects (such as Valerius of Ostia) during the two hundred years or so of temporary theatres. This *Theatrum Tectum* (to use the name given to it in the dedicatory inscription) was built at the expense of the same Roman magistrates who constructed the amphitheatre for the Roman colonia. It was a concert hall for music and recitation, added to the enlarged and modernized great theatre on the east side of its stage. Thus Roman Pompeii received what Statius in his *Silvae* (III, 5. 91) describes from Naples: a great group consisting of an open and a covered theatre. The hall had a wooden roof without supports. This was one of the great prides of Imperial Rome, and the Theatrum Tectum is the first specimen known to us of that daring construction. The theatre is of concrete, surrounded by a rectangular outer wall and faced with opus incertum which has strengthening additions of tiles and tends towards being reticulate. The high walls slice the cavea to right and left. The back corners of the rectangular building were used for entrances, in addition to semicircular stairs right and left of the seats round the orchestra. Calculated to hold an audience of 1,500, the five sectors of seats and their passageways were not interrupted by cross aisles (*praecinctiones*). As in the remodelled larger theatre, vaulted entrances (*confornicationes*) lead to the orchestra; above them were platforms (*tribunalia*) and behind them three rows of seats. The stage was low and wide.

The theatre of Alba Fucens belongs to the same epoch. It was enlarged in Early Imperial times, and only some parts of its cavea remain. Most of the seats rested upon the living rock of the Pettorino Hill east of the town, but the north-west side of the cavea was completed by a structure of concrete. The ends of the tiers of seats were supported by grandiose terrace walls (*analemmata*) of polygonal work. In front of them was a portico leading to the side entrances (*parodoi*), which otherwise were open, as in Greek theatres. There are no confornicationes, and the theatre of Alba Fucens was thus not, in the Roman way, united to a great block comprising stage-house, stage, and cavea. We meet the same arrangement in the plan of Pompey's theatre on the Forma Urbis. On the stage are pits for movable scaffolding, but behind its low and wide platform only vestiges of the stage-house remain. The portico and a short cross street connected the theatre with the eastern main street of Alba Fucens, the Via dei

Pilastri, and with the Temple and Portico of Hercules on the other side (Figure 70).[79]

The final summing-up of this stage of Roman theatrical architecture is the Theatre of Pompey, built during Pompey's second consulship in 55 B.C. and dedicated in 52. We know this revolutionary structure from the plan on the Forma Urbis, numerous literary sources, the considerable remains of the substructure of the cavea, which was built in concrete covered by reticulate, and other parts of the great group on the Campus Martius.[80] Tacitus (*Ann.*, XIII, 54) tells us of the barbarians who visited Rome in Nero's time and were guided to 'the usual places shown to barbarians, among them the Theatre of Pompey'. To Nero, who on one occasion gilded the whole façade, it seemed small, especially compared with the gilded façade of his Domus Aurea; but Dio Cassius (XXXIX, 38) affirms that the Romans took pride in the theatre even in his time, and Ammianus Marcellinus mentions it as one of the great monuments of fourth-century Rome (XVI, 10. 14). It was variously referred to as 'the marble theatre', 'the great theatre', and sometimes simply as 'the theatre'.

The plan on the Forma Urbis, dated between A.D. 203 and 211, reveals the same arrangement as the theatre of Alba Fucens: a low, wide stage, open parodoi with porticoes, and a semicircular orchestra. To begin with the stage-house was probably wooden, but Pliny mentions that it held copies of celebrated sculptures of high quality and that around it were statues from fourteen nations. As in the theatre at Pompeii, there was a great rectangular peristyle behind the stage-house with roomy recesses (*exhedrae spatiosae*) provided with seats for philosophers, etc., in conformity with Vitruvius's rules (V, 9; 11. 2). The senate was probably assembled in one of these *exhedrae*, which contained a statue of Pompey, or perhaps in some other hall connected with the peristyle, on the occasion when Caesar was murdered.[81] An important novelty was that the entrances were no longer external but placed inside, as in the later theatres and amphitheatres of the Imperial Age; we do not know whether this reflected the arrangements in the wooden theatres or was a new architectural scheme.

In contrast to the rectangular building of the small theatre at Pompeii, the façade of Pompey's theatre followed the curved outline of the cavea. Our sources praise especially the fact that Pompey placed a shrine of Venus above the cavea, and that the steps to it served as a most monumental ascent to that temple. It was said that Pompey did this to disarm opposition to the permanent theatre as such, and indeed in his public invitation to the dedication he announced it not as a theatre but as a Temple of Venus, 'under which we have placed steps for spectators of shows'. On top of the cavea there were other shrines of Honor, Virtus, Felicitas, and one more goddess.[82]

Plutarch (*Pompey*, 42, 4) says that Pompey very much admired the theatre of Mitylene and 'had a model of it made, intending to erect one in Rome to the same design, but larger and more magnificent'. There has been much speculation about this statement and about what Pompey actually took over. It should certainly be kept in mind that all the main features of Pompey's theatre agree with what the Romans and Campanians had already achieved from the third century onwards in their adaptation of Greek features. Thus, for example, the concave or amphitheatrical comitia (Figure 69), with a curia on the central axis on top of the stairs, shows the same disposition as the

Theatre of Pompey. The theatre-temples of Gabii, Praeneste, Tivoli, and Pietrabbondante afford equally striking parallels.[83]

UTILITARIAN ARCHITECTURE

To turn now to utilitarian architecture, one must first of all recall the Porticus Aemilia (see p. 107; Figure 62) on the quay of the Tiber, south of the Aventine. Behind, warehouses – granaries – were built by Servius Sulpicius Galba, who was consul in 108 B.C. Evidently Rome adopted the system of the hellenistic world known from Rhodes, where, according to Strabo (XIV, 2. 5), the people were supplied with provisions and the needy supported by the well-to-do. As early as the fifth and fourth centuries, and long before any far-reaching Mediterranean trade had started, our sources repeatedly tell us about supplies of corn and food from Sicily, Cumae, and the Etruscan coastal towns that were brought to Rome in river-boats via the Tiber, or from Ostia. Famine threatened if the Tiber became unnavigable, if internal strife hampered agriculture, or if the magistrates lacked proper care. It is evident that some kind of granaries became necessary along the riverside long before these. The Romans ascribed the Columna Minucia (above, p. 80), which was erected somewhere outside the Porta Trigemina in the south-western part of the great city wall of 378 B.C., to Lucius Minucius, a magistrate who in 439 B.C. was in charge of the provision of Rome's grain and food, and who took possession of the stores brought to the town by the demagogue Maelius and distributed them on easy terms to the people. This tale, legendary or not, attests that the surroundings of Galba's granary were thought of as an early centre for the import of victuals. Horrea publica are known to us only from the Imperial Age; Late Republican horrea may have been walled and citadel-like, like the granaries of Syracuse, and they probably had courtyards surrounded by storage rooms of the same type as the tabernae. All the horrea of Imperial Rome exhibit such a plan, and the markets of hellenistic towns seem to have been the origin. In the Near East the tradition has lived on through the centuries in caravanserais (khans).[84]

Strabo, with Greek towns and their harbours in mind, notes (V, 3. 5) with amazement that the port-town of Rome was 'harbourless on account of the silting up'. The merchant ships anchored outside the mouth of the Tiber at Ostia. Tenders then took their cargoes, brought them to the riverside harbours of Rome, and took back cargoes in exchange; or they relieved the overseas ships of part of their cargo so that they could be towed to Rome. In other words, Ostia had only an old-fashioned river harbour like those along the Laurentine and Rutulian coast, from which the new commercial centre took over the legend of Aeneas. The need for granaries, etc., at Ostia for its own consumption and for temporary storage was probably met by wooden warehouses on the riverside east of the castrum and north of the decumanus (Figure 54), which was vacant until the first century B.C. In the second half of the century, rows of tabernae in reticulate (the so-called Magazzini Repubblicani), surrounded by porticoes with tufa piers, were built on the north side of the decumanus, towards the north gate of Ostia's city wall.[85]

As seen in the Hercules Victor terrace at Tivoli (p. 140), streets lined with shops were sometimes united in a way that suggests a shopping centre and are reminiscent of the tunnels of tent-makers and saddlers in the old bazaars of Aleppo. Buttressing the citadels of Ferentinum and Tibur (Tivoli) are warehouses of concrete, dating from about 100 B.C. and faced with opus incertum. They had high, broad barrel-vaulted corridors running transversely from the streets towards the hillsides (Plate 98), and they recall the stone-built barrel-vaulted structures, on which a great podium was raised, that Herod built at Caesarea Maritima in Palestine. The latter were probably warehouses too, but the warehouses at Ferentinum and Tivoli were more accomplished and had a row of five shops along one side. At Ferentinum these tabernae are barrel-vaulted. The floor of the 'nave' in front of them rises by low and broad steps towards its inner end. The entrance was about 26 feet high. The Tivoli warehouse is more elegant, and, moreover, the height of the entrance was about 30 feet, and that of the first shop inside the entrance arch some 35 feet. The first two shops have high barrel-vaults, and the three inner ones are covered by apsidal vaults.[86] It seems evident that the souks, warehouses, and covered streets of the Orient served as models, but concrete and vaulting made it possible for the Roman builders to develop the borrowed ideas in a new and monumental way. The architectural tradition stemming from these Late Republican innovations was evidently an inspiring factor when, in the second century A.D., the monumental warehouses were built outside the Forum of Trajan and at Ostia.

As the lofty entrances to the warehouses of Tivoli and Ferentinum show, in the last centuries B.C. arches became the rule for city gates, façades with or without flanking columns, archivolts, and springing arches (so-called 'frontoni siriani') above the entrance to porticoes as well as for fornices, heralding the triumphal arches of the Empire. They are also a most important part of utilitarian architecture. In 179 the Pons Aemilius in Rome was equipped with stone-built piers of tufa ashlar work supporting a wooden bridge; Livy (XL, 51. 4) reports that the censors of 142 built arches (fornices) on these supports. Later, in 62, the magistrate in charge of roads, L. Fabricius, built the beautiful Pons Fabricius between the left bank of the Tiber and the Tiber island. It was constructed of tufa ashlar blocks faced with travertine. In 109 the Pons Mulvius (Ponte Molle) of 220 on the Via Flaminia north-west of Rome was replaced by a bridge of tufa ashlar with arches of travertine – part of which can still be seen in the present bridge. Livy (XLI, 27. 5) relates that the censors of 174, when re-ordering the roads outside Rome with gravel and footpaths, also built bridges, and these were probably arched. Beautiful early examples are the bridge on the Via Amerina, constructed in the third century (Figure 58), and the old, low one below the Ponte di Nona on the Via Praenestina.[87]

The arch also revolutionized a field of utilitarian architecture where even a Greek like Strabo (V, 3. 8) admits that the Romans were outstanding: aqueducts and sewers. Marzabotto shows how the Etruscans solved the problem of sewerage by channels covered by slabs. We have seen that the largest of the Roman sewers, the Cloaca Maxima – originally a stream running obliquely through the forum – was probably an open channel still in the second century, at least on the forum. Otherwise, the sewers may have been more or less similar to those of Marzabotto. In any case, at the end of the

second century the Cloaca Maxima was vaulted with close-fitting stones (Strabo, *loc. cit.*) and widened. Strabo writes that 'sewers in some places were roomy enough even for wagons loaded with hay to pass through them'. Perhaps that was due to reconstructions during the Augustan Age, but parts of vaults survive which must be much older than that; for example, the three concentric arches at the mouth of the Cloaca Maxima on the left bank of the Tiber opposite the island (to judge from the material) must be dated as early as about 100 B.C., though some attribute them to Agrippa.[88]

The first aqueduct built by the Romans was the Appia of 312 B.C. The channel was almost entirely subterranean, like that of its successor Anio Vetus of 272. After countless centuries with the provision of water by the Tiber and by wells, and after the great, though primitive, undertaking of Appius Claudius, the great revolution in this field was the Aqua Marcia, built in 144–140 by Quintus Marcius Rex. The channel (*specus*) was lined with a thick cement of lime and pounded terracotta, and, like the Etruscan sewers, covered by slabs. Since the flow of the current was carefully calculated, it brought a constant stream of water into the town. It was carried by arches, which starts one of the greatest architectural traditions of Imperial Rome. The arches and their piers were built of tufa ashlar, a proof of how the Romans trusted their various tufas and also of how ingeniously they economized by using especially strong blocks only where they were needed, and cheaper kinds where they were not. This is typical for the Late Republican centuries. Frontinus, in his famous books on the aqueducts of Rome, in discussing the Marcia (7, 8, 91, 92, and *passim*) tells us that when the officials in charge of the Sibylline books were consulting them for another purpose, they discovered that the water from the River Anio, which furnished the Marcia with water, ought not to be brought to the Capitol. Marcius Rex's influence overcame these scruples, but the episode indicates that the new high aqueducts were felt to have broken the continuity of time-honoured traditions.[89] This is one of the most impressive instances of the clash between old Roman habits and new structural ideas.

TOMBS AND CEMETERIES

Something of the contest between ancient traditions and Etruscan and hellenistic influences appears also in the Roman cemeteries. The tomb of the Scipiones has already shown us a chamber tomb in Rome of the Etruscan type. It was enlarged in the second century and embellished by the great sarcophagus of the consul of 298, L. Cornelius Scipio Barbatus. It displays a mixture of elements of the Doric and Ionic styles which is characteristic of the second century. Of the same time is the present main façade of the tomb, facing a cross-road between the Via Appia and the Via Latina. It consists of a high podium, crowned by a heavy, moulded cornice. Above was a wall of ashlar with demi-columns of tufa (peperino); only a piece of the wall and the base of one Attic-Ionic column are preserved. To the right of the original rock-cut door of the podium is an arched entrance of tufa blocks (Anio tufa) which leads to an added gallery. The podium was once decorated with a historical painting, but was covered by plain paint

both before and after that decoration. While the façade of the Scipiones is typical of stuccoed and painted Roman architecture, the rock-cut chamber tomb of the Sempronii on the slope of the Quirinal has an elegant travertine façade with an arched entrance through a high podium, crowned by a delightful floral frieze and dentils under the moulding of the cornice.

Tomb chambers of tufa ashlar have been excavated on the Esquiline. A much-discussed historical painting in one of them represents a transaction between a Roman general and probably an enemy and is generally dated to the late third or early second century. In the Via di S. Croce in Gerusalemme, south-east of Republican Rome, are chamber tombs with plain façades of tufa ashlar, built by well-to-do freedmen of noble Roman families. One is decorated with sculptured shields, as were the halls of archaic Etruscan tombs and as is seen in Roman architecture through the centuries. Above the doors of two others were travertine slabs with portraits in niches, characteristic of the Roman realistic portraits of people of all classes, but probably resembling the cupboards in the atria of the aristocracy in which death masks were kept. On the one hand these middle-class tombs recall Etruscan grave-streets as seen in sixth-century Orvieto (Plate 27); on the other, they are the predecessors of the endless rows of small tomb-houses outside towns of the Imperial Age.[90]

In one of his Satires (I, 8), Horace describes a burial place for paupers outside the agger of the Servian Wall, before Maecenas laid out his gardens, 'where of late one sadly looked out on ground ghastly with bleaching bones'. This was a cemetery for inhumation tombs to which slaves carried their fellows' corpses, cast out from narrow dwellings. The graves between the tomb-houses of the middle class in the cemetery of Isola Sacra between Ostia and the Imperial harbours, which are marked only by amphorae or concrete covers, show a considerable improvement on the former inhumation graves of the proletariat. Burials of this kind probably also took place outside the densely occupied areas of Imperial Age tomb-houses. Perhaps a martyr such as St Peter was buried in such a place.

Although influences from the East may have contributed to the establishment of the vast system of Jewish and Christian catacombs in Imperial Rome, one should remember that as early as Late Republican times chamber tombs could be enlarged to galleries with tiers of coffin-like recesses for inhumation. A subterranean rock-cut tomb north-west of Antium has three galleries connected by a vestibule. Along the side walls are table tombs (loculi) in two or three storeys, closed by tiles (or in one case tiles and a marble slab) as in the catacombs.

In the last centuries B.C. cremation became the prevailing form of burial. Rectangular enclosures were surrounded by 6- or 7-foot-high concrete walls. As there are no entrances, they must have been entered by ladders. The finds prove that funeral pyres for burning corpses were lit in these busta, and that the urns containing the ashes could be buried there. Sometimes there is also an added enclosure for the pyre, an ustrinum. Niches in the walls for urns were added to the busta later – no doubt the origin of the columbaria of the Augustan Age. Enclosures of this kind, from the very end of the Late Republican Age and Early Imperial times, have been excavated in a cemetery outside

the Porta Laurentina of Ostia, among the crowded burial grounds north of St Peter's (below the present car park), and among the graves round S. Paolo fuori le Mura.[91]

Associated with the cremation tombs are the most conspicuous and typical burials of the age: the monuments in the hellenistic style which were aligned along the roads outside the city gates, as can still be seen among the Imperial tombs of the Via Appia. The surroundings of Pompeii display this new and charming feature of the towns. Such monuments were erected by wealthy and cultivated citizens and became the fashion. To this day they bring us personal messages from the Pompeians and their hellenistic culture as we approach or leave their towns. A tombstone of a Vestal Virgin on one of the green banks of the Anio at Tibur (Tivoli) and Lydia's injunctions, preserved in a delightful poem by Propertius (IV, 7. 81 f.) composed the night after she had been cremated, prove that tombstones were also erected where rivers entered towns:

> Where fruitful Anio broods among its branchy fields, . . .
> There on a pillar write a phrase worthy of me,
> But short, to catch the Roman traveller's eye:
> Here in the earth of Tiber golden Cynthia lies,
> A glory added, Anio, to your banks.[92]
>
> (Gilbert Highet's translation)

Between the Porticus Aemilia on the Tiber and the horrea of Galba was erected a tomb for S. Sulpicius Galba, the consul of 108 (Plate 101). It is a quadrangular monument of Monte Verde tufa with an inscription tablet of travertine. The preserved lower part of the monument rests upon a substructure of two courses of tufa blocks with a moulded cornice, and was decorated by ten fasces, five on each side of the inscription. Nothing remains of the structure which crowned the tomb. The tomb of the Sempronii (see above, p. 176) should also be mentioned once more in this connexion.

Two Roman tombs outside Agrigento, dating from the beginning of the first century, give us a full impression of the elegant new style of repositories for urns. In these two the structures above the high podia are preserved and prove clearly the dependence of these podium tombs on the hellenistic architecture of Asia Minor. In the 'Oratory of Phalaris' a low podium containing the tomb chamber supports a small prostyle tetrastyle Ionic temple with a Doric entablature, used for the memorial services. The 'Tomb of Theron' (Plate 100) is a quadrangular cella raised above a high podium with a heavy moulded cornice containing the tomb chamber. The Doric entablature of the cella rests on Ionic columns at each of the four corners of the small building. On all four walls are elegant blind doors. Clearly this kind of tomb had no relation to indigenous Italic burial traditions.

Contemporary with these tombs and closely related to them is the tomb of C. Publicius Bibulus outside a gate of the Servian Wall in front of the northern slope of the Capitoline Hill (Plate 102). It was an oblong, rectangular tufa structure with a façade of travertine, oriented southwards. The inscription towards the street outside the gate testifies that it was erected by the Senate 'honoris virtutisque causa'. The building above the podium seems to have been a small temple in antis with a narrow prodomus

resembling the 'Oratorio di Falaride'. In the centre of the north-west side is a fairly wide door, where perhaps a statue was placed. Right and left of this door and at the corners of the back wall are Tuscan pilasters. Resting on them is the architrave and a frieze with garlands hanging from bucrania and decorated also by libation bowls above the garlands. Between the pilasters were tablets with a protecting cornice above, probably intended for painted decoration, as in the great basilica of Praeneste (Plate 87). Though this monument has some Roman flavour, the general hellenistic character is obvious.

Altogether hellenistic is the charming Tomb of the Garlands (La Tomba delle Ghirlande), one of the monuments outside the Porta Ercolano on the western side of Pompeii. It is all ashlar work. Upon a low podium the tomb is raised, rectangular in shape, probably containing a cella for the urn. The wall is decorated by elegant short flat pilasters with garlands between them.[93] The hellenistic tombs on the Via Appia also remain.

Tombs of a different kind adorn the Via Appia outside the great wall which connects the town of Terracina with the castrum on the Hill of Jupiter Anxur. They are constructed of coarse concrete covered by opus incertum, which, as always, was once stuccoed and painted. The tomb chambers have their façades towards the Via Appia. Above a podium crowned by a cornice stands the monument. It has semi-columns at the corners, of baked brick, like the strengthening layers which Vitruvius describes. The bases of the semi-columns and the quoins of the podium are of stone. These façades were probably crowned by a tympanum, and suggested a prostyle temple cella with two columns in the pronaus.[94]

Occasionally tombs now also show romantic historical associations, a caprice which, however, became more popular only in Imperial times. Pyramids, for example, as tombs in cemeteries and references in poetry prove, became fashionable in Augustan times. A corbelled tholos tomb outside Cumae, generally dated to the third century but very likely later, seems to be an archaistic imitation of Bronze Age Greek beehive tombs. One of these, as we know from Pausanias (II, 16. 6), the so-called 'Treasury of Atreus', remained famous and was visited in Roman times. The Italian imitation has a dome with straight walls resting upon a high dado with moulded cornice.[95]

It has already been mentioned (p. 78) that Etruscan tombs with a central column supporting the apex of a vault or rock-cut ceiling inspired Late Republican builders. That seems clearly to be the case also with regard to the tomb which Pliny (XXXVI, 91) describes when he speaks of the tomb of King Porsenna at Chiusi. A tomb of the Imperial Age on the Via Appia outside Ariccia displays all the most characteristic features of the early model. But, while such fancies remained rare, the old Etruscan and Latin mounds had a renaissance of great importance and long duration all over the Empire. How far they surpassed their Etruscan prototypes in monumental height and grandeur is manifested by the mausolea of Augustus and Hadrian, or – to adduce an example from the provinces – the 'Tombeau de la Chrétienne' in Numidia. This predilection for the tombs of the *atavi reges* (to use Horace's phrase from his first ode) had begun already in a more modest and genuinely Etruscan way in Late Republican times. On the Via Appia some five miles south of Rome are two mounds showing the most patent Etruscan

ancestry, the Tombs of the Orazi or of the Orazi and Curiazi (Plate 103). The northern-most is pre-Augustan and stands, as far as our knowledge goes, at the beginning of the series. Like all the smaller Etruscan mounds of the sixth and fifth centuries, the Roman tumuli have the tomb-chambers in the centre, accessible by a dromos. The podium is reminiscent of the Etruscan rock-cut podia (Plate 15), but was built up with a façade of tufa ashlars, backed up by internal semicircular supporting walls. On top of the podium, round the lowest part of the mound, small upright stone slabs seem to have been arranged. Strict axiality and the height and monumentality of the podia became more and more accentuated later on, and constituted a difference between the colossal Roman tombs and the greatest old Etruscan mounds – especially those with scattered chambers; but the beginnings show the closest affinity with what could be seen in so many places between the Tiber and the Arno, and in Latium as well.[96]

CONCLUSION

Rarely does the beginning of a new epoch stand out as clearly as does the Age of Caesar and Augustus – in contemporary testimonies, in art, in the whole political system, and also in architecture, as the *nova magnificentia* (Livy, I, 55. 9; 56. 2) and a severely classical style broke with the freer architectural decoration in the Greek style as it had characterized the last century of the Republic and the time of Caesar. The marble of Luna (Carrara) was discovered, or, in any case, first fully exploited; it was easy to export, since the quarries stood above the harbours of Luna, and the cargoes could be conveyed to Rome on the Tiber. Strabo tells us that marble from Luna, mono-lithic slabs and columns, became used for superior work of all kinds, both in Rome and in other towns.[97] The final victory of marble in all public buildings, the perfect Augustan reticulate, and many distinctive external features mark this new start in Roman archi-tecture. Vitruvius comments bitterly upon the innovators: yet he himself was tireless in drawing up rules for achieving a purified style in the new public buildings and for expressing in them the authority sought by Augustus. Like Caesar before him, Augustus aimed in this way at revealing the greatness of Rome's finally stabilized power by his modernized Rome. Yet the great new programme of the city of Rome was mainly a new, more splendid, classicized version of the hellenized Late Republican town, described by Vitruvius in his fifth book. As Pliny points out (XXXIII, 151, and *passim*), the new luxury was inspired by hellenistic splendour; but no one can understand the leading architectural devices of Augustan and Early Imperial Rome who does not keep in mind that they enshrined the traditions of some six centuries. These centuries began with the great Etruscan architecture of the seventh and sixth centuries and the early Roman version of it, at a time when Rome became a forceful, more independent branch of the Etruscan culture of central Italy. In the course of increasing commerce with the Greek towns, both the Etruscans and the Romans created their own architectural dialect and their own patterns for towns, to be remembered beside the great Greek solutions: the Homeric and Archaic towns, which inspired the early Etruscans, and the classical and

hellenistic towns, which had such world-wide influence. Cicero once wrote to Atticus (XIII, 35) that he thought it scandalous that Caesar, wishing to enlarge Rome, should summon a Greek architect, who 'two years before' had never even seen the city: 'O rem indignam.'

Examining Late Republican Rome, one sees everywhere that the starting-points for Imperial development were principally the hellenized Roman features analysed in this chapter, and that it was not a question of making direct copies of contemporary hellenistic architecture. The monumental axiality which we see at Praeneste, at Tibur, at Terracina, had acquired its own characteristics; in its Roman shape it now became the guide for the builders of the Imperial fora, the thermae, and almost all the monumental architecture of the Empire. No less decisive for the future was the combination of Greek, Etruscan, and Italic idioms in the temples and in various types of upper-class houses. Theatres and tenement houses were left to the Augustan architect to perfect, but the principles were already in existence, as were also the use of concrete, vaulting, warehouses, paved streets, high aqueducts on arches, and vaulted sewers in their improved Roman shape.

The inner propylaea of Eleusis, built by Appius Claudius Pulcher about 50 B.C., and, among other Roman architectural achievements, the capitolia and the axiality created by the odeion in the agora in Athens, prove that the Roman variety of hellenistic architecture had made its way in the Eastern world even before Imperial times. It is most illuminating to read the comments of Strabo (XVII, 1. 10) on the suburb of Nicopolis, outside Alexandria,[98] and its Roman architecture of Caesar's time, which even in a centre such as the capital of the Ptolemies already surpassed the hellenistic buildings. He mentions especially an amphitheatre and a circus (*stadium*), and here we should again remember the amphitheatrical cistern in the Egyptian landscape of the Praeneste mosaic.

Behind all this architectural progress, we must recall Vitruvius, brooding over the perfect styles of building, and affirming in the introduction to his seventh book the great knowledge of Roman architects of the Late Republican Age. This is his comment on an early-first-century temple in Rome: 'If it had been of marble, so that besides the refinement of art it possessed the dignity which comes from magnificence and great outlay, it would be reckoned among the first and greatest works of architecture.'

PART TWO

ARCHITECTURE IN ROME AND ITALY FROM AUGUSTUS TO THE MID THIRD CENTURY

BY

J. B. WARD-PERKINS

AUGUSTAN ROME

In 44 B.C. the murder of Caesar plunged the Roman world into the last and bloodiest of the civil wars that had bedevilled the last century of the Republic. It was not until thirteen years later, in 31, that the defeat of Antony and Cleopatra left as undisputed ruler of the Roman world Caesar's nephew and heir, Caesar Octavian, and indeed four years later still, in 27, that Octavian was granted the title of Augustus and his position formally established upon an effective, if not yet explicitly acknowledged, basis of individual personal rule. Now, for the first time within living memory, the civilized world was able to draw breath and to profit from a long period of internal peace and stable government. Now, at last, the immense energies and creative potentialities of the Rome of Sulla and Cicero, Pompey and Caesar could find a constructive outlet in the ordering and developing of the Empire of which she suddenly found herself the undisputed centre and mistress.

One of the first beneficiaries of the new situation was the city of Rome itself. It was Augustus's boast that he 'found Rome a city of brick and left it a city of marble', and in his autobiographical testament, the *Res Gestae Divi Augusti*, we have in his own words a list of the public monuments in Rome which he claimed to have built or restored.[1] When one recalls that this list makes no mention of the many important buildings created in the capital on the initiative of other magistrates or wealthy private citizens, it is indeed an impressive document; and since through all its many vicissitudes the subsequent architectural development of the city during the Empire took place very largely within the framework established by Augustus, it is with the Augustan city and its buildings that any study of the Roman architecture of the Imperial Age is bound to start.

We do not lack for information. The record of building activity in the capital between the death of Caesar and that of Augustus in A.D. 14 is almost embarrassingly full by comparison with the number of surviving monuments. To follow it up in all its detail would be to compile a list of buildings about many of which we know virtually nothing except the fact and circumstances of their erection. Nevertheless it is important to have some idea of the extent and character of the building programme as a whole. One of the most striking characteristics of the surviving Augustan buildings is their variety; and although this may be explained in part as the product of an age in rapid transition, it was undoubtedly accentuated by the legacy of the recent past, by the diversity of patronage in its early, formative stages, and by the very size of a programme that could only be carried out by pressing into service all the very varied resources available. These have left their mark upon the surviving buildings; and before turning to the latter, it is essential first to glance at the historical record.

One very important factor in shaping the early development of Augustan architecture

was the legacy of ideas and of uncompleted buildings inherited from Julius Caesar, at the vigour and versatility of whose vision one cannot cease to marvel. His was the grandiose conception of replanning the city on the partial basis of which Augustus, through Agrippa, laid out large parts of the Campus Martius and himself remodelled the ancient centre of the Forum Romanum; his were the first plans for the Saepta and the Theatre of Marcellus, the Curia, the two basilicas in the forum, and the Rostra; it is in his buildings that we find the first consistent use of the mortar made with red pozzolana which was to revolutionize Roman building practice; and it is almost certain that it was he who first envisaged the hardly less revolutionary innovation of the large-scale exploitation of the quarries of Carrara (Luni). It is characteristic of the sober genius of Augustus that he recognized the significance of the programme of his brilliant predecessor, and that he was able to put so much of it into practice.

Another important legacy from the preceding age was the tradition whereby triumphing generals were expected to contribute to the public welfare by devoting a part of the booty from their campaigns to building. Several of the most important works of Augustus himself and of his successor, Tiberius, are recorded as having been paid for *ex manubiis* (i.e. from spoils of war); and many of the buildings in the period immediately following the death of Caesar were in fact the work of public-spirited or politically ambitious private individuals. In an age when the tastes of the patron were still an important factor, this circumstance alone would have been enough to ensure a considerable stylistic variety. Recorded examples of such private munificence include a temple of Neptune in the Circus Flaminius, vowed in 42 B.C. by L. Domitius Aheno-barbus, a follower of Brutus and later of Antony, and built probably in 33 B.C.; the restoration of the very ancient shrine of Diana on the Aventine by L. Cornificius at some date after 33 B.C.; the Amphitheatre of Statilius Taurus in the Campus Martius, dedicated in 30 B.C. and the first stone amphitheatre in the capital; the Porticus Philippi and the Temple of Hercules Musarum, built by L. Marcius Philippus in the late thirties or early twenties; the Atrium Libertatis, built after 39 B.C. by C. Asinius Pollio, another friend of Antony, to house the first public library in Rome; and, one of the last of these great private benefactions, the Theatre of Balbus, built by L. Cornelius Balbus and dedicated in 13 B.C. Of none of these, except for traces of the Theatre of Balbus beneath the Palazzo Caetani and possibly of the Temple of Neptune, are there any identifiable remains, although the plans of several are known from the Severan marble map of Rome (Plate 145).[2]

Other Augustan buildings have been more fortunate. Enough remains, for example, of the restoration of the Temple of Saturn in the Forum Romanum undertaken, probably in the early twenties, by L. Munatius Plancus to show that it was built partly of Italian marble; the surviving column bases are of an unusual hybrid form, which probably represents an early attempt at translating into the new medium a type that was current in Late Republican Rome. The Regia, the official residence of the Pontifex Maximus, restored after a fire by Cn. Domitius Calvinus in 36 B.C., is another early marble building of which the carved detail betrays the inexperience of the masons engaged upon it. By contrast, the Temple of Apollo in Circo (sometimes known as the

Temple of Apollo Sosianus, after its founder, C. Sosius) is a building of considerable technical refinement. The elaborately carved detail (Plate 110) closely resembles that of the arch erected in the forum in 19 B.C. in honour of Augustus's diplomatic victory over the Parthians, with which it must be roughly contemporary. The gulf that separates the elegant, sophisticated work on this temple from that of the Regia or the Temple of Divus Julius, dedicated in 29 B.C., is the measure of the variety which was possible even in this early phase, and which was to provide the ferment for so much of the later Augustan achievement.[3]

After Augustus himself, the great builder of the first half of his reign was his friend and collaborator, Marcus Agrippa, whom we find already in 33 B.C. engaged upon the programme of public works with which he was to be concerned off and on until his death in 12 B.C.[4] A great deal of his work was of a strictly practical, utilitarian character. Under his direction the whole drainage system of the city was overhauled and renovated; the retaining walls of the Tiber were repaired against flooding and a new bridge, the Pons Agrippae, added; a fine new warehouse, the Horrea Agrippiana, was built beside the Vicus Tuscus, between the Forum Romanum and the riverside wharves of the Forum Holitorium; and the city's water supply was doubled by the radical restoration and enlargement of the four existing aqueducts and by the addition, by Agrippa and after his death by Augustus himself, of no less than three that were new, the Aqua Julia in 33 B.C., the Aqua Virgo in 19 B.C., and the Aqua Alsietina in 2 B.C. Not much of Agrippa's own work has survived the repairs and restorations of the centuries. It remained, however, the basis of almost all subsequent work in these fields, and an interesting record of a slightly later phase of the same programme can be seen in the still-surviving arch which carried the restored Aqua Marcia (5 B.C.) over the Via Tiburtina, and which was later incorporated into the third-century walls as one of the city gates (Plate 120). Built throughout of travertine, it is a characteristically Augustan monument, in its material and detail still firmly rooted in the practices of the later Republic, but formally, with its archway framed by pilasters and pediment, already reaching out towards the new types of arch and gateway that were to play so large a part in the monumental architecture of the Empire.

Agrippa's activities as a builder were not by any means limited to this severely practical programme. On the level ground of the Campus Martius he built a whole new monumental quarter, which included the Saepta, the Pantheon, the Basilica Neptuni, and a bath-building, the Thermae Agrippae, laid out in a spacious setting that included gardens, porticoes, a canal, and an artificial lake. The whole area was swept by the disastrous fire of A.D. 80, and little or nothing of Agrippa's work has come down to us. The Saepta, completed in 26 B.C., is recorded as having been an enclosure with marble porticoes a mile in length. Of Agrippa's Pantheon, dedicated the following year, the core of the podium has been recognized, incorporated within the foundation of its Hadrianic successor; the plan appears to have resembled that of the Temple of Concord, with a porch which was narrower than the body of the temple behind it.[5] Of the Basilica Neptuni also dedicated in 25 B.C. we know nothing except that it was also known as the Stoa of Poseidon, and was presumably therefore a multiple columnar building, open

along one side in the manner of the Republican basilicas of the Roman forum. Of the Thermae, which were served by the Aqua Virgo and cannot therefore have been completed until after 19 B.C., enough is known to show that they merited their reputation as the first of the series of great public bath-buildings that were to play so large a part in the later development of Roman monumental architecture.

The details are scanty, but they are enough to show that Agrippa's work in Rome offers in miniature a faithful picture of the Augustan building programme as a whole in its early, formative stage. The utilitarian programme, tuned as it was to the practical requirements of daily life, was conservative in character. The sewers were built in squared stone, the aqueducts in typical contemporary concrete work, with a rather coarse facing of tufa reticulate; the bridge over the Tiber, which disappears from the record at an early date, may have been an experimental, and in the event unsuccessful, venture in the latter medium. For work of a more spectacular character we have to turn to Agrippa's monuments in the Campus Martius. The Saepta, which he inherited from Caesar, had been one of the first Roman buildings of this size, if not the very first, to be planned in marble.[6] We shall never know whether, in conceiving this grandiose project, Caesar intended from the first to make use of the marble of Carrara; but it was certainly the opening of these quarries that made this aspect of Augustus's building programme possible, and by the twenties the new material was evidently already available in large quantities. The Pantheon, too, must have been built partly at any rate in marble, and Pliny records the significant detail that the columns, presumably those of the porch, were decorated with caryatid figures by the Athenian sculptor Diogenes.[7] The influence of Athenian craftsmen is one of the continuing features of the Augustan scene, culminating in the Forum Augustum, the many classicizing Attic details of which again included caryatid figures, copied from those of the Erechtheion (Plate 108). In the case of the Pantheon we can document not only the fact but also something of the circumstances of the loan. One of the few buildings which Agrippa is known to have built outside the city of Rome is the odeion in the agora at Athens, a building which in its own way represents a no less striking convergence of Greek and Roman tastes and skills, Greek in its material, craftsmanship, and detail, Roman in its bold axial relationship to the other buildings of the agora, and perhaps also in the technical experience that devised its huge timber roof of 80 foot unsupported span. There is nothing to suggest that Cicero's correspondent, Appius Claudius Pulcher, the donor of the Inner Propylaea at Eleusis, was ever responsible personally for any public building in Rome. But it was undoubtedly enterprises such as these which afforded the background of reciprocal Graeco-Roman exchange that is so characteristic of the Augustan Age.

Of the buildings erected by Augustus himself and listed in the *Res Gestae* we are fortunate in possessing the remains of several of the most important. None is complete, and of several others, such as the temples of Divus Julius and Apollo Palatinus or the mausoleum, the surviving elements are tantalizingly fragmentary. But enough has come down to us to convey at least a partial picture of the quality as well as the mere quantity of the architecture of Augustan Rome.

The Theatre of Marcellus (Plate 105 and Figure 83) owes its preservation to its

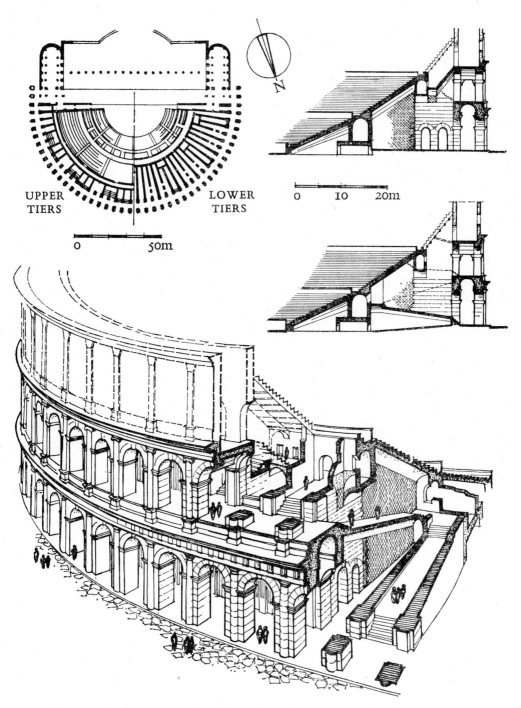

UPPER
TIERS

LOWER
TIERS

N

0 50m

0 10 20m

Figure 83. Rome, Theatre of Marcellus, dedicated in 13 or 11 B.C. (cf. Plate 105).
Plan, sections, and sectional view

conversion in the Middle Ages into a fortress, and in the sixteenth century a palace, of the Savelli family. Projected though probably not actually begun by Caesar, it was not finally completed and dedicated until 13–11 B.C. The stage-building still lies buried; to judge from its representation on the Severan marble plan of Rome it was, and remained through successive restorations, quite simple in plan, with none of the elaborate play of projecting and receding features that characterizes the stage-buildings of later practice.[8] The substructures of the seating, on the other hand, are well preserved beneath the later palace, and the curved façade, freed from later accretions and restored, is among the most impressive surviving monuments of the capital. The scheme of the façade, a system of superimposed arcades framed within the compartments of a purely decorative classical order, stems directly from the traditions of the later Republic, as represented in the great sanctuaries at Praeneste (Palestrina) and at Tivoli and, in Rome itself, in the Tabularium (Plates 84, 74, and 72). The principal advances on the earlier buildings are the use of travertine for the entire façade and the greater boldness of the rhythm of contrasting voids and solids. It has usually been assumed that the external order was triple, as later in the Colosseum. It should, however, be noted that in fact only the two lower orders, Doric and Ionic respectively, are preserved, and a recent study has suggested that the lost superstructure may have been a plain attic (as, for example, in the amphitheatre at Pola, in Istria) rather than the Corinthian order of canonical practice.

That there was a superstructure of some sort, corresponding in height approximately to the walls of the present palace (which thus presents an appearance not altogether dissimilar to that of the Roman building), is certain from the remains of the seating and of the elaborate substructures that supported it. The latter (Figure 83), built partly of cut stone and partly of reticulate-faced concrete with concrete barrel-vaults, were radially disposed, incorporating an ingeniously contrived system of ascending ramps and annular corridors for the ingress and egress of the spectators (about 11,000 according to the latest calculation), who sat in three ascending tiers of seats, each tier pitched more steeply than the one below it, and the uppermost certainly of timber. The outer corridor was vaulted with a series of radially disposed barrel-vaults carried on massive transverse architraves, one bay to each compartment of the façade, in order to counteract the outward thrust of the upper tiers of seating. The façade and outer ring of galleries were in effect as much a gigantic buttressing feature as a convenience in handling large crowds of spectators, and they demonstrate the characteristic ingenuity with which the Roman architect was prepared to turn such problems to practical advantage. While the theatre derives directly from the great Republican monuments of Latium, it looks forward no less directly to such engineering masterpieces as the Colosseum.

The Theatre of Marcellus represents a substantially pre-existing Republican tradition of building which was able to survive, with remarkably little new admixture, the impact of the Augustan Age. It was a developing tradition, but the development was in answer to new practical demands rather than to the stimulus of ready-made ideas brought from without. At the other end of the scale we have a monument such as the Ara Pacis Augustae, the Altar of the Augustan Peace, which once stood on the west side of the Via Flaminia just north of Agrippa's buildings.[9] Decreed in 13 B.C. and dedicated four

years later, it consisted of an almost square enclosure on a low platform and, on a smaller, stepped platform in the centre, the altar itself. The whole of the superstructure is of Carrara marble, and the elaborately carved detail, which includes symbolic figured panels, a long processional frieze, panels of spreading acanthus scrollwork, and a frieze of pendant garlands, is of a quality unsurpassed in the history of Roman monumental sculpture. Here is a monument for which there was no native tradition. The material, marble, was one of recent introduction, and from the detail of the ornament it can be seen that the workmen who carved it were Greek. Even the plan of the altar seems to be derived from that of the Altar of Pity in the Athenian agora. And yet the content of the monument and the theme that it expresses are already subtly but unmistakably Roman. No idealized procession this, but a portrayal of the actual procession which took place on the fourth of July 13 B.C.; and the figured carvings stand at the head of the long line of architectural reliefs which are one of Rome's principal contributions to the sum of classical artistic achievement. At no moment in the history of Roman architecture was the Roman genius for adopting, adapting, and taking creative possession of the traditions of others to play a larger part than in the Augustan Age.

The traditionalism of the Theatre of Marcellus and the hellenism of the Ara Pacis represent the two poles of Augustan architectural taste. It was the mingling of these two

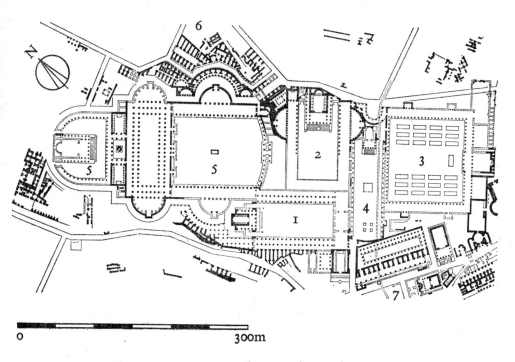

Figure 84. Rome, the Imperial Fora. Plan

1. Forum of Caesar (Forum Iulium)
2. Forum of Augustus (Forum Augustum)
3. Templum Pacis
4. Forum Transitorium
5. Forum of Trajan and Basilica Ulpia
6. Markets of Trajan
7. North-east corner of the Forum Romanum

currents that provided the ferment for much that was best and most vigorous in this and the immediately ensuing period. Nowhere is this process illustrated better than in the Forum Augustum, which in many respects marks the culmination of Augustus's whole building programme (Figure 84 and Plate 106). The Temple of Mars Ultor (Mars the Avenger), which stood in the same relation to the forum as the Temple of Venus Genetrix to the Forum of Caesar, had been vowed as long before as the battle of Philippi in 42 B.C.; but it was still incomplete when the forum itself was inaugurated in 2 B.C., and much of the work of both buildings belongs undoubtedly to this later period. The forum and the temple may reasonably be regarded as representative of the architecture of the Augustan Age at the moment of its full maturity.

The purpose of the forum, like that of the Forum of Caesar before it, was to provide additional space for the public needs of the growing population of the city, and it followed essentially the plan established by its predecessor, though in a considerably developed form. The temple stood at the far end of an elongated open space flanked by two colonnaded halls, off which opened two semicircular courtyards set at the extremities of a cross-axis that corresponds with the line of the façade of the temple. Today, with the lateral halls razed and half the length of the forum buried beneath the street, the proportions look very different (Plate 106); but when standing the temple, which was almost square in plan with a deep porch, can only have been really visible from the front and, set on its lofty podium at the head of a flight of seventeen steps, it towered impressively above the long, surprisingly narrow space between the flanking porticoes (Figure 85). Suetonius records the further detail that Augustus was unable to purchase all the land

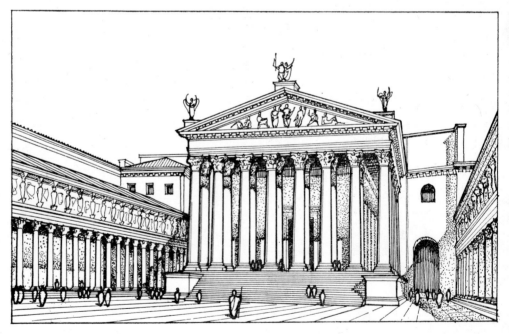

Figure 85. Rome, restored view of the Temple of Mars Ultor, dedicated in 2 B.C., and part of the Forum Augustum (cf. Plate 106)

that he wished to use. This probably refers principally to the east corner, where the resulting asymmetry of the ground plan was skilfully concealed by the flanking porticoes.

For all the hellenizing detail, and there was much of this, the basic conception of the design was very Roman. The plan itself, with the temple set on a lofty platform against the rear wall dominating the rectangular space before it, is in the direct Italian tradition; so too is the rigid axiality of the whole design, imposed forcibly on the ground, where a Greek architect might well have preferred to exploit the irregularities of the setting. Roman architects were always prone to treat individual monuments in isolation, and in this case the effect was accentuated by the enormous precinct wall, 115 feet (35 m.) high, which served the double purpose of a firebreak and a visual screen between the forum and the crowded tenement quarter of the Subura. The sense of enclosure was made more complete by the height of the flanking porticoes, the façades of which carried an attic above the colonnade, upon which caryatid figures supported a coffered entablature and framed a series of roundels carved with the heads of divinities. The only contrasting accent was that afforded by the two courtyards that opened off the inner sides of the porticoes. They doubtless served a practical purpose, probably as courtrooms, and their form may well have been suggested in the first place by the limitations of the space available at the east corner of the building. The introduction of a discreet cross-accent was, however, a no less characteristically Roman device, taken up and developed a century later in the Forum of Trajan.

The broad conception of the forum, then, its purpose and its plan are all characteristically Roman. In its detail, on the other hand, there was a great deal that was new and exciting. Whereas the splendid bossed masonry of the enclosure wall, with its skilful alternation of Gabine stone and travertine, is in the best Late Republican tradition, the finely drafted marble masonry of the temple, with its tall socle of marble orthostats capped by a projecting course decorated with a carved maeander, is no less distinctively Greek, almost certainly from Asia Minor and derived from the same source as, for example, the Temple of Augustus at Ankara (Plate 203). That the architect was also familiar with the monuments of Attica, including such near-contemporary buildings as the Inner Propylaea at Eleusis, is clear from such features as the caryatids of the forum (Plate 108) and an exquisite Pegasus pilaster-capital from the temple (Plate 109), as well as from a great many details of the mouldings of both forum and temple. Many of the workmen too must have been Greek, brought in to work the profusion of marble columns, entablatures, pavements, and wall-veneers with which the forum was enriched – not only the white marble of Carrara, but coloured marbles from Numidia, Phrygia, Teos, Chios, and Euboea, to name only those that can still be seen in place. This was not the first time that coloured marbles had made their appearance in Rome, but it was the first time that they had been used on this lavish scale. The contrast between the gleaming white of the temple and the profusion of colour around it must have been as effective as it was novel, provoking Pliny to class this with the Basilica Aemilia (another lavishly marbled building) and Vespasian's Forum Pacis as the three most beautiful buildings in the world.[10]

About the interior of the temple, which was gutted by the marble-burners of the Middle Ages, we know sadly little except that it was very richly detailed. There was an apse, in which stood statues of Mars, Venus, and the Deified Julius, and the roof was supported by two lines of columns set out from the walls, with corresponding pilasters against the walls themselves. One of the column bases, recorded in the Renaissance, closely resembles those of the Temple of Apollo in Circo, indicating yet another strain in the pedigree of the ornament of the temple and forum.[11] These strains had not yet fused, and never did fuse, into a single 'Augustan' style; but they were rapidly being absorbed into a wide and varied repertory of styles and motifs that was at the call of every Roman builder. Never again in the history of Roman architectural ornament was there to be so extensive and so vigorous an infusion of new idioms and new ideas, or so wide a range of decorative traditions all in active contemporary use.

Although there was hardly a monument in the Forum Romanum with the building or rebuilding of which Augustus was not in some way associated, much of this work consisted of the completion or restoration of buildings initiated by Julius Caesar. Four of the principal buildings with which he was in this way concerned, the Basilicas Aemilia and Julia, the Curia (senate house), and the Rostra, were all part of Caesar's project to bring some sort of architectural order into the hitherto haphazard development of this time-honoured centre. A fifth, the Temple of Divus Julius (the Deified Julius), dedicated in 29 B.C. but possibly substantially complete some years earlier, was in effect a completion of the same scheme, balancing the Rostra and establishing a decisive architectural accent at the narrow south-east end of the open space of which the two basilicas formed the two long sides.

Except as elements of this ambitious plan the Rostra (orators' platform) are of historical rather than of architectural interest, and the Augustan Curia was so badly damaged in the fire of A.D. 284 that it had to be completely rebuilt by Diocletian. Coin representations show that it was very like its successor, a tall, gabled building with three rectangular windows above a shallow porch stretching the length of an otherwise plain façade (Plate 107A).[12] Of the two basilicas, on the other hand, enough is known to give us quite a good idea of their general appearance. Though broadly similar in design, location, and purpose, they offer an interesting picture of the variety of architectural practice prevailing in Augustan Rome.

The more conservative of the two was the Basilica Aemilia. Rebuilt after a fire in 14 B.C.,[13] recent excavation has shown that the new building (Figure 86A) followed very much the same lines as its predecessor. It consisted of a long, narrow central hall, lit by a clerestory and surrounded on all four sides by an internal portico with a gallery over it. This hall, which measured some 295 by 90 feet (90 by 27 m.), was open to the south-east, and along the north-east side it had an additional row of columns, which from its position close to the outer wall seems to have been decorative rather than structural in intention. Constructionally it seems to have been a rather conservative building, remarkable more for the wealth of its materials and decoration than for any novel architectural features. Along the south-east side, towards the forum, it was closed by a row of outward-facing shops, the Tabernae Novae, probably themselves in two storeys and

A

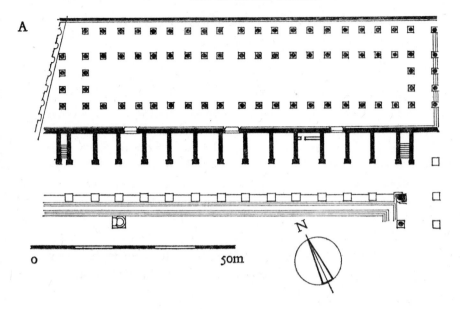

0 50m

N

B

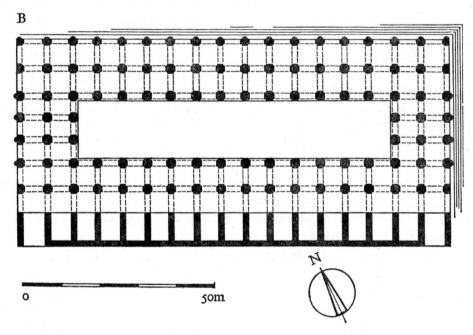

0 50m

N

Figure 86. Rome, (A) Basilica Aemilia, rebuilt after 14 B.C., and (B) Basilica Julia, rebuilt between
c. 12 B.C. and A.D. 12. Plans. For the façade of the portico in front of the Basilica Aemilia, cf. Plate 111

opening on to a two-storeyed portico, the façade of which was composed of piers
carrying arches, framed within the compartments of a boldly projecting Doric order
(Plate 111). This portico is usually identified as the Portico of Gaius and Lucius, dedicated
in 2 B.C., and it was for all practical purposes an independent building, a translation

into contemporary Roman constructional terms of the hellenistic stoa. The façade was manifestly designed to answer that of the Basilica Julia opposite.

The Basilica Julia, destroyed by fire shortly after its completion, probably in 12 B.C., and completely rebuilt between then and A.D. 12, offers an interesting contrast. Built to house the centumviral law courts (which were held in the central hall, divided up if necessary by curtains or wooden screens), in one respect it conforms more closely to the Republican pattern, in that it was open on three sides and closed only on the south-west side, away from the forum, where a two-storeyed row of shops or offices opened inwards on to the outermost of the internal porticoes and the gallery above it (Figure 86B). But although in other respects the plan (345 by 150 feet, or 105 by 46 m., exclusive of the offices) is only a rather more elaborate version of that of its sister basilica, with a double instead of a single ambulatory portico and gallery surrounding the central hall, the principle of construction is entirely different. Instead of being carried on columns, the structure was arcaded, on rectangular piers, and the ambulatory porticoes were vaulted, only the central hall being timber-roofed.[14] The inner piers were cruciform and built of travertine, those of the outer row of solid marble, and the arcades of the two principal façades were framed within the semi-columns and entablatures of a double Tuscan order. Except for the greater richness of the materials, the structural scheme is remarkably similar to that of the Theatre of Marcellus and offers an interesting, and in this form and context unique, example of the reinterpretation of the traditional architectural theme of the columnar basilica in terms of contemporary constructional methods.

The architecture of the Augustan temples was by its very nature weighted on the side of conservatism. In the relatively restricted space available within the city there was no room for the daring innovations that had characterized the great sanctuaries of Latium in the Late Republic; and although under Augustus and his successors there were still such distinctively Italic features as the tendency to place the actual temple against a rear wall, facing forwards, and the almost universal use of a tall podium, with or without a frontal flight of steps, the general trend was undoubtedly towards a more typically Greek hellenistic tradition. Many of the older shrines, with their low columns and spreading roofs, must still have survived. But as they burned or were restored they were replaced by buildings which, both in their proportions and in much of their detail, approximated far more closely to the norm of late hellenistic design.

One of the earliest and finest of the Augustan temples was that of Apollo on the Palatine, built between 36 and 28 B.C. Of solid Carrara marble and adorned with many famous statues, it was acclaimed as one of the wonders of its day. Adjoining it were a portico carried on columns of Numidian marble (one of the first recorded uses of coloured marbles on such a scale) and a Greek and a Latin library. After the great fire of A.D. 64 the temple and libraries were rebuilt by Domitian, and the remains of the latter can be seen behind the great triclinium of the Flavian Palace. Of the temple, on the other hand, nothing has survived except part of the foundations and a few marble fragments, enough to show that it was probably pseudo-peripteral in plan, but little more. Vitruvius records that the columns were unusually widely spaced.[15] It is a reasonable conjecture that at this early date a marble building of such high repute leaned heavily on the ex-

perience of Greek craftsmen. Had more of it come down to us, much that is obscure about the later development of Augustan architecture might well have been made clear.

The neighbouring Temple of the Great Mother (Magna Mater, or Cybele) offers a striking contrast. Its restoration by Augustus after a fire in A.D. 3 followed thoroughly conservative lines, probably re-using much of the material of the Republican building and a part of its actual structure, with a liberal use of stucco both for the finished masonry surfaces and for the architectural detail. A first-century relief in the Villa Medici, which illustrates the façade of the Augustan building (Plate 112), gives an interesting picture of the refinement that was possible in this material, so much used and so rarely preserved. The masonry convention portrayed approximates closely to that of the Temple of Mars Ultor.

At a time when there was so much building going on all at once, there must have been many other instances of a similar conservatism. Of the eighty-two temples in the city which Augustus claimed to have restored in 28 B.C. one cannot doubt that many were done in traditional materials and following traditional lines. Even where the restoration amounted in effect to a complete rebuilding there must often have been a considerable stylistic time-lag. An extreme example of this may be seen in the three small temples of the Forum Holitorium, preserved as a result of their partial incorporation in the structure of the medieval church of S. Nicola in Carcere (Figure 74). On the evidence of the materials employed and other seemingly archaic features, all three have been accepted as Republican buildings, possibly even as early as the second century B.C.; but it now seems probable that at least one, the Doric temple, which is built in travertine, and very possibly all three, are almost entirely Augustan work, replacing the buildings destroyed in the fire that devastated the whole area in 31 B.C. The two almost identical Ionic temples incorporate features that appear to derive from the Late Augustan Temple of Castor, and one of them is almost certainly to be identified with the Temple of Janus, which was not finally ready for re-dedication until A.D. 17. At a time when supplies of materials and the labour resources of the city must have been strained to the uttermost it is not altogether surprising that these small and unimportant shrines should have had to wait so long for completion, or that when complete they should have retained many features that belonged properly to an earlier age.[16]

There are two other Augustan temples that call for brief comment, the Temples of Castor (Plate 104) and of Concord, both very ancient buildings beside the Forum Romanum that were completely rebuilt during the last twenty years of the emperor's life. That of Castor,[17] as rebuilt by Tiberius between 7 B.C. and A.D. 6, was a grandiose peripteral structure standing on a double podium, the front of which, like that of the near-by Temple of Divus Julius, rose sheer from the pavement of the forum and was used as an additional platform for public speakers. The main body of the podium was of blocks of tufa enclosing a core of concrete, except beneath the columns, which rested on piers of travertine; the whole was faced with Carrara marble, and between the column footings there were recesses which may have been used as strongrooms. The three surviving columns, 47 feet (14·20 m.) high and capped by a section of the original entablature, all of Carrara marble, were already a landmark in the fifteenth century.

The cella has almost entirely vanished, but the interior is known to have had a decorative order of columns along each of the side walls, as in the Temple of Mars Ultor. Attempts to date the superstructure to an otherwise unrecorded restoration undertaken in the late first or early second century A.D. are certainly mistaken. There are manifest differences, it is true, between this work and that of the near-contemporary Temple of Mars Ultor; but there are also a great many details that are no less typically Augustan and, as we have seen, the possibility of such difference is characteristic of the Augustan Age. Of the two buildings, the surviving remains of the Temple of Castor give the impression of being the work of craftsmen who were less directly under the influence of Greek models.

The Temple of Concord, also rebuilt by Tiberius and dedicated in A.D. 10, stood on the site and repeated the unusual plan of its predecessor, in which the longer axis of the cella lay across the building, so that the porch occupied a part only of the front of the cella.[18] It was distinguished by the opulence of its marbles and the wealth of fine sculpture and painting with which it was endowed, and although sadly little of all this remains, that little is enough to show that the architectural ornament too was extremely rich, foreshadowing the opulent schemes of the ensuing Julio-Claudian age. The surviving fragments include a section of the richly carved main cornice (Plate 113); a column base from the internal order of the cella, closely resembling those of the Temple of Mars Ultor; and a figured Corinthian capital with pairs of rams at the four angles in place of the usual angle volutes. The massive door-sill was of Chian marble, and other marbles attested from the floor and walls of the interior include Euboean, Phrygian, and Numidian.

To anyone familiar with the subtleties of Greek temple architecture it is natural to ask whether in the case of the Augustan temples one can make any useful generalizations about the types of plans employed, the spacing of the columns, the proportions, etc. The question is one that would have been perfectly intelligible to the section of contemporary architectural opinion of which Vitruvius is the representative figure; and if the contemporary answers did not always satisfy Vitruvius and his colleagues, this is not altogether surprising in an eclectic age which was also one where technical achievement was rapidly outrunning the forms of architectural expression currently available.

The plans, as one might expect, reveal little uniformity. There were too many models available, too many competing architects of very varied training, taste, and experience. Of the four largest temples, that of Concord was a special case; the other three, Mars Ultor, Diana, and Castor, were octastyle and peripteral, the first-named on three sides only, in accordance with the familiar type classified by Vitruvius as *sine postico*. The rest were all hexastyle and indiscriminately prostyle, pseudo-peripteral, or peripteral.[19] There was a marked tendency towards height at the expense of length, an extreme case being the Temple of Mars Ultor with its eight columns across the façade and only nine (including the terminal pilaster against the rear wall) down either side; and the height was in most cases increased by the use of unusually lofty podia, double in the case of Divus Julius and Castor. The latter stood over 100 feet high from the pavement to the apex of the gable. In no less than four of the temples (Divus Julius, Apollo in Circo, Castor, and Saturn) the podium also rises sheer in front, accentuating the effect of height.

This may in each case be due to special circumstances; but it is worth noting, since it was not without its effect on subsequent architecture in the provinces (e.g. the Temple of Rome and Augustus at Lepcis Magna, the Capitolium at Sabratha). With the exception of the three temples in the Forum Holitorium (which can hardly be considered as typically Augustan buildings) and possibly also of Saturn, Divus Julius, and Apollo Palatinus, all three of them early buildings, the normal order was, and was thereafter to remain, Corinthian, and the columns seem to have settled down to a norm of fairly close spacing. This last, though it may have been dictated as much by practical as by theoretical considerations, once again had the effect of increasing the appearance of height. Finally it may be noted that the three largest temples all had elaborately carved orders down the internal side walls of the cellas. This feature, which initially at any rate had a practical as well as a decorative purpose, lessening the span of the roof, had Greek precedents, but in the present case it is far more naturally to be regarded as derivative from such Republican prototypes as the apsed hall at Praeneste and the Nymphaeum of the so-called Villa of Cicero at Formia. It had already been used in Pompey's Temple of Venus Victrix, and it was to play a considerable part in the temple architecture of the post-Augustan age.

The domestic architecture of the Augustan period is discussed in a later chapter. In the present context it must be enough to note that it was here, particularly in the big country residences of the wealthy, that the Augustan builders made some of their most significant advances. Another field in which, side by side with traditionalism, fantasy and experiment played a surprisingly large part was that of funerary architecture. This too will be referred to briefly in a later chapter. The outstanding public monument in this field was the Mausoleum of Augustus in the Campus Martius, beside the river, begun in 28 B.C. and ready for use in 23 B.C. Cleared of the accretions of centuries, it is today a sorry ruin; but enough remains to establish the essential form, which was that of a tall, hollow, concrete drum, 290 feet (88 m.) in diameter, faced with travertine and surmounted by an earthen tumulus, at the centre of which stood a colossal bronze statue of the emperor. There were a central tomb-chamber and no less than four internal rings of concrete, faced according to their position with travertine or tufa reticulate, and broken up into compartments to contain the earthen mass. It was an exceptionally large example of a type of grandiose family mausoleum that was in widespread use among the noble families of the period, two finely preserved and approximately contemporary examples being those of Caecilia Metella beside the Via Appia and of Munatius Plancus at Gaeta. The summit of the tumulus was planted with evergreen trees and it stood in wooded grounds, which included a grove of black poplars, within the enclosure of the family crematorium. Landscaping is not a feature that survives the passage of time but, as we know from the literary sources, it was widely used and esteemed, and was indeed an integral feature of many architectural schemes. Another well attested Augustan example is that of Agrippa's buildings in the Campus Martius, a short distance to the south of the mausoleum – in which, very appropriately, he was one of the first to be buried.

In the techniques of building, the Augustan Age was marked rather by a steady advance in the handling of existing techniques than by any notable innovations. In the

use of locally quarried ashlar masonry it was increasingly the finer qualities only, notably travertine and Gabine stone, that were employed in positions where they could be seen, the other, poorer varieties being relegated to footings and internal walls. With the example of the temples of the Forum Holitorum before us, one must beware of excessive reliance upon such criteria as evidence of date: what applied to public building did not necessarily apply to private construction; still less did it apply outside the immediate periphery of the capital. But with the ever-increasing availability of concrete as a cheap and efficient substitute, there was a clear tendency for cut stone to be used, if at all, sparingly and to deliberate effect. Notable examples of fine ashlar masonry in Augustan Rome are the Theatre of Marcellus and the precinct wall of the Forum of Augustus, or, used purely structurally, the podium of the Temple of Castor.

As regards concrete, although there were no sensational innovations in the uses to which it was put, there was a steady improvement in the quality of the concrete itself. Whereas, for example, in Late Republican monuments it is still normal to find horizontal lines of cleavage running right through the core, corresponding to the successive stages of the work, by the turn of the century this phenomenon is becoming increasingly rare; the masons had evidently evolved a slower-drying mixture, enabling the whole body of the core to fuse into a virtually homogeneous mass. So too, arches and vaults reveal a clear evolutionary tendency from the Republican form with irregular chunks of stone laid radially around the intrados, like the voussoirs of an arch, to one in which the whole mass, intrados and all, is bedded horizontally and which stood, once the centering was removed, purely by virtue of the quality of the concrete. Most important of all, Roman builders had begun to realize that for everyday purposes the local red volcanic sand (*pozzolana*) had the same remarkable properties as its namesake, the *pulvis puteolanus* from Puteoli (Pozzuoli) on the coast of Campania, which they had long been importing for the building of harbours, bridges, and similar hydraulic works. It was the hydraulic character of this local red pozzolana, when mixed with lime, which gave the Roman mortar of the Empire its great strength; and although the Romans were unaware of the theoretical reasons for this phenomenon, the pages of Vitruvius show that by the twenties of the first century B.C. they had achieved a wide practical experience of the properties of this and other types of mortar. The study of the monuments shows that it was in the time of Caesar that pozzolana mortar made its first appearance in Rome, but that it was only under Augustus that it passed into general, everyday use.[20]

The evolution of the successive types of concrete facing has been extensively studied and offers a useful criterion of date, though one to be used with far greater caution than is often the case. A careful study, for example, of the masonry used in the Agrippan repair-work to the aqueducts shows how wide a range of practice was possible even between the different firms engaged upon a single enterprise. One cannot expect absolute uniformity. In Rome, already quite early in the Augustan Age, reticulate work with tufa arches and quoins had very largely replaced the earlier, more irregular forms, and it remained the commonest type of facing until well into the following century. The most significant innovation was undoubtedly the occasional use of brickwork,[21] which makes a cautious appearance in the monuments from the middle of the first

century B.C. onwards. Throughout the Augustan period such 'bricks' were invariably broken tiles or roof-tiles, broken or sawn to shape; and although Vitruvius, writing between 25 and 22 B.C., refers to their use in apartment-house construction, not until a quarter of a century later do we have, in the Columbarium of the Freedmen of Augustus, a building of which the outer face was built entirely of bricks. The Rostra Augusti (*c.* 20 B.C.) offer an early instance of their use in a public monument. The great value of this new medium was that it allowed the builder to dispense wholly or in part with vertical shuttering, and although its full potentialities in this respect were not realized until well after the death of Augustus, taken in conjunction with the improvements in the quality of the concrete itself, it paved the way for the revolutionary advances that took place under his successors.

<div align="center">★</div>

Faced with the quantity and variety of building that took place in Rome in the sixty-odd years that lie between the death of Caesar in 44 B.C. and the death of Augustus in A.D. 14, it is at first sight hard to detect any single consistent pattern. In a sense this is a true picture. The architectural development of Augustan Rome (as indeed that of almost any period and place within the Empire for the next three hundred years) falls into a number of distinct and at times bewilderingly varied patterns. It is only with the hindsight of history that one can see what these had in common and whither they were leading.

Fundamental to the shaping of the Augustan building programme were the historical circumstances in which it took place. It was the return of peace and prosperity to a war-weary world that called into being a programme of such unprecedented proportions; and the fact that Rome was now the undisputed mistress and centre of the civilized world meant inevitably that the resources of skill, materials, and artistic talent of that world were all at her disposal. The surprising thing is not that there are derivative elements in the architecture of Augustan Rome, but that these were so rapidly and effectively acclimatized in their new home. More significant in the long run are the reciprocal currents that began to flow outwards from Rome. Just as the architecture of Republican Italy is unintelligible except within the larger framework of the hellenistic world, so now for the first time the arts of the hellenistic East began to find themselves affected by their participation in a yet larger organism, that of the Roman Empire.

A very important factor in this situation was the strength of the native Italic tradition. The hellenistic, and ultimately hellenic, element in this native tradition was inevitably pronounced; but it had been absorbed into, and in part transformed to meet the requirements of, a vigorous and organically developing Republican architecture which had strong local roots of its own. A distinctive characteristic of this architecture had been its exploitation of the structural and aesthetic possibilities of the arch, relegating the column and architrave of hellenic practice to a secondary and often purely decorative role; another was the substitution of vaulting for the time-honoured system of roofing in timber. The strength of this tradition is apt to be obscured by the bias of the numerically largest group of surviving monuments, the temples, at the expense of the secular architecture,

in which the native Republican element was far more pronounced but of which fewer examples have come down to us. Buildings such as the Theatre of Marcellus and the Basilica Julia, which belong to a line of development that leads directly from the sanctuaries of Latium and the Tabularium to the Colosseum and the Circus of Domitian, are in fact representative of a wide class of administrative and commercial buildings, of which all too few have survived. Yet another characteristic of this Italic tradition was the development to meet local conditions of such distinctive architectural types as the basilica. The Basilica Aemilia, for all its wealth of exotic materials, was as Roman a building as the Basilica Julia, though in detail more old-fashioned. Even the temples prove on examination to be far less directly hellenizing than at first sight they appear. The basic architectural forms already had a long period of acclimatization and adaptation behind them; it was only the materials and detailed treatment that were new. So far as we know, there was no building in Augustan Rome (certainly not after the very early years) that was so directly and unashamedly derivative from Greece as the little Republican circular temple in the Forum Boarium.

In its most vigorous and characteristic forms the Republican building tradition was ultimately connected with the exploitation and development of the building materials available in Central Italy. The hellenizing strain in the architecture of Augustan Rome was no less intimately associated with the introduction of an alien material, marble. Previously available only as an exotic luxury, the opening of the quarries of Carrara within the space of a few years poured so abundant a supply of it upon the Roman market that, to work it, it was necessary to import large numbers of skilled craftsmen; and the only part of the ancient world where marble-workers were readily available was Greece. Taken in conjunction with the deep Roman admiration for all things Greek, the result was a profound and rapid hellenization of the established Republican traditions of architectural ornament. The sculptors, many of them trained in the neo-classicizing schools of Attica, inevitably brought and used the motifs with which they were themselves familiar. What is unexpected in all this is not so much the fact of the sudden appearance of a new decorative repertory as the rapidity with which it was absorbed and adapted to suit the requirements of a specifically Roman taste. Judged by the standards of classical Greece the proportions and detail of a great deal of this work are deplorable – but it would be wrong to apply such standards. This was something new. Within the space of a few decades we can see the emergence from the melting-pot of a style that was new and specifically Roman, a style which was to dominate the architectural ornament of the capital for over a century to come.

By comparison the importation of large quantities of coloured marble for the columns, pavements, and wall-veneers of the great Augustan monuments was a less revolutionary event than it might at first sight seem to have been. There was nothing new in architectural polychromy as such; this was only a richer, subtler variant of a familiar idea. What was more significant was the scope which the new material offered for an ever-increasing dissociation of decoration and structure, a tendency which was already at work in the architecture of the Republic, but which only reached full fruition within the brick-faced concrete architecture of the later Empire.

Seen within the perspective of its own generation, the dominant note of Augustan architecture in Rome appears as one of opulence, coupled with a cautious conservatism and a respect for the architectural traditions of Rome's own recent past. Its only really important formal innovations lay in the field of architectural ornament. But the size, the quality, and the variety of the great Augustan building programme made it an unfailing source of inspiration to successive generations of architects; the circumstances of its creation gave it a unique authority; and it was the school in which the builders of the next generation learned the mastery of the materials which they were to put to such new and revolutionary uses. In architecture, as in so much else, the real significance of the reign of Augustus was that it set the stage for the age that was to come.

ARCHITECTURE IN ROME UNDER THE JULIO-CLAUDIAN EMPERORS
(A.D. 14–68)

FOR all the variety of influences already at work, the architecture of Augustan Rome has a topographical and chronological unity that makes for simplicity of presentation. This is still true, though to a lesser extent, of the period that follows. With a few notable exceptions such as Spain and Gaul, the provinces were still, architecturally speaking, largely self-contained and can justifiably be discussed separately. Within Italy the situation was more complex. But although in certain fields Campania still exercised a considerable creative individuality, elsewhere the flow of ideas was still predominantly from the centre towards the periphery. Throughout the first century A.D. it was Rome itself that continued to call the architectural tune. It is reasonable, therefore, to begin with an account of public building in the capital and in the immediate neighbourhood; and since the individual emperors undoubtedly exercised a strong influence upon the work undertaken under their auspices and in their names, this has been classified according to their reigns. Two subjects call for more extended treatment and will be discussed separately. One of these is the domestic architecture of town and country during the period in question. The other is the profound change in architectural thinking which took place in the period between the accession of Nero and the death of Hadrian, and which has here been termed the 'Roman Architectural Revolution'.

Tiberius (A.D. 14–37)

The reign of Augustus's successor, Tiberius, saw little building in Rome itself. While his predecessor was still alive he had contributed largely to the official programme, being directly responsible for two of the largest and finest of the later Augustan monuments, the Temples of Castor and of Concord; and after Augustus's death Tiberius carried to completion a number of works that had been left unfinished. But after half a century of unprecedented building activity, a pause cannot have been altogether unwelcome; and the increasing embitterment of his later years, culminating in the retirement to Capri, removed what little incentive there may have been to the continued embellishment of the capital.

The majority of the recorded buildings of Tiberius in Rome belong, as one would expect, to the earlier part of his reign. Several small temples dedicated in A.D. 17 were all buildings of which the restoration had been begun and left unfinished by Augustus. An arch erected in the Forum Romanum in A.D. 16 to commemorate the German victories of his destined successor, Germanicus, and a pair added to the Forum Augustum in A.D. 19, in honour of Germanicus and the younger Drusus, are of interest chiefly for the

evidence that the scanty surviving remains give of the development of a specifically Julio-Claudian style of architectural ornament. The same is true of the restoration of the Basilica Aemilia in A.D. 22, a restoration which appears to have involved the substantial replacement and enrichment of the upper part of the building. Of the Horrea, or ware-houses, of Sejanus nothing is known; it is to Ostia that we have to look for similar build-ings of Tiberian date. Nor has anything survived of the restoration of the stage-building of the Theatre of Pompey, undertaken after a fire in A.D. 21. The fact that it is one of the only two Tiberian public buildings in the capital thought worthy of mention by Tacitus indicates that it was a work of some importance, and in the context it can hardly have been other than the replacement of the earlier structure by one of more elaborate plan and built of marble.[1]

The second building mentioned by Tacitus is the Temple of the Deified Augustus, an undertaking to which, for dynastic reasons alone, Tiberius must have felt himself com-mitted, and which he did in fact bring to virtual completion before his death in A.D. 37, although it was left to his successor, Caligula, to dedicate it. It lay in the as yet un-explored area to the south of the Basilica Julia. No remains of it have been recorded, but it is usually identified with an Ionic hexastyle building which figures prominently on the coinage of Caligula (Plate 107B). A less generally accepted, but not unattractive, sugges-tion is that it is the Temple of Apollo Palatinus, another building which had very close associations with Augustus; and that for the Temple of Divus Augustus we have to look instead to a coin type which makes its appearance during the last few years of Tiberius's life, between A.D. 34 and 37, and which is usually interpreted as a representa-tion of the Temple of Concord. What the conventional view leaves unexplained is why the latter building, dedicated in A.D. 12, should have been so singled out for representa-tion a quarter of a century later; nor can there be much doubt that the Ionic treatment of the temple featured on the Caligulan coins accords better with what we know of the somewhat experimental architecture of the early years of Augustus's reign than with what we know of the tastes of the ageing Tiberius. This is clearly a matter that only further exploration can decide. For the present it must suffice to note that the conven-tional interpretation of the coin evidence, though widely accepted, is not altogether free from difficulties.[2]

Architecturally, as indeed also politically, the most significant Tiberian building that has survived in the capital is the camp of the Praetorian Guard, built in A.D. 21–3 at the instigation of its commander, Tiberius's aide and evil genius, Sejanus. In it were con-centrated the troops that had hitherto been scattered throughout the city and its environs; and although its location just outside the city limits respected the letter if not the spirit of the convention that no troops might be stationed in Rome, its establishment was a decisive step down the slippery slope that led to open autocracy. Architecturally, too, it marks an epoch: not only does it represent the first appearance in the capital of an architecture that had been evolved in the military encampments of the Provinces, but the outer walls, large stretches of which can still be seen incorporated in the third-century city walls (Plate 114), have the additional distinction of being the first major public monument to have been built almost entirely in brick-faced concrete. The plan,

a rectangle with rounded corners, measuring 470 by 406 yards (430 by 371 m.) and enclosing an area of over 14 acres, is that of a typical military camp, divided, equally about the longer axis and unequally about the shorter, by two intersecting streets and served by four gates placed at the corresponding points of the outer walls. The form of the gateway is a translation into brick of an architectural type that was already firmly established in stone (e.g. the Augustan arch at Rimini), in which the archway is framed between decorative pilasters that carry a pedimental entablature set against a plain, rectangular attic. Flanking the gateway, and projecting a mere foot from the face of it, was a pair of low, rectangular towers, and there were similar towers at intervals along the rest of the wall. The outer face of the wall itself stood upon a three-stepped plinth, rising 9 feet 6 inches (2·90 m.) to a projecting string-course, which marks the height of the pavement of the internal rampart wall; above this stood a parapet 4 feet (1·20 m.) high, with a coping upon which were set small, widely spaced merlons. The little that has survived of the internal barrack-blocks suggests that, in contrast to the outer walls, they were largely built in reticulate work. Considering the novelty of the medium, the treatment of the outer walls is remarkably assured. Walls, towers, and gates alike, though fully adequate to the limited military requirements of the situation, were clearly designed almost as much to impress as for their defensibility. The mouldings of the gates in particular can be seen to foreshadow a simple but effective tradition of decorative brickwork which was to play a long and distinguished part in the architecture of the capital.

Another building that might be expected to throw light on this interesting transitional phase in the history of Roman monumental construction is the new residence which Tiberius built on the Palatine. Augustus's own residence was almost ostentatiously modest in scale and old-fashioned in design. Beside it, on the north-west corner of the Palatine, Tiberius, shortly after his accession, began to add a new and larger residence, the Domus Tiberiana. The site, a rectangular platform measuring 200 by 130 yards (180 by 120 m.), is now very largely inaccessible beneath the gardens laid out upon it in the sixteenth century by Cardinal Alessandro Farnese. There are records of brick-faced as well as of reticulate masonry, and an oval fish-pool near the south-east angle suggests that the strict rectilinearity of the outer perimeter was not rigidly observed throughout the building. Nearly all of what is now visible, however, towards the forum, is the work of later emperors, and it may well be that work on the new building was far from complete and was suspended when Tiberius finally abandoned Rome. It is outside Rome, on Capri, and perhaps also at Albano, that we have to look if we are to form any idea of the way the earlier Julio-Claudian emperors were housed. This will be discussed in a later chapter.[3]

Caligula (A.D. 37–41)

The reign of Tiberius's successor, Gaius, better known as Caligula, may be thought to have been too brief and his character too frivolous to have left much permanent mark on the architectural development of Rome. Of his grandiose plans for the remodelling of the Palatine, and in particular for the enlargement of the Domus Tiberiana in the direc-

tion of the forum, little has survived. There are the scanty traces of an arched courtyard with a central pool on the site of the medieval church of S. Maria Antiqua and at the upper level there is a huge vaulted cistern, of interest in that it offers the first recorded instance of the lightening of a vault by the use, as aggregate, of carefully selected materials, in this case a porous yellow tufa mixed with pumice.[4] Caligula began, but did not complete, the construction of two new aqueducts, while demolishing the terminal section of the Aqua Virgo to make way for a new amphitheatre, which in the event was never built. The Circus of Gaius in the Vatican area, which was to achieve notoriety under Nero on the occasion of the persecution of the Christians after the fire of A.D. 64, and its near neighbour, the Gaianum, an open space for the practice of chariot-driving, are of more topographical than architectural importance. It was to adorn the former that Caligula brought from Heliopolis, in Egypt, the obelisk that now stands in the centre of the piazza in front of St Peter's. The list of public works is short. Even if one adds the buildings of Tiberius that Caligula completed and dedicated, it does not constitute a very distinguished achievement.

There are, however, two aspects of the building activity of Caligula that are perhaps of rather wider significance. One is in the field of domestic architecture. Suetonius records that outside Rome he built many villas and country houses; and Pliny the Elder writes that the whole city was ringed around with the dwellings of Caligula and Nero. The coupling of the names of Caligula and Nero is significant. Just as nineteenth-century Rome was still encircled by the villas and parks of the princely families (many of which, indeed, were laid out in conscious imitation of classical precedents), so Rome at the end of the Republic was all but enclosed within a ring of wealthy villas and gardens, many of which in course of time passed by purchase, inheritance, or expropriation into imperial possession. It was probably under Tiberius that the Horti Lamiani (on the right bank of the Tiber) and the Horti Sallustiani (near the modern Palazzo Barberini) became imperial property. It was while directing architectural operations in the former that Caligula received the delegation of Jews from Alexandria of whose reception Philo has left us such a graphic account.

Building of this sort must have been very much to the emperor's taste; and although nothing of it has survived, we can at least get an indication of the wealth and quality of its ornament from the galleys of Lake Nemi. The traditional view of these strange vessels is surely the right one. They were villas afloat, equipped with every luxury, including running water, and adorned with floors and walls of patterned marble and mosaic, partitions and doors covered with painted wall-plaster, or painted and inlaid with strips of ivory and gilded bronze, marble colonnettes, painted terracotta friezes, tiles of gilded bronze, as well as sculpture and numerous finely wrought fittings of moulded bronze. What is almost more striking than the luxuriance of the ornament is the superb quality of the joinery and of the workmanship generally. In all of this one is reminded irresistibly of the decorative taste displayed in the palaces of Nero twenty years later; and one may hazard a guess that in the formal qualities, too, of the architecture there was much that anticipated later practice. In an age when the tastes of the patron might be quite as important of those of the artist, and in a field that lent itself so admirably to experiment

Q

and fantasy, the impact of Caligula's enthusiasm upon the domestic architecture of its age should not be underestimated.

Another field in which the emperor's tastes found ample scope for personal expression was that of religious architecture. Although the great Augustan building programme must have left the buildings of the traditional state cults in better condition than they had ever been before, the vital currents of contemporary religious belief were increasingly turning towards the so-called mystery religions of the East. The practices of these religions ranged from the frankly orgiastic fertility rites of Cybele and Attis, through the often exalted mysticism of the cults of Isis and Mithras, to the austerely rational beliefs of such quasi-philosophical sects as the Neo-Pythagoreans; but all shared with Christianity the powerful inducements of a message that was addressed ultimately to the individual, offering to the qualified initiate comfort in this world and salvation in the next. Together they unquestionably constituted the most powerful spiritual force at work during the first three centuries of our era.

The architectural impact of the mystery religions was as varied as their message. Those that were politically acceptable were free to develop a monumental architecture of their own, although not by any means all of them did in fact do so.[5] Of those that were unwilling or unable to compromise with the state some, like Christianity, were content to forgo an architecture of their own and to meet in private houses. Others were driven, quite literally, underground. The so-called Underground Basilica beside the Via Praenestina (Plate 118) is such a building. Constructed about the middle of the first century A.D. to serve the requirements of a Neo-Pythagorean sect, it was suppressed soon after its construction and was filled in and forgotten. The form, an antechamber and a basilican nave with three equal aisles leading up to a single apse, anticipates that which, for not dissimilar reasons, the Christians were to adopt nearly three centuries later; and the method of construction, whereby trenches were cut in the tufa and concrete laid in them to form the walls and the piers, the remaining tufa being excavated only after the walls and vaults had set, is a good illustration of the ingenuity of the Roman architect in handling the new medium. With its uniquely preserved facing of delicately moulded stucco and its air of timeless withdrawal, it is a singularly moving monument, one of the few that call for little or no effort of the imagination if one is to clothe the bare bones with the flesh and blood of the living building.

Midway between the two extremes came those cults which, while prepared to conform to the requirements of the state, were able to retain much of their outward as well as of their spiritual individuality. Prominent among such were the cults of the hellenized Egyptian divinities, Isis and Serapis; and the chance that Caligula was personally attracted by the former gave its devotees an opportunity that they were quick to seize. The room on the Palatine with Isiac paintings, preserved by its incorporation soon afterwards into the substructures of the Flavian Palace, is almost certainly the work of Caligula; and there is a strong presumption that it was he who was responsible for building the sanctuary of Isis and Serapis in the Campus Martius. The latter was damaged in the fire of A.D. 80 and restored by Domitian, and again by Alexander Severus. As recorded in the Severan marble map of Rome (Figure 87) it comprised two distinct

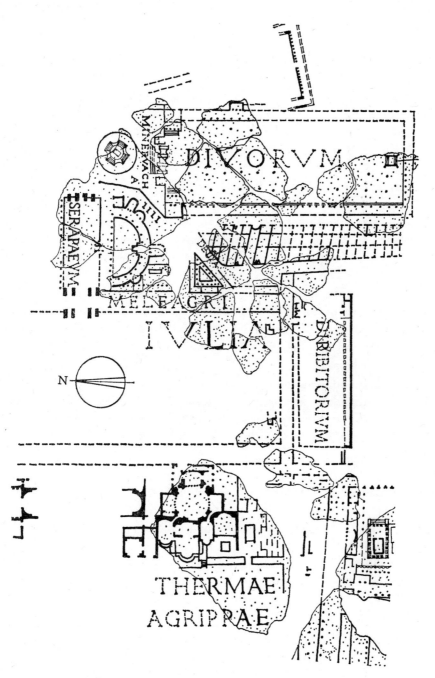

Figure 87. Part of the Severan Marble Plan of Rome, showing the Porticus Divorum, the Temple of Minerva Chalcidica, the Sanctuary of Isis and Serapis, part of the Saepta Julia, the Diribitorium, the Baths of Agrippa, and (*bottom right*) the north end of the group of Republican temples in the Largo Argentina and the north-east corner of the colonnaded gardens behind the Theatre of Pompey

shrines opening off the long sides of an enclosed rectangular forecourt. Whether Domitian's restoration followed the same general lines as its predecessor we cannot say; nor do we know to what extent the remarkable curvilinear plan of the southern building reproduces or reflects Isiac practice elsewhere. Architecturally, the significant fact is that it was in a field such as this that new architectural ideas were free to circulate, and that they should in this instance have involved so radical a break-away from the traditional forms of classical religious building.

The fittings of the sanctuary, as distinct from the buildings, were unequivocally Egyptian in character, many of them being actual Egyptian pieces imported for the purpose. Much of the sculpture still survives, in the Capitoline Museum, in the Vatican, and elsewhere, and two of the smaller obelisks are still in use near the site of the temples, one of them in the piazza in front of the Pantheon, the other carried by Bernini's elephant in the Piazza della Minerva. A taste for Egyptian and egyptianizing themes is a recurrent feature of Roman architectural ornament, ranging from the import of such formidable pieces as the great obelisks, which, resurrected and put to new use, are still such a striking feature of the Roman scene, down to the dilutely and romantically egyptianizing Nilotic scenes beloved of interior decorators of all periods. The Egyptian cults were not by any means the only influence at work. There were the Alexandrian stucco-workers, for example, and more generally there was the Alexandrian component in the hellenistic tradition that was responsible, at its best, for such masterpieces as the great Barberini mosaic in the sanctuary at Palestrina. But the cults, too, had a part to play, and the establishment of these exotic temples in the Campus Martius is a minor but significant landmark in the long process of the orientalization of Roman beliefs and Roman taste.

Claudius (A.D. 41–54)

The emperor Claudius had little in common with his predecessor. Elderly and pedantic, but endowed with an unexpected streak of practical good sense, not for him the costly luxury of building for its own sake. Although at least two more estates, the Horti Luculliani on the Pincian Hill and the Horti Tauriani on the Esquiline, were confiscated to the imperial domain during his reign, there is no record of any new construction in either. He seems to have been responsible for some alterations and additions on that part of the Palatine that was later occupied by the Flavian Palace, but nothing of any great extent; and his religious dedications appear to have been limited to the addition of altars or statues to existing buildings and the building of an altar modelled on the Ara Pacis, the Ara Pietatis Augustae, in honour of Augustus's widow, Livia. At least one temple that had been destroyed by fire, that of Felicitas, was not rebuilt. There are records of two commemorative arches celebrating the victories of the emperor's generals in the field, but such arches may by this date be considered a commonplace requirement of Imperial architecture. Both are known from coins, and that which carried the Aqua Virgo over the Via Lata is also known from old drawings.[6] So far as one can judge, they were very similar in general design, with widely spaced twin columns

resting on a single base and supporting an entablature with an attic above, the principal difference between the two being that the entablature of one was pedimental whereas that of the other was plain. Both probably carried equestrian statues of the emperor between trophies.

A task which Claudius inherited from his predecessor, and which must have been more to his taste, was the completion of the two aqueducts begun by Caligula but left unfinished, the Aqua Claudia and the Aqua Anio Novus, and the replacement of the destroyed terminal sector of the Aqua Virgo. The last-named was built throughout of a hard grey-brown tufa (*peperino*) with travertine details, and an engraving by Piranesi of one of the several arches that carried it over the streets of the city centre (Plate 117) shows it to have been treated in the same highly mannered rustication as another, better-known Claudian building, the Porta Maggiore. The latter is the monumental double arch on which the two new aqueducts crossed the Via Labicana and the Via Praenestina just before their point of junction. Used by Aurelian as the nucleus of the Porta Praenestina, one of the gates in the third-century city walls, in 1838 it was stripped of its later accretions, and it stands today as the finest and most familiar of the surviving Claudian monuments of the city (Plates 115 and 116). Over 80 feet high, it is built throughout of fine travertine masonry. That of the attic, which carried the two conduits and bore a handsome commemorative inscription, is dressed smooth, whereas, apart from the carved capitals and entablatures, that of the lower part has been deliberately left rough, as laid, without the slightest attempt at refinement. This was a deliberate mannerism, not simply unfinished work, and it was doubtless work such as this that inspired architects of the Renaissance such as Michelozzo, in the Palazzo Medici-Riccardi in Florence, and Bernini, in the Palazzo del Montecitorio. Highly mannered rustication of this sort is found in several Claudian buildings in and near Rome,[7] and taken in conjunction with the no less characteristically Claudian, and in such a context decidedly old-fashioned, predilection for cut-stone masonry, one is tempted to regard it as a personal fancy of the emperor himself. Away from the city the two new aqueducts were built in the normal contemporary faced concrete, the main distinguishing feature being the very poor quality of much of the work. The Claudian contractors seem to have deserved their reputation for graft.

Without question, Claudius's most important contributions to the development of Roman architecture lie in a field which one might be tempted to dismiss as mere engineering, were it not that it was so obviously the practical forcing-house of much that was most vital in contemporary Roman building. It was in great public works such as the new harbour at the mouth of the Tiber, near Ostia, and the draining of the Fucine Lake that engineers and architects (the distinction would have been meaningless to a Roman) learned, even if the contractors did not always apply, the complete mastery of their materials which lay behind the revolutionary architectural progress of the later part of the century. The draining of the Fucine Lake was one of the many projects which Julius Caesar is said to have had under consideration at the time of his death; and it is not at all improbable that Claudius was further influenced in his choice by his own antiquarian researches into the Etruscans, those early masters of hydraulic lore. It is

significant that at about the same date (the masonry is Julio-Claudian) there was also a restoration of the emissary of Lake Albano, the original drainage of which in the early fourth century B.C. had been achieved under Etruscan guidance. Whatever the precedents, the draining of the Fucino into the river Liri, four miles distant, was an enormous undertaking. It took eleven years to complete; and although ancient writers understandably make much of the several humiliating setbacks which the project underwent as a result of the venality and incompetence of the contractors, the planning and organization of the work was of a high order. A detail which illustrates how strongly Roman building practice rested on experience rather than on theory is that much of the mortar used is of poor quality because, in mixing it, the builders chose to use a ferruginous red sand from the bottom of the lake, which bears a superficial resemblance to the red pozzolana of the Roman Campagna, rather than the readily accessible yellow pozzolana, which looked like clay. Claudius was still importing pulvis puteolanus from Pozzuoli for his harbour works. The very considerable practical knowledge already acquired of the uses of pozzolana was evidently not accompanied by any theoretical appreciation of its hydraulic properties.[8]

One of the principal purposes of the new harbour at Ostia was to ensure the regularity of the grain-supply, and it is not surprising therefore that Claudius should have concerned himself also with improving the arrangements for its storage and distribution. A great deal of the storage was provided at Ostia itself.[9] But although fewer buildings of the sort have been identified in Rome, this must be partly due to the difficulties of distinguishing and dating such utilitarian buildings from the very fragmentary remains that have come down to us. It has recently been suggested that the traces of a very large porticoed building along the west side of the Via Lata beneath and adjoining the Palazzo Doria, long but erroneously thought to be those of the Saepta, are in fact what survives of the Porticus Minucia Frumentaria, which about this date seems to have become the main distributing centre within the city.[10] The piers surviving beneath the church of S. Maria in Via Lata are of travertine and rusticated in the Claudian manner; they were free-standing and carried flat arches. Others, no longer visible, were cruciform, indicating a vaulted superstructure. If this is indeed the Porticus Minucia, which is known from inscriptions to have had at least forty-two distinct entrances, or offices, one must assume that much of the storage space was accommodated on an upper storey or storeys, and was accessible, as often at Ostia, by ramps.

Another commercial building which from its masonry may well be of Claudian date is the easternmost of the two early buildings beneath the church of S. Clemente. It consists of a number of small, uniform chambers grouped around three sides of a rectangular enclosure (the fourth side, with the entrance, is missing). The openings into the individual chambers are narrow, suggesting that the commodity handled was less bulky than grain; and the provision of windows may indicate that the building combined the functions of depot and bazaar.

Finally, one may mention the grandiose temple and precinct begun in Claudius's honour immediately after his death by his widow and alleged poisoner, Agrippina. Although the visible remains are almost entirely the work of Nero, who incorporated

the site into the gardens of the Golden House, and of Vespasian, who completed the temple, the elaborately rusticated travertine masonry (Plate 122 and Figure 91) is so very closely in the tradition of the Claudian Aqua Virgo and the Porta Maggiore (and so very much in contrast with the elegant refinement of most Neronian building) that they constitute a fitting postscript to the work of the emperor in whose memory they were erected.

Nero (A.D. 54–68)

The emperor Nero was seventeen when he succeeded his stepfather, Claudius. He was a young man of decided artistic tastes and some talent, but temperamentally unstable and wholly unfitted for the responsibilities of unbridled power. Two circumstances singled his reign out to be a turning-point in the history of Roman architecture. One was the fire which in A.D. 64 destroyed half the centre of ancient Rome, with results that may fairly be compared with the aftermath of the Great Fire of London of 1666. The other was the situation created by the great advances in building materials and techniques that had taken place during the preceding half century. Although there was no single dominating architectural personality comparable to Sir Christopher Wren, contemporary building practice had within itself the resources for a development unprecedented in the history of ancient architecture. They only awaited an outlet and a stimulus. The fire provided the one, Nero the other.

The resulting revolution in architectural technology and taste, of which Nero's buildings were the first public expression, and the wider implications of the great imperial residences upon which he lavished so much money and attention are discussed later.[11] In the pages that follow we are concerned only with his public building, and with his palaces in so far as they affected the architectural development of the city as a whole or illustrate the personality of their builder.

During the early part of his reign Nero's interests were those of a wealthy young patrician of his day. In the Vatican area he completed the unfinished Circus of Caligula and built a new bridge across the river, the Pons Neronianus, to give access to it. He laid out a temporary stadium in the Campus Martius (possibly the forerunner of the Stadium of Domitian) and in 57 a temporary amphitheatre, the lavish appointments of which – marbles and precious gems, ivory inlay, golden nets hung from tusks of solid ivory, and star-spangled awnings – are very much in character with what we know of the builder of the Domus Aurea. In more serious vein he was responsible for a market-building on the Caelian, the Macellum Magnum, dedicated in 59. The building itself has vanished, but coins show a two-storeyed columnar pavilion within what appears to have been a porticoed enclosure, also of two storeys.[12] It was evidently an elaborate version of the single-storeyed market-buildings of Pompeii, Lepcis Magna, and other early sites.

Nero's most popular building was without question the public baths, the Thermae Neronianae, which he completed in 62 or 64 in the Campus Martius, near the by now sadly inadequate Baths of Agrippa. 'What worse than Nero, what better than Nero's baths?' was Martial's verdict.[13] The building underwent a major restoration at the hands of Alexander Severus in 227, and it was on this occasion that it took on the form that

was recorded in the Renaissance, showing a symmetrical building of the same general type as the Baths of Titus, Trajan, and Caracalla. It is no longer possible to tell what, if any, part of this represents Nero's original design, but it seems that it must at least have had a symmetrical layout and, if so, that it may in fact have represented a first step towards the formation of the 'Imperial' type which was to dominate later Roman practice. Adjoining the baths was a gymnasium – an interesting anticipation of the provision made in the great public bath-buildings of the second and third centuries for the social and educational activities which had belonged to the Greek gymnasium.[14]

Nero had inherited from his father a town house beside the Via Sacra, and it must have been this fact which first suggested the idea of the Domus Transitoria, which was to link the extensive imperial properties on the Esquiline and on the Palatine by building across the low saddle that is now crowned by the Arch of Titus and the church of S. Maria Nova. Although it was all swept away in or after the fire, enough has come down to us to give an idea of the combination of rich materials and a meticulous refinement of detail which was the hallmark of Nero's personal taste. One well preserved fragment,[15] buried deep within the platform of Hadrian's Temple of Venus and Rome, comprises a small, circular, and presumably domed chamber at the intersection of two barrel-vaulted corridors (Figure 88). There were shallow, marble-lined pools behind columnar screens in two of the arms, and the whole was paved in rich colours, partly in marble,

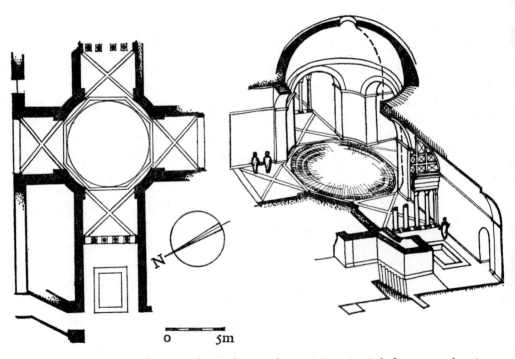

Figure 88. Rome, junction of two corridors within Nero's Domus Transitoria, before A.D. 64, later incorporated within the platform of the Temple of Venus and Rome. Plan and sectional view. The form of the dome is conjectural

partly in a geometric design of tiles of semi-opaque glass paste. Apart from its materials, however, this fragment of a larger complex, with its wide penetration of a small, circular, and probably centrally lit, domed chamber by vaulted corridors, offers a valuable foretaste of one of the most striking and significant features of the Golden House, namely the interest of its architect in the interplay of enclosed curvilinear forms. As we shall see in a later chapter, the Golden House may well have been the first major public monument in which this tendency found monumental expression. But the ferment was already at work, and in a surprisingly sophisticated form.

Another well preserved fragment of the Domus Transitoria is the sunken fountain court, or nymphaeum, beneath the triclinium of the Flavian Palace (Figure 89). This was an elongated rectangular building recessed into the valley bottom between the two eminences of the Palatine Hill. In the centre was an open courtyard, with an elaborately scalloped fountain and cascades occupying the whole of one wall and, opposite it, a

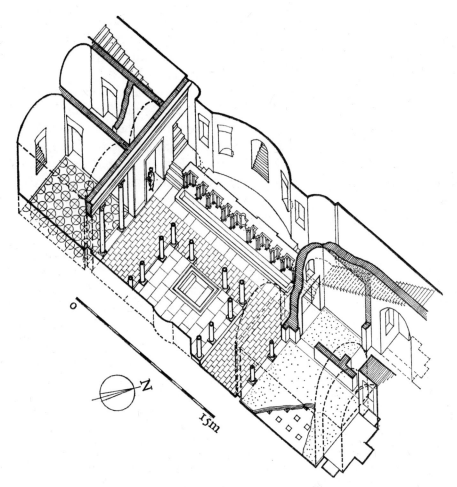

Figure 89. Rome, fountain court of Nero's Domus Transitoria, destroyed in A.D. 64 and later incorporated in the substructures of Domitian's Palace. Axonometric view

square dais covered by a columnar pavilion; facing each other across the courtyard from either end, there were two suites of small rooms, very richly decorated with marble intarsia paving, marble panelling, and vaulted ceilings covered with paintings and elaborate stucco-work, enriched with coloured glass and semi-precious stones. This was a suite for intimate, *al fresco* dining and repose in hot weather, comparable both in form and in intent to such Renaissance nymphaea (themselves based on classical models) as that built by Ammanati in the Villa di Papa Giulio. The fountain bears a distinct family resemblance to the scaenae frons of a theatre, the pavilion to those that one sees in the wall-paintings of Pompeii; the materials were the richest money could buy – on the floor and walls are specimens of all the finest varieties of marble and porphyry from Greece, Asia Minor, Egypt, and Africa, several of them appearing here for the first time; and the workmanship matched the materials. To cite a single instance, the decoration of the walls was protected from damp by an air-space contrived by means of specially constructed tiles. The floor too was specially damp-proofed.

The fire of 64, which started in the Circus Maximus and spread thence eastwards and southwards across the Palatine and Caelian towards the Esquiline, swept away the Domus Transitoria and with it many of the oldest and most populous quarters of Rome. Of the fourteen administrative Regions into which the city was divided, three were totally destroyed and only four were untouched. Nero had the authority which, in similar circumstances, Wren lacked, and he was quick to seize his opportunity. To provide for his new and yet more ambitious residence, the Domus Aurea or Golden House, he annexed the properties adjoining his own estates throughout an area of some 300–350 acres, roughly the equivalent of Hyde Park, or about one-third of Central Park, New York, and comprising the whole basin of which the depression occupied by the Colosseum is the natural centre. For all the perversity of its conception, the result was a remarkable and highly individual complex of buildings and parkland which, in several respects, can fairly claim to have been a turning-point in the history of Roman architecture.

In essence the Golden House was a wealthy country residence established in the heart of urban Rome (Figure 90). It was this fact, not its opulence, which was its crime in the eyes of Nero's contemporaries, and it was this fact which determined the whole layout. The centrepiece was an artificial lake on the site later occupied by the Colosseum. Facing out across the lake from the sheltered lower slopes of the Oppian Hill (an offshoot of the Esquiline) was the main domestic wing; streams fed by specially built branches of the aqueducts cascaded down the slopes; and, grouped along the waterside and scattered picturesquely through the parkland as far as the eye could reach, were fountains, baths, porticoes, pavilions, and tempietti. The boundaries were sited so that from the terrace in front of the residential wing one saw nothing of the encircling town. Only towards the forum, along the Velia, was there a monumental group of buildings. Here the fire had destroyed the Temple of Vesta and everything to the south of it, and here Nero built a grandiose vestibule on the site later occupied by the Temple of Venus and Rome. In the centre stood a colossal gilt bronze statue of himself, 120 feet high; and down the northern slopes of the Velia the Via Sacra was taken out of its traditional winding course

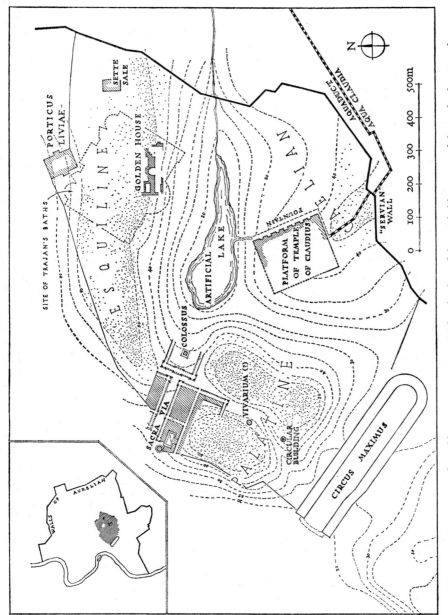

Figure 90. Rome, Nero's Golden House, A.D. 64–8. Sketch-plan of the probable extent of the park, showing the known structures

and made the axis of a monumental approach flanked by multiple streetside colonnades.[16]

All this was swept away after Nero's death, and over most of the area its only lasting result was to make available to Nero's successors the ground upon which were built most of the great monuments of Rome during the next half-century – the Forum of Peace, the Temple of Venus and Rome, the Colosseum, the Baths of Titus and of Trajan, and the Flavian Palace, to name only some. Only the residential wing survived long enough to be incorporated within the substructures of Trajan's Baths and so preserved to be rediscovered by the artists and antiquarians of the Renaissance. Its vaulted chambers were the *grotte* where Raphael and his followers saw and studied the models for the style of which the name 'grotesque' has since passed into the language – a strange but not altogether inappropriate memorial to the bizarre fancy of its one-time imperial patron.

The Romans were not alone in failing to observe the real architectural significance of what was going on around them. By its contemporaries the Golden House was seen principally as a feat of engineering and as a repertory of mechanical marvels.[17] Nero's taste was above all for the novel and the spectacular, and his architects, Severus and Celer, were practical engineers who had been associated with the ambitious enterprise (begun but never completed) of cutting a canal from Lake Avernus to the Tiber. They were well equipped to provide such wonders as the artificial lake; a revolving banqueting hall (or a hall with a revolving ceiling) representing the motions of the heavenly bodies; coffered ivory ceilings which scattered flowers and scent upon the guests beneath; baths supplied with sea-water and with water from the sulphur springs near Tivoli; and indeed to plan and to carry into effect within the compass of a few years the whole vast programme of landscaping and construction that lay behind the contrived rustic simplicity of this extraordinary enterprise. That one of them was also the architect of vision who saw and exploited the aesthetic possibilities of the new concrete medium is entirely possible; but upon this aspect of the Golden House the sources are silent.

Nero himself is remembered (and would undoubtedly have wished to be remembered) for his Golden House. He deserves, however, to be given credit also for the admirable regulations which he drew up to govern the rebuilding of Rome after the fire.[18] The new city was to be laid out with regular, broad streets instead of the tortuous alleyways of the old town; streetside porticoes were to be provided, from the flat roofs of which fires could be fought; no building was to be more than seventy feet high;[19] every house was to be structurally independent of its neighbours; timber was to be restricted to a minimum and the use of certain fire-resistant stones encouraged. Human nature being what it is, these regulations were not always observed. But for a more positive view of their effectiveness one has only to look at the streets and apartment-houses of second-century Ostia, which in this, as in so much else, copied what was going on in Rome. Nero's regulations expressed and codified changes that were already in the air. The time was ripe for the replacement of the ramshackle tenement-houses of old Rome by the neat, orderly insulae which the newly developed concrete medium had made possible. The Great Fire furnished the occasion; and if it was, broadly speaking, a new Rome that rose from the ashes, Nero deserves a substantial share of the credit.

ARCHITECTURE IN ROME FROM VESPASIAN TO TRAJAN

(A.D. 69–117)

Vespasian (A.D. 69–79)

W HEN the dust and confusion of the civil war that followed Nero's death had settled, the Roman Empire found itself with a new dynasty, the Flavians, established on the imperial throne. The family was of sound, middle-class, Central Italian stock, and the founder of the dynasty, Vespasian, a capable general and a shrewd administrator, had all the virtues and limitations of his modest origins. The heir to a bankrupt treasury, which during the ten years of his rule he successfully replenished by a policy of rigid economy and sound finance, not for him the indulgence of lavish building for its own sake. One may be sure that any architectural enterprise of his was undertaken with a clear purpose. It is perhaps for this reason that the list of his work, though short, contains so much of real architectural importance.

An immediate and urgent necessity was the rebuilding of the official state sanctuary, the Temple of Jupiter Optimus Maximus on the Capitol, which had been burnt to the ground during the last stages of the civil war. Re-dedicated in A.D. 75, it was again totally destroyed by fire five years later, and no fragment of Vespasian's building has come down to us. But from the literary record and from representations on coins[1] (Plate 107c) we know that, as was appropriate in such a case, the design was conservative, somewhat taller than its Late Republican predecessor and doubtless making far more use of fine marbles, but in other respects following the traditional plan and repeating such time-honoured features as the four-horsed chariot of Jupiter above the apex of the gable.

The decision to complete the Claudianum, the temple of the Deified Claudius, left incomplete and partially dismantled by Nero, was an astute political move, designed to lend respectability to the new dynasty's claim to succeed the Julio-Claudians and yet at the same time to dissociate itself from the policies of its last representative, Nero. Of the original project very little had probably survived except the great platform, some 220 by 175 yards (200 by 160 m.) in extent, which occupied the top of the Caelian Hill. To this was added a wide axial staircase on the shorter, northern side, towards the Colosseum, and down the west side, facing the Palatine, a double order of travertine arcades, the remains of which have recently been restored fully to view within the grounds of the monastery of the Passionist Fathers; down the east side the nymphaeum added by Nero was allowed to remain. The west façade[2] (Plate 122 and Figure 91) consists of two orders of elaborately rusticated masonry; the lower openings are rectangular, with flat arches and a cornice carried on shallow Doric pilasters, and the upper openings

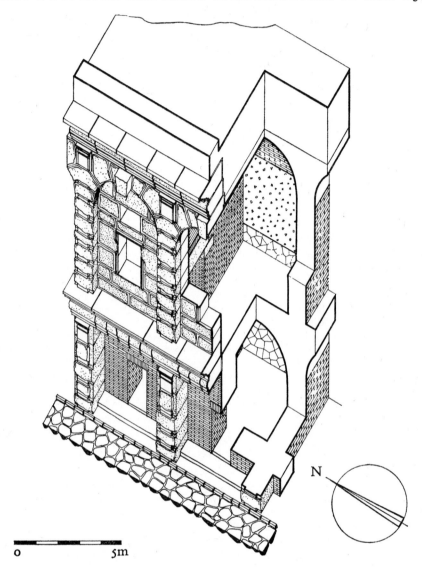

Figure 91. Rome, Temple of the Deified Claudius (Claudianum), façade of platform, soon after A.D. 70* (cf. Plate 122)

round-headed, framed between pilasters that rise to carry a projecting entablature. The keystones of the upper arches project in bold relief, and of the masonry only the pilaster capitals, the two cornices, and the architrave of the upper order are carved, all the rest being left rough and in high relief, with only a hint of the architectural framework in the deeply channelled joints. Set back within the openings of this double order were the closure walls of a continuous façade. Those of the ground floor were of brick-faced concrete, with single doorways opening into a range of shops; those of the upper floor of rusticated travertine, with rectangular windows lighting a range of interconnecting

*From this point onwards, all dates are assumed to be A.D. unless otherwise noted.

218

chambers. It is, however, the arcaded framework that dominates the scheme, presenting a bold, rhythmical façade towards the Palatine. For all its complexity of detail, one is closely reminded of the Temple of Jupiter Anxur at Terracina (Plate 81), from which it is indeed in the direct line of descent.

Of the temple itself nothing is preserved, but the plan is known from the Severan marble map of Rome. It was a hexastyle prostyle building, set on a tall podium, and it stood somewhat to the east of the centre of the platform, facing westwards across the shorter axis. The open space around it was planted with rows of trees, or shrubs, and it was at any rate in part enclosed by shady porticoes. That the surviving travertine façade (and *a fortiori* the temple and other superstructures) is the work of Vespasian is almost certain. Not only is it built against the core of an earlier, simpler platform, but it faced on to a paved street, which would have been completely out of place in the parklands of the Domus Aurea. But the masonry, with its mannered rustication, is so characteristically Claudian, recalling that of the Porta Maggiore and the Aqua Virgo, that one is tempted to wonder whether it may not have been modelled on some surviving elements of the original project.

The temple and precinct of Peace, the Templum Pacis, often though less correctly referred to as the Forum of Vespasian, was another dynastic monument, vowed in 71 after the capture of Jerusalem and designed, like Augustus's Ara Pacis, to identify the new dynasty with the blessings of peace after a period of civil and external strife.[3] It took the form (Figure 92) of a rectangular enclosure, 120 by 150 yards (110 by 135 m.) in extent, laid out upon the same alignment as the Forum of Augustus, towards which it faced, but from which it was separated by the line of the Argiletum, the busy street that linked the Forum Romanum with the crowded urban quarter of the Subura. The greater part of the site was occupied by an open space, slightly shorter than it was broad, which was laid out as a formal garden and enclosed on three sides by porticoes with columns of red Egyptian granite. On the fourth side, towards the Argiletum, instead of a portico there was a colonnade of even larger columns of africano marble, set close up against the entrance wall; and pairs of columns of the same marble spanned the entrances to four square exedrae which opened, two and two, off the lateral porticoes. The temple faced north-westwards, down the shorter axis, and instead of projecting into the open central area it was so placed that the façade stood on the line of the south-east colonnade, the porch occupying the breadth of the portico and the apsed cella projecting beyond it, terraced into the rising ground of the Velia. Opening off the south-east portico on either side of the temple was a range of large halls, one of which contained a library. Another was later used to house the great Severan marble map of Rome.

There are many points of interest about this plan. The choice of the shorter axis and the use of trees, or shrubs, to accentuate the architectural design are features that it shares with the Claudianum. The exedrae opening off the lateral porticoes recall the great precinct of Baalbek or, later, Hadrian's Library at Athens. The colonnade along the inner face of the north-west wall is an early, if not the earliest, monumental example of the application to an external wall of a decorative device long familiar in interior architecture (it is a pity that we do not know exactly how the entablature of the

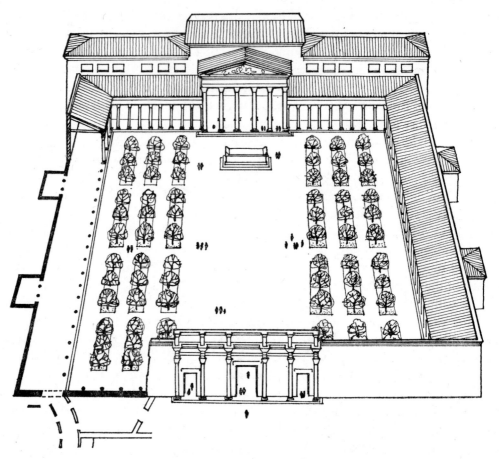

Figure 92. Rome, Templum Pacis ('Forum of Vespasian'), 71–9. Restored view, looking south-eastwards

colonnade was related to the wall behind it). Above all, the relation of the temple to the precinct, though not without formal parallels (e.g. the market at Puteoli, or the 'Marmorsäle' of the bath-buildings of Asia Minor),[4] has qualities of reticence that are, to say the least, unusual in metropolitan Roman architecture. The precinct was focused upon, but in no way dominated by, the temple. To an exceptional degree it was the whole building that constituted the *Temenos Eirenes*, as the Greek writers call it, and it derived its effect as much from the simplicity of its lines and the skilful interplay of trees and architecture as from the richness of its materials and the wealth of its fittings. In it, alongside such trophies of the Jewish war as the Seven-branched Candlestick and the Ark of the Covenant, were displayed some of the finest masterpieces of Greek painting and sculpture, and Pliny names it as one of the three most beautiful buildings of the Rome of his day (the others on his list being the Forum of Augustus and the Basilica Aemilia). One of the last great buildings in the conservative Roman tradition, barely touched by the innovating currents of contemporary architectural thought, it was also one of the finest.

Very much the same might be said of the Flavian Amphitheatre or, to give it its familiar name, the Colosseum (Plate 121 and Figure 93). One of the wonders of its own day, ever since the Middle Ages it has been a symbol of the majesty and enduring might of Rome. One recalls the words of the Venerable Bede, as translated by Byron:

'While stands the Coliseum, Rome shall stand;
When falls the Coliseum, Rome shall fall:
And when Rome falls – the World.'

For that very reason it is not an easy building to view dispassionately in its contemporary context. Even its popular name, however apt, lacks classical authority and may well be derived at second-hand from the Colossus of Nero, which stood near by.

Of the amphitheatres already existing in Rome, that of Taurus had been recently damaged by fire, and those of Caligula and Nero were both temporary structures, manifestly inadequate to the needs of a rapidly growing population. As a popular gesture by the new dynasty, the construction of a new, permanent amphitheatre was a wise choice. Equally shrewd was the choice of the site, the valley bottom that had housed the artificial lake of Nero's Golden House. At one resounding stroke Vespasian was able to redress one of the most bitterly resented wrongs of his predecessor, while at the same time securing an ideal site for his new building – central, ready-excavated, easily drained, and with a subsoil of compact, lithoid tufa perfect for carrying the vast weight of the projected building. It was probably begun early in his reign and was unfinished at his death. Exactly which parts are the work of Vespasian, and which of Titus and Domitian, are questions of little importance. Apart from modifications to the attic storey during construction, the outstanding characteristic of the building is the skill and foresight with which the unknown architect can be seen from the very outset to have marshalled the whole gigantic enterprise towards its predetermined conclusion.

The problem that he faced was the seating and the orderly handling of vast and potentially unruly crowds of spectators, usually estimated as between 45,000 and 55,000 persons. There were plenty of precedents, though none on this enormous scale. The solution adopted by the architect of the Theatre of Marcellus (Figure 83), itself presumably modelled on that of the yet earlier Theatre of Pompey, is one that we find in an infinite number of local variants throughout the theatres and amphitheatres of the Roman world, in every province and at every date, wherever these had to be built up from level ground instead of resting against the slope of some convenient hillside. The seating was terraced upwards and outwards on the vaults of a network of radiating, wedge-shaped chambers and ambulatory corridors; and into the resulting voids was fitted a system of radiating staircases or ramps (*vomitoria*) and lateral passageways, so contrived as to provide separate access to each wedge (*cuneus*) of seating, and within each wedge to the several concentric sectors (*maeniana*) into which the whole of the interior was divided by horizontal gangways. In the case of the Colosseum there were no less than seventy-six numbered entrances; and wherever necessary, movement could be further controlled by wooden barriers. In addition to providing lateral circulation, the outer ring of corridors helped to buttress the outward thrust of the seating.

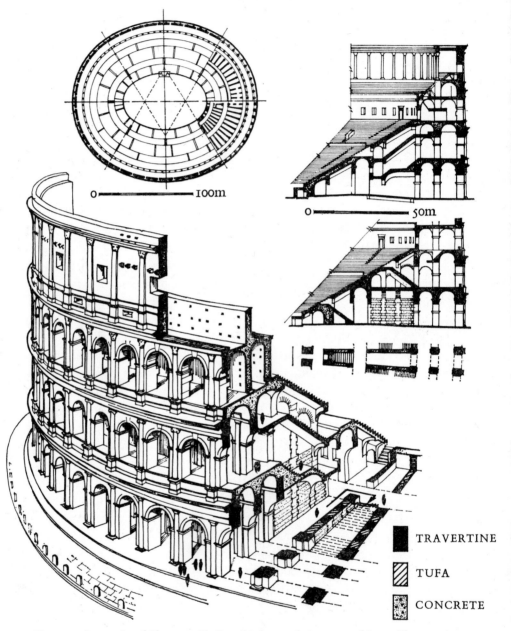

0 ——— 100m

0 ——— 50m

■ TRAVERTINE

▨ TUFA

▦ CONCRETE

Figure 93. Rome, Amphitheatrum Flavium (Colosseum), inaugurated in 80. Plans, sections, and sectional view (cf. Plate 121)

222

All this was familiar ground. What was new was the sheer size of the structural problems involved. The plan, as regularly in the amphitheatres of the Roman world, was an ellipse, and it measured no less than 615 by 510 feet (188 by 156 m.) externally and 280 by 175 feet (86 by 54 m.) internally, the seating (*cavea*) forming a uniform ring 167 feet (51 m.) wide and 159 feet (48·50 m.) high from the pavement to the outer cornice. Up to the full height of the third external order the seating was of marble carried on substructures of vaulted masonry. Above this height it was of wood (the 'maenianum summum in ligneis' of the texts) in order to reduce the weight at a point where the outward thrust was contained only by the thickness and solid construction of the outer wall. Below this level the doubling of the ambulatory corridors and the radially vaulted vomitoria afforded a system of buttressing that was more than adequate to the demands made upon it. Porches in the middle of the two long sides gave access to the imperial box and to the seating for senators (Figure 93).

Structurally, the interest of the building lies mainly in its choice of materials and the evidence that it offers of working methods. After making ample provision for drainage, a ring of concrete footings 25 feet thick was laid down to support the cavea. On this was built a framework of piers of travertine, specially quarried near Tivoli, and it was this squared stone masonry which constituted the essential load-bearing skeleton of the entire building up to the springing of the vaults of the second order. Between the piers were inserted the radial walls, which were of squared tufa up to an irregular line corresponding roughly with the floor of the second order, and above this of brick-faced concrete. With the exception of one of the smaller, internal corridors, which has a groined vault, the vaults are all of barrel form, in some cases incorporating ribs of brick, a very early use of a device which, though of little or no independent structural value, was widely used in later Roman architecture to facilitate the actual processes of construction.[5] The use of a variety of materials was undoubtedly an economy in time as well as cost, since each was handled by a different group of workmen, the tufa and the concrete being added when the travertine skeleton was already in place, and the timberwork and the marble seating later still. The work was further speeded by dividing the building laterally into four or more sectors. At least two gangs can be seen to have been at work simultaneously on the surviving half of the travertine facing of the attic storey, and in a building that had been so carefully thought out in advance there would have been no difficulty in applying the same system throughout.

Architecturally there was little that was new in the travertine façade (Plate 121). It consisted of three superimposed orders, Doric, Ionic, and Corinthian respectively, of which the half-columns and entablatures were purely decorative, and above these a tall attic storey with lofty Corinthian pilasters supporting the crowning entablature. The three orders framed arches opening on to the ambulatory corridors, while smaller, rectangular windows, placed in alternate bays, lit the corridors serving the upper part of the cavea. Except for the elaborately marbled porches surmounted by statuary which projected from the four cardinal points of the plan, the entire circumference was uniformly treated. All this follows conventional lines, the architect's principal contribution lying in the skill with which he handled the proportions of what could so easily have

become a mere unwieldy bulk of masonry, and in the unobtrusive ingenuity with which he manipulated the detail of the orders to meet the requirements of the structures within. Two points only call for comment. One is the use of huge decorative shields of gilded bronze, alternating with the windows of the attic storey; the supports for these are still visible. The other is the arrangements for supporting the *velarium*, the huge awning that protected the spectators from the sun, for the manipulation of which a special detachment of sailors was quartered near by. The poles supporting this were carried on large brackets, three of which can be seen just below the entablature of each bay of the attic; and it was further braced by bollards set at pavement level a short distance out from the steps of the lowest order.[6]

About the interior, which was stripped of its marbles during the Middle Ages, there is little to be said. The remains of an order with large granite columns must come from a portico somewhere near the top of the building, perhaps carrying a timber roof over the wooden seats of the *summum maenianum*. The elaborate network of service corridors and chambers below the arena is mainly the work of Domitian. Among them were lifts with an ingenious system of counterweights for hoisting scenery or wild beasts to the floor above, a feature for which the amphitheatre at Puteoli in Campania offers interesting parallels.

The Colosseum was not a building of any great originality. It was as conservative in its structural methods and choice of materials as it was in design, preferring in both cases to refine upon a tradition that went right back to the Republic, to buildings such as the temple at Praeneste and the Tabularium. Formally and materially it represents a strain in Roman architecture that was very shortly to be swept away by new techniques and new aspirations. For all that, this was a tradition capable of a great strength and dignity, and one well suited to display the qualities of bold, orderly planning and technical competence which characterize the best Roman work of all periods. In the Colosseum it found a worthy consummation.

Titus (A.D. 79–81)

Vespasian's elder son and successor, Titus, did not live long enough to stamp his personality upon the architecture of Rome. Apart from continuing his father's work on the Colosseum, he was responsible for initiating only two major enterprises, the Temple of the Deified Vespasian and a new public bath-building, the Thermae Titi. He was also accorded an honorary arch, probably to be identified with the triple arch that stood in the middle of the curved end of the Circus Maximus; and it is not impossible that he began the well-known arch at the end of the Via Sacra, between the forum and the Colosseum.

For the Temple of Vespasian he chose a site at the foot of the Capitoline Hill, beside the Temple of Concord. Apart from the steps, which owing to the limitations of space available were set back between the columns of the façade, the hexastyle peristyle plan followed conventional lines. Rather unusually for so late a date the travertine of the podium was left exposed, but the cella (which was almost certainly completed by

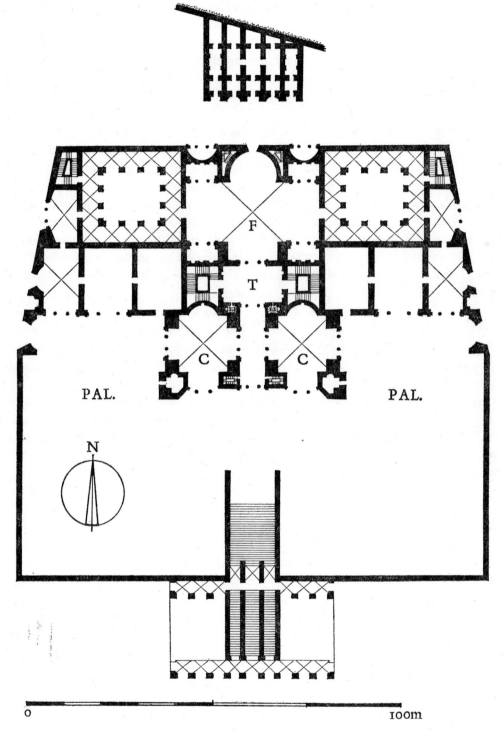

Figure 94. Rome, Baths of Titus, inaugurated in 80. Plan, after Palladio

ꜰ Frigidarium ᴛ Tepidarium ᴄ Caldarium ᴘᴀʟ. Palaestra

Domitian) was elaborately finished in fine marbles. The three standing columns are an early example of the careful restoration of an ancient building, undertaken by Valadier in 1811. The entablature, preserved in the substructures of the Tabularium, is an outstanding example of Flavian architectural ornament, bold, deeply cut, and very rich, a style native to Rome, where one can follow its evolution, step by step, from Late Augustan and through Julio-Claudian and Flavian times down to Domitian and the early years of Trajan.

The Baths of Titus, built in haste to grace the dedication of the Colosseum in A.D. 80, followed the precedent established by Vespasian in using ground that had belonged to Nero's Golden House, standing alongside the main domestic wing and looking out over the valley. Except for the remains of a portico of brick-faced concrete with engaged columns, across the street from the Colosseum, hardly anything has survived, but the plan, which is known from a measured sketch by Palladio (Figure 94), suggests that this was the essential structural material throughout.[7] Palladio's plan, whatever the reliability of its detail, reveals unmistakably that the layout was of the so-called 'Imperial' type. This type, which had a long and important history before it, consisted essentially of a large, approximately rectangular enclosure and, placed symmetrically within it, a central bathing block. The bathing block was itself symmetrical about its shorter axis, transversely across the northern end of which (or in the later examples centrally) stood the main *frigidarium*, or cold room, a lofty three-bay, groin-vaulted hall, buttressed by smaller, barrel-vaulted bays containing cold-plunges; and at the south end, often projecting so as to take full advantage of the sun, the main *caldarium*, or hot room. Along the north side were disposed two identical ranges of smaller suites of changing rooms (*apodyteria*), exercise yards (*palaestrae*), latrines, and other services, and along the south side two identical ranges of smaller heated rooms. Around the outer perimeter of the enclosure lay the cisterns, and facing inwards from it on to gardens were halls to house the manifold social activities for which these great bathing establishments served as centres – meeting rooms, libraries, lecture halls, museums, etc. Such in brief was the fully developed 'Imperial' type of baths. Those of Titus were small by comparison with the later giants (less than half the equivalent linear dimensions of those of Trajan), and the outer enclosure was little more than a large rectangular terrace along its southern side. But most of the essential elements were already present, as indeed they may well have been twenty years earlier (though this cannot now be proved) in the Baths of Nero.[8] In either case, like so much that is vital to the development of later Roman architecture, the seeds are to be sought in the fruitful middle years of the first century A.D.

Domitian (A.D. 81–96)

Domitian, Vespasian's second son, succeeded his brother in A.D. 81. During the fifteen years of his reign he was responsible for a great deal of building, and although his work, viewed as a whole, may be regarded as broadly progressive rather than revolutionary, it did by its very quantity leave its mark upon Roman architecture at a critical stage in its

development. It included, moreover, the creations of Rabirius, one of the few Roman architects of distinction whose name is known to us. Domitian has every right to be considered one of the great builder emperors.

Domitian's work may conveniently be discussed under three headings: buildings that he inherited unfinished from his father or his brother; those that he restored after the great fire of 80; and those that he initiated *ex novo*, although he did not in all cases live to complete them.

To the first category belong the Colosseum, the Baths of Titus, and the Temple of Vespasian, all of which have already been sufficiently described. The well-known arch at the head of the Via Sacra may also have been begun by Titus, but it was certainly finished after his death as a commemorative monument. Built of Pentelic marble about a concrete core, it is remarkable chiefly for the simple dignity of its architectural lines and for its sculptured ornament, which includes the two familiar panels illustrating Titus's triumph after the capture of Jerusalem. It is also one of the earliest public monuments to use the Composite capital, which had been invented by Augustan architects but which only now began to come into common use. Incorporated in the Middle Ages into a fortress of the Frangipane family, it was not restored to its familiar form until 1821, by Valadier, whose use of travertine to distinguish the new from the original masonry is an early and wholly successful example of scientific restoration.

The fire of 80 left a heritage of buildings damaged or destroyed which extended all the way from the Capitol to the Pantheon and which ranged from the Temple of Jupiter Optimus Maximus, re-dedicated barely five years before, to the great complex of monuments built by Agrippa in the Campus Martius. Almost without exception the buildings destroyed are known to have been restored by Domitian, and something is known about several of them from the Severan marble map of Rome, including the Temple of Isis and the Baths of Agrippa (Figure 87). But of the buildings themselves little or nothing has survived. On the Capitol only the little Republican Temple of Veiovis beside the Tabularium has preserved any substantial remains of its Domitianic restoration, which took the form of replacing the timber roof by a fireproof concrete vault and decorating the interior with an elaborate scheme of coloured marble. The Temple of Jupiter was once again restored on traditional lines, with a wealth of fittings such as gilded bronze tiles and doors plated with gold. But although this time it stood undamaged until late antiquity, hardly a trace of Domitian's work has come down to us.

The buildings initiated by Domitian himself cover a remarkably wide range of techniques and architectural styles. At one end of the scale we have the Flavian Palace, described later in this chapter; and at the other we have the stadium in the Campus Martius, now the Piazza Navona, the houses of which incorporate much of the original structure. Constructionally a two-storey version of the Colosseum adapted to the elongated shape of a racetrack, it was a thoroughly conservative building, with its marble seating carried on substructures of travertine and brick-faced concrete and the travertine arcades of its outer façade framed in the traditional manner by decorative classical orders. Indeed, its principal claim to distinction is that it is the last building in Rome which w e know to have used travertine ashlar as a monumental material in its own right.

Between the two extremes lie a large number of buildings which, though essentially in the classical monumental tradition, can be seen to have introduced novelties of design or detail that are significant for the subsequent development of Roman architecture.

Nothing has survived of the Porticus Divorum, but the plan is known from the Severan marble map (Figure 87). An elongated rectangular enclosure, dedicated to the two deified emperors of the Flavian dynasty, it probably served also as a marshalling ground for the triumphal processions of Domitian himself. At one end stood a grandiose triple arch (the Porta Triumphalis?) and at the other an altar. Two small tetrastyle temples faced each other across the inner face of the arch, and along the rest of the two long sides and across the far end ran colonnaded porticoes. The proportions are quite different from those of Vespasian's Temple of Peace, but in other respects there are many similarities: the formal planting of the central space; the rectangular exedrae that open off the porticoes; the emphasis upon the monument as a whole at the expense of the individual temples; and the deliberate exclusion of the outer world by means of high enclosing walls.

In this last respect we can trace two distinct currents in the temple architecture of the Early Empire. In the Roman Forum, for example, successive emperors were content to follow the traditional Italic practice of treating each temple as an integral part of the urban setting to which it belonged. On the other hand, ever since the later Republic the creation of porticoed enclosures such as the Porticus Metelli (146 B.C.) had been tending towards the creation of architecturally independent precincts, a tendency which was accentuated and given fresh emphasis in the Imperial Fora. The great enclosing walls of these may, as it is often claimed, have been designed partly as firebreaks; but it is almost certainly true also that they reflect the increasing Roman contacts with the hellenistic East, in particular with Syria and Egypt, where the enclosed, inward-facing sanctuary was the rule rather than the exception.[9] In the eastern provinces, as we shall see, the tradition was continuous into Roman times. Here in the west one result was to accentuate the trend towards formalism that was one of Roman architecture's strongest and most enduring characteristics. The Roman architect was not the blind slave to symmetry that he is often portrayed as being. But it is true that in his monumental architecture he had little of the classical Greek architect's instinctive feeling for placing buildings in casual but harmonious relationship, and that he was happiest when dealing with problems that were capable of clearly defined, 'drawing-board' solutions.

Another area in which Domitian was engaged was that of the Imperial Fora (Figure 84), where he built the Forum Transitorium, dedicated after his death by Nerva, and where he seems to have been active also both in the Forum of Caesar and in the area later occupied by Trajan's Forum. Eusebius in fact lists the last-named as one of Domitian's buildings, and it is certain that at the end of it adjoining the Forum of Augustus it was Domitian who started cutting back the lower slopes of the Quirinal Hill to clear space for some monumental building.[10] Since, however, it is no less certain that the Domitianic project was very different from that finally put into effect, the credit for the planning as well as for the execution of the latter must go to Trajan and to his architect,

Apollodorus of Damascus. We shall never know what exactly Domitian had in mind for this area.

The rebuilding of the Temple of Venus Genetrix in the Forum of Caesar is another enterprise that was certainly completed by Trajan, who is known from an inscription to have re-dedicated it in 113, the year of his own great forum. The evidence for attributing the inception of the work to Domitian, namely the distinctively Flavian style of its richly carved entablature (Plate 124), is not in itself conclusive. Sculptural styles did not change overnight, and this could have been a purely Trajanic project, carried out by workmen trained under the previous regime. On the other hand, the whole area had suffered damage in the fire of A.D. 80 and it is not impossible that the repairs were begun by Domitian but finished after his death by Trajan, who deferred their inauguration to coincide with that of his own forum. The plan of the new temple closely followed that of its predecessor, of which it incorporated the podium. The front of the latter rose sheer from the pavement in front, access to it being by two small lateral staircases, and the temple itself was short in proportion to its breadth, with very closely set columns, eight across the front and eight down either flank. The columns, three of which were re-erected in the thirties, and the entablature were of Luni marble, and there were decorative colonnades of Numidian marble with very elaborately carved capitals and bases against the inner walls of the apsed cella. A feature of the marble revetment of the cella is that it was channelled to imitate drafted masonry.

The Forum Transitorium occupied a long and narrow space (about 395 by 150 feet; 120 by 45 m.) between the Fora of Caesar and Augustus on the one hand, and the Temple of Peace on the other. The site offered little scope for architectural originality, and is remarkable chiefly for the still-standing remains ('Le Colonnacce') of the decorative colonnades with which the two long walls were treated (Plate 126). These were free-standing to capital height, only the entablature and the attic storey above being bracketed out to form a series of pedestals and re-entrant bays. Attic and frieze alike were richly carved. Such semi-engaged decorative colonnades had long been a common feature of interior architecture, but their use as a monumental enrichment of exterior walls was a novelty of which there is no certain example before the Flavian period. Of the Temple of Minerva, which stood at the south end, in much the same relation to the forum as the Temple of Venus Genetrix to the Forum of Caesar, the greater part was still standing until 1606, when it was demolished to provide materials for the fountain of Paul V on the Janiculum, and it is known both from Renaissance drawings and from the Severan marble plan. It was hexastyle prostyle with elegantly fluted columns of Phrygian marble and a colonnaded interior ending in an apse. The awkward problem of the projecting south-eastern apse of the Forum Augustum was resolved in characteristically Roman manner by siting the end wall of the forum proper at the level of the front of the cella so as to conceal the greater part of the wall behind, and by using the irregular space beyond to house a semicircular portico (the Porticus Absidata), which served as a monumental entry from the crowded urban quarters to the north and east into the new forum and, through it, to the Forum Romanum, to the Fora of Caesar and of Augustus, and to the Temple of Peace. After over a century of piecemeal development this whole

monumental complex now for the first time began to acquire a certain architectural unity.

There are two of Domitian's buildings of which we may particularly regret the absence of any surviving remains. One is the Temple of Minerva Chalcidica, which stood in the angle between the Porticus Divorum and the Iseum (Figure 87). The plan of it on the Severan marble map is curiously at variance with the record of a circular temple with an outer and an inner ring of columns given by Panvinio on the basis of measurements by Pirro Ligorio.[11] The other is the family mausoleum which Domitian built on the Esquiline, on the site of the family house of the Flavii where he himself had been born. References to it by contemporary writers show that it was circular in shape.

Finally, before turning to the great complex of buildings on the Palatine which represents the principal contribution of Domitian and his architect, Rabirius, to the history of Roman architecture, it is well to be reminded of the tremendous amount of everyday architecture that was going on in Rome throughout the latter part of the first century A.D. The great fires of 64 and 80 had left a legacy of destruction that must have taken many years to make good, and while much of this was undertaken by successive emperors, a great deal more was left to private initiative. This is not the place to catalogue the long list of buildings on the Caelian, Aventine, and Esquiline Hills, in the Campus Martius, and elsewhere, known from their brick-stamps and other indications to belong to the Flavian period.[12] They include private houses (a good example is that which lies beneath the apse of the church of S. Clemente), private bath-buildings (Martial, writing under Domitian, mentions eight such), shops, warehouses (the Horrea Vespasiani, the site of which is not known, and the Horrea Piperataria, or Spice Market, on the site of what later became the Basilica of Maxentius), minor public monuments such as the Meta Sudans, and a multitude of fragments of masonry which, in the nature of things, are almost bound to remain anonymous. What happened at Ostia under Hadrian and Antoninus Pius was happening in Rome a generation or so earlier. These buildings, many of them individually of little importance, together constituted an almost total reconstruction of the heart of ancient Rome, and they were the school in which the builders of the later Empire learned much of their craft.

Domitian's enduring monument is the great imperial residence on the Palatine, known officially as the Domus Augustana (or Augustiana) and in popular usage as the Palatium (Plate 123). The residential block of the Golden House had remained in intermittent use for some time after Nero's death, but the construction of the Colosseum and the Baths of Titus, cutting it off from the centre of the city, deprived it of any value it may have had as an official residence. It is not surprising, therefore, that Domitian should have decided to abandon it altogether and to turn instead to the development of the pre-Neronian nucleus on the Palatine. Here there already existed the Domus Tiberiana, which, together with a group of venerable monuments at the angle overlooking the river, occupied the whole of the Germalus, the western of the two eminences into which the Palatine Hill was divided. Except for its northern spur, the whole of its eastern counterpart, the Palatium, had already been appropriated by Nero; and it was here, occupying the saddle between the two and the whole of the central and south-

eastern part of the Palatium, that Domitian built the main block of his great palace (Figure 95).

The Domus Tiberiana itself does not seem to have been greatly altered, but below it, at the level of the forum, the area between the Temple of Castor and the Horrea Agrippiana was converted into a monumental vestibule serving the whole complex. The vestibule we know from brick-stamps to have been an afterthought, added during the last years of Domitian's life. All the rest was undertaken early in his reign and, except for the stadium, was completed in time for the inauguration of the palace in 92. The architect was Rabirius.[13] His plan lacks the rather obvious formal unity of many Roman buildings, but there is nothing makeshift about it. It was an ingenious and on the whole very successful answer to the problem of combining the conflicting requirements of a palace and a private residence on a site of some initial complexity. With remarkably few

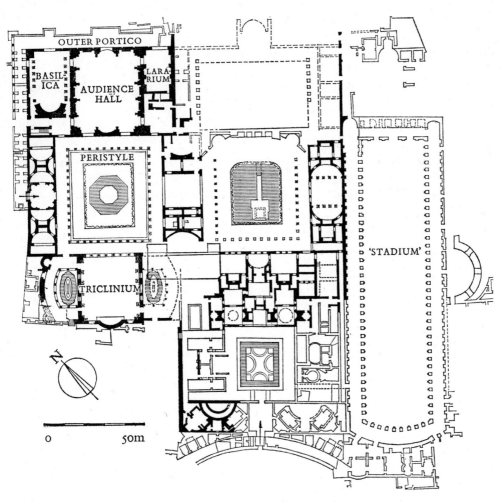

Figure 95. Rome, Flavian Palace (Domus Augustana), inaugurated in 92. Plan. Solid colour indicates buildings at the upper level now in whole or part upstanding

additions and modifications (undertaken chiefly by Hadrian and Septimius Severus) Domitian's building was to remain the official Roman residence of the emperor right down to late antiquity, bequeathing its name to posterity as the type of all subsequent 'palaces'.

Of the factors that determined the choice of plan, the most important was the need to site the state rooms where they would be readily accessible from the Clivus Palatinus, the road that ran up the valley between the Germalus and the Palatium and at the time the only direct means of access from the city centre. They were accordingly grouped together at the west end, terraced up above the saddle, where they formed an almost independent block, with the main façade facing down the valley and a secondary façade towards the Domus Tiberiana. (Within the make-up of the terrace were incorporated and preserved the Late Republican 'House of the Griffins', Caligula's Isiac hall, and the nymphaeum of Nero's Domus Transitoria.) To the east of the official wing, alongside but almost independent of it, lay the emperor's private apartments, and to the east of this again a sunken garden in the shape of a stadium. On the side facing the Circus Maximus it was the domestic wing which dictated the layout of the façade, with a wide, shallow, central exedra, flanked on one side by the imperial box, overlooking the circus, and on the other by a formal terrace masking the irregularities of plan that arose at this point from the need to respect the Augustan Temple of Apollo and other venerable monuments. Towards the forum, on the other hand, the whole architectural emphasis was upon the façade of the public wing, which reared its impressive bulk directly above the head of the Clivus Palatinus. As one approached up the hill the domestic wing lay round the corner to the left, with its main block set well back beyond a pair of colonnaded courtyards. On plan the as yet only partly excavated buildings to the north of the stadium may seem to balance the projection of the public wing; but they were certainly far less bulky, and there does not in fact seem to have been any attempt to treat the whole north façade as a monumental unit. The intention here was rather to emphasize the separate character of the two parts of the palace. It was only internally, at the level of the two peristyle courtyards, that the two wings were linked by a clearly established cross-axis. Towards the east Domitian's work remained unfinished at his death, and it was left to Septimius Severus to complete the development in this direction.

The official wing of the palace formed an elongated rectangular block, with three great state rooms opening directly off the façade and, beyond them, a large colonnaded courtyard leading to the state banqueting hall (*triclinium*). The state rooms were (from west to east) the basilica, in which the emperor sat in judgement, and two rooms conventionally known as the 'throne room' ('Aula Regia') and the 'palace chapel' (*lararium*). The basilica was a large rectangular hall, with an apse at the far end and, set about 6–7 feet out from the side walls, two ranges of Numidian marble columns, which helped to provide a broad seating for what is usually thought to have been a coffered vault – a disposition which in its essentials goes right back to the vaulted nymphaea of the Late Republic.[14] Quite soon after construction the outer wall began to show signs of settlement, and the whole north-west angle had to be elaborately buttressed by Hadrian. That the central hall, the throne room, was vaulted is doubtful. The span was consider-

ably greater than that of the basilica, and although the walls were robust and well buttressed laterally it is very questionable whether they would have stood up to the resulting pressures. Projecting rectangular piers broke the inner faces up into a series of bays, within which were decorative aediculae containing statuary, the bays themselves being framed between tall fluted columns of Phrygian marble carrying a highly decorated order; a shallow apse at the south end housed the imperial throne. The 'Lararium' was a smaller room, and would have presented no problem to vault, although the addition of internal buttresses by Hadrian suggests that even here Rabirius may have under-estimated the structural problem involved. There was no axial staircase leading up to the façade, but an external portico, which ran right across the façade and along part of the west side, linked the state rooms with the Clivus Palatinus and the Domus Tiberiana.

The courtyard behind was surrounded by a portico enclosing a fountain and a formal garden and it was flanked by a series of small rooms of interesting curvilinear design. The whole of the south side was dominated by the great triclinium, or banqueting hall. Nearly as large as the throne room, it must have been timber-roofed. Towards the courtyard it was open between six huge columns of grey Egyptian granite behind an octastyle porch of the same proportions and materials. At the far end there was a shallow apse and a raised dais for the emperor and important guests, and along each of the side walls, helping to support the roof, stood columns of the same granite, between which two doors and three large windows opened on to a pair of identical fountain courtyards. Except for a portico round three sides, the latter were open to the sky, with a large, elaborately scalloped, oval fountain in the centre, the curve of which was picked up and repeated by the outer wall and portico of the courtyard itself. Wherever they sat the guests would have looked out on vistas of ornamental water and greenery, framed in a setting of richly variegated marble. To ensure their comfort in any weather Hadrian inserted a hypocaust beneath the floor – a very early example of such heating used domestically.

The private wing of the palace was built on ground that sloped steeply down towards the Circus Maximus, and the level corresponding with the official wing was here that of the upper storey. The main entrance was in the ground floor, 35 feet below, and opened off the middle of the curved portico that occupied the centre of the south façade. From it a rectangular vestibule led into a square central courtyard (Plate 123), the two storeys of which were probably carried on piers with arches (as in the later apartment-houses of Ostia) rather than on columns. The whole central area was occupied by an elaborately curvilinear fountain in the form of four juxtaposed 'pelta' designs adorned with statuary. Along the east and west sides, grouped about rectangular light-wells, were stairs to the upper storey, together with a number of smaller rooms, some of them at mezzanine height; along the north side, terraced into the rock of the hillside, were the three polygonal domed chambers which are the best-known features of this, until recently, very ill-published monument (Figure 99). In the upper storey most of the rooms faced inwards on to the central courtyard, with a vista through into the peristyle courtyard to the north. Owing to the rise of the ground the latter was already at the

upper level and was the principal architectural link between the domestic and the official wings. The importance of the domestic wing lies above all in the evidence which it gives of the architect's intense interest in creating novel spatial forms and of the great progress that had been made in this direction during the twenty years since Nero built his Golden House. This aspect of the building will be discussed more fully in the following chapter.

The sunken garden that delimited the domestic wing to the east was a conceit, laid out in the semblance of a stadium,[15] 175 yards long and 55 yards wide (160 by 50 m.), with five large vaulted chambers in place of starting gates at the north end, fountains representing the turning-posts (*metae*), and a segmental curve at the south end. Around three sides ran a double portico, the lower one arcaded with brick piers, the upper one probably colonnaded. In the middle of the east side there was a large vaulted exedra, suggesting that the garden might also be used for displays (as it is today), and at the south end, facing outwards, was the imperial box overlooking the Circus Maximus. Unfinished at Domitian's death, the whole complex was completed, with some modifications, by Hadrian. To the east of it, traces of Flavian masonry show that Domitian was planning yet further work, possibly a bath-building on the site of that finally constructed by Septimius Severus; the aqueduct which served the latter, an offshoot of the Neronian branch of the Aqua Claudia, was in origin certainly Domitianic. Towards the north, too, the great platform which occupied the whole of the northern spur of the Palatium, and which carried the Aedes Caesarum (the shrine of Augustus and all succeeding deified emperors, later incorporated into Elagabalus's Temple of the Sun), seems to have reached its definitive form under Domitian, thereby not only establishing the line of the Clivus Palatinus, but also restricting the effective northern façade of the palace to the west wing – a circumstance of which, as we have seen, the architect took full advantage. Finally one may note Domitian's reconstruction of the two Augustan libraries, damaged in the fire of 64, in the angle behind the triclinium; and, terraced down the slopes beyond them, the so-called Paedagogium and the lodging of the imperial heralds, completing the build-up of the whole southern façade of the palace. It is only when one assembles all these scattered elements that one can fully appreciate the ingenuity and thoroughness with which Domitian and his architect, Rabirius, tackled the problem of welding the whole Palatine Hill into a coherent architectural unity, as a proper setting for the great palace itself.

The palace vestibule, the grandiose public entrance from the forum, was one of Domitian's last works, left incomplete at his death and finished by Hadrian. It replaced an earlier and differently oriented structure, perhaps Caligula's notorious extension of the Domus Tiberiana, and it consisted of three distinct elements: the huge reception hall (long thought to be the Temple of Augustus), which lay immediately behind and was oriented upon the Temple of Castor; beside this hall and to the east of it, the building which later became the church of S. Maria Antiqua, and which is plausibly identified as the quarters of the palace guard; and to the east of this again, zigzagging up the hillside, the triple ramp that led up to the Clivus Victoriae and the Domus Tiberiana.

The reception hall itself was a huge construction of brick-faced concrete, measuring

109 by 80 feet (33·10 by 24·50 m.) internally, of which the ceiling or vault sprang from at least 60 feet above pavement level. A portico ran round the two exposed façades, of which that along the west side was replaced by Hadrian with a series of buttresses, no doubt as a result of the settlement which finally brought the roof and almost the entire west wall to the ground. The interior seems to have been quite plain except for a series of alternately rectangular and curved recesses, the doorways being off-axis and sited so as to blend unobtrusively with the pattern of the recesses.[16] The reason for this was no doubt partly practical, to facilitate the strict control of visitors, who then had to pass by a devious route through the guardrooms to reach the ramp beyond. It is hard to believe, however, that in forgoing so established an architectural device as the monumental axial entrance, the architect was not also aware of the greatly enhanced impact of sudden, unprepared entry upon the enormous, almost empty space beyond. With the possible exception of the throne room (which was, anyway, very different in conception, with a well established movement from one end of the hall to the other) this was in fact the largest uninterrupted volume of space (some 700,000 cubic feet) that had ever yet been brought beneath a single roof. Lit from above by two large windows placed in the two end walls, it must have been a very impressive building indeed, and an awe-inspiring foretaste of the architectural marvels that lay beyond.

Nerva and Trajan (A.D. 96–117)

Domitian was murdered in A.D. 96. The only claim of his successor, Nerva (96–97), to architectural distinction is that he completed and dedicated in his own name the forum built by his predecessor. Without question the principal event of his reign was his choice as heir and successor of the great soldier-emperor Trajan, the effective founder of the adoptive dynasty which was to reign unchallenged for nearly a century to come and to bestow on the greater part of the known world a period of unprecedented peace and material prosperity. Trajan, born of an old Romano-Spanish family and the first Roman from the provinces to become emperor, was a dynamic personality, active in many fields, and the buildings of his reign, though distinguished rather by the grandeur of their conception than by any great architectural originality, may be regarded as marking the climax, and in many respects the completion, of the great building programme in the capital initiated over a century before by Augustus.

The literary record of Trajan's building activity is curiously defective. There is no mention, for example, of the rebuilding of the House of the Vestals in the Forum Romanum to substantially the form in which we see its remains today, although it is certain from the brick-stamps that this was undertaken during the first decade of his reign. The rebuilding of the Forum of Caesar and the Temple of Venus Genetrix is another wholly or partially Trajanic enterprise about which the literary sources are silent. Allowing for the gaps in the record, however, it is evident that his work in and near the capital falls under three main heads: the building of the great baths on the Esquiline Hill; the undertaking of a series of major engineering works to improve the port and wharf facilities of Ostia and Rome; and the definitive completion of the complex of

monumental piazzas, temples, and other public buildings that had grown up to the north of the Forum Romanum by his construction of the forum, basilica, libraries, and market that occupy the low ground between the Forum Augustum and the southern slopes of the Quirinal (Figure 84).

The Thermae Traianae, the great Baths of Trajan on the Esquiline, were dedicated in 109, and although there was a consistent tradition in later antiquity which coupled Trajan's name with that of Domitian, this was certainly mistaken. The Golden House, on the site of which it stood, was not burnt until 104; and the evidence of the large number of surviving brick-stamps shows conclusively that the whole structure was Trajanic, the work of Apollodorus of Damascus.[17] The claim, sometimes made, that this was the first of the great 'Imperial' baths requires qualification. The essential elements of the 'Imperial' plan were already present in the Baths of Titus, and may indeed go back to Nero's bath-building in the Campus Martius. What was new and significant for the future was the sheer bulk of the structure (the actual bath-building covered three times the area of that of Titus) and the development of the outer precinct to include the gardens, libraries, meeting rooms, lecture halls, and rooms for all the many social activities which henceforth were to be regarded as an essential part of one of these great centres of daily social life.[18]

The site chosen was that part of the Golden House which lay immediately to the north-east of the Baths of Titus and included the main residential wing of Nero's Palace, which thus finally vanished from sight barely forty years after its first construction. Fortunately the axis chosen for the new layout was somewhat oblique to that of the earlier buildings, in order to take fuller advantage of the sun in the afternoon, the normal time for bathing; and since the site of the Neronian palace coincided with that part of the new construction which had to be terraced outwards from the hillside, the existing structures were left very largely intact. (It is to such terracing operations that we owe many of the best-preserved monuments of ancient Rome – for example, the House of the Griffins, the S. Clemente Mithraeum, and the Vatican cemetery.) Little enough of the baths has survived, but that little is sufficient to confirm the substantial accuracy of the careful drawings made in the sixteenth century, when a great deal more was still visible. These reveal an overall plan that conforms closely to that of the later and far better preserved Baths of Caracalla and of Diocletian, except that the main bathing block, instead of being free-standing in the middle of the outer enclosure, projects inwards from the middle of the northern side. Compared with the contemporary Baths of Sura on the Aventine,[19] the layout of which on the Severan marble plan is still that of a typically Pompeian bath-building, with the bath-suite occupying the whole of one side of a porticoed courtyard (Plate 144), this is a thoroughly up-to-date plan. It displays many similarities of detail to Domitian's palace, and it reveals its architect, Apollodorus, as a master of the contemporary concrete medium.

Another ambitious but essentially practical enterprise was the construction of a new inner harbour at Portus, the suburb and eventual successor of the ancient Tiber-mouth harbour of Ostia. The steady deterioration of the Tiber as a navigable stream had created a problem that called for a drastic and definitive solution. Claudius had sought

an answer by abandoning the actual river-mouth and cutting a pair of canals on a more direct line to an artificial harbour a mile or so to the north. Here too, however, the predominantly northward set of the coastal currents was already creating serious diffi- culties, and these Trajan's engineers now undertook to resolve by digging a vast inner basin, the flow of water into and out of which could be controlled and the basin itself maintained by dredging. The basin, hexagonal in shape and nearly half a mile in mean diameter, was equipped with berths for nearly a hundred ships, and all around it, parallel with the wharves, ran warehouses (*horrea*), long series of deep rooms of equal size, set back to back and opening on to porticoes or covered galleries. There was also a light- house of canonical classical type, with its beacon carried on a superimposed series of diminishing cubical structures, after the model of the Pharos of Alexandria; a colossal statue of Trajan; a portico of which the exaggeratedly rusticated travertine masonry shows it to be a relic of the Claudian harbourside buildings; a pair of temples, whose curved pediments indicate a dedication to the Egyptian divinities Isis and Serapis;[20] and a substantial bath-building. One of the warehouses, probably of Severan date, has ramps leading to an upper gallery, and the raised pavements of the ground floor show that it was for grain.

Another commodity attested by the surviving remains at Portus is marble, many blocks and columns of which have been recovered still in the rough form in which they were shipped from the quarries. They were evidently offloaded here and transhipped to barges for transport to the marble yards of the capital, which lay in the 'Marmorata' quarter on the river bank below the Aventine. Such transhipment seems to have been normal practice,[21] and a natural corollary of the work at Portus was the improvement of the riverside facilities of Rome itself. When the modern embankments were built along the left bank the extensive remains were uncovered of a system of wharves, berths, and mooring-rings, loading-ramps and warehouses, all in characteristically Trajanic brick- and-reticulate masonry. This reticulate work, a conscious revival of a practice that had gone out of use in the capital half a century earlier, was to enjoy a considerable vogue under Trajan and his immediate successors and is one of the many symptoms of a re- newed interest in the architectural heritage of Rome's own recent past. Another com- mercial building, found and destroyed in 1878 on the right bank near the Farnesina, was an imperial storehouse for wine, built in 102. It was a rectangular structure, resembling the horrea, with vaulted storehouses full of amphorae at ground level and above them a complex of courts surrounded by long porticoes of plaster-faced travertine columns – a surprisingly late use of this material in such a context.

The monument upon which above all Trajan lavished his resources and which most vividly mirrors the curiously eclectic architectural aspirations of his reign is the forum which he built out of the spoils of the Dacian War and dedicated in 113 (Figure 84). Physically as well as stylistically this was a building of an unusual complexity. To pro- vide a level space some 220 yards long and 130 yards wide (200 by 120 m., exclusive of the exedrae) for the main complex, the saddle of higher ground between the Quirinal and Capitoline Hills and the lower slopes of the Quirinal itself were cut back to a maxi- mum depth of 125 feet (38 m.), a figure of which Trajan's column, 125 feet high, was

designed to preserve a dramatic visual record. Three-fifths of this level area was reserved for the open space of the forum proper and for the two lateral porticoes, the central sections of the outer walls of which were broken outwards to form large semicircular exedrae. Both the plan and the order of the lateral colonnades, the attic storey of which is decorated with large ornamental roundels and caryatid figures of Dacian prisoners, clearly derive from the Forum of Augustus. The gently outcurving entrance wall seems, on the other hand, to have been inspired by the flanking walls of the Forum Transitorium. In the centre of it, surmounted by a six-horse chariot, was a monumental entry, of which the coins give a lively picture; and the centre and focus of the whole forum, at the intersection of the two axes, was a gigantic equestrian statue of the emperor. There were gilded statues of horses and military standards along the roofs of the lateral colonnades, and there was a great deal of other statuary, some of it carved in polychrome marbles and all of it devoted to the theme of the emperor's triumphs. But despite the opulence of its detail, the forum was saved from mere grandiloquence by its fine proportions and by the purposeful sweep of the design as a whole. When the emperor Constantius II visited Rome for the first and only time, in 357, of all the monuments of the city this was the one which he most admired.[22] There was a grandeur of conception about it to satisfy even the most jaded taste.

The fourth side of the forum was occupied, not by a temple as in all the previous Imperial fora, but by a huge, transverse, basilican hall. The Basilica Ulpia (the name derives from Trajan's family name of Ulpius) was by any standards an imposing building. The main hall, exactly twice as long as it was broad, extended the full width of the forum (some 400 feet). Within it two ambulatory colonnades enclosed a long, narrow, central nave, the timber roof of which had a span of 80 feet (25 m.) and was nearly 260 feet (80 m.) long. At either end of the building, spatially independent except as viewed through the columns of the ambulatories, were two large apses. The main hall is usually, and probably rightly, restored as having had galleries over one or both the ambulatory colonnades. The apses had semi-engaged decorative orders round the inner faces and must have been independently lit; but how exactly they were related in elevation to the rest of the building is uncertain. Outstanding among the rich variety of marbles with which the interior was lavishly faced were the columns of grey Egyptian granite. Another noteworthy feature was the ceiling, which was sheathed with sheets of gilded bronze. It was presumably coffered and lit by clerestory windows, soaring in brilliant and effective contrast above the relative obscurity of the galleries beneath. Externally the dominating feature was a shallow tetrastyle porch in the centre of the façade, at the culminating point of the axis established by the outer archway of the forum and the central equestrian statue. It was flanked by two smaller porches.

Beyond the basilica, within a small colonnaded courtyard off which, to right and left, opened a pair of libraries, stood Trajan's Column. It is characteristic of the 'drawing-board' mentality of so much Roman architectural thinking[23] that, although the column (and later Hadrian's Temple of the Deified Trajan) picked up the line of the long axis of the forum, there was no visual continuity whatsoever between the two. The library complex was quite independent, accessible from the basilica only by a pair of doors,

which seem to have been deliberately placed so as to avoid any direct relationship with those of the main façade. Unlike the basilica and forum, the libraries were built of brick-faced concrete and vaulted, presumably as a protection against fire and damp. They were plain rectangular halls of conventional classical library design, the cupboards for the scrolls being contained in two tiers of rectangular recesses, of which the upper tier was accessible from a gallery served by an independent staircase.

The column stood 125 feet (38 m.) high and was built throughout of finely jointed blocks and drums of Carrara marble of colossal dimensions (each drum weighed about forty tons). It comprised a tall plinth carved with Victories and trophies of arms, a sculptured shaft with a Doric capital, and a pedestal on which stood a gilded bronze statue, perhaps originally an eagle (it is so shown on coins) but after Trajan's death a figure of Trajan himself. Within the base was a tomb-chamber, destined for the emperor himself, and carved out of the solid marble of the shaft was a spiral staircase of 185 steps. There were many Republican precedents for the erection of such commemorative columns. What was singular and original about Trajan's Column was the continuous spiral frieze that wound unbroken from base to capital, carved in exquisite low relief with a dramatized historical narrative of Trajan's two Dacian wars. It is hard to admire unreservedly the relegation of this sculptural *chef d'œuvre* to a situation in which even the vigorous use of colour would have left many of the upper scenes barely visible, let alone intelligible in terms of the narrative which they set out to portray. On the other hand, there cannot be the slightest doubt either of the masterly quality of the sculpture itself or of its outstanding importance for the later development of Roman narrative art; and that the scheme of the column and its sculpture struck the imagination of antiquity is shown by the several copies of it that were erected later, in Rome by Commodus and in Constantinople by Theodosius I and by Arcadius.

How the north end of the forum complex was originally planned we do not know. Whatever stood here was swept away a few years later by Hadrian to make way for the temple which he built in honour of his deified predecessor. The remains of the temple itself still lie buried beneath and beyond the church of S. Maria di Loreto, but from the coins and from a fragment of the Severan marble map of Rome we know that it was an enormous octastyle building, standing on a tall podium and set against the semicircular rear wall of a colonnaded enclosure. Its size is graphically attested by part of one of its columns, of grey Egyptian granite, which is now lying near the base of Trajan's Column. It measures just over 6 feet 6 inches (2 m.) in diameter, as compared with the 5 feet 11 inches (1·80 m.) of the similar columns in the porch of the Pantheon, and when complete it must have weighed about a hundred and seventeen tons.

To the north-east of the forum complex, terraced steeply up the artificially steepened lower slopes of the Quirinal Hill, lay the Markets of Trajan, an elaborately planned commercial quarter, containing more than one hundred and fifty individual shops and offices and a large covered market hall, linked by stairs and streets and accessible at three different levels – at the foot of the hill by a broad street laid out along the outer perimeter of the forum and basilica; at the level of the third storey by what in the Middle Ages became the Via Biberatica; and two storeys higher again by a street facing towards

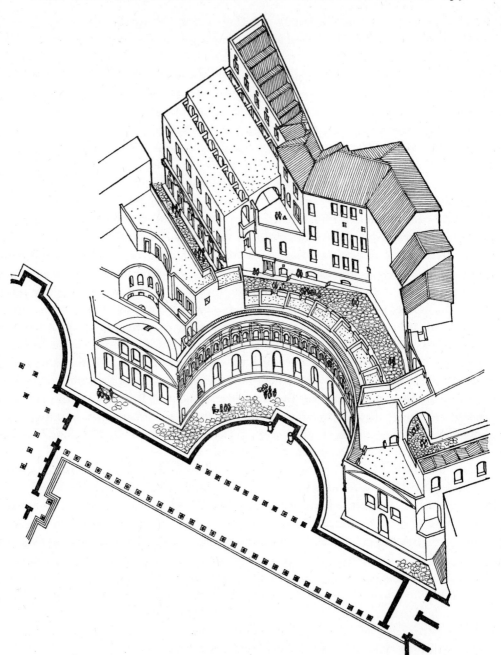

Figure 96. Rome, Trajan's Market, *c.* 100–12. Axonometric view. Centre foreground, the hemicycle of Trajan's Forum; left foreground, one end of the Basilica Ulpia (cf. Plate 127)

the Quirinal (Figure 96). The whole complex was built of brick-faced concrete with travertine details and the unit throughout was the *taberna*, the single-roomed, wide-doored, barrel-vaulted shop of standard Roman commercial practice. Both in plan and to a lesser extent in elevation (there was often a wooden mezzanine gallery lit by a win-

dow above the door) this unit itself was capable of considerable adjustment, and used in conjunction with vaulted corridors and staircases it lent itself admirably to the requirements of what could hardly have been a more irregular site. An interesting technical novelty is the use of tiles as a substitute for planking in the centering of the vaults, a device that had made a first tentative appearance in the Domus Aurea and in the Colosseum and which was to be widely used in the second and third centuries to achieve flexibility and speed of construction by reducing carpentry to a minimum.

The shops were for the most part laid out in single rows, facing on to streets or corridors that followed closely the run of the steeply sloping hillside. At one point only were they grouped into a more intimate relationship. This was in the covered market hall (Plate 129 and Figure 97), a tightly planned building laid out at three distinct

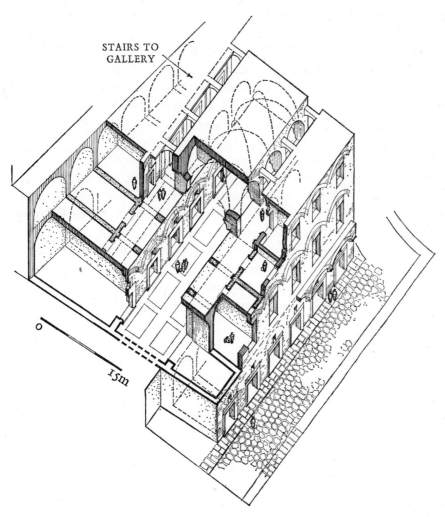

STAIRS TO
GALLERY

0

15m

Figure 97. Rome, Trajan's Market. Axonometric view. The main market hall, *c.* 100-12.
Foreground, the street that later became the Via Biberatica (cf. Plates 128–9)

241

levels. There was an independent row of six shops facing directly on to the Via Bibera-tica, at one end of which a flight of steps led up to the next storey above, which was that of the main market hall. This was a vaulted rectangular space, 92 feet long and 32 feet wide (28 by 9·80 m.), with two rows of six shops each opening off either side of it at two levels, those of the upper floor being shallower and served by a gallery-like corridor with balustraded openings corresponding to the six bays of the central vault. The latter was cross-vaulted, a utilitarian version of the vaulting characteristic of the central hall of one of the great 'Imperial' baths, with massive travertine brackets used instead of marble columns to reduce the span at the springing-points. Staircases linked the successive levels, and there was a second entrance at gallery level leading in from the upper street. The whole design has the inevitability of good planning and, compared with the stolid simplicity of the earlier market halls at Tivoli and Ferentino, it admirably exemplifies the progress which Roman architecture had made in practical as well as in monumental fields since Late Republican times.

Although this was essentially an architecture of function, remarkable chiefly for its practicality and for its extraordinary flexibility in the face of a potentially very difficult site, it could, wherever appropriate, achieve a certain austere monumentality. The three-storey façade of the market hall towards the Via Biberatica (Plate 128), with its robust, travertine-framed shop-fronts at ground level and shallow 'balconies' bracketed out over the mezzanine windows, is a typical example of what, as we know from the streets of Ostia, was the appearance of much of the new Rome that had been coming into being since the great fire of 64. More elaborate is the well-known hemicyclical façade where the lowest street frontage of the markets conformed to the outward curve of the forum exedra (Plate 127). Here the range of uniform, round-headed windows which is the dominant feature of the upper of the two storeys is framed within the pilasters and continuous entablature of a decorative order, which was broken out in shallow relief to form a series of linked aediculae, every fourth pediment of which was triangular, alter-nating with groups of three in which a low segmental pediment was framed by two triangular half-pediments. Such broken pedimental schemes had made their appearance at least half a century earlier on the walls of Pompeii, but they had yet to establish themselves in monumental usage, at any rate in Italy. Their employment on this occasion is doubtless to be connected with the use of a medium – stuccoed brickwork – which was still in the process of developing a monumental language of its own.

(In view of the long-established belief that this well-known façade was a part of Tra-jan's Forum itself, it is worth emphasizing that it was never in fact visible from within the forum, nor could it ever have been viewed frontally, as it is today, to the detriment both of its proportions and of the quality of its detail. It was meant to be seen from street level, obliquely and in receding perspective (Plate 127), its length suggested by the curve of the street and by the repeated rhythm of its design, but nowhere in fact visible in its entirety, and its delicate relief picked out by the cross-fall of the light and contrasting with the massive simplicity of the wall opposite.)

The Forum and the Markets of Trajan were contemporary and complementary monuments, the two halves of a single plan; and yet it would be hard to imagine two

groups of buildings that were more different in almost every respect – the one ruthlessly imposed upon its site and developed with an arrogant self-sufficiency within the circuit of its high containing walls, the other conditioned at every turn by the accidents of the ground on which it was built and meaningful only in terms of its wider architectural setting; the one ultra-conservative in its choice of materials, in its spatial relationships, and in its taste for rich classical ornament, the other the last word in contemporary taste and techniques. The contrast is, of course, symptomatic of an age in transition. The markets represent one of the outstanding achievements of the 'modern' architecture which is the subject of the next chapter, whereas the forum and basilica belong to a field in which the traditional pomps and grandiosities were still a required currency. It is inevitably the former that engage the sympathies and interest of the twentieth-century observer, but it is well to remember that it was the latter that was regarded both by its contemporaries and by later generations as the outstanding monument of its age; and since this is also one of the few great Roman building schemes of which we know the name and something of the history of the architect, it is worth while, in conclusion, to inquire briefly what was his architectural training and what was his impact upon the contemporary architectural scene.

There is little to suggest that Apollodorus of Damascus was influenced by his Eastern origins. His bridge over the Danube reveals him as a first-class structural engineer, and even the short list of buildings in Rome that can be attributed to him with certainty[24] is sufficient to indicate a broad catholicity of taste and ability. On the one hand the baths (and the markets, if we may accept these also as his work) show him to have been quite as much at home in the contemporary Roman concrete medium as his predecessor, Domitian's architect, Rabirius: from such of their work as has survived, Rabirius may perhaps be thought to have been the more important innovator, but in this respect both Apollodorus and Rabirius belong to the same broad stream of historical development. The forum and basilica, on the other hand, have surprisingly little to do with recent architectural trends in Rome. The combination of basilica and forum into a single, closely knit unit in itself derives from schemes that had been evolved elsewhere in Italy and in the western provinces – one of the earliest instances of such reciprocal influence upon the architecture of the capital.[25] At the same time both the planning and the detail of the forum reveal a marked break away from the Flavian tradition and a return to the Augustan sources. We see this very clearly in the adoption of such features as the exedrae of the forum and the caryatid order of the flanking porticoes, both copied directly from the Forum Augustum. We see it again in the details of the individual mouldings, many of which are barely distinguishable from those of the Augustan building.[26] More generally we can see it in the rejection of concrete (except, for practical reasons, in the libraries) in favour of the traditional materials, dressed stone and timber. Apart from its two apses, the Basilica Ulpia is still essentially an enlarged and enriched version of an Augustan monument. In its ornament too, just as Augustus's own architects had turned to the classical monuments of Athens for inspiration, so now Apollodorus turned back to those of Augustus.

By the authority of its example the Basilica Ulpia did more perhaps than any other

single building to keep alive in the capital a tradition which in many other fields was dying, if not already dead. This was the building which above all others came to be felt to epitomize the grandeur of Roman Imperial might at the peak of its power. Though it had no immediate successors in Rome, and though two centuries later, when Maxentius gave the capital its last great public basilica, it was the contemporary architecture of the great bath-buildings that supplied the model, the Basilica Ulpia was very widely copied in the provinces. Moreover, it was still standing in Constantine's day, venerable and universally admired; and whatever may have been the reasons that led him and his advisers to select the basilica as the preferred architectural type for the places of worship of the newly enfranchised Christian religion, Trajan's building was one that must inevitably have been in every mind. The Basilica Ulpia may not have been a building of any profound architectural originality. But there are few monuments of antiquity that enjoyed a greater and more enduring prestige, or that did more to shape the subsequent course of architectural history.

MATERIALS AND METHODS: THE ROMAN ARCHITECTURAL REVOLUTION

THE death of Trajan in 117 is as good a moment as any to pause and take stock of what had been happening to the architecture of Rome in the 160-odd years since the murder of Caesar. Not that there was any real break in the development at this time, or indeed at any other time before the third century. But the new era was to bring new problems and new perspectives. The impetus of the great Augustan building programme was all but spent. For over a century it had carried the architecture of the capital along on its own momentum. Throughout the first century, besides creating the circumstances that made possible the revolution in architectural thinking which is the special subject of the present chapter, it had been the accepted framework of reference for all architectural thinking, progressive and conservative alike. Now the horizons were once more widening. The balance of wealth and prosperity was beginning to shift away from Italy and towards the provinces, and increasingly it was towards the latter that the architect of the second century looked for those aspects of his craft which were not satisfied locally.

There were, of course, certain elements of the classical tradition which were now so deeply and so widely rooted that they transcended all frontiers. The classical system of column, capital, and entablature, for example, was to remain an established part of the architectural scene for centuries to come, whatever the setting and whatever the circumstances; not until Justinian was architecture to break significant fresh ground in this respect. But there were a great many other, hardly less fundamental respects in which there were wide divergences of practice from one part of the Mediterranean world to another. In Italy, for example, the widespread tendency to relegate the traditional classical forms to a purely decorative role had already taken on a monumental shape of its own during the last century of the Republic, and it was upon the well established Italic version of this wider hellenistic tradition that Augustus had drawn for an important part of his own programme. The Stadium of Domitian, the last great public building in Rome to clothe the arcaded structure of its façade in a continuous framework of applied classical 'architecture', marks the end of an epoch that spans the whole of the last century of the Republic and the first century of the Empire.[1]

Many of the changes that were now taking place are, of course, explicable in purely local terms. In the case just referred to, for example, one can see that brick-faced concrete, henceforth the building material *par excellence* of the capital, lent itself naturally to an altogether simpler exterior architecture, one that was expressive of the constructional material with little or no overlay of extraneous classicizing detail. It is to the interiors, and to the decorative skins of marble and painted stucco with which they were clothed, that such detail was increasingly relegated. But even in such essentially conservative fields of practice as temple architecture and the carving of the detail of the

classical orders, one can detect an important shift of allegiance. The Augustan monuments remained in this respect an inexhaustible repertory of ideas and motifs, time and again to be quarried by later Roman architects in search of inspiration. But, just as the Stadium of Domitian marks the end of an epoch, so one may single out a building such as Trajan's Forum as one of the last representatives of a tradition of planning and ornament that derives, almost without a break, from the buildings of Augustan Rome. Barely a generation later, for his great Temple of Venus and Rome, we find Hadrian looking instead to Asia Minor. This is symptomatic of what was happening in many fields. Although the development of concrete architecture was, and was for some time to remain, essentially a domestic phenomenon, the stage was being set for wider things.

We have already had occasion to observe, in buildings such as the Golden House and the Flavian Palace, something of the new spatial ideas that were developing in Rome during the second half of the first century A.D. As has so often happened in the history of architecture, it was the advent of new materials and new methods that stimulated and shaped the new theoretical approach. In this case the new material was Roman concrete, and to follow the development of progressive architectural thinking during the period in question, it will first be necessary to recapitulate briefly the earlier stages of its development and to describe in rather greater detail than has yet been done its properties, its advantages, and its limitations.

First, a word of definition. Roman concrete (*opus caementicium*) was not a concrete in the modern sense of the term, a material that could be mixed and poured, or used in its own right independently of other materials. It was a combination of mortar and lumps of aggregate (*caementa*) and it was almost invariably laid in roughly horizontal courses, not poured, the only difference from the mortared rubble of contemporary usage (into which, indeed, the poorer qualities of Roman concrete shade imperceptibly) lying in the better quality of the mortar. It was, in fact, the strength of the mortar that gave Roman concrete its unique properties; and although the concrete core was regularly faced with other materials, the facing was structurally of altogether secondary importance.

In the fully developed Roman concrete these properties were the result of mixing lime with the local volcanic sand (*pozzolana*). This was not a sudden, dramatic discovery; still less was it the result of any theoretical knowledge of the chemical processes involved. It was the product of centuries of trial and error, each generation adding its quota of practical experience until, by the last century of the Republic, what had started as a mere inert fill suitable only for the interiors of platforms, city walls, etc., had become a building material in its own right, which could be used not only for the construction of walls but also of arches and vaults. The history of pozzolana (the Latin *pulvis puteolanus*) is in itself a graphic illustration of the extent to which the whole development was governed by the chance discoveries and rule-of-thumb wisdom of successive generations of contractors. One of its most valuable properties is that with it one can make a mortar that will harden in contact with water, a property that must have been discovered in the first place in the course of waterside building in the harbour of Puteoli (the modern Pozzuoli) in Campania, whence it took its name and whence it was regularly imported to the capital for use in bridges, riverside wharves, and harbour jetties.

There are plentiful supplies of an identical volcanic sand in and around Rome, and under Augustus the local pozzolana was in fact already being used regularly in ordinary building. And yet fifty years later we find Claudius still importing it from Puteoli for his harbour works at Ostia.[2]

It is against such a background of cautious, practical conservatism that we have to envisage the whole history of the early development of Roman concrete. Such slow, empirical advances are in the nature of things hard to document. It is the successes that survive, the failures that are swept away. For example, the workmanship of Agrippa's very extensive programme of aqueduct building and repair was so faulty that it had to be undertaken afresh almost in its entirety by Augustus twenty years later. The Aqua Claudia, dedicated in A.D. 52, needed drastic repairs in 71, and again under Domitian. These are simply two examples about which we happen to be unusually well informed, thanks to the survival of the treatise of Frontinus, who had himself been a water commissioner. It is not altogether surprising therefore that under Augustus, and for a long time thereafter in conservative building circles, squared stone was still the preferred material whenever it was a question of carrying a serious load. Although by the beginning of the Christian era concrete was already in widespread use as an efficient and economical substitute for the ashlar walls and timber roofing of traditional classical practice, there is little indication that it was yet thought of as a monumental building material in its own right. In this respect the great Republican sanctuaries of Latium stand in curious isolation from what immediately followed them.

An aspect of Roman concrete construction that has led to a great deal of confusion of thought is the regular practice of applying a facing of some other material to the exposed wall-surfaces. These wall-facings range from the squared stone or the irregular stone patchwork (opus incertum) of the earliest faced walls (Plate 74 and Figure 61), through the neat chequerboard opus reticulatum which took shape during the last years of the Republic (Plate 137), to the brickwork (opus testaceum) characteristic of the fully developed Roman concrete. But the study of these facing techniques, valuable though it may be as a guide to the chronology of individual monuments, is of only marginal importance to any understanding of the architectural properties and possibilities of Roman concrete as such. It was in the mass of mortar and aggregate forming the core that the strength of Roman concrete lay. Apart from providing a neat finish suitable for the application of marble or stucco, the principal function of the facing was to simplify the actual processes of construction by providing a carefully built and quasi-independent framework within which the main body of the wall could be laid with a minimum both of shuttering and of skilled supervision.

The relative unimportance of the facing is a fact that needs to be stressed, since to facilitate its construction the concrete-builders of the Empire, and in particular those working in brick, made widespread use of such familiar devices as the use of built-in arches over doorways, windows, and any point of special architectural strain (Plates 147–9). The arches, the flat-arched lintels, and the relieving arches that are such a characteristic feature of the brick-faced monuments of the capital convey an almost irresistible impression of a 'live' material within which each of these elements plays an active part

in carrying and distributing the load of the structure as a whole. In reality this is true only in a very special and limited sense. They did unquestionably play an active and useful part during the actual construction of the building, and to a diminishing degree during the period of its drying out. Once the concrete had hardened, however, they served no further structural purpose whatsoever; indeed, by introducing potential lines of cleavage they were, if anything, a source of weakness. The same is true in varying degrees of such features as the brick ribs not uncommon in later Roman vaulting, or the so-called 'bonding courses', flat single courses of large tiles that were introduced at regular intervals into many Roman walls, running right through them, facing and core alike (Plate 147). The use of brick ribs will be discussed in a later section. The main purpose of the 'bonding courses' was to provide a neat, level finish at the end of each stage of construction, but they served also to prevent any minor settlement in the still fluid mass of the concrete from spreading vertically.[3]

It was the strength of the core that really mattered, and it was the steady progress in the quality of this that was the most significant advance of the Augustan and early Julio-Claudian period. From the time of Augustus onwards the quality of the mortar itself was improved by the regular addition of the local pozzolana. Another significant improvement was the gradual elimination of the horizontal lines of cleavage that mark the divisions between the successive stages of the work in so many of the earlier concrete buildings. This was presumably achieved by using a somewhat slower-drying mixture, which enabled the successive horizontal layers of the core to fuse into a virtually homogeneous mass. As the quality of the concrete improved, so the vaulting techniques too were simplified, and the vaults themselves strengthened, by the omission of the radially laid intrados of rough stones which characterizes so many Republican vaults. Henceforth the concrete of the vaults was laid against the shuttering in precisely the same horizontal beds as the walls themselves, and it stood by virtue of the almost monolithic quality of the finished concrete mass.[4]

Roman architects were surprisingly slow to appreciate the revolutionary architectural possibilities inherent in the new material that was developing under their eyes. When it did come, however, the realization was rapid and complete; and thanks to the fortunate circumstance of the survival of a number of the key monuments, we are able to document the process in unusual detail. At Hadrian's death in 137 there must have been persons still living who could remember Nero and the great fire of 64; and yet between these two dates there took place all the essential stages of the revolution in architectural thinking which is Rome's great original contribution to the history of European art.

The first great public monument in which we can detect the ferment at work is Nero's Golden House. To contemporary eyes it was the incongruity of the setting – a luxurious country villa in the heart of Rome – and its manifold engineering marvels that constituted the principal novelty of this singular building.[5] Seen in such a perspective the great recessed courtyard in the centre of the façade with its flanks splayed out to form three sides of an irregular hexagon, though a newcomer to the architecture of the capital, was one for which, as we shall see in Chapter 14, there were already plenty of precedents in the seaside villas of Campania and Latium. Though symptomatic of the general

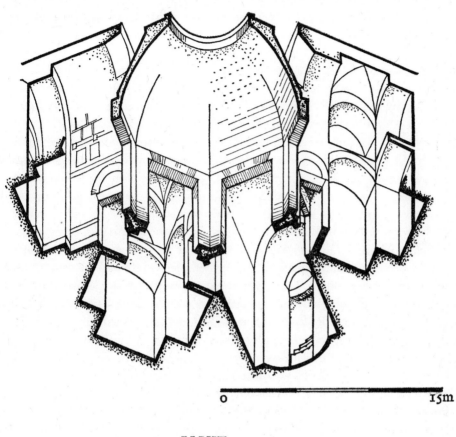

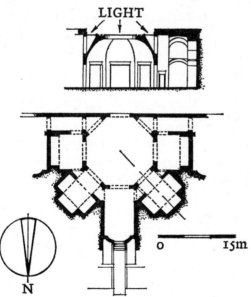

LIGHT

N

Figure 98. Rome, Nero's Golden House, 64–8. Octagonal hall. Axonometric view from below, section, and plan

breakdown of the tyranny of the right-angle, its architectural significance is slight in comparison with that of the octagonal hall in the middle of the east wing. The latter (Plate 130 and Figure 98) is a structure of which it would be hard to overestimate the historical significance. Here, for the first time in the recorded history of Roman architecture, we have a room which was not only breaking away from the conventionally rectangular pattern of the complex of which it was a part, but was also deliberately designed to exploit the novel spatial effects so obtained. The fact that many of the resulting problems of planning were left unresolved and that much of the detail, such as the small, box-like, triangular spaces in the angles between the radiating chambers, is clumsy, cannot conceal the startling novelty of the vision so embodied. This is essentially an architecture of the interior, in which light and space are every bit as important as the actual masonry. In a subtle but significant way the emphasis has suddenly shifted from the solids to the voids. At the same time there is a deliberate playing down of the constructional problems. Walls and vaults are no longer the distinct and contrasting factors of a clearly stated structural equation, but the complementary and merging elements of an envelope enclosing a shape. Moreover, the shape itself is elusive. Although the plan is rigidly centralized upon a common focus, the eye is in fact drawn away from the centre, out through the oculus or down the tantalizing vistas opened up by the radiating chambers. The lighting, too, through oblique slots above the extrados of the dome, displays the same qualities of deliberate evasiveness. Here in embryo we have all the elements that were to characterize so much of later Roman architecture.

To see how new all this was, one has only to pause to reflect on the extent to which all previous architecture of the ancient world had been dominated by the concept of mass, and by the explicit statement of the structural problems involved in supporting a roof on four walls. Whether in Greece or in the ancient East its effects had been very largely achieved by the orderly marshalling of masonry and by the contraposition of such tangible features as wall and roof, platform and superstructure, column and architrave. Greek architecture had been logical, rational, lucid, an architecture of which the niceties lay in the subtle exploitation of familiar structural themes. In particular it had been essentially an architecture of the exterior, to be viewed and comprehended from without rather than experienced from within. Even when, as in such great assembly halls as the Telesterion at Eleusis, it became necessary to roof over a large interior space, the result was at best an uneasy balance between the physical requirements of the situation and an aesthetic tradition to which such problems were essentially alien. It was left to Rome to evolve an architecture to which the concept of interior space was fundamental, and of this evolution the octagon of the Golden House is a decisive milestone.

Because the Golden House is the first building in which we can clearly and unequivocally observe the full impact of this new vision, it does not, of course, follow that it was the result of a sudden, blinding revelation, or indeed that this was even the first time that it had found explicit architectural expression. On the contrary, the plan of the octagon itself has all the appearance of having been evolved independently in the first place and rather summarily adapted to fit into its present location. One thinks inevitably of the garden pavilions, fountain grottoes, and other architectural conceits of the wealthy parks

of Julio-Claudian Rome, which have left tantalizing traces in the contemporary literature (e.g. Varro's celebrated aviary at Casinum) and painting, but so sadly few actual remains. Here was a natural ground for experiment and fantasy, and it may very well be that, like so much else in the Golden House, the immediate inspiration for the octagon came from some garden pavilion of the Domus Transitoria.[6]

More important, however, than the possible derivation of the octagon, as such, from some particular building is the recognition that most of the ideas which it embodies were in themselves already familiar features of the architectural scene. What was new was their convergence upon a single building. Already, for example, in the Roman architecture of the Late Republic one can detect a growing awareness of the properties of interior space. This is the essential difference between the Greek stoa and the Roman basilica and it is none the less significant for being in other respects still contained within the rigidly rectilinear framework of a conventional classicism. Seen from this point of view the Basilica Ulpia and the central hall of Trajan's Market are the collateral branches of a single Roman tradition. Hardly less significant was the growing taste, already evident in Augustan times, for curvilinear or polygonal forms, a taste for which the wealthy seaside villas, with their spreading porticoes, their fountains, and their tempietti, afforded such ample scope. At a more functional level it found expression also in the building of amphitheatres and theatres, a task for which by its flexibility concrete early showed itself to be admirably suited. From the placing of sloping vaults over the radial segments of an ellipse, a regular feature of amphitheatre construction, it was a short step to the realization that with concrete one was no longer tied to the very restricted repertory of architectural forms proper to the traditional building materials. Once a concrete had been developed which, by comparison with other known building materials, would stand as an almost monolithic unit, there was very little but the force of tradition to limit the shapes of either walls or vaults. The key to a new world of architectural ideas stood ready in the lock, and by Nero's death it had been firmly and irrevocably turned. In the Golden House not only do we find the architect actively exploring the possibilities of the new medium for the creation of new and exciting spatial forms but – possibly for the first time ever – we also find him giving these forms monumental expression within the best known and most discussed building of its day.

Once this decisive step had been taken progress was rapid and assured, as we see very clearly in the great palace of Domitian, completed less than twenty-five years after the Golden House.[7] The first and most obvious advance is in the quality of the material and the virtuosity of its handling. Even if the vaulting of the vestibule be left out of account as possible but unproven, the barrel-vault of the basilica was already a notable achievement. (That it needed buttressing very soon after construction is not altogether surprising when one recalls that the architect's only guide was experience; it was only by working up to the limit, and at times exceeding it, that such experience could be gained.) Hardly less striking are the notable increase in the deliberate use of curvilinear features and the growing reliance for effect upon the properties of interior space. Of the many examples of the former one may select for mention the suite of small rooms along the west side of the courtyard of the official wing; a small domed room in the upper storey

of the domestic wing, in plan a circle inscribed in a square, with two rows, one above the other, each of eight decorative recesses, alternatively curved and rectangular; and the somewhat similar but more elaborate pair of domed rooms in the north wing of the ground floor of the domestic wing (Figure 99). The last-named in particular, with their studied avoidance of the expected (even the doors being sited with a deliberate disregard for symmetry or axiality) are for their date astonishingly advanced; and while one may

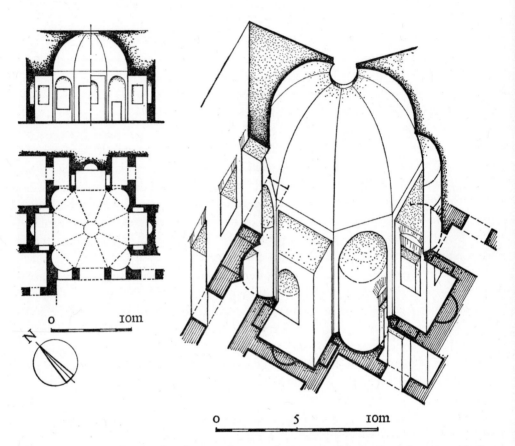

Figure 99. Rome, Flavian Palace (Domus Augustana), inaugurated in 92. Domed octagonal hall.
Sections, plan, and axonometric view from below

feel that some of the architect's less ambitiously elaborate ventures, such as the fountain courts adjoining the great Triclinium, were more successful, these domed rooms give us the full measure of his determination at all costs to create new and interesting interior forms. The only limitation in this respect by which he still felt constrained was that imposed by the traditional rectilinear framework of the building as a whole. Apart from the façade towards the Circus Maximus with its gently curving central portico, the whole building, whether viewed from without or from its own inner courtyard, was still clothed in a rectilinear decorum which gave scarcely a hint of the ferment within.

Side by side with this increasing use of curvilinear features we find an increasing

awareness of the value of suggestion and surprise, as well as of sheer size, in the creation of impressive interiors. The suggestive glimpses afforded to diners in the great Triclinium, out into the central courtyard and across into the small garden courts to right and left, were an essential part of the total architectural effect, a lesson of which a generation later Hadrian was to show himself well aware in planning the dining halls of his villa near Tivoli. As for the element of surprise, one has only to imagine the sense of shock with which the huge, almost empty spaces of the vestibule, lit from high above, must have burst upon the visitor ushered in through the modest doorway which was the principal entrance to the palace from the world outside.

Another group of buildings well suited for the expression of the new spatial ideas was the series of large 'Imperial' bath-buildings. The Roman taste for public bathing as a social relaxation was from the outset an important factor in the development of the new architecture. Vaulted concrete was a medium ideally suited to the practical requirements of the Roman bath; and just as bath-buildings were to become one of the earliest and most influential means of the dissemination through the provinces of the new architectural ideas current in the capital, so in Rome itself these ideas took shape under the strong influence of (and themselves did much to promote) the rapid development of contemporary bathing-habits, both public and private, in and immediately after Augustan times. Foremost among the buildings in the new style were the 'Imperial' bath-buildings described in the preceding chapter. Those of Titus certainly, and very possibly those of Nero before him, were already built almost exclusively of concrete. Essentially compact, functional buildings, they offered little scope for the more elaborately fantastic curvilinear forms. They were, on the other hand, ideally suited for the development of large, dignified interiors and of the interlocking vistas by means of which the individual rooms were made to participate in the larger unity of the building as a whole. In the Baths of Titus the forms that were to dominate the great public bath-buildings of the capital for the next two and a half centuries had not yet taken decisive shape. The main cold hall (*frigidarium*) is still at one end of the central axis instead of, as functionally it belonged and as thirty years later we find it in Trajan's Baths, at the centre of the whole complex, with vistas opening out in all directions. Moreover, if Palladio's drawing (Figure 94) is right in showing this hall as essentially cruciform in plan, with a groin-vaulted central bay buttressed on three sides by barrel-vaults and on the fourth by the large apse which closed the axial vista, this all-important feature was itself still feeling its way towards its final form.[8] It was left to Trajan's architect, Apollodorus of Damascus, to take the decisive step of substituting for the lateral barrel-vaults groined vaults of a height and size equal to that over the central bay, thereby establishing an axis at right angles to that of the building as a whole and creating that deliberate sense of spatial ambivalence which one can still experience today in the frigidarium of the Baths of Diocletian, now the church of S. Maria degli Angeli. (It was precisely on the question of axis that the plans of Michelangelo and of Vanvitelli for the remodelling of this church found greatest scope for difference.) Apart from the form of the frigidarium, which we may note in passing was a variant of that used by Apollodorus himself in the central hall of Trajan's Market, and which was to play an even more important role in the

T 253

development of later Roman architecture, it was principally in the greater size and elaboration of the plan as a whole and the introduction of a great many more circular, semicircular, and, in two instances, oval features that Trajan's building differed from its predecessor. With its construction the pattern for the great public bath-buildings of the capital was established on lines which it was to follow with remarkably little change for the next two centuries.

The ferment of new architectural thinking which we have termed the Roman Architectural Revolution had not sprung upon the world unheralded, and it was to be many generations, indeed centuries, before its implications had been fully comprehended and explored. By contrast the actual period of revolutionary experiment was, as such moments of intense intellectual or artistic activity often are, remarkably brief. By the death of Hadrian in 138 it may be said to have achieved all its immediate objectives; and it is accordingly with a brief discussion of Hadrian's work in this field that we may fittingly conclude this account of the emergence in the capital of the new architecture of the middle and late Empire.

Hadrian's Villa,[9] that imperial Xanadu in the heart of the Campagna, near Tivoli (Plate 174), is a monument that does not lend itself to easy generalizations. The product of a restless, inquiring mind, with a strong bent for architectural experiment and backed by unlimited resources, it is hardly surprising that it should have come to include a number of extraordinary buildings, of which almost the only common elements are the ingenuity with which they exploit the possibilities of the gently undulating site and their complete technical mastery of the material, concrete faced with brick or reticulate work, of which it is almost entirely built. Curvilinearity has become a commonplace. In the emperor's private island retreat, for example, the so-called Teatro Marittimo (118–25), there is hardly a straight line anywhere; instead, within the severely simple triple circle of the surrounding portico and moat, there is a bewildering medley of convex and concave chambers facing on to a miniature courtyard with a central columnar fountain, the scalloped plan of which echoes that of the façades of the surrounding chambers (Plates 134–5 and Figure 100A). The theme of curve and countercurve is one that we find further elaborated in the second phase of the villa's construction (125–33), notably in the central courtyards of the pavilions of the Piazza d'Oro and of the West Palace, or Accademia, the former of which is delimited by eight identical, alternately projecting and re-entrant, segments of curved colonnade (Figure 100B), the latter by a circle which is interrupted for about two-thirds of its circumference by four large convex colonnades. The result is in both cases a curvilinear, cruciform plan of extraordinary complexity, between the columns of which could be glimpsed a bewildering variety of matching or counterposed rooms and courtyards. The latest studies suggest that neither building was roofed; but there is a small room of the same general shape in the Lesser Baths (another building of the second phase) with a correspondingly curvilinear octagonal vault which merges imperceptibly into a dome.

Apart from the semi-dome of the Serapaeum (Plate 136), a 'melon' or 'pumpkin' vault of which the nine radiating segments are alternately concave and flattened,[10] there are no grandiose interiors – the character of the villa lent itself to virtuosity rather than mere

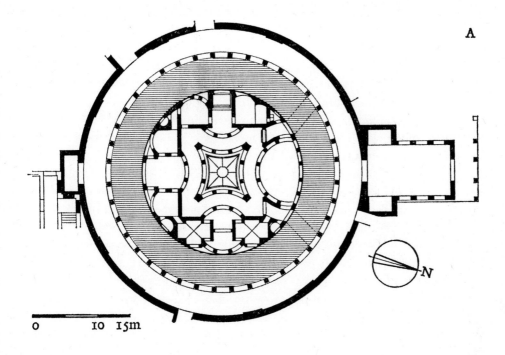

A

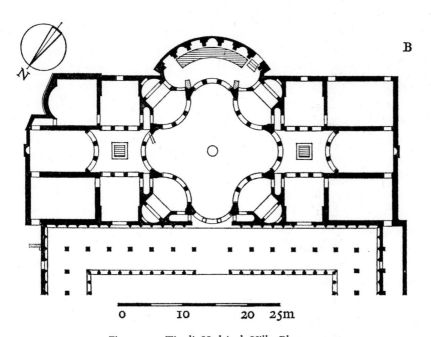

B

Figure 100. Tivoli, Hadrian's Villa. Plans

(A) Island villa ('Teatro Marittimo'), 118–25 (cf. Plates 134 and 135)
(B) Piazza d'Oro, pavilion, 125–33

255

size – but a great deal of ingenuity has been lavished on the invention of new and exciting room-shapes. In the Lesser Baths, for example, one feels that the architect's principal object has been to discard the obvious, both in the forms of the rooms themselves and in the jigsaw-like planning of the complex as a whole. At ground level it is still compressed into a rectilinear framework; but the roof plan defies rational reconstruction. In the vestibule of the Piazza d'Oro (Plate 137) we can follow the process a stage further. The plan itself is a variant of one that we have already met in the Flavian Palace, a circle inscribed in a square, with eight alternately rectangular and curved recesses; the recesses are arched, and above them the ribs of the octagonal 'pumpkin' vault merge into the uniform curvature of a dome with a central oculus. There are other examples of this inscribed form elsewhere in the villa, in the several bath-buildings, for example, or in the basement of the Roccabruna pavilion. What is altogether new and unprecedented in the Piazza d'Oro vestibule is that the outer square frame has been stripped away, and that the outside of the building follows the outline of the internal recesses. Here, for the first time, we see the principles of the new architecture pressed to their logical conclusion and the forms of the exterior dictated simply and solely by those within. One of the last entrenched positions of traditionalism had been overturned, and the way lay open to a whole new field of architectural endeavour. There was still a long way to go before any really satisfactory solution was found to the problem of creating an exterior architecture genuinely expressive of the new interior forms. But at least the problem had been recognized and brought into the open.

There could hardly be a greater superficial contrast to the villa than Hadrian's other great monument in the contemporary manner, the Pantheon. By comparison with the villa, the prevailing note of which is one of restless experiment, the Pantheon seems the very embodiment of solid achievement; and although in this respect appearances do less than justice to the architect's originality in solving a number of formidable problems, both structural and aesthetic, for which there were no clear precedents, there is certainly no other single building which so fully, and by the very fact of its survival so vividly, sums up the achievement of the sixty years since Nero's Golden House was planned. With the building of the Pantheon the revolution was an accomplished fact. Architectural thinking had been turned inside out; and henceforth the concept of interior space as a dominating factor in architectural design was to be an accepted part of the artistic establishment of the capital.

Agrippa's Pantheon, rebuilt by Domitian after the fire of 80, had again been destroyed or badly damaged in 110, and it was entirely rebuilt by Hadrian between the years 118 and, at latest, 128. The dispute as to whether any part of the existing building is earlier or later than the time of Hadrian has been resolved once and for all by the study of the brick-stamps, which show that, apart from minor repairs, the whole structure is unquestionably Hadrianic.[11] It consists of two quite distinct elements, the huge domed hall, which served as the cella of the temple, and the no less huge columnar porch which in antiquity constituted almost the entire visible façade of the building towards the long narrow colonnaded precinct in front of it (Plate 131 and Figure 101). In judging the effect of this façade one must remember that in antiquity the eye-level was a great deal lower

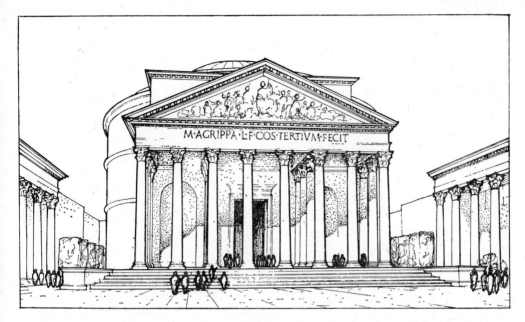

Figure 101. Rome, Pantheon, *c.* 118–*c.* 128. Restored view of the façade, as seen from eye-level in antiquity

(and the relative level of the gable correspondingly higher) than it is today. Even so the junction of the two elements is in detail so clumsily contrived that it is not surprising that scholars have been tempted to see in them the work of two different periods. In reality, however, the difference is one of function, not of date. The porch is the architect's concession to tradition. This was the sort of face which a religious building should present to the world. It could be – and still is today – forgotten the moment one stepped across the threshold into the cella.

The formal scheme of the rotunda (Figure 102) is deceptively simple – a circular drum, internally half the height of its own diameter (142 feet; 43·20 m.), surmounted by a hemispherical dome, the crown of which is thus, in accordance with the precepts of Vitruvius,[12] exactly the same height above the pavement as the diameter of the building. Internally the drum is divided into two zones, and externally into three, by cornices, the uppermost zone of the exterior corresponding to the lower part of the dome. The exterior is otherwise quite plain, but the interior is more elaborate. The lower zone is considerably the taller (40 feet; 12·30 m.), and it is interrupted at regular intervals round the circumference by an apsidal recess directly opposite the door and by six columnar exedrae, alternately rectangular and curved, as well as by eight smaller aediculae projecting from the wall-faces between the exedrae. Evenly spaced around the upper zone, which is 31 feet (9·50 m.) high, are sixteen smaller, rectangular, window-like recesses. The dome is coffered, with five diminishing rows of forty coffers each, in antiquity stuccoed and perhaps gilded, and the only light comes from the great central oculus (Plates 132–3).

There were many precedents for the essentially octagonal layout of the interior: for

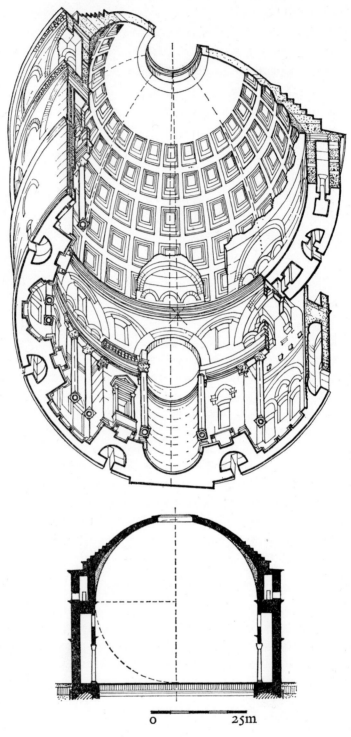

Figure 102. Rome, Pantheon, *c*. 118–*c*. 128. Axonometric view and section

example, in the Augustan or early Julio-Claudian 'Temple of Mercury' at Baiae, which had already achieved a diameter of 71 feet (21·55 m.),[13] or more recently in the circular nymphaeum of Domitian at Albano (diameter 51 feet; 15·60 m.). But there were no precedents on this enormous scale – the span of the dome was not surpassed until modern times (that of St Peter's measures 139 feet; 42·50 m.) – and its successful completion was an outstanding achievement of structural engineering. The secret of its success lay in three things: the huge and immensely solid ring of concrete, 15 feet (4·50 m.) deep and 24 feet (7·30 m.) wide (enlarged during construction to 34 feet; 10·30 m.) upon which the building was founded; the tried quality of the mortar; and the very careful grading of the *caementa*, the materials used as aggregate. The selection of specially light caementa for vaulting was already familiar building practice;[14] but here the grading runs right through the building, from the heavy, immensely strong basalt (*selce*) of the footings to the very light, porous pumice of the part of the dome nearest to the oculus. By this means, and by diminishing the thickness of the envelope to less than 5 feet at the centre, the actual turning moment was kept uniform throughout at about 35–40 lb. per square inch. For this the walls of the drum, 20 feet thick, were more than adequate; indeed, it was possible to reduce the dead weight by introducing a series of cavities, both those that are visible from the interior as recesses, and a number of smaller spaces that were completely enclosed. It was the presence of these cavities that led the architect to incorporate the elaborate series of 'relieving arches' which are so conspicuous a feature of the outer face of the drum. He was determined at all costs to prevent settlement during the drying out of the enormous mass of concrete (the cavities themselves would have helped to hasten the drying process), and the whole structure, including the lower part of the vault, was further laced with horizontal courses of tiles, at vertical intervals of 4 feet (1·20 m.). There is, on the other hand, no factual basis for the elaborate series of brick arches and ribs which Piranesi claimed to have seen in the dome. The only brickwork feature of the dome is the triple ring of tiles closing the oculus. Even the three relieving arches shown internally in Figure 102 are part of the vertical inner face of the uppermost zone of the drum itself. The lowest part of the coffering is a superficial (and structurally otiose) inner skin, added to complete the required hemispherical profile of the dome.

For all the magnitude of the engineering problems involved, the result was far from being a mere technical *tour de force*. Familiarity cannot deaden the impact of the interior as one steps through the great bronze doors into the rotunda. In startling contrast to the grandiose, but essentially conventional monumentality of the porch, where it is the very size and solidity of the columns that rivet the attention, inside the building one is conscious, not of the solid mass of the encircling masonry, but of light and colour and of the seemingly effortless lift of the dome, soaring high above. Quite apart from the element of sheer surprise, this is due in no small part to the skilful disposition of the columnar recesses, which, with their glimpses of heavy shadow beyond the brightly lit façade, effectively break up the solidity of the masonry drum and convey an illusion of a spatial continuum spreading beyond the rotunda itself. The illusion is furthered by the pattern of the marble veneer. Instead of an inert mass of brickwork, one is

confronted with a fictitious pattern of verticals and horizontals, reassuringly evocative of the traditional classical orders and effectively diverting the eye from the real structural problems of the building. To complete the illusion, there is the deliberate lack of orientation achieved by lighting the whole building from a single, central source. Apart from the very unobtrusive axis established by the door and apsidal room opposite it, in the horizontal plane the building is directionally neutral from floor to ceiling. The eye is almost inevitably drawn up, through the richly traceried pattern of light and shade cast by the coffering, to the light that floods in through the great central opening. Such effects have to be experienced. They can be analysed, but they cannot really be described. Few who have seen the Pantheon will, however, dispute that it is one of the great buildings of antiquity. It has also been one of the most influential. Perhaps the first great public monument – it is certainly the first on anything like this scale that has come down to us – to have been designed purely as an interior, it ranks with the Colosseum as one of the few Roman buildings that have been a continuing source of inspiration to architects ever since.

Quite apart from its merits as a building, the Pantheon is of importance also as being one of the few Roman monuments that can be experienced under something very like the conditions prevailing in antiquity. Unlike, for example, Greek architecture, which even in a partially ruined condition can still convey much of the spirit of the original, Roman concrete architecture, stripped of its marbles and mosaics, its intarsias and its stuccoes, calls for a powerful effort of the imagination if one is to recreate anything of the atmosphere of light and colour upon which so much of its effect depended. It is not at all surprising that it should be its engineering achievements, so starkly and emphatically revealed, which have come to dominate the popular conception of Roman architecture, at the expense of the many other qualities which it once possessed, but which can so rarely be directly experienced. For this reason alone, if for no other, any account of Roman building materials and practices under the Early Empire must include a brief survey of the decorative materials, and particularly of the marbles which played so large a part in determining the appearance of the finished building.

Although already in hellenistic times coloured marble was beginning to be used both for columns and pavements and as a substitute for painted plaster in interior decoration, in Italy it was still something of a rarity until the last few decades of the Republic. It was not really until the time of Augustus, with the opening of the Carrara (Luni) quarries and the ever-increasing importation of foreign coloured marbles, that marble, both white and coloured, began to be a commonplace of the monumental architecture of the capital. Employed at first chiefly as a substitute for the travertines and tufas of established architectural usage, it soon came to be valued as a material with which to clothe the bare bones of the new concrete architecture, and the rapid increase in the use of the latter was accompanied by a hardly less rapid development in the uses of marble veneering. Painted wall-plaster and floor mosaics, though still the predominant decorative materials in domestic use, early gave place in monumental architecture to floors and walls of marble and to vaults of polychrome mosaic or moulded stucco.

Of the marbles known to antiquity (the term may be taken to cover also the por-

phyries and granites in common use) the majority of those that were most highly prized came from the Aegean and from Egypt. Marble was a costly commodity, expensive both to quarry and to transport, and an early result of the great increase in demand created by the building programme in the capital was a reorganization of the whole system of supply, begun by Tiberius and carried to completion by his immediate successors. The essence of the new system was to concentrate production at a limited number of carefully selected, imperially-owned quarries, situated wherever possible so as to take advantage of cheap water-transport. Quarrying methods were reorganized on mass-production lines and large stocks were built up, to be held in the form either of roughly squared blocks, equally suitable for the carving of individual architectural members and for sawing into slabs, or else of pieces, principally columns, that were already roughed out to shape and only needed the final stages of carving after receipt.[15]

The results were rapid and far-reaching. By the middle of the first century we already find most of the familiar types represented in buildings such as Nero's Domus Transitoria; and under the Flavian emperors large monolithic columns of imported marble, still a feature to be remarked in Julio-Claudian times, were rapidly becoming a commonplace of the monumental architecture of the capital. Even outside Rome considerable quantities were already available for small-scale private use before the destruction of Pompeii in 79. Some of the individual pieces were of enormous size. The columns of the Pantheon, of red and grey Egyptian granite, were 41 feet (12·50 m.) high, weighing nearly eighty-four tons, and others are recorded nearly half as long again.[16] When one reflects that a single block of marble weighing a ton would have furnished the material for 35–45 square yards of paving or for panelling up to 100 square yards of wall-surface, it is not altogether surprising that the Roman emperors could afford to be lavish in its employment.

At first the uses made of the new material were strictly conventional, as one sees them, for example, in the Forum of Augustus – pavements made up of simple geometrical patterns of contrasting colours, and architectural wall-schemes which echo those of the free-standing orders which they accompany. Very soon, however, one can detect the beginning of a tendency towards a greater elaboration, as in the boldly curvilinear pavements and complex wall-patterns of Nero's palaces, coupled with a growing divorce of the decorative forms from the real framework of the underlying structure. In the Pantheon, for example, only the lateral recesses are functional; the columns and pilasters of the apse opposite the door are no more than an extension of the same architectural scheme, and the whole of the upper order[17] is a superficial fiction, with no justification whatsoever in the physical structure of the building.

The use of the classical orders as a purely decorative façade was not, of course, in itself a novelty. It was, indeed, one of the most successfully and widely used of the conventions which the Augustan architects inherited from their Late Republican predecessors, both in their monumental building and in a great deal of their domestic wall-painting. But the orders of the Theatre of Marcellus or the flanking pilasters of a pseudo-peripteral temple still reflect the essential structural realities of the building which they adorn; even the painted columns of a Second Style wall-painting appear to support a

real roof. With the development of concrete, on the other hand, there began to emerge an architecture which, as we have seen, was no longer capable of being expressed in the traditional terms; and since throughout antiquity it was these traditional terms which continued to be the everyday language of classical ornament, it was inevitable that the internal veneer of such concrete buildings should come to be treated increasingly as an element almost independent of the underlying structure. It is not until late antiquity that we find this tendency pressed to its logical conclusion as a means of 'dematerializing' the structural envelope and accentuating the effects of light and space; but the seeds of the later development were already present in Hadrianic architecture.

Of all the decorative materials used by the Romans, stucco is the least durable, and although it was undoubtedly the normal medium for the covering and decoration of concrete vaults (Plates 119, 138), there are few great public monuments in which any substantial remains have been preserved. Most of what we know about the stucco ornament of Imperial Rome comes from a number of minor buildings, mainly tombs, which chance has preserved intact, and it would be unwise to deduce from these that such motifs as the free foliate arabesques of the Tomb of the Axe under the church of S. Sebastiano found any place in the public architecture of the day. What little we do know about the employment of stucco in the latter appears to suggest two principal uses. One of these was to furnish the moulded detail of the coffering which the concrete architects inherited from the traditional repertory and applied, with great effect, to the domes, semi-domes, and barrel-vaults of buildings such as the Pantheon (Plate 133), the great public baths, and the Basilica of Maxentius. The other was to form the elaborate schemes of panelling, applicable both to barrel-vaults and groined vaults and often combined with painting or gilding, of which we can still see traces in, for example, the Sala della Volta Dorata of the Golden House, in the passages of the Colosseum and the Palatine, and in the bath-buildings of Hadrian's Villa, as well as in a number of tombs and private houses. This, the style so successfully imitated and adapted by Robert Adam, depended for its effect very largely on the delicacy of its detail, and one may reasonably doubt whether it was used to any great extent in the main halls of the larger public monuments. Both uses have this in common, that they derive from practices already current in the Late Republic, for example in the coffering of the semicircular exedrae of the Temple of Fortune at Praeneste and in the elaborately panelled stuccoes of the barrel-vaults of the Farnesina villa. This was evidently a very conservative medium. It has to be borne in mind when trying to visualize the appearance of these great concrete-vaulted interiors, but it cannot be said to have played an important part in their development.

With mosaic it was a very different matter. Probably developed first in the late hellenistic East, at Pompeii and Herculaneum it was still restricted to fountains and garden architecture, and occasionally used as a substitute for painting in small figured wall-panels.[18] In Rome, on the other hand, the development of large-scale vaulting and a rapidly growing taste for luxurious bathing establishments, both public and private, was already creating a new situation. Mosaic was an ideal decorative medium for the humid interiors of bath-buildings, and although none of the surviving examples in

Rome or Ostia is as early as the first century, the statement of the Elder Pliny (who perished in the eruption of 79) that the Baths of Agrippa did not make use of mosaic because it had not yet been invented, clearly implies that in the meanwhile it had become a familiar feature of the bath architecture of his own day. Indeed, if the traces of mosaic on the dome of the 'Temple of Mercury' at Baiae are original, it began to be applied to vaulting very soon after the time of Agrippa; and by the end of the first century it was in widespread use, not only in bath-buildings, but also in theatres (the Theatre of Scaurus), in palaces and wealthy villas (the Palatine, Domitian's villa near Sabaudia), garden pavilions (the nymphaeum in the Gardens of Sallust), and, generally, wherever there were buildings of a sufficiently opulent character with concrete vaults to be adorned. At Hadrian's Villa it has left many traces – in the two 'Libraries', for example, in one of the cryptoporticoes, in the Pavilion of the Semicircular Arcades, and on the semi-dome of the Canopus.

This is not the place for a discussion of the development of vault mosaics as such. It is important, however, to note that, although there was inevitably an exchange of patterns and ideas between the mosaics of floors and vaults, the two media were in fact quite distinct. They were handled by different groups of craftsmen (*tessellarii* and *musivarii* respectively), and whereas the normal materials of the former were stone or marble, with glass confined at first almost exclusively to the small figured panels that were often inset into them, the mosaics of wall and vault were from the outset made almost entirely of glass. Quite irrespective of the designs used, the gently rounded contours, the irregular surfaces, and the play of light upon the backgrounds of white or deep, translucent blue glass, all helped to minimize the solidity of the surfaces and to accentuate the spatial qualities of this vaulted architecture. It was not until Christian times, with the invention of gold-ground mosaic, that this particular aspect of the mosaicist's craft came to full fruition. But the seeds had been sown long before; and while it was the forms of the new architecture which in the first place suggested this particular use of mosaic, in the later stages the qualities of the mosaic itself were to play a far from unimportant part in shaping the development of structure and decoration alike.

ARCHITECTURE IN ROME FROM HADRIAN TO ALEXANDER SEVERUS
(A.D. 117–235)

Hadrian (A.D. 117–38)

THE death of Trajan in 117 marks the end of an era. Rome was at the height of her power, her authority unquestioned from the Tyne to the Euphrates. But the tide had reached its peak. Trajan's successor, Hadrian, turned his back resolutely on the mirage of Oriental conquest and devoted himself instead to the benefits of peace and sound administration; and although a contemporary observer would no doubt have attributed – and rightly attributed – any immediate changes of policy to the more cautious temperament of the new emperor, it is easy for a later generation to see that his was a just assessment of the spirit and needs of a changing world.

In architecture, as in many other fields, one of the most significant manifestations of the new age was the steady decline of Italy in relation to the rest of the Empire. During the first century A.D. it would still be possible, even if somewhat misleading, to write a history of Roman architecture based almost entirely on a study of the buildings of Rome itself. This is not simply because many of the earlier emperors were avid builders who lavished their attention on the capital, nor even because it was during this period that the architects of the capital were making their great original contribution to the architectural progress of the ancient world, the contribution that is described and discussed in the previous chapter. Both of these circumstances were themselves the products of the broader historical situation whereby Italy was still the effective centre of the Roman world, and Rome the centre of Italy. That privileged status Italy was now rapidly losing; and although it was to be a long time before the city of Rome lost its unique position, as the years passed it did increasingly find itself the first only among a number of powerful and prosperous cities, all of which might also be candidates for the benefits of imperial patronage. It is hardly surprising that, faced with this situation and confronted by the extraordinary wealth of fine building already existing in the capital, the later emperors should have been more discriminating in their architectural favours. The student of Roman architecture may be permitted a similar discrimination. Many fine and important buildings were to be built in Rome during the next two centuries; but in a sense that is not true of the first century, they are a part only of the larger picture.

Within the city of Rome the major contributions of Hadrian (117–38) to the architectural landscape were four: the Temple of the Deified Trajan at the north end of Trajan's Forum; the Pantheon (nominally a restoration of Agrippa's Pantheon but in fact an entirely new building); the Temple of Venus and Rome on the Velia; and Hadrian's own mausoleum across the river, together with the bridge leading to it, the

Pons Aelius. He was also active in restoring existing buildings, notably in the Forum of Augustus and on the Palatine, where several of the more audacious enterprises of Rabirius were already in serious need of reinforcement and consolidation. Outside the city he was busy throughout his reign with the plans for his great country residence, near Tivoli; and at Ostia it is hardly an exaggeration to say that the city as we see it today is very largely his creation.

The Temple of Trajan and the Pantheon have already been sufficiently described. Both belong to the earlier part of Hadrian's reign; and although it would be hard to imagine two buildings more profoundly different in their architectural intention and design, this is of course precisely the situation that we have already encountered in the public monuments of the previous reign, between the Baths and the Markets of Trajan on one hand and the forum and the basilica on the other. When one turns instead to the details of the architectural ornament, so often a useful indication of the training of the craftsmen employed on a given building, one does in fact find in both a strong degree of continuity with the work of the previous reign. For all its diversity, the earlier architecture of Hadrian was in its public face a direct and logical development of what had gone before.

The clear element of continuity lends added point to the innovating tendencies that make themselves felt in Hadrian's later work. We do not know when the Temple of Venus and Rome was begun, but it was not consecrated until 135. Dedicated to the personification of Rome and to the legendary ancestress of the Roman people, it occupied the site of the vestibule of Nero's Golden House on the crest of the Velia. The roof was destroyed in the fire of 283, and the surviving remains of the twin cellas are those of the radical reconstruction undertaken a few years later by Maxentius. The plan, however, with the two cellas placed back to back and facing, respectively, across the Colosseum and down the Via Sacra towards the forum, repeated that of Hadrian's building. This was a gigantic decastyle peripteral temple, laid out on the basis of a double square (344 by 172 feet; 105 by 52·5 m.) and placed, not on a podium in the usual Roman manner, but in the centre of a rectangular temenos-like platform, above the pavement of which it was raised merely by a low encircling flight of steps. Along the two outer long sides of the platform ran colonnades of grey Egyptian granite columns, while the two short sides were open.

The design we know to have been that of Hadrian himself, and it was bitterly criticized by Apollodorus, with whom by this date the emperor had quarrelled.[1] The substance of the criticism is recorded and is revealing of the architectural personalities of both men. Apollodorus, oriental by name but Roman by training, maintained – and he was surely right – that in its setting the temple itself was too low and needed to have been placed on a tall podium. He is not recorded as having added, though he might well have done so, that Hadrian's mistake was in trying to import elements of traditional Greek practice into second-century Roman usage. In Roman surroundings a decastyle temple needed height to offset its unusual breadth. Instead, Hadrian had chosen to place his temple on a low, stepped plinth, giving it the overall proportions, but none of the grace, of a traditional Greek Doric temple.

The fact that the Temple of Venus and Rome was, as regards the temple itself, an aesthetic failure in no way lessens its historical significance. It is not only the planning that reveals the cosmopolitan interests of its imperial designer. The scanty surviving remains of the peristasis date from the time of Hadrian, not of Maxentius, and they too reveal a complete break with contemporary Roman tradition. The material is itself significant. Trajan had used predominantly the white marbles of Carrara for the architectural members of his forum and basilica and for his column. Hadrian preferred the marbles of Greece: for the porch of the Pantheon Pentelic, and for the Temple of Venus and Rome the blue-veined marble of Proconnesus; and whereas in the Pantheon he had been content with Rome-trained sculptors for the imported materials, for the later building he imported the workmen also. The profiles of the order and the decorative mouldings and the manner of their carving all betray the direct influence of Asia Minor. Whether or not these were the actual workmen who had built the Traianeum at Pergamon,[2] there can be no doubt that that was the sort of enterprise in which they had been trained.

This was a major innovation. In an age when there were no hard-and-fast distinctions between planning and execution, between craftsmanship and design, it meant far more than the mere introduction of a new repertory of decorative motifs. It meant that after more than a century of virtually self-sufficient development the architectural thought and practice of the capital were suddenly exposed to a whole new world of ideas. Not since the time of Augustus had there been such an infusion of new blood.

The fourth of the major architectural tasks undertaken by Hadrian within the city was the building of a mausoleum for the new imperial family. That of Augustus, last opened to receive the ashes of Nerva, was now full, and the placing of Trajan's remains within the chamber at the foot of his column offered no precedent for general use. The site chosen by Hadrian lay on the right bank of the Tiber, opposite the Campus Martius. To give direct access to it he built a new bridge, the Pons Aelius, dedicated in 134. The mausoleum, unfinished at Hadrian's death in 138, was completed by Antoninus Pius and dedicated two years later. It remained in active use throughout the second century, the last recorded burial within it being that of Caracalla in 217.

Hadrian's Mausoleum, now Castel S. Angelo, was a considerably elaborated version of that of Augustus. It consisted of a marble-faced, podium-like base, 276 feet (84 m.) square and 33 feet (10 m.) high; a main drum, the mausoleum proper, 210 feet (64 m.) in diameter and 69 feet (21 m.) high, the top of which was planted with a grove of cypresses; and, rising from the middle of the latter, a smaller pedestal and drum crowned either by a statue of Hadrian or by a quadriga. The tomb-chamber and the ramps and stairs that led up to it and to the terrace above were contained within the body of the main drum, which was in turn faced with marble. The whole was elaborately embellished with gilded fittings and statuary. Already in the sixth century it had become a bridgehead fortress, and throughout the Middle Ages it was the principal stronghold of the popes in times of trouble, so that it is not altogether surprising that it has come down to us stripped of every bit of its superficial decoration. From drawings made in the late fifteenth and early sixteenth centuries, however, and from the *disjecta membra*

that can be attributed to it, one can see that, though carved in Italian marble, it followed closely the models established a few years earlier in the Temple of Venus and Rome.[3] The innovations from Asia Minor embodied in the latter building had taken firm root, and from now on they were to be an essential ingredient in the decorative repertory of the capital.

Antoninus Pius to Commodus (A.D. 138–93)

The fifty-odd years that followed the death of Hadrian are a lean period in the architectural history of the capital. After a long series of lavish builders, there followed three emperors, Antoninus Pius (138–61), Marcus Aurelius (161–80), and Commodus (180–93), who were content to restrict themselves to the bare minimum consistent with dynastic prudence and the proper maintenance of imperial authority.

The military triumphs of the imperial house continued to be celebrated by the erection of triumphal arches, but with the exception of the well-known series of sculptured panels from an arch, or arches, of Marcus Aurelius, eight of which were later incorporated in the Arch of Constantine and three more are in the Conservatori Museum, nothing of these has come down to us. The Column of Marcus Aurelius (the 'Antonine Column'), modelled very closely on Trajan's Column and recording the events of the Danubian wars of 172–5, was a memorial rather than a triumphal monument. The same was true of its neighbour and immediate predecessor, the Column of Antoninus Pius, which was a monolith of red Egyptian granite standing on a tall sculptured base, now in the Vatican.

Another, and architecturally more substantial, aspect of the public image of empire was the proper provision for the cult of the deceased and deified members of the imperial family. This was a field which even the Antonine emperors could not afford to neglect. Of the temples built by Hadrian in honour of Matidia, Trajan's widow, and by Commodus in honour of Marcus Aurelius we know nothing except their probable location in the Campus Martius. Hadrian himself was commemorated in a large temple (the 'Hadrianeum') of which eleven marble columns and the remains of the cella are still standing along one flank of the 'Borsa', in the Piazza di Pietra. It was dedicated in 145. From it, presumably from the plinth of a decorative order within the cella, comes the well-known series of rather arid, classicizing reliefs now in the Conservatori Museum, depicting personifications of the provinces of the Empire. Architecturally the principal interest of the surviving remains is the mixture of styles and motifs represented in the entablature. Side by side with elements of purely Asiatic extraction (e.g. the convex profile of the frieze) are others that come from the first-century Roman repertory, while the alien austerity characteristic of the Temple of Venus and Rome has already begun to give place to the natural Roman taste for ornamental exuberance.[4] Those of Hadrian's Asiatic craftsmen who had stayed on were rapidly being assimilated, and motifs which ten years earlier had been exotic intruders were by now becoming part of the common stock of the architectural ornament of the capital.

The well-known Temple of Antoninus and Faustina in the Forum Romanum was begun by Antoninus himself in 141 in honour of his deceased wife, Faustina. A

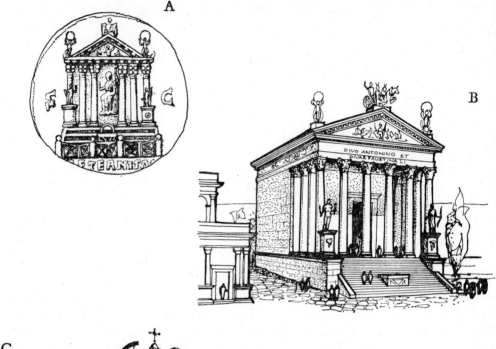

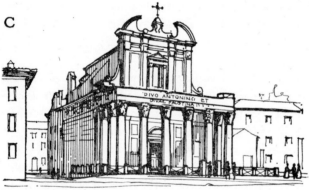

Figure 103. Rome, Temple of Antoninus and Faustina, begun in 141

 (A) As shown on a contemporary coin
 (B) Restored view
 (C) As the church of S. Lorenzo in Miranda

hexastyle prostyle building of conventional plan standing on a tall podium, it owes its preservation to its conversion in the Middle Ages into the church of S. Lorenzo in Miranda, the Baroque façade of which (1602) marks the level to which this whole area had risen by the beginning of the seventeenth century (Figure 103C). With its walls of squared tufa, once marble-faced, its entablature of Proconnesian marble, its columns of green Carystian marble, and its carving, which combines elements of both Trajanic and Hadrianic derivation (the principal source seems to have been Trajan's Forum) within the framework of a rather lifeless, academic eclecticism, it is a typical building of its day, but not a very interesting one. Its principal interest is as a reminder of the

vicissitudes, structural and aesthetic as well as historical, through which many of the familiar monuments of ancient Rome have passed before presenting themselves today, scrubbed and stripped down to whatever has survived of their classical skeletons. In a great many cases the result represents the appearance neither of the original building nor of any stage through which it has subsequently passed. Although complete restoration, as in the case of the near-by Arch of Titus, may rarely be justifiable, a building such as the Curia offers a warning of the hazards of partial restoration. In this respect the present aspect of the Temple of Antoninus and Faustina, though no more representative of the building's appearance at any stage in its past history, does at least offer a visual synopsis of that history. Furthermore, in this instance we do happen to possess the evidence for completing the classical picture. Figure 103A shows the temple as it appears on a contemporary coin, together with all the statuary which was its principal distinguishing feature and which is so very rarely preserved. The restored view (Figure 103B) shows it as it might have been glimpsed (though never in fact in its entirety from this frontal view) between the back of the Temple of the Deified Julius and the Regia.

Apart from the restoration by Antoninus Pius of the venerable Temple of the Deified Augustus, a restoration which is illustrated on coins and which is usually interpreted as having involved the rebuilding as octastyle Corinthian of what had been originally a hexastyle Ionic building,[5] the recorded works of restoration during this period are almost all of a routine character. During the second half of the century architectural interest passes almost entirely into the domain of private rather than of public building. Some aspects of this private activity are discussed in Chapter 14. Within the private sphere belongs also the building, or rebuilding, of two sanctuaries of Oriental divinities, one on the Aventine, dedicated to Jupiter Dolichenus, the Syrian Ba'al, shortly after 138; the other, on the Janiculum, rebuilt in 176–80 in honour of Jupiter Heliopolitanus, the head of the Syrian triad worshipped at Baalbek. The latter, though modest in scale, had a well developed architectural layout, with a polygonal sanctuary and altar at the east end of an elongated rectangular enclosure, and a temple at the west end. The temple, with an apsed nave and aisles and triple narthex-like vestibule, is of interest, not so much because of its resemblances (in themselves fortuitous) to certain Early Christian buildings, as because it illustrates a characteristic which these individually unpretentious but cumulatively powerful Oriental cults had in common with Christianity, and which found common expression in their architecture. With a very few exceptions the older classical cults were of an essentially public character; the altar stood in front of the temple, and the sacrifices or other rituals took place in full view of all who cared to participate. The rituals of the Oriental cults were no less essentially private, privileged occasions, and their sanctuaries turned inwards upon themselves, screened by high walls from the gaze of the profane.

The Severan Emperors (A.D. 193–235)

The civil war that followed the murder of Commodus in 193 ended with the establishment of a new dynasty, the provincial Roman origins of which were even more strongly

marked than those of its predecessor. Its founder, Septimius Severus (193–211), was a tough, able soldier of African extraction, whose wife, Julia Domna, was the daughter of the hereditary high priest of the great sanctuary of Ba'al at Emesa in Syria; and although by an ingenious process of retrospective auto-adoption he contrived to present himself officially to the world as the legitimate heir and successor to the Antonine emperors, he was well aware that dynastic considerations called for a certain display of architectural munificence. After the lean years of the later second century the list of building undertaken in Rome by Severus himself and by his successors, Caracalla (211–17), Elagabalus (218–22), and Alexander Severus (222–35), is a lengthy one; and although, architecturally speaking, the forty-odd years of Severan rule may be classed as an age of consolidation and achievement rather than of important new experiment, the work of these years could not help reflecting the wider changes in the political and social structure that were taking place throughout the Roman world. If the architecture of the Severan age is primarily one of fulfilment, it is also in some important senses one of transition.

A first charge on the architectural resources of the new regime was the restoration and modernization of existing monuments. Among the buildings recorded as having been restored by Severus himself and his immediate family are the Temple of the Deified Vespasian; the Pantheon (where the work can have involved little more than the repair of the existing ornament); the Porticus Octaviae, the surviving pedimental brick porch of which is entirely his work; and Vespasian's Temple of Peace and the buildings lying between it and the Temple of Vesta and the House of the Vestals, all of which had been damaged in a recent fire, in 191. An important by-product of this last-named work was the preparation of a detailed map of contemporary Rome, which was carved on 151 slabs of marble and affixed to the wall of one of the halls adjoining the Library of Peace. Though sadly fragmentary, enough of it has been preserved to make it a document of unique value for our knowledge of the vanished monuments of the ancient city (Plates 144 and 145).[6]

Not least of the services of the marble plan is the graphic portrayal (cf. Figure 53) of the innumerable private houses, apartment-houses, shops, and other commercial buildings about which the literature and the archaeological and epigraphic record can preserve only a tantalizingly incomplete and haphazard record. One recognizes in it all the types of building familiar from second-century Ostia; and although a few private houses of the old-fashioned, Pompeian type still survived, their comparative rarity shows how profoundly the face of the capital had changed during the last 100–150 years. Now and then one of the lesser buildings escapes from its anonymity. An example of presumably Severan date is the headquarters of the guild of tanners, the Coraria Septimiana, known from inscriptions to lie near the Ponte Rotto. We also know the names and locations of many of the wealthy properties. One of these, the Horti Variani, had belonged to the father of Elagabalus, and at the time of the latter's death was being developed as an imperial residence. Its surviving remains include a small amphitheatre, the Amphitheatrum Castrense; a full-sized circus for chariot racing; a bath-building, restored in 323–6 by the empress Helena, which is now destroyed but which was

recorded by Palladio; and a spacious, arcaded audience hall with large square windows, subsequently converted by Constantine into the church of S. Croce in Gerusalemme. The Amphitheatrum Castrense, with its two-storey façade of traditional type carried out entirely in brick-faced concrete (cf. the theatre at Ostia), is a typical example of an architecture that stands midway between the early Empire and late antiquity but is difficult to classify as belonging to either. In such a case the transition was almost imperceptible.

The Severan emperors were active in the provision of public baths. With the steady increase in population and a rising standard of living, supply was evidently hard put to it to keep up with demand. (The Regionary Catalogue of A.D. 354 lists no fewer than 952 bathing establishments in the capital.) Septimius Severus himself is credited with a large bath-building, the Thermae Septimianae, in the Aventine district, and Alexander Severus, besides renovating the Baths of Nero in the Campus Martius, is said to have erected lesser baths throughout the city. Dwarfing all these, however, were the Thermae Antoninianae of Caracalla, dedicated in 216 and still in sheer bulk alone one of the most impressive buildings that have come down to us from antiquity (Plates 141–2 and Figure 104). The layout of Caracalla's Baths followed essentially the model established a century before in the Baths of Trajan, the principal innovation being that of the surrounding enclosure. The latter, nearly 500 yards square and enclosing an area of almost 50 acres, combined the practical function of water storage with provision for all the subsidiary social amenities proper to a great bath-building. The central bath block stood in the north-eastern half of the enclosure, and except for the vast circular bulk of the main caldarium projecting from the centre of the south-west side, it was contained within a simple rectangular perimeter, 234 yards long and 120 yards wide (214 by 110 m.). It was a model of tight, rational planning, based on two identical bathing circuits laid out symmetrically about the shorter axis, with a hardly less important transverse axis running at right angles down the centre line of the building. At the intersection of the two axes stood the great three-bay, vaulted frigidarium. At one end of the shorter axis lay the main caldarium, a vast, circular, domed hall with a span (115 feet; 35 m.) not much smaller than that of the Pantheon and far taller, with large, scalloped windows in the drum; at the other end lay the *natatio*, or swimming pool. At the two ends of the longer axis were two identical *palaestrae*, or exercise yards, surrounded by terraced porticoes. The hot rooms occupied the whole of the south-west long side, with large arcaded windows facing the afternoon sun, while the more secluded north-east side housed the changing rooms, latrines, and other offices. Invisible service corridors, stairs, and galleries gave access to the furnaces and cisterns.[7]

The Baths of Caracalla are the embodiment of the concrete architecture of the earlier Empire at the moment of full maturity. One can, of course, detect in it problems and aspirations still to be resolved. The great circular caldarium, for example, with its moments of indecision between circular and octagonal planning belongs to a tradition that still had a long development before it; but the large windows in the drum already represent an important step forward in the direction that was to be followed by the monuments of the later third century.[8] Another problem still unresolved was that of

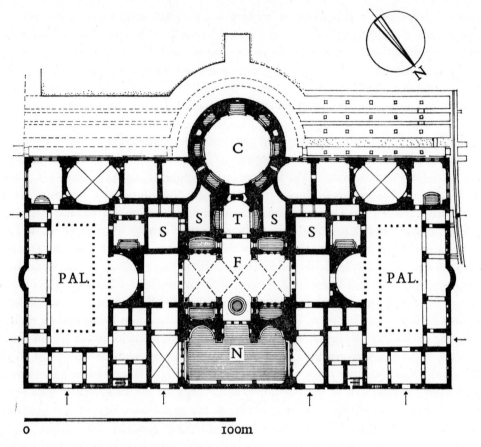

Figure 104. Rome, Baths of Caracalla, 212–16. Plan

c	Caldarium	s	Services
T	Tepidarium	F	Frigidarium
PAL.	Palaestra	N	Natatio

devising an architecture of the exterior consonant with that within. On three sides the main bathing block is little more than a gigantic masonry box; only the south-west façade, with its long rows of uniform windows leading up to the powerfully projecting bulk of the central caldarium, faces up to and answers the problem of presenting to the world outside a front that was both expressive of what lay within and at the same time interesting in itself. The interior on the other hand was, within its terms of reference, a thoroughly satisfactory solution to the architectural problem, smoothly functional and yet eloquent of the ideals described in the previous chapter. The formal extravaganzas of Hadrian's Villa would have been out of place. In their place we have elusive vistas and an adroit exploitation of the spatial ambivalence of intersecting axes, contrasting in the hot wing with a deliberately contrived self-sufficiency (in a smaller building one would call it intimacy), each room detached from its neighbours and facing inward upon itself except on the one side where it was wide open to the gardens

beyond. The colouring, too, and the use of light was subtle and assured. One notes, for example, the effective contrast between the coarse texture and plain black and white colouring of the floor mosaics, the warmly tinted marble veneers on the walls, and the vivid polychromy of the stuccoes or mosaics on the vaults; or again the alternating pools of shadow and light that gave depth and quality to the long axial vistas. The style is one that is out of tune with modern taste – or perhaps it would be truer to say that it has so often been perverted by its imitators and would-be imitators into a cold, meaningless grandiosity that it is hard for modern eyes to assess it dispassionately. Above all it needs to be thought of in terms, not of the overpowering lumps of masonry that have survived, but of its mastery of soaring space, light, and colour. Viewed imaginatively in these terms it comes to life as an architecture full of vigour and resource, admirably suited to the needs of its day and an eloquent expression of the robust assurance of the Roman Empire at the height of its power and wealth.

The same qualities of resource and of high technical competence are characteristic also of the Severan work on the Palatine. This was directed principally towards the development of the southern corner of the hill, extending in this direction the already existing Flavian Palace; and in addition to the modification of the so-called stadium and the completion of a bath-building that had been projected but barely started by Domitian, it involved the building of a whole new wing, terraced out upon the massive arched substructures which are so conspicuous a feature today of the view of the Palatine from the Aventine and the Circus Maximus. The substructures in particular, though still awaiting detailed study, can be seen to represent an extraordinary economy of materials and effort. All too little has survived of the buildings that stood upon them at the level of the main palace, but that little suffices to show in places an almost frightening disregard for the disposition of the walls and vaults beneath; the architect of this wing was very sure both of his materials and of his own ability to use them.

The most singular of the Severan buildings on the Palatine was the Septizodium, a lofty decorative façade dedicated by Septimius Severus in 203, of which the plan is known to us from the marble map and of which the eastern corner was still standing to its full height until demolished for its materials in 1588 (Plate 143). It took the form of an elaborate columnar screen, three orders high, and in plan consisting of three apsed recesses flanked by two shallow rectangular wings, the free-standing equivalent of the stage-building of a contemporary theatre. It was probably equipped as a fountain and the name[9] suggests a symbolical association with the seven planets. Architecturally its only function was as a screen concealing the buildings behind. The nearest analogies to it are the nymphaea that were used for precisely this purpose in many cities of Asia Minor during the first and second centuries A.D.

One other detail of the Severan work on the Palatine is worth recording in passing, if only because of its long-term consequences: Alexander Severus is credited with introducing here the type of paving in red and green porphyry which bears his name (opus alexandrinum) and which was to be the inspiration and material source of the pavements of countless Roman churches in the later Middle Ages.[10]

The official religious foundations of the Severan emperors were few but important;

and although they seem to have been cast in a somewhat conservative architectural mould, in other respects they represent a significant advance towards the beliefs and aspirations of late antiquity. Alexander Severus undertook a major restoration of the Iseum in the Campus Martius, Caracalla built a new and splendid temple on the Quirinal in honour of Serapis, and Elagabalus a no less magnificent temple on the Palatine to house the cult-image of the Ba'al of Emesa, together with an adjoining garden and shrine of Adonis. None of these divinities, it will be noted, was a member of the traditional pantheon; and although their choice reflects the particular Eastern connexions and sympathies of the reigning dynasty, it is nonetheless symptomatic of the religious tendencies of the age. Even Septimius Severus's dedication of a temple to Hercules and Dionysus[11] sounds less conventionally classical when its recipients are disclosed as the romanized versions of Melqarth and Shadrap, the patron divinities of Severus's own native city, Lepcis Magna.

The location of Septimius's building is not known, and it may well have been of a domestic rather than a public character. The Temple of Sol Invictus Elagabalus occupied the site of what had been the Aedes Caesarum on the east spur of the Palatine, opposite Hadrian's Temple of Venus and Rome. The platform is still a prominent landmark and the foundations of the temple itself have been partly excavated, beside and beneath the church of S. Sebastiano al Palatino. From these remains and from representations on coins[12] it can be seen to have been a large (200–230 by 130 feet; 60–70 m. by 40 m.) hexastyle peripteral building standing within a rectangular porticoed enclosure, with a monumental entrance facing on to the Clivus Palatinus. After Elagabalus's death it was re-dedicated to Jupiter the Avenger (Juppiter Ultor) (Plate 107D).

Caracalla's Temple of Serapis is to be identified with a gigantic building on the western edge of the Quirinal, near the Piazza del Quirinale, of which considerable remains were preserved and recorded in the fifteenth and sixteenth centuries.[13] It stood within a rectangular enclosure, and the most singular feature of the design, dictated presumably by the desire for strict orientation, was that it was the rear (west) wall which dominated the composition, flanked by the ramps of a grandiose double stairway which led down the steep slopes to the Campus Martius, 70 feet below. The temple itself faced towards the higher ground and, if Palladio is to be believed, it was unique among Roman temples in having a façade of twelve columns. It was certainly of gigantic proportions, the heights of the shafts being recorded as 57 feet 11 inches (17·66 m.), the capitals as 8 feet 1 inch (2·47 m.), and the entablature as 15 feet 10 inches (4·83 m.).[14] The alleged Egyptian affinities of the plan may be questioned. The drawings and the scanty surviving remains show the temple itself at any rate to have been, apart from its size, a building of conventionally classical type. The most puzzling feature of the surviving remains is the strongly 'Asiatic' character of the ornament, very similar both in choice of motifs and in treatment to that of the Hadrianeum, from which it would be hard on this evidence alone to separate the present building by more than a decade or so. The difficulty is all the greater in that it differs markedly in this respect from other known Severan monuments, which in their choice and treatment of traditional motifs reveal a decided bias towards the rich exuberance of the Flavian period. This is not

altogether surprising in that the largest single enterprise of Septimius Severus's reign had been the restoration and extension of the palace, where Flavian ornament was predominant; and it must have been workmen trained on this site who moved on to build the Baths of Caracalla.[15] One can only conclude that at least one of the workshops employed by the Severan emperors was eccentric in this respect, and preferred for its models the austerer grandeurs of the 'Asiatic' type.

Two other Severan buildings in the capital call for brief mention. One is the camp of the Equites Singulares, the Severan imperial bodyguard, extensive remains of the headquarters building and barrack blocks of which have come to light beneath the church of St John Lateran. The plan is distinctively military, but the methods of its construction and the manner of its detailing are indistinguishable from those of its civilian neighbours, an interesting anticipation of the meeting and mingling of military and civilian architectural forms which is so characteristic of the later third century. The second building is the well-known arch in the Forum Romanum (A.D. 203) (Plate 104). Except for the plain inscribed panel running the full length of the attic, the design of the arch itself is traditional, but both the form of the four great panels depicting the story of Severus's Eastern campaigns and the style and manner of their carving represent a whole-hearted renunciation of the traditional classical formulae (as still embodied in the panels of the Arch of Marcus Aurelius barely twenty-five years earlier) and look instead decisively forward towards late antiquity.

Private Funerary Architecture in the Second Century

Of the very large body of private building that figures on the Severan marble plan of Rome, a great deal was of relatively recent, second-century date. To some extent it must have provided the element of continuity that was lacking in the official programme. For example, had it not been for a large and continuing private demand, the slump that took place in the production of bricks after the Hadrianic boom (a slump of which the brick-stamps offer clear evidence) might well have taken on disastrous proportions. As it was, although a certain number of the smaller producers were forced out of business, there was an ample margin of organized production upon which Severus and his successors could base their great new programme of public works. There was also a large reservoir of skilled building labour upon which to draw.

Building had ceased to be a luxury for the wealthy few. An ever-increasing proportion of the private building both of Rome and Ostia was in fact in the hands of a new and rapidly growing middle class, a great many of whose members were of freedman stock, the sons and grandsons of enfranchised slaves, almost all of whom came originally from the Eastern provinces. They were intelligent and adaptable; business, trade, and the minor ranks of officialdom were increasingly in their hands. They could afford to build or to rent houses and apartments equipped with the latest luxuries, and their tombs throng the urban cemeteries. The former are described in a later chapter. The latter are in their own way no less revealing than the domestic architecture, displaying the arts of second-century Rome in some of their most attractive and unexpected aspects.

Many of the manifestations of Roman funerary architecture are so diverse and so full of personal idiosyncrasies as almost to defy brief analysis. If this is less true of second-century Rome than of many other periods and places, the merit lies very largely with the requirements and tastes of this new middle class. Already in the first century A.D. (e.g. in the cemeteries beneath S. Sebastiano)[16] one can detect the emergence of a type of unpretentious family tomb which, for all its variations of detail, followed broadly standardized lines. This was a small vaulted or gabled structure, built in reticulate work or, increasingly as time passed, in brick, and equipped internally with recesses for the ash-urns of the dead. The interior was often gaily painted or stuccoed; but apart from giving a certain prominence to the principal burial, usually by framing it within a small decorative aedicula in the middle of the rear wall, there was at first very little concession to architectural complexity.

The subsequent development of this commonplace architectural type is a copybook example of the familiar evolutionary cycle from classical simplicity to baroque exuberance. Once launched, the process was remarkably rapid. One can follow every stage of it, from bud to full-blown flowering, in the tombs of the Vatican cemetery between (in round figures) the years 120 and 180. The initial stimulus was of a practical nature, namely the gradual shift which was taking place about this time from cremation towards inhumation. To provide for the new rite the lower parts of the walls were marked off as a continuous plinth, within which were housed the large curved or segmentally arched burial recesses (*arcosolia*); the ash-urns continued to occupy the upper part. Within this framework there came into operation what seems to be an innate propensity of classical forms to proliferate and to recombine in certain remarkably stereotyped aclassical patterns. No sooner had the aediculae spread to the lateral walls than they began to disintegrate and multiply and to coalesce into a continuous architectural framework of running pedimental entablatures and colonnettes. At first the schemes were relatively simple and coherent; but they very soon began once more to disintegrate into elaborate split-pedimental fantasies, of which the forms were worked up into an ingenious counterpoint of curved and straight, concave and convex, plain and decorated, and the colour schemes and materials into contrasting zones of plain colour and polychromy. The Tomb of the Caetennii ('Tomb F') in the Vatican cemetery (Plate 139, Figure 105) will serve to illustrate this final stage. There are many formal analogies with the decorative schemes portrayed on the walls of Pompeii a century earlier, or again with the approximately contemporary façades of Petra (Plate 221), so close indeed that one might well be tempted to suspect reminiscences from the one or cross-influences from the other, were it not that in this case one can document the whole process of growth as one of predominantly organic development from within. This is the way that, divorced from function, classical ornament is apt to behave. To the student of the sixteenth and seventeenth centuries the phenomenon will need no further explanation.

One must not imagine that a development of this sophistication took place solely upon the walls of these crowded urban cemeteries, although it is here that we can best observe it. In the second century at any rate there was a parallel but architecturally more

ambitious line of development of which a few examples have come down to us in the more spacious cemeteries of the suburbs. Built free-standing, sometimes in the form of a low gabled tower, the interiors of these suburban mausolea are rarely preserved in any detail (a partial exception, with fine stucco-work vaults, is the pair of tombs beside the

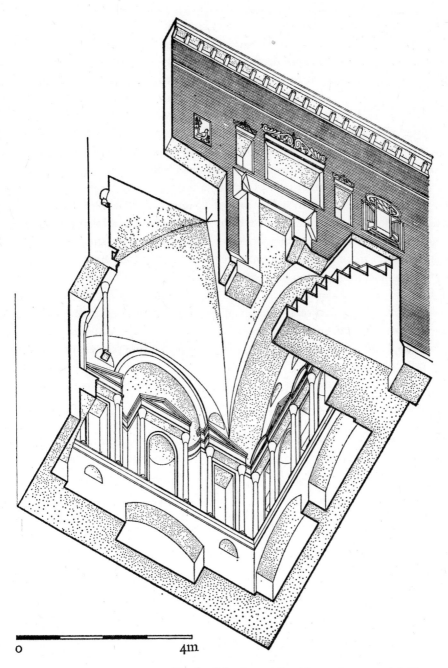

Figure 105. Rome, Vatican Cemetery, Tomb of the Caetennii, mid second century (cf. Plate 139)

Via Latina),[17] but such of the exteriors as have come down to us are remarkable for the exceptional quality of the brickwork (Plates 125 and 146). Capitals and entablatures, doorways and window-frames, were built up in moulded terracotta, and the wall-faces themselves were carried out in a brickwork that was specially selected for its decorative qualities and was not uncommonly even treated with a deep crimson slip and picked out along the joints with a hairline of gleaming white plaster. All these devices were freely imitated on the façades of the urban cemeteries, and in a more restrained manner in the domestic and utilitarian architecture also of the cities. Although the more elaborately decorative forms seem to have dropped out of use after the second century, these mausolea were undoubtedly an important factor in developing the taste for brick as a building material in its own right which characterizes so much later Roman building.

The subsequent history of the interior architecture of these tombs can be briefly stated. Just when the baroque schemes described above had reached a point of such complexity that it is hard to see how they could have developed further, they were rendered functionally obsolete by the virtual abandonment of the rite of cremation. The whole elaborate paraphernalia of niches and orders was dropped, never to be revived. In its place we get tombs like that of Quintus Marcius Hermes in the Vatican cemetery (c. 180–200), the interior of which, with its two zones of plain arcosolia, is of an almost aggressive architectural simplicity. Simple, broadly planned interiors were to remain characteristic of Roman funerary architecture for a long time to come, as we see them, for example, in the Hypogeum of the Aurelii a few decades later, in the catacombs, or even in the Late Roman imperial mausolea. The emphasis had shifted emphatically to the symbolic representational content of the painting or mosaic that now tended to cover every inch of the smooth, stuccoed surfaces, or to the elaborate carving of the marble sarcophagi which are so popular a feature of the funerary art of later antiquity.

OSTIA

No description of classical Rome is complete without some reference to the remains of Ostia. Not only was Ostia the harbour town of Rome and connected with it by the closest possible ties, but its abandonment in the early Middle Ages resulted in the preservation of the evidence for many aspects of classical architecture of which all trace has vanished for ever in Rome itself. This is particularly true of the everyday commercial and domestic buildings which in Rome were torn to pieces in the Middle Ages for their materials or else lie buried deep beneath the buildings of the modern town. The pages that follow give some account of the development of the city as a whole and something of the story of its principal public monuments. The apartment-houses, which today strike such an impressive note of modernity, are discussed in a later chapter.

The Early Imperial City

The main outlines of the town plan of Ostia had already been established early in the first century B.C. when Sulla enclosed the city within the circuit of walls which, except along the sea front, was to remain the effective limit of urban development throughout antiquity (Figure 54). These walls enclosed an irregular trapezoidal area of some 160 acres, one long side of which fronted on to the lowest reach of the Tiber. Near the centre of the Sullan city lay the 'castrum', the primitive nucleus, which was a fortified rectangular enclosure, approximately 220 by 140 yards in extent and divided into four equal quarters by two intersecting streets.[1] It was the roads leading from the gates of the castrum which determined the physiognomy of the later town. That from the east gate, the eastern decumanus, was a prolongation of the major axis, running parallel with the river and dividing the eastern half of the Sullan town into two almost equal and roughly rectangular halves. The north-east quadrant, between the eastern decumanus and the river, was early declared public property and developed on strictly controlled rectangular lines. The rest of the town grew up as best it might about the lines established by the road to Laurentum and by the pair of roads leading to the seafront (the western decumanus) and to the Tiber mouth (the Via della Foce), which left the south and west gates of the castrum respectively, and all three of which swung to left or right immediately on leaving the line of the early walls. There was, in short, a clear contrast between those areas (the castrum, the north-east sector, and to a lesser degree the south-east sector) which were available for orderly, rectangular development and those (the whole area west and south of the castrum, between it and the sea) in which development was determined by the prior existence of irregularly disposed topographical features.

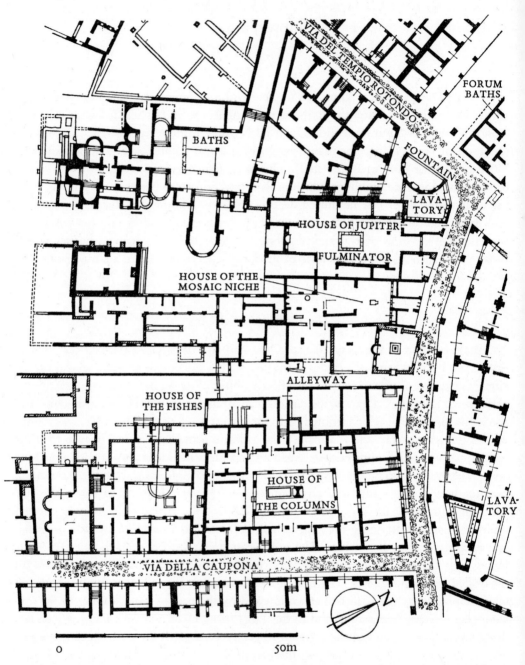

Figure 106. Ostia. Plan of a typical quarter, to the south of the forum, including private houses, a medium-sized bath building (*balneum*), streetside porticoes, a fountain, and two public lavatories, and along all the main street frontages shops (*tabernae*) and in many cases staircases leading directly to apartments on an upper storey

It was within this framework that the whole of the subsequent development of Ostia took place. By the end of the Republic several of the main sanctuaries had been established. Rather surprisingly there was still no forum, or at best only a very small one; but a pair of very late Republican or Augustan temples, one of them perhaps the original Capitolium, constituted a formal civic nucleus facing on to the main decumanus where later the forum was to be. The remains of several pre-Imperial commercial buildings include a formally planned market quarter (the 'Magazzini Repubblicani') with rectangular blocks of shops built of reticulate work about a framework of tufa piers. They were fronted on three sides by tufa porticoes, the first recorded instance of such a feature.

The first century of the Empire was marked by a change in the tempo rather than in the pattern of development. The only major monument attributable to Augustus (and it must be remembered how much of the early city was buried or swept away in the second century) is the theatre, built in its original form by Agrippa (i.e. before 12 B.C.) (Figure 107). It was laid out on an open site between the eastern decumanus and the river with, behind it, a large (410 by 260 feet; 125 by 80 m.) rectangular, double-colonnaded portico enclosing a garden. The quadrangle behind (the *porticus post scaenam* or 'Piazzale of the Corporations') was an integral part of the theatre complex and was intended to serve as a covered retreat for the audience, in accordance with the best Vitruvian precepts;[2] but in the absence at this date of a forum or public basilica, it is very likely that it also served from the first as a commercial meeting-place – as it certainly did in the later second century, when the outer colonnade was broken up into sixty-one small rooms, the mosaics of which reveal them as the offices (*stationes*) of the merchants and shipwrights of Ostia itself and of its principal overseas clients and customers. The double portico, with its inner row of tall Ionic columns and outer row of Doric columns, is an adaptation of a familiar hellenistic model; and although in general at this date Ostia lagged well behind the capital in its use of materials (the theatre was built entirely of tufa), the Ionic columns offer an interesting early example of brick (in this case tiles cut to shape) used as a building material in its own right and faced with stucco.[3]

The first, and for some time the only, building at Ostia to reflect the new Augustan architectural dispensation in the capital was the Temple of Rome and Augustus, a substantial hexastyle prostyle building of Tiberian date, the façade of which was built of Italian marble and carved by sculptors who were brought in from Rome for the purpose. At the same time the space in front of it was cleared to form the nucleus of the later forum. With this exception, the new buildings of the Julio-Claudian and Early Flavian period at Ostia continued to follow traditional lines. New street-front porticoes were added both to private houses and to commercial buildings, preparing the way for what was to be one of the most distinctive and attractive features of the later architecture of the city. These porticoes, both here and in Rome, have been compared with the colonnaded streets of the Eastern provinces, and there is indeed a family resemblance. But there is also an important difference: whereas in the colonnaded streets of Syria and Asia Minor it was the street that was planned as a unit, to which the buildings

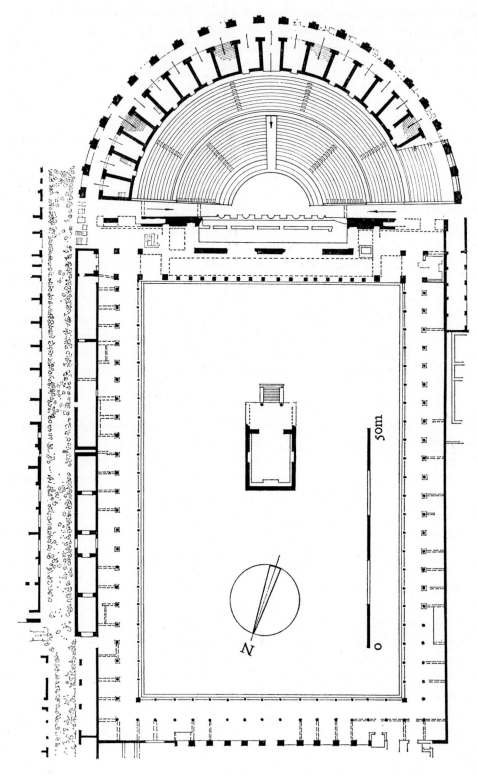

Figure 107. Ostia, theatre and Piazzale of the Corporations. Before 12 B.C., with substantial later modifications. Plan

adjoining it had to conform, the streetside porticoes of Ostia and of the Western provinces always remained formally part of the buildings of which they were the frontage. Colonnaded streets in the Eastern manner are not found in the West before late antiquity.[4]

The most important commercial buildings of this early period are three of the large public warehouses (*horrea*) that were used for the storage of grain and other commercial commodities prior to their reshipment up-river. These were large, enclosed, rectangular buildings with storage rooms opening off the four sides of a colonnaded or porticoed courtyard (e.g. the possibly Tiberian 'Horrea of Hortensius'; Figure 108), the central area of which might also contain similar but outward-facing blocks (e.g. the Claudian 'Grandi Horrea'). In Rome we find this plan already well established in the Republican Horrea Galbae (cf. p. 107) and in the Augustan Horrea Agrippiana near

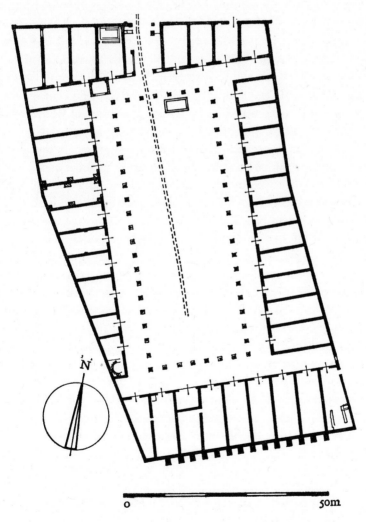

o 50m

Figure 108. Ostia, 'Horrea (granaries) of Hortensius', *c.* 30–40. Plan

the forum. The regular type of private house at Ostia throughout the first century continued to be the old-fashioned atrium-peristyle house; and although there are the recorded remains of at least three small baths of first-century date, made possible by the construction of an aqueduct in the thirties, it was not until the early second century that the town received its first large, up-to-date public bath-building.

Ostia in the Second and Third Centuries

The overall impression conveyed by the first-century remains of Ostia is one of a cautiously progressive conservatism. In some respects, notably in its poorer-class domestic architecture, Ostia had lagged far behind Rome, where overcrowding had long ago necessitated a drastic new approach to the problems of urban housing. In a great many other ways, however, the better-class domestic and commercial quarters of the capital must have looked very much like this before the great fire of A.D. 64. At this date the wave of prosperity that followed the building of the Claudian and Trajanic harbours had still to make itself felt in Ostia. The revolution in building methods for which the reconstruction of the capital after the Neronian catastrophe offered such scope did not reach Ostia until about thirty years later. When it did come, however, it came in no uncertain manner. If the surviving remains of the first-century town afford a tantalizing glimpse of the streets and buildings of pre-Neronian Rome, second-century Ostia offers a picture of its successor that is almost embarrassingly rich.

The detailed stages of the rebuilding need not concern us. Before his death in 96 Domitian seems to have put in hand the modernization of several city blocks between the castrum and the theatre; and in the forum area he had added to the limited facilities available by rebuilding what is usually identified as the curia and by building opposite it a large basilica of conventional Early Imperial type, with one long side open to the forum square and an internal ambulatory. It was under Trajan, however, that the reconstruction of the town really gathered momentum, to be continued on an even larger scale under Hadrian and completed under Antoninus Pius. Trajan's work lay chiefly in the district between the castrum and the sea. By Hadrian's death in 137 the whole of this western quarter and the whole quarter between the castrum and the river had been rebuilt; with a few exceptions (the theatre, the Claudian horrea, and a few minor, mainly religious buildings) the same is true of the north-east quarter, between the eastern decumanus and the river. Antoninus Pius was concerned mainly with completing what Hadrian had begun, although he seems to have initiated at least one major public building, the Forum Baths (Figure 110A); and private enterprise was still actively at work throughout his reign, in buildings such as the House of Diana (Plate 148), the Schola del Traiano, the Horrea Epagathiana (Figure 109B and Plate 152), and the House of Fortuna Annonaria (Figure 130A). After the middle of the century the tempo dropped rapidly. Later emperors were active sporadically in the field of public works, notably Commodus, who rebuilt the large Claudian horrea, and Septimius Severus, who rebuilt (or completed rebuilding) the theatre at the barracks of the Vigiles and restored a number of warehouses and bath-buildings. The last important public building in the excavated

area, the round temple west of the basilica, dates from the reign of Alexander Severus (222–35), or possibly Gordian (239–44), who had family connexions in the district. By that date Ostia was already launched on the decline from which it never recovered.

What was the cause of this outburst of building activity during the first half of the second century? First and foremost it was the sudden access of prosperity and the explosive growth of population that followed the reorganization of the harbour facilities of the capital city at a moment of already rapid growth and material development. Of the factors that shaped it, unquestionably the most important was the availability of the new building techniques and materials which had been developed during the first century A.D., and which were now becoming available at increasingly advantageous prices as a result of the reorganization of the brickyards undertaken by Trajan and Hadrian. Hardly less important must have been the sheer force of example of a wealthy and powerful neighbour. Ostia lacks the great imperial monuments of the capital, but in all other respects it was following the models established by the recent and still continuing rebuilding of central Rome.

From the wealth of surviving buildings, we can here select for description only a very small representative sample. The commonest of all Ostian building types, repeated with little or no variation in a very wide variety of contexts, was the *taberna*, the Roman version of the simple one-roomed shop which has served the artisan and the retail trader in Mediterranean lands at all periods. In its developed Roman form (as in Plate 148) this was a tall, deep, barrel-vaulted chamber, open in front almost to its full width. It could be closed by means of a series of sliding panels of a type of which the ashes of Pompeii have preserved the exact imprint. Inside there was a wooden mezzanine, for storage or for lodging, accessible by wooden steps and lit by a small window over the door. An architectural unit so simple and so flexible could be adapted to almost any context, ranging from a single row of shops fronting directly on to the street to the intricate multi-level complexity of Trajan's Markets in Rome. Tabernae might be ranged along a street-front or grouped around a courtyard to form a market; or they might be part of the frontage of an apartment-house, just as today one finds their modern equivalents everywhere built into the façades of the palaces of Renaissance Rome. But whereas in Rome the great majority were carved out of existing properties, as they had once been in Pompeii, at Ostia they were regularly an integral part of the buildings to which they belonged.

The apartment-houses of Ostia are described in the next chapter. In terms of the new building technology, the combination of shops and multi-storeyed dwellings was the logical answer to population pressures, increased land values, and a steadily rising standard of living among the professional and mercantile classes. From casual references in classical writers we know that Ostia was not the only harbour city where this was happening;[5] nor were the resulting architectural solutions confined to domestic architecture. The palazzo type of apartment-house, built around a central courtyard, needed little modification to serve as the barracks of the local fire brigade (Figure 109A), as the headquarters and social centre of one of the prosperous trade associations (*collegia*), or as a multi-storeyed private warehouse for the storage of retail goods (Figure 109B).[6] The

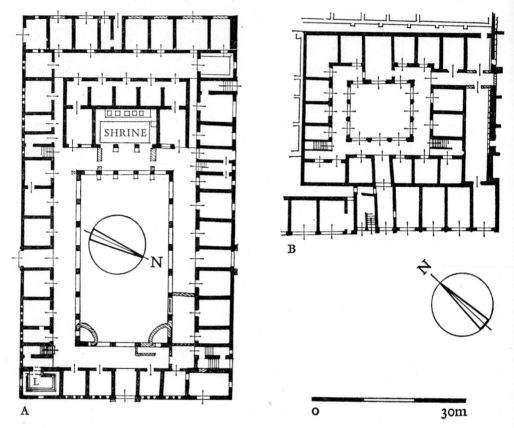

Figure 109. Ostia

(A) Barracks of the Vigiles, headquarters of the fire brigade, 117–38. Plan
(B) Horrea Epagathiana, warehouse, c. 145–50. Plan (cf. Plate 152)

public granaries and warehouses of the type already established in the first century A.D. lent themselves to a very similar development, with ramps instead of stairs leading to the upper storeys.

Only three of the city's temples of the Imperial Age were conspicuous public monuments: the Tiberian Temple of Rome and Augustus, the centre of the imperial cult; facing it down the enlarged forum, the Hadrianic Capitolium, a very richly marbled brick construction, of which the unusually tall podium was presumably dictated by a wish to dominate the multi-storeyed houses of the neighbourhood (Plate 147); and a large circular temple, of unknown dedication and late Severan date, with a decastyle porch.[7] As one might expect in a harbour town, the Oriental cults were widely and variously represented from an early date. None of their buildings are of any architectural distinction, but the large triangular enclosure that housed the temples and orgiastic rites of Cybele, Attis, and Bellona offers an unusually clear picture of the buildings and fittings appropriate to such a cult. Of the bath-buildings three at least were large public thermae, all built within the first sixty years of the second century with the help of imperial money. The Hadrianic Baths of Neptune (Figure 110B) and the Antonine Forum

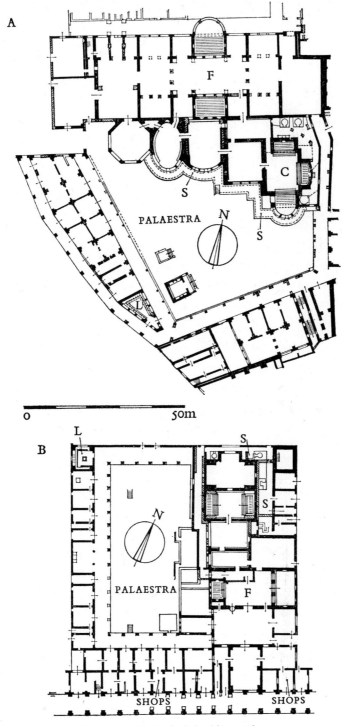

Figure 110. Ostia, bath-buildings. Plans

(A) Forum Baths, c. 160
(B) Neptune Baths, 117–38. Note the shops and arcade along the main street frontage of the Neptune Baths

F Frigidarium C Caldarium L Lavatory S Services

287

Baths (Figure 110A) offer an interesting contrast in design. The former represent a logical development of the latest Pompeian type, as represented there by the Central Baths, with the bathing block occupying one side of a rectangular, colonnaded palaestra and shops along the main street-frontage. The Forum Baths were more adventurous in design, combining a frigidarium wing of conventionally rectilinear form with a range of interestingly diverse polygonal and curvilinear hot rooms, stepped out so that the large southward-facing windows might take full advantage of the afternoon sun. Across the street is a finely preserved public lavatory.[8]

In Chapter 10 we have discussed in general terms the characteristics and aims of the new architecture and, in some detail, some of its manifestations in the monumental architecture of the capital; and in describing the Markets of Trajan, we caught a glimpse of it at a rather more prosaic, though still basically monumental, level. It remains to ask briefly what was its impact upon the architecture of daily life as so fully and vividly exemplified by the buildings of second-century Ostia.

In terms of planning the answer is simply and briefly stated. Pressure of population and the rise in land values made for tighter, more economical planning, the most conspicuous manifestation of which was a tendency to build upwards all those types of building that lent themselves to such a development. Shops with apartments over them,

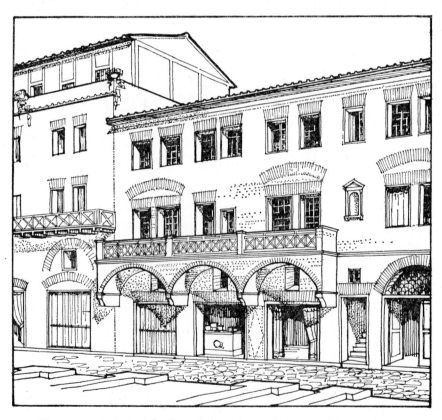

Figure 111. Ostia. Façade of an insula with a cookhouse on the ground floor

apartment-houses of three, perhaps in places even four or five, storeys, commercial buildings of two and sometimes three storeys became the regular rule.

The formal changes are less easily summarized. The element common to all may perhaps most simply be stated as a decisive movement away from those architectural usages, however time-honoured, which no longer had any meaning in terms of the contemporary concrete medium, and an ever-increasing readiness to treat the brickwork facing as a material in its own right.[9] These changes were not applied in any doctrinaire spirit, nor were the traditional practices abandoned overnight; but we find the latter increasingly relegated to certain well defined spheres within which traditionalism still had a claim to speak as the accepted architectural language. The marble colonnade, for example, still had connotations of grandeur and was felt to be proper for such buildings as temples, major civic monuments, and the porticoed exercise yards of bath-buildings; and, more generally, the classical orders remained an important constituent element of most interior decorative compositions, whether in private houses or in large public buildings. On the other hand, instead of the columns and architraves of the familiar classical system the courtyards of apartment-houses (Plate 150) and commercial buildings and the street-front porticoes (Plate 153) now invariably used plain brickwork piers and arches, and the street frontages (Plates 148–9) were hardly less uncompromisingly 'modern'. At Ostia one can study the impact of the new Roman architecture, not in the context of court or temple, but as it affected the everyday surroundings of the man in the street (Figure 111). One is made vividly aware how far the Romans of the second and third centuries had already progressed towards producing an architecture of which many of the essential concepts were to remain valid right down to our own times.

ITALY UNDER THE EARLY EMPIRE

Campania

WHEN, in 42 B.C., the future emperor Augustus united the lowlands beyond the river Po, the former province of Cisalpine Gaul, to the rest of the Italian peninsula, he was completing a process of unification begun many centuries before when Rome first began to establish her hegemony over her Latin neighbours in the west-central coast-lands. The Roman military colonies both within and beyond the limits of Italy had long been centres for the diffusion of Roman ideas and Roman habits. But it was barely half a century since the Social War had given the greater part of the peninsula parity of rights and duties with the capital, and within the formal unity of the twelve administrative regions of Augustan Italy there were ethnic, linguistic, social, and cultural differences as extreme as any with which modern Italy has had to contend. Architecture was no exception. Each region had its own problems and its own traditions; and although outside the immediate periphery of Rome it was perhaps Campania alone which made any substantial contribution to the Early Imperial architecture of the capital, the experience gained elsewhere in Italy, notably in the north, was undoubtedly an important factor in shaping the architecture of many of the newly emergent provinces. Before turning to the latter, it is necessary to glance briefly at some of the cities and monuments of provincial Italy.

The impact of the Greek architecture of South Italy and Sicily upon that of Rome already belonged to a remote past. There are very few important monuments of the Imperial Age in Magna Graecia. The centres of wealth and influence had long shifted elsewhere. By contrast, Campania was at the peak of its prosperity during the last century of the Republic and under the Julio-Claudian emperors. An inexhaustibly rich soil supported a population in which Greek, Samnite, and Roman elements mingled to create and to enjoy the solid, middle-class prosperity to which Pompeii and Herculaneum bear such eloquent witness; Puteoli had not yet been supplanted by Ostia as the gateway for the rich trade with the eastern Mediterreanean; and since the early years of the first century B.C. the shores of the Bay of Naples had become the fashionable playground of the wealthy Roman. This was fertile ground for the dissemination and development of new ideas.

It is the relative completeness of Pompeii that inevitably strikes the modern visitor. What is not so immediately apparent is that in A.D. 79, when the eruption of Vesuvius overwhelmed the city, it was still in the full tide of reconstruction after another, and only relatively less disastrous, natural catastrophe, the earthquake of 62.[1] Very few of the public buildings that one now sees had been completely repaired; some were still in ruins, many more, including almost the whole of the forum area, were still in the

hands of the builders. It is above all the fact that so much of the town incorporates work from the last fifteen years of its existence that gives the remains a special interest in the present context. By comparison, the changes of the previous fifty years were relatively modest and had mostly taken place within the well established framework of an essentially conservative tradition.

The immediately pre-eruption domestic architecture of Pompeii and Herculaneum, the excavation of which has done so much to shape the familiar picture of Roman living, is described in the following chapter. Change was in the air. The evidence of Herculaneum, which in such matters was the more progressive of the two cities, suggests that another few decades of existence might well have seen the introduction of a local version of the Ostia-type apartment-house. Many of the older houses were in fact already being broken up into smaller units; upper storeys had become a commonplace; and at Pompeii the arcaded streetside Porticus Tulliana just north of the forum shows that at least one aspect of the post-Neronian architecture of the capital was making itself felt in the years just before 79. But the scene was still dominated by the old-style atrium-peristyle houses of the later Republic. Here too things were changing; but the most immediately obvious innovations lay not so much in the architecture as in the styles of painted ornament, which reveal a steady evolution away from the architectural illusionism of the so-called Second Style towards decorative schemes that subsist in their own right, almost unrelated to the underlying architectural facts.[2]

It is, however, in the public monuments that we can better see the extent (and the limitations) of the city's response to the changing conditions of the first century A.D. Moreover, apart from the special circumstances of the earthquake, what was happening at Pompeii was happening in innumerable other small towns up and down the length of Italy, and, farther afield, in the provinces. There were certain public buildings which any town of substance was expected to have. In this respect Pompeii, with its characteristic mixture of traditionalism and innovation, of Republican and Early Imperial building types and techniques, will serve admirably as an introduction to the municipal architecture of Italy and the western provinces during the first century A.D.

The list of public monuments at Pompeii is in itself instructive. Apart from minor wayside and domestic shrines the religious life of the community was taken care of by nine temples. Two of these, the Doric temple in the so-called Triangular Forum and the Temple of Apollo, date from the earliest days of the city's history; and three others, the Capitolium and the temples of Jupiter Meilichius and of Venus, are certainly pre-Imperial, the first-named being the official religious centre of the Sullan colony, sited at the head of the formal centre of the city, the forum. The other four were all post-Republican foundations, and the dedications are characteristic of the times – two, the temples of Fortuna Augusta (3 B.C.) and Vespasian, being associated with the imperial cult, and a third, that of Isis, being a private benefaction in favour of one of the most influential of the Oriental mystery religions, for which Puteoli's many Eastern connexions made Campania receptive ground. Between them these three temples represent the two most powerful and consistent trends in contemporary religious practice, the one very early developing into a formal state religion embodied in the person of the reigning

emperor and his divinized predecessors, the other as an essentially individual response to the spiritual problems of the age. (It is significant in this respect that the Temple of Isis is one of the very few buildings that had been completely rebuilt and redecorated before the eruption.) The fourth of the Imperial Age dedications, the public Lararium, a shrine to the city's tutelary divinities, was a propitiatory foundation undertaken immediately after the earthquake.

Of the city's other public buildings the basilica, the curia (the meeting place of the city fathers) and its associated offices, and the comitium (the voting precinct of the city assembly) were, as one would expect, grouped around the forum (Figure 112). These, as again one would expect in a Sullan colony, were all in origin Republican buildings, as also were the principal places of public entertainment, the two theatres and the amphitheatre. Two of the three public bath-buildings were also of Republican date. To this substantial nucleus were added during the last century of the city's history the macellum, the meat and fish market, and the Forum Holitorium, the vegetable market, both of which now acquired permanent buildings adjoining the forum; the Schola Iuventutis, the headquarters of the youth movement; the palaestra, a grandiose open-air exercise yard with enclosing porticoes and a central swimming pool; and the headquarters of the guild of fullers, the most influential of the city's commercial corporations, built for them during the reign of Tiberius by their wealthy patroness, the priestess Eumachia. The prominence of the last-named building, which occupies a large, central site beside the forum, is a noteworthy anticipation of the position which we find these guild headquarters acquiring later, in second-century and third-century Ostia. The palaestra, an Augustan building, represents an initiative that was not generally followed outside Campania, where we meet it again at Herculaneum. It has been aptly described as a hellenistic gymnasium without the actual gymnasium block. In ordinary Roman practice this function was taken over by the large public bath-buildings which regularly incorporated swimming pools and porticoed courtyards for athletics. Here at Pompeii, where the existing bath-buildings were situated too near the crowded centre for any such development, a solution more in accordance with Greek practice would not have seemed out of place.

Finally, to complete the catalogue of the public monuments of the Imperial Age, there is the forum area itself, the tufa porticoes and pavement of which were already in process of replacement in travertine at the time of the earthquake and were still incomplete in 79. We are reminded that no less than the individual buildings, the streets and piazzas of the old-established Italian towns were the product of a long and often piecemeal growth.[3] That, despite this haphazard development, the civic centres of Roman towns should so often have achieved a unity and a dignity which may not unfairly be compared with that of their medieval successors is a tribute both to the vitality of the civic institutions of the Roman town and to the essential good manners of the architectural tradition through which they found expression.

Almost without exception the public buildings of Pompeii were badly damaged in the earthquake. At least two of the most important, the Capitolium and the basilica, were still lying in ruins in 79, presumably awaiting a more radical rebuilding than was

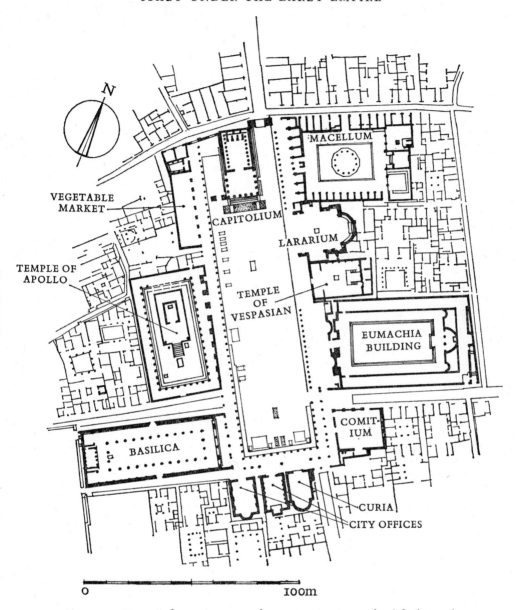

Figure 112. Pompeii, forum, in course of reconstruction in 79. Plan (cf. Plate 155)

possible in the period immediately following the disaster. A few, such as the Temple of Apollo and the amphitheatre, had needed little more than patching and buttressing, and others, such as the theatre and the Forum Baths, though still far from completely re-stored, were partially back in service. Many more, however, were still in the builders' hands, and although they made use wherever practicable of existing structures, the majority would on completion have been substantially new buildings.

The picture which these buildings convey of architectural practice at Pompeii during

the decade before its final destruction is, broadly speaking, one of the widespread adoption of the building techniques of contemporary Rome, coupled with a rather cautious conservatism towards the new ideas that were accompanying these techniques. The extensive re-use of earlier building materials led to a variety of unusual, makeshift practices; but the dominant facing material in the new work is brick, the most noticeable difference from Rome being that, whereas a really up-to-date (and perhaps imperially financed) building such as the Central Baths (Plate 157) might have large square windows spanned by flat arches of brick, with brick relieving arches above them in the Roman manner, timber lintels were still the regular practice in the houses and shops. One of the most valuable lessons to be learned from Pompeii and Herculaneum, and one that can all too rarely be documented archaeologically, is that timber was still far more widely used in the everyday architecture of the ordinary Italian town than one might be led to suspect by the remains that have come down to us, which are in the nature of things those usually of the more solidly constructed public buildings. Not only were the door-frames, architraves, balconies (Plate 158), and roofs of wood, but much of the superstructure too was often timber-framed, as it had been in Republican Rome.[4]

Although the upper part of the seating of the theatre was still in ruins in 79, the stage-building, with its triple system of alternately rectangular and curved re-entrant features and counter-projecting aediculae, seems to have been completely remodelled after 63 to conform with the increasing elaboration of contemporary theatrical design. Another monument to be influenced by contemporary trends was the Building of Eumachia (Plate 155). The main lines of the plan, a rectangular porticoed enclosure, are simple enough; but the façade that opens on to the forum portico is enlivened by two shallow, curved recesses, and not only do the lateral porticoes end in small apses, but there is also a larger, central apse, screened by a pair of columns, at the far end of the main axis. The handsome, carved marble door-frame, on the other hand, and the continuous scheme of decorative wall-panels, with alternately triangular and curved pediments, are both inherited from the original Tiberian building, the latter being copied also in the adjacent Temple of Vespasian. The most elaborately 'contemporary' of the forum buildings was the Lararium (Figure 112), which consisted of an open courtyard flanked by two rectangular, barrel-vaulted recesses, leading up to a spacious apsidal feature, which in turn was broken out into a shallow central apse with, on the diagonals, two smaller, rectangular recesses; the altar stood in the centre. The contours of the wall-features are further enriched with pilasters, recesses, and projecting plinths, and although the building can have been only partially vaulted, the architectural intention clearly derives from the centralized vaulted architecture of the capital. Similar wall-recesses coupled with shallow plinths can be seen in the curia, where they may almost certainly be interpreted as the structural basis for shallow aediculae of plaster, or even of veneer marble, one of the standard devices for breaking up the wall-surfaces of later Roman architecture. The brick piers of the adjoining hall are on the other hand functional, being intended to support the wooden cupboards housing the contents of the tabularium, or city record office.

Another contemporary feature is to be seen in the adjoining macellum, the meat and

fish market (Figure 112). The plan of the market itself, a rectangular porticoed enclosure with offices at the far end and a circular pavilion (*tholos*) in the centre, follows well-established models, e.g. already in 8 B.C. at Lepcis Magna in Tripolitania (Figure 174). To judge from the recent discovery of a market building of this type at Morgantina in Sicily, dating from the second century B.C. (Plate 156), the form may well have originated in South Italy, spreading thence to North Africa, Greece (Corinth), and the capital, where the old macellum just north of the forum had a central tholos in Varro's day (i.e. before 27 B.C.). The Macellum Liviae, built by Augustus on the Esquiline, and Nero's Macellum Magnum on the Caelian, followed similar models.[5] The Pompeian building incorporated three rows of single-room shops (*tabernae*), one facing inwards and forming part of the market, and two facing outwards on to the adjoining streets. This use of valuable street frontages and courtyards for the incorporation of individual shops into other buildings, both public and private, was a natural development of increasing urban congestion and rising land values. Already widespread in the latest phase of Pompeii, it is one of the characteristic features of the architecture of Ostia (cf. Figure 106). Another striking example at Pompeii is the Central Baths (Plate 157 and Figure 113) which, when finished, would have been the most up-to-date building of the

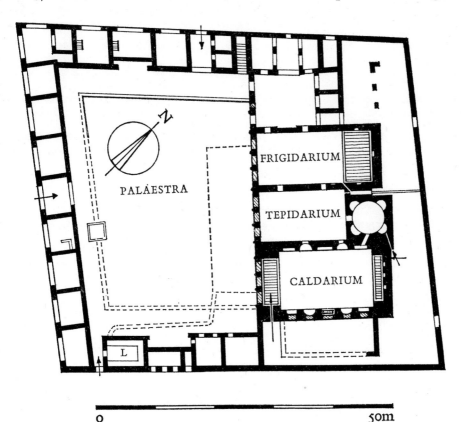

o 50m

Figure 113. Pompeii, Central Baths, 63–79. Plan (cf. Plate 157)

L Lavatory

city. Here there were shops on two adjacent frontages, backing on to the quadrangular exercise yard which occupied rather more than half the available space; along the corresponding third side were the smaller offices of the baths themselves, the bathing suite proper being concentrated along the fourth, a simple but effective arrangement reminiscent of that of the traditional hellenistic gymnasium. The brickwork detail, however, was thoroughly contemporary, particularly the façade of the main block with its severely effective alternation of half-columns and large square windows and the lofty recesses, alternately curved and rectangular, which occupy well over half the wall-surface of, and give life and movement to, the interior of the main hot room. The opening of doors and windows in the curved features is another striking innovation. Together with the still incompletely excavated Suburban Baths at Herculaneum, this building offers a vivid glimpse of how much greater the transformation might have been if the earthquake and the eruption had happened even twenty-five years later than they did.

To what extent does the fantasy architecture of the latest stages of Pompeian wall-painting (as distinct from the often demonstrably realistic architectural landscapes which it incorporates) represent a decorative style in real architecture that has not survived elsewhere in more tangible form? It is not easy to generalize; there is a natural tendency in such cases for painters to mannerize and to exaggerate, nor it is always the minor art that is copying the major. With the improved excavational techniques of the last half-century, however, it has become increasingly clear that there is a very substantial element of real, three-dimensional practice behind a great many of the features portrayed. When therefore one finds, for example, a painting illustrating a façade, the two projecting wings of which terminate in the two halves of a broken pediment, it is reasonable to assume that this was already an accepted feature of the architectural repertory.[6] Again, allowing for an element of painterly exaggeration, it seems very likely that the slender, candelabrum-like colonnettes, elaborately figured or foliated finials, brackets, balustrades, pergolas, and other, often at first sight purely fantastic, architectural details of the so-called Third Style (e.g. Plates 159 and 160) echo the verandas and balconies, the windows, the sun-terraces, the decorative wall-schemes in gilded metal work, the draperies and hangings, that one would have found in real life in the wealthy villas of Baiae and of Rome itself.

It may well be that some of the characteristic elements of the Third Style derive ultimately from other sources – from the decorative innovations attributed by Vitruvius to the Asiatic Greek architect, Apaturius of Alabanda, for example, or from the sort of dream architecture recorded as having graced the shipboard pavilion of Ptolemy IV of Egypt.[7] That the luxurious courts of the late hellenistic monarchs should have left their mark in such a field as this is very easy to believe. It does not follow, however, that such alien manners and motifs reached the walls of Pompeii direct. The processes of borrowing and assimilation are likely to have been complex; and just as some of the hellenistic elements demonstrably present in Second Style Campanian painting can be shown to have taken definitive shape in the real architecture of Late Republican Italy, so there is every reason to believe that a great many of the Third Style motifs are based

on contemporary architectural forms in local use. Once again we are reminded how much our knowledge of ancient architecture is based on the bare bones, stripped of their flesh and blood. The value of Pompeii and Herculaneum lies not only in the actual surviving buildings, but also in the glimpses that one can catch on their walls of many other aspects of classical architecture which might otherwise have been irretrievably lost.

The remains of the cities buried in 79 do not by any means exhaust the wealth of fine classical monuments of the Early Empire which Campania has to offer. The seaside villas are described in the next chapter. Here it must suffice to mention a few only of the more important of the other buildings.

Besides possessing, at Pompeii, the earliest all-masonry amphitheatre known, Campania can boast also two of the largest and best preserved of those of later date, at Capua (560 by 455 feet; 170 by 139 m., in size second only to the Colosseum) and at Pozzuoli (490 by 370 feet; 149 by 116 m.).[8] The former, in origin probably a late Julio-Claudian monument, but extensively remodelled under Hadrian, the latter a Flavian building, they may be compared with the approximately contemporary North Italian amphitheatres of Verona (500 by 405 feet; 152 by 123 m.; it is estimated to have held some 25,000–28,000 spectators) and Pola in Istria (435 by 345 feet; 132 by 105 m.). The known earlier amphitheatres of Italy had all been either partially recessed into the ground and only in part built up above it (e.g. Sutri, Lucera, Syracuse, Terni; cf. also Mérida, in Spain), or else, like those of North Italy (e.g. probably Piacenza) and of Rome itself, were built of timber on masonry footings. With the construction of the Colosseum and of these four amphitheatres the form reached its full maturity. That of Pozzuoli is remarkable also for the quality of its brick-and-reticulate masonry (only the outer ring, now largely robbed, was of stone) and for the elaboration of the service corridors and other substructures, in which one can make out all the details of such features as the lifts for raising the wild beasts to the floor of the arena above.

The Verona amphitheatre[9] (which owes its preservation in part to an endowment for its maintenance established in the thirteenth century – a remarkably early instance of such civic enlightenment) has a great deal in common constructionally with the Colosseum, including a very similar use of dressed stone for the essential framework of the building, concrete playing a lesser and structurally secondary role. Of the three orders of arched openings of the outer face, the uppermost were not the arches of an encircling gallery but were windows that rose clear above the seating. The same is true of Pola, where little more than the outer ring has survived, the windows in this case being rectangular openings in an otherwise plain attic. Both at Verona and at Pola the pilasters of the façade are restricted to the two lower orders and are carved in very shallow relief, thus emphasizing the pattern of the arches rather than that of the orders themselves. This is exactly the opposite of the effect sought by the builders of the closely contemporary amphitheatres of Nîmes and Arles, who went out of their way to accentuate the rhythmical pattern of the classical framework; and it may not be altogether fanciful to detect in the attitude of their Italian colleagues the dawning of a new sensibility, based on the more strictly functional simplicity of the new concrete medium in which they were increasingly having to work.

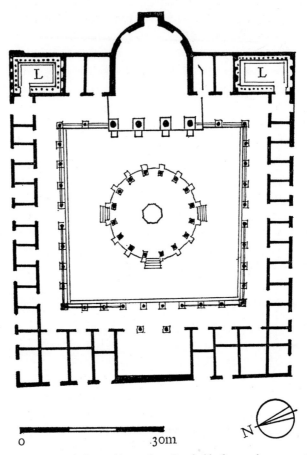

Figure 114. Pozzuoli (Puteoli), market, first half of second century. Plan
L Lavatory

The macellum, or market building, at Pozzuoli (Puteoli)[10] is a fine example of the type already noted at Pompeii, though of somewhat later date, the columns being of imported granite and Carystian marble (Figure 114). The paved courtyard, 125 feet (38 m.) square with a central pavilion, is surrounded on four sides by a two-storeyed portico, off which open thirty-two small shops. In the middle of the east side the colonnade is interrupted by the four larger columns of a temple to the divinity, possibly Serapis, under whose protection the market was placed, and the two eastern angles were occupied by public lavatories. The integration of temple and portico into a single façade is a device which we have already met in Vespasian's Templum Pacis in the capital, and it is one that was widely used also in the provincial architecture of the second century A.D.

Little has survived of the luxurious villas for which Baiae was once famous, but the thermal establishments that crowded the southern slopes behind and above the present village have fared better.[11] The remains of one of these can still be seen, terraced impressively up the hillside; and there are no less than four circular halls, housing thermal springs, which were the architectural speciality of the place. The earliest of these, the

so-called Temple of Mercury, consists of a masonry drum, circular internally and supporting a dome with a central oculus and, half-way down the curve of the dome, four square windows. The drum, which enclosed a circular pool, now buried, has a diameter of no less than 71 feet (21·55 m.), and the inner face of it is interrupted by four small apsidal recesses, alternating with two large and two small rectangular openings, a formula which suggests that the immediate inspiration for this grandiose hall is to be sought in the very much smaller, circular frigidaria of the early bath-buildings at Pompeii, to which the suite of rooms adjoining the rotunda, securely buttressing it against the hillside, bears a very close resemblance. The masonry is a good early reticulate, and the materials of the dome, which tapers to a mere 2 foot (60 cm.) thickness near the crown and was decorated with mosaic, are laid radially, in the Republican manner. Even if this latter were a conscious archaism, adopted because it was thought to give greater strength, the building can hardly be later than the early Julio-Claudian period, and it represents a remarkable architectural achievement for so early a date.

The Temple of Mercury, with its evident anticipations of the Domitianic rotunda at Albano and ultimately of Hadrian's Pantheon, offers an unusually clear instance of a type of building that was evolved first in Campania and only later taken over by the architects of the capital. Its subsequent development locally can be studied in the very similar 'Temples' of Diana and Venus at Baiae itself, and in the 'Temple of Apollo' near by, on Lake Avernus, all three of which are probably second-century date. That of Diana is now deeply buried, but the visible superstructure is octagonal, with eight large windows at the spring of the dome and, below them in the interior, the usual alternation of apsidal and rectangular recesses and doorways. The dome (diameter 95 feet; 29·50 m.) is featureless. In the Temple of Venus (Plate 161) the octagonal drum is proportionately taller, with buttresses at the outer angles; the dome (diameter 86 feet; 26·30 m.) was of the same general type as the semi-dome of the Canopus at Hadrian's Villa, with eight concave 'melon' or 'pumpkin' segments alternating with eight narrow, flat segments, and there were shallow balconies externally and internally at window level. The Temple of Apollo beside Lake Avernus was the largest of the three, with a circular drum rising from an octagonal base. Though only about 20 feet less in diameter than the Pantheon (or St Peter's), the drum was pierced with windows.

Another category of monument well represented in Campania is its tombs, in the neighbourhood of Capua, outside the gates of Pompeii, and elsewhere. The variety is great, but through it, despite vagaries of personal taste that often baffle systematic analysis (the Pyramid of Cestius in Rome is a striking example of this), one can detect certain consistent strains of development. Two of these merit brief mention. One is that which derives from the simple, drumlike form set on a square podium of which the Tomb of Caecilia Metella, beside the Via Appia, is the classic example. The other is that represented by the well-known mausoleum of Saint Rémy (Glanum) in Provence (Plate 187), a tower-like structure crowned by some sort of open pavilion or canopy with a pyramidal or conical roof. The first of these was an Italian innovation of the first century B.C., and wherever one finds it, whether in the wilds of the Dobrudja at Adamklissi, in Pamphylia at Attaleia (Plate 214), or in Africa near Tiddis, it derives more or less

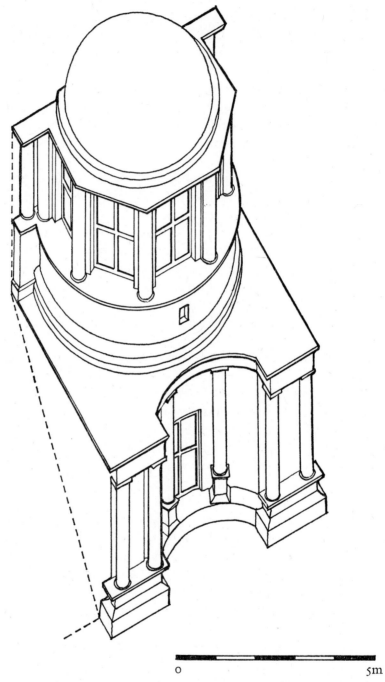

Figure 115. Pozzuoli (Puteoli), tomb beside the Via Celle, second century.
Axonometric view

directly from Italy. The second probably originated in Syria, but it early became acclimatized in Italy and the West, where it took on characteristics of its own, as in the often needle-thin tower-tombs of Africa.

What one sees in the Campanian tombs is a gradual elaboration of (principally) the first of these types, at first by the introduction of relatively simple decorative schemes that accentuate the basic architectural framework, and later by the elaboration of these schemes in a manner which deliberately sets out to disrupt it, merging them with elements drawn both from the tower-tombs (e.g. in the Tomb of the Istacidi at Pompeii) and from such other local tomb types as the columbarium, the exedra, etc. To the first category belong the mausolea of Marano and another near Pozzuoli, the square bases of which are divided into panels by pilasters; or the 'Carceri Vecchie' near Capua (Plate 164), the scalloped outline of which must surely derive from the structural niches that were incorporated in so many of the earlier Roman mausolea (the Mausoleum of Augustus, the Tomb of the Plautii, etc.). Outstanding examples of the later, baroque phase are a tomb beside the Via Celle near Pozzuoli (Figure 115), which might almost be a work of Borromini, and the remarkable tomb known as 'La Conocchia' near Capua (Plate 165).

Northern Italy

In Northern Italy our knowledge of the architecture of the Roman period suffers greatly from the lack of any major excavated site comparable to those of the south and centre. There is no northern Pompeii, no Ostia. Aquileia, which might have furnished a key to the archaeology of the whole of the northern Adriatic as well as much of the Danube basin, has yet to be tackled on a scale commensurate with the problems involved: scattered buildings, part of one of the cemeteries, the tantalizing remains of the river port – there is little more. Velleia was too unimportant and too remote for its remains to throw much light on the major architectural tendencies of its day. As a result we are dependent almost entirely on what we can learn from chance excavations and from the study of those individual buildings which happen to have come down to us.

Another serious gap in our knowledge is the almost total lack of any surviving buildings of the Republican period. That Northern Italy was where Rome learned a great many of the lessons which she was later to apply so successfully elsewhere we can hardly doubt. It was, above all, in the cities and towns, great and small, of Cisalpine Gaul that she adapted and perfected the system of planning and the types of building which enabled her with so sure a touch to launch Gaul and the other provinces of the West upon the path of urban development. But although we can catch glimpses of this at Aosta, at Brescia, and at Velleia, most of the evidence is lost for ever beneath the flourishing modern cities which everywhere attest the vision and good sense of their Roman founders.

In Tuscany and Umbria Rome had still been dealing with people who had much in common with herself. Once across the Apennines things were different. Over a large

part of the Po basin the dominant element was Celtic, closely related to the Celtic peoples of what is now France. Until absorbed into Italy in 42 B.C. this was in fact the province of Gallia Cisalpina and, as was to happen later in Gaul proper, Roman urban civilization, modelled on that of Central Italy, found itself on congenial soil. By the time of Augustus all except the Alpine fringes had become Italy in fact as well as in name. Virgil came from Mantua, Livy from Pavia, Catullus from Verona. Despite this early and enduring romanization, however, North Italy also had, and throughout the Roman Empire continued to have, certain affinities with the provinces beyond the Alps, affinities with which the facts of history and geography had endowed it. As time passed these were to play an increasingly important part in shaping the wider architectural development of the later Empire.

When we turn to the architecture of the Augustan Age we find that it is the Alpine fringes rather than the established cities of the plains that have left the most substantial traces. The monument of La Turbie above Monte Carlo was erected in 7–6 B.C. to commemorate Augustus's subjugation of the Alpine tribes. It consisted of a huge cylindrical drum with twenty-four recesses framed between as many Tuscan columns, the whole capped by a conical crown and standing on a square plinth. It is a grandiose version of the familiar type of Late Republican and Early Imperial mausoleum of which that of Caecilia Metella on the Via Appia is the best known example; and, if rightly restored, it affords a striking example of a method of architectural planning that was common throughout antiquity, whereby the major dimensions are all related in some simple proportion to some basic unit, in this case a module of 4 Roman feet. The arch at Susa, built two years earlier in Augustus's honour by a group of the same tribes, is an interesting example of the commemorative arch at an early stage of its development as an independent monumental type (Plate 162). Three-quarter columns on the plinth at the four angles and a long straight entablature crowned by a plain attic frame a simple arch with shallow pilasters and archivolt. The pilaster capitals are of a type characteristic of the Republican colonies in the North, whereas the architectural form belongs to the new, Imperial Age; and the naïve, lively carving of the frieze (the subject at one time or another of much misdirected erudition) is patently the work of a local craftsman doing his best in an unfamiliar medium. For all its crudities, the arch embodies all that was vigorous and actual in the contemporary art of North Italy.

We find very much the same qualities expressed in the architecture of Aosta (Augusta Praetoria). Founded in 24 B.C. and the last military colony to be established on Italian soil, it is also the one that has retained the most of its Roman physiognomy and buildings. Sited at a crossroad on the important trans-Alpine route across the St Bernard passes, it is one of the very few Roman towns where the rectangular grid of streets, comprising sixteen equal rectangular blocks, each of them measuring 590 by 460 feet (180 by 140 m.) and most of them further subdivided into four, is matched by a perfectly rectangular perimeter of walls (Figure 116). The rectangular grid is a commonplace of Roman urban design. The regular outline of the walls, found also at Turin (Augusta Taurinorum, founded c. 25 B.C.) but rare elsewhere, must on the other hand reflect the influence of contemporary military planning. The surviving monuments of Aosta, all

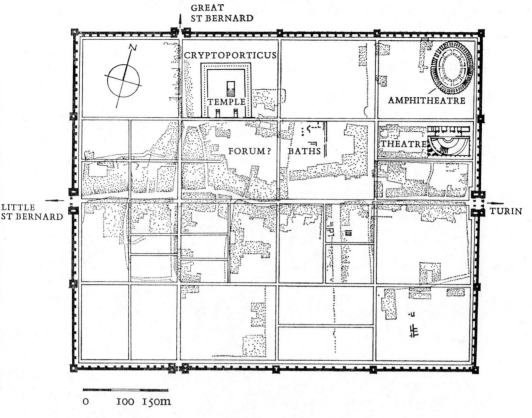

GREAT
ST BERNARD

CRYPTOPORTICUS

TEMPLE

AMPHITHEATRE

FORUM? BATHS

THEATRE

LITTLE
ST BERNARD

TURIN

0 100 150m

Figure 116. Aosta (Augusta Praetoria), laid out in 24 B.C. Plan of the Roman in relation to
the modern town

probably of Augustan date, include the walls and gates, an arch, a theatre, an amphi-
theatre, and the remains of a temple framed on three sides by the substructures of a
monumental double portico which is very similar to the 'cryptoporticus' at Arles,[12]
discussed in a later chapter. The gates are of the familiar Italian and Gaulish type, dis-
cussed further below, in which the actual gateway and the arcaded parapet walk above
it are flanked by projecting towers and the former opens into a rectangular inner court-
yard; the towers in this case are square and the single carriageway is flanked by two
smaller footways. The arch is a somewhat clumsy building, the archway being crowded
into place between the inner pair of the four half-columns of the façade, all four of
which stand on a continuous plinth that encircles all four faces of each pier, truncating
the pilasters of the archway. The attic has not survived, but the order was mixed Doric–
Ionic, a hellenistic feature that was quite early abandoned by the Augustan architects of
Central Italy;[13] and the capitals of the archway pilasters are of the same Republican type
as those of the arch of Susa. Of the amphitheatre one can say little more than that the
masonry had the same robust, rather crude finish as that of the theatre. The latter is
unusual in that the cavea is fitted into a rectangular perimeter, the street façade of which,

with its massive buttresses and four ranges of arches and windows, makes up in strength for what it lacks in elegance. The stage-building with its shallow, very tentatively curved recess framing the central door, illustrates much the same stage in the development of Roman theatre design as the roughly contemporary theatre at Arles. It has been

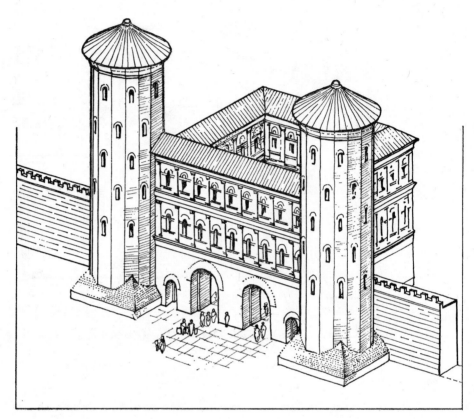

Figure 117. Turin (Augusta Taurinorum), Porta Palatina, probably early first century.
Restored view. Only the lower parts of the two towers survive

suggested that this may have been an odeum, or covered theatre and concert hall, rather than the usual open building.

At Turin the Porta Palatina (Figure 117) illustrates what is essentially the same type of gate as that of Aosta, but in more elaborate form. The central carriageway is double; the towers are sixteen-sided; and the gallery above, together with its framing pilasters and entablature, is repeated twice. But these are inessential embroideries upon the same basic theme. At Como, for example, and at Avenches (Aventicum) in Switzerland (which is Flavian) the towers are octagonal; in the Porta Venere at Spello (Hispellum) in Umbria, another fine Augustan building, they are decagonal; at Asti (Hasta) sixteen-sided; the 'Torre di Ansperto' at Milan has twenty-four sides; at Fano (A.D. 9–10) and in the Gaulish gates of the same type (Nîmes, Autun) the towers are rectangular

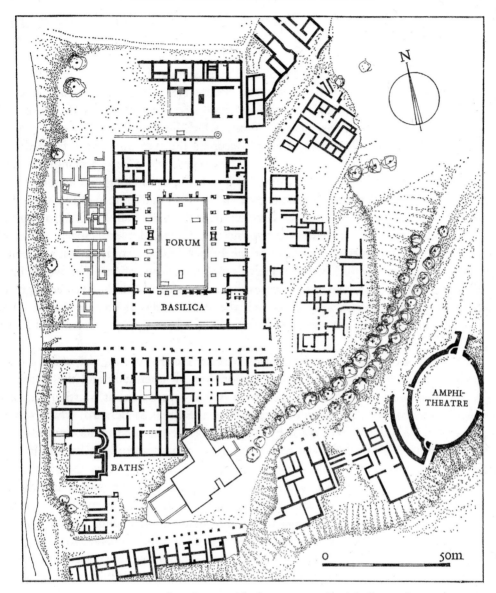

Figure 118. Velleia, forum, early first century. Plan (cf. Plate 167)

with rounded fronts. Circular towers are not recorded in this context, but they are found in the contemporary type of gate (Arles, Fréjus, Vindonissa) in which the actual gateway stands at the back of a recessed forecourt.

The most extensive excavations in North Italy are those of the little town of Velleia (Veleia) in the Apennine foothills, south of Piacenza. Created in the first place to be the administrative and commercial centre of a vast area of mountain and forested uplands, the excavated remains of inscriptions, municipal statuary, bronzes, and objects of domestic use attest the prosperity which it enjoyed under the Early Empire. Without these finds one would hardly have guessed at such material well-being merely from the

architectural remains; and yet the history of Velleia must be that of countless small towns in Italy and the provinces. Its early growth seems to have been shaped by topographical convenience rather than any coherent plan, but under Augustus the centre of the town was remodelled by the creation of a rectangular forum together with the appropriate municipal offices (Plate 167 and Figure 118). At the upper end stood a basilica; at the opposite end a temple and on either side of it, flush with the cella and of roughly the same size, a row of large rooms, which no doubt housed the curia and other municipal buildings. Rows of shops occupied the two long sides, fronted by porticoes with columns of stuccoed brick. The basilica was a large rectangular hall measuring 114 by 38 feet (34·85 by 11·70 m.) internally, open along one long side towards the forum and structurally plain except that at either end a screen of two columns marked off a rectangular annex of the same width as the main hall. Like the paving of the forum, the basilica was owed to the munificence of a wealthy local citizen, and in it were found eleven statues of members of the Julio-Claudian family and the famous bronze tables recording the details of Trajan's charitable foundations. The blocks immediately adjoining the forum, which were rebuilt to conform with the new rectangular layout, include two streetside porticoes and, above the basilica, an atrium-house. The rest of the town, including a small amphitheatre and a bath-building, retained its old, irregular layout.

The scheme of the forum at Velleia is closely related to that of Pompeii, and it is one that we find repeated, at every level of elaboration, all over Italy and the Western provinces. An even more elementary version is that represented at Martigny in the Valais, the first roadside hamlet on the far side of the Great St Bernard, which was a native centre, Octodorus, refounded by Augustus beside the road under the name of Forum Augusti Vallensium.[14] Later rebuilt in more elaborate form by Claudius, it was at first a simple rectangular enclosure, comprising an open space, 148 by 180 feet (45 by 55 m.), with shops down two sides and what may have been a very simple basilica or covered market across the north end. At the other end of the scale we have the forum of Brescia (Brixia), as built or remodelled by Vespasian. Of the long, narrow forum itself we have enough only to show that it was flanked by colonnades, the sweep of which was interrupted by a slight projection of the trabeation above each column, a characteristic late-first-century innovation that is repeated, for example, in the flanking order of the Forum Transitorium in the capital.[15]

The principal surviving monument of Roman Brescia is the Capitolium, which stood at one end on higher ground, terraced above and separated from the main forum by the line of the city's main transverse street – a disposition commonly adopted in the provinces, notably in Gaul (cf. Augst, Saint-Bertrand-de-Comminges, etc.; also Sabratha in Tripolitania).[16] The building itself (Plate 163) is noteworthy for its almost Palladian plan, the hexastyle, pedimental porch of the central one of the three cellas projecting boldy forward from, and dominating, the rest of the columnar façade. Parallel with the main forum and alongside it there seems to have been another, similar monumental enclosure, with the theatre at the head and flanked by what may be the basilica. A building at the foot of the forum itself has been thought to be the curia. The details are

uncertain; but the broad lines of the layout are clear enough and serve to illustrate what, to judge from the scattered remains of monumental buildings dating from the Early Empire, must have been happening in the centres of many of the cities of North Italy. A somewhat special case, rather better documented than most, is that of Assisi. Here the ground sloped too sharply for the normal longitudinal layout and the forum was sited along the slopes, with the still-surviving temple terraced directly above it in the middle of one long side. In this case we do not know where the other public buildings were.

(In parenthesis, it should be remarked that the development of this characteristic forum type, although it may contain certain echoes of contemporary military practice, was in itself essentially a civil phenomenon. In certain specific instances, e.g. at Aosta, it is probably right to detect the direct influence of contemporary military design. But the influence was by no means all in one direction; and as the camps of the legionary and auxiliary troops came to take on a more permanent character, they in turn borrowed much from contemporary civil practice. In the frontier areas the exchange must in fact have been close and continuous, and the results no doubt filtered gradually through to other regions. But except in this very generalized sense it is mistaken to claim, for example, the Forum and Basilica of Trajan as a military layout, on the grounds of its undoubted formal resemblances to the headquarters complex of a large legionary fortress. Both were products of an organic and closely interrelated evolutionary development, in which it was probably the new cities of North Italy and the neighbouring provinces that played a determining role.)

Of the scattered individual monuments only a few call for detailed comment. The Temple of Rome and Augustus at Pola, built between A.D. 2 and 14, was one of a pair flanking a much larger temple (the Capitolium?) on the north side of the forum. It was tetrastyle Corinthian, the frieze being carved with an acanthus scroll which, like that of the Maison Carrée at Nîmes, reflects the style introduced into Italy by the sculptors of the Ara Pacis. Of several fine bridges, that which carries the Via Aemilia across the river at Rimini is a handsome Tiberian (A.D. 22) structure of five equal arches built of dressed stone, with decorative aediculae on the outer faces of the piers. It still stands, parapets and all, very much as on the day it was built (Plate 168). Another impressive early bridge was that which carried the Via Flaminia at a height of about 100 feet over the river Nera at Narni. It was unusual in that the arches, which have strong, simple archivolt mouldings, were almost exactly semicircular and, being of different widths, had to spring from the piers at different heights. As in the Pont du Gard, projecting bosses were left in the faces of the piers to facilitate maintenance.

The most numerous and varied group of surviving North Italian monuments is that of the arches and city gates, of which those at Aosta, Susa, and Turin have already been described. From the outset they were used for a variety of purposes: as city gates, as entrances to fora or similar enclosures, as free-standing bases for commemorative statuary, or even as funerary monuments. The earliest dated member of the northern series, at Rimini, was one of a pair built in 27 B.C. to mark the completion of the restoration of the Via Flaminia; its fellow stood near the Pons Mulvius, outside Rome. The

type originated very simply as a pedimental frame in low relief enclosing an arch, as we see it still in the early (pre-Augustan?) Porta Santa Ventura at Spello or the Porta Tiburtina in Rome; but at Rimini one can already see signs of the disintegration of this basic type in favour of a looser decorative grouping of its constituent elements. The proportions of the archway have widened, and the pediment no longer rests on the flanking columns but is poised uneasily between them. The Arch of the Sergii at Pola, a funerary monument dating from the last decades of the century, represents another strain, being essentially a richer version of the arch at Susa, with paired instead of single half-columns flanking the arch and an entablature and attic that repeat the articulation of the façade below. The Claudian Porta Aurea at Ravenna (A.D. 43), now destroyed but known from Renaissance drawings and surviving details, was an altogether more elaborate structure. It had a double carriageway beneath twin pediments, the whole framed between three pairs of half-columns, of which the two outer pairs were more widely spaced to make room for decorative aediculae and richly carved medallions. Of the superstructure, presumably an arcaded gallery as in the city gates already described, there is no record. The elaborate quality of the ornament is characteristic of much Julio-Claudian work in Italy.

Less florid in detail but even more elaborate in conception are the two partially surviving city gates of Verona. The present façade of the Porta dei Leoni masks an earlier structure, probably Early Augustan, which is known chiefly from Renaissance drawings. This was an eminently sober, dignified monument, very like the Porta Palatina at Turin, with plain stone archways set in a facing of brick and a mixed Doric–Ionic order (as at Aosta) over the lower of the two arcaded galleries. The elaboration of its successor, rebuilt probably after the troubles of A.D. 69, shows how far architecture had travelled in the hundred-odd years that intervene. The scheme of the lower part is still essentially the same, but the carriageways are now framed by half-columns and by pediments of which the horizontal member is omitted, and the arches of the gallery are set in elaborately carved aediculae; at the same time the upper gallery has been entirely remodelled, with four spirally fluted colonnettes on projecting plinths framing a large curved statue recess in the centre between two narrow, plain wings. The roughly contemporary Porta dei Borsari (Plate 166) is closer in layout to the earlier models, but a great deal of the decorative detail is quite extraordinarily baroque in character – spirally fluted columns, contrasting curved and triangular pediments, pilasters springing from brackets, aediculae alternating with simple projecting columns or pilasters, and, perhaps the most striking feature of all, the contrasting rhythms of the two galleries, which are so devised that the aediculae of the upper gallery are poised, on brackets, above the voids between the aediculae of the lower gallery. For all the other features referred to one can find individual parallels in Italy already in the early first century A.D., but for the last-named one has to turn to the eastern provinces, whence these baroque façades drew much of their inspiration.[17]

With the latest of the Early Imperial arches in North Italy, that of Trajan at Ancona (A.D. 115), and the almost exactly contemporary arch at Benevento in Central Italy (114) we return to a more sober, classical manner (Plate 169). The first impression con-

veyed by the two monuments could hardly be more dissimilar – Ancona with its tall, graceful lines and very simple ornament consisting of little more than framed decorative panels and applied bronze wreaths, and the robust, rather pedestrian solidity of Benevento, overloaded with symbolic and allegorical relief sculpture in the grand manner. But both can, in fact, be seen to derive very closely from the Arch of Titus in Rome; and we have the Arch of the Gavii at Verona to show that this return to a more formal classicism was felt outside the narrow circle of monuments that were directly inspired from the capital. In the North, no less than in Rome itself, the reigns of Trajan and Hadrian mark the end of an epoch.

Since it was through provincial, and particularly through northern, Italy that many of the architectural forms and practices of the capital first reached the European provinces, we may usefully conclude this chapter with a few remarks on one or two of the building types in question. Some, like the theatre and the amphitheatre, call for no explanation beyond that given elsewhere in describing the individual monuments. Others have connotations that may vary greatly according to the context, and a knowledge of the formal background is necessary if one is to appreciate the full architectural significance of the several variant forms.

In the first place, the centre of every Roman city, the forum. Throughout antiquity this retained something of its original character as an open space available for all the manifold communal activities of urban life in Mediterranean lands: market-place, place of political assembly, law court, a setting for public spectacles, the natural meeting-place for private citizens doing business, and, since all these activities were in some degree under divine protection, a focus for the religious life of the community. It was, in short, the piazza, a flavour that it never wholly lost. As time passed, however, and urban life grew more complex, special provision came to be made elsewhere for many of these activities, in basilicas, market buildings, theatres, amphitheatres, sanctuaries. Some of these buildings might be adjacent to the forum, others not. There was no regular rule about their location, and they came into being as local circumstance demanded. In Rome, for example, the cattle market had at a very early date moved to a more convenient site beside the river, whereas gladiatorial displays were still held in the Forum Romanum right down to the very end of the Republic. Broadly speaking one may say that by the Early Empire, apart from certain luxury trades such as the goldsmiths, the connotations of the latter had become those of a civic centre rather than a market-place; and with the foundation of the Imperial Fora the development may be said to have taken final shape and to have crystallized into an explicit architectural form.

Of the many individual types of Roman building that were regularly associated with the forum, by far the commonest was the basilica. In strict architectural usage the term denotes a columnar hall with clerestory lighting, a type to which some at any rate of the great Republican basilicas of the Forum Romanum belonged, and to which a great many of the later buildings of the same name did in fact conform. A great many, on the other hand, did not; nor was the term *basilica* by any means confined to large public halls erected alongside the forum. At Velleia, for example, already in Augustan times we see a building which has few of the architectural characteristics of the ancestral type

but which stood beside the forum and was certainly called *basilica*. At the same time we find the name *basilica* used in a variety of contexts that have nothing whatever to do with the forum or public affairs: the halls flanking the stage-building of a theatre; one of the rooms of a bath-building; the audience hall of a private villa; a cloth market; the headquarters of the Roman silversmiths; a covered exercise yard for troops; the private meeting-place of a religious cult. Not all of these buildings were basilican even in the architectural sense; it is quite clear that in course of time the name came to be applied to any large covered hall, regardless of its architectural form. The variety of possible usage is bewildering, and in view of the widespread discussion that there has been about the classical origins of the Christian basilica (a discussion which has frequently confused the type of building and the name) the fact of this variety is important. There can be little doubt, however, that in antiquity the term *basilica* would, unless further specified, have called to mind the great halls that played so large a part in public life and affairs, and it may conveniently and properly be so used in the present context.

The Capitolium, a symbol of Roman majesty *in partibus*, is another type of monument which, though ultimately derived from Rome, from the state Temple of Jupiter, Juno, and Minerva on the Capitol, is found everywhere in a bewildering variety of architectural forms, some copying or adapting the plan of the parent building with its three separate cellas, some indistinguishable architecturally from any other temple, and many adopting local variants of their own – a single cella divided by columns into nave and aisles (Mérida, Cuicul) or with three separate apses (Thugga, Timgad); three almost identical temples, side by side (Baelo in Spain, Sufetula); or even a double cella (Lambaesis). The only secure common denominator is the dedication. Usually (though not invariably, e.g. Timgad) the Capitolium stood at or near the city centre, and in most cases it is probably a justifiable assumption that its erection signified some event in the city's progress towards full Roman status.

Like the basilica, the Capitolium found its way occasionally to the eastern provinces, a notorious example being the central temple of the colony, Aelia Capitolina, that was established by Hadrian in 137 on the site of Jerusalem. But it was far commoner in the West, and more particularly in the provinces adjoining the western Mediterranean, to which the conception of the old Capitoline divinities came easily.

A common and in many respects complementary equivalent of the Capitoline cult was that of the reigning emperor, usually accompanied by that of the goddess Roma. This was widely adopted from Augustan times onwards in the East, where it was a simple extension of hellenistic practice; but although the direct worship of the living ruler was for a long time prudently avoided in Rome itself, the same result was achieved in the thinly disguised form of the official cult of the emperor's deified predecessors, and this practice was widely followed also in the West. Where Sabratha in Tripolitania had its Capitolium, its neighbour Lepcis had a temple of Rome and Augustus, established under Tiberius.

Some of these temples of the imperial cult, like that of Claudius at Colchester, were official foundations, others were established by private individuals; and once again the architectural forms adopted were very diverse. They might take the form of separate

temples, as in Rome itself, at Pompeii, at Terracina, at Ostia, and in innumerable cities of the provinces, or they might be annexed to other buildings, as to Vitruvius's basilica at Fano or to the basilicas of Lucus Feroniae and Sabratha. A distinctive and important architectural type was that established by the Caesarian 'Kaisareia' of Antioch and Alexandria, discussed in a later chapter, a type which struck echoes in Rome itself, possibly in the Imperial Fora, almost certainly in buildings such as the Porticus Divorum.

Yet another category of building for which Rome offered an obvious standard model for any who wished to use it was the curia. Buildings based more or less directly on the senate house in the Forum Romanum are not uncommon, particularly in the African provinces. On the other hand, many cities were content with models of their own devising, and in the eastern provinces we still find examples of the equivalent Greek type, the bouleuterion, with its seating arranged like a theatre. One such that was restored in traditional form in Roman times can be seen at Nysa on the Maeander.

There were these and other standard building types available for use, but it is a mistake to attach too much weight to them. Such stereotypes clearly were congenial to the Roman mind; and yet one is constantly being astonished by the flexibility with which they were adapted to local circumstances. It seems likely that they were just as often selected by the free choice of the local inhabitants, wishing to be more Roman than the Romans, as by any imposition of ideas from above. This is a question that has to be studied case by case. For the present it is sufficient to remark that Late Republican and Early Imperial Italy did furnish architectural prototypes that were freely and widely copied, particularly in the western provinces. They are less common in the eastern half of the Empire, which had well established traditions of its own.

DOMESTIC ARCHITECTURE IN TOWN
AND COUNTRY

The Towns

As late as the first century B.C. the atrium-house with or without a peristyle garden was the standard residence of the well-to-do Roman, whether in Rome or in Campania. The weight of tradition was considerable. Even so potentially disruptive a force as the very great increase in wealth among the upper classes had found an outlet principally in the introduction of new and costlier materials and furnishings; and although space too was beginning to become an important consideration (as one can see if one compares a wealthy Late Republican town house in Rome, such as the House of Livia on the Palatine, with its Pompeian equivalent) the difference still amounted to the compression of familiar architectural forms rather than to the emergence of any that were radically new.

With the establishment of the Empire the seeds of change took firmer root. Populations continued to grow rapidly and the pressures on space were no longer confined to the big cities but were felt even in prosperous country towns like Pompeii. Wealth was no longer the prerogative of a small ruling class, but was beginning to spread to a new and growing middle class, whose tastes and rapidly rising standards of living demanded comparable living conditions. Abroad horizons were widening, bringing fresh and fruitful exchanges of ideas; and at home the development of new building materials and techniques provided the means for putting these ideas into effect. The stage was set for a new and altogether more complex chapter in the story of Roman domestic architecture.

The development that followed defies concise, tidy analysis. The cross-currents were too many and, as the range of possible choice increased, one must reckon also on the irrational factor of personal taste. Within the compass of a general survey the most that one can hope to do is to indicate some of the broader trends that were already beginning to make themselves felt even before the destruction of Pompeii and Herculaneum in A.D. 79.

One of the most insidious of these trends was the steady drift of the wealthy classes away from the town house, or *domus*, to the *villa* established in the less congested areas of the suburbs, or even in the open countryside near the town. At Pompeii, as land values rose, many of the older houses began to be split up into apartments or put to commercial use. By the time of the eruption wealthy town houses like that of the Vettii were rapidly becoming the exception. In Rome it might be convenient to retain one's family residence near the centre, as Nero's father had done beside the Via Sacra, or the Flavian family on the Esquiline; but it was only in his properties outside the city that the wealthy owner could find real scope for his architectural ambitions.

Within the towns the inevitable result of population pressure was to set a premium on forms of planning which were economical in ground space, or which offered scope for development upwards. The older houses did not disappear overnight. As late as the beginning of the third century one finds a few of them still depicted on the Severan marble plan of Rome (Plate 145). But in new building the relaxed sprawl of the old atrium-peristyle house no longer made economic sense. The most conspicuous casualty of the new planning was the atrium. Once the physical and social centre of the Italic house, it had already begun to lose its predominant role during the later Republic, as more and more aspects of daily life moved to the lighter, more secluded setting of the peristyle. Now, with the addition of increasingly substantial upper storeys and galleries, it became in many cases little more than a passageway and a light-well, finally disappearing altogether. A diametrically opposite, but in the final result very similar, line of development is represented by the enlargement of the atrium through the multiplication of the columns around it so as to create in effect a miniature peristyle. This was Vitruvius's *atrium corinthium*, as we see it in the house of the same name at Herculaneum. Carried to its logical conclusion the result is, once again, a house in which the principal rooms are grouped around a central garden courtyard.[1]

One can follow the first of these processes very clearly in a pair of houses at the southern edge of Herculaneum (Plates 171 and 172 and Figures 119 and 120). This quarter was developed in late Julio-Claudian times, with well-to-do houses terraced out

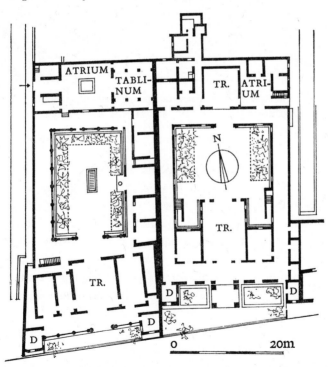

Figure 119. Herculaneum, House of the Mosaic Atrium (*left*) and House of the Stags (*right*), shortly before 79. Plan

TR. Triclinium D Diaeta

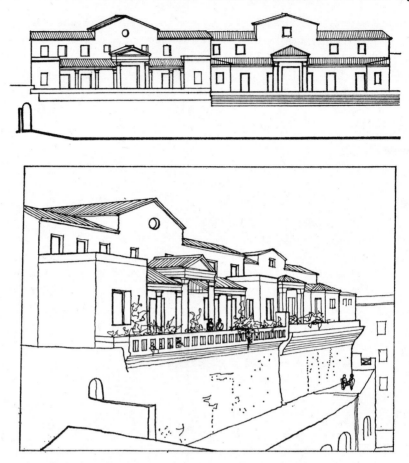

Figure 120. Herculaneum, House of the Mosaic Atrium and House of the Stags.
The south façade, built out over the old city wall. Elevation and restored view
(cf. Plate 171)

across the line of the old town wall so as to take advantage of the view towards the sea. In one of these houses, the House of the Mosaic Atrium,[2] the traditional forms were still partially observed in the north wing, which was laid out across the main axis of the building. It consisted of a central atrium, shorn of its lateral rooms, preceded by a porter's lodge, entrance corridor, and kitchen, and at the far end, instead of the traditional tablinum, it had a winter dining-room of the rather unusual, basilican type described by Vitruvius as an *oecus aegyptius*.[3] The central garden, on the other hand, was built in the new manner (Plate 172). Piers and a half-columnar order of brick framed the large square windows of a corridor which ran round three sides of it, in place of the open colonnade of a traditional peristyle; and on the fourth side there was a range of living-rooms fronted by a narrow corridor of which the wall towards the garden was a mere framework of timber and glass.[4] At the south end another range of rooms opened on to an outer portico, which faced towards the sea; two small living-rooms (*diaetae*) projected at either end, framing a long, narrow terrace; and in the

centre, facing outwards towards the sea and inwards across the garden, was the principal summer dining-room and reception hall of the private wing, a room which within the context of the domestic architecture that was now taking shape it is convenient to refer to as a *triclinium*.[5] Throughout the building there were upper storeys over the smaller rooms.

In the neighbouring and closely contemporary House of the Stags[6] one sees this

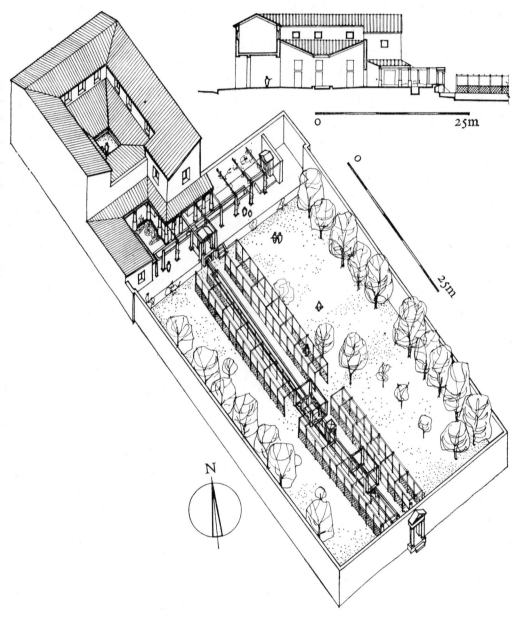

Figure 121. Pompeii, house and garden of Loreius Tiburtinus, 62–79. Section and view
(cf. Plate 173)

development carried one stage farther. The rudimentary atrium, which was roofed right over, has here become little more than an entrance lobby and passageway; and the semblance of an earlier, more traditional layout which determined the different orientation of the north wing of the House of the Mosaic Atrium has been abandoned altogether in favour of a symmetrical layout about the axis of the garden courtyard. The inner triclinium faces axially down the garden; the corridor around the side of the garden has shed all pretence of being a peristyle; and the terrace wing at the south end is symmetrically disposed about a large outer triclinium, its terrace garden flanked by the same two small projecting diaetae with large panoramic windows for day-time relaxation and repose. The terrace wing is clearly a product of special circumstances: the site was such that the owner could here, in his town house, indulge in one of the panoramic terraces currently fashionable in the villas of the suburbs, as in the Villa of the Mysteries and the Villa of Diomede at Pompeii. But the symmetrical layout about a central courtyard and the emergence of the triclinium as the most important room in the house are both features that had a long development before them, not least because they brought the Italian house back into line with the developed peristyle houses of the other Mediterranean provinces.

One more example, this time from Pompeii. The House of Loreius Tiburtinus[7] (Plate 173 and Figure 121) was still in process of modernization and redecoration at the time of the eruption. The forepart of the house, grouped in two storeys around a spacious atrium, was still that of the early building. The miniature peristyle, on the other hand, was now little more than an intimate extension of the terrace which occupied the full length of the north end of a large garden beyond, and which was the nucleus of a plan for the main living-rooms that closely resembles that of the terrace of the House of the Stags. Terrace and garden were formally linked in an elaborate T-shaped scheme of pergolas, tempietti, statuary, and fountain basins, and whether from the luxurious central triclinium, from the open-air dining-room at the east end of the terrace, or from the diaetae at the west end, the eye was led out across the garden to the mountains beyond.

With the destruction of Pompeii and Herculaneum in 79 we lose the best source for our detailed knowledge of the single-family town house in Central Italy; and the individuality of the latest Pompeian houses is a warning against trying to establish any too-rigid sequence of onward development on the basis of the much smaller number of post-Pompeian examples known to us. Houses like that excavated on the Esquiline in the eighteenth century (Figure 122) or the late-second-century House of Fortuna Annonaria at Ostia (Figure 130A) are a logical product of the sort of processes that we have been describing.[8] The standard private house of the second and third centuries at Ostia is the peristyle-house, consisting of a portico accessible more or less directly from the street and enclosing three or four sides of a garden or courtyard, with rooms opening off the portico. But this no longer represents the main stream of urban architectural development. With the second century (and indeed in Rome itself since the middle of the previous century) the focus of interest shifts decisively away from the domus, the old-fashioned town house, to the insula.

The term *insula* requires definition. Its modern usage, to define the city block, the

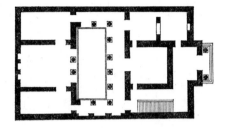

Figure 122. Rome, House on the Esquiline, probably
first or second century. Plan, after Lanciani

area delimited by four streets, is a convenient but inaccurate convention. In antiquity it
meant an apartment-house, occupied by a number of families, in contrast to the *domus*,
which was essentially a single-family unit. It might occupy an entire block, but more
often than not it was only one of several buildings which together comprised an insula
in the larger sense of the term. It came into being as a result of population pressures and
the rise of a new and prosperous middle class; and its importance may be measured by
the fact that when the regionary catalogues were drawn up in the fourth century there
were 46,000 insulae in Rome and only 1,790 domus.[9]

The essential architectural quality of the insula was its height in proportion to the
area which it covered. This element of height was in itself nothing new. It had long
been a feature of the tenement-houses of old Rome. But these were notorious fire-traps
and liable to collapse upon their inmates. It was not until the Early Empire that the new
building materials and techniques made it possible to rationalize the experience of the
past into a type of building that was convenient, economical of space, structurally
sound, and, at any rate by ancient standards, fireproof. Echoes of the new fashions had
reached Pompeii and Herculaneum before 79. But it was the rebuilding of Rome after
the great fire of 64 which established the brick-and-concrete insula as the norm for
urban domestic architecture; and it is the houses of Ostia, where the full impact of the
new fashion was not felt until a generation later, which tell us what this new architecture
was like.

Although it is the broad uniformity of the finished product that immediately im-
presses the modern visitor, it was in fact the innate flexibility of design which made the
insula such a successful building type. The simplest plan was probably also the oldest.
Already in Late Republican Pompeii one finds upper storeys added over a row of shops
along the street front, and it is not impossible that the type had originated in Rome and
had been introduced to Pompeii by the Sullan colonists. At Ostia one sees insulae of this
elementary type along the main cardo, between the forum and the river, or again along
the main decumanus, in front of the Neptune Baths. The same idea, but without the
shops, is found in the so-called Casette Tipo (Region i, 12 and 13),[10] which were laid
out on a single occasion in a series of uniform blocks, symmetrically disposed; and, in a
more elaborate version, in the garden houses (iii, 9), which consisted of two large apart-
ment blocks laid out on a common plan in the middle of a large garden. In contrast to
the inward-looking Pompeian house, the individual rooms at Ostia were lit, wherever
possible, from the outside, and it was no doubt this consideration which determined the
most elaborate and most strikingly individual development of the type in which the

apartments were arranged around a central courtyard in the manner of a Renaissance *palazzo* (Plate 150). The courtyard was regularly arcaded, and it ranged in scale from what, in the House of Diana (ii, 3. 3), was hardly more than a monumental light-well to the spacious central *cortile* of the House of the Muses (iii, 9. 22). There were individual staircases to the upper storeys; window-glass was common in the better-class blocks; and although water had to be fetched from a common tap, many apartments had provision for individual sanitation, with chutes for garbage disposal. Heating was by means of braziers. If one makes allowance for the perishable fittings, of which, unlike Pompeii, there are here only scant remains, these apartment-houses represent a standard of middle-class living unequalled until quite recent times.

The external appearance of these buildings (Plates 148 and 149) was severe, relieved by an occasional string-course or by projecting 'balconies'[11] and dependent on the quality and texture of the brickwork (which was regularly exposed and even, on occasion, picked out in a crimson slip with white pointing) and on the rhythm of doorways, arches, and windows. This was essentially a practical, functional architecture and, combined with the regular incorporation of shops at street level, it strikes a singular note of modernity. That there was any real architectural continuity between classical and later medieval or Renaissance Rome is very doubtful. But the solutions arrived at are often extraordinarily similar. The necessary complement to a visit to the ruins of Ostia is a walk in the streets of old Trastevere.

Suburbs and Countryside

Outside the city things were very different. Town house and country house had long parted company. What had started as a community of peasant farmers had gradually evolved into the highly stratified society of the Late Republic and the Augustan Age. We have a great deal still to learn about the detailed impact of this social revolution upon the countryside of Italy; but one of the immediate results of the widening of the range of the social scale was inevitably to diversify the pattern of living. At one extreme there were now the great landowners with estates up and down the length of Central Italy, and even farther afield. Though very far from being extravagantly wealthy by contemporary standards, Cicero, for example, had more than a dozen scattered properties in Latium and Campania. Some of these wealthy property owners still preferred to live close to the land; and we have the examples of such agricultural specialists as Cato, Varro, and Columella to show us how much they might contribute to the well-being of their estates. But (and this was increasingly true of the Late Republic and the Early Empire) the vast majority now used some of their estates as part-time country residences, and their standards of comfort and luxury were those of the town rather than of the country. At the other extreme, side by side with the freedmen and slaves cultivating the properties of absentee landlords, there were innumerable little men, both smallholders and tenant farmers, living close to the soil and cultivating the land on which they lived.

It is against such a background that one has to view the architecture of the Italian

countryside under the Early Empire. If the result is at first sight bewildering in its variety, it can nevertheless be seen to fall very roughly into three broad categories: there were the country residences of the wealthy, corresponding roughly to the country villas of Renaissance Italy; there were the *villae rusticae*, with which one may compare the long-established *fattorie* and *casali* of the Roman Campagna, centres of substantial agricultural estates, run by bailiffs but often including a lodging for the visits of the landowner himself; and at the lower end of the scale there were the modest farmhouses of the small-holders and tenant farmers. That one will, in practice, find infinite gradations between the several categories is the inevitable fate of any such classification. It will serve none the less as a basis for discussion.

In the age of Augustus one can still distinguish two main types of wealthy country residence. One was the relatively compact platform-villa, a long-established type characteristic of (though not confined to) the Roman Campagna and southern Latium. The other was the far more loosely integrated seaside villa with spreading porticoes, best known to us at this early date from the coastlands of Campania.[12] The two types had already met and mingled – not altogether surprisingly when one recalls that they represent ultimately a fusion between the same two traditions, between the old compact Italic atrium-house and the familiar type of hellenistic house built around a central colonnaded courtyard. Within the town the result was the essentially inward-looking atrium-peristyle house. In the countryside there had, on the other hand, from a very early date been a contrary tendency to open up the house outwards. Already in the third century B.C. the Villa of the Mysteries, the best known of the 'suburban' villas of Pompeii, was surrounded on at least three sides by a terraced portico. In this case the peristyle on the north-east (upper) side of the building was a later addition, of the late second century B.C.; and it was later again, towards the middle of the first century A.D., that the south-western wing was transformed by the addition in the centre of a large, projecting, semicircular veranda flanked by a pair of comfortable diaetae at the two corners (Figure 123). Here, in the successive transformations of the Villa of the Mysteries, we catch a vivid and instructive glimpse of the impact of the two conflicting trends in the Late Republican and Early Imperial domestic architecture of the country-side: on the one hand the development of a compact platform-villa, grouped around a peristyle courtyard but already beginning also to look outwards; and, on the other, the emergence of a type of country residence of which the dominating factor was increasingly the outer façade, which frequently took on a quasi-monumental character in relation to the landscape of which it was a closely integrated part.

The platforms of the well-to-do Republican villas are a commonplace of the landscape from the Sabina right down to southern Latium and Campania. Many continued to be content with the simple rectangular plan, built upon a single level around a central courtyard. Such, for example, were the well-known villas of the country around Pompeii or the recently excavated San Rocco villa in northern Campania (Figure 124).[13] But long before the end of the Republic one can discern a tendency to terrace the villa platform outwards so as to catch the breeze in summer and to enjoy the views which so many of those villas were manifestly sited to command. From this it was only a short

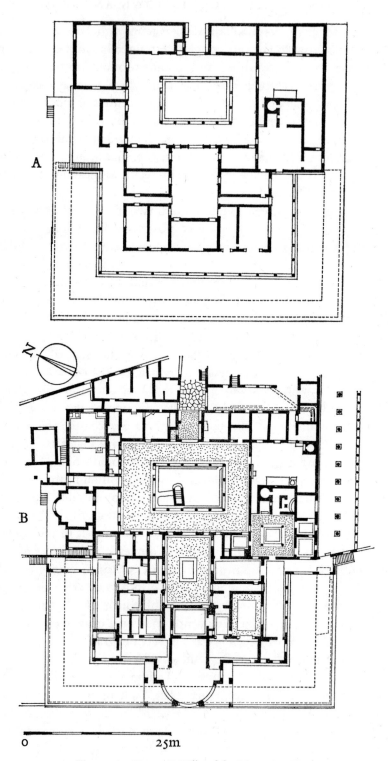

Figure 123. Pompeii, Villa of the Mysteries. Plans
(A) Second half of the second century B.C. (B) Before the earthquake of A.D. 62

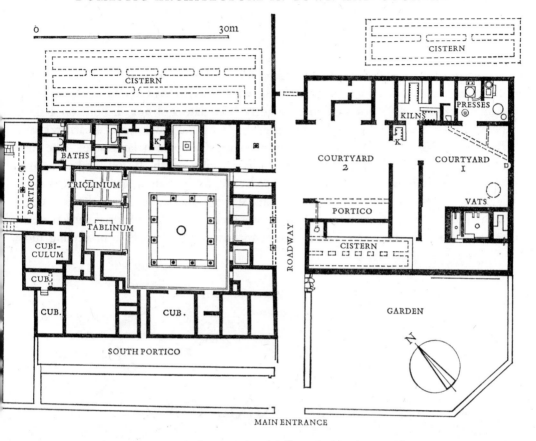

Figure 124. Francolise, San Rocco Villa, early first century. Plan

step to increasing the number of terraces and developing the plan about an axis running up and down the slope of the hillside. Around Terracina and Gaeta there are multiple-terraced villas of this sort which must go back at least to the second century B.C. An unusually well documented example is the Late Republican villa of which Hadrian incorporated the substantial remains into his own great villa near Tivoli.[14] This was laid out at two levels, of which the lower platform contained a garden with a typical Republican nymphaeum, while the upper housed the villa proper, along the axis of which, stretching back from the façade, lay an atrium opening on to a tablinum, beyond this a second tablinum facing on to a large peristyle, and beyond this again, cut into the hillside, a stepped, semicircular exedra.

The second type of Early Imperial villa, with its more informal layout, is less immediately recognizable on the ground. From the frequency of its representation, however, in the wall-paintings of Pompeii and Herculaneum (Plate 159), and from the regular association of such representations with seaside landscapes, we may reasonably deduce that it was originally developed locally, presumably when, in the closing decades of the first century B.C., the Campanian coastlands began to take the place of Formia and Gaeta as the fashionable seaside resort of the wealthy Roman. In this setting, with its

321

distinctive landscape and strong Greek traditions, one can readily understand the adoption of a layout that relied less on the formal qualities of the architectural design than on the relation of the buildings to the natural scenery around them.

One of the few such villas to have been fully and systematically explored is not in Campania at all but at Val Catena on the island of Brioni Grande in the northern Adriatic (Figure 125).[15] Although of slightly later date and not all built on a single occasion, the layout of the buildings, strung loosely around the shores of a narrow coastal inlet, very closely resembles that depicted in the Campanian landscapes. The main residential block lay along the southern shore, facing north. It consisted of a large, rectangular, single-storeyed block some 230 by 260 feet in extent, grouped around two peristyle courtyards, with a portico and terrace along the façade, facing the head of the inlet. To the east of it, stretching along the southern shore, lay a formal garden, partly terraced out into the water, and a private anchorage sheltered by a protecting mole.

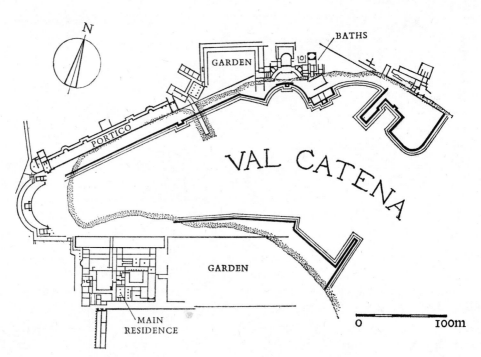

Figure 125. Island of Brioni Grande, villa of Val Catena, first–second century. Plan

The coast of the northern side of the inlet was more irregular, an irregularity that was deliberately exploited in the layout of the quays and buildings along it. The principal features on this side were an improved anchorage near the point; towards the centre an elaborate suite of baths and sunny, southward-facing rooms, and beside it, a rectangular ⊔-shaped portico, also facing south; and, directly opposite the main block but facing south-east at a slight angle to it, a quayside portico 475 feet (145 m.) long. At the head of the inlet, facing down it and linking the residential block to the long portico, was a large, concave feature, consisting of three small shrines placed symmetrically at the

centre and two extremities of a curved Doric portico, and, behind and above them, a second portico carried on a covered passageway, or *cryptoporticus.*

The whole layout is of extraordinary interest and variety, qualities that are repeated in the treatment of the individual groups of buildings, notably in the complex of living-rooms and baths on the north side of the inlet. This was grouped around a curved, re-entrant courtyard which occupied the greater part of the frontage. The curve of the, façade repeats on a slightly smaller scale that of the harbourside terrace in front of it, and along the whole length of it ran a portico, interrupted only at the head of the curve by four large columns, which must have carried a gable projecting from the building behind. The gable marked the position of a large, open or partially open tablinum, with views both outwards across the water and inwards, through the arches or windows of a projecting, curved inner wall, on to a peristyle garden behind. Opening off the portico to either side of the central room, on the oblique axes of the curve, there were two smaller chambers (*diaetae*). The long portico follows a simpler, but no less effective, plan. This was the *ambulatio*, where the owner of the villa and his close friends might take their exercise or sit and enjoy the view from one of the seats placed in the small rectangular or curved recesses along the rear wall. A square central chamber might serve as a more intimate dining hall; and if the owner wished seclusion, there was a small private suite at the south-west end of the portico.

With this example before one, it is obvious that a painting such as that from the House of Lucretius Fronto at Pompeii (Plate 160) is no flight of fancy, but depicts real architecture, the sort of building that the artist had seen many times along the neighbouring coasts, possibly even an actual country property belonging to the owner of the house. Here is the same porticoed façade as at Val Catena, the same curving setback on the central axis, in this case with a circular pavilion in the centre, perhaps to house a fountain. For the convex porticoed feature at the ends of the two wings one may compare the Damecuta villa on Capri, described below. The projecting wings themselves, to be seen on another Campanian painting, from Stabiae, recall the ⊔-shaped portico at Val Catena, or that of another Dalmatian villa, at Punta Barbariga near Pola, where the summer quarters were grouped around a ⊔-shaped peristyle, which opened westwards directly on to the sea.[16] There are several other Campanian paintings, now in Naples illustrating the broader layout of these seaside, or lakeside, villas, with their long, low porticoes and deliberately informal grouping, to which it was essentially the setting of trees, rocks, and water that gave unity and meaning. This was architecture in a landscape; a highly sophisticated landscape, it is true, but not for that reason any the less deeply felt or less skilfully handled.

For an actual Augustan example of one of these Campanian seaside villas one may turn to the island of Capri. Though better known as the refuge to which Tiberius retired during the last ten years of his reign, the whole island had in fact been acquired fifty years before by Augustus, of whom it was a favourite summer resort, and to whose hand may certainly be attributed the so-called 'Palazzo a Mare'.[17] This lay along the open crest of the low cliffs, between 100 and 150 feet above sea-level, half a mile to the west of the Marina Grande, in the middle of the north coast of the island; and although

the many structures then surviving suffered greatly in the early nineteenth century and one can now make out very little of the detail of the individual buildings, the broad lay-out can be traced from the series of terraced platforms strung out along the cliff-top for a distance of well over 600 yards. The main residential block lay towards the east end, with a bath-building just behind it, and a short distance to the west, at the same general level, there is the platform of what may have been a long ⊔-shaped portico, facing out to sea across a garden laid out at a slightly lower level. Beyond this again the terraces drop gently westward, with a slight shift of alignment, and near the west end, built into and down the face of the cliff, are the remains of the so-called 'Bagni di Tiberio', a separate waterside block of apartments with its own enclosed pool, or miniature anchorage. A rather larger harbour lay just outside the villa proper, to the east, and scattered throughout the whole area are the cisterns so essential for the amenities of a summer villa. To judge from what has survived, it was not a particularly elaborate or luxurious example of its type. Such indeed would have been out of character with the vaunted simplicity of the emperor's tastes. Strung out along the cliffs, however, against a backcloth of wooded mountains, it belongs unmistakably to this fascinating class of villas, in which, as perhaps in no other domestic architecture of the ancient world, land-scape and buildings were so unmistakably and indissolubly two parts of a single whole.

Slightly later than the Palazzo a Mare, and far better preserved, are two other Capri residences, the Villa Jovis (the name is ancient) and the Damecuta villa, both of which bear the unmistakable stamp of the sombre personality of Augustus's successor, Tiberius.

The Villa Jovis (Plate 170 and Figure 126) is magnificently situated on the rocky eastern summit of the island, perched on a cliff that drops a thousand feet sheer to the sea below.[18] The site did not lend itself to spacious treatment; and the suspicious temper of the emperor forbade the luxury of development on lines that would have made it readily accessible from without. Despite these restrictions, however, the architect suc-ceeded in planning a residence that was no less a part of its setting than the seaside villas just described, incorporating several of their most characteristic features. In such a posi-tion the collection of every drop of rainwater was an urgent necessity, and the core of the villa was a rectangular courtyard measuring 100 by 100 feet (30 by 30 m.), suspended over a network of massive, vaulted cisterns. Built around and against this nucleus, at a number of different levels connected by staircases and ramps, were four distinct wings. The entrance, with a columned vestibule and guardroom, was at the south-west angle. Along the south side, separated from the main block by a corridor, lay a suite of baths; along the west side, built up against the sheer outer face of the cistern block, were the odgings of the emperor's entourage, three almost identical storeys of simple, cell-like rooms, each opening on to a long, narrow corridor; and along the north and east sides, cut off from the rest of the building and carefully shielded against any unauthorized access, were the quarters of the emperor himself. In the buildings of the east wing, a suite of rather larger rooms backing on to a projecting hemicycle, one may recognize the audience hall and reception rooms necessary to an emperor even in retirement. To the north, almost completely detached beyond a suite of four rooms occupied by the emperor's personal servants and bodyguard, lay the emperor's private apartments.

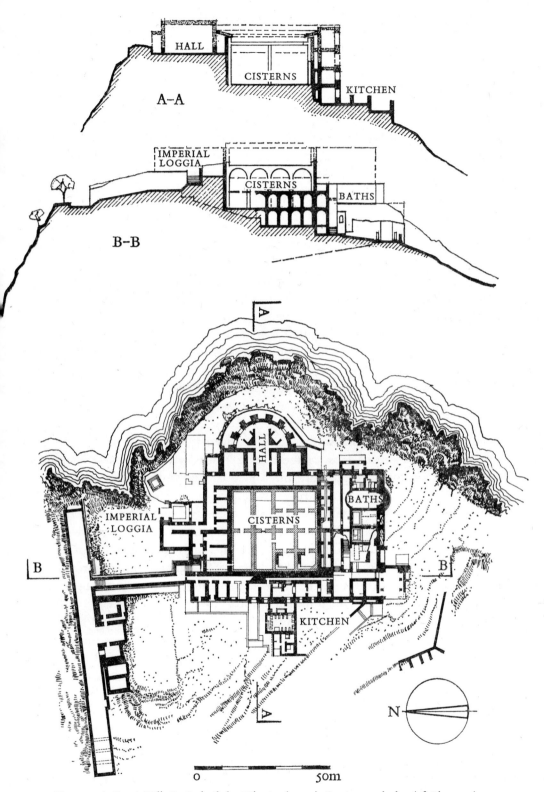

Figure 126. Capri, Villa Jovis, built by Tiberius (14–37). Sections and plan (cf. Plate 170)

325

Very modest in scale but richly appointed, they opened on to a sheltered terrace, with steps leading up to a belvedere offering magnificent views over the greater part of the island and the Bay of Naples. From the entrance to the private apartments a corridor, with a ramp and flights of steps, led down to a long, narrow terraced walk, set on the lip of the steep northern slopes, some distance from, and 60–70 feet below, the level of the main block. This was the ambulatio of the villa, just like that of the Val Catena villa, with recesses for seats and, in the centre, a vaulted dining-room with a small suite of private rooms opening off it. Other related structures are a signal tower and lighthouse, situated on an eminence a hundred yards to the south of the main block; below, and projecting from the western wing, a large kitchen; and, somewhat detached from the rest, a group of massive foundations sometimes identified as those of the observatory of the emperor's private astrologer, Thrasyllus. To the west, terraced down the slopes, are traces of gardens.

Few Roman buildings that have come down to us convey such a vivid impression of the personality of the unknown architect and of his skill in wedding the somewhat unusual terms of his commission to the potentialities of a magnificent but difficult site. Here, on a waterless mountain-top, throughout the summer months the emperor could conduct affairs of state or retire into absolute seclusion, enjoying the beauties of nature and as safe as human ingenuity could contrive, and yet maintained by an ample staff and surrounded by every comfort. A modern housewife might criticize the location of the kitchen, but hers is a point of view that would not have been understood in antiquity; by contemporary standards it was unusually large and well appointed. The planning was as sensitive as it was skilful. The diversity of interest resulting from the loose, spreading layout of most of these luxury villas was here achieved within the limitations of a compact, highly organized plan by means of a skilful play of levels. On such a site a more relaxed plan might well have spelt architectural confusion.

The site of the Damecuta villa, 500 feet above sea-level on the broad, shelving promontory that slopes gently downwards from Anacapri, towards the north-west corner of the island, lacked the rugged grandeur of the Villa Jovis but offered far greater scope for the development of the individual buildings.[19] The remains, being more accessible, have suffered far more than those of the Villa Jovis, and, apart from the huge cisterns on the upper part of the site, the principal features now visible are those along the brow of the cliffs that slope steeply towards the north-west. Here the central feature is an ambulatio of the familiar pattern, following the line of the cliff edge, with alcoves for seats on the landward side. At the south-west end are the substructures of what appears to have been a residential block, of which the most conspicuous feature is the curved projection of the central part of the seaward façade, with the footings of a porticoed loggia running around the outer face, and at the opposite end of the ambulatio, below the rock platform of a medieval tower on the site of what was perhaps a belvedere, there is an isolated suite of small but luxuriously fitted rooms, terraced into the cliff face and approached only by a narrow ramp and steps. As in the Villa Jovis, this must be the emperor's private suite. That the same architect was responsible for the two buildings one can hardly doubt. The main difference is that here he was free to develop his

plan upon more conventional lines, more closely resembling those of the Augustan Palazzo a Mare. The baths, the service buildings, and the lodging for the emperor's retinue were scattered over a considerable area within the grounds, which every analogy suggests were elaborately planted and landscaped.

To follow the story up in the same detail is impossible within the compass of a general review of Roman architecture. Nor is it necessary. If one makes allowance for the rapid increase in luxury during the first century A.D., for the impact of the new building materials and for the innumerable cross-currents inevitable within a society in a state of rapid evolution, the story is in its essentials one of the development of architectural themes that were established under Augustus and his immediate successors.

One important current somewhat paradoxically leads back to Rome. The Roman taste for landscaping and for gardens was, it seems, one of the many introductions from the hellenistic world that took steady root and throve on Italian soil. Already by the end of the Republic it had manifested itself in a wide variety of related forms: within the towns by the addition of the peristyle to the old atrium-house and by the creation of such monumental formal gardens as the Porticoes of Pompey and of Livia;[20] in the open countryside by the creation of the landscaped country villas of southern Latium and Campania and, within a generation or two, on the Adriatic coast too, and in North Italy; and thirdly, as the city centres grew more and more crowded, by the development of the villae suburbanae and the parks (*horti*) of the wealthy upper classes. By the middle of the first century B.C. Rome was already ringed around by such private properties, very much in the manner of the belt of Renaissance villas and parks which formed an almost continuous ring around the old city right down to 1870. Some of these estates were subsequently built over: the gardens adjoining the Baths of Agrippa and the Mausoleum of Augustus were probably carved out of what was left of the horti of the Republican Campus Martius. Others, such as the Gardens of Lucullus, of Sallust, and of Maecenas, survived as parks and private residences; and belonging wholly neither to town or country, they were the natural meeting-point of the two divergent architectural traditions. For example, the great hemicycle of the Early Augustan villa suburbana beneath the Farnesina[21] finds its closest contemporary analogies in Campania. They were, moreover, a natural field for fantasy and experiment. We have already suggested that the garden pavilions, fountain-buildings, and grottoes of those parks may have had a lot to do with shaping the new spatial conceptions that characterize the public architecture of the later first century A.D. Last but not least, like the English eighteenth-century parks which in many ways they so closely resemble, they were the embodiment of the cultured ideals of the age. It is to the pages of Cicero or Pliny that we have to turn for a glimpse of what lay behind the 'gymasium' porticoes and garden terraces (*xystoi*), or of the literary conceits which shaped the precursors of the 'stadium' of the Domus Augustana and the 'Academy' of Hadrian's Villa.[22]

In course of time a great many of these properties fell into imperial hands, and as they did so they offered an irresistible outlet for the more frivolous architectural whims of the reigning emperor. Both Caligula and Nero were active in this field, and under the latter a combination of circumstances gave a new and dramatic twist to the resulting

development. Nero was born at Antium (Anzio), and one of his earliest architectural ventures was to remodel the villa of his birth.[23] Too little has come down to us (and that little too ill studied) to convey any coherent picture of the whole, but it was un-undoubtedly a luxurious seaside estate of a type familiar from innumerable earlier examples. Another early venture (it was in occupation by A.D. 60) was the villa at Subiaco.[24] This too was built around the nucleus of an earlier building, but in this case the site was completely transformed by damming the valley below the later monastery to create an artificial lake, so creating a landscaped 'seaside' villa within the setting of an upland Apennine valley. Yet another contributory circumstance was Nero's inheritance of a property on the Velia and his decision to link the imperial estates on the Palatine and on the Quirinal and Caelian Hills into a single residence, the Domus Transitoria. It was from these ingredients that the idea of the Golden House took shape – a land-scaped villa of which the central feature was an artificial lake, and at the same time a villa suburbana and its surrounding parkland transplanted to the heart of Rome. Here, on a scale never to be repeated, was embodied the Roman vision of *rus in urbe*.

This determination to have the best of both worlds, to enjoy all the advantages of an advanced urban civilization within a setting of the rustic amenities that Italy was so well equipped to offer, is perhaps the most consistent single characteristic of all this wealthy country architecture of the Early Empire. It cut right across the traditional formal proprieties of peristyle and portico, of town and country, of nature and art. When Tiberius or Caligula remodelled the upper terrace of Pompey's great platform-villa at Albano,[25] with its magnificent views out across Lanuvium towards the sea, the scheme adopted was essentially that of the House of the Stags at Herculaneum, with a central pergola and garden flanked by two diaetae; but the conventions of conservative, rectangular planning were thrown to the winds. The diaetae were angled so as to take full advantage of the summer and winter sun, and the rooms behind were fitted in around the hemicycle of the north-east façade in a manner which in the context must surely reflect the latest models among the villae suburbanae of the capital. From this sort of thing it was only a short step to the octagon of the Golden House.

Half a century later the Villa of Pompey became part of Domitian's great estate at Albano.[26] The latter's country house beside the Lago di Paola, near Monte Circeo,[27] seems to have been a seaside portico-villa of conventional type. That at Albano, on the other hand, was comparable both in scale and character to the Golden House and Hadrian's Villa, a palace in all but name. The park stretched from Castel Gandolfo to Albano and from the lake to beyond the Via Appia, and besides incorporating several earlier landscaped villas it was dotted with buildings of its own, among which one can still identify a theatre, a 'stadium', 'gymnasium' terraces and promenades, waterside jetties, and an abundance of pavilions and fountain-buildings. The main residence occupied one end of one of three descending terraces on the seaward side of the crest and, though never adequately explored, it can be seen to have been a building of consider-able pretensions, at least three storeys high and making full use of the latest building methods and materials, as we see them in the buildings of Rabirius on the Palatine.

All these traditions and trends were caught up and consummated in Hadrian's great

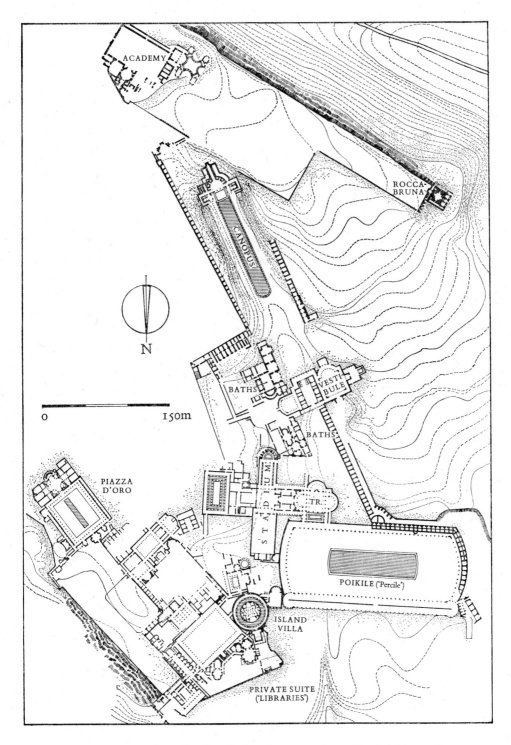

Figure 127. Tivoli, Hadrian's Villa, between 118 and 134. Plan (cf. Plate 174)
TR. Triclinium

329

villa at Tivoli (Plate 174 and Figure 127). The architecture of most of the individual buildings was strictly contemporary. The layout, on the other hand, with its deliberate juxtaposition of conflicting axes that follow the natural lie of the ground,[28] stems straight from the landscaped villas of the previous century, and the themes of the individual buildings and groups of buildings belong to an even earlier tradition, that of the wealthy Late Republican villa – the terraced 'gymnasia' with their libraries and sculpture galleries, the theatres, the belvedere tower ('Roccabruna'), the covered portico for exercise (the 'Percile'), the bath-buildings, the pavilions and *al fresco* dining halls. The names given to many of these buildings[29] were not the whims of a much travelled emperor, nor were they in any significant sense copies of the famous places and monuments whose names they bear. They were traditional conceits, to which Hadrian's own well-known philhellenic tastes were no more than a contributory factor.

The country residences of the emperor and of the very rich were one aspect only of the rural scene, albeit one which increasingly tended to become identified with the more progressive trends in contemporary architecture. Side by side with these great estates there were innumerable smaller properties for which the peristyle-villa long remained the established norm. Many of the early buildings remained in active use, remodelled and modernized but still recognizably grouped around their original courtyard nucleus. The Tuscan villa of Pliny the Younger, for example, still possessed an atrium, *ex more veterum*.[30] For another thing, over large parts of the Mediterranean world, from Spain to Syria, the peristyle-house was the standard form of better-class domestic architecture both in town and country; and with the steady breaking-down of regional barriers Italy was bound to be influenced increasingly by provincial practice. In the absence of systematic excavation we do not know nearly as much as we should like to know about the lesser country houses of Roman Italy (far less than we know, for example, about their Romano-British equivalents), but it is almost certainly true to say that among villas of any architectural pretensions the peristyle-house remained by far the commonest type right down to late antiquity. There were of course also innumerable smaller, simpler buildings in everyday local use; but about these we are even worse informed. For the present they must be held to fall within the province of the archaeologist and the social historian rather than of the historian of classical architecture.

Under the later Empire the interest of the Italian villa in suburb or country shifts increasingly away from landscape and large-scale planning and towards the architectural treatment of the individual buildings. Here, while most villa owners seem to have been content with relatively minor adaptations of the traditional schemes, a certain number did follow the lead of Domitian and of Hadrian in exploring their development in terms of the new concrete architecture. One such experiment was that embodied in the 'Grotte di Catullo', a very large platform-villa built, probably early in the second century, at the northern tip of the peninsula of Sirmione, on Lake Garda (Figure 128).[31] The plan was symmetrical about its longer, north–south axis and consisted of a rectangular central block, 590 feet long and 345 feet wide (180 by 105 m.), with two small rectangular blocks projecting at the two ends. That at the north end was built up on enormous substructures to carry a terrace, offering magnificent views

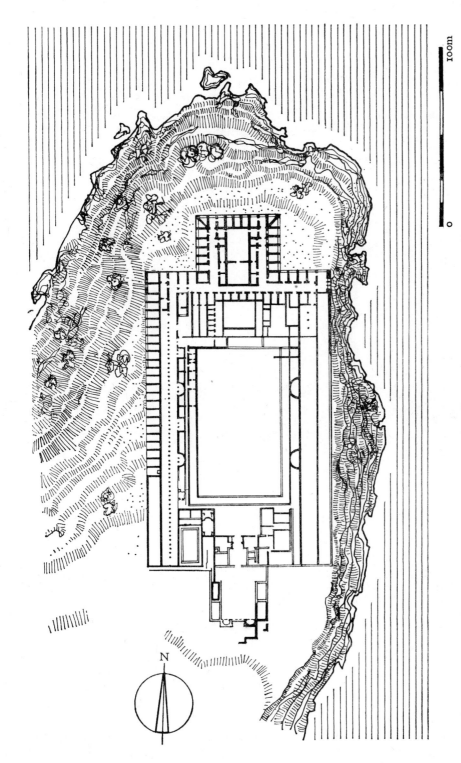

Figure 128. Sirmione, 'Grotte di Catullo', probably early second century. Plan

out over the lake, and although the actual superstructures have gone, the plan suggests the familiar central triclinium and pergola flanked by diaetae. The other living quarters faced inwards on to the very large garden courtyard which occupied the centre of the main block. The layout, though based on the peristyle-villa, was monumental in conception and was clearly the product of the same sort of architectural thinking as that embodied in the ceremonial wing of the Domus Augustana.

The 'Grotte di Catullo' represent an experiment that was not followed up widely, if at all. A more representative picture of second-century enterprise is offered by the wealthy 'suburban' villa of Sette Bassi, outside Rome near the sixth milestone on the Via Latina (Plate 175 and Figure 129). This was the product of three successive building campaigns undertaken in rapid succession between about 140 and 160.[32] The first of these was conventional in plan and consisted of a compact residential block, grouped around a vestigial covered atrium and a peristyle and smaller courtyards, and occupying the south side of a large garden peristyle. Except for a number of smaller upper rooms

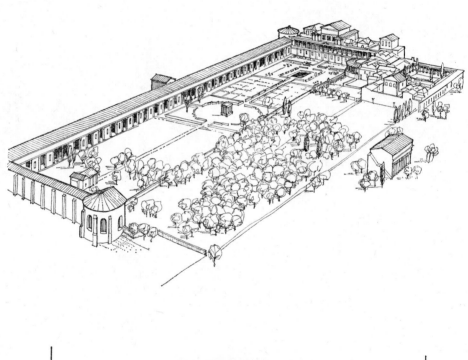

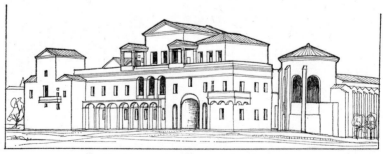

Figure 129. Rome, Via Latina, Villa of Sette Bassi, c. 140–60. Restored view of villa and façade

the whole building occupied a single level, and the exterior at this stage was very simple. Very soon after completion a second wing was added, along the west side of the entrance peristyle. This involved terracing out on substructures and, although smaller, the added wing was more ambitious in design. The southern half of the new west façade was occupied by a projecting hemicyclical veranda, with a portico enclosing a fountain court, and the outer face of the supporting terrace was crowned with a decorative motif of shallow segmental arches carried on travertine brackets, akin to the 'balconies' of Ostia and of the façade of Trajan's market hall overlooking the Via Biberatica. The third stage was the most elaborate of all. This involved the building of a new wing across the north end of the area immediately west of the existing building and the addition of a vast cryptoporticus, over 1,000 feet long, enclosing the whole area west and south of the residential complex as a formal, terraced garden. The new north wing was monumental both in scale and in intention. The whole length of it was built up on terraced substructures to counteract the natural westward fall of the ground, and the *piano nobile* was divided almost equally between, at the east end, two suites of rooms (one of them a bath-building) opening off an arcaded courtyard, and at the west end two very large, lofty reception halls. The latter rose clear of all the surrounding structures and occupied the full width of the building between the pair of corridors which ran down the north and south façades at this level; and although there was no attempt at formal symmetry, the large triple windows and gabled roofs of these halls, towering high above the continuous roof-line of the corridors, did in fact provide a most effective focus for the whole composition at the point where the natural fall in the ground gave it the maximum of emphasis.

For all its debt to the villas of the previous century – the garden, for example, is patently a sophisticated version of the 'stadium' or 'hippodrome' motif – this was a strictly contemporary building. The arcaded courtyards, the windows, the brick mouldings and bracketed 'balconies', all of these came straight from contemporary urban practice. So did the decorative use, without any stucco surfacing, of such elements as window-frames and relieving arches and of the masonry facing itself, in this case a very early and effective use of *opus mixtum*, in which the brickwork alternated with bands and panels of small tufa blocks. Among the many features that looked forward to later practice (at Spalato, for example) were the high lighting of the main halls and the corridors along the main façades. The small inner 'peristyle' of the early block, with its principal living-room looking out across a small arcaded garden courtyard on to an elaborate fountain structure, was already moving towards a type of plan that was common in fourth-century Ostia. Perhaps the most striking anticipation of late antique and medieval practice was the use of slender, sloping buttresses to support the plunging outer faces of the cryptoporticus and of the circular towers at the angles of it.

The most obvious distinguishing characteristic of the Sette Bassi villa is its application of up-to-date building techniques and masonry finishes to introduce an element of taut monumentality within the hitherto rather relaxed sprawl of the landscaped country residence. Domitian seems to have set the fashion in his villa at Albano; tower-like residential blocks two and three storeys high are a feature of several other wealthy

second-century villas on the periphery of Rome – the Villa of the Quintilii on the Via Appia, for example, or the 'Mura di S. Stefano', near Anguillara;[33] and as late as 300 the residential block of the Villa of Maxentius seems to have followed the same pattern. In other respects the wealthy domestic architecture of the Central Italian countryside seems to have been content to exploit the existing models. The Horti Variani of Elagabalus were still an elaborately landscaped villa suburbana of which the known buildings include a circus, an amphitheatre (the Amphitheatrum Castrense), a bath-building (the Thermae Helenae), and the great audience hall which Constantine converted into the church of S. Croce in Gerusalemme.[34] The Villa of Maxentius, with its more compact articulation of residence, circus, and mausoleum, does, like so much of Maxentius's work, suggest the impact of new ideas. In the event, however, these were stillborn. The representative monuments of the immediately pre-Constantinian age, which will be discussed in a later chapter, are the great villa of Piazza Armerina and Diocletian's palace at Spalato.

The Late Roman Town Houses of Ostia

It remains to make brief reference to the rather surprising re-emergence in late antiquity of the domus as a significant feature of the metropolitan city scene. Once again it is Ostia that furnishes the evidence. For nearly two centuries such single-family residences as had been built at Ostia were almost invariably of the peristyle type, built around a colonnaded or arcaded courtyard. Good examples are the second-century House of Fortuna Annonaria (Figure 130A)[35] and the somewhat later, more orthodoxly planned House of the Columns (Figure 106).[36] There was invariably one main reception room, the *triclinium*, and the first-named had also one centrally-heated room – the earliest example in domestic use yet recorded from Ostia. But these were the exceptions. Right down to the middle of the third century the standard urban residence even of the well-to-do was the apartment-house, or *insula*.

Under the later Empire, however, as land values dropped, there was a marked shift of emphasis away from the insula and back to the domus. The late antique private houses of Ostia follow no regular plan, preferring to adapt themselves wherever possible to the structures of already existing buildings. But they do have a great many distinctive features in common with each other – a courtyard, usually containing an elaborate fountain; opening off the courtyard, often up several steps, the main living-room of the house; central heating in one or more rooms and in several cases private lavatories; a lavish use of coloured marbles on walls and floors; and a marked taste for apses and for triple-arched columnar screens of a type widely used in late antiquity as an alternative to (and no doubt originally developed from) the 'arcuated lintel' convention. In the already existing House of Fortuna Annonaria (Figure 130A) the innovations were aimed mainly at the enlargement and embellishment of the triclinium by the addition of a large apse, a fountain (with a latrine behind it) along the south wall, and a triple-arched screen towards the courtyard. The House of Cupid and Psyche (Plate 176 and Figure 130B)[37] rather unusually had an upper storey over the western range of small rooms.

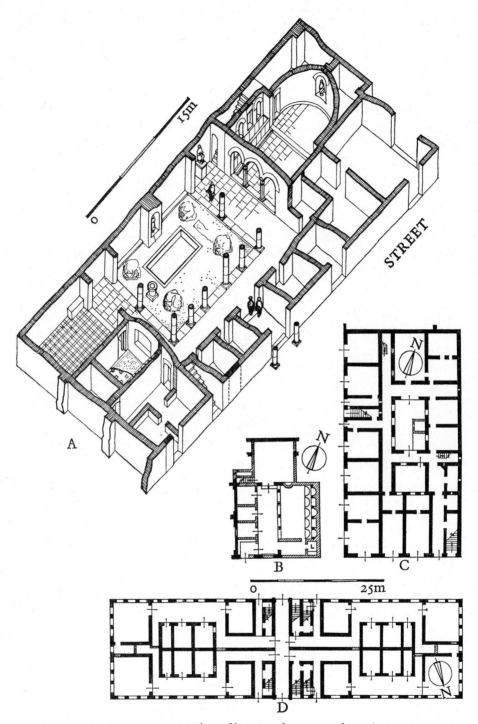

Figure 130. Ostia. Plans of houses and apartment-houses

(A) House of Fortuna Annonaria, late second century, remodelled in the fourth century
(B) House of Cupid and Psyche, c. 300
(C) House of Diana, c. 150
(D) Garden House, 117–38

Even so more than half the available floor space was taken up by the luxuriously marbled, centrally heated triclinium and by the large central corridor, one side of which was an arched columnar screen looking out across the garden courtyard to the elaborate fountain that occupied the whole of the east wall.

These houses represent something quite new in Italian domestic architecture. Analogies have been sought in North Africa,[38] but the closest parallels would seem to lie rather with the contemporary houses of Syria, as revealed by the Antioch excavations. With their intimate association of triclinia and fountain courtyards and their seemingly deliberate avoidance of symmetry, buildings such as the early-third-century house at Seleucia illustrated in Figure 160 or the late-third-century House of Menander at Antioch[39] do indeed have a great deal in common with these late Ostian houses. At a time when the old regional barriers were everywhere breaking down, nothing is in fact more likely than that Ostia, with its many Oriental connexions, should have drawn upon the experience of the wealthiest and most influential city of the Roman East.

PART THREE

THE ARCHITECTURE OF THE ROMAN PROVINCES

BY

J. B. WARD-PERKINS

THE EUROPEAN PROVINCES

WITHIN the confines of Italy it is still possible to speak of 'Roman architecture' and to understand thereby an architecture which reflects that of the capital so closely that the term is intelligible without further qualification. There were indeed diversities of local taste and practice, but these were no more than one would expect to find as a result of the very considerable differences that still existed in Italy under the Early Empire, in historical and social traditions as well as in climate, materials, and building practices. As Roman political authority expanded, however, Rome found herself the political mistress of a kaleidoscopic variety of peoples covering every shade of the civilized spectrum. It was her great achievement that, after an initial period of exploitation and misrule under the Late Republic, she did succeed in welding this heterogeneous assortment into a body politic within which all the participants could feel themselves to be in some real sense Romans. But this took time. Under the Early Empire there was still a wide gulf between the superficial unity of the political framework and the extraordinary diversity of cultures, social habits, and languages contained within it. Any study of classical art in the wider setting of the Empire is almost bound, therefore, to find expression in a dialogue between those elements that accompanied the uniting of a large part of the civilized world upon a basis of peaceful, day-to-day exchange and those that derived instead from the individual traditions and propensities of its very diverse constituent peoples.

Of the many cultural boundaries that one can draw within the Roman Empire, by far the most important is that which separated the Greek-speaking provinces of the eastern Mediterranean, including the eastern Balkans and Cyrenaica, from the Latin-speaking West. The difference is one not merely of language (there were indeed substantial areas in the west, in Southern Italy and Provence, where Greek long remained the common language of the educated classes) but also of recent history. The eastern part of the Roman Empire corresponds closely in extent with the hellenistic kingdoms established after the death of Alexander, and throughout these territories Rome was dealing with peoples who either boasted a far longer native tradition in the arts than she did, or else had at the very least undergone the same hellenistic experience as herself. In matters of the arts she was dealing here with her equals or superiors. In the European West she was, on the other hand, for the most part confronted by civilizations which, whatever their potentialities, were substantially inferior to her own. Even here the process of romanization can be seen in the long run to have been one of give and take; but in the early stages it was undoubtedly Rome that was the dominating member of the exchange.

Within the Latin-speaking half of the Empire there were regional and local differences hardly less far-reaching than those between East and West – differences of

geographical orientation, inwards towards the Mediterranean or outwards towards the Atlantic, the Rhine, and the Danube; differences of cultural background, between those territories that already had enjoyed some measure of urban life under Greek or Carthaginian rule and those that the Romans found still organized upon a purely tribal basis; and differences of historical circumstance, between those which settled down rapidly under civilian rule to enjoy the fruits of the Roman Peace and those in which Roman civilization was, and long remained, dependent upon the presence of the army. When one recalls the great differences also of climate and of natural resources (over much of Northern and Central Europe, for example, timber was still available for building in almost unlimited quantities) it is hardly surprising that the resulting provincial architecture should be seen to cover a very wide range of local practice.

Nevertheless, by comparison with the provincial cultures of the eastern half of the Empire those of the European provinces during the first two and a half centuries of our era do display the wider unity of a civilization which in almost all its manifestations stemmed more or less directly from Italy. It is this wider unity which must be held to justify the devotion of the greater part of this chapter to the architecture of a single region, Gaul. Roman Gaul is broadly representative of what was happening all along the northern frontiers of the Empire. It was unique only in the degree to which it succeeded in making Roman civilization its own.

The Iberian Peninsula

Spain[1] was the only western province with an early flowering in any way comparable to that of Gaul. Spaniards were among the first provincial citizens to take their place as equals within the Empire; Seneca was born at Córdoba, Quintilian at Calahorra (the Roman Calagarris), near Zaragoza, and the first two non-Italian emperors, Trajan and Hadrian, were both of Romano-Spanish stock, from Italica near Seville. Then as now, however, Spain was a land of strong contrasts. Despite the fact that large parts of it had been under Roman rule since 206 B.C., Augustus two hundred years later had to engage in long and bitter fighting before the entire peninsula was finally subdued; and although it had valuable resources, particularly in minerals, romanization was never as broadly based as it was in Gaul. Even if one makes allowance for the continuous occupation since Roman times of most of the major cities and the consequent destruction of most of the finer monuments, one can hardly fail to be struck by the relative poverty of the Roman architectural tradition.

The finest monuments are significantly those of the Early Empire, from Augustus to Trajan. By contrast the two preceding centuries of Republican rule have in themselves left little tangible mark on the archaeological record. There must have been fortifications and public works of a specifically Roman character during this period; and the establishment of military colonies, of which Italica (206 B.C.) was the first, had undoubtedly helped to spread urban life on the Mediterranean model. But although there is at present little to show how much of all this was based directly on Italian models and how much was evolved locally within the framework of the established Graeco-

Punic building tradition, there can in fact be little doubt that, as in Provence and in Punic Africa, the real long-term significance of the Republican Roman presence in Spain was that it prepared the ground for the outburst of building activity that took place under Augustus and his immediate successors. To cite a single example, Mérida, the military colony of Augusta Emerita founded in 25 B.C., by 18 B.C. already possessed a fine theatre and by 8 B.C. an amphitheatre; and the other known structures of Mérida that are attributed to the Augustan or the immediately following period include three aqueducts, a circus, and a magnificent sixty-arch bridge across the river Guadiana.

A characteristic of this early work, and one which continued for a long time to make itself felt in Spanish provincial building, was the fine tradition of opus quadratum stone masonry. One meets it in a variety of finishes. In the great aqueduct at Segovia, nearly 900 yards and 128 arches long and nearly 100 feet high at its highest point (Plate 177), the blocks were deliberately left rough to give an air of strength to the unusually tall, slender piers.[2] The aqueduct at Tarragona, another impressive but more conventionally proportioned structure, over 200 yards long and 250 feet high, used a coarse mason's drafting, the bridge at Mérida a heavy bossing, akin to the decorative *bugnato* of Renaissance practice. Another justly renowned bridge is that built in 106 by Trajan over the Tagus at Alcántara (Plate 178). This was a structure of deceptively simple-looking proportions (the six arches are, in fact, of four different spans) with an arch spanning the carriageway over the central pier and a small bridgehead temple. A most unusual feature of the dedicatory inscription is that it names the architect, Gaius Julius Lacer. One is reminded of another Trajanic bridge-builder who was also an architect, Apollodorus of Damascus.[3]

Other buildings that deserve passing mention are the Temple of Rome and Augustus (A.D. 16) at Barcelona, a peripteral building of which the scanty remains suggest a close relationship to the Maison Carrée at Nîmes; the mid-second-century Capitolium at Baelo (Bolonia) near Cádiz, which consisted of three distinct temples placed side by side, as at Sbeitla (Sufetula) in Africa (Plate 253); the recently excavated forum complex at Conimbriga in Portugal, the peristyle, twin-cellaed temple of which was framed on three sides by a double portico resting on a cryptoporticus;[4] the elegant but strangely old-fashioned arch of Licinius Sura, one of Trajan's generals, at Bara; the small four-way arch at Capera; and the amphitheatre at Italica, the fourth largest (540 by 460 feet; 165 by 140 m.) in the Roman world and the scene of countless *venationes*, the Roman precursors of the bull-fight of today. But the list of outstanding monuments is short; there is little in the later Imperial architecture of the peninsula that might not have been found in any second-class African city. Architecturally, as in much else, Spain in the second and third centuries A.D. seems to have been something of a backwater.

Gaul, Britain, and the Germanies

Among the provinces of the Roman West, Gaul occupied a unique position, a position which it owed in part to the wealth of its natural resources and its geographical situa-

tion at the crossroads of North-Western Europe, in part to the accidents of history which had endowed it with a vigorous, sensitive people, capable of absorbing and putting to good use the best that classical civilization had to offer. The Mediterranean coastlands and lower valleys of the Rhône had had the additional advantage of long contact with the Greek colony of Massilia (Marseille), and so it is not altogether surprising that some of the finest of the surviving monuments of the Early Empire are to be found in Provence and in the immediately adjoining districts of central and southern Gaul.

As in Spain, the results of this early exposure to classical ways did not at once make itself felt in a specifically Roman form. The territory of Gallia Narbonensis (corresponding roughly to the modern Provence and Languedoc) was annexed in 121 B.C., but there is little or nothing in the way of monumental architecture to show before the great Augustan reorganization in the years following 19 B.C. For a picture of provincial life during the preceding century we have to turn instead to the little city of Glanum near Saint Rémy-de-Provence. Glanum had originally been established as a Massiliote trading-post, and the principal excavated remains of the pre-Imperial town are those of its private houses. These are well planned, solidly built, rectangular structures, the rooms of which open upon a central columnar courtyard, very different in detail from the houses of contemporary Pompeii, though the standards of comfort and building practice are in no way inferior. They offer an at present unique picture of the solid foundation of Greek culture and craftsmanship upon which the Roman Imperial achievement in southern Gaul was based (Plate 180).

Between 58 and 51 B.C. Caesar conquered and annexed the 'Three Gauls', which, together with Narbonensis and the military frontier provinces of Upper and Lower Germany, henceforth comprised the whole of present-day France and Belgium, and parts of the Rhineland, the Netherlands, and Switzerland. The years that followed, under Caesar himself and his heir and successor, Augustus, were ones of rapid and enlightened progress. Retired legionaries were settled in the colonies of Arles (Arelate), Béziers (Baeterrae), Fréjus (Forum Julii), Narbonne (Narbo), and Orange (Arausio), and, in the newly conquered territories, at Lyon (Lugdunum), at Nyon (Noviodunum) on the Lake of Geneva, and at Augst (Augusta Raurica) on the upper Rhine; the native cities of Nîmes (Nemausus) and Vienne (Vienna) received municipal charters; and all over Gaul new towns arose along the great trunk roads and on the sites of, or replacing, the old tribal capitals. The Romans were notoriously reluctant to think of the administration of their empire in terms of any but the urban civilization with which they were themselves familiar, and wherever an appropriate urban system did not exist it had to be created. How well they planned is shown by the subsequent history of their foundations. Even in Britain, where for a time in the Dark Ages city life was virtually obliterated, the Roman urban legacy, beginning with London itself, is still strong. In Gaul the Roman roads and towns became the essential framework of all subsequent progress. Before turning to individual monuments it will be well therefore to cast a brief glance at the towns themselves for which this essentially urban architecture was created.

In many cases the very success of these foundations has obliterated almost all trace of their beginnings. Of one of the earliest and greatest of the Gallo-Roman cities, the veteran

colony of Lugdunum (Lyon), founded in 43 B.C. by Lucius Munatius Plancus, the only substantial monuments now visible are the aqueducts and the fine Early Augustan theatre and the adjoining odeum, or concert hall. Of the river port that brought the city its wealth and of the great sanctuary dedicated to Augustus at the confluence of the Rhône and the Saône by the representatives of all the Gauls, there is now hardly a trace. From the records of chance finds we know that both the circuit of the city walls and the layout of the streets were irregular. The former was normal practice in Gaul, even in conjunction with the most rigidly rectilinear of street plans (e.g. Fréjus, Nîmes, Autun). The irregularity of the street plan is, on the other hand, unusual and must indicate the existence already of a substantial Gaulish settlement on the site of Plancus's foundation.

Plancus's other colonial foundation, Augusta Raurica (Augst), the predecessor of the modern Basel, is in this respect more characteristic of Early Imperial practice. Here the nucleus of the colony was laid out in a neat grid of rectangular insulae, each measuring 165 by 195 feet (50 by 60 m.), along the crest of a ridge of high ground between two valleys. The surviving buildings offer a vivid picture of the monumental centre of a typical Gallic city; and although none is actually as early as the original foundation, they are precisely the sort of building which these formal quadrangular layouts were from the outset designed to accommodate. It is easy to dismiss such 'gridiron' planning as unimaginative, but one cannot deny the extraordinary convenience and practicality of a standard layout within which these towns could, over the years, develop the complex of public and private buildings appropriate to their status, without ever losing that sense of organic unity which, one and all, they so markedly possessed. Hardly less convenient was the possession from the outset of a definitive layout of streets and drains.

The group of public buildings which came in time to occupy the centre of the colony of Augst included a basilica and forum, two large temples, a theatre, and a spacious

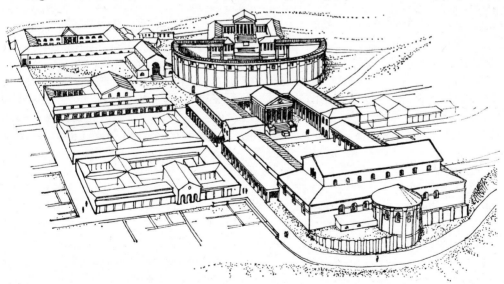

Figure 131. Augst (Augusta Raurica), restored view of the centre of the town, mid second century with later modifications

public market (Figure 131). The basilica, the forum, and one of the temples formed a single architectural complex, occupying three complete insulae and divided into two unequal parts by the main street of the town. On the west of the street, facing it and framed on three sides by a monumental portico, stood the Capitolium, a large hexastyle peripteral building of conventional classical type standing on a tall podium. Across the street, to the east, the line of the lateral porticoes was continued to form the long sides of the rectangular open space of the forum proper, the far end of which was closed by the massive bulk of the basilica. Originally an aisled building with two large, shallow apses at the two ends, it was later converted by the suppression of the apses into a grandiose rectangular hall, 210 feet long and 90 feet wide (64 by 28 m.), with an internal ambulatory and galleries above it. Rows of shops or offices (*tabernae*) faced inwards along the two long sides of the forum and outwards along the exterior both of the forum and of the temple precinct, those of the latter carrying a second storey. Street-side porticoes along the two long sides gave an exterior unity to the whole complex, interrupted only by the passage of the transverse street, which was itself interrupted by two porch-like structures through which only foot traffic was able to enter the actual forum.[5]

The whole complex appears to date from just before the middle of the second century A.D., and its plan, with its formal conjunction of a forum and a large official temple facing each other across the line of a transverse street, is one that was widely adopted in the western provinces. We meet it again, for example, in Roman Paris (Lutetia) and at Saint Bertrand-de-Comminges (Lugdunum Convenarum), at Sabratha in Tripolitania, and perhaps, in a modified form omitting the temple, in Britain also, at Caerwent, Caistor, Silchester, and Wroxeter.[6] An unusual feature of the basilica at Augst is the circular, tower-like structure added in the third century against the middle of the steeply plunging east side of the basilica. It contained five tiers of seats arranged as in a miniature theatre and was evidently the *curia*, the meeting-place of the 100 decurions who constituted the city council. The similarly placed exedra of the basilica at Alesia probably served the same purpose.

Of the rest of the central group of buildings, the theatre, just to the west of the Capitolium precinct, was sited on a slightly different orientation so as to take full advantage of the head of an oblique re-entrant on the western side of the ridge. Originally an Augustan or Julio-Claudian building, it was remodelled in 73–4 to serve as an amphitheatre, and then reconverted once more into a theatre and enlarged *c.* 120–50. Beyond and to one side of it, terraced out above the steep western slopes, stood the market. This consisted of porticoes, with shops opening off them, enclosing three sides of a rectangular open space measuring 160 by 100 feet (49 by 31 m.); a monumental entrance, together with what may be the offices of the market officials, occupied the fourth side; and opening off the north-east angle there was a covered market hall. The latter comprised two rows of shops facing each other across an elongated rectangular hall, with stairs leading up to a second storey, which was presumably served by a wooden gallery. The second temple stood in the angle between the market and the theatre, on the summit of the prominent isolated spur of Schönbühl. Originally a

large open sanctuary containing two small square shrines of typically Celtic form,[7] it was replaced, probably towards the middle of the second century, by a large (80 by 60 feet; 24 by 18 m.) hexastyle peripteral temple of purely classical type, enclosed within a monumental double portico. Temple and portico were laid out on the axis of the theatre, the stage-building of which was deliberately, and uniquely, left open in the centre so as to afford a vista down the axis. There is no means of telling whether (as often in Gaul) there was any ulterior religious significance in this relationship.

To complete the picture of the Roman city one may mention two large public bath-buildings, one established about the middle of first century A.D. and still reflecting Pompeian models, the other probably built a few years later. The former was subsequently modernized and the latter rebuilt on a more ambitious plan, both during the course of the second century. There was also an important sanctuary in the valley to the west comprising, in its fully romanized form, a triple shrine, in plan somewhat resembling the Capitolium at Brescia, set within a large porticoed enclosure, beside the entrance to which stood a bath-building. The dedications, to the local divinity Sucellus as well as to Aesculapius and Apollo, confirm that it was in origin a native healing-sanctuary, associated with a spring. Another vivid glimpse of the lively syncretism of Gallo-Roman religious life is afforded by a small temple to the east of the town. Dedicated to the Asiatic Mother Goddess, Cybele, the forecourt was a simple classical building, whereas the temple at the far end of it was of the purely native, square type described later in this chapter.

The picture revealed in the preceding paragraphs must, broadly speaking, be typical of what happened to many of the early foundations in other parts of Gaul. Apart from such obvious necessities as city walls and aqueducts and a certain number of prestige monuments (such as, in Britain, the Temple of Claudius at Colchester, begun within a decade of the Roman landing), the public buildings established at the actual moment of foundation were probably few, and even they must normally have been conditioned by the materials and building skills that were available locally. The important thing was that the initial plans did allow for the expansion which almost inevitably followed once city life had taken root.

Typical also is the picture of an architecture that stems unmistakably from Italy, much of it almost certainly from North Italy. It was not long since most of Italy north of the Apennines had itself been part of Gaul,[8] and history and geography alike suggest that it was the experience gained in the Republican colonies in the plains and foothills of Gaulish North Italy which shaped the pattern of Rome's civilizing mission in trans-alpine Europe. This was the immediate source of the sort of planning which we see at Augst and (still on Italian soil, but part in fact of the same Augustan programme in and beyond the Alps) at Aosta (Figure 116). The closest parallels for the gates of Nîmes or Autun are with Aosta, Turin, and Verona; and the basilicas, the podium-temples, the theatres and amphitheatres, the market buildings, all of these derive more or less directly from Italian models. The masonry techniques, discussed below, are another link with North Italy.

In course of time the net came to be spread more widely. At Augst, for example, the

forum-basilica scheme derives ultimately from the sort of thing one sees at Velleia a century earlier (Figure 118), but the two apses of the basilica, as first constructed, strongly suggest the more immediate influence of the Basilica Ulpia. The market hall too looks like a provincial version of that in Trajan's Market. Contacts with other provinces grew more frequent. Provence in particular began quite soon to look farther afield; and in common with the whole Empire Gaul saw a gradual breaking down of the old regional boundaries. But Italy long remained the principal outside source of Gallo-Roman architectural inspiration.

The typical monumental building materials of Roman Gaul were dressed stone and a version of the omnipresent Roman concrete which may conveniently be referred to by the conventional name of 'petit appareil'. The former needs no introduction. As in Spain, and as one can see at Glanum, it was a heritage from the pre-Roman past of Provence which acquired fresh standing from the Augustan monuments of Rome itself. The 'petit appareil' was a coursed and mortared rubble, similar in composition and general consistency to the concrete of Late Republican Italy, but with a facing of small squared stones (Plate 191) instead of the opus incertum or opus reticulatum of metropolitan practice.[9] The closest relevant parallels are with the stone-using parts of North Italy. The mortar was very variable in quality, but at its best this Gallo-Roman work came very near to having the strength of the finest Roman Imperial concrete, of which it may be regarded as a close collateral relative. The principal innovation of the later Empire was the introduction of bands of brick, each of several courses, which bear a superficial resemblance to the bands of brick found in association with some Italian reticulate work (e.g. at Hadrian's Villa) but which in fact frequently differ in running right through the core,[10] serving as levelling courses and to some extent as a guarantee against settlement. They are not found before the early second century. Brick-faced concrete in the Roman manner is not found outside the military areas before late antiquity. Another material in common use was timber, during the earlier stages of the occupation even in public architecture and throughout antiquity for domestic and utilitarian building. It was often supplemented by mud brick or adobe, as until modern times in many parts of France and Britain.

Although much of the best Early Imperial work is, not surprisingly, to be found in Provence, the military colonies and tribal capitals in the Three Gauls and subsequently in Britain and the Germanies had their share of fine early buildings that were designed with an eye to prestige as well as to the practical needs of the inhabitants. One of the first requirements of such foundations was a defensive wall, and from the outset the city gates were designed to impress. One common type, with many parallels in North Italy,[11] is that which one sees at Nîmes and at Autun (Plate 183), in which an elaborate multiple arch, flanked by projecting rounded towers and crowned by an arcaded gallery, opened on to a rectangular inner courtyard. Another, more distinctive form is found in Provence at Fréjus (Forum Julii) and at Arles. Here the actual gate is set at the base of a large incurved courtyard with two almost free-standing, circular towers. Nîmes, it is worth recalling, was not primarily a military settlement but a romanized tribal capital that had received colonial status; and Autun (Augustodunum), another tribal capital

replacing the old hilltop fortress of Bibracte, was not founded until 16 B.C., thirty-five years after the conquest. The city wall was already fast becoming a symbol of status rather than a strict military necessity.

Another immediate requirement for each new town was an abundant water supply. At Nîmes, for example, the fine spring that existed within the circuit of the walls was not in itself sufficient, and between 20 and 16 B.C. Agrippa built an aqueduct that brought to the town the waters of a group of springs near Uzès, 31 miles distant. In accordance with normal Roman practice the channel was, wherever possible, trenched or tunnelled below ground, or carried on a low wall, and was skilfully sited along the contours so as to afford a steady, gentle drop, calculable over the whole distance as about 1 in 3,000. At one point, however, it had to cross the gorge of the river Gardon, and here can still be seen one of the most impressive of all monuments of Roman antiquity, the Pont du Gard (Plate 179). Built throughout of squared stone, it is 295 yards (269 m.) long and carried the water channel across the valley at a height of 160 feet (49 m.) above the stream. The harmonious lines of the structure are based (as in so many ancient buildings) upon an extremely simple set of numerical proportions: 4 units for the central arches, 3 for the lateral arches, 1 for the arches of the uppermost tier, and 6 for the height of the whole structure. The bosses left projecting from the inner faces of the upper arches were to carry centering, in the event of repairs. Just inside the walls of Nîmes one can still see the *castellum divisorium*, a large circular basin with a settling tank and a series of outlets by means of which the water could be allocated as required to the municipal water system.

The aqueduct bridge, with its elegant arches and often grandiose proportions, is such a familiar and conspicuous symbol of Roman engineering skill that it is worth remarking, in passing, that the Roman engineer was perfectly familiar with the other ways of transporting water across an obstacle. He was even ready as a last resort to pump it uphill, as at Lincoln;[12] and there are numerous examples of all dates where it was carried across a valley in a sealed pipe. In Gaul itself there were several fine instances of the latter along the course of the Mont Pilate aqueduct, one of the four aqueducts which served second-century Lyon with some 2,700,000 cubic feet of water daily, or again where fresh water was carried across the bed of the Rhône at Arles in a battery of lead piping. We shall meet another fine example at Aspendos in Asia Minor (Plate 213). The reason such systems were not used more often is that they were expensive both to install and to maintain. By comparison manpower was abundant and cheap.[13]

Gaul is poor in surviving road bridges. There certainly were permanent bridges even over such major rivers as the Rhine and the Saône, with masonry piers founded, where necessary, on iron-shod wooden piles. In such cases the superstructures were almost certainly of timber. Smaller bridges were arched in masonry. A well preserved example, the carriageway of which is spanned by two ornamental arches, can be seen at Saint Chamas (Bouches-du-Rhône). The fast-flowing Rhône was crossed at Arles by a bridge of boats, similar to that portrayed on Trajan's Column, crossing the Danube.

Another field that is poorly represented is that of the civic centres of the Early Imperial foundations, most of which have been overlaid by buildings of a considerably

347

later date. From the rather unsatisfactory accounts of the excavation of the 'Basilica' at Saint Bertrand-de-Comminges (Lugdunum Convenarum) on the upper Garonne it seems clear that the original building, a long narrow hall with transverse columnar partitions (an elaborate version of the basilica at Velleia), was early, perhaps even Augustan; but it is far from clear that its function was not from the outset commercial, as it undoubtedly was under the later Empire, when a series of tabernae were opened up around all four sides of the main hall. The basilica at Alesia, like those of Augst and of Paris, is unlikely to be earlier than the second century, after the Basilica Ulpia in Rome had constituted a new model that was widely imitated in the western provinces. At Glanum there are the remains of a finely built rectangular assembly hall with rising steps for seats on three sides; but this is of pre-Roman date, the bouleuterion of the Greek city.

Arles is the only one of the major Early Imperial foundations where one can see substantial remains of what is certainly one of the large public buildings, if not indeed of the forum itself. This is the so-called 'Cryptoporticus', a large vaulted substructure occupying three sides of a rectangle, across the fourth side of which ran one of the main streets of the town. Each arm consisted of two parallel, barrel-vaulted corridors separated by massive stone piers carrying segmental arches, and the vaults were lit by windows splayed downwards from the open space in the centre. In late antiquity, probably under Constantine, the northern side was interrupted by the footings of a temple set obliquely across it; and beside them, shovelled in after some civic disaster, was found a mass of Early Imperial official sculpture and inscriptions. The substructures, evidently those of a monumental double portico enclosing a central space, may well be those of a part of the actual forum, and they have, not implausibly, been related to a passage of Vitruvius which describes the substructures of porticoes as suitable places for the public storage of such commodities as fuel and salt. Vaulted substructures of this distinctive type are not uncommon in Gaul – at Narbonne, beneath what may be the market (*macellum*) mentioned by Sidonius; at Reims (Durocortorum) beneath the porticoes of what is probably the forum; and in a very elaborate form at Bavai (Bagacum), north of Reims, beneath the porticoes of the early-second-century forum. A very similar structure at Aosta, in North Italy (Figure 116), encloses a precinct containing one large and two smaller temples; as at Arles the fourth side faces on to a street.[14]

About the religious architecture we are rather better informed. Two of the best known surviving monuments, the Maison Carrée at Nîmes (Plate 184) and the Temple of Augustus and Livia at Vienne, are both official foundations, erected almost certainly during the lifetime of Augustus,[15] and it is no surprise to find them purely classical both in design and in execution. Both are hexastyle, standing on tall podia, the former being pseudo-peripteral, the latter seemingly peripteral *sine postico* in the Late Republican Roman manner; and the direct, contemporary influence of the capital is further shown by such details as the handsome acanthus scrollwork of the frieze of the Maison Carrée and the channelled masonry of the cella, as in the Ara Pacis and the Temple of Mars Ultor, respectively.

At Narbonne we catch a vivid glimpse of the way such influence might be brought to

bear. The remains of the Capitolium indicate a very large temple (the linear dimensions of the ground plan, 158 by 108 feet; 48 by 36 m., are twice those of the Maison Carrée), the effect of size and height being deliberately enhanced by its situation at the far end of a long, narrow enclosure surrounded by a double portico; the superstructure was octastyle pseudo-peripteral, with a triple cella, and it was built throughout of Carrara marble. Recently the wreck of a Roman ship has been identified off the coast of the French Riviera near Saint Tropez, the cargo of which consisted of roughed-out columns, capitals, and other architectural members of the same material and dimensions;[16] and since these are unparalleled elsewhere in Gaul or Spain, there can be little doubt that this is a shipment to Narbonne that never reached its destination. As we have already seen in the case of Augustan Rome, the introduction of new materials and techniques almost inevitably meant the introduction of foreign craftsmen and fresh artistic traditions. Here at Narbonne, in what must have been one of the most admired buildings of its day, we have the same story all over again.

These officially inspired classical temples were only one side of the coin. If there were clear and powerful classicizing influences at work from Italy, there was also a strain of vigorous Gallic conservatism which, as it came to acquire the means of monumental expression, was to play an important part in the creation of a more specifically Gallo-Roman architecture. Apart from the formal establishment of such official provincial and municipal cults as those of the emperor and the Capitoline triad, the romanization of religion was virtually limited to the easy assimilation of Roman names and attributes by local divinities, whose sanctuaries continued to play a large and active part in the daily life of the native Gaulish population. Many of these sanctuaries were in the open countryside, associated with springs or other natural features. They often stood within or beside a large enclosure, suggestive of pilgrimages or gatherings for popular festivals; and annexed to these enclosures were shops, covered halls, porticoes, inns, theatres, and other buildings. The sanctuary of Sanxay (Vienne), in a forest clearing twenty miles south-west of Poitiers, was a small town in itself. Another striking example is the late-fourth-century pilgrim shrine of Nodens at Lydney in Gloucestershire, with its temple, its dormitory portico for the sick, and its well appointed inn and bath-building.

The actual temples vary in detail, but the basic form is remarkably constant and consists of a square, circular, or octagonal tower-like cella with a single doorway and, in all but the simplest, an external portico with a low roof running right round the building. There are countless examples of such temples in Gaul, Britain, and the Rhineland, of all periods from the first to the fourth centuries A.D., and of every degree of elaboration, from simple rustic chapels to great tribal or provincial sanctuaries. The simpler ones continued to be built of timber, the native material. At the other end of the scale we find such notable monuments as the 'Temple of Janus' at Autun, 43 feet (13 m.) high and built of 'petit appareil' masonry with brick details (Plate 191), or the second-century Temple of Vesunna, patron divinity of Périgueux (Vesunna Petrucoriorum), the cella of which was a cylindrical tower of fine 'petit appareil' masonry, once faced with marble. Both had wide external porticoes and stood within monumental rectangular enclosures.

In Provence, as one might expect, such native temples disappeared early. Unfortunately we do not know the original form of the shrine of the spring-god, Nemausus, who gave his name to Nîmes; but the surviving Early Augustan temple of Vernègues (Bouches-du-Rhône), another water shrine, is a purely classical building. In the Rhineland, on the other hand, we have the Altbachtal sanctuary at Trier (Augusta Treverorum) (Figure 132A), which comprised no less than seventy temples, big and little, mostly square but a few circular, embracing with little apparent change the whole

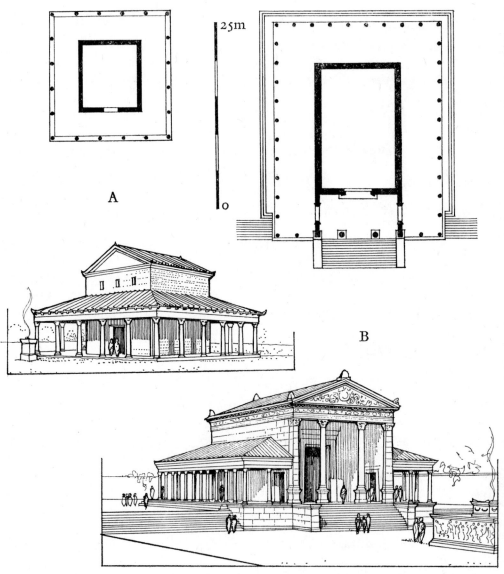

Figure 132. Trier (Augusta Treverorum). Plans and elevations of

(A) Temple 38 in the Altbachtal sanctuary, second century
(B) Temple of Lenus-Mars, in its latest, classicizing form, third century

period from the first to the fourth centuries. A similar conservatism is characteristic of many country areas, notably in northern Gaul and Britain. Elsewhere the progress of romanization brought changes. In the Augustan colony of Augusta Raurica, as we have seen, the temples of the hilltop sanctuary of Schönbühl were of native type until replaced by a monumental classical structure at some date in the later second century. Such classical replacements must have been a great deal commoner than can now be documented; the Temple of Lenus-Mars at Trier (Figure 132B) illustrates just such a development. Hardly less frequent was the assimilation of classical and native types, of which it must suffice to cite the examples of Périgueux and Autun, already described, or even more strikingly the pilgrimage sanctuary (c. A.D. 200) of Champlieu, in the open countryside of the Forest of Compiègne, half-way between Senlis and Soissons (Figure 133). Here the temple stood in the centre of a rectangular colonnaded enclosure, also colonnaded, along one side of which was a theatre, with a bath-building just beyond it. The temple itself was square, but it stood on a podium in the classical manner; it had a small porch, half the width of the façade and probably gabled; and each of the four faces was elaborately carved with two angle-pilasters and six half-columns, just as if this were a pseudo-peripteral classical temple. The whole was gaily coloured. Architecture and sculpture alike, it represents a lively fusion of classical and native elements in the service of a simple but vigorous provincial culture.

The theatres of Gaul include some of the earliest known examples outside Italy. Typologically, if not in point of time, pride of place goes to that of Fréjus, where it was only the substructures of the cavea and of the façade that were of solid masonry ('petit appareil'), the upper part being of timber and the columns of the stage-building of stone, or timber, faced with painted stucco. An inscription of Claudian date found at Feurs (Loire), recording the reconstruction in stone of an originally timber theatre, suggests that many of the stone theatres of Gaul may have had similar beginnings, that of Fréjus being unusual chiefly in that it was never subsequently brought up to date. There are, however, several stone theatres that are almost certainly of Augustan or early Julio-Claudian date. Much of the surviving sculptural detail at Arles, for example, notably the mixed Doric–Corinthian entablatures of the three external orders of the cavea, is undeniably early. At Lyon the original form of the theatre is unfortunately largely obscured by later alterations (Plate 182), but the surviving column bases are of a very distinctive type which went out of use in Rome well before the end of the first century B.C. Few of these South French monuments are closely dated epigraphically, but there is a growing body of evidence to show that the broad lines of the subsequent Early Imperial development were laid down under Augustus.

In terms of the stage-building this development seems to have taken the form of an evolution from simpler towards more complex forms, followed (but not before the second century) by the substitution of marble for the original local materials. At Fréjus the rear wall (scaenae frons) of the stage is simply a straight wall, the three symmetrical doors of which were framed in some way by a screen of columns. At Arles the outer extremities of the wall are straight, but the central door stands within a projecting porch at the back of a shallow, curved exedra, as in the roughly contemporary theatre at

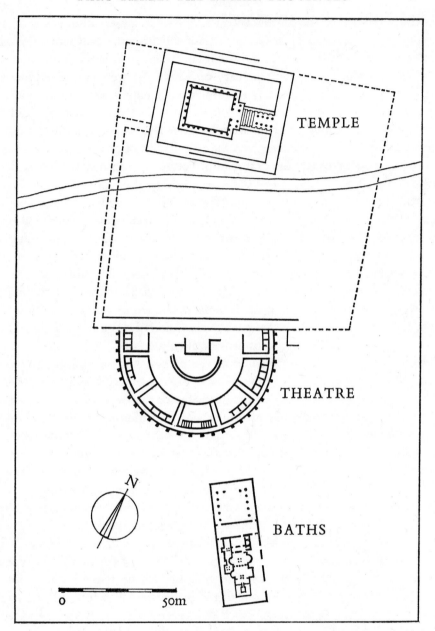

Figure 133. Champlieu, Gallo-Roman sanctuary, *c.* 200. Plan

Aosta. It is only at Orange and Vienne that we meet what was thereafter to be the standard monumental type in the provinces, in which the central exedra is matched by two others, often rectangular, framing the two lateral doors and creating the elaborate play of curving and rectilinear, projecting and re-entrant features which is so characteristic and striking a feature of Roman theatrical architecture (cf. Plate 250).

Both at Vienne and at Orange (Figure 145B) the theatres were built up against steep rocky hillsides and, contrary to the usual practice, the public had to reach its seats from

above. That of Vienne retains traces also of a common but rarely preserved feature of these theatres, the curving portico at the head of the cavea, and, overlooking the cavea from the centre of this portico, there was a small temple, as in the Theatre of Pompey in Rome and in several of the North African theatres.[17] The theatre of Orange is remarkable chiefly for the almost total preservation of the structure, though very little of the ornament, of the stage building. The external appearance of the latter would have been lightened in antiquity by the monumental portico that once stood against the base of it and by the rhythmical repetition of the vertical staves that were contained in the two surviving series of brackets to support the awning (*velum*) over the interior. But the range of blind arcading that occupies the middle register is far too shallow to be effective, and the total effect is decidedly bleak. Here, as in many other fields, Roman architects had yet to produce an effective integration of the demands of interior and exterior.

Many of the early amphitheatres of Gaul were, and in some cases they remained, largely of timber, as in North Italy. The evidence for this comes mainly from the military zones; but that they were by no means restricted to military use is demonstrated by that of the Flavian colony of Aventicum (Avenches), or again at Xanten (Vetera), where the small earth-and-timber amphitheatre of the Claudian fort was replaced by the far larger timber construction on masonry footings which served the Trajanic colony. Of the stone-built structures by far the best preserved are those of Arles (Plate 186) and Nîmes (Plate 185), which resemble each other so closely that they must be almost contemporary, that of Arles being perhaps the later by a decade or two. In the absence of any direct evidence of date one can only compare them with the monuments of the capital, from which they bear every indication of being closely derived. The most significant and effective innovation upon their Italian models was the introduction of a repeated vertical accent by the carrying of the projection of the pilasters and demi-columns of the façade straight up through the entire building, entablatures and all. This is not at all the line of development followed in the roughly contemporary amphitheatres at Verona and Pola, but one can see something very like it in the late-first-century forum at Brescia, and it clearly establishes the two Provençal amphitheatres as later than the Colosseum, where the overriding emphasis is still upon the horizontal continuity of the four encircling cornices. Both buildings should probably be attributed to the Late Flavian or Trajanic period. The no less clear reminiscence of the Theatre of Marcellus in the vaulting of the upper galleries must be an archaism, attributable to the architect's lack of confidence in his materials. It must be remembered that there had been no technical advances in Gaul comparable to those that had recently taken place in the concrete of the capital, a fact which helps to explain the singular absence of monuments that are obviously attributable to the later first century. If it is at times tempting to label every Early Imperial building in Gaul as Augustan, this is in part at any rate because both the canons of provincial architecture and taste and the means of expressing them had been so firmly and decisively established in the Augustan era.

Bath-buildings were another aspect of Roman material civilization which, not

surprisingly, had a great appeal in northern climates, and they spread rapidly and widely throughout the northern provinces. It is unfortunate that, apart from tantalizing fragments at Paris (in the Hôtel de Cluny) and Poitiers (Limonum), the only major installations surviving in the great cities are the somewhat uncharacteristic 'Imperial'-type baths of Trier and of Arles, which are described in a later chapter. But there are a great many of the smaller public baths in both town and countryside, and although no two plans are exactly alike one can distinguish two fairly consistent lines of formal development. One of these, with a solid block of bath-rooms grouped irregularly along one side of an open palaestra, derives from the same tradition as the baths of Pompeii, and no doubt it represents the form in which Roman-style bathing first reached Gaul. The other, which seems to be a peculiarly Gallo-Roman development, is distinguished by a straight axial sequence of frigidarium, tepidarium, and caldarium, usually accompanied by a palaestra and often by one or more circular rooms of varying purpose.[18] A third type, functionally distinct from the other two, is that found in the numerous spas of Roman Gaul. Many of these took shape around sacred springs, and, like healing-sanctuaries throughout the Roman world, they offered a unique combination of religious, curative, and social amenities. In Britain the Temple of Sulis Minerva and the

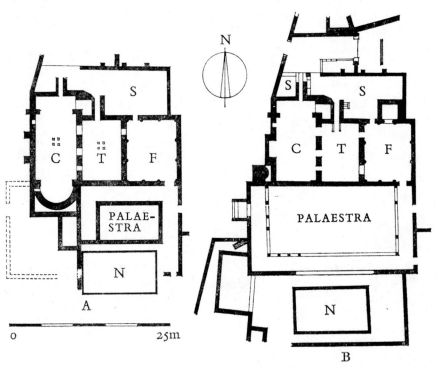

Figure 134. Bath-building at Saint Rémy (Glanum). Plans
(A) in its original form, second half of the first century B.C., and
(B) as reconstructed in the second half of the first century A.D.

s Services c Caldarium t Tepidarium f Frigidarium n Natatio

bathing establishments of Bath (Aquae Sulis) were part of just such a complex.[19] The bath-buildings of this third group are distinguished by the high proportion of rooms with large central plunge-baths fed directly from the springs. Typical surviving or recorded examples are those of Évaux (Creuse), Royat (Puy-de-Dôme), Badenweiler in the Rhineland (Figure 135C), and Les Fontaines Salées (Yonne, near Vézelay). At Amélie-les-Bains (Pyrénées-Orientales) the plunges are accompanied by small individual cubicles.

Good examples of the 'Pompeian' type of bath-building are to be seen at Glanum, built at some date after 45 B.C. and remodelled, with an enlarged palaestra, in Flavian times (Figure 134). At Saint Bertrand-de-Comminges, in Aquitania, the North Baths (Figure 135A), though of second-century date, still have much in common with the Central Baths at Pompeii (Figure 113), whereas the baths adjoining the forum are a good

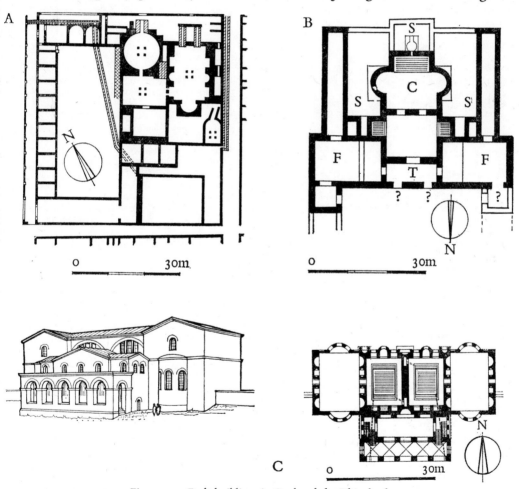

Figure 135. Bath-buildings in Gaul and the Rhineland
(A) North Baths at Saint Bertrand-de-Comminges (Lugdunum Convenarum), second century. Plan
(B) Verdes, date uncertain (second century?). Plan
(c) Badenweiler, original form of the buildings, probably first half of the second century. Elevation and plan

s Services c Caldarium f Frigidarium t Tepidarium

example of the second type. The latter might be very simple, as in the bath-building attached to the festival sanctuary of Champlieu, described above (Figure 133), or it might be elaborated in a number of ways, often of considerable architectural character and pretension. To mention only a few of the more striking, we have the baths of Canac, just outside Rodez (Aveyron), which were developed symmetrically almost as if a miniature version of the 'Imperial' type; at Drevant (Cher) and at Verdes, near Beaugency (Loir-et-Cher) (Figure 135B), both single bathing-suites with a number of supplementary features, which again were developed symmetrically about the main block; and those of Vieil-Évreux (Gisacum), in Normandy, and of Allonnes, near Le Mans, two schemes which incorporated a pair of separate but identical suites of bathing-rooms within a single large, symmetrical complex. One has only to compare such buildings with any comparable series of bath-buildings in Asia Minor or North Africa (or indeed, after the initial stages, in Italy itself) to appreciate the individuality of this Gallo-Roman architecture.

The only other early group of public monuments that calls for brief mention is that of the monumental arches of Provence, which are closely related to those of northern Italy, differing chiefly in the generally greater wealth of their architectural forms and sculptural decoration. That at Glanum, for example, Early Augustan and the earliest surviving member of the series (Plate 187), is a more elaborately articulated version of the arch at Aosta. Slightly later, but still Augustan, were the now destroyed 'Arcus Admirabilis' at Arles and that of Susa (9–8 B.C.) (Plate 162). The arch at Orange (Plate 188), long thought to very early, is now known to be of Tiberian date (soon after A.D. 21). Even so, it is the earliest surviving triple arch to have been built as such (the Parthian Arch of Augustus in the Forum Romanum is rightly characterized as three single arches placed side by side), and it is remarkable for the virtuosity alike of its architectural forms (which, it must be remembered, were designed to be viewed as the basis for a monumental group of statuary) and of the relief carving with which it is covered. A feature that deserves remark is the breaking back of the horizontal cornices of the pediments of the tetrastyle façades on the two ends, in a manner which is reminiscent of the painted architecture of the Third Pompeian Style.[20] A closely related monument is the Mausoleum of the Julii at Glanum (Plate 187). The nearest parallels to the architectural form, a four-way arch standing on a tall, sculptured podium and crowned by a circular pavilion with a conical roof, are again with Italy (Aquileia, Sarsina, Nettuno), whereas the sculptured panels can be seen to be closely derived from the scenes of a well-known hellenistic painting.[21] Whether or not it is legitimate to see in this the continuing influence of Massilia, the individuality and skill of this distinctive school of sculpture offers yet another proof of the extraordinary creative vigour of Augustan Provence.

For the domestic architecture in the early Gaulish towns we are virtually dependent on the excavations at Glanum and Vaison. Within their limitations – both were country towns of quite modest importance – they afford a valuable picture of middle-class domestic life in Gaul under the Early Empire. They are, moreover, complementary, the former rooted in its own strongly hellenistic traditions, the latter a small but pros-

perous tribal capital developing on lines which have much in common with Italian practice. The houses of Glanum (Plate 180) are built around peristyle courtyards, as at Delos and like the later houses at Pompeii; and although these are mostly so small as to resemble a columnar atrium, the resemblance is here at most one of assimilation, not of derivation.[22] The atrium as such was never common north of the Alps and, when found, is invariably of the developed, columnar form. A good Gaulish example is that of the House of the Silver Bust at Vaison (Figure 136), which in other respects too, with its

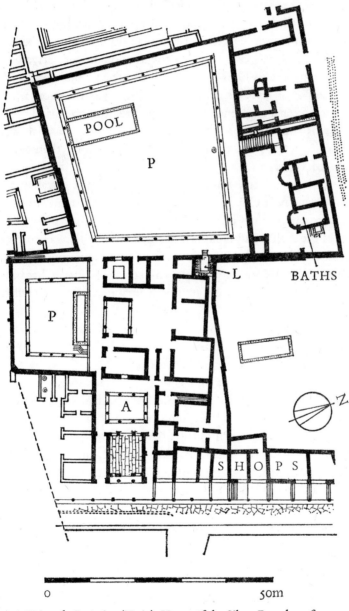

Figure 136. Vaison-la-Romaine (Vasio), House of the Silver Bust, later first century. Plan
P Peristyle L Lavatory A Atrium

357

somewhat informal layout, large garden peristyles, and bathing suite, offers a vivid picture of a well-to-do Italianate town mansion of the later first century A.D. The shops along the street frontage and the streetside porticoes (Plate 181) are other typical features of Gallic city architecture that have obvious Italian analogies.

Between the extremes of such wealthy mansions and the simple one-room tabernae of the artisan, such as we see clustered beside the main streets of the roadside settlements of the Three Gauls, or in Britain at St Albans (Verulamium) and at Silchester, there was a variety of detailed practice which defies brief analysis. The materials and building techniques were local, timber predominating in many areas, but over all was spread with varying intensity the familiar veneer of Roman domestic life – tiled roofs, painted plaster on the walls, window-glass, floors of concrete or mosaic, private or communal bath-buildings, mass-produced household vessels of bronze, fine pottery, or glass, and, pervading all, a degree of civic order which distinguishes the most modest of road-stations from the haphazard agglomerations of the pre-Roman period.

Outside the towns romanization, though no less thorough, was slower in coming. A few of the wealthy villas are demonstrably early, among them being the great country mansion of Chiragan on the upper Garonne, with its astonishing series of marble portraits and other early sculpture, and the recently excavated first-century residence at Fishbourne, near Chichester (Figure 137).[23] At first, however, such wealthy country houses were the product of special circumstances. Over most of Gaul, Britain, and the Germanies the architectural pattern of the Roman villa was one which evolved slowly within the established social framework of town and country; and it was because, in consequence, it was able to put down deep roots that it became one of the most individual and enduring aspects of the Romano-provincial civilization of the north-western provinces.

The essence of the villa system in the provinces was that the house was not merely a country residence (as it had become in parts of Central Italy); it was also the centre of a working estate, which might be of considerable size. The villa of Bignor, Sussex, for example, must have been the centre of a very large estate. A great many villas have been excavated and studied, notably in Britain and the Rhineland, and as one would expect they reveal a wide variety of planning, materials, and local historical circumstance. In Britain, for example, much of the finest work belongs to the fourth century, by which time in some other, more exposed parts of the northern frontier villa-building had virtually ceased.[24] But through all the variety of plans and styles one can detect an architectural evolution which in its broad outlines is remarkably consistent, and which is the product of a long process of mutual assimilation between native farming traditions and building practices and the more advanced material civilization of the south. The earliest villas were simple, rectangular, barn-like houses, normally timber-framed and subdivided internally into living quarters, storage, and stabling. In many cases they can be seen to have replaced even simpler pre-Roman farmhouses, as in Britain, for example, at Lockleys, near Welwyn, and at Park Street, near St Albans, and in the Rhineland at Mayen and at Köln-Müngersdorf.

From such simple beginnings it was a short step to the addition of a linking portico or

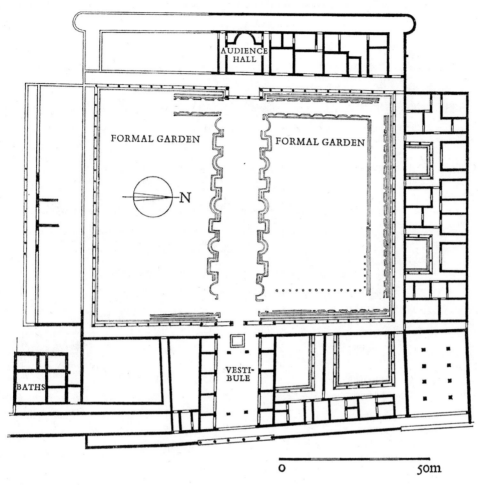

Figure 137. Fishbourne, villa (probably the residence of the last native king, Cogidubnus).
Third quarter of the first century. Plan

corridor along one long side and the progressive relegation of stabling, storage, and the other practical requirements of the farm to separate buildings within the outer farm-enclosure; the corridor was commonly flanked by a pair of projecting rooms (one of which might house part of an added bath suite), and although this remained in essence a tradition of single-storeyed building, there was a growing tendency to add towers, cellars, and even partial second storeys. An early stage of this development, *c.* 100, is well illustrated at Ditchley, Oxfordshire (Plate 189) and, rather more elaborately, at Köln-Müngersdorf (Figure 138). From the corridor-villa with outhouses it was a natural step to bring order into the complex by grouping the several buildings round one or more courtyards, and from this point of view the courtyard-villa may be re-garded simply as a corridor-villa writ large. At the same time, however, porticoes and courtyards lent themselves to treatment in ways that were quite specifically classical; and with the spread of such luxuries as window-glass, painted wall-plaster, mosaic pavements, and central heating, it is small wonder that one should find an ever-

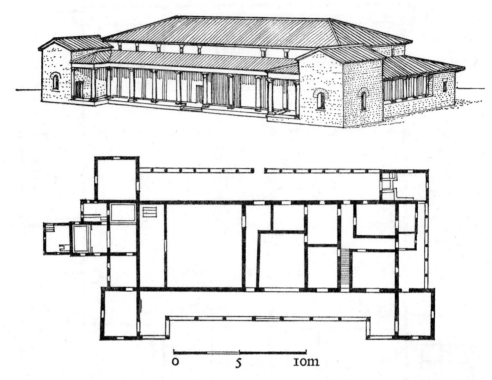

Figure 138. Köln-Müngersdorf, villa, in its fully developed form, third century. Elevation and plan

increasing assimilation also of the external forms and something of the planning of Mediterranean classical usage. One sees this, for example, in the great villa at Nennig, on the upper Mosel (Figure 139). The basic plan, with two tower-like wings flanking a porticoed façade, stems from the local Romano-provincial tradition; but the architectural detail, the two storeys of the frontal portico, the grouping of the rooms of the main wing around internal peristyle courtyards, and the convergence of the whole scheme upon a great central triclinium, all of these represent the influence of more directly classical ideas. At a less ambitious level one can see the same forces at work in a building such as the villa at Chedworth, in Gloucestershire (Figure 140), which started in the early second century as three separate half-timbered wings grouped around the head of a small valley, and which was only later developed into a single unitary plan, with inner and outer courtyards, a large new triclinium, various other reception rooms, and an up-to-date new bathing suite.

At its best this was a domestic architecture of considerable pretensions and some elegance, and it was rooted in standards of solid material comfort which were not to be seen again in Europe before the nineteenth century. These, it should be remembered, were the country houses of the world of Ausonius and Sidonius Apollinaris, the world within which the Visigothic and Frankish chiefs acquired the far-from-negligible veneer of classical culture which they were to carry forward into the Middle Ages.

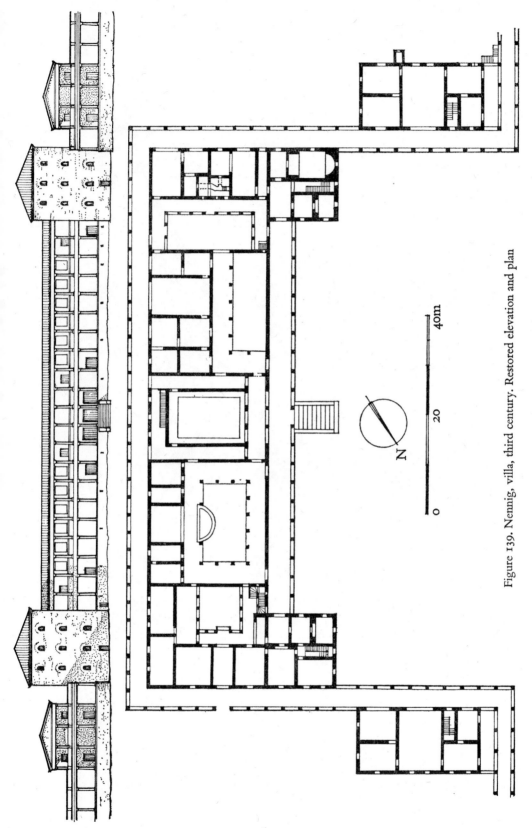

Figure 139. Nennig, villa, third century. Restored elevation and plan

Figure 140. Chedworth, restored view of the villa, c. 300

It will have been remarked that although Britain and the Germanies were frontier provinces, little or nothing has been said in this, or indeed in any other, chapter about military architecture. The fact is that, by comparison with the hellenistic world and with Byzantium, the Roman Empire added little to the science of military architecture as such. Works like Hadrian's Wall were essentially police barriers, the legionary and auxiliary fortresses of the frontiers police posts and supply bases directed against an enemy who was dangerous only in the open field. Along the eastern frontiers the potential threat was more sophisticated; but although one might have expected the germs of later military thinking to have taken shape in Syria, there is in fact remarkably little evidence of any such development. As late as the third quarter of the third century the Aurelianic walls of Rome or the roughly contemporary walls of Nicaea, in Bithynia,[25] show little effective advance on the best hellenistic work.

Architecturally the real significance of the military stations of the frontier zones was that they were centres for the dissemination of Roman material culture and the outward forms of Roman life. As the garrison towns became established on a permanent basis, there was inevitably an increasing interdependence between the forms and practices of civil building and of the comparable branches of military building. But the revival of interest in military architecture as such was a product of the crisis of the third century and belongs to the history of late antiquity.

Central and South-Eastern Europe

To the north and east of Italy lay the provinces of the Danube basin and the Balkans, an area populated then as now by peoples of widely differing ethnic and cultural backgrounds. Outside the Greek colonies of the Black Sea coast and the cities along the northern fringes of mainland Greece itself this was a relatively backward area, with no previous tradition of monumental architecture. Along the upper and middle Danube, in the provinces of Noricum, Pannonia, and Moesia, the architecture of the Roman age was essentially a provincial derivative of that of northern Italy, developed under the strong influence of the great legionary fortresses and of the civil settlements that grew up beside them. Along the lower Danube, in Lower Moesia and northern Thrace, the army was still an important factor, but here, apart from the curious island of Latin speech which still persists in the modern Rumania, the classical background was Greek. The eastern shores of the Adriatic were another provincial extension of Italy, this time, however, with fewer military overtones. The one region which, to judge from the vigour of its native pre-Roman culture, might have thrown up a Romano-provincial civilization with a distinctive personality of its own was the trans-Danubian province of Dacia, but here Roman rule was too short-lived for its results to come to full fruition. Over most of the area the surviving monuments are few, and it will here be possible to refer to a few only of the more important sites and buildings.

Within the area of the upper Danube basin the earliest stages of romanization are graphically illustrated by the recent excavations on the Magdalensberg, ten miles northeast of Klagenfurt, in Carinthia,[26] the hilltop fortress capital of the pre-Roman kingdom

of Noricum and the first capital of the Roman province. The forum is a long, narrow open space terraced into the steep southern slopes near the brow of the hill (Plate 190). Here, scratched on the plastered walls of the pre-conquest buildings, one can see the records of the Italian traders from Aquileia and the south whose activities did much to pave the way for the formal annexation of the kingdom in 15 B.C. Adjoining the forum are a well equipped bath-building; a complex with an audience hall heated in the Roman manner, which appears to have been the meeting-place of the provincial assembly; and the porticoed precinct and substructures of a large prostyle tetrastyle temple, built in part of white marble from the recently opened quarries on the Drau just above Villach. The temple was still under construction when, in A.D. 45, the town was abandoned in favour of the more convenient site of Virunum on the plain below. The forum of Virunum followed more conventional lines; it was a large rectangular enclosure of which the western part was occupied by the porticoed precinct of an official temple, the eastern half by a porticoed piazza with a long, narrow basilica at the east end, and the other two sides by ranges of small halls – a layout closely comparable to that of Augusta Raurica.

The Magdalensberg and Virunum lay in long-settled country just across the border from Italy. Over most of this region the decisive event was the advance of the Roman army to the Danube. As happened everywhere along the northern frontiers, from the Atlantic to the Black Sea, the legionary and auxiliary fortresses were the inevitable focus of the local economy, and alongside them grew up the civil settlements which in the second and third centuries were to become the established social and cultural centres of provincial life. Two of these frontier towns have been systematically excavated, Aquincum, just above Budapest, and Carnuntum, 25 miles below Vienna. The patterns are broadly similar – a loose, near-rectangular network of paved streets separating rather large insulae, some neatly divided into long narrow plots, others bearing evident traces of development over a considerable period of time. Only in the centre was space at a premium, and even here there is little or no trace of any tall building. The third-century houses were solidly built, single-storeyed structures of stone and timber, a recurrent type having the living rooms opening off a central corridor behind a wide timber porch. The standards of comfort and decoration derive from Rome: window-glass, painted wall-plaster and moulded stucco, an occasional floor mosaic, and regularly one room with central heating; but apart from a single peristyle-house at Aquincum and near it a market building of Italian type, with shops around the four sides of a rectangular porticoed courtyard (and of course such direct importations as aqueducts, bath-buildings, and amphitheatres), there is surprisingly little evidence of the influence of Mediterranean building types. This was in every sense of the word a thoroughly provincial architecture.

Two buildings call for brief individual mention. One is the civil amphitheatre at Carnuntum, the extraordinarily irregular plan of which must be due to the piecemeal replacement in masonry of what was originally an all-timber structure. The other is identified as the palace of the provincial governor at Aquincum.[27] It was a rectangular, courtyard building, with round towers at the angles of the main, east façade (Figure 141).

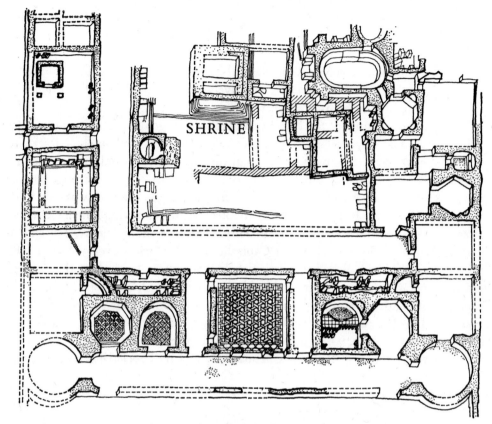

Figure 141. Aquincum, ceremonial wing of the Governor's Palace. Ascribed to the early second century. Plan

Along the north side of the courtyard lay the private residence and bath-building, along the south side storerooms and workshops, and in the centre a small prostyle classical temple for the imperial cult. The mosaic-paved state rooms opened off a corridor that ran the full length of the east front, with in the centre a square audience hall and, to right and left, symmetrical suites of heated rooms, each with an attached latrine. There are obvious affinities here with later palace design, a tradition which the residences of the Roman officials in the provinces must have done much to shape.

Along the lower Danube Roman authority was not fully established until the campaigns of Trajan in the early second century. The only significant pre-Roman building tradition was that of the old Greek colonies of the Black Sea coast, and it is no surprise therefore to find that the dominant innovation of the Roman period is a 'marble style' architecture of typically second-century Asia Minor type.[28] Geography and long-established commercial ties ensured that the formative architectural contacts should all lie with Asia Minor and the Aegean. The marble came from the quarries of Proconnesus (Marmara); and the carving of capitals and other architectural members, freely copied in the excellent local limestones, is indistinguishable from that of Bithynia – or indeed of Pamphylia, or Tripolitania. Another significant link with the same architectural school

is the occasional use of a rubble-concrete masonry faced with courses of small squared blocks of stone and laced with bands of coursed brick, notably in a Severan bath-building at Histria and in a fine harbourside warehouse-building, also Severan, at Costanza (Tomis). For all practical purposes the classical architecture of this region right down into Byzantine times may be regarded as a lively provincial outlier of the region of which Constantinople is the natural centre.

The Roman architecture of the Illyrian coast reflects its geographical position no less clearly. There is a persistent substratum of provincial late Greek building practice, represented by the frequent remains of pre-Roman fortification walls and, more generally, by a fine tradition of cut-stone masonry. As one would expect, this is strongest as one approaches the modern Albania and the Greek frontier. Upon this basis was established a pattern of small-town Roman municipal architecture, the surviving remains of which indicate a close dependence upon North Italy. Towards the north-western end, in Liburnia, Aenona (Nin) has yielded a Capitolium with tripartite cella, Asseria (near Benkovac) a handsome, elaborately articulated, Trajanic archway-gate (Figure 142) and a rectangular, porticoed forum with a long, narrow, aisleless basilica, and Zadar (Roman Iader) a forum complex with a free-standing temple, transverse street, and two-storeyed porticoes, all very reminiscent of the forum at Augusta Raurica.[29] The remains of Roman Salona, which include an amphitheatre and a large bath-building, are overshadowed by those of the later, Christian city and by Diocletian's residence near

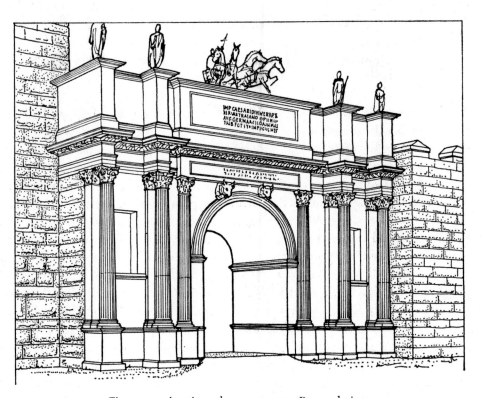

Figure 142. Asseria, archway-gate, 112. Restored view

by at Split (Spalato). The most distinctive of the earlier buildings is a peristyle, tetra-style temple, the plan and ornament of which bears a significantly close resemblance to those of the Augustan temple at Pola.

The best preserved and best recorded remains from the south-eastern part of the territory are those of Doclea in Montenegro, near the Albanian frontier. These include a temple of Diana, distyle *in antis* against the rear wall of a square, porticoed enclosure; a second temple, very similar but smaller and free-standing; a large public bath-building, of rectilinear design throughout except for one or two apsidal exedrae; a peristyle-house; and a forum and basilica (Figure 143) laid out in accordance with the familiar

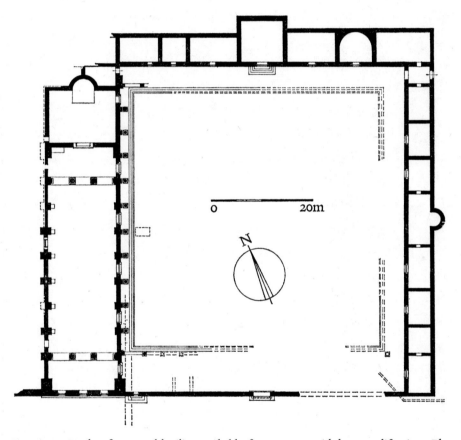

Figure 143. Doclea, forum and basilica, probably first century, with later modifications. Plan

North Italian pattern. The basilica is remarkable for the use of arcading in place of the flat architraves of normal classical practice in the two transverse screens, an anticipation of the monumental use of this feature both in Spalato and (if the Doclea building is rightly dated to the early second century) in the Severan buildings at Lepcis Magna.[30] The masonry of the Doclea buildings is characteristic of this whole region, alternating dressed local stone (and some imported marble) with the coursed, mortared rubble-work faced with small squared blocks of stone which seems everywhere to have been

the local equivalent of the Roman opus reticulatum and brick-faced concretes, and which in this case derives presumably from North Italy. The buildings were mostly timber-roofed; but just across the border of Albania, at Butrinto (Roman Buthrotum), there is a shrine of Aesculapius with a vault of radially laid bricks, which must in the context reflect the influence of Asia Minor and of northern Greece.

CHAPTER 16

GREECE

Corinth

ROMAN GREECE was a poor country, rich only in the memories of its own glorious past. Architecturally its principal resources were its splendid building materials and its fine traditions of craftsmanship, both in the handling of masonry and in the carving of architectural ornament. Philhellene sentiment found sporadic outlet in the endowment of Athens with some handsome new buildings. But for the rest it would almost certainly be true to say that in Roman times the architectural significance of Greece was felt as much outside its own boundaries as within them. One cannot, however, for that reason disregard the architecture of Roman Greece altogether. Not only was classical Greece the ultimate source of a great deal that was still vital to the architecture of the West, but also it was still a source of contemporary inspiration; and the very fact that the native tradition had long ago lost its own initial impulse makes it easier here than in any other part of the hellenic world to detect the currents that were beginning to flow in the other direction, from west to east, and to distinguish between those elements in the contemporary architectural scene that were little more than the conventional repetition of traditional lessons and those that were new and charged with significance for the future.

For a representative picture of Roman building outside Athens we are fortunate in possessing an unusually full and carefully documented picture of the heart of Corinth, the capital of the province of Achaea (southern Greece).[1] Corinth, sacked and ruthlessly depopulated by Mummius in 146 B.C., had been refounded in 44 B.C. The period immediately following its refoundation was not one for ambitious building schemes, and the original colonists seem to have been content with re-establishing the agora (the Greek equivalent of the Roman forum) on its old site and with refurbishing the few earlier buildings that were still standing, notably the main sanctuaries and the great fourth-century South Stoa. It was only under Augustus that the city centre began to take on a more distinctive shape; and since, thanks to the skill of its American excavators, we can follow most of the essential features of its subsequent development, it is worth describing in some detail, not only as a representative cross-section of the architecture of Roman Greece, but also as a typical example of the sort of processes of growth and adjustment which lie behind the seeming monumental unity of so many of the complexes of provincial Roman architecture that have come down to us in other provinces.

In hellenistic times the agora had been an irregularly shaped open space, some 500 feet in length, delimited on the south long side by the great South Stoa and on the north side by the Fountain of Peirene and by a second but smaller stoa, the North-west Stoa, built up against the steeply scarped slopes of the hill that carried the Temple of

369

Apollo. It was traversed obliquely by the line of the road from Kenchreai to the port of Lechaion, and across the west end, terraced above it, ran the Sikyon road. The first act of the new settlers was to rehabilitate the two stoas and the fountain, the town's chief water-supply; and, in place of the characteristically Greek informality of the gently sloping central area, to divide the site into two level terraces, of which the upper one seems from the outset to have been intended primarily to serve the administrative requirements of the provincial capital, leaving the lower one free for the ordinary day-to-day business of the city. As was the normal practice, the agora was closed to traffic. Its principal entry lay up steps from the Lechaion road.

The subsequent development of the site (Figure 144) took place by stages. The reign of Augustus saw the first monumental layout of the Lechaion road and the adjoining basilica; the building of the Temple of Hermes (D) and the Pantheon (G), the first two of six temples which by A.D. 200 formed an almost continuous row across the west end of the lower agora; the addition of a new and more ambitious façade to the Fountain of Peirene; and the beginning of the rebuilding of the South Stoa and the addition to it

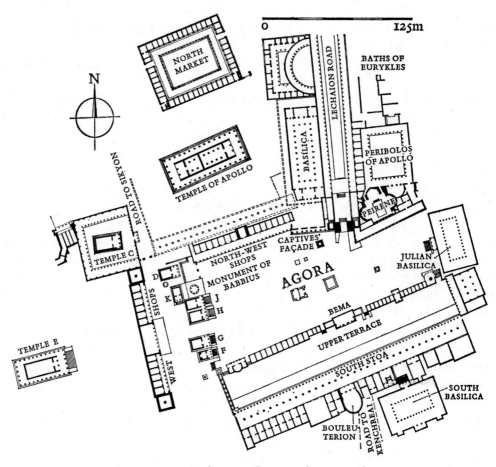

Figure 144. Corinth, agora, first–second century. Plan

of the first of a long series of administrative buildings. The immediate successors of Augustus, Claudius in particular, were no less active. To this period belong the establishment of colonnades on either side of the Lechaion road; the building of the Julian Basilica, closing the east end of the lower agora, and the South Basilica and the bouleuterion, both opening off the South Stoa; the establishment of a row of shops along the front of the terrace between the upper and the lower agora, with a monumental tribunal, or *bema*, in the centre, serving as an official platform for the appearance of the governor; the addition of one new temple (F) and the rebuilding of another (G) along the western terrace; and, dominating the whole from the higher ground to the west, a large temple (E) which is probably to be identified as the Capitolium. In front of this last building, forming a low façade to the temple precinct, was a row of shops (the West Shops) symmetrically disposed about a central propylon. To the same Early Imperial phase of building activity belong the Roman theatre (on the site of its Greek predecessor) and, just to the north of the Temple of Apollo, a market building in the form of a rectangular peristyle enclosure with some forty shops opening off its four inner porticoes.

Most of this building was done in the local limestone (*poros*) and faced with fine stucco, which as late as the middle of the first century A.D. were still the normal monumental building materials at Corinth. There were, however, already significant signs of change. The Temple of Tyche (F), a handsome tetrastyle Ionic building, and the monument of Cnaeus Babbius Philinas, a circular octastyle tempietto with a low conical roof, both date from the reign of Tiberius and both make liberal use of a blue marble and of white Attic marble for the finer work, the detail of the ornament in both cases clearly revealing the influence of the classical buildings of Athens, notably of the Erechtheion. A few years later the Pantheon (G) was rebuilt wholly or partly in Attic marble. The bema is another structure of which the marble detail harks back to earlier Attic models.

Under the Flavian emperors there was a decided change. The year 77 was marked by a serious earthquake, which badly damaged many of the older buildings. In the subsequent rebuilding of the city centre, marble was the material used regularly for the orders, for the facing of wall-surfaces, and for all decorative detail. To this phase belong the rebuilding and enlargement of the basilica beside the Lechaion road, of the colonnades of the road itself, of the shops and of the peristyle courtyard (the 'Peribolos of Apollo') across the street from the basilica, and of the monumental archway at the point where it entered the agora; the replacement of the old North-west Stoa by a line of concrete-vaulted shops; the rebuilding in marble of the Capitolium and of the pronaos of the Temple of Hermes (D); the building of a large new temple (C) and its enclosing colonnaded precinct beside the Sikyon road, just above the historic fountain of Glauke; and the building, near the theatre, of an odeion, or covered concert hall. Towards the middle of the second century the irregular layout of the north side of the lower agora was tidied up by the addition of an elaborate columnar façade (the Captives' Façade) linking the North-west Shops to the propylaea; a large bath-building and latrine were built beside the Lechaion road, north of the Peribolos of Apollo; more public

offices and a lavatory were added to the South Stoa; and the Fountain of Peirene was remodelled by the addition to the courtyard of three great concrete-vaulted exedrae with elaborate marble facings. This last was done on the orders of the Attic millionaire and benefactor Herodes Atticus, who some years later (*c.* 175) also rebuilt the odeion. The last two decades of the century saw the line of temples at the west end of the lower agora completed by the addition of twin temples (H and J), dedicated respectively to the emperor Commodus, personified as Hercules, and to Poseidon.

By the year 200, then, not long after the Greek traveller and writer Pausanias visited Corinth and described its monuments, the centre of the city had assumed substantially the form which it was to retain with only minor alterations throughout the later Empire. The processes of building and rebuilding that have just been described are exceptional only in the detail in which they can be documented. The same sort of thing was happening in innumerable cities, large and small, up and down the length of the Empire. We shall be glancing at another, Lepcis Magna in North Africa, in a later chapter.[2] If the Roman agora at Corinth had a certain logic and coherence, it was because, despite all changes of materials, style, and architectural usage, the original plan was soundly conceived, and because the successive additions to it were all made within the framework of a single developing, but fundamentally conservative, tradition.

The basis of this tradition was Greek. We see this in the building materials and techniques. Concrete makes only a limited and grudging appearance, and then chiefly in contexts which more or less directly derive from Late Republican and Early Imperial Italy – in the cores of the temple podia, in the substructures of the theatre and odeion, in the vaulting of the North-west Shops and of Herodes Atticus's additions to Peirene, and in the second-century Baths of Eurykles. We see it again in the decorative detail and in the continued use, throughout the first century, of the Ionic and of an evolved Doric order, with direct Attic influence still clearly manifest. Above all we see the native Greek heritage in the planning, orderly but flexible, balanced but never giving way to the demands of an over-rigid symmetry. The organization of the commercial quarters in particular is characteristically Greek. The formal grouping of the shops in orderly units stems straight from the tradition of the great hellenistic stoas. This is neither the dense concentration of the bazaar quarters of the Orient (as we see it, for example, at Dura, in Syria),[3] nor the haphazard mingling of shops and houses characteristic of so much of Pompeii, of Ostia, and (as we know from the Severan marble plan) of Rome itself. It is true that Italy too had its formal market buildings, comparable to those of the North Market at Corinth; but in view of the early and widespread distribution of such market buildings in Campania and in Magna Graecia (Pompeii, Pozzuoli, and Morgantina), it is tempting to regard these as a hellenistic Greek or South Italian, rather than a specifically Republican Roman, development. The Market of Caesar and Augustus at Athens offers an earlier parallel in Greece itself.[4]

There were, of course, elements intrusive to this native tradition. Some of these are demonstrably derived from Central Italy and from Campania. Reticulate masonry, a rarity in Greece, appears in a mausoleum beside the Kenchreai road. The limited use of concrete has already been noted. Italian precedents presumably determined the use of the

Tuscan order in the original poros temple of Hermes, as well as the form of the Augustan façade of Peirene, with its engaged Doric order framing a row of arches and carrying an engaged upper, Ionic order. More generally one can detect the influence of Rome in the paving of the agora in marble[5] and in the predominance of certain stereotyped architectural forms, such as that of the temple set on a tall podium, with steps on the front only, instead of the uniformly-stepped *krepis* of the ordinary Greek temple – contrasting types of which the Temple of Tyche offers an early and rare conflation. To the same category of Roman architectural innovations one may assign the several bath-buildings, one of the most popular and widespread of Western importations to the hellenistic East, and the as yet unexplored, third-century (?) amphitheatre, a type of building which was, by contrast, always something of a rarity in the Greek-speaking world.

Two of these typically Roman building types, the basilica and the theatre, are worth describing and discussing in rather greater detail. Although the actual remains of these buildings are not particularly well preserved at Corinth, the archaeological documentation is unusually clear. Their architectural history will serve to illustrate many features that are liable to recur wherever buildings of this sort are found in the eastern half of the Empire.

Of the two, the basilica is in the context the less important, since such buildings were never common in the Roman East.[6] The fact that Corinth possesses no less than three is as clear evidence as one could wish of the strength of the Italian influences at work under the Early Empire. The earliest and architecturally the most important of the three is that built towards the end of the first century B.C. beside the Lechaion road. The elongated plan (Figure 144), with its ambulatory colonnade and its entrance and tribunal at the two ends of the long axis, clearly relates it to the basilica at Pompeii and no less clearly distinguishes it from the contemporary basilicas of Rome and Central Italy, which were regularly laid out parallel to, and in very close association with, the adjoining forum. The latter was the disposition adopted by the basilicas of Smyrna, of Berytus in Syria, and of Cyrene, in all of which the façade towards the adjoining open space consists, in the Roman manner, of a colonnade. In this respect (as indeed in a great many others) it was the stoa that was the normal East Roman equivalent of the Western basilica. The Lechaion road building is of interest, therefore, as illustrating the very close links that united the newly refounded city with Campania and southern Italy. This type of basilica seems, on the other hand, to have had little influence on later architecture elsewhere in the Roman East. At Corinth itself two more basilicas were added some fifty years after the first, both of which adopt the commoner transverse layout. Since, however, they differ markedly from those of the capital in being architecturally independent entities, accessible only up a tall flight of steps and through a single door, they may perhaps be regarded as somewhat eccentric local variants of the parent type.

The Roman theatre at Corinth occupied the same naturally sloping site as its Greek predecessor, but unlike, for example, that of Roman Ephesus it was a completely new building. The superimposition of the two structures does, however, serve to illustrate some of the main differences between the Greek and the Roman theatre. These

differences were well summarized by Vitruvius, writing in the twenties of the first century B.C.; and although in practice often obscured by the historical development of the Roman from the hellenistic theatre and, particularly in the Greek-speaking part of the Empire, by the subsequent interaction of the Roman and native traditions, they are in fact clear enough in their broad outlines (Figure 145).

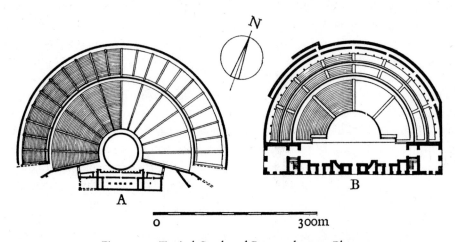

Figure 145. Typical Greek and Roman theatres. Plans

(A) Epidaurus, mid fourth century B.C.
(B) Orange (Arausio), first century

One of the basic differences between the Greek and the Roman theatres lay in the relationship between the seating and the stage-building. In the former the 'orchestra' still retained its originally circular shape, except for that part of it which was occupied by the stage, and the seating (*koilon*, Latin *cavea*) enclosed substantially more than half of the circle so described; the two lateral entrances to the orchestra (*parodoi*) were open passages and met at an obtuse angle, separating the seating from the stage-building. In the Roman theatre orchestra and seating were both semicircular, and the parodoi, now vaulted and known as *confornicationes*, faced each other directly across the front of the stage and carried a rectilinear extension of the seating across to meet the two lateral projections of the stage-building. This important development had already taken place when the Large Theatre at Pompeii was rebuilt, soon after 80 B.C., and thereafter in the typical Roman theatre stage and seating were part of a single, organically planned structure, enclosed within a single continuous perimeter.[7]

A second and hardly less fundamental difference between the Greek and the Roman theatre lay in the size and elaboration of the stage-building. There is much that is still controversial about the exact nature and chronology of the transition from one to the other; but since on any reckoning this took place in Republican times, it need not here be discussed further, beyond remarking that the context of the development was one that was not limited to Italy but was widely manifest also in the late hellenistic architecture of the eastern Mediterranean. This is an important reservation when one comes to consider the impact of the Roman theatre on the provinces of the Roman East; but

even if it means that the Roman contribution consisted primarily in giving formal shape and direction to tendencies that were in themselves of considerably wider application, there can be no doubt of the distinctively and unmistakably Roman character of the finished product. The classical Greek and earlier hellenistic theatres had seen the introduction of substantial stage-buildings, but these were independent structures, consisting essentially of a rectangular building (*skene*, Latin *scaena*) placed tangentially to the theoretical circumference of the orchestra; in front of it, projecting forward from the scaena between two rectangular wings (*paraskenia*), was the stage itself, upon which part, but part only, of the action took place. Now, in the Roman version, besides the linking of the stage-building to the cavea, the stage itself (*pulpitum*) was deepened so as to accommodate the entire action; the façade of the stage-building (*scaenae frons*) was heightened and given an elaborately articulated decoration of superimposed columnar orders framing three symmetrically placed doorways; and the whole stage was covered with a timber roof, which sloped forwards and upwards from the summit of the scaenae frons and was supported at either end by the parascaenia. The formula was in detail capable of widely varying interpretation; but a glance at the three best preserved of the innumerable theatres of the Roman world, at Orange (Figure 145B), at Aspendos (Plate 210), and at Sabratha (Plate 250), will suffice to show that these were variations on a single, immediately recognizable theme. Another feature that distinguishes the Greek from the Roman theatre is the provision of shelter for the audience between performances, or in the case of rain. In the Greek theatre this novelty took the form of a separate building (e.g. the Stoa of Eumenes at Athens). In the Roman theatre colonnades were very commonly incorporated as organic elements of the design, in the shape either of a roofed ambulatory round the top of the cavea (Plate 210) or of a colonnaded court behind the scaena (Figure 107), or both (e.g. Figure 175A).

The subsequent evolution of the Roman theatre, though in detail complex, is in its broad outlines simple enough. It may be said to develop along two main lines, both of which are well illustrated by the remains at Corinth.

Formally it was the stage-building that was the centre of architectural interest. In this respect it is customary to classify the stage-buildings of the Roman world as belonging to an 'Eastern' or to a 'Western' group, of which the former is distinguished by its continued emphasis upon the actual façade of the stage-building, articulated about its three monumental entrances and variously enriched with columnar aediculae or continuous orders, whereas the latter is developed in depth, with an elaborate alternation of re-entrant and projecting features, which tends increasingly to throw emphasis upon the decorative screen at the expense of the wall behind it. The choice of terms to indicate this difference is not a happy one, since (to quote only the most glaring exception) the theatres of Roman Syria are almost exclusively of the so-called 'Western' type. Provided, however, that one makes full allowance for the complex interaction of what were, after all, two closely related and continuously developing branches of a single tradition, the classification itself, which is well exemplified in the difference between the theatres of Aspendos and of Sabratha, is sound enough. The distinction seems to lie between those provinces (Greece and Asia Minor) which had a long and essentially

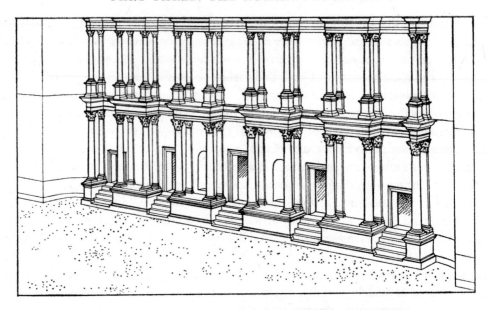

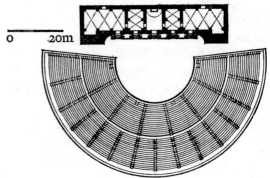

0 20m

Figure 146. Stobi, theatre,
second century. Elevation
and plan

Greek theatrical tradition of their own, and those which derived their theatrical architecture mainly from southern Italy and from Rome. In this respect the theatre at Corinth
clearly reflects its many western contacts. The remains of the Augustan stage-building
are rather scanty, but the form of the second-century marble scaenae frons can be
reconstructed almost in its entirety. With its three deep, curved re-entrants, framing in
reverse a pair of apsidal exedrae that open off the portico beyond, the stage-building
is little more than a slender supporting background for the columnar screen. At the
other end of the scale stands the approximately contemporary (Hadrianic) but in many
respects extremely conservative theatre at Stobi in Macedonia (Figure 146).[8] Here not
only does the seating occupy a segment of well over 180 degrees, in the Greek manner,
but it is still separated by open parodoi from the stage-building, and the façade of the
latter consists of little more than a straight wall with five equally spaced doors framed
between a uniform series of simple bi-columnar aediculae.

The other principal line of development within the Roman period was one of function. The standards of theatrical spectacle were everywhere declining. Already in the

first century there are literary references to the staging of gladiatorial contests in theatres, and during the second and third centuries a great many theatres were in fact adapted to serve these and similar purposes, particularly in the eastern half of the Empire, where amphitheatres were exceptional. At Corinth the adaptation dates from the early third century and took the form of cutting back the stage and the front rows of seating to form an arena, with a high surrounding wall to protect the spectators and with openings for the introduction of the wild beasts used in the ever-popular hunting displays. Another and unusually well preserved example of such a transformation can be seen at Cyrene. The Hadrianic theatre at Stobi, referred to in the previous paragraph, was actually built to serve the double purpose, with an arena which could, when required, be converted by the addition of a temporary wooden stage. This tendency was not confined to the East. At the other end of the Roman world small theatre-amphitheatres are characteristic also of the remoter parts of Belgic Gaul and of Britain.[9]

Later again, the arena of Corinth was converted into a tank for aquatic displays. The practice is thought to have originated in the East, where there is evidence for some such installation at Daphni, the fashionable suburb of Antioch, as early as the beginning of the second century. It achieved widespread popularity – and notoriety – in late antiquity. The theatre at Ostia is one of many that were converted to such purposes. The well-known 'bikini' girls of the Piazza Armerina mosaics presumably represent performers.

For more cultured tastes there were still the small covered theatres, or *odeia*, which were used for readings, lectures, and concerts, and which were commonly, as at Corinth, closely linked architecturally with their larger neighbours of conventional, open design – at Athens, for example, at Naples and Pompeii, at Lyon (Plate 182), at Vienne, and at Syllion in Pamphylia. In plan many of these odeia (e.g. in Greece at Nicopolis and at Buthrotum) were simply theatres in miniature; in others, as at Pompeii, at Epidauros, and at Termessos in Asia Minor, the curved seating was enclosed within a rectangular outer wall, which carried the roof. This latter form closely resembles, and may well derive from, such hellenistic buildings as the *bouleuterion*, or council hall, of Miletus (at Gortyna in Crete a circular bouleuterion was in fact converted into an odeion). Limitations of size alone prevented the roofed rectangular form from being more widely adopted in northern climates, as it was at Aosta (Figure 116). On the other hand convention must have dictated the rectangular plan of the Odeion of Herodes Atticus at Athens, which is too large to have been roofed. Herodes Atticus was responsible also for rebuilding the odeion at Corinth. This was a building of ordinary theatrical shape, seating some 3,000 spectators. As was customary in odeia, the stage-building was of a simple, severely rectangular design. After a fire in the early third century it, too, was converted into a miniature arena.

To conclude this picture of the monuments of Roman Corinth, it may be noted that the external influences, though predominantly Italian, did not all come from the West. The formal colonnading of the Lechaion road early in the first century A.D. almost certainly reflects the city's commercial activities in the Levant. By the second and third centuries this striking architectural form had become almost as common in Asia Minor as it was in Syria, but at this early date it was only in the cities of coastal Syria that one

would have found the necessary models. The flourishing architecture of Roman Asia Minor does in fact seem to have had surprisingly little impact upon that of Corinth. A possible exception is the Captives' Façade, a scenic columnar façade which was designed to bridge an awkward hiatus in the northern frontage of the lower agora, and which may have served as a background for dramatic performances in the agora.[10] Even in this instance, however, the fact that four of the columns of the upper façade were replaced by caryatid figures, a recurrent and typically Attic motif, suggests that the immediate inspiration may have lain nearer home, and only at second-hand in the cities of western Asia Minor, where this type of decorative columnar screen was first developed.

Athens

It was in such relatively new foundations, or refoundations, as Corinth that the springs of provincial life still flowed. Athens by contrast was a backwater. She had suffered grievously in the sack of 86 B.C. and during the Civil Wars, and did not revive fully until the time of Hadrian.[11] Moreover, even had she wished to do so, she could never escape from the shadow of her own rich past. Students from all over the Roman world might flock to her university; philhellene emperors and private citizens might endow her with new and splendid buildings; but there were no living traditions other than those of an ever-lively intellectual curiosity and of a craftsmanship which was equally at home in moving a venerable monument, block by block, from one site to another, in turning out reproductions of old masters or decorative sculpture in the classical manner, or in producing the magnificent (and within its limited range strikingly original) series of Attic figured sarcophagi.

Against such a background of impoverished versatility it is not altogether surprising that the monuments of Roman Athens should present a bewildering variety of faces. If we except the activities of such Roman architects as the Marcus Cossutius who was called in when Antiochus Epiphanes between 174 and 164 B.C. undertook the construction of the Olympieion, the great Temple of Olympian Zeus, the Roman series begins, characteristically, with the munificence of a Roman private citizen, Appius Claudius Pulcher, friend and correspondent of Cicero, who between 50 and 48 B.C. gave money for the building of the Inner Propylaea at the sanctuary of Eleusis. This, with its mixed Doric and Ionic order, its beautifully carved, figured Corinthian capitals (Plate 193), and, on the inner face, its caryatid maidens copied from those of the Erechtheion, was a little masterpiece of inventive eclecticism. Roughly contemporary (the exact date is disputed) is the 'Tower of the Winds' (Plate 197), the elegant octagonal monument built to house the water-clock of Andronicus of Cyrrhus, the graceful lotus-and-acanthus capitals of which were copied and re-copied right through Christian times and survived to inspire a further long series of copies in neo-classical England and Scotland.[12] To the same genre of monuments belonged the little Temple of Rome and Augustus on the acropolis. This was a small circular building, little more than a tempietto, and it too drew freely on the decorative detail of the Erechtheion. The extraordinary influence of

the latter building upon the architectural ornament of the Augustan Age may in part be explained by the fact that it had recently had to undergo a substantial restoration after a fire. Its ornament was part of the repertory familiar to the Attic craftsmen of the day.

Beside these buildings, which illustrate the characteristically Attic mixture of anti-quarianism and inventiveness at its best, the Market of Caesar and Augustus was a decidedly prosaic building.[13] Built from money given by Julius Caesar and Augustus and dedicated between 12 and 2 B.C., it consisted of a paved rectangular piazza, some 270 by 225 feet (82 by 69 m.), enclosed on all four sides by Ionic porticoes, of which those along the two shorter sides housed shops, as at Corinth, whereas along the two longer sides the porticoes were double and were presumably designed to shelter tem-porary stalls. The main entrance, off-axis on the short, west side, faced the agora, and consisted of a conventional Doric tetrastyle propylon, much of the detail of which was obviously inspired by fifth-century classical models. From this, and from the use of certain archaizing structural devices, it seems very likely that some of the workmen had been employed in transporting and reassembling on a new site in the Agora the fifth-century B.C. Temple of Ares from Acharnai in northern Attica. There are at least two other well attested examples of this practice about this date, elements of the temples of Athena at Sounion and of Demeter at Thorikos being used for making the porches of new temples in the Agora.[14] Nothing could better illustrate the cult of the classical in Athens of the Early Roman period, or the economies to which the city was driven by its poverty.

Unquestionably the most original and important monument of the Augustan period was the great odeion built as an adjunct to the Gymnasium of Ptolemy by Agrippa, about 15 B.C., on a dominating site in the middle of the south side of the agora, over-looking the Panathenaic Way (Figure 147).[15] From the outside it consisted essentially of a lofty rectangular, gabled hall, towering above the sloping roof of a concentric outer structure, of which three sides were occupied by an outward-facing gallery and the fourth, towards the north and at a lower level owing to the slope of the ground, by the rectangular stage-building. The main entrance to the seating and to the gallery lay at the south end, at gallery level; a small porch in the middle of the north side gave inde-pendent access to the stage-building. Except for a shallow lobby at the south end the entire central structure was occupied by the seating and stage of the lecture hall, which was almost exactly square (82 feet; 25 m.) and only very slightly less (76 feet; 23 m.) from orchestra to ceiling. The stage was narrow and severely rectilinear, and the orchestra and seating gently segmental in plan, the latter being pitched at an unusually shallow angle so that the back row fell level with the floor of the lobby and the outer gallery. When full it seated about 1,000 spectators. Except for whatever statuary there may have been and for the painted stucco of the walls, decoration seems to have been concentrated on the stage front and orchestra, both of which were elaborately treated in polychrome marble; the carved ornament of the former once again reflects the classi-cizing tastes of the day, being copied straight from fifth-century models.

Above the level of the gallery roof the walls of the odeion were treated, both

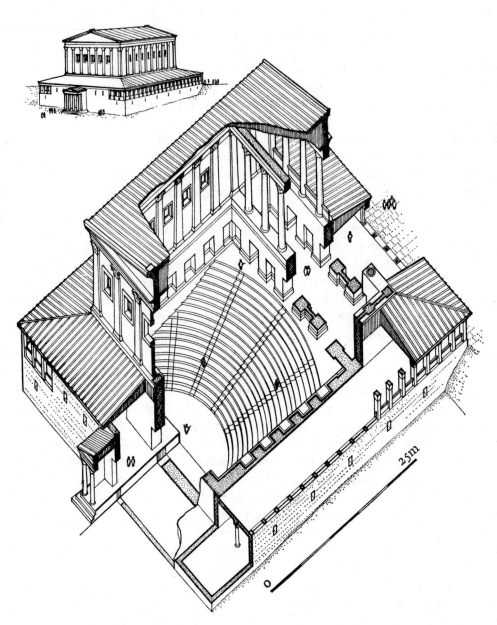

Figure 147. Athens, Odeion of Agrippa, *c.* 15 B.C. Elevation and axonometric view

internally and externally, as an almost independent structure. Along three sides the roof was carried on a series of massive rectangular piers, which projected inwards and outwards from a comparatively thin curtain wall to form the pilasters of a Corinthian order, eight along the north façade and ten along the east and west sides. Along the south façade and above the partition wall between hall and lobby there were, instead, open colonnades, each consisting of six columns placed between the two corresponding piers of the outer walls; the capitals of the outer colonnade were Corinthian (Plate 192), those of the inner colonnade of the same lotus-and-acanthus form as those of the Tower of the Winds. There were presumably rectangular windows in the curtain wall between the pilasters, but the bulk of the light came, most effectively, from behind and above the spectators, through the colonnades and so forwards and downwards towards the stage.

Although completely out of scale with its setting, this was by any standards an impressive building, and to the Athenians who watched it going up there was much about it that must have seemed very strange. The workmanship and detail were unmistakably Attic, but for the building itself there were no local precedents. The restoration of the historic Odeion of Perikles some fifty years earlier [16] had been carried out on traditional lines; and although we know all too little about it, we do know that it was notoriously bad for vision on account of the many supports for its tent-like roof. Agrippa's Odeion did have a great deal in common with a building such as the bouleuterion at Miletus, notably in its division both internally and externally into two storeys and in its detailed treatment of the upper storey; but even at Miletus the roof was supported by uprights, with an open central span of only 50 feet. The only comparable buildings at this date were in Italy. In particular, the Covered Theatre at Pompeii, with a span of 90 feet (27·60 m.), offers so many points of resemblance that it is hard to believe that the architect of Agrippa's Odeion did not have it, or some building very much like it, in mind when planning his own building. Another Italian building with which the odeion presents a certain analogy is the Basilica Aemilia, with its external galleries that seem to have been designed primarily for the viewing of spectacles in the adjoining forum. The siting, too, a dominating mass set axially at one end of a large open space, follows a typically Italian pattern and one that had few, if any, precedents among the more freely grouped monuments of classical and hellenistic Greece. The elaborate use of polychrome marbling is yet another detail that suggests contemporary Western influence. Together, these indications constitute a powerful case for regarding the Odeion of Agrippa as, in essence, an Italian building planted on Greek soil.

In an earlier chapter [17] we have already noted the many motifs in the architectural ornament of Augustan Rome which appear to be derived directly from Attica, motifs which include not only revivals from the great monuments of the past, notably from the Erechtheion, but also derivations from such near-contemporary masterpieces as the figured capitals of Eleusis. The fact that a few years earlier Agrippa had been intimately concerned with the largest building project of contemporary Athens does much to explain this phenomenon and indicates how readily men and ideas were passing between the two cities. It also shows that this was a two-way traffic. The flow of materials and craftsmanship from east to west was matched by a flow of architectural ideas from

west to east. It is the former of which the results are the more immediately distinctive and which tend, therefore, to attract more notice. It is the latter, on the other hand, which were the more important in the long run, and which constitute the essential element in the romanization of the architecture of the hellenistic East.

During the greater part of the first century A.D. there was little building of importance in Athens. The only substantial exception was the rebuilding of the Theatre of Dionysus under Nero, between 54 and 61. The form of the seating was left untouched on this occasion; and although the stage-building was modernized, this seems to have been on very conservative, strictly rectilinear lines, the scaenae frons probably closely resembling that of the theatre at Stobi (Figure 146).

The second and early third centuries were, by contrast, a period of relative prosperity, a prosperity to which the exportation of fine building materials and Attic architectural craftsmanship continued to make an important contribution. To the resulting urban expansion Hadrian gave shape by building an aqueduct and formally adding a whole new quarter to the east of the old city. The many remains of private houses, bath-buildings, and gymnasia that have been recorded in this area show that Hadrian's was no mere empty gesture. The principal monument within it was the Olympieion, which was now finally completed and dedicated in 132, some 700 years after the project was first conceived by Peisistratus and 300 after it was redesigned by Cossutius on lines that were followed with very little change in the finished building. In the ancient world such projects, if they were not brought rapidly to completion, were apt to hang fire, sometimes for decades, sometimes for centuries (one recalls the Didymaion near Miletus, begun by Alexander the Great and finally completed by Caligula), and they must have been an important factor in ensuring the continued vitality of traditional building practices and motifs.

The other surviving early-second-century monument of the new quarter, the arch which divided the new from the old city (Plate 195),[18] is one of those singular creations which do not fit neatly into any category. A product of much the same mixture of conservative taste and intellectual curiosity as is embodied in the Inner Propylaea at Eleusis, its curious proportions do not make sense until one restores to it mentally, not only the statues which stood within the rectangular framework of the upper order and on the two free ends, but also the strong vertical accent of the columns that flanked the archway, standing on independent pedestals and bracketed out from the entablature, in obvious imitation of those of the façade of Hadrian's Library (Plate 194). The scheme is then revealed as an elaborate interplay between two superimposed architectural schemes, on the one hand the projecting columns, which are made to seem to carry the architectural framework of the upper storey, and on the other the deliberately muted structure of the arch proper. The effect is enhanced by the deliberate displacement of the one relative to the other, so that it was the statuary, not the structure of the upper storey, that picked up the essential lines of the arch. The intention was akin to, though more elegantly contrived than, that of the great fountain-building at Miletus (Figure 153). It betrays the working of a thoroughly baroque mentality operating within the conventions of a rather formal classicism.

The Stoa and Library of Hadrian occupied a rectangular site adjoining, and of roughly the same dimensions as, the Market of Caesar and Augustus.[19] In plan it was a very close copy of Vespasian's Templum Pacis in Rome, a porticoed garden enclosure symmetrical about the longer axis, with a range of large rooms along the side facing the single entrance and with small exedrae opening off the porticoes of the two long sides; a long pool ran down the centre of the garden. The only difference of substance from the parent building was that the principal room, being a library, not a temple, did not call for the gabled pronaos that breaks the line of the inner portico of the Templum Pacis. The façade, of which the left half and one column of the tetrastyle central porch are preserved to cornice height (Plate 194), was an extended and in detail simplified version of that of which part is still standing in the Forum Transitorium. One must envisage it crowned by a plain attic serving as a background for a row of statues placed above the columns. In detail it illustrates a nice balance of influences. The green cipollino columns from Euboea and the hundred columns of Phrygian pavonazzetto which once carried the inner porticoes belong, as does the idea of an almost free-standing columnar screen, to the architecture of contemporary Rome. So does the raising of the order on a base, to give added height, with the difference, however, that the base here is not an engaged plinth but a free-standing pedestal, a device which was already widely popular in the Roman East but which was found only sporadically in the West before Christian times. The decorative drafting of the masonry is another convention which had only a limited vogue in Early Imperial Rome,[20] but which was at home in Asia Minor. Very little of all this was native to Athens, any more than it was to Lepcis Magna, where we shall be meeting the same scheme in slightly developed form some seventy years later.[21] The significance is wider. Already in the more sophisticated provinces we can detect the beginnings of the break-down of the old regional differences and of the emergence of an architecture which was, in the fullest sense of the term, Imperial Roman.

The period immediately following Hadrian's work in Greece was dominated architecturally by the figure of Herodes Atticus, the wealthy patron of the arts whose benefactions included the restoration in Pentelic marble of the stadium at Athens for use in the Panathenaic games of 143–4; the building of the odeion and the rebuilding of the Peirene Fountain at Corinth; the erection of a handsome fountain-building beside the Altis at Olympia; and, towards the end of his life, the construction of the odeion which today, consolidated and restored, still serves as an open-air theatre and concert hall for the city of Athens. Enough has survived of the nymphaeum at Olympia to permit an almost complete reconstruction, including the statuary, which was such an important part of these monumental fountain-buildings.[22] It consisted of a raised semicircular exedra and basin with a columnar inner façade incorporating five gabled aediculae, within and above which stood statues of members of the imperial family; flanking the exedra at the same level were statues of Herodes himself and his wife; in front of it, at a lower level, a long rectangular basin; and at either end of the latter, framing the whole composition, a pair of elegant, conical-roofed circular tempietti. The elements were all familiar; indeed, an apsidal nymphaeum and a small tempietto-like fountain building

(the latter notable for its use of a brick dome, one of the earliest known in Greece) figure independently among the monuments that were added to the agora at Athens at just about this date, following the completion of the Hadrianic aqueduct in 140. It was precisely in the manipulation and recomposition of such familiar architectural forms that this mid-second-century Greek architecture was most at home.

The odeion, though carried out in a more sober vein, was essentially a building of the same eclectic spirit. The square outline and basic simplicity of the stage-building are those of the traditional odeion; but it seated 5,000 people, and with a span of about 250 feet it could never have been roofed without internal supports, of which there is no trace. The internal arrangements are those of a theatre, the orchestra and seating, before restoration, following the old Greek layout, whereas the scaenae frons is a simple version of that of a Roman theatre, with what appears to have been a single columnar order, or series of aediculae, framing the three doorways and the eight statuary-recesses that constitute the main decoration at stage level. Above this rose the double row of round-headed windows which are such an impressive and unusual feature also of the severely monumental outer façade. The layout of these, it will be observed, forms a characteristic counter-rhythm to that of the lower order.

Athens was sacked by the Herulians in 267; but even before this date there had been no building of importance in the city after the end of the second century, and very little elsewhere in southern Greece, until late antiquity, to which the brief spell during which Thessalonike (Salonica) was an Imperial capital served as an effective curtain-raiser. The Indian summer of Athens came even later, in the fourth and fifth centuries.

Other Roman Sites

Outside Corinth and Athens the only major site of the Roman period to have been excavated is that of Philippi in Macedonia. The city was founded by Philip of Macedon, but the visible remains are almost entirely those of the Roman military colony, established here in 42 B.C. and reinforced twelve years later, shortly after the battle of Actium. The agora, terraced into the gentle slopes at the foot of the acropolis, offers an unusually complete picture of a Graeco-Roman city centre that was laid out afresh, on monumental lines, in the second century A.D. It was grouped symmetrically about its shorter, north–south axis around a rectangular, marble-paved open space, about 50 by 100 yards in extent. Along the north side the terrace wall of the Via Egnatia and the rocky cliffs of the acropolis formed a back-drop to the orators' platform (*bema*), which stood against the centre, flanked by a pair of small temples and long, narrow fountain basins. The other three sides were laid out as multiple stoas, with colonnaded frontages towards the central space and, opening off the inner colonnades, shops, offices, and, on the east side, a public library. Facing each other across the central area at the north ends of the two short sides were two temple-like buildings, distyle *in antis*, one of which contained low stepped benches round the three inner sides of the cella and was evidently the *bouleuterion*, or council chamber. The whole complex, which replaces an earlier, less spacious layout, appears to have been built between 161 and 179.

Other excavated buildings at Philippi include a large bath-building of scrupulously rectilinear design, an unusually complete public lavatory, and the Roman theatre, built on the site of its Greek predecessor and, like so many theatres in the eastern provinces, remodelled in the third century to serve as an amphitheatre. The material in common use is the bluish local marble, and the motifs and workmanship both indicate close links with the workshops of Bithynia and western Asia Minor. The same is true of the rather scanty Early Imperial remains of Thessalonike.[23] Evidently the position of both cities upon the Via Egnatia, the principal land route from Italy to Asia Minor, had already gone far to establish the community of style and building practice which is such a marked feature of later Imperial and Early Byzantine architecture throughout this whole area.

Scattered throughout Greece there are innumerable other Roman monuments, but most of them have received little serious study. One that deserves brief mention is a nymphaeum (so named in a fragmentary inscription) which was excavated some years ago at Argos in the Peloponnese.[24] It was a circular building of the Corinthian order, with eight columns and a conical, scale-patterned roof. It dates from the second half of the second century and was thus roughly contemporary with the similar, but smaller, pavilions of the Nymphaeum of Herodes Atticus at Olympia and the little domed pavilion in the agora at Athens.

In conclusion it should be remarked that Greece and the Greek islands were the source of more than half of the precious marbles that were most widely used in Roman times for decorative paving, wall-veneers, columns, and statuary throughout the Mediterranean area. Among those quarried for export were the splendid white marbles of Attica, the red marble (*rosso antico*) and green porphyry of Laconia, the green-veined cipollino of Carystos, in Euboea, and the handsome verde antico of Thessaly. From the Aegean came Parian, the most prized of statuary marbles; Chian, both a black variety and the variegated brown and grey porta santa; the multicoloured breccia de' settebasi of Skyros; and africano and a soft, translucent grey marble from Teos, on the Asiatic coast. The shipments were often accompanied by Greek workmen and they played an important part in the dissemination of Greek motifs and Greek craftsmanship, wherever these are found.

ASIA MINOR

Building Materials and Techniques

ASIA MINOR shared with mainland Greece the heritage of a rich classical past. There were, however, also important differences. In the first place, the classical backgrounds were in detail very different. Whereas in mainland Greece the native Greek element in the Roman architecture was dominated by the prestige of the monuments of classical Athens, in Asia Minor, if there was any single authorative monumental tradition, it was the Ionic tradition of which the work of Hermogenes is the embodiment; and the hellenistic kingdoms, notably Pergamon, had been active creative centres when Athens was already a venerable pensioner. Then again, despite a century of piracy, civil war, and gross misrule, Asia Minor was still a country of rich resources. Ephesus was one of the great cities of the Roman world, and the map of Asia Minor is dotted with the names of cities great and small which enjoyed a prosperity in Roman times such as they have never had before or since. As a creative force Greece was spent. Asia Minor, on the other hand, was still a live and active exponent of the hellenic tradition. Situated, by temperament and tradition as well as by the facts of history and geography, midway between the two extremes of Rome and the Ancient East, it was to be an increasingly powerful force in shaping the development of the architecture of the later Roman Empire.

Asia Minor is a land of fine building-stones and marbles, and in Roman times it was still, for the most part, a land of plentiful timber. These were the natural and obvious materials for monumental architecture. There were many cities – Hierapolis on the Maeander, for example, or Assos and Alexandria Troas – which remained true to this tradition right down to Byzantine times. As late as the sixth century it was still to dressed stone that the architects of Hagia Sophia in Constantinople and of the church of St John at Ephesus instinctively turned for the piers of their great vaulted monuments.

From Augustan times onwards, however, dressed stone found itself competing with a material which closely resembles, and patently derives from, the concrete of Roman Italy.[1] It did not have the strength and hydraulic properties which Roman engineers derived from their use of the dark volcanic sands of Latium and Campania; but in other respects it was very similar, consisting of rubble laid in horizontal beds in a thick lime mortar and brought to a finish with a facing of finer materials (Plate 198). To outward appearances it is the facing that distinguishes it from the parent material. Such distinctively Italian facings as opus reticulatum are very rare. Instead, we find the local materials used in whatever way suited them best. At Miletus, for example, where the river boulders and pebbles are by nature intractable, much of the facing is extremely coarse (Plate 199); and in parts of Cilicia the volcanic basalt lent itself most readily to a

sort of opus incertum. Wherever the stone permitted, however, it was customary to dress it into small rectangular blocks, which were laid in courses very much in the manner of the 'petit appareil' of Roman Gaul, of which indeed it is the almost exact equivalent. The courses of the facing, unlike the facing of Roman concrete, normally coincide exactly with those of the core. Corners, doors, and windows were regularly turned with larger blocks.

The earliest datable example of this technique is in the superstructure and abutments of the aqueduct of Caius Sextilius Pollio at Ephesus (between A.D. 4 and 14; Plate 201), and by the middle of the century it was already firmly established, at any rate in the cities of the west coast. At Miletus, for example, one can watch the increasing sophistication of its use in a series of monuments ranging from the Baths of Cnaeus Vergilius Capito (Claudian), through the Humeitepe Baths and the aqueduct and substructures of the great nymphaeum (both Trajanic), to the mid-second-century Baths of Faustina, in which for the first time it begins to be used in combination with brick, another and later Roman innovation. Its early and widespread use in bath-buildings is no accident. It was precisely in buildings of this sort, in terraced platforms, and in the great vaulted substructures of such buildings as theatres and amphitheatres that concrete had first proved itself as a monumental building material in Italy; and it was such buildings that were among the earliest and most distinctively Roman contributions to the established hellenistic repertory.[2]

Whereas, however, in outward appearance it is the facing that immediately distinguishes this masonry from Roman concrete, structurally there was another and profounder difference; the mortar lacked the strength needed for the creation of vaulting in the fully developed Roman manner. Up to a certain span barrel-vaults, domes, and semi-domes could be constructed, as they had been in Late Republican Italy, by selecting elongated slabs of stone and laying them radially as if they were so many bricks. One can see vaulting of this sort in every one of the Milesian buildings referred to in the previous paragraph (cf. also Plates 199 and 206). Like the vaulting of Republican Italy, however, the finished product stood more by virtue of the disposition of the materials than because of the inherent strength of the mortar itself. It is altogether exceptional to meet a mortar (as one does occasionally in Cilicia, where there were supplies of volcanic sand similar to that of Italy) which had the almost monolithic strength of that used in the best Roman concrete.

An immediate and architecturally very important result of this lack of suitable materials was that the sort of concrete building which was being undertaken in Rome during the second half of the first century A.D., and which has been described in detail in Chapter 10, could have no immediate and direct counterpart in Asia Minor, or indeed anywhere else in the Roman East. As unquestionably the most progressive architecture of its day, it was bound in the long run to make itself felt all over the Roman world; but its impact could not take the obvious form of direct imitation. What did happen in Asia Minor (to confine the inquiry for the moment to the technical problems of vaulting, which was in practice the principal limiting factor) was that a substitute material had to be found, one which might not have all the properties of Roman

concrete, but which could be used with a greater freedom than either the dressed stone or the mortared rubble which were its only local alternatives. The material chosen was brick.

Although brick was regularly used in Asia Minor in classical times, it is poorly represented in the archaeological record. Crude, sun-dried brick was common both in Greek and in Roman architecture; but its remains are rarely preserved outside the dry climates of the Near East. Kiln-baked brick is, by contrast, virtually indestructible; for that very reason, however, classical buildings have everywhere been ruthlessly pillaged by later generations in search of building materials. In Asia Minor climate and the building robbers have both been active, and as a result actual surviving examples of Roman brickwork, and *a fortiori* of Roman brick vaulting, are decidedly rare.

Of the two materials, although crude brick had long been known and used in Asia Minor, in the total absence of surviving examples it is impossible to prove that it was also used for vaulting. It was, however, undoubtedly so used both in Roman Egypt and in Roman Syria; and since at least one of the relatively few surviving fired-brick vaults of Asia Minor, that beneath the basilica at Aspendos, in Pamphylia (Plate 200), is of a very distinctive form for which all the precedents are in the mud-brick architecture of the Near East, there is a good case for regarding the use of brick vaulting as having first taken shape in Asia Minor under the influence of, and using the characteristic materials of, her eastern neighbours.[3]

With fired brick we are on firmer ground. There can be no doubt that this was introduced to Asia Minor from Italy, probably early in the second century A.D., certainly in time to be used in the upper storey of the Library at Ephesus (Plate 209). How it was used, we may illustrate by reference to two of the principal monuments of Roman Pergamon. One of these is the Serapaeum,[4] of which some of the secondary buildings are of the usual mortared rubble faced with small squared blocks, but of which the great central hall (Plate 205) is constructed entirely of brick. At first sight this bears a remarkable resemblance to the brickwork of Rome, but the resemblance is in fact only skindeep. Instead of being built in the Roman manner of concrete or mortared rubble faced with brick, the masonry is here of mortared brick throughout. That this was no mere local eccentricity is shown by such other surviving examples as the second-century superstructure of the Harbourside Baths at Ephesus (Plate 208) and the upper parts of the pressure-towers of the third-century aqueduct at Aspendos (Plate 213). This was regular practice in the brickwork of Roman Asia Minor; and, as we shall see, it was this form and not its metropolitan Roman counterpart which was taken over by the architects of Constantinople.

The other Pergamene monument to make extensive use of brick is the Temple of Asklepios Soter, dated by the excavators to just before the middle of the second century (Figure 148).[5] The materials and methods used in this building acquire added significance from the fact that it was almost certainly directly modelled on the Pantheon, built some twenty years earlier. Instead, however, of the carefully graded, brick-faced concrete of the Pantheon, the drum was built of fine ashlar and the dome of brick, laid radially and reinforced at the spring by an outer ring of mortared rubble (which, with a fine

facing of small squared blocks and heavy ashlar quoins, was the material of the adjoining, semi-subterranean rotunda; Plate 206). One could hardly ask for a more graphic illustration of the blend of ideas that went to make up this provincial architecture: a Roman design carried out in a building tradition of which the immediate antecedents were local, but which in matters of vaulting was prepared to assimilate and to adapt a material, kiln-baked brick, which also was derived from Rome. When one reflects that the mortared rubble, too, is a translation into local terms of an earlier phase of Roman concrete construction, one realizes how closely interwoven were the various traditions that went to make up the architecture of Roman Asia Minor.

One other use of brick calls for brief remark, in which bands of brickwork alternate with wider bands of mortared rubble. This is another characteristically Asiatic usage which makes its first appearance during the second century A.D., and which was ultimately to be taken over by the architects of Constantinople, the *locus classicus* of its use being the great Theodosian land walls of that city. A fine Roman-period example is that of the city walls of Nicaea in Bithynia, built between 258 and 269 (Plate 202). Once again the resemblance is to the 'petit appareil' masonry of Roman Gaul rather than to the superficially similar brick-and-reticulate opus mixtum of Central Italy. The brickwork is not merely part of the facing but runs right through the core, to which it was presumably designed to give strength and cohesion, preventing settlement within the rather loosely mortared rubble mass.

The Central Plateau

Asia Minor is a large country and in many parts of it communications are difficult. In describing the monuments of the Roman period, it will be convenient to distinguish three main areas: the central plateau, the valleys and plains of the western coastal belt, and the southern coastal plains of Pamphylia and Cilicia.

Of the three, the central plateau, accessible at only a limited number of points from the coast and from the sources of classical civilization, is in the context by far the least important. Had more been preserved of such flourishing centres as Iconium (modern Konya), one might have been able to form a clearer impression of the architecture of the provinces of Galatia and Cappadocia; but what little there is leads one to suspect that it was in every sense of the word provincial. The only exception is Ancyra, the modern Ankara, which as capital and principal road-centre of Galatia occupied a privileged position. Here there are the substantial remains of at least two important monuments. One is the Temple of Rome and Augustus (Plate 203), on the walls of which was carved the best preserved text of the will and testament of the emperor Augustus, the *Res Gestae Divi Augusti*. This was a large, octastyle, pseudo-dipteral temple, of which the surviving detail of the cella is so very close in layout and style to the manner of Hermogenes that it has even been thought to be a building of the second century B.C. The outer order was, however, Corinthian, and there are several details that are hardly credible as hellenistic work. It was the product of a conservative but (as we have already

seen from its influence upon the Temple of Mars Ultor in the Forum Augustum in Rome) still very live tradition.

The other major surviving monument of Ancyra is a very large bath-building, re-markable chiefly for the size and number of its hot rooms.[6] This appears to date from the reign of Caracalla (211–17) and was laid out on a grandiose rectangular plan, symmetrical about its shorter axis. At the west end there was a projecting apse, and at the east, as one entered, a large piscina (*natatio*). In front of it was a huge colonnaded peristyle. The baths were built throughout of mortared rubble faced with small squared blocks, alter-nating with courses of brick. Brick was used also for the vaulting of drains and stair-cases, and some of the smaller rooms may have been vaulted, although the main roofs must have been of timber. Architecturally as well as socially this was as thoroughly Western a building as the temple was native hellenistic.

Antioch-in-Pisidia, founded as a Roman colony soon after 25 B.C. to control the wild mountain tribesmen of the south-western extremity of the central plateau, illustrates an earlier and elsewhere very little documented phase of this process of westernization. It had been a hellenistic foundation, and traces of a rectilinear street-plan may date from this period. Otherwise the surviving remains are Roman; and since the colony does not seem to have maintained its early promise but to have soon settled back into a comfort-able mediocrity, the initial architectural impact of the Roman foundation is unusually clearly documented.[7]

The principal excavated monument is the temple identified as that of Augustus, per-haps in association with the local divinity Mên. It occupies a commanding site, framed by the broad hemicyle which constitutes the rear wall of a large terraced platform. Around the hemicycle ran a two-storeyed portico, Ionic above and Doric below; and the centre line of the temple was projected downhill by Tiberius to form a grandiose axial approach. This was characteristically Roman planning, and the temple itself, in startling and significant contrast to that of Ancyra, was a building in the Roman manner, standing on a lofty podium, with a tetrastyle porch at the head of a frontal flight of steps. The lavish ornament, though drawn from the late hellenistic repertory, incor-porates several of the motifs that contemporary architects in the West were busy making their own (notably the friezes of acanthus scrollwork and of bulls' heads and garlands). By selection, if not by actual workmanship, this was a very Roman building.

Other monuments are the fine Augustan aqueduct, built throughout of squared stone; a theatre, unexcavated; a large vaulted platform of mortared rubble masonry faced with ashlar, which served as the basis for a later building; and a monumental arch of the early third century. This last, a nightmare blend of Early Imperial motifs and of others derived from the contemporary marble architecture of the coast, is a typically provincial product of baroque taste misunderstood.

The Western Coastlands

The western coast was the traditional heart of classical civilization in Asia Minor, and throughout the Roman period, together with the adjoining province of Bithynia along the southern and eastern shores of the Propontis, it remained the vital creative centre. In a great many respects the Roman architecture of Ephesus and Pergamon, of Aphrodisias, Tralles and Hierapolis in Caria, of Cyzicus and Nicaea in Bithynia, remained remarkably true to its hellenistic antecedents. But within a somewhat conservative framework of ideas, there was also a spirit of lively experiment; and it was precisely because in certain aspects of planning, decoration, and technique the resulting innovations were coupled with a strong traditionalism, and because the basic artistic vocabulary was in consequence so familiar, that the art and architecture of this region was to be such a powerful factor in influencing the taste of late antiquity. One has only to measure the monuments of Ephesus against the rather arid antiquarianism of contemporary architecture in Athens to appreciate the vitality and vigour of the former. In architecture, as in so much else, it was the cities of Asia which were the repositories of the living hellenistic tradition.

Of the three principal excavated sites – Ephesus, Miletus, and Pergamon – the most important in Roman times was Ephesus, capital of the province of Asia and the main port for the whole of south-western Anatolia. The centre of the town beside the harbour had been laid out on orderly lines by Lysimachus soon after 300 B.C., but the steep hillsides overlooking the centre defied orderly planning, and although one of the most exciting of all ancient sites to visit, Ephesus is also, archaeologically speaking, one of the most elusive. The very exuberance of the creative fancy displayed makes its architecture far less susceptible to orderly classification than that of other, more orthodox centres. Roman Miletus lacked this progressive spirit. Its remains betray all the conservatism of a city which had passed its prime, not only in its planning, which clung rigidly to the four-square layout established by Hippodamos in the fifth century B.C., but also in the quality of much of the detail. At Pergamon, the third of the excavated sites, the main development in Roman times took place on new ground, across the plain at the foot of the acropolis on which were clustered the principal monuments of the hellenistic city. Outside these three towns we catch only occasional glimpses of the city plans. At Aphrodisias, for example, which stood on level ground, the heart of the city seems to have been an area of large colonnaded open spaces, loosely interrelated within a rectangular layout which resembles that of the centre of Miletus. At Knidos, too, the terraced plan of the Roman city conformed closely to that of its hellenistic predecessor. At Nicaea, on the other hand, the two intersecting colonnaded streets which divided the city into four roughly equal quadrants must have been a Roman innovation.

When one turns to the individual monuments one is made aware from the outset of the influence of two architectural currents that were in detail very different. There were some fields in which local hellenistic traditions continued for a long time to predominate. There were others in which, for lack of native models, the architects were bound to

look to Italy for inspiration. The history of architecture in western Asia Minor during the first three centuries of our era is very largely the history of the development and mutual assimilation of these two traditions.

Religious architecture belonged decisively to the former category. The cities of the province of Asia were already well provided with fine temples built in durable materials; and in the absence of any compelling alternative it was almost inevitably to the great sanctuaries of the hellenistic age that the architects of the succeeding period turned in planning such new building as was called for.[8] The most popular model seems to have been that typified by the buildings of the second-century B.C. architect Hermogenes. We have already remarked this in the case of the Augustan temple at Ancyra. Except for the omission of the opisthodomos, the Temple of Domitian at Ephesus followed the same plan.[9] The recent excavations at Aphrodisias have not yet established the date or structural history of the Temple of Artemis; but this too was certainly an octastyle Ionic building, and the fragmentary remains of the cella wall, incorporated in the structure of the Christian apse, are of the same distinctive masonry. Yet another building in the same general tradition is the Temple of Zeus at Aizani in Phrygia (Plate 204),[10] which was completed about A.D. 125, and which bears a close relationship to the last and most ambitious of the series, the great Temple of Hadrian at Cyzicus.[11] The latter was completed in 139, was damaged soon afterwards in an earthquake, and was re-dedicated in 167. Only a scrub-covered mound of rubble now marks the site, but half of the columns were still standing when it was seen, described, and drawn by Cyriacus of Ancona in the fifteenth century. From him we learn that the podium measured some 100 by 200 feet (a double square); that it was a peripteral octastyle building of the Corinthian order, with fifteen columns down either flank; and that the cella walls and columns stood some 70 feet high, 10 feet higher than those of the Temple of Jupiter at Baalbek. Even allowing for a margin of error in the calculations of Cyriacus, it was unquestionably a gigantic building. It was also very elaborately ornamented with figured friezes, vine-scroll columns, richly carved doorways, and a bust of Hadrian in the pediment (recalling the *imago clipeata* of Antoninus Pius in the pediment of the Outer Propylaea at Eleusis); and at some point in the building which cannot now be precisely identified, colonnades carrying architrave-moulded arches in place of the traditional flat architrave – the first clearly attested example of the use of this motif in monumental architecture. We shall meet it next at Lepcis Magna in North Africa.

A temple of even greater historical importance was that of Zeus Philios and of Trajan (the 'Traianeum') at Pergamon.[12] This occupied a magnificent site on the old citadel, facing out across the theatre and framed on three sides by the porticoes of a rectangular courtyard. The temple itself was hexastyle peripteral, of the Corinthian order, and it differed from those just described in being raised up on a podium in the Roman manner; the cella had two columns *in antis* and the masonry was drafted, with smooth pilasters at the angles. Striking features of the building were the fine openwork acroteria, based on such hellenistic models as those of Hermogenes's Temple of Artemis Leukophryene at Magnesia; and the large, staring Medusa heads of the frieze, alternat-

ing with triglyph-like fluted motifs. The frieze is unquestionably the source of the similar motifs used at Side in the earliest buildings of the new, marble style which swept Pamphylia in the second century; and there is good reason for the belief that the architect of Hadrian's Temple of Venus and Rome in the capital had worked on the Traianeum.[13] It was evidently a much admired and influential building.

The Temple of Hadrian at Ephesus (Frontispiece), by comparison, is a surprisingly modest little streetside building, remarkable chiefly for the fact that the outer corners of the façade are carried on rectangular piers, instead of on columns, and that the central span of the façade, mouldings and all, is arched up into the pediment.[14] This device, the 'arcuated lintel' or 'Syrian arch', is one of a number of Syrian architectural motifs that quite early found their way into Asia Minor. It derives ultimately from ancient Mesopotamia and seems to have made its first appearance in a classical context in southern Syria in the time of Augustus. Another Syrian intruder, the colonnaded street, is discussed below.

Still in the classical tradition, but very different in detailed treatment, was the grandiose temple behind the Library at Ephesus, which must date from the second half of the second century.[15] This was another octastyle Corinthian building but, most unusually for a building of this size, it was prostyle and, even more unusually, vaulted. The architectural ornament was very elaborate, and it stood on a tall podium against the rear wall of a rectangular precinct, a typically Roman disposition that is rare in Asia Minor. The probable identification of this building as a temple of the Egyptian Gods, or Serapaeum, is of particular interest when one contrasts it with the very nearly contemporary Serapaeum at Pergamon.[16] The former, for all its unusual features, is still essentially a building of traditional classical type – one of the last to be built in western Asia Minor. The latter was as unclassical in plan as it was in materials (Plate 205). It consisted of a lofty hall, 170 feet long and 85 feet wide (52 by 26 m.), with what appear to be galleries and a large window at the east end; the hall was flanked symmetrically by a pair of almost square courtyards, each colonnaded on three sides and opening centrally towards the east into a domed rotunda; and the whole complex formed the eastern extremity of a huge rectangular enclosure, nearly 200 yards in length, beneath which the river Selinus flowed in two vaulted tunnels. Whether or not this elongated, axial layout reflects Egyptian models, the whole architectural concept could hardly be more remote from the conventions of religious architecture which we have just been describing. We are reminded once again that this was just the sort of context in which new architectural ideas most readily made themselves felt. The third-century Serapaeum at Miletus, though a far more modest building built in a superficially classical style, is another instance of this – a basilican hall with a rectangular pedimental porch and, where a church would have had an apse, a square, internal, canopied naos.[17]

The Temple of Asklepios Soter at Pergamon has already been described. It too was part of a much larger complex, which in its present form dates almost entirely from the period between about 140 and 175 (Figure 148). The sanctuary was grouped rather loosely around and within a large rectangular enclosure, 405 by 345 feet (124 by 105 m.), surrounded on three sides by porticoes, of which that on the south side stood

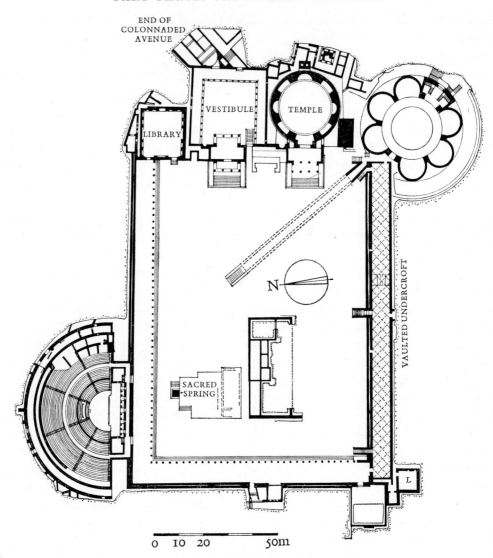

END OF
COLONNADED
AVENUE

VESTIBULE

TEMPLE

LIBRARY

N

VAULTED UNDERCROFT

SACRED
SPRING

L

0 10 20 50m

Figure 148. Pergamon, Sanctuary of Asklepios (Aesculapius), c. 140–75. Plan

L Lavatory

on a vaulted substructure. There was a substantial theatre, of which the rectilinear
scaenae frons repeated the scheme of the nymphaeum at Miletus and the Library at
Ephesus. Along the east side lay, from north to south, a plain rectangular library; a
tetrastyle propylon, balancing the pronaos of the adjoining temple; the temple itself;
and, set obliquely to the south-east corner, an even larger rotunda (diameter 87 feet;
26·50 m.), the timber roof of which presumably had a central oculus and rested on a
cylindrical drum, rising above and buttressed by six apsidal chapels, with a cryptoporti-
cus beneath (Plate 206). In the open central area there were various buildings associated
with the cult, including the sacred spring. Leading to it was a colonnaded street. The
classical detail is rich and varied, mainly a very elaborate Ionic, but including some

Composite capitals, a form which begins to be found in Asia Minor during the second century.

Once again the corresponding building at Miletus was of more modest dimensions. Its most noteworthy feature was the porch, which faced on to the same piazza as the bouleuterion, the market gate, and the nymphaeum and was a tetrastyle structure with an arcuated lintel.[18]

Another field in which the continuity of established local tradition was bound to make itself felt strongly was that of the monumental architecture associated with the city's day-to-day public and commercial life. At Miletus the main squares, markets, and council building of the hellenistic city continued to serve, little changed, throughout Roman times. Even at Ephesus the agora, when it was radically rebuilt in the third century A.D., retained its hellenistic form of a colonnaded square, with shops opening off the surrounding porticoes. The early-second-century agora at Aphrodisias, another building in the hellenistic manner, seems to have been a large, rectangular space, formally enclosed on three sides by double porticoes; in the middle of the fourth side stood what has been tentatively identified as an odeion, but which may well have served also as a council building. The mid-second-century council house (the 'Gerontikon') at Nysa in the Maeander valley was a theatre-like building of just this sort, with open rectangular parodoi separating it from the wall which in a theatre would constitute the scaena.[19]

There were, of course, certain innovations. One of these was the early and widespread adoption of the colonnaded street. Originating apparently in the Syrian coastlands in the time of Augustus, it was very soon copied and acclimatized in Asia Minor. It had already reached Corinth by the middle of the first century A.D. What is perhaps the earliest surviving example in the cities of the west coast (the published accounts are not explicit on this point) is that which ran towards the harbour of Ephesus from the agora. Others of relatively early Imperial date can be seen at Nicaea, Pergamon, and Hierapolis, of which the last-named is unusual in that some stretches of it are not actually colonnaded, but take the form of an ordinary street with engaged semi-columnar Doric façades. The best known and most elaborate of the colonnaded streets of Asia Minor, the Arkadiané (Plate 207) at Ephesus, is as it stands a creation of the fourth century A.D.[20]

Two public buildings that deserve special mention are the agora at Smyrna and the Library of Celsus at Ephesus. The former[21] was a very large complex, dating from the mid second century A.D. and still incompletely excavated (Figure 149). It consisted essentially of a long, narrow basilica (about 525 by 90 feet; 160 by 27 m.) which occupied the north side of an open, rectangular piazza, 425 feet (130 m.) wide and of uncertain length, enclosed on two (and probably three) sides by two-storeyed triple porticoes. The southern façade of the basilica was colonnaded and symmetrically disposed about a central porch. Internally, on the other hand, the emphasis was longitudinal, with a monumental entrance and shallow internal lobby at the east end, and at the west end what appears to have been some sort of tribunal. Instead of columns, the internal supports were composite, cruciform piers, of which the taller members were treated as half-columns carrying a normal longitudinal entablature, and the shorter ones as piers

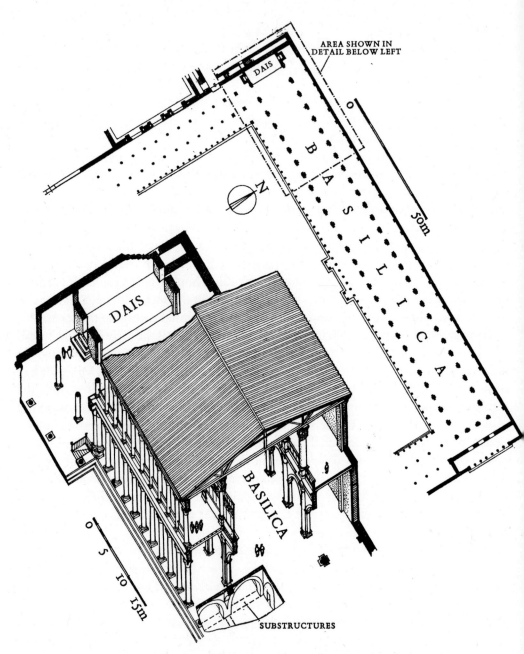

AREA SHOWN IN
DETAIL BELOW LEFT

DAIS

BASILICA

30m

DAIS

BASILICA

0 5 10 15m

SUBSTRUCTURES

Figure 149. Izmir (Smyrna), agora and basilica, mid second century. Partial plan and restored axonometric view of the north-west angle

carrying arches at a lower level between the columns. At the east end this internal arcading turned immediately inside the porch to form an ambulatory; at the west end it ran straight through to frame the tribunal. On the side facing the agora there was an upper gallery, facing outwards, and on this side at any rate the central hall of the basilica was lit, not by clerestory windows, but by grilles in the rear wall of the outer gallery. Both in its planning and in its detail this is an unusual and highly sophisticated building, in which the several elements of undoubtedly Western derivation (the basilican plan, the arcading, the Composite capitals) have been skilfully assimilated and adapted into what, constructionally and decoratively, is still a developed hellenistic tradition.

The Library at Ephesus (Plate 209),[22] completed about A.D. 135, was built by the son and grandson of a wealthy and distinguished citizen, Caius Julius Celsus Polemaeanus, who had been consul in Rome and who was accorded the unusual honour of being buried within the city limits, in a vaulted chamber beneath the Library apse. This handsome building was a lofty rectangular hall, wider than it was long (55 by 36 feet; 16·70 by 10·90 m.), with a small central apse in which no doubt stood a statue of Celsus himself (Figure 150). Round three sides ran tiers of rectangular recesses to house the cupboards for the books. Two orders of columns carried the balustraded galleries which served the upper rows of cupboards, and both these and the mausoleum were reached by stairs which were built into the thickness of the lower walls, and which served the additional purpose of protecting the books from damp. There may have been a square oculus in the centre of the flat ceiling. The richly carved façade (Plate 211) illustrates Ephesian decorative architecture at its best, a deceptively simple scheme of bicolumnar aediculae, of which those of the upper storey are displaced so as to straddle the spaces between those of the lower storey. Other characteristic features are the alternation of curved and triangular pediments, a widespread late hellenistic device which took on a new lease of life in contexts such as this; and the pedestal bases which gave added height to the columns of the lower order, a recent innovation with a long history before it in late antique and Early Christian architecture.

The amphitheatre was an Italian building type that never took root in the eastern Mediterranean. Only three examples seem to have been recorded in Asia Minor, at Pergamon, Cyzicus, and Anazarbos in Cilicia, although many theatres were doubtless adapted, like that of Corinth, to meet the same requirements. On the other hand, the western coastlands were already well endowed with theatres and the majority of these were remodelled in Roman times. It will be sufficient here to describe two representative examples.

At Ephesus[23] the magnificent auditorium, built up against the steep hillside and seating some 24,000 spectators, though restored and enlarged in the second half of the first century A.D., was in plan still essentially a Greek building (Plate 207). The stage-building too, restored under Domitian (81–96), was Greek in its structural independence of the seating, but in other respects it was a Roman building of 'Eastern' type, with a rectilinear scaena wall and, framing the five doors, a scheme of two columnar orders which so closely resembles that of the theatre at Aspendos (Plate 210) that it is temping to regard it as the model for the latter building. Subsequently, about A.D. 200, a third order

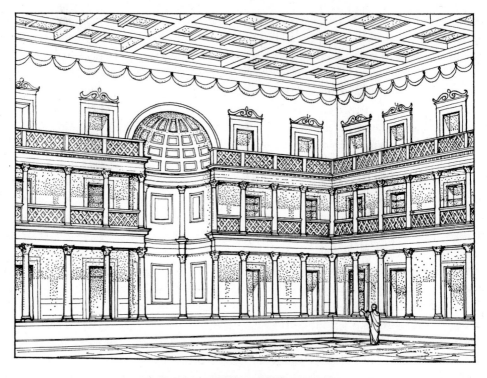

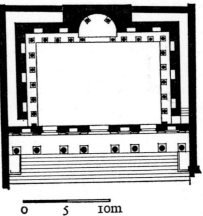

Figure 150. Ephesus, Library of Celsus, completed *c.* 135. Restored view and plan

was added, of a rather weak, half-hearted design and set slightly back from the lower two. In the absence of projecting parascaenia it is doubtful whether the stage could ever have been roofed.

The theatre at Miletus[24] was far more radically romanized. Here the seating as well as the stage-building was enlarged and re-designed, being extended upwards and outwards on vaulted substructures and forwards, across the parodoi, to meet the stage-building. The latter had a façade of the three orders in the usual Roman manner, with parascaenia and a roof. The only unusual features were that, instead of the triple re-

398

cessing of the usual 'Western' type, there was here a single shallow and unusually wide, curved, central recess, across the front of which the columnar façade was carried on four independent columns; and that the grouping of the aediculae of the several orders displayed the same deliberate ambivalence as we have already observed in the Library of Celsus at Ephesus.

The importance of the bath-building as a medium for the introduction of Roman building practices and techniques has already been stressed. The baths of Asia Minor were not, however, mere slavish copies of those in Italy. Quite apart from the many technical adaptations and modifications which they underwent to suit local materials and building traditions, there were also important differences of social usage. The most important of these was undoubtedly the established position of the hellenistic gymnasium. The gymnasium and the bath-building had already met and come to terms in Italy.[25] Now in Asia Minor architects were faced with much the same problem, with the difference that the Roman bath-building of the Early Empire was a more developed and architecturally more aggressive type than its predecessor in Late Republican or Augustan Pompeii. There, were, of course, other factors at work to complicate the picture; climate, for example, as we are reminded by the baths at Ankara, or the countless small differences of local habit and fashion which must be held to account for much of the almost infinite variety of detailed layout that one encounters in the bath-buildings of the Roman provinces. In the present context, however, it is not the detailed functioning and internal arrangement of these buildings that matters, but the factors which affected their broad architectural development; and of these the limitations imposed by local materials and the influence of the Greek gymnasium were unquestionably the two most important.

It is, characteristically, at Ephesus that we find the latter problem most vigorously and successfully handled (Figure 151).[26] The best excavated and documented of these buildings is that built by the wealthy Ephesian friend of Antoninus Pius (138–61), Publius Vedius Antoninus. This occupied a rectangular site to the north of the stadium, some 250 by 425 feet (76 by 130 m.), with the long axis running east and west. At the west end an area of just under two-fifths of the whole was occupied by the bath-building proper, and an equivalent area at the east end by an open palaestra enclosed by four colonnades. Projecting from the east end of the former and from the west end of the latter, and so defining a monumental corridor of H-shaped plan, were, respectively, the swimming pool of the baths and a very richly decorated rectangular exedra opening off the west portico of the palaestra. The latter (the 'Kaisersaal' or 'Marmorsaal'), a recurrent feature of these buildings, had an open columnar façade and an elaborate scheme of two decorative orders, niches, and statuary round the three inner walls. The monumental corridor, here H-shaped and barrel-vaulted in mortared rubblework or brick about a framework of stone arches carried on projecting piers, is another feature that recurs, in a variety of plans, throughout the Ephesian series. One meets it again, in a less obviously utilitarian guise, in the Baths of Faustina at Miletus. The actual bathing block, like all the Early Imperial Ephesian series, was of rigidly rectilinear design and calls for little detailed comment. The main caldarium, here at the western extremity of

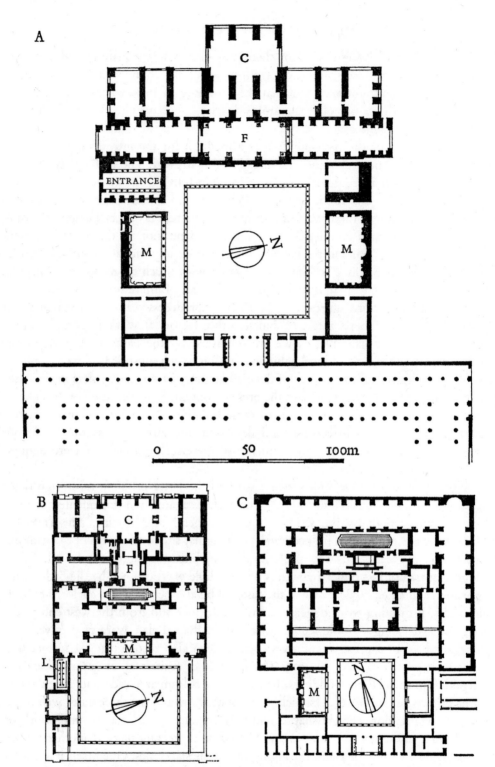

Figure 151. Ephesus, bath-buildings (gymnasia). Plans
(A) Harbour Baths, partial plan, probably late first century, several times remodelled
(B) Baths of Vedius, mid second century
(C) East Baths, early second century, remodelled *temp*. Severus (193–211)

c Caldarium f Frigidarium m 'Marmorsaal' l Lavatory

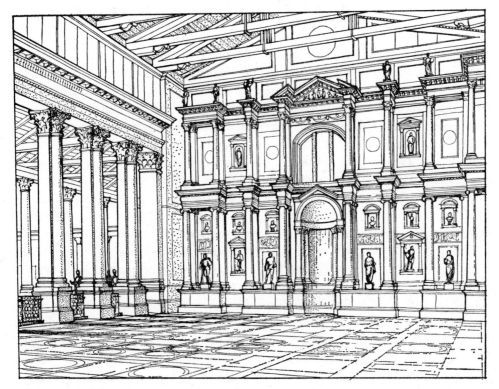

Figure 152. Ephesus, Harbour Baths, second-century marble decorative screen. Restored view

the central axis, appears to be a translation, in terms of the local materials and vaulting techniques, of the typical frigidarium plan of the bath-buildings of the capital. It has been suggested, very plausibly, that the curved outer surfaces of the vaulting were visible externally, as they certainly were at Miletus.

The Theatre Baths, dated on rather tenuous grounds to the early second century, reveal a broadly similar disposition, except that the relative orientation of the bath-building is here reversed, the caldarium range backing directly on to the palaestra; the monumental corridor, here ⊔-shaped, lies beyond the bathing block and beyond this again a further range of rooms, of which the central one appears to be the equivalent of the Marmorsaal – an unusual disposition that was not repeated.

More important and informative is the vast complex which occupied the whole of the north side of the Arkadiané. This comprised three distinct elements: at the west end the towering bulk of the Harbour Baths (Plate 207), in its present form a building of the later second century; in the centre, axial to the baths, a large porticoed enclosure with two rooms of the Marmorsaal type facing each other on the cross-axis (Figure 152); and at the east end, still on the axis, a huge open space (220 by 260 yards) enclosed by multiple porticoes ('the Porticoes of Verulanus') which are convincingly identified as *xystoi*, or covered running-tracks of the traditional late hellenistic type, as described by Vitruvius. The whole complex, except for the baths, seems to have been laid out during the reign of Domitian (81–96), and it is thought to occupy the site of the hellenistic gymnasium

referred to by Strabo. It is a plausible conjecture – but no more – that the surviving bath-building replaces an earlier, less ambitious structure of Domitianic date. The East Baths, near the Magnesia Gate, embody yet another variant of the same broad design. In this case the bath-building is ascribed to the early second century, the palaestra-gymnasium to a reconstruction of the reign of Severus (193–211). The latter resembles that of the harbour complex in layout, the hall opposite the Marmorsaal being in this instance clearly identifiable as a finely decorated lecture hall, with raised benches round the three inner sides.

The dedicatory inscription of the Vedius foundation refers to it as a *gymnasion*, and there is comparable epigraphic evidence from the harbour complex. Even without such aid, however, there could be no doubt about the double parentage of these build-ings: from the hellenistic gymnasium and from the Roman bath-building.[27] What is no less clear is the progressive change in the relative importance of the two elements. In the Domitianic complex the palaestra and exercise grounds occupy two-thirds of the total area; a hundred years later, in the East Baths, only just over one quarter. Architecturally too the bath-building comes increasingly to dominate the complex, though never to the exclusion of its other functions. The hellenistic gymnasium had been a great deal more than just a place for athletic exercise. It was a centre also not only for education and the arts, but also for the youth organizations and other select quasi-aristocratic clubs which played so large a part in the city's social life. In Italy some of these activities found themselves channelled elsewhere (as at Pompeii, for example, where the local youth organization had a *schola* beside the Via dell'Abbondanza), others were quietly and naturally incorporated into the public bath-buildings. The development in Asia Minor followed broadly similar lines. Some of the manifestations, such as provision for the imperial cult in the Marmorsaal of the Vedius building, might be new; but even here there is a suspicious resemblance in plan and situation to the *ephebeion*, the school-room of the old hellenistic gymnasium.

At Miletus one can see something of the same processes at work.[28] The earliest of the series, the baths built by Cnaeus Vergilius Capito during the reign of Claudius (41–54), were built on the site of a hellenistic gymnasium, of which part was retained to form the colonnaded palaestra of the bathing block; and although the Humeitepe Baths (*c*. 100) embody a rationalization of the same sort of plan in which the gymnasium ele-ment is reduced to the bare minimum of a porticoed palaestra, the Faustina Baths (mid second century) quite obviously reflect the contemporary Ephesian development – all the more obviously because the irregular shape of the site involved the dismemberment of the complex into its constituent elements. The bath-building itself, a loosely organ-ized circuit of barrel-vaulted halls, illustrates the norm of Asiatic usage far more closely than the neat, symmetrical layouts of Ephesus. It also incorporates early examples of the use of brick barrel-vaults, side by side with others of mortared rubble. It is indeed in their constructional details that the main interest of the Milesian bath-buildings lies, forming as they do a well dated early series of structures in the Roman manner, built partly in squared stone, partly in faced rubblework, and vaulted in mortared rubble (Plate 199). The Baths of Capito, in particular, with their numerous apsidal recesses and

a domed circular room with small apses in the four corners, constitute a direct link with the early bath-architecture of Campania. It is interesting to observe that, as in the Hunting Baths at Lepcis Magna, the curve of some at any rate of the vaults was visible externally as well as from within. This is an aspect of the architecture of Roman Asia Minor which it is hard to document in detail, but it is certainly one in which these buildings broke fresh ground, accustoming the eyes of their contemporaries to outlines that were neither the familiar pitched roofs nor flat terraces.

Only three other bath complexes of western Asia Minor call for brief mention.[29] One is that of the Upper Gymnasium at Pergamon, of which the West Baths are of early (mid-first-century) date and the colonnaded palaestra and East Baths Hadrianic (117–38), both being additions to, or developments of, an already existing gymnasium of characteristically hellenistic type. Along the north side of the palaestra were ranged an odeion and two exedrae of the Marmorsaal type. The construction throughout is in mortared rubble with carefully dressed stone facings. At the other end of the constructional scale are the great baths built over the mineral springs at Hierapolis, a huge complex of scrupulously rectilinear vaulted halls carried out almost exclusively, vaults and all, in dressed stone. In this case the familiar rectangular exedrae are two, facing each other across the outer palaestra; one of them may have contained a library. The layout of the baths at Aphrodisias (Hadrianic, 117–38), which were built partly of squared stone and partly of mortared rubble, appears to have followed the lines of the harbour complex at Ephesus; at the west end, symmetrically disposed about the long east–west axis, the massive bathing block; in front of it a small but very richly decorated porticoed enclosure; and in front of this again, stretching the full length of the adjoining agora, a very much larger, elongated enclosure measuring 695 by 225 feet (212 by 68 m.), which is of earlier date (A.D. 14–28) but which now presumably served as a palaestra.

Before leaving the cities of western Asia Minor a further word must be said about the marble ornament which was such a characteristic and so historically important a feature of this whole school of architecture. Marble was, and had long been, a material that was in plentiful supply, in a great many cases (e.g. Ephesus, the cities of the Maeander valley, Aphrodisias) drawn from local quarries. Already in the hellenistic period there was a well established tradition of decorative craftsmanship; and although the Roman period saw a notable expansion in production, resulting in a great deal more marble being available at proportionately lower prices,[30] there was no break in this tradition. The architectural ornament of Roman Asia Minor was firmly rooted in hellenistic practice.

To appreciate the strength of this hellenistic tradition one has only to compare the detail of a building such as the Traianeum at Pergamon with that of the almost exactly contemporary Temple of Venus Genetrix in Rome (Plate 124). The latter marks the culmination of a century of vigorous Western development which had seen the introduction of many new motifs and the radical transformation of many old ones. In Asia Minor, although there was a steady stylistic development in the direction of the more summary, coloristic style characteristic of the later second century, the basic decorative vocabulary underwent remarkably little change. The importance of this fact in determining the decorative repertory of the 'Imperial' architecture of the second and

Figure 153. Miletus, fountain-building (nymphaeum), beginning of the second century. Restored view

third centuries will be discussed later in this chapter. It is the other side of the coin that concerns us here. Whereas in Rome the taste for decorative innovation found expression in the exuberant detail of individual mouldings and motifs, here in Asia Minor it was channelled into more strictly architectural forms, of which the elaborate columnar façades to which we have already had occasion to refer many times in the present chapter were the most striking and characteristic expression.

The architecture of these façades was essentially baroque, in the sense that it relied for its effect upon the recombination of the familiar elements of the classical orders in unfamiliar and often highly artificial schemes. In this respect it closely resembled that of the stage-buildings of the Roman theatre. There can indeed be little doubt that both were the product of a movement that originated in the luxurious atmosphere of the hellenistic courts and was already widely influential in late hellenistic times. The early stages are difficult to document in detail, since they seem to have been very largely carried out in ephemeral materials; but, as we have seen in an earlier chapter, they are very fully reflected in the wall-paintings of Pompeii, many of which, allowing for the exaggerations and distortions of the medium, do present a lively picture of this vanished court architecture.

The next stage (and it is important to remember that this was not necessarily a single event, but a series of related events) was the monumentalization and partial rationalization of this fantasy architecture to meet the requirements of everyday public building. In the case of the Roman theatre we are fortunate in being able to document the moment of transition, from the Theatre of Scaurus to the Theatre of Pompey. What seems to have happened in western Asia Minor, and particularly in, and within the sphere of, Ephesus, is that with the resumption of large-scale building under the Early Empire the same conventions were reinterpreted and widely applied, not only to stage-buildings but wherever a columnar façade of this sort might be thought to lend a note of opulence to the public architecture of the city. At Ephesus alone we find them used for gateways, for the ceremonial halls ('Marmorsäle)' of the great bath-gymnasium complexes, for the façade of the Library and for the scaenae frons of the theatre.

The earlier gateways at Ephesus were soberly conceived and executed.[31] The West Gate of the agora was a severely simple Ionic building, with a broad flight of steps leading up to a columnar façade between two projecting distyle features. In elevation the Harbour Gate retains the simple Ionic structure, but the plan, though still rectilinear, was more complex, with three openings alternating with four distyle projections. As late as c. 160 we still find much the same basic scheme in the West Market Gate at Miletus, except for the addition of an upper storey with small pediments on the outer wings and a larger broken pediment in the centre. Only in the gateway-arch at the south end of the marble-paved street leading down from the theatre at Ephesus do we escape this relatively sober note. The openwork treatment of this (as a setting for statuary?), and the deliberate disproportion of the upper order spanning the arch of the lower, are reminiscent of, though less successful than, the Arch of Hadrian at Athens.

With the theatre at Ephesus and the Library we pass to more characteristic examples of the Asiatic columnar façade. The latter building, with its subtle proportions and

deceptive simplicity of line (Plate 211), illustrates the dignity of which, at its best, this style was capable. At the other extreme, crowded with detail and often seeming to court eccentricity for its own sake, are the 'Marmorsäle' of the great bath complexes. The Harbour Baths at Ephesus (Figure 152) had a lofty colonnade across the front and two alternately projecting and re-entrant columnar orders along the three inner walls, each elaborately carved and diversified with contrasting rectilinear and curvilinear features and ingenious broken pedimental schemes, and the whole carried out in rich polychrome marble; to complete the effect one must imagine the gleaming white of pavements and statuary and the more sombre tones of the painted or gilt timber coffered ceilings. With buildings of which one can only study the effect in restorations it is hard to judge at what point opulence shades off into vulgarity. In some of the provincial replicas, e.g. that recently excavated at Side in Pamphylia,[32] one is left in little doubt of the answer – deeply satisfying though such a building was, no doubt, to local civic pride. At its best, however, this was a style in which wealth was tempered with sophistication, and it was one that was admirably attuned to the spirit of its age.

The nymphaeum erected at Miletus in honour of the emperor Trajan's father[33] was a decidedly pedestrian building (Figure 153), but it will serve to illustrate the characteristics of the large group of scenographic fountain-buildings of which it was one of the earliest monumental examples. These were essentially elaborate columnar façades, put up to close a vista or simply to mask what lay behind – in this case to complete the monumental frontage of the piazza opposite the bouleuterion and the West Gate of the agora. Except as purely scenic decoration the detail is architecturally meaningless; it bears no relation whatsoever to whatever is hidden by the screen. As such it became a favourite device of civic planners in the smaller cities, notably those of southern Asia Minor, where it became almost a symbol of status, comparable to the possession of a colonnaded street. Outside Asia Minor it was less common. An outstanding example is the Septizodium in Rome, erected to screen the utilitarian buildings at the south end of the Palatine (Plate 143). Another closely comparable building is the Captives' Façade at Corinth (p. 378), which was designed to mask an awkward gap in the north façade of the agora.

Pamphylia and Cilicia

The cities of southern Asia Minor, though rich in buildings of the Roman period, are architecturally far less important than those of the western coasts and valleys. Not only was theirs a later flowering, but when it came it was very largely derivative. Few areas had suffered more from the political disorders of the Late Republic, and it was only under Augustus and his successors that urban life once more gathered momentum. The strain of classical hellenism had never been very robust, and the principal architectural legacy from the past seems to have been the buildings erected in Pamphylia under Pergamene domination in the second century B.C., among them the well preserved city walls of Attaleia (Antalya) and Perge and, possibly, the two-storeyed stoa beside the agora at Aspendos. This was a tradition of fine dressed masonry, and it remained the basis of

local building-practice throughout antiquity. Superimposed upon it was the new Roman-period architecture.

The architecture of Roman Pamphylia falls into two clearly distinguished phases. During the first, corresponding to the period from Augustus to Trajan (27 B.C.–A.D. 117), the materials were local and the sources various. A small tetrastyle pseudo-peripteral temple at Side (Figure 155A) stands on a podium and is as Western in plan as the Temple of Augustus at Antioch-in-Pisidia. The same may be said of a large cylindrical mausoleum standing on a square basis overlooking the harbour at Attaleia (Plate 214). On the other hand, both in its plan and in the detail of its ornament, which is still purely hellenistic, a small fountain-building at Side, built in 71 (Figure 154), is a modest version of what we may imagine the predecessors of the great Trajanic nymphaeum at Miletus to have been. Another monument which is still in the hellenistic manner, but which may well in fact be of Augustan date, is the fine South Gate at Perge (Plate 212).[34]

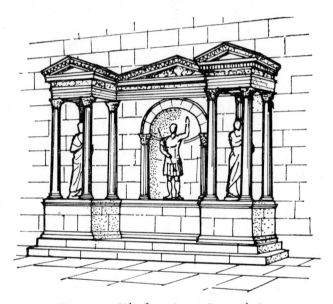

Figure 154. Side, fountain, 71. Restored view

As a monumental building style, this 'Romano-Pamphylian' architectural tradition disappeared almost overnight in the early second century, superseded by one based on the new material, marble, which had now for the first time become available in large quantities. The overwhelming majority of the marble used architecturally in Pamphylia came from the quarries of Proconnesus (Marmara), and the techniques and styles were those of western Asia Minor. At Side this is most strikingly evident in the smaller and slightly earlier (Hadrianic?) of the two hexastyle peripteral temples ('N 1') overlooking the harbour, the details of which (notably the frieze) derive straight from the Traianeum at Pergamon. The larger of the two ('N 2'), with Composite instead of Corinthian capitals but otherwise very similar, is perhaps a decade or two later. Both in plan (Figure 155B) and in detail these temples bear a very close resemblance to that of

Antoninus Pius (138–61) at Sagalassos, about 60 miles inland, another and well dated example of what one may conveniently refer to as the Imperial 'marble style' architecture. As we shall see, Pamphylia is only one of a number of Mediterranean provinces upon which it had a deep effect.[35]

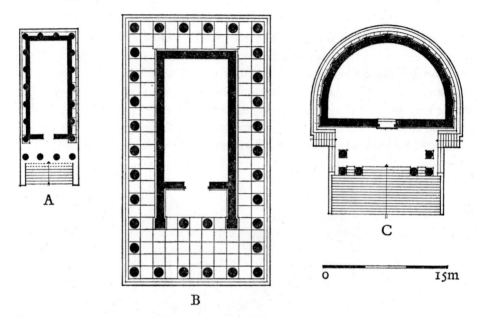

Figure 155. Side. Plans of temples

(A) Small temple beside the theatre, first century
(B) Temple N 1, early second century
(c) Apsidal Temple, third century

By the middle of the second century this was the only style in monumental use in Pamphylia. At Side alone we meet it in a range of buildings that includes three colonnaded streets; a city gate like that of Perge (see below) and, opposite it, a monumental nymphaeum; a theatre, among the decorative motifs of which is the same distinctively Pergamene frieze motif as in Temple N 1; a square porticoed piazza behind the stage-building, which (like the Piazzale of the Corporations at Ostia) was also a place of business, with rows of offices or shops; a large porticoed enclosure of uncertain purpose, perhaps a gymnasium, the principal feature of which is an extremely elaborate late-second-century 'Marmorsaal'; a small third-century temple on a tall podium, with a semicircular cella and a gabled porch, of which the central opening was three times as wide as the other two and arched as in the Temple of Hadrian at Ephesus (Figure 155c); a small circular temple with a conical roof, added in the third century to the piazza behind the theatre, in honour of the city's guardian divinity, or Tyche; and, perhaps as late as the early fourth century, a grandiose funerary temple and precinct in the northwest cemetery. All of these, except possibly the nucleus of the theatre cavea, which is of traditional Greek shape, were essentially new buildings, and they illustrate not only the

overwhelming impact of the new material and style, but also the solid basis of middle-class urban prosperity upon which its rapid diffusion rested.

The other cities of Pamphylia tell the same story. At Perge the transformation of the South Gate into a nymphaeum (Plate 212), with an elaborately carved two-storeyed marble order following the curve of the walls of the inner courtyard, is important in that it can be closely dated by its statues and their inscriptions to the years between 117 and 122.[36] The date is doubly significant since the accompanying triple arch at the inner end of the courtyard, a Trajanic monument, was built entirely of the fine white limestone from the near-by Pisidian mountains, the last known building to have made such monumental use of local materials. Dressed stone masonry did, of course, continue to be used everywhere for the walls and vaults that accompanied the fine marble detail. At Perge, as at Side, this was the basic material of the large Roman-type theatre; of the stadium, with its ingeniously vaulted substructures; of the as yet unexcavated market, which seems to have been of the same general type as, for example, that at Corinth, with the addition of a central pavilion; and of the two well preserved public bath-buildings. The latter, each in plan a loose agglomeration of rectangular halls, are note-worthy for the surviving traces of their brick barrel-vaulting.

At Aspendos[37] the outstanding monument is the theatre, outstanding because alone of its kind it has preserved intact its stage-building (Plate 210). This is a good example of the traditional 'Eastern' type, and it could well have been copied directly from the stage-building at Ephesus. The narrow wooden stage projected at the level of the central steps, which are modern; the vaulted gallery around the head of the cavea is a later addition. On the hill above lay the agora, flanked on one side by a two-storeyed stoa of late hellenistic type and on the other by a basilica of the third century A.D.; it was closed at one end with a two-storeyed columnar screen. The basilica was a long, narrow building with a single apse at one end and a square, tower-like vestibule at the other. Analogy with the Hadrianic basilica at Kremna in Pisidia, one of the few other certainly pre-Christian basilicas in Asia Minor, suggests that this vestibule served the purposes of the imperial cult.

The most singular building at Aspendos is the aqueduct (Plate 213). Contrary to the normal Roman practice of letting water follow a gentle gradient, it was here carried under pressure across the broad valley to the north of the town, the total distance being divided into three segments by means of pressure towers. These two towers, built partly of brick and partly of mortared rubble with brick courses about a framework of dressed stone, are fine examples of a sort of masonry which, as we have remarked above, was to play an important part in the transition from Roman to Byzantine architecture. Another portent of the future is the pitched-brick barrel-vaulting of two cisterns below the basilica (Plate 200), a characteristically Byzantine feature for which all the precedents lie in the mud-brick architecture of Egypt and Syria.[38] Here we have a rare surviving example of the sort of Roman-period building which was the intervening link between the two traditions.

About the architecture of Cilicia, the coastal province at the south-east corner of Asia Minor, one can be even briefer. In the absence of the large-scale excavation of any

single major site, the picture presented by the individual monuments inevitably lacks coherence. The remains of cities such as Seleucia (Silifke), Elaeusa (Ayaş), Korykos, Pompeiopolis, and Anazarbos indicate that after a period of local development, in common with the whole eastern coastline of the Mediterranean they came under the influence of the 'marble style' architecture of western Asia Minor; but the impact was far less marked than in Pamphylia. Culturally as well as geographically Cilicia belonged quite as closely to the North Syrian coastlands and to the great metropolis of Antioch as it did to the rest of Asia Minor. The colonnaded street of Diokaisareia, for example, is one of the earliest known (Tiberian?), and the brackets projecting from its columns to carry statuary are a Syrian feature of which Palmyra offers innumerable examples. The 'windswept' Corinthian capitals of the streets at Pompeiopolis seem to point in the same direction. Another distinctive feature of the architecture of Roman Cilicia is the good quality of much of its concrete, due almost certainly to the use of the volcanic sand which is available locally. In this respect the harbour mole at Elaeusa and the baths at Korykos are well up to Central Italian standards; and in the case of a small bath-building at Elaeusa, with a facing of opus reticulatum and courses of brickwork, one can actually document the connexion.

The Contribution of Asia Minor to the Architecture of the Empire

Seen within the larger perspective of the Roman Empire as a whole, the architecture of Asia Minor emerges as a broadly conservative tradition, but one which was prepared to adapt itself to changing times, and itself to absorb and to adapt those extraneous elements which met its own particular social, political, or cultural requirements. Although its strength lay in its solid foundation of hellenistic taste and practice, this was no sterile traditionalism. We see this very clearly in its treatment of the new ideas which came in from Italy, the largest single source of outside inspiration, particularly under the Early Empire. Some, which answered an immediate need, were adopted as they stood. Such were the roads and bridges, the aqueducts, cisterns, and other hydraulic works of which the engineers of Rome were the acknowledged masters. A few, such as the amphitheatres and basilicas of Western practice, took only precarious hold. Many others (the bath-building is an outstandingly successful instance) were adapted and absorbed into the steadily developing provincial tradition of which the cities of the western coast were the vital centres, the Anatolian plateau and the southern coastal provinces the peripheral recipients. Other currents were at the same time flowing in from the East, bringing in such diverse elements as the colonnaded street, the sanctuaries of the Oriental gods, and the brickwork vaulting-systems of Egypt and Babylonia. Roman Asia Minor, in common with most of the Roman world, was the recipient of many outside influences, but the local tradition was vigorous and consistent enough to absorb them and give them new direction. Right through into late antiquity Asia Minor, for all its essential conservatism, was a vital creative centre.

At the risk of over-simplifying a picture of which the very essence is its complexity, one may perhaps select two facets of the resulting tradition as outstandingly important

for the history of classical architecture as a whole. One was its translation of the techniques and aspirations of the concrete architecture of the West into terms which were both meaningful and structurally practicable under the very different conditions prevailing in the Aegean world. This was one of the essential preconditions of Early Byzantine architecture, which, in this particular respect, can be seen to be firmly rooted in the Middle Imperial architectural practice of the Roman provinces bordering on the Aegean and the Sea of Marmara. The other, and even more influential, manifestation of this Asiatic tradition was that embodied in its use of the familiar orders of the classical architectural system. Here Asia Minor occupies a somewhat paradoxical position as both a guardian of tradition and an innovator; a guardian in respect of the time-honoured elements of the system and the detail of their decoration, an innovator in the manner and spirit of their use. While the architects of Italy were busy exploring new materials and new spatial forms, their colleagues in Asia Minor were taking the traditional classical elements and recombining them to produce novel visual effects. Both in their very different ways were helping to shape the development of Roman architecture towards the new forms and aspirations of late antiquity.

Finally we may emphasize once more the significance of Asia Minor's predominant position in respect of the supply and handling of what in the second and third centuries A.D. became the monumental building material *par excellence* of a large part of the Roman world – marble. Even in Rome the results of this fact are evident in the architecture of Hadrian and his successors. In many places, as in Pamphylia and in parts of North Africa, the impact was such as radically to reshape the building traditions of the earlier Empire; and everywhere, throughout the Mediterranean basin, the new style left its mark on the most influential buildings of the age. If the emergence of an 'Imperial' architecture, broadly uniform wherever it is found, is rightly regarded as one of the characteristics of the later Roman Empire, it owes much to the quarries and the marble-workers of Asia Minor.

THE ARCHITECTURE OF THE ROMAN EAST

IF within the Greek world the study of the architecture of the Roman age is complicated by an essential duality of direction between the native hellenic tradition and that derived from Rome herself, when we turn to the eastern coastline of the Mediterranean world and to the lands that lay beyond it the duet becomes a trio, if not indeed a chorus of mixed voices. Both the Achaemenid Persians, who were masters of the whole area from the sixth to the fourth centuries B.C., and the hellenistic Greeks, who succeeded them as a result of the whirlwind conquests of Alexander the Great, found themselves ruling over peoples who counted as many millennia of civilized life as their masters, Iranian or Greek, could count centuries. Alexander and his successors did manage to impose on their Oriental subjects some of the superficials of hellenism, and even in certain favoured areas some of its realities. But the centuries which followed the establishment of the hellenistic kingdoms were in the main characterized by a resurgence of the time-honoured habits and customs of the ancient East. In dealing with the hellenic world Rome had been confronted by an essentially kindred civilization, of which her own was indeed in many respects a direct offshoot. In the eastern provinces, on the other hand, she found herself face to face with a multitude of local cultures which, however receptive to the superficials of classical life, spiritually had little in common with Greece and Rome. Here and there, as in the Greek foundations of north-western Syria, hellenism had struck deep roots. Elsewhere Rome found herself face to face with an older and more intractable world.

In studying the architecture of the Roman East we have, then, to bear in mind not only the familiar dualism of Greece and Rome, but also the deep-seated antithesis between East and West, between the classical and the Oriental worlds. Not that the contrast often presents itself in such simple, uncomplicated terms. For centuries the ideas of the ancient East had been filtering through to the Western world. Even in Rome, and as early as the first century A.D., they were beginning to be an important factor in shaping, for example, the architecture of the ruler cult and of the mystery religions. Again, the art of Arsacid Parthia, for all its anti-classical tendencies, had roots in a past to which hellenism had contributed many of the formative ideas and a great deal of the formal vocabulary. All these currents had already met and mingled their waters. Now for the first time, however, all three moved forward as a single stream. If one views the architecture of Roman Syria within the larger context of the history of Mediterranean architecture, it is the fact that the architectural traditions of Greece, of the Orient, and of Rome were here meeting and developing on common ground that may be considered to have been foremost in giving shape and purpose to its especial contribution.

Politically the history of Rome's eastern frontier is one of continuous rivalry and occasional open warfare with the successive rulers of Iran. By the middle of the second

century B.C. the Arsacid Parthian dynasty, originally the product of a nationalist reaction against the Graeco-Iranian hellenistic kingdom of the Seleucids, had successfully established its authority over the whole vast territory that lay between the great westward bend of the Euphrates on the west and the Kushāna Kingdom of the Indus valley on the east. Here, and here alone along the many thousand miles of her frontiers, Rome was faced by a major civilized power with whom she had to come to terms. Like the Romans themselves, the Parthian (c. 240 B.C.–A.D. 226) and Sassanian (from A.D. 226) rulers of Persia had their moments of weakness and of strength, upsetting the uneasy balance; but such moments of open, dramatic warfare were the exception. Most of the time both parties were content with a state of peaceful coexistence, during which the frontier between them was as much a zone of mutual influence and profitable exchange as it was a barrier. Along it, as the effective instruments of such a policy, lay a chain of client principalities in varying degrees of dependence upon one or other of the great powers. Armenia, Cilicia, Commagene, Emesa, Hatra, Judaea, Nabataea, Osrhoene, Palmyra, Pontus – these are some of the buffer states, great and small, which at one time or another owed allegiance to Rome, to Parthia, or successively to both.

It was only in exceptional circumstances and under an exceptionally gifted ruler that one of these border communities might aspire to a genuinely independent policy; and in course of time most of them came to be absorbed by Rome or by Parthia. In the fields of thought, religion, and the arts, on the other hand, they have a significance that far transcends their political importance. Not only were they the heirs to a civilization far older than that of either of the contending powers, but they had a community of culture, belief, and commercial interest that made little of the political boundaries of the day. The average citizen of third-century Dura or Palmyra would have felt far more at home in Parthian Hatra than in Roman Antioch, let alone in Rome itself. These frontier cities were not only a medium of fruitful exchange between East and West: they were the homes of people who had themselves an important contribution to make to the rapidly evolving civilization of the worlds on either side of them.

This whole region passed within the Roman orbit when, in 64 B.C., as a result of the conquests of Pompey the Great, Rome fell heir to the tattered remnants of the great Seleucid Empire. There is no need to follow in any detail the successive stages of the organization of the province of Syria (which in the present context may be treated as including also the provinces of Judaea and Arabia). More important are the facts of geography. Central and southern Syria may be regarded as being divided broadly into three zones: an often very narrow coastal belt of which the natural outlet was towards the west by sea, through the ports of Phoenicia; a frontier zone of varying extent, which faces eastwards across the desert; and between the two a belt of hills and mountains, comprising the greater part of the modern Lebanon and Palestine. Within this mountain belt the upland of the Bekaa, between the formidable twin ranges of Lebanon and Anti-Lebanon, formed a well defined unit, across which the route from Damascus to Sidon and Tyre formed one of the two main outlets for the immensely profitable trans-desert caravan trade through Palmyra. (The other outlet lay slightly to the north, through Emesa (Homs).) Palestine seems on the whole to have shared Lebanon's

tendency to look either westwards or inwards upon itself, rather than eastwards across the Jordan to the relatively poor, marginal territories of Nabataea (corresponding roughly to the western fringes of the Arabian desert, from Damascus to the Gulf of Aqaba) and the cities of the Decapolis. The natural outlet of this latter region was north-wards, through Damascus.

It is only at the northern end of the Syrian coastline, in the modern Syria, that there was a rich hinterland beckoning eastwards as well as westwards. Here the great bend of the Euphrates swung to within a hundred miles of the Mediterranean; and from here, cutting obliquely across the west–east pattern of sea, mountain, and desert, ran the age-old route down the Euphrates to Seleucia, the successor of Babylon, near the modern Baghdad, and the rich commerce of the Persian Gulf. This was the site chosen, with rare historical foresight, by Seleucus I for his new capital of Antioch, founded in 300 B.C.; and it was almost inevitable not only that Antioch should be chosen to be the ad-ministrative capital of the Roman province of Syria, but that it should also become the commercial and cultural, and in Christian times the spiritual, metropolis of the whole Roman East. Together with the neighbouring Seleucid foundations of Apamea, Lao-dicea, and the seaport of Seleucia, Antioch had been the no less unquestioned focus of hellenization in Syria, and the loss of the monuments of these cities is a gap in our knowledge comparable to the loss of their great Egyptian contemporary and rival, Alexandria.

In partial compensation for the disappearance of ancient Antioch and of its twin capital of Seleucia-on-the-Tigris, the cultural metropolis of hellenistic and of Parthian Mesopotamia,[1] we have the evidence of Dura, which was successively a hellenistic, a Parthian, and a Roman stronghold on the middle Euphrates, and of Hatra, a Parthian and for a brief while Roman outpost in northern Mesopotamia. Together with the caravan city of Palmyra, they offer a vivid picture of the debatable country that lay on the eastern fringe of the Roman world, belonging wholly neither to it nor to Parthian Iran. Another area rich in classical architecture, though mostly rather late and of a rather modest, provincial character, is the Djebel country of northern Syria, north and south of the road from Antioch to Aleppo. To the north and north-east, beyond the Euphrates, lay the alternative land route to Mesopotamia, through Edessa and Nisibis to the upper Tigris, but of the Roman architecture of this region we know virtually nothing. Finally, beyond the Mesopotamian frontier to the east lay lands as richly varied as those which we have been describing, but which from the point of view of the classical world may be referred to simply as Parthia.

Judaea: The Buildings of Herod the Great

The logical starting-point for any description of the Roman architecture of Syria would be some account of the basis of hellenistic Greek experience and practice upon which, here as elsewhere in the eastern provinces, the Romans were building. In the virtual absence of surviving Greek monuments of the hellenistic period, we must instead be content to note that such evidence as there is strongly suggests that, outside

the great hellenistic foundations of the north,[2] we should probably be wrong to look for any widely diffused provincial architecture that was genuinely Greek in character. There are, of course, clear traces of Greek influence in central and southern Syria: the common use of the Ionic order, for example, in the Roman period, and many of the architectural mouldings in later use. But there is also a large and growing body of evidence to suggest that, despite borrowings from both Persian and Greek sources, in a considerable number of areas at any rate the tradition with which the Romans were confronted was in many essentials still that of a native, local architecture.

This fact does much to explain why the initial impact of Imperial Rome on Syria was far greater and more immediate than it had been in Greece or Asia Minor. One can see this very well in the building programme of Herod the Great (d. 4 B.C.), the figure who, architecturally as well as politically, dominates the earliest phase of Roman rule in this area. Herod, as we learn from Josephus,[3] was a prodigious builder, not only in his own kingdom of Judaea and the several territories annexed to it, but up and down the whole Syrian coast and as far afield as the Dodecanese, Pergamon, and Nicopolis in Epirus. The list of his work includes one important new foundation, the harbour town of Caesarea, and several lesser towns; temples in honour of Augustus at Samaria, at Caesarea, and at Paneion on Mount Hermon, the latter stated to have been of white marble; a colonnaded street at Antioch; monumental market-places (*agorai*), stoas, and fountains at Caesarea, Berytus (Beirut), and Tyre; the doubling of the Temple precinct at Jerusalem and its enclosure within porticoes; a monumental peristyle at Ascalon; theatres at Sidon, Damascus, and Caesarea; an amphitheatre at Caesarea; gymnasia at Tripolis, Damascus, and Ptolemais; a bath-building at Ascalon; an aqueduct at Laodicea (Latakieh); and numerous fortresses and palaces. After half a century of political trouble during which there can have been very little significant building, such an ambitious programme was bound to leave its mark.

A few of these buildings are known to us, mostly from excavations undertaken in the last few decades. Herod's Temple of Augustus at Samaria was found to be sadly robbed and overlaid by later building, but enough survived to show that it consisted of a rectangular *temenos*, or precinct, 165 by 205 feet (50 by 63 m.) internally, terraced out from the crest of the hill and enclosed on three sides by porticoes; and dominating the fourth side at the head of a long flight of steps, the temple itself, which was of the Corinthian order and seems to have been peripteral on three sides, with a plain back wall.[4] The layout is one for which there are several parallels in the Early Imperial architecture of central and southern Syria, including Baalbek, where it may derive from hellenistic Syrian models. Whether in this instance it also reflects contemporary Roman practice (as the very unusual omission of the colonnade on the fourth side of the temple might suggest) is a question that cannot be answered on the evidence now available.

Of the great Herodian Temple at Jerusalem there are the substantial remains of the platform and its stone-vaulted substructures, but little more. We are better informed about Caesarea, where the recent excavations have revealed the theatre and some of the vaulted substructures overlooking the harbour. The former was built of concrete, with stone seating. The stage-building, as rebuilt in the second or third century, was of

typically Roman design, with a curved central exedra flanked by two rectangular recesses and adorned with a decorative screen of imported marble and granite columns. The earlier, Herodian stage-building is described as having a shallow, rectangular niche in the centre, with wide curved niches at the sides and projecting wings with columns, and as having 'more in common with [late] hellenistic design than with the deep recession of the Roman scaenae frons'.[5] The Herodian floor of the orchestra was of stucco, painted to simulate marble. It was later marble-paved, and later again converted into a tank for aquatic shows.

The remains at Jericho are notable principally for their use of opus reticulatum, very rare in the East and doubtless used here in deliberate imitation of a terraced villa in the contemporary Italian manner.[6] The same Italian influences are evident in the small but spectacularly situated residence (the 'Hanging Palace') at the northern tip of Masada (Plate 217). This was built of dressed stone faced with stucco and consisted of three platforms terraced down the knife-edge northern extremity of the plateau. The upper platform comprised a rectangular suite of nine rooms, including cubicula paved with black-and-white mosaics and fronted by a semicircular colonnaded terrace, which looked directly out over the middle platform, 60–70 feet below. A circular pavilion stood on the middle terrace and, behind it, a covered colonnade. The lower terrace, 40–45 feet lower again, was entirely occupied by a belvedere, with four porticoes enclosing an open central area. The walls of the belvedere, inside and out, consisted of a series of structural piers linked by a vestigial curtain wall, of which almost the entire intercolumnar space was occupied by lofty rectangular windows – an extreme form of a typically late hellenistic device, the germ of which is already present in the bouleuterion at Miletus, but for which the closest recorded parallels are to be found in Italy, e.g. in the House of the Mosaic Atrium at Herculaneum (Plate 172). On the plateau above were storerooms and cisterns, a large public bath-building in the Roman manner, and a second, larger palace (the 'Western Palace') with a throne room and reception halls as well as living quarters grouped around a central court with a portico. This was a late hellenistic architecture with strong Italian overtones – just what one would have expected from a patron of Herod's known tastes and upbringing.[7]

The surviving remains of Herod's work elsewhere are tantalizingly fragmentary; but they too convey a picture of an architecture which, though inevitably shaped by local practices, leaned heavily upon ideas and techniques brought in from the classical world, from Italy as well as from the hellenistic East. Although the fine masonry with its stucco detail is, in the context, a local tradition, the reticulate work at Jericho and the concrete of the theatre at Caesarea were both Italian innovations. The agora, the porticoed enclosure, and the gymnasium belong to the stock-in-trade of hellenistic town planning, but the amphitheatre at Caesarea and the baths at Masada and at Ascalon are distinctively Western innovations; perhaps also the *peripteros sine postico* plan of the temple at Samaria and, more generally, the widespread use of terracing on vaulted substructures. About the theatre at Caesarea it is difficult to be precise. As an institution, the theatre had never really taken root in hellenistic Syria,[8] and in the absence of a local tradition those of the Roman period are almost exclusively of the so-called 'Western' type. Herod's building

appears to represent a rather different, earlier tradition, the immediate inspiration of which has yet to be determined. The colonnaded street which Herod built at Antioch is the earliest recorded, and it is by no means impossible that it was in fact the first ever to be built, representing a translation into the local idiom and a monumentalization of the *viae porticatae* of later Republican Rome.

It was not until late antiquity that Judaea once more came to occupy the centre of the architectural stage. After the Jewish revolts and the reduction of Judaea to the role of a small, second-class province, architectural interest is concentrated chiefly on the development of the synagogue. There is an early group of these in Galilee, the members of which are basilican in plan, with monumental façades, and date from the late second and early third centuries. They have often been claimed as precursors of the Christian basilica; but they are singularly isolated both in place and time – none is later than the middle of the third century – and the connexion is very doubtful. They should be regarded rather as one of the innumerable borrowings of this versatile and symbolically neutral architectural type for other purposes, without wider significance.[9]

Baalbek and the Lebanon

For a more comprehensive vision of the historical development of classical architecture in the Syrian coastlands one has to turn from Judaea to the cities and dependencies of Phoenicia, corresponding roughly to the modern Lebanon. Here not only do we have the great sanctuary of Jupiter Heliopolitanus at Baalbek, but there are many well preserved lesser sites and, in recent years, a growing body of material from the coastal cities, which together enable us to view the buildings of Baalbek in increasingly sharp perspective.[10]

The complex origins of the religious architecture of the Roman East are closely bound up with the historical development of the cults themselves. At Baalbek the cult, originally that of a typical triad of native agricultural divinities, had already undergone considerable modification in hellenistic times, probably under the influence of Ptolemaic Egypt. The great god of the storm, Ba'al, had been equated with Zeus, and whether by an act of formal syncretism or by a process of natural assimilation, the youthful god of regeneration and rebirth (Adonis, Echmoun or Tammuz) took on the character and attributes of a divinity who was at this time acquiring ever-increasing popularity as a god of personal regeneration and rebirth after death, namely the god known to the classical world as Dionysus or Bacchus. It is typical of the practical good sense of the Romans that they should have chosen to promote this long-established sanctuary, rather than, as in Gaul or Asia Minor, a conventional shrine of Rome and Augustus, to serve as a focus for the religious loyalties of central Syria.[11]

The only specific reference to this enormous enterprise in ancient literature, a statement by the seventh-century Antiochene historian, John Malalas, that it was built by Antoninus Pius, is certainly mistaken.[12] An inscription on one of the columns of the façade of the great temple proves that the latter was already standing to capital height in A.D. 60, and it must in fact have been planned quite soon after the foundation of the

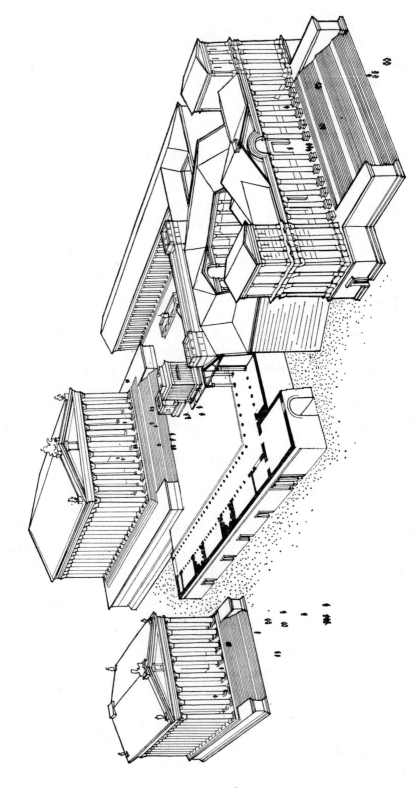

Figure 156. Baalbek, sanctuary, began early first century, completed c. 250. Axonometric view

Roman Colonia Julia Augusta Felix Heliopolitana *c.* 16 B.C.[13] It was not the first monumental sanctuary to occupy the site.[14] Recent excavation has shown that the platform of the great courtyard rests on the remains of an ancient tell, and built into this tell there had been at least three substantial previous sanctuary buildings, the first of which is thought to be as early as, or earlier than, the sixth century B.C. All three had followed the same orientation as the present building and seem to have been centred upon the area occupied by the later altar; and adjoining the façade of the third was a tower-like altar closely comparable to those of Machnaka and Kalat Fakra, which are described below. Whether the pre-Roman sanctuary included a temple proper or was simply a monumental temenos with altars is at present an open question. The altars were certainly an essential feature, so much so that provision was made to keep those of the hellenistic sanctuary accessible during the early stages of work on its Roman successor. Like many of the great shrines of the ancient world, Baalbek was a long time building, and even so it was never fully completed. A study of the decorative detail shows that the great altar was finished soon after the middle of the first century A.D., the courtyard around it, after several changes of plan, not until nearly a century later. About the middle of the second century the 'Temple of Bacchus' was added (it is perhaps to this building that Malalas's sources were referring); and over the next hundred years there were added a monumental forecourt and propylaeon, dated by inscriptions and coins to the time of Caracalla (211–17) and Philip the Arab (244–9) (Figure 156).

The Temple of Jupiter was, by any standards, a very large building, and it was made to seem even larger by its elevation on a podium which towered 44 feet (13·5 m.) above the great court, at the head of a grandiose flight of steps. The temple itself, built throughout of the superb, honey-grey local limestone, was decastyle, with nineteen flanking columns and a deep columnar porch. Its columns rose another 65 feet (19·90 m.) from floor to capital (Plate 219), and the gable was thus nearly 130 feet above the floor of the great court. The cella, which faced east, was removed in its entirety when in the Middle Ages the whole sanctuary became an Arab fortress, but the plan of the footings and the analogy of other known early temples in the area alike suggest that there was a raised sanctuary (*adyton*) at the west end, a simpler version of that found later in the Temple of Bacchus. In front of the temple stood a porticoed courtyard, the central open space of which measured 320 by 280 feet (97 by 86 m.), and on the axis of this courtyard, between the façade of the temple and the original propylon, stood two square, tower-like structures, the larger of which rose no less than 55 feet (17 m.) above the pavement of the courtyard, from which the flat platform-roofs were accessible by stairs. These were artificial 'high places', designed for the sacrificial rites of the sanctuary. The larger of the two is sited so close to the main entrance to the courtyard that the temple must at first have been invisible to the visitor entering the sanctuary on the conventional central axis. Only when he turned and moved to right or left would the towering bulk of the great temple façade have broken upon him in all its immensity.

It is customary to refer to the element of sheer size at Baalbek as if it were a characteristically Roman innovation, and rather a vulgar one at that. In fact, although the height was indeed exceptional, the dimensions of the actual temple (158 by 259 feet, or 48 by

88 m., at the stylobate) fall well short of such classical Greek giants as the temples of Artemis at Ephesus (180 by 374 feet; 55 by 114 m.) and of Zeus Olympios at Akragas (173 by 361 feet; 52·75 by 110 m.), or the hellenistic Didymaion, near Miletus (167 by 358 feet; 51 by 109 m.). In Rome itself it had no equal until Hadrian's Temple of Venus and Rome (194 by 387 feet; 59 by 118 m.).[15] Its plan in relation to the forecourt closely resembles that of Herod's temple at Samaria and may well be based on hellenistic models. Much of the detail, on the other hand, is specifically Roman. The earliest capitals of the temple (the design was modified in the course of the work) are based on models to be found in Augustan Rome, notably in the Temple of Castor. Another character-istically Roman trait, rare in the East, is the use of shell-heads that splay downwards, not upwards, in the decorative niches. Again, much of the decorative carving of the great altar-tower is purely Roman in character, in significant contrast to the work of other squads engaged on the same building, whose sharply outlined, rigidly geometric carving is no less clearly the product of a markedly conservative Oriental tradition. The entabla-ture of the Temple of Jupiter, 13 feet high, exhibits an even more complex parentage. The proportions and relative scale of the ornament are those of a mid-first-century Roman monument, whereas the detail of some of the mouldings, such as the foliate ornament of the sima and the maeander below it, are patently hellenistic in origin; a curious, corkscrew-like horizontal moulding is paralleled only on the great temple of Shamash at Hatra in Mesopotamia and on a few Judaean monuments;[16] and the frieze, a boldly conceived design in which the forequarters alternately of bulls and lions project above foliate brackets, as if supporting the load of the cornice, must have been designed expressly for the temple, since the bull and the lion are the attributes of Ba'al-Hadad (Jupiter) and of Atargatis-Allat (Venus), the two senior members of the local triad. The bracket itself must in the context be a Persian legacy, comparable to the twin-bull capitals of Persepolis and Susa and, nearer home, of Sidon.[17] This motif too is repeated at Hatra.

The Temple of Bacchus was smaller than its gigantic neighbour (115 by 217 feet; 35 by 66 m.), but it was still by any ordinary standards a large building. In plan it differed principally from its predecessor in the proportionately far greater area that was reserved for the cella, an emphasis which was presumably due to the requirements of the cult. The architectural ornament, though based on that of the earlier building, is extraordinarily elaborate, the interior of the cella in particular (Plate 220) being a master-piece of disciplined opulence, in which the soaring dignity of the main architectura lines stands out in vivid and effective contrast to the intricacy of the secondary detail. It is instructive to contrast it with the rather dry, Attic sobriety of the nearly con-temporary façade of Hadrian's Library at Athens (Plate 194). The spirit of Baalbek is far closer to that of the Severan Forum at Lepcis Magna (Plate 244), where the doorways of the tabernae serve very much the same purpose in giving height and scale to the main decorative order. Other refinements are the receding planes of the wall surfaces (which, one asks, is wall and which pier or recess?) and the ingenious, if not wholly successful attempt to link the architecture of the adyton with that of the cella as a whole. In the treatment of the walls it may not be altogether fanciful to see the Syrian architect's

answer to the increasing illusionism and emphasis on the properties of space that characterize so much of the contemporary architecture of the Roman West.

The great courtyard in front of the Temple of Jupiter seems to have been planned from the outset on broadly the same lines as what one sees today, although the present building represents a major reconstruction undertaken to comply with the more sophisticated requirements of second-century taste. Opening off the three porticoes there was a series of alternately rectangular and semicircular exedrae, within and between which every inch of wall-surface was occupied by tall pilasters and, between the pilasters, giving height and scale, two tiers of decorative aediculae. The contrast between the rectangular and the curved exedrae was accentuated by differences of detailed treatment. The former had flat timber roofs, and the wall decoration consisted of two continuous and closely interlocking orders of aediculae projecting from the wall to form a virtually independent columnar screen. The latter had semi-domes, and their wall-pattern resembles, with minor embellishments, that of the Temple of Bacchus. In both there was an elaborate interplay of curvilinear and rectilinear forms. The columns of the main porticoes and of the exedrae were of red granite from Assuan and grey granite from the Bosphorus (the transport alone of these up from the coast, each weighing over 10 tons, was a remarkable feat), and the vanished colonnettes of the aediculae were presumably of imported marble. Once again one is led to admire the subordination of the wealth of detail to the grandeur of the total effect, to which the repetition of the columns and aediculae lent scale and movement and the contrast of the granite and the local stone a welcome note of colour. When the colonnades were still standing as a frame and a foil for the elaborate detail within, the whole overshadowed by the towering bulk of the great temple, this must have been a building to impress the most jaded taste.

The hexagonal forecourt is now so ruinous that it is hard to judge the effect of the unusual plan.[18] The details were closely modelled on those of the great court, but the proportions were quite different, dwarfing the central space and heightening the eventual impact of the court beyond. In front of it lay the propylon, the last of the additions, dating from the reigns of Caracalla and of Philip. Here too, though there was ittle new in the detail save the arching of the architrave over the central opening (new perhaps to Baalbek but already a well established feature of the temple architecture of southern Syria),[19] and the moulded pedestals which gave added height to the twelve granite columns and to the gilded bronze detail of the entablature, one can nevertheless detect a subtle change in the spirit of the composition as a whole. The towers which flank and dominate the façade, while looking back to the Early Imperial monuments of the Hauran and of the Decapolis, and ultimately perhaps to the Temple of Jupiter at Damascus, also herald a long line of such symmetrical schemes in the architecture of Christian Syria.[20] While the temples and the great court are still firmly rooted in the classical world, here one is conscious of having already stepped across the threshold of late antiquity.

The last in date of the surviving monuments of Baalbek is the little third-century Temple of Venus which stood across the street from the main sanctuary in an enclosure

of its own. After the grandeurs of the Temple of Zeus it strikes a welcome note of elegance and refinement. The plan, an ingenious combination of a circular cella with a rectangular pronaos, had no close precedent (Figure 157). It stood on a tall podium, and from the front it might easily be mistaken for a typical temple building of southern

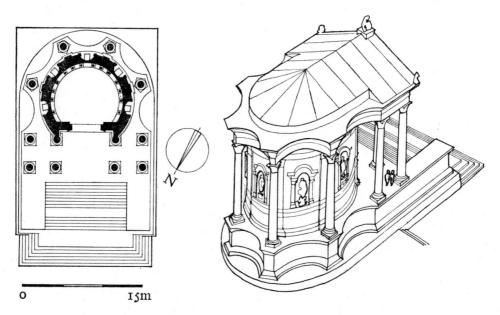

Figure 157. Baalbek, Temple of Venus, third century. Plan and axonometric view

Syria.[21] The circular cella speaks a very different language. It was roofed with a shallow stone dome, and it may have been the need to buttress this which first suggested to the architect the idea of an outer colonnade of which the entablature should be composed of five horizontal arches, their crowns tangential to the base of the dome and their two extremities projecting outwards to rest on the columns of the peristyle. The result was a plan that was partly scalloped and partly circular, a contrast of which the architect took full advantage, balancing the concave surfaces of the podium and entablature and of the niches in the cella wall against the convex surfaces of the cella itself and of the bottom steps of the podium so as to create an elaborately receding play of curve and counter-curve. Among the many refinements may be mentioned the uniquely five-sided Corinthian capitals and bases. This is a building to delight the fancy of any Baroque architect. The buildings of the great sanctuary, whether they look forward or backward, are essentially buildings of their own time and place. Here is one that eludes such classification – a monument to the sophisticated taste alike of the architect and of his public, and a reminder that great architecture, however much it may be conditioned by circumstances, is the product of the individual genius of its creator.

Baalbek was two and a half centuries building. The first impression that it conveys is almost inevitably one of a powerful continuity, extending often to the most trivial details, such as the abacus ornament of the capitals right through the series. Nevertheless

there were, as we have seen, also important innovations of content and style, above all innovations of planning; and although in the presence of the temples one is conscious first and foremost of their overwhelming influence upon the temple architecture over a large area of central Syria, it is pertinent to ask to what extent they themselves were shaped by forces that were more widely at work in this region in late hellenistic and Roman times. How much of all this is the legacy of traditional native practice, and how much the product of successive waves of alien classical influence, both hellenistic and Roman?

To such questions the many lesser sanctuaries of Lebanon offer at any rate a partial answer.[22] Although few are closely dated and many, particularly the later ones, exhibit the strong influence of Baalbek, there are also several which, whatever their absolute date, clearly illustrate a stage of development prior to that of any buildings now preserved at Baalbek. The characteristic monument of these early sites is a tower-like 'altar'. In its earliest recognizable architectural form this has simple but distinctive 'Egyptian' mouldings (a flattened torus near the base and at the top a flaring sima above a plain torus). In at least one instance, at Machnaka in the mountains above Byblos, an altar-tower of this type can be seen to incorporate a yet earlier structure in the form of a plain box of dressed stone slabs; and the hellenistic altar was itself subsequently given more conventionally classical form by the addition of an outer ring of slender Doric columns with an entablature and an openwork parapet above. On another early site with a long history, Kalat Fakra near the head of the Adonis river, the development took the form of loosely grouping the successive altars within the periphery of a single 'high place'. Four of them have survived – one with typical Egyptian mouldings and a crowstep-ornamented parapet (Plate 218); a small columnar structure of a type which recurs on several other sites (Hossn Sfiri, Hossn Suleiman, Niha), and which appears to be a miniature version of the latest phase of Machnaka; a large tower with internal staircases and terraces, the detail of which includes Egyptian mouldings and a gallery with Phoenician volute capitals; and a small altar of conventional Roman shape.

The group of Kalat Fakra serves very well to illustrate both the range and the extraordinary conservatism of this Lebanese architecture. The Phoenician volute capital goes back with little change to the beginning of the first millennium B.C. in Phoenicia and Palestine; the crowstep parapet, which we shall meet again at Damascus, Petra, and Palmyra, had a comparable background in Mesopotamia, and it remained in use throughout the area right into Arabic times. At Kalat Fakra the capitals and the Egyptian mouldings were still in use as late as A.D. 43, the date of the tower. By then Roman Baalbek was already taking shape; and there – as no doubt happened on many other sites – the earlier altars were superseded and replaced. Even so, tradition was strong enough at Baalbek to impose on an otherwise classical layout the architecturally incongruous element of the great altar-towers, to the form of which the tower at Kalat Fakra offers an obvious parallel.

It is to such local factors that we must look also for the explanation of the very distinctive interiors of these Lebanese temples. In the later, more elaborate versions, as in the 'Temple of Bacchus' at Baalbek, or Temple A at Niha (Figure 158), the sanctuary

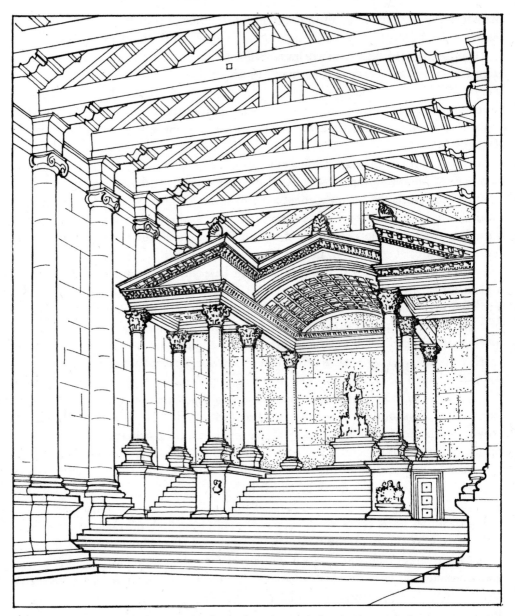

Figure 158. Niha, interior of Temple A, late second century. Restored view

proper (*adyton*) consists of a raised, canopied platform occupying the whole of the far end of the cella.[23] But this can be seen to have developed from an altogether simpler type in which the cult-statue stood within a simple canopied aedicula set in the rear wall at the head of a flight of steps.[24] The essential features were the canopy and the steps. Unlike the simple, rather intimate room which housed the cult-statue of a Greek temple, this was the throne room of the divinity, where he received his worshippers in audience. The conception is one that we find expressed in very similar terms throughout southern Syria, at Gerasa for example, or at Petra. The architectural language of these temples is

424

classical, but it is used to express an idea altogether alien to the traditional temple of Mediterranean lands.

The smaller sanctuaries of the Lebanon do, therefore, help us greatly to appreciate the strength of the native Semitic traditions that still underlay the classical veneer even in a countryside so readily accessible from the Mediterranean coast. They also illustrate the surprising persistence of Achaemenid Persian architectural influences. The hellenistic legacy is less unexpected, although it is well to remember that part of this may well be due to the diffusion in Roman times of classical ideas previously established in the cities of the coast. Among such we may number the location of several of these temples within a monumental porticoed temenos; the frequency of the Ionic and, less commonly, Doric orders; and perhaps also the long, narrow shape of most of the lesser temples, which are predominantly prostyle or *in antis*. The upper temple at Kalat Fakra (Figure 159) is of particular interest in this connexion, as illustrating the influence of

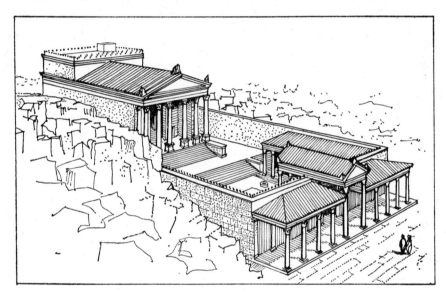

Figure 159. Kalat Fakra, temple, late first or second century. Restored view

first-century Baalbek or else of some common hellenistic model.[25] Although the building in its present form can hardly be earlier than the second half of the first century, the altar in the forecourt is still of the traditional type, with Egyptian mouldings.

The wave of fresh architectural ideas from the classical world which had followed the re-establishment of peace and prosperity under Augustus, and which found such vigorous expression in the planning of first-century Baalbek, was of relatively short duration. Further exploration of the coastal cities would doubtless modify this impression in detail. But just as in Rome itself the architects of the Julio-Claudian period were largely engaged in assimilating and exploiting the innovations of the previous generation, so too in the Lebanon the rest of the first century A.D. seems to have been devoted primarily to the working out of the new ideas and to the creation of the distinctive Romano-provincial style of which Baalbek was the focus and the continuing inspiration.

Once again, as in southern Asia Minor, it was the advent of marble which upset the balance of the local Early Imperial style; and if in the Lebanon the results may at first seem less startling than in Pamphylia, this is partly at any rate because the facts of geography limited its direct impact upon those monuments with which we are most familiar. Even at Baalbek the granite columns of the great courtyard bear witness to the fascination of the new materials, and the entablatures which they carried, though still carved in limestone, bear the unmistakable imprint of the new stylistic repertory. In the coastal cities the results were immediate and far-reaching. At Tyre the only well preserved first-century monument is an elaborate triple arch spanning the landward end of Alexander's causeway, and this is a characteristically Early Imperial structure of sandstone faced with stucco. The later buildings – the colonnaded street, the baths, the great temple of Hercules-Melqarth – all had columns of imported marble or granite, with Proconnesian marble capitals and entablatures that follow familiar 'marble style' models. The same is true of the colonnaded street and nymphaeum at Byblos, the only substantial monuments of the period yet uncovered there. The remains of Berytus lie deep beneath the modern Beirut; but the long series of Proconnesian marble capitals recovered casually and now housed in the National Museum would alone suffice to show that, from the second century onwards, the prevailing architectural style was in this respect based on that of western Asia Minor; and it is possible that in this case chance has preserved the remains of the actual building which set the fashion. The exact nature of this building, which came to light in digging the foundations of the modern parliament house, is disputed; but it certainly included a handsome Corinthian order, now partially re-erected in front of the museum, with columns of reddish limestone breccia and the remaining elements of Proconnesian marble, an interesting and unusual feature of which is the instructions for assembly carved on each individual block, apparently at the quarry. A fragmentary inscription records that it was built 'with its columns and marbles' by Berenice, sister of Agrippa II and for a time mistress of the emperor Titus.[26] This is just the sort of wealthy context in which one might expect to find the forerunner of what in the second century was to become normal municipal practice.

North-West Syria

It is sad that so little should have survived of the cities of northern coastal Syria, and in particular of Antioch. Here, if anywhere, one would have seen the monuments which set the pattern for the lost buildings of hellenistic Syria. Here again one would have seen, written large, the successive waves of Roman influence, the pattern of which, with its strong Western bias, was already established in the list of buildings for which Julius Caesar was responsible in Antioch itself: a bath-building and aqueduct, a theatre, an amphitheatre, and a monumental centre, the Kaisar(e)ion, for the cult of Rome and its rulers – a programme which neatly foreshadows that undertaken by Herod twenty years later.[27] Here, finally, one would have seen something also of the reverse architectural currents which under the later Empire began to flow from East to West and

which are at present most tangibly represented by the magnificent series of floor-mosaics from the city and its suburbs.[28]

Of all this building we have to be content with the remains of several of the smaller baths and of a number of houses. In plan the former (Figure 164B) ring changes on a few simple rectangular, octagonal, apsed, and occasionally circular forms, comparable at their most elaborate to the Hunting Baths at Lepcis Magna (Figure 176A) and no doubt derived from the same sources.[29] We do not know how they were roofed. Among the private houses and villas it is clear that the single-storey peristyle-house was the dominant type. Some of these were of considerable wealth and elaboration, grouped loosely about a number of minor courtyards. The most obvious common characteristic is the emphasis on the triclinium, which opens between columns or piers on to a courtyard, often accompanied by an elaborate fountain and usually laid out with a firm disregard of axial symmetry. An early-third-century house like that at Seleucia, the port of Antioch (Figure 160),[30] will serve as an example of the sort of building which may well have

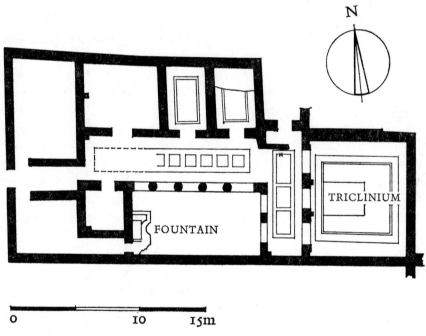

Figure 160. Seleucia-Pieria, near Antioch. Plan of a Roman house, early third century. The lighter lines indicate patterned mosaic floors

inspired the late antique houses of Ostia. Of the rich monumental architecture of the city there is hardly a trace. From the pages of Malalas and other writers we know that this architecture existed; we can be sure of its importance; but when it comes to details we have to accept the fact of a gap at the heart of our subject.

To fill that gap we have sadly little from the other cities of northern Syria.[31] What we do have, instead, is the often outstandingly well preserved remains of the innumerable

small country towns and villages which occupied the higher ground inland from the coastal plain, midway between Antioch and Aleppo.[32] This was the countryside which supported the great classical cities, and it conveys an extraordinarily vivid picture of what, under fortunate circumstances, Roman civilization could mean to the humble dweller in the provinces – a picture all the more remarkable in that a great many of the surviving buildings date from the fifth and sixth centuries, a time when over much of the Roman world civilization was crumbling fast. The late date of so many of the actual buildings does not matter greatly in the present context, since those architectural forms that are not specifically Christian seem to have changed very little since Early Imperial times; and although much of the architecture of these grass-roots communities is of greater interest to the social than to the architectural historian, it does inevitably reflect many aspects of contemporary urban practice.

The basic architectural forms were extremely simple and were determined by an abundance of good building stone and a tradition of fine craftsmanship in handling it. Except for the apses and semi-domes of bath-buildings and churches, the buildings were uniformly rectilinear, with gabled, or occasionally flat, roofs and a clearly marked tendency to build upwards rather than outwards. Towers and two-storey, or even three-storey, buildings are a commonplace. Another regular feature is the portico, sometimes conventionally classical in its detail, far more commonly translated into an open framework of alternately vertical and horizontal squared monoliths. A few buildings stand out as representative of a somewhat wider classicism. One such is the temple of Burdj Bakirha (A.D. 161), a modest prostyle building which, with its podium and rudimentary adyton, would not have been out of place in the Lebanon. Another is the small third-century private bath-building at Brad (Roman Barade), the curvilinear plan and vaults of which derive unmistakably from metropolitan practice (Figure 161C) and look forward in their turn to the small bath-buildings that were one of the more distinctive legacies of Roman to Early Muslim architecture in Syria.[33] It must represent the taste of some wealthy city-landlord. Such intrusive buildings were, however, exceptional. The great majority ring the changes on the very simple range of building forms that constitute the constructional repertory of this whole local group.

Domestic architecture bulks large, thanks to its use of exactly the same architectural vocabulary and durable materials as the public buildings. Most of the surviving houses date from the fourth to sixth centuries, but they repeat forms that were already established on the spot in the Early Empire. The basic unit was a rectangular building, one room thick, subdivided by transverse partitions, or rows of posts, and almost invariably opening along one long side, usually the south side, on to a portico. In what is probably rightly regarded as its primitive local form, the roof was flat and the span no larger than could be achieved with the poor local timber. The village houses at Taqle (Figure 161A) illustrate a developed and modestly prosperous version of the type (fourth to fifth centuries) with the dwelling-rooms in an upper storey over the stable. As early, however, as the first century A.D. the introduction of the classical gabled roof with tiles made possible the development of the more spacious, better built versions which characterize the wealthier houses from the Early Empire onwards, as at Banaqfur in the first century

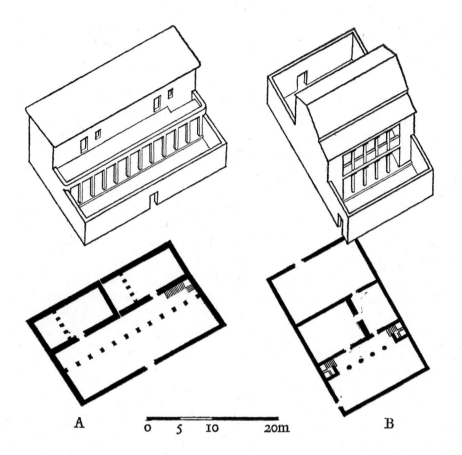

Figure 161. Buildings in North Central Syria.
Elevations and plans

(A) House at Taqle, fourth century
(B) House at Banaqfur, first century
(C) Bath-building at Brad, third century

(Figure 161B) or Benabil in the second. These were regularly two storeys high, with a double portico along the façade, and they normally opened on to a square courtyard, around which might be grouped storage-towers, and other service buildings. The type remained in use, little changed, into late antiquity.

The public buildings, including the earliest, pre-basilican churches, both in plan and in general appearance represent a closely related development. Such, for example, were the bazaars, rows of small shops opening off the rear wall of a portico and regularly two storeys high. The resemblances to the hellenistic stoa can hardly be accidental, and one of them, at Babisqa (A.D. 536), is in fact so named. Very similar in form were the inns (*pandocheia*). Yet another related type of public building was the *andron*, consisting of a gabled hall with one or more porticoed annexes. This seems to have been an all-purpose community meeting-place, and one such hall, at Me'ez, dates from as early as A.D. 29. Even such an alien type as the bath-building was in time assimilated to local practice, as we see at Serdjilla (A.D. 473) and Babisqa (fifth to sixth centuries).

As seems to have happened so often in the classical world, it was only in commemorating the dead that this very homogeneous, practical architecture found scope for real individuality. Tall paired columns (Sermada, A.D. 132); tetrapylon monuments crowned with pyramidal roofs (Dana, Brad, second to third centuries) or, later, domes (Tomb of Bizzos at Ruweiha, sixth century); gabled sarcophagi perched on lofty plinths in the manner of Asia Minor; gabled tempietti (Babutta, first century; Ruweiha, 384); rock-cut tombs and façades; square towers with tall pyramidal roofs (Rbe'ah, second century), following a type which was widespread in Syria (Hermel) and Cilicia (Diokaisareia) and which was echoed as far afield as Italy and North Africa – these are some only of the forms that were in recurrent use over many centuries. They illustrate once again the difficulty of reducing to order a funerary architecture in which so large a part was played by quirks of personal taste.

Damascus

Damascus, well watered and situated at the focal point of central Syria, has paid the price of a long and prosperous history in the almost total loss of its classical monuments. Little more can be made out than the outline of a typically hellenistic, gridded street plan; superimposed upon it a pair of Roman colonnaded streets, one of them the 'street called strait' of the Acts of the Apostles; the probable positions of the agora and the theatre; and, on the site of the Ummayad Mosque, the scanty remains of the city's principal shrine, the Temple of Jupiter Damascenus. This stood near the west end of a symmetrical porticoed temenos (now the outer wall of the mosque), which in turn was enclosed within a vast outer enclosure, measuring some 325 by 450 yards and encircled by double colonnades. Begun presumably under Augustus, the temple and temenos were well advanced by A.D. 15–16.[34] The principal surviving elements belong to the temenos, and these offer a glimpse of an architecture which, though classical in intention and in much of its detail (notably the handsome Corinthian order of the propylaea),[35] still embodied many traditional features, including 'Egyptian' mouldings and merlon

parapets. Among the several anticipations of later Romano-Syrian practice we may note the towers at the outer corners of the façade, the rectangular columnar exedrae facing on to the courtyard and, more generally, the characteristic relationship of propylaea, temenos, and temple. This was one of the great monuments of the Early Imperial East, and had more of it come down to us no doubt much of the later story of Roman architecture in central and southern Syria would be much easier to read.

Southern Syria: Petra and the Decapolis

The picture conveyed by this rapid survey of the architecture of coastal Syria and its immediate environs, though often deficient in detail, is in its broad lines clear and consistent. About the hellenistic cities, the main source of pre-Roman classical influence, we are sadly ill-informed; but even in this, the area of closest and most continuous contact with the rest of the Mediterranean world, we see that in the countryside outside the cities native traditions and ideas were still powerful. The balance varied sharply in accordance with historical, geographical, and social circumstances, but Persian, hellenistic, and native Semitic traditions were still factors to be reckoned with in Roman times. The pattern of Roman influence, sketched at Antioch by Caesar, took substantial shape under Augustus, notably at the hands of Herod. It was based on the introduction, both from the Greek world and from Italy, of a number of new building types, and even building techniques, and these, at various social levels and in varying degrees, seem for the next hundred years or so to have constituted the principal Roman contribution to the architectural scene. The next significant turning-point came early in the second century, and in this case the medium was a new material, marble, and the main source of inspiration the Romano-provincial architecture of western Asia Minor.

It is against such a background that one has to view the development of Roman architecture along the frontiers of Syria, southwards and south-eastwards towards the Red Sea and the Arabian desert, and eastwards towards Mesopotamia.

With the tangled political history of the first of these areas under the Early Empire we need not concern ourselves in any detail. For a time in the early first century B.C. the whole region east of Jordan and south of Damascus had been part of the kingdom of the Nabataeans, who continued to rule the southern part as client kings until its annexation by Trajan in A.D. 106. Of the rest, the village-dwellers of the mountains and plains of the Hauran, although retaining close cultural and commercial ties with the Nabataean kingdom, were until A.D. 93 part of the domain of Herod and his successors; whereas the strip of country immediately to the east of the Jordan, the principal area of prior hellenization, was in 63 B.C. organized into a loose confederation of ten cities, the Decapolis, which long retained a considerable measure of independence within the framework of the newly constituted province of Syria. The whole area is very rich in remains of the Roman period, the outstanding surviving sites being those of Petra, the capital of the Nabataean kingdom, and of Gerasa (Jerash), one of the cities of the Decapolis. Throughout the whole period the principal source of classical influence was probably Damascus.

Petra, romantically situated in an almost impregnable basin within the mountains of Edom, is best known for the rock-cut tombs which honeycomb the surrounding cliffs. The monuments of the town itself have received far less attention. They included an aqueduct, a central colonnaded street, a theatre, a large peripteral Corinthian temple, a streetside nymphaeum (akin to, but smaller than, that of Gerasa), bath-buildings, and, at the west end of the street, an elaborate triple arch leading into the temenos of Qasr Fira'un (Qasr el-Bint), the large temple which is the principal monument still upstanding within the city.

It is only recently that excavation within the town has begun to lay the basis for a sound chronology of the monuments of Petra.[36] Except for the Qasr Fira'un temple the buildings now visible within the town almost all belong to the period after Trajan's annexation of the province of Arabia in 106; and the whole series of tombs must also be far later than in the past many scholars have chosen to believe. The Nabataeans, the latest of the many nomadic Arab peoples to move in from the desert and to settle in southern Jordan and Palestine, were already established in Petra in the late fourth century B.C.; but it was not until the first century B.C. that a crude stone-and-mud architecture began to give place to dressed masonry or that the accompanying remains indicate a correspondingly developed level of material culture. This was the moment when the Nabataean kingdom reached the height of its power, controlling most of the region from the Red Sea to Damascus; and it was evidently the resulting contacts with the hellenistic cities to the north (and subsequently with the Roman province of Syria) which stimulated the real flowering of Nabataean civilization.

Although the rock-cut tombs of Petra are in detail very varied, they fall into a well defined typological sequence, which must correspond broadly also with that of their chronological development. The sequence is based on the form of the façade, which is quite independent of that of the tomb-chamber, and is characterized by the use of a shallow, almost two-dimensional relief as a means of representing real, three-dimensional architectural schemes. In the earliest phase (first century B.C.) the dominant type is the rock-cut tower, a form of tomb architecture which was widespread in the hellenistic and Roman East, and which is vividly represented, for example, in the cemeteries of Palmyra. The ornament is very simple, the two principal recurrent forms being the 'crowstep' crenellation (later simplified into a V-shaped crowning motif of two outward-facing, stepped triangles) and the 'Egyptian' cornice, both motifs which we have seen to be characteristic of late hellenistic Lebanon, and which at Petra remained in use throughout the first two periods. The second, 'classicizing' phase, which lasted through the first century A.D. and into the second, is characterized by the increasing introduction of such classical elements as columns (pilasters) and capitals, doorways and windows with classical mouldings, and (in combination with the earlier forms) more or less conventionally classical entablatures. The façades become columnar, with two or four pilasters supporting a horizontal entablature, and in the more elaborate versions (conventionally known as the 'Hegra' type)[37] there is an added, attic-like upper storey, which portrays the truncated part of a similar tower-tomb, just as if it were part of a separate building set back from, and looking out across, an independent façade (Plate

223). It only remained to take the classical gable, already familiar from the doorways of the later tombs of the second phase, and to apply it to the façade as a whole in place of the traditional stepped crowning motif, so producing the 'temple' tomb typical of the third phase. Whether or not this step had already taken place before the Roman occupation in 106 is, in the context, a question of small importance, since there is no sharp break in the development; nor can there any longer be any real doubt that the more elaborate temple tombs of Petra are those of the wealthy Romano-Nabataean burghers of the second-century city.

The subsequent development followed a predictable course. The only substantial additions to the repertory were the broken pediment and the circular pavilion with a conical roof. The distinctive Nabataean capitals, the urn-like finials, the Doric friezes with large discs in the metopes, the quarter-columns on the inner faces of the angle-pilasters, all these were inherited from the previous phase. What was new was the scale and elaboration of the development of these motifs. This was 'baroque' in precisely the same sense as the Third Style painted architectural schemes at Pompeii a century earlier, or such contemporary phenomena as the marble façades of western Asia Minor, the stucco tomb interiors of Rome, and the adyton architecture of the temples of the Lebanon. These can all be seen to have obeyed an inner evolutionary logic, which was at the same time shaped also by precedent. Decorative schemes that were first developed in the court architecture of the hellenistic age might find themselves repeated almost verbatim, in another medium and in an entirely different context, two centuries later. The resemblance of these tombs to the hellenistic prototypes is often uncannily close; but it is the product of an evolution far longer and more complex than many scholars have been prepared to allow for.

Viewed with the hindsight of an assured chronology, the tomb façades of Petra can be seen to be the late, eccentric manifestations of a long-established tradition. The façade of the tomb known as ed-Deir (Plate 221) will serve to illustrate two of the most tell-tale aspects of this phenomenon. In the lower storey the doors and windows are theoretically credible as the details of an inner wall glimpsed between the columns of the façade, as we see them already in the columnar tombs of the preceding, classicizing phase. The upper storey, on the other hand, is carved in the round and might well be taken to derive directly from the real architectural scheme of which it is a representation – until one looks at the windows, which reveal it as a retranslation into three dimensions of a bas-relief decorative scheme that had already begun to lose touch with its sources. Its vitality lies entirely in its response to its own very specialized local problems. The other significant characteristic is that this tomb and its fellows are out of all proportion to the models from which they derive. This explains why no photographs can do justice to the sheer size of the façade of ed-Deir, 150 feet long by 125 feet high (46 by 38 m.), larger than the west front of Westminster Abbey. It is enormously impressive; but for all the sophistication of the basic tradition, there is also more than a touch of the barbaric about its manifestations at Petra.

Of the buildings within the city only two, the arch and the standing temple, call for brief notice. The arch, recently partly restored, is a monument of Roman type, with the

three archways framed by pilasters and semi-columns on one side and on the other by columns placed on free-standing moulded plinths.[38] As in many outlying Syrian arches, however, the proportions are altogether unclassical, and a great deal of the detail too (e.g. the pilaster capitals and the fine zoomorphic Ionic capitals of the columns, and the quarter-columns adjoining the outer pilasters) is of typically Nabataean derivation. The Roman arch of Si' in the Hauran (c. 150–75) and the East Arch at Bostra offer many points of resemblance. The temple (Qasr Fira'un) presents an even more extraordinary mixture of classical and Oriental elements (Plate 222 and Figure 162).[39] In classical terminology it may be described as tetrastyle *in antis*, standing on a wide podium with frontal steps; the façade may well have been of conventional pedimental form, and the encircling entablature, with its console cornice and Doric frieze, was of classical derivation. In plan, however, the building was almost exactly square (105 feet; 32 m.) and in elevation, if one includes the podium, very nearly cubical, the ceiling of the cella being no less than 60 feet (18 m.) above the inner pavement level. The cella was divided from the pronaos by a massive cross-wall with a huge central doorway, and was itself further subdivided into a narrow transverse hall which ran the full breadth and height of the building, and a triply divided sanctuary, or *adyton*, of which the two lateral compartments were two storeys high and colonnaded, framing the lofty central recess that housed the cult-statue. Stairs led up to the galleries and to the roof, which was terraced. How exactly the superstructure was finished we do not know, but analogy suggests the likelihood of a frontal gable backing against a tall enclosing parapet-wall. An interesting feature of the construction is the extensive use of timber string-courses and tie-rods, no doubt intended as a precaution against earthquakes.

Many features distinguish this remarkable building from conventional classical practice, and almost without exception these can be seen to stem from architectural forms and usages that had wide currency also in the non-Roman East. The square plan, for example, is almost certainly attributable to the influence of the square, box-within-a-box type of temple, of which there is a fine example, ascribed to the first century A.D., at Khirbet et-Tannur, barely 50 miles north of Petra.[40] The broad cella can be documented in north Syria from the Bronze Age onwards and in the Roman period it was the standard plan for the many small temples at Dura and at Hatra, in Mesopotamia, in several cases combined with a tripartite adyton.[41] The tripartite sanctuary was used widely both within pagan Roman Syria and beyond the frontiers, and it has long been recognized as the source of this typical feature of the Christian churches of Syria.[42] Good late-second-century examples in the Hauran are the Tychaeon (Temple of Tyche) at es-Sanamen (A.D. 191) (Plate 230) and the temple at Slem, 20 miles north of Bostra. Yet another typical feature of Syrian temple design is the flat, terraced roof.[43] The evidence for this is most clearly displayed in the temple at Dmeir (A.D. 149) near Damascus. This curious building has two identical façades, superficially pedimental with an arch framed between the two inner pilasters, but in reality consisting of two pairs of angle-towers, each framing a central vaulted porch. One of these towers contained a staircase, and all four rose above the pediments and must have been connected along the flanks of the temple by a parapet enclosing the flat roof over the cella.

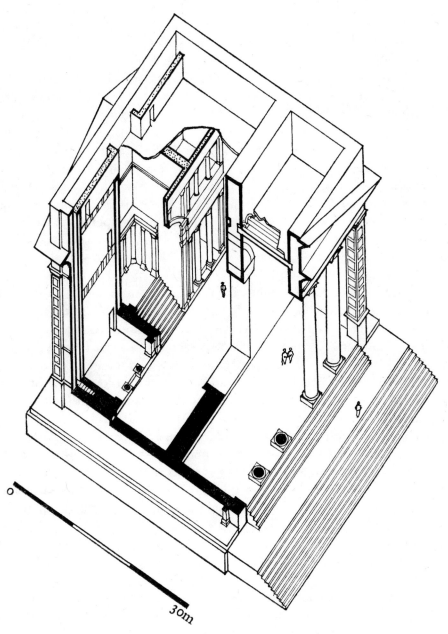

Figure 162. Petra, 'Qasr Fira'un' temple, probably second century. Axonometric view

435

The plan of Dmeir is obviously eccentric in a number of respects; but the terraced roof can in fact be seen to be a feature of many more conventionally classical temple buildings in Syria, among them the temples referred to above, at Slem and at es-Sanamen. In the former the two angle-towers, both of which contained staircases, were at the front and flanked a distyle porch, the pilasters and columns together constituting a gabled classical façade; above this the outer angle-pilasters rose clear to carry a second, horizontal entablature, which ran right round the building, enclosing the terrace. At es-Sanamen the towers were at the back, over the lateral chapels, and the porch was of conventional prostyle form. The dispositions vary greatly in detail; but once the fact of these flat roofs is accepted, they can be recognized with confidence on a great many other sites – in the Lebanon possibly even in the Temple of Bacchus at Baalbek, almost certainly in a dozen lesser temples; in the Hauran in the Temple of Zeus at Kanawat; in the Temple of Bel at Palmyra (Figure 170); in the temples of Zeus and of Artemis at Gerasa; and in the mountains of Moab, east of the Dead Sea, in the temples at Dhat Ras, Mhayy, and Qasr Rabbah, of which the two last-named are noteworthy also as possible precursors of the scheme of the third-century entrance portico at Baalbek. The function of these terraces must have been liturgical. It is by no means unlikely that in some measure they correspond to, and took the place of, the tower-like altars of earlier practice.

At Gerasa one is, superficially at any rate, in a very different world. Although there had certainly been a native community here, probably on the hill to the north of the 'forum' opposite the Temple of Zeus, it was formally refounded as a city under the name of Antioch-on-the-Chrysorhoas by Antiochus IV of Syria (175–164 B.C.); and while it would probably be easy to exaggerate the impact of this event on the externals of daily life, the contacts established then, and subsequently as one of the cities of the Decapolis, did undoubtedly predispose Gerasa to the acceptance of the classical forms that dominate the surviving remains.

For a time the establishment of Rome in Syria seems to have made remarkably little difference. Excluded as it was from the territories of Herod and his successors, the Decapolis may well have become something of a backwater. The first certainly attested enterprise under Roman rule is the rebuilding of the temple and temenos of Zeus. The actual temple was again rebuilt in the mid second century; but we know that its predecessor, already building in A.D. 23 and still not complete in 70, was of the Ionic order, and that the site and layout, with the temple at the head of a long flight of steps leading up from a porticoed forecourt, are those of the earlier building. They recall Herod's temple at Samaria, and allowing for the difference of site the Early Imperial sanctuary at Baalbek. Another early building, also known to have been Ionic, was the temple thought to have been dedicated to the Nabataean divinity Dushara, later demolished to make way for the Christian cathedral.

Apart from these rather scanty traces of earlier work, the city as one sees it today is a product of the 150 years following the middle of the first century A.D. The first step in its creation was the layout of a new and far more ambitious street plan and the establishment around it of a new circuit of walls and gates, of which at least one, the North-

West Gate, was complete by 75. The walls enclosed a polygonal area on both banks of the River Chrysorhoas, the main town being terraced up the sloping spurs on the west bank. The axis (*cardo*) of the new layout was a colonnaded street running northwards from the 'forum', and this was crossed at right angles by two transverse colonnaded streets (*decumani*), which were carried across the river on bridges. Both the cardo and the decumani were designed and partly carried out in the Ionic order, as also were the porticoes that were added at about the same time around the 'forum' (Plate 227). The latter was an irregular oval space just inside the South Gate, between the probable site of the hellenistic city and its principal sanctuary, the Temple of Zeus, and it may well in fact have been a market for the caravans coming in from the south. Yet another first-century building (under construction in the reign of Domitian, 81–96) is the great South Theatre, beside the Temple of Zeus, a building of typically 'Western' type[44] and one of the earliest surviving theatres in Syria. The emphasis on the Ionic order in almost all these early buildings confirms the evidence from the Lebanon that this was the dominant order in late hellenistic Syria. It also indicates that, although economically and socially Gerasa was at this time very closely linked with the Nabataean kingdom, architecturally its contacts were with the classical world.

The real turning-point in the history of Gerasa was its incorporation in 106 within the newly annexed province of Arabia. The first act of the new provincial government was to lay out a network of fine roads – the only Trajanic monument as yet identified at Gerasa is, appropriately enough, the North Gate (115), facing down the road to Pella and to the cities of the coast – and within a short time the tide of romanizing prosperity was in full flood. The emperor Hadrian spent part of the winter of 129–30 at Gerasa; and although the solemn addition on this occasion of a new city quarter seems to have proved a somewhat empty gesture (the new South Gate and the archway delimiting it are the only monuments that were certainly completed), the next few decades saw a transformation of the already existing town. The Temple of Zeus was rebuilt and ready for dedication in 163. In the middle of the town the central and southern sections of the cardo were widened and converted to the Corinthian order; the Temple of Artemis and its precinct were rebuilt and enlarged, with an elaborate processional way leading up to them; the precinct and propylaea of the adjoining 'Cathedral' Temple were remodelled and, between the two, there was added in 191 a richly adorned fountain building. Other buildings of the later Antonine period were the North Theatre (c. 161–6); the great West Baths; a new temple, Temple 'C'; and, a mile outside the town, the festival sanctuary of Birketein.

The central monument of all this was the temple of the city's protecting divinity, Artemis, which today still dominates the whole site. It was a large (74 by 131½ feet; 22·60 by 40·10 m.) Corinthian building, hexastyle peripteral in plan, with a deep porch and standing on a very tall (14 feet 2 inches; 4·32 m.) podium. Stairs beside the main door indicate a terraced roof behind the conventionally gabled porch, and within the cella the floor rose steadily westward to the adyton and to the statue recess high in the rear wall; height was obviously an important consideration. The temple stood near the centre of a rectangular temenos, 395 feet wide and 530 feet deep (121 by 161 m.), which

was enclosed on three sides by porticoes and on the fourth side by the rear wall of a propylaeon, consisting of a portico running the full width of the building at the head of a grandiose flight of stairs and flanked by pavilions, or low towers – very much as at Baalbek half a century later. The workmanship of the temple itself is fine but far from elaborate. For its effect it relied instead on its magnificent situation and on the mounting height and growing architectural tension of the approach up the processional way. This started at a bridge across the river, from which a sloping ramp led up to a triple gateway. Beyond this lay the east propylaea, consisting of a short stretch of colonnaded street leading in turn to a monumental courtyard, which faced westward on to the cardo, its curiously splayed, trapezoidal plan being evidently designed to give an uninterrupted view across the street to the main propylaea. At this point the temple complex was terraced high above the west side of the street, the terrace wall being masked by a two-storeyed façade of shops; and in the centre of this façade stood the propylaea proper, a huge tetrastyle porch of which the rear wall was in effect a triple arch with square doorways and flanking aediculae. From this arch seven flights, each of seven steps, led straight up to the forecourt (Plate 226), the whole of the far end of which was occupied by a magnificent flight of twenty-seven steps, over 100 yards wide, leading up to the propylon of the temenos proper. It was not until one entered the temenos that the actual temple, glimpsed from afar, would have been fully visible – again one thinks of Baalbek – but the whole progress up the processional way had been building up to this moment.

The rebuilt Temple of Zeus was a somewhat larger (octastyle) version of that of Artemis, which it otherwise very closely resembled in plan, differing mainly in the greater elaboration of its detail, with pilasters along the inner walls of the cella and deep aedicula-framed recesses along the outer faces, between the columns. These decorative aediculae, a regular feature of the second-century architecture both of Gerasa and of the Hauran, are yet another indication of a close relationship with the architectural world of Baalbek. Temple 'C' was a much smaller building and far less conventional in plan. Built on what had been a cemetery area, it consisted of a rectangular, porticoed temenos, 65 feet wide by 50 feet deep, of which the temple occupied the middle of the fourth side, its tetrastyle porch projecting into the central space; the cella was T-shaped, with a square inner sanctuary opening off a transverse hall. On the analogy of the hellenistic Heroon at Calydon in Aetolia it has been identified as the commemorative shrine of some distinguished citizen; but in the context it seems far more likely to have been a superficially classicized version of the sort of T-shaped temple that one meets at Dura and at Hatra, and indeed, in slightly more elaborate form, in the Qasr Fira'un at Petra. Even at this moment of enthusiasm for the externals of classicism, the native element did not lie far below the surface.

The West Baths are chiefly remarkable for the fine quality of the stone vaulting, which includes three instances of hemispherical vaults over square rooms (Plate 229), possibly the earliest surviving example of this feature in Syrian architecture.[45] In view of the exaggerated claims sometimes made about the Oriental origins of this particular architectural form, it is worth emphasizing that formally identical spherical vaults

were being built at this time in many parts of the Empire, in Italy in concrete, for example, and in Egypt in mud brick. It was already a commonplace of Imperial architecture, and it is the materials and techniques that constitute the main point of interest. In this case there can be no doubt that in their planning, laid out symmetrically about a typically tripartite frigidarium, the baths derive closely from Western usage, worked out in terms of local building practices. Another obvious intruder from Mediterranean lands is the nymphaeum beside the cardo, built in 191 (Plate 225). The central, semi-circular exedra and the two wings were both faced with a double order of columns, framing alternately rectangular and curved recesses; the lower order was veneered with green Carystian marble, imported from the Aegean, and the exedra was vaulted with a semi-dome of light volcanic *scoriae*.[46] That fountain-buildings of this sort were being erected also in the coastal cities we know from the nymphaeum at Byblos, a typical marble style structure of about the same date. The closest formal parallel (without the semi-dome) is the great Severan nymphaeum at Lepcis Magna in Tripolitania. Another, and even more elaborate, example within the Decapolis was the great nymphaeum beside the main street of Philadelphia (Amman). Yet another was that of Pella, which was sufficiently remarkable to be recorded on the city's coinage.[47]

The Hauran

The wave of prosperity which led to this outburst of building in second-century Gerasa was part only of the tide of material well-being which flowed over the whole province of Arabia during the hundred years following its annexation until checked by the military disasters and political anarchy of the mid third century. We have seen something of the results of this already at Petra. We have still to glance at the remaining district of southern Syria, the Hauran.[48]

Here, somewhat paradoxically, it is the buildings of the period before the annexation of the province that matter most in the wider context of the history of architecture in the Roman Empire. As in the comparable country districts of northern Syria described above, Roman civilization, once established, struck deep; but it was in every sense of the word a provincial civilization. Except for the capital, Bostra (Bosra), very few of the native villages rose under Roman rule to be more than small country towns. Their architecture is of the greatest interest to the social historian, but its impact outside the province was slight. There was, however, one important respect in which the Hauran differed from north Syria, and that was in the very considerable innate artistic talent of its people, the Nabataeans. Under the stimulus of contact with the mature civilizations of the hellenistic East they had already developed a fine architecture of their own; and although the forms were derivative the spirit and the technical skills were strikingly individual, and they were quite vigorous enough to leave their mark on the architecture of Roman Syria as a whole.

The outstanding monument of this early period is the great sanctuary of Si', the ancient Seeia, in the mountains north-east of Bostra, near Kanawat (Figure 163). This is dated by inscriptions to the last few decades of the first century B.C., at a time when the

439

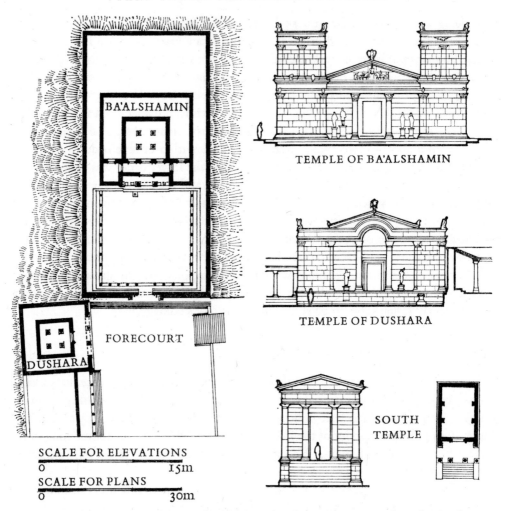

BA'ALSHAMIN

TEMPLE OF BA'ALSHAMIN

TEMPLE OF DUSHARA

FORECOURT

DUSHARA

SOUTH
TEMPLE

SCALE FOR ELEVATIONS
0 15m
SCALE FOR PLANS
0 30m

Figure 163. Seeia (Si'), sanctuary of Ba'alshamin, late first century B.C., and South Temple, late first century A.D. Plans and elevations

Hauran had recently been attached to the territories of Herod the Great. As built then, it consisted of a processional way leading up to a triple gate at the entrance to the first of two long, narrow, rectangular precincts. The first of these had colonnaded terraces on either side and at the far end on the left, facing inwards, stood the Temple of Dushara. The plan of this was very simple, a square cella within a square enclosing wall, of which the façade was open in the centre, with two columns set *in antis*. The cella was roofed, the outer corridor open, and the dominant feature of the façade was the carrying of the otherwise horizontal entablature up to form an arch over the central pair of columns. From the outer courtyard a single, very elaborately sculptured doorway led into the inner temenos, which had porticoes on three sides, and on the fourth side, facing the entrance, the Temple of Ba'alshamin. This was similar to its fellow, but rather more elaborate, the façade in this case being capped by a low pediment and framed between

two low towers. The roof of the cella (as presumably also that of the Dushara Temple) can be seen to have been carried on four internal columns. At some later date the sanctuary was enlarged by the addition of an outer courtyard, containing a temple of more or less conventional prostyle tetrastyle form (the South Temple) and entered by an outer monumental archway.

One could hardly ask for a more vivid illustration of the complexity of the influences that were at work upon the Syrian frontiers. Though this architecture of Si' was a direct product of the more settled conditions established by Roman rule, the form of the two early temples was as alien to classical thinking as the divinities in whose honour they were built. The square-in-square plan, though widely distributed in Nabataea (e.g. at Khirbet et-Tannur, and at Sur and Sahr in the Lejja, a northern outlier of the Hauran), has long been recognized as probably of Iranian origin, an identification that has recently been confirmed by the excavation at Surkh Khotal in Afghanistan of just such a temple, built in the late first or early second century A.D. by the great Graeco-Buddhist king Kanishka.[49] Though the square, enclosed form was subsequently given up in the Hauran in favour of columnar temples of classical derivation, the proportions of many of the latter (e.g. Qasr Fira'un at Petra; Maiyamas and Brekeh in the Hauran) clearly reflect its continuing influence. The plan of the sanctuary as a whole, with its enclosed, axial layout, seems on the other hand to derive from the same hellenistic sources as the sanctuaries of central Syria; and this was certainly true of much of the architectural detail – the colonnades, the quasi-classical orders, the door-frames, the telltale orthostat-and-capstone socle of the triple gate – even if in the process it was often so elaborated and transformed as to be barely recognizable. Side by side, however, with the classical egg-and-dart, the kymation, the key-pattern, and the palmette sima, there are other motifs that closely resemble the earliest architectural mouldings of Palmyra, which have been convincingly interpreted as following contemporary Parthian models.[50] Notable among the latter is the variety and range of vine-scroll patterns. The crowstep and the 'Egyptian cornice', characteristic of the Phoenician coastlands and of early Petra, are conspicuously absent. In their place we have inverted foliate column bases of Persian type. The first specific indication of the influence of Petra can be seen in the use of 'Hegra'-type capitals in the later, prostyle temple, which can hardly be earlier than the last years of Nabataean independence, and in the quarter-columns of the possibly even later (c. A.D. 150?) outer gate, which must derive from those of the rock-cut façades of Petra. In the earlier phase the sources of classical inspiration must have lain elsewhere, in Herod's northern territories. Rather unexpectedly, they do not seem to have included the Ionic capital. Those of the earlier buildings are all of a distinctive type which, like the earliest capitals of Palmyra, derives from a free hellenistic version of the Corinthian capital.

The architecture of Si', though somewhat barbaric, was fertile of new ideas. No less than three of its characteristic features were to make themselves felt far beyond the frontiers of Nabataea. One was the central arching up of the architrave (the 'arcuated lintel' or 'Syrian arch'), of which this is the earliest known example in a classical context; another was the framing of the façade between two equal towers. Both of these

were devices with a long and important history of classical and medieval Christian usage before them.[51] Less momentous in its results, though hardly less far-travelled, was the little ring of acanthus leaves inserted between the shaft and base of a classical column. Originally perhaps a Ptolemaic Egyptian device, this was picked up at Gerasa (e.g. the Hadrianic Arch), entered the repertory of the marble-workers of Asia Minor, and is found as far afield as Rome (Temple of Venus Genetrix), Nîmes (the Fountain Building), and Lepcis Magna (the Severan Basilica).[52] It is not impossible that the vine scroll too first entered the classical architectural repertory through this door. Within its limitation this was unquestionably an architecture of ferment and considerable creative power.

Locally, too, it established the essential pattern of building for the next hundred years. When, after the creation of the new province, prosperity flowed in, and with it the more conventionally classical architectural types of Roman Syria, the newcomers found already established the building practices and craftsmanship which were to distinguish Romano-Nabataean architecture from that of any other province of the Empire. Over a large part of the area the local building stone was a hard volcanic basalt, an intractable material in the handling and carving of which the Nabataean craftsmen had acquired an extraordinary skill. In the absence of suitable timber, the ordinary method of roofing was to build a series of transverse arches and to lay long slabs of stone from one arch to the next. One sees this everywhere, in the houses, in the temples (beginning with the third temple at Si'), and in such public buildings as the late-second-century basilica at Shakka, the forerunner of countless Christian churches of the same distinctive form. An alternative, which may well go back to Achaemenid Persian models, was to lay the slabs upon a close-set system of columnar supports, as in the two earlier temples at Si'. Both, as one sees e.g. in the 'Praetorium' at Mismiyeh (Plate 235), were well established local building types. Another form of roofing, which had no local precedents and must derive directly from Roman practice, was the concrete vault, built of light volcanic *scoriae*. This is found sporadically as early as the late second century, e.g. over the entrance hall of the 'Palace', a large public building, at Shakka (cf. the nymphaeum at Gerasa, A.D. 191);[53] but it does not seem to have gained wide currency until the emperor Philip (241-5) built the city of Philippopolis (Shehba) on the site of his birthplace and endowed it with a grandiose bath-building in the Roman manner, with suites of rectangular, barrel-vaulted halls grouped symmetrically about two circular, domed caldaria (Plate 228). Elsewhere in the Hauran (e.g. at Shakka) domes were achieved over square rooms by laying courses of converging slabs across the angles, and it is suggested that the domes themselves were not spherical but of a pointed elliptical profile, as in the still preserved church of St George at Zor'ah (515) and no doubt also in the similar but grander cathedral church of St George at Bostra, built three years earlier. Together with concrete vaulting one notes also the introduction of a new type of masonry, with a facing of coarse opus quadratum about a core of mortared rubble. The analogy with the faced rubblework of Asia Minor is clear, and in the context of such buildings as the baths at Philippopolis and at Bostra, it too must derive ultimately from Roman concrete, once again presumably by way of the cities of the coast.

Side by side with this technical mastery of their difficult material the Nabataeans showed also an extraordinary skill and taste in carving it, the crisply cut detail being made to stand out in sharp, incisive contrast to the plain surfaces of the buildings as a whole (Plate 230). Some of the most effective items in their repertory were carried over from the pre-Roman period, notably the ubiquitous key pattern, but the choice and treatment were, within the limitations of the medium, scrupulously classical. The normal order was Corinthian, but there are examples of both Ionic (e.g. the temple at Hebran, 155) and of a sort of Composite (the temples at 'Atil, 151, and Slem). A characteristic feature, shared with the developed mid-second-century architecture of Baalbek and Gerasa, is the importance of the decorative aedicula, often though not invariably incorporating an upward-splaying shell-head niche ('Atil, Hebran, es-Sanamen, Shakka, etc.). In the Hauran we find rectilinear aediculae already in the temple at Suweida,[54] a building which has been ascribed to the first century B.C., before Si', but which is in fact far more likely to represent the mutual assimilation of native and classical traditions under Herod's successors. It was a quasi-Corinthian peripteral building, with a cella that was almost square and eight columns down the flanks, six across the façade, and seven across the back. (This last feature, otherwise unique, was repeated a century or so later in the peripteral temple at Kanawat, the Corinthian columns of which were raised on high moulded pedestals.) The ornament of the third century reveals a development towards a drier, more academic style; but it includes very few new motifs, and there is scarcely a hint of influence from the 'marble style' ornament of the Syrian coastlands. It is only under the somewhat artificial conditions represented by Bostra and Philippopolis that one finds any trace of actual marble imports, and then only for veneering.

Apart from the more elaborate, terrace-roofed and peripteral buildings mentioned in the previous section, the temples were mainly quite small buildings, some with and some without the 'Syrian arch' façade, and either prostyle (the unfortunately fragmentary Der el-Meshkuk, of 124; Brekeh; Maiyamas) or *in antis* ('Atil, 151; Mushennef, 171; and, in rather eccentric form, Hebran, 155). For other public buildings one has to look principally to Bostra and Philippopolis. Bostra, laid out by Trajan to be the capital of the new province, had a grid of fine colonnaded streets, with several arches and gates, of which the East Arch, with its Nabataean capitals, may well be Trajanic. A street-corner fountain-building was an ingenious adaptation of that at Gerasa to an angled site, with a 'Syrian arch' frontal. The South Baths (Figure 164A), constructionally very similar to the probably roughly contemporary baths at Philippopolis, are of patently Western derivation, no doubt by way of the bath-buildings of the coastal cities. The entrance hall, for example, with its apsidal recesses in the four angles is of a typically Italian form found also in 'Bath C' at Antioch (Figure 164B). The concrete vaulting, on the other hand, though inspired by Western models, can be seen to have acquired a physiognomy of its own, incorporating at least one very unusual form, a domical vault 30 feet square with a central oculus, as well as an octagonal dome, 45 feet in diameter, which is of such a daringly shallow pitch that it would have been quite impossible to construct without the use of the light volcanic materials available locally. The handsome

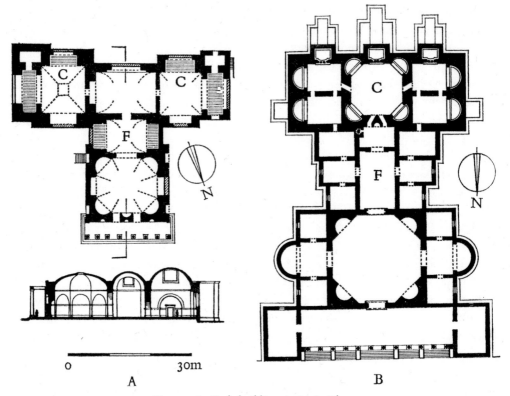

Figure 164. Bath-buildings in Syria. Plans

(A) Bostra, South Baths, probably third century
(B) Antioch, Bath C, rebuilt in the fourth century following the second-century plan
C Caldarium F Frigidarium

second-century theatre, with its triapsidal stage-building and a colonnade at the head of the cavea, is another building of basically Western design, but it too has been adapted to local materials and tastes, omitting such features as the parodos and the tribunal above it and reducing the purely decorative elements to a bare minimum. It is, for example, very doubtful whether the stage-building incorporated the familiar columnar screen. This was certainly omitted at Philippopolis, where one sees the same austerely functional tendencies carried to their logical conclusion by the omission also of the now meaningless exedrae of the scaenae frons.

Two of the monuments of Bostra are of unusual interest as being perhaps connected with the machinery of provincial government. One is the 'Basilica', a large, well-lit hall, which was part of a larger complex of (probably) third-century date (Figure 165). It was, exceptionally, timber-roofed in the conventional manner; it had a single, concrete-vaulted apse at the far end, and it opened off the end of a longitudinally colonnaded forecourt, or street. There were external porticoes along the two flanks, below the windows. The whole scheme is very suggestive of a ceremonial audience hall, comparable to the Constantinian Basilica at Trier. For less ceremonial occasions there was the hall incorporated in the 'Palace'. This was a large rectangular building (120 by

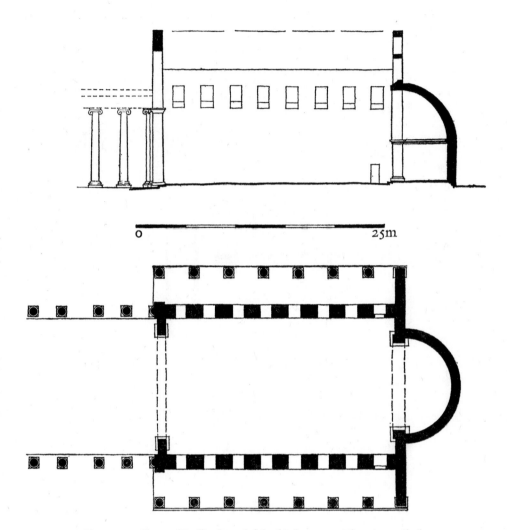

Figure 165. Bostra, 'Basilica', probably third century. Elevation and plan

160 feet; 36 by 48 m.) of second-century date, the two main wings of which faced each other across an internal porticoed courtyard. The porticoes were of two storeys and the rooms of three, except for a monumental, trilobed hall (*triconchos*) which occupied the full height of the *piano nobile* in the middle of one side. This large and obviously official building can hardly be other than the residence of the governor, with a domestic wing on one side and on the other an official wing for the conduct of the day-to-day business of the province. There·are many points of comparison with the third-century Palace of the Dux Ripae at Dura (Figure 169) and, two centuries later again, but still expressing the same duality of function in not dissimilar terms, the Palace of the Dux at Ptolemais in Cyrenaica.[55]

Finally, a word about the domestic architecture which, as in north Syria (and for much the same reasons), varied remarkably little over the centuries and which today

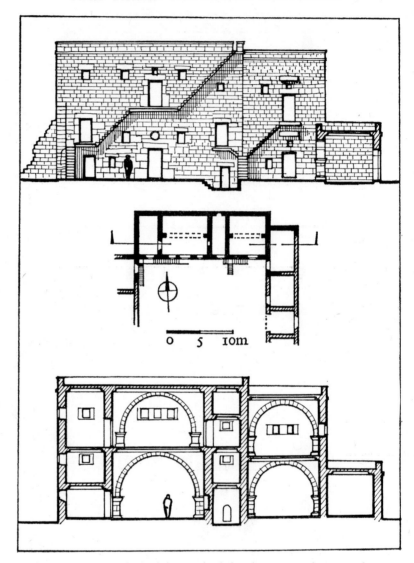

Figure 166. Umm el-Jemal, house, third–fourth century. Elevation, plan, and section

constitutes a very high percentage of the surviving remains. The layout of the individual houses varies greatly, but it can almost always be seen to be based on combinations of the same two constructional units, small rectangular rooms, the width of a single large roofing-slab, alternating with larger rooms that were roofed with the help of one or more transverse arches, the latter because of their greater height frequently corresponding to two storeys of the former. Three and even four storeys were not uncommon, with a flat, terraced roof, and in such cases the ground floors were used for stabling and storage, the upper floors as living-rooms. A characteristic feature is the use of external, corbelled stone staircases (Figure 166). Porticoes, as in north Syria, are found occasionally,

but they were not native to the tradition. The houses faced inwards, and anything up to half a dozen might open off the same irregular, enclosed courtyard. Exceptionally, as at Medjel in the southern Hauran, this scheme was fitted into a neat, rectangular plan, like a Roman insula and perhaps copying urban practice. Usually, however, the grouping was more casual, about a haphazard network of irregular open spaces, alleyways, and courtyards, which might be those of any Oriental country today. Umm el-Jemal (Figure 166) and Busan offer examples of this that have been published in some detail.[56]

The Mesopotamian Frontier Lands: Dura-Europos and Hatra

Dura, the Greek Europos, was successively a Greek, a Parthian, and a Roman town. Founded by Nicanor about 300 B.C. and settled with colonists from Macedon, on the break-up of the Seleucid Empire it passed in about 140 B.C. to the Parthians, and except for a brief interlude under Trajan it remained in Parthian hands until, in the sixties of the second century A.D., it was occupied by Rome. Septimius Severus, c. 200, made it an important garrison town. Fifty years later the pendulum swung again. In 256 it was besieged by Shapur, captured and sacked, and then abandoned to the desert. The emperor Julian hunted lions among its ruins. Though never a city of the first rank, its position as one of the few readily defensible sites along the great natural highway that led up the Euphrates, from Seleucia-on-the-Tigris and the Persian Gulf to Antioch, gave it a considerable strategic importance in moments of crisis between East and West, and in times of peace a stake in the valuable caravan trade up and down the river and across the desert to Palmyra and Hatra. To us its unique importance is that, alone among the cities of the frontier, it has been excavated on a scale and by methods which permit a real vision not only of what it was but also of how it grew to be what it was, and of the social and cultural forces that determined that growth.

The first and most powerful impression left by the remains of Dura is how remarkably shallow and ephemeral was the architectural impact of Greece. Apart from the continuing use of certain simple members such as columns and door-frames, the only really durable legacy of the hellenistic foundation was the town plan, laid out on strict Hippodamian lines with a regular network of streets intersecting at right angles to delimit a series of uniform insulae, each twice the length of its breadth (230 by 115 feet; 70 by 35 m.), in accordance with normal Seleucid practice. The original builders of the city made extensive use of Greek building materials and methods, including stone socles for their walls, and by virtue of their superior construction these walls tended to survive and to be incorporated into later structures even when these reverted, as they soon did, to the normal local practice of building in mud brick and plaster. The last enterprise to be planned on Greek lines was a rebuilding of the sanctuary of one of the city's patron divinities, Artemis, or, as she was known locally, Nanaia.[57] This was undertaken after the Parthian occupation, and it was to have been a small peripteral temple in the Greek manner; but in fact it was never completed, and shortly before 32 B.C. its place was taken by a new and more ambitious building of purely Oriental type, one of at least eight such temples to be built during the next two centuries. The story of Seleucid

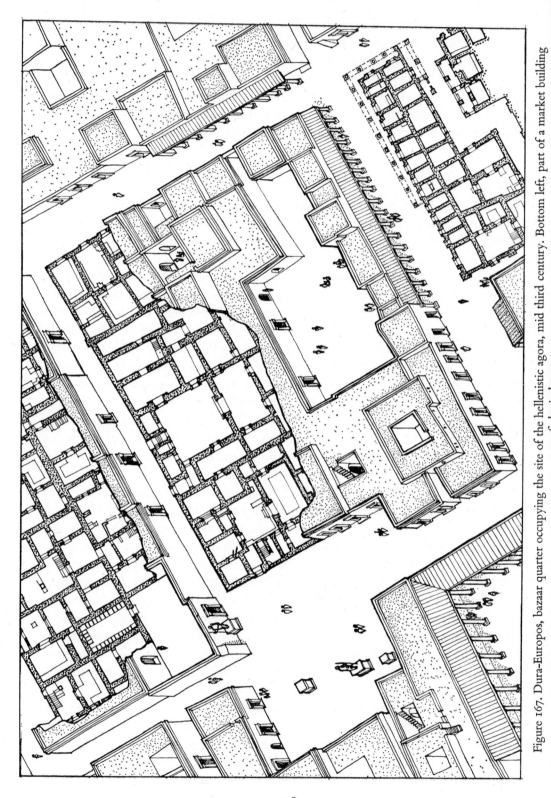

Figure 167. Dura-Europos, bazaar quarter occupying the site of the hellenistic agora, mid third century. Bottom left, part of a market building

Greek architecture in Mesopotamia is told in miniature in the agora.[58] This was planned to occupy eight insulae beside the intersection of the two main streets, with a double row of uniform shops facing outwards and inwards along one side and, along two at any rate of the other three sides, a single row of similar shops, facing inwards across the open central area and fronted by colonnades; alone among the buildings of Dura it had a pitched roof, tiled in the Greek manner. In fact only one half of this scheme was ever finished; soon there began the process of piecemeal rebuilding and encroachment which by the second century A.D. was to transform the whole layout, open space and all, into a maze of narrow alleyways and tortuous, shop-fronted dwellings. In its last phase, under Roman rule, a little order was established by the erection of streetside porticoes along the most important frontages and by the opening up of a small market square, with shops grouped around it. But in all essentials the city centre had long reverted from its Greek beginnings into a busy Oriental bazaar quarter (Figure 167).

Apart from the rather scanty remains of the official residences, the majority of the buildings from the period prior to the installation of a Roman garrison are private houses and temples. The former were flat-roofed and mostly single-storeyed buildings, with the rooms grouped irregularly around a small courtyard. This was essentially a local, Mesopotamian pattern, closely analogous to the contemporary houses of Hatra, the centre of a Parthian (and for a brief while in the third century a Roman) client principality, in the desert 180 miles to the north-east of Dura and 60 miles south-west of Mosul. The temples, too, find their closest analogies in the lesser sanctuaries of Hatra.[59] The standard plan is that of a transverse hall, with the cult-statue set in a smaller chamber opening off the middle of one long side, opposite the entrance. Often, though not invariably, the central shrine is flanked by two subsidiary chapels, an arrangement which was widely copied in southern Syria,[60] and which is one of several pagan themes that were to play an important part in the architecture of the Christian period. The T-shaped sanctuary of the Temple of Dushara at Gerasa may well reflect the same tradition. At Dura and at Hatra the central shrine is regularly set within a courtyard, around which were loosely grouped smaller shrines, altars, treasuries, and residences for the priests.

These temples might come to incorporate classicizing elements such as, for example, the tetrastyle porch that was added in the third century A.D. to the Temple of Bel (or the Palmyrene Gods) at Dura (Figure 168); but such features were as superficial as the classical names that were given to many of the divinities worshipped. Whatever the classical veneer, these were essentially native Semitic gods, from Babylonia, Mesopotamia, Arabia, northern Syria, and Phoenicia, and their temples and forms of worship were just as distinctively native to this Mesopotamian frontier-land. Only the Jewish and Christian communities stood aloof, adapting the architecture of existing houses to serve their special requirements.[61] The Mithraeum, too, for all the Iranian origins of the cult of Mithras, may be considered as somewhat apart from the rest, having been introduced by the Roman garrison and consisting at first only of a single room within a private house. This was later rebuilt and enlarged, but the architectural forms remained those proper to the rituals of this most cosmopolitan of cults, with little or no reference to local religious usage.[62]

449

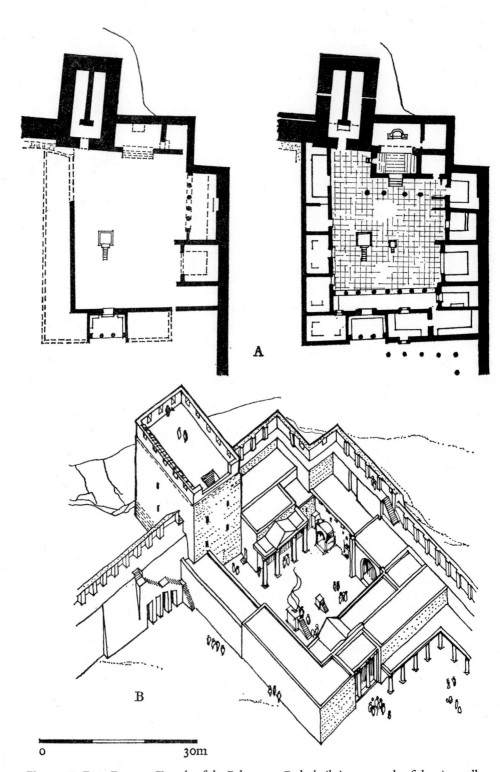

Figure 168. Dura-Europos, Temple of the Palmyrene Gods, built into an angle of the city walls

(A) Plans, first and early third centuries
(B) Restored view, early third century

450

The installation of a Roman garrison by Septimius Severus involved the expropria-
tion of nearly a quarter of the area within the walls and the building of barracks and
officers' quarters, a headquarters building (*praetorium*) fronting on to a colonnaded
street, a parade ground, several bath-buildings, a small amphitheatre for the recreation
of the troops,[63] and an official residence for the commander of the Euphrates frontier
zone, the Dux Ripae.[64] The last-named, added only a decade or two before the city's
destruction, was a building of some pretensions (Figure 169). The residence proper
occupied one side of a shallow rectangular courtyard finely situated on the low cliffs
overlooking the river and flanked by two short, projecting wings. The central feature of
the layout was an apsed dining hall; the commander's private suite lay at one end, and
opening off the other end there was a small bath-building.[65] Behind the residential
wing there lay a large peristyle surrounded by service rooms, servants' quarters, a
stable, and a suite of reception rooms; and behind this again a second peristyle with two
monumental entrances and a single large hall opening off it, which together were
clearly intended for public ceremonies and for the exercise of the commander's judicial
functions. As in the case of the residence of some other high officer near the praetorium,
and of the praetorium itself, the whole layout represents an alien, imported architecture,
the analogies for which lie in the West. Local materials and building techniques im-
posed certain features such as the flat roofs and the arches of the façade (very reminiscent
of twentieth-century Italian 'colonial' architecture in Libya), but that was all. Even
the unit of measurement was the Roman foot, instead of the local Semitic cubit. The
roofs of Dura were normally flat, carried on timber rafters, which must have been im-
ported for the purpose down-river. Ceilings were of plaster, laid on a framework of
rushes and sometimes curved to imitate vaulting. Here and there, too, the excavators
found evidence of vaulting both in mud brick and in fired brick, used in the age-old
Mesopotamian manner, with the bricks pitched on edge across the line of the vault
instead of being laid radially as in normal Roman work. The chances against the sur-
vival of such vaulting are heavy, and it must have been far more common in Syria
than the recorded examples would suggest. From Syria it spead to Asia Minor, to be-
come (in fired brick) the standard vaulting technique of Constantinople.[66]

Dura offers us a vivid picture of the busy Mesopotamian world that lay neither wholly
within nor wholly outside the Roman frontiers. Its buildings, as such, have little to do
with the contemporary development of classical architecture. They do, on the other
hand, afford a valuable illustration of what often underlay the superficially classical
forms of those parts of Syria that were in more immediate contact with the Roman
world; and the paintings on their walls and their sculptures foreshadow much that was
to become the common artistic language of later classical antiquity. This was where the
classical world and Iran met on common ground, and it was here that many of the
religious and artistic ideas for which the architecture of late antiquity was the vehicle
first took shape.[67]

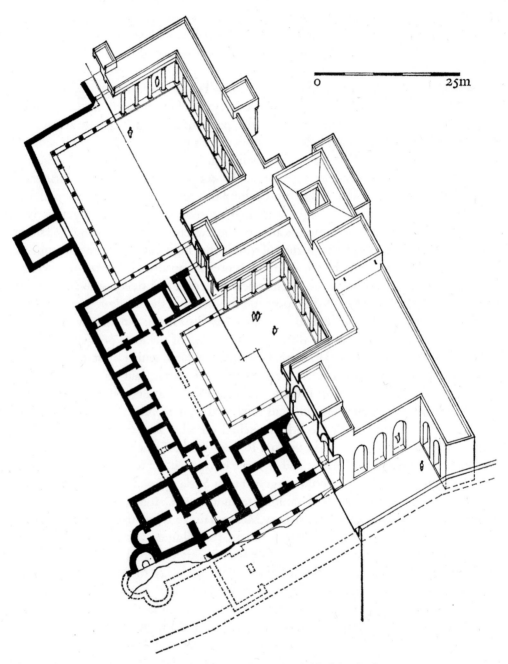

Figure 169. Dura-Europos, Palace of the Dux Ripae, first half of the third century. Axonometric view

Palmyra

Palmyra, situated in the heart of the Syrian desert at a point almost equidistant from Damascus and Emesa on the one hand and the Euphrates near Dura on the other, was the fortunate possessor of an abundant water supply. It was the far-sighted exploitation of this fact, coupled with the establishment of stable rule in Syria by the Romans, which made possible Palmyra's meteoric career as a great merchant city. By setting up and policing a system of regular caravan routes, she was able to offer to the merchants engaged in the fabulously rich luxury commerce between the Roman world and Asia a safe and direct outlet to the ports of Phoenicia. For a brief moment in the third century A.D. the virtual eclipse of Roman military power in the East enabled Odenaethus of Palmyra and his wife Zenobia to exercise *de facto* rule over Syria and much of Anatolia and Egypt. But this was a fleeting and, in the event, disastrous moment of glory. The city was captured and sacked by Aurelian in 272, and henceforth its only importance was as a legionary fortress within the new frontier system established by Diocletian.

The architectural language of Palmyra is a mannered, but in its essentials orthodox, provincial classicism, strikingly and surprisingly different from that of Dura when one remembers how many and close were the links between the two cities. The difference is only in part to be explained by Palmyra's closer and more continuous political connexions with Rome and by its abundant supplies of a fine building stone. In part also it was the product of a very different historical background. Dura, for all that it was an official Seleucid colony, rapidly took its place within an older world in which local Semitic influences were strong enough to absorb and to orientalize the Macedonian settlers. Palmyra, on the other hand, was a creation of very recent date, and, in so far as there was any pre-Roman tradition of monumental architecture, it must have been that of the great hellenistic city through which all its commerce ran, Seleucia-on-the-Tigris.[68] Our only knowledge of the earliest architecture of Palmyra comes from a deposit of architectural mouldings, capitals, and other details found in a context that can be dated (in round figures) to the second half of the first century B.C.[69] This reveals a late, fanciful, hellenistic architecture that had absorbed a large number of alien, non-classical elements, for which (in the absence of comparable excavated material from Seleucia itself or from the trading stations of the Persian Gulf) the closest parallels are with the relief sculptures of Gandhara and Mathura, in India. The architecture of pre-Roman Palmyra was that of a western outpost of an orientalized but still recognizably hellenistic East, and it started with a clear bias towards classical forms and classical solutions.

During the early years of the first century A.D. there was a sharp change of orientation. This is clearly reflected in the earliest of the surviving monuments of the city, the great sanctuary of Bel (Plate 231). Like Baalbek, it was a long time building. In its finished form the temple stood within a quadrangular enclosure surrounded on all sides by colonnaded porticoes, of which that on the west side, opposite the temple door-

way, was considerably taller and incorporated a monumental entrance; within the courtyard, on either side of the axis, stood the altar and a large basin for ceremonial purification. The temple itself (Plate 232) was dedicated in A.D. 32. The three lower colonnades of the precinct were added towards the end of the first century, the west colonnade under Hadrian or Antoninus, the propylaea under Marcus Aurelius or Commodus.[70]

In its original form the temple stood upon a stepped platform in the Greek manner, which was altered to the present low podium when the surrounding precinct was laid out in its definitive form. Viewed from ground level, from the outside, it was a fairly conventional, octastyle, peripteral building of classical type, except that the entrance was placed in one of the long sides, slightly off-axis, with a complex door-frame inserted between two of the columns of the peristasis, and that the classical cornice was capped by a parapet of crowstep merlons in the old Persian manner (Figure 170). But the resemblance to a classical temple was only skin-deep. Behind the conventional triangular pediments, instead of a pitched roof there were terraces, accessible from

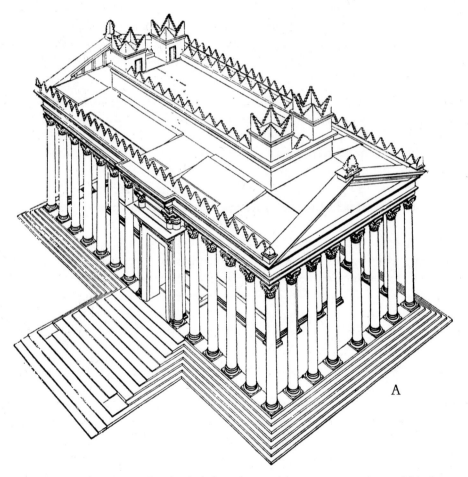

Figure 170. Palmyra, Temple of Bel, dedicated in 32. (A) Axonometric view and (B) plan

454

within by turreted staircases set in three of the four angles of the cella; while inside, two small inner shrines (*thalamoi*) [71] faced each other down the length of the cella-building from the heads of two tall, opposed flights of steps. Each is framed between the projecting shoulders of the staircase wells, and cut into the flat lintel above is a shallow, saucer-like false dome, carved in the one case with a representation of Bel at the centre of the firmament. There is much about this curious layout that awaits explanation, but a great deal is doubtless due to the anomalies inherent in the attempt to express the requirements of the local cult within the framework of an orthodox classical architecture. The remarkable thing is that already as early as the twenties of the first century A.D. the prestige of Rome should have reached so far as to make the attempt worth making.

The subsequent history of Palmyrene architecture follows a predictable course. A study of the Corinthian capitals [72] shows that when the Temple of Bel was built in A.D. 32 the immediate models, though tending towards an orthodox Vitruvian classicism, still retained elements of the freer, more fanciful treatment of the hellenistic age. By the end of the first century, however, orthodoxy was as firmly established here as it was at

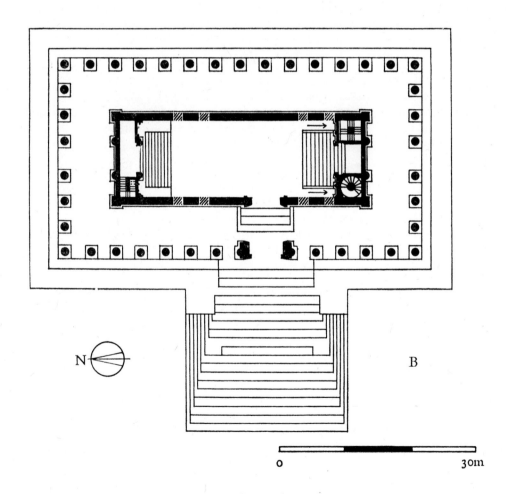

N

B

o 30m

Baalbek; and although the figure sculpture of Palmyra remained to the end obstinately 'oriental' in spirit, the architecture of the great age of Palmyrene prosperity was no less firmly linked with that of the rest of Roman Syria.

The feature of Palmyra that first strikes the eye and the imagination of every visitor is its colonnaded streets (Plate 233) – so much so in fact that it is worth recalling that Palmyra was in no way exceptional in this respect among the cities of the Roman East, and that it was, moreover, quite a latecomer in the field. None of the colonnaded streets of Palmyra is earlier than the time of Hadrian,[73] nor were they laid out on a single occasion in accordance with any coherent plan. The main axial street, for example, 35 feet (11 m.) wide and about three-quarters of a mile in length, falls into three sections, the changes of direction in which were masked respectively by a grandiose monument consisting of four square platforms, each carrying a statue beneath a tetra-columnar pavilion (*tetrakionion*), and by a fine triple archway. The tetrakionion monument recalls the very similar crossroads monument at Gerasa, a city with which the oval colonnaded piazza at the south end of the shorter, but unusually spacious (70 feet; 22 m.), transverse street at the west end of the town offers another link. The archway (Plate 234), built in 220, was wedge-shaped in plan, a simple but effective device of which the Roman world seems to have made surprisingly little use. (The only comparable example that comes to mind is the arch on the harbour-frontage at Ephesus.)[74] At two points recent excavations have revealed fountain-buildings in the form of apses with flanking recesses fronted by tetracolumnar façades that spanned the lateral porticoes. A striking feature of the whole complex was the rows of brackets projecting from the columns on either side, to carry statues, a practice for which one can find parallels elsewhere in Syria (Apamea) and in Cilicia (Pompeiopolis, Diokaisareia), though nowhere on such a large scale. However upsetting to the classical purist, it offered an orderly and not unattractive alternative to the clutter of civic statuary at ground level with which most classical cities were content.

The theatre and the agora were both second-century foundations which suffered badly when the city was hastily fortified in the third century. The former was a conventional building of rather academic 'Western' type, the most notable feature being the sector of colonnaded street which followed the outer curve, providing a ready-made alternative to the porticoes for the shelter and refreshment of spectators which regularly accompany theatres elsewhere. The latter, a square porticoed enclosure of Hadrianic date, was more unusual in that it incorporated, along the east side, a basilican hall, a type of building which never achieved the same popularity in the eastern half of the Empire as it did in the west. In this case it may have been, in whole or part, a kaisareion, associated with the imperial cult.[75]

Other surviving monuments are the temples of Nabô and of Ba'alshamin; the remains of a number of houses; a public bath-building; the towers of the cemeteries; and the military headquarters established by Diocletian at the west end of the city.

The Temple of Nabô faced south but was in other respects a temple of conventional Romano-Syrian type, a hexastyle peripteral building of the Corinthian order set on a lofty podium in the centre of a trapezoidal, porticoed temenos.[76] In front of the steps

stood the great altar, a square, box-like structure with surrounding columns, closely comparable to those found on some of the Lebanese sites, and beyond this again a monumental propylaeon. The cella was of simple rectangular plan, with a raised platform at the north end and traces of a stair, leading presumably to a terraced roof. The two flanking walls were crowned with stepped merlons. The temple itself dates from the second half of the first century A.D., while the precinct colonnades, which most unusually were of the Doric order, were added on various occasions during the second century. In its present form the Temple of Ba'alshamin dates from A.D. 130.[77] Apart from two windows in the cella, a wholly unclassical feature which reminds us that, like the temples of the Lebanon and southern Syria, this was thought of as the audience hall and dwelling-place of the divinity, it was a building of conventional classical design, prostyle tetrastyle, with a deep Corinthian porch and pilasters along sides and back.

The bath-building, a Diocletianic addition, is remarkable principally for the surprising conservatism of its layout, around a central peristyle court. One room was octagonal, all the rest rectangular. The better-class houses, the only ones yet explored, were also of typically hellenistic peristyle design.[78] The tower-tombs strike a grimmer, more personal note. Though of little architectural interest in themselves, they remind us that the roots of this idea, which in one form or another spread to almost every corner of the Roman world, lay in the ancient East. Other tombs, many of them elaborately painted and carved, took the form of hypogea or of pedimental classical temples.[79]

The so-called 'Camp of Diocletian', with its cruciform street plan leading up to an open space and dominated from the far side by a grandiose headquarters building with a central chapel of the standards, falls unmistakably within the broad category of military headquarters buildings which one sees already established in the Trajanic praetorium of the Third Legion at Lambaesis in Africa, and which was to be repeated in innumerable related variants throughout the Empire during the next two centuries. We have already met just such a building, dating from the early third century, at Dura. Unfortunately there is as yet no general agreement as to whether the building at Palmyra represents an adaptation of an existing layout or whether it was essentially a new creation of the Diocletianic period,[80] and until that is achieved there is little profit in speculating as to its relations with other possibly comparable buildings of the late third century, such as the palace at Antioch and Diocletian's residence at Spalato.

THE NORTH AFRICAN PROVINCES

Egypt

DESPITE their manifold diversity, the countries of the ancient East presented a certain fundamental unity in their reaction to the stimulus of classical culture. The same cannot be said of North Africa. Here we are confronted by the heirs to three distinct ancient civilizations, all of which in differing manners and degrees continued to make themselves felt throughout the Roman period. In Egypt the hellenistic Greek culture of the Ptolemies had overlaid, but even at its most sophisticated had never succeeded in eradicating, the stubborn traditionalism engendered by two millennia of Pharaonic rule. In Cyrenaica the enduring substratum of provincial taste was hardly less tenacious of its metropolitan Greek origins. The whole of the rest of North Africa, west of the Greater Syrtis, had for many centuries been part of the commercial empire ruled by Carthage; and although the fact of Punic rule did not leave so immediate and distinctive a mark on the outward forms of architecture and the other arts, it did constitute the basis of a broad unity of thought and taste that extended along the whole central and western seaboard, from Tripolitania in the east to the Atlantic coastlands of Morocco in the west.

Roman Egypt, from the moment of its annexation after the death of Cleopatra, occupied a singular position among the provinces of the Roman Empire. The fact that it was ruled by a viceroy responsible directly and solely to the emperor may be explained very simply by the anxieties and fears of the last years of the Republic, when there had been a real danger of the effective centre of the Roman world shifting eastward, as it was to do three and a half centuries later under Constantine. But it also reflects Roman awareness that this strange country, the roots of whose civilization ran so deep and nurtured a plant so oddly resistant to many of the blandishments of classical civilization, was in some way different from all other regions of the ancient East of which Rome found herself heir. If one compares the architecture of Upper Egypt in the classical period with that of almost any other province of the Roman Empire, one cannot but be impressed by its staunch preference for the tried forms of tradition. The inhabitants of Philae, wishing to honour Augustus, might erect in 13–12 B.C. a more or less conventionally classical building, a prostyle tetrastyle temple with a shallow porch and a mixed Corinthian–Doric order. (Plate 236 illustrates a similarly classicizing building, the Hadrianic Temple of Serapis at Luxor.) But the adjoining 'kiosk' of Trajan, a century later, was still very largely native Egyptian in style (Plate 237); and as late as 296 the near-by Arch of Diocletian, with its slightly parabolic arches and boldly blocked-out mouldings, had absorbed the external forms, but hardly anything of the spirit, of conventional classicism.[1]

Romanization did, of course, make itself felt in a great many fields. Two small

nymphaea of classical type flank the processional approach at Dendera; a house of the Roman period at Edfu had a private bath-building in the Roman manner; and the Diocletianic camp at Luxor, for all its almost literal incorporation of the Pharaonic temple buildings (one of the temple halls which was later used as a church, became for a while the chapel for the legionary standards), was itself laid out on a four-square classical plan, with intersecting colonnaded streets and a tetracolumnar monument at the intersection. Locally, within and beyond the frontiers, the Romans left a substantial legacy of architectural forms and building practices to the flourishing Christian and pagan civilizations of late antiquity. But in terms of the architecture of the Roman world as a whole Upper Egypt was, and remained, a backwater.

The one group of buildings that deserves mention – not because it was in any way unusual, but because its excavation was, for once, well observed and documented – is that of the small townships of Karanis and Soknopaiou Nēsos in the Faiyûm. The mud-brick houses, with their scanty use of timber and even scantier use of stone, afford one of the very few surviving examples of a building material and of building techniques which have all too rarely come down to us but which were in fact in widespread use in many parts of the Mediterranean Roman world. In particular, the barrel-vaults and shallow saucer-domes, many of them carried out in a pitched-brick technique requiring a bare minimum of timber shuttering, anticipate one of the most distinctive features of Early Byzantine building practice (Plate 238).

In the hellenistic cities of the Delta things must have been very different. Here the almost total loss of the remains of Roman Alexandria constitutes a gap in our knowledge hardly less serious than that of its great sister metropolis in the east, Antioch. There are descriptions of the city and of such individual monuments as the Pharos, the library, and the great first-century synagogue; but such literary descriptions afford notoriously slippery ground for the student of architecture and can at the best be used to supplement the picture to be gained from the surviving monuments. The *disjecta membra* of the classical city show that for a time the architecture of Roman Alexandria retained a decided flavour of the rather mannered hellenism of the previous age. But there are hints of influence from Italy, as, for example, in the introduction of the ubiquitous Roman-style bath-building or in the high podium of a small Ionic tetrastyle temple in the suburb of Ras el-Soda.[2] Subsequently, in the later Empire, the capitals and other architectural members preserved in the museum and elsewhere include a high proportion of 'marble style' decorative material, most of it in Proconnesian marble. In this respect Alexandria was evidently subject to the same all-pervading influences as the coastal cities of southern Asia Minor and Syria and the rest of the North African littoral.

One of the most influential of the lost buildings was the Kaisareion, erected by Caesar in 48–47 B.C. a few months before the lost building of the same name in Antioch. It seems to have been a large, inward-facing temenos surrounded by porticoes, and it has been plausibly argued that it derived from some such monument as the temple enclosure, classical in its details but in its layout still essentially Pharaonic, which was erected *c.* 240 B.C. by the garrison of Hermoupolis Magna in honour of Ptolemy III

and Berenice.[3] The Alexandrian building in its turn seems to have exercised a powerful influence on the architectural forms adopted elsewhere in the Roman world, including the capital, for the purposes of the newly instituted ruler cult. One can hardly doubt, for example, that the Caesareum at Cyrene (Plate 239 and Figure 171) was to some extent

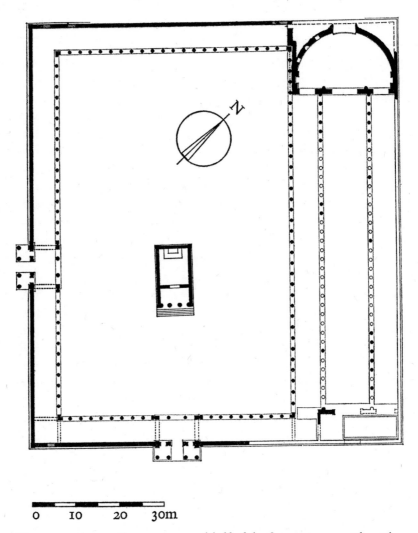

Figure 171. Cyrene, Caesareum, second half of the first century B.C. Plan. The basilica is a modification of the first century A.D., the central temple an addition of the second century (cf. Plate 239)

modelled on its illustrious neighbour. This was a rectangular open space, some 170 by 265 feet (51 by 81 m.), surrounded on three sides by Doric porticoes and on the fourth by a building which in its original form may have been a stoa or a range of columnar exedrae, but which was later rebuilt as a basilica of which the whole of one end was occupied by a large semicircular exedra. (The temple in the middle of the open area is a later, second-century addition.) Comparable forum-basilica complexes are known from

several other sites within the Greek-speaking world, and at least one of these, at Palmyra, seems to have been associated with the imperial cult and may be tentatively identified as the Kaisareion of local epigraphy. Other well preserved examples are at Kremna, in Pisidia, and at Smyrna (Figure 149).

In more general terms one may suspect the influence of the same tradition in Rome too, not only in such direct manifestations of the ruler cult as the Porticus Divorum of Domitian (Figure 87) but also perhaps even in the planning of the Imperial fora. All these were porticoed monuments, enclosed and inward-facing in a manner that was alien to the native tradition of urban architecture inherited from the Republic; and the assignation of the post of honour in the first such forum to a temple of Venus Genetrix, divine ancestress of the Julian family, came as near to expressing the sentiments of the ruler cult as contemporary opinion in Rome would have permitted. There were, of course, other influences at work as well. But it would have been natural for Caesar, in planning his forum, to have drawn upon his own recent experience in Alexandria and in Antioch. If so, this, one of the most widely diffused schemata of Roman Imperial architecture, appears as an ultimate product of the hellenistic influences that had shaped so much of the architecture of the previous century. It is significant of the subsequent shift in the architectural centre of gravity within the Roman world that the known later Kaisareia, all of them in the eastern provinces, should have incorporated basilicas, a specifically Western type of building which, in the context, must almost certainly reflect the prestige of the last of the Imperial fora in Rome, the Forum of Trajan and the Basilica Ulpia.

The life and art of Egypt seem to have exercised a peculiar fascination on Roman minds at all levels and in all periods. Some of the resulting products, such as the famous Barberini mosaic at Praeneste (c. 80 B.C.), with its lively scenes of Egyptian life and fauna displayed within a framework of rich Nilotic landscape, are of a quality that must reflect closely the decorative tastes of the Ptolemaic court; and although many more bear the stamp of an artificial convention comparable to the 'chinoiserie' of a later age, it was a convention of a remarkable durability and resilience, which continued to make itself felt in painting, stucco-work, and mosaic throughout the Roman period. There was also a lively commerce in Egyptian obelisks, sphinxes, fountain basins, and ornamental statuary. Augustus set the fashion by transporting two large red granite obelisks from Heliopolis, one of which he erected on the axis of the Circus Maximus, the other as a sundial in the Campus Martius. In all no less than forty-two such obelisks are known to have been imported by successive emperors. This commerce owed much to the popularity of the cults of Isis and Serapis, whose sanctuaries in Rome, Benevento, and elsewhere have yielded a rich haul of architectural sculpture and statues, both originals and copies. Another possible factor in the dissemination of egyptianizing motifs was the widespread use of stucco as a decorative medium. The organization of this craft in classical times awaits study, but there are some grounds for believing that there may have been close links with Alexandria, the gypsum deposits of which were certainly exploited widely from an early date.[4]

Finally we may note the development of an important export trade in such highly

prized Egyptian building stones as the red granite of Syene (Assuan), the imperial porphyry of the Jebel Dokhan in the eastern desert, and the grey granite ('granito del foro') from the near-by quarries of Mons Claudianus. The Flavian Palace, the Basilica Ulpia, the Pantheon, the great court at Baalbek, the Severan forum and basilica at Lepcis Magna, are a few only of the great monuments of the Empire for which the vast monolithic columns, weighing up to 300 tons, were shipped all over the Mediterranean basin. As a source of luxury building materials the quarries of Egypt were second only to those of Greece and of Asia Minor.

Cyrenaica

Roman Cyrenaica, unlike Egypt, was a poor province, richer in history than it was in fine contemporary monuments; and although much of Cyrene itself has been excavated as well as considerable areas of Ptolemais and Apollonia, there are few Roman buildings that are of more than local significance. One such, the Caesareum at Cyrene, has been described above. Its use of the Doric order is characteristic of the staunch conservatism of that city. As late as the time of Hadrian Doric was employed for the reconstruction of the Temple of Apollo, destroyed a few years earlier during the great Jewish revolt.[5] Used monumentally, Corinthian makes its first certain appearance in the large public bath-building erected by Trajan within the sanctuary of Apollo (or possibly in its restoration by Hadrian, after the same revolt). The capitals of this are typical 'marble style' importations from Asia Minor; but although such importations must constitute one of the stylistic sources of the series of small Corinthian temples and other public buildings erected at Cyrene in local stone during the course of the second century, they do not seem to have been as numerous or to have made the same impact as in most other coastal provinces of the eastern and central Mediterranean. Throughout its later history Cyrene maintained close commercial and sentimental ties with Athens. The bulk of the imported marble (Cyrenaica itself has no supplies) is Attic, and it would not be surprising if further research were to reveal architectural links, too, with Athens and with mainland Greece.

Ptolemais, a hellenistic coastal foundation, and Apollonia, the port of Cyrene, were more up-to-date in their tastes and artistic connexions. The most significant monument in this respect is the so-called 'Palazzo delle Colonne' at Ptolemais (Figure 172). This was a wealthy private residence, probably of the early first century A.D., occupying the greater part of an elongated rectangular insula. The whole building was terraced upwards on substructures to counter the natural slope of the site, and the main residential quarters too were developed in elevation, with rooms and colonnades of very differing heights and a second storey over the main peristyle – an echo presumably of the vertical development imposed by the crowded urban conditions of Alexandria, the domestic architecture of which this building assuredly represents. The plan is essentially that of a typical late hellenistic peristyle-house, with a large room (the oecus)[6] for domestic use opening off the middle of the south side, and opposite it (in this case) a second and larger oecus for more public occasions, the roof of which was supported on an internal

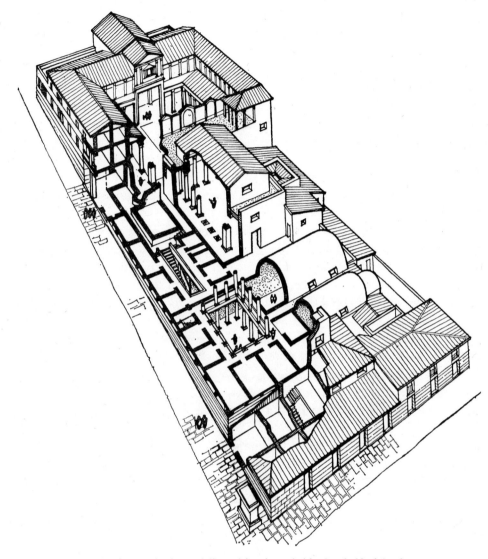

Figure 172. Ptolemais, 'Palazzo delle Colonne'. Probably first half of the first century.
Axonometric view

ambulatory colonnade in a manner reminiscent of the similarly derived Second Style
architectural schemes of Late Republican Italy. Other rooms and offices were grouped
around a second, smaller peristyle, and a bathing-suite was added later at a lower level,
behind the shops that occupied the northern frontage. The architectural ornament was
lavish, with pavements of mosaic and of shaped marble tiles (*opus sectile*) and richly
carved architectural schemes carried out in the soft local stone and surfaced with stucco.
Among the characteristic motifs it must suffice to notice the heart-shaped angle piers;
the free interchange of Doric, Ionic, and Corinthian elements, and the juxtaposition of
orders of different heights; the columns that spring from a calyx of acanthus leaves (a

463

Ptolemaic motif that found its way also into Syria and sporadically elsewhere);[7] the arch springing from the two ends of an interrupted horizontal architrave;[8] the façade in the form of a false portico, with Ionic half-columns carrying a Doric architrave and framing large rectangular false windows (the scheme recalls that of Herod's palace at Masada and the House of the Figured Capitals at Utica); and the broken pediments framing independent pedimental aediculae within the setting of a miniature columnar screen in a manner that clearly foreshadows the marble columnar screens of Asia Minor. All this has very close affinities with the decorative architecture portrayed in the wall-paintings of Pompeii. Despite its Early Imperial date the Palazzo delle Colonne may be regarded as exemplifying the sophisticated late hellenistic domestic architecture from which so many elements of the decorative taste of Italy and the Mediterranean provinces were more or less directly derived.[9]

Whether (as seems very likely) this was in Cyrenaica, too, a specifically domestic style, to be contrasted with the more conservatively classical public architecture of the province, is a question that awaits further study. It was certainly widely represented in the province. At least two other Early Imperial houses of the same general character, though less elaborate, have been identified at Ptolemais; at Cyrene itself the first-century nucleus of the rich 'House of Jason Magnus' falls within the same general category, though the planning is more relaxed; and there are remains of similar workmanship both at Teuchira (Tocra) and at Apollonia. At the other extreme stands a building like the odeion at Ptolemais, the stage-building of which was absolutely plain except for the conventional three doors, which opened directly on to the orchestra. It has even been suggested that it was built originally as a council hall (*bouleuterion*) and only later converted to theatrical use by the addition of a wooden stage, and later again (as frequently elsewhere in late antiquity) by the waterproofing of the whole orchestra to provide for aquatic displays.[10] The magnificently situated Greek theatre at Cyrene was similarly converted by the elimination of the stage and the deepening of the rock-cut orchestra to form the arena of a small amphitheatre. Cyrene had in all no less than four theatre-like buildings (two are visible on Plate 239), some of which must certainly have been designed as places of public assembly. Hippodromes at Cyrene and at Ptolemais remind us that Cyrenaica was famed for its horses. Ptolemais possessed in addition two other theatres and, unusually for an Eastern province, an amphitheatre.

Tripolitania

West of the Great Syrtis one enters a world very different from Egypt and Cyrenaica. Here the Greeks never succeeded in establishing a foothold; from Tripoli to Cádiz and across the sea to Sardinia and western Sicily Rome was heir not to Greece but to Carthage, and the language, where it was not Punic or Berber, was Latin. If Cyrenaica was essentially a part of the hellenistic East, Roman Africa (as it is convenient to term the whole of this territory, from Tripolitania westwards) belonged no less decisively to the Western world. Thirteen centuries of Arab rule have overlaid but have not succeeded in entirely cancelling this distinction.

Roman Africa is almost embarrassingly rich in monuments. Not only did classical civilization strike deep, but the circumstances of the country's subsequent history have favoured the survival of many of its ancient cities and buildings. And yet, with a few notable exceptions, these buildings are more remarkable as documents of a vanished civilization than for any great artistic originality. The architecture of Roman Africa remained to the end very largely derivative.

Why was this? There can be no single answer, but one of the most important reasons lies undoubtedly in the historical background of the territory and its peoples. At the time of the first Greek and Phoenician colonies, the indigenous inhabitants of North Africa, including the Berbers, were still to all intents and purposes in the Stone Age; and whereas the Greeks in Cyrenaica brought with them a vigorous, proselytizing art of their own, the Phoenicians were a people singularly devoid of any native artistic talent. As craftsmen they borrowed freely from others, and as merchants and middle-men they carried their wares all over the western Mediterranean; but in this particular field they had little of their own to offer. If the remains of the art and architecture of the Phoenician colonies in the west are only now beginning to be recognized and discussed, it is largely because of their essentially derivative, colourless character. This is particu-larly true of the later pre-Roman period, when the distinctively Oriental influences had dwindled and the primary source of contemporary inspiration was the hellenistic art and architecture of South Italy and Sicily. The subsequent advent of Roman rule has almost inevitably tended, in consequence, to obscure the local contribution to a mixed civilization of which so many of the externals were obstinately and uniformly classical. And yet, as any student of the history, language, and institutions of North Africa is at once made aware, this was as much a 'Romano-Punic' or 'Romano-African' civiliza-tion as that of contemporary Gaul was 'Gallo-Roman'. To disregard this fact is to dissociate the art of Roman North Africa from the setting of daily life and thought within which it was created and by which it was conditioned.

Two cities about the early development of which we happen to be unusually well informed are Lepcis (or Leptis) Magna and Sabratha, two of the three cities from which the territory of Tripolitania took its name. Both were in origin Carthaginian trading-stations (*emporia*). Excavation has shown that Sabratha was the site of a seasonal, har-bourside trading post as early as the fifth century B.C. Lepcis was founded even earlier; but although the site of the Punic settlement is known, on the west bank of the sheltered wadi-mouth which constituted the harbour, the earliest extant remains are of the Augustan Age, when the quarter immediately inland from the primitive nucleus was laid out on a neat rectangular grid around an open space, the forum, and along the axial street which struck inland on a gentle curve, following the line of the higher ground to the west of the wadi. Individual buildings within the forum area were later rebuilt or embellished. But the subsequent establishment of a new and far more magnificent forum on another site meant that the Old Forum retained to an unusual degree the broad lines of its Early Imperial physiognomy right through pagan antiquity. Better than any other similar complex in North Africa, it offers a picture of the Roman archi-tecture of the province in the earliest, formative stages of its development.

The oblique alignment of the north-east side of the Old Forum must derive from that of some building, or buildings, of the Punic city (Figure 173). The rest is strictly rectangular. Along the north-west side stood three temples. The smallest of these, the North Temple (*c.* 5 B.C.–A.D. 2), served as the model for its larger neighbour, which was built between A.D. 14 and 19 and dedicated to Rome and Augustus. Both made use of the magnificent silvery-grey limestone which was to remain the characteristic building stone of Lepcis for over a century; both were peripteral on three sides only, in the Italian manner; both employed an order with highly distinctive Ionic capitals, and instead of the customary columns at the outer angles of the façade there were heart-shaped angle piers. All of these are recurrent features of the Early Roman architecture

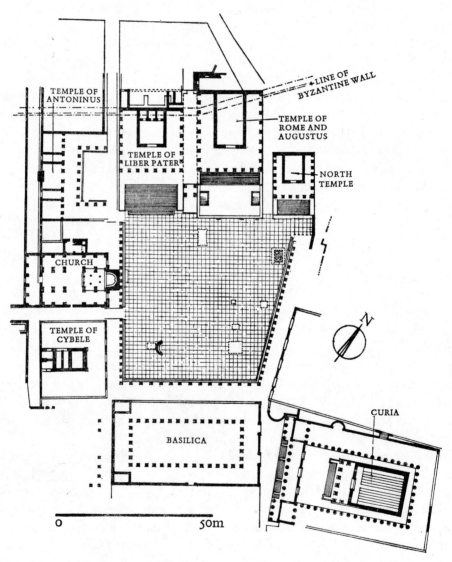

Figure 173. Lepcis Magna, Old Forum. Laid out in the second half of the first century B.C. and developed principally during the first century A.D. Plan

466

at Lepcis, and the proximate source of the capitals and angle piers (not to be confused with the similarly shaped but inward-facing angle piers of everyday hellenistic practice) is probably Late Punic rather than Italian. For all the superficial classicism of these buildings, it was in part at any rate a classicism at one remove from source. The Temple of Rome and Augustus is of interest also for its elaborate vaults and twin cella, and for the design of the podium, which rose sheer from the forum paving, with twin flights of steps incorporated in the flanks, just as in the Temple of Venus Genetrix in Rome. Similar platforms are a feature of a number of North African temples (e.g. Althiburos and Gigthis in Tunisia; Sabratha; Timgad), and in this instance the survival of two carved ship's prows (*rostra*) establishes beyond dispute that the purpose was to furnish a platform for orators. Another feature common to many Early Imperial monuments in Tripolitania is that the architraves seem to have been of wood.

Alongside the Temple of Rome and Augustus, with the pavement of the lofty podium arched across the street between the two to form a single platform, was the Temple of Liber Pater, or Dionysus, the Punic Shadrap. This was the earliest building of the whole group, being built originally of the soft quaternary sandstone which, faced liberally with stucco, was the pre-Augustan building stone of Lepcis. Opposite the two, some time before the middle of the century, was added a basilica (the 'Basilica Vetus'), a building which, though sited transversely so as to balance the bulk of the two main temples, internally was of the longitudinal South Italian type found at Pompeii and at Corinth, the main entrance lying in a small secondary piazza opposite the curia. Then, and not until then, in A.D. 53–4, the central area of the forum was given monumental form by the addition of limestone porticoes on three sides and a pavement of magnificent limestone slabs. This was followed, along the south-west side, by an enclosed precinct and temple of Cybele (71–2), by a temple of Trajanic date which was later converted into a church and, tucked into the western corner, by a small porticoed shrine in honour of Antoninus Pius (153). The curia, the meeting-place of the municipal council, lay just outside the forum proper, opposite the entrance to the basilica, on an earlier alignment. A temple-like building set within a porticoed enclosure upon a raised platform, it seems in origin to have been of Early Imperial date. As at Sabratha, the seating followed the canonical model of the Roman senate house, with two longitudinally facing tiers of low steps.

The Old Forum at Lepcis Magna, like the agora at Corinth, is an excellent example of the sort of monumental unity which sound basic planning and the use of congruous materials enabled Roman architects to achieve, often over long periods of piecemeal growth. Moreover, though derived almost exclusively from South Italian classical sources, either directly or else through Late Punic imitations, this was an architecture that reflected admirably the solid civic qualities of the local mercantile aristocracy. The donors of these buildings bore names like Iddibal, Balithon (Ba'alyaton), and Bodmelqart. The dedicating magistrates were still the Punic *sufetes*, and the dedicatory inscriptions were written in Neo-Punic script as well as in Latin. More than a century later the Lepcis-born emperor Septimius Severus spoke Latin with a strong Libyan accent, and his sister spoke it so badly that she had to be sent back to her native city.

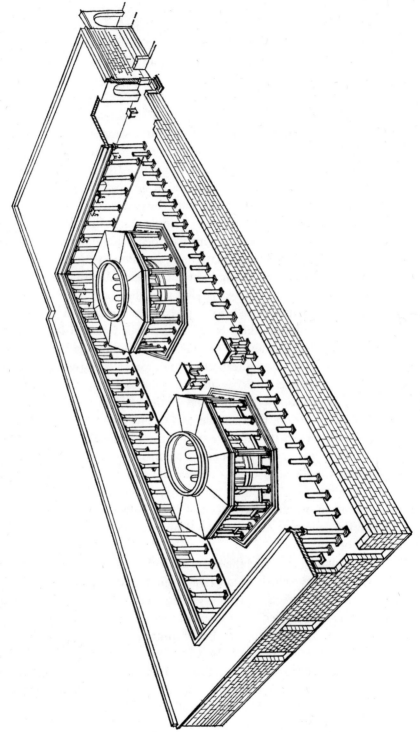

Figure 174. Lepcis Magna, market, 8 B.C. Restored view (cf. Plate 240)

Such a society responded rapidly to the opportunities of the Augustan Peace. Lepcis grew apace. Before the end of Augustus's reign another 275 yards of the axial street towards the south-west had been incorporated as the basis for the street grid of a whole new quarter, and before A.D. 27–30 almost another 400 yards south-westwards again, bringing the limits of the city to the point where the Arch of Septimius Severus later stood. The monuments that mark the stages of this rapid growth are a market building (8 B.C.) and a theatre (A.D. 1), both built on the outskirts of the area hitherto developed, and a porticoed façade, the Chalcidicum, built in A.D. 11–12 to mask one of the resulting irregularities of plan (Plate 242). The market (Figure 174) is an outstanding example of the Pompeian type of macellum, with a central pair of pavilions enclosed within a rectangular open space, around which, between A.D. 31 and 37, was added an encircling portico. The south pavilion was rebuilt in marble two centuries later, but its fellow (Plate 240) is still the original Augustan structure, of fine grey limestone, with a circular, windowed central chamber and an octagonal portico. There were no separate shops, the market benches being ranged between the columns of the pavilions and along the outer walls of the porticoes.

The theatre (Plate 243 and Figure 175A), despite later additions and modifications, is another building that has retained a great deal of the Augustan structure, including the splendid sweep of the original grey limestone seating. The columnar orders of the stage-building were replaced in marble in the later second century, but the plan of it, a large, boldly curved, apsidal recess flanked by two similar but slightly smaller recesses, is original, affording valuable evidence of the early development of this characteristically Imperial Roman architectural scheme. Other noteworthy features are the small tetrastyle temple, dedicated to Ceres Augusta, at the head of the cavea, as in several other North African theatres; [11] the porticoed foyer beyond the stage-building, as for example at Ostia and at Corinth; the colonnade around the head of the cavea, a feature which is repeated at Timgad, Thugga, and Cherchel; and the flooring of the orchestra, replaced in marble during the second century but originally, as in Herod's theatre at Caesarea, of gaily patterned, painted stucco.

The architectural models established at Lepcis under Augustus were maintained with remarkably little change throughout the first century A.D. The ornament grew fussier, and the Corinthian order tended to displace the Ionic; but as late as Trajan the building material in fine monumental use was still the local grey limestone. Then quite suddenly, under Hadrian, the marbles of Greece and Asia Minor (and occasionally of Italy) were introduced, and with them came craftsmen trained in the workshops of the Aegean world and of Rome. The impact was startling. The first building to have used columns and other architectural members of marble was the Hadrianic Baths, a large, symmetrically planned complex of the 'Imperial' type, derivative from the great public bath-buildings of Rome, though with only a very limited use of their characteristic concrete vaulting. Within a few decades the new materials and style had swept the field. After the time of Hadrian there was not a single new building of substance that did not make extensive use of imported marble, and a great many of the existing buildings were correspondingly remodelled – the porticoes and two main temples of the Old Forum,

A

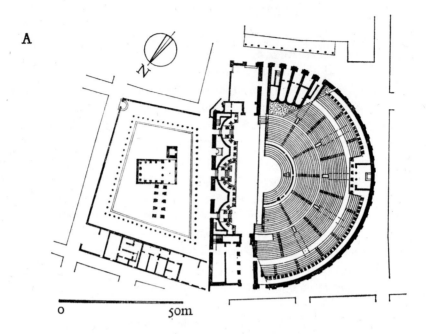

0 50m

B

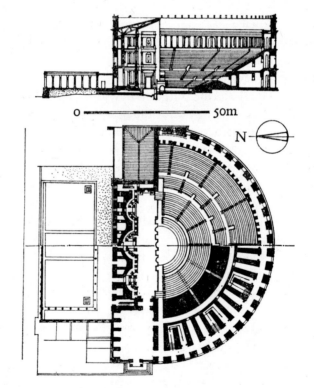

0 50m

N

Figure 175. Theatres in Tripolitania

(A) Lepcis Magna, A.D. 1–2 (cf. Plate 243)
(B) Sabratha, last quarter of the second century
 (cf. Plate 250)

470

the curia, the market, the theatre, and the Chalcidicum, to enumerate only those already named above. Almost overnight the buildings of Lepcis lost the individuality conferred by local materials, techniques, and styles. The columns were now imported ready-made, and the bases, capitals, entablatures, and other fittings were carved to standard classical designs and, at first, by the foreign workmen who have left their signatures upon them. In course of time the establishment of local workshops came to give them a certain individuality of style, but it was only within the wider framework of an Imperial art that was as much at home in Asia Minor or the Syrian coastlands as it was in Tripolitania. Much of the new architecture was rather dull, but it was ostentatiously expensive and it satisfied the pretensions of an age of material progress and civic prosperity.

The monuments of pre-Severan Lepcis – and to those already mentioned must be added half a dozen lesser temples, as many honorary arches, an aqueduct and cisterns, port installations, an amphitheatre, a circus, several smaller bath-buildings, a monumental exercise ground (*palaestra*), and sundry streetside porticoes, fountains, and public lavatories – jointly and severally offer a glimpse of what must have been happening in innumerable other cities, great and small, along the coastlands of North Africa. Not that one can often document the early phases of their growth in anything like the same detail. At Sabratha, for example, the local building stone was a friable sandstone that could only be used beneath a thick coating of stucco, needing constant attention; already in late antiquity there was very little left of the first-century city and its monuments. Lepcis was fortunate in this respect; and since it was also wealthier than the average North African city, its early expansion was correspondingly more rapid. Architecturally, however, the only important respect in which it seems to have differed from most of its neighbours was that, like the recently refounded Carthage, it developed within the framework of an orderly city plan. In most of the older North African cities, such as Hippo Regius (Bône), Tipasa, Thuburbo Maius, Thugga, and Gigthis, the Roman-period town plan reflects rather the impact of two quite distinct patterns, the tidy symmetry of the Roman monuments superimposed upon the more or less haphazard growth of the pre-existing town.

It is again to Tripolitania, to Sabratha, that one must turn for a well documented example of the processes of transition. One's first impressions of the old town adjoining the harbour are dominated by the neat rectangularity of the forum, but excavation has shown this to be in fact a drastic rationalization of what had previously been an irregular open space serving the late pre-Roman city as an occasional market-place. In plan, or from the air (Plate 249), the pre-existing layout is still clearly visible in the picturesque commercial and domestic quarter between the forum and the harbour, and again on either side of the main road leading inland from the forum towards the main east–west coast road. Only as one approaches the latter do the individual city blocks assume more regular shape; and it was not until the second century that a really strict rectilinear plan was adopted for the new quarter laid out to the south-east of the old city, towards the theatre. Here at Sabratha, as in the neighbouring city of Gigthis, the contrast leaps to the eye. Elsewhere, where the existing physiognomy of the town was already more

developed, as for example at Thugga, the individual monuments had for the most part to develop piecemeal as best they could within the framework of the existing urban scheme.

As originally laid out in stuccoed sandstone towards the middle of the first century A.D. the forum at Sabratha consisted of an elongated rectangular open space, flanked along the two long sides by shops and enclosing near the east end a large, gaily painted temple dedicated to Liber Pater. Along the western half of the south side, behind the shops, there was a basilica. In contrast to that of Lepcis this was of the Central Italian 'Vitruvian' type,[12] symmetrical about the shorter axis and incorporating, opposite the main door, a rectangular, apsed tribunal, which served both as a separate courtroom and as a chapel for the Imperial cult. The only other monumental building was a small temple, of pre-forum, possibly Augustan date, standing in a colonnaded enclosure, just off the north-west corner. The temple, free-standing within the enclosure, was a small, box-like structure, wider than it was long, set on a low podium at the head of a flight of steps. Despite the widespread adoption of classical names and other outward forms, native religious traditions were still strong, and (as we shall see later in this chapter) temple architecture is one of the few fields in which Roman North Africa did in fact display a certain originality.

During the course of the next three centuries all the forum buildings, with the single and presumably deliberate exception of the Temple of Liber Pater (which was rebuilt and enlarged in traditional materials), were rebuilt wholly or partially in imported marble. The innovations included the building at the west end of a large new temple, the Capitolium, presumably here, as normally elsewhere, symbolizing the city's achievement of some advance in civic status; the suppression of the rows of shops in favour of, in the western half, two longitudinal porticoes with imported granite columns and, on three sides of the eastern half, an elaborate double portico of (rather unexpectedly) traditional hellenistic type, with an outer Doric colonnade and an inner Ionic colonnade at twice the spacing; the addition of a municipal council hall, or curia, along the north side opposite the basilica; the rebuilding in more conventionally classical form of the early temple at the north-west corner; and the construction on either side of the main street, just outside the forum to the south, of two new and typically 'marble style' temples, one dedicated to Marcus Aurelius between A.D. 166 and 169, the other added a few years later. The Capitolium, the vaults of which were perhaps used as strongrooms, was of conventional classical plan except for the vertical front of the podium, forming a platform for orators, and for a pair of square projecting chambers on either side of the porch. The two marble style temples were both prostyle buildings standing in the Italian manner on lofty podia against the rear wall of a rectangular enclosure, the two flanking porticoes of which ended in apses against this rear wall. The Temple of Hercules, the Punic Melqarth, in the east quarter (A.D. 186) was of the same form.

The outstanding single monument of Sabratha is, of course, the late-second-century theatre, outstanding not so much because it was in any way unusual in its own day as because the discovery and accurate restoration to its full height of the façade of the

stage-building has made it possible to appreciate the visual subtleties of one of these elaborate columnar façades in a way that is quite impossible from even the best paper restorations (Plate 250 and Figure 175B). All that is missing is the coffered wooden ceiling, cantilevered forward over the stage, and the facing of marble veneer that covered the wall surfaces behind the columns. Rather surprisingly (for Sabratha, though prosperous, was not a very large town) it is one of the largest theatres to have come down to us in Africa, with a maximum diameter of 304 feet (92·60 m.) against the 290 feet (88·50 m.) of Lepcis, and second only to that of Hippo (c. 325 feet). The plan of the stage building closely resembles that of Lepcis, from which this theatre differs principally in the greater elaboration of the substructures of the cavea, with an outer ambulatory corridor and embellished externally with a triple order in low relief, both features that go back to the Roman tradition represented by the Theatre of Marcellus.

The domestic and commercial architecture is unusually well preserved and would repay far more detailed study than it can receive here. The irregular insulae of the old town present all the confusion and diversity of plan of a quarter that was continuously occupied for many centuries, with shops, dwelling-houses, workshops, and magazines jostling for position along the narrow streets. Shallow roadside colonnades here and there gave shade to the buildings behind, supporting the projection of the upper storeys to which the remains of staircases bear frequent witness. The ground floors were regularly of squared stone masonry, the upper storeys of timber and mud-brick, and the rarity of roof-tiles suggests that the roofs were flat in the Oriental manner. Interiors and exteriors alike were faced with stucco, and in the better-class houses one finds the abundant remains of painting (including painted plaster vaults), ornamental stucco mouldings, mosaic floors, and even marble veneer. The rectangular insulae of the new quarter (c. 180–90) repeat the same schemes, but in a more orderly, planned manner. The random columnar porticoes of the old quarter have become neat rows of columns fronting one or more sides of the insulae. On the outskirts of the town are the remains of several rich peristyle-villas.

A regular feature of the town houses of Sabratha, as elsewhere in North Africa, was the incorporation of large cisterns for the storage of rainwater for domestic use. There was also a public supply brought in by aqueduct, but this was normally directed only to the public fountains (which were intended for practical use as well as for decoration) and to the bath-buildings. Attached to the latter, and flushed by their outflows, were public lavatories, which were of communal character, with accommodation for as many as sixty persons at a time on long stone benches, and which were often lavishly ornamented with marbles and statuary (cf. Plate 246, in the Hadrianic Baths at Lepcis). Sewage, domestic waste, and rainwater alike were collected and discharged through large sewers laid beneath the paving of the streets. Domestic plumbing was confined to the more luxurious private houses. At Sabratha, for example, there was an exquisite, mosaic-paved little bath-building (the 'Oceanus Baths') attached to a rich suburban seaside villa near the eastern limits of the town. The general public used the large, irregularly planned baths overlooking the harbour; and between these two extremes there were numerous medium-sized establishments that were available on payment or

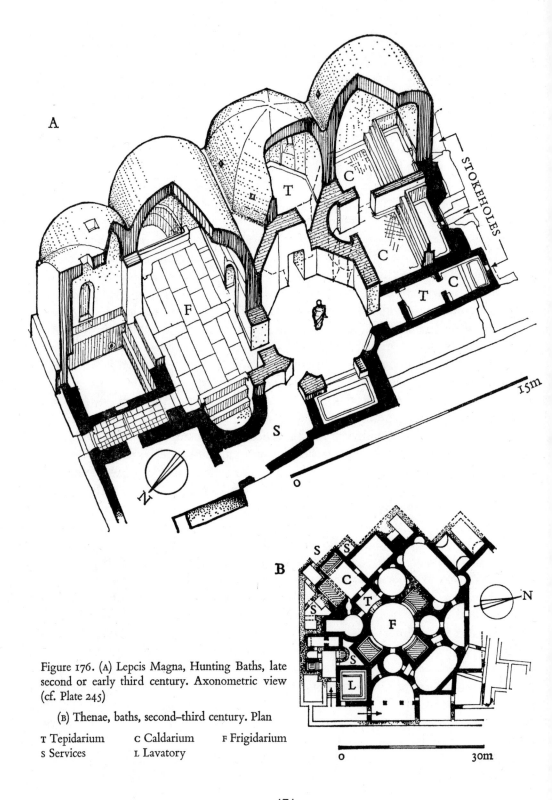

A

STOKEHOLES

C

C

T

T

C

F

S

N

15m

0

B

S S

C

T

F

S

L

N

0 30m

Figure 176. (A) Lepcis Magna, Hunting Baths, late second or early third century. Axonometric view (cf. Plate 245)

(B) Thenae, baths, second–third century. Plan

T Tepidarium C Caldarium F Frigidarium
S Services L Lavatory

474

were reserved for members of certain privileged groups. At Lepcis the 'Hunting Baths' (Figure 176A) seems from its decoration to have belonged for a while to the merchant association engaged in supplying exotic wild beasts to the amphitheatres of the Roman world. Fortunately for its credibility as a classical building erected probably in the early third century, it is exceptionally well preserved, nearly up to the crown of its concrete vaults. Concrete was not a material native to North Africa. It could be used, however, and on this occasion was used, to produce a building that patently derives from the concrete architecture of metropolitan Rome, but does so with a logic of application and a frankness of statement that are rare in the capital. Its parentage must be sought in buildings such as the Lesser Baths of Hadrian's Villa, but the plan of the interior has been rationalized into an orderly scheme, eliminating the purely extravagant in favour of a simple but effective juxtaposition of contrasting geometrical room-shapes; and the exterior was simply a candid restatement of the shapes within (Plate 245).

To the conservative citizen of Lepcis, nurtured on the sober splendours of the Hadrianic Baths, the Hunting Baths must have seemed a quite extraordinary building. And yet, within the field of bath-building (for which the vaulting offered many practical advantages), this sort of architecture had a considerable vogue in North Africa. The actual vaults are rarely preserved; but with the example of the Hunting Baths before one, they can be confidently restored in imagination. An outstanding example of the type is the bath complex at Thenae in Tunisia (Figure 176B), grouped around a central, domed frigidarium, buttressed by four radiating barrel-vaulted chambers, with smaller domed rooms in the four angles of the cross.[13] Outside North Africa, too, such exposed vaulting may have been far commoner than one's knowledge of conventional classical architecture might lead one to expect. The vaults were certainly visible, for example, in the Baths of Capito at Miletus, or again at Bostra and Philippopolis. In this the early Arab bath-builders were simply following classical practice. Even in Rome one is led to wonder about some of the later Imperial bath-buildings, which are usually thought of as having had pitched roofs of tiles throughout.

Lepcis, already one of the wealthiest cities of North Africa in its own right, had the good fortune to be the birthplace of the emperor Septimius Severus (193–211). During his reign the city was embellished with a whole new monumental quarter, comprising an enclosed harbour, a bath-building, a colonnaded street, a forum and basilica, and a piazza dominated by a monumental fountain-building (Plate 244). Other Severan enterprises included the enlargement of the existing circus and the building of a four-way (quadrifrons) arch.

Except for the arch, a hurriedly erected and very over-decorated structure, of interest more for the content and quality of its sculpture than for its architectural qualities, these were all buildings of real distinction. The harbour was an irregularly circular basin nearly 400 yards in diameter, with a lighthouse and a signal-tower on the extremities of the two moles; along the wharves stood ranges of warehouses, fronted by porticoes and two temples. From the waterside a colonnaded street, nearly 450 yards long and measuring 70 feet (21 m.) across the central carriageway, led up to a piazza adjoining the Hadrianic Baths. On the south-east side of this street was a bath-building (as yet un-

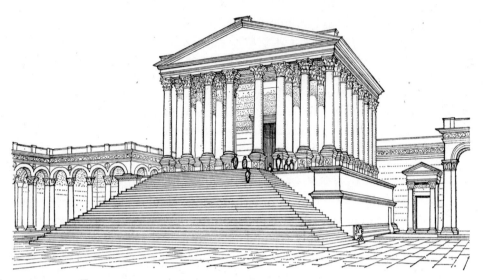

Figure 177. Lepcis Magna, temple in honour of the Severan family, *c.* 216. Restored view

excavated) and on the opposite side the great Severan forum and basilica. The principal building material throughout was a hard yellow local limestone, used in large dressed blocks and liberally supplemented with imported marbles and granites. For the more utilitarian structures and for the relatively few curved features, a concreted rubble was used, faced with courses of small squared blocks and laced with brick or timber.

The forum (Figure 178) consisted of an open rectangular space measuring nearly 200 by 330 feet (60 by 100 m.), at the middle of the south-west end of which, framed by open columnar halls, stood a large temple dedicated to the Severan family. The temple, which stood on a double podium at the head of a spreading flight of steps, was a tower-

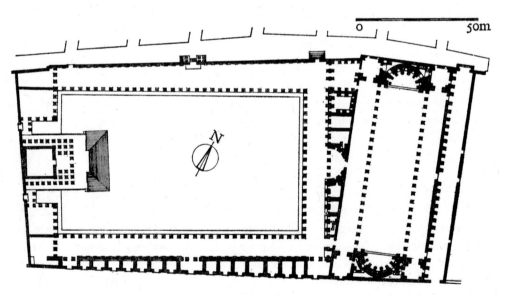

Figure 178. Lepcis Magna, Severan Forum and Basilica, dedicated in 216. Plan (cf. Plate 244)

ing octastyle building of solid Proconnesian marble with red granite columns (Figure 177). The same note of opulence was reflected in the colonnades that enclosed the remaining three sides, with columns of green Carystian marble and gleaming white Pentelic capitals and bases. Along the south-east side an elongated, wedge-shaped block of tabernae faced on to the Colonnaded Street, and another on the north-east side masked the change of direction as one passed from the forum into the basilica. The latter (Plate 247 and Figure 179) was a huge colonnaded hall, with apses at the two ends of the central nave. This has a span of 62 feet (19 m.) and there were galleries over the lateral aisles, giving a total height from floor to ceiling (assuming a shallow clerestory) of well over 100 feet (30 m.). A pair of bracketed orders encircled each apse (the curious central feature in each case is an afterthought, of Severan date) and there was an

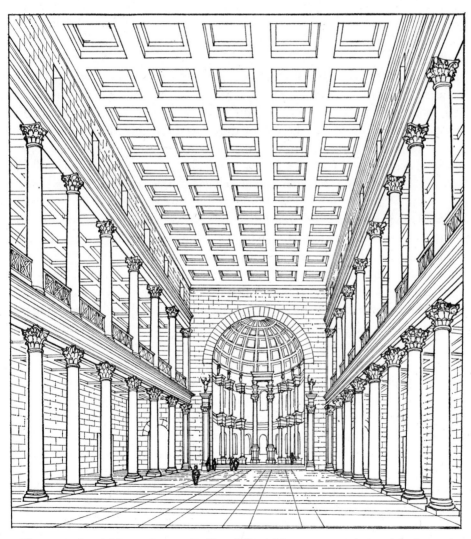

Figure 179. Lepcis Magna, Severan Basilica, dedicated in 216. Restored view (cf. Plate 247)

enclosed street with a decorative flanking order (also an afterthought) along the north-east façade. Yet another decorative order fronted the range of tabernae within the portico that faced the temple, across the forum (Plate 196). This was a rich, elaborate, and highly individual architecture. Among its many distinctive features we may note the liberal use throughout of independent pedestals to give added height to the orders; the graceful lotus-and-acanthus capitals of forum and street (Plate 216), and the substitution in both of arches for the horizontal architraves of traditional classical practice; the use both in the nymphaeum and in the basilica of small rings of acanthus foliage between base and column; and throughout the complex, an emphasis on height and elegance and on the qualities of fine masonry, set off by an elaborate use of coloured marbles and of rich, deeply carved architectural ornament.

That all this was the work of a single architect it is hard to doubt. Some of the site was ground reclaimed from the wadi that ran through the middle of the town, but much of it had to be adapted to the irregularities of pre-existing street frontages, and the unity of plan could only be achieved by a number of adjustments which bear the mark of a clearly defined architectural personality. Such, for example, were the angle-chapels of the basilica and the wedge-shaped blocks of tabernae between the forum and basilica, and between the forum and the Colonnaded Street. The piazza is a copy-book exercise in the resolution of such problems. Faced by the divergent orientations respectively of the street leading up to the theatre, of the street (probably also colonnaded) that flanked the Hadrianic Baths, and now of the Colonnaded Street, the original intention was to build a circular colonnaded piazza at the point of junction. While still under construction this safe, but somewhat neutral, device was scrapped in favour of the bolder scheme of establishing a new dominant axis by building a huge, eye-catching fountain-building symmetrically across the angle between the two colonnaded streets (Plate 248). A lesser architect (and, be it admitted, almost any architect trained in Rome) would have met such problems head-on by imposing an orderly, symmetrical plan upon the ground, as for example in the great Imperial fora of the capital. The architect of Lepcis had the more sensitive approach that makes a virtue of the problems posed by the site. One can see the same hand at work in the harbour, in the subtly receding planes of the steps and wharves of the east mole and in the deliberate contrast between the stepping up of the colonnades and the gentle slope of the mole itself. This was architecture in the grand manner, but it was interpreted with a light touch.

That the architect was a newcomer to North Africa there can be no doubt, and everything points to him having come (like many of his assistants, who left their signatures on the masonry and architectural detail) from the Greek-speaking world, probably from Asia Minor. The pedestal bases, the distinctive masonry formula of the outer wall of the forum and basilica, the Colonnaded Street, the screen-like fountain-building, the carved ornament, all these were typically and characteristically Asiatic. The lotus-and-acanthus capitals were Attic in design and in materials, and the little acanthus ring between base and column, ultimately an Egyptian and Syrian feature, is found in Asia Minor. The arcaded colonnades, anticipating by a century those of Diocletian's palace at Spalato, had themselves been anticipated in Hadrian's great temple at

Cyzicus. The only features that are unequivocally Western are the basilica and the temple. Here the architect's commission must have been to follow Roman models, among them the Forum and Basilica of Trajan; but the architectural vocabulary, materials, and methods that he used in carrying out his commission were those of his own background and training.

In all this the Severan building programme at Lepcis may be regarded as a logical extension and culmination of the artistic and commercial contacts built up in Tripolitania over the previous three-quarters of a century. Formally, like so much of this 'Imperial' or 'marble style' architecture, a building such as the Severan basilica was in consequence thoroughly conservative in spirit, a final flowering of the same Romanohellenistic tradition as the Basilica Ulpia itself. But Severan Lepcis was also a portent for the future. The product of imperial patronage, its almost total disregard of the old regional frontiers foreshadowed the great imperial foundations of the later third and fourth centuries, which pushed these same tendencies to their logical conclusion, creating an architecture that was neither 'Eastern' nor 'Western', but truly Empire-wide in scope. For all their essential conservatism the Severan buildings at Lepcis had within them the seeds of the new creative impulses that were to come to fruition in the architecture of late antiquity.

Tunisia, Algeria, Morocco

Lepcis and Sabratha were both cities that acquired their Roman shape within the setting of an already existing urban civilization. For a comparable vision of Roman city-life in areas where only the barest rudiments of such had existed before, we have to turn to the territories that lie to the west. Here Timgad (the ancient Thamugadi) and Djemila (Cuicul) will serve to present a picture of this other, but no less characteristic, aspect of Roman achievement in Africa.

Timgad, on the high plains of Algeria about 70 miles south of Constantine, was founded by Trajan in A.D. 100 as a colony of military veterans. Lambaesis, the new permanent camp of the Third Legion, lay only 15 miles to the west, and Timgad itself was sited so as to control one of the passes from the wild mountain country to the south. Such colonies had, however, another role. They were from the first intended also to be centres for the diffusion of Roman civilization in the one form that the Romans really understood, that of the Graeco-Roman town of Mediterranean lands. Apart from the military precision of its plan, this was the consideration that dominated the architecture of Timgad.

The site chosen was on gently rolling ground within easy reach of an abundant water supply. The layout (Plate 251) was a textbook example of orderly rectangular planning, based on a square of 1,200 Roman feet (about 1,165 English feet, or 355 m.) subdivided in each direction into twelve equal city blocks (*insulae*), of which in the event the westernmost row was, for some reason, never built. The only deviation from strict symmetry was that the main north–south street (*cardo*) stopped at the geometrical centre of the town, where it joined the main east–west street (*decumanus*). Beyond this point the

ground began to rise, and here, dominating the rest of the town, were sited the principal public buildings. The total area was not large (about 25 acres), and busy suburbs soon grew up beside the roads leading out from it. By the end of the second century the population is estimated at 12,000–15,000 persons.

Apart from the forum complex, a theatre, and one or more of the smaller bath-buildings (and possibly an open market-square, later built over), the entire available space was given over to the houses of the settlers. These at first were solid, undistinguished, single-storey structures, occupying a single insula or part of an insula and facing inwards on to a courtyard. Shops of the familiar taberna type occupied the better street frontages, and along the two main streets there were in addition streetside colonnades (Plate 252). These were discontinuous at the street junctions, in the Ostian manner; but being columnar, not arcaded, and uniform throughout their length, the effect is very like that of the colonnaded streets of the Eastern provincial cities. The building materials throughout were dressed limestone for the principal architectural features, and for the rest a version of the mortared stonework, faced with courses of small squared blocks and reinforced with larger squared blocks, which was the regular African equivalent of the variously faced concretes of metropolitan practice.[14] Timber was evidently still available in quantity from the mountains, and vaulting was the exception.

The theatre, which is estimated as having seated between 3,500 and 4,000 persons, is a building that might have been found in any one of dozens of smaller African cities.[15] The forum too (Figure 180) followed familiar lines, but in this case the stereotypes

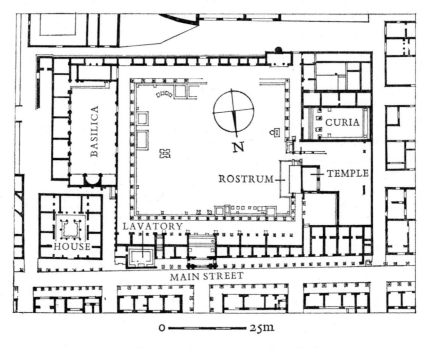

Figure 180. Thamugadi (Timgad), forum, 100. Plan (cf. Plate 251)

allowed for more variety of local interpretation. An almost square central space (140 by 165 feet; 43 by 50 m.) was entirely enclosed by Corinthian colonnades, except at one point where the podium of a temple was carried forward, so as to form a platform for public orators. (It is a singular fact that this is the only temple for which the original layout of the city made any provision.)[16] The basilica, which occupied the greater part of the east side, was a plain rectangular hall, 50 feet (15 m.) wide, with decorative pilasters down the two long walls; at the south end there was a raised tribunal, and opening off the east side a range of public offices. At the west side of the forum another handsome rectangular hall, veneered in marble and divided internally by steps and a columnar screen, was the meeting-place of the town council (curia), and there was a second, rather smaller hall, of unknown destination, at the north-west corner, beside the temple. Columnar exedrae and shops occupied the two long sides, those along the north side being in part at any rate terraced out over the shops and the large public lavatory which occupied the lower frontage, facing on to the main street.

This was the destined centre of the city's administrative life, and much of its commercial and social life too, and it followed a pattern which, though derived in almost all essentials from Italian practice, was almost infinitely adaptable to suit local circumstances. The ingredients were the open, paved piazza, usually colonnaded; the basilica, either a plain timber-roofed hall (as here and at Cuicul and Madauros)[17] or colonnaded internally (as at Tipasa, Sigus, and Thubursicu Numidarum);[18] the curia, a smaller but luxuriously equipped chamber, often with a forecourt or internal vestibule;[19] an official temple or temples; other municipal offices, such as a treasury or an archive building; a tribunal for speeches or public appearances; and assorted fountains, exedrae, statues, and shrines. At Timgad these ingredients found expression in a plan which escaped monotony by making effective use of a gentle rise in the ground level; and because the main lines of it must go back to the city's foundation, it offers an unusually clear picture of what were then held to be the essential requirements of the civic centre of one of the smaller provincial African towns.

The Trajanic colony prospered and expanded rapidly, and in the course of the second and third centuries it acquired a number of additional monuments and amenities. These included a Capitolium and one or two lesser temples, several monumental arches, two market buildings, a public library, and several fine public baths.

The Capitolium dates probably from the latter part of the second century. It was finely situated just outside the south-west corner of the early town so as to face obliquely across towards the city centre, and by local standards it was a very large, commanding building. The temple itself, which stood against the rear wall of a large porticoed precinct, was hexastyle Corinthian and peripteral on three sides, and it was very tall in proportion to its width, with the columns, themselves over 30 feet from pavement to capital, standing on a vaulted platform at the head of two flights of no less than thirty-eight steps; the cella was subdivided into three chapels, one for each member of the Capitoline triad. In all of this the Capitolium of Timgad was an almost aggressively Roman building, so Roman in fact that one suspects it of copying some well-known monument in one of the coastal cities, perhaps even the lost Capitolium of Carthage.[20]

The 'Arch of Trajan' (Plate 252) belongs to a group of monuments which was equally Roman in origin, but which was rapidly becoming acclimatized in a no less distinctively African form.[21] Arches are found in North Africa in large numbers and of every degree of complexity, from simple archways framed between shallow pilasters, as at Verecunda (Marcouna) near Lambaesis, up to the elaborately adorned four-way (*quadrifrons*) arches of Lepcis and Tébessa. At Timgad alone there were three other such arches: a single archway framed on each face between four free-standing columns, erected in honour of Marcus Aurelius between 166 and 169 across the Lambaesis road; another in 171 across the Mascula (east) road; and the North (Cirta) Gate, completed in 149, each pier of which carried an inner pilaster and an outer half-column. One can establish a classification of these North African arches in terms of the number of arches, the number and disposition of the framing elements, and the use, or not, of free-standing columns, but elaboration is as often an index of means and taste as of chronology. The 'Arch of Trajan' at Timgad is certainly earlier than Severus, but probably not much earlier, since the closest parallels are with the probably Severan arch at Lambaesis and that of Macrinus (A.D. 217) at Diana Veteranorum (Zana). The most singular element of its design is the segmental pedimental feature that frames the aediculae above the lateral arches.

Market buildings (*macella*) were another feature of the Italian repertory that had reached Africa at an early date – perhaps even in Punic times. One recently excavated at Hippo Regius (Figure 181A) consisted of two distinct elements, a rectangular, colon-

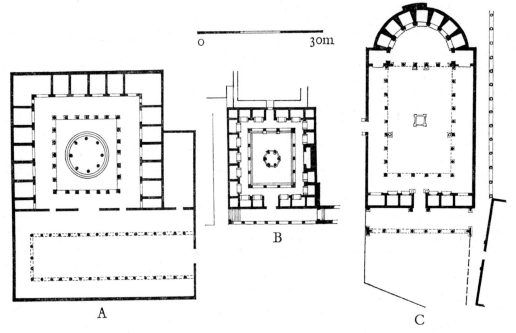

Figure 181. North Africa, market buildings. Plans

(A) Hippo Regius (Hippone), date uncertain
(B) Cuicul (Djemila), Market of Cosinius, second century (cf. Plate 241)
(C) Thamugadi (Timgad), Market of Sertius, third century

naded outer courtyard for temporary markets, and, opening off one side of it, an inner courtyard on the Pompeian model, with permanent stalls around three sides of it and a circular pavilion in the middle. Similar macellum buildings, with or without outer courtyards or pavilions and often containing a statue or shrine of Mercury, the god of commerce, are known from half a dozen other African sites.[22] Of the two at Timgad, the Market of Sertius, built in the third century just outside the 'Arch of Trajan', was a building of some pretensions (Figure 181c). Beyond an irregular forecourt it consisted of an enclosed rectangular courtyard, colonnaded on three sides and equipped with stalls along the inner face of the façade. Across the far end a taller colonnade carried the gabled façade of an apsidal hall with seven radiating stalls round the curve. After the sober rectangularity of the Trajanic city the apse strikes a refreshingly different note. But the real surprise, amidst all the banalities of provincial classical detailing, is the tall, narrow arches of the inner façade, resting on independent square entablatures as if on so many detached architectural brackets.

The East Market, within the old town, was another relatively late building, and it had an even more unusual plan.[23] Behind an outer portico, with a range of market stalls on either side of a central semicircular vestibule, were a pair of small, partly intersecting, apsidal inner courtyards, set side by side, facing forwards, and ringed around with stalls. In this case the architect was faced with the problem of inscribing an elaborately curvilinear design within the framework of a pre-existing insula; and even if the result suggests enthusiasm rather than experience, it is interesting and significant that he should have tried. Much the same situation confronted the architect of the library, the gift of a wealthy third-century citizen.[24] In this case the solution adopted was to inscribe the library proper, an elongated apsidal hall, between two rectangular chambers at the far end of a shallow rectangular forecourt, porticoed on three sides and itself flanked by small reading rooms or offices. Around the curve of the central hall, framed between the marble columns of a projecting order, were the recesses that housed the cupboards for the storage of the rolls, with a larger central recess for a statue of the emperor or presiding divinity. Here and there one detects a certain hesitancy, notably in the relation of the semi-dome to the vaulting (or timber roof?) over the first bay of the library hall; but on the whole the result is a reasonably successful compromise between old and new.

By the third century the ripples of the 'new' metropolitan architecture were evidently disturbing the calm even of those remote backwaters of Empire. In Africa, as elsewhere, a very important part in the introduction of the new ideas must have been played by the bath-buildings. No less than fourteen of various dates and sizes have been identified at Timgad alone, and it was a poor town indeed that did not boast three or four. No two are exactly alike, but amidst an almost infinite variety of plan one can distinguish two broad trends, both of which, as it happens, are well represented at Timgad. The North Baths, built in the third century and the only building at Timgad to be faced throughout in brick, was a compact rectangular structure (Figure 182B) measuring 200 by 260 feet (60 by 80 m.), symmetrical about its shorter axis and patently derived from the great public bath-buildings of Rome. The Hadrianic Baths at Lepcis

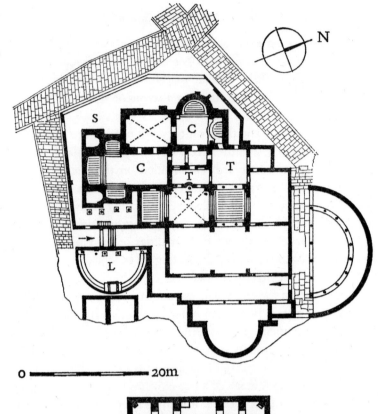

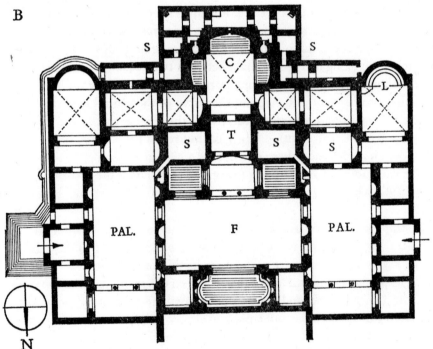

Figure 182. Thamugadi (Timgad), bath-buildings. Plans

(A) South Baths, mid second century (B) North Baths, third century

s Services c Caldarium t Tepidarium f Frigidarium l Lavatory PAL. Palaestra

(123) were probably the first of these 'Imperial' bath-buildings in Africa, and they were followed twenty years later (143) by the great Antonine Baths at Carthage (Figure 184), with its highly original and ingeniously planned ring of interlocking hexagonal caldaria. This was an enormous prestige monument, 650 feet long and lavishly equipped with mosaics and imported marbles, and it must have made a great impression throughout the African provinces. Other known examples of the type are at Cuicul (183) (Figure 183), at Utica, at Uthina, at Cherchel (of Severan date), the Licinian Baths at Thugga (*temp*. Gallienus, 259–68), the late 'Large' Baths at Lambaesis, and an unfinished mid-fourth-century (?) bath-complex recently excavated at Lepcis.[25] The two last-named give a good idea of the range of architectural possibilities inherent in the same

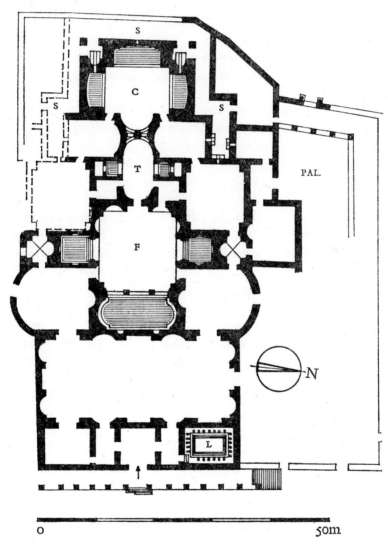

Figure 183. Cuicul (Djemila), bath-buildings, 183. Plan

s Services c Caldarium t Tepidarium f Frigidarium PAL. Palaestra L Lavatory

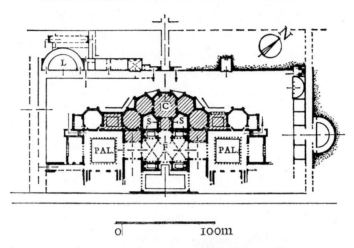

Figure 184. Carthage, Antonine Baths, 143. Plan

L Lavatory C Caldarium S Services PAL. Palaestra F Frigidarium

basic type: the former long, narrow, and almost ostentatiously rectilinear in plan, the latter a tightly planned complex of ingeniously interlocking curves, which made use also of columnar arcading, as in the Severan forum at Lepcis. The Timgad baths, though of rather sober design, were spacious and workmanlike, and it is probably right to detect the hand of an architect brought in for the purpose.

The South Baths, built in the mid second century on an irregular plot of ground just outside the south gate, were different in almost every respect (Figure 182A). They were of the far commoner type with a single circuit of hot and cold rooms, within which functionalism might yield to a certain symmetry within the individual rooms, or groups of rooms, but rarely, if ever, to a symmetrical treatment of the exterior. In the older towns this would be lost to sight among the houses of a crowded urban quarter, as in the Summer Baths at Thuburbo Maius. Usually, however, these large buildings were wholly or partly free-standing, and in that case there were two possibilities open to the architect. He might still contrive to present a decorously monumental face to the outer world, as he did, for example, with some success in the Large Baths at Madauros. The alternative adopted by the architect of the South Baths at Timgad was to make a virtue of the irregularities of his site by deliberately laying out the rectangular framework of his building at 45 degrees to the adjoining city grid and filling in the angles with boldly projecting apses and curved exedrae. When one reflects that the rooms of the actual bathing-suite were certainly vaulted, and that the vaults may well have had exposed outer surfaces, as in the Hunting Baths at Lepcis, one can imagine something of the impact of such a building upon the staid burghers of Timgad.

At first glance nothing could resemble Timgad less than Cuicul (modern Djemila), 70 miles to the north-west, on the old main road from Cirta (Constantine) to Sitifis (Sétif), Timgad four-square and uncompromising on the edge of the plain, Cuicul clinging to the northern extremity of a narrow triangular plateau overlooking the heads of two plunging valleys, with only the rudiments of a formal layout (Plate 254).

486

Between them they represent the two ever-present poles of Roman city planning. But although the buildings of Cuicul as a result display an animation and a sense of adventure that are sadly lacking amidst the bourgeois proprieties of Timgad, one has only to scratch the surface to find how closely the two cities resemble each other.

This is hardly surprising. Like Timgad, Cuicul was a military colony, founded only three years earlier (96 or 97) to control an important road up through the mountains of the Kabylie. Like Timgad again it prospered, and it grew rapidly in the only direction that was physically possible, southwards up the ridge. By the second half of the century the buildings outside the walls already included a theatre (161) and a large bath-building of 'Imperial' type (183); and a few years later the expansion was given definitive shape by the conversion of the open space outside the old walls into a new and larger forum, dominated by an arch in honour of the emperor Caracalla (216) and a fine temple to the reigning Severan dynasty (229).[26]

The architectural ingredients followed a familiar pattern. Within the old town there were the main street with flanking colonnades, the forum complex, a market building, a public baths occupying the greater part of one of the rectangular insulae, numerous private houses, and (in this respect unlike Timgad) two temples. The forum square was colonnaded along two sides, and along the other two sides were a basilica in the shape of a plain rectangular hall with a raised tribunal at one end, a large Capitolium with tripartite cella, and a curia building with an internal vestibule. The Market of Cosinius (Plate 241 and Figure 181B) was a typical macellum with porticoes and stalls grouped around an open square with a central hexagonal pavilion. In it, as at Lepcis, one can see the city's official weights and measures. Of the temples, that of Venus Genetrix was unusual in having only the porch and steps projecting from the rear wall of a colonnaded precinct; the other, a long, narrow prostyle building of unknown dedication, stood free within a porticoed enclosure. A number of fine peristyle courtyard-houses with handsome mosaics are of later date, replacing the simpler residences of the earlier settlers. Peristyle houses of this type, usually with a principal living-room, the *triclinium*, dominating the courtyard and with a greater or less emphasis on compactness of planning in accordance with pressures on building space, were typical of the better-class town houses of North Africa. There were a great many local variants, ranging from the extraordinary houses of Bulla Regia, with two equally prominent residential storeys (perhaps for summer and winter use), to the more commonplace, relaxed layout of a building such as the second-century 'House of the Muses' at Althiburos, in Tunisia (Figure 185B), which was free-standing in its own grounds, or that of 'Venus and her Court' at Volubilis, in Morocco (Figure 185A), built towards the middle of the third century as part of a city quarter of well-planned residential insulae. Figure 186 illustrates a town house of the same general type at Tipasa, in this case terraced out so as to take advantage of a sloping, seaward-facing site and incorporating shops at ground level within the streetside porticoes. The detailed disposition varied greatly with the wealth of the owner and with local circumstance, but the basic type is remarkably uniform.[27] A feature which these houses shared with the bath-buildings and other public architecture was the wealth of the polychrome mosaic ornament of pavements, walls, and

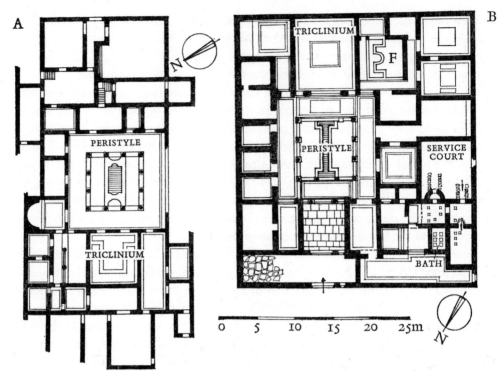

Figure 185. (A) Volubilis, House of Venus, mid third century. Plan
(B) Althiburos, House of the Muses, second century. Plan
F Fountain

vaults. Here at any rate was a field in which North Africa broke fresh ground, preparing the way for one of the most characteristic aspects of late antique architecture.

Apart from its magnificent setting, terraced into the steep eastern slopes, the theatre of Cuicul, of the same order and size and seating capacity as at Timgad, was a rather ordinary building. The baths of 183 (Figure 183) display far more originality – in their clever adaptation of the 'Imperial' plan to an unusually narrow site, in the diamond-shaped scheme of oblique vistas that runs right through from the main entrance to the main axial caldarium, and in the (for the date and place) remarkably sophisticated use of internal curvilinear forms. Once again one suspects an architect brought in for the purpose. The New Forum was dominated by two buildings, the Arch of Caracalla (which narrowly escaped transport to Paris in 1842) and the Temple of the Severan Family (Plate 255). The latter was a prostyle tetrastyle building with an almost square cella, set against the rear wall of a square enclosure with colonnades down the two long sides. The plan is that of dozens of North African temples; but the site and the raising of the temple itself on a very tall podium at the head of three flights of monumental steps give it an authority and a dignity that transcend the commonplaces of the familiar everyday formulae. This is one of those buildings which, without any particular intrinsic distinction, are nevertheless just right in their context.

One other aspect of the architectural history of Cuicul deserves brief mention. In many cities of North Africa the third quarter of the fourth century was a period of sur-

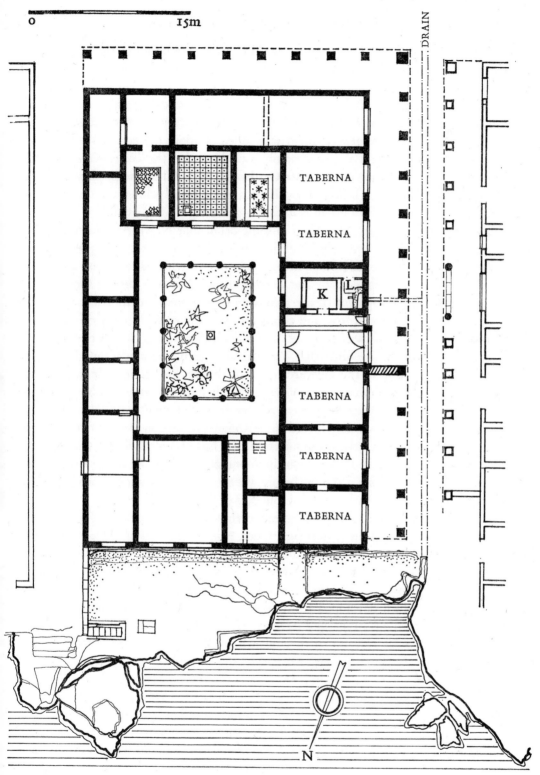

Figure 186. Tipasa, house overlooking the sea, third century. Plan

к Kitchen ʟ Lavatory

prising building activity. Not only do we find many public monuments, including pagan temples, undergoing restoration, but even new buildings, such as a granary at Rusicade (Philippeville). Cuicul had its share of impressive Christian buildings on the south hill, but it also acquired (364–7) a large new civil basilica, a rectangular hall with a single apse at the far end on the model of the contemporary audience halls. Another basilican hall of the same general form was added at about the same date beside the Arch of Caracalla and was almost certainly a cloth-market (*basilica vestiaria*). Inscriptions refer also to a portico named after Gratian (d. 383). All this took place at a time when in many parts of the Empire civic life was going rapidly downhill. One sees that in this part of Roman Africa urban civilization was a vigorous growth.[28]

The preceding pages have described in some detail four North African cities about which we happen to be unusually well informed. Two of these, Lepcis Magna and Sabratha, give us a picture of Roman urban life in an area where Rome was building on foundations already established by the Carthaginians. Here one can get some idea of the continuity of development of the architecture of Roman North Africa; and also (because these were harbour towns in close everyday contact with many other parts of the Mediterranean) an idea of some of the outside influences by which that development was conditioned. The other two, Timgad and Cuicul, were new foundations, involving the imposition of the outward forms of Roman life on areas in which such amenities had hitherto been few or non-existent. Their architecture was bound at first to be derivative; and because they were remote from the main creative centres, new ideas were slower to penetrate. Nevertheless, Roman civilization, once established, put down deep roots. The Christian architecture of Timgad and Cuicul lies outside the scope of this volume; but, no less than the monuments of the Antonine and Severan Age, it is a product of what had gone before, the ultimate justification of the vision and sound good sense of the Early Imperial founders of these cities.

One could continue the catalogue almost indefinitely. There are the surviving monuments of the great coastal cities, Carthage, Utica, Hippo Regius (Bône), Tipasa, Caesarea (Cherchel), cities which, like Lepcis and on a more modest scale Sabratha, were the principal exponents in Africa of a larger Mediterranean culture and the immediate source of much that we find in the often better preserved cities of the interior. Of the latter, many of which developed from pre-Roman communities (a fact that is very evident in their tortuous streets and irregular layouts), the number of those that have preserved considerable remains of their Roman-period architecture is almost embarrassingly large – Gigthis, Mactar, Madauros (the birthplace of Apuleius), Sufetula (Sbeitla), Theveste (Tébessa), Thibilis (Announa), Thuburbo Maius, Thugga (Dougga), Volubilis, to name only some of the more substantial. Then again there were the small country towns which, without ever achieving formal urban status, did in fact take on much of the outward appearance of their grander neighbours; one among many hundreds that happens to have been fully explored is Castellum Tidditanorum, near Cirta. But although all these sites contain buildings of interest, to pursue them in detail would be to lose sight of the broader picture in a wealth of accessory detail. Instead, the rest of this chapter will try to summarize a few of the more general aspects of this

Roman North African architecture – its pre-Roman inheritance, the successive outside influences to which it was subjected, and something of its wider affiliations.

We have already caught a glimpse of the local pre-Imperial architectural traditions that lay behind the earliest surviving architecture of Lepcis Magna and Sabratha. As one moves westwards towards the more immediate orbit of Carthage they become very much more apparent. For a long time the building materials and techniques in every-day use, including the widespread use of stucco for superficial detail, remained those of pre-Roman custom. To a more limited extent this was true also of the architectural detail. Here, understandably, the first casualties of increasing Roman influence were those features that had little or no previous history of classical usage. Such were the Phoenician volute capitals and the very distinctive 'Egyptian' mouldings, both of which we have already met in use in Syria as late as the first century A.D.,[29] and which had found their way, through Phoenicia, to Sicily, Sardinia, and North Africa at least as early as the fifth century B.C. Both figure, for example, on a tower-like mausoleum of the second century B.C. at Thugga, and in the cornice (in this instance with Doric columns and capitals) of the Medrecen, a great circular, tumulus-like mausoleum of one of the Numidian kings, perhaps Micapsa (d. 118 B.C.), not far from Lambaesis. In Africa neither form seems to have survived long, if at all, into the first century A.D. The Ionic capital continued to be used at Lepcis, throughout the century. In Tunisia, on the other hand, where the impact of Late Republican Rome was stronger and more direct, its place was commonly taken by capitals which seem to be more or less close copies of the Italic Tuscan order, introduced in the early first century B.C. As late as the time of Trajan the capitals of the forum at Thubursicu Numidarum (Khamissa) and those of the streetside colonnades of Timgad (Plate 252) were of this type.

As was often the case in the Roman world, it was in the field of religion, in temples and tombs, that the results of native influence were strongest and most persistent. Among the very large number of Roman-period temples that have come down to us in Africa one can distinguish two main groups. One is the typical forward-facing temple of the Republican Italic tradition, normally prostyle or pseudo-peripteral and regularly standing on a podium at the head of a flight of steps. This sort of temple is found with almost monotonous regularity throughout the territory, either standing alone or else placed against the rear wall of a sanctuary enclosure, which was usually, though not invariably, rectangular and very often colonnaded (Plates 256–7, at Thuburbo). They vary greatly in size and elaboration, from simple, box-like shrines (e.g. Thibilis) to large temples that are peripteral on three sides (Gigthis (Figure 187B), the Capitolium at Timgad) or even, exceptionally, on all four (Cirta, the Temple of Caelestis at Thugga); but although the names of most of the divinities worshipped (e.g. Mercury, Saturn, Apollo, Caelestis) thinly conceal those of the old native gods, the externals of the cult have been almost totally classicized.

The other recurrent group is most readily defined as consisting of a sacred enclosure with a small inner shrine opening off it, at the same level or at most up one or two steps. Good examples of such temples are those of the Cereres at Thuburbo Maius (Figure 187A), the temple at Sufetula that was later converted into the Church of Servus, and the

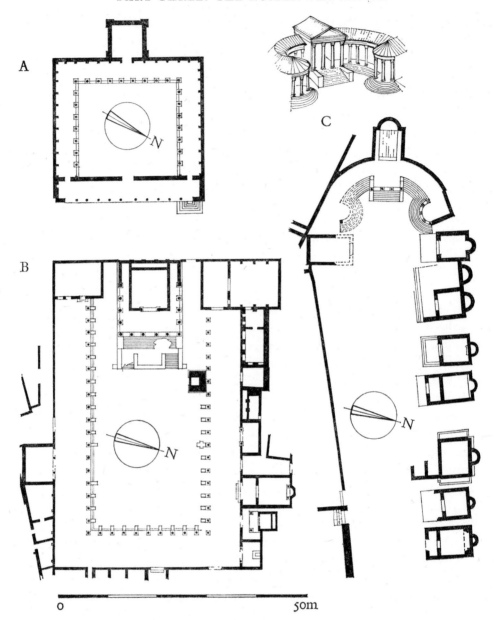

Figure 187. North Africa, temples

(A) Thuburbo Maius, Temple of the Cereres, first century. Plan
(B) Gigthis, Temple A (Capitolium?), second century. Plan
(C) Lambaesis, temple dedicated in 162 to Aesculapius and a group of other divinities. Elevation and plan

Temple of Saturn at Thugga. To the same group belong the Romano-Punic temple at Nora in Sardinia and one recently excavated at Lixus in Morocco.[30] In at least one case, at Thugga, the Roman-period sanctuary is known to overlie a Punic *tophet*, and there can be little doubt that such buildings expressed in classical terms a type of shrine that was

already familiar in Punic Africa. It must go back to the very old Semitic tradition of a 'Holy of Holies', which was not so much a temple as a repository for sacred objects, set apart from the open sacred precinct within which the actual religious rituals took place.

With the passage of time the distinction between the 'Punic' and the 'Roman' types, never very sharply drawn, became increasingly blurred – as in very similar circumstances it did in Gaul. The substitution of the columns of an open exedra (Sufetula, Thugga) for the doorway of the primitive enclosed cella (Temple of the Cereres at Thuburbo Maius; cf. the Temple of Mercury in the same city, and perhaps also the North-west Forum Temple at Sabratha) was already a step in this direction. A further step was to set the cella on a podium, while still leaving it projecting beyond the rear wall of the enclosure, as at Cuicul in the Temple of Venus Genetrix, at Theveste, at Thugga in the mid-second-century Temple of Minerva, and in a temple dedicated in 162 to a group of divinities at Lambaesis (Figure 187C). (This last was also a remarkable and, for Africa, unprecedented example of baroque planning, with its porch tightly framed between the convex inward projections of a shallow concave portico.) [31] It only remained to bring the cella within the framework of the precinct and the resulting building was indistinguishable from a 'Roman' temple within its precinct, a fact which no doubt goes far to explain the wide popularity of this type of sanctuary throughout the territory.

Outside the field of religion, few of the ideas that shaped the architecture of Roman Africa were other than Italian. Already in Punic times the influence of Magna Graecia and Sicily had been strong, and with the annexation of the province of Africa in 146 B.C. Rome and Campania also came directly into the picture. In the present state of knowledge it is not easy to assess the impact of Republican Italy in any detail; but some at any rate of the building types that were common later, e.g. the Italic podium temple and the macellum, are presumably a legacy from this Republican phase. More generally, the widespread acceptance of classical forms and ideas as the natural medium of architectural expression paved the way for the rapid development that followed the establishment of the Augustan Peace.

During the first century A.D. the materials and building techniques were still very largely those of the preceding phase, and wherever, as at Lepcis, one can view the architecture of this period in a sufficiently broad perspective, it can be seen to have retained and developed a considerable individuality of detailed expression. This had the makings of a genuinely Romano-African architecture. But the building types – the basilicas and the state temples, the theatres and the aqueducts – these were all essentially Italian; and with the establishment of military colonies and other new settlements the relationship received fresh emphasis. There is more than a grain of truth in the view that a city such as Timgad was in conception a small Italian town transplanted to the frontiers.

By the early second century horizons were beginning to widen. Italy and the western provinces continued to be Africa's natural outlet (a more detailed study would reveal many points of contact with Mediterranean Spain), and the new concrete architecture

began to make steady inroads on the entrenched positions of provincial architectural conservatism. At the same time, however, an entirely new situation was created by the wholesale adoption of marble as the building material *par excellence* for monumental use. The main supplies of fine marbles and granites came from the Aegean and from Egypt, and with them came new traditions of craftsmanship and architectural decoration. Within a generation local materials and styles disappeared from monumental use in the coastal cities and their place was taken by an opulent, but for the most part rather dull, 'marble style' architecture, of which the norms were no longer provincial but Empire-wide. The Antonine Baths at Carthage and the Severan buildings of Lepcis Magna together epitomize the convergence of these two currents, from Italy and from the eastern Mediterranean. Though never a creative centre in its own right, throughout its history Roman Africa showed itself ready to receive and to put to good use the architectural creations of others, and its surviving remains are an unrivalled exemplar of what the Empire could mean in this respect.

PART FOUR

LATE PAGAN ARCHITECTURE IN ROME AND IN THE PROVINCES

BY

J. B. WARD-PERKINS

ARCHITECTURE IN ROME FROM MAXIMIN
TO CONSTANTINE (A.D. 235–337)

WITH the murder of the last emperor of the Severan dynasty, Severus Alexander, in 235 the Empire entered on a period of anarchy, civil war, and external disaster from which it was only finally rescued by the energy and ability of the great soldier emperors of the last two decades of the century. Beset on every side by revolts and by incursions from beyond the frontiers, their treasuries strained to the utmost by the requirements of their troops, the successive emperors had neither the time nor the resources to indulge in ambitious building projects. Under Aurelian (270–5) the tide of adversity was temporarily stemmed; and although the city wall which bears his name was a matter of urgent necessity, his great Temple of the Sun on the edge of the Campus Martius was a monument in the best tradition of imperial patronage. But Aurelian was assassinated in 275, and the only architectural event of note during the next decade was the disappearance of several venerable monuments in a fire which swept the north end of the forum in 283. It was not until 284 that Diocletian finally succeeded in restoring the authority of the central government and ushered in the last great building phase of Rome before, in 330, Constantine transferred the seat of government to his new capital of Constantinople.

Of Aurelian's two great enterprises, the walls, which with relatively minor variations were to remain the defensive circuit of Rome down to 1870, were begun in 270 or 271 after the incursion of a horde of Germanic tribesmen into the Po valley had shown that even the capital of the Roman world could no longer afford to disregard its own defences. It was a vast undertaking. The total circuit is over 12 miles (about 19 km.) in length, and despite a virtual mobilization of the building industry[1] the wall took about ten years to build. It was $11\frac{1}{2}$–13 feet (3·5–4 m.) thick at the base and in its original form $25\frac{1}{2}$ feet (7·8 m.) high, with a continuous open wall-walk, protected by a parapet and merlons. Square towers projected at intervals of 100 Roman feet (97 English feet, or 29·6 m.). In addition to numerous posterns there were eighteen principal gates, each with one or two stone arches, flanked by two-storeyed semicircular towers and surmounted by a windowed gallery to house the mechanism of the portcullis (Figure 188). Only the actual gateways were of stone. Elsewhere the material throughout is concrete faced with brick, almost all of it re-used material. Evidently the organization of the state-owned brick industry had broken down completely since Severan times. At various later dates, notably under Maxentius and again under Arcadius and Honorius in 403, the walls were heightened and most of the gates strengthened or rebuilt (Plate 263).

No other single Roman monument so aptly symbolizes the changed role of Rome within the Empire. Hitherto the military architecture of the frontiers had impinged very

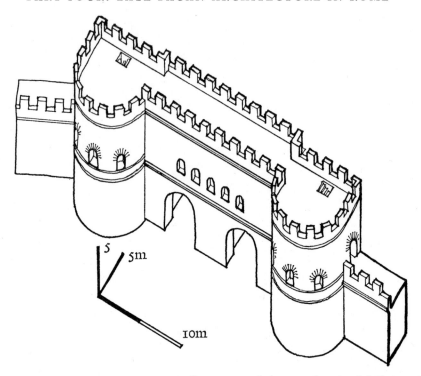

Figure 188. Rome, Porta Appia, as originally constructed, 275–80. Elevation (cf. Plate 263)

little upon the civil architecture of the Mediterranean provinces. Now for the first time we find the architecture of the frontiers transported to the capital. Furthermore Rome was only one of innumerable European cities which found themselves faced suddenly with the need to defend themselves in grim earnest against the menace from the north. The tide had turned and was everywhere beginning to flow in reverse. As for the Aurelianic walls of Rome, the very fact of their building must have made an immense impression upon contemporary thought and taste, and it can be no accident that the clean, functional lines of their towers and gates foreshadow so much that is most characteristic of the late antique architecture of the capital.

Aurelian's other great enterprise, the Temple of the Sun (Sol), was no less symptomatic of its age. It reflects the same broadly monotheistic trend of religious thinking, Eastern in origin, as was manifest also in Christianity. Even the dedication recalls such nearly contemporary monuments as the Christ-Helios mosaic of the Vatican cemetery and the Sol Invictus coinage of Constantine himself. The occasion for the temple's foundation and the funds for its building were furnished by Aurelian's reconquest in 273 of Zenobia's short-lived Oriental empire of Palmyra. Of the classical buildings nothing is now visible. They lay just to the east of the modern Corso, beneath and near the church of S. Silvestro, and our knowledge of them is derived almost entirely from a plan and drawing made by Palladio in the sixteenth century, when quite a lot must still have been standing (Figure 189).

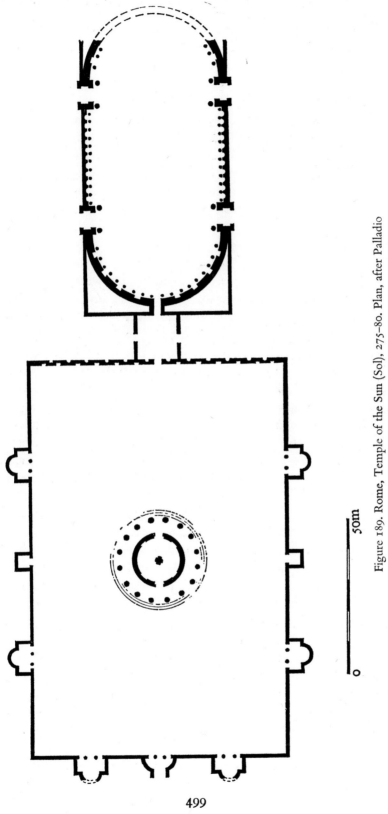

Figure 189. Rome, Temple of the Sun (Sol), 275–80. Plan, after Palladio

50m

0

Palladio's plan shows a circular temple in the centre of a large rectangular enclosure (413 by 284 feet; 126 by 86·4 m.), the single entrance to which lay at the north end, in the middle of one short side, and was itself approached through a vestibule set in the middle of one of the two apses of what he shows as an elongated forecourt with opposed apsidal ends. It is difficult to judge the credibility of such a plan out of its architectural context (which alone could explain, for example, the ninety-degree shift in the conventional relationship between forecourt and inner precinct), but most of the detail is plausible enough. The inward-looking inner precinct (which must have been porticoed, though it is not so shown in Palladio's plan) and the central position within it of the temple, both have good Syrian precedents, including the great Temple of Bel at Palmyra itself; the columnar exedrae opening off the inner precinct might well have been borrowed from Vespasian's Temple of Peace; and the circular temple, the scale of which can be judged from the eight porphyry columns (height $22\frac{1}{2}$ feet, or 6·88 m.) which Justinian took from it to use in his church of Hagia Sophia, would have been as symbolically appropriate to its purpose as, a century later, were the cruciform plans of Early Christian architecture. The plan of the forecourt, on the other hand, and the double demi-columnar order with broken pediments which adorned it patently derive from Trajan's Forum, and the scanty surviving remains of the architectural decoration echo that of the Baths of Caracalla, where Aurelian is known to have undertaken repairs after a fire. For all its unusual features, Palladio's plan does seem to make good sense as an early manifestation of that same far-ranging eclecticism of which the Imperial foundations of Constantine were shortly to offer so many striking examples.

The work of Diocletian (284–305) was, by contrast, broadly conservative in its taste. His Curia, or senate house, rebuilt after the fire of 283, followed very closely the time-honoured lines and proportions of its Domitianic and Julian predecessors. Internally it was a plain rectangular hall, with low steps for the seating of the senators running down either side towards the dais of the presiding magistrate and with a coffered timber ceiling, the height of which, half the sum of the length and breadth, still observed the Vitruvian prescription for the acoustics of such a building. The unusual proportions were deliberately emphasized by contrasting the severely plain upper walls, lit on three sides by single windows just below ceiling height, with the three pairs of columnar aediculae and the rich polychrome marbling of the lower walls and floor. From the outside, as one sees it today (Plate 104), it looks bleak and strangely out of proportion, but one has to remember that in antiquity, flanked by the Basilica Aemilia and the Secretarium Senatus (now the church of S. Martina), one saw little more than the pedimental façade, dominated by the three large windows which were yet another legacy from its historic precedessors. The construction of the pediment, of brick with small travertine consoles, was strictly contemporary, and just below it can be seen the remains of a facing of stucco, imitating drafted masonry. A singular feature is the progressive angling of the consoles as one approaches the corners. One meets this in painting at a very early date, but I know of no earlier example in real architecture.

Diocletian's great bath-building on the high ground north-east of the Viminal was begun in or soon after 298 and completed in 305–6. It followed closely the scheme

established by the Baths of Caracalla, from which it differed principally in the more uniform distribution of the secondary structures around the perimeter (one of the angle rotundas survives as the church of S. Bernardo) and in the greater simplicity and tighter planning of the huge (785 by 475 feet; 240 by 144 m.) central block (Figure 190). In particular one may note the opening up of the vista down the whole length of the long axis, a tantalizing alternation of light and shade viewed between receding pairs of columns; the neat, efficient planning of the service courtyards; the alternation of enclosed rectangular and curvilinear spaces along the shorter axis; and, most strikingly of all, the substitution of a rectangular, cross-vaulted caldarium with four projecting apses for the great domed rotunda of the Baths of Caracalla. If the latter building had marked the coming of age of this most ambitious of all Imperial building types, the Baths of Diocletian certainly represent its full maturity.

From the outside, the baths relied for their effect almost exclusively on the marshalling of the masonry masses.[2] The interior on the other hand was as rich and varied as the exterior was simple. At one extreme we have the three tiers of elaborate columnar exedrae ranged along the stage-like buttresses and re-entrants which constituted the façade of the frigidarium towards the swimming-pool (*natatio*), and which are the sub-

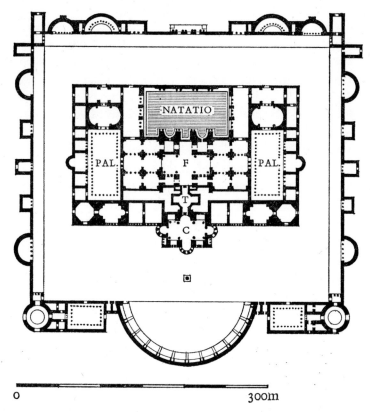

0 300m

Figure 190. Rome, Baths of Diocletian, c. 298–305/6. Plan

PAL. Palaestra F Frigidarium T Tepidarium C Caldarium

ject of one of the best known of Piranesi's prints; and at the other, the grandiose simplicity of the great triple-vaulted frigidarium, converted by Vanvitelli on the designs of Michelangelo into the church of S. Maria degli Angeli (Plate 259). Like the Pantheon this is a building to be experienced, not described. The vistas have been closed, the glow of marble and mosaic very largely replaced by paint. But for all its muted tones, one can still catch a glimpse of one of these great Roman interiors under something approaching Roman conditions.

The last of the pagan emperors of Rome, Maxentius (306–12), was another prolific builder. Nothing is now visible of the restoration of the offices of the senate (Secretarium Senatus) which was the complement and completion of Diocletian's work on the Curia itself; but at the other end of the forum, on the Velia, the surviving remains of the cella of Hadrian's Temple of Venus and Rome are entirely his work, undertaken after a fire in 307; and the same fire made way for the last and greatest of his architectural enterprises, the Basilica Nova, the great basilica which Constantine completed and which, despite its much diminished ruins, still contrives to dominate the whole surrounding scene. Another important group of buildings, beside the Via Appia, included a suburban residence, a racetrack, and a large family mausoleum. Maxentius is also credited with the first substantial modifications and additions to the Aurelianic walls.

The visible remains of the Temple of Venus and Rome retain the unusual plan, and almost certainly the general proportions also, of the Hadrianic building, the outer façade of which seems to have escaped the fire. The structure of the cella on the other hand, which is of brick-faced concrete throughout and was once faced from floor to ceiling with marble, is entirely the work of Maxentius (Plate 264). Continuous plinths project from the two side walls, each formerly carrying five porphyry columns, the entablatures of which constituted the spring of the coffered barrel-vault. Another pair of columns flanked each apse, and in the intervals between the columns of the side walls and in the shoulders and flanks of the apse there were decorative columnar aediculae, similar to those of Diocletian's Curia and of the swimming-pool façade of the baths. A striking and unusual feature is the lozenge-shaped coffering in the semi-dome of the apse.

Of the complex of Maxentian buildings beside the Via Appia (Plate 258), the villa still awaits serious exploration. The circus, on the other hand, which is estimated as having held about 15,000 spectators, offers an unusually detailed picture of one of those racecourses which played such a large part in the social, and frequently also the political, life of later antiquity. The architectural niceties were many. Here one can see, for example, the ingenious irregularities of plan which ensured a fair start for the competitors in the outer lines; the starting-gates (*carceres*) set between the traditional pair of flanking towers (*oppida*); the two turning-points (*metae*) at either end of the central barrier (*spina*), which was placed well off-axis so as to allow for the crowding of the initial lap; the imperial box, overlooking the finishing line, and a second box near the middle of the opposite side for the use of the judges and organizing officials; the entrances and exits for the ceremonial parades of the contestants; and on the central point of the spina, in imitation of the Augustan obelisk in the Circus Maximus, the site of the Egyptian

obelisk which Maxentius brought from Domitian's Temple of Isis in the Campus Martius and which Innocent X in 1651 retransported to the city to adorn Bernini's fountain in the Piazza Navona. Constructionally the building is of interest for its bold use of alternate courses of bricks and of small tufa blocks and for the large hollow jars used to lighten the mass of the vaulting that carried the seating (Plate 267), both characteristically late features which are discussed further later in this chapter.

The adjoining mausoleum was a circular, domed structure with a deep, gabled, columnar porch, set in the middle of an arcaded quadriporticus. It resembled the Tor de' Schiavi (c. 300) beside the Via Praenestina (Figure 191), and both were somewhat academic copies of the Pantheon. There were, however, significant differences. Unlike the Pantheon, which stood at the far end of its enclosure, these buildings were freestanding, to be viewed from all angles; each of them stood on a tall podium, within which were housed the funerary vaults; porch and rotunda were bound closely together by the continuous lines of the podium and entablature mouldings; and the height of the interior was increased in relation to the diameter and given greater emphasis by treating the inner face of the drum as a single decorative order. In common with many other imitations of the Pantheon at all periods these buildings posed (and were not altogether successful in resolving) problems which, by a happy instinct or by sheer good fortune, the architect of the Pantheon had been content to let go by default. But it is symptomatic of the age that the problems should have been faced at all. Among other interesting innovations are the insertion of four circular windows into the upper part of the drum of the Tor de' Schiavi, in place of the traditional central oculus, and, even more remarkable if it can be substantiated, the possibility that the porch of the same monument was vaulted and may therefore have had a centrally-arched façade in place of the conventional flat architrave. The suggestion[3] is based on an eighteenth-century painting, which shows the remains of large hollow jars in a concrete core at the junction of porch and drum; and although there is no other known example of the use of such a feature on this monumental scale in the architecture of pagan Rome, one hesitates to exclude such a possibility. By contrast, the arcading of the rectangular precinct which encloses Maxentius's building, with the piers and arches masked by the half-columns and entablature of an engaged decorative order, is a deliberate archaism, harking back to Late Republican and Early Imperial models.

The outstanding monument of Maxentius's reign was the basilica (the Basilica Nova) which he planned on the eastern slopes of the Velia, beside the Via Sacra (Plate 265 and Figure 192). Left unfinished at his death, it was completed by Constantine, and by any reckoning it was one of the great architectural achievements of classical antiquity. In all essentials the plan was that of the central hall of one of the great 'Imperial' bath-buildings, stripped of all its surrounding structures and with the emphasis placed on the long axis by the addition of a porch at the east end and opposite it, at the west end, a shallow apse destined to house a colossal statue of the emperor. Constantine subsequently switched the axis, adding a porch in the middle of the south long side and throwing out an apse from the rear wall of the exedra opposite it.

The central nave measured 260 by 80 feet (80 by 25 m.), its three soaring cross-vaulted

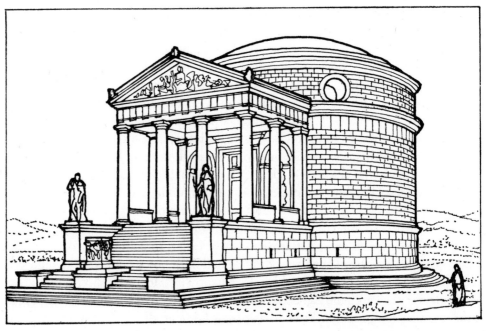

A

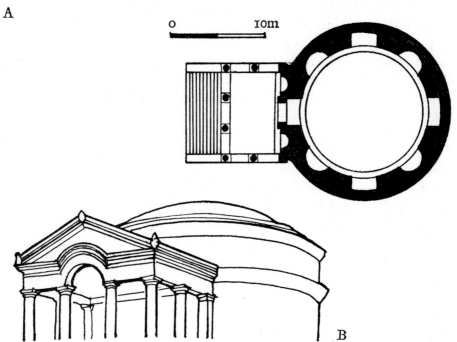

B

Figure 191. Rome, Mausoleum of Tor de' Schiavi, *c.* 300. (A) View and plan, after Durm.
(B) Possible alternative reconstruction of façade

bays, 115 feet (35 m.) from floor to crown, springing from the bracketed entablatures of eight huge fluted Proconnesian marble columns, equally spaced, four and four, down the two long sides and framing the arches of three gigantic, interconnected barrel-vaulted exedrae. It is the three exedrae on the north side which are still standing. Their structural function was to buttress the central nave; but at the same time they were so very much an integral part of it that, despite the inevitable bulk of the four main piers, one would have been principally conscious not of the internal subdivisions, but of the unity of the whole. This effect of spatial unity was enhanced by the virtual equipoise between the single long axis down the central nave and the three transverse axes across it.

Yet another building that has been attributed to Maxentius, rightly it may well be, though often for the wrong reasons, is the so-called 'Temple of Romulus', immediately to the west of the Basilica Nova.[4] Converted in the sixth century into the vestibule of the church of SS. Cosmas and Damian, it consisted of a domed rotunda, the entrance to which, instead of being housed in the conventional manner within a projecting porch, was flanked by two narrow, almost tangential wings, across the fronts of which two pairs of columns constituted the actual façade towards the Via Sacra. The rotunda was lit by four large windows set on the diagonal axes, and from it two doors led into the flanking halls. In its original form the courtyard was rectangular, but very soon after its construction (the masonry of the two phases is indistinguishable) it was converted to the curved shape, decorated with columnar niches, of which the rather battered remains can still be made out through the overlay of medieval masonry. The entablatures of the two projecting façades were bracketed out over the columns, but what if anything these carried above cornice level there is nothing to show.[5] An unusual feature of the order is the placing both of the columns of the façade and of those framing the great bronze doors (which are still those of the original building) on pedestal-like plinths, of a type which had been common in the eastern provinces for two centuries, but which is almost unknown in the monumental architecture of Rome itself before this date.

Neither the coin evidence nor the very confused medieval traditions of a 'Templum Romuli' in this area in themselves justify the identification of this building as a temple to the memory of Maxentius's infant son, M. Valerius Romulus, who died in 309. On the other hand, it immediately adjoins the area which Maxentius is known to have rebuilt after the fire of 307; the masonry is very like that of the Basilica Nova; and, whether or not one places any reliance on the fragment of a Constantinian inscription shown in a drawing of the façade by Panvinio, the fact that the latter was remodelled so soon after construction would tally very well with Constantine's known interest in the frontages facing on the Via Sacra. If not the work of Maxentius, it was certainly built very soon afterwards; and in the context it is hard to suggest any other than purely aesthetic reasons for the modifications to the façade – a deliberate exploitation of the contrast between convex rotunda and concave forecourt, both framed between the projecting wings. This last flowering of pagan architecture is full of tantalizing might-have-beens.

The defeat and death of Maxentius by Constantine in 312 did not immediately spell the end of imperial munificence in Rome. That only followed when, tired of the hos-

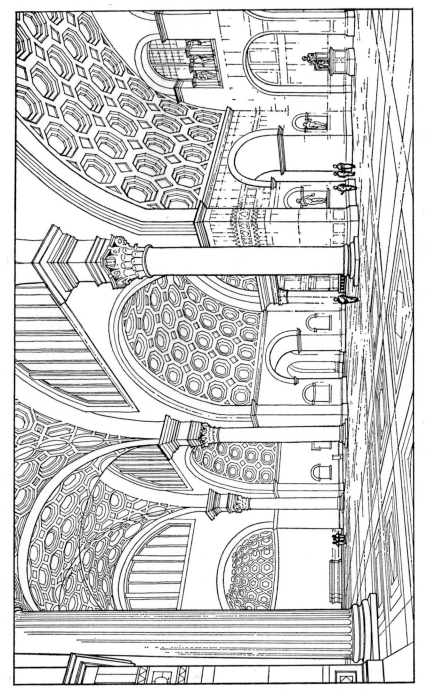

Figure 192. Rome, Basilica of Maxentius. Reconstructed view of the interior as originally planned by Maxentius (307–12) (cf. Plate 265)

tility of the wealthy pagan aristocracy, Constantine founded, and in 330 formally dedi-
cated, his new capital on the Bosphorus. During the early years of his reign Constantine
was as active as his predecessor had been; and while some of this activity, such as the
building of the new cathedral church of Rome, was specifically associated with the
requirements of the newly enfranchised Christian religion (and is discussed in another
volume), there was much that belonged also, like Constantine's own complex history
and personality, to the world that was passing. Besides the completion of the unfinished
buildings of Maxentius, no account of the last phase of pagan architecture in Rome would
be complete without a mention of Constantine's Arch, his Baths, and the two great
imperial mausolea of Tor Pignattara and S. Costanza.

Constantine's Arch (Plate 262), built to commemorate his victory over Maxentius,
was completed in 315. The design follows closely that of the Arch of Severus at the west
end of the forum, from which it differs principally in its more dignified setting and pro-
portions, in the more telling disposition of its sculptured ornament, and in the triple
articulation of the attic in correspondence with the pattern of the archways beneath.
The relief panels are partly contemporary and partly, like the statues of captured bar-
barians along the attic, taken from a series of earlier public monuments, and together
they constitute a unique repertory of the official sculptural art of the capital from Trajan
to Constantine. Understandably enough they are usually discussed in terms of their
more specifically sculptural qualities, and the Constantinian narrative panels in particular
are praised or blamed as an illustration of the profound changes in the aims and con-
ventions of official relief sculpture during this period. But although the narrative panels
would have distressed a Roman of the old school as deeply as they did the late Bernard
Berenson, there can in fact be no serious doubt that they represent the creative main
stream of one of the most vigorous currents in early-fourth-century art.

A more fruitful subject of criticism is the technical ineptitude of those elements, such
as the panels of the pedestals of the columns or in the spandrels of the arches, which
directly copy earlier models. Their poor quality has nothing to do with the alleged
decadence of the age: it is simply that the production of large-scale relief sculpture had
ceased in Rome some eighty years earlier. The narrative panels were made possible by
the presence in the capital of a lively contemporary school of sarcophagus carvers,
with whose work, both in scale and style, they have much in common. On the other
hand, with the ever-increasing austerity of architectural exteriors and the ever greater
reliance upon coloured marble, stucco, and mosaic for interiors, there was now little
or no scope for relief-carving in the grand manner. This was a genre which was all but
extinct in Rome by the middle of the third century,[6] and it is small wonder that the
sculptors of the larger panels on the Arch of Constantine found themselves out of their
depth. Their scant success is a measure, not of the artistic decadence of the age, but of the
shift that had taken place in decorative taste. With the exception of its narrative panels,
the Arch of Constantine is an evocation, perhaps a deliberate evocation, of an age that
was already obsolescent a century earlier.

Another building which, though carried out in a strictly contemporary idiom, be-
longed to the age that was passing is the bath-building which Constantine built early in

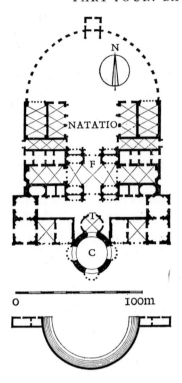

Figure 193. Rome, Baths of Constantine, c. 320. Plan, after
Palladio

F Frigidarium T Tepidarium C Caldarium

his reign on the Quirinal, near the Temple of Serapis. Much of this complex was still
standing at the beginning of the seventeenth century (Figure 193), and the plans and
drawings made by Palladio and du Pérac show that, despite the omission of several
familiar features owing to the limitations of the site, it was still in all essentials one
of the great Imperial series, developed symmetrically about an axial succession of swim-
ming pool, three-bay frigidarium, quadrilobate tepidarium (flanked by service court-
yards), and large, circular caldarium. Quite apart, however, from a general tendency
to develop the curvilinear elements of the familiar plan (which may be no more than
a reaction against the unusually severe rectilinearity of the Baths of Diocletian) there are
several details which distinguish it from the earlier members of the series. In particular
one may note the three apsidal plunge baths of the circular caldarium, lit by multiple
windows and closely akin to the columnar exedrae of the 'Temple of Minerva Medica';
and the marked emphasis not only on the central nave of the frigidarium at the expense
of the lateral exedrae but also, within the central nave, on the central bay – a deliberate
exploitation of the centralizing tendencies already noted in connexion with the Basilica
Nova.

Of the two imperial mausolea built by Constantine, Tor Pignattara, beside the Via
Praenestina, was originally destined for Constantine himself, although in the event it
was used only by his mother, Helena. It was a simple but grandiose adaptation of the
circular type (diameter 66 feet 2 inches; 20·18 m.) already established by the mausolea
of Tor de' Schiavi and of Maxentius. Instead of the gabled porch, however, it was entered
by a doorway opening off the end of the nave of the adjoining martyr-church, also

Constantinian, of SS. Peter and Marcellinus; and the upward-reaching tendencies of the earlier buildings were given full play by heightening the drum and opening in it eight large, round-headed windows. Corresponding to these on the outer face were eight even larger, scalloped recesses. The dome has fallen, but the spring of it can be seen to have been lightened by the use of the large, hollow jars (*pignatte*) from which the monument takes its name, and there are traces of the mosaic which once covered it. Up to the spring of the dome the walls were faced with panels of coloured marble. Architecturally the most interesting feature of this building is the scalloping of the outer face of the drum, a development which had already been foreshadowed in the Baths of Caracalla and in the annex to the 'Temple of Venus' at Baiae (p. 299). We see the same exploitation of curve and countercurve in the little 'Temple of Romulus' in the forum; and about this date, or soon after, the scalloped window-recesses were copied in another well preserved rotunda, the 'Tempio della Tosse', which was the vestibule of a wealthy villa in the plain just below Tivoli.

The mausoleum of Helena was still in its essentials a building in the pagan tradition. That of Constantine's daughter, Constantina (now the church of S. Costanza), had already crossed the divide. In place of the soaring simplicity of Tor Pignattara, its plan, with its barrel-vaulted and arcaded ambulatory buttressing the central rotunda (Plate 140), looked forward to a long series of centrally planned churches which were inspired initially by the Church of the Holy Sepulchre. But it was still a pagan building in one important respect: neither the surviving decorative mosaics of the ambulatory nor the more elaborate figured designs of the destroyed dome mosaic owed anything to Christianity. They were made by workmen whose fathers had worked in the Baths of Diocletian, and their great-grandfathers in the Baths of Caracalla. They offer a unique glimpse of an aspect of pagan classical architecture which elsewhere has perished almost in its entirety.

The most elaborate of the series of late rotundas in and around Rome is the pavilion in the Licinian Gardens, better known as the 'Temple of Minerva Medica' (Plates 260 and 261 and Figure 194). The gardens belonged to the emperor Gallienus (259–68), but brick-stamps show that the building is of the early fourth century, modified very soon after construction in order to buttress signs of settlement. Strictly speaking, it is not circular but decagonal (diameter 80 feet; 25 m.), with the lower parts of the walls broken out to form a ring of nine projecting apses, continuous except at the entrance, which occupies the tenth side. The apse opposite the door is slightly larger than the rest, and the two pairs of apses on the transverse axis were open to the exterior through triple arches carried on columns. The drum, too, was decagonal, lit by ten round-headed windows, and the transition to the dome was accomplished simply by merging the angles of the decagon inwards to form a circle. The latter was ingeniously constructed of light materials about a framework of brick ribs, and it offers an unusually clear picture of how one of these late vaults was built. The ribs were constructed of small pieces of brick, laid one upon the other in vertical bands that were linked horizontally by numerous rather larger cross-pieces. The ribs rose concurrently with the surrounding concrete envelope, and at frequent intervals, corresponding to the upward progress of

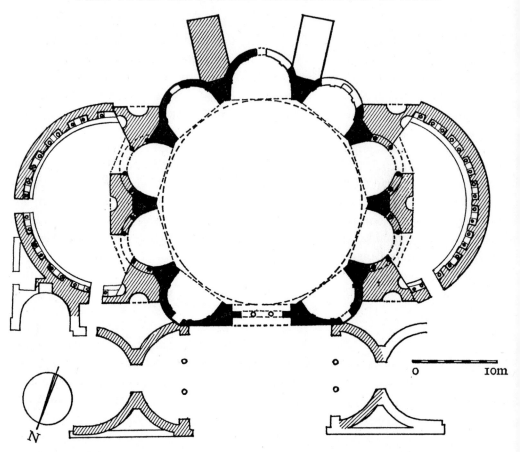

Figure 194. Rome, pavilion in the Licinian Gardens ('Temple of Minerva Medica'), early fourth century. Plan (cf. Plates 260–1). Original construction in black; added masonry shaded

the dome as a series of concentric rings of ever-diminishing diameter, the work was capped by a continuous layer of large tiles. By this means the whole mass of the dome was partitioned into small, virtually independent compartments, greatly facilitating construction and at the same time ensuring the localization of any settlement that might take place during drying-out.

Brick ribbing similar to that just described is a feature of many of these late pagan buildings in the capital, in the Villa of the Gordians for example, in the Baths of Diocletian, and in the Basilica Nova. Superficially it bears a certain resemblance to the ribbing of a Gothic vault, and this resemblance has sometimes been taken to imply a close similarity not only of function but also of theoretical intention. This is certainly mistaken. That these brick ribs were developed in the first instance with any clear idea of distributing the load of the vault down certain predetermined lines can be disproved by even the most cursory examination of their relationship to the vaulting of which they are a part.[7] Many break off short before reaching the crown, others side-step to right or left or are interrupted by the tile capping of the adjoining fill. It is quite certain

that they rose *pari passu* with the accompanying envelope of light tufa concrete, and there can be very little doubt that their primary function was to simplify the processes of construction. This fact does not, of course, preclude the possibility that they did in practice prove to be a source of strength within the vault as a whole, or that contemporary architects should have become aware of this. Illustrations of the Minerva Medica vault prior to 1828 do in fact show several of the upper ribs still standing independently of the envelope (Plate 261). A few years later the dome of S. Costanza is said to have incorporated eight ribs of solid brick.[8] It looks very much as if architects may indeed have been moving towards a conception of the vault as a differentially constructed fabric within which the structural stresses might be channelled along certain predetermined lines. But if so, it was a characteristically cautious, empirical approach, based, not upon theory, but upon observation of the results of building processes that had been adopted initially for quite other reasons.

As late as the beginning of the fourth century it would be true to say that the factors principally determining the stability of a Roman vault were still the quality of the mortar and of the foundations. By this late date the former could almost be taken for granted in the volcanic regions of Central Italy. The real enemy was settlement. Any fractioning of the unitary envelope of the vault was immediately liable to set up centrifugal pressures far greater than those inherent in the initial design. The prudent architect allowed for this; and the history of Roman concrete-vaulted architecture, from the Flavian Palace and the Pantheon onwards, is full of instances of buttressing added to remedy some such structural defect, real or imaginary. The Licinian Pavilion itself underwent substantial modification in this sense quite soon after its construction. But, whatever the constructional refinements, the essential characteristics of the vaults built in the Rome of Maxentius and of Constantine were still those of Roman concrete-vaulted architecture in its Early Imperial heyday.

If one turns to survey as a whole this last phase of architectural activity in pagan Rome one cannot fail to be struck by two things: by the complete triumph of brick-faced concrete as the standard constructional medium, and by the no less complete assurance and virtuosity with which it was handled. Except for a few monuments of purely traditional character, such as the triumphal arches, squared stone masonry is hardly found after the middle of the second century. In its superficial appearance the later brickwork, with its ever-increasing dependence on re-used materials and the occasional alternation of courses of brick and tufa, cannot compare with that of the earlier period; and although Diocletian's reorganization of the brickyards for a while reversed this trend, the results of this did not outlast the slump that followed Constantine's decision to transfer his capital to Constantinople. But one only has to glance at gigantic spans like those of the Basilica Nova to realize that this was a purely superficial deterioration. These builders were complete masters of their material; and if they were content with a rather cheaper, rougher finish than would have satisfied a more leisurely age, this was a small price to pay for the technical and organizational advances which made it possible, for example, to erect the Aurelianic walls or the whole huge complex of the Baths of Diocletian, each within the span of a single decade.

Of the constructional techniques characteristic of the period there is not much that need be added to what has already been said in connexion with the individual buildings. Most of them represent no more than the taking into general use of devices that were already known, if not fully exploited, at an earlier period. Already in the second century the alternation of courses of brick and tufa had figured extensively in Hadrian's Villa and in the Villa of Sette Bassi, but it was only now promoted to occasional monumental use and did not become general until even later. Brick ribbing had been used as early as Flavian times in the barrel-vaults of the Colosseum and sporadically, though sparingly, on a number of subsequent occasions (e.g. in the Severan substructures of the Palatine). The use of specially selected light materials, such as porous tufa or even pumice, for the aggregate of the vaults already appears in a highly sophisticated form in the Pantheon. All these were familiar techniques now brought into systematic use. Perhaps the most notable innovation was the use of large jars to lessen the weight of a concrete mass at such bulky points as the spring of a vault, as in the Villa of the Gordians, the Baths of Diocletian, and the Circus of Maxentius. This is a device that was to play an important part in the Early Christian architecture of Central and Northern Italy. Other late vaulting techniques which were already current elsewhere, but which do not seem to have reached pagan Rome, are the use of interlocking tubular tiles and the employment of brick, the one a North African innovation, the other derivative ultimately from the Roman East and recorded from as near home as at Spalato, in the Palace of Diocletian.

So far as concerns the forms of architecture, this was, as in so many other fields, an age of transition. With the hindsight of later knowledge it is easy to regard it as a mere *preparatio evangelii*, paving the way for the triumph of Christianity and the emergence of the highly individualized Early Christian architecture of the following century. Such a view, however, disregards the nature and strength of the forces of architectural change that were already at work before the time of Constantine, both in Rome and (as we shall see in the next and last chapter) in the Empire as a whole. It was the crisis of the third century quite as much as the triumph of Christianity which marks the transition of the classical world to late antiquity.

In Rome any architectural development was almost bound to turn upon the fuller exploitation of the constructional and aesthetic possibilities of concrete. The first phase of feverish, seminal experiment was long over and had been followed, since the middle of the second century, by a long period of consolidation and rationalization. Now, as the new architectural stereotypes took firm hold, there was a renewed moment of rather restless, experimental development. Broadly speaking, one might characterize it as dominated by a determination to explore the spatial possibilities inherent in such relatively newly established types as the domed rotundas and the great cross-vaulted central halls of the Imperial bath-buildings, at the expense of the inherited commonplaces of an older classicism. But there was no single, clear-cut stream of development. Rather there were a number of complementary and even contrasting streams. To the extent that it was only when these converged to supply the needs of the new religion that the overall pattern acquired shape and purpose, the conventional view of these

buildings as setting the stage for Christianity is a legitimate one; but it neglects what was in the minds of the men who built them. What at the time were the aims and objectives of the architects of late pagan Rome?

In the first place, it would be naïve to disregard the fact that some of these buildings were very large. The line that separates grandeur from mere grandiosity is a delicate one, and the student of Roman architecture is at a disadvantage in that the sort of effect that the Late Roman builders were aiming at is very hard to judge on a drawing-board: it needs to be experienced, and that is precisely what in most cases we cannot now do. Nevertheless one is probably on safe ground in regarding the Basilica Nova, for example, as having been a very impressive as well as merely a very large building. There was nothing new in this exploitation of the quality of size. The Colosseum, the Pont du Gard, the Temple of Jupiter at Baalbek are among the many distinguished Roman precedents, and they all stem from a capacity which the Romans at all times possessed in abundance, the engineer's complete mastery of his materials.

Another characteristic which this Late Roman architecture shared with earlier periods is its constant striving after height. The sensibility which had put the classical temple on to a podium and the classical order on to a tall plinth found fresh expression in the handling of interior space. If we take the interior proportions of the Pantheon as a norm, the subsequent history of this characteristically Late Roman type is *inter alia*, as we have seen, one of an ever-increasing emphasis on the vertical component. In this case the technical prerequisite was the ability to pierce the drum, so as to provide lighting at clerestory level, without impairing the stability of the dome. This had already been achieved in the 'Temple of Venus' at Baiae and in the Baths of Caracalla, and by the end of the century the older form, with a central oculus, was already obsolete. The Curia of Diocletian represents the same idea. In this case the proportions were inherited; but the disposition of the inner windows just below the very high ceiling certainly suggests a deliberate exploitation of the contrast between the emphatic horizontal lines of the lower part of the hall and the soaring simplicity of the coffered ceiling above.

The central plan continued to play an important part in architectural thinking, as indeed it had done from the moment that architects started to occupy themselves seriously with the problem of interior space. The serial grouping of the halls of bath-buildings had already made them aware that the impact of such enclosed space could be notably enhanced by putting it in direct, provocative relationship with the space beyond it; and already in the Pantheon we find a remarkably sophisticated use of the exedrae set in the thickness of the perimeter wall to give an illusion of opening outwards. But despite this, and despite the many experiments in the same sense in Hadrian's Villa, the idea was not immediately and systematically followed up, and the central-plan building *par excellence*, the rotunda, remained essentially a self-enclosed, autonomous unit. The opening up of windows in the drum in place of the single, spatially neutral central oculus was a step towards a more balanced, outward-looking treatment; but it is not really until the early fourth century, in the Licinian Pavilion, that we find a decisive break with tradition. Once again the elements of the plan, the multilobed rotunda and the curved columnar exedrae, can be seen to go back to Hadrianic precedents; but only

now were they brought together in a direct, vital relationship. Through the arches of the arcaded, columnar exedrae the observer within was brought into immediate contact with the world beyond.[9] Within a generation the architect of S. Costanza had introduced the parallel idea of a continuous arcaded ambulatory around the central domed area; and soon after the middle of the fourth century, in the church of S. Lorenzo at Milan, we find the two ideas converging within a single building. The way was open for one of the most fruitful schemes of Early Christian architecture, leading eventually to S. Vitale in Ravenna, to SS. Sergius and Bacchus in Constantinople, and even to Hagia Sophia itself.

Right down to the end of the pagan period it was the interiors of these buildings that were the predominant consideration of forward-looking architects. Even if it be an exaggeration to say that the exteriors were simply left to take care of themselves, in very few of them does one feel that the architect was primarily concerned with this aspect of his building. The language of a more traditional classicism was still spoken on occasion, particularly in contexts where a certain conservatism was appropriate; but the more closely one examines the individual instances, the more one is made aware that this was no longer a living idiom but a dialect inherited, and even on occasion deliberately revived, from the monuments of Rome's own past. The imitation of the Pantheon and of Trajan's Forum in the gabled porches of the imperial mausolea and in the decorative orders of Aurelian's Temple of the Sun; the revival of a scheme obsolete since Flavian times for the porticoes around the Mausoleum of Maxentius (and in Diocletian's palace at Spalato); the rendering of a traditional theatrical stage-building in terms of the columnar aediculae of contemporary decorative usage in the swimming-pool façade of the Baths of Diocletian: these are a few only of the most striking instances of an almost antiquarian attitude to the use of the familiar externals of an older classicism. We shall meet it again in the architecture of the provinces during the same period.

It is easier to document this breakdown of the old exterior values than it is to define any positive and consistent trend towards a new exterior aesthetic. A ready acceptance of the functional logic of the new material was not in itself sufficient to produce a satisfactory answer, as we can see very clearly from the bleak, barrack-like elevations of three of the four sides of the central block of the Baths of Caracalla (Plate 142). Only on the south façade of the same building do we find the succession of large windows used with some success as a frame and foil for the projecting mass of the central rotunda. It is perhaps the growing taste for these large windows (made possible by the more general use of lead-framed panes of window-glass or its equivalent) which offers the most consistent clue to the development of an exterior aesthetic in this late pre-Christian period. Grouped (as in the façade of the Curia) or spaced out in orderly lines (Plate 149), they could be used to give life and movement to the large, blank, exterior surfaces; and the scalloped framing recesses of the Tor de' Schiavi reveal a growing awareness of their more subtle aesthetic possibilities. We see this again very clearly in a building such as the Basilica at Trier, described in the following chapter. Whereas it could be argued that the external window-pattern of the Basilica Nova, for example, is determined primarily by the lighting requirements of the interior, that of the Trier

Basilica is based unmistakably on the deliberate choice of a bold pattern of rhythmically alternating voids and solids. Working essentially from the inside outwards, late pagan architecture had already arrived at its own equivalent of the older classical scheme based on column and architrave. The familiar comparison between this building and the early-fifth-century church of S. Sabina shows how far, in this respect too, Christian architecture started where pagan architecture left off.

THE ARCHITECTURE OF THE TETRARCHY
IN THE PROVINCES

THE military crisis of the third century A.D. was one which shook the whole Empire to its roots. A few favoured areas, such as Asia Minor and North Africa, escaped the full blast; but even there the financial difficulties of the time meant that public building dropped to a mere trickle by comparison with the second century. Gaul, Northern Italy, the Danube provinces, Greece, and Syria were all ravaged by hostile armies; and although Roman authority was eventually re-established and metropolitan Syria, for example, went on to enjoy another three centuries of prosperous life on the classical model, never again could the citizens of the Roman Empire face the future with the same unruffled assurance as before.

Not surprisingly, the world that re-emerged from the holocaust was a very different world from that of the previous age. Nowhere is this fact more apparent than in the relationship between Rome and the provinces. Italy had long ago lost its pre-eminence over the other provinces, but in the second century Rome itself was still the unchallenged centre of the Roman world. Now it had been made painfully clear that this world was too large to be ruled with success by any single man ruling from any single capital. The solution adopted by Diocletian, a consortium of two senior and two junior emperors (the 'Tetrarchy'), despite its many internal stresses was successful in carrying the Empire over the crucial period of military, civil, and economic reorganization. For a while in the earlier fourth century the towering personality of Constantine succeeded in re-establishing once more a single central authority. Then, without drama but finally and irrevocably, the Empire once more broke into its two halves, East and West, establishing the pattern which was to dominate the history of the northern shores of the Mediterranean for the next seven or eight hundred years.

The crucial single event in all this was the inauguration in 330 of Constantinople as the new capital of the Roman world. But one must not forget that, inspired though Constantine's choice of site proved to be, the venture as such was no novelty. Within the last forty years there had been half a dozen new capitals established, formally or *de facto*, up and down the length of the Empire by the rulers of the Tetrarchy: Antioch, Nicomedia, Thessalonike, Sirmium, Milan, Trier. All these were built very largely by local craftsmen, with local resources and with local materials; to this extent they represent the culmination of the long processes of regional development which constitute the architectural history of the several areas of which they were the capitals. But at the same time by the very circumstances of their foundation they tended to cut right across regional boundaries. Even allowing for the differences of climate and craftsmanship, of methods and materials, the formal requirements of an imperial residence or a public bath-building were very much the same in Syria as on the Danube or in Gaul. What

now happened in varying degree in all these new capitals had been foreshadowed nearly a century earlier at Lepcis Magna. The old regional barriers were everywhere breaking down. Never before or since was the Mediterranean world nearer to achieving a real *koine* of architectural usage.

Two of the Tetrarchy capitals, Nicomedia in Bithynia and Sirmium near Belgrade, have left hardly any tangible trace, and two others, Antioch and Milan, all too little.[1] About Trier and Thessalonike, on the other hand, we are quite well informed, and we can supplement this by reference to at least two other imperial residences of the same period, the palace at Spalato (Split) on the Dalmatian coast to which Diocletian retired in 305, and the great Sicilian country house of Piazza Armerina, which has been plausibly identified as the corresponding residence in retirement of his co-emperor, Maximian.

Trier

Trier (Augusta Treverorum), strategically situated on the Moselle in rear of the armies of the Rhine, was chosen by Constantius Chlorus to be his capital when in 293 he was nominated by Diocletian to be one of the junior members of the Tetrarchy, with a military and administrative command stretching from the Straits of Gibraltar to Hadrian's Wall and from the Rhine to the Atlantic. It was the residence successively of Constantius himself, of his son Constantine the Great, and of his grandson Constantine II, and again later of Valentinian (364–75) and Gratian (375–83), and it was not until 395 that the court was formally transferred to Milan and the headquarters of the military prefecture to Arles. During this period many of the most distinguished literary and ecclesiastical figures of the age lived here, including Ausonius, Lactantius, Athanasius, St Jerome, St Ambrose, St Martin of Tours, and St Augustine. For a century it was culturally as well as politically the first city of the West.

Trier was one of the most prosperous, as well as one of the oldest, cities of northern Gaul. The principal remains of the first three centuries of its history are the rectangular street plan, related to a bridge over the Moselle; the amphitheatre, originally of earth and timber but rebuilt in stone *c.* A.D. 100; a grandiose second-century bath-building of the 'Imperial' type, the St Barbara Baths; a number of private houses, some with fine mosaics; and several important religious sites, including both the predominantly Celtic sanctuary of Altbachtal and the more classicizing temple and terraced precinct of Mars Lenus on the slopes across the river.[2] This was a typically prosperous Gallo-Roman city, with strong native overtones in the fields of religion and of domestic building, but with a public architecture that was essentially classical.

When Constantius chose it as his capital, the city was still suffering from the effects of a disastrous incursion of the Franks and Alemanni in 275–6. The city walls must have been built immediately after this disaster (if not indeed already before it) and many of the older monuments needed restoration. In addition Constantius now started to lay out, and Constantine completed, a palace complex occupying many insulae in the north-east part of the town. The audience hall (the 'Basilica' or 'Aula Palatina') is still

standing. There are also the substantial remains of a large new bath-building (the 'Kaiser-thermen'), as well as traces of a circus and of the residential quarters, on a part of which Constantine later (c. 326) founded a great double church, the first cathedral church of northern Gaul. Other monuments of the period are the grandiose north gate of the city, the 'Porta Nigra', the exact date of which is disputed, and the Constantinian ware-house of S. Irminio, near the river.

The Basilica occupies the same site as an earlier and smaller, but similarly oriented hall, which may have been part of the palace of the regional procurator, de-stroyed in the incursion of 275–6. The right-hand wall of the present building and most of the façade are rebuilt, having been largely demolished when the building was part of the adjoining bishop's palace; but, apart from certain details of the façade, the main lines of the Constantinian building are nowhere in doubt (Plates 269 and 271 and Figure 195). The basic design was very simple: a severely plain, rectangular hall, measuring roughly 95 by 190 feet (100 by 200 Roman feet; 29 by 58 m.) and, beyond it, a project-ing, flat-ceilinged, semicircular apse; an elongated, single-storeyed, transverse fore-hall, or narthex, with a central porch opening on to the middle of one end of a large fore-court flanked by porticoes; and, bulking far larger in plan than in actuality, a pair of low, porticoed courtyards flanking the main hall. The floor was of black and white marble and heated by hypocausts, the outlet ducts of which were incorporated in the lower parts of the walls and controlled from the lower of two outer service galleries. The lofty ceiling was presumably coffered, as now restored. The lighting came from two rows of large, round-headed windows, which were continuous down the two long sides and round the apse, their rhythm accentuated internally by a framing architectural scheme in coloured marble. The intention of the whole design was to carry the eye up to the apse, where the emperor sat enthroned and where a series of mosaic-ornamented recesses lent a welcome note of colour to the rather austere simplicity of the scheme as a whole. The impressive proportions of the hall were further enhanced by an ingenious series of optical devices. The windows of the apse are not only shorter than those of the nave, but those of the upper row spring from a horizontal line 4 feet (1·20 m.) below the springing-line of the corresponding nave windows; and in both rows the two central windows are appreciably narrower than the outer pair. In addi-tion, the ceiling of the apse is correspondingly lower than that of the nave. The com-bined effect of these devices, viewed through the interrupting frame of the 'triumphal arch', is that the eye, assuming a uniformity of size and proportion between nave and apse, gives to the latter a depth and height considerably greater than in fact it possesses. Even if one knows the trick (clearly visible from the exterior, Figure 195A) one is still deceived. There can be no doubt that the optical effect is quite deliberate, and its use in this building, unparalleled even in Rome, is a measure of the architectural sophistica-tion of the provincial capitals of the Tetrarchy.

The exterior, which was faced with plain stucco, is dominated today by the vertical lines of the tall, narrow arches of the blind arcading which frames the two rows of windows. In antiquity this vertical emphasis was tempered by the pair of timber gal-leries which ran along the sides and around the apse, to service the two rows of win-

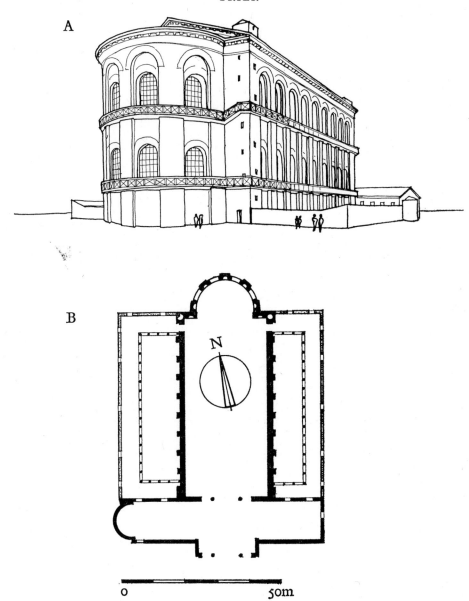

Figure 195. Trier, Basilica, early fourth century. (A) Reconstructed view of exterior (cf. Plate 269).
(B) Plan

dows. There are obvious analogies in this arrangement with the two rows of blind arcading which are such a conspicuous feature of the exterior of the contemporary horrea of S. Irminio (Figure 196). These are a pair of two-storeyed warehouses, each about 230 feet long and 65 feet wide, with the main working entrances facing inwards on to a long, narrow loading-yard between the two buildings. Internally there were fourteen transverse bays, lit by narrow slit windows, and the floor of the upper storey was carried on two longitudinal rows of stone piers.[3]

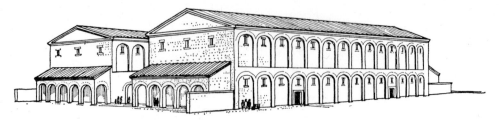

Figure 196. Trier, S. Irminio Warehouses, early fourth century. Elevation

The bath-building (the Imperial Baths, or 'Kaiserthermen') (Plate 270 and Figure 197) which occupied the southern extremity of the palace-complex was of a type already familiar in the provinces, a type for which the St Barbara Baths, built soon after the middle of the second century, offered a notable local precedent. In its broad lines the layout of Constantine's building followed that of the St Barbara Baths, which in turn were closely derived from, though by no means a slavish copy of, the Baths of Trajan in the capital. The main bathing-block (*c.* 450 by 400 feet) was designed to occupy one half of the elongated rectangular site, facing out across the large porticoed enclosure and low surrounding buildings that occupy the other half, in this respect conforming more closely to the model of the gymnasium bath-buildings of Asia Minor than those of Rome itself. There is no need to describe in detail the internal disposition of the bathing-suite. The principal advances of the Constantinian building upon its predecessor lay in the far greater compactness of the design of its main block, which was grouped tightly around the main axis, and in its liberal use of lively curvilinear forms in place of the rather banal, loosely organized rectilinearity of the earlier building. Another notable feature of the design was the grouping of all the services (heating, drainage, service corridors, and storage) within a self-contained cellar range below the raised floor level of the bath itself. In the event these baths were never completed as planned. Constantine's departure for the east in 316 led to an indefinite suspension of the work, and when Valentinian (364–75) undertook to complete them he did so on a much reduced scale, eliminating all except the tepidarium and the nucleus of the caldarium range, and enlarging and simplifying the forecourt so as to consist of little more than four ranges of small uniform square tabernae opening off a huge open courtyard.

The Porta Nigra (Plate 268) is the quintessential Roman gate, designed at all costs to impress the wayfarer with the might of Imperial Rome. Such unusual features as it possesses are due simply to the fact that, like many of the late antique monuments of Rome, it represents a deliberate return to earlier Imperial models. In this case the models were first-century buildings such as the Porta Palatina at Turin or, in Gaul itself, the Porte Saint André at Autun, the only serious concession to contemporary military planning being the greater robustness and depth of the towers, which were carried backwards the full length of the square internal courtyard so as to flank the inner and the outer gates alike. The decoration too derives from the same models, from the arched openings and framing orders of the galleries directly over the carriageways of the earlier gates. In this case, however, the motif has been taken and applied, incongruously but

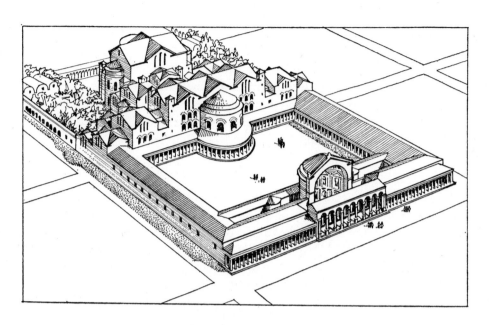

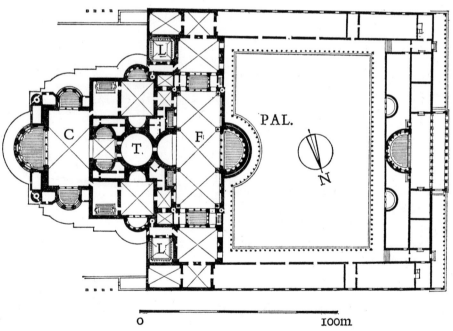

Figure 197. Trier, Imperial Baths ('Kaiserthermen'), early fourth century. Restored view (cf. Plate 270) and plan

ʟ Lavatory ᴄ Caldarium ᴛ Tepidarium ꜰ Frigidarium ᴘᴀʟ. Palaestra

521

with a certain barbaric magnificence, to the whole structure, two rows of arches running right round the whole building and a third right round the towers, 144 arches in all. The extraordinarily crude finish of the masonry, sometimes cited as analogous to the sophisticated rustication of the Porta Maggiore in Rome, is accidental: the building was never completed. There is no independent evidence to show exactly when in late antiquity this gate was put up. On historical grounds the most likely occasion would seem to be either when the town and its defences were rebuilt after the disaster of 275–6 or else during the early years of Constantine's reign. The latter date would better explain why, like Constantine's bath-building, it was left unfinished.

Thessalonike (Salonica)

Thessalonike (Salonica), strategically situated on the Via Egnatia, the main Roman land route from Italy to the Bosphorus and to Asia, was already a town of importance when Galerius (293–311) chose it to be the capital of his quarter of the Empire. At this point the Via Egnatia runs roughly east and west, and to accommodate his palace Galerius added a whole new quarter on either side of it, along the eastern edge of the existing city. To the south lay the palace proper, with a hippodrome (circus) along the eastern edge of it; to the north lay the rotunda which was perhaps destined to be the founder's tomb, and which is now the church of St George; and between the two ran a processional way with an elaborate triumphal arch marking the point where it crossed the Via Egnatia (Figure 198).

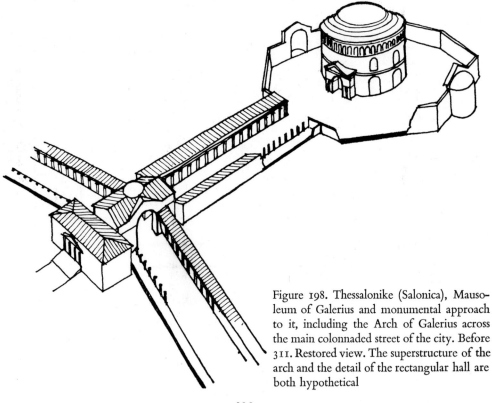

Figure 198. Thessalonike (Salonica), Mausoleum of Galerius and monumental approach to it, including the Arch of Galerius across the main colonnaded street of the city. Before 311. Restored view. The superstructure of the arch and the detail of the rectangular hall are both hypothetical

Of the palace itself little is known beyond the fact of its position alongside the hippo-drome, a relationship first established by the Flavian Palace in Rome and copied re-gularly in the palaces of later antiquity (Antioch, Constantinople, Trier). The only rooms to have been completely examined or cleared are an octagonal hall, nearly 80 feet (25 m.) in diameter, with apsidal recesses in the eight angles, and a large rectangular transverse hall which abutted on the south side of the arch, serving as a vestibule to the colonnaded processional way that led up from the arch to the ceremonial enclosure surrounding the rotunda. Viewed from the east or west the central archway spanned the road and may well have carried some sort of conventional superstructure as well as the usual group of statuary. The two lateral archways, on the other hand, spanned the footpaths within the flanking colonnades, precluding the normal architectural develop-ment of such an arch. Instead, the elaborate sculptural ornament, recording Galerius's victory over the Persians in 297, was concentrated upon the vertical faces of the piers. The piers themselves consisted of a marble facing about a core of mortared rubble, and the arches were of brick.

Both in plan and in elevation the rotunda (Plate 275 and Figure 199) was a free-stand-ing version of the caldarium of the Baths of Caracalla, with eight large, radiating, barrel-vaulted recesses at ground level and, directly above them, eight similar but somewhat smaller recesses housing a ring of large windows. The decoration of the interior was carried out in veneer marble, with two orders of pilasters and entablatures framing the recesses and, on the piers between the lower recesses, eight decorative aediculae, similar

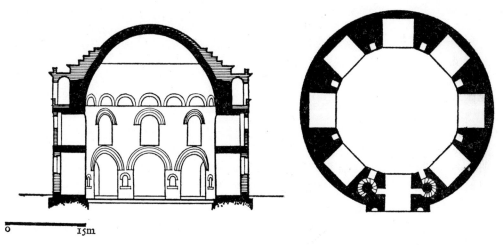

0 15m

Figure 199. Thessalonike (Salonica), Mausoleum of Galerius (church of St George). Mainly
before 311, but dome completed later. Section and plan (cf. Plate 266)

to those found in the buildings of Diocletian and Maxentius in Rome. There are the substantial remains of the original mosaics on the vaults of the radiating recesses. Those of the dome date from the conversion of the building into a church later in the fourth century, but they presumably replace an earlier series.

The plan of the building and much of its detail are unmistakably derived from Rome. Not so its construction. In the absence of the volcanic sands necessary for making Roman concrete, the materials and techniques are those described in an earlier chapter (pp. 386–9) as characteristic of Roman building in western Asia Minor and the northern Aegean. The walls are built of a mortared rubble, laced with bands of brick and faced, partly with brick, partly with courses of small, roughly squared blocks of local stone; and the arches and vaults are of brick. For the most part the individual bricks are laid radially in the traditional classical manner, in anything from one to three concentric rings, and so one sees them also in the substructures of the hippodrome. But both in the arch and in the vaulting of the radiating recesses of the rotunda there are panels also of brickwork, 'pitched' in the manner characteristic of most Byzantine vaulting (Plate 266). Instead of being laid radially, parallel with the axis of the arch or vault, they are laid end to end along the line of curvature. In crude brick this was a technique that goes back to the Middle Kingdom in Pharaonic Egypt and at least to the beginning of the first millennium B.C. in Mesopotamia. It called for the use of a quick-drying mortar, and it had the double advantage of needing only a very light, movable scaffolding and of being, in consequence, very flexible in its application. So far as concerns the Mediterranean world, the story of this device belongs rather to the history of Byzantine than of classical architecture. But the fact that it is found both here and at Spalato, albeit on a very modest scale, shows that by the end of the third century it was in fact already current in the Aegean provinces; and its use at about this date, or even slightly earlier, in the substructures of the basilica at Aspendos in Pamphylia (Plate 200) gives support to the suggestion that it derives ultimately, through the later classical architecture of Asia Minor, from the familiar mud-brick forms of Syria and Mesopotamia.[4]

An unusual constructional feature of the rotunda is that, whereas the lower part of the dome, to a height of 23 feet (7 m.), is a segment of a hemisphere based on a centre situated on the level of the springing line, the upper part has a different curvature, based on a centre about $6\frac{1}{2}$ feet (2 m.) higher. By this means the builders were able to reduce the effective span from $79\frac{1}{4}$ to $62\frac{1}{2}$ feet (24·15 to 19 m.), corbelling the lower part inwards without scaffolding and making the pitch of the crown less dangerously shallow. It was neglect of some such precautions that 250 years later brought the original dome of Justinian's church of Hagia Sophia crashing to the ground. In the present instance the pattern of the later mosaics makes the change of curvature virtually invisible from the ground.[5]

Spalato (Split)

The 'palace' which Diocletian built for himself on the Dalmatian coast and to which he retired in 305 was planned on very different lines (Figure 200). It was not really a palace at all, in the sense of being part of a larger urban complex; it was an independent self-contained country residence, enclosed on all sides within a near-rectangular (575 and 595 by 710 feet; 175 and 181 by 216 m.) circuit of defences. The walls were guarded by projecting square and octagonal towers; from gates in the middle of the two long sides

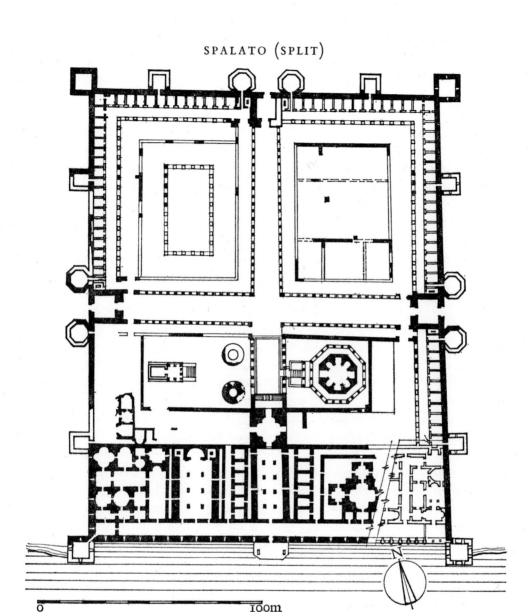

Figure 200. Spalato (Split), Palace of Diocletian, *c.* 300–6. Plan

and of the landward (northern) short side two axial colonnaded streets converged upon the geometrical centre of the city. A shorter length of street, the so-called 'Peristyle', flanked by open colonnades (Plate 272), continued the line of the north–south street across the intersection and led up to the residence proper, which occupied the southern extremity of the rectangle, overlooking the sea. The rest of the southern half was occupied by two large rectangular precincts, which faced each other across the 'Peristyle'. That on the left contained the emperor's mausoleum, that on the right a small temple and two small rotundas of uncertain character and purpose. There was no gate. On the southern side there was only a small postern; otherwise the walls presented

an unbroken façade towards the sea, crowned by the arches of a gallery which ran the full length between the two corner towers, interrupted only by three small gabled pavilions.[6]

For the plan of the residential wing, which was terraced out over lower ground, we are dependent largely on that of the still only partially explored substructures. These indicate a series of rectangular suites, physically separated by corridors and doubtless no less sharply distinguished in function. An emperor in retirement still had certain official and ceremonial duties. At Spalato the public rooms occupied the middle of the palace wing. On the central axis a circular vestibule led directly into a large rectangular hall, with a second doorway at the far end on to the corridor-gallery beyond. On either side of the central suite the same corridor gave access to two more large halls, both evidently of an official character. That to the right (west) had an apse at the north end and two longitudinal rows of piers or columns, and it was presumably a basilican audience hall; that to the left was perhaps a triclinium. Beyond these, at the two ends of the block, lay the domestic and bathing suites.

There is much about this layout to justify the comparison that is frequently made between this building and the traditional planning of the Roman castrum, with its transverse Via Praetoria and axial Via Principalis converging upon the praetorium, originally the actual residence of the commanding officer and later the official and ceremonial headquarters building. This is the sort of plan which one would have found in countless variants all along the frontiers of the Empire, where the neat orderly formulae of the military camps inevitably left their mark on the civil settlements that grew up under their protection. At Timgad, for example (Plate 251), the forum complex occupied precisely the same position in relation to the T-shaped plan of the city's main streets as the praetorium of the near-by camp at Lambaesis, the station of the Third Legion from which the majority of the new settlers were drawn. From the moment that Roman military architecture ceased to be a matter of the temporary lodging of mobile units and began to be concerned with the provision of permanent barracks and other facilities for units that might be established in one place for decades, or even for centuries, the mutual interaction of civil and military architecture had become a lively factor in the architectural development of the frontier provinces.

The crisis of the third century gave fresh substance to this relationship. Many of the frontier provinces were, culturally speaking, late starters, and it was only now that they really began to acquire an architectural voice of their own; and at the same time, from Gaul to the Levant, vast regions which for centuries had basked in comfortable security found themselves thrust into close and urgent contact with military affairs and military ways. The Aurelianic walls of Rome were symptomatic of a profound shift in the centre of gravity of the Roman world, a shift which affected every aspect of civilized life, architecture included.

The fortifying of the towns took the obvious form of surrounding them with often hastily devised, irregular circuits of walls. The villas and farms of the open countryside presented a more varied problem and the answers were correspondingly varied. In a few outlying areas, as in parts of northern Gaul, the wealthy villas were simply aban-

doned. Elsewhere, for example in North Africa, one can trace the emergence of a variety of more or less defensible building types, ranging from the well-to-do villa with massive towers that figures so largely in the later African mosaics down to the small, square, fort-like *gasr* (from the Latin *castrum*) of the Libyan frontiers. Here and there along the northern frontiers, a tendency to regroup into larger defended communities can be seen to have been accompanied by the emergence of individual fortified buildings of quasi-military character. The villa at Sumeg, near Lake Balaton in Hungary, is such a building. An even more striking example is the fourth-century 'villa' at Pfalzel near Trier. This was a lofty, square keep built around an open courtyard and defended by closely spaced, projecting rectangular towers. It may have been a country retreat for the emperor when in residence at Trier. In Syria the Byzantine castle of Kasr ibn-Wardan and the early Arab *châteaux* and hunting lodges represent a similar development.

Diocletian's fortified villa at Spalato was thus not an isolated phenomenon. If one makes allowance for the obvious differences of scale and elaboration, it can be seen to reflect the same current of events as that which produced a whole series of fortified villas, quasi-military in plan, which began to emerge on to the provincial scene during the closing years of the third century. To what extent it established the type (as one may suspect in the case of the often-quoted fortified residence of Mogorjelo), and to what extent it merely embodied features that were already being developed elsewhere along the northern and eastern frontiers, only further work can show. The creation of an age in rapid transition, it may well have done both.

Another precedent that has sometimes been cited for the building at Spalato is the city and palace of Philippopolis (Shehba) in southern Syria, the birthplace of the emperor Philip (244–9). Historically Philip's work here affords a welcome chronological link between the building activities of Septimius Severus at Lepcis Magna and those of the Tetrarchy emperors in their several capitals. But it is clear that at Philippopolis the palace (about the details of which we have very little information) was part only of a larger urban unit; and one suspects that the latter's incorporation of two intersecting colonnaded streets might have been matched in any city of the eastern provinces that underwent substantial rebuilding at this date. A far more plausible precedent is that of the palace which Diocletian built at Antioch, seemingly within the framework of a fortress begun by Valerian (254–9) on the island opposite the hellenistic city. The remains of this palace and of the adjoining new quarter lie deep beneath the silt of the Orontes, but they are described by the fourth-century writer Libanius, whose description deserves quotation:[7] 'The whole of it is an exact plan, and an unbroken wall surrounds it like a crown. From four arches which are joined to each other in the form of a rectangle [i.e. a tetrapylon], four pairs of stoas [i.e. four colonnaded streets] proceed . . . towards each quarter of the heaven. Three of these pairs running as far as the wall, are joined to its circuit, while the fourth is shorter but is the more beautiful . . . since it runs toward the palace, which begins hard by, and serves as an approach to it. The palace occupies . . . a fourth part of the whole [island]. It reaches to the middle, which we have called an ompholos [i.e. to the tetrapylon].' Libanius adds that at the far side the wall

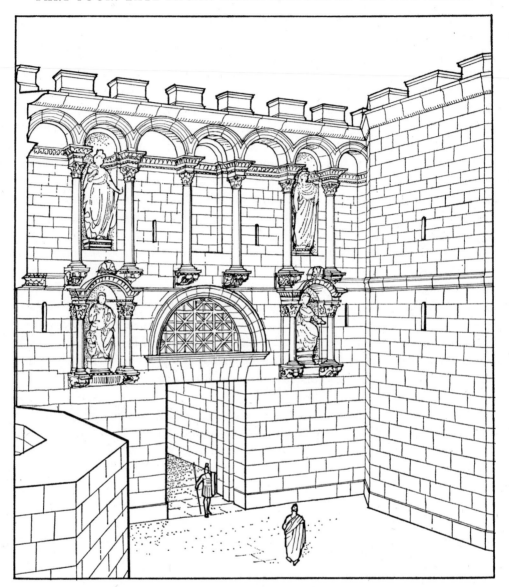

Figure 201. Spalato (Split), Porta Aurea, *c.* 300–6. Restored view

was crowned by a colonnade offering a view over the river and the suburbs beyond. Adjoining it was a hippodrome. The plan was certainly not a neat rectangle, and the palace did not occupy the whole of the fortified enclosure. But there are obvious analogies with the plan of Spalato, and it seems not unreasonable to believe that this was indeed one of the buildings which Diocletian and his architects had in mind a few years later in planning his Dalmatian residence.

That an architect and workmen from the eastern provinces were among those employed in the building of Spalato there can be little doubt. Among the elements that can be seen to stem more or less directly from Syria or Asia Minor are the several in-

stances of the use of the Syrian 'arcuated lintel' and the arcading of the columnar screens on either side of the so-called 'Peristyle' (Plate 272). The whole treatment of the Porta Aurea (Figure 201) is typically Syrian, with its characteristic combination of an open arch with a horizontal lintel, the bracketing out on consoles of its decorative arcade, and the deliberate ambivalence of the receding planes of the wall surface, just as in the Temple of Dionysus at Baalbek. The preference for fine, squared-stone masonry, extending even to the barrel-vaulting of the small temple, points in the same general direction. So too does the use of brick vaulting, which includes examples of the same 'pitched' brickwork as at Thessalonike and an ingenious variant of the same technique in the dome of the mausoleum, which is built up of superimposed, interlocking fans of brickwork, converging upwards towards the crown.[8] For the immediate inspiration for all these features one would have had to look east of the Aegean, to Asia Minor or to Syria. At the same time, however, there are other elements that point no less unmistakably westwards. The design of the mausoleum, for example, octagonal externally and circular internally, with eight alternately rectangular and apsidal recesses, falls squarely within the series of Roman imperial mausolea described in the previous chapter. Other features for which the known parallels lie in Italy rather than in the East are the circular vestibule (as in the 'Tempio della Tosse' at Tivoli) and the framing of the arches of the seafront gallery between the half-columns of an applied decorative order, an archaism employed also in the courtyard of the Mausoleum of Maxentius and on the Porta Nigra at Trier. The known precursors of the apsed audience hall also belong to the West. In the present state of knowledge it would be unwise to insist on the immediate source of any of these features: the very fact that they could meet and mingle so freely is a sufficient indication of the geographical fluidity of ideas and motifs which is so characterististic of the monumental architecture of the Tetrarchy. This is a building that belongs exclusively neither to East nor West.

Piazza Armerina

If the great villa of Piazza Armerina has been rightly identified as the country retreat of Diocletian's colleague, Maximian, it was the almost exact counterpart of the residence at Spalato.[9] Both were built to serve the requirements of an emperor in retirement, and it is characteristic of the age that these requirements should have been able to find such very differing formal expression.

Unlike Spalato, Piazza Armerina, situated in a secluded valley of south-central Sicily, did not feel the need of defences. Instead of the compact, orderly planning of Diocletian's residence, we have here the relaxed, single-storeyed sprawl of the old-style Italian country villa (Figure 202). One can distinguish five principal elements within the layout. At the west end lay the monumental triple entrance and horseshoe-shaped forecourt (I); from this the visitor turned half-right into the main body of the villa, which comprised, in roughly axial succession, a vestibule (IIa), a peristyle garden flanked by living quarters (IIb) (Plate 273), a transverse corridor (IIc), and a large apsidal audience hall (IId); accessible from the south end of the corridor was a private wing (III) consisting

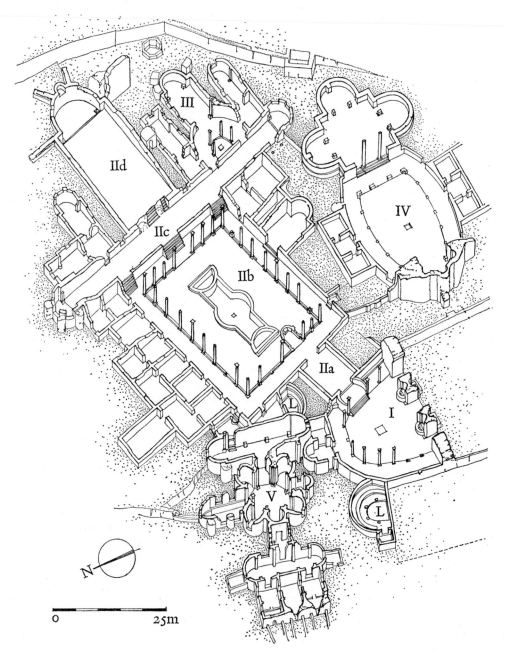

Figure 202. Piazza Armerina, villa, probably of Maximian, early fourth century. Axonometric view (cf. Plates 273–4)

of a miniature semicircular courtyard, with two bedroom suites and a small triclinium; to the south lay an independent ceremonial wing (IV) with a trilobed triclinium (*triconchos*) and an oval, porticoed forecourt; and projecting obliquely from the north-west corner of the peristyle there was a bath-suite (V). Not all of this elaborate complex was laid out on a single occasion. There are several structural abutments, indicating successive building campaigns or changes of detailed intention, and the magnificent series of decorative floor-mosaics in particular must have taken years, if not decades, to complete. But, despite any such additions and adjustments, there is a manifest unity of basic intention about the whole design which argues that it was from the outset planned in something very closely resembling the form in which it has come down to us. This is no rich man's whim, but the product of a clear-eyed, organic conception of what was proper to the residence of a great aristocratic landowner.

Two traditions in particular seem to have contributed to the overall conception of the villa, as well as to its detailed treatment. One of these was that of the Italian country villa, as quintessentially interpreted in Hadrian's great villa near Tivoli. Here, at Piazza Armerina, for all the much reduced scale, one can see the same loose aggregation of quasi-independent suites of rooms, the same skilful exploitation of the terrain to produce lively juxtapositions of contrasting axes. The principal differences are that somewhere along the way the old intimate association with the surrounding landscape has been lost, giving place to an inward-turning self-sufficiency; and that what had begun as a picturesque disregard for the conventions of formal symmetry has been promoted to the status of a positive architectural rationale. Symmetry is now something to be avoided at all costs, or at best employed as a foil to emphasize the avoidance of the axial vistas of traditional classical planning. The forty-five-degree turn from entrance courtyard to vestibule, the blocking of the onward vista from the vestibule by a domestic shrine (Plate 274), the slight but sufficient shift of axis between the peristyle (with its emphatically axial fountain pool) and the audience hall, the steady rise in level from entrance to audience hall, all these are as deliberately contrived as the studiedly casual access from the main complex to the triclinium group or to the bath suite.

The other recognizable strain in the pedigree of the Piazza Armerina villa is the wealthy peristyle-villa of North Africa. Socially as well as geographically Sicily was almost as much a part of Africa as of Italy. Many of the great patrician families had vast estates in Tunisia and Algeria, and whoever was responsible for ordering the mosaics of the great transverse corridor (IIc) must also have had a stake in the profitable business of exporting exotic African beasts to the amphitheatres of the north. At least one of the groups of mosaicists active in the villa is best known for its work in Africa. Small wonder that the architecture too should reflect African precedents. Although we know all too little about the wealthy villas of the African countryside, recent studies[10] indicate several lines of development that were moving towards the sort of scheme adopted at Piazza Armerina. One (shared with many other provinces) was the increasing dominance of the triclinium as the focal point of domestic design. Another was the breaking out into looser form of the tight rectangular perimeter of the traditional peristyle-house. Both of these (and the transverse corridor separating the triclinium from the main peri-

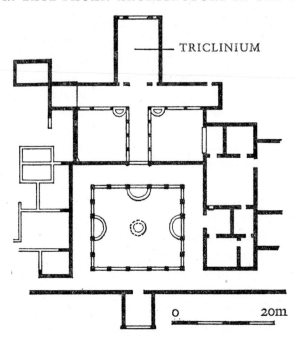

Figure 203. Portus Magnus, near Oran, villa, *c.* 300. Plan

style complex) are features of an approximately contemporary villa at Portus Magnus, near Oran in Algeria (Figure 203). Another feature that seems to have first taken shape in the residences of the provincial landed aristocracy is the triconchos. The bath-suite, too, is of a type which, originating in Italy, had found favour and been widely developed in North Africa.

How much of all this is a direct translation to Sicily of contemporary African practice (which was at every stage itself influenced from Italy) and how much it represents an individual interpretation, under more direct Italian influence, of established African schemes, only further research will show. In either case Piazza Armerina offers us a vivid glimpse of the wealthy patrician villa of pagan antiquity on the eve of its extinction as a significant building type. In the troubled centuries to come there was no longer any place for the open villas of an earlier, more expansive age. The future lay with Spalato rather than with Piazza Armerina. This is not to say that individual features of the latter did not find a place within the new order. We have already remarked on the relationship between Spalato and the square pre-Islamic and Islamic fortress-palaces of Syria, such as Kasr ibn-Wardan (564) and Mschatta (eighth century). The central feature of both is a great triconchos audience hall, and the link, directly or indirectly, must in both cases be Constantinople, where two of the commonplaces of later palace design were both foreshadowed at Piazza Armerina – the triconchos and the semicircular porticoed forecourt, or *sigma* (so-called from the Greek capital letter S, which at this date was written like a Latin capital C). The best known examples are the triconchos and sigma which Theophilus (829–42) added to the Great Palace; but as early as 447 we have a reference to a triconchos, evidently an official building, in the new

capital; and the substantial remains of the palaces of Antiochus (*c.* 431–6) and, probably, of Lausus (*temp.* Arcadius, 383–408) show that both consisted of complexes of circular and multilobed rooms opening off a great central sigma. At Ravenna we find peristyle, apsed audience hall and triconchos associated in the large, badly excavated building just to the east of the church of S. Apollinare Nuovo. Since 404 Ravenna had been the residence of the imperial court; and although the identification of this building as the Palace of Theodoric (d. 526) lacks any secure basis, this is undoubtedly the sort of context to which the building must belong. As a social phenomenon, then, the Piazza Armerina villa may be one of the last of its line. Architecturally, on the other hand, it foreshadows several important future developments in the history of ceremonial public building.

North Italy

By the end of the third century the effective centre of power in Italy had moved away from Rome to the Po valley. For a time, until succeeded by Ravenna, Milan was the most important city in the European West. Ausonius, writing about 388, refers to the theatre, a circus, the double walls, temples, a palace, a mint, and a bath-building erected by Maximian,[11] and the almost total loss of its late pagan architecture leaves a serious gap in our knowledge of the period. The imperial palace was a creation of the second half of the third century and one of the few surviving monuments is in fact a stretch of the city wall, together with a twenty-four-sided brick-faced tower, belonging to the extension that was made by Maximian (after 286) in order to bring within the defences a part of the new palace quarter, including the palace baths and the adjoining circus. Another is part of a bath-building, thought to be of Constantinian date, situated just inside the Vercelli Gate and consisting of a circular, domed caldarium with a number of smaller radiating chambers. Ravenna has fared better, but it belongs decisively to the Christian world and, except for the palace referred to in the previous section, none of its buildings are secular.

Tantalizingly fragmentary though they are, the remains in North Italy tell a familiar story, In Milan, the curvilinear, centralizing forms of the Vercelli Gate bath-building are in the same tradition as the Baths of Constantine in Rome; they were to be taken up later in the century (*c.* 370) and given fresh coherence and monumentality in the great church of S. Lorenzo, probably the palace church of the Arian emperors and itself the head of a line that led ultimately to S. Vitale in Ravenna.[12] The external buttress-like arcading of the church of S. Simpliciano, built by the successor of St Ambrose (d. 397), is a close repetition of that of the S. Irminio warehouse at Trier and probably, though only the ground-plan of these is known, of the very similar late antique warehouses at Aquileia and at Veldidena in Austria.[13] The fourth-century villa at Desenzano (Figure 204) beside Lake Garda, with its curvilinear and polygonal room-shapes, its elaborate fountain courts and fine polychrome mosaics, has many points in common both with Piazza Armerina and the late houses of Ostia. Most striking of all, as evidence of the wide variety of late pagan traditions which at this time were converging upon North

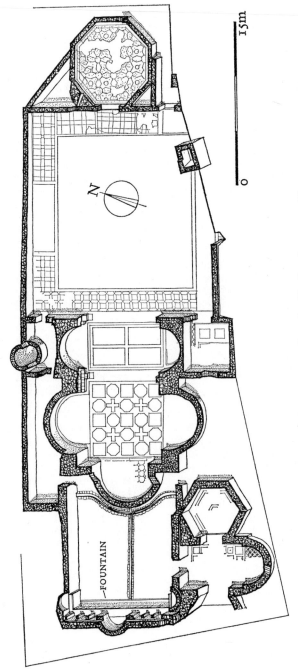

Figure 204. Desenzano, part of a rich villa, fourth century. Plan

Italy to shape the newly emergent Christian architecture, is the steady abandonment by the latter of concrete vaulting in favour of lighter materials – the large pottery vessels of Rome itself, the brickwork of the Roman East, and the interlocking tubular vaulting of North Africa.[14] The picture that can be drawn from such scattered fragments is bound to be itself fragmentary, but it is enough to show that in such matters North Italy was right in the main stream of contemporary architectural development.

Constantinople

With the foundation of Constantinople a page of history was turned. That the full implications of the event were apparent at the time to Constantine's contemporaries, or even to Constantine himself, we may well doubt. To most the new city must have seemed (and before Constantine's final break with the pagan aristocracy of Rome it would rightly have seemed) to be merely another of the new capitals called into being by the conditions of the Tetrarchy. In the context of the recent past it was no more than the culmination of tendencies already widely manifest during the previous half-century. We today can see that its foundation sealed the fate of the old pagan order; but it was within the framework of ideas and traditions inherited from the pagan world that the new city first took shape.

During the first half of the present century there was much controversy about the sources of Early Byzantine architecture, and in particular as to whether it should be regarded as a product of the architecture of 'the West', i.e. of Rome and of Roman Italy, or of 'the East', in the sense of new forces and traditions at work in and through the provinces of the eastern half of the Empire. The fact that we today are in a position to view the question more dispassionately and in a deeper perspective is due very largely to our greater knowledge of the architecture of the immediately preceding period. Any detailed analysis of the effective sources of early Byzantine architecture lies outside the compass of the present volume;[15] but few nowadays would dispute that it was the product of a number of convergent traditions, some derived from Rome, some from the Roman East, and some again from the other provinces, from the Aegean world, and from the new capitals along the northern frontiers. Some of these represent the deliberate choice of the city's planners, others were adopted almost unthinkingly as part of the inherited attitudes and skills of the age. To this last category belong the building materials and techniques of the new city, which were those already current in the region of which Constantinople was the natural centre: dressed stone, faced rubblework, and, to an ever-increasing degree, brick, used both for vaulting and as a solid building material in its own right. At the other end of the scale there was a deliberate appeal to the traditions of the old capital, to its regional organization, its plan, and its major public buildings. The almost total destruction of the pre-Justinianic city makes it very hard to judge how significant this reference to Rome was architecturally. Many of the analogies were no doubt rather superficial. But there is also a great deal in the surviving architecture of the sixth century which derives unmistakably from pagan Rome. It is a reasonable guess that many of the public buildings of Constantine's city were indeed

interpretations in local materials of the time-honoured monuments of the old capital.

Between those two extremes, and surely bulking very large in the minds of Constantine and his advisers, lay the accumulated experience of the last fifty years, gained at Antioch, at Nicomedia, at Thessalonike, at Sirmium, at Milan, and at Trier. In the late pagan architecture of these cities the old distinctions between east and west, between capital and province, and between one province and another had already gone far towards losing their meaning. At the beginning of the fourth century the ancient world was as near as it had ever been to possessing an architecture that was truly cosmopolitan both in character and distribution; and it was this cosmopolitan tradition to which Constantinople seemed destined to be the principal memorial.

In the event, the facts of history and of geography were to operate otherwise. Constantinople was founded at the end of a long period during which the whole tendency of the age had been towards an ever-increasing unity of culture and ideals. It was to develop in an age that was moving steadily in the reverse direction. The classical world was breaking up. The division of the Empire into east and west, followed by the collapse of Roman rule in the west and the rise of Islam, drove Byzantine civilization in upon itself. Increasingly cut off from the west, it drew more deeply on its Greek heritage, while Christianity gave it a new, theocratic content. But although the architecture of Byzantium reflects the needs and aspirations of this new and very different world, it was also essentially and continuingly a product of its own historic past. That past was the architecture of the late pagan Roman Empire.

LIST OF PRINCIPAL ABBREVIATIONS

NOTE: Other abbreviated titles are given fully in the general bibliography
or in the relevant chapter bibliography.

Acta Ath. Suec.	*Acta Instituti Atheniensis Regni Sueciae*
Acta Rom. Suec.	*Acta Instituti Romani Regni Sueciae (Skrifter utgivna av Svenska Institutet i Rom)* (cf. *Opus. Rom.*)
A.J.A.	*American Journal of Archaeology*
A.J.P.	*American Journal of Philology*
Andrén, *Origine*	A. Andrén, 'Origine e formazione dell'architettura templare etrusco-italica', *Rend. Pont.*, XXXII (1959–60), 21–59
Anz.	*Archaeologischer Anzeiger* (in *J.D.A.I.*)
Arch. Cl.	*Archeologia classica*
B.A.S.O.R.	*Bulletin of the American Schools of Oriental Research*
B.C.H.	*Bulletin de correspondance hellénique*
B. d.'Arte	*Bollettino d'Arte*
Bianchi Bandinelli, *Sovana*	R. Bianchi Bandinelli, *Sovana*. Rome, 1929
Blake (1947)	Marion Blake, *Ancient Roman Construction in Italy from the Prehistoric Period to Augustus*. Washington, 1947
Blake (1959)	Marion Blake, *Roman Construction in Italy from Tiberius through the Flavians*. Washington, 1959
B.M.C.	*British Museum Catalogue [of Coins]*
B.P.I.	*Bollettino di paletnologia italiana*
Bull. Comm.	*Bullettino della commissione archeologica comunale di Roma*
C.I.L.	*Corpus inscriptionum latinarum*
Civiltà del ferro	*Studi pubblicati nella ricorrenza centenaria della scoperta di Villanova. Documenti e studi a cura della deputazione di storia patria per le province di Romagna*, VI (1960)
Cosa	F. Brown and E. H. and L. Richardson, *M.A.A.R.*, XX (1951), 5–14; XXVII (1960)
C.P.	*Classical Philology*
C.R.A.I.	*Comptes rendus de l'Académie des inscriptions et belles lettres*
Crema	*L'architettura romana (Enciclopedia classica*, III, vol. XII, *Archeologia (Arte romana)* a cura di Paolo E. Arias). Turin, 1959
Dionysius	Dionysius of Halicarnassus
Ducati	P. Ducati, *Storia dell'arte etrusca*, 2 vols. Florence, 1927
Dura	*The Excavations at Dura Europos. Preliminary Reports*. New Haven, 1929–52
Encicl. Art. Ant.	*Enciclopedia dell'arte antica classica e orientale*
Etruscan Culture	See: *San Giovenale*
Fasti A.	*Fasti archaeologici*
Fontes	*Fontes ad topographiam veteris urbis Romae pertinentes colligendos atque edendos curavit G. Lugli*
Forma Urbis	*La Pianta marmorea di Roma antica, Forma Urbis Romae*, a cura di Gianfilippo Carettoni, Antonio M. Colini, Lucos Cozza, Guglielmo Gatti. Rome, 1960
Giglioli	G. Q. Giglioli, *L'Arte etrusca*. Milan, 1955
Gjerstad, *Early Rome*	E. Gjerstad, *Early Rome*, I–III (*Acta Rom. Suec.*, in 4°, XVII). 1953, 1956, 1960
G.G.A.	*Göttingische gelehrte Anzeigen*
I.L.N.	*Illustrated London News*

Itinerari	*Itinerari dei Musei e Monumenti d'Italia.* Rome, Libreria dello Stato
J.D.A.I.	*Jahrbuch des deutschen archaeologischen Instituts*
J.H.S.	*Journal of Hellenic Studies*
J.Ö.A.I.	*Jahreshefte des Österreichischen Institutes in Wien*
J.P.	*Journal of Philology*
J.R.S.	*Journal of Roman Studies*
M.A.A.R.	*Memoirs of the American Academy in Rome*
Mél. Rome.	*Mélanges d'archéologie e d'histoire de l'École française de Rome*
Mem. Linc.	*Memorie dell'Accademia nazionale dei Lincei*
Mem. Nap.	*Memorie della Accademia d'archeologia, lettere e belle arti di Napoli*
Mem. Pont.	*Atti della Pontificia Accademia romana di archeologia, Memorie*
Milet	Th. Wiegand (ed.), *Milet. Ergebnisse der Ausgrabungen und Untersuchungen seit dem Jahre 1899.* 2 vols. Berlin, 1932
Mon. Ant.	*Monumenti antichi*
Nash	E. Nash, *Pictorial Dictionary of Ancient Rome.* 2 vols. 2nd ed. London, 1968
N.S.	*Notizie degli scavi di antichità*
Opus. Arch.	*Opuscula archaeologica*
Opus. Rom.	*Opuscula Romana.* Studies collected in special volumns of *Acta Rom. Suec.*
P.A.A.R.	*American Academy in Rome, Papers and Monographs*
P.A.P.A.	*Proceedings of the American Philological Association*
P.A.P.S.	*Proceedings of the American Philosophical Society*
P.B.S.R.	*Papers of the British School at Rome*
Platner-Ashby	S. B. Platner, *A Topographical Dictionary of Ancient Rome.* Completed and rev. by T. Ashby. London, 1929
Polacco	L. Polacco, *Tuscanicae dispositiones.* Padua, 1952
P.P.S.	*Proceedings of the Prehistoric Society*
P.W.	Pauly-Wissowa, *Realencyclopädie der classischen Altertumswissenschaft*
Rend. Linc.	*Rendiconti dell'Accademia dei Lincei*
Rend. Nap.	*Rendiconti della Accademia di archeologia, lettere e belle arti di Napoli*
Rend. Pont.	*Atti della Pontificia Accademia romana di archeologia, Rendiconti*
Rh.M.	*Rheinisches Museum für Philologie*
R.M.	*Mitteilungen des deutschen archaeologischen Instituts. Römische Abteilung*
Robertson	D. S. Robertson, *A Handbook of Greek and Roman Architecture,* 2nd ed. Cambridge, 1943
San Giovenale	*Etruscan Culture, Land and People. Archaeological Research and Studies Conducted in San Giovenale and its Environs by Members of the Swedish Institute in Rome.* Columbia University Press, New York, 1962
Scavi di Ostia	G. Calza, Maria F. Squarciapino, G. Becatti, Raissa Calza, *Scavi di Ostia,* I–V. Rome, 1953–64
Serv. ad Aen.	*Servii grammatici qui feruntur in Vergilii commentarii.* Recensuerant G. Thilo et H. Hagen. Aenaidos librorum commentari. Recensuit G. Thilo. Leipzig, 1881. (Servius on the Aeneid)
S.H.A.	Scriptores Historiae Augustae
St. Etr.	*Studi etruschi*
T.A.P.A.	*Transactions of the American Philological Association*

NOTES TO PART ONE

CHAPTER I

3 1. Augustine, *De Civitate Dei*, IV, 31 (Varro); Plutarch, *Numa*, 8. Tertullian, *Apologeticus*, XXV, 12.

5 2. Diodorus, V, 39; IV, 20. In general for the Stone and Bronze Age settlements and material, see T. E. Peet, *The Stone and Bronze Ages in Italy*, and G. Patroni, *Architettura preistorica generale ed Italica. Architettura etrusca.* Especially important, in addition, are: G. Kaschnitz von Weinberg, 'Italien mit Sardinien, Sizilien und Malta', *Handbuch der Archäologie im Rahmen des Handbuchs der Altertumswissenschaft*, VI, 2 (Munich, 1954), 311–402; M. Pallottino, 'Le Origini storiche dei popoli italici'; Pia Laviosa Zambotti, 'Sulla costituzione dell'eneolitico italiano e le relazioni eneolitiche intermediterranee', *St. Etr.*, XIII (1939), 11 ff.; *Le Più Antiche Culture agricole europee* (Milan, 1943); C. F. C. Hawkes, *The Prehistoric Foundations of Europe to the Mycenaean Age*; V. G. Childe, *The Dawn of European Civilization*, 2nd ed. (London, 1939), and *Prehistoric Migrations in Europe* (Oslo, 1950); A. M. Radmilli, *La Preistoria d'Italia*. For Sicily: L. Bernabò Brea, *Sicily before the Greeks*. For caves: F. Biancofiore, *La Civiltà dei cavernicoli delle Murge baresi* (with bibliography) (Bologna, 1964). Round villages of Apulia: J. Bradford, *Ancient Landscapes* (London, 1957), 86–103; J. B. Ward-Perkins, 'The Early Development of Roman Townplanning', *Acta Congressus Madvigiani*, IV (Copenhagen, 1958), 110.

6 3. C. E. Östenberg, *Luni*; cf. also *N.S.* (1961), 103–24; A. Boëthius, 'La Continuità dello habitat etrusco nella zona di S. Giovenale di Bieda', *Fondazione per il Museo Claudio Faina, Orvieto, Collana di Quaderni d'archeologia e di storia* (1964).

9 4. Still basic for the Apennine culture remains U. Rellini, 'Le Stazioni enee delle Marche', *Mon. Ant.*, XXIV (1931), 130–280; 'La Civiltà enea in Italia', *B.P.I.*, LIII (1933), 63–96, and *La Più Antica Ceramica dipinta in Italia* (Rome, 1934). Among recent studies, especially: D. Trump, 'The Apennine Culture of Italy', *P.P.S.*, XXIV (1958), 165–200; R. Peroni, 'Per una definizione dell'aspetto culturale "subappenninico" come fase cronologica a sè stante', *Mem. Linc.*, ser. 8, IX (1960); S. M. Puglisi, *La Civiltà appenninica*,

especially 43–57, with A. C. Blanc's critique of Puglisi's excavations, *Rivista di antropologia*, XLIV (1957), 243–63. For south Italy, see Chapter 2, Note 2. Sant'Omobono: *Bull. Comm.*, LXXVII (1959–60), with studies by E. Gjerstad, R. Peroni, E. Paribeni, and G. Colonna. Gjerstad, *Early Rome*, III, 387, 400–13, 460, 462 ff.; Bolsena: *Anz.* (1957), 247; R. Bloch, *Atti del settimo congresso internazionale di archeologia classica*, II (Rome, 1961). Bed of pebbles in an Apennine hut at San Giovenale, *San Giovenale* (Swedish ed., Malmö, 1960), 306, figure 265. Manfria near Gela: A. W. Van Buren, 'News Letter from Rome', *A.J.A.*, LXV (1961), 387, plate 125; Boëthius, 'La Tomba del tetto stramineo a Cerveteri', *Palladio*, XV (1965), 1–6. Apennine huts around Civitavecchia: F. Barbaranelli, *B.P.I.*, N.S. IX (1954–5), 381–400; *Anz.* (1957), 260; '*Centumcellae*', I (1960), 6–9. Mycenaean finds (in addition to Luni): W. Taylour, *Mycenean Pottery in Italy*; Biancofiore, *La Civiltà micenea nell'Italia meridionale* (Rome, 1963); Stella Luigia Achillea, *La Civiltà micenea nei documenti contemporanei* (Rome, 1965), 218, note 71. Ischia: G. Buchner, *B.P.I.*, N.S. I (1936–7), 65 ff. Aeolian Islands: Bernabò Brea and Madeleine Cavalier, *Civiltà preistoriche delle isole eolie e del territorio di Milazzo* (Rome, 1956); *B.P.I.*, N.S. X (1956), 7–98. Bernabò Brea, *Sicily before the Greeks*, 104. For Sicily also: E. Sjöqvist, *A.J.A.*, LXII (1958), 157 (Morgantina). Fortifications: Puglisi, *op. cit.*, 60, 79, 81, 85. Trump, *loc. cit.*, 178. Casa Carletti: *St. Etr.*, X (1936), 330, plate XXXII, 2.

5. 'Anaktoron' of Pantalica: Bernabò Brea, *Sicily before the Greeks*, 162 ff. Tombs: plate 33 ff. For truddhi, trulli: Patroni, *Architettura preistorica*, 92, 125; G. Chierici, 'I trulli in pericolo', *Palladio*, N.S. I (1951), 125–7; M. Castellano, *La Valle dei Trulli* (Bari, 1960).

p. 10 6. The Terramare or palafitte arginate (Patroni, *op. cit.*) were first distinguished from the Apennine culture by Rellini (cited Note 4), Patroni, *Athenaeum*, N.S. VIII (1930), 425–51, and E. Ciaceri, *Le Origini di Roma* (Milan, 1937), 153–6. See also *J.R.S.*, XXX (1940), 95 f. The comprehensive work is: G. Säflund, *Le Terremare delle provincie di Modena, Reggio Emilia, Parma, Piacenza* (*Acta Rom. Suec.*, VII, 1939); see Rellini's review in *B.P.I.*, N.S. III (1939), 113–26, with additional remarks *loc. cit.*,

IV (1940), 169–73, and in *Il Lazio nella preistoria di Roma* (Rome, 1941), 29. For the date: J. E. Forssander, 'Europäische Bronzezeit', *Kungl. Vetenskapssamfundet i Lund. Årsberättelse 1938–1939*, III, 76–91; F. Matz, *Klio*, XXXIII (1940), 143–7; XXXV (1942), 299 ff. For the earlier urnfields of the Iron Age and their supposed connexion with the Terramare see Trump, 190, 194, and Puglisi, 78, both cited in Note 4.

p. 10 7. Pertosa: Peet, *The Stone and Bronze Ages in Italy*, 405 ff., and Patroni, *Architettura preistorica*, 76, figure 97. Delia Bousadin, 'Figurazioni architettoniche nelle incisioni rupestri di Valcamonica. Ricostruzione della più antica dimora camuna', *B.P.I.*, N.S. XIII (1960–1), 33–112; E. Anati, *Camonica Valley* (New York, 1961); G. Pavano, 'La scrittura musiva dei petroglifi di Valcamonica', *Rivista di studi classici*, XIII (1965), 44–65.

p. 12 8. G. Lilliu, *La Civiltà dei Sardi, dal neolitico all'età dei nuraghi*, and Margaret Guido, *Sardinia*. Lilliu, *I Nuraghi, torri preistoriche di Sardegna* ('La Zattera', 1962). Important is a find of one of the Sardinian figurines in a tomb of the Early Iron Age: R. Bartoccini, *Atti del settimo congresso internazionale di archeologia classica*, II (Rome, 1961), 280 f., plate XVII. *Arch. Cl.*, XVIII (1966), 1–15. G. Pesce, *Sardegna punica* (Cagliari, 1961); and 'La Civiltà punica in Sardegna', *Il Veltro*, VII, 5 (1963), 781–812. S. Moscati, 'The First Inland Carthaginian City to be found in Sardinia', *I.L.N.* (3 April 1965), 19. Famous is the Roman gibe preserved by Festus: 'Sardi venales, alius alio nequior.' S. Moscati, 'Scoperti puniche in Sardegna', *Rend. Pont.*, XXXIX (1966–7), 15–32; J. D. Evans, *Malta*; S. Moscati, 'La Penetrazione fenicia e punica in Sardegna', *Mem. Linc.*, ser. 8 (1966), 217–50.

CHAPTER 2

p. 14 1. For the transition from the Apennine Bronze Age, see Chapter 1, Note 4. Early Iron Age: E. Gjerstad, *Early Rome*, I–II, and 'Discussions Concerning Early Rome', *Opus. Rom.*, V (1962), 1–74, with A. von Gerkan's reply, *Rh. M.*, CIV (1961), 132–48; P. G. Gierow, *The Iron Age Culture of Latium*; H. Riemann, *G.G.A.*, CCXIV (1962), 16 ff.; A. Momigliano, *J.R.S.*, LIII (1963), 95–121; G. Colonna, *Arch. Cl.*, XVI (1964), 1–12; and T. Dohrn, 'Des Romulus' Gründung Roms', *R.M.*, LXXI (1964), 1–18. H. Müller-Karpe, 'Sulla cronologia assoluta della tarda età del bronzo e della prima età del ferro in Italia, nella zona alpina e nella

Germania meridionale', *Civiltà del ferro*, 447–60; *Vom Anfang Roms* (*R.M.*, *Ergänzungsheft* V, 1959); R. Peroni, *Mem. Linc.*, ser. 8, IX (1959), and *Civiltà del ferro*, 463–99. *San Giovenale*, 292 ff. Special studies: Tombs: F. K. von Duhn, *Italische Gräberkunde*. Grave circles: Blake (1947), 71; B. Andreae, *Anz.* (1957), 334–8; *L'Età del ferro nella Etruria marittima*, a cura della Soprintendenza alle Antichità d'Etruria di Firenze e dell'Associazione Pro Loco di Grosseto (Grosseto, 1965); for Veii: *N.S.* (1965), 49–236. Early Iron Age village submerged below the Lake of Bolsena; A. W. Van Buren, 'News Letter from Rome', *A.J.A.*, LXX (1966), 354.

2. For south Italy: L. Bernabò Brea and Madeleine Cavalier, *Mylai* (Novara, 1959), and L. Pareti in *Greci e Italici in Magna Graecia* (Naples, 1962), 155–7, with the review of Emeline Hill Richardson, *A.J.A.*, LXVIII (1964), 408 f.; D. Mustilli, 'Importazione e contatti culturali tra Magna Grecia ed Italia settentrionale', *Università di Torino. Pubblicazioni della facoltà di lettere e filosofia*, XIV, 4 (1963), 38 f. K. Kilian, 'Beitrag zur Chronologie der Nekropole Sala Consilina. Die Teilnekropole S. Antonio-S. Nicola', *Apollo*, II (1962), 81–103. J. de la Genière, 'Rapports chronologiques entre les vases géometriques et les objets de bronze dans la nécropole de Sala Consilina', *Apollo*, II (1962), 43–56.

3. By 'Oscans' I mean the old, Indo-European tribes of Campania and Samnium before the Etruscans and before the Samnites of central Italy and the eastern coast invaded Campania in the fifth century B.C. The Oscans of the coastal plain were no doubt akin to the Samnites of the mountains of central Italy and the eastern coast. Primitive Rome: Plutarch, *Romulus*, IX, XI; Dionysius, I, 88; F. Castagnoli, *Ippodamo*, 67–72; 'Roma quadrata', *Arch. Cl.*, XVI (1964), 178–80, with references and bibliography, to which Y. Hedlund, 'Mundus', *Eranos*, XXXI (1933), 53–70, must be added. For the Terramare and their supposed regular planning, see Chapter 1, Note 6, and Castagnoli, *Ippodamo*, 9–10.

4. Rapino: *Anz.* (1959), 224 f.; *Studi Calderini-Paribeni*, III (1956), 311 f.

5. Dionysius, I, 88; Macrobius, V, 19.13; C. O. Thulin, *Die Ritualbücher ... Göteborgs Högskolas Årsskrift*, I (Gothenburg, 1909), 3–10. For the rite in the Roman colonies see the well-known relief from Aquileia in addition to coins like those of Beirut: R. Mouterde and J. Lauffray, 'Beyrouth, ville romaine', *Publications de la*

direction des antiquités de Liban. Villes libanaises,
I (Beirut, 1952). Pomerium and Argeorum
Sacraria: Platner-Ashby, *s.v.* Tacitus, *Ann.*, XII,
24; Livy, I, 44; Serv. ad Aen., V, 755. See also
Momigliano, *J.R.S.*, XXXIII (1943), 121; Agnes
Kirsopp Michels, 'The Topography and Interpreta-
tion of the Lupercalia', *T.A.P.A.*, LXXXIV (1953),
35 ff.; von Gerkan, *Rh. M.*, XCVI (1953), 27 ff., and
Gjerstad, *Early Rome*, III, 44. Bologna: *N.S.* (1960),
291.

6. Gjerstad, *Early Rome*, II, 282–6; III, 48–78,
reviewed by P. Romanelli, *Gnomon*, XXXVI (1964),
816–23. Ash urn from Vulci with volutes and birds:
Andrén, *Origine*, 54, figure 21. M. Marella Vianello,
Antichità, II (1950); G. Carettoni, *B.P.I.*, LXIV
(1954–5), 261 ff.; *San Giovenale*, 293 ff., 322, 324.
Riemann, 'Die schwedischen Forschungen in
Südetrurien 1956–1962', *Gymnasium*, LXII (1965),
331–53. Leontini, Syracuse, and Lipari: Bernabò
Brea, *Sicily before the Greeks*, 142 f. and 172 f.
Romanelli, 'Certezze e ipotesi sulle origini di
Roma', *Studi Romani*, XIII (1965), 156 ff.

18 7. The model from Sala Consilina: *Mostra della
preistoria e della protostoria nel Salernitano, Catalogo
1962*, 64, 71, no. 168 (tomba 63), figure 19; *Apollo*,
II (1962), 85, figure 11. Cf. heraldic animals on
the roofs of Etruscan temples, Chapter 3. The
square shafts of Luni and San Giovenale: *San
Giovenale*, 298. Flood danger makes it perhaps less
likely that the sunk rooms were themselves habita-
tions rather than basements below protecting
buildings above. For contemporary Greek houses
cf. H. Drerup, 'Zum geometrischen Haus',
Marburger Winckelmann-Programm, 1962; 'Grie-
chische Architektur zur Zeit des Homers', *Anz.*
(1964), 180–219; Gierow, *The Iron Age Culture of
Latium*.

19 8. J. Sundvall, 'Die italischen Hüttenurnen';
W. R. Bryan, 'Italic Hut Urns and Hut Urn
Cemeteries', *P.A.A.R.*, IV (1925); Gjerstad, *Early
Rome*, II; Gierow, *The Iron Age Culture of Latium*;
'A Latial Iron Age Tomb-Group', *The Museum
of Mediterranean and Near Eastern Antiquities,
Bulletin No. 2* (Stockholm, 1962), 32–8; Andrén,
'An Italic Hut Urn without Floor', *ibid.*, *Bulletin
No. 4* (1964), 30–7; Müller-Karpe, *Vom Anfang
Roms* (with unfounded theories about affinities with
Crete and Este), 45–51. Interpretation of the ridge-
logs: Andrén, *Architectural Terracottas*, XXV f.
Stripes of tin: Berta Stjernquist, 'La Decorazione
metallica delle ceramiche villanoviane in una
nuova illustrazione', *Civiltà del ferro*, 431 ff. The lid

of the stele from Tarquinia (Figure 10) is discussed
by Andrén, *Origine*, 55.

9. Solinus, *Collectanea rerum memorabilium*, I, 21; p. 20
Ovid, *Tristia*, III, 1, 29–30; *Fasti*, VI, 263 ff.;
Plutarch, *Numa*, 14; Cassius Dio, fragment 6.2;
Serv. ad Aen., VII, 153. Gjerstad, *Early Rome*, III,
310–20 with references to A. Bartoli's excavations,
Rend. Pont., XXI (1945–6), 5 ff., *Mem. Linc.*, XLV
(1959), 19–68, and others. Recent excavations by
F. E. Brown (1964–6) have revealed remains of
the Early Iron Age village along the Via Sacra
below the regia of – probably – about 500 B.C.:
F. E. Brown, 'New Soundings in the Regia; the
Evidence for the Early Republic', *Entretiens sur
l'antiquité classique*, XIII (Fondation Hardt, 1967),
45–60 (rectangular huts with curved corners).

10. Cassius Dio, XLVIII, 43; Livy, 29. The hut p. 21
appears still in the *Libellus de regionibus Urbis Romae*,
Regio X in the fourth century A.D.; Romanelli,
Studi Romani, XIII (1965), 156 ff. For other sources:
Fontes, VIII, 1. liber XIX; Regio X (Palatine), 51 ff.
There was also a *tugurium Faustuli*; Solinus, *Col-
lectanea rerum memorabilium*, I, 18. Both were on the
south-western slope of the Palatine: Castagnoli,
Arch. Cl., XVI (1964), 174 f. For the prolonged life
of traditions from the huts of the Early Iron Age to
Roman times (and onwards): F. Barbaranelli,
B.P.I., N.S. X (1956), 455–89.

11. A useful analysis of the influence from the p. 22
Eastern world: J. Boardman, *The Greeks Overseas*
(London, 1964). For Ischia: G. Buchner, *Atti M.
Grecia*, N.S. I (1954), 11 ff.; *R.M.*, LX–LXI (1953–4),
37 ff.; *Rend. Linc.*, ser. 8, X (1955), 215 ff. Marghe-
rita Guarducci's explanation of the inscription
about Nestor's cup, *Rend. Linc.*, ser. 8, XVI (1961),
3–7, seems to me evident. Suggestions that Nestor
was only one of the seamen are far-fetched and
contrary to the Homeric style of the text, which, in
any case, proves Homeric influence. T. B. L.
Webster, *From Mycenae to Homer* (1964), 170, 210;
G. Buchner, 'Pithekoussai, oldest Greek Colony in
the West', *Expedition*, VIII, 4 (1966), 4–12. A
useful summary about the Greeks and Italy is
given by E. Wikén, *Die Kunde der Hellenen von dem
Lande und den Völkern der Apenninenhalbinsel bis
300 v. Chr.* (Lund, 1937).

12. Varro, *Lingua Latina*, VII, 35; cf. V, 32. I have p. 23
collected material proving that Etruscan was the
language of the whole population of Etruria and
wholly different from Latin (*San Giovenale*, 36).
The names of the Tiber prove the same: *Lydia
ripa*, Statius, *Silvae*, IV, 4. 4; *ripa veientana*; Horace

(to Maecenas), *Odes*, I, 20, 5 f., *paterni fluminis ripae*; and others. Important is Dionysius's statement (I, 30) that the Etruscan language was unlike all known languages, cf. v, 28; Livy, IX, 36; x, 4. Latin occurs only in the latest of the thousands of Etruscan tomb inscriptions, when the Roman influence gradually became more dominant than before.

p. 24 13. The different tales about the Etruscans are best summarized in *P.W.*, *s.v.* Tyrrhener. Important is what the Emperor Claudius says about Etruscan history in his decree about Lyon; *C.I.L.*, XIII, I, 1668. For the archaeological material: Å. Åkerström, *Studien über die etruskischen Gräber* (*Acta Rom. Suec.*, III) (1934); Margarete Demus Quatember, *Etruskische Grabarchitektur* (Baden-Baden, 1958); Luisa Banti, *Il Mondo degli etruschi* (Rome, 1960); Emeline Hill Richardson, *The Etruscans* (Chicago, 1964); T. J. Dunbabin, *The Western Greeks* (Oxford, 1948); Boardman, *The Greeks Overseas*, 103. Above all, M. Pallottino, *Etruscologia*, 6th ed. (Milan, 1968), and *Le Origini storiche dei popoli italici* (Florence, 1955). Pallottino is the leading authority among the defenders of Italic origin of the Etruscans. See also studies connected with *The Ciba Foundation Symposium on Medical Biology and Etruscan Origins* (1958); J. B. Ward-Perkins, 'The Problem of Etruscan Origins', *Harvard Studies in Classical Philology*, LXIV (1959), 1–26; H. Hencken, 'A View of Etruscan Origins', *Antiquity*, XL (1966), 205–11.

For different opinions: A. Furumark, *Det äldsta Italien*, 161 ff., discusses the tradition about the Tyrsenians from Lemnos as the most probable ancestors of the Etruscans in Italy. G. Säflund, *Historia*, VI (1957), 10–22, identifies the population of the Early Iron Age and their new settlements ('the Villanovans') with Etruscan immigrants. Recent excavations at the Banditaccia cemetery of Cerveteri reveal Early Iron Age tombs among and below the Etruscan tombs. They have been interpreted as remains of a continuous development and intermediate links. To my mind, here the complex only proves that the Etruscans usurped the Iron Age cemetery and that their new types of tomb in some cases influenced the old, local population. Very important in any case is R. E. Linington's article 'Prospezioni geofisiche a Cerveteri', *Palatino* x, 2 (1966), 147–57. See also P. Bosch-Gimpera, 'Réflexions sur le problème des Etrusques', *Melanges offerts à A. Piganiol* (École pratique des hautes études – VIe section, Centre de recherches historiques, Paris, 1966), 639–53.

14. It has to be borne in mind that nothing in our present material from Lydia reveals an emigration corresponding to Herodotus's tale and the different dates suggested by ancient sources, which can be combined with what archaeological finds from Italy attest. For Lydia: G. A. Wainwright, *Anatolian Studies*, IX (1959), 197 ff.; G. M. A. Hanfmann, 'Sardis und Lydien', *Akademie der Wissenschaften und Literatur in Mainz. Abhandlungen. Geistes- und Sozialwissenschaftliche Klasse, 1960*, especially 510 f. and 523 f. and the reports from the excavations in Sardes, *B.A.S.O.R.*, CLXXIV (1964), with references to preceding campaigns, p. 3. During Hanfmann's seventh campaign at Sardes (1964), a hellenistic Lydian inscription was found; *B.A.S.O.R.*, CLXXVII (1965), 10.

CHAPTER 3

1. The Celts: T. G. E. Powell, *The Celts* (*Ancient* p. *Peoples and Places*) (London, 1958); C. Fox, *Pattern and Purpose* (Cardiff, 1958); G. A. Mansuelli and R. Scarani, *L'Emilia prima dei Romani* (Milan, 1961); C. Peyre, 'L'Armament défensive des Gaulois en Émilie et en Romagne', *Studi romagnoli*, XIV (1965), bibliography, 82–103. Among other items, the invention of the genuine iron horseshoe about 430 B.C., F. M. Heichelheim, *An Ancient Economic History from the Palaeolithic Age to the Migrations of the Germanic, Slavic and Arabic Nations*, English ed. (Leiden, 1964), 88. *Archaeology*, XIII (1960), 251. The La Tène culture of the Celts, etc.: P. Lambrechts, 'Geschichte des Weltkeltentums und der Iberer', *Abriss der Geschichte antiker Randkulturen*, new ed. by Lambrechts, F. Altheim and others, *Oldenbourg, Abriss der Weltgeschichte* (1966), 3 ff. The Roman compendia of Etruscan religious 'Libri', M. Pallottino, *Etruscologia*, 230 f.

2. Opus craticium (later use): A. Scherbantin, p. 'Die Ausgrabungen auf dem Magdalensberg 1958–1959', *Carinthia*, CLI (1961), 49–74. Ashlar work (full survey): Blake (1947), 276–81; Lugli, *Tecnica edilizia*, 529–41. Timber and mud-brick: Ducati, 376–7, plates 162–3; Marzabotto: Mansuelli, *I.L.N.* (13 October 1962), 557; Vetulonia: I. Falchi, *N.S.* (1895), 272–7; Blake (1947), 75; E. Stefani, *N.S.* (1922), 379 ff.; Veii: J. B. Ward-Perkins, 'Excavations beside the North-West Gate at Veii 1957–1958', *P.B.S.R.*, XIV (1959), 58–67; Rome: Gjerstad, *Early Rome*, I, 130–48; Rusellae: Clelia Laviosa, *St. Etr.*, XXXIII (1965), 49–108 (with references to the four earlier campaigns of excava-

tion and bibliography); H. Riemann, *Gymnasium*, LXXI (1964), 115.

3. Walls of Arretium published by L. Pernier, *N.S.* (1920), 171–90. Average measurement: 44 by 29 by 14 cm. (17⅓ by 11½ by 5½ in.), roughly corresponding to Vitruvius's Lydian bricks (II, 3. 3 = Pliny XXXV, 171, 173) and bricks from Vetulonia measuring 45 by 30 by 11 cm. (17¾ by 11⅘ by 4⅓ in.). Bricks from Veii 30 by 23 by 15 cm. (11⅘ by 9 by 6 in.); Blake (1947), 276 ff. See further: Ducati, 365 f.; R. Naumann, *R.M.*, *Ergänzungsheft*, III (1958), 17 f.

29 4. For the flood of 54 B.C.: Dio Cassius, XXXIX, 61. 2. The famous words ascribed to Augustus (Suetonius, *Augustus*, XXVIII) generalize in a misleading way. He adorned the town with marble columns and marble-faced temples, but the domestic architecture of his age was mostly built of concrete and covered by opus reticulatum.

5. Blake (1947), 278; Lugli, *Tecnica edilizia*, and for the terracottas, Andrén, *Architectural Terracottas*; L. and Emeline Richardson, *Cosa*, II; Å. Åkerström, 'Untersuchungen über die figürlichen Terrakottafriese aus Etrurien und Latium', *Opus. Rom.*, I (1954), 191–231; Elisabeth D. Van Buren, *Figurative Terracotta Revetments in Etruria and Latium in the VI and V Centuries B.C.* (London, 1921); R. Bianchi Bandinelli, 'Arte etrusca e arte italica', *Enciclopedia dell'arte antica classica e orientale*, III (Rome, 1963), 476–503; Vagn Poulsen, 'Etruscan Art', *San Giovenale*, 361 ff.; S. Moscati and M. Pallottino, 'Rapporti tra Greci, Fenici, Etruschi ed altre popolazioni italiche alla luce delle nuove scoperte', *Accademia dei Lincei*, CCCLXIII (1966), 87. To be added after the Italian-Swedish excavation of 1967 are some 1,500 terracottas (sixth-century), all found in the remains of one temple at Ferentum (Ferento, Acqua Rossa).

6. Piazza d'Armi, Veii: Stefani, *Mon. Ant.*, XL (1944), 178 ff.; Andrén, *Architectural Terracottas*, 8 ff.; idem, *Origine*, 24, figure 2; Ward-Perkins, *P.B.S.R.*, XVI (1961), 25 ff. Volsinii: R. Bloch, *Mél. Rome*, LXIII (1950), 53 ff.; G. Maetzke, *St. Etr.*, XXIV (1955–6), 252; Andrén, *Origine*, 24 ff. The temple, however, is hardly earlier than the third century B.C.; cf. G. Colonna, *St. Etr.*, XXXIII (1965), 200, note 19.

30 7. Andrén, *Architectural Terracottas*, 453–7. We now can compare also the smaller Temple (B) at Pyrgi (Figure 17), where a Punic-Greek origin has been suggested (see below, Note 14).

31 8. Andrén, *Architectural Terracottas*, XXI ff.;

and *Origine*; Agnes Kirsopp Lake Michels, 'The Archeological Evidence for the "Tuscan Temple"', *M.A.A.R.*, XII (1935), 136 ff.; Luisa Banti, 'Il Culto del cosiddetto "Tempio del Apollo" a Veii e il problema delle triadi etrusco-italiche', *St. Etr.*, XVII (1943), 187–224, and *Il Mondo degli Etruschi*, *passim*; Polacco, 80 ff.; M. Cagiano de Azevedo, 'I "Capitolia" dell'Impero Romano', *Mem. Pont.*, V (1940–1), 1–76; Maetzke, 'Il Nuovo Tempio tuscanico di Fiesole', *St. Etr.*, XXIV (1955–6), 227–53; Piera Bocci, 'Nuovi Scavi', *St. Etr.*, XXIX (1961), 411–15. Reproductions of temples: Andrén, *Architectural Terracottas*, XXIV–XXXIV.

9. Andrén, *Architectural Terracottas*, XLI–XLVII; Maetzke, *St. Etr.*, *loc. cit.*, 247; F. Castagnoli, 'Peripteros sine postico', *R.M.*, LXII (1955), 139–43; A. Boëthius, 'Veteris capitoli humilia tecta', *Acta Instituti Romani Norvegiae*, I (1962), 28, note 1. *Alae* is a modern reading for *aliae* of the ms. I am convinced that the emendation is right and use it, in any case, like Morgan as a terminus technicus for the open, colonnaded wings outside the cella walls. S. Ferri, *Studi classici e orientali*, Pisa, VI (1957), 235 ff., defends *aliae*; cf. C. Fensterbusch, *Vitruvius*, note 244.

10. E. Gjerstad, 'A proposito della ricostruzione p. 33 del tempio arcaico di Giove Capitolino in Roma', *Acta Instituti Romani Norvegiae*, I (1962), 35–7.

11. Archaic evidence for temples with two columns: Giglioli, CXLVII; Ducati, plate 24; Andrén, *Architectural Terracottas*, XXVI, no. 14; XXX, 32; F. Pfister, 'Il Santuario della Dea Marica alle fori del Garigliano', *Mon. Ant.*, XXXVII (1938), 696–704. General discussion: Andrén, *op. cit.*, XLVII ff. Late specimens: Andrén, *op. cit.*, XXXII–XXXIV, nos. 41, 47; idem, *Origine*, 35 f.; G. Becatti, 'Un Rilievo con le oche capitoline', *Bull. Comm.*, LXXI (1943–5), 31–8; Nash, *s.v.* Juno Moneta. Largo Argentina: Temple A, first period: G. Marchetti-Longhi, 'L'Area sacra del Largo Argentina', *Itinerari* (1960); Crema, 42. Teano: W. Johannowsky, 'Modelli di edifici da Teano', *B. d'Arte*, XLVII (1962), 63 f. Alatri: Andrén, *Architectural Terracottas*, 390 f., figure 36. Temples with four or more columns in the pronaus; the fourth-century temple excavated by M. Torelli between Pyrgi and Civitavecchia with a cella measuring 26 by 26 ft (8 by 8 m.), no alae, and columns only in the pronaus: *I.L.N.* (6 May 1967), 24. For Roman specimens: *Cosa*, II, 45. For the future of the Roman temples with a cella, no alae, and four or more columns in the pronaus, cf. the Maison

Carrée or – among others – B. Cunliffe's reconstruction of 'The Temple of Sulis Minerva at Bath', *Antiquity*, XL (1966), 199–204.

p. 34 12. Vitruvius, IV, 7 (Morgan's translation): '1. The place where the temple is to be built having been divided on its length into six parts, deduct one and let the rest be given to its width. Then let the length be divided into two equal parts, of which the inner be reserved as space for the cellae, and the part next to the front left for the arrangement of the columns. 2. Next let the width be divided into ten parts. Of these, let three on the right and three on the left be given to the smaller cellae, or to the alae if there are to be alae, and the other four devoted to the middle of the temple. Let the space in front of the cellae, in the pronaus, be marked out for columns thus: the corner columns should be placed opposite the antae on the line of the outside walls; the two middle columns, set out on the line of the walls which are between the antae and the middle of the temple; and through the middle, between the antae and the front columns, a second row, arranged on the same lines.' (Cf. the reconstruction on Plate 12.) It is important for the discussion about the height of the columns, etc., to observe that Vitruvius discusses temples with three cellas without alae (or temples with one cella and alae), while the Capitoline Temple had colonnaded wings outside its three cellas.

p. 35 13. Luisa Banti, *St. Etr.*, XVII (1943), 197–210; Polacco, 94–100. Veii: Ward Perkins, *loc. cit.* (Note 6); U. Bianchi, 'Disegno storico del culto capitolino nell'Italia romana e nelle provincie dell'Impero', *Mem. Linc.*, ser. 8, 11 (1949), 349.

14. Ara della Regina at Tarquinia: P. Romanelli, *N.S.* (1948), 238 ff. Acropolis temple of Ardea: Stefani, *N.S.* (1944–5), 81 ff.; Andrén, *Origine*, 28–30, note 6. Portonaccio Temple of Veii: Stefani, *N.S.* (1953), 29–112; Andrén, *op. cit.*, 26 ff. Pyrgi: *Arch. Cl.*, XIII (1961), 240–2; XV (1963), 248–55; XVI (1964), 49–117 ('Relazione preliminare della settima campagna, 1964, e scoperta di tre lamine d'oro inscritte in etrusco e in punico'), plate XXV; Colonna, 'Il Santuario di Pyrgi alla luce delle recenti scoperte', *St. Etr.*, XXXIII (1965), 192–209. Colonna maintains that Temple B is earlier and displays Punic-Greek influence, while he dates the typically Etruscan (Vitruvian) Temple A to the first decades of the fifth century: *Arch. Cl.*, XVIII (1966), 85–102; Pallottino, 'I Frammenti di lamina di bronzo con iscrizione scoperti a Pyrgi', *St. Etr.*, XXXIV (1966), 175 f. For the history of the temple:

Diodorus, XV, 14. 3; Strabo, V, 2. 8. Fundamental for the study of Etruscan and Roman architecture is *Etruscan and Republican Roman Mouldings* by Lucy T. Shoe (Mrs Benjamin D. Meritt). I insist that the Etruscan mouldings have to be understood in connexion with the common Archaic architecture of the Near East – such as the seventh-century 'Lydian' wall of the central mound at Bin Tepe near Sardes (*B.A.S.O.R.*, CLXXVII (1965), 32, figure 30, and CLXXXII (1966), 27–30) and the gradually refined Greek mouldings. All the same, I admire Miss Shoe's convincing analysis of the 'Etruscan round', as it presents itself in a highly original and dynamic shape about 500 B.C. in the rock-cut foundations of the tumuli at Caere, and retains a tactile quality even when hellenistic taste started its overwhelming influence both in Etruria and Rome. Miss Shoe emphasizes in a brilliant way the difference between the Greek and otherwise individual later Roman progressive refinement of the mouldings and the untrammelled spirit of the Etruscans. The Etruscans, in their typical, free manner, disregarded accepted rules and developed their own shapes, as the impression produced on the spectators by the structures seemed to require. This creative Etruscan architectural decoration belongs to the essential prerequisites for its Roman offspring. The powerful Etruscan boldness of conception has to be brought into special prominence even when Etruscan capitals develop Greek prototypes, as for instance in the Tomba delle Colonne Doriche at Caere (cf. Lucy Shoe, 128, XXXVII, 2, and Boëthius, 'Of Tuscan Columns', *A.J.A.*, LXVI (1962), 25) or in the Etruscan Aeolic capitals. On the other hand, of course, the evident basic Greek influence must be borne in mind, notwithstanding the fact that the Etruscans strongly remodelled what they borrowed. For the podia, cf. especially Lucy Shoe, *op. cit.*, 83–94.

15. Tomba Ildebranda: Bianchi Bandinelli, p *Sovana*, 76–86; Castagnoli, *R.M.*, LXII (1955), 142; Margarete Demus-Quatember, *Etruskische Grabarchitektur*, 39.

16. Maetzke, *loc. cit.* (Note 8); Piera Bocci, *St.* p. *Etr.*, XXIX (1961), 411–15; R. Bartoccini, 'Tre Anni di scavi a Vulci', *Atti del VII congresso internazionale di archeologia classica*, II (Rome, 1961), 274, plate XII; Andrén, *Origine*, 31 ff.

17. Contrada Celle at Falerii, and Belvedere at p. Orvieto: Andrén, *Architectural Terracottas*, 81–8, 166 f.; and *Origine*, 28. Marzabotto: Andrén,

Architectural Terracottas, 314 f.; *I.L.N.* (13 October 1962), 556, figure 1.

40 18. Dionysius, III, 69 f.; IV, 59; Livy, I, 55, 56. 1; X, 23. 12; XL, 51. 3; Pliny, XXVIII, 14 ff.; XXXIII, 57, 111–12; XXXV, 157; XXXVI, 104, 185. For other references: Platner-Ashby and Nash.

42 19. For the remains on the Capitoline Hill: Gjerstad, *Early Rome*, III, 168–81; *San Giovenale*, 151 ff. I repeat that Vitruvius describes a temple with three cellas and eight columns in the pronaus, while the Capitoline Temple had columns along both sides (alae) and in front of the pronaus, which thus had eighteen columns in front of the temple. For rough substructures below podia and city walls: Ward-Perkins, *P.B.S.R.*, XXIX (1961), 34 ff., and Stefani, *N.S.* (1944–5), 83, figure 3.

43 20. Gjerstad, *Early Rome*, III, 168–77. Temple C in the Largo Argentina: Marchetti-Longhi, *Bull. Comm.*, LX (1932), 280–306; 'L'Area sacra del Largo Argentina', *loc. cit.* (Note 11); Crema, 42.

21. The temple of Ardea: Stefani, *N.S.* (1954), 14; Andrén, *Architectural Terracottas*, 447–52; Lucy Shoe, *Etruscan and Republican Roman Mouldings*, 20–2, 83–6. Altars: Shoe, *op. cit.*, 94–109; Castagnoli, 'Sulla tipologia degli altari di Lavinio', *Bull. Comm.*, LXXVII (1959–60), 145–72, and my remarks, *A.J.A.*, LXVI (1962), 250 ff.

22. For the temple of 69 B.C. see below, p. 137 f. Vitruvius's rule for the columns (IV, 7) is:

'2. Let the thickness of the columns at the bottom be one seventh of their height, their height one third of the width of the temple, and the diminution of a column at the top, one fourth of its thickness at the bottom.

'3. The height of their bases should be one half of that thickness. The plinth of their bases should be circular, and in height one half of the height of the bases, the torus above it and congee being of the same height as the plinth. The height of the capital is one half the thickness of a column. The abacus has a width equivalent to the thickness of the bottom of a column. Let the height of the capital be divided into three parts, and give one to the plinth (that is, the abacus), the second to the echinus, and the third to the necking with its congee.'

Commentary: Andrén, *Architectural Terracottas*, XLIX ff. For the measurements of Greek temples: W. B. Dinsmoor, *The Architecture of Ancient Greece* (London and New York, 1950), 337 ff. Dr P. Åström has checked the height of the columns of the Olympieion. Gjerstad, *Acta Instituti Romani*

Norvegiae, I (1962), 35–40 points out that Vitruvius's description of the Capitoline Temple as 'low' (*humilis*) in his paragraph about the aerostyle buildings (III, 3. 5) as it stands, if not a misplaced recollection of the old temple, refers to the temple of 69 B.C. Further discussion: Boëthius, 'Nota sul Tempio Capitolino e Vitruvio III, 3. 5', *Arctos*, N.S.V (1968).

23. Gjerstad, *Early Rome*, III, 423 f., figure 266. p. 44

24. Tuscan columns are presented in a masterly way by Lucy Shoe, *Etruscan and Republican Roman Mouldings*, 115 ff. Against scholars who have assumed an internal Italic or Mycenaean pre-history for Tuscan columns (Ducati, 92; Andrén, *Architectural Terracottas*, LIV f., and others), see Boëthius, *A.J.A.*, LXVI (1962), 249–54; Polacco, 55–68. The oldest Tuscan columns: Polacco, plate VI; Fiesole: *St. Etr.*, XXIX (1961), 413 f.; Vignanello: G. Q. Giglioli, *N.S.* (1916), 41–4. For Morgantina, see E. Sjöqvist, *A.J.A.*, LXII (1958), 160, and R. Stillwell, *A.J.A.*, LXV (1961), 279. It is interesting that Inigo Jones also had a special feeling for the Tuscan order as being the most primitive of the five orders and closest to the vernacular (Sir John Summerson, 'Inigo Jones', *Proc. Brit. Ac.*, L (1964), 174–6).

25. Forum Boarium: Gjerstad, *Early Rome*, III, 185 f., 448, figure 281, 1–2. Vulci: Polacco, 64, plate VI, 16; Ducati, 394, figure 453 f. For Aeolic capitals, see Plate 35; Antonia Ciasca, *Il Capitello detto Eolico in Etruria* (Florence, 1962); Lucy T. Shoe, *A.J.A.*, LXVIII (1964), 409 f. Doric capitals: *St. Etr.*, I (1927), 167, plate XLVI B; *San Giovenale*, 71.

26. 'Peopled capitals': Tomba Ildebranda, see p. 46 Note 15. Norchia: Polacco, 64 ff.; G. Rosi, *J.R.S.*, XV (1925), 42–7; E. v. Mercklin, *Antike Figuralkapitelle* (Berlin, 1962).

27. Vitruvius's words about a tympanum 'either p. 48 of masonry or wood' reveal that he could have had a Late Etruscan or Republican stone-built temple in mind. Stillicidium: Andrén's commentary in *Architectural Terracottas*, LXII–LXVI; *idem*, *Eranos*, XLIII (1945), 1–22; *idem*, *Origine*, 38 ff. Morgan's translation is of course impossible for greater temples, as pointed out by Andrén, Gjerstad, *Early Rome*, III, 185, note 4, and others. Other explanations: *Cosa*, II, 36 f. (tertiarius one third of the width of the cella); F. von Reber, *Des Vitruvius zehn Bücher über Architektur* (Stuttgart, 1865), 122 (one third of the height of the columns). The model

from Nemi: Andrén, *Architectural Terracottas*, XXXI, no. 37, and for the reconstruction LXIV f., LXVIII f.; M. Moretti, *Museo di Villa Giulia* (Rome, 1963), 233 f. Drip-lines: Temple of the lower town of Ardea, *N.S.* (1954), 10 f., 13; Andrén, *Origine*, 36. Capitolium of Cosa: *Cosa*, II, 86 f., 91, figure 65. Temple D at Cosa: *Cosa*, II, 33 f., 39, figure 24. Gabii: M. A. Basch, 'Las Excavaciones españolas en Gabii', *Atti del VII congresso internazionale di archeologia classica*, II (1961), 243–7. For the naiskoi of Sicily (Morgantina, Sabutina near Caltanisetta): Sjöqvist, *A.J.A.*, LXVIII (1964), 147; P. Orlandini, *Arch. Cl.*, XV (1963), 86–96, plates XXVII f. Fensterbusch, *Vitruv*, translates *stillicidium tecti absoluti*: 'ein Drittel des fertigen Daches'.

p. 50 28. *Cosa*, II, 206 ff., figures 22, 46. The temple from Satricum: Andrén, *Architectural Terracottas*, XXXII f., figures 7–8; Moretti, *op. cit.*, 263. Model of temple from Heraion: H. Drerup, *Anz.* (1964), 194, figure 6.

p. 51 29. Terracotta models: Andrén, *Architectural Terracottas*, XXV–XXXIV.

30. Caere: fragments of pedimental sculpture. *Ny Carlsberg Glyptothek. Den etruskiske samling* (Copenhagen, 1966), 29, no. 168 (with bibliography). Tarquinia: Romanelli, *N.S.* (1948), 254 f. For the terracottas from Cività Alba, Andrén, *Architectural Terracottas*, 298–300, plates 98–100. Capricious decoration: in addition to the Belvedere Temple of Orvieto, cf. fragments from Arretium (Arezzo), Maetzke, *B. d'Arte*, XXXIV (1949), 251 ff. Antefixes of Ardea: Andrén, 'Om figurdekoren i etrusko-italisk tempelarkitektur', *Arkeologiska forskningar och fynd utgivna med anledning av H.M. Konung Gustaf VI Adolfs sjuttioårsdag* (Stockholm, 1952), 125, note 12; *Opus. Rom.*, III (1961), 50–2, plates XX–XXI. Archaic gable in the Ny Carlsberg Glyptothek: *San Giovenale*, 57, figure 58. Pyrgi: *Arch. Cl.*, XIII (1961), 240–2; XVI (1964), 54–6. Other terracottas: *Arch. Cl.*, XVI (1964), 56, plates XXXI–XXXIII. Talamone: Andrén, *Architectural Terracottas*, 227 ff., plates 82, 83; O. W. von Vacano, 'Ricerche sul Tempio di Talamone', *N.S.* (1962), 297–300; Giglioli, CCCXXV. Orvieto (Via di S. Leonardo): Andrén, 160 f., plates 59–61 (dated by Andrén to the last quarter of the fifth century, while Luisa Banti, *Il Mondo degli etruschi*, 83, regards them as classicistic first-century art). Belvedere: Andrén, 171 ff., plates 64–7. Cività Castellana (Lo Scasato): Andrén, *op. cit.*, 125–30, plates 46–8.

31. For the Greek background of Italic terracotta decoration, Åkerström, *Die arkitektonischen Terrakotten Kleinasiens* (*Acta Ath. Suec.*, XI, 1966); and, in addition, Andrén, *Architectural Terracottas*. For central Italy: Åkerström, 'Untersuchungen über die figürlichen Terrakottafriese aus Etrurium und Latium', *Opus. Rom.*, I (1954), 191 f.; G. Kaschnitz von Weinberg, *Das Schöpferische in der römischen Kunst*, 98 ff. Retardation: Elisabeth Jastrow, 'Abformung und Typenwandel in der antiken Tonplastik', *Opus. Arch.*, II (1941), 1–28. Etruscan marble statues: Andrén, 'Marmora Etruriae', *Antike Plastik*, VI (1967).

32. Antefixes and protective decoration in central Italy: Andrén, *Architectural Terracottas*, CXVI–CCXLII. For antefixes of Ardea and retardation, *loc. cit.*, and Andrén, 'Om figurdekoren i etrusco-italisk tempelarkitektur' (*loc. cit.*, Note 30), 125 ff., figures 2–3.

33. Fratte (Marcina; Strabo, V, 4. 13): *Anz.* (1956), 447–50. Capitoline Temple: Pliny, XXVIII, 16; XXXV, 157; Plutarch, *Publicola*, 13 ff.; Livy, X, 23. 12, and Platner-Ashby, *s.v.* Spiral ornaments from Forum Boarium: Gjerstad, *Early Rome*, 187, 448, figure 280, 1–6. Spirals above the pediment: coin of M. Volteius M. f., H. A. Grueber, *Coins of the Roman Republic in the British Museum*, I (London, 1910), 388, plate XLII, I, circa 78 B.C. It is in all other details different from the Capitoline Temple of 509 B.C. It seems to me unlikely that all the tympana were decorated in this way. Probably the spiral ornaments adorned only the apex.

34. Portonaccio Temple of Veii: Stefani, *N.S.* (1953), 50, 111; Pallottino, 'Il Grande Acroterio femminile di Veio', *Arch. Cl.*, II (1950), 122–79. Other sculpture on ridge-poles: sarcophagus from Cerveteri (Procoio di Ceri), Moretti, *Museo di Villa Giulia* (*op. cit.*, Note 27), 91, figure 56; Vagn Poulsen, *San Giovenale*, figures 387–9; Giglioli, CXXXV, 2, CLVIII, 4. For Sicily and Magna Graecia: Andrén, *Architectural Terracottas*, CVII (with references). Elisabeth D. Van Buren, *Archaic Fictile Revetments in Sicily and Magna Graecia* (London, 1923), figures 72, 73.

35. To be added to Andrén's commentary is the fine appreciation of the classicistic style by L. Richardson in *Cosa*, II, 281–4.

36. Plates of bronze: L. Pareti, *La Tomba Regolini-Galassi del Museo Gregoriano Etrusco* (Città del Vaticano, 1957), 239–44, no. 217; 289 f., no. 238; plate XXXII; Vagn Poulsen, *San Giovenale*, figures 342–4, 368 f. Pyrgi: *Arch. Cl.*, XVI (1964),

plates XXXIV–XXXIX. Aedicula on the Via Appia: Serv. ad Aen., I, 8. Bronze gates of the Servian Wall: G. Säflund, *Le Mura di Roma repubblicana*, 199. Porta Raudusculana: Varro, *Lingua Latina*, v, 163; Valerius Maximus, *Memorabilia*, v, 6. 3. The gate of Collatia: Ovid, *Fasti*, II, 785. The aedicula of Concordia: Pliny, XXXIII, 19; Livy, IX, 46. Bronze revetments from Nemi and Palestrina: Andrén, *Architectural Terracottas*, CXXVI, 379 and 383 f.; Moretti, *Museo di Villa Giulia* (*op. cit.*, Note 27), 233, figure 164. Oriental, Archaic Greek, and hellenistic background: Palace of Antinous, *Odyssey*, VII, 86; what Herodotus (I, 179) relates about Babylon and Polybius (x, 27. 10 ff.) about Ecbatana, and Livy's description (XLI, 20. 9) of the Temple of Jupiter Capitolinus of Antiochus IV in Antioch, which had walls wholly covered by gilded plates.

55 37. Gjerstad, 'Die Ursprungsgeschichte der römischen Kaiserfora', *Opus. Arch.*, III (1940), 40 ff. Quite different Archaic Greek planning: Birgitta Bergquist, *The Archaic Greek Temenos*, *Acta Ath. Suec.*, XIII (1967). H. P. L'Orange, E. Dyggve, *Det Kongelige Danske Videnskabernes Selskabs Oversigt* (1961–2), 108. Dyggve, *Lindos*, III. *Fouilles de l'Acropole 1902–1914 et 1952* (see Bibliography to Chapter 6), 516–18. Kaschnitz von Weinberg, *Das Schöpferische in der römischen Kunst* (*op. cit.*, Note 31), 55 f., 70. Boëthius, *The Golden House of Nero*, 40 f.

38. Orientation of temples: Thulin, *Die Ritualbücher*, 45; Ragna Enking, *St. Etr.*, XXV (1957), 541–4; S. Weinstock, 'Templum', *R.M.*, XLVII (1932), 95–121; Pallottino, 'Deorum sedes', *Studi in onore di A. Calderini e R. Paribeni*, III (1956), 223–34; Vitruvius, IV, 5; Livy, I, 18. 5–9; Frontinus, *De limitibus*, 27 (= Thulin, *Corpus agrimensorum*, 11). Orientation of altars: Castagnoli, *Bull. Comm.*, LXXVII (1959–60), 155 f. The Capitolium of Cosa (*Cosa*, II, figure 71) shows orientation of altar after an older temple. Vitruvius, IV, 9. For the independent location of altars cf. Marzabotto (Figure 34).

56 39. Urartu: W. Kleiss, 'Zur Rekonstruktion des urartäischen Tempels', *Istanbuler Mitteilungen*, XIII–XIV (1963–4), 1–14. The reconstruction of Kleiss is refuted by Riemann, *Gymnasium*, LXXII (1965), 334. Pallottino, 'Urartu, Greece and Etruria', *East and West*, IX (1958), 39.

40. Thulin, *Die Ritualbücher*, 3–10, 30–41. Roma Quadrata: Chapter 2, Note 3. Castagnoli, *Arch. Cl.*, XVI (1964), 178–80.

41. Veii: *P.B.S.R.*, XXVII (1959), 58–65; XXIX p. 57 (1961), 31 f.; *N.S.* (1922), 379–85. Vetulonia: *N.S.* (1895), 272–7. Rusellae: Clelia Laviosa, *St. Etr.*, XXVIII (1960), 310–37; XXIX (1961), 31–45. Tarquinia: *N.S.* (1948), 218–23; *San Giovenale*, 289 ff.

42. Lugli, *Tecnica edilizia*, 9–153; Blake (1947), p. 60 3–9, 70–90, 250 ff. Luni: Östenberg, *Luni* (see Bibliography to Chapters 1–2). Populonia: A. De Agostino, *St. Etr.*, XXX (1962), 275–82. Veii: *P.B.S.R.*, XXIX (1961), 32–9. Capena: G. D. B. Jones, *P.B.S.R.*, XXX (1962), 140 ff. Cf. Dionysius, IX, 68. 3; Strabo, v, 3. 7. Rusellae: *R.M.*, LXVI (1959), 12, 14, 29 f.; Riemann, *Gymnasium*, LXXI (1964), 115.

43. Thulin, *Die Ritualbücher*, 31 f., and *Corpus agrimensorum*, Hyginus Gromaticus, Constitutio limitum, Thulin, 142 f., 21 ff.; 143, 8–18; 144, 9 ff.; 145, 10 f.; 154, 12 f.; 157, 3–7.

44. It now seems evident that about 600 and even before that the Greeks adopted regular town planning in new towns that had no obstacles to a regular plan: Smyrna (seventh century; cf. J. M. Cook, *The Greeks in Ionia and the East* (*Ancient Peoples and Places*) (London, 1962), 70–4), and in south Italy and Sicily, Selinus, Akragas, Paestum, Metapontum; cf. the summary by A. G. Woodhead, *The Greeks in the West* (*Ancient Peoples and Places*) (London, 1962), 21–3; Castagnoli, *Arch. Cl.*, XV (1963), 180–97.

Castagnoli, *Ippodamo*; Boëthius, *The Golden House of Nero*, 33–54, 187; Ward-Perkins, 'The Early Development of Roman Town-Planning', *Acta Congressus Madvigiani*, IV (Copenhagen, 1958), 109–29; A. von Gerkan, *Griechische Städteanlagen*, 42–61; F. Haverfield, *Ancient Town-Planning* (Oxford, 1913); Boëthius, *Acta Ath. Suec.*, *Opuscula Atheniensia*, I (1953), 172 ff.; M. Bizzarri, *La Necropoli di Crocefisso del Tufo in Orvieto* (Florence, 1962). Via dei Vasi Greci in Cerveteri: J. Heurgon, *La Vie quotidienne chez les étrusques*, 197. Urartian Zernaki Tepe affords us with a grid plan in the Near East of the eighth century, no doubt a link between towns, which inspired the Greeks, and the traditions from the Assyrian and Babylonian cities. C. A. Burney, *Anatolian Studies*, VII (1957), 37–53; Burney, G. R. J. Lawson, *loc. cit.*, x (1960), 177–96; A. L. Oppenheim, *Ancient Mesopotamia* (Chicago, 1965), 138; C. Nylander, 'Remarks on the Urartian Acropolis at Zernaki Tepe', *Orientalia Suecana*, XIV–XV (1965–6), 141–54.

p. 60 45. M. Bizarri, *La Necropoli di Crocefisso del Tufo in Orvieto*, I–II (Florence, 1962–6); Castagnoli, *Ippodamo*, 50, for *strigae* and *scamna*, 100; Ducati, 377 ff.; P. Arias, 'Considerazioni sulla città etrusca a pian di Misano (Marzabotto)', *Atti e memorie della deputazione di storia patria per le provincie di Romagna*, N.S. III (1953), 31–41; Mansuelli, *I.L.N.* (13 October 1962); Mansuelli and Scarani, *L'Emilia prima dei romani* (*op. cit.*, Note 1), 245–64. French excavations at Casalecchio north of Marzabotto reveal another regular town. Drainage: cf. Sheldon Judson and Anne Kahane, 'Underground Drainageways in Southern Etruria and Northern Latium', *P.B.S.R.*, XXXI (1963), 74–99. Spina: N. Alfieri and Arias, *Spina* (Florence, 1958); Heurgon, *op. cit.*, 170 ff.

p. 61 46. Castagnoli, *Ippodamo*, 44–9; Heurgon, *Recherches sur l'histoire, la religion et la civilization de Capoue préromaine* (Paris, 1942); Velleius Paterculus, I, 7, cites Cato, dating Capua to 471 B.C., probably alluding to an expansion of the town for Samnite immigrants, but see Pallottino, *La Parola del passato*, XI (1956), 81–8. The Etruscans in Campania: Boëthius in *Symbolae philologicae O. A. Danielsson dicatae* (1932). Fratte (Marcina) and the Sorrento peninsula: Pliny, III, 70; Strabo, V, 4. 13; P. C. Sestieri, *N.S.* (1952), 163; B. Neutsch, *Anz.* (1956), 355 ff. Etruscan graffiti from Pompeii and Fratte: Luisa Banti, *Il Mondo degli etruschi*, 13 f.; A. Maiuri, *Saggi di varia antichità* (Venice, 1954), 245–51.

p. 63 47. Recent discussion: Lugli, *Tecnica edilizia*, 295–9; Castagnoli, *Ippodamo*, 26–32. Fundamental: von Gerkan, 'Der Stadtplan von Pompei', *Gesammelte Aufsätze*, 144–58; Maiuri, *Mon. Ant.*, XXXIII (1930), 114 ff.; and *N.S.* (1943), 275 ff.

48. Giglioli, CXV, 2. For actors and theatres see below, p. 165, and Sibylle Haynes, 'Ludiones Etruriae', *Festschrift für Harald Keller*, 13–21.

p. 64 49. Heurgon, *La Vie quotidienne chez les étrusques*, 50 f., no doubt understands Diodorus, V, 40. 4 rightly; Diodorus (that is, Poseidonius) speaks about the luxury of the Etruscans and their attending artisan slaves (musicians, dancers and so on), their costly attire and 'demeures particulières de toute sorte c'est d'ailleurs aussi le fait de la plupart des hommes libres'. It is self-evident that Diodorus here is not speaking of atria and domus but of convenient dwellings of the free lower classes and the especially qualified slaves of the aristocratic households (cf. Pliny, II, 99; Appian, *Bellum Civile*, I, 36). Heurgon, *op. cit.*, 79–94, maintains a different view regarding the free lower classes of

Etruscans (with full bibliography). For the agricultural centre near San Giovenale (Sambuco): *San Giovenale*, 313–20.

50. For Vetulonia (and Veii) see Note 41. Marzabotto: Note 45. San Giovenale: *San Giovenale*, 299–305.

51. Megaron at Veii: *N.S.* (1922), 382, figure 3.

52. Sub-Apennine huts with benches of pebbles: Manfria (near Gela): A. W. Van Buren, 'News Letter from Rome', *A.J.A.*, LXV (1961), 387, plate 125; *San Giovenale*, Swedish edition (1960), 306, figures 264 ff. Morgantina: information received from Sjöqvist and Östenberg, *A.J.A.*, LXVIII (1964), 145. Tomba della Casa con Tetto Stramineo: *St. Etr.*, I (1927), 158 f., plate XXIII; R. Mengarelli, Caere: G. Ricci, 'Necropoli della Banditaccia'; Boëthius, 'La Tomba con tetto stramineo', *Palladio* (1965), 1–6; *Opus Rom.*, VI (1968). The same primitive system, of course, also remains if biers were put on the pebble benches.

53. Margarete Demus-Quatember, *Etruskische Grabarchitektur*, refers to this kind of house, 31, figure 5, 33; Åkerström, *Etruskische Gräber*, 30, figure 4. Most important are the plans in Moretti's *Nuovi Monumenti della pittura etrusca* (Milan-Lerici, 1966).

54. Earliest chamber tombs. Seventh-century chamber tombs at Veii: Tomba Campana, Giglioli, XCVI; Tomba delle Anatre, *Arch. Cl.*, XV (1963), 219–22, plates LXXXIV–LXXXVII. Bochoris tomb: M. A. Momigliano, 'An Interim Report on the Origins of Rome', *J.R.S.*, LIII (1963), 105 f. Tomba del Guerriero at Tarquinia: Åkerström, *Etruskische Gräber*, 39 f.; Gjerstad, 'Discussions Concerning Early Rome', *Opus. Rom.*, V (1962), 49, 60 ff. Tomba della Scimmia, Chiusi: Giglioli, CCIV; B. Schweitzer, *Bonner Jahrbücher*, CLXI (1961), 245. Tomba del Cardinale: Ducati, 378, figure 418. Decoration of the interior of tombs: R. Ross Holloway, 'Conventions of Etruscan Painting in the Tomb of Hunting and Fishing at Tarquinia', *A.J.A.*, LXIX (1965), 341–7 (with general discussion of the painted tombs); Emeline Hill Richardson, *The Etruscans* (Chicago, 1964); the Tomba Dipinta of Blera: *R.M.*, XXX (1915), 264 f.; the so-called 'Funeral toilet' wall painting: Maiuri, *Roman Painting* (Geneva, 1953), 23; chamber tomb at Ardea published by Boëthius, *Arkeologiska studier tillägnade H.K.H. Kronprins Gustaf Adolf* (1932), 262–72. Faded remains of paintings at Caere (Cerveteri): Moretti, *Mon. Ant.*, XLII (1955), 1049–135, and Moretti's and E. Berggren's description

of the Porzarago Tomb IX at San Giovenale, *N.S.* (1960), 31 ff. For recent discoveries: C. M. Lerici, *Alla scoperta delle civiltà sepolte* (Milan, 1960), 377–402. Bartoccini, C. M. Lerici, Moretti, *La Tomba delle Olimpiadi* (Milan, 1959); Moretti, *La Tomba della Nave* (Milan, 1961); 'Tomba Martini Marescotti' (with plan of the cemetery of Caere (Cerveteri), *Quaderni di Villa Giulia*, I (Milan, 1966); F. Roncalli, *Le Lastre dipinte da Cerveteri* (Studi e materiali dell'Istituto di etruscologia e antichità italiche dell'Università di Roma, 1965); Lucia Ricci Portoghesi, 'Una Nuova Lastra dipinta cerite', *Arch. Cl.*, XVIII (1966), 16–22, plate III. General surveys of Etruscan art, see above, Note 5; P. J. Riis, *Etruscan Art*, 77–96.

55. Ornate façades: Åkerström, Margarete Demus-Quatember, *passim* (see Note 53); Rosi, 'Sepulchral Architecture as illustrated by the Rock Façades of Central Italy', *J.R.S.*, XV (1925), 1–59; Bianchi Bandinelli, *Sovana*; Clusium: *Mon. Ant.*, XXX (1925), 268. Protecting roofs above entrance: Rosi, *loc. cit.*, 24; Åkerström, *Etruskische Gräber*, 74–90, 92–4, 98–104; Demus-Quatember, 37 f., figure 25. It is evident that these façades only reproduce doors and other decorative details of real houses. Elegant hillside houses: *San Giovenale*, figure 105; K. Lehmann and F. Noack, *Baugeschichtliche Untersuchungen am Stadtrand von Pompeji* (Leipzig, 1936); Rosi, *loc. cit.*, 38–42. Doors: the voussoir arches of the later centuries have to be distinguished from rock-cut arches and corbel vaults with a keystone; Blake (1947), 195–7.

56. Gabled roofs: Populonia: Luisa Banti, *Il Mondo degli etruschi*, 96; Boëthius, 'The Old Etruscan Towns', *Classical, Mediaeval and Renaissance Studies in Honor of B. L. Ullman* (1964), 9. Tomba delle Anatre at Veii: *Arch. Cl.*, XV (1963), 219–22, plate LXXXIV; Lerici, *Alla scoperta delle civiltà sepolte*. See further Andrén's catalogue in *Architectural Terracottas*, XXV–XXXIV, nos. 11–48, 385 f., 388, 394, 400 f., and his and Moretti's other works cited in Notes 53 and 54; Giglioli, CXI–CXIII, CXV, CCII.

57. Vitruvius, X, 13. 2, 6–7; 14. 1; 15. 1; 16. 12; E. Wistrand, *Vitruviusstudier* (Göteborg, 1933), 12 ff., and *Eranos*, XXXVII (1939), 39 f.

58. Flat roofs: Boëthius, *loc. cit.*, 9; Ducati, 378, figure 418; San Giovenale: *N.S.* (1960), 27, 38, 61; *San Giovenale*, figures 16, 60, 61; Margarete Demus-Quatember, *Etruskische Grabarchitektur*, plate 13.

59. Vitruvius, VI, 3. 1. Tomba del Tablino at Caere: *N.S.* (1955), 106–13; Margarete Demus-

Quatember, *op. cit.*, 33 f., 45; *St. Etr.*, I (1927), plates XXX f., XLV. *San Giovenale* (Tomba della principessa Margrethe and other *cava aedium tuscanica*), 64 ff., figures 16, 38, 60, 67, 69–71. For Marzabotto, see Mansuelli, *R.M.*, LXX (1963), 44 ff.

60. The development of the *cava aedium tuscanica*: Maiuri, *N.S.* (1930), 381 ff.; (1942), 404 ff.; (1944–5), 130 ff.; Polacco, 117. Atria displuviata: Tomba della Mercareccia: Ducati, 379, figure 419. Model from Chiusi: Ducati, 381; Giglioli, CCCXXXVI, 3. Tomba dei Pilastri: Ducati, 379. Origin: Gjerstad, *The Swedish Cyprus Expedition*, IV, 2 (Stockholm, 1948), 232 ff.

61. Peristyle at Ostia: R. Meiggs, *Roman Ostia* p. 75 (Oxford, 1960), 252. Columns, see Note 24. Hip-roofed houses with colonnades: *San Giovenale*, figure 63. Abundant evidence for the popularity of especially Corinthian columns in Giglioli; see also Clelia Laviosa, *Scultura tardo-etrusca di Volterra* (Firenze, La Strozzina, 1964). Tomb of the Volumnii: von Gerkan, 'Das Grab der Volumnier bei Perugia', *Gesammelte Aufsätze*, 338–51. For military decorations see city gates such as the so-called 'Gate of Augustus' at Perugia and 'Tomba Giglioli' at Cerveteri: Moretti, *Nuovi monumenti della pittura etrusca*, n. 1072, pp. 307–16.

62. Tomba del Granduca (Paccianese) at Chiusi: p. 76 Åkerström, *Etruskische Gräber*, 172; Giglioli, CCCXCV, 2; Ducati, 398, figures 458 ff. The so-called Tomba di Pitagora at Cortona imitates a barrel vault by crescent-shaped gables carrying longitudinal stone slabs: Åkerström, *op. cit.*, 175 f. Margarete Demus-Quatember, *Etruskische Grabarchitektur*, 25, figure 11. Ducati, 73, figure 68. The barrel-vaulted tombs are of the last centuries B.C. Unadorned arched façades: the terrace wall, later used as a back wall behind the Stoa of Eumenes at the Theatre of Dionysus at the Acropolis of Athens; Lindos: Dyggve, *Lindos*, III (*see* Bibliography to Chapter 6), 256 f., 289, 529 f. Boëthius, *The Golden House of Nero*, 74, note 74. Etruscan urn in the Worcester Museum: *Worcester Art Museum Annual*, V (1946), 15 ff. City gates (Volterra): Blake (1947), 199; Lugli, *Tecnica edilizia*, 338 ff.

63. Wooden roofs: Lehmann, 'The Dome of Heaven', *Art Bulletin*, XXVII (1945), 2 ff. Cf. Vitruvius's description of vaulted ceilings of framework (V, 10. 3) and wooden vaults of baths of the Imperial Age in Gaul, A. Grenier, *Manuel d'archéologie gallo-romaine*, IV (Paris, 1960), 455 f.

p. 76 64. The particularism of the Etruscans is especially well brought out by Luisa Banti in *Il Mondo degli etruschi*.

p. 77 65. Clelia Laviosa, 'Rusellae', *St. Etr.*, XXVIII (1960), 294 ff., plates LXVIIb, LXVIII. Populonia: A. Minto, *Populonia* (Florence, 1943), 335, note 53; De Agostino, *St. Etr.*, XXX (1962), 282. Ostia: *J.R.S.*, LI (1961), 202. Etruscan roads in general, in addition to older authors (especially Dennis, Ashby, and Tomassetti): Ward-Perkins's and M. W. Frederiksen's studies of roads in south Etruria and the Ager Faliscus, *P.B.S.R.*, XXIII (1955), 44–72, plates XIV–XXI; XXV (1957), 67–208, plates XVII–XLVII; *J.R.S.*, XLVII (1957), 139–43; Ward-Perkins, 'Etruscan Engineering: Road Building, Water-Supply and Drainage', *Hommage à Albert Grenier, Collection Latomus*, LVIII (1962), 1636–43 (with bibliography), and E. Wetter, *San Giovenale*, 169 ff. Bridges, abutments: *op. cit.*, figures 279, 280; Ward-Perkins, *op. cit.*, 1641, note 1; *J.R.S.*, LV (1965), 290. Falerii Veteres: *P.B.S.R.*, XXV (1957), 145.

66. Margarete Demus-Quatember, *Etruskische Grabarchitektur*, 63–76; H. Sichtermann, 'Archaeologische Funde und Forschungen in der Kyrenaica 1942–1958', *Anz.* (1959), 274 ff. Cyprus: *I.L.N.* (2 December 1967), 29 f. Most important for the connexion with the Lydian mounds are the monumental chamber tombs of the Bin Tepe cemetery of Sardes. The central of the three great mounds which dominate the skyline of Bin Tepe seems undoubtedly to be the tomb of Gyges (seventh-century B.C. king of Lydia), with its group of twelve 'Gugu' signs: *A.J.A.*, LXIX (1965), 148, plate 38, figures 10, 11, and the reports: *B.A.S.O.R.*, CLXXVII (1965), 27–34; CLXXXII (1966), 27–30.

p. 78 67. Åkerström, *Etruskische Gräber*, 39 ff. discusses the first chamber tombs; Colonna, 'I Lastroni di pietra arcaici di tipo tarquinese', *Studi e materiali dell'Istituto di Etruscologia e antichità italiche dell'Università di Roma*. Fundamental publication on Caere (Cerveteri): R. Mengarelli, R. Vighi, Ricci, Moretti, 'Caere', *Mon. Ant.*, XLII (1955); *N.S.* (1955), 46–113. For the stone slabs of the doors, cf. Luisa Banti, *Il Mondo degli etruschi*, 308, plate 40.

68. Regolini Galassi Tomb: Pareti, *La Tomba Regolini-Galassi*, 59 f., figure 42. La Cocumella di Caiolo (San Giuliano): *San Giovenale*, 311 f.; Bizzarri, *La Necropoli di Crocifisso (op. cit.*, Note 44). Meloni del Sodo: Åkerström, *Etruskische Gräber*, 175–9. Luisa Banti, *op. cit.*, 103, 114, 117. Mar-

garete Demus-Quatember, *Etruskische Grabarchitektur*, 25, figures 8–9. The chamber tombs with a slit have been called 'Egyptian tombs': Åkerström, *op. cit.*, 44, 54 f., 90 f.; at San Giovenale: *N.S.* (1960), 44, figure 43; 51, figure 51; *San Giovenale*, 284 ff.

69. Tholos tombs in general: Ducati, 64 ff.; Margarete Demus-Quatember, *Etruskische Grabarchitektur*, 17–20; Åkerström, *Etruskische Gräber*. La Montagnola di Quinto Fiorentino: G. Caputo, *Arte antica e moderna* (1962), 58–72; and *B. d'Arte* (1962), 115–52. Central pillar: Tomba della Pietrera, Vetulonia; Tomba di Casal Marittimo (reconstructed in the Museo Archeologico of Florence, as is also the Tomba Inghirami, Volterra, plate 68; Giglioli, XCIV, 1; CCCXCV). From Roman times: the so-called 'Tomba di Cicerone' near Formia.

70. Vetulonia: Åkerström, *op. cit.*, 129 ff. p. Populonia: Åkerström, *op. cit.*, 148–54. Casal Marittimo: Åkerström, *op. cit.*, 163. Rome: Gjerstad, *Early Rome*, III, 88–131; Domus Flavia, 104 ff., 124 ff. Corbelled Roman frigidaria and caldaria and a dome of a tomb near Cumae, Crema, 17, 124 f., figure 14. Rock-cut tholos tomb at Riello near Viterbo: Ducati, 67, figure 55. Tullianum: Platner-Ashby, Nash, *s.v.* Corbelled vault of a tomb from the Early Iron Age and of the nuraghi in Sardinia (Figure 5) and trulli in Apulia and Sicily, see above, Chapter I, Note 5. Orvieto: Bizzarri, *La Necropoli di Crocefisso del Tufo in Orvieto (op. cit.*, Note 44), 45, figure 18.

71. Porsenna's tomb: F. Messerschmidt, 'Das Grabmal des Porsenna', *Das neue Bild der Antike*, II (1942), 53 ff. Becatti, *La Colonna coclide istoriata* (Rome, 1960). Pliny, XXXVI, 91–3. Quadrangular podium at San Giovenale: *N.S.* (1960), 31 f. For Ross Holloway's explanation of the Late Republican and Augustan romantic revival of old types of tombs see *A.J.A.*, LXX (1966), 171–3; and below, Chapter 6, Note 96.

72. Åkerström, *Etruskische Gräber*, *passim*; Mar- p. garete Demus-Quatember, *Etruskische Grabarchitektur*, 34–40; Rosi, *J.R.S.*, XV (1925), 1 ff. A. Gargana, 'La Necropoli rupestre di S. Giuliano', *Mon. Ant.*, XXXIII (1931). Bianchi Bandinelli, *Sovana*. Tomba delle Iscrizioni at Vulci: Bartoccini, *Atti del VII congresso internazionale di archeologia classica*, II (1961), 278 f. Lerici, *Nuove Testimonianze dell'arte e della civiltà etrusca* (Milan, 1960), 54–61. Lucia Morpurgo, 'Un Sepolcrato precristiano in Anzio', *Rend. Pont.*, XXII (1946–7),

153–63. Cf. also the chambers around the central hall in the tomb of the Volumnii family (Figure 38) and, in addition, the six chambers around the Tomb of the Inscriptions at Vulci.

73. Åkerström, *op. cit.*, 73 ff.; 'Porte finte', 79, 87, 97; Margarete Demus-Quatember, *op. cit.*, 36–8; *San Giovenale*, 101, figures 101–2 (Luni).

82 74. Criticism of the Etruscans also by Athenaeus, XII, 517 ff. Analysis of this criticism: Heurgon, *La Vie quotidienne chez les étrusques*, 46–51; *San Giovenale*, 9 ff.; 117. Tomba François at Vulci, see *San Giovenale*, 102, note 41 (with bibliography).

75. Dionysius, I, 29. 2; Plutarch, *Camillus*, XXII, 2 (Heraclides Ponticus).

CHAPTER 4

85 1. Fundamental are Platner-Ashby, Nash, *Fontes*; F. Castagnoli, *Roma antica* (Istituto di Studi Romani, Topografia e urbanistica di Roma) (Bologna, 1958). Remains of earliest walls of Rome: *Le Piante di Roma*, a cura di A. P. Frutaz, I–III (Istituto di Studi Romani) (Rome, 1962); *Gnomon*, XXXV (1964), 817; P. Romanelli, Terrace Wall at the Southeast Corner of the Palatine: *Mon. Ant.*, XLVI (1963), figure 7; G. Säflund, *Le Mura di Roma repubblicana*; E. Gjerstad, *Opus. Rom.*, I (1954), 50–65; P. Quoniam, 'À propos du mur dit de Servius Tullius', *Mél. Rome*, LIX (1947), 41–64; A. von Gerkan, *Rh. M.*, CI (1957), 82–97; CIV (1961), 132–48. General: G. Lugli, *Tecnica edilizia*, 170, 187, 250 f.; Blake (1947), 116 f. The aggeres: Ardea: A. Boëthius, *Opus. Rom.*, IV (1962), 29–34 (with bibliography); Antium: Lugli, *op. cit.*, 270 f.; Satricum: Castagnoli, 'Satrico', *L'Universo*, XLIII, 3 (1963), 505–18; Veii: J. B. Ward-Perkins, *P.B.S.R.*, XXVII (1959), 66–71; XXIX (1961), 32–9. The walls of Pompeii: Lugli, *op. cit.*, 295–9; Boëthius, *The Golden House of Nero*, 44, note 38, with references to Maiuri's fundamental research.

The discussion about the date of the foundation of Rome: A. Momigliano, 'An Interim Report on the Origins of Rome', *J.R.S.*, LIII (1963), 95 ff. (with bibliography), and Gjerstad, 'Discussions Concerning Early Rome', *Opus. Rom.*, III (1961), 69 ff.; V (1965), 1–74; G. A. Mansuelli, *Etruria and Early Rome*; Romanelli, 'Certezza e ipotesi sulle origini di Roma', *Studi Romani*, XIII (1965), 156 ff.; R. Bloch, *Tite-Live et les premiers siècles de Rome*.

87 2. Etruscan influence: Livy, I, 8. 3; Strabo, V, 2. 2; Diodorus, V, 40; Dionysius, III, 61–2. Fasces: *St. Etr.*, XXVIII (1960), 459–61. Limitatio: C. O.

Thulin, *Die Ritualbücher* (*op. cit.*, Chapter 2, Note 5); Festus, Pauli excerpta, Lindsay 505: 'Termino sacra faciebant, quod in ejus tutela fines agrorum esse putabant.' 'Archaic Greek' Alphabet, for instance Dionysius, II, 54. 2; IV, 26. 5. The Duenos inscription and Etruscan graffiti: Gjerstad, *Early Rome*, III, 160–5, 214 (with bibliography). Etruscan seventh-century inscription found at the church of S. Omobono, Rome; *Palatino*, VIII (1964), 32 f. Shoes: Serv. ad Aen., VIII, 458.

3. Via Sacra: Recent excavations by Frank Brown below the regia have revealed below it a part of the Early Iron Age village on the Via Sacra (see Chapter 2, Note 9), cult places, and remains of temples. Gjerstad, *Early Rome*, II; Å. Åkerström, 'Untersuchungen über die figürlichen Terrakotta-friese aus Etrurien und Latium', *Opus. Rom.*, I (1954), 191–230; Gjerstad, *op. cit.*, III, 185, 189, 423, 448 ff.; Andrén, *Architectural Terracottas*. Houses of the Quattro Fontane: Bianca Felletti Maj, *N.S.* (1952), 284–6. 'Ricerche intorno a S. Pietro in Vincoli, I: A. M. Colini, L'Esplorazione archeologica dell'Area', *Mem. Pont.*, IX, II (1966), 11–13. Corbelled cisterns: Blake (1947), 117 f.; Lugli, *Tecnica edilizia*, 251; Gjerstad, *op. cit.*, III 97, 106, 124

4. Regia: Chapter 2, Note 9, Chapter 4, Note p. 89 3. Etruscan origin of the atria: Varro, *Lingua Latina*, V, 161. The atria of Ostia: *Scavi di Ostia*, I, 107 ff.; R. Meiggs, *Roman Ostia*, 252 f. Pliny's villas: *Epist.*, II, 17. 4; V, 6. 15. The atrium-house of Saepinum: V. Cianfarani, *Guida delle antichità di Sepino* (Milan, 1958), 45. Tabernae: oldest remains: N. Sandberg, *Eranos*, XXXIV (1936), 82–103. The old traditions about the forensic tabernae: Dionysius, III, 67. 4; XI, 37. 5, 39. 7; XII, 2. 8; Livy, I, 35. 10; III, 48. 5; IX, 40. 16; XXVI, 27. 2–4. Forum of Pompeii: Crema, 36; A. Maiuri, *N.S.* (1941), 371 ff. Ostia: *Scavi di Ostia*, I, 98 (tabernae outside the castrum). Among the descriptions of country-side habitation with unfortified villages (*pagi*) and their refuges see, for instance, Dionysius, V, 22. 1; VIII, 16. 5. For the plain old country houses of the rich, see Dionysius, VIII, 12. 3; XI, 2. 3; XIX, 15. 1, 17. 4.

5. For early subterranean sewers, see Livy, I, p. 91 38. 6, 56. 2; V, 55. 5; Dionysius, III, 67. 5. For the present Cloaca Maxima: Nash, *s.v.*

6. The author, taking into account Frontinus, maintains that the Romans learned to build castra when they captured Pyrrhus's camp after the battle of Beneventum. Livy, XXXV, 14. 8, says that

Hannibal admired Pyrrhus's camps while Plutarch (*Pyrrhus*, 16) tells us that Pyrrhus admired the Roman camps. The oldest Roman castrum known at present is the permanent fourth-century castrum fortress of Ostia (Figure 54), but what the Romans learnt from Pyrrhus may have been temporary camp fashions for ambulatory campaigns.

p. 92 7. Gjerstad, *San Giovenale*, elucidates the historical and cultural context, summarizing his research for *Early Rome*, III.

For the plan of the temple and the height and decoration of the building see my discussion of the Etruscan temples (Chapter 3, Note 22). For Vulca: Pliny, XXXV, 157. For the calendar connected with the Capitoline Temple of 509: K. Hanell, *Das altrömische eponyme Amt*, 99 ff. and Gjerstad, 'Notes on the Early Roman Calendar', *Acta Archaeologica*, XXXII (1961), 193–214.

p. 93 8. For the enlarged area see also Livy, XXV, 3, and Velleius Paterculus, II, 3. 2. For statues, for instance: Cicero's third Catiline oration, 19–20. For the favisae: Varro by Gellius, *Noctes atticae*, II, 10. For the archaic phase of the Temple of Castor and Pollux see *M.A.A.R.*, V (1925), 79–90; Blake (1947), 121; Nash, *s.v.* Archaic terracottas probably from the temples of Castor and Pollux and Saturn: *Rend. Linc.*, XVI (1961), 59, plate III.

p. 94 9. For the monuments around the rostra see especially Pliny, XVIII, 15; XXXIV, 20. As places for them Pliny points out: 'in foro', 20, 24, 30; 'in comitio', 21, 26; 'in rostris', 23, 24 ('oculatissimo loco'), which also confirms the unity of the forum and the comitium. Columna Maenia: E. Welin, *Studien zur Topographie des Forum Romanum*, 130–74 (with bibliography); H. Lyngby, *Eranos*, LIX (1962), 136 f. and G. Becatti, *La Colonna coclide istoriata*.

CHAPTER 5

p. 100 1. For a general survey of the polygonal walls, see G. Lugli, *Tecnica edilizia* and 'Conclusioni sulla cronologia dell'opera poligonale in Italia', *Studi minori di topografia antica*, 27–32, and Blake (1947), 92–104. For discussion of Lugli's date by A. von Gerkan, *G.G.A.*, CCXII (1958), 178–97 and others; see Lugli's reply, *Rend. Linc.*, ser. 8, XIV (1959), 321 (with bibliography). Samnite walls: G. Colonna, Saepinum, *Arch. Cl.*, XIV (1962), 80–107. Cosa: *Cosa*, 1. Another date proposed by von Gerkan, 'Zur Datierung der Kolonie Cosa', *Scritti in onore di G. Libertini* (1958), 149 ff.; *J.R.S.*, LII (1962),

266. Pyrgi and Minturnae (Figure 55): F. Castagnoli, *Ippodamo*, 86–8. Alba Fucens (older and later walls): *Atti del VII congresso internazionale di archeologia classica*, II (1961), 287; *Rend. Linc.*, ser. 8, XIII (1958), 97–8.

2. For the use of the tufas see Lugli, *Tecnica* p. *edilizia*; Blake (1947); T. Frank, *Roman Buildings of the Republic (P.A.A.R.*, III) (Rome, 1924); Gjerstad, *Early Rome*, III, 174. The final date of the Servian Wall established already by Frank and corroborated by G. Säflund, *Le Mura di Roma repubblicana*; Blake (1947), 124; Lugli, *op. cit.*, 258 ff.; von Gerkan, *Gesammelte Aufsätze*, 108–38; P. Quoniam, *Mél. Rom.*, LIX (1947), 41–64. For vivid discussion concerning the question of whether the Tiber was left open and the Forum Boarium district was defended by walls running down to the river from the Capitoline and Aventine Hills (as I believe) or if – at least originally – a wall connected the Capitoline, the Palatine, and the Aventine: H. Lyngby, *Beiträge zur Topographie des Forum Boarium Gebietes in Rom* (*Acta Rom. Suec.* in 8°, VII, 1954), with bibliography. For the acropolis wall of Ardea: A. Boëthius, *Opus. Rom.*, IV (1962), 29–43.

3. Terracottas from Ostia: A. Andrén, *Architectural Terracottas*, 369; P. Mingazzini, *Rend. Pont.*, XXIII–XXIV (1947–9), 75–83; *Scavi di Ostia*, I, 75, plate XXII. For the gates: *Cosa*, I, 41 ff.; Lugli, *Tecnica edilizia*, 113. For the date and historical circumstances of Falerii Novi (Santa Maria di Falleri): Lugli, *op. cit.*, 271; M. W. Frederiksen and J. B. Ward-Perkins, *P.B.S.R.*, XXV (1957), 73 ff.; Zonaras, VIII, 18; Polybius, I, 65; Livy, *Epitome*, XX; Valerius Maximus, VI, 5. 1; Eutropius, II, 28.

4. For arches: Blake (1947), 123, 192 ff.; Crema, p. 9–12; Lugli, *Tecnica edilizia*, 36, 659–93, and 'Considerazioni sull'origine dell'arco a conci radiali', *Studi minori di topografia antica*, 97–138. The bridge on the Via Amerina: Frederiksen and Ward-Perkins, *loc. cit.*, 99; P. Gazzola, *Ponti romani*, II (Florence, 1963); review by Frederiksen, *J.R.S.*, LV (1965), 290 (with list of bridges). Ponte del Diavolo: A. Rava, *Atti del III convegno nazionale di storia dell'architettura 1938* (1940), 263–6.

5. Town planning and castra: generally, Casta- p. gnoli, *Ippodamo*, and 'Limitatio', *Dizionario epigrafico di antichità Romane*, IV (1964), 1379–83; E. Kirsten, 'Die Entstehung der griechischen Stadt', *Anz.* (1964), 891–910. Old, irregular towns precluding modern planning: 'Corpus agrimensorum romanorum', Hygini Gromatici constitutio limitum, 144. Difficulties due to rugged ground: *op.*

cit., 145, 154. For Norba see G. Schmiedt and Castagnoli, *L'Antica Città di Norba, Documentazione aerofotometrica* (Florence, 1957). F. W. Walbank, *A Historical Commentary on Polybius*, I (Oxford, 1957), 709–23. Castra: Castagnoli, *Ippodamo*, 85–103; Boëthius, *The Golden House of Nero*, 49–53; Crema, 33–5, 280; Ward-Perkins, *Town Planning Review*, XXVI (1955), 148 ff., and *Acta Congressus Madvigiani*, IV (Copenhagen, 1958), 118–21. Polybius, VI, 31, emphasizes especially that the regular town planning of the towns inspired the Romans to their regular castra. For the castrum-forts, Castagnoli, *op. cit.*, 85–94; Maria Merolla, 'Allifae', *Arch. Cl.*, XVI (1964), 36–48. Strabo, XII, 4. 7; V. Tscherikower, *Die hellenistischen Städtegründungen von Alexander dem Grossen bis auf die Römerzeit* (Leipzig, 1927), 135. A small square fortress excavated by Danish archaeologists on Failaka in the Emirate of Kuwait may be compared. It seems clear that it was built by Alexander, and – even if it mainly served as defence for Greek temples – it belongs to the fortifications by which Alexander strengthened his position, settling in them Greek mercenaries, who were willing to live there (Arrian, *Anabasis*, VII, 21). E. Albrectsen, 'An Outpost of Alexander's Empire: the Recently Excavated Fortress on Failaka', *I.L.N.* (2–7 August 1960), 351–3. K. Jeppesen, 'Et Kongebud til Ikaros', *Kuml* (1960), with a sketch of the settlement on p. 154 and English summary on p. 188.

06 6. Rubble work and barrel vaults of Cosa: *Cosa*, I, 59 ff., 88. Pompeii: Lugli, *Tecnica edilizia*, 379–85, and on the Porticus Metelli (built in 147 B.C.), 451, plate CVIII, 2. The history of concrete before its Roman age: Lugli, *Tecnica edilizia*, 375 ff., and 'L'Opus Caementicium in Vitruvio', *Studi minori di topografia antica* (1965), 33–40; Crema, 12 ff.; Varro, *De re rustica*, I, 14. 4; Pliny, XXXV, 169; Appian, *Historia romana*, VIII, 129. For Greek concrete: Thucydides, I, 93 (χάλιξ καὶ πελός); *Corinth*, III, I: Acrocorinth (1930), 38–42. Cf. Strabo on the jetties of the harbour of Puteoli, V, 4. 6. In the second century the Romans began to build the podia of the temples of concrete – to start with, rather poor and grey: the temples of Concord (121 B.C.) and Castor and Pollux (117 B.C.) on the Forum Romanum.

08 7. Crema, 61; Lugli, *Tecnica edilizia*, 11 f., 35, 450, *et passim*, plates CVII, 1–3; CVIII, I. For a date about 100 B.C.: Blake (1947), 249, 251; and with arguments deserving unprejudiced consideration:

von Gerkan, *Scritti in onore di G. Libertini* (1958), 149 ff.; his review of Lugli's *Tecnica edilizia*, *G.G.A.* CCXII (1958), 178 ff.; *Gesammelte Aufsätze*, 121; critical remarks on the commentary of Forma Urbis by Gerkan, *G.G.A.*, CCXIV (1962), 136–8. Von Gerkan denies both the possibility of dating the incertum of the great hall at the Tiber as early as 193–174 and the identification of this hall with the Porticus Aemilia. The fact that the hall shows no remains of earlier walls is thus irrelevant for him.

8. The Via Appia: Lugli, *Tecnica edilizia*, especially 158, plate XVI, 2–3, and for later ashlar constructions *op. cit.*, plate XLVII, 3. Paved roads: Livy, X, 47. 5 (part of the Via Appia 292 B.C.), and XLI, 27 (streets in the town 174 B.C.); *Epitome*, XX (Via Flaminia). Aqua Appia and aqueducts in general: Esther Van Deman, *The Building of the Roman Aqueducts*, 23–8; T. Ashby, *The Aqueducts of Ancient Rome*, 49–54.

9. G. Marchetti-Longhi, *L'Area sacra del Largo* p. 111 *Argentina (Itinerari)* (1959), 34–41, 49; Crema, 42 f. F. Krauss and R. Herbig, *Der korinthisch-dorische Tempel am Forum von Paestum* (Berlin, 1939). E. von Mercklin, *Antike Figuralkapitelle*, 66. Together with this should be remembered the pre-Roman Temple of Apollo at Pompeii with high podium and a peristyle with Ionian columns: Crema, 45; an interesting analysis is given by G. Kaschnitz von Weinberg, *Die Grundlagen der republikanischen Baukunst*, 68, together with a most suggestive survey of the hellenistic–Roman temples. Corinthian and Doric style combined: Vitruvius, IV, I. 2. Ionic and Doric style: Jeppesen, *Paradeigmata* (*Jutland Archaeological Society Publications*, IV) (Aarhus, 1958); review by von Gerkan, *G.G.A.*, CCXIV (1960), 1–15; Jeppesen, *Acta Archeologica*, XXXII (1961), 226 f.

10. For a general description, sacred sites, places p. 113 for jurisdiction, etc., see E. Welin, *Studien zur Topographie des Forum Romanum*, Platner-Ashby, and Nash. For the Maeniana: Boëthius, *Eranos*, XLIII (1945), 94–101. The Columna Maenia (above, p. 94) was a column near the rostra erected in honour of Caius Maenius, consul in 338 B.C. Pliny, VII, 212; XXXIV, 20; Cicero, *Div. in Caecil.*, 16. 50. With this reference to the Columna Maenia Asconius wrongly connects a later Maenius, who in 184 B.C. sold the domus of the Maenii at the comitium but reserved a stand for spectators of the gladiatorial games above one column in front of the house. In some comedy or jest in Rome this column of the late descendant of the great Maenius,

who sold the old house of the family, was called Columna Maenia. We don't know if this nickname became popular or not in Rome. Welin, *op. cit.*, 130–74. Forensis dignitas: Varro, *De vita populi romani*, II, quoted by Nonius, 532.

p. 113 11. Comitium: E. Sjöqvist, 'Pnyx and the Comitium', *Studies presented to David Moore Robinson*, I (St Louis, 1951), 400–11; L. Richardson, 'Cosa and Rome', *Archaeology*, X (1957), 49–55 (cf. J. A. Hanson, *Roman Theater-Temples*). For Agrigentum see A. D. Trendall, *Archaeology in South Italy and Sicily* (Archaeological Reports for 1963–4 published by the Council of the Society for the Promotion of Hellenic Studies and the Managing Committee of the British School of Archaeology at Athens, 1964), 42, plate 13.

p. 114 12. Boëthius, *The Golden House of Nero*, 129–88 (with bibliography). Lugli, 'Il Valore topografico e giuridico dell'insula in Roma antica', *Studi minori di topografia antica*, 81–96. For another opinion about the word 'insula': von Gerkan, *Gesammelte Aufsätze*, 301. At Herculaneum a tenement house with upper storey around a central court has been excavated, but the type of house such as the Casa a Graticcio seems to be developed from the peri-style houses of the Greek towns and thus to be basically different from the Roman insulae, built upon tabernae. For the Casa a Graticcio: A. Maiuri, *Ercolano* (Rome, 1962), 407–20. It is in any case quite different from the Roman insulae of Ostia with shops along the streets and is probably to be connected with the peristyle houses of the Greek towns (especially Naples). There is no reason to assume that the tenement houses mentioned by Livy were of this type. Though it seems evident to me that insula in towns of the Imperial Age (like Ostia) means tenement house, it may be added that the word in older towns (like Pompeii) might have been used for quarter.

13. Pomponius Mela, II, 7; Strabo, XVI, 2. 13 and 23. For Carthage, see above Note 6 and G. and Colette Picard, *Daily Life in Carthage* (New York, 1961), 48, and *Carthage* (London, 1964).

14. The Circus Flaminius was built along the Tiber from the Pons Fabricius towards the Monte dei Cenci: G. Gatti, 'Dove erano situati il teatro di Balbo e il Circo Flaminio', *Capitolium*, XXXV, 7 (1960), 3–12; *Palatino*, V (1961), 17–20. Nash, *s.v.* For constructions of spectators' galleries of wood: Pliny, XXXVI, 116–20; Suetonius, *Nero*, 12; Vitruvius, V, 5. 7. As in the Greek theatres, sloping hillsides could be adapted or earthen embankments

constructed, as around the stadium of Olympia. The theatre of 155 B.C.: Livy, *Epitome*, XLVIII; Valerius Maximus, II, 4. 2; Tertullian, *Apologeticum adversus gentes*, VI; *De spectaculis*, X; Appian, *Bellum Civile*, I, 4. 28.

15. Crema, 126, figure 116; P. Nicorescu, *Ephemeris Dacoromana*, I (1923), 1–56; Nash, II, 352. The Tomb of the Salvii at Ferento (Ferentium, Ferens): A. Degrassi, *Rend. Pont.*, XXXIV (1961–2), 59–77. For the date of the Barbatus sarcophagus: H. Kähler, *Rom und seine Welt*, *Erläuterungen* (Munich, 1960), 110 ff. T. Dohrn, 'Der vatikanische "Ennius" und der poeta laureatus', *R.M.*, LXIX (1962), 88.

CHAPTER 6

1. For the early use of marble and the aedes of p. Jupiter Stator built by Metellus: Velleius Paterculus, I, 11. 5; D. E. Strong and J. B. Ward-Perkins, 'The Round Temple in the Forum Boarium', *P.B.S.R.*, XXVIII (1960), 7–32. For the marble columns from Athens in the rebuilt Capitoline Temple of 69 B.C. see A. Boëthius, 'Nota sul tempio Capitolino e Vitruvio III, 3. 5' (in studies dedicated to H. Zilliacus, *Arctos*, N.S.V (1968); A. W. Van Buren, 'News Letter from Rome', *A.J.A.*, LXIX (1965), 360.

2. For the use of tufa and travertine see Blake (1947), 29 ff.; G. Lugli, *Tecnica edilizia*, 302–26. For the use of travertine only for capitals, bases, inscriptions, etc., from about 130, see *ibid.*, 327 f., and Blake (1947), 44–8 *et passim*. For the rubble see *Cosa*, II. The late terracotta revetments from all Central Italy are described in A. Andrén's *Architectural Terracottas* and thoroughly restudied in *Cosa*, II, 151–367.

3. For the *luxuria*: Pliny, XXXVI, 3–8; 114; Augustine, *De civitate Dei*, III, 21. Especially illuminating are Dionysius's remarks on the old Roman traditions, II, 19. 3; X, 55. 5; 60. 6; XIX, 17. 4; H. Drerup, 'Zum Ausstattungsluxus in der römischen Architektur', *Orbis antiquus*, XII (1957).

4. For the late use of polygonal work: Lugli, p. *Tecnica edilizia*, 44, 80, 124–6 (Signia), 137–42 (Norba), plate XV. For quasi-reticulate and reticulate: Lugli, *op. cit.*, 501–5; Blake (1947), 227–75.

5. Vitruvius, II, 8. 17. Morgan's translation is unsatisfactory. Vitruvius speaks of piers of stone, a structure of burnt brick (protecting the top of the

walls), and walls of concrete (*parietes caementiciae*). What Vitruvius means by *structurae testaceae* can be seen in II, 8. 18 and in the turrets of second-century villa terraces at Cosa (below, p. 160), which are built of coarse rubble with interposed protecting layers of roof tiles with fringes (Plate 96). Another instance can be found in the Late Republican tombs along the Via Appia outside Terracina: *Forma Italiae*, I, 1.1. Lugli, *Anxur Terracina* (Rome, 1926), Zona VI, no. 8, 12, figures 2, 3, 6. For the tenement house in Terracina, *op. cit.*, *Terracina alta*, Zona III, no. 6, figure 17. The Palatine: Boëthius, 'Das Stadtbild im spätrepublikanischen Rom', *Opus. Arch.*, I (1935), 176–8.

21 6. The excavations below the Neronian portico south of the Via Sacra can be found in Lugli, *Monumenti minori del Foro Romano*, 139–64, 171. For the shop in the north-western corner of the Terme del Foro see A. Maiuri, *Atti del I Congresso nazionale di studi romani*, I (1929), 164.

7. Stabian baths: Crema, 17, 74, figures 15, 79. Domical vaults: tabularium, Crema, 17, 58. Temple of Hercules Victor at Tivoli: Crema, 57 f., figure 55. The nymphaeum at Formia: Crema, 125, figure 114. N. Neuerburg, *L'Architettura delle fontane e dei ninfei nell'Italia antica*, 145–7.

22 8. The earlier appearance of the forum of Pompeii can be found in Maiuri, *N.S.* (1942), 319 f. For the tabernae, *N.S.* (1941), 371–86. The position of the Temple of Apollo on the western side of the forum, and an oblique wall, built along the short north side before the dominating temple was constructed, show that the place in earlier times did not have the later rectangular shape and orientation.

Cosa, I, 72, figure 66; L. Richardson, 'Cosa and Rome', *Archaeology*, X (1957), 49–55.

9. For the hellenistic piazzas: J. B. Ward-Perkins and M. H. Ballance, 'The Caesareum at Cyrene', *P.B.S.R.*, XXVI (1958), 137–94; E. Sjöqvist, 'Kaisareion', *Opus. Rom.*, I (1954), 86 ff.; Boëthius, *The Golden House of Nero*, 68 f. The origins are discussed by E. Gjerstad, *Opus. Arch.*, III (1944), 40 ff., and by R. Martin, *Recherches sur l'agora grecque* (Paris, 1951), but see also Bergquist (Chapter 3, Note 37).

10. E. Dyggve, *Lindos*, III, 1–2; the importance for Roman architecture especially discussed on pp. 257, 517. Martin, *L'Urbanisme dans la Grèce antique* (Paris, 1956), has especially well analysed the unaxial Greek architecture, showing its striking difference in comparison with hellenistic axiality. F. Fasolo and G. Gullini have in a most convincing way defined the new character acquired by hellenistic architecture in Italy in their monumental work *Il Santuario della Fortuna Primigenia a Palestrina*. See also H. Kähler, *Das Fortuna Heiligtum von Palestrina Praeneste*, and for the architecture of the mid fourth century K. Jeppesen, *Paradeigmata* (Jutland Archaeological Society Publications, IV, 1958). See also Kähler, *Wesenszüge der römischen Kunst* (Saarbrücken, 1958).

11. Forum of Pompeii: Maiuri, *N.S.* (1942), p. 124 319 f. The Temple of Hercules at Alba Fucens: F. de Visscher, J. Mertens, J. Ch. Balty, 'Le Sanctuaire d'Hercule e ses portiques à Alba Fucens', *Mon. Ant.*, XLVI (1963), 334–95. For the temple and the Hercules statue: de Visscher, *Heracles Epitrapezios* (Paris, 1962), 44. The two pilasters on the rear wall and the pillars in front of the statue seem to have carried some lighter, probably wooden cupola, a structure which is evidently a predecessor of the vaulted ciboria of medieval churches. For Brixia: M. Mirabella Roberti, 'Il Capitolium repubblicano di Brescia', *Atti del VII Congresso internazionale di archeologia classica*, II (1961), 347–73. In Flavian times a Capitolium replaced the four Late Republican temples, Crema, figures 316, 323. P. C. Sestieri, *Paestum (Itinerari)* (1953).

12. See above, p. 116. For the tabernae see p. 127 Vitruvius, V, 1. 2: 'round about in the colonnades put the bankers' offices; and have balconies on the upper floor properly arranged so as to be convenient; and to bring in some public revenue'. In paragraph 3 Vitruvius adds that 'the columns of the upper tier should be one-fourth smaller than those of the lower'. The wide intercolumniations no doubt required 'series of wooden beams laid upon the columns' instead of architraves of stone, as described by Vitruvius, III, 3. 5. For Lucus Feroniae see R. Bartoccini, *Colonia Julia Felix Lucus Feroniae* (Rome, 1960), and *Atti del VII Congresso internazionale di archeologia classica*, II (1961), 252 f.; G. D. B. Jones, *P.B.S.R.*, XXX (1962), 191–5.

For the combination basilica-tabernae cf. my article, 'Das Stadtbild im spätrepublikanischen Rom', *Opus. Arch.*, I (1935), 189–95; G. Fuchs, 'Zur Baugeschichte der Basilica Aemilia in republikanischer Zeit', *R.M.*, LXIII (1956), 17 f.; and Sandberg, *Eranos*, XXXIV (1936), 82 ff. For the basilicas: Livy, XL, 51. 2–8. Cato's statement about the paving of the forum: Pliny, XIX, 24.

Fornices: Crema, 100; Platner-Ashby and Nash, *s.v.* Comitium: Cicero, *Laelius*, 25, 96; Plutarch, *C. Gracchus*, 5, 3. Caesar's rostra: Dio Cassius, XLIII, 49. 1–2.

p. 127 13. For discussion and bibliography see Crema, 61–8. Vitruvius (V, 1. 4–5) describes a basilica which is probably similar to the basilicas of the Forum Romanum in his day, and in V, 1. 6–10, a basilica which he supervised in Colonia Julia Fanestris (Fano). He further (VI, 3. 9) describes in private houses so-called Egyptian oeci with an arrangement similar to the basilicas, and mentions basilicas in VI, 5. 2.

p. 128 14. For Cato's Basilica Porcia see especially Livy, XXXIX, 44, and Aurelius Victor, *Viri illustres*, XLVII, 5. The basilica, which Plautus mentions (*Curculio*, 472), may have been the oldest building below the Basilica Aemilia; see the remains on the plan of G. Carettoni, *N.S.* (1948), III. Cf. Fuchs, *loc. cit.*, 25, note 40; and G. E. Duckworth, *Studia latina Petro Johanni Enk oblata* (1955), 58–65.

15. The basilica of Ardea is published in *Bollettino dell'Associazione internazionale di studi mediterranei*, III, 3 (August–September 1932), 1 ff.; E. Wikén, V, 1–2 (April–July 1934), 7–21, plates II–III. Boëthius, 'Ardeatina', *Apophoreta Gotoburgensia Vilelmo Lundström oblata* (1936), 353 f. The old sacrifices: Strabo, 5, 3. 5. The basilica of Ardea measures 150 by 78 feet (45·80 by 23·80 m.). For the water cistern it should be remembered that old temples in central Italy usually had a well, cistern, or tank close at hand; see *Cosa*, II, 108, note 77.

16. For the public use of the basilicas in Late Republican times: E. Welin, *Studien zur Topographie des Forum Romanum* (*Acta Rom. Suec.*, in 8°, VI) (1953), 111 ff. The basilica of Cosa: *Cosa*, I, 75–8; F. E. Brown, *Roman Architecture*, 22 f., plates 27–9. The length of the basilica on the outside is 117 feet (35·52 m.). Brown reconstructs the basilicas of Cosa and Ardea with colonnaded fronts (*op. cit.*, plates 27 and 29). The tabularium (dated 78 B.C.; Plate 72) and the later Roman basilicas – such as the Julia and the Ulpia – had arcades towards the fora.

p. 129 17. To me Fuchs' identification of the column bases F 1, 3, 2 on Carrettoni's plan and the Aemilia of 179 B.C. seems convincing (*loc. cit.*, Note 12). This building was later repaired in 80–78 B.C., when, according to Pliny, XXXV, 13 the consul M. Aemilius Lepidus put up portrait shields on it, and also in 55–54 B.C. (Cicero, *Ad Atticum*, IV, 17, 7; Plutarch, *Caesar*, 29). Until now no remains have clarified how the northern, rear side of the Basilica

Aemilia was built. The coin of 59 B.C. has been interpreted in two different ways. Fuchs contends that it depicts the northern, long side and that the northern aisle of the basilica was open towards market-places behind the basilica, like a colonnaded portico; in this case, the portrait shields would have decorated the façade of this northern side of the building. I agree with other scholars, who assume that the basilica, as in the Imperial Age, had a wall outside the northern aisle, and explain the coin as representing one side of the interior of the nave with its two-storeyed aisles. They assign the shields to this interior. The wording of Pliny makes it clear that the shields belonged to the basilica and not to the portico with the tabernae towards the forum.

18. Maiuri, *Ercolano*, 284–90. For the Egyptian, p. Corinthian, and tetrastyle oeci, which are all related to the basilicas, see also Crema, 115 f., figures 106–8.

19. Tabularium: for bibliography and photo- p. graphs see Nash, II, 402–8. For the combination of arcades and flanking columns see above, p. 129; G. M. A. Hanfmann, *Worcester Art Museum Annual*, V (1946), 15 ff.; *J.H.S.*, LXV (1945), 50. Boëthius, *The Golden House of Nero*, 74, note 74.

20. The standard works for the Late Republican p. temples are: R. Delbrück, *Hellenistische Bauten in Latium, Das Capitolium von Signia*, and *Die drei Tempel am Forum Holitorium*; and Lucy Shoe, *Etruscan and Republican Roman Mouldings* (*M.A.A.R.*, XXVIII) (1965); see further Lugli, *The Classical Monuments of Rome*, and *I Monumenti antichi di Roma e suburbio* with Supplemento. For further references: Crema, 41–9.

Temple A on the Largo Argentina: G. Marchetti-Longhi, *L'Area sacra del Largo Argentina (Itinerari)*, 47–55; Nash, I, 136–51 (*s.v.* Area sacra del Largo Argentina). The temples on the Forum Holitorium: Lugli, *I Monumenti antichi di Roma e suburbio*, I, 331 ff., and *Classical Monuments*, 317–33.

21. Andrén, *Architectural Terracottas, passim*. For p. the aesthetic valuation see above all *Cosa*, II, 137, 165, 183, 225, and *passim*. Pedimental groups: Giglioli, CCCXVII, CCCXVIII, CCCXXI, CCCXXXV; *Cosa*, II, 312 ff. For late Greek pedimental sculpture: Phyllis Williams Lehmann, *The Pedimental Sculptures of the Hieron in Samothrace* (New York, 1962), 24–6.

22. Cf. Boëthius, 'Of Tuscan Columns', *A.J.A.*, LXVI (1962), 249–54 (p. 252, note 22) and above, p. 40. For Cosa: *Cosa*, II, 43, 102 ff. The

tufa columns of the Capitolium (about 150) are the earliest stone columns found at Cosa. The Doric capital of Temple D, second phase (100–75 B.C.), *Cosa*, II, III. For the temple on the Via delle Botteghe Oscure in Rome see Nash, I, 202 f. For the revival of the so-called Aeolic capitals, once so popular in Archaic architecture, see Antonia Ciasca, *Il Capitello detto eolico in Etruria* (Florence, 1962).

36 23. Temples with two columns in the pronaus: above p. 33; W. Johannowsky, 'Modelli di edifici da Teano', *B. d'Arte*, XLVII (1962), 63–9; F. Krauss and R. Herbig, *Der Korinthisch-dorische Tempel am Forum von Paestum* (Berlin, 1939). Jupiter Stator: *Forma Urbis*, plate XXIX. For the extensive literature see further the works by Delbrück (cited above, Note 20), Agnes Kirsopp Lake, 'Archaeological Evidence for the "Tuscan Temple"', *M.A.A.R.*, XII (1935), 114–49. A. de Franciscis, 'Templum Dianae Tifatinae', *Archivio storico di Terra di Lavori*, I (Caserta, 1956), 301–58. M. Almagro Basch, 'Las Excavaciones españolas en Gabii', *Atti del VII Congresso internazionale di archeologia classica*, II (1961), 237–48. J. A. Hanson, *Roman Theater-Temples*, 29–39. For Ostia: *Scavi di Ostia*, I, 105 f.

For the date of the temples of Gabii, Cagliari, and the other Late Republican temples, see further Crema, 42, 49. He suggests a date at the beginning of the second century for Gabii and the beginning of the third century for Cagliari. Comparing the temples of Cosa, the mouldings of the podia, etc., I maintain that these dates and others still more ancient which have been suggested are too early.

37 24. For Temple B on the Largo Argentina: Marchetti Longhi, *L'Area sacra del Largo Argentina* (*Itinerari*), 55–62; Nash, I, 136.

25. For the Capitolia see *Cosa*, II, 49 ff.; Agnes Kirsopp Lake, *loc. cit.*, 101–13; J. Johnson, *Excavations at Minturnae*, I (Philadelphia, 1935), 18–41. The Roman colony was founded in 296 as a castrum-fort (above, p. 104) with an aedes Jovis (Livy, XXXVI, 37); the forum with its Capitolium was built east of the castrum-fort in the second century (Johnson, *op. cit.*, 5). See further especially Luisa Banti, *St. Etr.*, XVII (1943), 187; M. Cagiano de Azevedo, *Mem. Pont.*, V (1940), 1–76; U. Bianchi, *Mem. Linc.*, ser. 8, II (1950), 349 ff.; Polacco, 80; and Crema, 37–9 (with bibliography).

38 26. The Capitoline Temple: Gjerstad's description, *Early Rome*, III, 168–90, and the *Acta* of the Institutum romanum Norvegiae in Rome, I (1962),

35–40, with criticism of the interpretation of Vitruvius, III, 3. 5 in my article 'Veteris Capitoli humilia tecta', *loc. cit.*, 27–33. Cf. above, p. 31 ff., Notes 9–10.

The text of Vitruvius, III, 3. 5 is / baryce / barycephalae humiles latae, but as Professor E. Wistrand has pointed out, *baryce* is most likely a dittography. For Tacitus, *Historiae*, III, 71, see Wistrand, *Eranos*, XL (1942), 169, and Boëthius, *The Golden House of Nero*, 60–1, notes 57 and 59. The suggestion about memorial coins representing a gable of a temple in conventional form has been made by F. Castagnoli, *Arch. Cl.*, V (1953), 104–5. The temple was heightened after the fire in A.D. 69 (Tacitus, *Historiae*, IV, 53); Boëthius, 'Nota sul tempio capitolino e Vitruvio, III, 3. 5', *Arctos*, N.S.V (1968).

27. A. M. Colini, 'Aedes Veiovis inter Arcem et Capitolium', *Bull. Comm.*, LXX (1942), 1–55. Bibliography, Nash, II, 490. For Vitruvius's rather misleading remarks (IV, 8. 4) and the Imperial Age: Crema, 47. The Pantheon of Agrippa in its original form had the same kind of plan as the Temples of Veiovis and Concord: Kähler, 'Das Pantheon in Rom', in *Meilensteine der europäischen Kunst* (Munich, 1965), 47 f., 55 f.

28. For these temples see J. A. Hanson, *Roman Theater-Temples*, 29–39. Crema, 49, and de Franciscis, *Templum Dianae Tifatinae*, 340, suggest that that temple also had some similar arrangement in front. For Morgantina see *A.J.A.*, LXVI (1962), plate 29. 2.

29. P. Mingazzini, *N.S.* (1949), 213 ff.; *Studi Sardi*, X–XI (1950–1), 161 ff.; Hanson, *op. cit.*, 32 f.

30. C. Carducci, *Tibur* (Istituto di Studi Romani, 1940), 64–75. Fasolo and Gullini, *Il Santuario della Fortuna Primigenia a Palestrina*, 353 ff., 424–33. Hanson, *op. cit.*, 31 f. p. 140

31. Strabo, V, 3. 12. Appian, *Bellum Civile*, I, 94, p. 143 says that Praeneste was very rich and that Sulla gave it over to plunder. In contrast to that he mentions that 'no plunder was gained' from Norba after its destruction shortly afterwards. The only possible conclusion seems to me to be that both the lower and the upper sanctuaries were built on the site of older shrines as a kind of simultaneous memorial of the victory and sacrifice of atonement. Fasolo and Gullini in their monumental work, cited in Note 30 above, try in a most interesting way to prove that the upper part of the sanctuary was built in the middle of the second century B.C. (cf. later

NOTES TO PART ONE

B. d'Arte, XLI (1956), 73 ff.; *Arch. Cl.*, VI (1954)). In my opinion Lugli has entirely disproved this in *Rend. Linc.*, ser. 8, IX (1954), 51–87, *Arch. Cl.*, VI (1954), 305–11, and *Palladio*, N.S. IV (1954), 174–8. See also his *Tecnica edilizia*. Especially important observations are added by Kähler, *Das Fortuna-heiligtum von Palestrina Praeneste*; see also *Gnomon*, XXX (1958), 366–83, Helga von Heintze, *Gymnasium*, LXIII (1956), 526–44, and G. Jacopi, *Il Santuario della Fortuna Primigenia (Itinerari)* (1963), bibliography, 23 f.

p. 143 32. This is the reconstruction by Fasolo and Gullini, *op. cit.*, and the conclusion of their painstaking discussion.

p. 145 33. This is G. Becatti's explanation of the term, *Scavi di Ostia*, IV, 254–9. Cf. *J.R.S.*, LIII (1963), 231 f. Pliny, XXXVI, 184–9; Varro, *De re rustica*, III, 1. 10: 'villam ... pavimentis nobilibus lithostratis spectandam'. Other explanations, refuted by Becatti: Marion Blake, *M.A.A.R.*, VIII (1930); Maiuri, *La Villa dei Misteri*; Fasolo and Gullini, *op. cit.*, 307 ff.; D. Gioseffi, 'La Terminologia dei sistemi di pavimentazione', *Rend. Linc.*, ser. 8, X (1955), 572–95.

34. 'locus saeptus religiose', in Cicero's words, *loc. cit.* The identification with the small enclosed shrine on the fourth terrace was first suggested by Mingazzini, *Arch. Cl.*, VI (1954), 295–301, and later Kähler, *op. cit.*, accepts and expounds Mingazzini's assumption.

p. 146 35. In identifying the round temple with the Temple of Fortuna I follow Kähler, *op. cit.* D. Vaglieri, 'Preneste e il suo tempio della Fortuna', *Bull. Comm.*, XXXVII (1909), 212–74, maintains in a most convincing way that the basilica, the buildings in front of the grottoes, and the aerarium were a civic centre.

p. 147 36. Lugli, in *Forma Italiae*, I, 1. 1, 154–78. Fasolo and Gullini, *op. cit.*, 362, 415–21. They date the great wall to the time of the war against Hannibal (pp. 326–8), and suggest that the urgent need of a defence against Hannibal caused construction in great haste with the new building material, concrete, of coarsest quality.

37. V. Cianfarani, 'Santuari nel Sannio', *Soprintendenza alle antichità degli Abruzzi e del Molise* (1960), 7–16, plates 4–5. For Morgantina see *A.J.A.*, LXVI (1962), plate 29. 2.

p. 148 38. Lugli, *Tecnica edilizia*, 127–31, 326, plate VI, 1. A. Bartoli, *B. d'Arte*, XXXIV (1949), 293–306, *Rend. Linc.*, ser. 8, IX (1954), 470–506. Gullini,

Arch. Cl., VI (1954), 185–216. C. C. van Essen, *Arch. Cl.*, XIII (1961), 145–51. V. Celani, *Ferentino* (1965).

39. For Bavai, Arles, Reims, Narbonne, and Aosta see R. A. Staccioli, *Rend. Linc.*, ser. 8, IX (1954), 645 ff.; *Arch. Cl.*, VI (1954), 284 ff.; Lugli, *Atti del X Congresso di storia dell'architettura* (1959), 187–97; Boëthius, *The Golden House of Nero*, 70, note 67.

40. Porta di Casamari (S. Maria) at Ferentinum: Lugli, *Tecnica edilizia*, 326, plate LXX, 2.

41. G. Säflund, *Le Mura di Roma repubblicana*, 22– 6. Another arch of the same type on the Quirinal, *op. cit.*, 88–91. Lugli, *Tecnica edilizia*, plate LXVI, 1–2.

42. For the walls of Alba Fucens: Mertens, 'L'Urbanizzazione del centro di Alba Fucens', *Mem. Linc.*, VII (1953), 171 ff., 'Alba Fucens, urbanisme et centuriation', *Atti del VII congresso internazionale di archeologia classica*, II (1961), 283–93, with bibliography, and *Rend. Linc.*, ser. 8, XIII (1958), 97–9; de Visscher, 'Alba Fucens 1957–1958', *Académie Royale de Belgique, Bulletin*, ser. 5, XLIV (1958), 507 ff., and 'Alba Fucens: A Roman Colony', *Archaeology*, XII (1959), 123–32; Mertens, 'Problèmes et methodes de la recherche dans une ville republicaine: L'example d'Alba Fucens', *Studi Romagnoli*, XIII (1962), 133–41.

43. Lugli, *Anxur Tarracina, Forma Italiae*, I, 1. 1 (Rome, 1926), 67–9, figures 13–14, and *Tecnica edilizia*, 147.

44. Fundi: Lugli, *Tecnica edilizia*, 152–4, plates VI, 3, CXXI, 1. Cora: *op. cit.*, 134–7, 425.

45. Lugli, *Tecnica edilizia*, 475–7, 295–9, figure 99; *N.S.* (1943), 275 ff.; *Mon. Ant.*, XXXIII (1930), 114 ff.

46. G. Calza and Becatti, *Ostia (Itinerari)* (1961), 7. R. Meiggs, *Roman Ostia*, 34 ff. Raissa Calza, *Ostia* (Rome, 1965). Lugli, *Tecnica edilizia*, 418 f., 477, 494 f., plate CXII, 3. *Scavi di Ostia*, I, 79–88.

47. Lucus Feroniae: Bartoccini, 'Il Rifornimento idrico della colonia Julia Felix Lucus Feroniae', *Autostrade*, nos. 7–8 (1963), 16. For regular Late Republican towns: Castagnoli, *Ippodamo*, 81, and especially *Surrentum (Sorrento)*, 90 f.; *Alife*, 93. *Strigae* and *scamna* are terms used for camps and land surveying, Castagnoli, *op. cit.*, 18, 48 f., 83, 85, 91, 98; Hyginus Gromaticus, *De munitione castrorum*, 1.

48. *Atrium testudinatum*: Crema, 105, 108; above, p. 71. Casa dello Scheletro: Maiuri, *Ercolano*, 265 ff., and *Ercolano (Itinerari)* (1962), 34 f. For the architectural term *atrium* and its different meanings other than referring to the main hall of the *cava aedium tuscanica* see Welin, *Studien zur Topographie des Forum Romanum* (*op. cit.*, Note 16), 199 ff. and *passim*.

53 49. Crema, 115 f. Casa del Tramezzo di Legno: Maiuri, *Ercolano*, 207 ff.

50. Ostia: *Scavi di Ostia*, I, 108; Meiggs, *Roman Ostia*, 253.

54 51. G. Fiorelli first observed that the oldest atria at Pompeii did not have impluvia: *Gli scavi di Pompei dal 1861 al 1872* (Naples, 1873), XII, 78 ff. This has been confirmed by Maiuri's excavation in the Casa del Chirurgo, *N.S.* (1930), 391. See also Crema, 105, 108.

52. Saepinum: *Anz.* (1959), 232, Livy, XLIII, 13. 6. Most interesting for the old history of the domus are also the numerous phases of the reconstruction of the Casa del Fauno, revealed by excavations by the German Archaeological Institute. An excellent analysis of the history of an atrium house is given by L. Richardson, Jr, in 'The Casa dei Dioscuri and its Painters', *M.A.A.R.*, XXIII (1955). For the investigations of the German Archaeological Institute in the Casa del Fauno, see A. W. Van Buren, 'News Letter from Rome', *A.J.A.*, LXVII (1963), 401 f.

53. A handy survey is given by K. Schefold, *Die Wände Pompejis* (Deutsches Archäologisches Institut, Berlin, 1957). See also Richardson, *op. cit.*, and for the paintings, Note 62 below.

55 54. Tetrastyle atria: Casa del Fauno; Casa delle Nozze d'Argento, see H. G. Beyen, *Pompejanische Wanddekoration*, II, I, 48 ff.; Casa del Labirinto. Corinthian atria: Casa di Epidio Rufo; Casa di Castore e Polluce; Casa dell'Atrio Corinzio at Herculaneum; Casa dei Dioscuri, Richardson, *op. cit.*, 7–18 (dated 110–85 B.C.).

55. Meiggs, *Roman Ostia*, 252.

56 56. The main treatment of this subject remains P. Grimal, *Les Jardins romains*, 155. Crema, 105, 113 f. The importance of the new prolonged axiality and views has been analysed with fine comprehension by H. Drerup, *R.M.*, LXVI (1959), 147, 155, and in a study of the Roman villas in the *Marburger Winckelmann-Programm* (1959).

57. Boëthius, 'Das Stadtbild im spätrepublikanischen Rom', *Opus. Arch.*, I (1935), 182–9; *The Golden House of Nero*, 137, figure 78. Forma Urbis, plate LIII, Meiggs, *Roman Ostia*, 123 f.

58. Maiuri, *Ercolano*, 286–90. Crema, 116, figure 106.

59. Crema, 116, figure 109. Richardson, *op. cit.*, p. 157 63–5, note 370, 110 claims that room 48 in the Casa dei Dioscuri is the only Cyzicene oecus so far (1955) discovered in Pompeii.

60. F. Noack and K. Lehmann-Hartleben, *Baugeschichtliche Untersuchungen am Stadtrand von Pompeji* (Berlin, 1936). Crema, 112, figure 101. For the coastal villas see V. Spinazzola, *Pompei*, II (Rome, 1953), 859, figure 861.

61. Casa dei Grifi: G. E. Rizzo, *Le Pitture della 'Casa dei Grifi' con note topografiche di A. Bartoli* (Rome, 1936). Crema, 21 (figures 18, 19), 117, and 121. The houses on the south side of the Palatine: Carettoni, 'Una Nuova Casa repubblicana sul Palatino', *Rend. Pont.*, XXIX (1956–7), 51–62; 'I Problemi della zona augustea del Palatino', *Rend. Pont.*, XXXIX (1966–7), 55–75; N. Degrassi, 'La Dimora di Augusto sul Palatino e la base di Sorrento', *loc. cit.*, 77–126. See now *N.S.* (1967). Suetonius, *Augustus*, XLV; Dio, LVII, 11.

62. The first of the so-called Pompeian Styles p. 158 was introduced to Italy from the hellenistic world in the third century B.C. (or even earlier): Villa Jacona at Gela, dated between 339 and 282, P. Orlandini and D. Adamesteanu, *Guida di Gela* (Milan, 1958), 36; the Ganymede House in Morgantina, dated between 260 and 250 B.C., *A.J.A.*, LXIV (1960), 131–3. For the history of the First and Second Styles see above all Beyen, *Die pompejanische Wanddekoration*, II, I. For the great wall paintings see also Phyllis Williams Lehmann, *Roman Wall Paintings from Boscoreale*. Later discussion: A. M. G. Little, 'A Series of Notes in Four Parts on Campanian Megalography', *A.J.A.*, LXVII (1963), 191–4, 291–4; LXVIII (1964), 62–7; Anne Laidlaw, 'The Tomb of Montefiore', *Archaeology*, XVII (1964), 33–42: first-century chamber tomb with vaulted entrance and exquisite paintings (walls and ceiling) in the Second Pompeian Style.

For the sectile pavements, lithostraton, and mosaics see Becatti's conclusive interpretation, *op. cit.* above, Note 33.

For the luxury of the villas and the transition to the Augustan Age see Strong, 'Some Observations on Early Roman Corinthian', *J.R.S.*, LIII (1963), 78; for the later periods of the Villa dei Misteri and the Casa del Menandro see Maiuri's

monographs and Phyllis Williams Lehmann, *Roman Wall Paintings from Boscoreale* (dating p. 3), and Beyen, *op. cit.*, 122 f. (Casa del Menandro).

p. 159 63. G. Pesce, *Il 'Palazzo delle Colonne' in Tolemaide di Cirenaica* (*Monografie di archeologia libica*, II, Rome, 1950). C. H. Kraeling, *Ptolemais, City of the Libyan Pentapolis* (Chicago, 1962), establishes beyond question the Early Imperial date of the Palazzo delle Colonne (*A.J.A.*, LXIX (1965), 80) believed by Pesce to be a hellenistic building. Delos: Robertson, 300–2; *Exploration archéologique de Delos* (Paris, 1922–4), VIII. See also Giovanna Tosi, 'Il Palazzo principesco dell'arcaismo greco alla Domus Flavia', *Arte antica e moderna*, V (1959), 241–60. A. von Gerkan, *Gnomon*, XXIII (1951), 337, dates the palace at Ptolemais to the Flavian age. Cf. also H. Sichtermann, *Anz.* (1959), 251–3, 338, and Crema, 434 f., figure 128.

64. The classic work on villas is Maiuri, *La Villa dei Misteri*. Important also are Drerup, 'Die römische Villa' (cited in Note 56), and D. Mustilli, 'La Villa pseudourbana ercolanese', *Rend. Nap.* (1956). See further Crema, 120–2, with bibliography. The main ancient sources are Cato, *De agricultura*, Varro, *De Re Rustica*, especially I, 13, Vitruvius, VI, 6, Columella, I, 6. The typical villas with courtyards are discussed by M. Rostovtzeff, *The Social and Economic History of the Roman Empire*, 2nd ed. (Oxford, 1957); A. Mau, *Pompeii* (Leipzig, 1908), 382–8, and others. For the simple villa see G. Forni, *Athenaeum*, N.S. XXXI (1953), 173; the Villa Sambuco (second century B.C.) near San Giovenale, cf. *San Giovenale*, 313–20. Two rustic villas, Posto and San Rocco, are being excavated by P. H. von Blanckenhagen in collaboration with Ward-Perkins on the present Villa Francolise site, *A.J.A.*, LXVIII (1964), 192. They date from the last two centuries B.C. and exhibit courtyards (in contrast to the Villa Sambuco), wells, an oil-separating cistern, slave quarters, etc., but were rebuilt in Imperial times. Compare also E. Berggren, 'A New Approach to the Closing Centuries of Etruscan History', *Arctos*, V (1967), 29–43, and the Dema House in Attica (about 420 B.C.): J. E. Jones, L. H. Sackett, A. J. Graham, *A.B.S.A.*, LVII (1962), 75–114. Boëthius, *The Golden House of Nero*, 96. For the smaller farms: G. D. B. Jones, 'Capena and the Ager Capenas', 'M. Forco', *P.B.S.R.*, XXXI (1963), 147–58.

p. 160 65. Lugli, *Tecnica edilizia*, 452, plate CXXVI. D. Levi, *St. Etr.*, I (1927), 477 ff. Crema, 121, figure 110. Castagnoli, *M.A.A.R.*, XXIV (1956), 164 f.

66. Lugli, *Tecnica edilizia*, 161, 452, plate VIII, 3, CXXVI, 1. Maiuri, *Villa dei Misteri*, 87–9.

67. For the Villa dei Papyri, I am convinced by Mustilli (cited in Note 64 above), but see also Maiuri, *Ercolano* (*Itinerari*) (1959), 73–9. The Late Republican villa below Hadrian's villa was discovered by Lugli, *Studi minori di topografia antica*, 384–403 (*Bull. Comm.*, LV (1927), 139–204). Kähler, *Hadrian und seine Villa bei Tivoli* (Berlin, 1950).

68. Fundamental is K. M. Swoboda, *Römische p und romanische Paläste*, 2nd ed. (Vienna, 1924), 29 ff. See further L. d'Orsi, *Gli Scavi di Stabia*, 2nd ed. (Stabia, 1961), plate XXXI, and Boëthius, *The Golden House of Nero*, 100.

69. Lugli, 'Nymphaea sive musaea', *Studi p minori di topografia antica*, 169–81 (*Atti del IV congresso nazionale di studi romani*, I (1938), 155–68). For the use of the words 'nymphaeum' and 'musaeum': Mingazzini, *Arch. Cl.*, VII (1955), 156–62, uses the word 'musaeum' for natural grottoes with later extensions and 'nymphaeum' only for monumental, public fountains. Cf. Neuerburg, *L'Architettura delle fontane e dei ninfei nell'Italia antica*, 27–9. Crema, 122–5. The grottoes from Locri are published by P. E. Arias, *Palladio*, V (1941), 193–206. Drawings by Clésseau of the nymphaeum of Albano, *Journal of the Society of Architectural Historians*, XXII (1963), 123, figures 5 and 6, and Neuerburg, *op. cit.* Bovillae: Neuerburg, 159 f.; Lugli, *Tecnica edilizia*, plate LXVIII. Doric Nymphaeum: Neuerburg, 157 f. Villa di S. Antonio, Tibur: Neuerburg, 249 f. Lugli, *Tecnica edilizia*, plate CXXII, 1. The nymphaea of the 'Villa di Cicerone', Neuerburg, 145–7. Subterranean halls ('aestivi recessus' or 'specus'): P. Mingazzini, *Festschrift Eugen v. Mercklin* (1964), 96 f. One 'recessus' of this kind was perhaps originally the subterranean hall of the lower town of Ardea, though used as a tomb in the second century B.C. and in early medieval times as a church: A. Ferrua, *Rend. Pont.*, XXXVII (1964–5), 283–306.

70. *Scavi di Ostia*, I, 117 f.

71. For the baths and palaestrae: Crema, 68–75; p Staccioli, *Arch. Cl.*, X (1958), 273–8; XIII (1961), 92 ff.; Rosanna Maccanico, 'Ginnasi romani ad Efeso', *Arch. Cl.*, XV (1963), 35; J. Delorme, 'Les Palestres', *Exploration archéologique de Delos*, XXV (1961), 145; *Gymnasion, Étude sur les monuments consacrés à l'education en Grèce* (*Bibliothèque des Écoles Françaises d'Athènes et de Rome*, CXCVI)

(Paris, 1960). For Orata: Pliny, IX, 168 f.; Cicero as quoted by Nonius, 194; Valerius Maximus, IX, I. Greek hypocausts: Olympia (about 100 B.C.); H. Schleif, *Die neuen Ausgrabungen in Olympia* (Berlin, 1943), 14; *Neue deutsche Ausgrabungen im Mittelmeergebiet und im vorderen Orient* (Berlin, 1959), 273; Gortys (Arcadia, second century B.C.), *B.C.H.*, LXXVII (1953), 263 ff., LXXIX (1955), 331 f. R. Ginouvès, *L'Établissement thermal de Gortys d'Arcadie* (*Études Péloponnésiennes*, II) (Paris, 1959). For medieval distribution in Europe: *Fornvännen* (1950), 182 ff.; (1954), 241 ff.; (1961), 110 ff.; A. Sandklef, *Varbergs museum, årsbok* (1960), 56 ff.; Åström, *loc. cit.* (1963), 147, 159. Scipio and the palaestrae: Plutarch, *Pyrrhus*, 16; Dio, fragment 57, 62; Livy, XXIX, 19. II. For thermae and balneolae of Imperial Rome see the concluding summaries of the *Libellus de regionibus Urbis Romae*. For the peristyles behind the stage-houses and Pompey's theatre: Plutarch, *Pompey*, 42, 3; Hanson, *Roman Theater-Temples*, 43 ff. (with discussion of Greek prototypes).

165 72. The site of the Circus Flaminius: G. Gatti, *Capitolium*, XXXV, 7 (1960), 3–12; *Palatino*, V (1961), 17–20; Nash, *s.v. Theatrum terra exaggeratum*; *C.I.L.*, X, 3772, 3782. Gioiosa Ionica: S. Ferri, *N.S.* (1926), 332 ff. General survey and bibliography: Crema, 95–100.

73. For the history of the Roman theatres and their interrelations with hellenistic and South Italian Greek theatres: Margarete Bieber, *The History of the Greek and Roman Theater*; A. Neppi Modona, *Gli Edifici teatrali greci e romani*; Crema, 187–203. See also E. Paratore, 'Storia del teatro latino', in *Storia del teatro, diretta da M. Praz* (Milan, 1957). A recent contribution to our knowledge about the Etruscan *ludiones*: see Chapter 3, Note 48.

168 74. For the early history of the theatre of Pompeii: Margarete Bieber, *op. cit.*, 170–3; Crema, 91; Maiuri, *N.S.* (1951), 126 ff. The question about the precise meaning of the word proscenium (Προσκήνιον, Vitruvius, V, 7. 1) refers mainly to the Greek theatres; see Margarete Bieber, *op. cit.*, 114–16. For the proscenium of Roman theatres (stage, stage-house) see Polybius in Athenaeus, XIV, 615b, where proscenium seems to be a place between the ὀρχήστρα and the stage (σκηνή), mentioned *ibid.*, 615d. Scaenae frons: the terracotta relief from the Santangelo Collection in the National Museum of Naples, see Crema, 87, figure 80, and Margarete Bieber, *op. cit.*, 129 ff. where also the vase paintings

representing Italian popular comedies are illustrated and analysed. For koilon and cavea, G. Caputo, *Dioniso*, IV (1935), 254. Seats (*spectacula, cavea*): Plautus, Amphitruo, 65–8; Miles gloriosus, 81–3; Poenulus, 17–35, 1224; Truculentus, 968. Livy, XXXIV, 44, 54 (for 194 B.C.); the summary of Livy's book XLVIII ('and for some time thereafter the people stood to see the theatrical performances') cannot be exact. The same confusion between permanent theatres and seats for the spectators by Valerius Maximus, II, 4. 2. Siparia and aulaea: Crema, 81 f., Margarete Bieber, *op. cit.*, 179 f. Aulaea from Pergamon: Donatus, *Excerpta de comoedia*, 8 (p. 30 in the Teubner edition of *Aelii Donati quod fertur Commentum Terenti*, I). For the reform of 194 B.C. see Livy, XXXIV, 44. 5; 54.

75. Convincing is Hanson's discussion in *Roman Theater-Temples*, 9–26. For the theatre of 154 B.C.: Livy, *Epitome*, XLVIII; Valerius Maximus, II, 4. 2; Velleius Paterculus, I, 15. 3; Appian, *Bellum Civile*, I, 28; Augustine, *De civitate Dei*, II, 5; Hanson, *op. cit.*, 24 f.; Margarete Bieber, *op. cit.*, 170; Crema, 85–6. Pietrabbondante: Cianfarani, *Santuari nel Sannio* (1960), plate I.

76. Pliny's main description of the theatres of p. 169 Scaurus and Curio: XXXVI, 114–17. Statues: XXXIV, 36. Marble walls: XXXVI, 50. Glass mosaics: XXXVI, 189. Columns: XXXVI, 5–7, where Pliny also expatiates on the distribution of columns, etc., to the domus. Six columns of marble from Hymettus transferred to Crassus's house from the theatre of his aedileship, Pliny, XVII, 6. The paintings in Claudius Pulcher's theatre, Pliny, XXXV, 127. Scaurus, 3,000 statues on the stage, though temporary, are found in XXXIV, 36. Marcus Scaurus's 'stage was the first structure to have marble walls whether they were of veneer or of solid blocks'. In XXXVI, 189, can be found the glass mosaics on the walls of the theatre of Scaurus; columns of Lucullean marble in XXXVI, 7. See also Crema, 86, and H. Drerup, 'Zum Ausstattungsluxus in der römischen Architektur', *Orbis antiquus*, XII (1957), 17. For the relation between the Roman theatres and the theatres of Segesta and Tyndaris: Margarete Bieber, *op. cit.*, 170. For the crocodiles see Pliny, VIII, 96.

77. Crema, 95–100 (with bibliography). p. 170

78. For the Late Republican rearrangement of p. 171 the theatre of Pompeii, see Margarete Bieber, *op. cit.*, 170–3; Crema, 91; Maiuri, *N.S.* (1951), 126 ff. See also G. Traversari, *Gli Spettacoli in acqua nel*

teatro tardo-antico (Rome, 1960); *Dioniso*, XV (1952), 308 ff.

p. 172 79. For the recent discussion of the small theatre of Pompeii, see Crema, 92. On the wooden roofs of Rome see Diribitorium, Dio, LV, 8; Pliny, XVI, 201, and XXXVI, 102. For the theatre of Alba Fucens: *Archaeology*, XII (1959), 128 f.; *Anz.* (1959), 210 f. Other theatres probably having Late Republican first periods are: Faesulae (Fiesole), Crema, 93; Ferentum, P. Romanelli, *Dioniso*, II (1929), 260 ff.; Gubbio, P. Moschella, *Dioniso*, VII (1939), 3 ff.; 'Notiziario', *Bull. Comm.*, LXVII (1939), 83.

80. Forma Urbis, plate XXXII, pp. 103–6, plate VI, p. 45 (rebuilt by Tiberius). See Plutarch, *Pompey*, 42, 52; Tacitus, *Ann.*, III, 72 (fire), XIV, 20; Dio, XXXIX, 38; LXII, 8; Pliny, VII, 34; and Platner-Ashby, *s.v.*; Ammianus Marcellinus, XVI, 10. 14. See also Hanson, *op. cit.*, 43–55; Margarete Bieber, *op. cit.*, 181–4; Neppi Modona, *op. cit.*, 77–9; Crema, 93–5. Platner-Ashby and Nash, *s.v.*

81. Plutarch, *Caesar*, 66. For the discussion about the place where Caesar was murdered see Crema, 95, Hanson, *op. cit.*, 48, note 28, and Marchetti Longhi, *Rend. Pont.*, ser. 3, XII (1936), 267–79.

82. For the entire discussion about the Temple of Venus see Hanson, *op. cit.*; Tertullian, *De spectaculis*, X, 5; Gellius, X, 1. 6–7. For the other shrines on the top of the theatre: Suetonius, *Claudius*, 21, 1, and *C.I.L.*, I², p. 324, and the Fasti Amiternini and Allifani.

p. 173 83. For the comitia, in addition to what is said above, p. 113, see Sjöqvist, *Studies Presented to David Moore Robinson*, I (St Louis, 1951), 405–6 and Hanson, *op. cit.*, 38. See further Kähler, *Das Fortunaheiligtum von Praeneste* (quoted in Note 10), 219–28. Pietrabbondante: Cianfarani, *Santuari nel Sannio* (1960), 23–5.

84. For the Horrea Galbae see Platner-Ashby and Nash, *s.v.* The granaries of Syracuse are mentioned in Livy, XXIV, 21. 11. For hellenistic markets, cf. Pergamon, Magnesia, and, among others, Dura Europos, IX, figure 11; Ward-Perkins, 'The Roman West and the Parthian East', *Proc. Brit. Ac.*, LI (1965), 186, plates LI–LII. For the caravanserais, for instance that of Kassope in Epirus, see *J.H.S.*, LXXIII (1953), 120, and Boëthius, *The Golden House of Nero*, 79, 134. For the early importation of provisions by river boats on the Tiber or by merchantmen from the Etruscan coast, Sicily, and south Italy, see Livy, IV, 52. 6 (412 B.C.); V, 13. 1 (399 B.C. – the Tiber became unnavigable, but the price of corn, owing to the supply which had been brought in before, did not go up). See also Dionysius, VII, 1. 1–3 and 2. 1 (about 490 B.C. – a great quantity of provisions from Sicily), and XII, 1 (Maelius brought many merchantmen laden with corn from Tuscany, Cumae, and other parts of Italy by river boat via Ostia). Among other testimonies about river boats on the Tiber is Dionysius, X, 14; L. Casson, 'Harbour and river boats of Ancient Rome', *J.R.S.*, LV (1965), 31–9.

85. On the magazines of Ostia, especially the Horrea on the Via del Sabazeo: Meiggs, *Roman Ostia*, 124. For the Magazzini Repubblicani see *Scavi di Ostia*, I, 112, 185, figures 41, 190 f.; Meiggs, *op. cit.*, 130. On transport to Rome: J. Le Gall, *Le Tibre, fleuve de Rome dans l'antiquité* (Paris, 1953).

p. ? 86. See Boëthius and N. Carlgren, *Acta Archaeologica*, III (1932), 181 ff.; Bartoli, *B. d'Arte*, XXXIV (1949), 293 ff.; Gullini, *Arch. Cl.*, VI (1954), 202 (on Ferentinum); and Carducci, *Tibur* (Istituto di Studi Romani, 1940), 60. For Caesarea Maritima see *I.L.N.* (2 November 1963), 728–31.

87. See Crema, 'La Formazione del "Frontone Siriaco"', *Scritti di storia dell'arte in onore di Mario Salmi*, I (1961), 1–13. For the bridges see Crema, 12, Platner-Ashby, and Nash, *s.v.* Ponte di Nona: Lugli, *Tecnica edilizia*, 356; Blake (1947), 211 f. For the construction of the bridges in general: T. Frank, *Roman Buildings*, 139, 141 f. Pons Mulvius: Blake (1947), 134, 213.

p. ? 88. On the Cloaca Maxima see Frank, *op. cit.*, 74, 142; Blake (1947), 38, 159, 198; Lugli, *Tecnica edilizia*, 257, 308, 357; Nash, *s.v.*; Crema, 12.

89. The Roman economy in the use of more valuable material is especially clear when travertine was used. Reticulate was sometimes strengthened by alternating layers of travertine blocks, evidently making the network façade more sturdy. Burnt brick, *tiles*, was also used in the same way in walls both of concrete and of sun-dried bricks (Vitruvius, II, 8. 17 f.). See below, p. 178. For the aqueducts in general see T. Ashby, *The Aqueducts of Ancient Rome*, 88–158; Esther Van Deman, *The Building of the Roman Aqueducts*, 67–146; Blake (1947), 134; Lugli, *Tecnica edilizia*; Frank, *op. cit.*, 137 ff. Aqua Marcia: Boëthius, *The Golden House of Nero*, 78, figure 39.

p. ? 90. For the tombs of the Scipiones and the Sempronii see Nash, *s.v.*, and Crema, 126; among other contributions see especially P. Nicorescu, 'La Tomba degli Scipioni', *Ephemeris Dacoromana*,

1 (1923), 1–56. See also Kähler, *Rom und seine Welt* (Munich, 1958), plate 70, with discussion of the tomb of the Scipiones and the sarcophagus of Barbatus, plate 38. For the tomb with historical painting on the Esquiline see also *Bull. Comm.* (1889), 340 ff., and A. Momigliano, *J.R.S.*, LIII (1963), 96, note 9 (with bibliography).

77 91. Calza, *La Necropoli del porto di Roma nell'Isola Sacra* (Rome, 1940), 44, figure 9. Early tomb apartments resembling the catacombs: Lucia Morpurgo, 'Un Sepolcreto precristiano di Anzio', *Rend. Pont.*, ser. 3, XXII (1946–7), 155–66; H. J. Leon, *The Jews of Ancient Rome* (Philadelphia, 1960), 46–66. Maria Floriani Squarciapino, *Scavi di Ostia*, III, 63–113. Lugli, 'Scavo di un sepolcreto romano presso la Basilica di S. Paolo', *N.S.* (1919), 300, 312. F. Magi, 'Ritrovamenti archeologici nell'area dell'autoparco vaticano', *Triplice omaggio a Sua Santità Pio XII*, II (Città del Vaticano, 1958), 92. For *bustum* and *ustrinum*: Festus, p. 29, 10 Lindsay (32, 4).

92. Together with these monuments, which show that the riversides could be used in the same way as the surroundings of the roads, is to be remembered that in Imperial times common burials were aligned along the Tiber. They have been found south and north of the districts around the Forum Boarium and the branches of the city walls, which very likely already in the fourth century were built from the Capitoline Hill and the Aventine to the Tiber to protect the settlement on the Forum Boarium, which already belonged to Early Rome. Le Gall, *Le Tibre, fleuve de Rome dans l'antiquité*, 188 f.

78 93. For these tombs of Bibulus and Ser. Sulpicius Galba see Crema, 129 f., Nash, II, 319, 370, with bibliography. For tombs of Pompeii and of south Italy and Sicily: Crema, 128 ff.; A. de Franciscis-R. Pane, *Mausolei romani in Campania* (Naples, 1957), and P. Marconi, *Agrigento* (Florence, 1929), 121–7. For sepulchral monuments in Asia Minor: W. B. Dinsmoor, *The Architecture of Ancient Greece* (London and New York, 1950), 256–64, 328–30.

94. For the sepulchral monuments of Terracina see Lugli, *Anxur Tarracina*, in *Forma Italiae*, I, 1. 1, 184, 186, nos. 8 and 12, figures 2, 3, 6.

95. Tholos tomb at Cumae: Crema, 17, 125, figure 14.

79 96. See Crema, 130 f., 243, figures 118, 260, and B. Götze, *Ein römisches Rundgrab in Falerii* (Stuttgart, 1939). Ross Holloway's idea (*A.J.A.*, LXX

(1966), 171–3) that the tombs of the princes of Troy should have been the model for Roman mounds of the Late Republican and Augustan Age seems narrow-viewed, even if we take into consideration the romantic revival of other famous, foreign types of tombs, such as the Pyramid of Cestius (cf. Horace, III, 30) and the tholos tomb at Cumae (see above, p. 178) in Late Republican and Augustan times. Ross Holloway has obviously forgotten that Etruscan ancestry was à la mode in Augustan Rome (Horace, *Odes*, I, 1 and III, 29). He further overlooks the obvious imitations of Etruscan tumuli on the Via Appia, of which one is Late Republican (see above, p. 178; also Crema, 131, 243, figure 260). Dionysius (I, 64) and Vergil (*Aen.*, XI, 849 f.) further attest that there were old mounds in Latium, which appealed to the Romans. There was, of course, no unbroken tradition whatever between the archaic Etruscan and Latin tumuli and their sophisticated return to vogue, but it seems self-evident to me that it was the ancient Etruscan and Latin monuments which inspired the late Romans and became the models for such archaistic tombs as the mounds of the Via Appia, as well as for the distinguished tumuli, which were provided with high sculptured substructures in hellenistic style, like the tombs of Augustus, of Caecilia Metella on the Via Appia, of Munatius Plancus at Gaeta, or the Torrione di Micara at Tusculum (with its burnt brick on the inside; Vitruvius, II, 8. 4). These round Roman tombs no doubt created a fashion in and around the Empire, a trend which we can follow from the mound called the 'Tombeau de la Chrétienne' in Mauretania to Belgium. This does not, of course, prevent people from speculating widely and connecting the tomb of Augustus with the tombs of the 'epic past', that is, of his Trojan forefathers and their greatest enemy, Achilles. It seems less far-fetched, however, to bring to mind Aeneas' or Anchises' small mound near Lavinium, 'round which have been set out in regular rows trees that are well worth seeing', to quote Dionysius (*loc. cit.*).

97. See Strabo, V, 2. 5, and Pliny, XXXVI, 14; 135. Blake (1947), 53; Lugli, *Tecnica edilizia*, 327–9.

98. See Cagiano de Azevedo, 'I "Capitolia" p. 180 dell'Impero Romano', *Mem. Pont.*, ser. 3, V, 1 (1940), 1–76. For the lesser propylaea of Eleusis: Dinsmoor, *op. cit.* (Note 93), 286–7; G. E. Mylonas, *Eleusis and the Eleusinian Mysteries* (Princeton, 1961), 156–60, *et passim*; Boëthius, *The Golden House of Nero*.

NOTES TO PART TWO

CHAPTER 7

p. 183 1. Suetonius, *Augustus*, 28. 3; the word used for brick refers to sun-dried, not kiln-baked, bricks. The *Res Gestae* (often referred to as the *Monumentum Ancyranum*, the most complete surviving copy being that inscribed on the walls of the Temple of Rome and Augustus at Ancyra, the modern Ankara) were inscribed on two bronze tablets beside the entrance to the Mausoleum of Augustus.

p. 184 2. For dedications by private individuals under Augustus, see Suetonius, *Augustus*, 29. 5, and Tacitus, *Annals*, III. 72. A building specifically recorded as having been paid for by Augustus himself *ex manubiis* is the Porticus Octaviae, a rectangular colonnaded enclosure adjoining the Theatre of Marcellus and replacing the Republican Porticus Metelli; presumably also the eighty-two temples claimed to have been restored in 28 B.C., the year after his own great triumph. The Temple of Castor and probably that of Concord also were rebuilt by Tiberius from the proceeds of his triumph in 7 B.C. Of the buildings that are wholly or partly lost, the plans of the Temples of Diana (Plate 144; an adjoining fragment, now lost, is known from an old drawing) and probably of Neptune, of the Porticus Philippi and of the Theatre of Balbus are known from the Severan marble map. The Porticus Philippi adjoined and closely resembled the Porticus Octaviae. The remains of the theatre, long thought to be those of the Circus Flaminius, are now known to lie buried beneath the Palazzo Caetani (G. Gatti, *Capitolium*, XXXV (July 1960), 3–12). The library housed in the Atrium Libertatis was yet another inheritance from Caesar.

p. 185 3. For the chronology of the surviving Augustan buildings, see Strong and Ward-Perkins, 'Temple of Castor', 4–5. The Augustan column bases of the Temple of Saturn, *ibid.*, 5–12, plate IX, b. The Arch of Augustus in the forum awaits publication.

4. Agrippa's work of flood-control and consolidation, though less grandiose in conception than Caesar's plans for tackling the same problems (Cicero, *Letters to Atticus*, XIII, 33a. 3), established a mean level within the Campus Martius that was little altered throughout antiquity; see Shipley (Agrippa), *passim*, and Blake (1947), 159–63. The

detailed study of the masonry of the aqueducts by Miss Van Deman yielded a striking picture of the variety of the work undertaken by the different contractors, many of them using a mortar that in practice proved inadequate for its purpose. The squared stone masonry of parts of the Horrea, with its engaged Corinthian columns, is in the same tradition as that of the Theatre of Marcellus.

5. The present Pantheon, long thought to be in part the work of Agrippa, is entirely the work of Hadrian, who reproduced the dedicatory inscription of his predecessor; cf. below, p. 256. The Agrippan building seems to have faced in the opposite direction, with the door into the cella approximately beneath that of the present building.

6. As early as 54 B.C. (Cicero, *Letters to Atticus*, p. IV. 16. 14). Attached to the Saepta was a covered hall, the Diribitorium, begun by Agrippa and completed in 7 B.C. (cf. Figure 87). Its timber roof, reputed to have had the widest span of any ever built (Pliny, *Natural History*, XVI. 201), offers another link with the odeion at Athens. For the latter, and for the Lesser Propylaea at Eleusis, see below, pp. 378 ff.

7. Pliny, *Natural History*, XXXVI. 38.

8. For the pair of apsed halls (*basilicae*) flanking p. the stage-building, cf. the Augustan theatre at Iguvium (Gubbio), *C.I.L.*, XI, 5820.

9. The background of the figure sculpture is unmistakably Attic, whereas the acanthus scrollwork, though derived immediately from the workshops of Attica, stems ultimately from hellenistic Pergamon. For the Altar of Pity, see H. A. Thompson, *Hesperia*, XXI (1952), 47–82.

10. Pliny, *Natural History*, XXXVI. 102. For the p. masonry of the temple, see *J.R.S.*, XXXVIII (1948), 65–6, figure 10. For the caryatids and Pegasus capital, C. Ricci, *Capitolium*, VI (1930), 157–89, and G. Q. Giglioli, *R.M.*, LXII (1955), 155–9; and for Attic details in general, *P.B.S.R.*, XXX (1962), 18–25.

11. *P.B.S.R.*, II (1904), plate 124, b and c. p.

12. Reproduced by G. Lugli, *Roma antica, il centro monumentale* (Rome, 1946), figure 28, and Nash, I, figure 358.

13. A further reconstruction in A.D. 22 (Tacitus, *Annals*, III. 72) seems to have involved mainly the upper order of the central hall.

194　14. The 'Anaglypha Traiani' (Lugli, *op. cit.* (Note 12), 160–4; Mason Hammond, *M.A.A.R.*, XXI (1953), 127–83) show the keystones of the façade arches carved as the forequarters of chimaeras – a Greek architectural motif found also in the Forum Augustum.

15. Vitruvius, III. 3. 4. It has been suggested (O. L. Richmond in *Essays and Studies presented to William Ridgeway* (Cambridge, 1913), 198–211) that this rather than the Temple of Divus Augustus is the Ionic building shown on a coin of Caligula; see below, p. 203.

95　16. Blake (1947), 165–6. Strong and Ward-Perkins, 'Temple of Castor', 8–9.

17. A. von Gerkan (*R.M.*, LX–LXI (1953–4), 200–6) and others have proposed a date late in the first century A.D. But see Strong and Ward-Perkins, *loc. cit.*

96　18. Cf. the little Republican Temple of Veiovis; perhaps also Agrippa's Pantheon. The plan of Concord was dictated by the space available.

19. Pseudo-peripteral: Apollo in Circo, Apollo Palatinus(?), Saturn(?), Divus Julius(?). Prostyle: Magna Mater. Peripteral: the restored Temple of Minerva on the Aventine (Plate 144; see above, Note 2) and the three small temples in the Forum Holitorium, of which the northernmost is *sine postico* (for which see F. Castagnoli, *R.M.*, LXII (1955), 139–43). For the orders of Saturn and Divus Julius, see Ward-Perkins, *P.B.S.R.*, XXXV (1967), 23–8.

98　20. Blake (1947), 41–4. See below, pp. 246–7.

21. Roman brickwork was never more than a facing to the concrete core within. The flat exposed surface usually conceals a triangular or irregular profile, designed to bite into the structure behind. See below, Chapter 10.

CHAPTER 8

203　1. The surviving remains of the upper order of the Basilica Aemilia accord well with the date of the Tiberian restoration recorded by Tacitus (*Annals*, III. 72). Pliny (*Natural History*, XXXVI. 102) admired it greatly.

2. For identification of the Ionic temple as that of Apollo, see O. L. Richmond in *Essays and Studies presented to William Ridgeway* (Cambridge, 1913), 203–6. The only capital of appropriate date and scale now preserved near the site is of the Corinthian order (H. Kähler, *Römische Kapitelle des Rheingebietes* (Berlin, 1939), Beilage 2, 4).

3. See below, pp. 323 ff.　p. 204

4. By the second half of the century this was p. 205 normal practice in building vaults of any substantial size, e.g. in the Colosseum.

5. The Temple of Cybele on the Palatine (above, p. 206 p. 195) was a purely classical building. So too in its detail was the Sanctuary of the Asiatic Divinities at Ostia (R. Meiggs, *Ostia* (Oxford, 1960), 356–9, figure 26); but the layout, around a large enclosed precinct, is that of a cult whose mysteries had to be shielded from the eyes of the profane. The precinct was probably established under Claudius.

6. F. Castagnoli, *Bull. Comm.*, LXX (1942), 57–73.　p. 208

7. E.g. the Porticus Minucia (p. 210 and Note 10, p. 209 below); a portico in the Claudian harbour at the Tiber mouth (Lugli, *Tecnica edilizia*, plate XXXIII, 6).

8. Blake (1959), 84. Cf. Tacitus, *Annals*, XII. 57; p. 210 Pliny, *Natural History*, XXXVI. 124. For the continued importation of pulvis puteolanus from Pozzuoli, see Pliny, *Natural History*, XVI. 202.

9. For the warehouses of Ostia, see below, p. 283.

10. F. Castagnoli, *Mem. Linc.*, ser. 8, I (1948), 175–80. For the surviving remains, see E. Sjöqvist, *Acta Rom. Suec.*, XII (1946), 47–153.

11. See below, pp. 248 ff.　p. 211

12. *B.M.C.: Empire*, I, plates 43, 5–7, and 46, 6.

13. Martial, VII. 34: 'quid Nerone peius? quid thermis melius Neronianis?'

14. See below, pp. 226, 399.　p. 212

15. M. Barosso, *Atti del III Congresso nazionale di storia dell'architettura* (Rome, 1941), 75–8.

16. Miss Van Deman's reconstruction of these p. 216 porticoes (*A.J.A.*, XXVII (1923), 402–24; *M.A.A.R.*, V (1925), 115–25) is discussed at length in Blake (1959), 44–6. The façades consisted of a rising series of arches framed between the semi-columns of an engaged, probably Ionic order. The porticoes represent a monumental application of Nero's own town-planning regulations.

17. Tacitus, *Annals*, XV. 42, where the architects, Severus and Celer, are characterized as 'magistris

et machinatoribus'. Suetonius, *Nero*, 31, lists the mechanical marvels. Cf. the phraseology in Seneca, *Letters*, 90 (XIV, 2), 7 and 15.

p. 216 18. Tacitus, *Annals*, XV. 43.

19. Repeating an Augustan ordinance (Strabo, V. 3. 7 (235)) which had evidently been allowed to lapse. The height was subsequently reduced by Trajan (Aurelius Victor, *Epitome*, 13. 13) to 60 feet.

CHAPTER 9

p. 217 1. *B.M.C.: Empire*, II, 168, nos. 721, 722; cf. Nash, II, 532, figure 657. For the earlier temple, see above, p. 39.

2. A. M. Colini, *Mem. Pont.*, VII (1944), 137–61; A. Prandi, *Il Complesso monumentale della Basilica Celimontana dei SS. Giovanni e Paolo* (Rome, 1953), 373–420.

p. 219 3. The evidence of the scanty remains now visible is supplemented by that of excavation (A. M. Colini, *Bull. Comm.*, LXV (1937), 7–40) and of the Severan marble map (*Forma Urbis*, 73, plate XX; cf. Nash, I, figure 536).

p. 220 4. Puteoli, see below, p. 298. The 'Marmor-säle' of Asia Minor, p. 399.

p. 223 5. See below, pp. 509 ff. The brick arches in the vaults that span the vomitoria have been interpreted as the remains of a prior skeleton vaulting-system that enabled the workmen to operate simultaneously at several different levels; but this is certainly mistaken. They could never have stood, let alone carried a load, independently of the rest of the vault.

p. 224 6. For the awnings, see Durm, *Baukunst*, 687–9 and figures 754 (Pola) and 755 (Nîmes).

p. 226 7. Reproduced by Nash, II, figure 1280.

8. See above, pp. 211–12.

p. 228 9. E. Sjöqvist, *Acta Rom. Suec.*, XVIII (1954), 104–8. See also below, p. 461.

10. Colini, *Bull. Comm.*, LXI (1933), 264.

p. 230 11. F. Castagnoli (*Arch. Cl.*, XII (1960), 91–5) interprets the stepped feature as the base of the cult-statue within the temple. A coin of A.D. 94–6 (*B.M.C.: Empire*, II, 241, plate 67, 7; Nash, II, 66, figure 753) indicates a circular columnar building of conventional type.

12. Listed by Blake (1959), 124–31.

13. Many other buildings have been attributed to p. Rabirius (see MacDonald, 127–9), some no doubt correctly; but this is the only one for which there is specific ancient authority (Martial, *Epigrams*, VII, 56).

14. Opinions as to the roofing of the large Domi- p. tianic state halls range from a belief that all had concrete barrel-vaults (so recently MacDonald, 56–63; Wataghin Cantino, 66–9) to the suggestion that the Aula Regia was in fact a courtyard open to the sky. The problem is one to which there can be no clear-cut, decisive answers. The writer's own conclusions are coloured by the belief that this was an ambitious, experimental architecture in which the resources of the new building methods were being pushed to the limits. The effective spans of the four halls, allowing for such features as internal supporting columns, are: basilica, 48 feet (14·5 m.); Aula Regia, 95 feet (29 m.); Triclinium, 95 feet (29 m.); vestibule, 72 feet (22 m.) from east to west, or 101 feet (31 m.) across the longer, but far more substantially buttressed, north–south span.

15. For the significance of such gardens, see p. below, p. 327.

16. The vaulted structures within the hall, cited p. by Tamm, 81, appear to be later insertions.

17. Dio Cassius, LXIX. 4. 1. p.

18. For which Nero had made provision in a separate building, the short-lived gymnasium (above, p. 212).

19. *Forma Urbis*, 79, plate XXIII.

20. As shown on coins (*B.M.C.: Empire*, II, no. p. 471, plate XI, 189). The characteristic rounded pediments are echoed locally in the second-century mausolea of the Isola Sacra cemetery.

21. Lionel Casson, *J.R.S.*, LV (1965), 31–9.

22. Ammianus, XVI. 10. 15. p.

23. P. von Blanckenhagen, *Journal of the Society of Architectural Historians*, XIII (1954), 23–6.

24. The only buildings in Rome specifically p. attributed to Apollodorus are the Baths of Trajan, the forum, and a lost odeum (Dio Cassius, LXIX. 4). But the markets and forum are so essentially complementary that it is hard to believe that they were not in conception at any rate the work of a single mind. For the bridge over the Danube, see Procopius, *Buildings*, IV. 6. 12–13; cf. Dio Cassius, LXVIII. 13; it was of timber on stone piers.

25. The military layouts sometimes cited as the model adopted by Trajan should be regarded rather as a parallel phenomenon.

26. The suggestion of M. E. Bertoldi (*Studi Miscellanei del Seminario di Archeologia . . . dell'Università di Roma*, III (1962), 27–31) that this is the result of a Hadrianic rebuilding of the Forum Augustum creates more difficulties than it resolves.

CHAPTER 10

1. There were of course later exceptions, as for example the theatre at Ostia. With the transfer of the 'framed arch' motif, however, to the new building materials it lost the illusion of a robust functionalism which characterizes all its previous manifestations, from the Tabularium and the Temple of Fortuna at Praeneste to the Stadium of Domitian. The Early Imperial tradition was revived in the third century; see below, p. 514.

2. Pliny, *Natural History*, XVI. 202.

3. The spacing of the courses often, but by no means invariably, corresponds with that of the successive putlog (scaffolding) holes.

4. The planks of the shuttering were not uncommonly replaced or supplemented by tiles (cf. Lugli, *Tecnica edilizia*, plate CCVI, 1–2). Good early examples of this can be seen in the Domus Aurea, in the Colosseum, and in the Markets of Trajan. Arches, doors, windows, and recesses of all sorts continued to be framed in brick, the frames playing a part during the actual processes of construction similar to that of the facing of the adjoining wall-surfaces.

5. See above, pp. 214 ff.

6. Varro's aviary: III. 5. 12–17; cf. A. W. Van Buren and R. M. Kennedy, *J.R.S.*, IX (1919), 59–66. The fragment of the Domus Transitoria preserved under the Temple of Venus and Rome (pp. 212–13, Figure 88) clearly indicates an awareness of the possibilities implicit in the new architecture.

7. See above, pp. 230 ff.

8. For a much later survival of the same vaulting pattern, cf. the Cluny Baths in Paris.

9. See further pp. 328 ff. and Figure 127. The successive building phases of the villa can be determined in considerable detail from the brickstamps (H. Bloch, *Bolli laterizi e la storia edilizia romana* (Rome, 1947), 102–17). That the walls of the Piazza d'Oro octagon cannot have carried a concrete vault is shown by F. Rakob in *Gnomon*, XXXIII (1961), 243–50. It remains a possibility that there was some sort of superstructure in lighter materials.

10. Hence the slighting reference to Hadrian's 'pumpkins' (κολοκύνται) in Dio's account (LXIX. 4) of Hadrian's quarrel with Apollodorus. F. E. Brown in *Essays in Memory of Karl Lehmann* (New York, 1964), 55–8.

11. Bloch, *op. cit.* (Note 9), 102–17.　　　　p. 256

12. IV. 8. 3 and V. 10. 5.　　　　p. 257

13. A. Maiuri (*B. d'Arte*, X (1930–1), 241–52) p. 259 argues for an Augustan date. The construction of the dome, with an aggregate of large, irregular chunks of tufa laid radially, is still in the Republican tradition.

14. The earliest recorded example is Caligulan (p. 205).

15. See J. B. Ward-Perkins, 'Tripolitania and p. 261 the Marble Trade', *J.R.S.*, XLI (1951), 89–104; also in *Enciclopedia dell'Arte Antica*, IV (1961), 866–70.

16. See below, Chapter 11, Note 14.

17. The present design of the upper order dates from 1747. The original form is shown on Plate 132, and a short section has since been so restored.

18. The only useful study of this important but p. 262 neglected aspect of Roman architectural decoration remains that of Cecchelli. To wall-mosaic was later added the coloured marble intarsia which found such vivid expression in the Basilica of Junius Bassus, and in the recently discovered building at Ostia.

CHAPTER 11

1. Dio Cassius, LXIX. 4. 3. F. E. Brown, *Essays in* p. 265 *Memory of Karl Lehmann* (New York, 1964), 55–8.

2. As very plausibly suggested by D. E. Strong, p. 266 'Late Hadrianic Ornament', 133.

3. *ibid.*, 129 and 142–7.　　　　p. 267

4. *ibid.*, 123–6.

5. But see above, Chapter 7, Note 15, and p. 203. p. 269

6. The map, a remarkably accurate vertical pro- p. 270 jection at a scale of approximately 1:250 (according to Gatti, in *Forma Urbis*, 206, it was 1:240), dates from between 203 and 211. Plates 144–5 illustrate three characteristic sections; cf. also Figure 87.

p. 271 7. There is no adequate recent survey. E. Bröd-ner, *Untersuchungen an den Caracallathermen* (Berlin, 1951) is useful for the part which it covers, but is almost certainly mistaken in its belief that the palaestrae were roofed.

8. So also the placing of the windows in shallow, scalloped recesses, so as to admit more light; cf. Tor Pignattara, below, pp. 509, 514. This feature had been anticipated in Campania, at Baiae, in the annex to the 'Temple of Venus' (p. 299).

p. 273 9. 'Septizodium' rather than 'Septizonium' (*Forma Urbis*, 67 and plate XVII, fragments 8a and b). Cf. *C.I.L.*, VI. 1032, and G.-C. Picard, *Monuments et Mémoires, Fondation Piot*, LII (1962), 77–93.

10. S.H.A., *Severus Alexander*, XXV. 7.

p. 274 11. Dio Cassius, LXXVII. 16. 3.

12. Reproduced by Nash, I, figures 663 (Sol In-victus) and 664 (Juppiter Ultor = *B.M.C.: Empire*, VI (1962), 134, no. 208).

13. Palladio's plan and Van Heemskerck's and du Pérac's drawings of the remains still visible in the fifteenth and sixteenth centuries are reproduced by Nash, II, figures 1160, 1165, and 1168. Fre-quently but mistakenly identified as Aurelian's Temple of the Sun, which lay farther to the north (see below, pp. 498–500).

14. The granite shafts of the Pantheon measure 41 feet (12·50 m.); those of Baalbek (limestone) 54 feet 7 inches (16·64 m.). One still lying in the quarries of Mons Claudianus measures 60 feet (18·40 m.) and weighs an estimated 268 tons: T. Kraus and J. Röder, *Mitteilungen des deutschen archäologischen Instituts, Abteilung Kairo*, XVIII (1962), 113. The columns of the Temple of Divus Traianus were of the same order of size.

p. 275 15. P. von Blanckenhagen, *Flavische Architektur* (Berlin, 1940), 90–9.

p. 276 16. G. Mancini, *N.S.* (1923), 46–75; E. L. Wads-worth, *M.A.A.R.*, IV (1924), 64–8.

p. 278 17. Wadsworth, *loc. cit.*, 69–72 (Tomb of the Valerii) and 73–8 (Tomb of the Pancratii).

4. For the wooden *viae porticatae* of Late Re-publican Rome, see K. Lehmann-Hartleben in *P.W.*, 2, 3, s.v. 'Städtebau', 2059–60. There was a symmetrically planned street with flanking arcades inside the Porta Nigra at Trier. For streetside porti-coes of substantially Ostian type in the Western provinces, see below, pp. 358 (Gaul) and 480 (N. Africa).

5. For multi-storeyed houses at Tyre, Strabo, XVI, 2. 23.

6. Barracks of the Vigiles (fire brigade) (Region ii, 5, 1): P. K. Baillie-Reynolds, *The Vigiles of Im-perial Rome* (Oxford, 1926), 107–15 (but it was never a private house; Meiggs, *Ostia*, 305, note 4). The House of the Triclinia (Region i, 12, 1), head-quarters of the collegium of builders. The Horrea Epagathiana et Epaphroditiana (Region i, 8, 3), built presumably by two well-to-do freedmen of these names: *N.S.* (1940), 32. Later warehouses, e.g. Region i, 8, 2; ii, 3, 2; ii, 12, 1; and at Portus.

7. The gable of the Capitolium reached about 70 feet above pavement level, suggesting that some of the adjoining buildings may have approached the statutory height-limit of 60 feet established by Trajan (Victor, *Epitome*, 13. 13). For the circular temple, C. C. Briggs in *M.A.A.R.*, VIII (1930), 161–9 (but a Constantinian date cannot be ac-cepted). For the sanctuary of Cybele, G. Calza, *Mem. Pont.*, VI (1943), 183 ff.

8. Such public lavatories were regularly situated near bath-buildings or fountains so as to take ad-vantage of the outflow of waste water; two more can be seen in Figure 106. For a study of the Forum Baths in terms of the technical problems involved in heating them, see E. D. Thatcher, *M.A.A.R.*, XXIV (1956), 169. Of the smaller, privately owned baths (*balnea*) one in the Via della Foce (Region i, 19, 5) offers an unusually complete fourth-century example of a type best represented in North Africa and at Piazza Armerina.

9. G. Calza, *Architettura e arti decorative*, III (1923–4), 11.

CHAPTER 12

p. 279 1. See above, Figure 54 and pp. 149–51.

p. 281 2. Vitruvius, V, 9.

3. But cf. the Basilica of Pompeii, in Campania, nearly a century earlier.

CHAPTER 13

1. The evidence is fully discussed by Maiuri in *L'ultima fase*. The delay may well have been aggravated by the parsimony of Nero in the last years of his reign. It was evidently Vespasian who first gave help from public funds.

2. The so-called Third and Fourth Pompeian Styles. Though named after and best studied at Pompeii, these do in fact represent far wider contemporary trends.

3. So too in the provinces. Cf. the agora at Corinth and the forum at Sabratha (below, pp. 369 ff. and 471–2).

4. For wooden constructions and fittings, see specially the accounts of the more recent excavations here and at Herculaneum, by Spinazzola and Maiuri.

5. The macella of Rome are known from the literary sources (see Platner–Ashby, s.v. 'Macellum'), from representations on coins (above, Chapter 8, Note 12), and from the Severan marble plan.

6. The earliest certainly attested broken pediment in real architecture seems to be in the Palazzo delle Colonne at Ptolemais in Cyrenaica (see below, p. 464). The ultimate source of the motif is assuredly hellenistic.

7. Vitruvius, VII. 5. The description of Ptolemy's pleasure-barge by Kallixeinos of Rhodes is preserved by Athenaeus (v. 204d–206c, ed. Kaibel, 1887); see F. Caspari, J.D.A.I., XXXI (1916), 1–74.

8. A. Maiuri in Mem. Nap., III (1953). For the partially timber amphitheatres of North Italy, S. Aurigemma, Historia, VI (1932), 159.

9. P. Marconi, Verona romana (Bergamo, 1937), 101–14. Pola: A. Gnirs, J.Ö.A.I., XVIII (1915), Bb. 163–76.

10. Pozzuoli: Maiuri, Campi Flegrei, 24–8; Dubois, Pouzzoles antiques, 286–314.

11. For the excavations at Baiae, see A. Maiuri in B. d'Arte, (1930–1), 241–53; and XXXVI (1951), 359–64.

12. See below, p. 348.

13. For the hellenistic mixed order, see S. Stucchi, L'Agora di Cirene, I (Rome, 1965), 201–2.

14. Grenier, Manuel (see bibliography to Chapter 15), III. 1, 380–2.

15. The best plan remains that published by G. Saletti in Museo Bresciano illustrato, I (Brescia, 1838). A similar projection of the basal plinth appears already in Augustan times on the monument of La Turbie (above, p. 302).

16. See R. G. Goodchild, Antiquity, XX (1946), 70–7.

17. See below, pp. 405 ff.

CHAPTER 14

1. See above, p. 155. p. 313

2. Maiuri, Ercolano, 280–302. p. 314

3. Vitruvius, VI. 3. 9. For the basilican oecus aegyptius and other similar exotic room-forms, see Maiuri in Studies Presented to D. M. Robinson, I (St Louis, 1951), 423–9.

4. One of the factors which made the opening-up of the old atrium-house possible was the adoption of window glass, a development said by Seneca (d. A.D. 65) to have taken place during his own lifetime (Letters, 90. 25).

5. As the Pompeian house lost its stereotyped lay- p. 315 out, so the terms oecus, tablinum, and triclinium lost the precision of their earlier meanings; the distinction becomes largely one of archaeological convention. For the subsequent emergence of the triclinium as the principal room of the Roman house, see I. Lavin, Art Bulletin, XLIV (1962), 5; also below, p. 531.

6. Maiuri, Ercolano, 302–22.

7. A. Maiuri and R. Pane, La Casa di Loreio p. 316 Tiburtino e la Villa Diomede in Pompei (Rome, 1947), 5–9.

8. R. Lanciani, Mon. Ant., XVI (1906), 266. Becatti, 'Case Ostiensi', 23–5, figure 22.

9. R. Meiggs, Ostia (Oxford, 1960), 237 ff. The p. 317 two fundamental articles are by G. Calza in Mon. Ant., XXIII (1914), 541–608, and in Architettura e arti decorative, III (1923–4), 3–18 and 49–63.

10. This and the following references are to the plan of the Regions and insulae of Ostia appended to Scavi di Ostia, I.

11. The 'balconies' (maeniana), carried by seg- p. 318 mental arches supported by travertine brackets (e.g. Figure III), do not always correspond with the floor levels inside the building and seem anyway too narrow to have been functional. For the regular exposure of the brickwork, see Calza, Mon. Ant., XXIII (1914), 11.

12. The 'peristyle' and 'portico' villas, respec- p. 319 tively, of Swoboda's classification. It should be emphasized that where, as here, the distinctions are far from clear-cut, any classification is bound to be largely a matter of convenience; and that some sort of platform (basis villae) is a regular feature of the seaside portico villas (cf. Plate 160).

13. N.S., XIX (1965), 237–52; P.B.S.R., XXXIII (1965), 54–69.

p. 321 14. G. Lugli, *Bull. Comm.*, LV (1927), 139–204.

p. 322 15. A. Gnirs, *J.Ö.A.I.* between VII (1904), Bb. 131–41 and XVIII (1915), Bb. 99–158.

p. 323 16. H. Schwarb, *Schriften der Balkankommission*, II (1903).

17. Maiuri, *Capri*, 66–9.

p. 324 18. *ibid.*, 29–56.

p. 326 19. *ibid.*, 56–65.

p. 327 20. Porticus Pompeii: *Forma Urbis*, 104–6, tavola XXXII; cf. Propertius, *Elegies*, II. 32. 11–16. Porticus Liviae: *Forma Urbis*, 69–70, tavola XVIII; cf. Pliny, *Natural History*, XIV. 11.

21. G. Lugli, *Mél. Rome*, LV (1938), 5–27; now convincingly identified by H. G. Beyen (*Studia Vollgraf* (Amsterdam, 1948), 3–21) as the town house of Agrippa and Julia (19–12 B.C.).

22. Grimal, *Jardins, passim*. Varro, while criticizing the fashion for gymnasia and other hellenizing fancies in the villas of his day (*On agriculture*, II. intr.), had a palaestra in his own villa at Tusculum (III. 13). For the hippodrome of Pliny's Tuscan villa, see *Letters*, V. 6. 32–3. Cicero's villa at Tusculum had a favourite terrace known as 'the Academy'.

p. 328 23. Blake (1959), 40–1.

24. *ibid.*, 41–2. Nero was dining here in 60 (Tacitus, *Annals*, XIV. 22).

25. Lugli, *N.S.* (1946), 60–83.

26. Lugli, *Bull. Comm.*, XLV (1917), 29–78; XLVI (1918), 3–68; XLVII (1919), 153–205; XLVIII (1920), 3–69.

27. Lugli, *Forma Italiae: Regio 1*, vol. 1, 2, 65–76 and map 3; G. Jacopi, *N.S.* (1936), 21–50.

28. Bloch, *op. cit.* (Chapter 10, Note 9), 117–83 and especially 182–3. To the first phase of the construction (A.D. 118–25) belong certainly the nucleus of the East Palace and the complex of buildings associated with the Stadium.

29. The names actually attested (S.H.A., *Hadrian*, XXVI. 5) are those of four buildings in Athens (the Lyceum, the Academy, the Prytaneum, and the Stoa Poikile), the Vale of Tempe in Thessaly, and the great Sanctuary of Serapis at Canopus in Egypt; also 'the Underworld'.

30. *Letters*, V. 6. 15.

31. There is no adequate publication of this important building.

32. T. Ashby, *P.B.S.R.*, IV (1907), 97–112; N. Lupu, *Ephemeris Dacoromana*, VII (1937), 117–88; Bloch, *op. cit.* (Note 28), 256–68.

33. Villa of the Quintilii: T. Ashby, *Ausonia*, IV (1909), 48–88. Le Mura di S. Stefano: T. Ashby, *R.M.*, XXII (1907), 313–23; cf. *P.B.S.R.*, XXIII (1955), 66, plates XVII, XVIII.

34. Nash, s.v. 'Amphitheatrum Castrense' (I, 13–16), 'Sessorium' (II, 384–6), and 'Thermae Helenae' (II, 454–7).

35. See above, p. 316 and Note 8.

36. Reg. iv, 3. Becatti, 'Case Ostiensi', 114–17, figure 14.

37. Reg. i, 14. Becatti, *loc. cit.*, 105–7, figure 4.

38. E.g. the triple-arched windows of one of the houses of a mosaic from Thabraca (reproduced by Becatti, figure 51).

39. Doro Levi, *Antioch Mosaic Pavements* (Princeton, 1947), figure 26.

NOTES TO PART THREE

CHAPTER 15

p. 340 1. In Latin usage *Hispania* or *Hispaniae* ('the Spains') covered the whole Iberian peninsula. It comprised the three provinces of Baetica in the south, Lusitania in the south-west, south of Oporto, and Tarraconensis, covering the whole of the north and north-east.

p. 341 2. The projecting string-courses had a practical as well as an aesthetic purpose, namely to support scaffolding during construction or repairs. The aqueduct still serves Seville.

3. *C.I.L.*, II, 761. For Apollodorus's bridge, see Chapter 9, Note 24.

4. The plan resembles those of Narbonne and Sabratha (pp. 348–9, 472). The temple is probably of Flavian date. I owe this information to M. R. Étienne. For the cryptoporticus, cf. p. 348 and Note 14.

5. The exclusion of wheeled traffic from the forum area was regular Roman practice.

6. R. G. Goodchild, *Antiquity*, XX (1946), 70–7. Cf. also Virunum in Austria, Zadar (Iader) in Dalmatia, and in modified form Brescia (Brixia).

7. See below, p. 349.

8. Gallia Cisalpina was not formally incorporated into Italy until 42 B.C.

9. Occasional uses of opus reticulatum (e.g. in the aqueducts of Lyon) represent quirks of local taste, copied directly from Italy.

10. But by no means invariably. Mr R. M. Butler, to whom I owe this observation, cites Carcassonne, Nantes, Rennes, Sens, Toul, Bavai, and Jublains as instances of town walls where the tile-courses do not penetrate the full width of the core.

11. See above, p. 303.

12. F. H. Thompson, *Archaeological Journal*, CXI (1954), 106–28.

13. For the syphons on the 45-mile-long Hadrianic Mont Pilate aqueduct (Aqueduc du Gier) at Lyon, see Grenier, *Manuel*, IV, 129–36. Arles, *ibid.*, 85. The second-century B.C. aqueduct at Alatri in Central Italy was already of this type (*C.I.L.*, X. 1, 5807; cf. *P.B.S.R.*, XXIII (1955), 115–23).

14. V. 9, 5–9. For a good summary of the discussion, see Grenier, *Manuel*, III, 305–22. It must be remembered that substructures which, given a damp or sloping site, might be primarily a matter of constructional convenience, could have been put to very varied uses as local circumstances demanded.

15. The dates now generally accepted for the Maison Carrée (19–12 B.C., re-dedicated A.D. 1–2) and for the temple at Vienne (dedicated originally to Rome and Augustus before A.D. 14, re-dedicated shortly after A.D. 41 to the Deified Augustus and Livia) depend in each case on the readings of two successive inscriptions, of which only the holes for the pegs attaching the bronze letters have survived; see Grenier, *Manuel*, III, 147–9 and 396–7.

16. F. Benoit, *Rivista di studi liguri*, XVIII (1952), 219–44.

17. See below, Chapter 19 and Note 11 thereto.

18. The 'Reihentyp' of Krencker's classification (D. Krencker and E. Krüger, *Die Trierer Kaiserthermen* (Augsburg, 1929), 177).

19. Most recently, B. Cunliffe in *Antiquity*, XL (1966), 199–204.

20. Amy, *L'Arc d'Orange*, plates 6 and 64. To be distinguished from the 'arcuated lintel' of contemporary Syrian practice. See below, Chapter 18 and Note 51 thereto.

21. G. Brusin and V. de Grassi, *Il Mausoleo di Aquileia* (Padua, 1956). Sarsina: A. Aurigemma, *Palladio*, I (1937), 41–52. Nettuno: G. Giovannoni, *Roma*, XXI (1943), 378–9. Cf. the destroyed 'Three Monuments' of Terni, *N.S.* (1907), 646–7.

22. Cf. the fine terraced town house at Aix-en-Provence described by Benoit in *Gallia*, V (1947), p. 357
98–122. This had a large inner peristyle and a small entrance peristyle of 'Rhodian' type, i.e. with one portico taller than the rest, as regularly at Delos and in Cyrenaica.

23. Cunliffe, *Antiquity*, XXXIX (1965), 177–83, p. 358
and interim reports in *Antiquaries Journal*, annually since XIII (1962).

24. The wealthy villas of Gallia Belgica, for example, virtually come to an end after the third century. But in many other regions (e.g. in the district around Metz and again in the south-west; evidence conveniently summarized by I. Lavin, *Art Bulletin*, XLIV (1962), 25 and note 201) villas were reconstructed or continuously occupied right through the fourth century.

25. A. M. Schneider and W. Karnapp, *Die* p. 363
Stadtmauer von Iznik (Nicaea) (*Istanbuler Forschungen*, IX) (Berlin, 1938).

26. Conveniently summarized in *Encicl. Art. Ant.*, IV, 772–5. Detailed interim reports annually in the local review, *Karinthia I*.

27. The date attributed to it by the excavators p. 364
(early second century) is surprisingly early and, pending publication of the evidence, can only be accepted with reserve.

28. See Gabriella Bordenache, 'Attività edilizia a p. 365
Tomi', *Dacia*, N.S. IV (1960), 255–72, notably the remains of two buildings dedicated in A.D. 116–17 and in 161–2 respectively.

29. I am indebted to Mr John Wilkes and to the p. 366
excavator, Dr M. Suić, for information about this as yet rather inaccessibly published site.

30. Sticotti's account of this building is careful p. 367
and his arguments for dating it appear convincing; but one would welcome independent evidence of so notable an innovation at this early date.

CHAPTER 16

NOTE. For the architecture of Greece prior to the Roman period, see A. W. Lawrence, *Greek Architecture* (*Pelican History of Art*), 3rd ed. (Harmondsworth, 1968).

p. 369 1. For the individual buildings at Corinth referred to in the pages that follow, see the following volumes of *Corinth*:

I, I (1932). Topography, the Lechaion Road, the Propylaea, the Julian Basilica.

I, 2 (1941). Northwest Stoa and Shops, the Captives Façade, the Peribolos of Apollo, Temple E.

I, 3 (1951). The Lower Agora, including the buildings along the West and Central terraces. Temples E–K. The Market.

I, 4 (1954). The South Stoa and its Roman successors.

I, 5 (1960). The Julian and South Basilicas.

I, 6 (1964). The Springs of Peirene and Glauke.

II (1952). The Theatre, the Odeion.

p. 372 2. See below, pp. 465 ff.

3. See below, p. 449 and Figure 167.

4. The earliest example at present known is the recently discovered market at Morgantina. For similar market buildings in North Africa, see pp. 469, 482–3.

p. 373 5. The Greek agora had been gravel-paved, as was that of Athens right through the Roman period. For the use of Italian-type mouldings at Corinth, see L. T. Shoe in *Essays in Memory of Karl Lehmann* (New York, 1964), 300–3. For the Italian origin of the colonists, Pausanias, II. I. 2.

6. Only three are recorded from Asia Minor, at Aspendos, Kremna, and Smyrna. For the basilica in Syria, see below, Chapter 18, Note 75.

p. 374 7. See above, pp. 170–1.

p. 376 8. B. Saria, *Anz.* (1938), 81–148.

p. 377 9. For theatre-amphitheatres, used for hunting spectacles (*venationes*), see Dio Cassius, LXXVIII. 9. 7 (θέατρα κυνηγετικά), and Richard Stillwell in *Corinth*, II, 7; and for their adaptation for aquatic displays (κολυμβήθρα, John Chrysostom, *In Matthaeum Homiliae* (ed. Migne, *Patrologia*, 1860), VII, 7, G. Traversari, *Dioniso*, XIII (1950), 18–32; XV (1952), 302–11.

p. 378 10. As suggested to me by Professor H. A. Thompson. It lies directly opposite the bema.

11. See Pausanias, I. 20. 7.

12. H. S. Robinson, *A.J.A.*, XLVII (1943), 291–305, with previous bibliography.

p. 379 13. There is no adequate publication of this building. See notes and bibliography in Robinson, *loc. cit.* The best plan is that in Travlos, figure 55.

14. *A.J.A.*, LXVI (1962), 200; Agora *Guide*[2] (1962), 68.

15. H. A. Thompson, *Hesperia*, XIX (1950), 31–141. For the identification of the adjoining building as the Gymnasium of Ptolemy, see *A.J.A.*, LXIX (1965), 177; *Hesperia*, XXXV (1966), 41. Lecture halls of comparable size were added in the Roman period to the old gymnasia of Epidaurus and Pergamon.

16. Judeich, *Topographie*[2], 97. It was the work of a mixed team of architects, some Greek and some Roman.

17. See above, p. 186.

18. The wording of the inscriptions, the workmanship, and the very close resemblance to the two arches that flanked the approach to the Outer Propylaea at Eleusis all suggest that it was erected by Antoninus Pius rather than by Hadrian himself.

19. M. A. Sisson, *P.B.S.R.*, XI (1929), 50–72.

20. See above, p. 191.

21. See below, p. 478 and Plate 196.

22. Did it carry a semi-dome of some light material (brick?), as Professor H. A. Thompson has suggested to the writer, and as the plan rather suggests? Some of these apsidal nymphaea certainly did (e.g. Gerasa), but not all.

23. Notably the mid-second-century monument, now dismantled, known as 'Las Incantadas', which incorporated a Corinthian façade with a much smaller order of pseudo-caryatid figures above it. P. Perdrizet, *Monuments and Mémoires Piot*, XXXI (1930), 51–90; Lucia Guerrini, *Arch. Cl.*, XIII (1961), 40–75.

24. G. Roux, *B.C.H.*, LXXVIII (1954), 160–2.

CHAPTER 17

1. See D. Talbot Rice (ed.), *The Great Palace of the Byzantine Emperors* (Edinburgh, 1958), II, 52–104, discussing many of the buildings referred to in this chapter. A provincial variant of opus caementicium; cf. Pliny, *Letters*, x. 39, describing the walls of the new gymnasium at Nicaea as 'caemento medii facti nec testaceo opere [i.e. brick facing] praecincti'. This whole correspondence (*Letters*, x. 37–40) offers a vivid glimpse of provincial architectural practice in relation to that of Rome.

7 2. Ephesus, aqueduct of Pollio: *Forschungen*, III (1923), 256–63; Keil, *Führer*[5], 133–4. Miletus, bath-buildings: below, Note 28. Miletus, nymphaeum: below, Note 33.

8 3. *Great Palace*, II, 90–5. The *locus classicus* for this sort of vaulting is Karanis in Egypt; see below, p. 459 and Plate 238.

4. E. Boehringer in *Neue deutsche Ausgrabungen im Mittelmeergebiet und im vorderen Orient* (Berlin, 1959), 136–8. For the masonry, *Great Palace*, II, 85 and plate 30.

5. Th. Wiegand in *Abhandlungen der deutschen Akademie der Wissenschaften zu Berlin, Phil.-hist. Klasse* (1932).

0 6. *Anz.* (1932), 233–49. Adjoining it was a colonnaded street.

7. D. M. Robinson, *A.J.A.*, XXVIII (1924), 435–44; *Art Bulletin*, IX (1926), 5–69.

2 8. Several of the great hellenistic foundations (e.g. the Didymaion near Miletus) were still being completed in Roman times, closely following the original designs. A recent study (G. Gruben, *Athenische Mitteilungen*, LXXVI (1961), 155–96) suggests a similar history for the great Temple of Artemis at Sardis.

9. *J.Ö.A.I.*, XXXVII (1932), Bb. 54–61. Keil, *Führer*[5], 124–7, figure 67.

10. Le Bas, *Voyage en Grèce et Asie Mineure* (1888), plates 23–6; G. Jacopi, *Bull. Comm.*, LXVI (1938), suppl. 44–8. There is no adequate modern publication.

11. G. Perrot, *Revue archéologique* (1864), 350–60. B. Ashmole, *Journal of the Warburg and Courtauld Institutes*, XIX (1956), 179–91, and *Proceedings of the British Academy*, XLV (1959), 25–41.

12. *Alterthümer*, V (1895).

3 13. D. E. Strong, *P.B.S.R.*, XXI (1953), 131–3.

14. *J.Ö.A.I.*, XLIV (1959), 264–6; Keil, *Führer*[5], 118–20. For the 'arcuated lintel', see D. F. Brown, *A.J.A.*, XLVI (1942), 389–99. It derives ultimately from ancient Mesopotamia; see also below, Chapter 18, Note 51. To be distinguished from the somewhat similar hellenistic device of resting an independent arch on the two ends of an interrupted trabeation (Crema, 142–3).

15. *J.Ö.A.I.*, XXIII (1928), 265–70. Keil, *Führer*[5], 105–8.

16. See above, Note 4. The apse dates from its conversion to a church.

17. *Milet*, I. 7, 180–210.

18. *Milet*, I. 7, 229–61. p. 395

19. Ephesus, agora: *Forschungen*, III. 1 (1923), 1–168; Keil, *Führer*[5], 94–8. Aphrodisias, odeion: *I.L.N.* (27 February 1965), 23. Nysa, Gerontikon: W. von Diest, *Nysa ad Maeandrum* (*J.D.A.I.*, Ergänzungshefte, x) (1913); K. Kourouniotes, *Archaiologikon Deltion*, VII (1921–2), 1–68 and 227–41.

20. For the Arkadiané, see *Forschungen*, I (1906), 132–40; Keil, *Führer*[5], 71–3.

21. R. Naumann and S. Kantar in *Kleinasien und Byzanz* (*Istanbuler Forschungen*, XVII) (1950), 69–114.

22. *Forschungen*, V. 1 (1953). There are interesting p. 397 library buildings also at Nysa (Von Diest, *loc. cit.*) and in the Asklepieion at Pergamon (Wiegand, *op. cit.* above, Note 5).

23. *Forschungen*, II (1912). Keil, *Führer*[5], 87–93. There was also a small second-century theatre, or odeion, near the Magnesia Gate, Keil, *Führer*[5], 130–2. For the so-called 'Eastern' and 'Western' types of theatre, see above pp. 375 ff. For the theatre at Aspendos, below, p. 409.

24. F. Kraus, *Bericht über den VI Internationalen* p. 398 *Kongress für Archäologie* (Berlin, 1940), 387–93.

25. See above, pp. 212, 236, 292. p. 399

26. Maccanico, 'Ginnasi romani'; also Keil, *Führer*[5], 56–61, 74–86, and 141–2. For a restored drawing of the Vedius Baths, showing exposed barrel-vaults, see Miltner, *Ephesos*, Abb. 68.

27. To the younger Pliny, writing as governor p. 402 of Bithynia (*Letters*, X. 39), the terms *gymnasium* and *balineum* appear to be interchangeable.

28. *Milet*, I. 9 (1928): A. von Gerkan and Fr. Krischen, *Thermen und Palaestren*.

29. *Altertümer von Pergamon*, VI (1923), 80–92. p. 403 Hierapolis: Krencker and Krüger, *op. cit.* (Note 18 to Chapter 15), 288–95. Aphrodisias: G. Mendel, *C.R.A.I.* (1906), 159–78.

30. J. B. Ward-Perkins, *J.R.S.*, XLI (1951), 89–104.

31. West Gate of the agora: *Forschungen*, III p. 405 (1923), 18–39; Keil, *Führer*[5], 73–4; the Gateway-arch: *J.Ö.A.I.*, VIII (1905), Bb. 69. Miletus, West Market Gate: *Milet*, I, 7, 69–155.

32. Mansel, *Ruinen von Side*, 109–21. p. 406

33. *Milet*, I. 5 (1919).

p. 407 34. Side: Mansel, *op. cit.*, 90–1, Abb. 71–2 (temple) and 66–74, Abb. 48–57 (fountain). Perge, South Gate: Lanckoronski, I, 60–1. Attaleia, mausoleum: *ibid.*, 11–12.

p. 408 35. Temples at Side: Mansel, *op. cit.*, 77–86. Sagalassos: Lanckoronski, II, 130, 145–9.

p. 409 36. *Anz.* (1956), 99–120.

37. Lanckoronski, I, 85–124. For the aqueduct: Ward-Perkins, *P.B.S.R.*, XXIII (1955), 115–23; also above, p. 347.

38. See above, p. 388 and Note 3.

CHAPTER 18

p. 414 1. Seleucia is described by Roman writers as a great city, with a population of 600,000, and as having retained a great deal of its classical culture. See Pliny, *Natural History*, VI. 122, and Strabo, XVI. 2. 5.

p. 415 2. Antioch and its harbour-town of Seleucia Pieria, Apamea, and Laodicea; also no doubt Damascus. Paradoxically, it is the Greek colonial foundations on the periphery, outside the Roman frontiers, that are just as likely to yield buildings of specifically Greek type; e.g. the little ashlar-built distyle *in antis* temple built by Seleucus III on the island of Failaka, off Kuwait (K. Jeppeson, *Kuml. Årbog for Jysk Arkeologisk Selskab* (1960), 153–98).

3. *Jewish War*, I. 21. 1.

4. *Samaria-Sebaste*, I (London, 1942), 123–9.

p. 416 5. A. Frova and others, *Scavi di Caesarea Marittima* (Milan, 1965). Cf. *I.L.N.* (26 October 1963), 684–6; (2 November 1963), 728–31; (4 April 1964), 524–6.

6. *B.A.S.O.R.*, CXX (December 1950), 11; J. B. Pritchard, 'The Excavation of Herodian Jericho, 1951', *Annual of the American School of Oriental Research*, XXXII–XXXIII (1952–4), 1–13.

7. The closest parallels to the handsome polychrome mosaics of the entrance hall are with Delos.

8. But see F. Wetzel and others, *Das Babylon der Spätzeit* (*Ausgrabungen der deutschen Orient-Gesellschaft in Babylon*, VIII) (1957), 3–22.

p. 417 9. Many of the accepted ideas of Jewish architecture will require revision in the light of the newly excavated synagogue at Hamath Tiberias. Built in the last quarter of the third century A.D., it was of a completely different and, despite official connexions, far less pretentious architectural form:

a columnar hall with a severely plain exterior but with rich mosaics inside. The most startling feature is the central mosaic, added *c.* 300, which portrays Apollo-Helios in his chariot, framed within a zodiac and supported by the four seasons. The synagogue was rebuilt in the fifth century on conventional basilican lines which clearly owe much to contemporary Christian practice.

10. The pages that follow owe much to the Emir Maurice Chehab, Director of the Department of Antiquities of the Lebanon, and his assistant, M. H. Kalayan, for allowing access to the results of the recent work, much of it still unpublished.

11. It is nowhere stated in the sources that this was an official enterprise, but the scale of it hardly leaves room for doubt. It is significant that the patron divinities of a number of other Syrian cities, including the Tyche of Antioch, appear on the coffering of the Temple of Bacchus. For the character of the cult and its date, see H. Seyrig, *Syria*, XXXI (1954), 80–96, especially 96, note 1.

12. (XI), 280. 12, ed. Schenk (Stuttgart, 1931), 50, cf. 494.

13. *Bulletin du Musée de Beyrouth*, I (1937), 95 ff.

14. The evidence for von Gerkan's contention (*Corolla Ludwig Curtius* (1937), 55–9) that the present podium is that of an earlier hellenistic building is not conclusive. It is equally possible that the podium and peristasis are those of the Early Roman building, of which the forecourt in the original, simpler version was planned to extend back to the seventh column along either flank; that the podium was then replanned (though never in fact completed) so as to afford a wide platform all round the existing temple (or conceivably, though less probably, to carry the peristasis of an even larger, dodecastyle temple); and that the forecourt in its re-designed, second-century version was at first meant to be extended so as to enclose the temple on all sides, but that this plan too was modified during construction, cutting it short along the line of the existing façade, as one now sees it. See also D. Krencker, *Anz.* (1934), 268–86.

15. A. Muñoz, *La Sistemazione del Tempio di Venere e Roma* (Rome, 1935), 16. The building most closely comparable to Baalbek in size and proportions was Hadrian's temple at Cyzicus, which measured about 155 by 300 feet (47 by 92 m.) at stylobate level and was slightly taller from base to capital; see above, p. 392.

16. The 'Tomb of Absolom' at Jerusalem (Durm, *Baukunst*, figure 833) and a stray architrave bracket at Samaria (*Samaria-Sebaste*, I, 35 and plate 85. 1–2).

17. E. von Mercklin, *Das antike Figuralkapitelle* (Berlin, 1962), 27–30 and Abb. 109–31; and in *R.M.*, LX–LXI (1953–4), 184–99. See also *Proceedings of the British Academy*, LI (1965), 192 and plate LV (bull brackets at Hatra).

18. It apparently represents a change of plan. The original intention may have been to build a rectangular outer court the full width of the inner courtyard (or else to extend the existing court to the propylaea).

19. The so-called 'arcuated lintel' or 'Syrian arch'; see above, p. 393; below, p. 441 and Note 51.

20. R. Krautheimer, *Early Christian and Byzantine Architecture (Pelican History of Art)* (Harmondsworth, 1965), 114–15. For coins of Abila in the Decapolis illustrating a similar façade, see H. Seyrig, *Syria*, XXXVI (1959), 60–2, plate XII, 1–4. See also below, pp. 437–8 and 439 ff., and Note 51.

21. It stood within a separate colonnaded precinct, recently excavated, obliquely across the street from the main sanctuary.

22. The accounts of Kalat Fakra, Niha, and some of the other lesser sanctuaries given by Krencker and Zschietzschmann require some modification in the light of recent work. For Machnaka, see H. Kalayan, *Bulletin du Musée de Beyrouth*, XVII (1964), 105–10.

23. Niha, Temple A: Krencker-Zschietzschmann, 106–15.

24. E.g. Niha, Temple B (*ibid.*, 116–18), the spring-side shrine of Temnin el-Foka (*ibid.*, 138–40), and Zekweh, which is relatively late in date but archaic design, *ibid.*, 198–202.

25. *ibid.*, 40–6.

26. J. Lauffray, *Bulletin du Musée de Beyrouth*, VII (1945), 13–80; Seyrig, *ibid.*, VIII (1949), 155–8.

27. G. Downey, *A History of Antioch*, 154–7.

28. D. Levi, *Antioch Mosaic Pavements* (Princeton, 1947). The promised study of the architectural remains is still awaited.

29. 'Bath C' (Figure 164B) (*Antioch*, I, 19–31) is said to be a rebuilding (*c.* 350–400) on the same foundations as an early-second-century building. The central octagonal hall, inscribed within a square with apsidal recesses in the diagonal angles, has many Pompeian and Roman precedents. The plan suggests vaulting, but if so it must have been in very light materials.

30. *Antioch*, III, plan VIII (p. 259); cf. the far more elaborate house at Daphni (no. 1) in *Antioch*, III, plan VII = Levi, *op. cit.*, figure 26 (the 'House of Menander'). For an exceptionally symmetrical house plan, see *Antioch*, II, 183–6 = Levi, figure 63 (second half of the third century).

31. At Laodicea (Latakieh), remains of colonnaded streets and a four-way arch: C. M. de Vogüé, *La Syrie centrale*, plate 29; J. Sauvaget, *Bulletin d'études orientales*, IV (1934), 81–114. At Apamea, a colonnaded street, a basilica, and other public buildings, excavated many years ago by M. Mayence but still virtually unpublished; cf. Butler, *Architecture*, 52–7.

32. For the individual sites referred to in this area, see Butler, *North Syria*, and Tchalenko. Cf. also R. Krautheimer, *Early Christian and Byzantine Architecture (Pelican History of Art)* (Harmondsworth, 1965), 106–8. p. 428

33. E.g. the hunting lodge of Caliph Walid I (705–15) at Qasr el-Amr: K. A. C. Creswell, *Early Muslim Architecture*, I (Oxford, 1932), 253–72. Cf. the military bath-buildings at Dura (*Sixth Season*, 84–105) and 'Bath E' at Antioch (Levi, *op. cit.*, figure 100; Constantinian).

34. Seyrig, *Syria*, XXVII (1950), 34–7. p. 430

35. Watzinger and Wulzinger, Abb. 18.

36. Preliminary accounts in *I.L.N.* (10 and 17 November 1962), 746–9 and 789–91. p. 432

37. From its appearance, together with earlier, simpler types of tower tomb, at Medaein Saleh (the ancient Hegra) in the northern Hejaz, an important station on the trade route southwards from Petra. The cemeteries of Hegra are chronologically valuable since, unlike those of Petra, they are dated by inscriptions to the first three-quarters of the first century A.D. They do not include any temple tombs. RR. PP. Jaussen and Savignac, *Mission archéologique en Arabie* (Paris, 1909), 307–404.

38. G. R. Wright, *Palestine Exploration Quarterly* (1961), 124–35. p. 434

39. Wright, *ibid.*, 8–37; P. J. Parr and others, *Syria*, XLV (1968), 1–66.

40. N. Glueck, *Deities and Dolphins* (New York, 1965), 73–160. For this well attested Nabataean form, see further p. 439–40.

p. 434 41. See below, p. 449.

42. Krautheimer, *op. cit.*, 110 and note 21.

43. R. Amy, *Syria*, XXVII (1950), 82–136. Recent work at Araq el-Emir, between Jericho and Amman, identifies it as a temple of the same general type, begun by Hyrcanus and left unfinished on his death in 175 B.C.: P. W. Lapp, *B.A.S.O.R.*, CLXXI (October 1963), 3–38; cf. Butler, *South Syria*, 1–22. Cf. also coins of Capitolias in the Decapolis, depicting a temple façade with angle-turrets above the pediment and what appears to be an altar on the roof, above the cella (Seyrig, *Syria*, XXXVI (1959), 66–70, plate XII. 6–14). For the temple at Dmeir, see Amy, *art. cit.*

p. 437 44. As defined on pp. 375 ff.

p. 438 45. Other Syrian analogies: Creswell, *op. cit.* (Note 33), figures 382 (Mausoleum of Qusayr an-Numajjis) and 386 (Samaria, pagan tomb).

p. 439 46. No doubt from the Hauran, where there are similar vaults (cf. below, p. 442).

47. For the fountain buildings of Asia Minor, see p. 406. Lepcis Magna, p. 478. Amman: Butler, *South Syria*, 54–9. Pella: Seyrig, *Syria*, XXXVI (1959), 42.

48. 'The Hauran' may for convenience be used to describe the whole area, south-east of Damascus, of which the Djebel Hauran is the centre. Unless otherwise noted the buildings referred to in this section are all published in Butler, *South Syria*.

p. 441 49. D. Schlumberger, *Proceedings of the British Academy*, XLVII (1961), 77–95. Preliminary reports annually in the *Journal Asiatique*, since 1959.

50. Below, p. 453 and Note 69.

p. 442 51. For the 'Syrian arch' or 'arcuated lintel', see D. F. Brown, *A.J.A.*, XLVI (1942), 389–99; Crema, 142–3, 344–5. The motif first appears on Assyrian reliefs. The towered façade stems ultimately from Persepolis; E. F. Schmidt, *Persepolis* (1955), 125, figure 59. For its uses in Roman Syria, see above, pp. 421 and 437–8.

52. R. Naumann, *Der Quellbezirk von Nîmes* (Berlin–Leipzig, 1937), 46–53; J. B. Ward-Perkins, *J.R.S.*, XXXVIII (1948), 64.

53. Perhaps even as early as A.D. 160–9 over the central bay of the military shrine (the 'Praetorium') at Mismiyeh (Roman Phaena), seen and drawn by De Vogüé (*La Syrie centrale*, plate VII) and other early travellers before it was destroyed for its building stone; see also E. Weigand, *Festschrift H.*

Bulle (Stuttgart, 1938), 71. The four corner bays were roofed with flat slabs, the four arms of the internal cross with barrel-vaults, also of slabs, buttressing the central bay.

54. Butler, *Architecture*, 327–34. p.

55. The use of the triconchos for the domestic p. audience hall of the Residence at Bostra, and probably also at Dura (Note 65), anticipates what was to become a commonplace of the palace architecture of late antiquity, including Early Muslim Syria; cf. below, pp. 532–3. For the palace at Ptolemais, see R. G. Goodchild, *Antiquity*, XXXIV (1960), 246–58.

56. Umm el-Jemal: G. U. S. Corbett, *P.B.S.R.*, p. XXV (1957), 39–66. Busan: Butler, *South Syria*, 336–40.

57. Rostovtzeff, 17–18. No detailed publication has yet appeared.

58. *Dura, Ninth Season*, part 3. p.

59. Interim accounts of most of the temples are given in the Reports on the successive seasons; cf. Rostovtzeff, 41–6. The excavations at Hatra, begun in 1950, are still largely unpublished. A good summary with some sketch plans by H. Lenzen in *Anz.* (1955), 334–75; cf. F. Safer in *Sumer*, vols VIII–IX (1952–3).

60. E.g. in the temple of Qasr Fira'un at Petra (p. 434).

61. The house-church at Dura: *Dura, Fifth Season*, 238–53; C. H. Kraeling, *The Christian Building* (*The Excavations at Dura-Europos. Final Report*, VIII. 2) (New Haven, 1967); Krautheimer, *op. cit.* (Note 20), 6–7. The synagogue: C. H. Kraeling, *The Synagogue* (*ibid.*, VIII. 1) (New Haven, 1956).

62. *Dura, Seventh and Eighth Seasons*, 62–134.

63. *Dura, Fifth Season*, 201–37 (the praetorium); p. *Sixth Season*, 49–63, 84–104 (bath-buildings). One of the latter in its original form dates back to the Parthian period and is one of the earliest tangible traces of Roman architectural influence on Dura.

64. *Dura, Ninth Season*, part 3, 1–25.

65. The larger room at the south end of the façade, adjoining the private suite, was probably a domestic audience hall of triapsidal (*triconchos*) plan; cf. Bostra, p. 445. Unfortunately all but the side wall and one lateral apse have disappeared over the cliff.

66. *Dura, Sixth Season*, 84 (Bath M 7) and 266 (House of the Scribes). For its use in Asia Minor, see pp. 388–9.

67. Rostovtzeff, *passim*.

68. Of which Palmyra was probably at the time a political protégé (Appian, *Civil War*, v. 9). See also above, p. 414 and Note 1.

69. Seyrig, *Syria*, XXI (1940), 277–337. The deposit, which included the earliest known Palmyrene inscription (44 B.C.), almost certainly comes from the predecessor of the present temple.

70. The date of the temple itself is given by an inscription (J. Cantineau, *Syria*, XIV (1933), 170–4), that of the porticoes by a comparison (D. Schlumberger, *ibid.*, 283–317) with the capitals of such dated monuments as the tower-tombs of Iamblichos (A.D. 83) and Elahbel (A.D. 103). Inscriptions on the porticoes giving dates as early as A.D. 14 (*ibid.*, 291, note 4) are recut, replacing earlier texts – a common Palmyrene practice.

71. For the term *thalamos*, see Lucian's description (*The Syrian Goddess*, 31) of the temple at Hierapolis.

72. See Note 70 above.

73. Inscriptions of A.D. 76 and 81 are another instance of the disconcerting Palmyrene habit of re-cutting earlier texts.

74. *Forschungen in Ephesos*, III (1923), 172–88. The arch also served to link the stretch to the west with the very much wider (nearly 130 feet; 40 m.) processional way leading to the Temple of Bel.

75. Interim account by Seyrig in *C.R.A.I.* (1940), 237–49. For the basilica as a possible kaisareion, see *P.B.S.R.*, XXVI (1958), 181–2. Other pre-Constantinian basilicas in Syria were those of Apamea (Butler, *Architecture*, 55), Shakka in the Hauran (*ibid.*, 365), and Samaria.

76. A. Bounni and N. Saliby, *Annales archéologiques de Syria*, XV (1965), 124.

77. P. Collart, *ibid.*, VI (1956), 67–90.

78. They include an instance of the 'Rhodian' peristyle, in which one colonnade is taller than the rest.

79. Tower-tombs: E. Will, *Syria*, XXVI (1949), 87–116. Hypogea: e.g. the tomb of Iarhai (A.D. 108), *Syria*, XVII (1936), 229–66. Pedimental tombs: e.g. Tomb 86, with a hexastyle, pedimental façade (*Palmyra*, I, 71–6; II, plates 38–44).

80. *Palmyra*, 85–105. Its latest excavator, K. Michalowski, regards the 'Chapel of the Standards' as a pre-existing temple, which had a colonnaded street leading to it (*Encicl. Art. Ant.*, V, s.v. 'Palmira'). Crema considers it to be Antonine. To the writer the *prima facie* reasons for regarding it as substantially a Diocletianic building seem strong. For similarly intersecting colonnaded streets in the Diocletianic camp at Luxor, see U. Monneret de Villard, *Archaeologia*, XCV (1953), 96.

CHAPTER 19

1. L. Borchardt, *J.D.A.I.*, XVII (1903), 73–90; p. 458 cf. the small Hadrianic Temple of Serapis at Luxor, tetrastyle and peripteral on three sides, built throughout of brick (J. Leclant, *Orientalia*, XX (1951), 454, and XXX (1961), 183). For what is claimed to be the platform of a prestige temple of Roman type begun (but not finished) by Cornelius Gallus in 23–22 B.C. in the fortress of Qasr Ibrim, on the frontier towards Nubia, see *I.L.N.* (11 July 1964), 50–3. Kiosk of Trajan: L. Borchardt and H. Ricke, *Aegyptische Tempel mit Umgang* (1938), 13 f. Arch of Diocletian: U. Monneret de Villard, *La Nubia romana*, 5–10, figures 4–8.

2. *I.L.N.* (19 November 1966), 32. A. Adriani, p. 459 *Annuaire du Musée gréco-romain d'Alexandrie*, 1935–39 (1940), 136–48.

3. Cf. also the yet earlier Ptolemaion, erected p. 460 soon after 304 B.C. by the Rhodians in honour of Ptolemy I and described by Diodorus (XX. 100. 4) as a long rectangular temenos with two inward-facing porticoes. I owe this reference to Professor E. Sjoqvist.

4. R. E. M. Wheeler, *Antiquity*, XXIV (1949), 15; p. 461 *Rome Beyond the Frontiers* (London, 1954), 170.

5. Most recently discussed by S. Stucchi in p. 462 *Quaderni*, IV (1961), 55–81. For other temples of Roman Cyrene, see R. G. Goodchild, J. M. Reynolds, and R. C. Herington, *P.B.S.R.*, XXVI (1958), 30–62 (Temple of Zeus), and R. G. Goodchild, *Quaderni*, IV (1961), 83–7 (the Valley Street excavations).

6. In later Roman terminology the *triclinium*; see above, p. 314.

7. See above, p. 442; below, p. 478. p. 464

8. To be distinguished from the Syrian 'arcuated lintel'; see above, Chapter 17, Note 14.

9. Pesce dates the building to the second century B.C., A. von Gerkan (*Gnomon*, XXIII (1951), 340) to the Flavian period, and Mingazzini to the third

century A.D. In the absence of archaeologically well dated comparative material, an Augustan or early Julio-Claudian date seems on historical grounds the most likely. Dr Gideon Foerster informs me that a very similar building has been found at Samaria.

p. 464 10. Goodchild and Kraeling in Kraeling, *Ptolemais*, 89–93.

p. 469 11. G. Caputo, *Dioniso*, XIII (1950), 164–78. For other African theatre-temples, see E. Frézouls, 'Teatri romani dell'Africa francese', *Dioniso*, XV (1952), 90–101; Hanson, *Roman Theater-Temples*, 59–67.

p. 472 12. See above, p. 131. Provisional account in *Reports and Monographs of the Department of Antiquities in Tripolitania*, II (1949), 23.

p. 475 13. Krencker and Krüger, *op. cit.* (Chapter 15, Note 18), 224–5, Abb. 317, after *Anz.* (1905).

p. 480 14. Corresponding to the 'petit appareil' of Roman Gaul or the coursed rubblework of Asia Minor.

15. It seems to have had a portico and a small temple at the head of the cavea and a single portico behind the stage-building (*porticus post scaenam*), as at Thugga. For the upper portico, cf. Caesarea (Cherchel), Lepcis, and Thugga (Caputo, *Il Teatro di Sabratha*, 50–6); and for similarly placed temples, above, p. 469 and Note 11.

p. 481 16. There must have been some provision for the imperial cult, either in the basilica or in one of the rooms opening off the forum.

17. Gsell, *Mdaourouch*, 66 and 71–2, plate XVII; probably the 'Basilica vetus' of *Inscriptions latines d'Algérie*, 2135. Dr F. Rakob informs me that the basilica at Simitthu (Hadrianic) was a plain hall with internal piers along the walls and an apse at either end.

18. Tipasa (unpublished; *not* Gsell, *Monuments*, figure 38) had longitudinal colonnades and an apse flanked by 'chapels'. Sigus: Gsell, *Monuments*, 129–32, figure 37. Thubursicu: Gsell, *Khamissa*, 67–74, plate II.

19. See Merlin, *Le Forum de Thuburbo Maius*, 34, for a list of African curiae.

20. Carthage: *C.I.L.*, VIII, 1013. The known African Capitolia are very varied, some with tripartite cella (Cuicul, Thibilis, Thuburbo Maius), some single (Thugga), and at least one bipartite (Lambaesis). Sufetula (Plate 253) had three separate temples. A distinctive local form has lateral pro-

jections flanking the cella, as at Abthugni and Althiburos: Cagnat and Gauckler, 1–18; Gsell, *Monuments*, 133–54; Gsell, *Announa*, 70–3 (Thibilis); cf. Sabratha (above, p. 472).

21. For the arches and monumental gates of p. Algeria, see Gsell, *Monuments*, 155–85. In Africa such arches were used indiscriminately across streets or street-crossings, as gates into cities or into major sanctuaries (e.g. that of Mercurius Sobrius at Vazi Sarra, Cagnat and Gauckler, 68–9, plate XXI) or as independent monuments (Arch of Caracalla at Volubilis). All but the simplest must be visualized as having normally carried statuary.

22. Hippo Regius: J. Lassus, *Libyca*, VII (1959), p. 311–16. With pavilion: Cuicul (below, p. 487) and possibly Thugga (Poinssot, *Ruines de Dougga*, 33–4), where it opened off a large courtyard. Without pavilion: Gigthis (Constans, 'Gigthis', plate XIII), Thurburbo Maius (Merlin, 49–51), and Thibilis (Gsell, *Announa*, 76–9, plate XIX, 2).

23. Ballu, *Sept années*, 13–16.

24. H. F. Pfeiffer, *M.A.A.R.*, IX (1931), 157–65.

25. Lézine, *Monuments romaines*, 9–28, with p. sketch-plans. Lambaesis: Krencker and Krüger, *op. cit.* (Note 13), 214–15, Abb. 295. Lepcis: R. G. Goodchild, *Libya Antiqua*, II (1965), 15–27. Also Thysdrus (El-Djem): *Bulletin Archéologique* (1920), 465–71.

26. For further details of these buildings, see p. interim accounts in *Bulletin Archéologique* (1911–21), notably the Old Forum (1915, 117–23), the Market (1916, 218–34), the Temple of Venus Genetrix (1911, 106–9), and the Baths (1919, 87–94, and 1921, lxvii).

27. A. Merlin, *Forum et maisons d'Althiburos* (*Notes et documents*, VI) (1913), 39–45; R. Étienne, *Le Quartier nord-est de Volubilis*, 77–80. Cf. the 'House of the Laberii' at Uthina in Tunisia: P. Gauckler, *Monuments et Mémoires Piot*, III (1896), 177–299. For a very compact, two-storeyed version of early date, see the 'House of the Figured Capitals' at Utica, A. Lézine, *Karthago*, VII (1956), 3–53.

28. Much of the evidence is epigraphic and is p. conveniently assembled in Warmington, 35–40.

29. See A. Lézine, *Architecture punique: recueil de* p. *documents* (Tunis, 1956).

30. A. Lézine, *Architecture romaine*, 99–118. p. Lixus, information from M. Taradell.

31. R. Cagnat, *Mem. Pont.*, I (1923), 81–8. Gsell, p. *Monuments*, 140–3.

NOTES TO PART FOUR

NOTES TO PART FOUR

CHAPTER 20

97 1. Malalas, Chr. XII, 299.

01 2. Much, if not all, of the exterior was stuccoed, including the mouldings.

03 3. I owe this suggestion to Alfred Fraser, who will shortly be publishing the painting in question. Professor F. W. Deichmann tells me that tile-stamps prove the building, traditionally the tomb of the Gordians, to have been erected c. 300.

05 4. This account is based on a survey of the building undertaken by the writer in collaboration with Alfred Fraser. For the extensive bibliography concerning this building and its identification, see Nash, II, 268.

5. It is tempting to restore a split pediment, framing the dome behind; but there is no evidence for this. The alternatives are a pair of small gables or else a pair of flat entablatures, perhaps embellished with statues over the columns.

07 6. The reliefs from the Arcus Novus of Diocletian (303–4), now in the Boboli Gardens, Florence, must similarly have been looted from some monument of the first half of the third century.

10 7. As was clearly demonstrated by Cozzo.

11 8. 'Non . . . a cassetta, ma veramente massivi in mattoni' (G. Giovannoni in *Atti del II Congresso Nazionale di Studi Romani* (1931), 291, reporting recent *sondages* by himself).

14 9. Dr Rakob has pointed out to me that, here too, Hadrian's Villa anticipates later practice. The winter triclinium known as the 'Latin Library' was directly accessible from the garden through just such a columnar exedra.

CHAPTER 21

17 1. The current excavations at Sirmium have not yet revealed any certain remains of the imperial palace. A richly appointed peristyle-house with a separate bath suite is clearly a private residence.

2. See above, pp. 350–1 and Figure 132.

3. For possibly similar buildings at Aquileia and at Veldidena in Austria, see below, p. 533 and Note 13. p. 519

4. See above, p. 388 and Chapter 17, Note 3. p. 524

5. Dr H. Torp informs me that the mausoleum was apparently unfinished on the death of Galerius, and that the upper part of the dome was only completed when it was converted into a church.

6. Cf. the gallery of the palace at Antioch (p. 528). Such galleries derive ultimately from the porticoes of the porticus villas, through buildings such as the Villa of Sette Bassi (p. 333). p. 526

7. Libanius, *Orations*, XI. 204–7 (written in 360). p. 527

8. Durm, *Baukunst*, figure 857. Crema, figure 753. For the semi-engaged internal orders within the mausoleum, cf. the late Severan circular temple at Ostia (*M.A.A.R.*, VIII (1930), 161–9), and the 'Tempio di Portunno' mausoleum at Portus (Crema, 563–4, figure 745). p. 529

9. The identification, first proposed by H. P. L'Orange (*Symbolae Osloenses*, XIX (1952), 114–28), is accepted by the excavator, Gentili. That the main layout dates from the early fourth century is shown by the coin evidence and by the mosaics.

10. Notably in I. Lavin ('The House of the Lord'; see bibliography). p. 531

11. *Order of Famous Cities*, vv. 35–45. p. 533

12. Krautheimer, 55–7, figure 20.

13. S. Simpliciano: Krautheimer, plates 12B and 13. Aquileia: M. Mirabella Roberti, *Aquileia Nostra*, XXXVI (1965), 45–78. Veldidena: A. Wotschitzky, *J.Ö.A.I.*, XLIV (1959), Bb. 5–32.

14. Krautheimer, 131, 132.

15. See R. Krautheimer's volume in *The Pelican History of Art* (*op. cit.*). p. 535

579

SELECT GLOSSARY

In the glossary which follows Greek terms are given in their Latin form, where such is attested, or else in the English form in common use. The extent of anglicization, especially as regards plurals, is a matter of taste. The classical plurals are here added in brackets to those words that are most likely to be met in this form.

Fuller glossaries will be found in Dinsmoor and in Robertson. For the names of the various types of building construction used in Rome and Central Italy, see further G. Lugli, *La Tecnica edilizia romana con particolare riguardo a Roma e Lazio*, 2 vols (Rome, 1957), 48–50.

abacus. The upper member of a capital.

acropolis. Citadel (Latin, *arx*).

acroterium (-a). Ornamental finial(s) at the apex or outer angles of a pediment.

adyton. Sanctuary of a Syrian temple; also occasionally *thalamos* (p. 455).

aedicula (-ae). Diminutive of *aedes*, a temple; whence a small columnar or pilastered tabernacle used ornamentally.

Aeolic capital. Palmiform capital evolved by the Greeks of north-western Asia Minor.

agger. Rampart.

ala (-ae). Outer passage(s) flanking the side walls of the cella (or cellas) of an Etruscan temple (Vitruvius, IV. 7. 4, *aliae* in MS). Wings extending to right and left at the far end of an atrium. See Figure 45.

ambulatio. Terrace for exercise.

amphitheatre. Oval building with seating facing inwards on to a central arena for gladiatorial or similar spectacles.

anathyrosis. The smooth marginal dressing of the outer contact band of a masonry joint, the central portion being left roughened and sunk so as to avoid contact.

andron. Room in a Greek house reserved for men. The passage between two peristyles (Vitruvius, VI. 7. 5). In Roman Syria a public hall (see p. 430).

anta (-ae). Pilasters forming the ends of the lateral walls of a temple cella. When the façade consists of columns set between two antae the columns are said to be *in antis*.

antefix. Decorative termination of the row of covering tiles (*imbrices*) laid over the joints between two rows of flat tiles (*tegulae*) of a roof.

Apennine Culture. The principal Bronze Age culture of peninsular Italy (from about 1500 B.C.).

apodyterium (-a). The changing room of a bath-building.

ara (-ae). Altar.

Archaic. Term in conventional use to denote the art and architecture of the pre-classical phase, from the seventh century B.C. until about 500 B.C.

architrave. The horizontal element, of stone or timber, spanning the interval between two columns or piers.

arcuated lintel, or 'Syrian arch'. An arched entablature over the central intercolumniation of an otherwise conventional classical façade, the mouldings of which are carried without a break across the arch. See pp. 441–2.

areostyle (Greek, *araiostylos*). With columns widely spaced, as regularly in Etruscan temples. As distinct from eustyle (mediumly spaced) and pycnostyle (closely spaced).

arx. Citadel (Greek, *acropolis*). In Rome the name of the northern part of the Capitoline Hill.

ashlar. Regular masonry of squared stones laid in horizontal courses with vertical joints.

asseres. See Figure 24.

atrium. See Figures 45, 48. The central hall of a Roman house of Etruscan type (*cavum aedium tuscanicum*) between the entrance passage (*fauces*) and the tablinum in the middle of the far end. In the later centuries B.C. the central part of the roof (*compluvium*) sloped inwards to a central opening (*impluvium*) to collect rainwater for the cisterns beneath. *See also* cava aedium tuscanicum.

attic. Upper storey above a cornice (e.g. commonly in monumental arches).

Ausonian Culture. The Apennine Bronze Age culture of the Lipari (Aeolian) islands.

balneum, balineum (-a). Bath-building, public or private, of ordinary size, as distinct from the great public baths (*thermae*).

basilica. In strict architectural usage an elongated rectangular building with an internal ambulatory enclosing a taller central area, or else with a

central nave and lateral aisles, in either case lit by a clerestory; often provided with one or more apses or tribunes. Originally a roofed extension of the forum for the use of the public, from the Late Republic onwards it was used for a variety of official purposes, notably judicial. During the Empire the term came to be used of any hall that was basilican in plan, irrespective of its purpose; and also of any large covered hall, irrespective of its plan.

basis villae. The platform of a Roman villa.

baths (balnea, thermae). For the individual rooms of a Roman bath-building, *see* caldarium, frigidarium, laconicum, natatio, palaestra, tepidarium; *also* hypocaust, piscina.

bucraneum (-a). Decorative motif in the form of an ox-skull (or bull's head), shown frontally.

bustum. Enclosure for the performance of cremation and the conservation of ash-urns.

caementa. The irregular chunks of stone or brick used as aggregate in Roman concrete (*opus caementicium*).

caldarium (-a). The hot room, or rooms, of a Roman bath.

cantherius. Spar under roof, rafter (see Figure 24).

capellaccio. The local tufa stone of the hills of Rome; used monumentally in the sixth century B.C., later only for constructions of secondary importance.

capital. The upper member of a classical column or pilaster.

carceres. The starting gate of a hippodrome or circus.

cardo. Part of the terminology of the Roman surveyors (*agrimensores*). The planning of the countryside and, wherever possible, of the associated towns was based ideally on the intersection at right angles of two main streets, the *cardo* (north–south) and the *decumanus* (east–west). Hence, by extension, in modern usage, the two main streets of a town, whether they comply with the rules of surveying or not.

caryatid. Sculptured human (strictly a female) figure used instead of a column to carry an entablature.

castrum. Military camp, theoretically rectangular though in practice commonly square or trapezoidal in plan. The layouts normally conform to one of two main types, one with two main streets (*via quintana* and *via principalis*) running parallel to the long sides, the other (characteristic of permanent fortresses) with two main streets (usually known as *cado* and *decumanus*) intersecting at right angles.

cava aedium (cavaedium). The Vitruvian term for the types of Late Republican and Early Imperial houses represented at Pompeii, Herculaneum, and Ostia. Vitruvius (VI. 3) distinguishes five main types: *tuscanicum* (*see* atrium), which he, Varro, and others ascribed to the Etruscans; *tetrastyle*, with columns at each angle of the compluvium; *Corinthian*, with intermediate columns also; *displuviatum*, with roof sloping downwards and outwards on all four sides; and *testudinatum*, with a ridge roof.

cavea. The auditorium of a theatre, so called because originally excavated from a hillside. The seating of an amphitheatre.

cella. The central chamber or sanctuary of a temple.

cenaculum. Dining-room; later an upper storey.

chalcidicum. Monumental porch constituting the façade of some other building. In particular the porch in front of the short end of a basilica.

circus (Greek, hippodrome). Long narrow arena, curved at one end (exceptionally at both ends), for chariot racing.

clerestory. Upper row of windows lighting the nave of a basilica, above the inner colonnades.

coenatio. Dining-room.

colonia. Military colony of Roman or Latin citizens.

columbarium (-a). Literally pigeon-cote, whence a sepulchral chamber with rows of small recesses like nesting-boxes to hold the ash-urns.

comitium. Enclosed place of political assembly, notably that at the north-western corner of the Forum Romanum.

compluvium. The open portion of the roof of a Roman atrium, above the impluvium.

conclavium. Oblong, closed room. Dining-room. Bedroom.

confornicatio. Vault.

consuetudo italica. Vitruvius's term for Late Republican Roman usage.

corbel. Stone bracket supporting a projecting feature.

Corinthian order. See Plate 83.

cornice. Projecting element, designed to throw rain water from the face of a building. The upper member of a classical entablature, subdivided into bed-moulding, corona, and sima (see Plate 113).

crypta. Subterranean gallery. Crypt.

cryptoporticus(-us). Underground vaulted corridor, usually with oblique lighting through the vault.

cubiculum. Bed chamber.

cunei. The wedge-shaped blocks of seating, divided by radiating passages, in a theatre or amphitheatre.

curia. The meeting-place of the Roman Senate. Whence, the assembly place of any municipal council.

cyclopean masonry. Massive polygonal masonry. Originally that of Mycenaean Greece, but often used also of the polygonal limestone walls of Central Italy, from about 400 B.C.

dado. The lower part of a wall when treated decoratively as a continuous plinth or wainscot.

decastyle. Consisting of ten columns.

decumanus. See cardo.

dentils. Decorative motif of rectangular blocks in the bed-mould of a cornice, or occupying the place of a frieze; derivative from the ends of the joists carrying a flat roof. See Plate 124.

diaeta (-ae). Living-room.

distyle. Consisting of two columns.

dolium (-a). Large earthenware jar.

domus(-us). House, the well-to-do residence of a single family as distinct both from the huts or tenements of the poor and, under the Empire, from the apartment houses (*insulae*) of middle-class usage.

Doric order. The order evolved in the Doric and western region of Greece, exemplified by the Parthenon. See Plate 78.

drafting. The dressing back of one or more edges of a block of stone to facilitate the laying of a neat joint. Also used decoratively, to accentuate the pattern of the jointing of an ashlar wall.

dromos. Horizontal or sloping passage forming the entrance to a subterranean chamber.

echinus. The convex moulding which supports the abacus of a Doric capital. The moulding, carved with egg-and-dart, placed under the cushion of an Ionic capital.

engaged order. Decorative order projecting from, but forming an integral part of, the wall against which it stands. 'Semi-engaged' when only the entablature is engaged and the columns are free-standing.

entablature. The horizontal superstructure carried by a colonnade, or the equivalent superstructure over a wall.

exedra (-ae). Semicircular or rectangular recess.

extrados. The outer curved face of an arch or vault.

fastigium. Roof or gable (pediment).

fauces. The entrance to an atrium. The passageway between an atrium and a peristyle.

fornix (-ces). Term used for the earliest triumphal arches.

forum (-a). An open square or piazza for public affairs. Market-place.

fossa. Ditch or trench, especially that outside a city wall.

fossa grave. Trenched inhumation burial.

frieze. The middle member of an entablature, often enriched with relief sculpture. Any horizontal band so carved.

frigidarium. The cold room of a Roman bath.

guttae. Small, peglike motif beneath the triglyphs and mutules of a Doric entablature.

hellenistic. Belonging to the period between Alexander the Great (d. 321 B.C.) and Julius Caesar (d. 44 B.C.).

hexastyle. Consisting of six columns.

hippodrome. See circus.

horreum (-a). Building for storage. Granary.

hortus. Garden. Park.

house. For the parts of a Roman house, *see* ala, andron, atrium, cenaculum, coenatio, conclavium, cubiculum, diaeta, fauces, ianua, peristyle, tablinum, triclinium, vestibulum; *also* compluvium, hypocaust, impluvium.

hypocaust. Floor with an airspace beneath for the circulation of hot air.

ianua. The outer door of a house.

imbrex. Roof-tile, semicircular or triangular in section, covering the joint between the flanges of two rows of flat roof-tiles (*tegulae*).

impluvium. Shallow pool in the atrium of a Roman house, to catch the rain falling through the compluvium.

insula. Tenement or apartment house, as distinct from a private house (*domus*). Also, in conventional modern usage, a city block (see pp. 316–17).

intrados. The inner curved face of an arch or vault.

Ionic order. The order evolved in Ionian Greece. See Plate 77.

laconicum (-a). The hot dry room of a Roman bath.

latifundium (-ia). Large landed estate.

limitatio. The laying-out of field-boundaries (*limites*).

macellum. Market (strictly a meat market).

maenianum. Balcony.

'marble style'. Style associated with the widespread diffusion of marble as a building material in the second century A.D.

meander. Key pattern.

megaron. The principal hall of a Mycenaean palace and, later, of a Greek house. In modern usage applied to houses and temples having an open porch (*pronaos* or *prodomos*) flanked by two antae and often provided with columns.

merlons. The crenellations of a fortress wall. Used as a decorative motif in Roman Syria.

meta. Turning-point for the chariots in a Roman circus.

metope. The panel, plain or sculptured, between the triglyphs of a Doric entablature.

musaeum. See nymphaeum.

mutule. A projecting slab on the soffit of a Doric cornice.

naiskos. Diminutive of *naos.* A small shrine.

naos. Shrine. The cella of a Greek temple.

natatio. The swimming pool of a public bath.

nuraghe (-i). Sardinian tower-like fortress (see Figure 5), used from the thirteenth century B.C. until Roman times.

nymphaeum (-a). Originally a cave with running water, dedicated to the Nymphs. Whence, any artificial fountain grotto (*musaeum, specus aestivus*) or, by extension, any public fountain.

octastyle. Consisting of eight columns.

odeum (Greek, *odeion*). Small roofed theatre, for concerts and lectures.

oecus (Greek, *oikos*). The main room of a Greek house, successor of the Mycenaean megaron. In Roman houses a banqueting room, of which Vitruvius (VI. 3. 8–10) distinguishes four kinds: Tetrastyle, Corinthian, Egyptian, and Cyzicene.

opus caementicium (*structura caementicia*). Roman concrete masonry of undressed stones (*caementa*) laid in a mortar of lime, sand, and, in Rome and Campania, pozzolana (q.v.). By extension, any comparable mortared rubblework in the provinces, even though made without pozzolana.

opus incertum. The facing of irregularly shaped small blocks used with opus caementicium from the second century B.C. (cf. Figure 61), and developed from the irregular rubble facing of the previous century, as at Cosa. In its later stages, as the irregularities assumed a more regular pattern, it is known (in modern usage) as *opus quasi reticulatum.*

opus latericium. Masonry of crude brick.

opus mixtum. Conventional name for opus caementicium faced with panels or bands of reticulate and brick.

opus quadratum. Ashlar masonry, of large squared stones laid in horizontal courses.

opus reticulatum. The successor to opus incertum (earliest known example the Theatre of Pompey, 55 B.C.), with a facing consisting of a network of small squared blocks laid in neat diagonal lines. From the Latin *reticulum*, a fine net. Cf. Plate 137.

opus sectile. Paving or wall decoration made of shaped tiles of coloured marble.

opus signinum. Floor of concrete varied by irregular splinters of terracotta, stone, and marble; *see* Chapter 6, Note 33. Used conventionally also of any Roman waterproof concrete made with crushed brick.

opus testaceum. Masonry of Roman concrete faced with fired brick.

opus vittatum. Conventional term for opus caementicium with a facing of courses of small squared blocks of stone (normally tufa) alternating with one or more courses of brick. Often used also of the provincial masonry here referred to as 'petit appareil', but better restricted to metropolitan usage and its immediate derivatives. The hybrid term 'opus listatum' (from the Italian 'opere listato') should be avoided.

orchaestra. Originally the circular 'dancing floor' of a Greek theatre; whence the corresponding semicircular space in front of the stage (*proscaenium*) of a Roman theatre.

orthostat (or *orthostate*). Upright slab of stone; particularly of those used in the Greek manner to form the lower part of a wall.

ostium. Harbour, river-mouth. Whence Ostia, the port of Rome.

palaestra. Exercise ground.

parodos. Lateral entrance to the orchestra of a theatre.

pediment. The triangular gabled end of a ridged roof, comprising the tympanum and the raking cornice above it.

pendentive. Concave triangle of spherical section, constituting the transition from a square or polygonal building to a dome of circular plan. Cf. squinch.

peperino. Volcanic tufa stone from the Alban Hills, south-east of Rome.

peripteral. Having a continuous outer ring of columns.

peristasis. The ring of columns round a peripteral building.

peristyle. The inner, colonnaded garden court of a Pompeian (or hellenistic) house. Also used by Vitruvius as the equivalent of peristasis.

'*petit appareil*'. Conventional name for the characteristically Gallo-Roman type of opus caementicium, with a core of mortared rubble and a facing of courses of small squared blocks of stone. See p. 346. Widely used in many other provinces and often, from the second century A.D. onwards, laced with courses of brick.

piscina (-ae). Pool (literally 'fish-pool'). The plunge baths of a Roman bath-building.

pisé. Stiff clay used as a building material, laid within a shuttering of boards and regularly faced with stucco.

pitched brick. Brickwork laid end to end across the vertical curvature of an arch or vault, instead of radially as in normal western Roman usage. Apparently an eastern innovation. See pp. 388, 524 and Plate 200.

platea (Greek, *plateia*). Wide street, in contrast to angiportus (-ūs, Greek, *stenōpoi*), lanes or alleyways.

podium (-*a*). Platform, used most commonly of temples or columnar façades; normally with mouldings at top and bottom.

pozzolana (Latin, *pulvis puteolanus*). The volcanic ash of Central Italy, so named from Puteoli (Pozzuoli), where its properties were first recognized; the material which gave Roman concrete its strength and hydraulic properties. See p. 246.

praecinctio. Horizontal passageway between the successive tiers of seats of a theatre or amphitheatre.

prodomus. See pronaus.

pronaus (Greek, *pronaos*). Porch in front of the cella of a temple.

propylaeum (-*a*). Entrance gate-building(s) to the enclosure of a temple or other monumental building. Also *propylon*, strictly a simpler version of the same.

proscaenium. The stage of a theatre, in front of the stage-building (*scaena*).

prostyle. Having a projecting columnar façade.

pseudoperipteral. As peripteral, but with some of the columns engaged instead of free-standing.

pulpitum. Raised platform, tribune.

puteal. Stone well-head.

quadrifrons (Greek, *tetrapylon*). Arch over the intersection of two streets, with four equal façades.

quadriporticus. Enclosed courtyard with porticoes on all four sides.

reticulate (*work*). See opus reticulatum.

revetment. Superficial facing (e.g. of terracotta or marble) applied to a wall built of some other material.

ridge pole. Beam along the ridge of a roof.

rostra. The speakers' tribune of the comitium of the Forum Romanum, so called because it was ornamented with the prows (*rostra*) of the ships captured at Antium in 338 B.C. By extension, any speakers' platform.

rustication. The use of masonry in its crude, quarry-dressed state as a form of sophisticated decoration.

sarcophagus. Stone coffin.

scaena (Greek, *skene*). Stage-building of a Roman theatre. The façade of it (*scaenae frons*) formed the backdrop of the stage (*proscaenium*).

scamna (sing., *scamnum*). Rectangular house- or barrack-blocks, laid out with their short sides facing the main street of a town or camp. The opposite of *striga*.

scandula (*scindula*). Wooden roof-shingle.

semi-column. Half-column, of an engaged order or composite pier.

sigma. Semicircular portico (from the late Greek capital S (*sigma*), which was written 'C'). See p. 532.

sima. Crowning moulding (originally the gutter) of a cornice.

sine postico. Vitruvian term for a temple peripteral on three sides only, with a plain back wall or a back wall with short projecting alae.

siparium. Curtain. The curtain of a theatre, which was raised from a slot in the front of the stage.

socle. The lower part of a wall. Originally a constructional feature, in Roman times it was commonly treated as a purely decorative dado.

specus. Cave. The channel of an aqueduct.

spina. The long, narrow dividing wall down the centre of a circus.

squinch. Arched structure across the interior angle of a square chamber, to support the spring of a circular or octagonal vault or dome. Cf. pendentive.

stadium. A racecourse, six hundred Greek feet long.

stele. Upright stone slab, as used for tombstones, for all kinds of sculptured reliefs, and for inscriptions.

stillicidium. The lowest parts of the eaves of a house, from which the rainwater drips.

stoa. The Greek equivalent of the Latin *porticus*. Particularly of public buildings, often with multiple colonnades and sometimes two-storeyed.

striga. As scamna, but with their long sides parallel to the main street.

taberna (-*ae*). Rectangular chamber opening directly off the street and used as shop, workshop, or habitation for the lower classes. See p. 285.

tablinum (*tabulinum*). The central room at the far end of an atrium, originally the main bedroom; record room (whence the name).

tabularium. Archive building.

tegula (-*ae*). Roofing tile.

temenos (-*oi*). Sacred enclosure or precinct.

templum. Originally the place marked out by an augur for the purpose of taking auspices. Whence any consecrated place, sanctuary, asylum.

tepidarium (*-a*). The warm room of a Roman bath.

Terramara. Conventional term for the culture of the Bronze Age villages of the second half of the second millennium B.C. in the south-central Po valley (from the Emilian dialect word for the rich black earth quarried from such sites as a fertilizer).

testudinate. Having a ridge roof.

tetrakionion. Pavilion or aedicula carried on four columns.

tetrapylon. See quadrifrons.

tetrastyle. Carried on four columns, e.g. of a façade, of an aedicula, or of an atrium with columns at the four corners of the impluvium.

theatre. For the parts of a Roman theatre, see p. 374; also cf. cavea, cunei, orchaestra, praecinctio, proscaenium, scaena, siparium, vomitorium.

thermae. Large public baths, as distinct from *balnea*.

tholos (*-oi*). Vaulted circular tomb. Circular pavilion.

tignum. Wooden beam.

torus. Rounded convex moulding; as (twice) in the typical Attic column base (e.g. Plate 134).

travertine. Silvery-grey calcareous building stone quarried near Tivoli and extensively used in Late Republican and Early Imperial Rome.

tribunal. Raised platform for magistrates.

triclinium (*-a*). Originally a dining-room, so-called from the conventional arrangement of three banqueting couches (*klinai*) around three sides of a square. In later Roman usage the principal reception room, or rooms, of a house. See pp. 315, 531.

triconchos. Room of trefoil or three-lobed plan.

triglyph. Projecting member separating the metopes of a Doric frieze and divided into three strips by two vertical grooves.

tufa. The principal local building stone of Latium and Campania, a concreted volcanic dust. The many qualities include capellaccio, peperino, and the stones of Monte Verde, Grotta Rossa, Grotta Oscura, and Gabi.

Tuscan order. The plain shafts with bases and capitals which are occasionally found in early Etruscan contexts (e.g. tombs of the sixth century B.C., the recently excavated temple at Vulci) are evidently those included by Vitruvius in his description (IV. 7. 2 f.) of the Tuscan style; but the Etruscans seem in fact to have preferred the Aeolic and other Greek capitals. The Tuscan order of conventional archaeology was probably created by the Etruscans in Italy. We can follow it from the sixth century B.C. to Republican and Imperial architecture.

Tuscanicae dispositiones. Vitruvius's term for the Etruscan style of temple architecture.

tympanum. The vertical wall-face of a pediment beneath the raking cornice.

ustrinum (*-a*). Place for burning corpses.

velum, velarium. The awning stretched above a forum, a theatre, or an amphitheatre to protect the public from the sun.

vestibulum. Vestibule; especially of the entrance from the street to the fauces of a house.

volute. The spiral scroll of an Ionic capital.

vomitorium (*-a*). Entrance to a theatre or amphitheatre.

voussoir. Wedge-shaped stone forming one of the units of an arch.

BIBLIOGRAPHY

GENERAL

I. GENERAL WORKS ON ROMAN ARCHITECTURE

ANDERSON, W. J. *Architecture of Greece and Rome*, II, *The Architecture of Ancient Rome*, by W. J. Anderson and R. P. Spiers, revised and rewritten by T. Ashby. London, 1927.

BECATTI, G. *L'Età classica* (*Le Grandi Epoche dell' arte*, III). Florence, 1965.
See especially the bibliography, 400–2.

BOËTHIUS, A. *Hur Rom byggdes under antiken*. Stockholm, 1938.

BOËTHIUS, A. *Roman and Greek Town Architecture* (*Acta Universitatis Gotoburgensis*, LIV). Gothenburg, 1948.

BROWN, F. E. *Roman Architecture*. New York, 1961.

CHOISY, A. *L'Art de bâtir chez les Romains*. Paris, 1873.

COZZO, G. *Ingegneria romana*. Rome, 1928.

CREMA, L. *L'Architettura romana* (*Enciclopedia Classica*, III, vol. 12, 1). Turin, 1959. English ed. in preparation. Quoted as: Crema.

DURM, J. *Die Baukunst der Etrusker. Die Baukunst der Römer* (*Handbuch der Architektur*, II, vol. 2). Stuttgart, 1905. Quoted as: Durm, *Baukunst*.

Enciclopedia dell' arte antica classica e orientale. Rome, 1958–66.

GIOVANNONI, G. *La Tecnica della costruzione presso i Romani*. Rome, 1925.

KASCHNITZ VON WEINBERG, G. *Ausgewählte Schriften*. 3 vols. Berlin, 1965.

KASCHNITZ VON WEINBERG, G. *Römische Kunst*, I–IV: I. *Das Schöpferische in der römischen Kunst*; II. *Zwischen Republik und Kaiserzeit*; III. *Die Grundlagen der republikanischen Baukunst*; IV. *Die Baukunst im Kaiserreich* (*Rowohlts Deutsche Enzyklopädie*). Reinbek bei Hamburg, 1961–3.

MERCKLIN, E. VON. *Antike Figuralkapitelle*. Berlin, 1962.

Mostra Augustea della Romanità. 4th ed. 2 vols. Rome, 1938.

NOACK, F. *Die Baukunst des Altertums*. Berlin, 1910.

PLOMMER, H. *Ancient and Classical Architecture* (*Simpson's History of Architectural Development*, I). London, 1956.

RAKOB, F. 'Römische Architektur', in T. Kraus, *Dasr ömische Weltreich* (*Propyläen Kunstgeschichte*, II), 153–201. Berlin, 1967.

RIVOIRA, G. T. *Roman Architecture*. Oxford, 1925 (translation of *Architettura romana*, Milan, 1921).

ROBERTSON, D. S. *A Handbook of Greek and Roman Architecture*. Cambridge, 1945.

VITRUVIUS. *De architettura libri X*. Transl. by M. H. Morgan. Cambridge, 1914.

VITRUVIUS. Ed. by Krohn (Teubner, 1912).

VITRUVIUS. *Vitruv zehn Bücher über Architektur. Übersetzt und mit Anmerkungen versehen von C. Fensterbusch*. Darmstadt, 1964.

WHEELER, R. E. M. *Roman Art and Architecture*. London, 1964.

2. GENERAL WORKS ON ROMAN TOWN PLANNING

CASTAGNOLI, F. *Ippodamo di Mileto e l'urbanistica a pianta ortogonale*. Rome, 1956.

GERKAN, A. VON. *Griechische Städteanlagen*. Berlin–Leipzig, 1924.

HAVERFIELD, F. *Ancient Town Planning*. Oxford, 1913.

LEHMANN, K. 'Städtebau Italiens und des römischen Reiches', *P.W.*, III–A, 2016–2124.

WARD-PERKINS, J. B. 'Early Roman Towns in Italy', *Town Planning Review*, XXVI (1955), 127–54.

3. GENERAL WORKS ON THE ARCHITECTURE OF ROME AND ITALY

ALFÖLDI, A. *Early Rome and the Latins* (Jerome Lectures, ser. VII). Ann Arbor, 1963.

BLAKE, M. *Ancient Roman Construction in Italy from the Prehistoric Period to Augustus*. Washington. 1947. Quoted as: Blake (1947).

BLAKE, M. *Roman Construction in Italy from Tiberius through the Flavians*. Washington, 1959. Quoted as: Blake (1959).

> A third volume covering the second century A.D., edited by Mrs D. Taylor-Bishop, is in preparation.

BOËTHIUS, A. *The Golden House of Nero* (Jerome Lectures, ser. v). Ann Arbor, 1960.

CARETTONI, G., COLINI, A. M., COZZA, L., and GATTI, G. *La Pianta marmorea di Roma Antica*. 2 vols. Rome, 1960. Quoted as: *Forma Urbis*.

CASTAGNOLI, F. *Roma antica* (Istituto di Studi Romani, *Storia di Roma*, XXII. *Topografia e urbanistica di Roma* di F. Castagnoli, C. Cecchelli, G. Giovannoni, M. Zocca, I). Bologna, 1958.

GERKAN, A. VON. *Von antiker Architektur und Topographie. Gesammelte Aufsätze*. Stuttgart, 1959. Quoted as: *Gesammelte Aufsätze*.

LANCIANI, R. *Forma Urbis Romae*. Milan, 1893–1901. Reprinted in: *Le Piante de Roma*, a cura di A. P. Frutaz, II, LI. 1–9 (plates 102–9).

Le Piante di Roma, I–III. A cura di A. P. Frutaz (Istituto di Studi Romani). Rome, 1962.

LUGLI, G. *Fontes ad topographiam veteris urbis Romae pertinentes colligendos atque edendos curavit Josephus Lugli* (Università di Roma. Istituto di topografia antica). Rome, 1952– (in progress).

LUGLI, G. *La Tecnica edilizia romana con particolare riguardo a Roma e Lazio*. 2 vols. Rome, 1957.

LUGLI, G. *Monumenti minori del Foro Romano*. Rome, 1947.

LUGLI, G. *Studi minori di topografia antica*. Rome, 1965.

LUGLI, G. *The Classical Monuments of Rome and its Vicinity*. Rome, 1929.

LUGLI, G. *I Monumenti antichi di Roma e suburbio*. 3 vols. Rome, 1930–8. Suppl., 1940.

LUGLI, G. *Roma Antica: il centro monumentale*. Rome, 1946.

MACDONALD, W. L. *The Architecture of the Roman Empire*, I: *an introductory study*. Yale University Press, 1965. Quoted as: MacDonald.

NASH, E. *Pictorial Dictionary of Ancient Rome*. 2nd ed. 2 vols. London, 1968. Quoted as: Nash.

NORDH, A. *Libellus de regionibus urbis Romae* (*Acta Rom. Suec.*, in 8°, III). Rome, 1949.

PLATNER, S. B., and ASHBY, T. *A Topographical Dictionary of Ancient Rome*. London, 1929. Quoted as: Platner–Ashby.

> A new edition is in preparation.

RICHMOND, I. A. *The City Wall of Imperial Rome*. Oxford, 1930.

RICHTER, O. L. *Topographie der Stadt Rom* (*Handbuch der klassischen Altertumswissenschaft hrsg. von Iwan von Müller*, III, 3. 2). Munich, 1901.

RYBERG, I. S. *An Archaeological Record of Rome from the Seventh to the Second Century B.C.* Philadelphia, 1940.

SCHUCK, H. *Rom. En vandring genom seklerna*. 2nd ed. rev. by E. Sjöqvist and T. Magnusson. Stockholm, 1956.

SHOE, L. T. *Etruscan and Republican Roman Mouldings* (*M.A.A.R.*, XXVIII). Rome, 1965.

TOEBELMANN, F. *Römische Gebälke*. Heidelberg, 1923.

VALENTINI, R., and ZUCCHETTI, G. *Codice topografico della città di Roma*. 4 vols. Rome, 1940–53.

4. INDIVIDUAL TYPES OF BUILDING

ALTMANN, W. *Die italischen Rundbauten*. Berlin, 1906.

ASHBY, T. *The Aqueducts of Ancient Rome*, ed. I. A. Richmond. Oxford, 1935.

BECATTI, G. *La Colonna coclide istoriata*. Rome, 1960.

BROWN, D. F. *Temples as Coin Types* (*American Numismatic Notes and Monographs*, XC). New York, 1940.

CALLMER, C. 'Antike Bibliotheken', *Acta Rom. Suec.*, X (1944), 145–93.

GAZZOLA, P. *Ponti romani*. Florence, 1963.

GÖTZE, B. 'Antike Bibliotheken', *J.D.A.I.*, LII (1937), 225–47.

HANSON, J. A. *Roman Theater-temples*. Princeton, 1959.

KÄHLER, H. 'Triumphbogen (Ehrenbogen)', *P.W.*, VII a, 373–493.

KRENCKER, D., and KRÜGER, E. *Die Trierer Kaiserthermen*. Augsburg, 1929.

BIBLIOGRAPHY

NASH, E. 'Obelisk und Circus', *R.M.*, LXIV (1957), 232–59.

NEUERBERG, N. *L'Architettura delle fontane e dei ninfei nell'Italia antica* (*Mem. Nap.*, v). Naples, 1965.

SWOBODA, K. M. *Römische und romanische Paläste.* Vienna, 1924.

VAN DEMAN, E. B. *The Building of the Roman Aqueducts.* Washington, 1934.

See also the following articles in the *Enciclopedia dell'Arte Antica*, most of which list all the examples in Italy and the provinces known to the writers, together with a substantial bibliography:

'Arcus'	M. Pallottino (I, 588–98)
'Anfiteatro'	G. Forni (I, 374–90)
'Basilica'	E. Coche de la Ferté (II, 2–15)
'Biblioteca'	H. Kähler (II, 93–9)
'Circo e Ippodromo'	G. Forni (II, 647–55)
'Magazzino (horreum)'	R. A. Staccioli (IV, 767–72)
'Monumento funerario'	R. A. Mansuelli (V, 170–202)
'Palestra'	G. Carettoni (V, 882–7)

PART ONE

CHAPTERS I–2

BERNABO BREA, L. *Sicily before the Greeks* (*Ancient Peoples and Places*). London, 1957.

Civiltà del ferro (*Studi pubblicati nella ricorrenza centenaria della scoperta di Villanova. Documenti e studi a cura della deputazione di storia patria per le provincie di Romagna*, VI). 1960.

DUHN, F. K. VON. *Italische Gräberkunde umgearbeitet und ergänzt von F. Messerschmidt* (*Bibliothek der klassischen Altertumswissenschaften*, II). Heidelberg, 1924–39.

EVANS, J. D. *Malta* (*Ancient Peoples and Places*). London, 1959.

FURUMARK, A. *Det äldsta Italien.* Uppsala, 1947.

GIEROW, P. G. *The Iron Age Culture of Latium*, I–II (*Acta Rom. Suec.*, in 4°, XXIV). 1964–6.

GUIDO, M. *Sardinia* (*Ancient Peoples and Places*). London, 1963.

HAWKES, C. F. C. *The Prehistoric Foundations of Europe to the Mycenaean Age.* London, 1940.

LAVIOSA-ZAMBOTTI, P. *Il Mediterraneo, l'Europa, e l'Italia durante la preistoria.* Turin, 1954.

LAVIOSA-ZAMBOTTI, P. *Ursprung und Ausbreitung der Kultur.* Baden-Baden, 1950.

LILLIU, G. *La Civiltà dei Sardi, dal neolitico all'età dei nuraghi* (*Letterature e civiltà*, XIV). Turin, 1963.

MANSUELLI, G. A., and SCARANI, R. *L'Emilia prima dei Romani.* Milan, 1961.

MONTELIUS, O. *La Civilisation primitive en Italie depuis l'introduction des métaux.* 2 vols. Stockholm, 1895–1910.

ÖSTENBERG, C. E. *Luni sul Mignone e problemi della preistoria d'Italia* (*Acta Rom. Suec.*, in 4°, XXV). 1967.

PALLOTTINO, M. *Le Origini storiche dei popoli italici* (*Relazioni del X Congresso Internazionale di Scienze Storiche*, XXIII. *Storia dell'antichità*, II). Florence, 1955.

PATRONI, G. *Architettura preistorica generale ed etrusca, Architettura etrusca* (*Storia dell'architettura a cura di U. Ojetti e M. Piacentini*, I). Rome, 1941.

PEET, T. E. *The Stone and Bronze Ages in Italy.* Oxford, 1909.

PUGLISI, S. M. *La Civiltà appenninica. Origine delle comunità pastorali in Italia* ('Origines'. Studi e materiali pubblicati a cura dell'Istituto italiano di preistoria e protostoria). Florence, 1959.

RADMILLI, A. M. *La Preistoria d'Italia alla luce delle ultime scoperte.* Florence, 1963.

RANDALL-MACIVER, D. *The Iron Age in Italy: A study of those aspects of the early civilization which are neither Villanovan nor Etruscan.* Oxford, 1927.

SÄFLUND, G. *Le Terremare delle provincie di Modena, Reggio Emilia, Parma, Piacenza* (*Acta Rom. Suec.*, in 4°, VII). 1939.

SUNDVALL, J. *Die Italischen Hüttenurnen* (*Acta Academiae Aboensis, Humaniora*, IV). 1925.

TAYLOUR, W. *Mycenaean Pottery in Italy and Adjacent Areas.* Cambridge, 1958.

CHAPTER 3

ÅKERSTRÖM, Å. *Studien über die etruskischen Gräber* (*Acta Rom. Suec.*, in 4°, III). 1934.

ANDRÉN, A. *Architectural Terracottas from Etrusco-Italic Temples* (*Acta Rom. Suec.*, in 4°, VI). 2 vols. 1939–40.

ANDRÉN, A. 'Origine e formazione dell'architettura templare Etrusco-Italica', *Rend. Pont.*, XXXII (1959–60), 21–59. Quoted as: *Origine*.

BANTI, L. *Il Mondo degli Etruschi* (*Le Grandi Civiltà del passato*, X). Rome, 1960.

BIANCHI BANDINELLI, R. *Sovana, topografia ed arte*. Florence, 1929.

BIZZARRI, U. *La Necropoli di crocifisso del tufo in Orvieto*, I–II. Florence, 1962–6.

BLOCH, R. *Etruscan Art*. London, 1959.

BLOCH, R. *L'Art et la civilisation étrusques* (*Civilisations d'hier et d'aujourd'hui*). Paris, 1955.

BLOCH, R. *The Etruscans* (*Ancient Peoples and Places*). London, 1958.

CIASCA, A. *Il Capitello detto eolico in Etruria* (*Università di Roma, Studi e materiali dell'Istituto di etruscologia e antichità italiche*, I). Florence, 1962.

CURTIS, C. D. *The Bernardini Tomb* (*M.A.A.R.*, III). 1919.

CURTIS, C. D. *The Barberini Tomb* (*M.A.A.R.*, V). 1925.

DELLA SETA, A. *Guida del Museo di Villa Giulia*. Rome, 1918.

DEMUS-QUATEMBER, M. *Etruskische Grabarchitektur. Typologie und Ursprungsfragen* (*Deutsche Beiträge zur Altertumswissenschaft*, XI). Baden-Baden, 1958.

DUCATI, P. *Etruria antica*. Milan, 1925.

DUCATI, P. *Gli Etruschi*. Rome, 1926.

DUCATI, P. *Storia dell'arte etrusca*. Florence, 1927. Quoted as: Ducati.

Etruscan Culture. Land and People (Archaeological Research and Studies conducted in San Giovenale and its environs by members of the Swedish Institute in Rome). New York and Malmö, 1962. Quoted as: *San Giovenale*.

FROVA, A. *L'Arte etrusca*. Milan, 1957.

GIGLIOLI, G. Q. *L'Arte etrusca*. Milan, 1935. Quoted as: Giglioli.

GJERSTAD, E. *Early Rome*, I–IV (*Acta Rom. Suec.*, in 4°, XVII). 1953, 1956, 1960, 1966. Quoted as: Gjerstad, *Early Rome*.

HERBIG, R. *Die jungetruskischen Steinsarkophage*. Berlin, 1952.

HEURGON, J. *Daily Life of the Etruscans*. New York, 1964.

HEURGON, J. *La Vie quotidienne chez les étrusques*. Paris, 1961.

HEURGON, J. *Recherches sur l'histoire, la religion et la civilisation de Capoue preromaine* (*Bibliothèque des écoles françaises d'Athènes et de Rome*, CLIV). Paris, 1942.

HOLLAND, L. A. *The Faliscans in Prehistoric Times* (*P.A.A.R.*, V). Rome, 1925.

KIRSOPP LAKE MICHELS, A. *The Archaeological Evidence for the 'Tuscan Temple'* (*M.A.A.R.*, XII (1935), 89–149).

LEHMANN, P. W. *Roman Wall Paintings from Boscoreale in the Metropolitan Museum of Art*. Cambridge, 1953.

MANSUELLI, G. A. 'La Casa etrusca di Marzabotto', *R.M.*, LXX (1963), 44–62, figure 8.

MANSUELLI, G. A. *Etruria and Early Rome*. London, 1966.

MENGARELLI, R. 'Caere', *Mon. Ant.*, XLII (1955), 1–23.
See also: Moretti, M., Ricci, G., and Vighi, R.

MESSERSCHMIDT, F. See: Von Duhn (Chapter I).

MESSERSCHMIDT, F. *Nekropolen von Vulci* (*J.D.A.I.*, Erg. H, XII). Berlin, 1930.

MORETTI, M. *Museo Nazionale di Villa Giulia*. Rome, 1962.

MORETTI, M. 'Necropoli della Banditaccia. Zona B "della tegola dipinta" – Caere', *Mon. Ant.*, XLII (1955), 1050–1135.

MORETTI, M. *Nuovi Monumenti della pittura etrusca*. Milan, 1966.

NOACK, F., and LEHMANN, K. *Baugeschichtliche Untersuchungen am Stadtrand von Pompeji*, 194 ff. Berlin and Leipzig, 1936.

NOGARA, B. *Gli Etruschi e la loro civiltà*. Milan, 1933.

PALLOTTINO, M. *Etruscologia*. 5th ed. Milan, 1963.

PALLOTTINO, M. *Mostra dell'arte e della civiltà etrusca*. Milan, 1955.

PALLOTTINO, M. *The Etruscans*. Harmondsworth, Penguin Books, 1955.

PARETI, L. *La Tomba Regolini Galassi del Museo Gregoriano Etrusco e la civiltà dell'Italia centrale nel sec. VII A.C.* Città del Vaticano, 1947.

POLACCO, L. *Tuscanicae dispositiones. Problemi di architettura dell'Italia protoromana (Università di Padova. Pubblicazioni della facoltà di lettere e filosofia, XXVII).* Padua, 1952. Quoted as: Polacco.

POULSEN, F. *Etruscan Tomb-Paintings, their Subjects and Significance.* Oxford, 1922.

RANDALL-MACIVER, D. *Italy before the Romans.* Oxford, 1928.

RANDALL-MACIVER, D. *Villanovans and Early Etruscans, a Study of the Early Iron Age in Italy as it is seen near Bologna, in Etruria and in Latium.* Oxford, 1924.

RICCI, G. 'Necropoli della Banditaccia, Zone A "del recinto" – Caere', *Mon. Ant.*, XLII (1955), 202–1047.

RICHARDSON, E. H. *The Etruscans. Their Art and Civilization.* Chicago, 1964.

RICHTER, G. M. A. *Ancient Italy. A Study of the Interrelations of its Peoples as shown in their Arts* (Jerome Lectures, ser. IV). Ann Arbor, 1955.

RIIS, P. J. *An Introduction to Etruscan Art.* Copenhagen, 1953.

RIIS, P. J. *Tyrrhenika. An Archaeological Study of the Etruscan Sculpture in the Archaic and Classical Periods.* Copenhagen, 1941.

San Giovenale. See *Etruscan Culture. Land and People.*

SHOE, L. T. *Etruscan and Republican Roman Mouldings (M.A.A.R., XXVIII).* 1965.

THULIN, C. O. *Corpus Agrimensorum Romanorum,* I, I. Leipzig, 1913.

THULIN, C. O. *Die Ritualbücher und zur Geschichte und Organisation der Haruspices (Die etruskische Disciplin, III) (Göteborgs Högskolas Årsskrift, I).* Gothenburg, 1909.

VAN BUREN, E. D. *Figurative Terracotta Revetments in Etruria and Latium in the VI. and V. Centuries B.C.* London, 1921.

VIGHI, R. 'Il Sepolcreto arcaico del Sorbo – Caere', *Mon. Ant.*, XLII (1955), 24–199.

CHAPTERS 4–5

BLOCH, R. *The Origins of Rome (Ancient Peoples and Places).* London, 1960.

BLOCH, R. *Tite-Live e les premiers siècles de Rome (Collection d'études anciennes).* Paris, 1965.

BROWN, F. E. *Cosa I, History and Topography (M.A.A.R., XX).* Rome, 1951.

BROWN, F. E., RICHARDSON, E. H., and RICHARDSON, L., Jr. *Cosa II, The Temples of the Arx (M.A.A.R., XXVI).* Rome, 1960.

BROWN, F. *Roman Architecture.* New York, 1961.

Cosa. See Brown, F. E., Richardson, E. H., and Richardson, L., Jr.

HANELL, K. *Das altrömische eponyme Amt (Acta Rom. Suec., in 8°, II).* 1946.

MANSUELLI, G. A. *Etruria and Early Rome.* London, 1966.

MEIGGS, R. *Roman Ostia.* Oxford, 1960.

SÄFLUND, G. *Le Mura di Roma repubblicana (Acta Rom. Suec., in 4°, I).* 1932.

Scavi di Ostia. See Calza, G. (Chapter 6).

WELIN, E. *Studien zur Topographie des Forum Romanum (Acta Rom. Suec., in 8°, VI).* 1953.

CHAPTER 6

BEYEN, H. G. *Pompejanische Wanddekoration vom zweiten bis zum vierten Stil,* I–II. The Hague, 1938–60.

BIEBER, M. *The History of the Greek and Roman Theater.* 2nd ed. Princeton, 1961.

BOËTHIUS, A. 'Roman Architecture from its Classicistic to its Late Imperial Phase', *Acta Universitatis Gotoburgensis,* XLVII (1941).

BOËTHIUS, A. 'Vitruvius and the Roman Architecture of his Age', Dragma Martino P. Nilsson dedicatum *(Acta Rom. Suec., in 8°, I (1939), 114–43).*

CALZA, G. (ed.). *Scavi di Ostia.* 5 vols. I. *Topografia generale,* a cura di G. Calza e di G. Becatti, I. Gismondi, G. Angelis D'Ossat, H. Bloch. Rome, 1953. II. *I Mitrei,* a cura di G. Becatti. Rome, 1954. III. I. *Le Necropoli,* a cura di Maria Floriani Squarciapino e di I. Gismondi, G. Barbieri, H. Bloch, R. Calza. Rome, 1958. IV. *Mosaici e pavimenti marmorei,* a cura di G. Becatti. Rome, 1961. V. I. *I Ritratti,* a cura di R. Calza. Rome, 1964.

CALZA, R. *Ostia*. Rome, 1965.

DEISS, J. J. *Herculaneum, Italy's Buried Treasure*. New York, 1966.

DELBRÜCK, R. *Das Capitolium von Signia*. Rome, 1903.

DELBRÜCK, R. *Die drei Tempel am Forum Holitorium*. Rome, 1903.

DELBRÜCK, R. *Hellenistische Bauten in Latium*, I–II. Strassburg, 1907–12.

DYGGVE, E. *Lindos. Fouilles de l'Acropole 1902–1914 et 1952*, III, 1–2. *Le Sanctuaire d'Athena Lindia et l'architecture Lindienne*. Berlin–Copenhagen, 1960.

FASOLO, F., and GULLINI, G. *Il Santuario della Fortuna Primigenia a Palestrina*. Rome, 1953.

FRANK, T. *Roman Buildings of the Republic, an attempt to date them from their materials* (*Papers and Monographs of the American Academy in Rome*, III). Rome, 1924.

GRIMAL, P. *Les Jardins romains à la fin de la république et aux deux premiers siècles de l'empire* (*Bibliothèque des écoles françaises d'Athènes et de Rome*, CLV). Paris, 1943.

HANSON, J. A. *Roman Theater-temples* (*Princeton Monographs in Art and Archaeology*, XXXIII). Princeton, 1959.

HARSBERG, E. *Ostia. Roms Havneby*. Copenhagen, 1964.

KÄHLER, H. *Das Fortuna Heiligtum von Palestrina Praeneste* (*Annales Universitatis Saraviensis, Philosophie-Lettres*, VII, 3/4, pp. 189–240). Saarbrücken, 1958.

KASCHNITZ VON WEINBERG. See General Bibliography.

LEHMANN, P. W. *Roman Wall Paintings from Boscoreale in the Metropolitan Museum of Art* (*Monographs on Archaeology and Fine Arts*, V). Cambridge, 1953.

MAIURI, A. *Ercolano. I Nuovi Scavi (1927–1958)*. Rome, 1958.

MAIURI, A. *La Villa dei Misteri*. Rome, 1931.

MAIURI, A. *L'Ultima Fase edilizia di Pompei* (Istituto di Studi Romani. Sezione campana. *Italia romana: Campania romana*, II). Rome, 1942.

MAIURI, A. *Pompei, Ercolano e Stabia* (*Musei e monumenti*). Novara, 1961.

MANSUELLI, G. A. *El Arco honorifico ed el desarollo de la arquitectura romana* (*Archivo español di arqueología*, XXVII). 1954.

MEIGGS, R. *Roman Ostia*. London, 1960.

NEPPI MODONA, A. *Gli Edifici teatrali greci e romani*. Florence, 1961.

Scavi di Ostia. See Calza, G.

SCHEFOLD, K. *Die Wände Pompejis. Topographisches Verzeichnis der Bildmotive* (Deutsches archäologisches Institut). Berlin, 1957.

SCHEFOLD, K. *Pompejanische Malerei, Sinn- und Ideengeschichte*. Basel, 1952.

TAMM, B. *Auditorium and Palatium. A Study of Assembly-rooms in Roman Palaces during the First Century B.C. and the First Century A.D.* (*Acta Universitatis Stockholmiensis. Stockholm Studies in Classical Archaeology*, II). Stockholm, 1963.

PARTS TWO TO FOUR

NOTE. For only a few of the buildings in Rome referred to in Chapters 7–11 and 14 is there a single definitive monograph. In almost every case the bibliography is cumulative over many years and has been recently and well summarized in Blake (1947 and 1959) and in Nash. See also Platner-Ashby (especially for the classical sources), Crema, and Lugli, *Centro*. The bibliographies of the individual chapters that refer to the city of Rome are limited to works that are of particular importance for the individual buildings or topics discussed in each.

CHAPTER 7

CALZA-BINI, A. 'Il Teatro di Marcello', *Bollettino del Centro di Studi per la Storia dell' Architettura*, VII (1953), 1–43.

COLINI, A. M. 'Il Tempio di Apollo', *Bull. Comm.*, LXVIII (1940), 1–40.

EHRENBERG, V., and JONES, A. H. M. *Documents illustrating the Reigns of Augustus and Tiberius*. 2nd ed. Oxford, 1955. Pp. 1–31: *Res Gestae Divi Augusti*.

FELLMANN, R. *Das Grab des Lucius Munatius Plancus bei Gaeta* (*Schriften des Institutes für Ur- und Frühgeschichte der Schweiz*, XI). Basel, 1957.

GIGLIOLI, G. Q. 'Cariatidi dell'Eretteo nelle porticus del Foro di Augusto', *R.M.*, LXII (1955), 155–9.

LUGLI, G. 'Architettura italica', *Mem. Linc.*, II (1949), 189–218.

MORETTI, G. *L'Ara Pacis Augustae*. Rome, 1948 .

REBERT, H. F., and MARCEAU, H. 'The Temple of Concord in the Roman Forum', *M.A.A.R.*, V (1925), 53–68.

RICCI, C. 'Il Foro d'Augusto e la Casa dei Cavalieri di Rodi', *Capitolium* (1930), 157–89.

SHIPLEY, F. W. 'The Building Activities of the Viri Triumphales from 44 B.C. to 14 A.D.', *M.A.A.R.*, IX (1931), 9–60.

SHIPLEY, F. W. *Agrippa's Building Activities in Rome*. St Louis, 1933.

STRONG, D. E. 'Some Observations on Early Roman Corinthian', *J.R.S.*, LIII (1963), 73–84.

STRONG, D. E., and WARD-PERKINS, J. B. 'The Temple of Castor in the Forum Romanum', *P.B.S.R.*, XXX (1962), 1–30.

TOYNBEE, J. M. C. 'The Ara Pacis Reconsidered', *Proceedings of the British Academy*, XXXIX (1953), 67–95.

WARD-PERKINS, J. B. 'An Early Augustan Capital in the Forum Romanum', *P.B.S.R.*, XXXV (1967), 23–8.

ZANKER, P. *Forum Augustum*. Tübingen, 1968.

CHAPTER 8

(See note at head of Part Two)

BENDINELLI, G. 'Il Monumento sotterraneo di Porta Maggiore in Roma', *Mon. Ant.*, XXXI (1926), 601–848.

BOËTHIUS, A. *The Golden House of Nero*. Ann Arbor, 1960.

UCELLI, G. *Le Navi di Nemi*. 2nd ed. Rome, 1950.

WARD-PERKINS, J. B. 'Nero's Golden House', *Antiquity*, XXX (1956), 209–19.

CHAPTER 9

(See note at head of Part Two)

BLANCKENHAGEN, P. H. VON. *Flavische Architektur und ihre Dekoration*. Berlin, 1940.

LUGLI, G., and FILIBECK, G. *Il Porto di Roma Imperiale e l'Agro Portuense*. Rome, 1935.

TAMM, Birghitta. *Auditorium and Palatium*. Stockholm, 1963.

WATAGHIN CANTINO, Gisella. *La Domus Augustana: personalità e problemi dell'architettura flavia*. Turin, 1966.

CHAPTER 10

(See note at head of Part Two)

BRUZZA, L. 'Iscrizioni dei marmi grezzi', *Annali dell'Istituto di Corrispondenza Archeologica*, XLII (1870), 106–204.

> Quarry-inscriptions on blocks of marble found in the Tiber-side marble yards.

CECCHELLI, C. 'Origini del mosaico parietale cristiano', *Architettura e Arti Decorative*, II (1922) 3–27, 49–56.

COZZO, G. *Ingegneria romana*. Rome, 1928.

GIOVANNONI, G. 'Contributi allo studio della tecnica nelle costruzioni romane', *Atti del II Congresso Nazionale di Studi Romani* (1931), 281–4.

LICHT, K. DE F. *The Rotunda in Rome*. Copenhagen, 1968.

LUGLI, G. *La Tecnica edilizia romana*. 2 vols. Rome, 1957.

MACDONALD, W. L. *The Architecture of the Roman Empire*, I: *an introductory study*. Yale, 1965.

VIGHI, R. *The Pantheon*. Rome, 1955.

WARD-PERKINS, J. B. 'Tripolitania and the Marble Trade', *J.R.S.*, XLI (1951), 89–104.

CHAPTER 11

(See note at head of Part Two)

APOLLONJ-GHETTI, B. M., and others. *Esplorazioni sotto la Confessione di San Pietro in Vaticano eseguite negli anni 1940–1949*. 2 vols. Vatican City, 1951.

BENARIO, H. W. 'Rome of the Severi', *Latomus*, XVII (1958), 712–22.

CALZA, G. *La Necropoli del Porto di Roma nell'Isola Sacra*. Rome, 1940.

MUÑOZ, A. *La Sistemazione del tempio di Venere e Roma*. Rome, 1935.

STRONG, D. E. 'Late Hadrianic Architectural Ornament in Rome', *P.B.S.R.*, XXI (1953), 118–51.

TOYNBEE, J. M. C., and WARD-PERKINS, J. B. *The Shrine of St Peter and the Vatican Excavations*. London, 1956.

CHAPTER 12

BECATTI, G. 'Case Ostiensi del Tardo Impero', *B. d'Arte*, XXXIII (1948), 102–28 and 197–224.

CALZA, R., and NASH, E. *Ostia*. Florence, 1959.

MEIGGS, R. *Roman Ostia*. Oxford, 1960.

Scavi di Ostia, I. G. Calza and others, *Topografia Generale*. Rome, 1953.

CHAPTER 13

A great deal of the essential bibliography for the Roman architecture of provincial Italy is scattered in small local monographs, in the national periodicals (of which *Notizie degli Scavi (N.S.)*, *Bollettino d'Arte (B. d'Arte)*, and *Monumenti Antichi (Mon. Ant.)* are the three most important in this respect), or in local periodicals too numerous to name. In nearly all cases this bibliography will be found under the name of the appropriate town or site in the recently published *Enciclopedia dell'Arte Antica*. Another valuable bibliographical source is the series *Italia Romana: Municipi e Colonie* published by the Istituto di Studi Romani, the published volumes of which cover the following cities:

Italy, North of Rome:

Ancona, Ariminum (Rimini), Auximum (Osimo in the Marche), Caesena (Cesena, with Forum Popili (Forlimpopoli) and Forum Livi (Forlí) in the Romagna, along the Via Aemilia), Faesulae (Fiesole), Florentia (Florence), Forum Iulii (Cividale nel Friuli), Mevania (Bevagna, prov. Perugia), Ocriculum (Otricoli, on the Via Flaminia north of Rome), Sestinum (Sestino, prov. Arezzo), Spoletium (Spoleto), and Tergeste (Trieste).

Latium and Southern Italy:

Aquinum (Aquino), Casinum (Cassino), Centumcellae (Civitavecchia, with Castrum Novum (Torre Chiaruccia) on the Via Aurelia), Iteramna Lirenas (near Cassino), Tibur (Tivoli), and Velitrae (Velletri).

1. Southern Italy

MAIURI, A., in *Encicl. Art. Ant.*, s.v. Ercolano (III, 408) and Pompei (VI, 354–6).

 For comprehensive bibliographies on Herculaneum and Pompeii.

CARRINGTON, R. C. *Pompeii*. Oxford, 1936.

DE FRANCISCIS, A., and PANE, R. *Mausolei romani in Campania*. Naples, 1957.

DUBOIS, Ch. *Pouzzoles antique (Bibliothèque des écoles françaises d'Athènes et de Rome*, XCVIII). Paris, 1907.

ENGEMANN, J. *Architekturdarstellung des frühen Zweiten Stils: illusionistische römische Wandmalerei der ersten Phase und ihre Vorbilder in der realen Architektur*. Heidelberg, 1967.

MAIURI, A. *I Campi Flegrei (Itinerari*, no. 32). 4th ed. 1938.

MAIURI, A. *Ercolano. I nuovi scavi (1927–1958)*. Rome, 1958.

MAIURI, A. *La Villa dei Misteri*. Rome, 1931.

MAIURI, A. *L'Ultima Fase edilizia di Pompei*. Rome, 1942.

MAU, A. *Pompeji in Leben und Kunst*. Leipzig, 1908.

RAKOB, F. '"Litus Beatae Veneris Aureum": Untersuchungen am "Venustempel" in Baiae', *R.M.*, LXVIII (1961), 114–49.

SPINAZZOLA, V. *Pompei alla luce degli scavi di Via dell'Abbondanza (anni 1910–1923)*. Rome, 1953.

VAN BUREN, A. W. *A Companion to Pompeian Studies*. American Academy in Rome, 1927.

2. Northern Italy

AURIGEMMA, S. *Velleia (Itinerari*, no. 73). Rome, 1940.

FORMIGÉ, J. *Le Trophée des Alpes (La Turbie)* (IIe Supplément à *Gallia*). Paris, 1949.

FRIGERIO, F. 'Antiche Porte di cittá italiche e romane', *Rivista archeologica dell'antica provincia e diocesi di Como*, fasc. 108–110 (1934–5).

KÄHLER, H. 'Die römischen Stadttore von Verona', *J.D.A.I.*, L (1935), 138–97.

MARCONI, P. *Verona Romana*. Bergamo, 1937.

RICHMOND, I. A. 'Augustan Gates at Torino and Spello'. *P.B.S.R.*, XII (1932), 52–62.

CHAPTER 14

For Herculaneum and Pompeii, see bibliography to Chapter 13.

BECATTI, G. 'Case Ostiensi del Tardo Impero', *B. d'Arte*, XXXIII (1948), 102–28 and 197–224.

CALZA, G. 'La Preminenza dell' "Insula" nella edilizia romana', *Mon. Ant.*, XXIII (1914), 541–608.

CALZA, G. 'Le Origini latine dell'abitazione moderna', *Architettura e arti decorative*, III (1923–4), 3–18 and 49–63.

GRIMAL, P. *Les Jardins romains* (*Bibliothèque des écoles françaises d'Athènes et de Rome*, CLV). Paris, 1943.

KÄHLER, H. *Hadrian und seine Villa bei Tivoli.* Berlin, 1950.

MAIURI, A. *Capri: storia e monumenti* (*Itinerari*, no. 93). Rome, 1956.

ROSTOVTZEFF, M. 'Die hellenistische-römische Architekturlandschaft', *R.M.*, XXVI (1911), 1–185.

SWOBODA, K. M. *Römische und romanische Paläste.* Vienna, 1924.

CHAPTER 15

1. Spain

TARACENA, Blas. 'Arte romano', in *Ars Hispaniae*, II. Madrid, 1947.

WISEMAN, F. J. *Roman Spain: an introduction to the Roman antiquities of Spain and Portugal.* London, 1956.

2 (a). Gaul: General Works

Detailed references to the very large and scattered bibliography referring to the buildings of Roman Gaul will be found in the relevant volumes of Grenier, *Manuel*. For the more important post-war excavations and discoveries, see also the annual accounts in *Gallia*. The bibliography that follows is restricted to a few only of the more useful general works and monographs on individual sites and monuments.

AUDIN, A. *La Topographie de Lugdunum.* Lyon, 1958.

AUDIN, A. *Lyon, miroir de Rome dans les Gaules.* Lyon, 1965.

BLANCHET, A. *Recherches sur les aqueducs et cloaques de la Gaule romaine.* Paris, 1908.

BROGAN, O. *Roman Gaul.* London, 1953.

Gallia, I (1946).

 In progress.

GRENIER, A. *Manuel d'archéologie gallo-romaine.*

 vol. III. *L'Architecture* (Paris, 1958). Fasc. 1: *L'Urbanisme.* Fasc. 2: *Ludi et Circenses.*

 vol. IV. *Les Monuments des eaux* (Paris, 1960). Fasc. 1: *Aqueducs, thermes.* Fasc. 2: *Villes d'eau et sanctuaires de l'eau.*

MAEYER, R. DE. *De Romeinsche Villa's in België.* Antwerp, 1937.

 With French summary.

STAEHELIN, F. *Der Schweiz in römischer Zeit.* 3rd ed. Basel, 1948.

2 (b). Gaul: Individual Sites and Monuments

AMY, R., and others. *L'Arc d'Orange* (XV^e Suppl. à *Gallia*). Paris, 1962.

CONSTANS, L. A. *Arles antiques* (*Bibliothèque des écoles françaises d'Athènes et de Rome*, CXIX). Paris, 1921.

FORMIGÉ, J. *Le Trophée des Alpes* (*La Turbie*) (II^e Suppl. à *Gallia*). Paris, 1949.

LAUR-BELART, R. *Führer durch Augusta Raurica.* 2nd ed. Basel, 1948.

LUGLI, G. 'La Datazione degli anfiteatri di Arles e di Nîmes in Provenza', *Rivista dell'Istituto Nazionale d'Archeologia e Storia dell'Arte*, XIII–XIV (1964–5), 145–99.

NAUMANN, R. *Der Quellbezirk von Nîmes* (*Denkmäler antiker Architektur*, IV). Berlin, 1937.

PIGANIOL, A. *Les Documents cadastraux de la colonie romaine d'Orange* (XVI^e Suppl. à *Gallia*). Paris, 1962.

 Remains of marble plans recording the survey of the territories of the colonia and details of the assignment of the individual plots.

ROLLAND, H. *Fouilles de Glanum* (*Saint-Rémy-de-Provence*) (I^re Suppl. à *Gallia*). Paris, 1946.

SAUTEL, J. *Vaison dans l'antiquité.* 3 vols. Avignon, 1941–2, and Lyon, 1942.

WUILLEUMIER, P. *Fouilles de Fourvière à Lyon* (IV^e Suppl. à *Gallia*). Paris, 1951.

 For the date of the theatre, see, however, A. Audin in *Latomus* (1957), 225–31.

3. The Germanies

Germania Romana: Römerstädte in Deutschland, vols. I and II (*Gymnasium*, Beihefte 1 and 5). Heidelberg, 1960 and 1965.

Neue Ausgrabungen in Deutschland. Berlin (Römisch-Germanische Kommission des Deutschen Archäologischen Instituts), 1958.

PETRIKOVITS, H. VON. *Das römische Rheinland.* Cologne, 1960.

ROEREN, R. 'Zur Archäologie und Geschichte Sudwestdeutschland im 3–5 Jahrhunderts', *Jahrbuch des Römisch-Germanische Zentralmuseums Mainz*, VII (1960), 214–94.

For Trier, see Bibliography to Chapter 21.

4. Britain

Good classified bibliographies to the extensive and widely scattered literature of Roman Britain will be found in the works of Richmond, Rivet, and Wacher, quoted below, and in W. Bonser, *A Romano-British Bibliography, 55 B.C.–A.D. 448*, Oxford, 1964. See also 'The Year's Work in Roman Britain' annually in *J.R.S.*

For interim reports on the post-war excavations at Verulamium (St Albans), Corinium (Cirencester), and Fishbourne, see *Antiquaries Journal* since 1956, 1960, and 1961 respectively. For an interim report on the re-examination of the bath and temple complex at Aquae Sulis (Bath), see *Antiquity*, XL (1966), 199–204; a full report is imminent.

The bibliography that follows is limited to a few general works and to sites mentioned in the text.

FRERE, S. S. *Britannia*. London, 1967.

HULL, M. R. *Roman Colchester*. Society of Antiquaries of London, 1958.

KENYON, K. M. 'The Roman Theatre at Verulamium', *Archaeologia*, LXXXIV (1934), 213–60.

LEWIS, M. J. T. *Temples in Roman Britain*. Cambridge, 1966.

LIVERSIDGE, J. *Britain in the Roman Empire*. London, 1968.

RADFORD, C. A. R. 'The Roman Villa at Ditchley, Oxon.', *Oxoniensia*, I (1936), 24–69.

RICHMOND, I. A. *Roman Britain*. London, 1963.

RICHMOND, I. A. 'The Roman Villa at Chedworth', *Transactions of the Bristol and Gloucestershire Archaeological Society*, LXXVIII (1959), 5–23.

RICHMOND, I. A., and TOYNBEE, J. M. C. 'The Temple of Sulis-Minerva at Bath', *J.R.S.*, XLV (1955), 97–105.

RIVET, A. L. F. *Town and Country in Roman Britain*. London, 1958.

WACHER, J. S. (ed.). *The Civitas Capitals of Roman Britain*. Leicester, 1966.

WINBOLT, S. E. In *Victoria County History, Sussex*, III (the Bignor villa).

WHEELER, R. E. M. and T. V. *The Prehistoric, Roman and Post-Roman site in Lydney Park, Gloucestershire*. Society of Antiquaries of London, 1932.

WHEELER, R. E. M. and T. V. *Verulamium: a Belgic and two Roman Cities*. Society of Antiquaries of London, 1936.

5. South-eastern Europe

The bibliography of Roman architecture in the Alpine, Danube, Balkan, and Adriatic provinces is mostly fragmentary and scattered. The two most important periodical publications in this respect are *J.Ö.A.I.* and *Dacia* (*recherches et découvertes archéologiques en Roumanie*, I (1924)–XII (1947) and new series since 1957). Two important recent monographs are:

THOMAS, B. *Römische Villen in Pannonien*. Budapest, 1964.

WILKES, J. *Dalmatia*. London, 1969.

The following refer to the principal sites mentioned in the text:

ADAMKLISSI
Florescu, F. B. *Das Siegesdenkmal von Adamklissi*. Bonn, 1965.

AENONA
Cagiano de Azevedo, M. 'Aenona e il suo Capitolium', *Rend. Pont.*, XXII (1946-7), 193–226.

AQUINCUM
Szilagyi, J. *Aquincum*. Berlin, 1956.

ASSERIA
J.Ö.A.I., XI (1908), Beiblatt 32–44 (Arch) and 47–53 (Forum).

BUTHROTUM (BUTRINTO)
Ugolini, L. M. *Albania Antica*, III: *L'Acropoli di Butrinto*. Rome, 1942.

CARNUNTUM
Swoboda, E. *Carnuntum: seine Geschichte und seine Denkmäler*. 2nd ed. Vienna, 1953.

DOCLEA
Sticotti, P. *Die römische Stadt Doclea in Montenegro* (*Schriften der Balkankommission, Antiquarische Abteilung*, VI). 1913.

HISTRIA
Condurachi, E. *Histria*. Bucharest, 1962.

SALONA
Ceci, E. *I Monumenti pagani di Salona*. Milan, 1962.

VIRUNUM
J.Ö.A.I., XV (1912), Beiblatt 24–36.

CHAPTER 16

Ancient Corinth: a guide to the excavations. 6th ed. American School of Classical Studies at Athens, 1954.

Corinth: Results of the Excavations conducted by the American School of Classical Studies at Athens. I, I (1932)–6 (1964) and II (1952). Quoted as: *Corinth.*

GIULIANO, A. *La Cultura artistica delle province della Grecia in età romana.* Rome, 1965.

Hesperia (Journal of the American School of Classical Studies at Athens), I (1932).

> In progress.

HILL, Ida T. *The Ancient City of Athens: its topography and monuments.* London, 1953.

HÖRMANN, H. *Die inneren Propyläen von Eleusis (Denkmäler antiker Architektur,* I). Berlin–Leipzig, 1932.

JUDEICH, W. *Topographie von Athen (Handbuch der Altertumswissenschaft,* 2, 2). 2nd ed. Munich, 1931.

KOUROUNIOTES, K. *Eleusis: a guide to the excavations and museum,* transl. O. Broneer. Archaeological Society at Athens, 1936.

ROBINSON, H. S. *The Urban Development of Ancient Corinth.* American School of Classical Studies at Athens, 1965.

TRAVLOS, J. *Poleodomikē Exelisis tōn Athenōn* (Development of the City-Plan of Athens). Athens, 1960.

> An English edition is in preparation.

CHAPTER 17

Altertümer von Pergamon, I (1912)–X (1937). Berlin.

DELORME, J. *Gymnasion.* Paris, 1960.

> Especially pp. 243–50.

Forschungen in Ephesos veröffentlicht vom Österreichischen Archäologischen Institute in Wien, I (1906)–V. I (1953).

GOUGH, M. 'Anazarbus', *Anatolian Studies,* II (1952), 85–150.

Jahreshefte des Österreichischen Archäologischen Institutes in Wien (J.Ö.A.I.), I (1898).

> In progress (containing year-by-year accounts of the Austrian excavations at Ephesus).

KEIL, J. *Führer durch Ephesos.* 5th ed. Vienna, 1964.

> With bibliography.

KRENCKER, D., and SCHEDE, M. *Der Tempel in Ankara (Denkmäler antiker Architektur,* III). Berlin–Leipzig, 1936.

LANCKORONSKI, K. *Städte Pamphyliens und Pisidiens.* 2 vols. Vienna, 1892.

MACCANICO, Rosanna. 'Ginnasi romani ad Efeso', *Arch. Cl.,* XV (1963), 32–60.

MAGIE, D. *Roman Rule in Asia Minor.* 2 vols. Princeton, 1950.

MANSEL, Arif Mufid. *Die Ruinen von Side.* Berlin, 1963.

Milet. Ergebnisse der Ausgrabungen und Untersuchungen seit dem Jahre 1899, ed. Th. Wiegand. Berlin–Leipzig. Especially the following:

> I, 5 (1919) The Nymphaeum
> I, 6 (1922) The North Market
> I, 7 (1924) The South Market
> I, 9 (1928) Baths and Gymnasia

MILTNER, F. *Ephesos: Stadt der Artemis und des Johannes.* Vienna, 1958.

Monumenta Asiae Minoris Antiqua, I (1928)–VIII (1962). Manchester University Press.

ROSENBAUM, E., and others. *A Survey of Coastal Cities in Western Cilicia.* Ankara, 1967.

SCHNEIDER, A. M., and KARNAPP, W. *Die Stadtmauer von Iznik (Nicaea) (Istanbuler Forschungen,* IX). Berlin, 1938.

VERMEULE, C. C. *Roman Imperial Art in Greece and Asia Minor.* Harvard, 1968.

WARD-PERKINS, J. B. 'Notes on the Structure and Building Methods of Early Byzantine Architecture', in D. Talbot Rice (ed.), *The Great Palace of the Byzantine Emperors,* II (Edinburgh, 1958), 52–104.

> Building practices in Roman Asia Minor.

CHAPTER 18

Annales Archéologiques de Syrie. Damascus, Direction Générale des Antiquités de Syrie, I (1951).

> In progress.

Antioch-on-the Orontes, I, *The Excavations of 1932;* II, *The Excavations of 1933–36;* III, *The Excavations of 1937–39.* Princeton, 1934–41. Quoted as: *Antioch.*

AVI-YONAH, M., and others. *Masada, Survey and Excavations, 1955–6.* Jerusalem, 1957.

> The excavation of the 'Hanging Palace'.

Baalbek, ed. Th. Wiegand. 2 vols. Berlin–Leipzig, 1921–3.

BACHMANN, W., and others. *Petra (Wissenschaftliche Veröffentlichungen des deutsch-türkischen Denkmalschutz-Kommandos,* III). Berlin–Leipzig, 1921.

BUTLER, H. C. *Publications of an American Archaeological Expedition to Syria in 1899–1900*, pt. 2: *Architecture and Other Arts*. New York, 1903. Quoted as Butler, *Architecture*.

BUTLER, H. C. *Princeton University Archaeological Expeditions to Syria in 1904–5 and 1909:*

Division II, part A (quoted as Butler, *South Syria*). Leiden, 1906–19.
Division II, part B (quoted as Butler, *North Syria*). Leiden, 1907–20.

COLLART, P., and COUPEL, J. *L'Autel monumental de Baalbek*. Institut français d'archéologie de Beyrouth, 1951.

COUPEL, J., and FRÉZOULS, E. *Le Théâtre de Philippopolis en Arabie*. Paris, 1956.

COLLEDGE, M. A. R. *The Parthians*. London, 1967.

DOWNEY, G. *A History of Antioch in Syria*. Princeton, 1961.

FRÉZOULS, E. 'Recherches sur les théâtres de l'Orient Syrien', *Syria*, XXXVI (1959), 202–27; XXXVIII (1961), 54–86.

HARDING, G. L. *The Antiquities of Jordan*. London, 1959.

KOHL, H. and WATZINGER, C. *Antiker Synagogen in Galiläea*. Leipzig, 1916.

KRAELING, C. H. *Gerasa, City of the Decapolis*. New Haven, 1938.

KRENCKER, D. M., and ZSCHIETZSCHMANN, W. *Römische Tempel in Syrien* (*Denkmäler antike Architektur*, v). Berlin–Leipzig, 1938.

Palmyra: Ergebnisse der Expeditionen von 1902 und 1917 (ed. Th. Wiegand). 2 vols. Berlin, 1932. Quoted as: *Palmyra*.

PARR, P. J., WRIGHT, G. R. H., STARCKY, J., and BENNETT, C. M. 'Découvertes récentes au Sanctuaire du Qasr à Petra', *Syria*, XLV (1968), 1–66.

RICHMOND, I. A. 'Palmyra under Roman Rule', *J.R.S.*, LIII (1963), 43–54.

ROSTOVTZEFF, M. *Caravan Cities*. Oxford, 1932.

ROSTOVTZEFF, M. *Dura-Europos and its Art*. Oxford, 1938.

Samaria-Sebaste, I. J. W. Crowfoot and others, *The Buildings*. London, 1942.

SAUVAGET, J. 'Le Plan antique de Damas', *Syria*, XXVI (1949), 314–58.

Scavi di Caesarea Marittima (ed. A. Frova). Milan, 1965.

SEYRIG, H. 'Palmyra and the East', *J.R.S.*, XL (1950), 1–7.

STARCKY, J. *Palmyre: Guide archéologique* (*Mélanges de l'Université Saint-Joseph*, XXIV). Beyrouth, 1941.

Syria, 1 (1920). Institut français d'archéologie de Beyrouth.

In progress.

TCHALENKO, G. *Villages antiques de la Syrie du nord: le massif du Bélus à l'époque romaine*. 3 vols. Paris, 1953.

The Excavations at Dura-Europos. Preliminary Reports. First Season (1927–28)–Ninth Season (1935–36). New Haven, 1929–52. Quoted as: *Dura*.

WATZINGER, C., and WULZINGER, K. *Damaskus: die antike Stadt*. Berlin, 1921.

WRIGHT, G. R. H. 'The Khazne at Petra: a review', *Annual of the Department of Antiquities of Jordan*, VI/VII (1962), 24–54.

YADIN, Y. 'The Excavation of Masada, 1963–64: preliminary report', *Israel Expedition Quarterly*, XV (1965), pts 1–2.

YADIN, Y. *Masada: Herod's Fortress and the Zealots' Last Stand*. London, 1966.

CHAPTER 19

1. Egypt

BOAK, A. E. R., and PETERSON, E. E. *Karanis. Excavations, 1924–28* (University of Michigan Humanistic Series, XXV). Ann Arbor, 1931.

BOAK, A. E. R. *Soknopaiou Nesos. Excavations at Dîme, 1931–32* (ibid., XXIX). Ann Arbor, 1935.

MONNERET DE VILLARD, U. 'The Temple of the Imperial Cult at Luxor', *Archaeologia*, XCV (1953), 85–105.

MONNERET DE VILLARD, U. *La Nubia romana*. Rome, Istituto per l'Oriente, 1941.

SJÖQVIST, E. 'Kaisareion: a study in architectural iconography', *Acta Rom. Suec.*, XVIII (1956), 86–108.

KRAUS, T., and RÖDER, J. 'Mons Claudianus', *Mitteilungen des deutschen archäologischen Instituts, Abteilung Kairo*, XVIII (1962), 80–120.

WACE, A. J. B., and others. *Hermoupolis Magna, Ashmunein*. Alexandria, 1959.

2. Cyrenaica

Africa Italiana: Rivista di Storia e d'Arte a cura del Ministero delle Colonie. 8 vols. 1927–41.

GOODCHILD, R. G. *Cyrene and Apollonia: an historical guide.* Department of Antiquities, Cyrenaica, 1959.

GOODCHILD, R. G. 'A Byzantine Palace at Apollonia, Cyrenaica', *Antiquity*, XXXIV (1960), 246–58.

KRAELING, C. H. *Ptolemais, City of the Libyan Pentapolis.* University of Chicago, 1962.

MINGAZZINI, P. *L'Insula di Giasone Magno a Cirene.* Rome, 1966.

Notiziario Archeologico del Ministero delle Colonie, I (1915)–IV (1927).

PESCE, G. *Il Palazzo delle Colonne in Tolemaide.* Rome, 1950.

Quaderni di Archeologia della Libia, I (1950)–IV (1961). Rome.

WARD-PERKINS, J. B., and BALLANCE, M. H. 'The Caesareum at Cyrene and the Basilica at Cremna', *P.B.S.R.*, XXVI (1958), 137–94.

3. Tripolitania

(See also *Africa Italiana, Notiziario Archeologico,* and *Quaderni di Archeologia della Libia,* s.v. 'Cyrenaica', above)

BARTOCCINI, R. *Le Terme di Lepcis.* Bergamo, 1929.

BIANCHI BANDINELLI, R. (ed.). *Leptis Magna.* Rome, 1963.

CAPUTO, G. *Il Teatro di Sabratha e l'architettura teatrale africana.* Rome, 1959.

DEGRASSI, N. 'Il Mercato romano di Leptis Magna', *Quaderni,* II (1951), 27–70.

DI VITA, A. *Sabratha.* Basel, 1969.

HAYNES, D. E. L. *An Archaeological and Historical Guide to the pre-Islamic Antiquities of Tripolitania.* 2nd ed. Tripoli, 1955.

ROMANELLI, P. *Leptis Magna.* Rome, 1925.

SICHTERMANN, H. 'Archaeologische Funde und Forschungen in Libyen, 1942–1961', *Anz.* (1962), 439–509.

SQUARCIAPINO, M. F. *Leptis Magna.* Basel, 1966.

TOYNBEE, J. M. C., WARD-PERKINS, J. B., and FRASER, R. 'The Hunting Baths at Leptis Magna', *Archaeologia,* XCIII (1949), 165–95.

WARD-PERKINS, J. B. 'Severan Art and Architecture at Leptis Magna', *J.R.S.,* XXXVIII (1948), 59–80.

WARD-PERKINS, J. B. 'Tripolitania and the Marble Trade', *J.R.S.,* XLI (1951), 89–104.

4. Tunisia, Algeria, Morocco

Much of the essential bibliography of Roman Tunisia, Algeria, and Morocco is scattered in local periodicals that are not generally accessible. In addition to the works listed below and in the Notes, descriptions of many of the excavated sites and buildings here mentioned will be found in the annual reports published in the *Bulletin archéologique du Comité des travaux historiques et scientifiques.*

BALLU, A. *Les Ruines de Timgad (antique Thamugadi).* Paris, 1897.

BALLU, A. *Les Ruines de Timgad: nouvelles découvertes.* Paris, 1903.

BALLU, A. *Les Ruines de Timgad: sept années de découvertes.* Paris, 1911.

CAGNAT, R., and GAUCKLER, P. *Les Monuments historiques de la Tunisie: les temples païens.* Paris, 1898.

CONSTANS, L.-A. 'Gigthis: étude d'histoire et d'archéologie sur un emporium de la Petite Syrte', *Nouvelles Archives des Missions Scientifiques,* XIV (1916), 1–113.

COURTOIS, C. *Timgad: antique Thamugadi.* Algiers, 1951.

ÉTIENNE, R. *Le Quartier nord-est de Volubilis.* Paris, 1960.

FEUILLE, G. L. *Thuburbo Maius.* Tunis, n.d. [c. 1955].

FRÉZOULS, E. 'Teatri romani dell'Africa francese', *Dioniso,* XV (1952), 90–103.

GSELL, S. *Monuments antiques de l'Algérie,* I. Paris, 1901.

GSELL, S., and JOLY, C. A. *Khamissa, Mdaourouch, Announa,* I, *Khamissa* (Thubursicu Numidarum); II, *Mdaourouch* (Madauros); III, *Announa* (Thibilis). Algiers–Paris, 1914–22.

Karthago, I (1950). Paris, Centres d'études archéologiques de la Méditerranée occidentale (formerly Mission archéologique français en Tunisie).

In progress.

LASSUS, J. 'Adaptation à l'Afrique de l'urbanisme romain', *VIIIe Congrès International d'Archéologie Classique*, Paris (1965), 245–59.

LESCHI, L. *Djémila: antique Cuicul*. Algiers, 1953.

LÉZINE, A. *Architecture romaine d'Afrique*. Tunis, n.d. [*c*. 1961].

LÉZINE, A. 'Chapiteaux toscans trouvés en Tunisie', *Karthago*, VI (1955), 13–29.

Libyca: Bulletin du Service des Antiquités de l'Algérie, I (1953) – IX (1961).

MAREC, E. *Hippone la Royale: antique Hippo Regius*. Algiers, 1954.

MERLIN, A. *Le Forum de Thuburbo Maius*. Tunis–Paris, 1922.

PICARD, G.-C. *Civitas Mactaritana* (*Karthago*, VIII). 1957.

PICARD, G.-C. *La Civilisation de l'Afrique romaine*. Paris, 1959.

POINSSOT, C. *Les Ruines de Dougga*. Tunis, 1958.

THOUVENOT, R. *Volubilis*. Paris, 1949.

WARMINGTON, B. H. *The North African Provinces from Diocletian to the Vandal Conquest*. Cambridge, 1954.

CHAPTER 20

See also note at beginning of Part Two, above, and bibliographies to Chapters 7–11, particularly 10.

BARTOLI, A. *Curia Senatus: lo scavo ed il restauro* (*I monumenti romani*, III). Florence, 1963.

DEICHMANN, F. W. 'Untersuchungen an spätrömischen Rundbauten in Rom', *Anz.* (1941), 733–48.

FRAZER, A. 'The Iconography of the Emperor Maxentius' Buildings in Via Appia', *Art Bulletin*, XLVIII (1966), 385–92.

L'ORANGE, H. P., and GERKAN, A. VON. *Der spätantike Bildschmuck des Konstantinsbogens*. Berlin, 1939.

MINOPRIO, A. 'A Restoration of the Basilica of Constantine', *P.B.S.R.*, XII (1932), 1–25.

RICHMOND, I. A. *The City Wall of Imperial Rome*. Oxford, 1930.

STETTLER, M. *Jahrbuch der Zentralmuseum, Mainz*, IV (1957), 123 ff.

 For the Licinian Pavilion.

CHAPTER 21

KRAUTHEIMER, R. *Early Christian and Byzantine Architecture* (*Pelican History of Art*), Chapter 3. Harmondsworth, 1965.

WARD-PERKINS, J. B. In D. Talbot Rice (ed.), *The Great Palace of the Byzantine Emperors*, Edinburgh, 1958, II, 52–104.

1. North Italy

DUVAL, N. 'Que savons-nous du Palais de Théodoric à Ravenne?', *Mélanges*, LXXII (1960), 337–71.

GHERARDINI, G. 'Gli Scavi del Palazzo di Teodorico a Ravenna', *Mon. Ant.*, XXIV (1917), 737–838.

CALDERINI, A. *Storia di Milano*, I (Milan, 1953), pts V, *Milano romana;* VI, *Milano durante il basso impero;* IX, *Milano archeologica.*

GHISLANZONI, E. *La Villa romana in Desenzano*. Milan, 1962.

2. Piazza Armerina

GENTILI, G. V. *La Villa Imperiale di Piazza Armerina* (*Itinerari*, no. 87). Rome, 1954.

GENTILI, G. V. *La Villa Erculia di Piazza Armerina: i mosaici figurati*. Milan, 1959.

LAVIN, I. 'The House of the Lord: aspects of the role of palace *triclinia* in the architecture of late antiquity and in the early Middle Ages', *Art Bulletin*, XLIV (1962), 1–27.

LUGLI, G. 'Contributo alla storia edilizia della villa romana di Piazza Armerina', *Rivista dell'Istituto Nazionale di Archeologia e Storia dell'Arte*, XI–XII (1963), 28–82.

NEUERBERG, N. 'Some Considerations on the Architecture of the Imperial Villa at Piazza Armerina', *Marsyas*, VIII (1959), 22–9.

3. Spalato (Split)

DUVAL, N. 'La Place de Split dans l'architecture du Bas-Empire', *Urbs* (Split, 1961–2), 67–95.

HEBRARD, E., and ZEILLER, J. *Spalato. Le Palais de Dioclétien*. Paris, 1911.

NIEMANN, G. *Der Palast Diokletians in Spalato*. Vienna, 1910.

SCHULZ, B. 'Die Porta Aurea in Spalato', *J.D.A.I.*, XXIV (1909), 46–52.

BIBLIOGRAPHY

4. Thessalonike (Salonica)

DYGGVE, E. 'La Région palatiale de Thessalonique', *Acta Congressus Madvigiani* (Copenhagen, 1958), I, 353–65.

HÉBRARD, E. 'L'Arc de Galère et l'église Saint-Georges à Salonique', *B.C.H.*, XLIV (1920), 5–40.

MAKARONAS, C. I. 'To oktagōnon tēs Thessalonikēs', *Praktika* (1950), 303–21.

5. Trier

EIDEN, H., and MYLIUS, H. 'Untersuchungen an den spätrömischen Horrea von St Irminen in Trier', *Trierer Zeitschrift*, XVIII (1949), 73–106.

KRENCKER, D., and KRÜGER, E. *Die Trierer Kaiserthermen*. Augsburg, 1929.

MEYER-PLATH, B. *Die Porta Nigra in Trier*. Trier, Landesmuseum, 1961.

Guidebook.

REUSCH, W. *Anz.* (1962), 875–903.

Summarizing recent work on the Aula Palatina, with bibliography to 1962.

REUSCH, W. *Augusta Treverorum: ein Gang durch das römische Trier*. Trier, 1965.

REUSCH, W. *Die Kaiserthermen in Trier*. Trier, Landesmuseum, 1965.

Guidebook.

THE PLATES

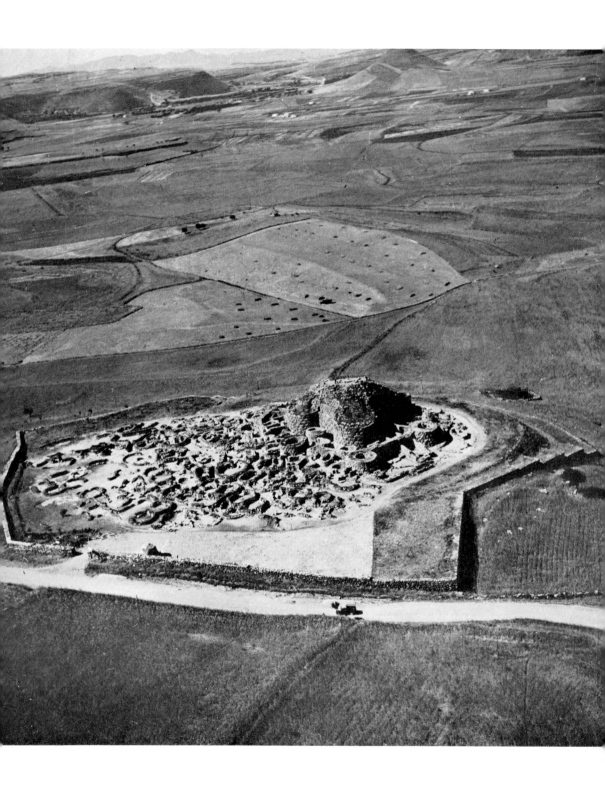

1. Su Nuraxi di Barumini, Sardinia, nuraghe, dating from *c.* 1500 B.C. and onwards

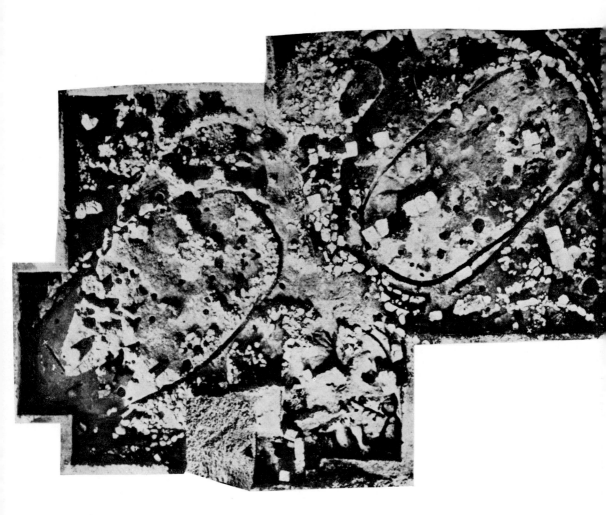

2. San Giovenale, remains of the Early Iron Age village

3. Hut urn from Castel Gandolfo, Early Iron Age. *Museo della preistoria e protostoria di Lazio*

4. Square hut urn from Tarquinia, Early Iron Age. *Florence, Museo Archeologico*

5. Implements from tomb no. 63 at S. Antonio, Sala Consilina, with ash urn and model of a house, Early Iron Age (Oenotrio-Ausonian). *Salerno, Museo Provinciale*

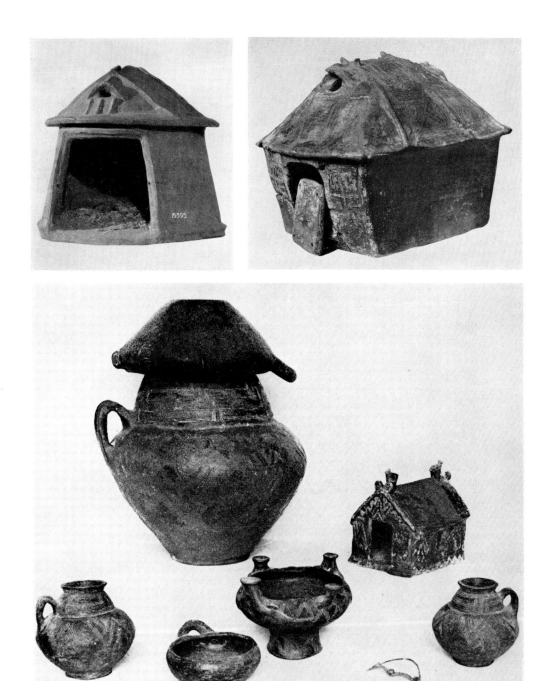

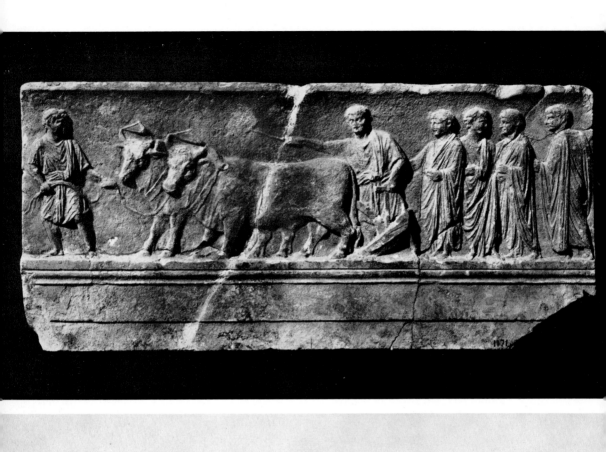

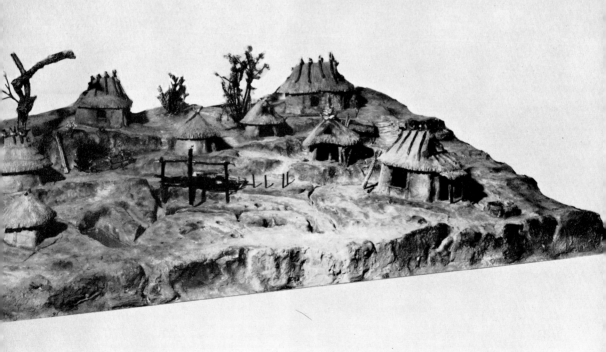

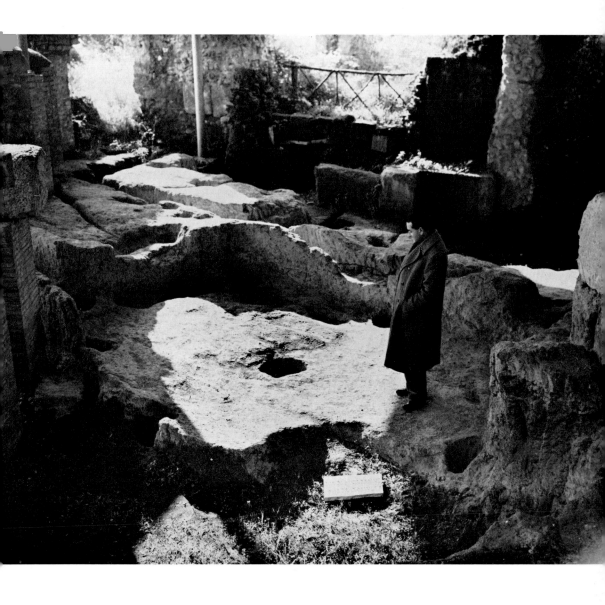

6. Relief from Aquileia showing the foundation of a colonia, fixing its border by means of a trench made by plough. Imperial Age. *Aquileia, Museo Archeologico*

7. Reconstruction by A. Davico of part of the Early Iron Age hut settlement on the Palatine, Rome

8. Rome, foundations of a hut in the Early Iron Age village on the south-west side of the Palatine

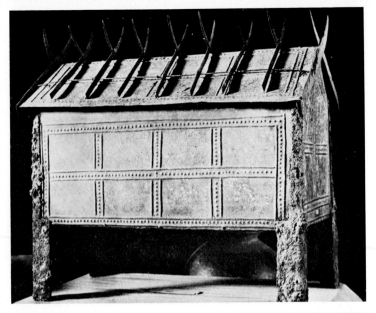

9. Faliscan ash urn, seventh century B.C. *Rome, Museo di Villa Giulia*

10. Hut urn from the cemetery at Monte Abatone, sixth century B.C. *Rome, Museo di Villa Giulia*

11. Model of a temple from Teano, Late Republican

12. Reconstruction of an Etruscan temple as described by Vitruvius (IV.7). *Rome University, Istituto di Etruscologia e di Antichità Italiche*

13. Model of a temple from Vulci, Late Republican. *Rome, Museo di Villa Giulia*

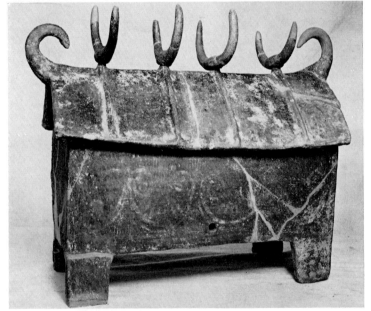

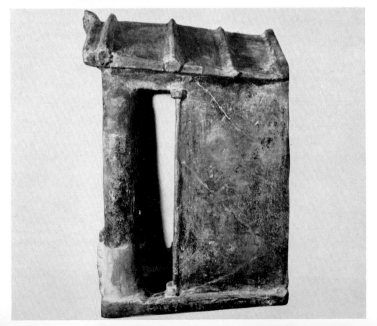

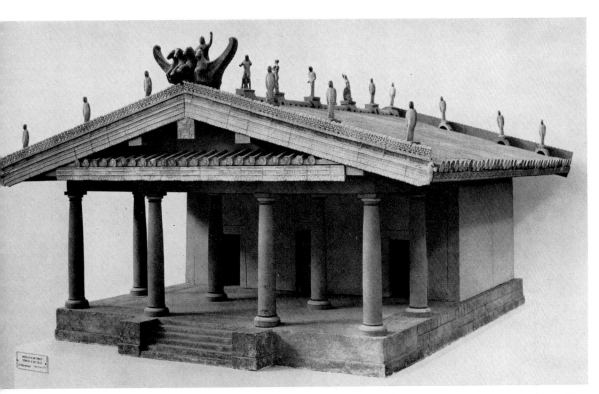

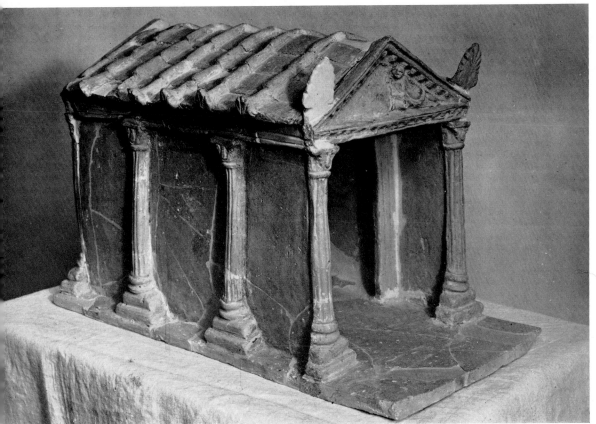

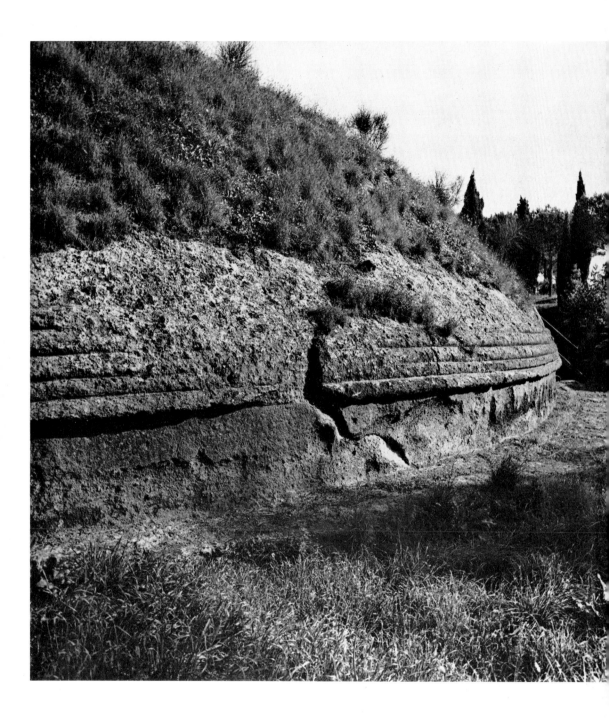

14. Rome, Temple C on the Largo Argentina, late fourth century B.C., podium

15. Caere (Cerveteri), Banditaccia cemetery, podium of a tumulus, sixth century B.C.

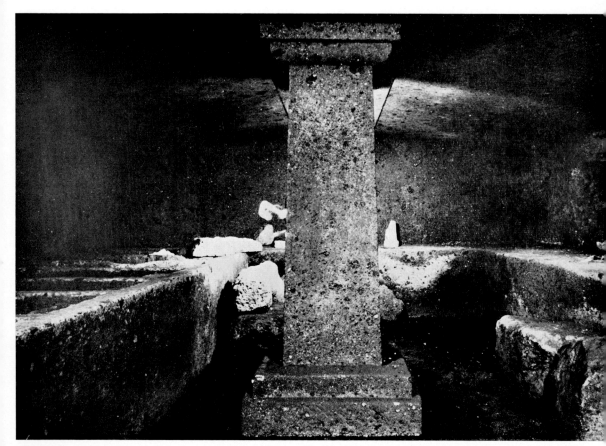

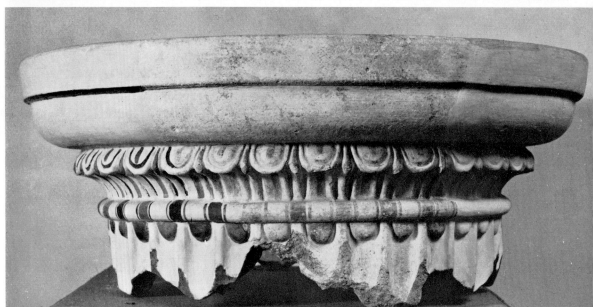

16. Caere (Cerveteri), Banditaccia cemetery, Late Etruscan tomb with Tuscan column

17. Capital of a temple on the Forum Boarium, Rome, sixth–fifth centuries B.C. *Rome, Palazzo dei Conservatori*

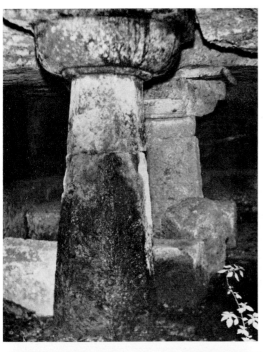

18. Caere (Cerveteri), Banditaccia
cemetery, Tomb of the Doric Columns,
sixth century B.C.

19. San Giuliano, Tomb of Princess
Margrete of Denmark, Doric capitals,
sixth century B.C.

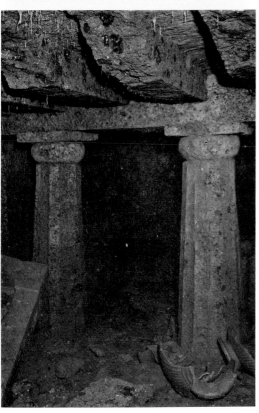

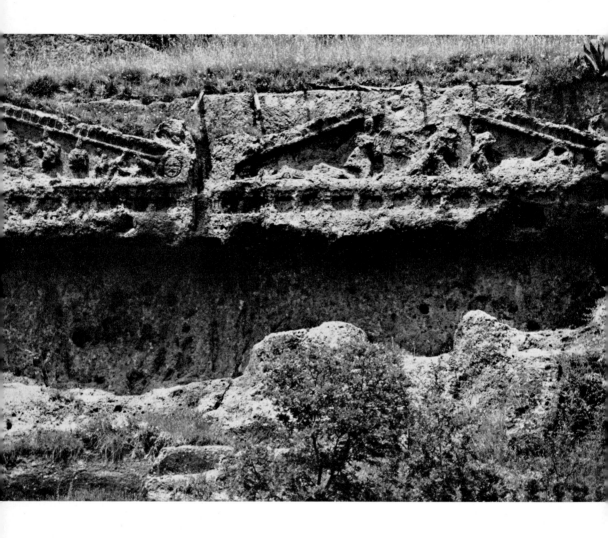

20. Norchia, tombs with temple façades, third century B.C.

21. Gabii, temple, late third century B.C., podium with benches for statues along the sides and back

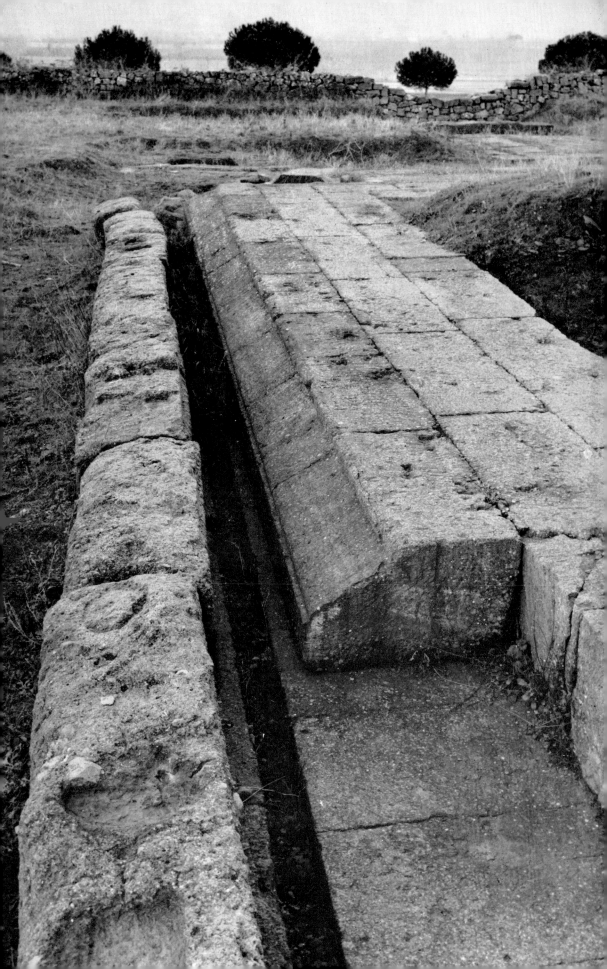

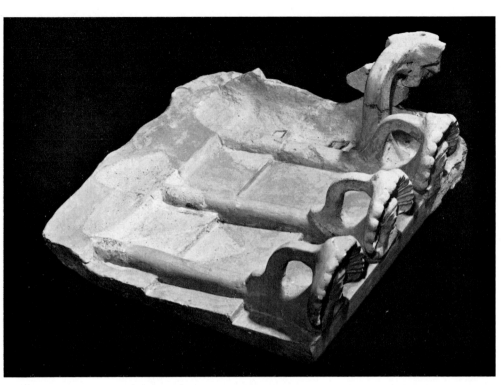

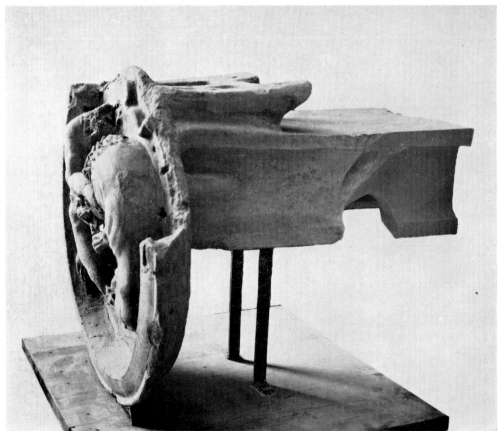

22. Roof of temple model with rectangular pantiles and semi-cylindrical cover tiles with ante-fixes. *Rome, Museo di Villa Giulia*

23. Ridge-pole revetment from a temple at Fratte, fourth century B.C. *Salerno, Museo Provinciale*

24. Antefix from Ardea, *c.* 500 B.C. *Rome, Museo di Villa Giulia*

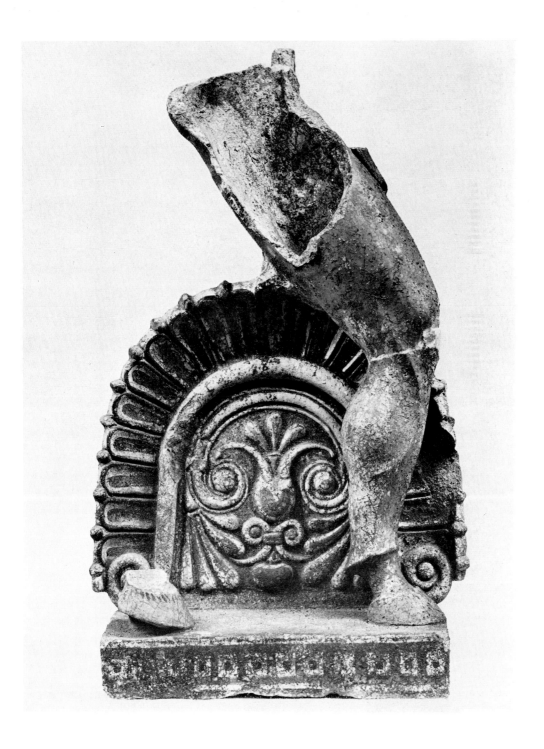

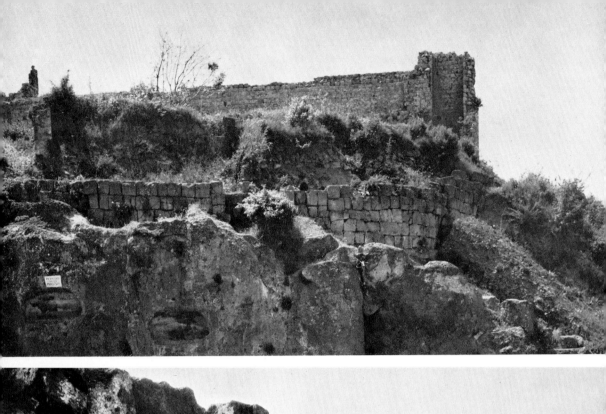

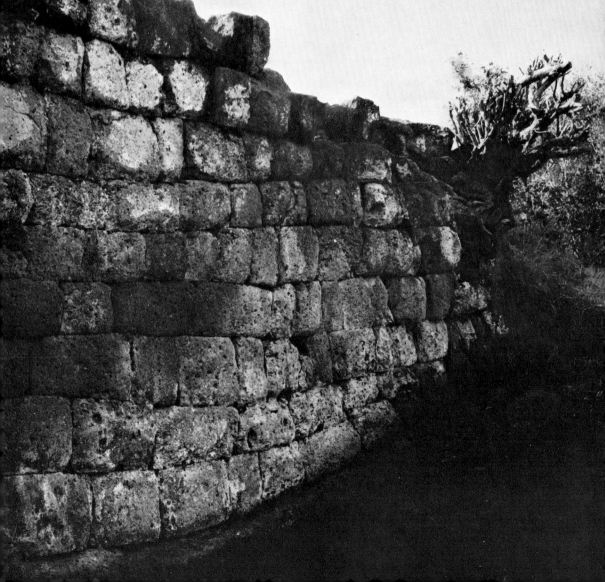

25. San Giovenale, Etruscan wall of the early fourth century B.C. below the thirteenth-century castle

26. Luni, walls, early fourth century B.C.

27. Orvieto, street in the Necropoli di Crocefisso del Tufo, begun sixth century B.C.

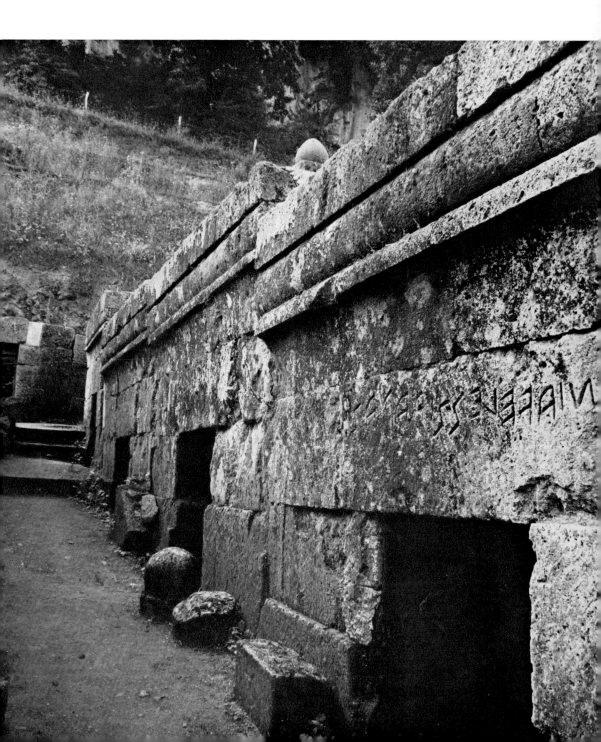

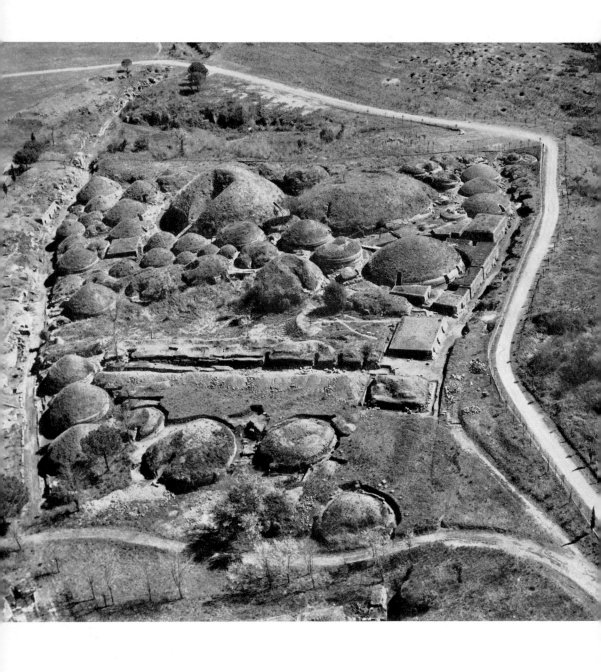

28. Caere (Cerveteri), Banditaccia cemetery, air view, showing tombs of Early and Late Etruscan date (c. 650–100 B.C.)

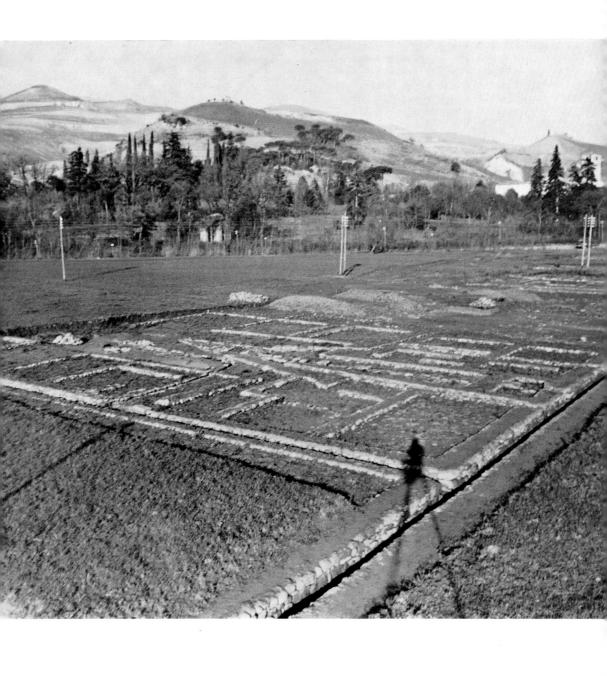

29. Marzabotto, founded *c.* 500 B.C., the acropolis hill and part of the town, showing a street with a drain in front of typical quarters

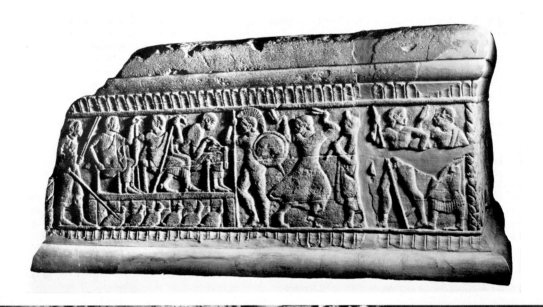

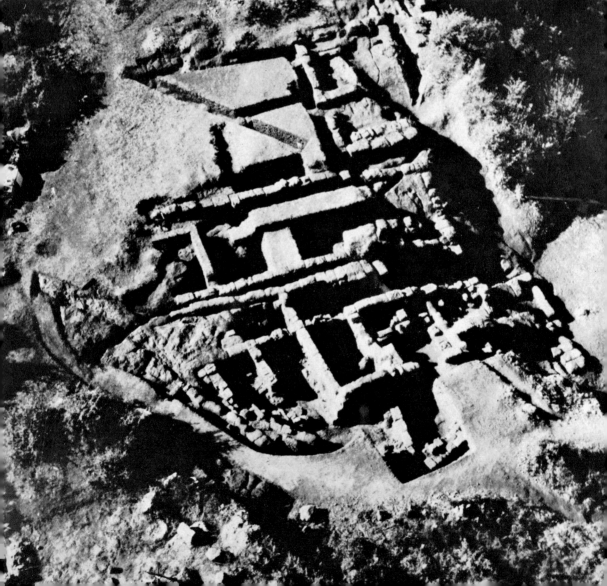

30. Relief from Clusium (Chiusi) showing wooden scaffolding for spectators and umpires of games, fifth century B.C. *Palermo, Museo Nazionale*

31. San Giovenale, houses of *c*. 600 B.C. on the northern side, east of the castle and the fourth-century town

32. San Giovenale, House K in the western quarter, bedroom, *c*. 600 B.C.

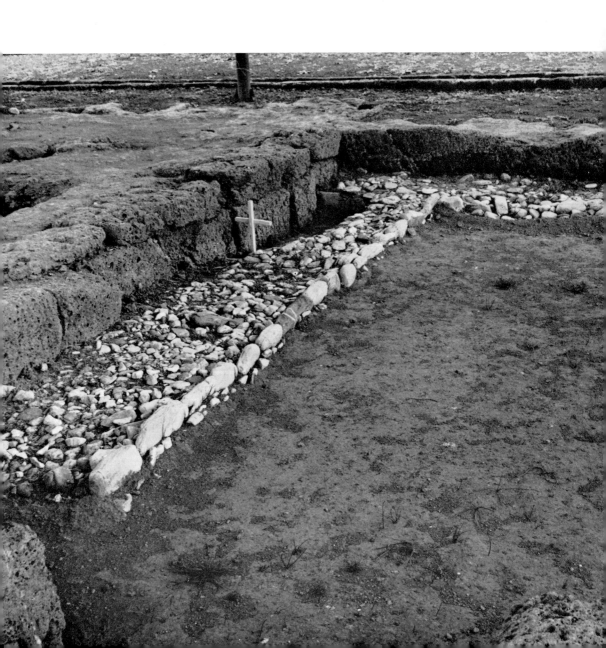

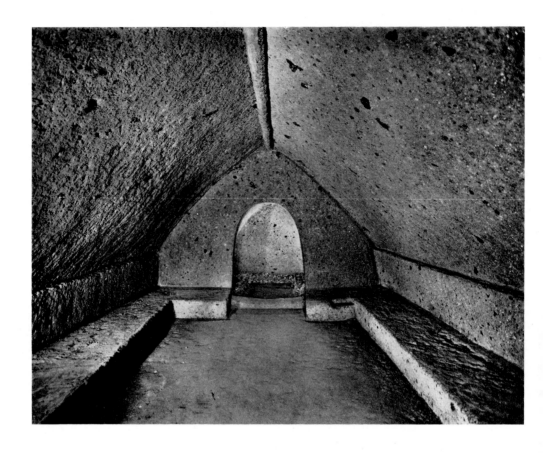

33. Caere (Cerveteri), Tomb of the Thatched Roof, late seventh century B.C.

34. San Giovenale, chamber tomb with lintel, sixth century B.C.

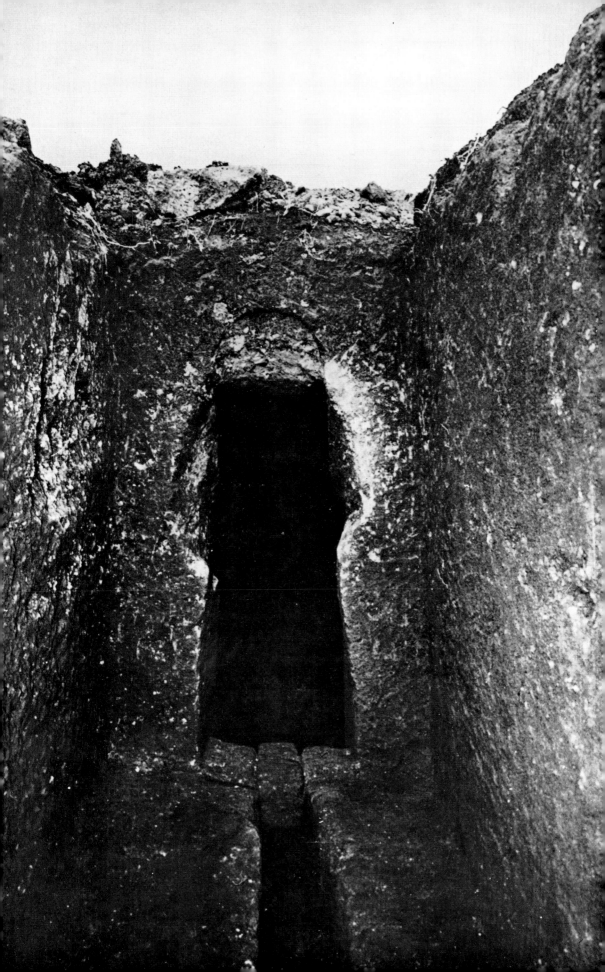

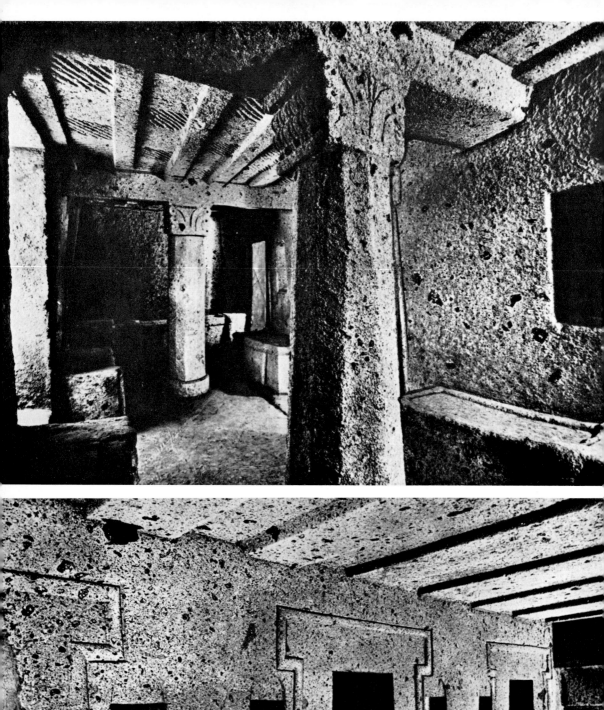
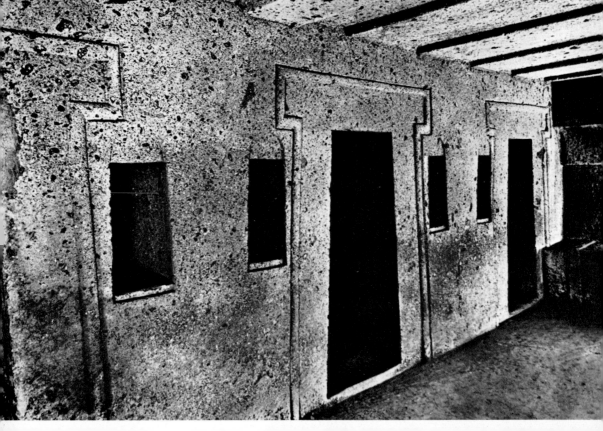

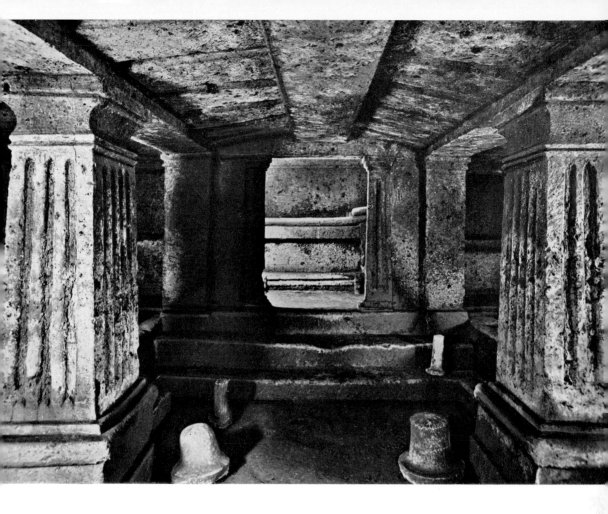

35. Caere (Cerveteri), Banditaccia cemetery, Tomba dei Capitelli, c. 500 B.C.

36. Caere (Cerveteri), Banditaccia cemetery, Tomba della Cornice, c. 500 B.C.

37. Caere (Cerveteri), Banditaccia cemetery, Tomba dell'Alcova, third century B.C.

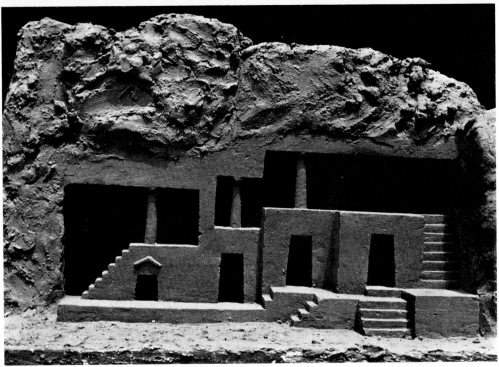

38. Luni, Tomb of the Caryatids, Second Pompeiian Style, *c.* 100 B.C.

39. Model of Late Etruscan tombs built into the hillside at San Giuliano

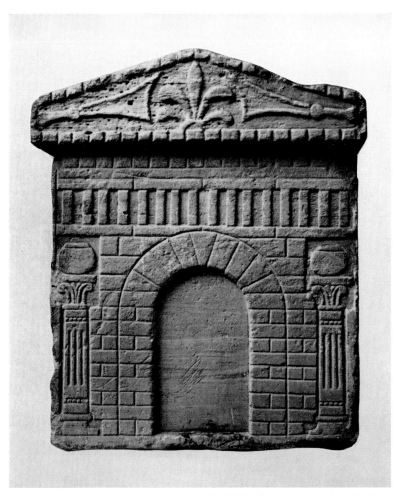

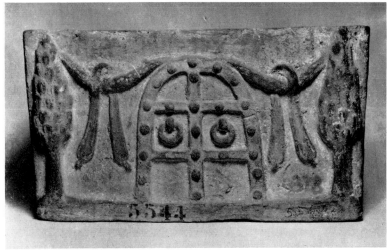

40. Ash urn with arched door from Chiusi, Late Etruscan. *Florence, Museo Archeologico*

41. The entrance to the underworld on a Late Etruscan ash urn. *Florence, Museo Archeologico*

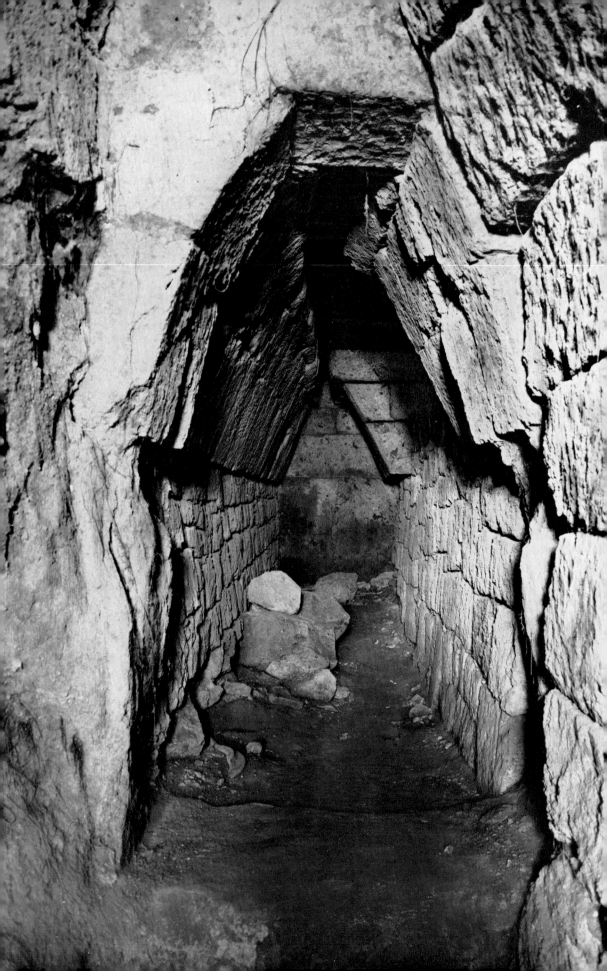

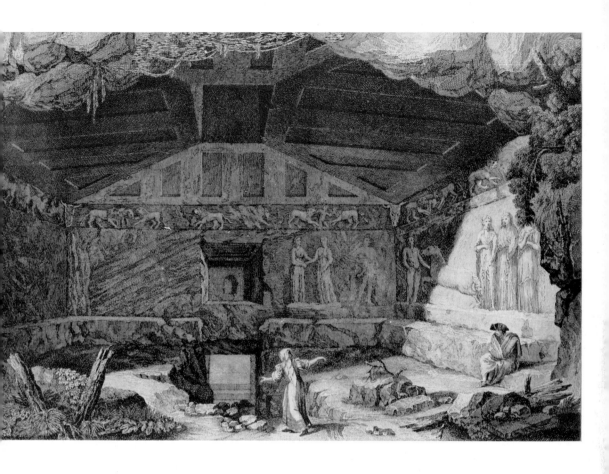

42. Caere (Cerveteri), Regolini Galassi tomb, c. 650 B.C.

43. Caere (Cerveteri), Tomba di Mercareggia, Late Etruscan, atrium displuviatum

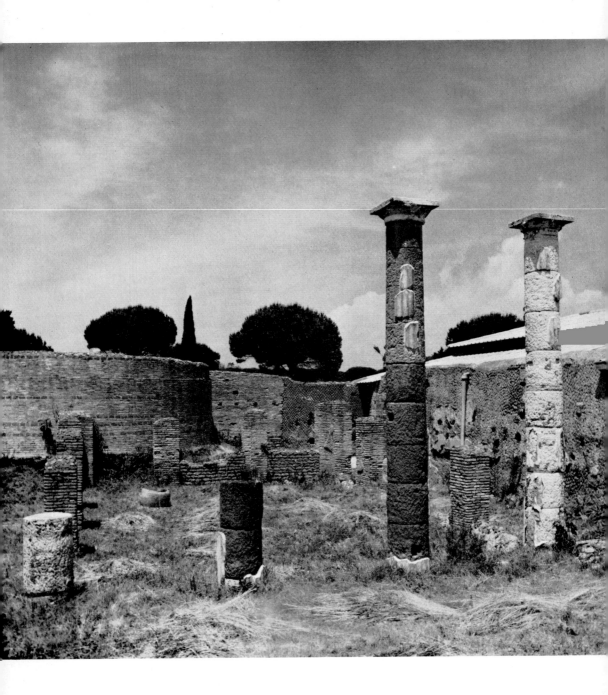

44. Ostia, peristyle, Late Republican

45. Tomb of the Volumnii near Perugia, second century B.C.

46. Tarquinia, Tomba Giglioli, second century B.C.

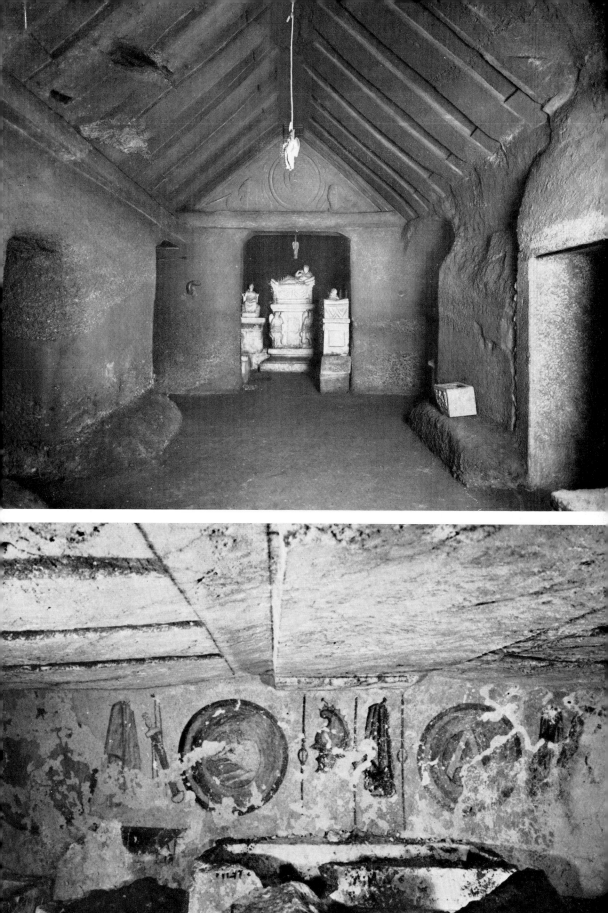

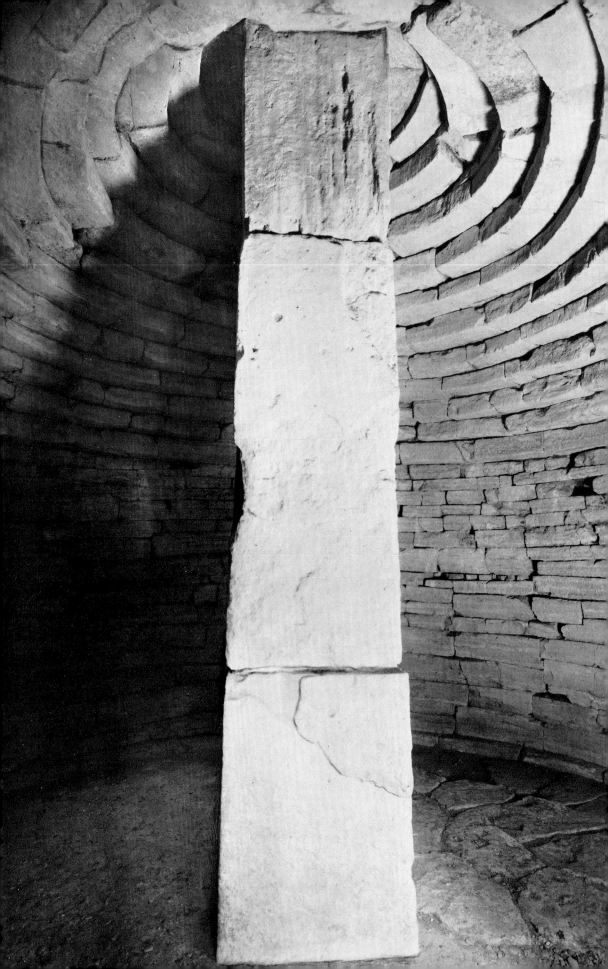

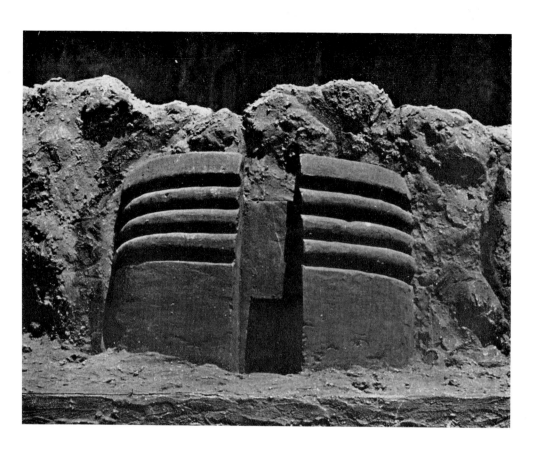

47. Tholos tomb from Casal Marittimo, *c.* 600 B.C., reconstructed. *Florence, Museo Archeologico*

48. Model of a Late Etruscan tomb with a round façade in the valley at San Giuliano

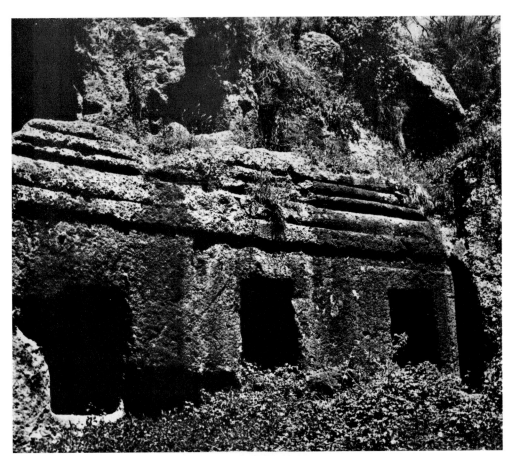

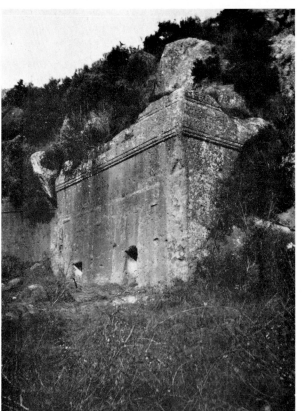

49. San Giuliano, tomb façades, after 400 B.C.

50. San Giuliano, 'Tomba della Regina', Late Etruscan

51. Luni, Tomb of the Caryatids, false door and entrance below the door, Late Etruscan

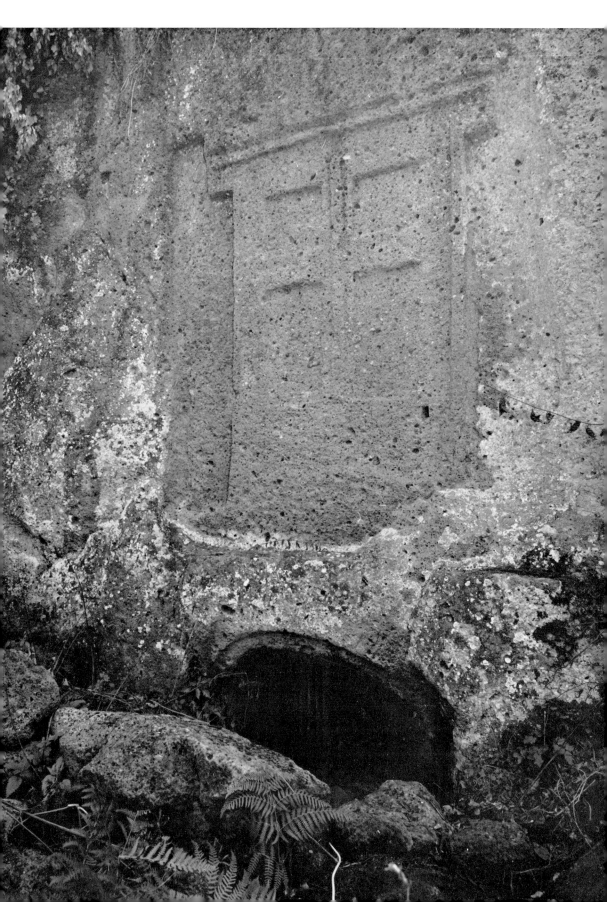

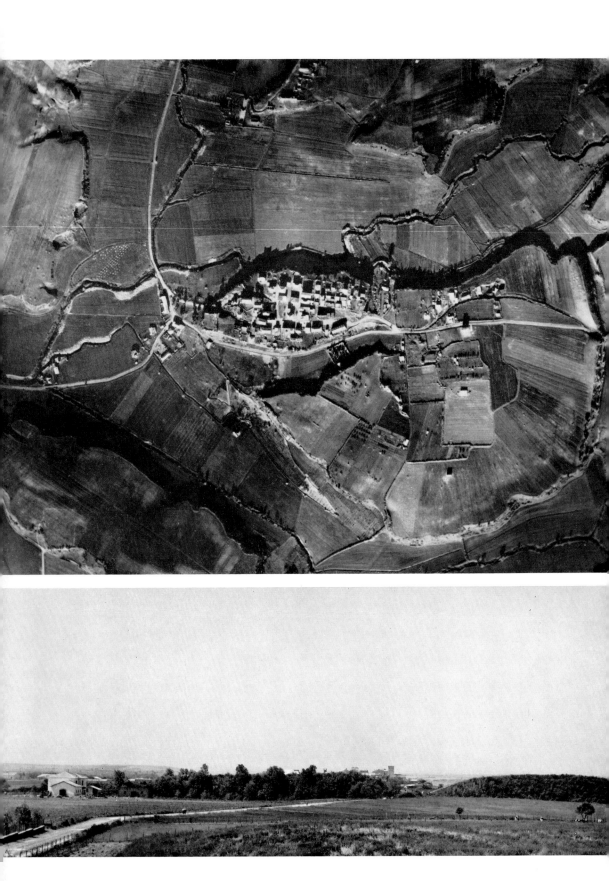

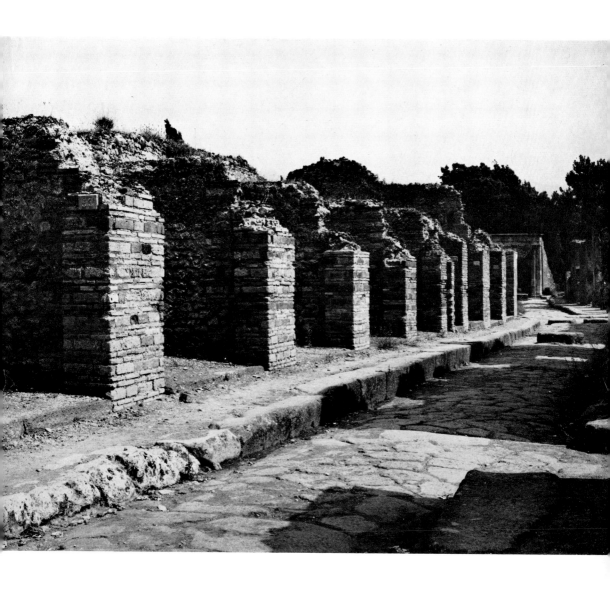

52. Ardea, air view, showing the site of the lower town and the acropolis with fortifications dating from the fifth century B.C. or earlier to about 300 B.C.

53. Ardea, agger, sixth-fifth centuries B.C., with the road in the centre

54. Pompeii, Strada dei Teatri, row of tabernae

55. Rome, old Via Sacra and Clivus Palatinus, after 390 B.C., in front of the Arch of Titus (on a higher level)

56. Terracotta revetment from the Forum Romanum, sixth century B.C. *Rome, Soprintendenza Foro Romano e Palatino*

57. Signia (Segni), gate in the wall, fourth century B.C.(?)

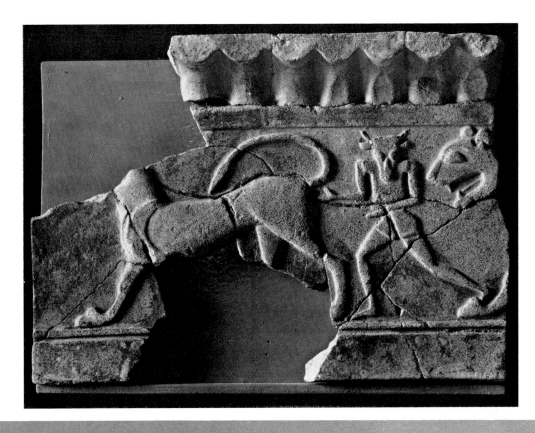

58. Arpinum, corbelled gate, 305 B.C.

59. Norba (Norma), walls and gate, fourth century B.C. (second half)

60. Cosa, city gate, with door chamber inside the wall (cf. Figure 56), 273 B.C.

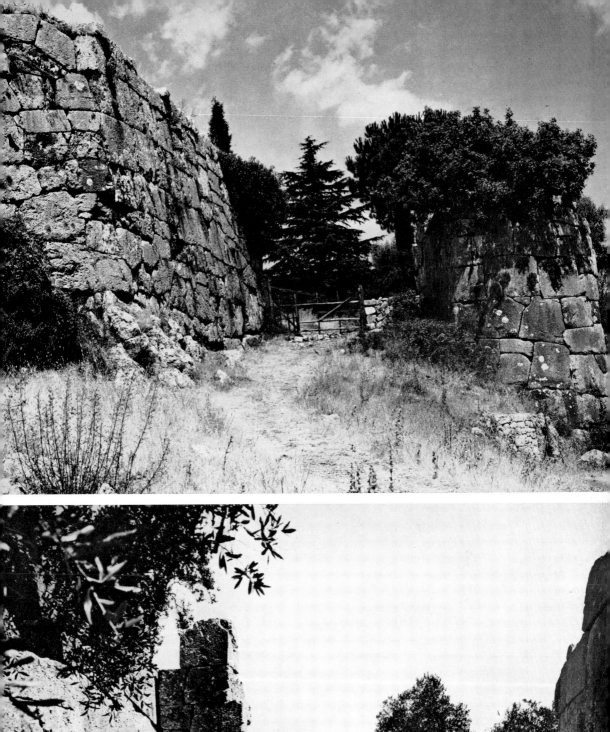

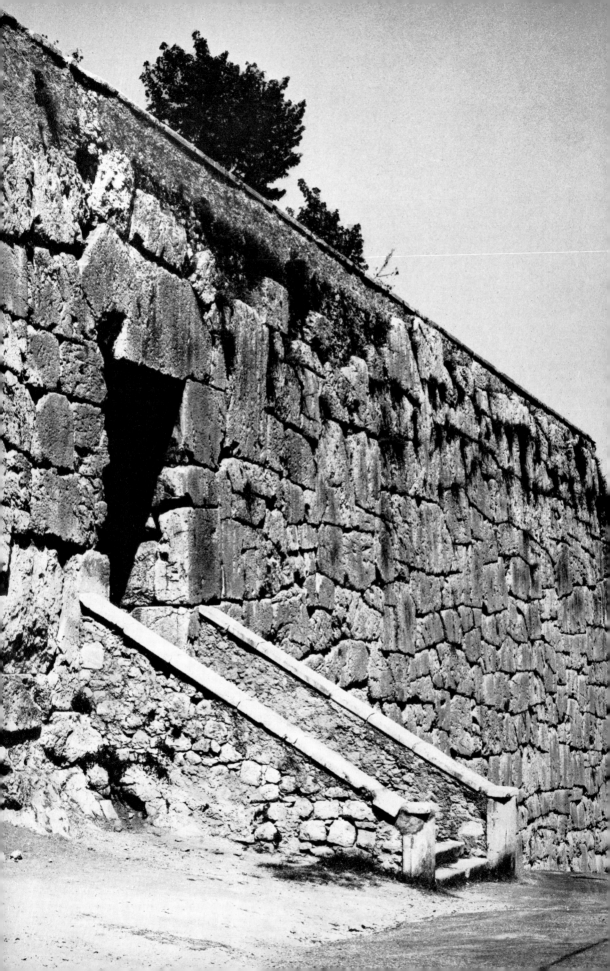

61. Alatrium (Alatri), terrace wall, third century B.C.

62. Signia (Segni), temple, terrace, probably fifth century B.C.

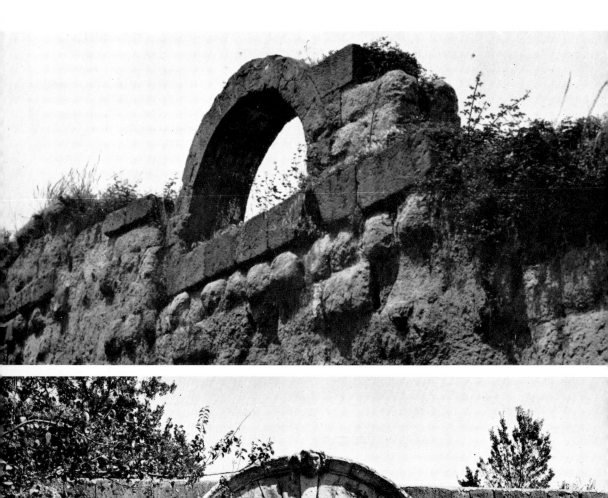

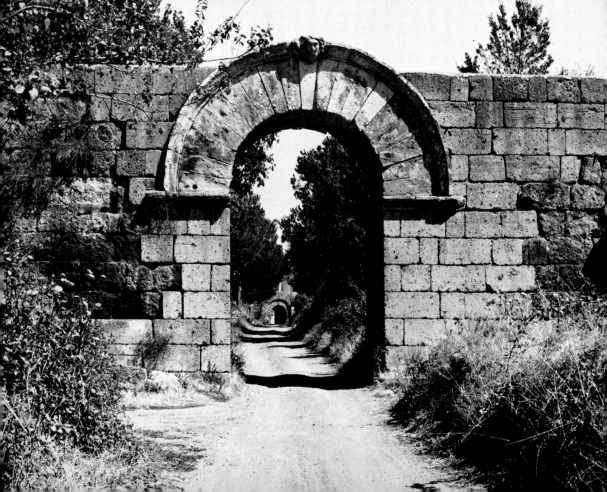

63. Rome, 'Servian Wall' at the Aventine, begun 378 B.C., rebuilt with an arch for catapults in 87 B.C.

64. S. Maria di Falleri, gate, 241–200 B.C.

65. Sarcophagus from the Via Cristoforo Colombo, third century B.C. *Rome, Palazzo dei Conservatori*

66. Pompeii, a typical Late Republican atrium

67. Rome, 'Temple of Vesta' on the Tiber, first century B.C. (first half) (?)

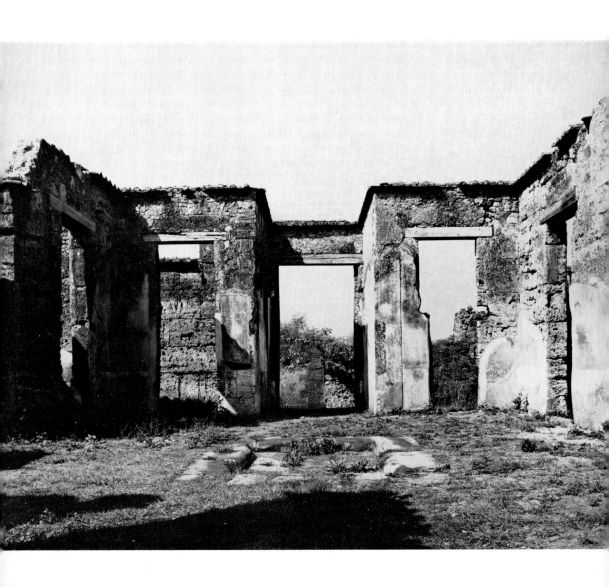

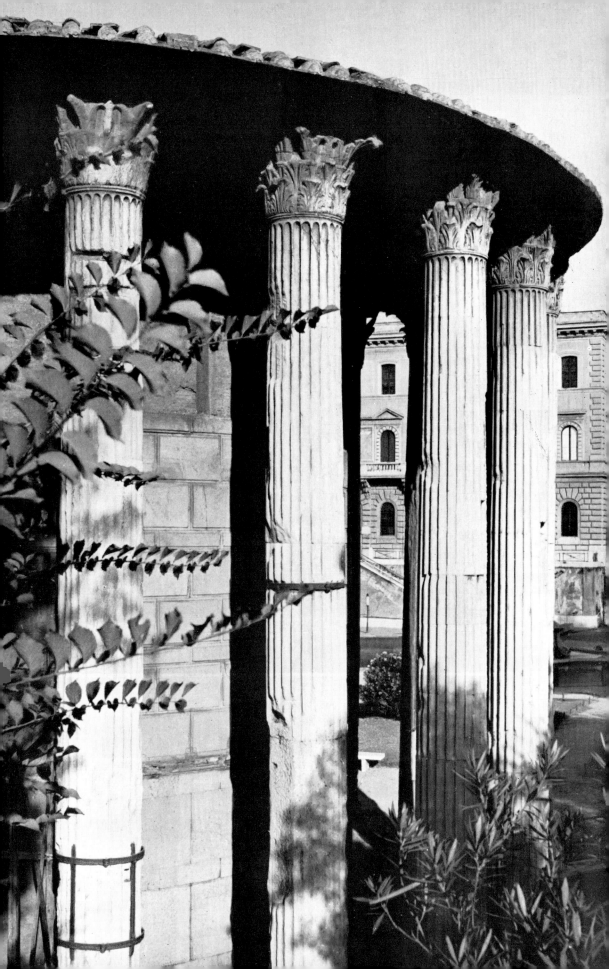

68. Rome, building on the south side of the Palatine, the left-hand arch Late Republican

69. Pompeii, forum baths, staircase and corridor to the baths, *c.* 80 B.C.

70. Pompeii, Via dell'Abbondanza, houses with porticoes (cenacula) on the second floor, built and rebuilt during the last centuries of Pompeii

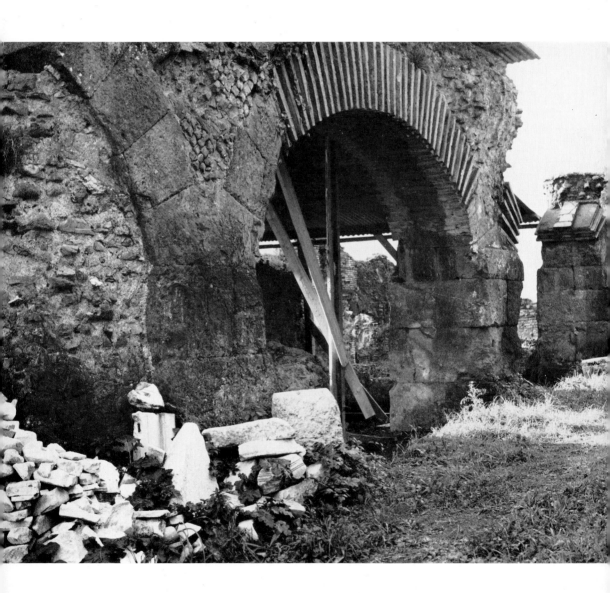

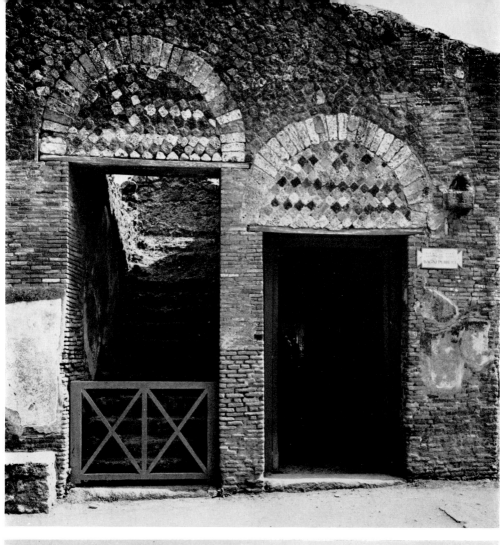

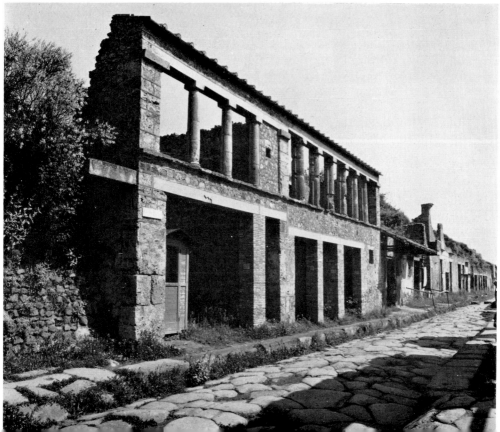

71. Rome, Porticus Aemilia, begun 193 and restored 174 B.C.(?), before the modern buildings on the site, showing the alternating arches on the first and second floors

72. Rome, Tabularium, 78 B.C.

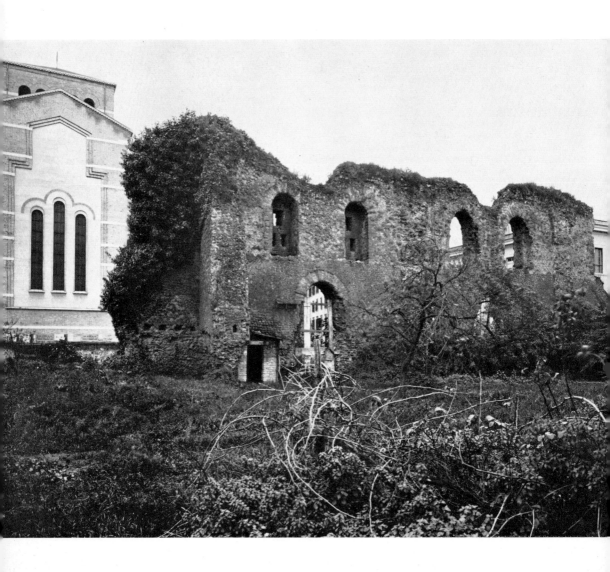

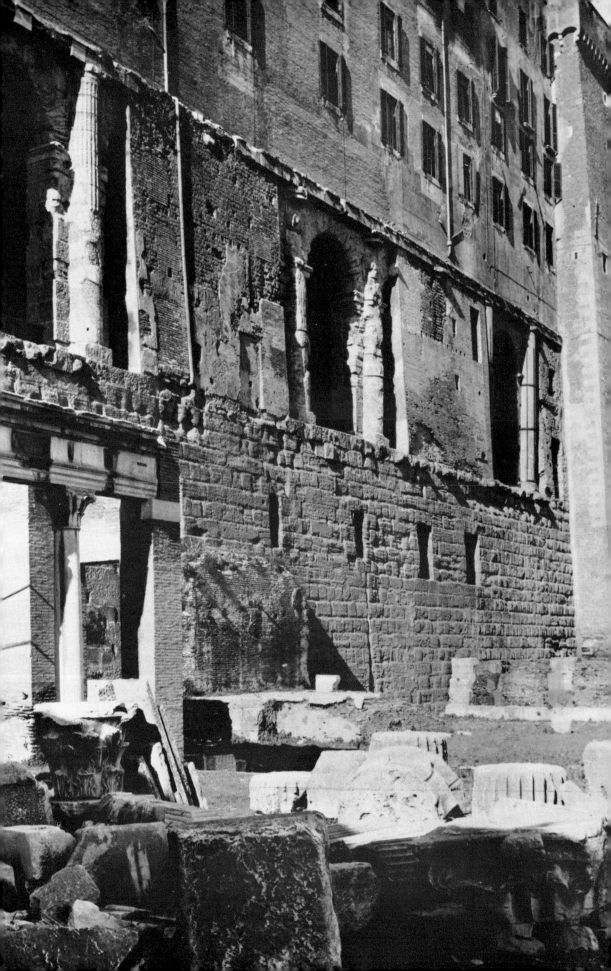

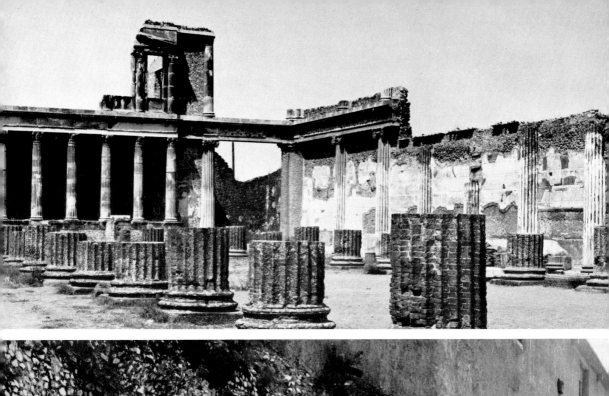

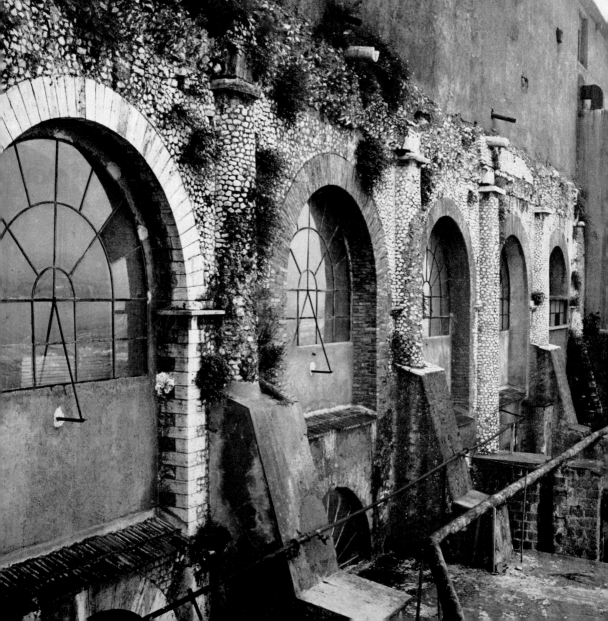

73. Pompeii, basilica, *c.* 120 B.C.(?)

74. Tibur (Tivoli), Temple of Hercules Victor, Late Republican, western façade of terrace

75. Rome, Forum Holitorium, Late Republican portico on the eastern side

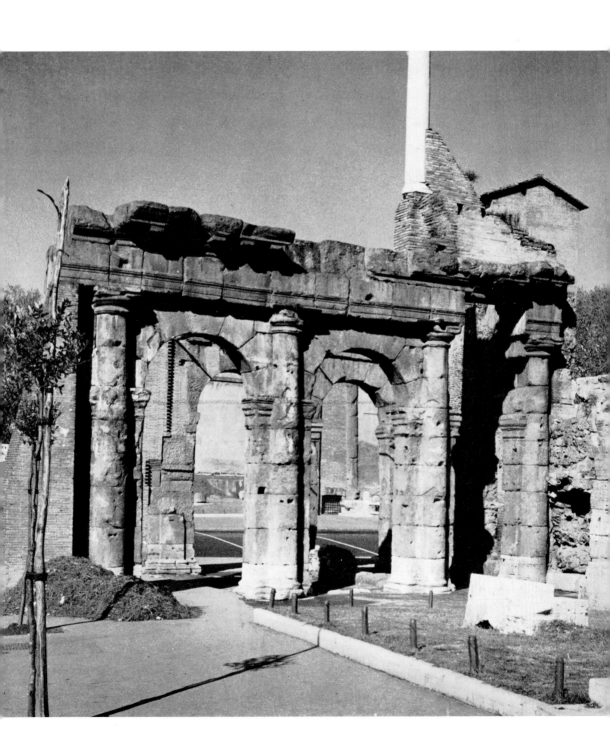

76. Rome, Temples A and B on the Largo Argentina, *c.* 100 B.C. and mid second century B.C.

77. Rome, 'Temple of Fortuna Virilis' on the Tiber, second century B.C. (second half)(?)

78. Cori, Temple of Hercules, late second century B.C.

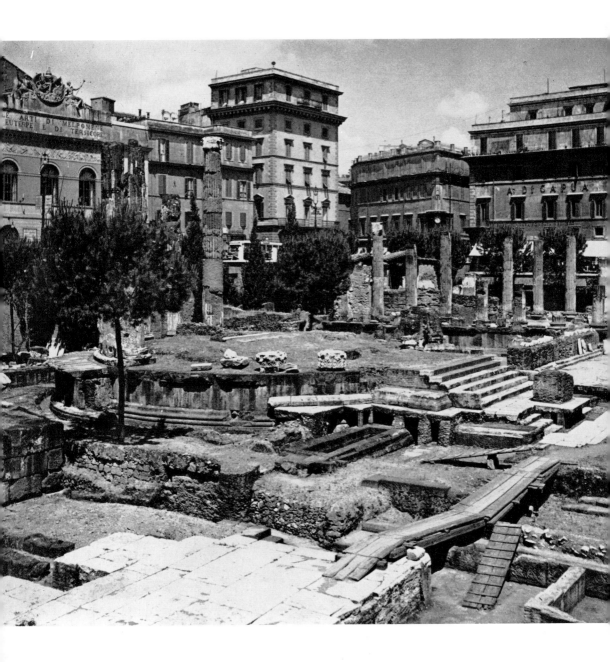

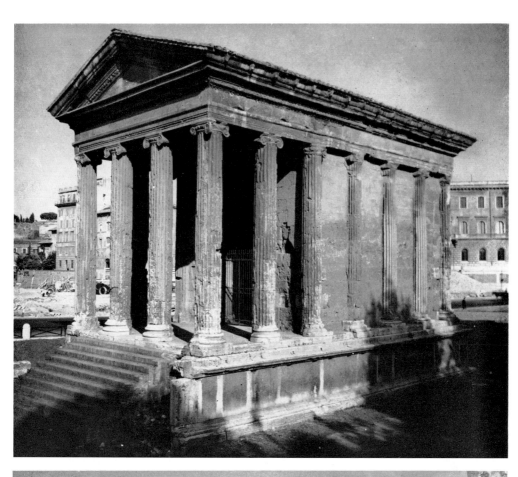

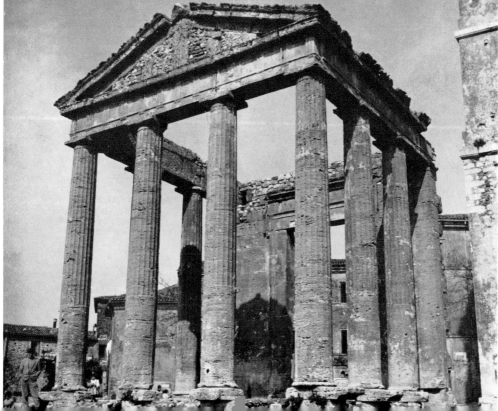

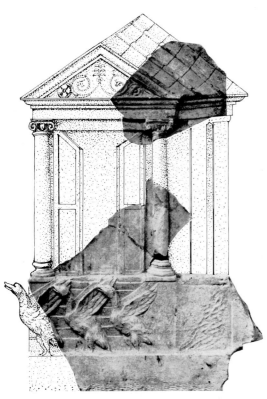

79. Relief of the Imperial Age, probably representing the Temple of Juno Moneta on the Arx in Rome, dedicated 374 B.C. *Ostia, Museum*

80. Tibur (Tivoli), tetrastyle temple, second century B.C. (second half) (?)

81. Reconstruction of the Temple of Jupiter Anxur at Terracina, *c.* 80 B.C., showing the terrace, temple, and castrum (with the beginning of the wall which connected it with the wall of the town). *Excavations Museum*

82. Gabii, theatre temple, second century B.C. (?)

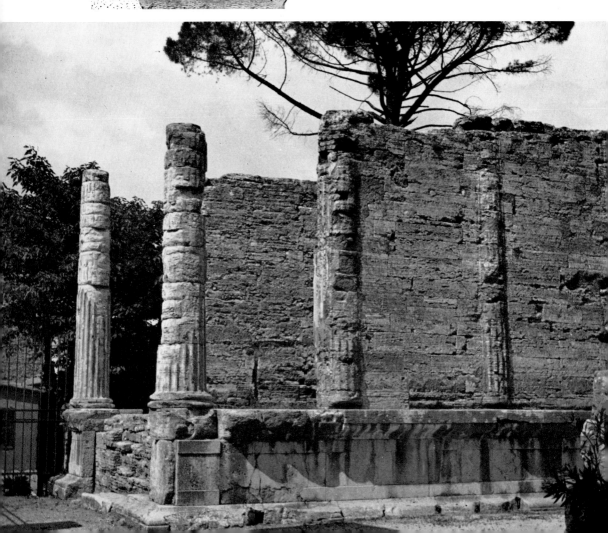

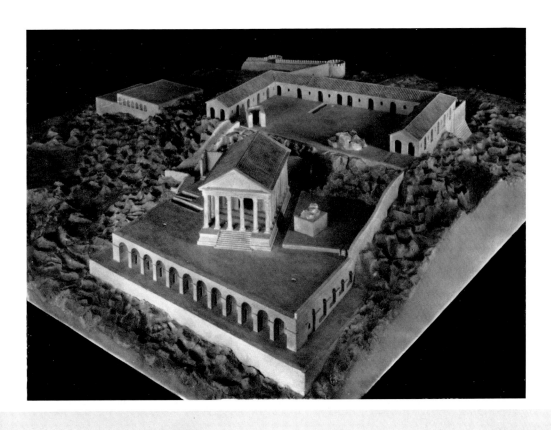

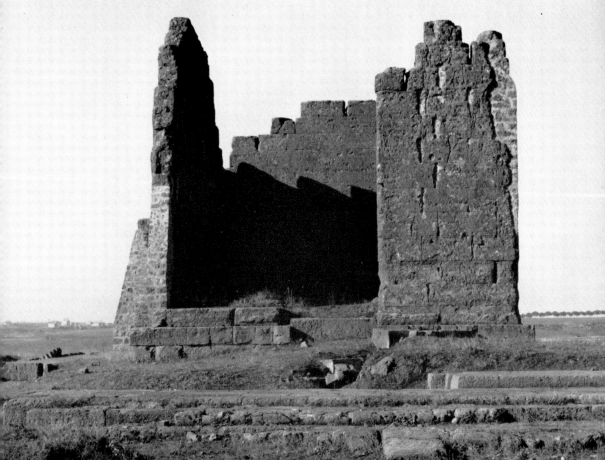

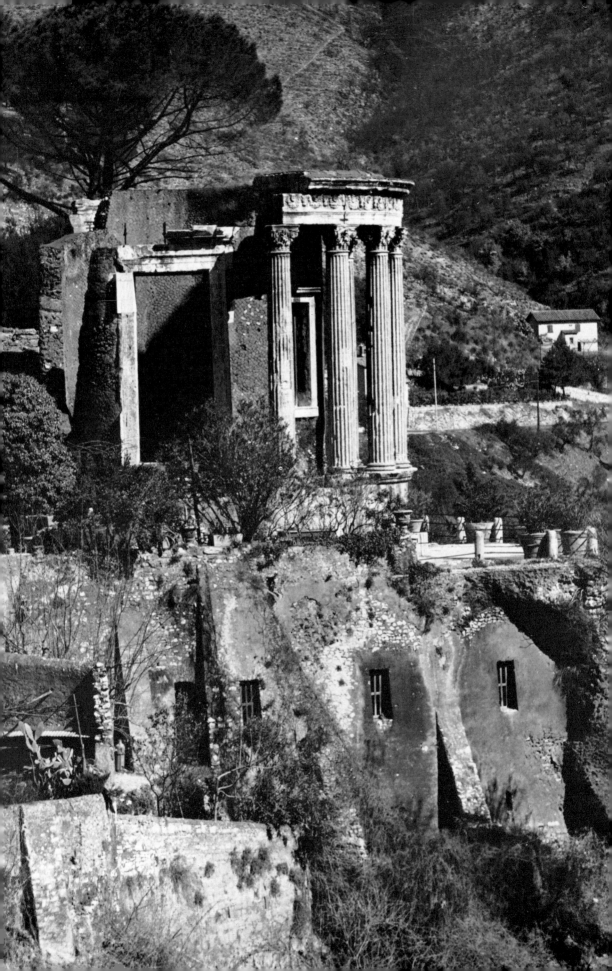

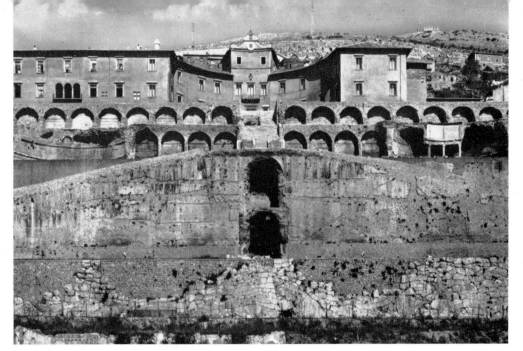

83. Tibur (Tivoli), 'Temple of Vesta', early first century B.C.

84. Praeneste (Palestrina), general view

85. Praeneste (Palestrina), curia, with aerarium on the left, *c.* 80 B.C. (The present ground level is some six feet higher than the Sullan level)

86. Praeneste (Palestrina), Corinthian above Doric portico in front of the basilica behind the temple, *c.* 80 B.C.

87. Praeneste (Palestrina), basilica, *c.* 80 B.C., north wall

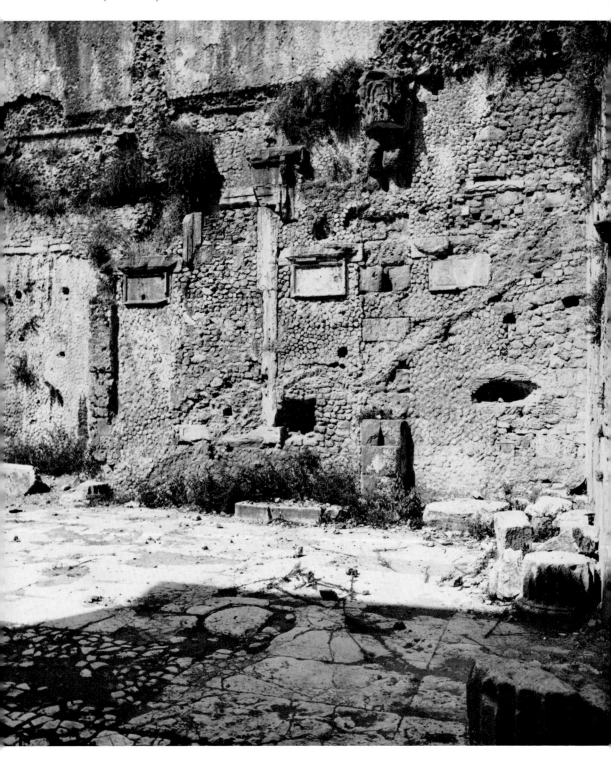

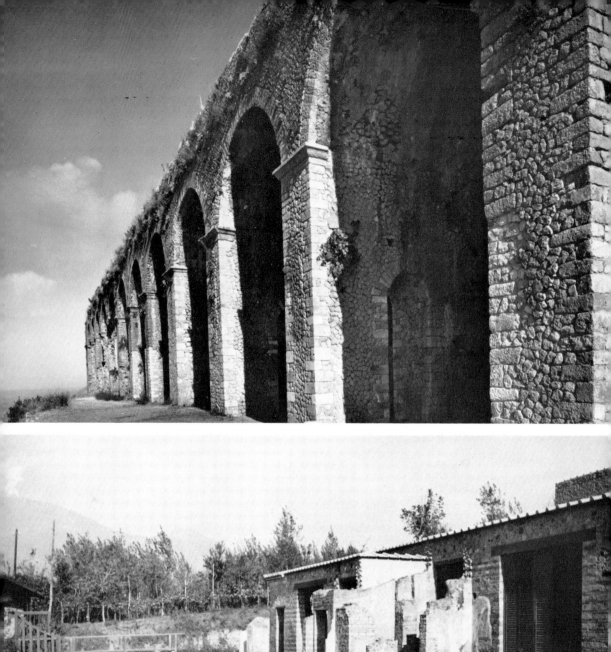
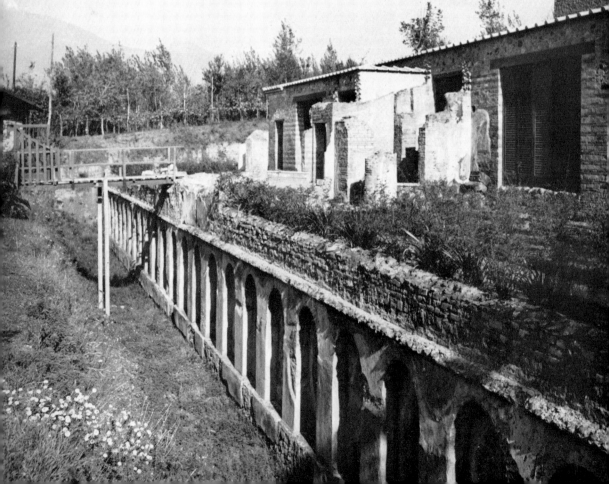

88. Terracina, Temple of Jupiter Anxur, *c.* 80 B.C., terrace

89. Pompeii, Villa dei Misteri, *c.* 200 B.C., basis villae (podium)

90. Ferentinum (Ferentino), acropolis, bastion added in the second century B.C. (second half)

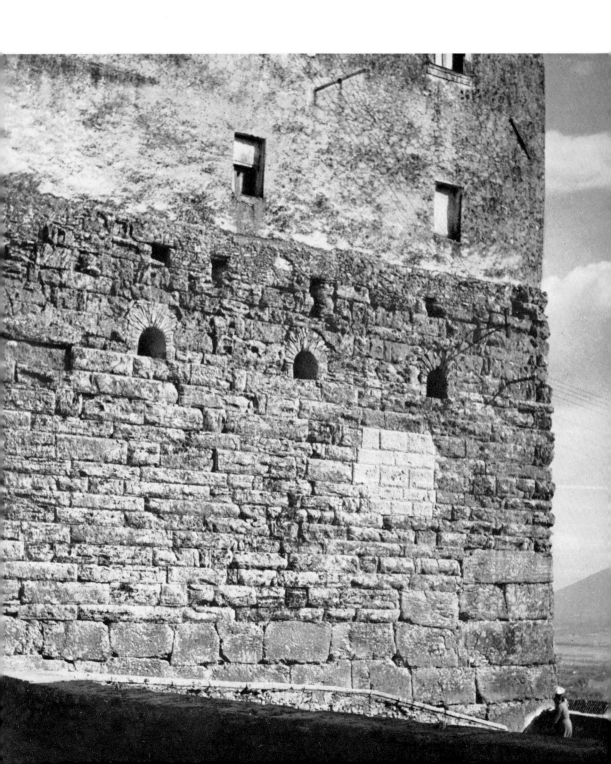

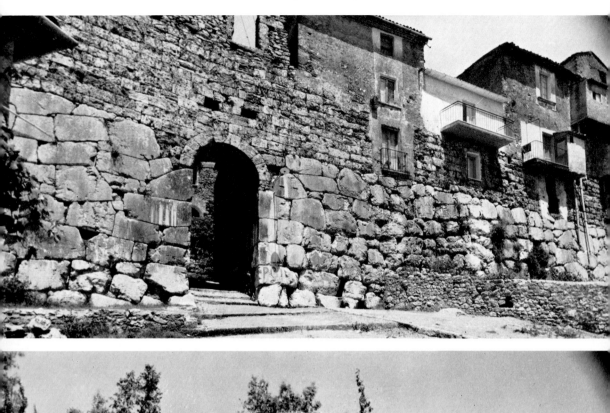

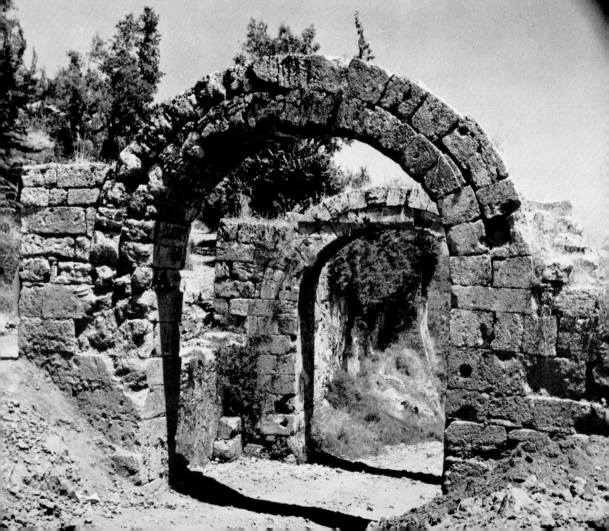

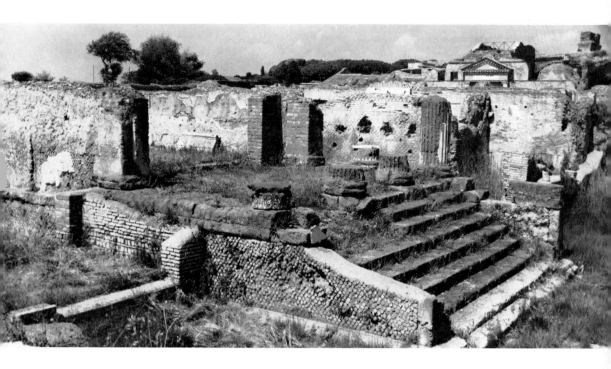

91. Ferentinum (Ferentino), Porta Sanguinaria, second century B.C.

92. Ferentinum (Ferentino), Porta Maggiore or 'di Casamari', *c.* 80–70 B.C.

93. Ostia, Late Republican temple on the lower level (next to the Temple of Hercules), with stuccoed tufa columns and opus incertum

94. Pompeii, Casa del Chirurgo, fourth or third century B.C.

95. Early Imperial Age paintings from Pompeii showing terraced villas by the sea

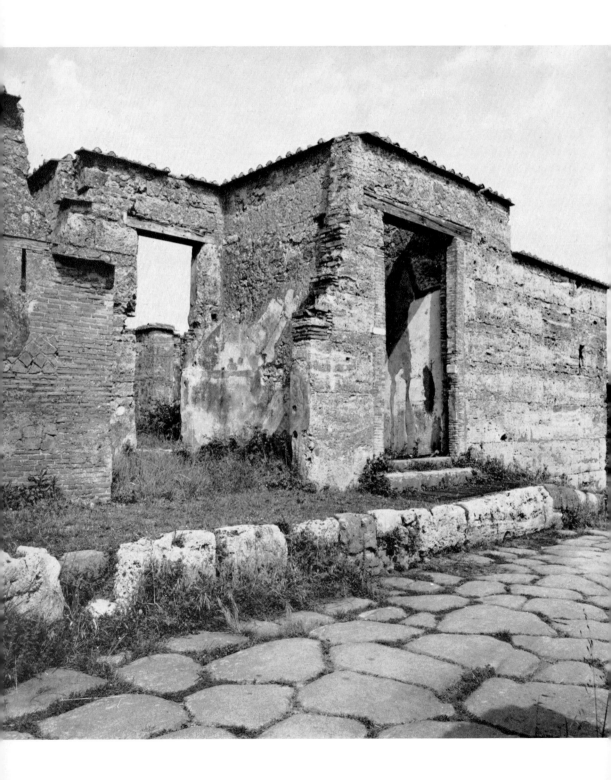

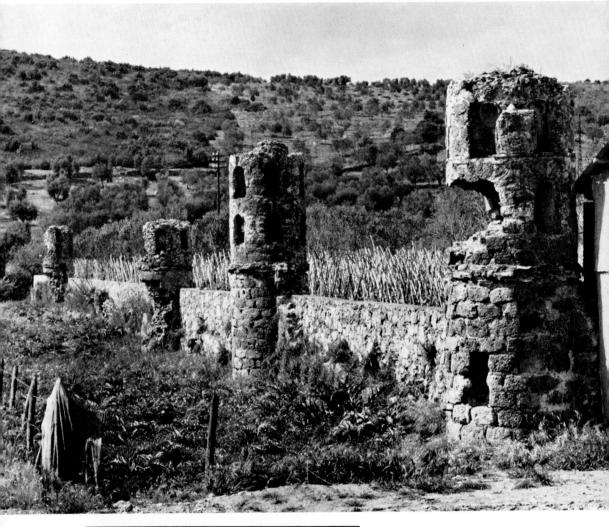

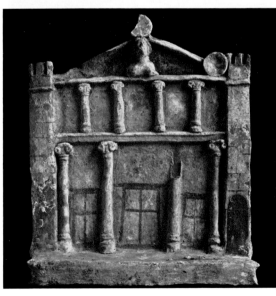

96. Cosa, villa, second century B.C.

97. Terracotta model of a stage building, c. 300 B.C. *Naples, Museo Nazionale*

98. Ferentinum (Ferentino), Via Latina, market hall, c. 100 B.C.

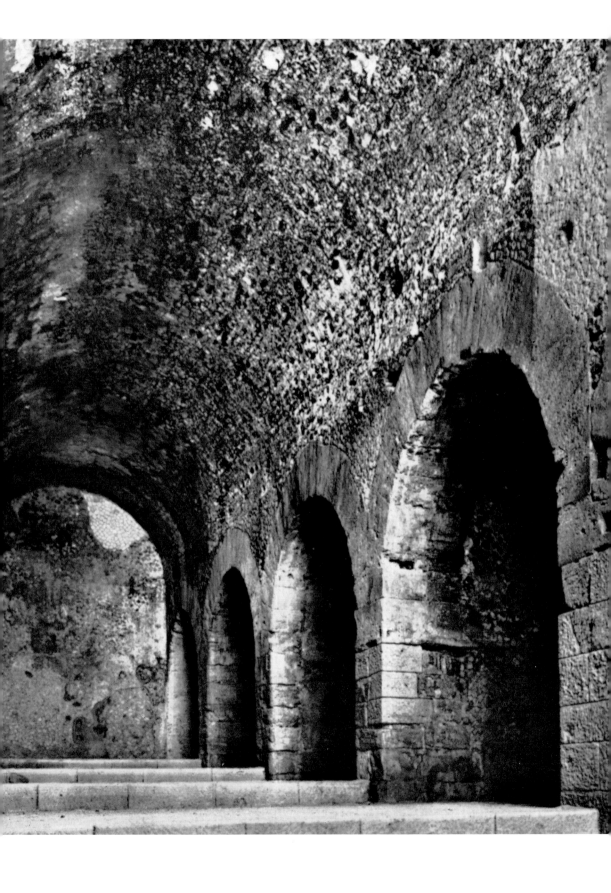

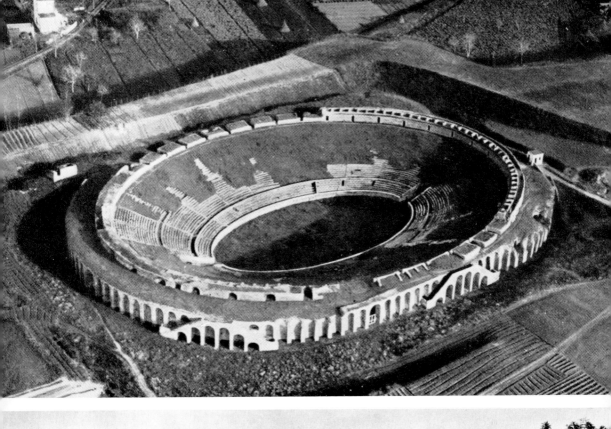

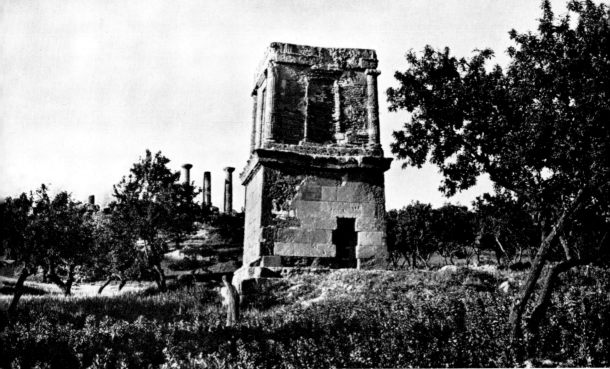

99. Pompeii, amphitheatre, after 80 B.C.

100. Agrigento, 'Tomb of Theron', hellenistic

101. Tomb of S. Sulpicius Galba, consul of 108 B.C.

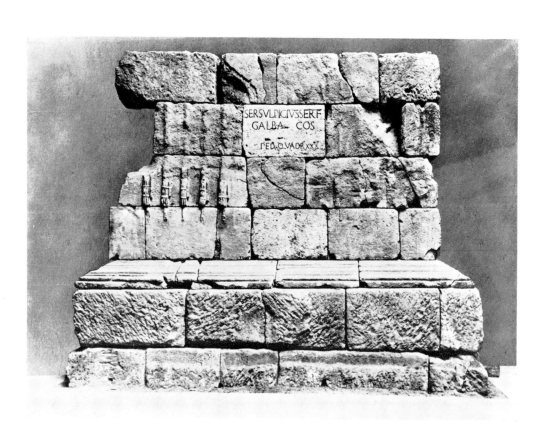

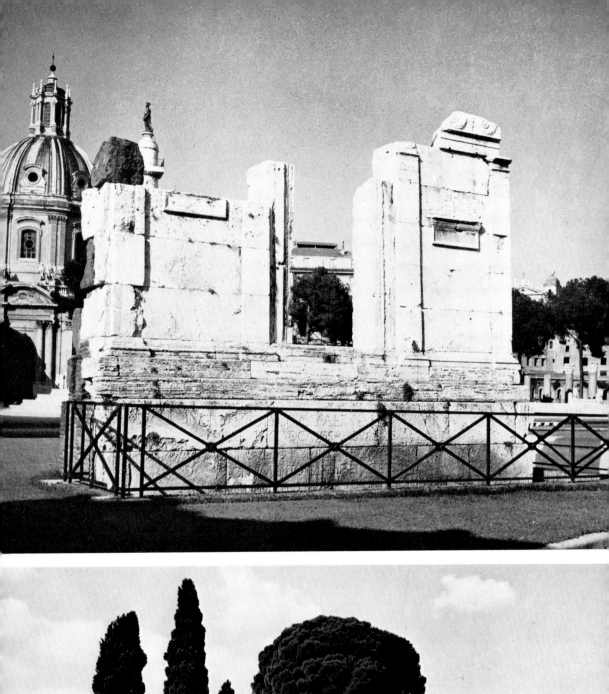

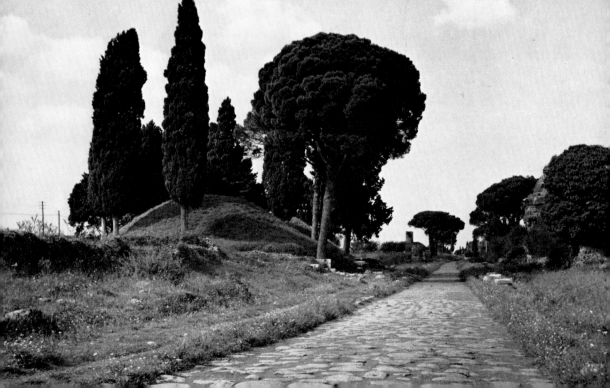

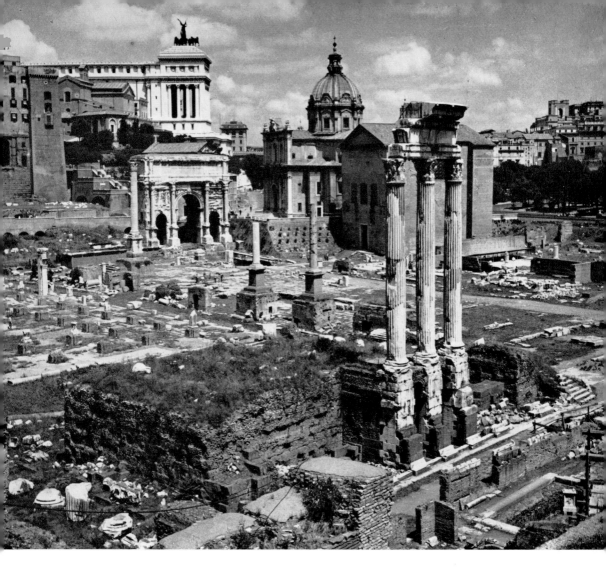

102. Rome, Capitoline Hill, tomb of C. Poplicius Bibulus, hellenistic

103. Rome, Via Appia, tumuli, from the south. The northern one is the Late Republican 'Tumulo degli Orazi e dei Curiazi'

104. Rome, Forum Romanum, seen from the Palatine. In the foreground the Temple of Castor, rebuilt between 7 B.C. and A.D. 6. Beyond it the Arch of Septimius Severus, A.D. 203, and the Senate House, rebuilt by Diocletian after the fire of A.D. 283

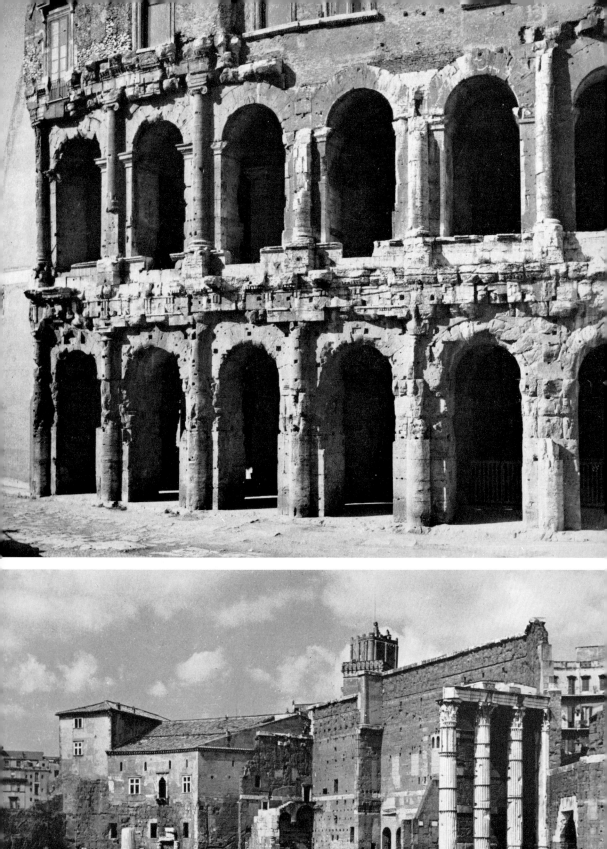

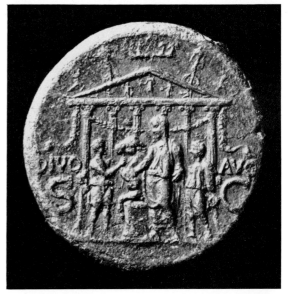

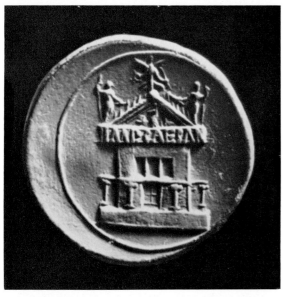

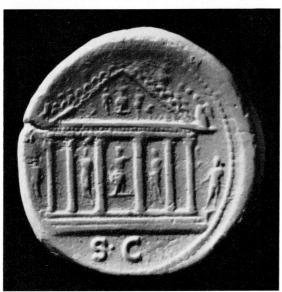

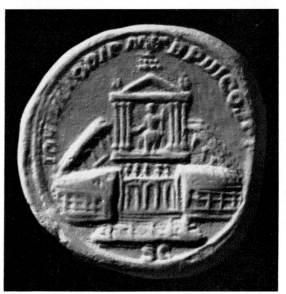

105. Rome, Theatre of Marcellus, dedicated in 13 or 11 B.C. Part of the outer façade (cf. Figure 83)

106. Rome, Temple of Mars Ultor, dedicated in 2 B.C., and part of the Forum Augustum (cf. Figure 85)

107. (A) Coin of Augustus showing the Senate House (Curia), as restored in 44–29 B.C. (B) Coin of Caligula, A.D. 37, showing an Ionic temple, usually identified as that of the Deified Augustus. (C) Coin of Vespasian depicting the Temple of Jupiter Optimus Maximus Capitolinus, rebuilt after A.D. 70, rededicated in 75, and again destroyed in 80. (D) Rome, coin of Alexander Severus, depicting Elagabalus's Temple of Sol Invictus, A.D. 218–22, after its rededication to Juppiter Ultor

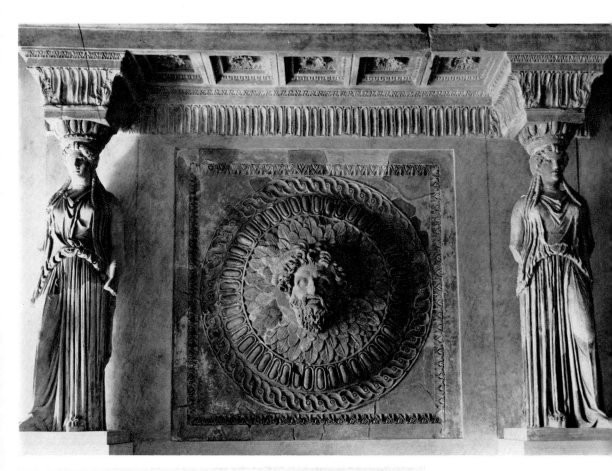

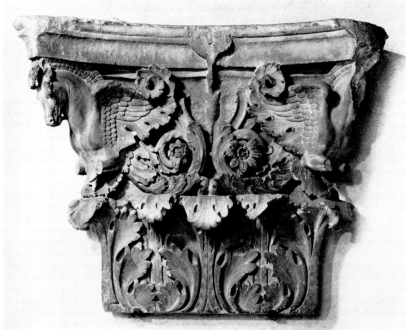

108. Rome, Forum
Augustum, *c.* 10–2 B.C.,
caryatid order from
the flanking colonnades

109. Rome, Temple
of Mars Ultor,
dedicated in 2 B.C.,
capital

110. Rome, Temple
of Apollo Sosianus,
c. 20 B.C., frieze from
the interior of the cella

111. Rome, Basilica
Aemilia, rebuilt after
14 B.C. Drawing by
Giuliano da Sangallo

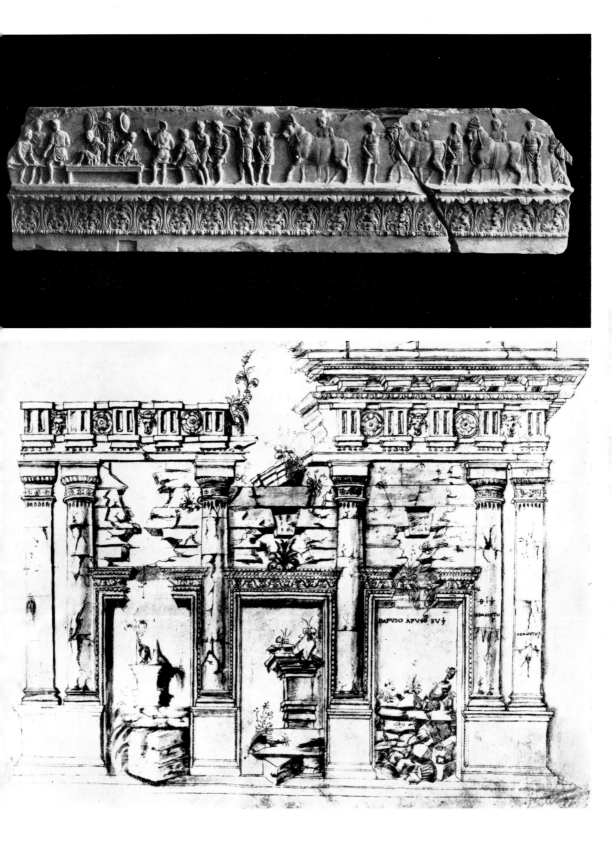

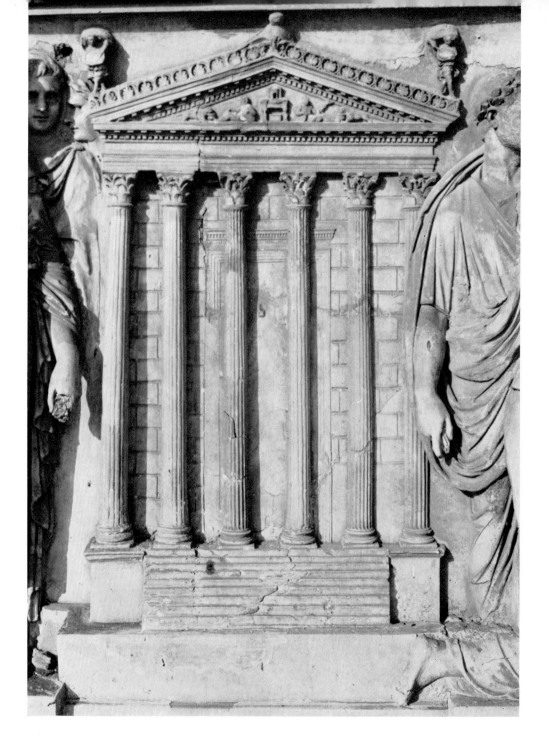

112. Relief, probably from the Ara Pietatis Augustae, dedicated in A.D. 43, depicting the façade of the Temple of Magna Mater on the Palatine, restored after A.D. 3

113. Rome, Temple of Concord, dedicated in A.D. 10. Restored marble cornice block, now in the Tabularium

114. Rome, Castra Praetoria, the north outer wall. The lower part, above the exposed footings, is original (A.D. 21–3); the upper part dates from its incorporation into the Aurelianic Walls (A.D. 270–82)

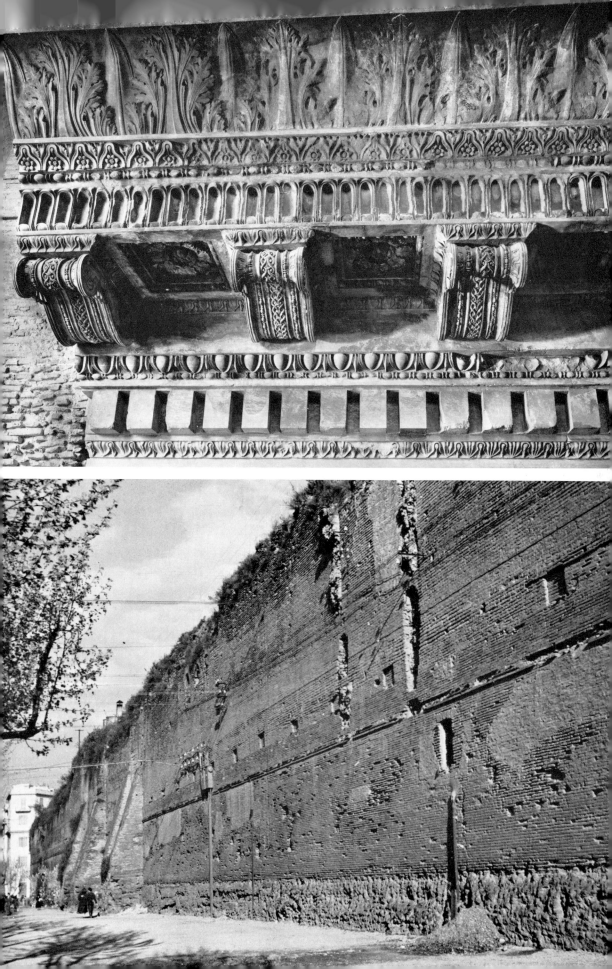

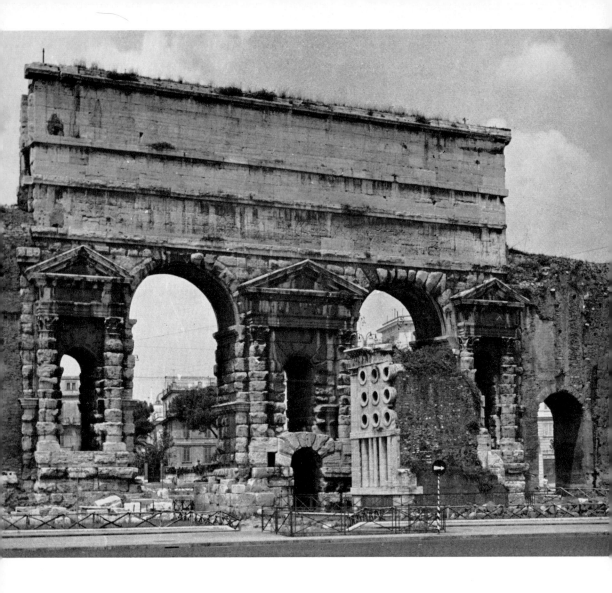

115. Rome, Porta Maggiore, a monumental double archway of travertine, built by Claudius to carry the Aqua Claudia and the Anio Novus across the Via Labicana and the Via Praenestina. Later incorporated into the Aurelianic Walls (cf. Plate 116)

116. Rome, the Porta Labicana (*left*) and Porta Praenestina (*right*) of the Aurelianic Walls (A.D. 270–82; modified by Honorius, A.D. 403), incorporating the Claudian archway at the Porta Maggiore; cf. Plate 115. Drawing by Rossini, 1829

117. Rome, archway of rusticated travertine, A.D. 46, carrying the restored Aqua Virgo. Engraving by Piranesi, based on the upper part of the arch, all that was visible in his day

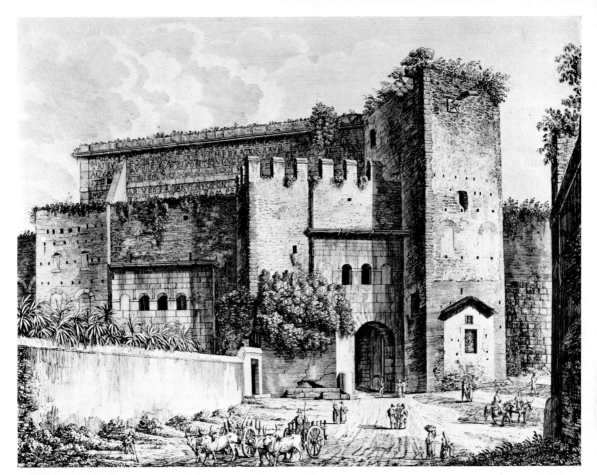

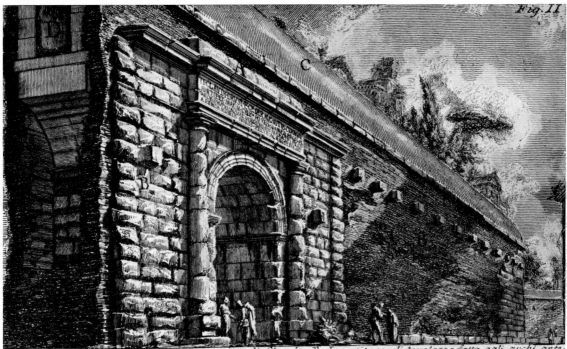

Condotto dell' acqua vergine. A Monumento di Claudio. B Investitura di tevolozza fatta agli archi antecedenti e susseguenti allo stesso monumento. C Nuova forma dell' aquedotto innalzata dai moderni cinque palmi dallo speco antico D Questo condotto rimane in oggi interrato a livello de capitelli del monumento.

Piranesi Archit. dis. inc.

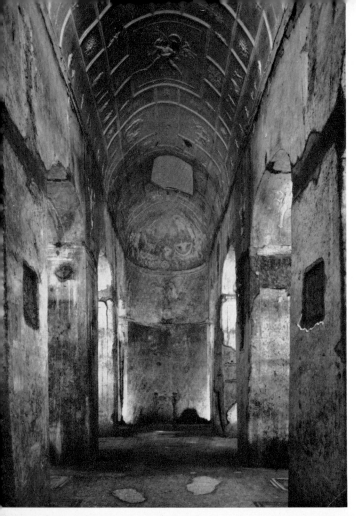

118. Rome, Underground Basilica beside the Via Praenestina, mid first century A.D. The stucco decoration (*below*) suggests that it was the meeting place of a Neo-Pythagorean sect

119. Pompeii, Forum Baths, stucco decoration of vaulting

120. Rome, Porta Tiburtina. Arch, 5 B.C., carrying the Aqua Marcia across the Via Tiburtina, later incorporated as a gateway into the Aurelianic Walls (A.D. 270–82)

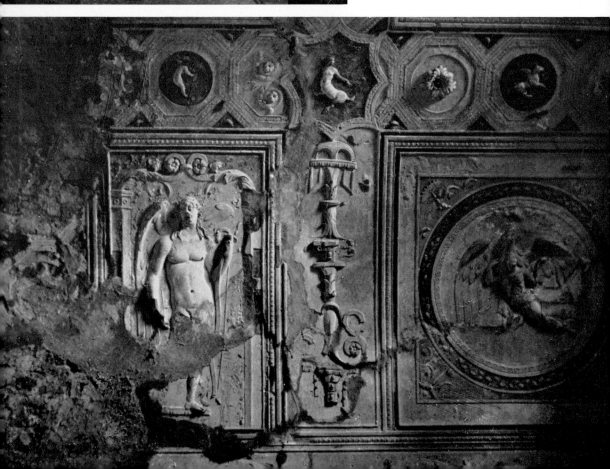

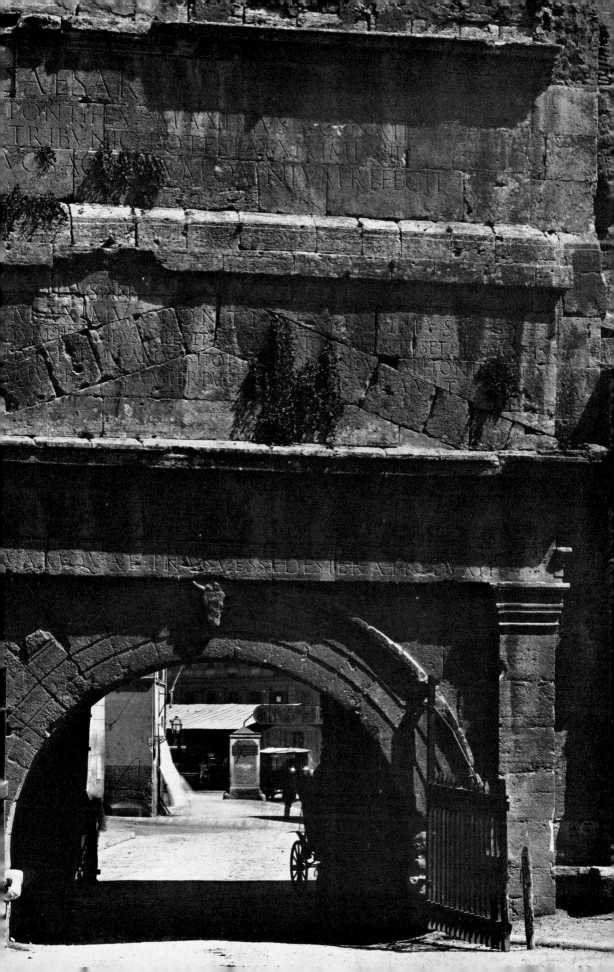

121. Rome, Amphitheatrum Flavium (Colosseum), inaugurated in 80 (cf. Figure 93)

122. Rome, Temple of the Deified Claudius (Claudianum), completed by Vespasian after 70. The rusticated travertine upper arcades of the west façade of the temple terrace (cf. Figure 91)

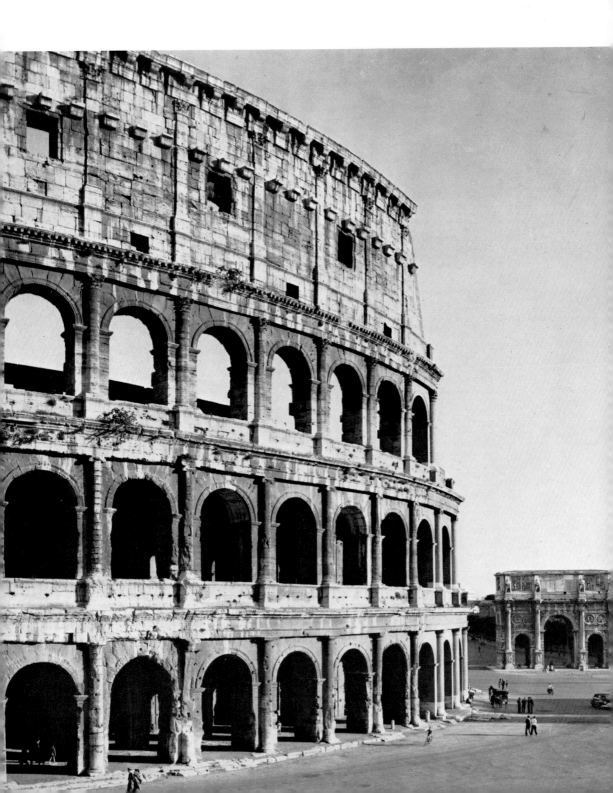

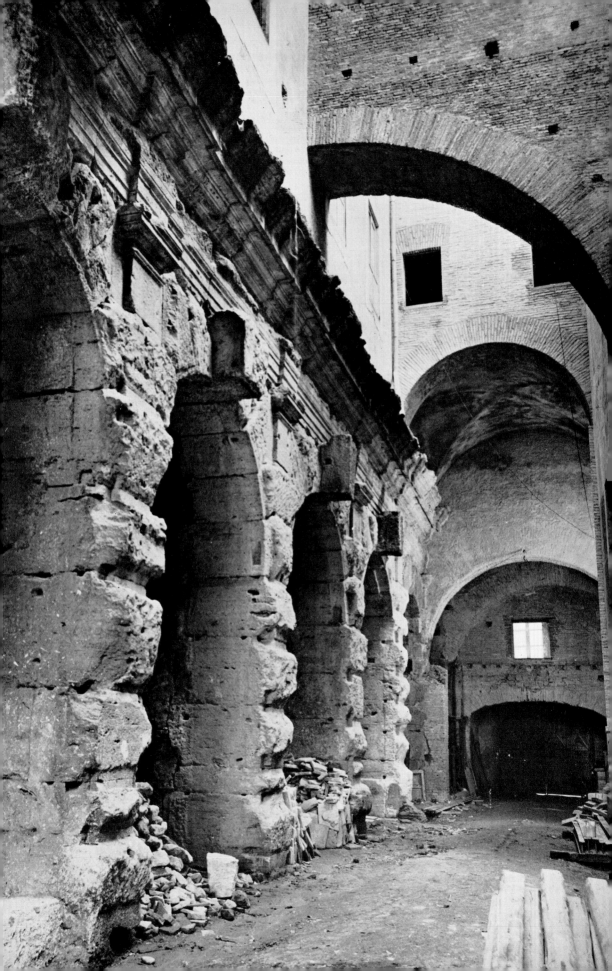

123. Rome, Flavian Palace (Domus Augustana), inaugurated in 92. The courtyard of the domestic wing (cf. Figure 95)

124. Rome, Temple of Venus Genetrix, rebuilt by Trajan and dedicated in 113. Marble cornice block from the pediment

125. Rome, Tomb of Annia Regilla, third quarter of the second century. Detail of moulded brick entablature (cf. Plate 146)

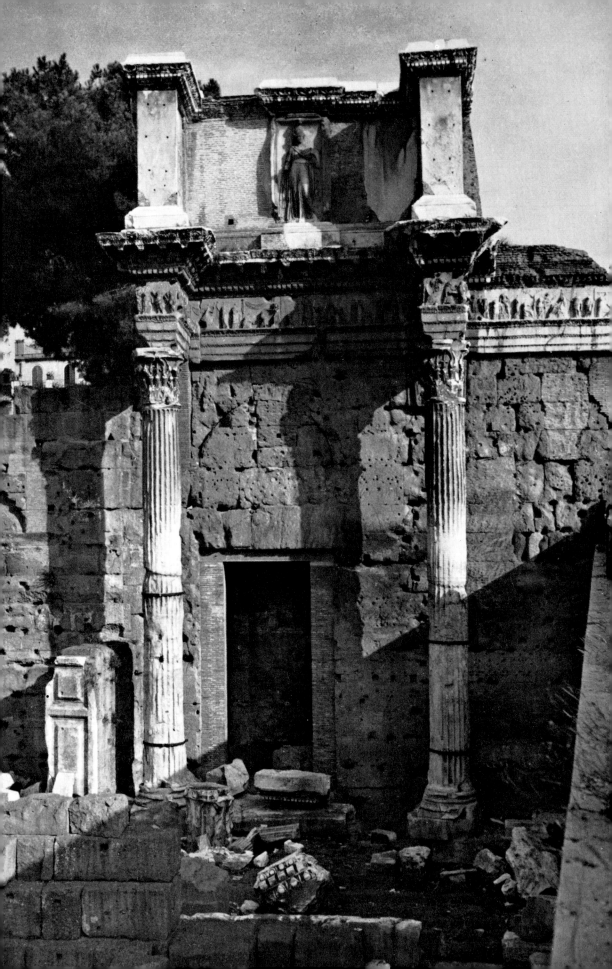

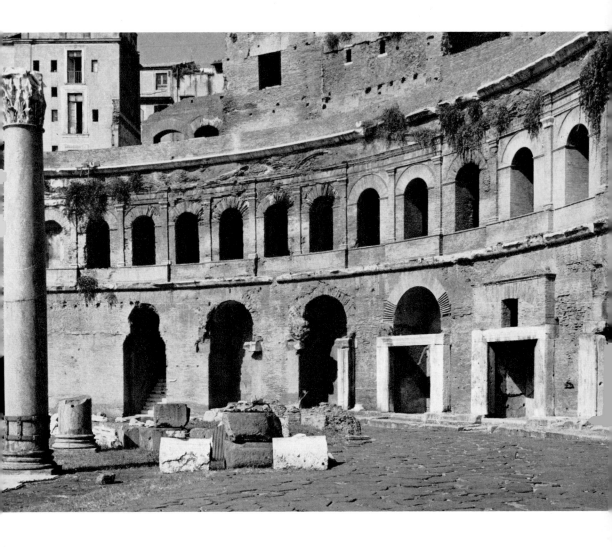

126. Rome, Forum Transitorium (Forum of Nerva), dedicated in 97. 'Le Colonnacce', part of the decorative façade towards the Templum Pacis

127. Rome, Trajan's Market, c. 100–12, façade of the lower hemicycle (cf. Figure 96). The pair of columns marks the entrance to the corresponding hemicycle of the forum

128. Rome, Trajan's Market, *c.* 100–12. The former Via Biberatica, with shops at ground level and, above them (*left*), the façade of the market hall (cf. Figure 97)

129. Rome, Trajan's Market, *c.* 100–12. Interior of the market hall (cf. Figure 97)

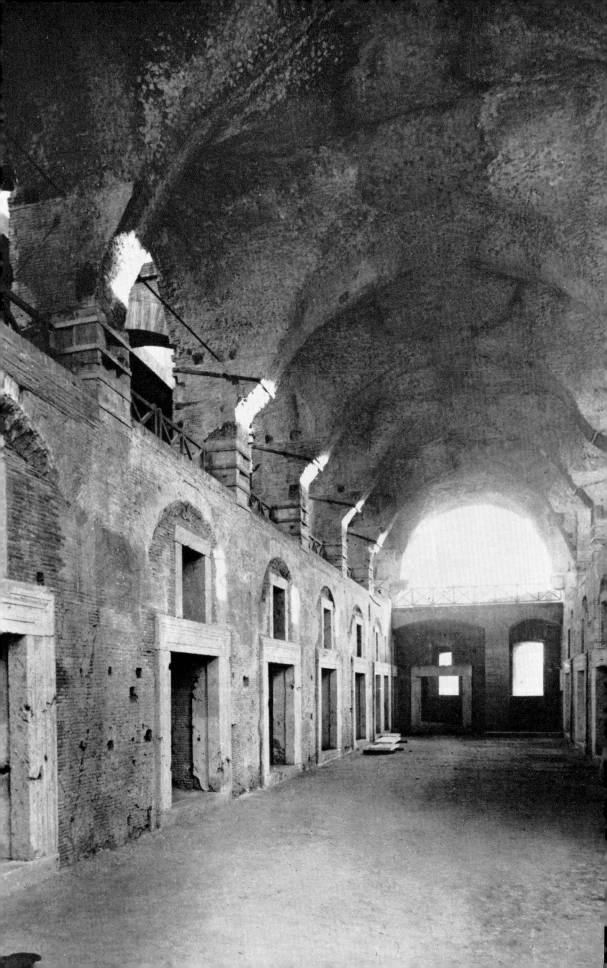

130. Rome, Nero's Golden House, 64–8. Octagonal fountain hall (cf. Figure 98)

131. Rome, Pantheon, *c.* 118–*c.* 128, façade (cf. Figure 101)

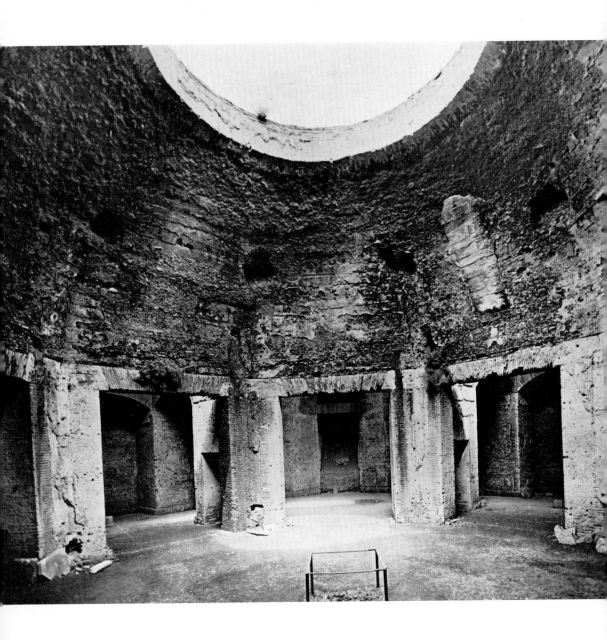

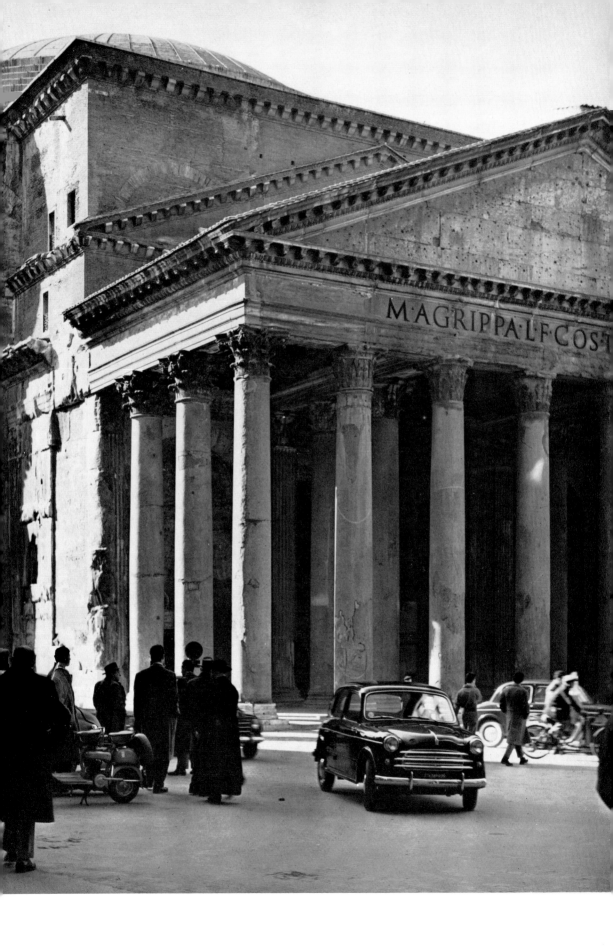

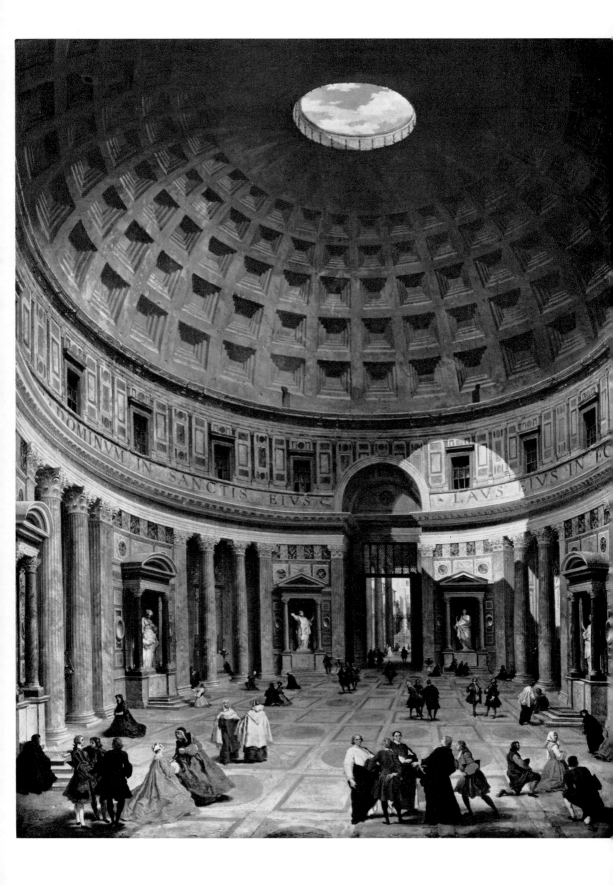

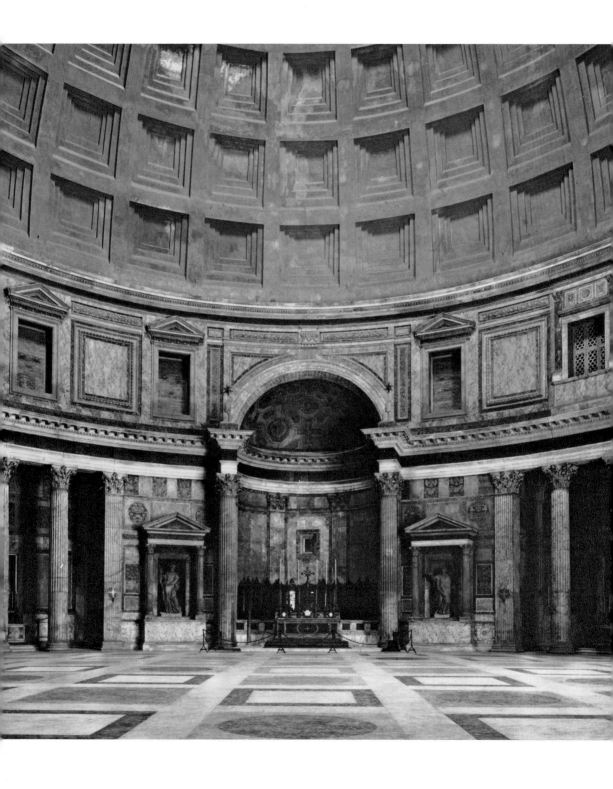

132. Rome, Pantheon, *c.* 118–*c.* 128, interior (after Panini)

133. Rome, Pantheon, *c.* 118–*c.* 128, interior

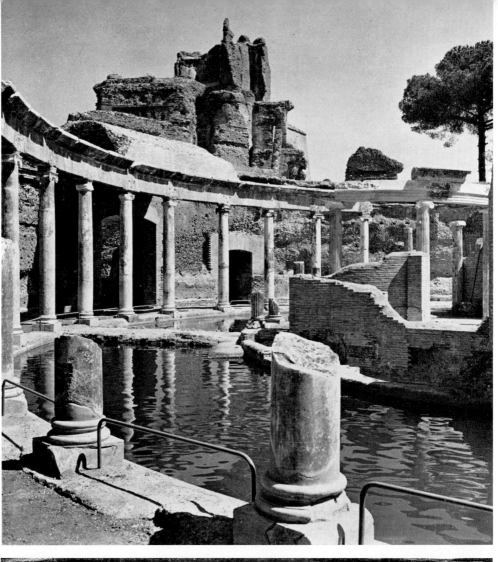

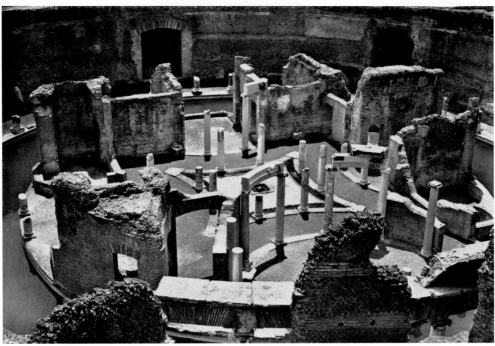

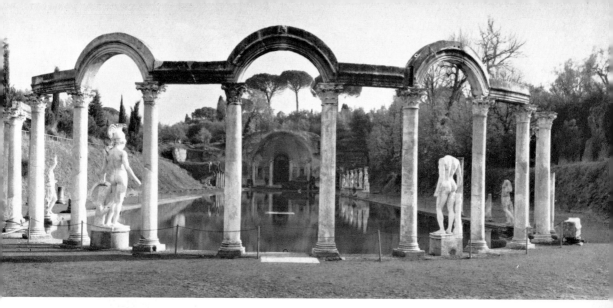

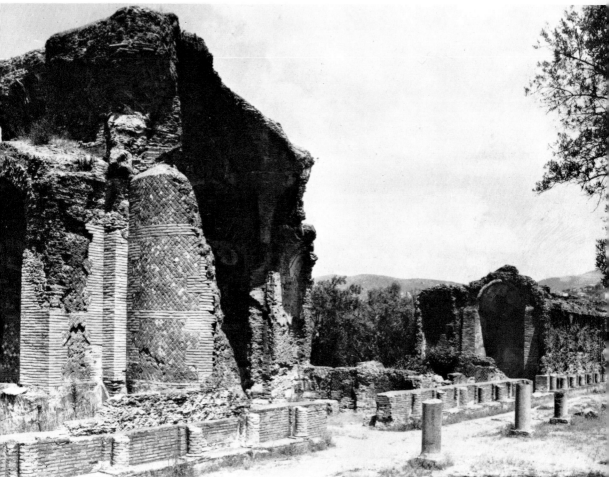

134 and 135 (*opposite*). Tivoli, Hadrian's Villa. The island villa ('Teatro Marittimo'), 118–25 (cf. Figure 100A)

136. Tivoli, Hadrian's Villa. The Canopus, after 130 (cf. Figure 100B)

137. Tivoli, Hadrian's Villa. Vestibule to the Piazza d'Oro, after 125

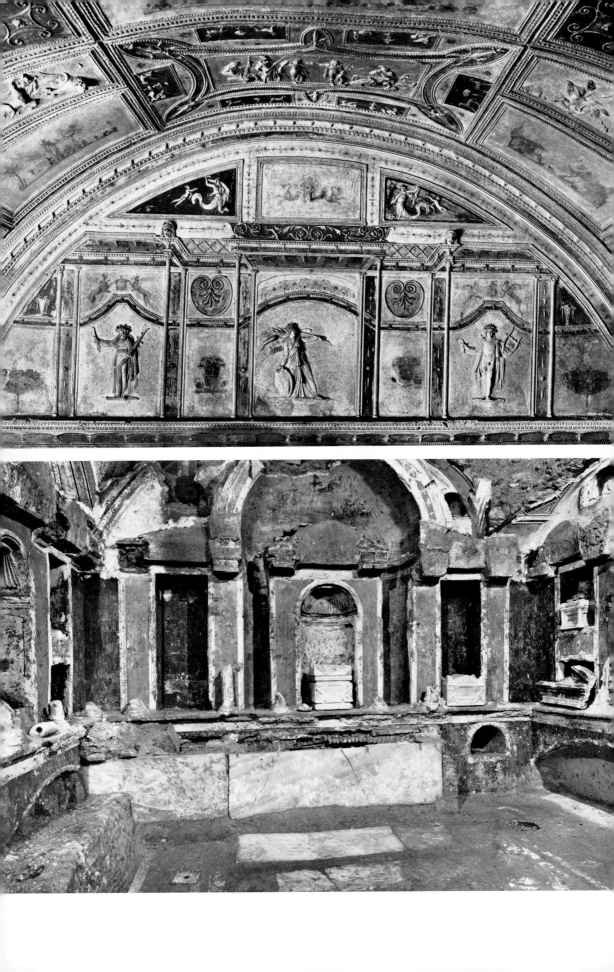

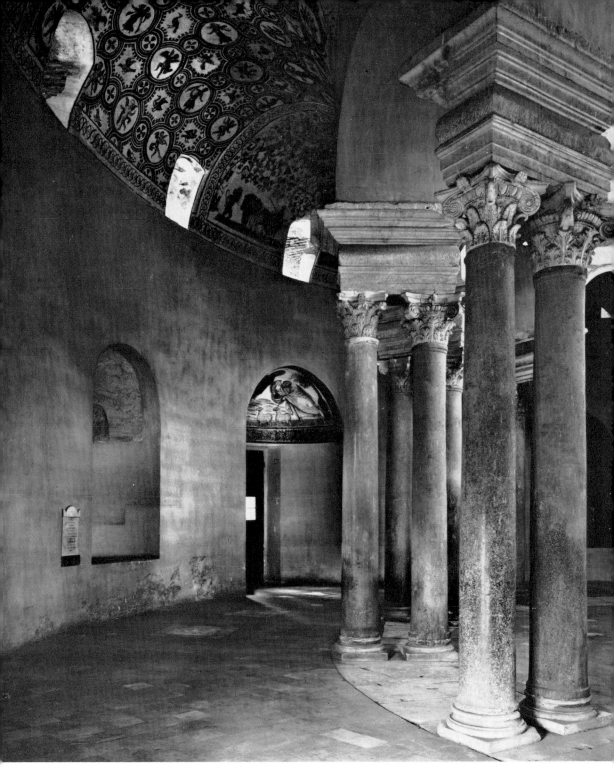

138 (*opposite, above*). Rome, Via Latina, painted stucco vaulting in the Mausoleum of the Anicii, second century

139 (*opposite, below*). Rome, Vatican cemetery, Tomb of the Caetennii, mid second century, interior (cf. Figure 105)

140. Rome, Mausoleum of Constantina ('Santa Costanza'), second quarter of the fourth century, showing the surviving mosaics of the ambulatory vault

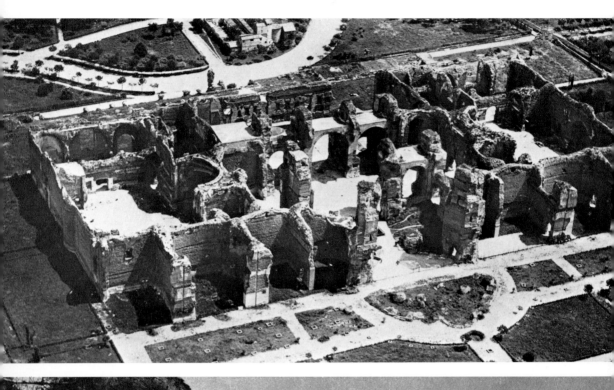

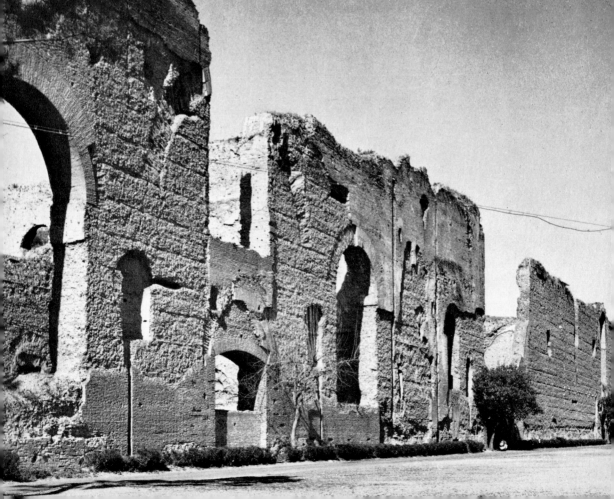

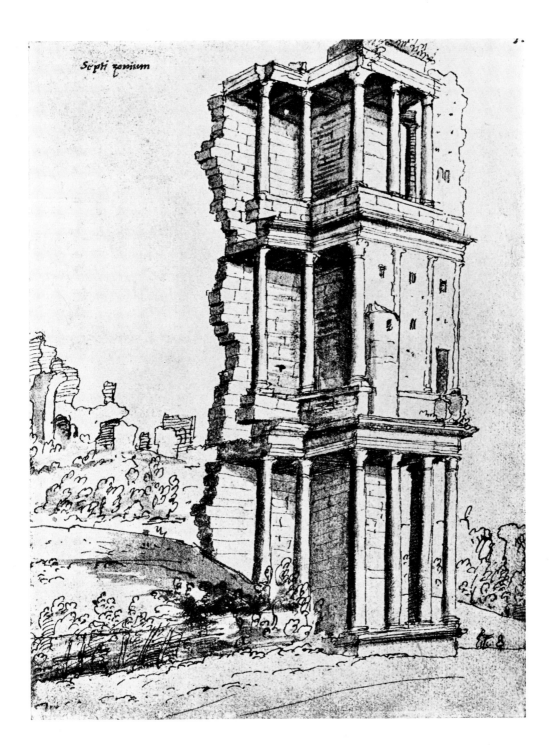

Septizonium

141. Rome, Baths of Caracalla, 212–16 (cf. Figure 104)

142. Rome, Baths of Caracalla, 212–16, north façade of the central block

143. Rome, Septizodium, dedicated in 203. Drawn by Martin van Heemskerk between 1532 and 1536

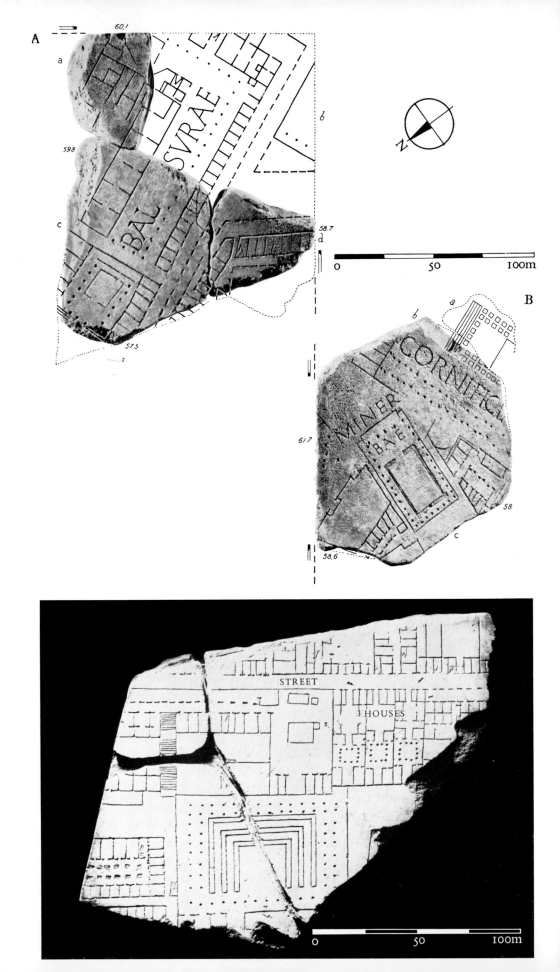

A

a

c

d

b

SVRAE

BAL

598

575

58.7

N

0 50 100m

B

b

a

c

CORNIFICI

MINER

BAE

617

58

58.6

STREET

3 HOUSES

0 50 100m

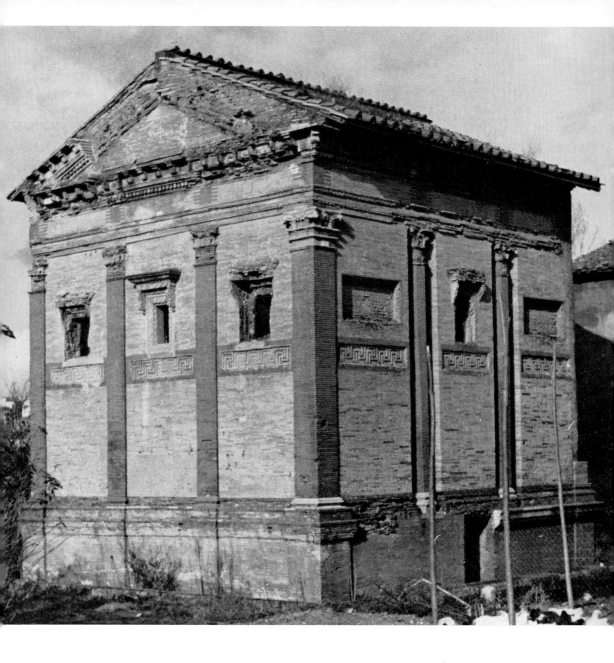

144. Fragment of the Severan Marble Map of Rome, showing part of the Aventine Hill with the Temples of Diana Cornificia, restored under Augustus, and of Minerva

145. Fragment of the Severan Marble Map of Rome, showing three old-style atrium–peristyle houses, rows of shops and street-front porticoes, a flight of steps leading up to a pillared hall (warehouse?) with internal shops or offices, and a porticoed enclosure with a central garden

146. Rome, Via Appia, Tomb of Annia Regilla, wife of Herodes Atticus, third quarter of the second century (cf. Plate 125)

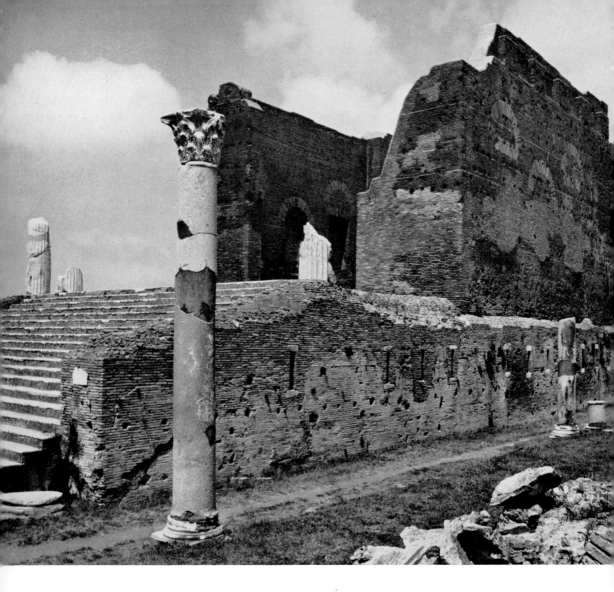

147. Ostia, Capitolium, *c.* 120. Originally faced throughout with marble, the brickwork structure illustrates the use of 'bonding courses' of tiles and of relieving arches over the internal recesses of the cella

148. Ostia, House of Diana, mid second century. South façade, with shops along the street frontage and stairs leading to the upper storeys (cf. Figure 130C)

149. Ostia, House of the Triple Windows, third quarter of the second century

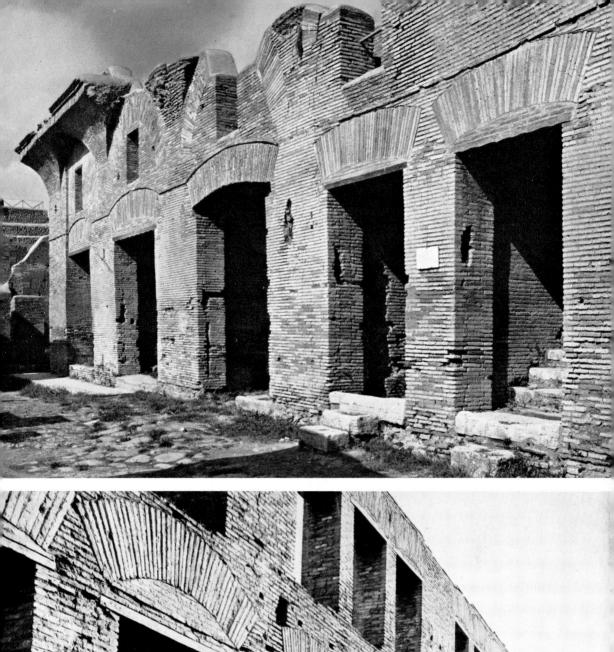

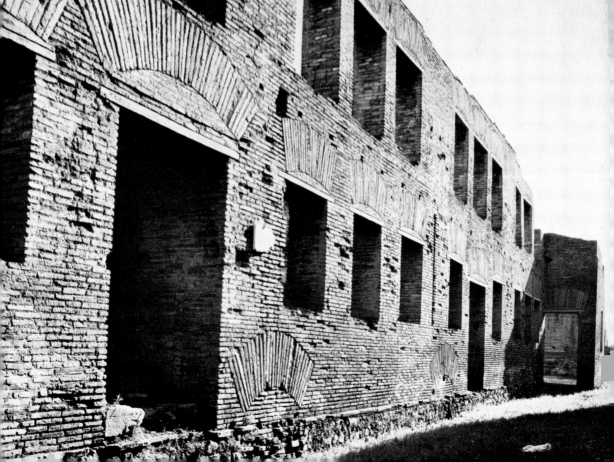

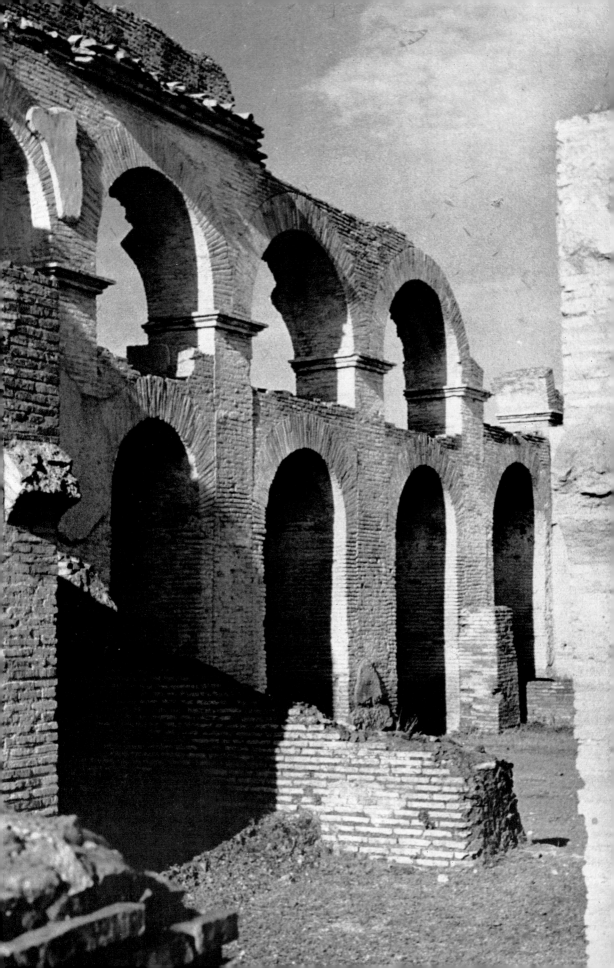

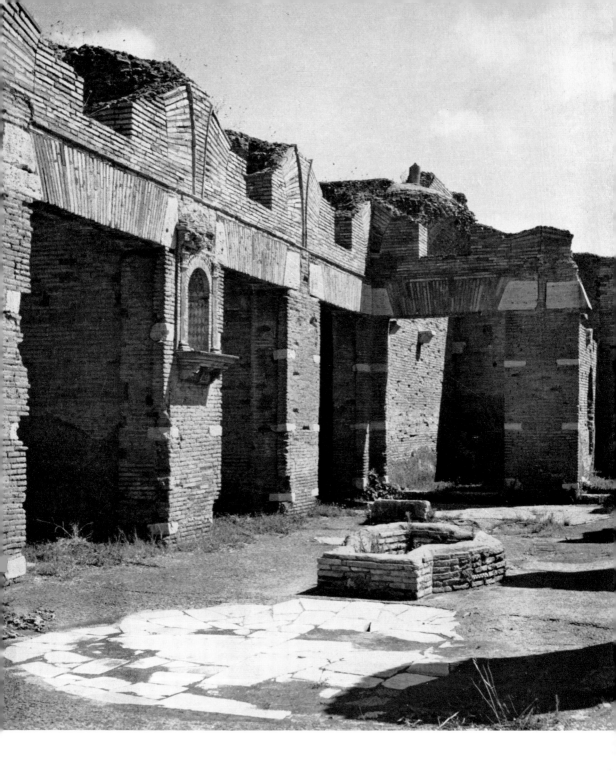

150. Ostia, House of the Charioteers, shortly before 150. Central courtyard

151. Ostia, 'House of the Lararium', second quarter of the second century. The ground floor was organized as a market building, with shops opening off the central courtyard. It takes its name from the small domestic shrine (*lararium*) visible centre left, opposite the main entrance

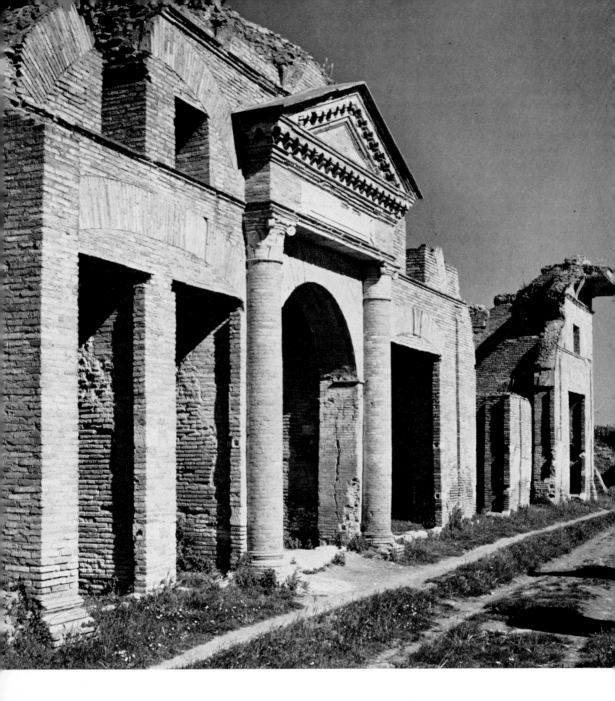

152. Ostia, Horrea Epagathiana, *c.* 145–50. West façade, showing the main entrance, stairs to the upper storeys (*foreground*), and, beyond the entrance, four shops (cf. Figure 109B)

153. Ostia, south-western decumanus, looking towards the Porta Marina, showing a streetside portico and fountain fronting a block of shops with staircases leading to the upper storeys. Second quarter of the second century

154. Ostia, row of shops (Regio IX, insula 15), mid second century

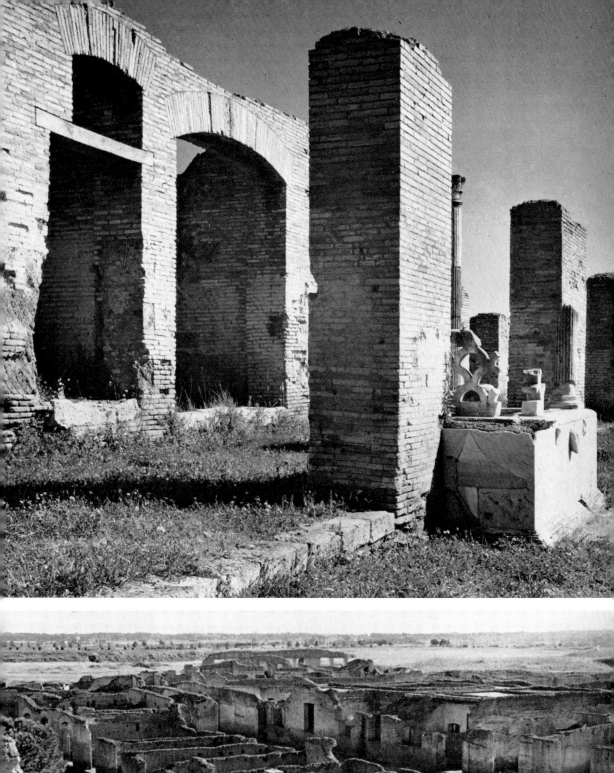

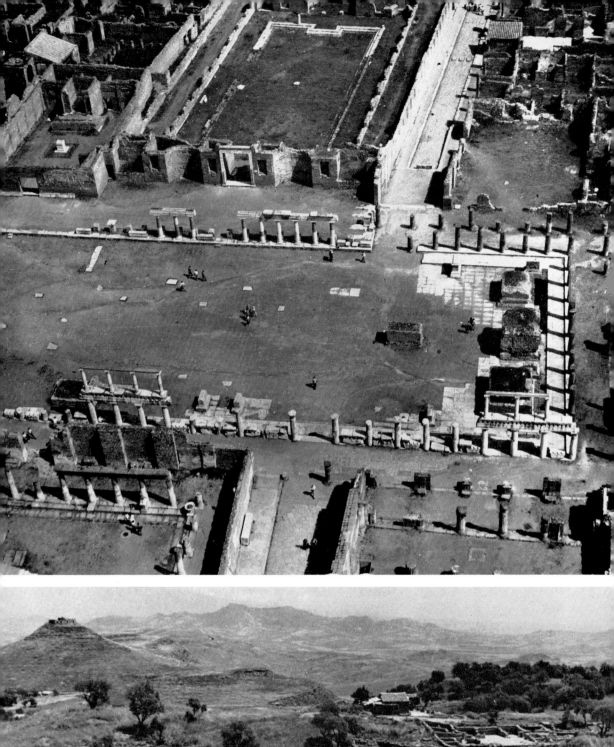

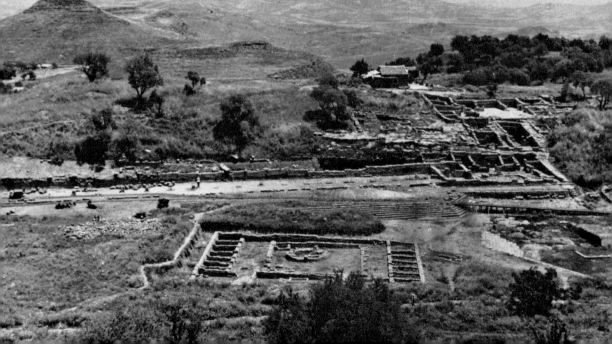

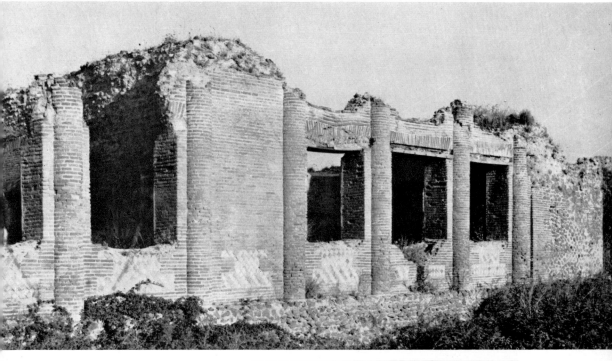

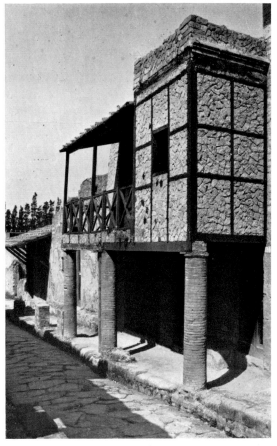

155. Pompeii, south end of the forum, looking across to the Building of Eumachia (cf. Figure 112). The whole area was still under reconstruction in 79 after the earthquake of 62

156. Morgantina, market building, second century B.C.

157. Pompeii, Central Baths, façade of the main wing, 63–79 (cf. Figure 113)

158. Herculaneum, streetside portico with timber-framed superstructure, before 79

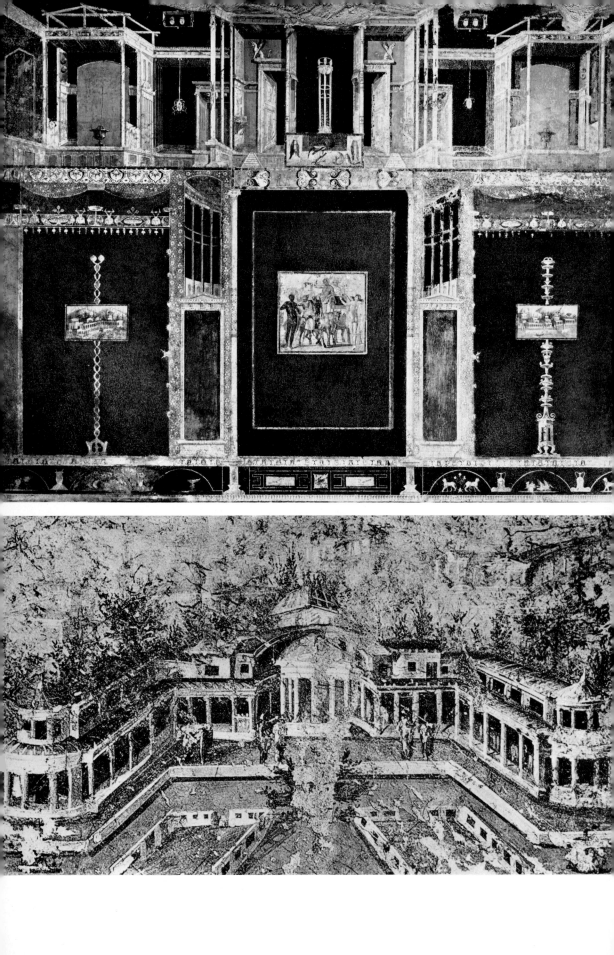

159. Pompeii, 'Third Style' architectural wall paintings in the House of Lucretius Fronto, mid first century. Note the views of seaside villas in the two lateral panel pictures

160. Pompeii, painting of a seaside villa with projecting wings and porticoed façade from the House of Lucretius Fronto, mid first century

161. Baiae, 'Temple of Venus', second quarter of the second century. The interior was faced with marble up to the base of the windows and with mosaic from that point upwards

162. Susa, Arch of Augustus, 9–8 B.C.

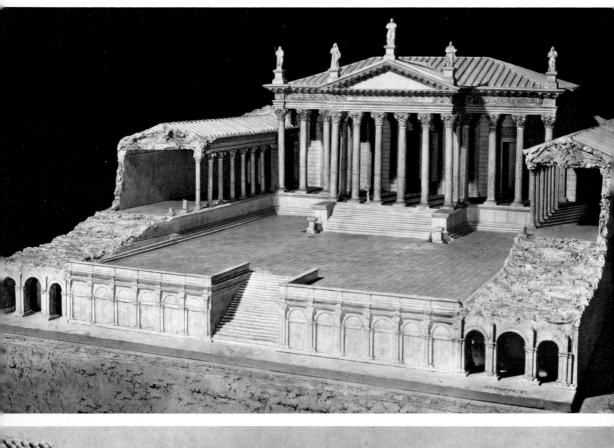

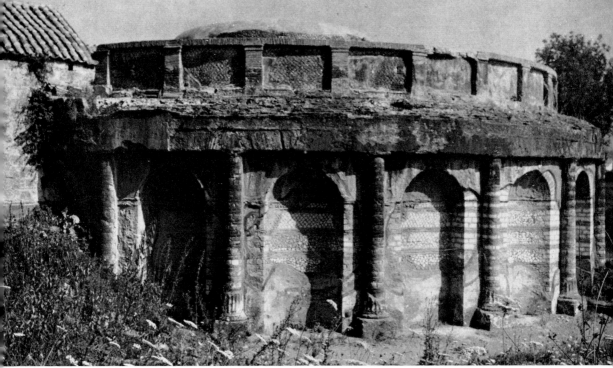

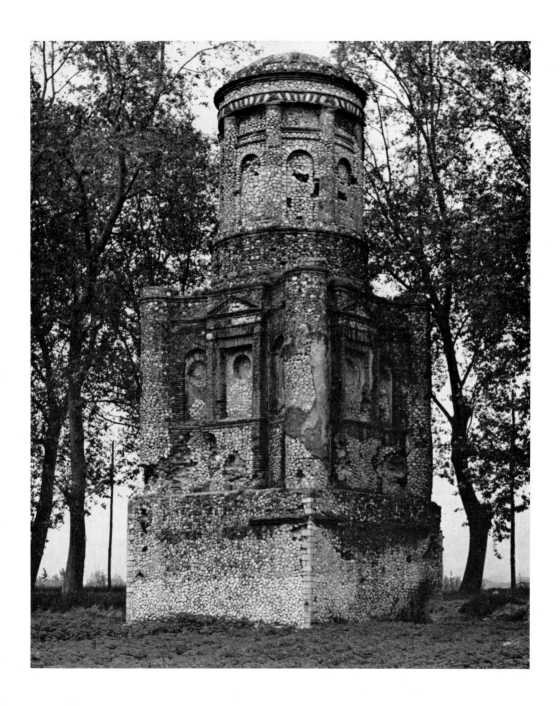

163. Brescia (Brixia), model of the Capitolium, third quarter of the first century

164. Santa Maria Capua Vetere (Capua), mausoleum ('Le Carceri Vecchie') beside the Via Appia, probably first half of the second century

165. Santa Maria Capua Vetere (Capua), mausoleum ('La Connocchia') beside the Via Appia, second half of the second century

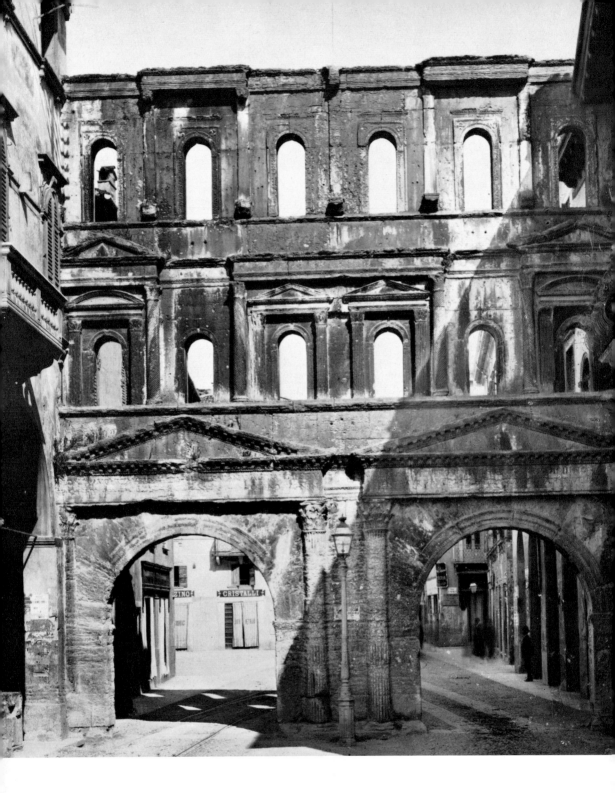

166. Verona, Porta dei Borsari, one of the city gates, formerly flanked by projecting towers, probably third quarter of the first century

167. Velleia, forum and basilica, early first century, from the air. In the left foreground the amphitheatre (cf. Figure 118)

168. Rimini (Ariminum), bridge, 22

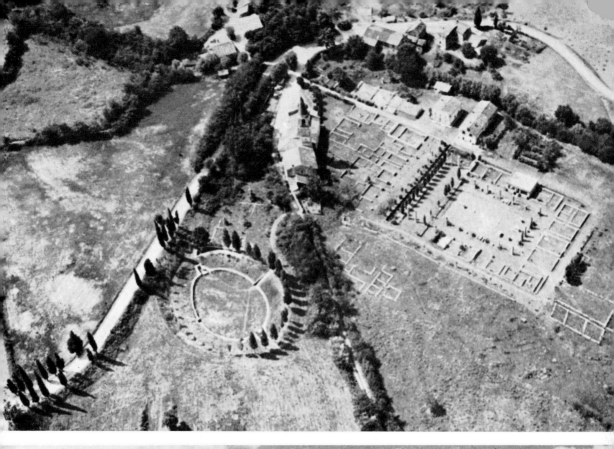

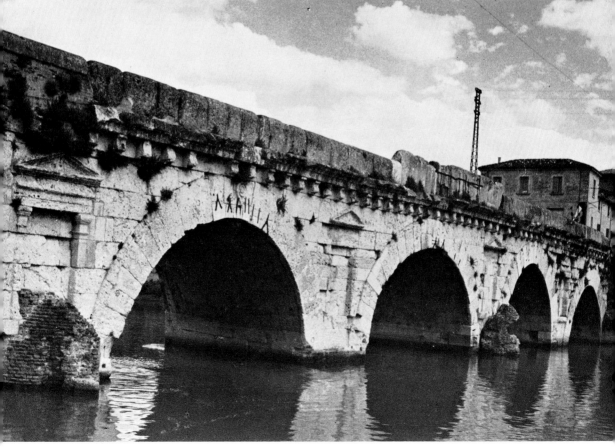

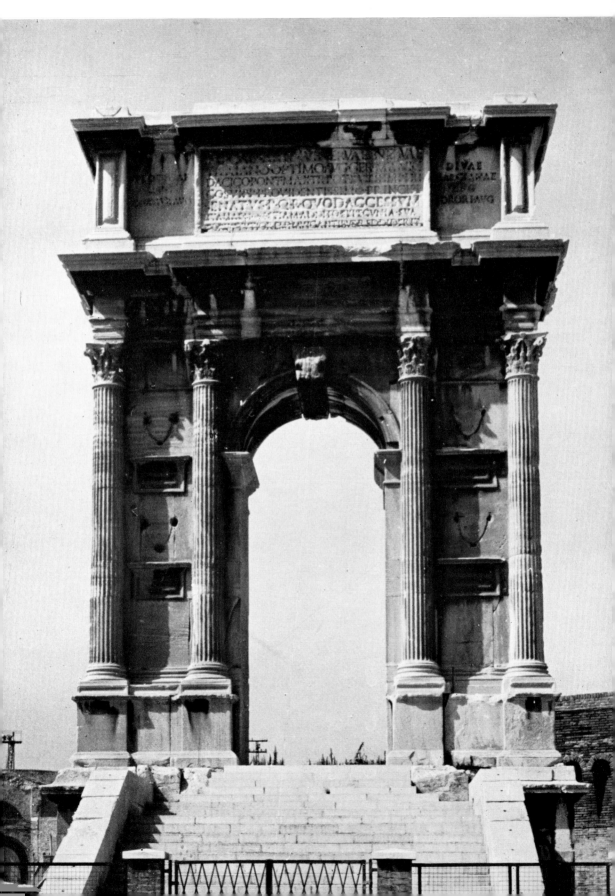

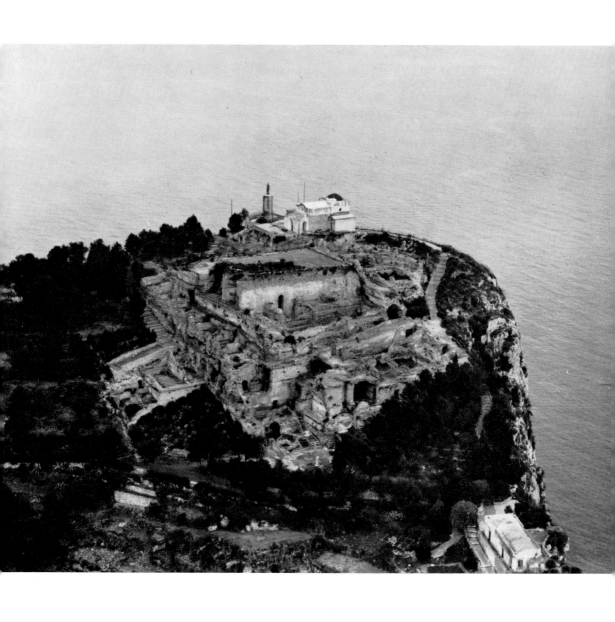

169. Ancona, Arch of Trajan, 115

170. Capri, Villa Jovis, the private, mountain-top retreat built by the emperor Tiberius (14–37)
(cf. Figure 126)

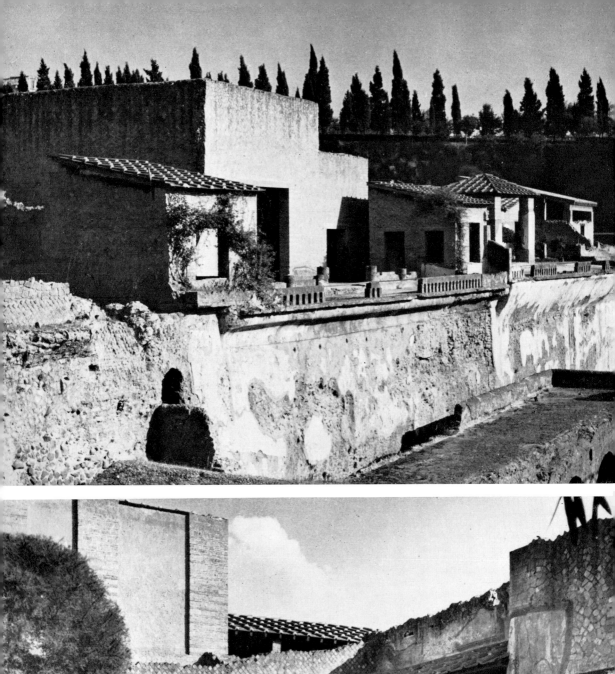

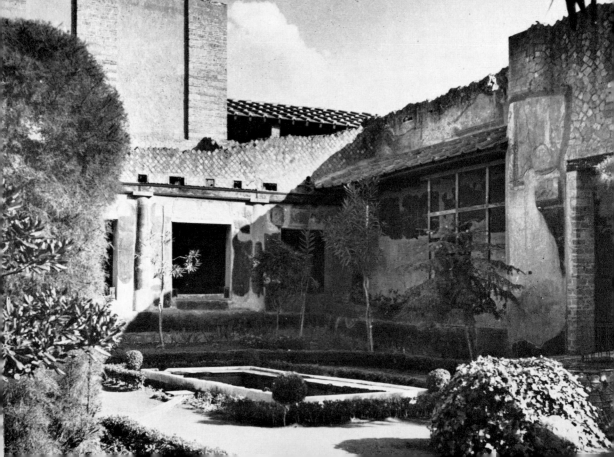

171. Herculaneum, the southern garden verandas of the House of the Stags and the House of the Mosaic Atrium, terraced out over the old city wall, shortly before 79 (cf. Figure 120)

172. Herculaneum, House of the Mosaic Atrium, the internal courtyard, showing on the right the glass-fronted passageway, shortly before 79

173. Pompeii, House of Loreius Tiburtinus, 62–79. View from the house down the axis of the formal garden (cf. Figure 121)

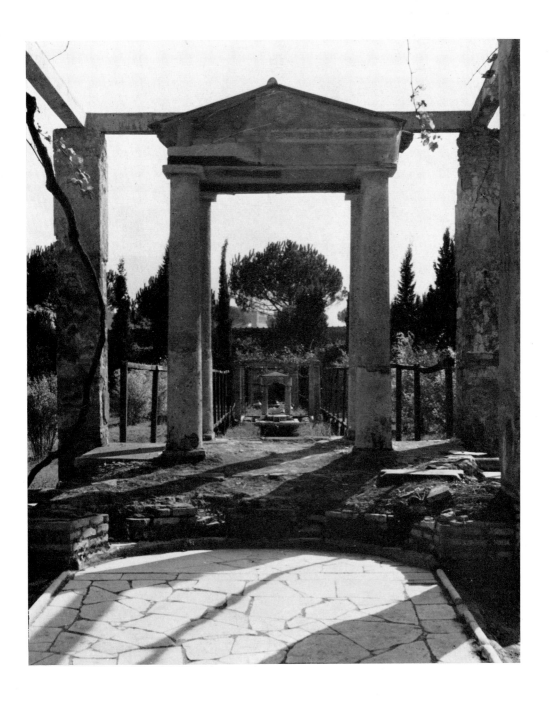

174. Tivoli, Hadrian's Villa, between 118 and 134, model (cf. Figure 127)

175. Rome, Via Latina, Villa of Sette Bassi, *c.* 140–60, façade (cf. Figure 129)

176. Ostia, House of Cupid and Psyche, *c.* 300, looking towards the corridor and fountain court (cf. Figure 130B)

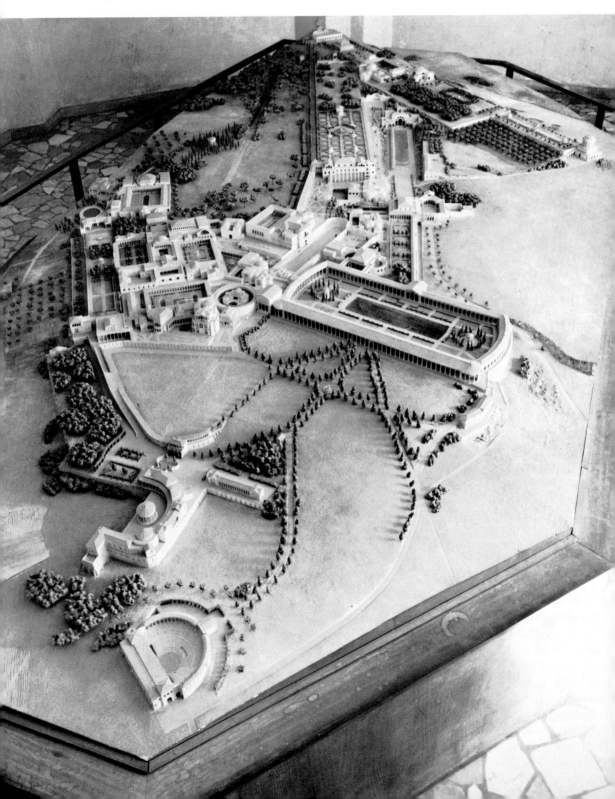

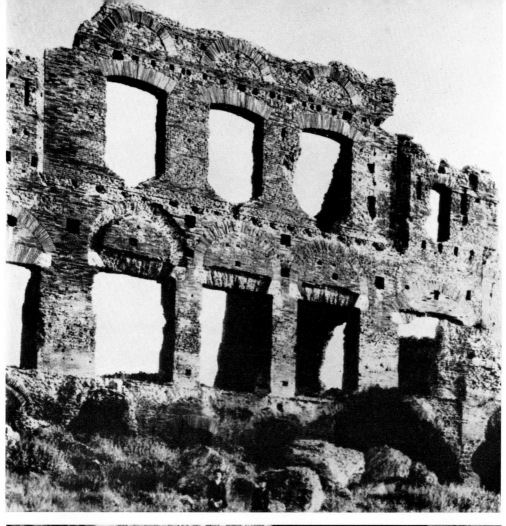

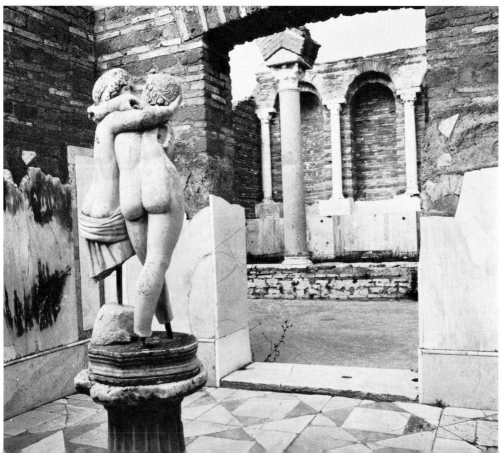

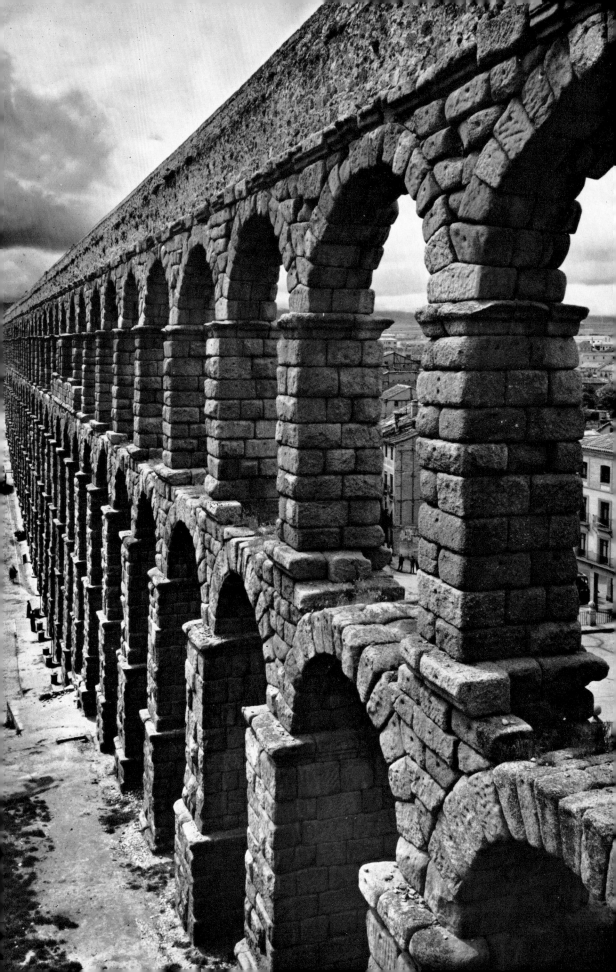

177. Segovia, aqueduct, variously dated to the early first and to the early second century. It still carries the city's water supply

178. Alcántara, bridge over the Tagus, 106

179. Pont du Gard, carrying the aqueduct of Nîmes over the river Gardon, late first century B.C. The bridge is 160 ft (49 m.) high

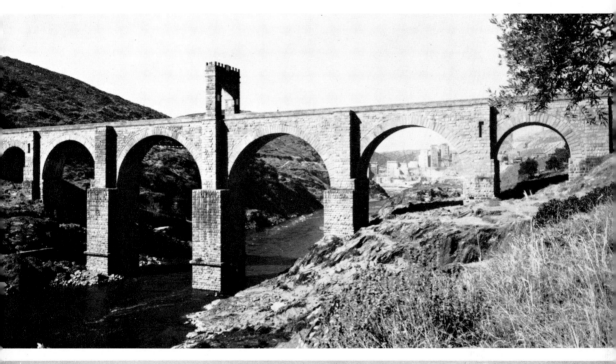

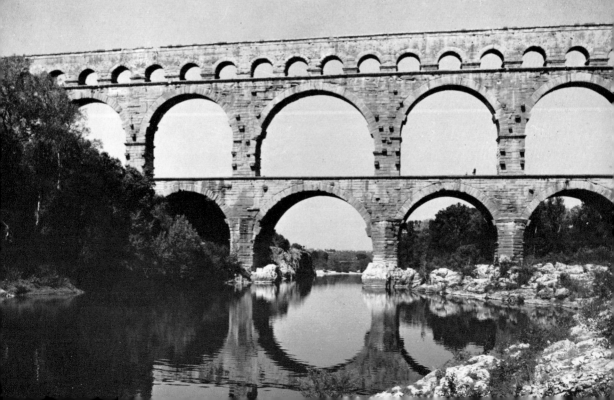

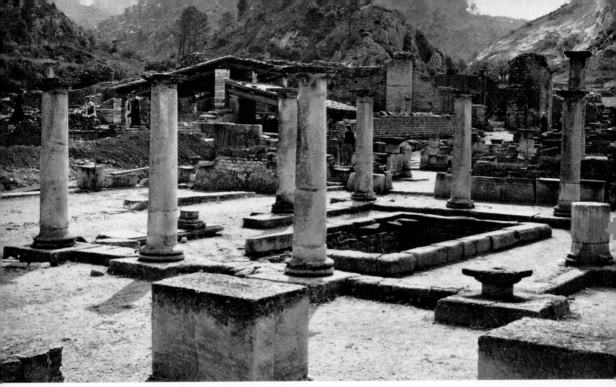

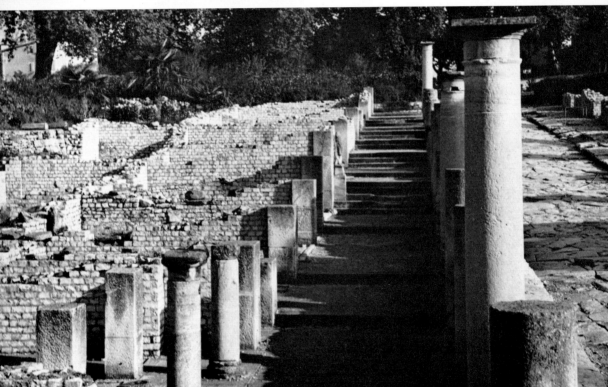

180. Saint Rémy (Glanum), courtyard house, first half of the first century

181. Vaison-la-Romaine (Vasio), street and streetside portico, later first century. On the left the entrance to the House of the Silver Bust (cf. Figure 136) and, beyond it, a row of shops

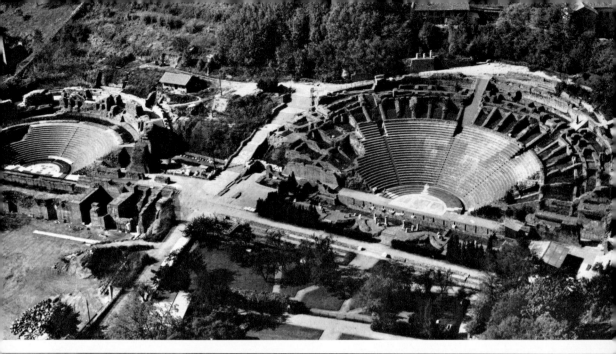

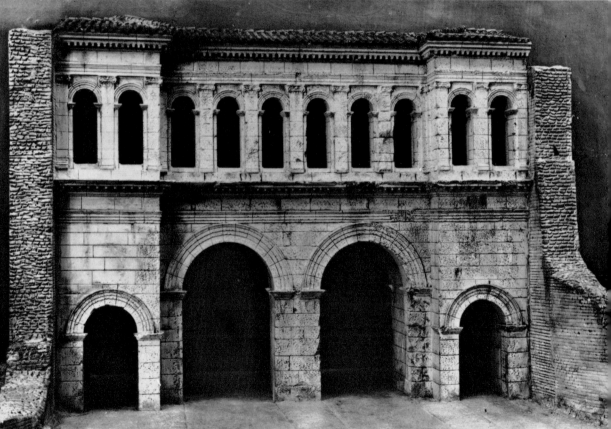

182. Lyon (Lugdunum), theatre and odeion, or hall for concerts and recitations. Both are Hadrianic (117–38), the former enlarging and embellishing a building of the end of the first century B.C.

183. Autun (Augustodunum), model of the Porte Saint-André, after 16 B.C. The gateway was flanked by semicircular, projecting towers

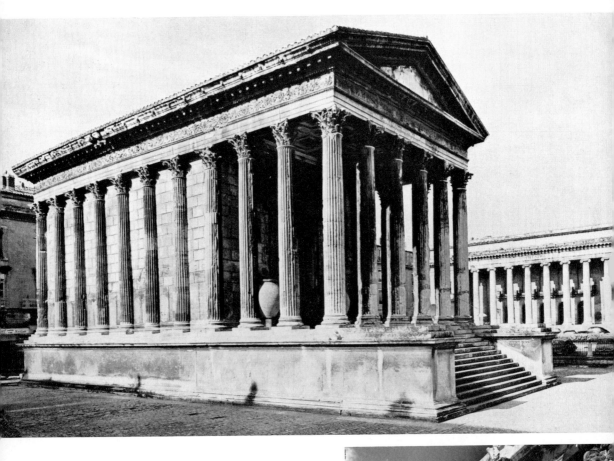

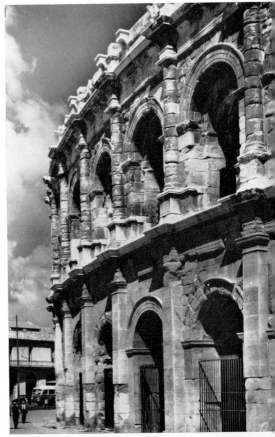

184. Nîmes (Nemausus), Maison Carrée,
begun *c.* 19 B.C.

185. Nîmes (Nemausus), amphitheatre,
second half of the first century A.D.

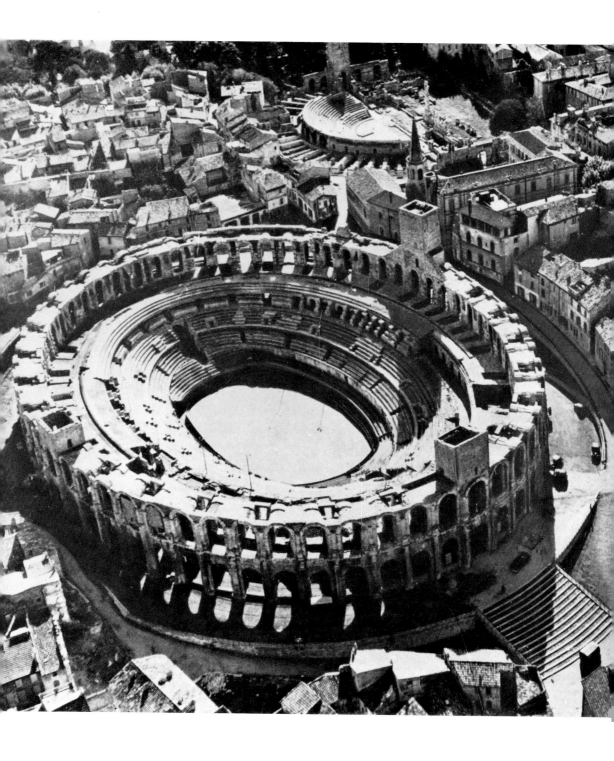

186. Arles (Arelate), amphitheatre, second half of the first century A.D. Beyond it lies the theatre

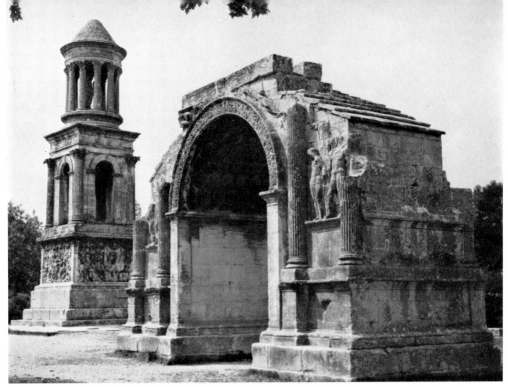

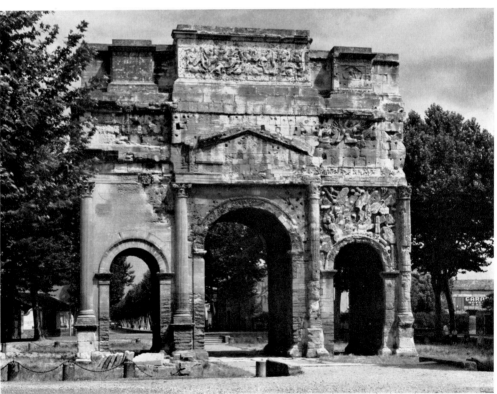

187. Saint Rémy (Glanum), arch and monument of the Julii, second half of the first century B.C.

188. Orange (Arausio), monumental arch, built shortly after 21

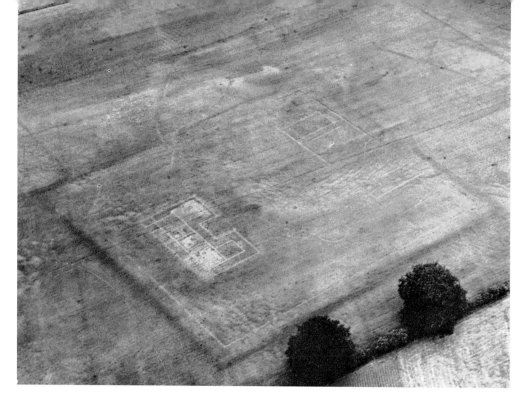

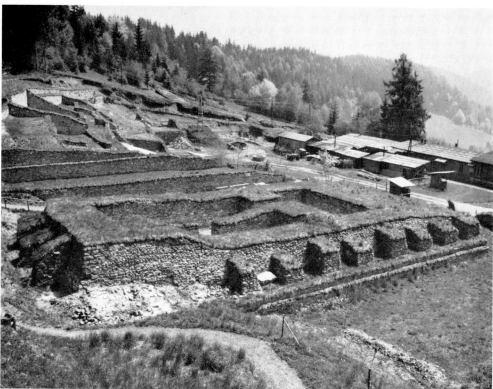

189. Ditchley, Roman villa and its dependencies revealed by air photography. *c.* 100

190. Magdalensberg, unfinished temple of Claudius and part of the forum. The site was abandoned in 45 in favour of Virunum on the plain below

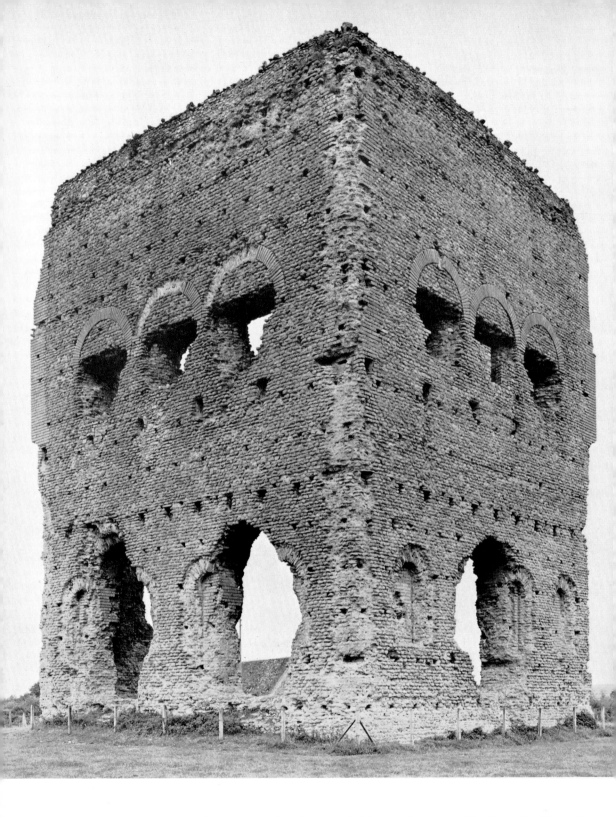

191. Autun (Augustodunum), temple of square Celtic type known as 'the Temple of Janus', second century

192. Athens, capital from the Odeion of Agrippa, c. 15 B.C.

193. Eleusis, capital from the Inner Propylaea, c. 50–40 B.C.

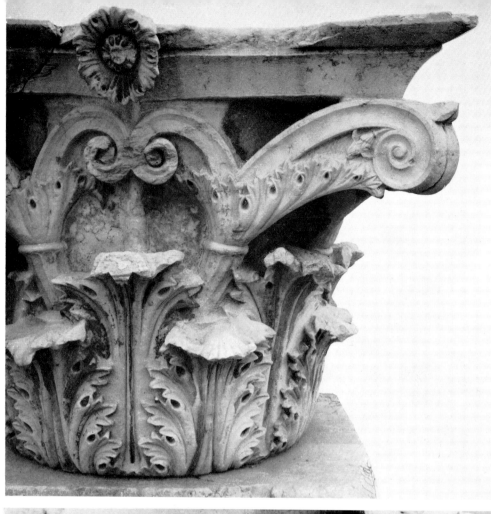

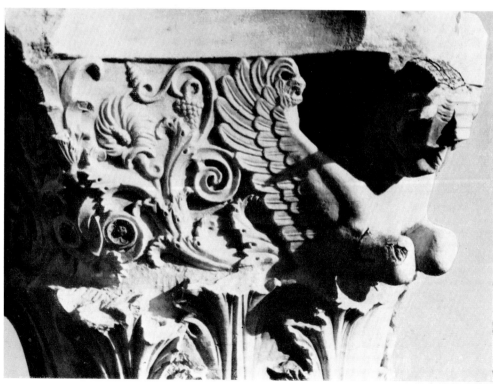

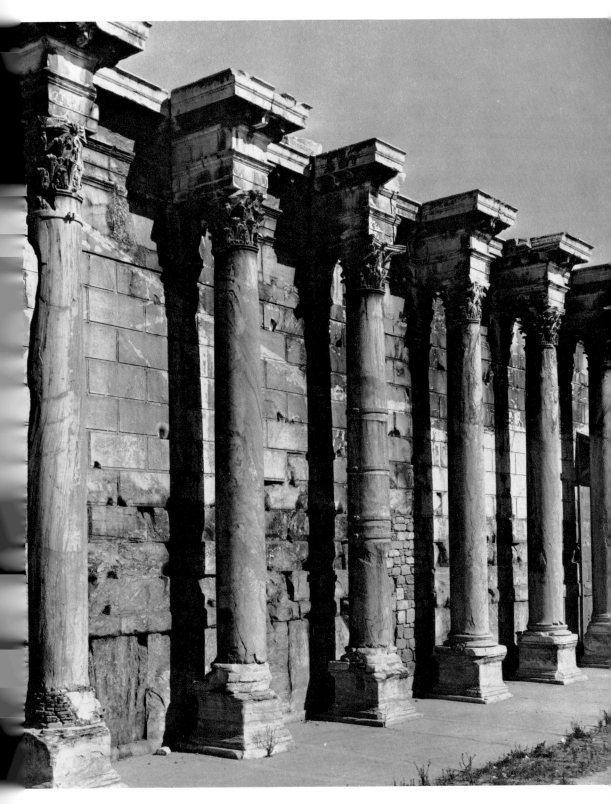

194. Athens, part of the façade of the Library of Hadrian (117–38)

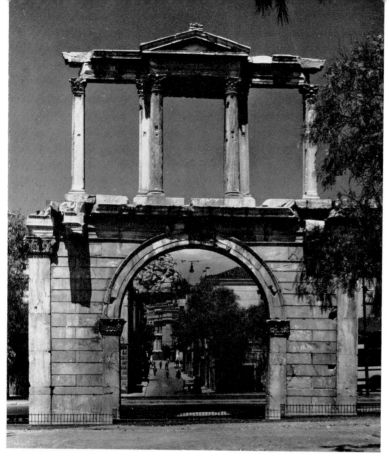

195. Athens, Arch of Hadrian, probably erected shortly after his death in 138

196. Lepcis Magna, north-east forum portico, early third century

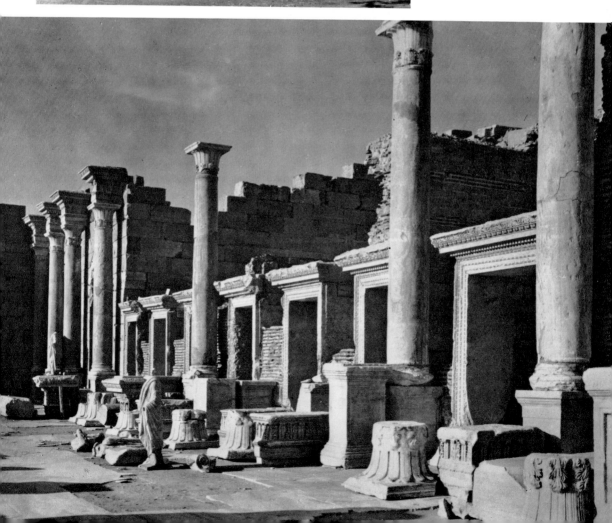

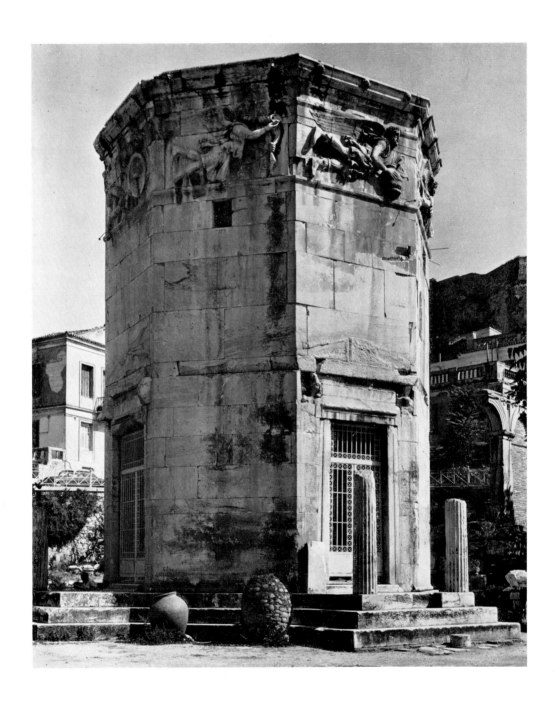

197. Athens, Tower of the Winds, towards the middle of the first century B.C.

198. Ephesus, Baths of Vedius, mid second century. Detail of the coursed rubble masonry, showing the core and the typical facing of small squared blocks

199. Miletus, Baths of Capito, mid first century. A coarser version of the masonry shown in Plate 198, with massive stone details and vaulting carried out in smaller stones. The shape of this dome was visible externally beneath a rendering of waterproof concrete

200. Aspendos, pitched brick vaulting in the substructures of the basilica, end of the third century

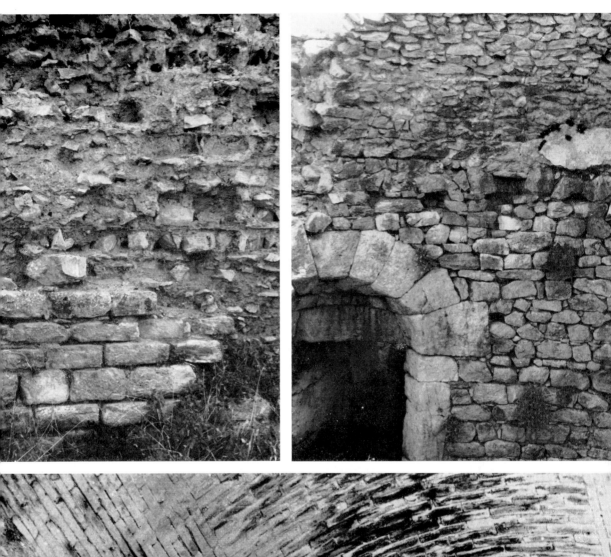

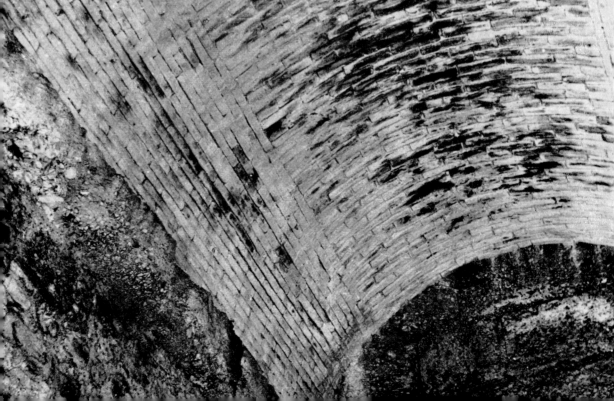

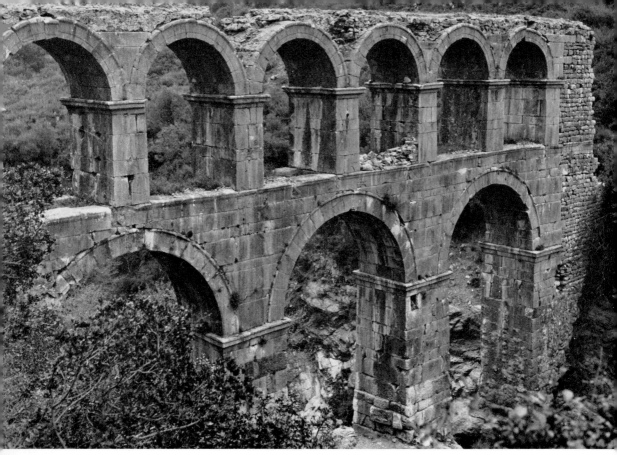

201. Ephesus, aqueduct of Pollio, between 4 and 14

202. Nicaea (Iznik), city walls, between 258 and 269. Tower, of brickwork, and (*right*) curtain wall of alternate bands of brickwork and rubble masonry

203. Ancyra (Ankara), Temple of Rome and Augustus (*temp.* Augustus, 27 B.C.–A.D. 14)

204. Aizani, Temple of Zeus, completed *c.* 125

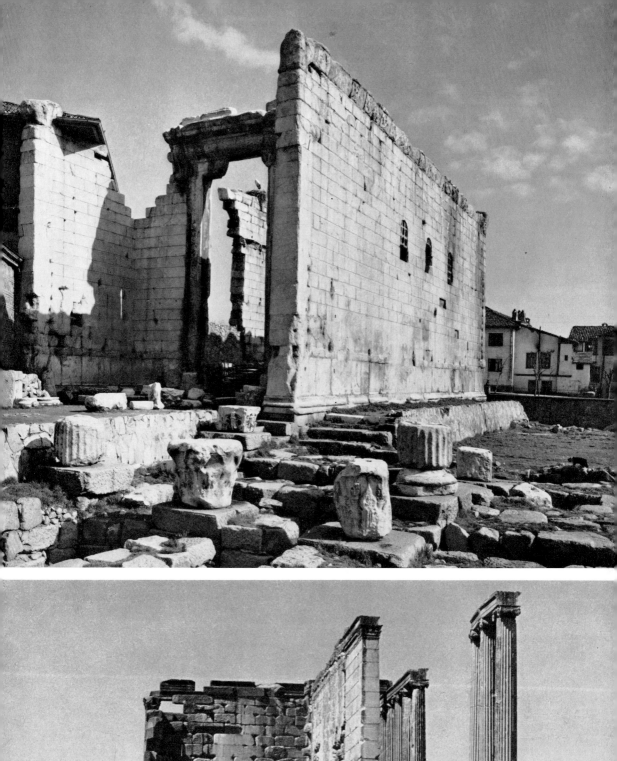
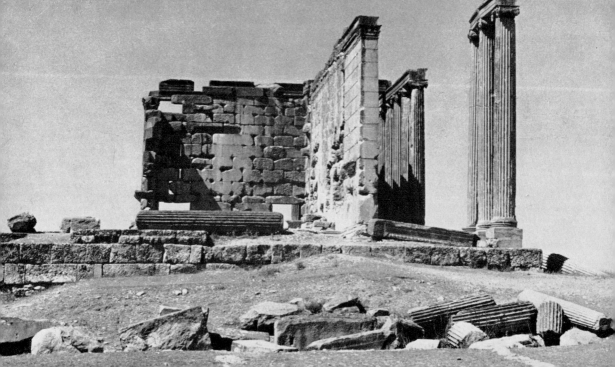

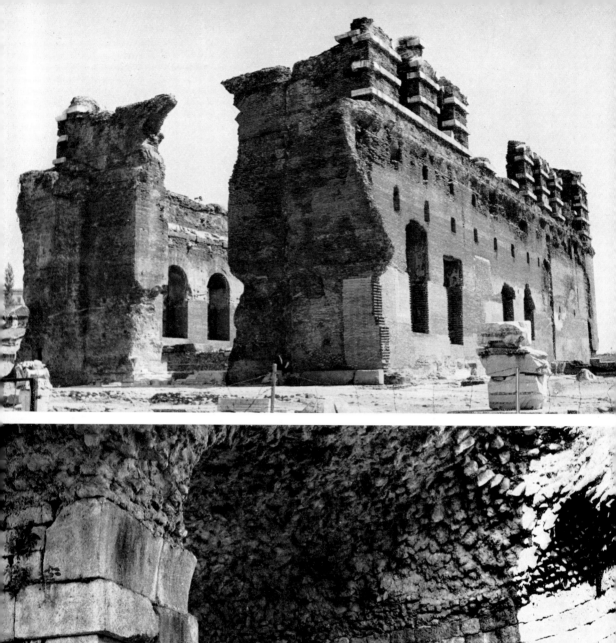

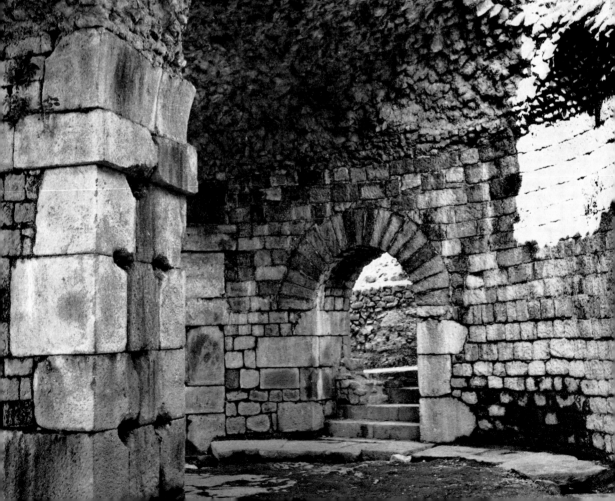

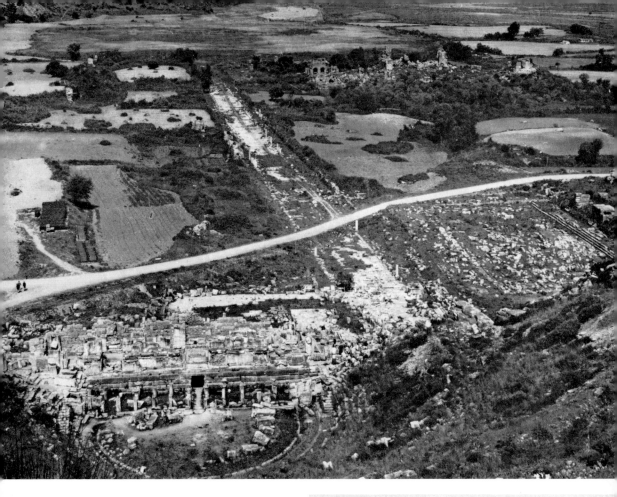

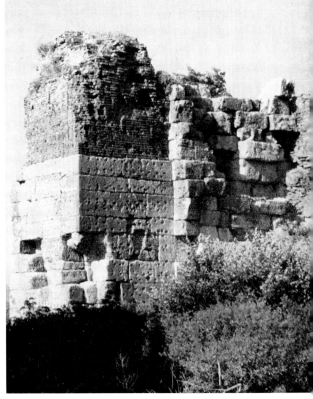

205. Pergamon, Serapaeum, central hall, beginning of the third century

206. Pergamon, Sanctuary of Asklepios (Aesculapius), between 140 and 175, partly subterranean rotunda at the south-east corner (cf. Figure 148)

207. Ephesus, theatre, restored and enlarged in the second half of the first century, and Arkadiané (colonnaded street), fourth century, looking towards the site of the ancient harbour. At the far end of the Arkadiané can be seen the bulk of the Harbour Baths

208. Ephesus, Harbour Baths, part of the late second century bath-building. The lines of holes are those of the pegs for fastening the slabs of fine marble veneer-panelling

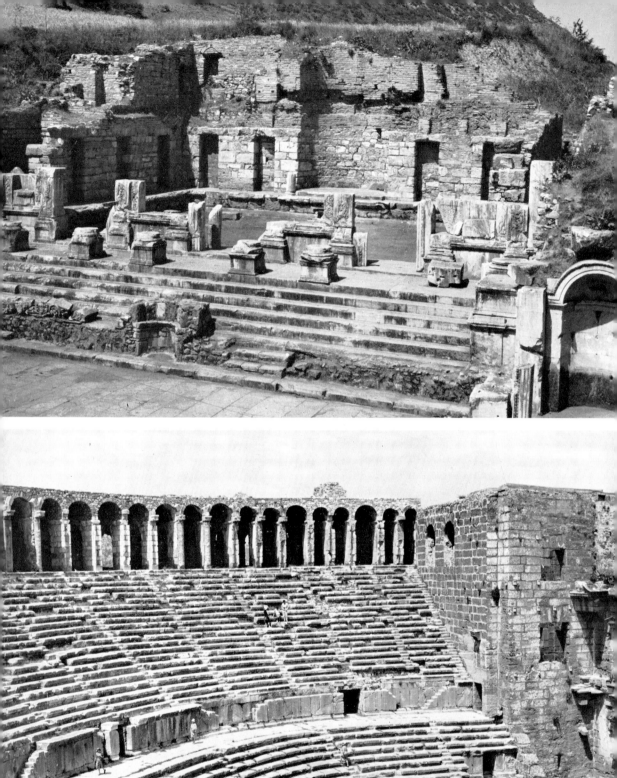
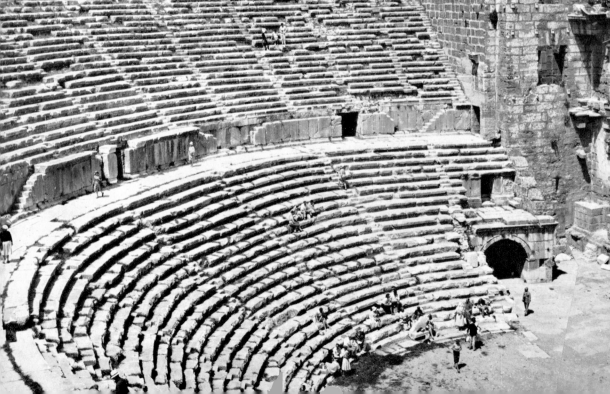

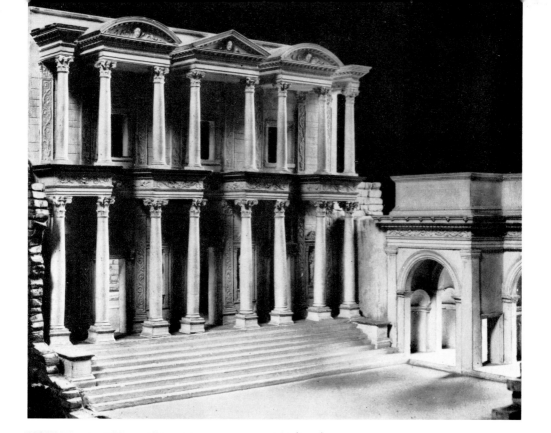

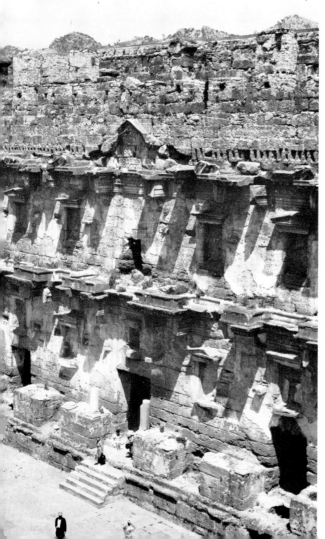

209. Ephesus, Library of Celsus, completed *c.* 135

210. Aspendos, theatre, second century

211 (*above*). Ephesus, Library of Celsus, restored model (cf. also Figure 150)

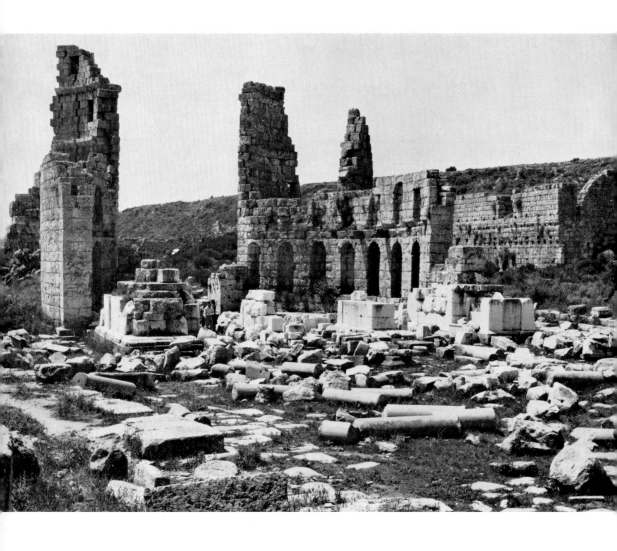

212. Perge, South Gate (Augustan?), remodelled into a nymphaeum between 117 and 122. Across the entrance to the nymphaeum the piers of an arch of Trajan (98–117)

213. Aspendos, one of the two pressure-towers of the third-century aqueduct

214. Attaleia (Antalya), mausoleum overlooking the harbour, first century

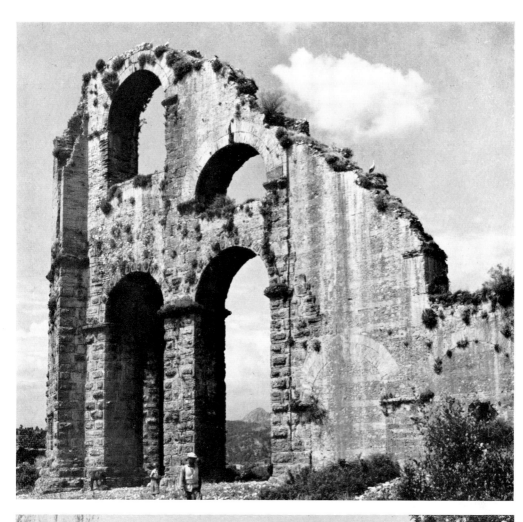

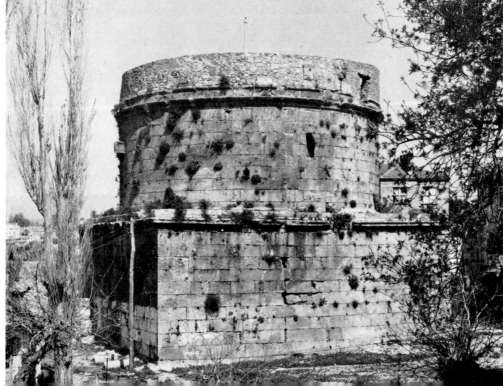

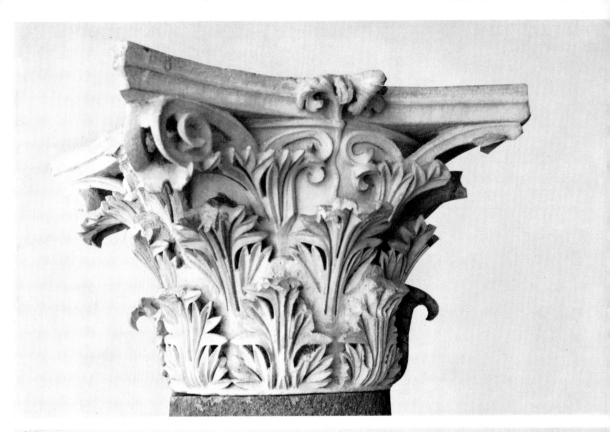

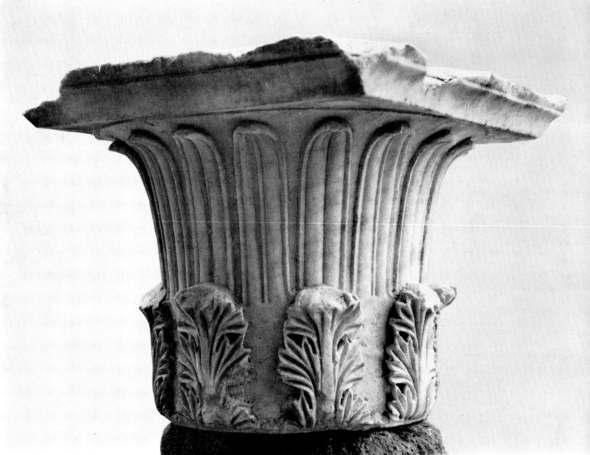

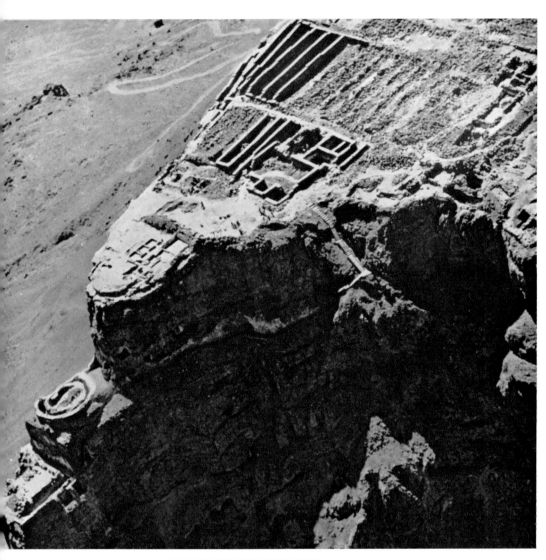

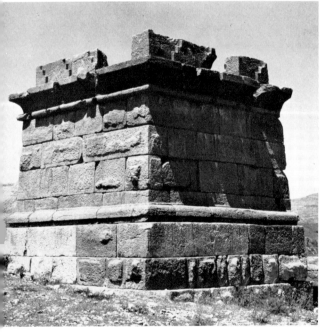

215. Pergamon, Sanctuary of
Asklepios (Aesculapius), typical
'marble-style' Corinthian capital of
the mid second century

216. Lepcis Magna, capital from the
Severan Forum, early third century,
made of Pentelic marble by an
Attic workman

217. Masada, 'Hanging Palace',
before 4 B.C.

218. Kalat Fakra, altar, first century
B.C. or A.D., with 'Egyptian'
mouldings and crenellated
ornament

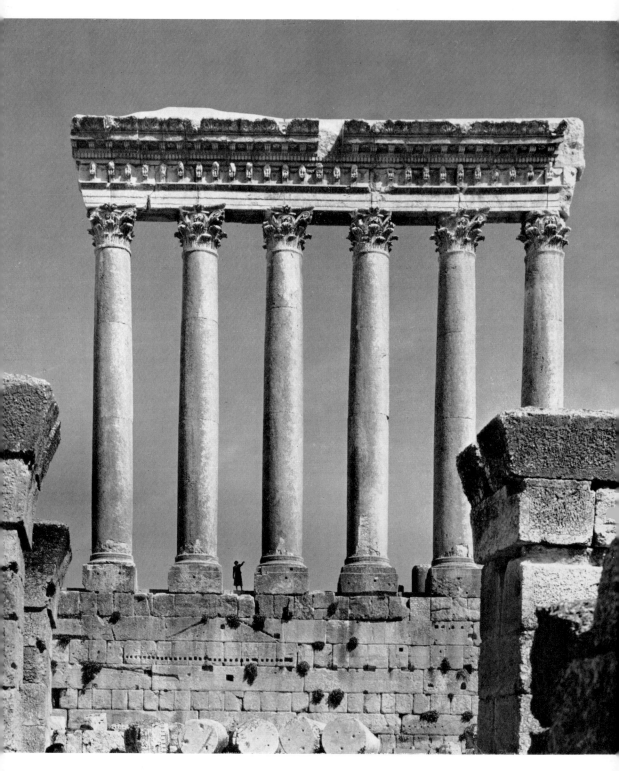

219. Baalbek, Temple of Jupiter Heliopolitanus, first century

220. Baalbek, Temple of Bacchus, mid second century

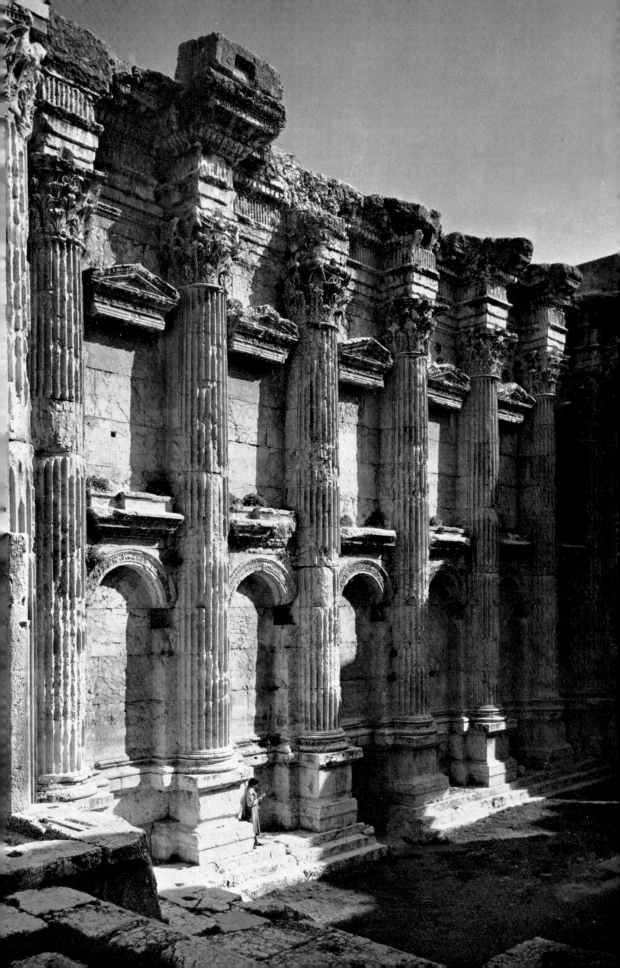

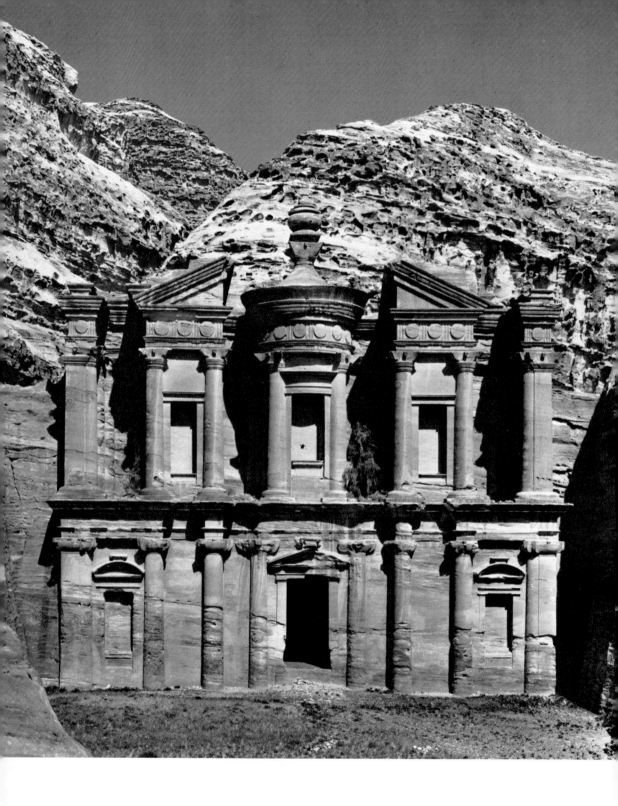

221. Petra, rock-cut mausoleum of ed-Deir, mid second century. The façade is 151 ft (46 m.) wide and 125 ft (38 m.) high

222. Petra, 'Qasr Fira'un' temple (cf. Figure 162), probably second century

223. Hegra (Medaein Saleh), rock-cut Nabataean mausolea of the third quarter of the first century

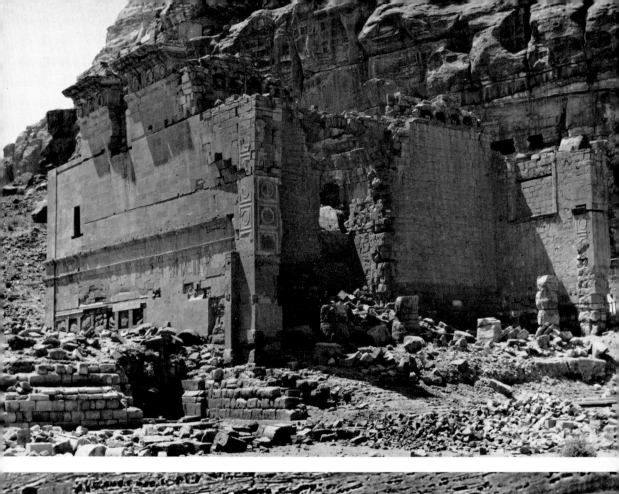

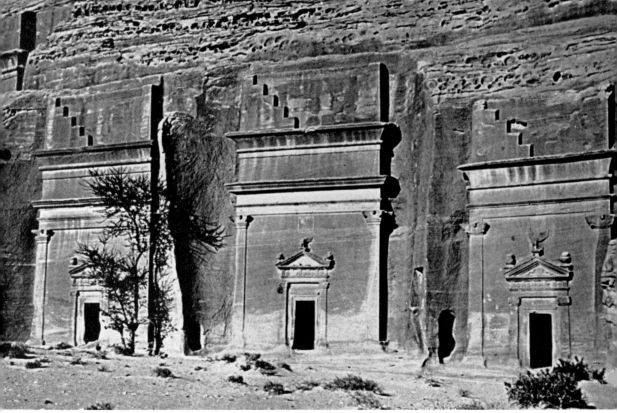

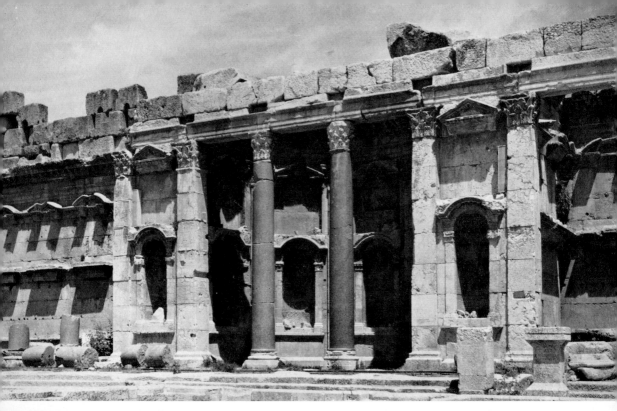

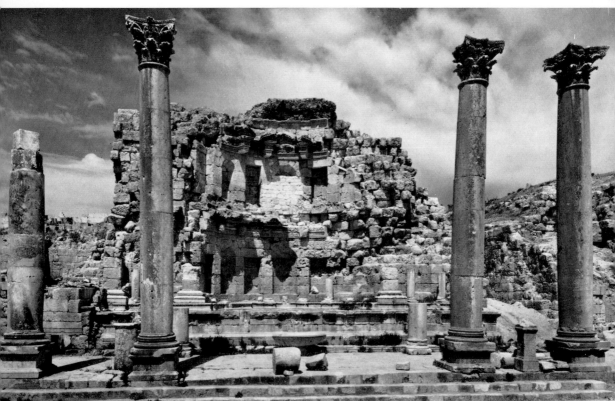

224. Baalbek, part of the forecourt, as rebuilt in the second century

225. Gerasa, fountain building, 191. The hemicycle was vaulted with light volcanic *scoriae*

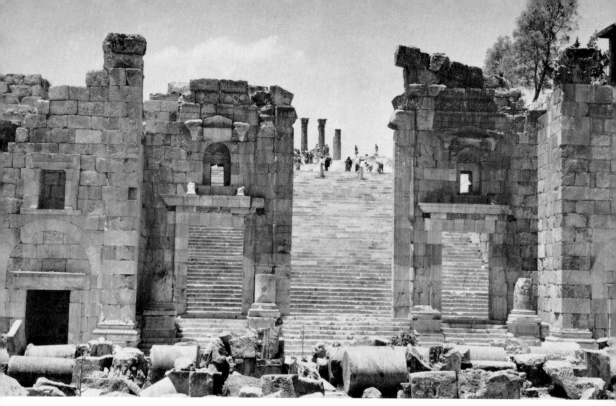

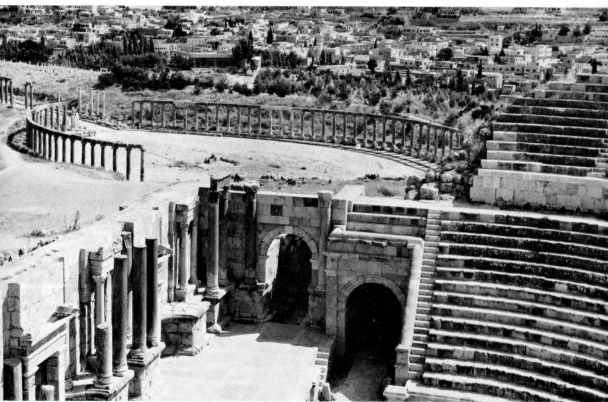

226. Gerasa, monumental approach to the Temple of Artemis, third quarter of the second century

227. Gerasa, oval piazza, third quarter of the first century. Foreground, part of the South Theatre, *temp.* Domitian (81–96)

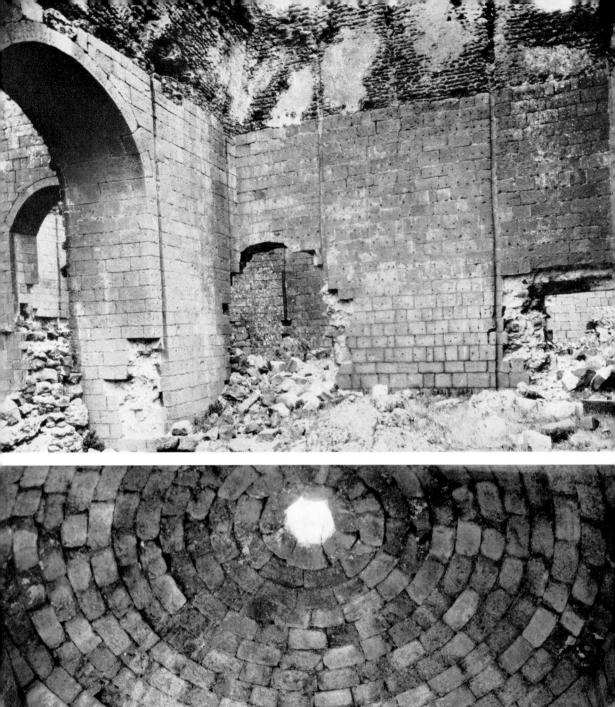
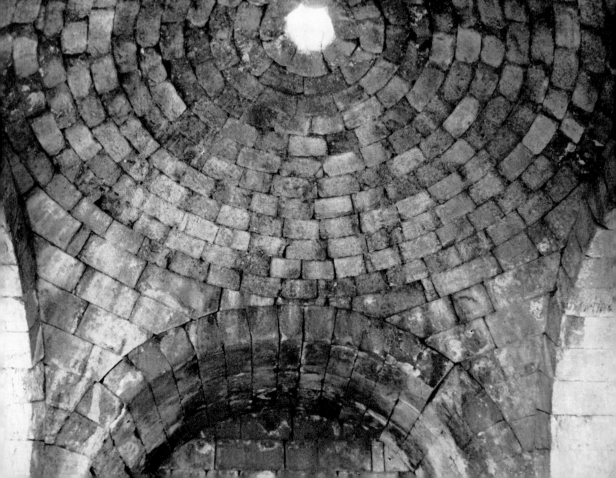

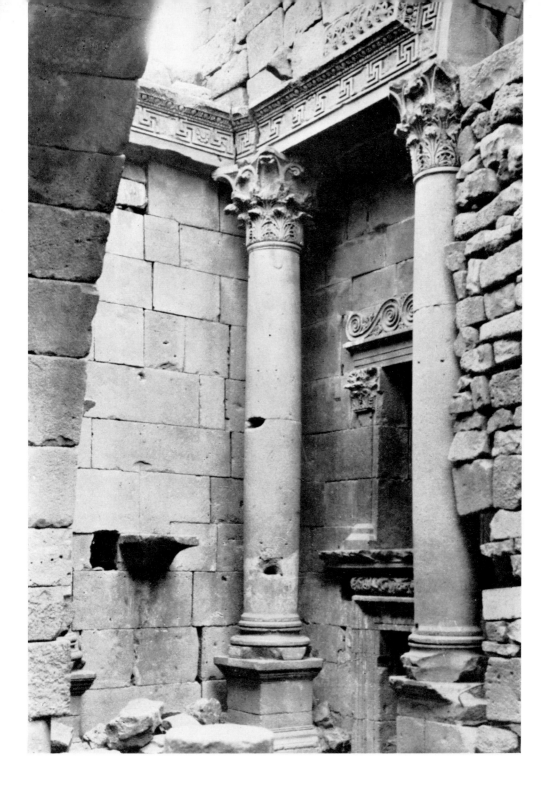

228. Philippopolis (Shehba), vaulted bath-buildings, 241–5

229. Gerasa, West Baths, third quarter of the second century. Hemispherical vault of dressed stone

230. Es-Sanamen, Tychaeon, 191

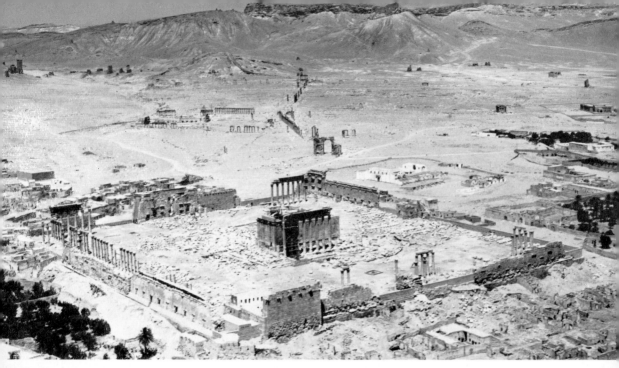

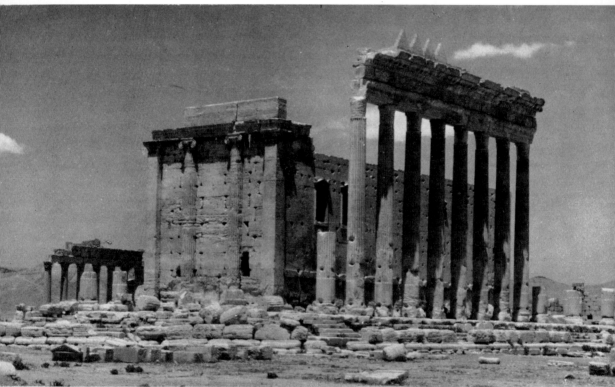

231. Palmyra, from the air. In the foreground, the Sanctuary of Bel. Left distance, tower tombs

232. Palmyra, Temple of Bel, dedicated in 32 (cf. Figure 170)

233. Palmyra, colonnaded street, second century

234. Palmyra, arch, 220, and colonnaded street, early third century

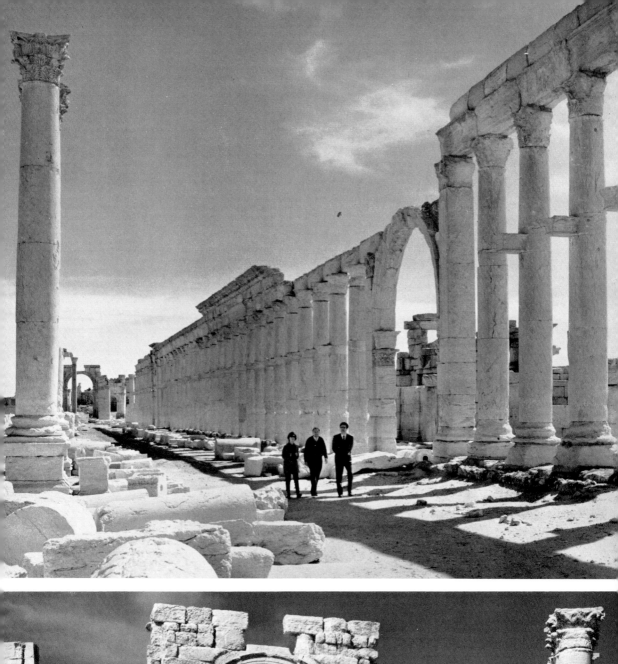

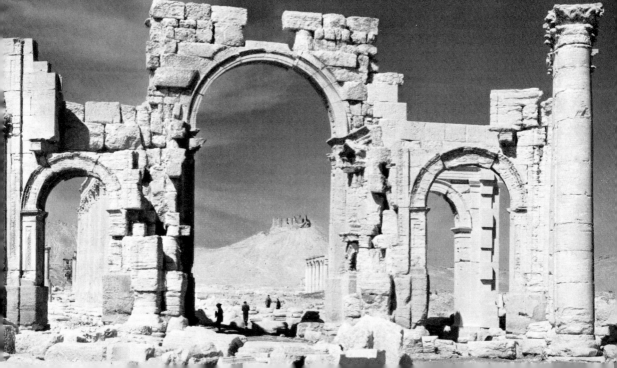

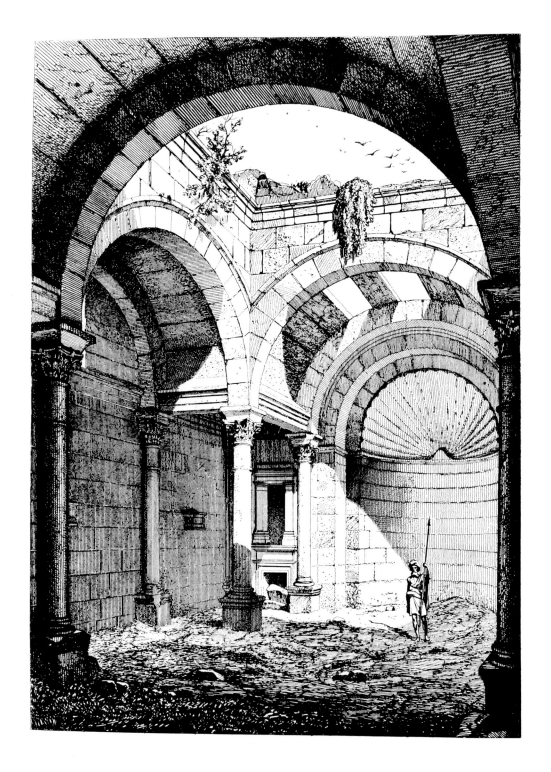

235. Mismiyeh, 'Praetorium', 160–9. Drawing by De Vogüé

236. Luxor, Temple of Serapis, 126

237. Philae, 'Kiosk' of Trajan, *c.* 100

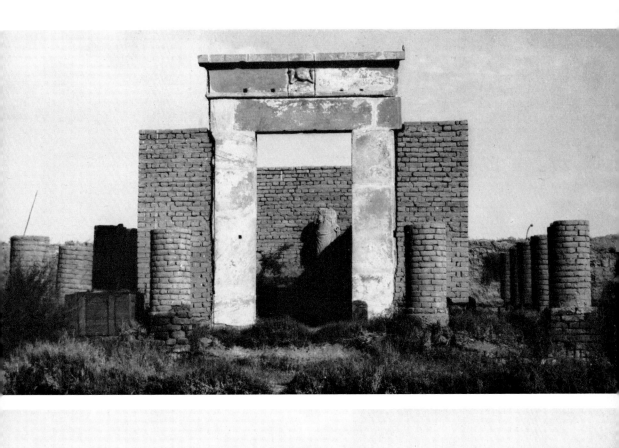

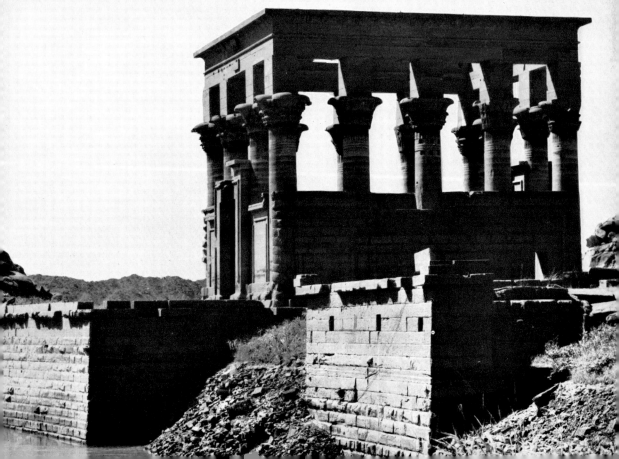

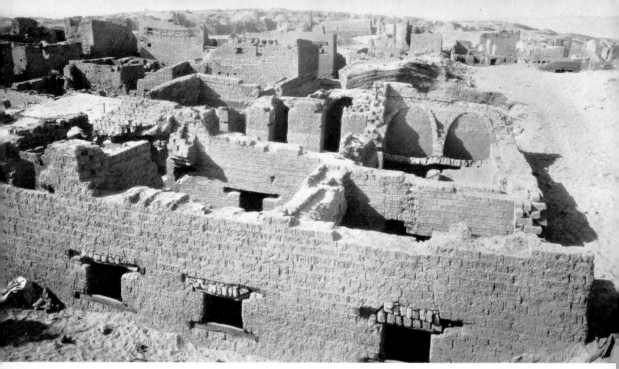

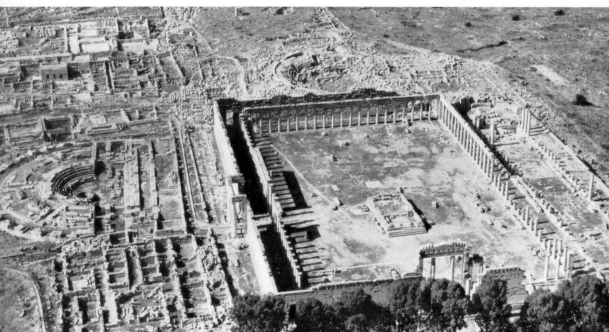

238. Karanis, House C 65, built of mud brick with timber details and (*top right*) pitched brick vaulting

239. Cyrene, Caesareum, second half of the first century B.C. with alterations and additions in the second century A.D. (cf. Figure 171)

240. Lepcis Magna, limestone market pavilion, Romano-Punic, 8 B.C. (cf. Figure 174)

241. Cuicul (Djemila), Market of Cosinius, mid second century, with remains of a central pavilion and (*left*) table of standard measures (cf. Figure 181)

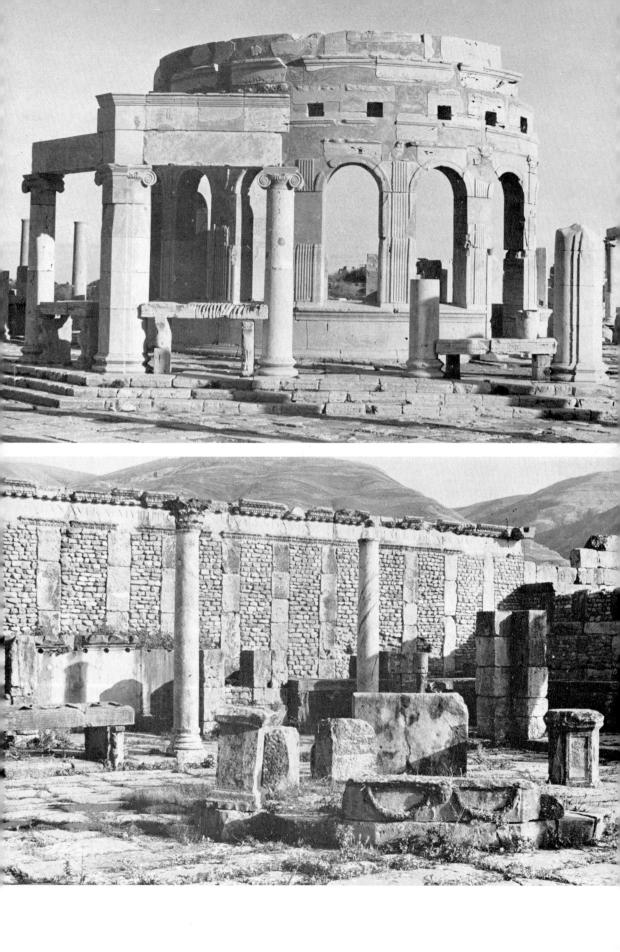

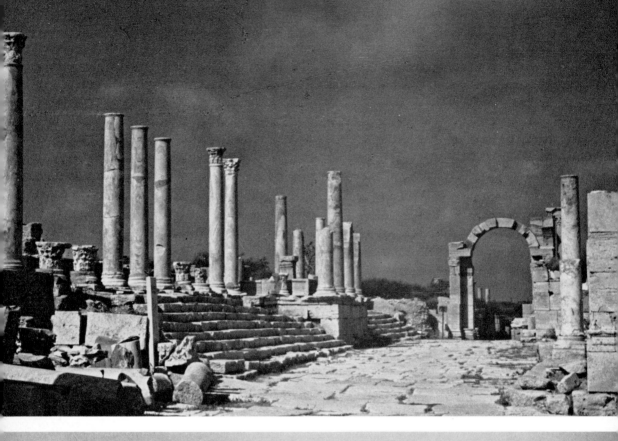

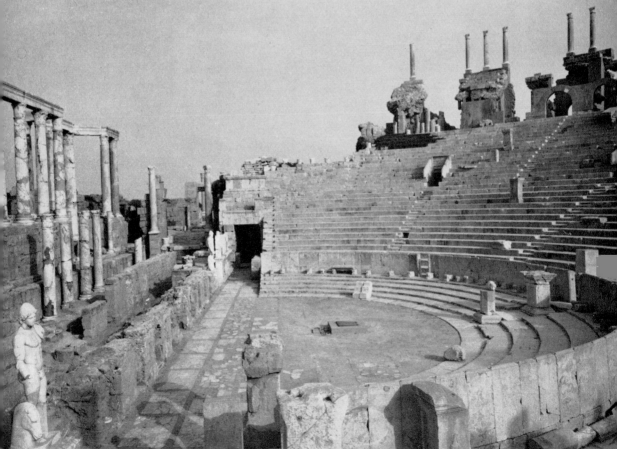

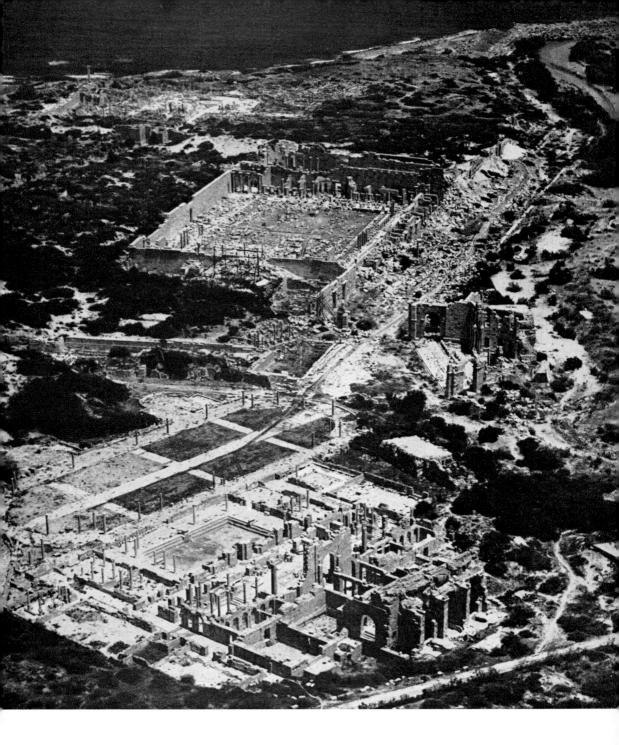

242. Lepcis Magna, main street, showing (*left*) the façade of the Chalcidicum, 11–12, remodelled in marble in the second century, and beyond it the Arch of Trajan

243. Lepcis Magna, theatre. The limestone seating is of 1–2, the partially re-erected marble stage colonnade of the second half of the second century. The lower columns on the left are not in position

244. Lepcis Magna, aerial view showing, in the foreground, the Hadrianic Baths; in the middle distance, the Severan Nymphaeum, Colonnaded Street, Forum, and Basilica; and beyond them (*left*) the Old Forum and (*right*) the silted-up Severan Harbour

245. Lepcis Magna, Hunting Baths, late second or early third century (cf. Figure 176A)

246. Lepcis Magna, Hadrianic Baths, public lavatory

247. Lepcis Magna, Severan Basilica, dedicated in 216 (cf. Figure 179)

248. Lepcis Magna, Severan Nymphaeum, beginning of the third century, viewed from the north-east end of the second-century palaestra

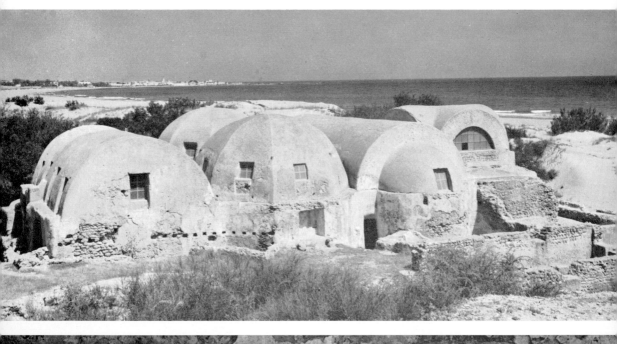

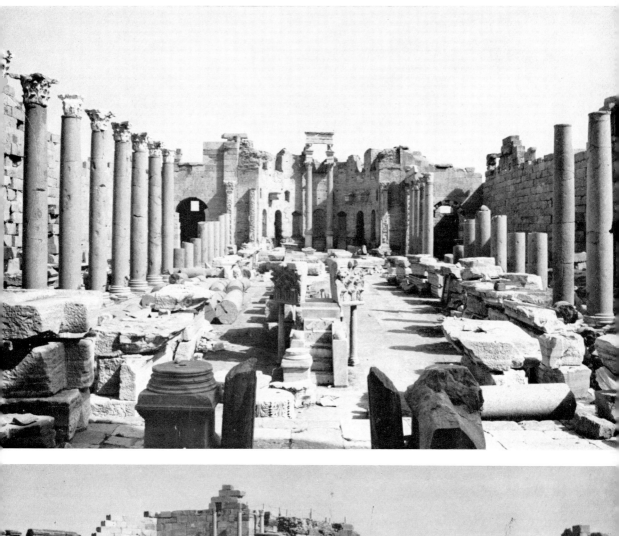
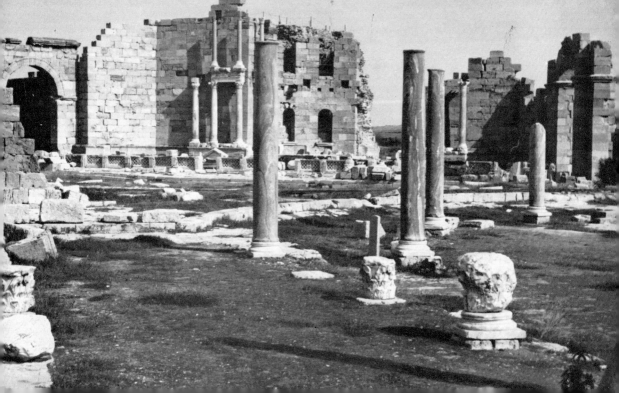

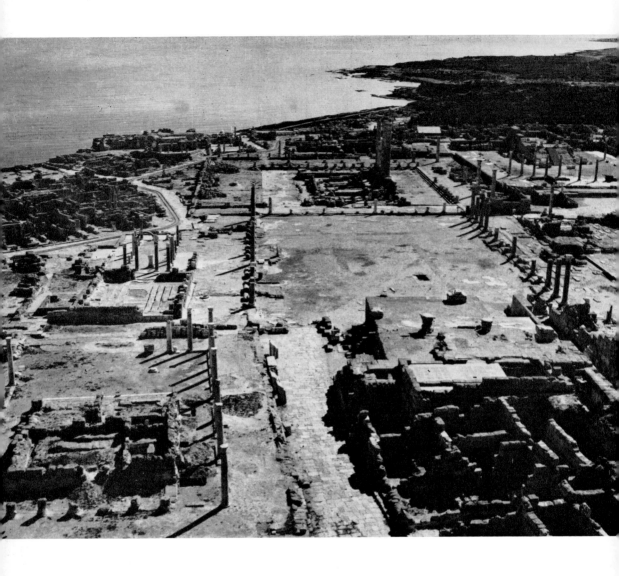

249. Sabratha, forum, first-second century. Foreground the Capitolium (*right*) and Temple of Serapis (?); middle distance Basilica (*right*) and Curia; far end (*left to right*) the Seaside Baths, the East Forum Temple, and the Antonine Temple

250. Sabratha, theatre, reconstructed stage-building, last quarter of the second century

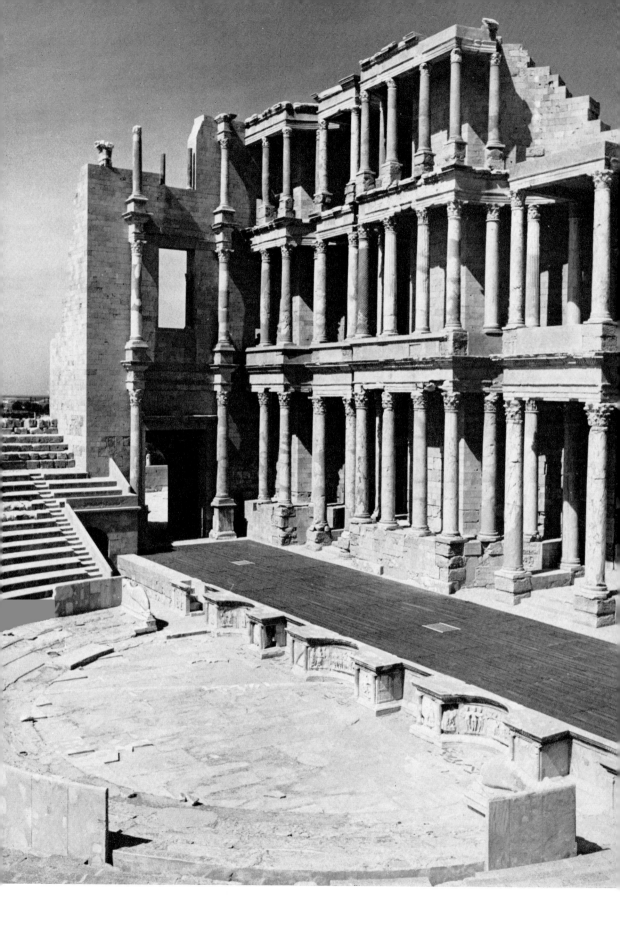

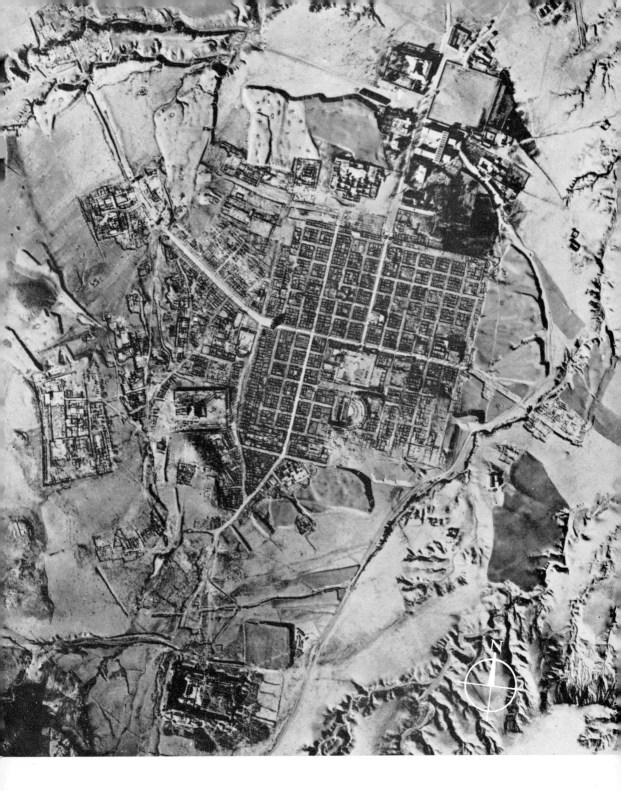

251. Thamugadi (Timgad), air photograph showing the regular chequerboard layout of the original foundation (100) and the irregular development of the following half-century

252. Thamugadi (Timgad), 'Arch of Trajan', late second century, and streetside colonnades

253. Sufetula (Sbeitla), forum and Capitolium, the latter comprising three distinct temples, mid second century

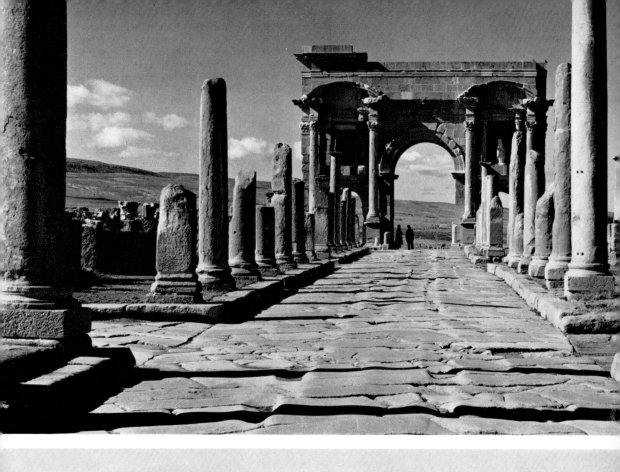

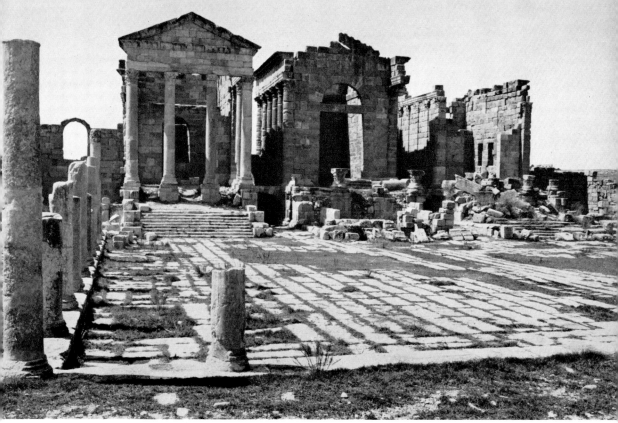

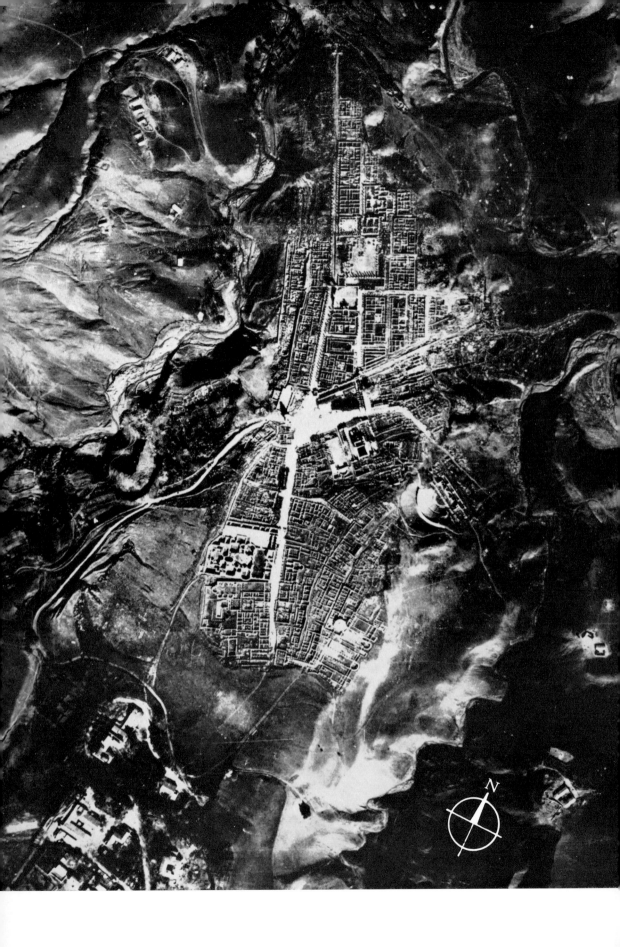

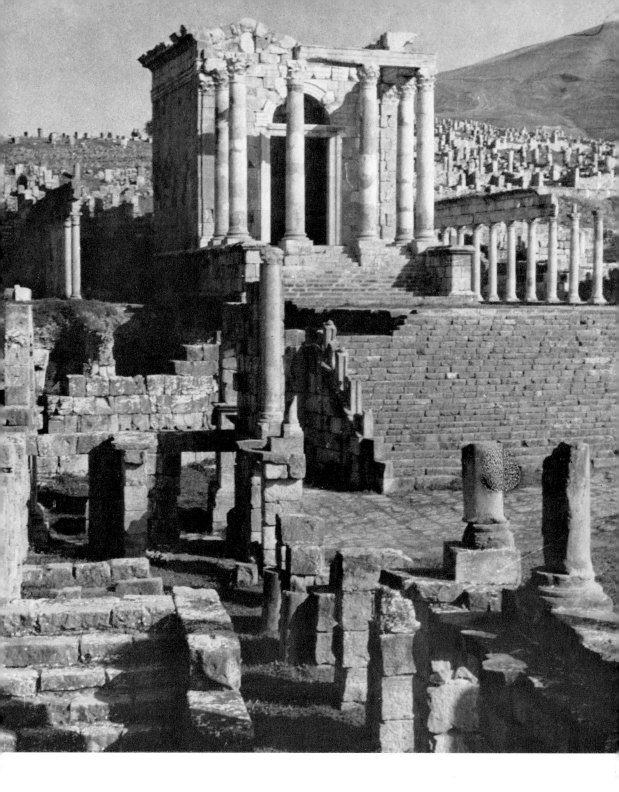

254. Cuicul (Djemila), air photograph showing the original foundation (96 or 97) laid out on a regular plan on the northern end of a steep spur and below, separated from it by the Severan Forum, the second-century and later city

255. Cuicul (Djemila), Temple of the Severan Family, 229

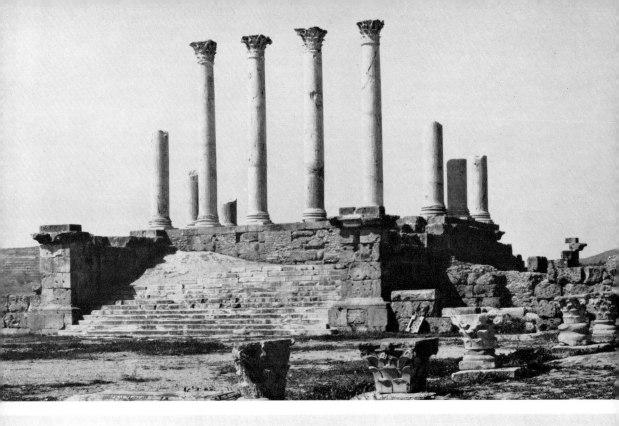

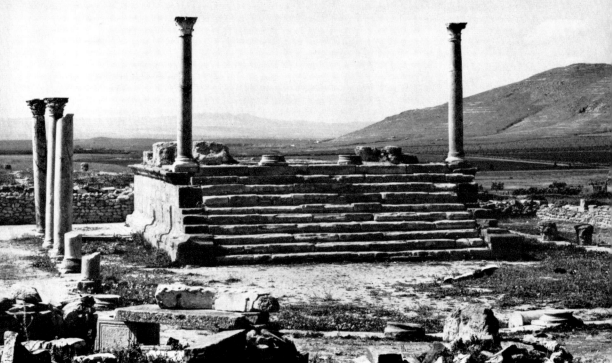

256. Thuburbo Maius, Capitolium, 168

257. Thuburbo Maius, unidentified temple, second half of the second century

258. Rome, Via Appia (*top left*) and the Circus, the Mausoleum, and (*right*) remains of the villa of Maxentius, 307–12

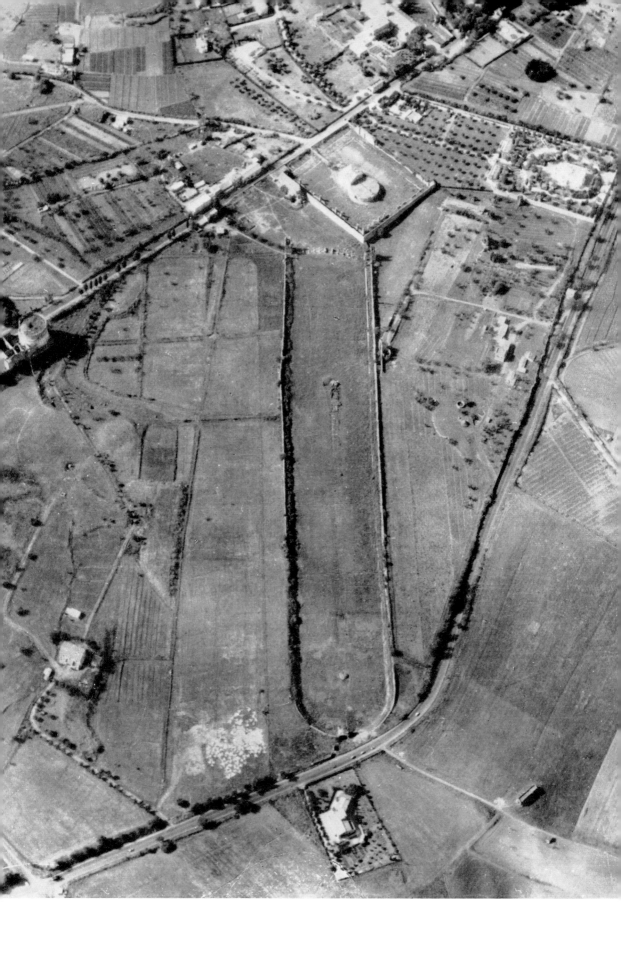

259. Rome, Baths of Diocletian, *c.* 298–305/6. The central hall remodelled as the church of Santa Maria degli Angeli

260. Rome, pavilion in the Licinian Gardens ('Temple of Minerva Medica'), showing the brick ribs incorporated in the vaulting and (below the vault) the backing for the original marble veneer. Early fourth century

261. Rome, pavilion in the Licinian Gardens, from a drawing by Franz Innocenz Kobell, 1780, when some of the brick ribbing was still standing independently

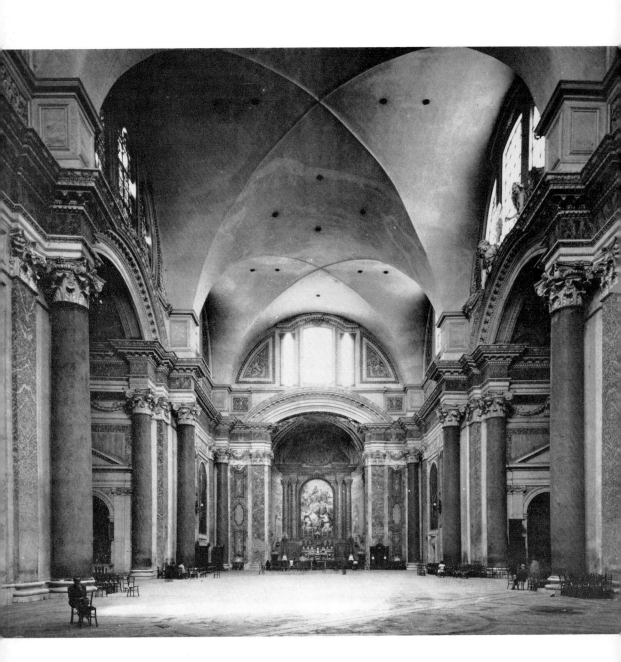

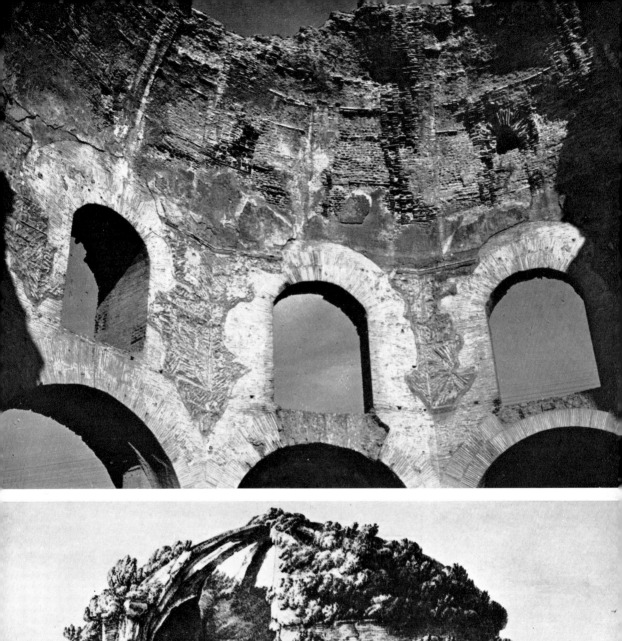
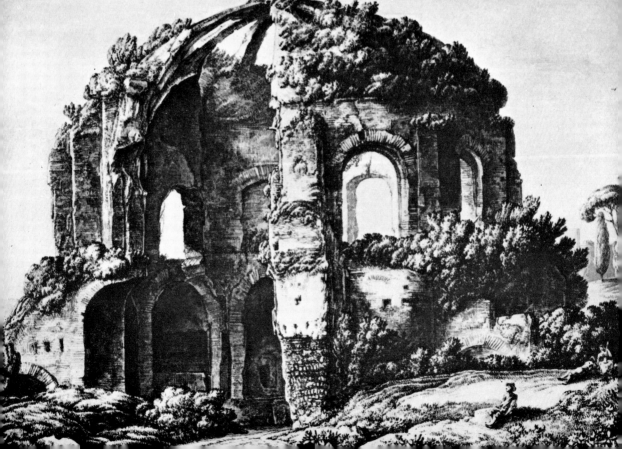

262. Rome, Arch of Constantine, completed in 315

263. Rome, Porta Appia (Porta San Sebastiano), in its present form the work of Honorius and Arcadius, 403 (cf. Figure 188)

264. Rome, Temple of Venus and Rome, cella, as restored by Maxentius, 307–12

265. Rome, Basilica of Maxentius, 307–12, completed by Constantine after 312 (cf. Figure 192)

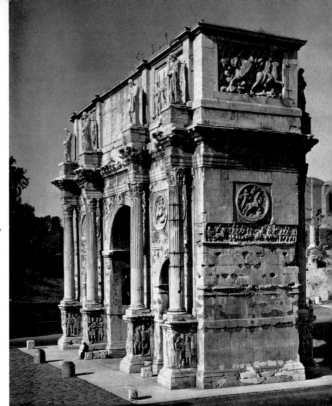

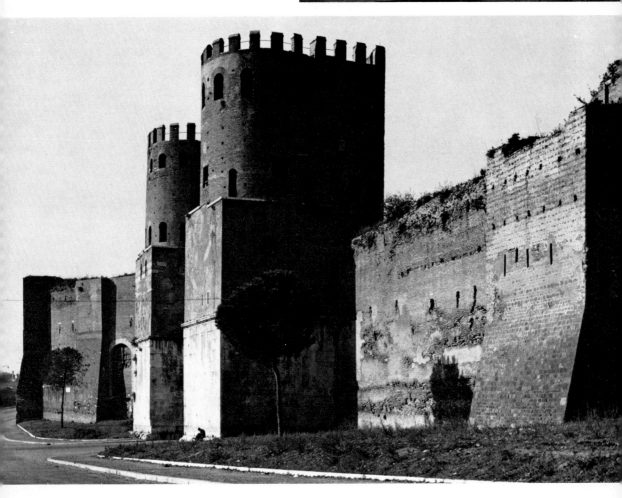

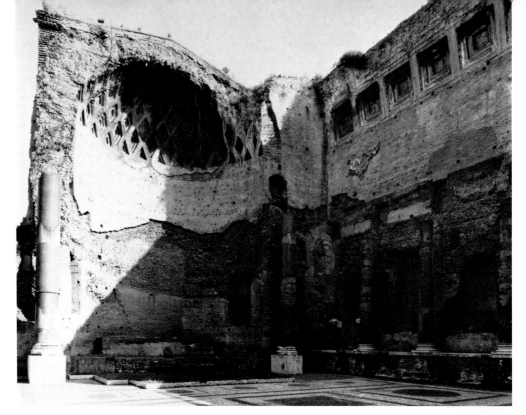

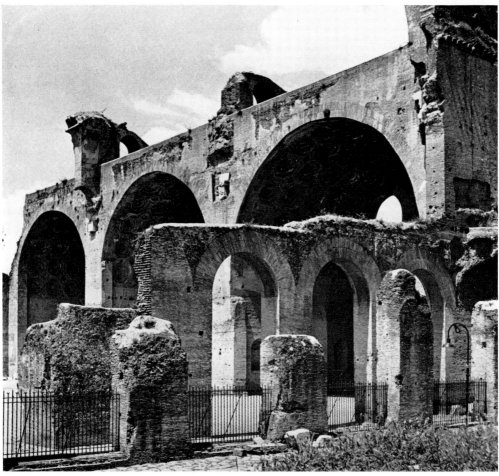

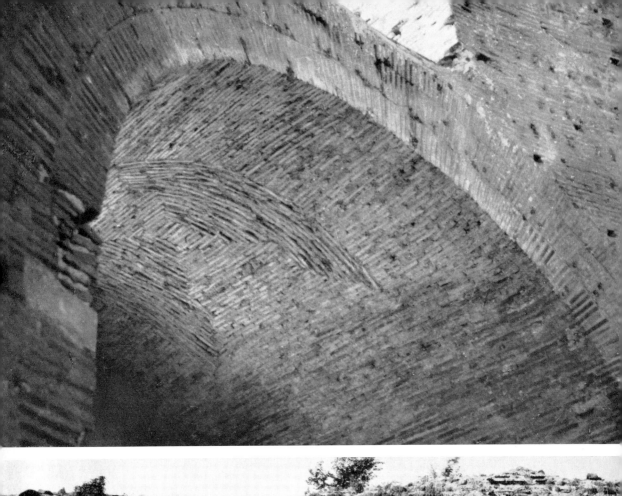

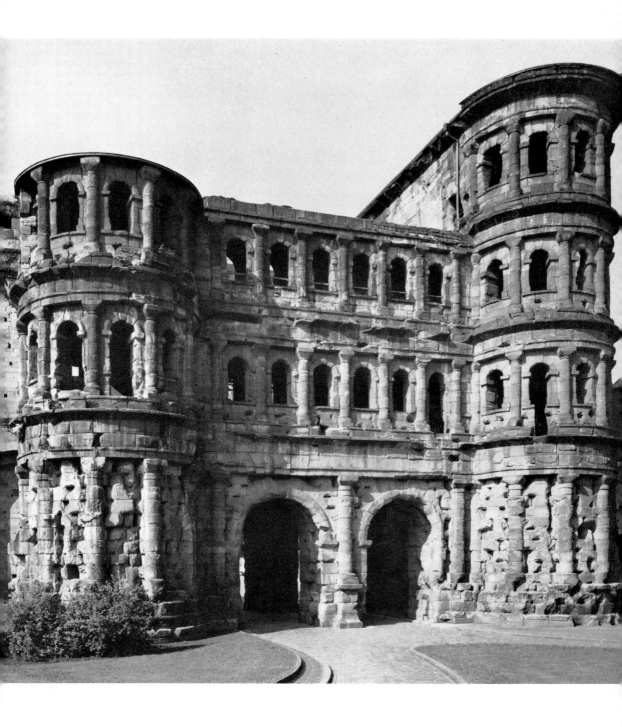

266. Thessalonike (Salonica), Mausoleum of Galerius (church of St George), mainly before 311. Detail of vaulting (cf. plate 275)

267. Rome, Circus of Maxentius, 307–12, showing typical late masonry with alternate courses of brick and small squared blocks of tufa and, incorporated in the vaulting, large earthenware jars (*pignatte*)

268. Trier, Porta Nigra, probably early fourth century. Unfinished

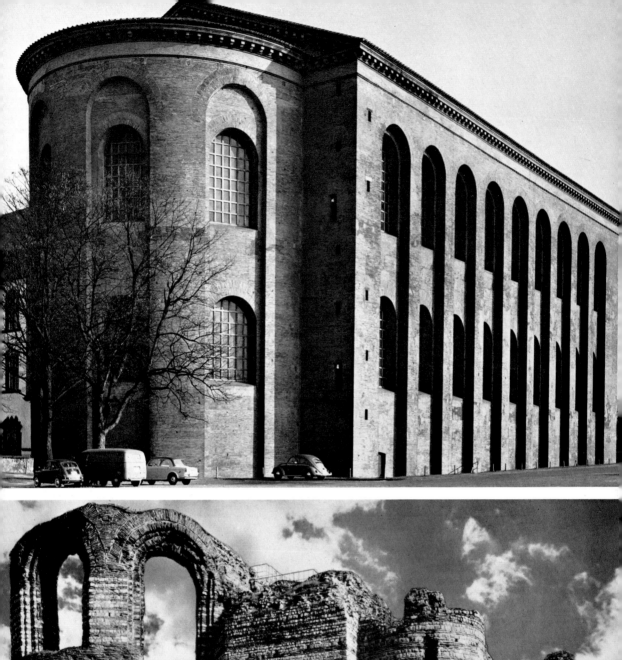

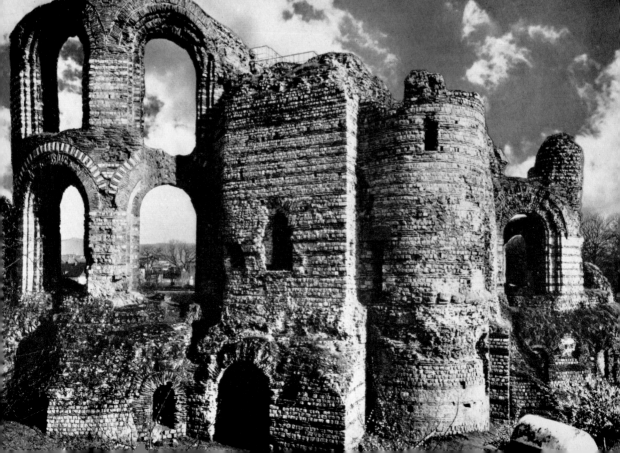

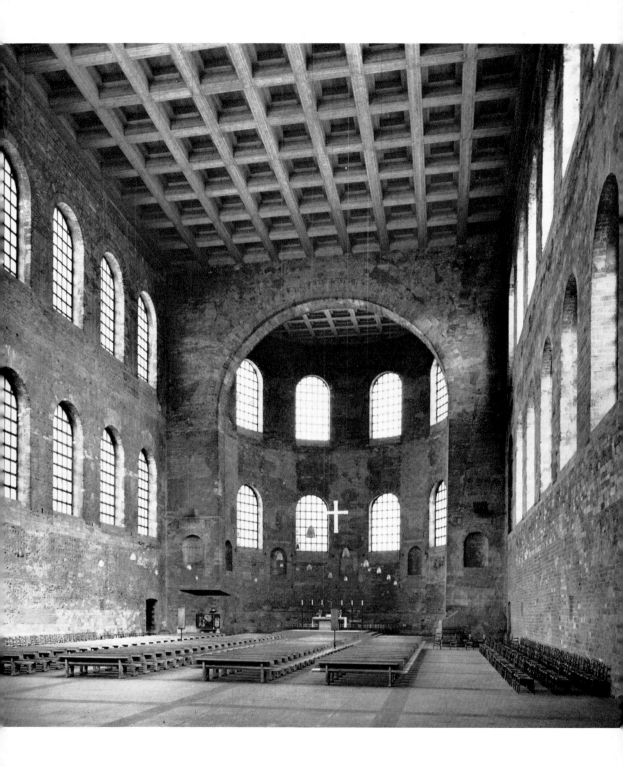

269. Trier, Basilica, early fourth century

270. Trier, Imperial Baths ('Kaiserthermen'), exterior of the main caldarium. Early fourth century

271. Trier, Basilica, early fourth century

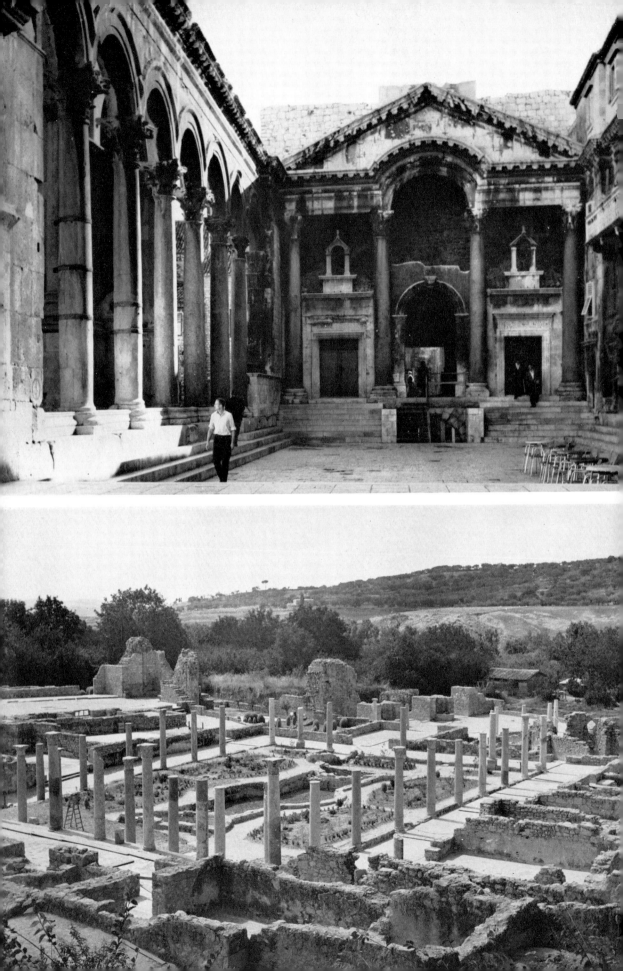

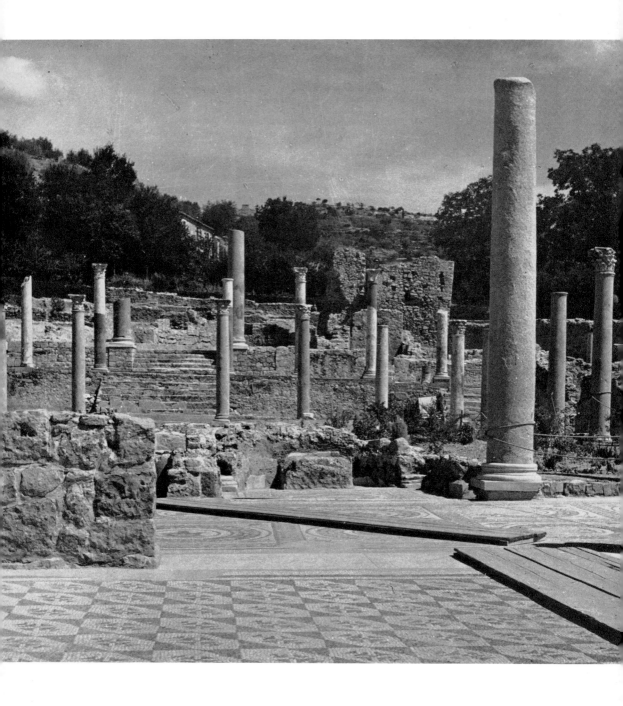

272. Spalato (Split), Palace of Diocletian, the 'Peristyle' or ceremonial courtyard leading up to the entrance to the main residential wing, c. 300–6

273. Piazza Armerina, general view of the central peristyle, looking towards the entrance, early fourth century (cf. Figure 202)

274. Piazza Armerina, view from the vestibule across the central peristyle towards the basilica, early fourth century

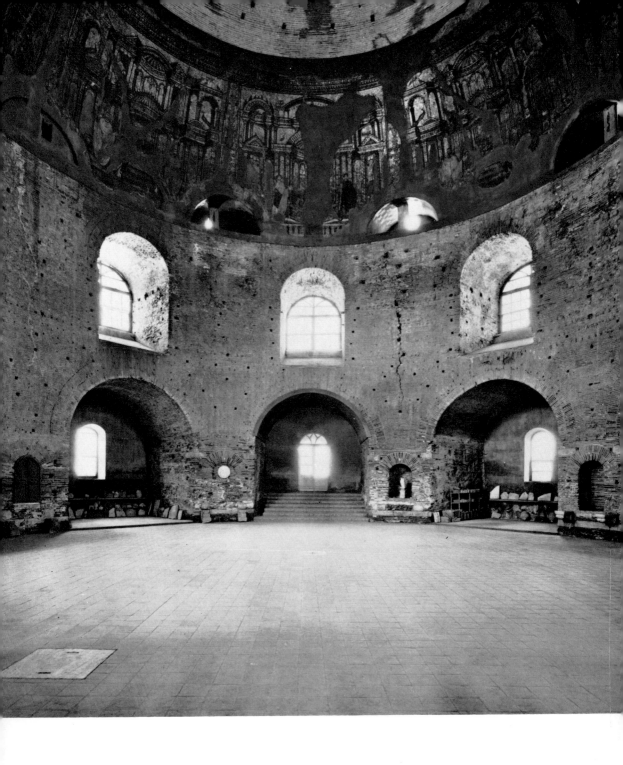

275. Thessalonike (Salonica), Mausoleum of Galerius (church of St George), mainly before 311. The mosaics of the dome are later

INDEX

Numbers in *italics* refer to plates. References to the notes are given to the page on which the note occurs, followed by the number of the chapter and the number of the note; thus, 575(18)²⁰ indicates page 575, chapter 18, note 20. Notes are indexed only when they contain information other than bibliographical, to which there is no obvious reference from the text. Classical authors are indexed only if they are referred to in the text; divinities only if they themselves are the object of substantial comment.

A

Abatone, Monte, Etruscan house model from, 29, 66, 70; *10*

Abila, coins of, 575(18)²⁰

Abthugni, Capitolium, 578(19)²⁰

Acharnai, Temple of Ares, 379

Acrocorinth, Upper Peirene Well, 105–6

Adam, Robert, 262

Adamklissi, monument, 299

Adonis, 417

'Aeneas, Tomb of', 80, 89, 563(6)⁹⁶

Aenona, *see* Nin

Aeolian islands, 6, 8, 9

Agrigento (Agrigentum, Akragas), 547(3)⁴⁴; comitium, 113; Olympieion, 42, 420; tombs, 177; *100*

Agrippa, 161, 184, 185–6, 197, 227, 247, 281, 347, 379

Agrippina, Empress, 210

Ahenobarbus, L. Domitius, 184

Aix-en-Provence, terraced town house, 571(15)²²

Aizani, Temple of Zeus, 392; *204*

Akragas, *see* Agrigento

Alatri (Alatrium), aqueduct, 571(15)¹³; temple, 44, 134; 543(3)¹¹; walls, 99, 100; *61*

Alba Fucens, 118, 132; basilica, 124, 125 (fig. 70), 127, 128, 129, 130, 151; forum, 124, 125 (fig. 70), 151; plan, 150 (fig. 81), 151–2; Portico of Hercules, 124, 125 (fig. 70), 131, 151, 172; Temple of Hercules, 44, 124, 125 (fig. 70), 127, 128, 129, 134, 151, 172; theatre, 562(6)⁷⁹; walls, 149, 150 (fig. 81)

Alba Longa, *see* Castel Gandolfo

Albano, 204; nymphaeum of Domitian, 259, 299, 560(6)⁶⁹; Pompey's (later Domitian's) villa, 328, 333

Albano, Lake, 210

Albanus, Mons, temple, 44

Alberobello, beehive houses, 9

Alcántara, bridge over the Tagus, 341; *178*

Alesia, basilica, 344, 348

Alexander the Great, 115, 382, 412; fortresses of, 104 (fig. 60), 115, 553(5)⁵

Alexandria (Egypt), 205, 414, 459–60, 461, 462; Kaisareion, 122, 311, 459–60, 461

Alexandria Troas, 386

Allifae, castrum, 104, 558(6)⁴⁷

Allonnes, baths, 356

Althiburos, Capitolium, 578(19)²⁰; House of the Muses, 487, 488 (fig. 185); temple, 467

Ambrose, St, 517

Amélie-les-Bains, baths, 355

Amerina, Via, bridge, 101, 102, 102–3 (fig. 58), 174

Amman (Philadelphia), nymphaeum, 439

Ammanati, 214

Ammianus Marcellinus, 172

Anazarbos, 410; amphitheatre, 397

Ancona, Arch of Trajan, 308–9; *169*

Ancus Marcius, King, 94

Ancyra, *see* Ankara

Andronicus of Cyrrhus, 378

Anguillara, 'Mura di S. Stefano', 334

Anicius, Lucius, 168

Ankara (Ancyra), 389; bath-building, 390, 399; Temple of Rome and Augustus, 191, 389–90, 390, 392, 564(7)¹; *203*

Announa, *see* Thibilis

Antalya (Attaleia), mausoleum, 299, 407; *214*; walls, 406

Antigonus Monophthalmus, 105

Antinoupolis, 105

Antioch (on-the-Orontes), 414, 426–7, 431, 459, 516, 517, 536; amphitheatre, 426; bath-buildings, 426, 427, 443, 444 (fig. 164), 575(18)³³; Capitolium, 547(3)³⁶; colonnaded street, 415, 417; hippodrome, 529; houses, 336, 427, (of Menander), 336; Kaisareion, 122, 311, 426, 459, 461; palace, 457, 523, 527–9, 579(21)⁶; theatre, 426

Antioch-in-Pisidia, 390, 407

Antiochus IV, King, 115, 436, 547(3)³⁶

Antiochus Epiphanes, 378

Antium, *see* Anzio

Antium, Battle of, 112

Antoninus Pius, Emperor, 266–9, 284, 399, 408, 417, 467, 572(16)¹⁸

Antony (Marcus Antonius), 183, 184

Anzio (Antium), 151, 328; Volscian town, 58, 96, (agger), 84; Nero's villa, 328; tombs, 176, 550(3)⁷²

Aosta (Augusta Praetoria), 103, 148, 301, 302–4 (fig. 116), 307, 308; amphitheatre, 303–4; gate, 303, 307, 308, 345, 356; plan, 302–3 (fig. 116), 345; temple, 303; theatre, 303, 351–2, 377; vaulted substructure, 348
Apamea, 414, 456, 574(18)², 577(18)⁷⁵
Apaturius of Alabanda, 296
Apennine culture, 6 ff., 12, 13, 15, 16
Aphrodisias (Caria), 391, 403; agora, 395; baths, 403; Temple of Artemis, 392
Apollodorus of Damascus, 229, 236, 243, 253, 265, 341
Apollonia (Cyrenaica), 462, 464
Appia, Via, 108, 146; *aedicula aenea*, 54; sub-structures, 100; tombs, 80, 114; *see also* Rome
Appian, 97
Appius Claudius, Censor, 108; *see also* Pulcher
Apuleius, 490
Aquileia, 301, 364; mausoleum, 356; relief from, 540(2)⁵; 6; warehouses, 533, 579(21)³
Aquincum, 364–5 (fig. 141)
Arados, houses, 114
Araq el-Emir, temple, 576(18)⁴³
Arausio, *see* Orange
Arcadius, Emperor, 239, 497
Architects, classical: *see* Andronicus of Cyrrhus, Apaturius of Alabanda, Apollodorus of Damascus, Celer, Cossutius, Hermogenes, Hippodamus of Miletus, Lacer, Rabirius, Severus, Valerius of Ostia
Architects, post-classical: *see* Adam, Ammanati, Bernini, Jones, Michelangelo, Michelozzo, Palladio, Panvinio, Piranesi, Pirro Ligorio, Raphael, Valadier, Vanvitelli
Ardea, 13, 58; *52*; basilica, 127, 128, 129 (fig. 71), 130; temple on the acropolis, 35, 38, 40, 52; *24*; temple in the lower town, 43, 48; terracotta revetments from, 92, 546(3)³⁰; tombs, 69 (fig. 40), 113, 548(3)⁵⁴, 560(6)⁶⁹; walls, 101 (fig. 57)
Arelate, *see* Arles
Arezzo (Arretium), Etruscan town, 25, 29; agger and fossa, 84 (fig. 51); *53*; city wall, 28; fragments from, 54, 546(3)³⁰
Argos, 95; nymphaeum, 385; Temple of Hera, 30; temple model from, 49
Ariccia, tomb on the Via Appia, 178
Ariminum, *see* Rimini
Aristotle, 61, 112
Arles (Arelate), 342, 517; amphitheatre, 297, 353; *186;* 'Arcus Admirabilis', 356; baths, 354; bridge, 347; 'cryptoporticus', 303, 348, 558(6)³⁹; gate, 305, 346; theatre, 304, 351; *186;* water supply, 347
Arpino (Arpinum), Cicero's grandfather's house, 89, 159; walls, 97, 100; *58*
Arquà Petrarca, lake dwellings, 10

Arretium, *see* Arezzo
Ascalon, 415, 416
Ashmunein, *see* Hermoupolis Magna
Aspendos, agora, 409; aqueduct, 347, 388, 409; *213;* basilica, 388, 409, 524, 572(16)⁶; *200;* cisterns, 409; stoa, 404, 409; theatre, 375, 397, 409; *210*
Asseria, archway-gate, 366 (fig. 142)
Assisi, 307
Assos, 386
Asti (Hasta), gate, 304
Athanasius, 517
Athens, 57, 95, 243, 369, 378–84, 386, 391, 462
 Acropolis, 122, 549(3)⁶²; hut on, 21
 Agora, 379, 384, 385, 572(16)⁵
 Altar of Pity, 189
 Aqueduct, 382, 384
 Arch of Hadrian, 382, 405; *195*
 East quarter, 382
 Erechtheion, 186, 371, 378, 381
 Geometric vases from, 22
 Gymnasium of Ptolemy, 379
 Library (Stoa) of Hadrian, 219, 382, 383, 420; *194*
 Market of Caesar and Augustus, 372, 379
 Odeia (of Agrippa), 180, 186, 379–81 (fig. 147), 564(7)⁶; *192;* (of Herodes Atticus), 377, 383, 384; (of Perikles), 381
 Olympieion, 42, 43, 115, 117, 137, 378, 382, 545(3)²²
 Stadium, 383
 Stoa (of Eumenes), 375; (of Hadrian), *see* Library of Hadrian
 Temples, 379; (of Rome and Augustus), 378–9
 Theatre of Dionysus, 382, 549(3)⁶²
 Tower of the Winds, 378, 381; *197*
'Atil, temple, 443
Attaleia, *see* Antalya
Attis, 206
Atys, King of Lydia, 24
Augst (Basel; Augusta Raurica), 306, 342, 343–5 (fig. 131); basilica, 343, 344, 346, 348; bath-buildings, 345; curia, 344; forum, 124, 343, 344, 364, 366; market, 343–4, 346; plan, 343, 345–6; temples, 343, 344–5, 351; theatre, 343
Augusta Emerita, *see* Mérida
Augusta Praetoria, *see* Aosta
Augusta Raurica, *see* Augst
Augusta Taurinorum, *see* Turin
Augusta Treverorum, *see* Trier
Augustodunum, *see* Autun
Augustus, Emperor, 28, 96, 116, 118, 126, 127, 132, 157, 179, 183 ff., 204, 245, 247, 260, 281, 290, 295, 306, 341, 342, 348, 369, 370, 379, 389, 406, 425, 431, 458, 461
Aurelian, Emperor, 209, 453, 497, 498, 500
Ausonian culture, 6, 8

Ausonius, 360, 517, 533
Authors, classical and Early Christian: *see* Ammianus
 Marcellinus, Appian, Apuleius, Aristotle,
 Ausonius, Cassius Dio, Cato, Catullus,
 Cicero, Columella, Cornelius Nepos, Dio-
 dorus, Dionysius of Halicarnassus, Ennius,
 Ephorus, Eusebius, Frontinus, Gellius, Her-
 odotus, Hesiod, Homer, Horace, Josephus,
 Juvenal, Lactantius, Libanius, Livius Androni-
 cus, Livy, Lucretius, Malalas, Martial,
 Naevius, Ovid, Pausanias, Philo, Plautus,
 Pliny the Elder, Pliny the Younger, Plutarch,
 Polybius, Posidonius, Propertius, Quintilian,
 Seneca, Seneca Rhetor, Statius, Strabo,
 Suetonius, Tacitus, Terence, Tertullian, Varro,
 Velleius Paterculus, Vergil, Vitruvius
Autun (Augustodunum), 343, 346–7; Porte Saint-
 André, 304, 345, 346, 522; *183*; 'Temple of
 Janus', 349, 351; *191*
Avenches (Aventicum), amphitheatre, 353; gate,
 304
Avernus, Lake, 'Temple of Apollo', 299
Ayaş (Elaeusa), 410

B

Ba'al, 269, 270, 274, 417
Baalbek, 269, 415, 417 ff., 425, 443; Sanctuary, 219,
 417 ff. (fig. 156), 426, 436, 438, 462; *224*;
 Temples (of Bacchus), 419, 420–1, 421, 423,
 436, 529, *220*, (of Jupiter Heliopolitanus),
 392, 417–18, 513, *219*, (of Venus), 421–2
 (fig. 157)
Babisqa, bath-building, 430; bazaar, 430
Babutta, tomb, 430
Babylon, 60, 547(3)[36]
Badenweiler, bath-buildings, 355 (fig. 135)
Baelo (Bolonia), Capitolium, 310, 341
Baeterrae, *see* Béziers
Bagacum, *see* Bavai
Baiae, 'Temple of Diana', 299; 'Temple of Mer-
 cury', 163, 259, 298–9; 'Temple of Venus',
 299, 509, 513, 568(11)[8]; *161*; villas, 296, 298
Balbus, L. Cornelius, 184
Banaqfur, houses, 428–30 (fig. 161)
Bara, Arch of Licinius Sura, 341
Barade, *see* Brad
Barcelona, Temple of Rome and Augustus, 341
Bari, rock-cut tombs, 7
Barumini, nuraghi, *1*
Bath (Aquae Sulis), baths, 355; Temple of Sulis
 Minerva, 354–5, 544(3)[11]
Bavai (Bagacum), vaulted substructures beneath
 forum, 348, 558(6)[39]; walls, 571(15)[10]
Bede, the Venerable, 221
Beirut (Berytus), 105, 426; agora, etc., 415; basilica,
 373; coins from, 540(2)[5]
Belverde, Casa Carletti, 8

Benabil, houses, 430
Benevento, arch, 308–9; Temple of Isis and Serapis,
 461
Berenice, 122, 426
Berenson, Bernard, 507
Bernini, Gianlorenzo, 208, 209, 503
Berytus, *see* Beirut
Béziers (Baeterrae), 342
Bibulus, C. Publicius, 177
Bieda (Blera), 25; tombs, 68, 70, 81
Bignor, villa, 358
Bin Tepe, 544(3)[14], 550(3)[66]
Blera, *see* Bieda
Bochoris tomb, 548(3)[54]
Bologna (Felsina), Villanovan village, 15, 16;
 Etruscan town, 26
Bolsena (Volsinii), 25, 539(1)[4]; Early Iron Age
 village, 540(2)[1]; temples, 25, 29, 30 (fig. 11),
 31, 39, 55, 543(3)[6]
Bône (Hippo Regius), 471, 490; market building,
 482–3 (fig. 181); theatre, 473
Bosco Reale, villa, 158
Bostra (Bosra), 439, 443–5; basilica, 444, 445 (fig.
 165); baths, 442, 443 (fig. 164), 475; East
 Arch, 434, 443; fountain-building, 443;
 'Palace' hall, 444–5; St George, 442; theatre,
 443–4
Bovillae, grotto, 161
Brad (Barade), bath-building, 428, 429 (fig. 161);
 tetrapylon, 430
Brekeh, temple, 441, 443
Brescia (Brixia), 301, 570(15)[6]; forum, 124, 306,
 353; temples, 138, (Capitolium), 306–7, 345,
 163
Brindisi (Brundusium), 108
Brioni Grande, *see* Catena, Val
Brixia, *see* Brescia
Brundusium, *see* Brindisi
Bulla Regia, houses, 487
Burdj Bakirha, temple, 428
Busan, houses, 447
Butrinto (Buthrotum), 368; odeion, 377
Byblos, colonnaded street, 426; nymphaeum, 426,
 429

C

Caere (Cerveteri), 23, 25, 96, 165, 546(3)[30, 34]
 Early Iron Age village, 13
 Etruscan tombs (Banditaccia cemetery), 28, 44,
 60, 64, 68, 71, 73, 77, 80, 114, 542(2)[13],
 544(3)[14], 548(3)[54]; *15–16*, *28*; (dell'Alcova),
 75, 81; *37*; (dei Capitelli), 72, 152; *35*; (delle
 delle Colonne Doriche), 544(3)[14]; *18*;
 (della Cornice), 71; *36*; (Giglioli), 549(3)[61];
 (di Mercareccia), 152; *43*; (Regolini Galassi),
 66, 70, 78; *42*; (dei Rilievi), 71, 75, 81;
 (degli Scudi e Sedie), 72, 152; (del Tablino),

Caere (contd.)
72, 74 (fig. 46), 152; (con Tetto Stramineo–Thatched Roof), 65, 66, 70, 539(1)⁴; 33; (dei Vasi Greci), 71, 72 (fig. 44), 152
Caerwent, forum, 344
Caesar, Julius, 93, 97, 126, 127, 172, 180, 183, 184, 186, 188, 192, 209, 342, 379, 426, 431, 459
Caesarea (Algeria), see Cherchel
Caesarea Maritima, 174, 415, 415–16, 416–17, 469
Cagliari, theatre-temple, 33, 138, 557(6)²³
Caistor, forum, 344
Calahorra, 340
Caligula, Emperor, 203, 204–8, 209, 234, 327, 328, 382
Calvinus, Cnaeus Domitius, 184
Calydon, Heroon, 438
Camarina, ridge-tile from, 53–4
Camonica, Val, carvings, 10
Campofattore, hut urn from, 18 (fig. 9)
Canac, baths, 356
Cannatello, Stone Age village, 5
Capena, 23, 560(6)⁶⁴; Etruscan fortifications, 59
Capera, arch, 341
Capito, Cnaeus Vergilius, 402
Capitolias, coins of, 576(18)⁴³
Capri, 202, 204; 'Bagni di Tiberio', 324; Damecuta villa, 323, 324, 326–7; 'Palazzo a Mare', 323–4, 327; Villa Jovis, 324–6 (fig. 126); 170
Capriola, Bronze Age huts, 7, 17
Capua, 26, 61, 63, 96; amphitheatre, 297; houses, 156; mausolea, 299, 301; 164–5; theatre, 165
Caracalla, Emperor, 266, 270, 274, 390, 419, 421
Carcassonne, walls, 571(15)¹⁰
Carletti, Casa, 8, 539(1)⁴
Carneades (philosopher), 140
Carnuntum, 364
Carrara (Luna), marble from, 116, 179, 184, 186, 189, 191, 194, 195, 229, 239, 260, 266, 349
Carthage, 12, 25, 105, 458, 464, 471, 490; Antonine Baths, 485, 486 (fig. 184), 494; Capitolium, 481; tenement houses, 114
Casal Marittimo, cemetery, 78, 550(3)⁷⁰; 47
Casalecchio, 548(3)⁴⁵
Casinum, Varro's villa, 162; (aviary), 251
Cassibile, rock-cut tombs, 9
Cassius Dio, 20, 118, 172
Cassius, Lucius, 168
Castel Gandolfo (Alba Longa), Doric Nymphaeum, 161; hut urn from, 3
Castelluccio, tombs, 9
Castellum Tidditanorum, see Tiddis
Castione, gabbioni, 10
Catena, Val, villa, 322–3 (fig. 125), 326
Cato, 61, 89, 105, 115, 116, 127, 159, 318
Catullus, 302
Catulus, Quintus Lutatius, 41, 116, 131, 132
Celer (architect of Nero's Golden House), 216, 565(8)¹⁷

Celsus Polemaeanus, Caius Julius, 397
Cerveteri, see Caere
Champlieu, Gallo-Roman sanctuary, 351, 352 (fig. 133); baths, 356
Chedworth, villa, 360, 362 (fig. 140)
Cherchel (Caesarea), 490; baths, 485; theatre, 469, 578(19)¹⁵
Chiragan, villa, 358
Chiusi (Clusium)
Bronze Age finds from, 8
Etruscan town, 25, 29; ash urns from, 70, 71, 76; 40; cippus from, 33, 34 (fig. 14); model of atrium displuviatum from, 73, 75 (fig. 47); relief from, 63; 30; tombs, 68, (Porsenna's), 80, 178, (della Paccianese or del Granduca), 75, (della Scimmia), 66, 548(3)⁵⁴
Chlorus, Constantius, Emperor, 517
Cicero, 15, 27, 43, 91, 96, 108, 114, 115–16, 137, 140, 147, 155, 159, 162, 165, 168, 180, 186, 318, 327, 378
Circeii, walls, 97
Cirta, temple, 491
Città Danzica, Early Iron Age village, 15
Civita Alba, Etruscan pediment sculpture from, 51
Civita Castellana (Falerii), 23, 25, 134, 550(3)⁶⁵; Bronze Age finds, 8; Contrada Celle, 39, 40 (fig. 21), 55; gates, 102; house model from, 29, 70; 9; Lo Scasato, 51; Temple of Juno, 30
Civitavecchia, Apennine pottery from, 8; Bronze Age huts, 539(1)⁴
Claudius, Emperor, 208–11, 236, 247, 306, 371, 402, 542(2)¹³, 565(8)⁵
Cleopatra, 183, 458
Clusium, see Chiusi
Cnossos, 8
Cocumella di Caiolo, 78
Colchester, Temple of Claudius, 310, 345
Cologne, see Köln-Müngersdorf
Columella, 318
Commodus, Emperor, 239, 267, 269, 284, 372
Como, gate, 304; lake dwellings, 10
Conca (Satricum), agger, 84; Temple of Mater Matuta, 30; temple models from, 33 (fig. 13), 49, 50 (fig. 27)
Conimbriga, forum complex, 341
Constantina, daughter of Constantine, 509
Constantine, Emperor, 271, 458, 497, 498, 500, 502, 503, 505, 507 ff., 516, 517, 518, 520, 522, 535–6
Constantine II, Emperor, 417
Constantinople, 239, 388, 451, 497, 507, 511, 516, 532, 535–6; Hagia Sophia, 386, 500, 514, 524; palaces, 523, 532–3; SS. Sergius and Bacchus, 514; Theodosian Walls, 389
Constantius II, Emperor, 238
Coppa Nevigata, 5, 8
Córdoba, 340

Cori (Cora), Temple of Castor and Pollux, 135 (fig. 75); Temple of Hercules, 51, 134, 136; *78*; walls, 97, 149

Corinth, 295, 369–78 (fig. 144), 383, 395, 397, 406, 467, 469, 569(13)[3]

Cornelius Nepos, 48

Cornificius, L., 184

Corsica, 7

Cortona, 29; tombs, 78, 549(3)[62]

Cos, Temple of Asklepios, 122

Cosa, 105, 117, 134; basilica, 122, 123 (fig. 69), 127, 128, 129, 130; Capitolium, 47 (fig. 24), 48, 49–50, 55, 110 (fig. 64), 132; comitia, 113, 122, 123 (fig. 69), 138; fornix, 162; forum, 122, 123 (fig. 69), 124; plan of town, 103, 151–2; temples, 44, 46, 48 (fig. 25), 110–11, 122, 134, 135, (Port), 33, 110–11 (fig. 65), (B), 33, 110–11 (fig. 65), (C), 49, 122, (D), 33, 110–11 (fig. 65), 134; villas, 160, 555(6)[5]; *96*; walls, 97–8, 100, 101, 148; *60*

Cosinius, market of, *see* Djemila

Cossutius, Marcus, 378, 382

Costanza (Tomis), warehouse-building, 366

Crassus, 118

Crete, 28

Cuicul, *see* Djemila

Cumae, 173; acropolis, 22; tholos tomb, 178, 550(3)[70], 563(6)[95, 96]

Cumae, Battle of, 26, 63

Curio, C. Scribonius, 169

Curius, house of, 89

Cybele, 206

Cydias (painter), 161

Cyprus, 8, 77

Cyrene, 462; basilica, 373; Caesareum, 122, 460 (fig. 171), 462; *239*; hippodrome, 464; 'House of Jason Magnus', 464; Temple of Apollo, 462; theatre, 377, 464; tombs, 77

Cyriacus of Ancona, 392

Cyzicus, 391; amphitheatre, 397; Temple of Hadrian, 392, 478–9, 574(18)[15]

D

Damascus, 414, 423, 430–1, 431, 574(18)[2]; agora, 430; colonnaded street, 430; gymnasium, 415; Temple of Jupiter Damascenus, 421, 430–1; theatre, 415, 430

Dana, tetrapylon, 430

Danube, Apollodorus's bridge, 243

Daphni (suburb of Antioch), houses, 575(18)[30]; theatre for aquatic displays, 377

Delos, 24, 76, 156, 159, 571(15)[22], 574(18)[7]

Dendera, nymphaea, 459

'Dercennus, Tomb of', 80

Der el-Meshkuk, temple, 443

Desenzano, villa, 533, 534 (fig. 204)

Dhat Ras, temple, 436

Diana Veteranorum, *see* Zana

Didyma, *see* Miletus

Dio Cassius, *see* Cassius Dio

Diocletian, Emperor, 93, 192, 453, 457, 497, 500, 511, 516, 517, 524, 527, 579(20)[6]

Diodorus 4, 64, 74, 81, 155

Diogenes (Athenian sculptor), 186

Diokaisareia (Cilicia), colonnaded street, 410, 456; monument, 430

Dionysius of Halicarnassus, 6, 20, 21, 23, 24, 30, 40, 41, 42, 43, 63, 80, 81, 82, 85, 87, 89, 91, 92, 93, 94, 108, 113, 135, 165

Dionysius, tyrant of Syracuse, 39

Ditchley, villa, 359; *189*

Djemila (Cuicul), 479, 486 ff., 490; Arch of Caracalla, 487, 488; basilica, 481, 490; bath-buildings, 485 (fig. 183), 487, 488; Capitolium, 310, 487, 578(19)[20]; curia, 487; houses, 487; Market of Cosinius, 482 (fig. 181), 487, 578(19)[22]; *241*; plan, 486–7; *254*; Severan Forum, 487, 488; *254*; Temples (of the Severan Family), 487, 488, *255*, (of Venus Genetrix), 487, 493; theatre, 487, 488

Dmeir, temple, 434–6

Doclea, 367–8 (fig. 143)

Dodona, 80

Domitian, Emperor, 194, 206–8, 221, 224, 226, 226–35, 247, 273, 284, 328, 330, 397, 401, 437

Dougga (Thugga), 471, 472, 490, 491, 493; Capitolium, 310, 578(19)[20]; Licinian Baths, 485; market, 578(19)[22]; Temples (of Caelestis), 491, (of Minerva), 493, (of Saturn), 492–3; theatre, 469, 578(19)[15]

Drevant, baths, 356

Duenos inscription, 85

Dura-Europos, 413, 414, 447–51, 453; bath-buildings, 575(18)[33]; bazaar quarter, 372, 448 (fig. 167), 449, 562(6)[84]; houses, 449; Palace of the Dux Ripae, 445, 451, 452 (fig. 169), 457; temples, 434, 438, 449, (of Artemis), 446, (Mithraeum), 449, (of the Palmyrene Gods), 449, 450 (fig. 168)

Durocortorum, *see* Reims

E

Ecbatana, 547(3)[36]

Echmoun, 417

Edfu, bath-building, 459

Elaeusa, *see* Ayaş

Elagabalus, Emperor, 270, 274, 334

El-Djem (Thysdrus), 578(19)[25]

Eleusis, 381; Inner Propylaea, 180, 186, 191, 378, 382; *193*; Outer Propylaea, 392, 572(16)[18]; Telesterion, 250

Emesa, 413; sanctuary of Ba'al, 270, 274

Ennius, 147, 165
Ephesus, 386, 391, 403, 560(6)⁷¹; agora, 395; Aqueduct of Pollio, 387; *201*; arch, 456; Arkadiané, 395, 401; *207*; Baths (East), 400 (fig. 151), 402, (Harbour), 388, 400 (fig. 151), 401–2 (fig. 152), 403, 406, (Theatre), 401, *207–8*, (of Vedius), 399–40 (fig. 151), 402, *198*; gateways, 405; Library of Celsus, 388, 394, 395, 397, 398 (fig. 150), 399, 405–6; *209*, *211*; odeion, 573(17)²³; St John, 386; Serapaeum(?), 393; Temples (of Artemis), 42, 420, (of Domitian), 392, (of Hadrian), 393, 408, *frontispiece*; theatre, 373, 397–8, 405, 409; *207*
Ephorus, 22
Epidaurus, odeion, 377, 572(16)¹⁵; theatre, 374 (fig. 145)
Es-Sanamen, Tychaeon, 434, 436, 443; *230*
Este, hut urns from, 19
Etruscans, origin of, 23–4
Eusebius, 228
Evander, 21
Évaux, baths, 355

F

Fabricius, L., 174
Faesulae, *see* Fiesole
Failaka, fortress, 553(5)⁵; temple and fortification, 104 (fig. 60), 574(18)²
Falerii, *see* Civita Castellana
Falerii Novi, *see* Santa Maria di Falleri
Fano (Fanum), basilica, 128, 129, 130, 131, 311, 556(6)¹³; forum, 122, 124; gate, 304
Farnese, Cardinal Alessandro, 204
Faustina, Empress, 267
Faustus, 148
Felsina, *see* Bologna
Ferentino (Ferentinum), bastion, 147–8 (fig. 80); *90*; gates, 148; *91–2*; market, 242; walls, 97, 147–8; *90*; warehouses, 174; *98*
Ferento (Ferentum), temple, 543(3)⁵; theatre, 562(6)⁷⁹; Tomb of the Salvii, 114
Feurs, theatre, 351
Fiesole (Faesulae), 25, 545(3)²⁴; temple, 36–7, 38, 39 (fig. 19), 136, 543(3)⁸; theatre, 562(6)⁷⁹
Fishbourne (Chichester), villa, 358, 359 (fig. 137)
Flaminius Nepos, C., 114
Florence, Palazzo Medici-Riccardi, 209
Fondi (Fundi), castrum and walls, 98, 104, 149
Fontaines Salées, Les, baths, 355
Formia, nymphaeum, 555(6)⁷; Tomba di Cicerone, 550(3)⁶⁹; villas, 321, (di Cicerone), 161, 197
Forum Augusti Vallensium, *see* Martigny
Forum Julii, *see* Fréjus
Francolise, S. Rocco Villa, 319, 321 (fig. 124), 560(6)⁶⁴
Fratte, *see* Marcina

Fréjus (Forum Julii), 342, 343; gate, 305, 346; theatre, 351
Frontinus, 91, 103, 108, 175, 247
Fucine Lake, 209–10
Fundi, *see* Fondi

G

Gabii, 100, 131; theatre-temple, 48, 54, 136, 139 (fig. 76), 140, 146, 168, 173; *21*, *82*
Gaeta, tomb of Munatius Plancus, 197, 563(6)⁹⁶; villas, 321
Galba, Servius Sulpicius, 173; tomb, 177; *101*
Galerius, Emperor, 522
Galilee, synagogues, 417
Gallienus, Emperor, 509
Gallus, Cornelius, 577(19)¹
Gargano, megalithic tombs, 7
Gela, Greek city wall, 28; Villa Jacona, 559(6)⁶²
Gellius, 41
Gerasa (Jerash), 431, 436–9, 443; arch, 442, 456; fountain building, 432, 437, 439, 442, 443, 572(16)²²; *225*; gates, 436–7, 437; piazza, 437; *227*; South Theatre, 437; *227*; North Theatre, 437; Temples (of Artemis), 424, 436, 437–8, *226*, (C), 437, 438, ('Cathedral'), 437, (of Dushara?), 436, 449, (of Zeus), 436, 437, 438; West Baths, 437, 438–9; *229*
Germanicus, 202
Gigthis, 471, 490; market, 578(19)²²; temples, 467, 491, 492 (fig. 187)
Gioiosa Ionica, theatre, 165
Gisacum, *see* Vieil-Évreux
Glanum, *see* Saint Rémy
Gordian, Emperor, 285
Gortyna, bouleuterion/odeion, 377
Gracchus, Tiberius Sempronius, 126
Gratian, Emperor, 517
Gubbio (Iguvium), theatre, 562(6)⁷⁹, 564(7)⁸
'Gyges, tomb of', 550(3)⁶⁶

H

Hadrian, Emperor, 232, 233, 234, 235, 239, 246, 254 ff., 264–7, 267, 284, 285, 297, 310, 330, 340, 378, 382, 383, 411, 437, 462, 564(7)⁵
Hadrian's Wall, 363
Hamath Tiberias, synagogue, 574(18)⁹
Hannibal, 26, 95, 96, 97, 100, 115, 146, 552(4)⁶
Hasta, *see* Asti
Hatra, 413, 414; bull capitals, 420; houses, 449; temples, 434, 438, 449, (of Shamash), 420
Hebran, temple, 443
Hegra, *see* Medaein Saleh
Helena, Empress, 270, 508
Heliopolis, obelisks from, 205, 461
Herculaneum, 290–1, 294, 297, 569(13)⁴; decoration at, 73, 262; houses, 71, 75, 88, 120, 130,

152 ff., 160, 291, 313–16 (figs. 119–20), 317, 328, 416, 554(5)[12]; *171–2*; palaestra, 292; streetside portico, 294; *158*; Suburban Baths, 296; villas, 321
Hermel, monument, 430
Hermes, Quintus Marcius, tomb of, 278
Hermogenes (architect), 386, 389, 392
Hermoupolis Magna (Ashmunein), Temple of Ptolemy III, 122, 459–60
Herod the Great, 415–17, 426, 431, 436, 440
Herodes Atticus, 372, 383
Herodotus, 7, 21, 60, 165
Hesiod, 22
Hierapolis, 386, 391, 395, 403
Hippodamus of Miletus, 60, 61, 391
Hippo Regius, *see* Bône
Hispellum, *see* Spello
Histria, bath-building, 366
Homer, 4, 9, 21
Honorius, Emperor, 497
Horace, 147, 154, 159, 162, 176, 178
Hortensius (orator), villa of, 161
Hossn Sfiri, altar tower, 423
Hossn Suleiman, altar tower, 423
Hymettus, Mount, marble from, 155, 168
Hyrcanus, 576(18)[43]

I

Iader, *see* Zadar
Iconium, *see* Konya
Iguvium, *see* Gubbio
Imbros, 24
Indo-Europeans, 15, 23
Innocent X, Pope, 503
Ischia, 4, 9, 22; Geometric vases from, 22; tumuli, 77
Iseo, lake dwellings, 10
Isis, 206, 237
Isola Sacra, cemetery, 176, 566(9)[20]
Italica, 340; amphitheatre, 341
Izmir, *see* Smyrna
Iznik, *see* Nicaea

J

Jerash, *see* Gerasa
Jericho, 416
Jerome, St, 517
Jerusalem, Capitolium, 310; Temple, 415; 'Tomb of Absolom', 575(18)[16]
Jones, Inigo, 545(3)[24]
Josephus, 415
Jublains, walls, 571(15)[10]
Julia Domna, Empress, 270
Julian, Emperor, 447
Justinian, Emperor, 245, 500, 524
Juvenal, 64, 153

K

Kalat Fakra, altar, 419, 423; *218*; upper temple, 425 (fig. 159)
Kallixeinos of Rhodes, 569(13)[7]
Kanawat, temples (peripteral), 443, (of Zeus), 436
Kanishka, King, 441
Karanis, 459, 573(17)[3]; *238*
Karphi, 28
Kassope, caravanserai, 562(6)[84]
Kasr ibn-Wardan, fortress-palace, 527, 532
Kavousi, 28
Khamissa (Thubursicu Numidarum), basilica, 481; forum, 491
Khirbet et-Tannur, temple, 434, 441
Knidos, 391
Köln-Müngersdorf, villa, 358, 359, 360 (fig. 138)
Konya (Iconium), 389
Korykos, 410
Kremna, basilica, 409, 572(16)[6]; Kaisareion, 461
Kyrene, *see* Cyrene

L

Lacer, Gaius Julius, 341
Lactantius, 517
Lambaesis, 479, 526; arch, 482; Capitolium, 310, 578(19)[20]; 'Large' Baths, 485; Praetorium, 457; Temple of Aesculapius and other divinities, 492 (fig. 187), 493
Laodicea, *see* Latakieh
Latakieh (Laodicea), 414, 574(18)[2]; aqueduct, 415; arch, 575(18)[31]; colonnaded streets, 575(18)[31]
Laurentum, 3, 151
Lavinium (Pratica di Mare), Early Iron Age village, 13; Latin town, 56, 58; altars, 545(3)[21]; 'tomb of Aeneas or Anchises', 563(6)[96]
Lecce, megalithic tombs, 7
Lemnos, 24
Leontini, primitive huts, 16
Lepcis (Leptis) Magna, 274, 367, 372, 383, 392, 465–17, 475–9, 490, 491, 493, 494, 517, 527; Arch of Septimius Severus, 469, 475, 482; Arch of Trajan, *242*; Basilica Vetus, 467; bath-building, 475, 485; Chalcidicum, 469; *242*; Colonnaded Street, 475, 477; *244*; Curia, 467; Hadrianic Baths, 470, 473, 475, 483–5; *244, 246*; harbour, 475, 478; *244*; Hunting Baths, 403, 427, 474 (fig. 176), 475, 486; *245*; market, 211, 295, 468 (fig. 174), 469; *240*; North (Forum) Temple, 466–7; Old Forum, 465, 466–7 (fig. 173); *244*; Severan Basilica, 442, 462, 475, 476–7 (figs. 178–9), 478, 479; *244, 247*; Severan Forum, 420, 462, 475, 476–8 (fig. 178); *196, 216, 244*; Severan Nymphaeum, 439, 478; *244, 248*; Temple in honour of the Severan Family, 476–8 (fig. 177); Temple of Liber Pater, 467;

Lepcis Magna (*contd.*)
 Temple of Rome and Augustus, 197, 310, 466–7; theatre, 469–70 (fig. 175), 473, 578(19)[15]; *243*
Lepidus, M. Aemilius, 126, 556(6)[17]
Lesbos, 24
Libanius, 527
Limonum, *see* Poitiers
Lincoln, water supply, 347
Lindos, 76, 122, 146
Lipari, 9, 22; acropolis, 8; huts, 16
Liternum, Scipio Africanus's villa, 162
Livia, Empress, 208
Livius Andronicus, 165
Livy, 20, 25, 27, 53, 61, 63, 64, 77, 81, 84, 87, 89, 91, 92, 93, 94, 96, 97, 107, 112, 113, 114, 115, 126, 127, 153, 154, 155, 164, 165, 168, 179, 302
Lixus, temple, 492
Lockleys (Welwyn), villa, 358
Locri, grottoes, 161, 560(6)[69]; ridge-tile from, 54
London, 342
Lucera, amphitheatre, 297
Lucretius, 82
Lucullus, 162
Lucus Feroniae, amphitheatre, 169; basilica, 311; forum, 126; plan, 151, 555(6)[12], 558(6)[47]
Lugdunum, *see* Lyon
Lugdunum Convenarum, *see* Saint Bertrand-de-Comminges
Luna (Luni), *see* Carrara
Luni (Monte Fortino), Apennine village, 5, 6 (fig. 2), 7–8 (fig. 3), chamber tomb, 8; Iron Age village, 13, 16, 17–18; Etruscan town, 23, 25, 28, 29, 57, tombs, 68, *38*, *51*, walls, 59 (fig. 33), *26*
Lutetia, *see* Paris
Luxor, Diocletianic camp, 459, 577(18)[80]; Temple of Serapis, 458, 577(19)[1]; *236*
Lydney, shrine of Nodens, 349
Lyon (Lugdunum) 342, 343, 542(2)[13]; aqueducts, 343, 347, 571(15)[9, 13]; odeion, 343, 377; *182*; Sanctuary of Augustus, 343; theatre, 343, 351; *182*
Lysimachus, 105, 391

M

Machnaka, altar, 419, 423
Mactar, 490
Madauros, 490; basilica, 481; Large Baths, 486
Maenius, C., 112, 553(5)[10]
Magdalensberg, 363–4; *190*
Magnesia(on-the-Maeander), market, 562(6)[84]; Temple of Artemis Leukophryene, 392
Maggiore, Lago, lake dwellings, 10
Maiyamas, temple, 441, 443
Malalas, John, 417, 419, 427
Malta, 6, 12, 28

Manfria, Bronze Age village, 8, 539(1)[4]; sub-Apennine huts, 548(3)[52]
Mantua, 302
Manziana, Ponte del Diavolo, 102 (fig. 59)
Marano, mausoleum, 301
Marcina (Fratte), 26, 61, 546(3)[33], 548(3)[46]; *23*
Marcouna (Verecunda), arch, 482
Marcus Aurelius, Emperor, 267
Marius, 143, 149
Marseille (Massilia), 342, 356
Martial, 153, 159, 162, 211, 230
Martigny (Forum Augusti Vallensium), 306
Martin of Tours, St, 517
Marzabotto, 26, 28, 39, 60–1 (fig. 34), 64, 65, 70, 72, 77, 89, 91, 174, 547(3)[38]; *29*
Masada, 416, 464; *217*
Massilia, *see* Marseille
Matidia, Empress, 267
Maxentius, Emperor, 244, 265, 497, 502–7
Maximian, Emperor, 517, 529, 533
Mayen, villa, 358
Medaein Saleh (Hegra), Nabataean mausolea, 575(18)[37]; *223*
Mediolanum, *see* Milan
Medjel, houses, 447
Medrecen, mausoleum, 491
Me'ez, andron, 430
Meloni del Sodo tombs, 78
Melqarth, 274
Mérida (Augusta Emerita), 297, 310, 341
Metapontum, 547(3)[44]
Metellus, Q. Caecilius, 116
Metz, villas, 571(15)[24]
Mhayy, temple, 436
Micapsa, King of Numidia, 491
Michelangelo, 253, 502
Michelozzo, 209
Milan (Mediolanum), 516, 517, 533, 536; bath-building, 533; palace, 533; S. Lorenzo, 514, 533; S. Simpliciano, 533; 'Torre di Ansperto', 304
Miletus, 386, 391, 395; aqueduct, 387; Baths (of Capito), 387, 402–3, 475, *199*, (of Faustina), 387, 399, 402, (Humeitepe), 387, 402; bouleuterion, 377, 381, 416; Didymaion, 382, 420, 573(17)[8]; gate, 405; gymnasium, 156; Nymphaeum, 382, 387, 394, 404 (fig. 153), 406, 407; Serapeum, 393; Temple of Asklepios, 395; theatre, 398–9
Minturno (Minturnae), castrum, 98 (fig. 55), 104, 105
Minucius, Lucius, 173
Mismiyeh (Phaena), 'Praetorium', 442, 576(18)[53]; *235*
Mithras, 206
Mitylene, theatre, 166, 172
Mogorjelo, fortified residence, 527
Molfetta, Stone Age village, 5
Montalto di Castro, 5

Monte Carlo, La Turbie, 302, 569(13)[15]
Monte Fortino, *see* Luni
Morgantina, 6, 9, 122, 147, 545(3)[24]; houses, 44, 65, 159, 548(3)[52], 559(6)[62]; market building, 295, 372; *156*
Mschatta, fortress-palace, 532
Mummius, Lucius, 168, 369
Muşaşir, relief of temple at, 55 (fig. 29), 56
Mushennef, temple, 443
Mycenae, 8

N

Naevius, 147
Nantes, walls, 571(15)[10]
Naples, 60, 61, 97, 103, 171, 290, 554(5)[12]; odeion, 377
Narbonne (Narbo), 342, 570(15)[4]; Capitolium, 348–9; vaulted substructure beneath market(?), 348, 558(6)[39]
Narni, bridge, 307
Nasica, *see* Scipio
Nemausus, *see* Nîmes
Nemi, galleys, 205; model of Etruscan temple roof from, 48, 49 (fig. 26), 51; revetments from, 54, 547(3)[36]
Nennig, villa, 360, 361 (fig. 139)
Neo-Pythagoreans, 206
Nero, Emperor, 172, 205, 210, 211–16, 217, 230, 295, 327–8, 382, 568(13)[1], 570(14)[24]
Nerva, Emperor, 228, 235, 266
Nettuno, mausoleum, 356
Nicaea (Iznik), 105, 391; colonnaded streets, 395; gymnasium, 572(17)[1]; walls, 363, 389; *202*
Nicanor, 447
Nicomedia, 516, 517, 536
Nicopolis (western Greece), 415; odeion, 377; (suburb of Alexandria), 180
Niha, altar tower, 423; Temple A, 423–4 (fig. 158); Temple B, 575(18)[24]
Nîmes (Nemausus), 342, 343, 346; amphitheatre, 297, 353; aqueduct, 347; fountain building, 442; gate, 304, 345, 346; Maison Carrée, 136, 307, 341, 348, 544(3)[11]; *184*; shrine of Nemausus, 350
Nin (Aenona), Capitolium, 366
Nora, Romano-Punic temple, 492
Norba, 97, 103, 553(5)[5], 557(6)[31]; acropolis temple, 33, 111 (fig. 65), 117; walls, 97, 100, 103, 554(6)[4]; *59*
Norchia, Etruscan tombs, 44–5, 46, 51, 52, 68, 69 (fig. 41), 81; *20*
Noviodunum, *see* Nyon
Numa Pompilius, 54, 92
Nuraghi, 6, 9, 11 (fig. 5), 12; *1*
Nyon (Noviodunum), 342
Nysa (on-the-Maeander), bouleuterion ('Gerontikon'), 311, 395; library, 573(17)[22]

O

Octavian, Caesar, *see* Augustus, Emperor
Odenaethus of Palmyra, 453
Olympia, 122, 165, 554(5)[14], 561(6)[71]; fountain building, 383–4, 385
Olynthus, 60, 103, 156
Oran, *see* Portus Magnus
Orange (Arausio), 342; arch, 356; *188*; theatre, 353, 374 (fig. 145), 375
Orata, G. Sergius, 163
Orvieto, 25; Crocefisso cemetery, 60, 68, 69, 78, 80, 89, 176; *27*; temples, 39, 51, 52, 134, (Belvedere), 31, 32 (fig. 12), 39, 51, 55
Ostia, 61, 118, 119, 162, 173, 265, 270, 275, 279 ff., 290, 334–6, 549(3)[61]
 Barracks of the Vigiles, 284, 285, 286 (fig. 109), 568(12)[6]
 Baths: Forum, 284, 286–8 (fig. 110); Neptune, 164, 286–8 (fig. 110); Via della Foce, 568(12)[8]
 Casette Tipo, 317
 Castrum, 89, 101, 104, 148, 149, 279, 552(4)[6]
 Cemetery, 176–7
 Forum, 281
 Granaries, *see* Warehouses
 Harbour, 209, 210, 235, 247; *see also* Portus
 Horrea, *see* Warehouses
 Houses, 71, 74, 88, 106, 113, 116, 152, 153, 154, 155, 156, 157–8, 280 (fig. 106), 284, 316, 333, 334–6, 427, 533; *44*; (of the Charioteers), *150*; (of the Columns), 334; (of Cupid and Psyche), 334–6 (fig. 130); *176*; (of Diana), 284, 318, 335 (fig. 130); *148*; (of Fortuna Annonaria), 284, 316, 334, 335 (fig. 130); (Garden), 335 (fig. 130); (of the 'Lararium'), *151*; (of the Muses), 318; (of the Triclinia), 568(12)[6]; (of the Triple Windows), *149*
 Insulae, 118, 120, 121, 155, 216, 233, 285, 288–9 (fig. 111), 317, 334, 554(5)[12]
 Magazzini Repubblicani, 281
 Piazzale of the Corporations, 281, 282 (fig. 107), 408
 Plan, 90 (fig. 54), 151, 279, 280 (fig. 106), 284, 372
 Schola del Traiano, 284
 Streets, 77, 281–2, 295; *153*; (Via della Fortuna Annonaria), 74
 Tabernae, 89, 114, 173, 281, 285, 288–9; *154*
 Temples, 136, 151, 281, 311, 557(6)[23]; *93*; (Capitolium), 132, 281, 286; *147*; (Cybele, Attis, and Bellona = Sanctuary of the Asiatic Divinities), 286, 565(8)[5], 568(12)[7]; (Isis and Serapis), 237; (Rome and Augustus), 281, 286; (round), 284–5, 286, 579(21)[8]; (Tetrastilo), 136
 Theatre, 164, 166, 271, 281, 282 (fig. 107), 284, 377, 469, 567(10)[1]
 Tombs, 89

Ostia (*contd.*)

Walls, 98, 149–51

Warehouses and granaries, 173, 174, 203, 210, 230, 237, 283, 284, 285–6; (Epagathiana), 284, 286 (fig. 109), 568(12)[6]; *152*; (Grandi), 283, 284; (of Hortensius), 283 (fig. 108)

Ovid, 20, 92, 137, 147

P

Padula, pottery from, 15

Paestum, 60, 105, 111, 547(3)[44]; comitium, 113, 138; forum, 124, 126; 'Tempio della Pace', 111, 112 (fig. 66), 124, 135, 136, 557(6)[23]

Palestrina (Praeneste), basilica, 143, 146, 178; *87*; curia, 143–5, 146, 148; *85*; fibula from, 85; forum, 143 ff. (fig. 79); *86*; plan, 143; revetments from, 54, 547(3)[36]; temple (old), 146; Temple of Fortuna Primigenia, 100, 122, 124, 131, 140–3 (figs. 78, 79), 146, 168, 173, 188, 197, 224, 262, 567(10)[1]; *84*; (Barberini mosaic), 208, 461; tombs, 78; treasury, 143, 146; walls, 97, 100

Palladio, Andrea, 225 (fig. 94), 226, 253, 271, 274, 498–500 (fig. 188), 502 (fig. 189), 508

Palmavera, nuraghi, 11 (fig. 5)

Palmyra, 413, 414, 423, 441, 453–7, 498; *231*; agora, 456; arch, 456, *234*; cemeteries, 432, 456, 457, 577(18)[70, 79]; bath-building, 456, 457; colonnaded streets, 410, 456; *233–4*; houses, 456; (Kaisareion?), 461; military headquarters, 456, 457; Temples (of Ba'alshamin), 456, 457, (of Bel), 436, 453–5 (fig. 170), 500, *231–2*, (of Nabô), 456–7; theatre, 456

Paneion, Temple of Augustus, 415

Pantalica, 'Anaktoron', 9 (fig. 4); rock-cut tombs, 9

Pantelleria, Neolithic huts, 5

Panvinio, 230, 505

Paola, Lago di, Domitian's villa, 328

Parabas, houses, 114

Paris (Lutetia), basilica, 348; Cluny Baths, 354, 567(10)[8]; plan, 344

Passo di Corvo, 5

Pausanias, 178, 372

Pavia, 302

Peisistratus, 382

Pella, nymphaeum, 439

Pergamon, 167, 386, 391, 415, 561(6)[74], 564(7)[9]; amphitheatre, 397; baths, 403; colonnaded street, 395; gymnasium, 403; library, 573(17)[22]; market, 562(6)[84]; odeion, 403, 572(16)[15]; Sanctuary of Asklepios, 388–9, 393–5 (fig. 148), 573(17)[22]; *206, 215*; Serapaeum, 388, 393; *205*; Temple of Dionysus, 147; Traianeum, 266, 392–3, 403, 408

Perge, baths, 409; market, 409; South Gate (Nymphaeum), 407, 408, 409; *212*; stadium, 409; theatre, 409; walls, 406

Périgueux (Vesunna Petrucoriorum), Temple of Vesunna, 349, 351

Persepolis, bull capitals, 420; towered façades, 576(18)[51]

Pertosa, Grotta di, 10

Perugia (Perusia), 29; city gates, 76, 549(3)[61]; Tomb of the Volumnii, 67 (fig. 38), 70, 72, 75, 81, 114; *45*

Peter, St, tomb, 176

Petra, 423, 431, 432–6, 441; 'Qasr Fira'un temple', 424, 432, 434 (fig. 162), 438, 441, 576(18)[60]; *222*; tombs, 276, 432, 432–3, 441; *221*

Pfalzel, villa, 527

Phaena, *see* Mismiyeh

Philadelphia, *see* Amman

Philae, 458; *237*

Philip of Macedon, 114, 384

Philip the Arab, Emperor, 419, 421, 442, 527

Philippeville (Rusicade), granary, 490

Philippi, 384–5; (battle of), 190

Philippopolis, *see* Shehba

Philippus, L. Marcius, 184

Philo, 205

Phoenicians, 12, 21

Piacenza, amphitheatre, 297

Piazza Armerina, villa, 334, 377, 517, 529–33 (fig. 202), 568(12)[8]; *273–4*

Pietrabbondante, theatre-temple, 168, 170, 173

Piraeus, 60

Piranesi, 209, 259, 502; *117*

Pirro Ligorio, 230

Pithekoussai, 541(2)[11]

Plancus, L. Munatius, 184, 343; (tomb), 197, 563(6)[96]

Plautus, 89, 91, 112, 127, 165, 167

Pliny (the Elder), 3, 4, 28, 52, 53, 87, 88, 93, 94, 95, 115, 116, 117, 137, 145, 153, 154, 155, 156, 161, 162, 168, 172, 178, 179, 186, 191, 205, 220, 263, 327; (the Younger), 572(17)[1]

Plutarch, 16, 87, 172

Poitiers (Limonum), baths, 354

Pola, amphitheatre, 188, 297, 353; Arch of the Sergii, 308; Temple of Rome and Augustus, 307, 367

Pollio, C. Asinius, 184

Pollio, C. Sextilius, 387

Polybius, 103–4, 105, 113, 168

Polycletus, 164

Pompeii, 26, 62 (fig. 35), 63, 136, 162, 261, 262, 290 ff., 553(5)[6]

Amphitheatre, 76, 146, 170, 292, 293, 297; *99*

Basilica, 62 (fig. 35), 127, 128, 130, 292, 292–3, 568(12)[3]; *73*

Baths: Central, 164, 288, 294, 295–6 (fig. 113), 355; *157*; Forum, 62 (fig. 35), 119–20 (fig. 68), 121, 163, 164, 292, 293; *69, 119*; Stabian, 62 (fig. 35), 163, 292, 555(6)[7]

Building of Eumachia, 292, 294; *155*

Capitolium, 123–4, 148, 291, 292–3, 310
Comitium, 292
Curia, 292, 294
Forum, 89, 121–2, 122–4, 126, 127, 292, 293 (fig. 112), 306; *155*; (Triangular), 291
Houses, 61, 69, 71, 152 ff., 270, 291, 312, 317, 554(5)[12]; *95*; (types) atrium, 72, 73, 75, 88, 113, 116, 120, 153, 154 ff.; multi-storeyed, 120; *70*; peristyle, 74, 120
Houses (individual): del Chirurgo, 70, 73 (fig. 45), 153, 559(6)[51]; *94*; di Diomede, 160, 316; dei Dioscuri, 559(6)[54, 59]; del Fauno, 75 (fig. 48), 559(6)[52, 54]; of General Championnet, 157 (fig. 82); di Giulia Felice, 157; del Labirinto, 156, 559(6)[54]; of Loreius Tiburtinus, 315 (fig. 121), 316; *173*; of Lucretius Fronto, 323; *159–60*; del Menandro, 559(6)[62]; dei Misteri (of the Mysteries), 74, 146, 156, 158, 159–60, 160, 316, 319, 320 (fig. 123); *89*; delle Nozze d'Argento, 155, 156; di Sallustio, 153, 156, 160; dei Vettii, 312
Lararium, 292, 293 (fig. 112), 294
Markets, 211, 292, 294–5, 298, 372
Odeion, *see* Theatres
Palaestra Samnitica, 164, 292
Plan, 62 (fig. 35), 89, 96, 103, 105, 372
Porticus Tulliana, 291
Schola Iuventutis, 292, 402
Streets, 77, 216, 295
Tabernae, 89, 114, 120–1, 121, 122, 285, 295; *54*
Temples: of Apollo, 122, 124, 133, 553(5)[9], 555(6)[8]; Doric, 291; of Fortuna Augusta, 291; of Isis, 291, 292; of Jupiter Meilichius, 291; Oscan, 30; of Venus, 291; of Vespasian, 291, 294
Theatres: Large, 166, 167, 171, 292; Roofed (Odeion), 171, 292, 293, 294, 374, 377, 381
Tombs, 177, 178, 299, 301
Villas, 319, 321, 323; *see also* Houses (individual)
Wall-paintings, 214, 261, 276, 291, 296–7, 321, 323, 405, 433, 464
Walls, 106, 149, 242, 551(4)[1]
Pompeiopolis, 410, 456
Pompey, 164, 172, 197, 413
Pont du Gard, 307, 347, 513; *179*
Populonia, 12, 25; cemetery, 70, 78, 79, 80; walls, 59
Porsenna's tomb, 80, 178
Portus, 236–7, 568(12)[6], 579(21)[8]; *see also* Ostia
Portus Magnus (near Oran), villa, 532 (fig. 203)
Posidonius, 63, 81
Pozzuoli (Puteoli), 198, 290, 291; amphitheatre, 224, 297; harbour, 246, 553(5)[6]; market, 220, 298 (fig. 114), 372; Temple of Serapis(?), 298; tombs, 300 (fig. 115), 301
Praeneste, *see* Palestrina
Praenestina, Via, Ponte di Nona, 174
Pratica di Mare, *see* Lavinium
Proconnesus, 365, 407

Propertius, 3, 20, 177
Ptolemais (Cyrenaica), 462; hippodrome, 464; houses, 464; odeion, 464; Palace of the Dux, 445; Palazzo delle Colonne, 159, 462–4 (fig. 172), 569(13)[6]; theatres, 464; (Syria), gymnasium, 415
Ptolemy III, 122
Ptolemy IV, 296
Pulcher, Appius Claudius, 168, 180, 186, 378
Punta Barbariga, villa, 323
Puteoli, *see* Pozzuoli
Pylos, 8
Pyrgi (Santa Severa), 25, 546(3)[36]; castrum and walls, 98 (fig. 55), 99 (fig. 56), 101, 104, 105; inscriptions from, 25; temples, 35, 37 (fig. 17), 38–9, 51, 543(3)[7]
Pyrrhus, 97, 146, 551(4)[6]

Q

Qasr el-Amr, hunting lodge of Walid I, 575(18)[33]
Qasr Ibrim, temple, 577(19)[1]
Qasr Rabbah, temple, 436
Quintilian, 340
Quinto Fiorentino, La Montagnola, 25, 44, 78, 79 (fig. 49); La Mula, 78

R

Rabirius, 227, 230, 231, 233, 234, 243, 265, 328
Raphael, 216
Ravenna, 10, 61, 533; 'Palace of Theodoric', 533; Porta Aurea, 308; S. Vitale, 514, 533
Rbe'ah, monument, 430
Reims (Durocortorum), vaulted substructures beneath forum(?), 348
Rennes, walls, 571(15)[10]
Res Gestae Divi Augusti, 183, 186, 389
Rex, Quintus Marcius, 175
Rhodes, 8, 173; Ptolemaion, 577(19)[3]
Riello, tholos tomb, 550(3)[70]
Rimini (Ariminum), 97; Augustan arch, 204, 307–8; bridge, 307; *168*
Rome, 1, 15, 16, 26, 56, 57, 84 ff. (fig. 52), 96 ff., 115 ff., 183 ff., 202 ff., 217 ff., 245 ff., 264 ff., 279, 290, 294, 497 ff., 516
 Amphitheatres
 Caligula, 221
 Castrense, 270, 271, 334
 Colosseum, 44, 131, 164, 188, 214, 216, 221–4 (fig. 93), 224, 227, 241, 260, 262, 297, 353, 512, 513, 565(8)[4], 567(10)[4]; *121*
 Flavian Amphitheatre, *see* Colosseum
 Nero, 221
 Statilius Taurus, 184, 221
 Aqueducts, 185, 205, 209, 234, 247
 Alsietina, 185
 Anio Novus, 209; *115*

Rome (*contd.*)
 Anio Vetus, 175
 Appia, 108, 175
 Claudia, 209, 234, 247; *115*
 Julia, 185
 Marcia, 175, 185; *120*
 Virgo, 185, 186, 205, 208, 209, 211, 219; *117*
Arae
 Pacis Augustae, 188–9, 208, 219
 Pietatis Augustae, 208; *112*
Arches
 Augustus, 185, 208–9, 356, 564(7)[3]
 Circus Maximus, 126
 Clivus Capitolinus, 126
 Constantine, 267, 507; *262*
 Fabianus, 126
 Germanicus, 202–3
 Germanicus and Drusus, 202–3
 Marcus Aurelius, 267, 275
 Novus, 579(20)[6]
 Pons Mulvius, 307
 Septimius Severus, 275, 507; *104*
 Stertinius, 165
 Titus, 224, 227, 269, 309; *55*
Argeorum Sacraria, 92
Atrium Libertatis, 184, 234, 564(7)[2]
Aventine: pre-Imperial buildings, 53, 92, 113,
 148–9, 168, 184; Imperial buildings, 230,
 236, 269, 271
Basilicas
 Aemilia, 126, 128–9, 130 (fig. 72), 191, 192–4
 (fig. 86), 200, 203, 220, 381, 565(8)[1]; *111*;
 tabernae, 89, 126
 early, 127–8
 Julia, 126, 192, 193 (fig. 86), 194, 200,
 556(6)[16]
 Junius Bassus, 567(10)[18]
 Maxentius (Nova), 230, 244, 262, 502, 503–5,
 506 (fig. 192), 510, 513, 514; *265*
 Neptuni, 185–6
 Nova, *see* Maxentius
 Porcia, 556(6)[14]
 Sempronia, 126, 128, 129
 Ulpia, 190 (fig. 85), 238, 243–4, 251, 346, 348,
 461, 462, 479, 556(6)[16]
 Underground (Via Praenestina), 206; *118*
Baths, 230, 253, 271
 Agrippa, 185, 186, 207 (fig. 87), 211, 227, 263
 Caracalla, 212, 236, 271–3 (fig. 104), 275, 500,
 501, 509, 513, 514, 523; *141–2*
 Constantine, 507–8 (fig. 193), 533
 Diocletian, 236, 253, 500–2 (fig. 190), 508, 509,
 510, 511, 512, 514; *259*
 Domitian, 273
 Helena, 334
 Nero, 211–12, 226, 236, 253, 271
 Septimianae, 270–1, 271
 Sura, 236

Titus, 212, 216, 224, 225 (fig. 94), 226, 227, 236,
 253
Trajan, 212, 216, 226, 235, 236, 253, 520
Bridges
 Aelius, 264–5, 266
 Aemilius, 174
 Agrippae, 185, 186
 Fabricius, 174
 Mulvius, 174
 Neronianus, 211
 Sublicius, 94
 Tiber (179 and 142 B.C.), 77
Caelian: pre-Imperial buildings, 13, 161; Im-
 perial buildings, 211, 217, 230, 295
Campus Martius, 184, 185–6, 197, 206, 211, 227,
 230, 267, 461, 497, 564(7)[4]
Capitoline: pre-Imperial buildings, 20, 21, 85, 87,
 93, 126, 131; Imperial buildings, 217, 224,
 227; *see also* Temples: Capitoline
Carcere Mamertino, 80
Cemeteries
 Aurelian Wall, sarcophagus from, 114; *65*
 Esquiline, 176
 S. Paolo fuori le Mura, 177
 S. Sebastiano, 276
 Servian Wall, 176
 Vatican, 177, 236, 276, 278, 498; *139*
 Via Appia/Via Latina, 175–6, 177, 178–9, 197,
 277–8, 299, 563(6)[96]; *138, 146*
 Via Sacra, 13, 14 (fig. 6), 16
 Via S. Croce in Gerusalemme, 176
Circuses
 Caligula, 211
 Domitian, 200
 Flaminius, 114, 165, 184, 564(7)[2]
 Gaius, 205
 Maxentius, 502–3, 512; *258, 267*
 Maximus, 63, 94, 114, 126, 164–5, 168, 214,
 224, 461, 502
Cloaca Maxima, *see* Sewers
Colosseum, *see* Amphitheatres
Columbarium of the Freedmen of Augustus,
 199
Columns
 Antonine (of Marcus Aurelius), 267
 Antoninus Pius, 267
 Maenia, 94, 113
 Minucia, 80 (fig. 50), 173
 Trajan's, 237–8, 238, 239, 267, 347
Comitium, 93, 94, 113, 126, 138
Coraria Septimiana (guild building), 270
Curia, 93, 94, 116, 148, 184, 192, 269, 311, 500,
 502, 513, 514; *104, 107*
Curia Hostilia, 93, 116, 148
Diribitorium, 207 (fig. 87), 564(7)[6]
Esquiline: pre-Imperial buildings, 13, 58, 84, 87,
 158, 176; Imperial buildings, 208, 214, 230,
 235, 295

Rome (*contd.*)
Fora
 Augustum, 186, 189–92 (figs. 84, 85), 198, 202,
 220, 228, 229, 238, 243, 261, 265, 565(7)[14],
 567(9)[26]; *106, 108*
 Boarium: 563(6)[92]; Bronze Age remains, 8;
 Etruscan temples, 44, 53, 92; *17*; fornix,
 126; fortification, 552(5)[2], 563(6)[92]; houses, 113
 Holitorium, 131; *75*; *see also* Temples
 Imperial, 124, 189 (fig. 84), 228 ff., 309, 311,
 461; *see also* Augustum; Iulium; Trajan's;
 Transitorium; Vespasian's
 Iulium, 189 (fig. 84), 228, 229, 235
 Nerva's, *see* Transitorium
 Pacis, *see* Vespasian's
 Romanum: pre-Imperial buildings, 13, 20, 54,
 76, 80, 92, 93–4, 102, 112–13, 121, 126–7,
 128–9, 131, 139, 153, 553(5)[6]; finds from, 85,
 87, 92, 184; *56*; *see also* Regia; Imperial
 buildings, 184, 189 (fig. 84), 192 ff., 202, 228,
 235, 309, 356; *104*
 Trajan's, 174, 189 (fig. 84), 191, 228–9, 236,
 237–9, 242–3, 246, 268, 461, 479, 500, 514
 Transitorium (of Nerva), 136, 189 (fig. 84), 228,
 229–30, 238, 306, 383; *126*
 Vespasian's (Pacis), 189 (fig. 84), 191, 216,
 219–20 (fig. 92), 228, 270, 298, 383, 500
Forma Urbis Romae, 88 (fig. 53), 107, 113, 136,
 156, 164, 172; *see also* Severan marble plan
Fortifications (*see also* Gates, Walls)
 agger and fossa, 84, 85, 100
 Castra Praetoria, 203–4; *114*
 Equites Singulares, camp of the, 275
Gaianum, 205
Gates (*see also* Fortifications, Walls)
 Appia, 498 (fig. 188); *263*
 Labicana, *116*
 Maggiore, 209, 211, 219, 522; *115–16*
 Praenestina, 209; *116*
 Tiburtina, 185, 308; *120*
Horrea
 Agrippiana, 185, 283, 564(7)[4]
 Galbae, 107, 174, 283
 Piperataria, 230
 Seiani (of Sejanus), 203
 Vespasiani, 230
Horti
 Campus Martius, 327
 Lamiani, 205
 Luculliani, 208, 327
 Maecenas, 327
 Sallustiani, 205, 263, 327
 Tauriani, 208
 Variani, 270, 334
Houses and Villas, 88 (fig. 53), 230, 270, 284,
 312, 551(4)[3], 559(6)[61]; *145*
 Augustus, 158, 559(6)[61]
 Clodius (Palatine), 155

Crassus, 561(6)[76]
Esquiline, 316, 317 (fig. 122)
Evander (Palatine), 3
Farnesina (beneath), 327
Flavian family (Esquiline), 312
Gordians, 510, 512
Grifi, dei (Palatine), 157, 232, 236
Lepidus, 158
Livia, 312, cistern, 80
Maenii, 553(5)[10]
Maxentius, *see* Palaces
Quintilii, 334
Romulus's huts, 20, 21, 115
Scipio, 113, 126, 153
see also Sette Bassi
Insulae, 28, 114, 118, 121, 270, 317
Janiculum: Imperial buildings, 269
Licinian Pavilion, *see* Temple of 'Minerva
 Medica'
Markets
 Macella, 569(13)[5]; (Liviae), 295; (Magnum),
 211, 295
 Trajan's, 189 (fig. 84), 239–43 (figs. 96–7), 251,
 253–4, 285, 288, 333, 346, 567(10)[4]; *127–9*
Mausolea, *see* Tombs
Meta Sudans, 230
Mithraeum (S. Clemente), 236
Odeum, 566(9)[24]
Paedagogium, 234
Palaces, Imperial
 Domus Augustana, *see* Flavian Palace
 Domus Aurea, *see* Nero's Golden House
 Domus Tiberiana, 204, 204–5, 230, 231, 234
 Domus Transitoria, 212–14 (figs. 88, 89),
 232, 251, 261, 328
 Flavian Palace, 157, 194, 206, 208, 213, 216,
 227, 230–5 (fig. 95), 246, 251–3 (fig. 99), 256,
 263, 273, 275, 327, 332, 462, 511, 523; *123*
 Nero's Golden House, 161, 162, 169, 211, 213,
 214–16 (fig. 90), 226, 230, 236, 241, 246,
 248–51 (fig. 98), 262, 328, 567(10)[4]; *130*
 Palatium, *see* Flavian Palace
 Villa of Maxentius, 334, 502; *258*
Palatine: pre-Imperial buildings, 3, 13, 16, 20, 21,
 58, 80, 87, 106, 119, 132, 155, 157, 158, 168,
 312, 555(6)[5]; Imperial buildings, 186, 194–5,
 204–5, 208, 213, 230 ff., 265, 273, 328, 512
Palazzo Montecitorio, 209
Pantheon, *see* Temples
Pincian: Imperial buildings, 208
Porticoes
 Gaius and Lucius, 193–4
 Livia, 327
 Pompey, 327
Porticus
 Absidata, 229
 Aemilia, *see* Warehouses
 Divorum, 207 (fig. 87), 228, 311, 461

Rome (*contd.*)

 Metelli, 228, 553(5)[6], 564(7)[2]

 Minucia, 210, 565(8)[7]

 Octaviae, 270, 564(7)[2]

 Philippi, 184, 564(7)[2]

 Quirinal: pre-Imperial buildings, 13, 42, 58, 92, 176, 558(6)[41]; Imperial buildings, 228, 237, 239, 274, 508

 Regia: of Romulus, 21; in Forum Romanum, 88, 93, 94, 184, 185, 551(4)[3]

 Rostra, 94, 127, 184, 192, 199

 Saepta, 184, 185, 186, 207 (fig. 87), 210

 S. Costanza, *see* Tombs and Mausolea

 St Peter's, 507

 SS. Peter and Marcellinus, 509

 S. Sabina, 515

 Secretarium Senatus, 502

 Septizodium, 273, 405; *143*

 Severan marble plan, 184, 188, 206, 207 (fig. 87), 219, 227, 229, 239, 270–1, 275, 313, 372, 564(7)[2]; *144, 145*; *see also* Forma Urbis Romae

 Sewers, 91, 108, 174–5, 186; Cloaca Maxima, 91, 112, 174–5

 Stadium, Domitian's, 211, 227, 245, 246, 273

 Stoa of Poseidon, *see* Basilica Neptuni

 Streets, 91, 108, 568(12)[4]; *145*

 Argiletum, 219

 Clivus Palatinus, 91, 232; *55*

 Via Biberatica, 241 (fig. 97); *128*

 Via Sacra, 91, 214–15; *55*

 Subura, 191, 219

 Tabernae, 88 (fig. 53), 192–3, 230, 239 ff., 270; *145*

 Tabularium, 76, 121, 126, 129, 131, 138, 140, 188, 200, 224, 226, 556(6)[16], 567(10)[1]; *72*

 Temples

 Aedes Caesarum, 234, 274

 Antoninus and Faustina, 267–9 (fig. 103)

 Apollo Palatinus, 186, 194–5, 197, 203, 232, 565(7)[19]

 Apollo Sosianus (in Circo), 132, 168, 184–5, 192, 196, 565(7)[19]; *110*

 Arx, 48, 92, 93, 135

 Augustus, Divus, 203, 269, 565(7)[15]; *107*

 Botteghe Oscure, Via delle, 134

 Capitoline: pre-Imperial, 34, 35, 36, 39–42 (fig. 22), 42, 43, 53, 84, 87, 91, 92, 92–3, 94, 96, 110, 115–16, 116, 132, 135, 136, 137, 138; Imperial, 217, 227; *107*

 Capitolium Vetus (Quirinal), 42

 Castor and Pollux (Forum Romanum): pre-Imperial, 93, 126, 127, 553(5)[6]; Imperial, 195–6, 196, 198, 202, 420, 564(7)[2]; *104*

 Ceres, Libera, and Liber (Aventine), 53, 93, 95

 Claudianum, 210–11, 217–19 (fig. 91); *122*

 Concord (Forum Romanum), 138, 185, 195, 196, 202, 203, 553(5)[6], 564(7)[2]; *113*

Cybele, *see* Magna Mater

Diana (Cornificia, on Aventine), 92, 184, 196, 564(7)[2]; *144*

Felicitas, 208

Flora (Aventine), 168

Fortuna (Forum Boarium), 44

'Fortuna Virilis', *see* Forum Boarium

Forum Boarium: circular temple ('of Vesta'), 116–17, 200; *67*; 'Fortuna Virilis', 51, 135, 135–6; *77*; *see also* Mater Matuta

Forum Holitorium, 132 (fig. 73), 133 (fig. 74), 134, 136, 138, 195, 197, 198, 556(6)[20], 565(7)[19]

Hadrianeum, 267, 274

Hercules, 138

Hercules and Dionysus, 274

Hercules Musarum, 184

Isis and Serapis, 206–8 (fig. 87), 227, 232, 274, 461, 503

Janus, 195

Julius, Divus, 132, 136, 185, 186, 192, 195, 196, 197, 565(7)[19]

Juno Moneta (Arx), 33, 135; *79*

Jupiter Dolichenus, 269

Jupiter Feretrius, 92

Jupiter Heliopolitanus, 269

Jupiter Optimus Maximus, *see* Capitoline

Jupiter Stator, 116, 132 (fig. 73), 136

Jupiter Ultor, *see* Sol Invictus

Largo Argentina, 138, 207 (fig. 87); Temple A, 108, 109 (fig. 63), 133, 135, 543(3)[11], 556(6)[20]; *76*; Temple B, 109 (fig. 63), 136–7; *76*; Temple C, 31, 34, 42–3, 108–10 (fig. 63), 132 (fig. 73), 135, 136; *14*; Temple D, 109 (fig. 63), 136

Magna Mater (Palatine), 106, 132, 195, 565(7)[19], 565(8)[5]; *112*

Marcus Aurelius, 267

Mars Ultor, 189–90 (fig. 85), 190–1, 195, 196, 390; *106, 109*

Mater Matuta (Forum Boarium), 44, 92; *17*

Matidia, 267

Mercury (Aventine), 93

Minerva (Aventine), 136, 229, 565(7)[19]; *144*

Minerva (Forum Transitorium), 136, 229

Minerva Chalcidica, 207 (fig. 87), 230

'Minerva Medica' (pavilion in the Licinian Gardens), 508, 509–11 (fig. 194), 513–14; *260–1*

Neptune (Circus Flaminius), 184, 564(7)[2]

Pacis, *see* Fora, Vespasian's

Pantheon (Agrippa's), 185, 186, 557(6)[27]; (Domitian's), 256; (Hadrian's), 256–60 (figs. 101–2), 261, 262, 264, 265, 266, 270, 299, 388, 462, 503, 511, 512, 513, 514, 564(7)[5], 565(7)[18], 568(11)[14]; *131–3*

'Romulus', 505, 509

Saturn (Capitoline), 92, 93

Rome (*contd.*)

Saturn (Forum Romanum), 184, 196, 197, 565(7)[19]

Serapis, 274; *see also* Isis and Serapis

Sol (Aurelian's) 497, 498–500 (fig. 189), 514, 568(11)[13]

Sol Invictus (Jupiter Ultor), 234, 274; *107*

Templum Pacis, *see* Forum of Vespasian

Trajan, 238, 239, 264, 265, 568(11)[14]

Veiovis, 138, 227, 565(7)[18]

Venus Genetrix, 190, 229, 235, 403, 442, 461, 467; *124*

Venus and Rome, 212 (fig. 88), 214, 216, 246, 264, 265–6, 267, 393, 420, 502; *264*

Venus Victrix, 113, 197

Vespasian, 224–6, 227, 270

Vesta, 20, 92, 93, 136, 214; *67*

'Vesta', *see* Forum Boarium

Theatres

Balbus, 166, 184, 564(7)[2]

Cassius, L., 168

Claudius Pulcher, 168, 169

Curio, 169

Marcellus, 44, 131, 168, 184, 186–8 (fig. 83), 189, 194, 198, 200, 221, 261, 353, 473, 564(7)[4]; *105*

Mummius, 168

Pompey, 113, 118, 164, 166, 170, 171, 172–3, 203, 221, 405

Scaurus, 169, 263, 405

Scribonius Libo, 168

Tombs and Mausolea (*see also* Cemeteries), 275–7

Anicii, *138*

Annia Regilla, *125, 146*

Augustus, 186, 197, 266, 300, 563(6)[96], 564(7)[1]

Aurelii, 278

Axe, of the (S. Sebastiano), 262

Bibulus, 177–8; *102*

Caecilia Metella, 197, 299, 302, 563(6)[96]

Caetennii (Vatican), 276, 277 (fig. 105); *139*

Cestius, Pyramid of, 299, 563(6)[96]

Constantina, *see* S. Costanza

Flavian family mausoleum, 230

Galba, 177; *101*

'Gordians' (Via Praenestina), *see* Tor de' Schiavi

Hadrian, 264, 266–7

Helena, *see* Tor Pignattara

Maxentius (Via Appia), 502, 503–5, 508, 514, 529; *258*

Orazi, 178–9; *103*

Plautii, 301

'Romulus', 94

S. Costanza, 507, 509, 511, 514; *140*

Scipiones, 175, 176

Sempronii (Quirinal), 176, 177

Tor Pignattara, 508–9, 568(11)[8]

Tor de' Schiavi, 503, 504 (fig. 191), 508, 514, 579(20)[3]

Tullianum, 80

Vestals, House of the, 235

Villas, *see* Houses

Viminal: pre-Imperial buildings, 84

Walls (*see also* Fortifications, Gates), 106, 552(5)[2], 563(6)[92]

Aurelianic, 185, 203, 209, 363, 497–8 (fig. 187), 511, 526; *113, 115–16, 120, 263*

Palatine, 87

Servian, 54, 85, 94, 100, 101, 148–9; *63*

Via Sacra, 119

Warehouses, 210, 237; Porticus Aemilia, 107–8 (fig. 62), 121, 174; *71*; (Horrea Galbae), 107, 174, 283; *see also* Horrea

Wharves, riverside, 237

Romulus, 16, 27, 56, 92

Romulus, M. Valerius (son of Maxentius), 505

Royat, baths, 355

Rusellae, 25, 547(3)[41]; defensive works, 15, 28, 59–60, 84; houses, 26; streets, 77

Rusicade, *see* Philippeville

Ruweiha, mausoleum, 430; Tomb of Bizzos, 430

S

Saar, tomb, 26

Sabaudia, Domitian's villa, 263

Sabratha, 465, 467, 471–3, 490, 491; basilica, 311; *249*; Capitolium, 197, 306, 310, 472; *249*; curia, 467, 472; *249*; forum, 306, 344, 472, 569(13)[3], 570(15)[4]; *249*; North-West Forum Temple, 493; Oceanus Baths, 473; Temple of Hercules, 472; Temple of Liber Pater, 472; Temple of Marcus Aurelius, 472; Temple of Serapis, *249*; theatre, 375, 470 (fig. 175), 472–3; *250*

Saepinum, atrium-house, 88, 154; walls, 97, 552(5)[1]

Sagalassos, temple, 407–8

Sahr, temple, 441

St Albans (Verulamium), 358; Park Street villa, 358

Saint Bertrand-de-Comminges (Lugdunum Convenarum), 306, 344; 'basilica', 348; bath-building, 355–6 (fig. 135)

Saint Chamas, bridge, 347

Saint Rémy (Glanum), 342, 346, 356; arch and monument of the Julii, 299, 356; *187*; bath-building, 354 (fig. 134), 355; bouleuterion, 348; courtyard houses, 342, 356–7; *180*

Sala Consilina, tombs, 15, 17, 29, 70; *5*

Salona, 366–7

Salonica, *see* Thessalonike

Samaria, architrave bracket, 575(18)[16]; basilica, 577(18)[75]; Temple of Augustus, 415, 416, 420, 436

Samos, Heraion, 42, 122

Samothrace, Heraion, 134

San Giovenale

Bronze Age village, 8

San Giovenale (*contd.*)
Early Iron Age village, 8, 13, 16–17 (fig. 8), 18, 65, 539(1)[3, 4]; *2*
Etruscan town, 23, 25, 26, 28, 29, 57, 64, 65, 66; *31–2*; bridge, 77; tombs, 27–8, 67 (fig. 37), 68, 70, 77, 550(3)[71]; *34*; Villa Sambuco, 560(6)[64]; *34*; walls, 41, 58, 59; *25*
San Giuliano, 25, 29, 91; tombs, 44, 68, 71, 72–3, 78, 80, 81, 152; *19, 39, 48–50*
Santa Maria Capua Vetere, *see* Capua
Santa Maria di Falleri (Falerii Novi), walls, 101; *64*
Santa Severa, *see* Pyrgi
Sanxay, sanctuary, 349
Sardes (Sardis), 23, 542(2)[24], 544(3)[14], 550(3)[66]; Temple of Artemis, 573(17)[8]; terracotta revetments, 51
Sardinia, 6, 7, 9, 12, 97, 491
Sarsina, mausoleum, 356
Satricum, *see* Conca
Sbeitla (Sufetula), 490, 493; forum and Capitolium, 310, 341, 578(19)[20]; *253*; temple, 491
Scaurus, M., 169
Scipio Africanus, 162, 164, 167, 168
Scipio Barbatus, L. Cornelius, 114, 126, 175
Scipio Nasica, P., 168
Seeia, *see* Si'
Segesta, temple, 30; theatre, 561(6)[76]
Segni (Signia), 97; Capitolium, 110 (fig. 64), 117, 134; *62*; city gates, 70, 100; temple, 44; walls, 97, 100, 554(6)[4]; *57*
Segovia, aqueduct, 341; *177*
Sejanus, 203
Sele valley, ceramics from, 15
Seleucia (Cilicia), *see* Silifke
Seleucia-Pieria, 414, 453, 574(18)[2]; house, 336, 427 (fig. 160)
Seleucus I, 414
Seleucus III, 574(18)[2]
Selinunte (Selinus), 105, 547(3)[44]; Temple GT, 42
Seneca, 159, 162, 340
Seneca Rhetor, 119
Sens, walls, 571(15)[10]
Serapis, 206
Serdjilla, bath-building, 430
Sermada, monument, 430
Servius Tullius, King, 85, 92
Sette Bassi, villa, 332–3 (fig. 129), 512, 579(21)[6]; *175*
Severus, Alexander, Emperor, 206, 211, 270, 271, 273, 274, 285, 497
Severus, Septimius, Emperor, 232, 234, 270, 271, 273, 274, 275, 284, 447, 451, 467, 475, 527
Severus (architect of Nero's Golden House), 216, 565(8)[17]
Shadrap, 274
Shakka, basilica, 442, 577(18)[75]; 'Palace', 442
Shapur, 447
Shehba (Philippopolis), 442, 443, 527; bath-buildings, 442, 475; *228*; palace, 527; theatre, 444

Si' (Seeia), arch, 434; Sanctuary of Ba'alshamin (and Dushara), 439–41 (fig. 163), 442
Sicily, 5, 6, 8, 9, 13, 15, 16, 22, 43, 48, 52, 53, 60, 65, 97, 158, 173, 491
Side, 393; city gate, 408; colonnaded streets, 408; fountain, 406, 407 (fig. 154), 408; temples, 407–8, 408–9 (fig. 155); theatre, 408
Sidon, bull capitals, 420; theatre, 415
Sidonius Apollinaris, 348, 360
Signia, *see* Segni
Sigus, basilica, 481
Silchester, 344, 358
Silifke (Seleucia), 410
Simitthu, basilica, 578(19)[17]
Sirmione, 'Grotte di Catullo', 330–2 (fig. 128)
Sirmium, 516, 517, 536, 579(21)[1]
Slem, temple, 434, 436, 443
Smyrna (Izmir), 23, 547(3)[44]; agora, 395–7 (fig. 149); basilica, 373, 396 (fig. 149), 572(16)[6]; Kaisareion, 461; walls, 59
Soknopaiou Nēsos, 459
Sorrento, 558(6)[47]
Sosius, C., 185
Sounion, Temple of Athena, 379
Sovana, tombs, 68, 70–1 (fig. 43), 81, (Tomba Ildebranda,) 36, 38 (fig. 18), 45–6, 75
Spalato, *see* Split
Spello (Hispellum), Porta Venere, 304; Porta Santa Ventura, 308
Sperlonga, cave, 161; pavilion, 146
Spina, 10, 26, 61, 548(3)[45]
Split (Spalato), Palace of Diocletian, 333, 334, 366–7, 367, 457, 478, 512, 514, 517, 524, 524–9 (fig. 200), 532; *272*; Porta Aurea, 528 (fig. 201), 529
Stabiae, 'Villa di Arianna', 161
Statius, 156, 171
Stertinius, L., 126, 165
Stobi, theatre, 376 (fig. 146), 377, 382
Stonehenge, 4
Strabo, 10, 12, 22, 43, 61, 66, 96, 108, 115, 116, 119, 159, 173, 174–5, 179, 180, 402
Subiaco, Nero's villa, 328
Suetonius, 96, 152, 158, 169
Sufetula, *see* Sbeitla
Sulla, 25, 93, 116, 117, 137, 143, 148, 279
Sulmona, 'Villa d'Ovidio', 118, 124, 147, 149
Sümeg, villa, 527
Sur, temple, 441
Surkh Khotal, temple, 441
Susa, Arch of Augustus, 302, 303, 307, 308, 356; *162*
Sutri, amphitheatre, 297
Suweida, temple, 443
Syllion, odeion, 377
Syracuse, 115; amphitheatre, 297; Athenaeum, 16; granaries, 173
Syros, 76

T

Tacitus, 23, 40, 96, 138, 151, 162, 167, 168, 169, 172, 203

Tages (Etruscan lawgiver), 56

Talamone (Telamon), 25; Etruscan pediments from, 51, 134, 546(3)[30]

Tammuz, 417

Taqle, houses at, 428, 429 (fig. 161)

Taranto (Tarentum), 108, 165; walls, 103

Tarquinia
 Early Iron Age village, 13
 Etruscan town, 23, 25, 26, 57, 547(3)[41]; 'Ara della Regina' Temple, 35 (fig. 15), 38, 51, 134; tombs, 68, 70, 71, 78; (delle Bighe), 63; (del Cardinale), 66, 68 (fig. 39); (Giglioli), 81; *46*; (del Guerriero), 548(3)[54]; (of Hunting and Fishing), 548(3)[54]; walls, 59
 finds from: archaic stele, 19 (fig. 10); hut urn, 16, 18; *4*

Tarquinius Priscus, 63, 92, 92–3

Tarquinius Superbus, 92, 93

Tarragona, aqueduct, 341

Taurus, Statilius, 184

Tavoliere, Neolithic settlement, 5 (fig. 1)

Teano, temple model from, 33, 557(6)[23]; *11*

Tébessa (Theveste), 490; arch, 482; temple, 493

Telamon, *see* Talamone

Temnin el-Foka, temple, 575(18)[24]

Teos, Temple of Dionysus, 134

Terence, 165

Termessos, odeion, 377

Terni, amphitheatre, 297

Terracina, insula with tabernae, 119 (fig. 67), 121, 555(6)[5]; Temple of Jupiter Anxur, 136, 146–7, 219, 311; *81*; (terrace), 76, 146–7; *88*; tombs, 178, 555(6)[5]; villas, 321; walls, 97, 149

Terramare villages, 6, 10, 12

Tertullian, 115

Teuchira, *see* Tocra

Thabraca, mosaic from, 570(14)[38]

Thamugadi, *see* Timgad

Thapsus, rock-cut tombs, 9

Thenae, baths, 474 (fig. 176), 475

Theodosius I, Emperor, 239

Theophilus, Emperor, 532

Thessalonike (Salonica), 384, 385, 516, 517, 522–4, 536; arch, 522; hippodrome, 522; Mausoleum of Galerius, 522 (fig. 198), 523–4 (fig. 199); *266, 275*; palace, 522, 523

Theveste, *see* Tébessa

Thibilis (Announa), 490; Capitolium, 578(19)[20]; market, 578(19)[22]; temple, 491

Thorikos, Temple of Demeter, 379

Thrasyllus (astrologer), 326

Thuburbo Maius, 471, 490; baths, 486; Capitolium, 578(19)[20]; *256*; market, 578(19)[22]; Temple of

the Cereres, 491, 492 (fig. 187), 493; Temple of Mercury, 493; unidentified temple, 491; *257*

Thubursicu Numidarum, *see* Khamissa

Thugga, *see* Dougga

Thysdrus, *see* El-Djem

Tiberius, Emperor, 157, 184, 195, 196, 202–4, 205, 261, 310, 323, 328, 371, 390, 564(7)[2]

Tiberius Gracchus, 64

Tibur, *see* Tivoli

Tiddis (Castellum Tidditanorum), 299, 490

Timgad (Thamugadi), 105, 479 ff., 490, 493; arches, 482; *252*; basilica, 481; baths, 480, 483, 484 (fig. 182), 486; Capitolium, 310, 481, 491; curia, 481; forum, 480, 480–1 (fig. 180), 526; houses, 480; markets, 480, 482 (fig. 181), 483; plan, 479–80, 526; *251*; streets, 480, 491; *252*; temples, 467; theatre, 469, 480

Timon, lake dwellings, 10

Tipasa, 471, 490; basilica, 481; house, 487, 489 (fig. 186)

Titus, Emperor, 221, 224–6, 227, 426

Tivoli (Tibur), 22; travertine from, 117; Iron Age village, 13, cemetery, 14; Hadrian's Villa, 253, 254–6 (fig. 100), 262, 263, 265, 299, 327, 328–9 (fig. 127), 346, 475, 512, 513, 528, 579(20)[9]; *134–7, 174*; (Republican predecessor), 160, 321; market, 242; Temple of Hercules Victor, 122, 140, 141 (fig. 77), 168, 173, 188, 555(6)[7]; (terrace), 76, 121, 131, 146, 174; *74*; 'Tempio della Tosse', 509, 529; 'Temple of Vesta', 135 (fig. 75), 137; *83*; Tetrastyle Temple ('della Sibilla'), 135; *80*; tombs, 177; Villa di S. Antonio, 161, 560(6)[69]; warehouses, 174

Tocra (Teuchira), 464

Tomis, *see* Constanza

Toul, walls, 571(15)[10]

Trajan, Emperor, 226, 228, 229, 235–44, 266, 284, 285, 306, 340, 341, 365, 431, 432, 443, 447, 462, 479, 566(8)[19]

Tralles, 391

Trier (Augusta Treverorum), 516, 517, 517–22, 536; Altbachtal sanctuary, 350–1 (fig. 132), 517; amphitheatre, 517; Basilica, 444, 514–15, 517–18, 518–19 (fig. 195); *269, 271*; circus, 518; houses, 517; Imperial Baths ('Kaiserthermen'), 354, 518, 520, 521 (fig. 197); *270*; Palace, 523; Porta Nigra, 518, 520–2, 529, 568(12)[4]; *268*; St Barbara Baths, 517, 520; S. Iriminio Warehouses, 518, 519, 520 (fig. 196), 533; Temple of Lenus-Mars, 350 (fig. 132), 351, 517; walls, 517

Tripolis (Syria), gymnasium, 415

Tullus Hostilius, 93

Turin (Augusta Taurinorum), 103, 302; Porta Palatina, 304 (fig. 117), 307, 308, 345, 520

Tusci, villa, 154
Tusculum, 89; Torrione di Micara, 563(6)⁹⁶; villas, of Cicero, 570(14)²², of Hortensius, 161, of Lucullus, 162, of Varro, 570(14)²²
Tyndaris, theatre, 561(6)⁷⁶
Tyre, agora etc., 415; arch, 426; baths, 426; colonnaded street, 426; houses, 114, 568(12)⁵; Temple of Hercules-Melqarth, 426
Tyrrhenus, 24

U

Umm el-Jemal, houses, 446 (fig. 166), 447
Uthina, baths, 485; 'House of the Laberii', 578(19)²⁷
Utica, 490; baths, 485; House of the Figured Capitals, 464, 578(19)²⁷

V

Vaison-la-Romaine (Vasio), 356–7; House of the Silver Bust, 357–8 (fig. 136); 181; street, 358; 181
Valadier, Giuseppe, 227
Valentinian, Emperor, 517, 520
Valerian, Emperor, 527
Valerius of Ostia (architect), 168, 171
Vanvitelli, 253, 502
Varese, lake dwellings, 10
Varro, 16, 23, 27, 41, 42, 43, 55, 60, 65, 80, 84, 85, 87, 89, 91, 92, 93, 94, 95, 112, 120, 145, 152, 153, 155, 162, 318
Vazi Sarra, Arch of Mercurius Sobrius, 578(19)²¹
Vedius Antoninus, Publius, 399
Veii, 40, 59, 100
 Bronze Age finds, 8
 Early Iron Age village, 13, 16
 Etruscan town, 25, 26, 28, 57 (fig. 30), 64 (fig. 36), 65, 66, 70, 84, 85, 543(3)³; fortifications, 41, 58 (fig. 32), 59; Ponte Sodo, 77; temples, 29, 543(3)⁸, 544(3)¹³; (Portonaccio), 35, 36 (fig. 16), 38, 53 (fig. 28); tombs, 25, 68, (delle Anatre), 22, 548(3)⁵⁴, 549(3)⁵⁶, (Campana), 70, 548(3)⁵⁴
Velia, arched gateway, 76
Veldidena, warehouses, 533, 579(21)³
Velitrae, see Velletri
Velleia (Veleia), 301, 305–6 (fig. 118), 309–10, 346, 348; 167
Velleius Paterculus, 168
Velletri (Velitrae), Early Iron Age tombs, 13–14, 15 (fig. 7); Volscian town, temple model from, 37, 39 (fig. 20)
Venice, 61
Venusia, 108
Verdes, bath-building, 355 (fig. 135), 356
Verecunda, see Marcouna
Vergil, 3, 21, 22, 80, 87, 89, 147, 302

Vernègues, shrine, 350
Verona, 302; amphitheatre, 297, 353; Arch of the Gavii, 309; Porta dei Borsari, 308, 345; 166; (dei Leoni), 308, 345
Verulamium, see St Albans
Vespasian, Emperor, 191, 211, 217, 221, 226, 306, 568(13)¹
Vesunna Petrucoriorum, see Périgueux
Vetera, see Xanten
Vetulonia, Iron Age grave circles, 14; Etruscan town, 18, 25, 28, 57 (fig. 31), 65, 91, (tombs), 78, 79, 85
Vieil-Évreux (Gisacum), baths, 356
Vienne (Vienna), 342; odeion, 377; Temple, 136, (of Augustus and Livia), 348; theatre, 352–3
Vignanello, tomb with a Tuscan column, 45 (fig. 23), 545(3)²⁴
Villanovan culture, 13, 15
Vindonissa, gate, 305
Virunum, 364, 570(15)⁶
Vitruvius, 1, 10, 20, 26, 27 ff. passim, 87, 105, 106, 108, 110, 114, 115 ff. passim, 194, 196, 198, 199, 257, 281, 296, 311, 313, 314, 348, 374, 401, 472, 500
Vix, bowl from, 26
Volsinii, see Bolsena
Volterra (Volaterrae), 25, 29; city gate, 76; Tomba Inghirami, 81, 550(3)⁶⁹
Volubilis, 490; Arch of Caracalla, 578(19)²¹; House of Venus, 487, 488 (fig. 185)
Vrokastro, 28
Vulca (sculptor from Veii), 40, 52, 92
Vulci, ash urn from, 541(2)⁶
 Early Iron Age village, 13
 Etruscan town, 23, 25; column from, 44; temple, 35, 39; temple model from, 37, 136; 13; tombs, 80, (François), 68, 81, (of the Inscriptions), 550(3)⁷²

W

Welwyn, see Lockleys
Wroxeter, 344

X

Xanten (Vetera), amphitheatre, 353

Z

Zadar (Iader), forum-complex, 366, 570(15)⁶
Zana (Diana Veteranorum), Arch of Macrinus, 482
Zekweh, temple, 575(18)²⁴
Zenobia of Palmyra, 453, 498
Zernaki Tepe, 547(3)⁴⁴
Zor'ah, St George, 442